Joan Miró

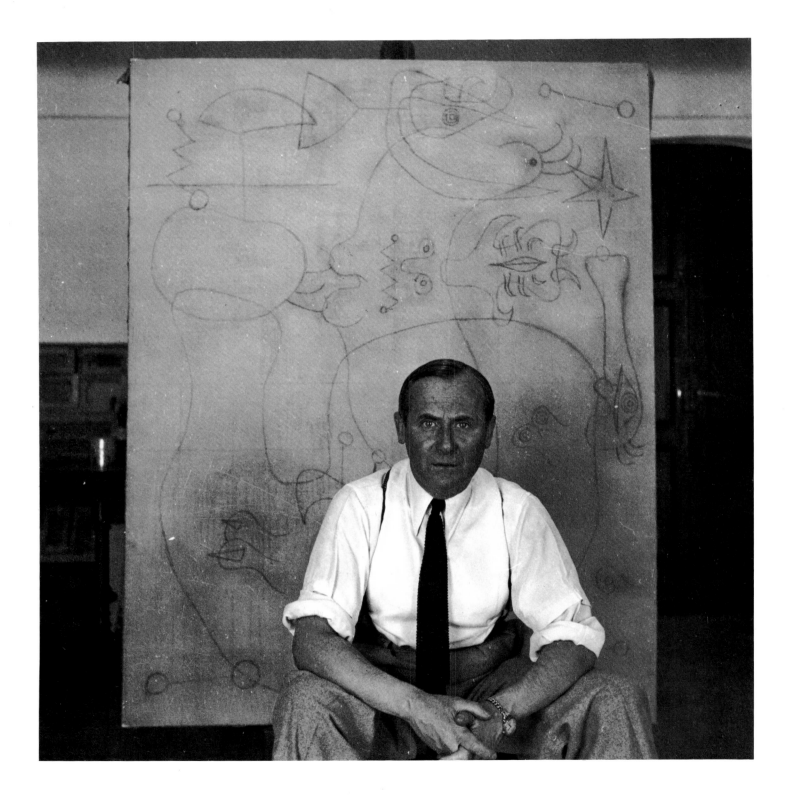

Joan Miró

Carolyn Lanchner

THE MUSEUM OF MODERN ART, NEW YORK

Published in conjunction with the exhibition "Joan Miró" at The Museum of Modern Art, New York, October 17, 1993–January 11, 1994 directed by Carolyn Lanchner, Curator, Department of Painting and Sculpture

The exhibition is sponsored by

ARGENTARIA

Corporación Bancaria de España

Support from the Generalitat of Catalonia (Autonomous Government of Catalonia) is also gratefully acknowledged. Additional support is provided by The International Council of The Museum of Modern Art and the National Endowment for the Arts.

An indemnity for the exhibition has been granted by the Federal Council on the Arts and the Humanities.

Transportation assistance has been provided by Iberia Airlines of Spain.

Produced by the Department of Publications
The Museum of Modern Art, New York
Osa Brown, Director of Publications
Edited by James Leggio
Designed by Steven Schoenfelder
Production by Tim McDonough
Composition by Trufont Typographers, New York
Color separation by L S Graphic, Inc., New York/Fotolito Gammacolor, Milan
Printed by L S Graphic, Inc., New York/Grafica Comense, Como
Bound by Novagrafica, Bergamo

Published by The Museum of Modern Art, 11 West 53 Street, New York, New York 10019

Clothbound edition distributed in the United States and Canada by Harry N. Abrams, Inc., New York. A Times Mirror Company

Printed in Italy

Front cover:
The Beautiful Bird Revealing the Unknown to a Pair of Lovers.
From the Constellation series. Montroig, July 23, 1941. (Cat. 176).
Gouache and oil wash on paper, 18 × 15″ (45.7 × 38.1 cm). The Museum of Modern Art, New York. Acquired through the Lillie P. Bliss Bequest

Back cover:
Self-Portrait I. Paris, October 1937–March 1938. (Cat. 146).
Pencil, crayon, and oil on canvas, 57 ½ × 38 ¼″ (146.1 × 97.2 cm). The Museum of Modern Art, New York. James Thrall Soby Bequest

Frontispiece:
Miró with an early state of *The Harbor* (p. 266), Barcelona, 1944. Photograph by Joaquim Gomis

*See Credits at page 484 for additional notices.

The Spaniard Joan Miró, whose centennial we celebrate this year, is one of a small number of artists who contributed decisively to the modern spirit. The most gifted painter to be associated with Surrealism, Miró pursued an essential art, creating a universe of great intensity where humor is never far away; freedom and rigor, poetry and craft are combined in a unique manner.

Argentaria recognizes that few institutions in the world have done as much as The Museum of Modern Art to promote the work of Miró. Among the first to recognize his genius, the Museum included Miró prominently in its pioneer exhibition of 1936, "Fantastic Art, Dada, Surrealism," and five years later, in 1941, mounted the first major museum retrospective of the artist's oeuvre.

Argentaria is proud to sponsor this magnificent exhibition, and to support both the timeless values that characterize Miró's art and the first museum to celebrate the genius of this great artist.

<div align="center">

Francisco Luzón
Chairman
ARGENTARIA
Corporación Bancaria de España

</div>

Contents

Foreword

This volume is published on the occasion of the retrospective exhibition "Joan Miró," held to honor one of the century's greatest artists in the centennial year of his birth. In addition to celebrating the achievement of Miró, the exhibition extends a long tradition of The Museum of Modern Art's exhibition program: to offer for comprehensive examination and reassessment works by individual major artists of the modern period.

Miró, twenty-four years younger than Matisse and twelve years younger than Picasso, was not the subject of a single-artist show at this museum until somewhat after his older peers. However, that exhibition, which took place in 1941, was the first major museum retrospective of Miró's work to be mounted anywhere in the world. Thereafter the Museum organized major Miró shows in 1959 and 1973. The present exhibition, just twenty years after the last devoted to Miró, continues the pattern established of affording the public a fresh look at Miró's work at roughly generational intervals. While Miró exhibitions have been held elsewhere, none in this country has attempted to represent the artist's work as fully as this centennial homage, which covers the entire range of the artist's career from 1915 until his death in 1983, and presents examples of virtually all the many mediums in which he worked. In undertaking this ambitious project, the Museum acts on the conviction that during this closing decade of the century, a reexamination of Miró's career will deepen our understanding of the nature of his contribution to our time.

No project of this scale can be realized without the generosity and cooperation of a great number of people and institutions. We have been very fortunate in the support we have received, and are deeply grateful to all who have assisted us. Our thanks to the many lenders to this exhibition and others who contributed to its realization are expressed elsewhere in this volume. However, we must acknowledge here a special debt to those institutions and private collectors who made multiple loans, depriving themselves for a time of large groups of major works. Prominent among such lenders are our colleagues at the Fundació Joan Miró, Barcelona; the Museo Nacional Centro de Arte Reina Sofía, Madrid; the Fundació Pilar i Joan Miró a Mallorca; and the Musée National d'Art Moderne, Centre Georges Pompidou, Paris; as well as those in Philadelphia, Chicago, Baltimore, and Washington. Among private collectors we owe immense gratitude to members of the Miró family, and we express to them our profound appreciation for their warm support and generosity.

Thanks should also be extended to the staff of The Museum of Modern Art, almost all of whom contribute in some degree to the realization of an endeavor of this scale. Foremost among them in this instance is Carolyn Lanchner, Curator in the Department of Painting and Sculpture, and Director of the Exhibition. With personal dedication to expanding appreciation and understanding of Miró's work, she has worked tirelessly, creatively, and most effectively to plan and accomplish this exhibition and publication.

The scope and complexity of this retrospective necessarily entail high costs. We are deeply appreciative of the generous sponsorship provided by Argentaria, Corporación Bancaria de España. Support from the Generalitat of Catalonia (Autonomous Government of Catalonia) is also most gratefully acknowledged.

Continuing their admirable history of assisting significant programs, the Museum's International Council and the National Endowment for the Arts made generous grants in support of this exhibition. Finally, the exhibition would not have been possible without the indemnity received from the Federal Council on the Arts and the Humanities.

Richard E. Oldenburg
Director
The Museum of Modern Art

Preface and Acknowledgments

The principal goal of this centennial tribute to Miró is to clarify his identity as a modern artist. Although Miró has been the subject of many exhibitions and a vast literature, a tendency to underestimate the rich variety of his work persists, and the mythology surrounding his working methods has rarely been examined. This exhibition and publication therefore seek to provide a comprehensive account of the many facets of Miró's art as well as to illuminate some particular aspects of his creative thinking. As with all great artists, the mystery of Miró's creative process cannot be unraveled, but it is hoped that the exhibition and book will provide the opportunity for a broader understanding of the oeuvre as a whole and will return viewers and readers to the art itself, where new possibilities will be revealed.

Our primary focus in the exhibition has been on Miró's painting, the medium most completely represented. Included are some one hundred sixty paintings, among them many widely acknowledged to be his greatest but also some less well known that have been exhibited only very rarely. In every case, though, our aim has been to select art-historically important paintings of the highest possible quality that, taken together, will represent every important phase of the artist's career. But paintings alone would not do justice to Miró, whose creative energies were also deeply invested in drawing, sculpture, ceramics, printmaking, and book illustration. Since these activities engaged him so intensely, are so interlinked with one another and intimately tied to his painting, it seemed essential that they be represented. Space limitations, however, precluded giving a truly comprehensive account of Miró's adventures in these mediums; we have, therefore, attempted to bring together examples of each sufficient to represent the scope and variety of Miró's achievement.

The exhibition is organized to follow Miró's general practice of working in series. Far more often than not, Miró after 1924 conceived and executed his work in distinct series. One of our major efforts has been to reunite as many significant objects from as many important series as possible. Visitors to the exhibition have the almost miraculous opportunity to see reassembled within this show — for the first time since their departure from Miró's studio — all of the twenty-three paintings on paper of 1940–41 known as the Constellations. Characterized by André Breton as "a *series* in the most privileged sense of the term," the Constellations manifest the full force of Miró's pictorial dynamics and poetic imagery. Appearing at a major transitional point in Miró's career, the Constellations both recapitulate his pre–World War II work and stake out the paths he subsequently followed. Rewarding results have come also from many of our other efforts to bring important series together. But not all our attempts have met with complete success. The individual absences some visitors may note are owed, in certain cases, to the fact that works were unobtainable and, in others, to our own limitations of space. For this reason, we have, on occasion, reproduced in the plates and the Catalogue section of this book essential works that were unavailable to the exhibition.

Although the preparation of any exhibition inevitably brings some disappointments, they have been surprisingly rare in this instance. Thanks to the support of nearly all the important public and private collections of his work, we have been able to assemble a retrospective adequate to Miró's achievement. If we put much energy into reuniting his series, it was so that they might be seen within the network of relations that interconnects across the entire oeuvre. Including many masterpieces from the early period and selected, catalytic works that fall between series, while encompassing the many mediums in which he worked, this exhibition should provide the basis for a fresh appreciation of the artist.

The aim of this book has been to retrieve what we can know about Miró. That somewhat grandiose aim was, of course, subject to the constraints on research time, travel, and available number of book pages that inevitably are imposed on a project of this nature. If our quasi-archaeological approach has been hampered by those limitations, I nonetheless believe that the results of our efforts published here will furnish a foundation for altered understandings of Miró. My essay focuses largely on Miró's art in relation to the serial character of his working methods, and examines the structural characteristics of certain of his works during the developmental years between 1923 and 1945, thereby contributing, I hope, to a clearer comprehension of his creative processes. Anne Umland's Chronology, as printed here, represents only a fraction of the material she compiled; nevertheless, it disentangles many of the conflicts between previously published chronologies of the artist, presents much new material from primary sources, and provides a means to assess more accurately the events in Miró's life in relation to his art.

Lilian Tone's Catalogue, documenting the history of every painting reproduced, should be an invaluable tool to all students of Miró's art.

An exhibition of this scale and ambition owes its existence to the assistance and collaboration of a great many individuals and institutions. We have been most fortunate in the extraordinarily generous help we have received, and the good will with which it has been given.

Our first debt of gratitude is to the lenders, public and private, without whom this exhibition could not have been realized. Those who allowed us to publish their names are listed in the Lenders to the Exhibition, printed elsewhere in this publication. Here, however, we want to add our profound thanks for their indispensable contribution to this project.

We are very specially indebted to the members of the Miró family, who not only are generous lenders but have supported this endeavor with a largeness of spirit and deed that has been extraordinary. They have as well given freely of their time and thought and shared their memories of Miró with us. We extend our warmest thanks to the artist's widow, Pilar Juncosa de Miró, to her daughter, Maria Dolores Miró de Punyet, and to the rest of the family, Emilio Fernández Miró, Cristina Jimenez, Teodoro Punyet Roigé, Teodoro Punyet Miró, Joanet Punyet Miró, and Lluís Juncosa. Lastly, with profound sadness at his early death, we thank David Fernández Miró, who in the last summer of his life helped me greatly with the early preparations for this exhibition.

Many museums have made uncommon concessions so that crucial works could be included in the exhibition. At the Musée National d'Art Moderne, Centre Georges Pompidou, Paris, we owe very special thanks to the generosity of our colleague and friend Dominique Bozo, who, as so often in the past, made work a pleasure and an object lesson in museum professionalism. We are grateful as well to Germain Viatte and Margit Rowell. We worked particularly closely with Ms. Rowell, who organized the Miró exhibition held earlier this year at the Museo Nacional Centro de Arte Reina Sofía, Madrid. A renowned scholar of Miró's work, Ms. Rowell willingly shared her profound knowledge of the artist with us and, along with her colleagues at the Centro de Arte Reina Sofía, María de Corral and Ylva Rouse, brought to all our dealings a professional courtesy and directness that we both admire and appreciate. We owe an enormous debt of gratitude to the Philadelphia Museum of Art and Anne d'Harnoncourt and Ann Temkin, as we do to The Art Institute of Chicago and James N. Wood and Charles F. Stuckey. Other museum directors and curators to whom special thanks are due for important multiple loans include: at The Baltimore Museum of Art, Arnold L. Lehman and Brenda Richardson; at the Fundació Joan Miró, Barcelona, Rosa Maria Malet, Victòria Izquierdo, Jordi Juncosa, Teresa Montaner, and Carme Escudero; at the Kunstsammlung Nordrhein-Westfalen, Düsseldorf, Armin Zweite and Volkmar Essers; at The Metropolitan Museum of Art, New York, William S. Lieberman; at the Fundació Pilar i Joan Miró a Mallorca, Pablo Rico Lacasa, Maria Francisca Rosselló Borràs, and Aina Bibiloni.

We owe thanks also to numerous other museum colleagues who have in various ways assisted in the realization of this project. Robert R. Littman, Director of the Centro Cultural Arte Contemporáneo, Mexico City, was generous, effective, and gracious in the aid he gave us. We are also most indebted to Stephanie Barron, Kay Bearman, Agnès de la Beaumelle, Peter Berkes, Manuel J. Borja-Villel, Ada Bortoluzzi, Martine Briand, E. John Bullard, Richard Calvocoressi, Laura Catalano, Núria Costa, Deanna Cross, Susan Davidson, Lisa Dennison, Christian Derouet, Carol S. Eliel, Patrick Elliott, Paloma Esteban, William A. Fagaly, Jean E. Feinberg, Siegfried Gohr, Keith Hartley, Melanie F. Harwood, Samuel K. Heath, Walter Hopps, Joseph D. Ketner, Christian Klemm, Kyriakos Koutsomallis, Tamatha Kuenz, Dan Kushel, William Leischer, Timothy Lennon, Michael Lloyd, Karla Loring, Teresa Martí, Paule Mazouet, Patrick McCaughey, Gillian McMillan, Isabelle Monod-Fontaine, Mary Murphy, Juliet Nations-Powell, Marco Obrist, Erika D. Passantino, Pat Pecoraro, Suzanne Penn, Joann Potter, Lieschen Potuznik, Nancy Press, Brigid Pudney-Schmidt, Samar Qandil, Rosa Reixats, José Sommer Ribeiro, Fiona Robertson, Cynthia Roman, Nathalie Schoeller, Daniel Schulman, Douglas G. Schultz, Mary Sebera, Hélène Seckel, Lubomír Slavíček, Mikio Soejima, Florence Willer-Perrard, John Wilson, and Paul Winkler.

This undertaking has drawn on the expertise of many Miró specialists and scholars. Foremost among them, we are indebted to Jacques Dupin; even had he not assisted in the innumerable ways he did, this project would have relied heavily on his still-indispensable 1962 book. A scholar and poet, and an old friend of Miró's, Dupin made his archives, correspondence, and his profound knowledge of the artist liberally available to us. He and his research assistant, Ariane Lelong-Mainaud, responded to our many queries with a truly rare grace and generosity; their contribution has been enormous. Robert S. Lubar was also exceptionally generous in sharing his expertise with us; his readiness to offer his deep knowledge of Miró's art and of Catalan culture at its roots was invaluably helpful. Special thanks are due also to William Jeffett, who very kindly made the results of his research available to us. Among the others who have given freely of their knowledge, we extend thanks to Frances Beatty-Adler, Maria Lluïsa Borràs, Victoria Combalía, Rory Terence Doepel, Malcolm Gee, Christopher Green, Dorothy M. Kosinsky, Françoise Levaillant, and Georges Raillard.

This project owes a great debt to the cooperation of many individuals at libraries and archives within and

outside the United States, whom we should like to thank: Valerie Balint, Karen Brungardt, Carole Callow, François Chapon, Montserrat Comas, Mary F. Daniels, Yves de Fontbrune, Vera d'Horta, Manuel Jorba, Stephen King, Linda Krenzin, Margaret Kulis, Renate Lance, Jordi Madern, Elizabeth Martinet, Takeshi Mizutani, Florence Mollien-Chauveau, Dominique Moyen, Ben Raemaekers, Caritat Grau Sala, Mireille Salen, Abigail G. Smith, and Michael Sweeney.

Many people have graciously assisted in the difficult task of compiling provenance information; among them we thank Anna Astner, Walter Bareiss, Perry Benson, Richard Deutsch, Louise Tolliver Deutschman, Paulo Figueiredo, Franc Giraud, James Laughlin, Jan Mitchell, Hans Neumann, Lawrence Rubin, and Ann Zwemmer.

Numerous individuals have been instrumental in helping us trace and secure loans. Here, we are grateful to Alexander Apsis, Celeste G. and Armand P. Bartos, Ernst Beyeler, Paul Bonaventura, Christopher Burge, Pietro Cicognani, Mrs. Gustavo Cisneros, Alexina Duchamp, Marie-Jeanne Dypréau, Jacques Elbaz, Richard L. Feigen, Michael Findlay, Marcel Fleiss, Dana Friis-Hansen, Eliane Ganz, Christian Geelhaar, Mariko Goto, Jean-Michel Goutier, Richard Gray, Pamela Griffin, Gilbert Haas, Stephen Hahn, Phyllis Hattis, Frederick D. Hill, James Berry Hill, Katherine Hinds, Nicole d'Huart, Catherine Lampert, the late Michel Leiris, Daniel Lelong, Wendy Loges, James Mayor, Jacqueline Monnier, Donald and Florence M. Morris, Claudia Neugebauer, Carlo Perrone, Emily Rauh Pulitzer and Joseph Pulitzer, Jr., John Richardson, Michèle Richet, Angela Rosengart, Werner Spies, David Sylvester, Tsutomu Takashima, John L. Tancock, Patricia P. Tang, Timothy Taylor, Eugene Thaw, and Marke Zervudachi.

We are immensely indebted to William Acquavella, who not only is an extraordinarily generous lender but responded with unfailing patience and generous assistance to the many requests we made of him. We are grateful to him, and to his assistants, Jean Edmonson and Kimberly Vick, also for valuable information provided to us from gallery files. At Acquavella Modern Art, Turkey Stremmel and Kathleen Akers were most helpful. Likewise we owe a deep debt of gratitude to the Galerie Maeght, Paris, which, in addition to lending generously, has helped us in myriad ways. Most particularly, we wish to thank Yoyo Maeght, who with great grace took much time from her very busy schedule to give invaluable help with this project, and Louis Gendre, who also aided us in important ways.

Very special thanks are due to the Pierre Matisse Foundation and its staff. Maria-Gaetana Matisse is a lender, and in other ways one of our most valued supporters. She and the other trustees of the Foundation allowed us access to the rich resource of the Miró/Matisse correspondence in the Foundation's archives; in countless other ways Mrs. Matisse responded with patience, gener-

osity, and wit to our seemingly endless demands. It has been my great good fortune and pleasure to work with her. We owe an incalculable debt to Andrea Farrington, who with astonishing good will and efficiency gave us vast amounts of her time and expertise. We are grateful as well to Olive Bragazzi, Sandra Carnielli, Elisabeth Farkas, and Margaret Loudon. At a variety of galleries we would like to thank Guy-Patrice Dauberville, Evelyne Ferlay, Jim Healy, Pascale Krausz, Elisabeth Kübler, Melissa De Medeiros, Andrew Murray, the staff of Charles Ratton and Guy Ladrière, Alison Read, and Samuel Lorin Trower.

Others who have facilitated this project and to whom we owe much gratitude are: Anna Agustí, Miguel I. de Aldasoro, David Allison, Chantal Bamberger-Bozo, Maria Ignez Corrêa da Costa Barbosa, Monique Beudert, Katherine Hutin Blay, Milton Blay, Diane Bouchard, Louise Bourgeois, Brian Boylan, Gilberte Brassaï, William Brown, Christophe Bürgi, Dominique Bürgi, Rina Carvajal, Francesc Català-Roca, Joyce Chambers, Susan Cooke, Sergio Corrêa Affonso da Costa, Oswaldo Corrêa da Costa, Patrick Cramer, Françoise Daix, Pierre Daix, Inge Hacker, Ursula Hätje, Gloria Henry, Yoko Hino, Dona Hochart, Mrs. Georges Hugnet, Ulla Hyttinge, Jean-François Jaeger, Shirley Jaffe, Maurice Jardot, Gloria Kirby, Pedro Corrêa do Lago, Alicia Legg, Cary Lochtenberg, Albert Loeb, Sylvia Lorent, Dora Maar, Terence Mahon, Mrs. Le Roy Makepeace, Ivo Mesquita, Jonathan Miller, Zuka Mitelberg, Toby Molenaar, Esty Neuman, Arnold Newman, Lydia Pfyl-Betschart, Charles A. Platt, Eva Prats, Mervin Richard, Mary Lloyd Robb, Robert Rosenblum, Prudence L. Rosenthal, Helene A. Rundell, Pierre Sernet, Anna Marie Shapiro, Robert Shapiro, Richard Sisson, Mary Beth Smalley, Michel Soskine, Edward J. Sullivan, Ciannait Tait, Katrin Theodoli, Anne Trembley, Michael Tropea, Luisa del Valle Firouz, Sue Erpf Van de Bovenkamp, Lola Mitjans de Vilarasau, Joanna Watsky, Sarah White, Neil Winokur, Rosalie S. Wolff, and John S. Zvereff.

A very large and particular debt is owed to David J. Nash, who with great good will gave freely of his time and expertise in connection with our application for U.S. Government Indemnification. We are also grateful to him and to his assistant, Tom Cashin, for valuable information provided to us from Sotheby's files. Clark B. Winter, Jr., more than merits our gratitude for the assistance he gave us in obtaining funding for this exhibition.

Within the Museum, the preparation of the exhibition and publication has drawn upon the resources of virtually every department. My foremost thanks go to the Museum's Director, Richard E. Oldenburg, who despite the pressures of a very heavy schedule always made time to assist with loan negotiations and other problems that inevitably arose. I am also indebted to Ethel Shein, Executive Assistant to the Director, who has significantly contributed to the realization of this project, and to Bonnie Weissblatt for the good humor and efficiency with which she met the addi-

tional demands it imposed. I also deeply appreciate the confidence and trust of Kirk Varnedoe, Chief Curator of the Department of Painting and Sculpture, whose quiet but extremely effective support was always to be relied upon in difficult moments.

As usual, the role played by Richard L. Palmer, Coordinator of Exhibitions, has been crucial to the accomplishment of this exhibition. Although sorely pressed by the many demands of the Museum's extensive programs, he nonetheless brought his characteristic skill and intelligence to overseeing the complicated logistics of this exhibition's organization. In many fundamental ways this project owes its existence to his professionalism and expertise; his contribution has been nothing less than essential — I am deeply grateful to him. He has been ably assisted by Eleni Cocordas, who attended to many important issues, as well as by Rosette Bakish and Maria DeMarco.

Once again it has been my good fortune to have had the advice and support of Beverly M. Wolff, the Museum's Secretary and General Counsel; she has contributed invaluably to the realization of both the exhibition and publication. The Museum owes her a great debt. In her office, we very sincerely thank Charles Danziger and Carol Rosenfeld for their most effective assistance.

Very particular thanks must go to Sue B. Dorn, Deputy Director for Development and Public Affairs; despite a difficult economic climate, she has worked tirelessly and effectively to enlist support for this exhibition. We are deeply grateful to her. Her assistant, Carolyn Breidenbach, also has our sincere gratitude. We owe thanks as well to Daniel Vecchitto, Director of Development, and John L. Wielk, Manager, Exhibition and Project Funding, and to William Fellenberg, Director of Membership, who have been deeply involved in, respectively, the funding and membership aspects of this project.

James S. Snyder, Deputy Director for Planning and Program Support, has played an important role in the administrative and organizational aspects of mounting the exhibition. With his customary skill, James Gara, Director of Finance, has attended to the financial planning of this project. For their active interest and energetic efforts to assure the broadest dissemination of information regarding the exhibition, I am deeply grateful to Jeanne Collins, former Director of Public Information, to Jessica Schwartz, Acting Director, Lucy O'Brien, Alexandra Partow, and Rynn Williams. In the Department of Education, my gratitude goes to Carol Morgan, Emily Kies Folpe, Romy Phillips, and Sarah Stephenson, who have been involved with the preparation of gallery texts, brochures, and plans for lectures, and to Chelsea Romersa and Donna Lindo, for their invaluable assistance with internships.

The complex logistics of this exhibition have placed a considerable burden on the Department of Registration. Diane Farynyk, Registrar, and Aileen Chuk, Administra-tive Manager, have smoothly and proficiently coordinated a daunting volume of shipping and in-house transportation of works of art; I cannot adequately express my thanks to either of them. Others in the department who deserve deep appreciation are Ramona Bannayan, Enrique Juncosa Darder, Alexandria Mendelson, and Nestor Montilla.

To the Department of Conservation I owe a very special debt. Its members have given their customary scrupulous care and attention to loans entrusted to the Museum, but beyond that they played an essential role in the research for this exhibition and publication. At my request they closely examined all the works by Miró in our collection (and some in others), with often revealing results. For this, I am especially grateful to Antoinette King, Director of Conservation, and James Coddington, our principal painting conservator; their patience and enthusiasm were unflagging. I cannot thank them sufficiently. I also owe many thanks to Anny Aviram, Karl Buchberg, Patricia Houlihan, Heather Galloway, and Erika Mosier.

Jerome Neuner, Director of Exhibition Production and Design, and Karen Meyerhoff, Assistant Director, have been of inestimable help in devising the installation and in related matters. Joan Howard and her staff in the Department of Special Events have skillfully and graciously attended to organizing events related to the opening of the exhibition, for which we are most grateful. Others who have contributed in a multitude of ways are Neil Clark, Walter Golinowski, Melanie Monios, Jo Pike, and Robert Stalbow.

An exhibition and publication of such scope are necessarily dependent on our Library and its staff, and this project has drawn on the resources of the Library most extensively. In this, we have been much aided by Clive Phillpot, Director, Janis Eckdahl, and Eumie Imm. Very special thanks are due Rona Roob, Museum Archivist, who took an informed interest in the project from its inception; her knowledge, not only of the Library's holdings but of national and international archival sources, has been invaluable. We are deeply grateful to her and her assistant, Rachel Wild. The Department of Rights and Reproductions most efficiently accepted the additional burdens we placed on it. We extend our thanks to its former Director, Richard L. Tooke, to its present Director, Mikki Carpenter, and to Thomas D. Grischkowsky and Ruth Janson. Kate Keller and Mali Olatunji have our sincere gratitude for producing photographs used in this publication.

The preparation of this book has been an enormous, complex task, and I am profoundly indebted to the dedicated members of the Department of Publications. Osa Brown, its Director, saw from the beginning that this exhibition should have a catalogue of the dimensions it merited and worked selflessly to make it possible. Paul Gottlieb, President of Harry N. Abrams, Inc., concurred,

12

despite discouraging economic indications, as did Harriet Schoenholz Bee, Managing Editor at the Museum. For their efforts and for their confidence, I am deeply grateful. It was my great good fortune and pleasure to work for the first time with James Leggio, who edited this extremely complex publication with consummate skill and a quietly dazzling intelligence. He has contributed innumerable improvements to every aspect of it; no words are adequate to express my debt to him. I would also like to offer my most profound thanks to Timothy McDonough, Production Manager, who, as always, brought the highest professionalism to overseeing all phases of the book's production, especially in the making of the color plates. It was once again a pleasure to work with him, as it was to work with Steven Schoenfelder, who designed this book with his characteristic sensitivity and high graphic ability. They have my most sincere gratitude and admiration. Michael Hentges, Director of Graphics, is also owed a great debt. Essential contributions were made as well by Alexandra Bonfante-Warren, Louise L. Chinn, Anna Jardine, Nancy T. Kranz, Kara Orr, Barbara Ross, Marisa Scali, Rachel Schreck, and Alarik Skarstrom, for which I am very grateful.

To my colleagues in the other curatorial departments of the Museum goes my deep appreciation for their support of a project whose scope necessarily caused them inconvenience. I am especially grateful to Riva Castleman, Chief Curator of the Department of Prints and Illustrated Books, and to Deborah Wye, Curator in the same department, who were effectively collaborators in the realization of this exhibition. Its print section was selected by Ms. Wye from the Museum's collection and other New York City sources and is installed in the department's galleries. For their collegial cooperation, good will, and professionalism, I sincerely thank them. In the Department of Drawings, special thanks are owed to Magdalena Dabrowski, Curator, and Beatrice Kernan, Associate Curator, whose advice and tangible assistance have been invaluable. Mary Chan, Kathleen Curry, and Robert Evren have also made contributions. I am grateful as well to Peter Galassi, Chief Curator of the Department of Photography, and to Susan Kismaric, Curator in the same department, both of whom have helped in important ways, as has Terence Riley, Chief Curator of the Department of Architecture and Design. A very special debt is owed John Elderfield, Chief Curator at Large, whose sympathetic understanding, counsel, and support have been invaluable.

The main burden of this project has fallen on the Department of Painting and Sculpture, and particularly on the curatorial and research team that worked directly with me in the preparation of both the book and exhibition. William Rubin, Director Emeritus of the department, has always encouraged this ambitious endeavor and generously been willing to give advice or assistance whenever called upon; I am deeply grateful to him. Cora Rosevear, Associate Curator, was exceptionally sensitive to problems of loan arrangements and has given much needed help, as has her assistant, Susan Bates Schlotterbeck. Gregg Clifton, Judith Cousins, Fereshteh Daftari, and Victoria Garvin have all made significant contributions. Robert Storr, Curator, has been supportive in many ways, not least in lending me books I despaired of finding. Outside those who were working directly on this project, my deepest thanks are owed to Kynaston McShine, Senior Curator, whose support, sympathetic counsel, and strategic sense of humor were always to be relied upon.

The project has benefited from the efforts of a number of outside researchers and interns of extraordinary efficiency who worked on it for varying periods over the three years of its preparation. Sincere thanks go to Maud Abeel, Rocio Barreiros, Carlos Basualdo, Jane Rachel Becker, Rejane Lassandro Cintrão, Aida Cordeiro, Erika Cosby, Christina DeFelice, Gloria Ferreira, Emilie E. S. Gordenker, Miranda Hanbro, Christel Hollevoet, and Dale Hudson. Sol Enjuanes Puyol's research in Barcelona has proved invaluable. We are profoundly indebted to Cristina Portell, who translated a vast volume of Miró correspondence from the Catalan; her work was essential to our research. We are also grateful to Mary Ann Newman for her Catalan translations.

Among all who have worked on this enterprise, I must single out those who have been most intimately involved with it — Adrian Sudhalter, Lilian Tone, and Anne Umland — to whom the Museum and I are inexpressibly indebted. Collectively, they were a "dream team," and individually, each a model of professionalism, talent, and intelligence. Adrian Sudhalter, who came to the project when it was already well under way, mastered its manifold complexities of content and procedure in almost no time. Her competence has extended from the most detailed tasks to those requiring highly imaginative problem-solving. I have relied on her efficiency as I have on such talents as her impeccable eye in matters of graphic presentation. Lilian Tone was responsible for the Exhibition History as well as the Catalogue section of this book, a vast undertaking for which we had too little time, yet her superb research ability, innate accuracy, and unwavering commitment accomplished what seemed a nearly impossible task. The Miró documentation she has assembled will remain an essential archival resource long after this exhibition has closed. Anne Umland, who has worked on this project almost since its inception, has been a collaborator in the truest sense. She not only handled many of the nitty-gritty particulars of exhibition organization but managed at the same time to compile the admirable Chronology. I have relied on her curatorial judgment and scholarly insight in every phase of this endeavor, from selection to installation. Without her critical support, neither exhibition nor book would have been possible.

C.L.

Peinture-Poésie, Its Logic and Logistics

Carolyn Lanchner

*I have always evaluated the poetic content according
to its plastic possibilities.*
 — Joan Miró

L'art est la science du poète.
 — Bertrand Aloysius, *Gaspard de la nuit*

A philosophy is never a house; it is a construction site.
 — Georges Bataille

Joan Miró wrote from Montroig on July 31, 1922, to his friend Roland Tual
in Paris: "I am sure that we, the young people who had the good fortune to
be born after Picasso . . . have a goal of capital importance. I am sure that we
are living in a wonderful time, a blessed time that will bear fruit. This is a
period that demands a great sense of individual responsibility."[1] Having
finished *The Farm* (p. 107) some three months before, Miró was now slowly,
but feverishly, at work on a group of paintings of "humble things"; the effort
"to give these things an expressive life wears me out terribly," he told Tual.
"After a work session I fall into a chair, totally exhausted, as though I had just
made love! . . . Each day I become more exacting with myself, which means
that I will redo a painting if a single corner is off by one millimeter to the left
or right."[2] Written when he was twenty-nine years old, these statements show
Miró to be self-consciously aware of the moment in history, and his place in
it, just as he is driven by a private, passionate will to create the unfamiliar
out of the familiar. They also bear witness to what one great poet called that
"laborious element" common to "fortunate poetry or painting, which, when it
is exercised, is not only labor but consummation as well."[3]

If Miró's art has come to exemplify what is known as *peinture-poésie,* it does
not wholly fit the term's definition as painting based on "a commitment to sub-
jects of a visionary, poetic, and hence, metaphoric order,"[4] for it is not the
subjects chosen but their treatment that qualifies his work as poetic. The ar-

dent desire to reveal the marvelous in the quotidian that the young artist tries to describe to Tual was to remain the driving force behind the many endeavors of Miró's long career. Moreover, the obsessive surveillance of his own methods that Miró recounts was to be a near constant in his later work. While his oeuvre now stands as the paradigm of all that is free and spontaneous in twentieth-century art, the tortuous paths he took to its achievement — although competently, even poetically, charted in the literature[5] — have often been misunderstood. By examining the formulation and practice of Miró's aesthetic strategies — the "logistics" of his art — during the first half of his career, the main part of this essay will attempt to increase our knowledge of how certain of Miró's works came into being. Like creation itself, the artist's inner creative process is ultimately unknowable; nonetheless, an investigation into its working mechanics, as developed by Miró, should bring us closer to understanding not only the logistics but the generative logic of the oeuvre.

But before attempting to identify salient aspects of Miró's working methods in the developmental years between 1923 and 1945 (the subject taken up in part II of this essay), an account of his arrival in the international avant-garde, and of the emerging character of his art, is in order.

I. Explorations

In declaring to Tual in 1922 that theirs was a generation fortunate to be born after Picasso, Miró reveals an appreciation of the potential for discovery within his particular time. Cubism, art's dominant game, had by then largely made its moves, displayed itself in its full range of permutations. Its earlier vitality exhausted, it had already become in Miró's eyes "classic" — no longer to be played through, but played from. To reformulate a famous declaration of Miró's, it is as if he were here saying to Tual, "How lucky that we have Cubism's guitar to break!" Its destruction was thus to be an act of construction and, implicitly, of homage. During the first half of the twenties, when that act seemed, as Miró remembers, to interest no one, the master guitar-maker was there to offer support: on one occasion Picasso told a discouraged Miró, "Pretend you're waiting for the subway; you have to get in line. Wait your turn, after all."[6]

The Turbulent Entry

There are several arguable opinions about just when Miró's turn came, but one authoritative view is that of André Breton, who in 1941 wrote: "Miró's turbulent entry upon the scene in 1924 marked an important stage in the development of Surrealist art."[7] That Breton should re-member Miró's entrance as turbulent — whereas he recalls Tanguy as making an "apparition," Magritte an "approach," and Dalí as "insinuating himself" — would seem to evidence an assessment of Miró's character and historical impact. Breton, in fact, credits Miró with the achievement of "a total spontaneity of expression . . . unrivalled innocence and freedom," and even speculates that Miró was a determining factor in what Breton sees as Picasso's "decision to throw in his lot with the Surrealists." But Breton's 1941 opinion of Miró was not wholly affirmative, concluding that what he considered the artist's arrested development had "set limits, intellectually, to the scope of his testimony."[8]

Earlier, in his 1928 book, *Le Surréalisme et la peinture*, justifying the cohabitation of painting and Surrealism, Breton had been equally impressed with Miró and equally disparaging — because, it would seem, although Miró validated pictorial Surrealism, he was nonetheless indifferent to its extra-pictorial mission. In Breton's Surrealist rhetoric of the time, the prescribed methodology for literature or the plastic arts was that form of psychic automatism which he had earlier invented and defined as "dictation by thought, in the absence of any control exercised by reason, and beyond any aesthetic or moral preoccupation."[9] The purer the practice, the more fully Surrealist would be the resulting work. Assessing Miró's pictures, Breton comes to the grudging conclusion that "unaided, Miró has verified in very summary fashion the profound value and significance of that pure automatism which, for my part, I have never ceased to invoke. . . . That may be the very reason why he could perhaps pass for the most 'Surrealist' of us all." But he laments Miró's lack of the "chemistry of the intellect" that sustains Breton himself and, he says, André Masson. This property that Miró does not have appears to be an adversarial ethos, a moral commitment to hold painting suspect. In contrast to Miró, Masson is commended by Breton for his distrust of art, which is "alive with snares." Here, Breton associates himself with Western culture's long tradition of iconophobia and the attendant political consequences; what Breton fears in painting is its potential power to speak in its own name. It must therefore, in the Surrealist regime as in any other, be contained or exploited. Miró's lack is thus his perceived inability to understand, "whether from spiritual or pragmatic reasons," his proper role as Surrealist foot soldier; for Breton, his art should be no more than a recruit in a cause that transcends painting.

It has been remarked elsewhere that Breton is less than consistent in his attempt to unite painting and Surrealist theory. He masks their incompatibility in extravagant folds of language, but acknowledges it by indirection; of the twelve artists discussed at any length in *Le Surréalisme et la peinture*, none besides Miró is designated as Surrealist. Called the most Surrealist of *us all*,

Miró by implication confers surreality on the rest of Breton's nominees. But the "pure automatism" that wins Miró his title is said to be marred by the sin of "delirious pride." Delirium as parallel to trance or dream was, by Surrealist prescription, of prime efficacy; by minimizing conscious control, it allowed for the semi-passive capture of buried imaginative impulse. But as Breton applies the word to Miró, it must have the meaning of mere confusion. For, says Breton, "delirium has no part to play in the sources of inspiration. . . . Pure imagination is the sole mistress of what she appropriates to herself . . . and Miró should not forget that he is simply one of her instruments." And hubris unbecomingly asserts itself elsewhere. Miró is, Breton testifies, "invincible on his own ground. No one else has the same ability to bring together the incompatible, and to disrupt calmly what we do not dare even hope to see disrupted." But, it seems, the artist has compromised this ability with a facile gesture; anyone "can learn . . . to draw a sword with a fine flourish, if only in order to be able to say 'Here is my card' at the appropriate moment and so have the right to choose the ground."[10]

Miró, whose unusually mild outward manner concealed a fierce aggressiveness, probably would have been astonished and delighted had he known what boldness Breton would later attribute to his behavior — especially of circa 1924. Virtually no account of Miró or Surrealism has failed to record the history of his early years in Paris and the goings-on at 45, rue Blomet, where Miró and André Masson had adjoining studios. It is, however, not without purpose to rehearse it briefly here. Jacques Dupin, a poet and the most authoritative of Miró scholars, describes the climate of the time as one of crisis, in which "painters, poets, and writers . . . if they were to take their place in history . . . would have to invent entirely new modes of expression . . . No. 45 Rue Blomet was then one of the avant-garde laboratories where the new language was being forged." Dupin then lists some of the poets and writers who, with Masson and Miró, constituted what is known as the rue Blomet group: Michel Leiris, Armand Salacrou, Roland Tual, Georges Limbour, Antonin Artaud, Robert Desnos, and Jacques Prévert. Contrasting the lives of Masson and Miró, Dupin characterizes Masson as leading a "disorderly, all but insane existence. . . . His studio was as famous for its indescribable disorder as was Miró's for its painstaking, almost alarming tidiness." When Miró stopped working, and had cleaned "both his studio and his person from top to bottom, he would dress up, favoring excessively sober, formal wear . . . his personal fastidiousness and provincial dandyism, along with his excessive courtesy and amiability, made him a very strange character indeed among the friends who gathered in the Rue Blomet, for whom sloppiness was *de rigueur*. Miró, too, was working like a madman . . . less with apparent passion than with a mania for orderliness."[11]

Whether Miró courted the mild distinction of eccen-

tricity is questionable; what is not is the force of his determination to assert a clear identity for his art. In order to express his particular experience of reality, he had somehow to reimagine the way painting could be made, to think his way out of the conventions it had thus far fostered. Like all truly original modern artists, he had — as he put it, with less originality than urgency — "to go beyond painting." In September 1923 he described his efforts to his friend J. F. Ràfols: "I know that I am following very dangerous paths, and I confess that at times I am seized with a panic like that of the hiker who finds himself on paths never before explored, but this doesn't last, thanks to the discipline and seriousness with which I am working."[12]

Complementary Dualities

Marcel Duchamp's version of Miró's arrival in avant-garde Paris complements Breton's and provides a succinct preface to a larger appreciation of the oeuvre. After remarking that Miró came of age in a period that no longer allowed "a young poet" to begin within the framework of movements initiated before the outbreak of World War I, Duchamp recalls Miró's pre-Paris paintings as realist in appearance, but marked nonetheless by an intense sense of irreality. "Later," Duchamp goes on, Miró "came to Paris, where he found himself among the Dadaists who were, at that time, effecting their transmutation into Surrealists. In spite of these contacts, Miró held himself apart from any direct influence and showed a series of canvases in which form, submitted to strong coloring, expressed a new two-dimensional cosmogony without the least tie to abstraction."[13]

Duchamp's comments implicitly confirm Breton's view that Miró lacked sufficient Surrealist ardor, and provide an insightful, if laconic, description of his art. More than likely, Duchamp's use of the word "series" was quite casual, chosen for its usefulness in denoting a particular group of works — from his description, probably those made between 1925 and mid-1927. But since Duchamp did not write his account of the twenties until 1946, perhaps there are grounds to see some significance in his choice of terms at that later date. Twenty years earlier, the tendency of Miró's work to organize itself into distinct clusters could not have been apparent, whereas by 1946 this pattern would have become evident to an attentive observer. While the oeuvre of almost any artist seems to divide into stylistically and/or thematically linked groups formed organically within the work, such divisions rarely constitute a predetermined cycle, and our perception of them often derives, at least in part, from the taxonomies later assigned by art historians and critics. By contrast, the serial rhythm that Duchamp may have noted in Miró's work results from a deliberate "programming" that the artist first developed in the mid-twenties, and which there-

after becomes a dominant pattern. This characteristic of Miró's working logic is best understood through a detailed, case-by-case examination, and therefore must await such consideration later in this essay.

To return to Duchamp's remarks, one particular phrase, "form, submitted to strong coloring, expressed a new two-dimensional cosmogony without the least tie to abstraction," provides a way to characterize Miró's art as a whole. By the time of Duchamp's writing, Miró's great gifts as a colorist were almost as widely recognized as they are now; only two years later Clement Greenberg would announce that Miró "has taught the world a lesson in color, using it with a vigor, economy and originality no other painter except Matisse has matched."[14] Agreed on this point, Duchamp and Greenberg differ on another. Duchamp's claim that Miró has constructed a new pictorial space "without the least tie to abstraction" is the opposite of Greenberg's nearly contemporaneous comment, that "with one abrupt leap . . . he arrived at the abstract";[15] between the two is located the center of Miró's genius. No other artist—not even Paul Klee—managed to make representational signs and imagery function in a formally abstract context as Miró did. In this sense, neither Duchamp nor Greenberg was wrong, although Miró might well have felt that Greenberg had taken the wrong tack. Miró always vehemently maintained that his art was never abstract. In an interview published in 1936, he remembered his response to an invitation to join the Abstraction-Création group: "And they ask me into their deserted house, as if the marks I put on a canvas did not correspond to a concrete representation of my mind, did not possess a profound reality, were not a part of the real itself! . . . Poetry is expressed through a plastic medium, and it speaks its own language. . . . I consider it an insult to be placed in the category of 'abstract' painters."[16] But the fact that he felt compelled to defend himself so hotly shows the seriousness of a nearly consummated affair.

Miró's exaggerated indignation at the suggestion that his art might be considered abstract had to do primarily with his will to retain the imagistic force of traditional painting. The word "abstraction" then seemed to stand for a practice based on a formal and ideologic dogmatism, bent on banishing all but the most elliptical of references to life as lived in the body. For Miró, whose oeuvre is a long rumination on the ubiquity of the body in space, such an outlook was repellent. But what seemed to him an adversarial relation turned out to be a complementary one, the yin and yang of twentieth-century abstraction. If Neo-Plasticism adduced one sort of model from Cubist structure that would serve future artists, Miró opened its space so radically that his art would furnish a prime example to such later generations of painters as the American Abstract Expressionists.

In the shallow, atmospheric space of Analytic Cubism, objects are displayed "noumenally," so to speak. Given simultaneously to our sight are contours that vision could never so apprehend in the non-fictive space of the ordinary world. There, when we look at a guitar, we can see perhaps its front and a little of one side; we know the other side to be there, but it is not visible. In making the "thereness" of the normally hidden other side apparent, Analytic Cubist space makes explicit what could be termed the ambiguity of depth, rendering problematic the so-called third dimension. According to Maurice Merleau-Ponty (whose argument is intended to apply to Cubist space), if we want to think of depth as a dimension, we must think of it as the first, since it denotes a specific position of a sighted body relative to surrounding objects in the world, and from it the other dimensions are therefore derived. But bodies and objects exist in constantly changing relationships, and as a result, depth has no fixed coordinates; it is instead a consequence of spatial extension, which, containing within itself all the dimensions, cannot itself be a dimension. Understood this way, depth is "the experience of the reversibility of dimensions, of a global 'locality'—everything in the same place at the same time, a locality from which height, width, and depth are abstracted, of a voluminosity we express when we say that a thing is there."[17]

To describe the "reality" in Cubism, Picasso chose an olfactory simile, explaining that "It is not a reality you can take in your hand. It's more like a perfume—in front of you, behind you, to the sides. The scent is everywhere but you don't quite know where it comes from."[18] This "reality" as spatial permeation that Picasso invokes is the illusion, conjured on a two-dimensional surface, of the real voluminosity of space in the sense described by Merleau-Ponty. Expanding on this meaning of space in Cubism, and certainly with some hints from Paul Klee,[19] Miró constructed a pictorial spatiality conforming to the phenomena of the world and yet seemingly metaphysical.

The tension in Miró's pictures between abstraction and representation is central, even as his work as a whole is poised between complementary dualities. The man himself was both visionary poet and meticulous craftsman—concerned to the point of obsession with balancing the demands of freedom and formality. Indeed each of the many different paths he explored, whether in painting, drawing, sculpture, or other mediums, was a response to this problem of duality: how to find fresh means of expressing a vision of the world as the site of ceaseless mutations between the terrestrial and the cosmic, the sensuous and the spiritual. At times, as in the series of Constellations of 1940–41 (pp. 238–60), he found his solution in complexity; but equally it was to be discovered in simplicity—in paintings, like *Painting (Blue)* of 1925 (p. 134), so radically purified that their coming into existence revealed a wholly new territory, not just to Miró, but to the art of his time. As the spare and the dense served, so too did scale—understood as measurable size (both external and

internal) and, transposed to weight, as the opposition between massive and tenuous. For example, in the series of tiny paintings made in 1932 (pp. 184–87), the depicted women swell their wood grounds with monumental presence, whereas in the mostly much larger paintings of 1925–27, a figure, such as the one in *Personage* (p. 130), can occupy its field with the ephemeral intensity of a whisper.

On Becoming an "International Catalan"

When Miró tells Tual in his July 31, 1922, letter that he is struggling to paint "humble things," he means the things of everyday life on the family farm in Montroig—a place so vital to him that, years later, he would say "it was like a religion."[20] Miró would always claim that the psychic energy behind his work arose from the intensity of his feelings for his native Catalonia, that the double-sidedness of his being—the artisanal and the visionary—embodied the *seny i rauxa*, the common sense and passion, imputed to the Catalan temperament.[21]

To account for the peculiar intensity of that summer of 1922, one need only compare the pictures he began then with those which had preceded them. It is unlikely that Miró himself was fully aware of it, but his "struggle" was nothing less than the final round in what had been another primary conflict in his art: that between his Catalan identity and the pressure of the international avant-garde.[22] The paintings begun in this summer were not a qualitative advance, but rather a bridge to a pictorial territory that would be fully Miró's own.

With customary deliberation, he worked on six paintings that we know of during the summer of 1922, five of which fall together as a group: *Still Life I (The Ear of Grain)* (p. 108), *Still Life II (The Carbide Lamp)* (p. 109), *Still Life III (Grill and Carbide Lamp)* (p. 110), and two others now lost or destroyed.[23] Closely related to the still lifes is the sixth painting, *Interior (The Farmer's Wife)* (p. 106). These pictures manifest an important structural change: while all Miró's previous paintings were constructed of parts that seemed to belong to a preexistent, perceptually given whole, in contrast the elements in these new pictures are assembled into a kind of wholeness that is less the result of what can be seen than of what can be conceived. As was his practice until sometime in 1923, Miró made these paintings before the motif;[24] nonetheless, emphasis has shifted from the perceptual to the conceptual. Put another and for Miró a more significant way, the particular integrity of these pictures narrows the gap between subject matter and style.

Before Miró's first trip to Paris, in March 1920, his need to become what he often called an "international Catalan" was expressed primarily by imposing a highly personal, often very effective blend of avant-garde pictorial practices (Cézannist, Fauvist, Cubist, and others) onto Catalan content. In his still lifes of the period, another, more contrived means to show his aspirations sometimes appears in the pointed juxtaposition of objects specifically Catalan with others emblematic of a wider cultural context, as, for example, in *"Nord-Sud"* (p. 87), where a Catalan *porró* shares space with a book by Goethe and with the title of Pierre Reverdy's eponymous contemporary review.[25]

Miró had never worked quickly, but in the two years after his first trip to Paris, he proceeded with even greater deliberation, producing, so far as is known, only four still lifes in 1920 in Spain and four extremely eclectic paintings in Paris in 1921. But this measured pace does not seem to reflect a particularly cautious state of mind. To judge by his letters of 1920, the initial encounter with Paris left him in a mood of violent conflict, determination, and pugnacity. He feels scornful of those Catalan artists insensitive to the jolt of Paris, whose "souls of ice have not felt this fire of passion and will yield withered fruit"; he is convinced that "the *new Catalan painting is better* than the new French painting,"[26] and he judges Picasso to be a painter of "*panther-like agility*," who, though "*neither understood nor comprehended*" by the people back home,"[27] is nonetheless "doomed" because, like "the French," he has an "easy road" and "paint[s] to sell."[28] These and similar remarks reveal a Miró more than ready to take on the competition, and explain what seems to be happening in the Catalan still lifes of 1920. No longer do foreign avant-garde practices look as if imposed on provincial subject matter; rather, in an aggressive reversal, transplanted style seems dominated by Gaudí-like flourish and the vigorous internal energy of depicted objects. This is particularly true of the magnificent *Still Life with Rabbit (The Table)* (p. 103) and *Horse, Pipe, and Red Flower (Still Life with Horse)* (p. 102); the largely monochrome palette of the former seems an especially impertinent gesture toward Analytic Cubism, while the strident clashes of color in the latter are a brash repudiation.[29]

The open book on the table in *Horse, Pipe, and Red Flower* has been identified as Jean Cocteau's *Coq et l'arlequin*; illustrated with line drawings by Picasso, it argued against foreign influence on French music.[30] Its prominent display, and the way its form and print echo the jagged pattern of lines at the left—a Miró code for Cubism—suggest, at the least, a certain irony and irreverence on the part of the young Catalan painter. As Dupin has pointed out, Miró uses the devices of Cubism in these pictures "wholly in his own way, and they will be relegated to the prop cupboard the moment he can do without them."[31] The problem was that he could not yet quite do without them.

The next four paintings Miró made, *Portrait of a Spanish Dancer* (p. 104), *Still Life—Glove and Newspaper (Table with Glove)* (p. 105), *Spanish Dancer* (Dupin 74),

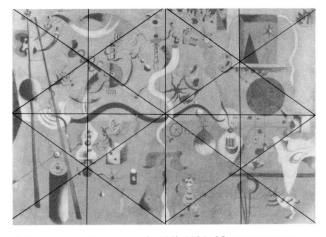

1. **Carnival of Harlequin** (P. 128), 1924–25, with drawing superimposed to indicate underlying grid

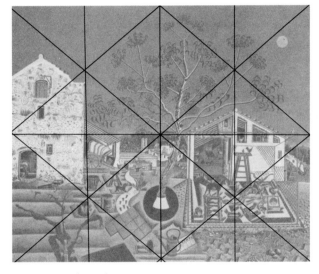

2. **The Farm** (P. 107), 1921–22, with drawing superimposed to indicate hypothetical grid structure

and *Standing Nude* (Dupin 75), were the first he executed in Paris, and they contrast starkly with the Catalan still lifes of the previous year. Where those paintings reveled in a complexity of composition that playfully toyed with the conventions of Cubism, these soberly display single images whose lateral and vertical extensions seem to map out the boundaries of their canvas fields. With the exception of *Still Life — Glove and Newspaper*, which can be read as a kind of self-portrait, these first products of Paris sacrifice subject to a harsh, Purist-derived stylization.[32] Miró said he was completely unable to paint on his first trip to Paris; the city paralyzed him.[33] On the evidence of these paintings from the next visit, it is fair to conclude that the experience of the French capital was still inhibiting.

At almost the same moment when Miró must have been finishing his initial Paris paintings, Maurice Raynal was writing an engaging, insightful preface for the catalogue of Miró's first one-artist exhibition in Paris, held at the Galerie La Licorne in spring 1921; in his text, Raynal addresses the young painter: "You are not yet convinced, but soon enough you will make a discovery that will open up the gates leading out of the hell of uncertainty. You possess all the necessary baggage to travel far. Run then, without hesitation, after your shadow."[34]

If the slow, painstaking, ten-month labor of producing that early masterpiece *The Farm* (p. 107) may be called running, Miró did indeed run. He was however in pursuit not of his shadow, but of his identity. As many accounts have shown, *The Farm* is inseparably tied to Miró's own person.[35] In meticulous detail, the life of the family farm in Montroig is recorded to display the factors forming his being — the indices of his developed self.

Years later, discussing *The Farm*, Miró was to say that an essential factor in his work had always been his need for self-discipline, and he related this to his experience of Cubism, saying, "Then there was the discipline of Cubism. I learned the structure of a picture from Cubism."[36] But in fact he took very little from Cubism, and that superficial, in designing *The Farm*. The quasi-lurking geometry that does, however, govern the painting may be better understood in comparison with any one of a number of works Miró began in 1924 in which a geometric grid is self-confessed in lines of red pencil left visible on the surface. Of the nine known pictures of this type, *Carnival of Harlequin* (p. 128) may suit comparative purposes best, as it is the closest in complexity and spirit to *The Farm*, even though its web of red lines is less obvious than in any of the others. Figure 1 shows the actual gridding of *Carnival of Harlequin*.[37] First, Miró establishes the center of his rectangle, running a diagonal — very often, as here, without absolute precision — from each corner to its opposite. Then he bisects the surface both vertically and horizontally; this produces four smaller rectangles which are each then partitioned by crossed diagonals to yield a set of four sub-centers. Thus he has a personal sort of Albertian "veil," providing lines of force and a series of intersections useful in making strategic decisions about composition. Since *Carnival of Harlequin*, like the other eight of this series, was done after a gridded drawing that it follows fairly closely (see cat. 40), its strategy was mapped out in advance; but there are others from this group, *Spanish Dancer* (p. 116), for example, where the transposed grid determines the structure of the final picture differently, and with more independent force than in the drawing (fig. 16).

While drawing was to play an extraordinarily generative role in Miró's later work, it appears to have been only ancillary at the time he was painting *The Farm*. There are no known drawings for any painting made between 1920 and the end of 1922, and Miró denied that he had ever made any for *The Farm*.[38] Difficult as this denial may be to accept, that is how the case must rest until and unless such drawings are discovered. What is being suggested here, however, is the likelihood that Miró was already

looking through some imagined "veil," similar to the actual one visible in *Carnival of Harlequin*, when he was painting *The Farm*. If the gridded structure of *Carnival of Harlequin* is imposed on *The Farm* (fig. 2), similar strategies become apparent. Most obvious, the tree in one painting, and the variegated components of the woman's body in the other, are stabilized by the central vertical: in *The Farm*, the vertical axis provides a pole from which the tree is cantilevered; in *Carnival of Harlequin*, the vertical serves as a staff around which a sinuous form twists. Given the intensity of activity in the latter picture and the number of odd creatures and things taking part, it is surprising that so few elements are *not* anchored to, or bisected by, one of the grid lines. And astonishingly, this is true also of *The Farm* and its merely hypothetical grid. As in *Carnival of Harlequin*, the diagonal that runs from the lower left corner to the upper right first establishes the placement of signature and date; it then neatly connects hawthorn bush to slope-sided bucket, to *A*-shaped stool, to farm wife, to horse, finally shooting past the upper side of the moon. Within the lower left quadrant, the imagined diagonal that runs from its upper left corner aligns the edge of the stall door with the edges of two other buckets; at the same time, the vertical that bisects the left half of the painting slices through the basket and the wheel of the cart just above it. In similar fashion, the vertical of the right half drops like a plumb line through the center of the chicken coop, and through the left side of the ladder, then lines up the frontally seen rabbit with its profiled mate.

Whatever pictorial model may have guided Miró in painting *The Farm*, a network of formal relationships, primarily triadic, dominates its structure. Faithful representation though it is, the intense sense of irreality that Duchamp saw in Miró's early pictures is here heightened. If *The Farm* shares a level of magic realism with such prior "detaillist" paintings as *Vegetable Garden and Donkey* (p. 96), it differs from them in its more developed insistence on calling attention to the way it was made.

Eight years after Miró completed *The Farm*, Louis Aragon, in a now famous essay on collage, was to deplore the inability of the human creature to find the extraordinary in the commonplace. "The real nature of the marvellous," he said, "is that man is without doubt the least amazed." The world lacks spirits who can interrogate its "most common modes of thinking," who sense in a sentence such as "The bread is on the table" the unusualness of the "extraordinarily ordinary."[39] Although Aragon made no reference to Miró in this passage, it negatively defines Miró's relation to objects in the world. The everyday was, Miró claimed, the site where "the eruption of the infinite in the finite takes place."[40] It is this poetic seeing-into-the-quotidian that Miró translates in *The Farm* and the series of small still lifes that follows.

Nothing could seem to contrast more sharply with the complex rendering of *The Farm* than the limpid articulation of the still lifes Miró began in the summer following its completion. Yet in their difference is also their similarity. In each, Miró celebrates the interconnectedness between the secret life of things and our own humanity. Miró deeply admired Walt Whitman, and these canvases are the pictorial counterpart of the poet's remark that "having looked at the objects of this universe, I find there is no one nor any particle of one but has reference to the soul."[41] Indeed thirteen years later, responding to a comment by Pierre Matisse concerning one of these still lifes, Miró would himself refer to "that moving poetry which exists in the most humble things, that radiating force of soul which they emanate."[42]

A spirit close to reverent governs the presentation of the small world of *The Farm*. With the exception of the tiny baby adrift in the center, all the objects, animate and inanimate, are set on ground lines or on some pedestal-like arrangement. This literal underscoring proclaims the singularity of each object within the teeming multiplicity of daily farm life, while it simultaneously makes distinct pockets of space at odds with a realistic depiction of sky and earth. Miró's tight formal control of his composition allows the vital specificity of each object to reverberate within a network of interdependent relationships, in a vivid metaphor of his lived experience.

In the group of still lifes that follows, virtually no analogue to the perceived space of the world is given. Instead, these small canvases reach for an expanded space corresponding less to the space of sight than to the space we feel, hear, or smell, but cannot see or touch. In this sense the whole surface of each picture is the counterpart of those individual spaces given to the objects in *The Farm*, their immeasurable "aura." Where *The Farm* wants to give us a detailed whole, the still lifes, conversely, dwell on the wholeness of the detail. In the earlier picture, the spatial niches apportioned to things effected a formal rupture with its representation of real space, while in the still lifes there is no disjunction in the interaction of pictorial elements and grounds that make little claim on illusionism.

Only three of the five still lifes survive, but they are enough to show stages in Miró's steady retreat from objective reality and received pictorial convention.[43] All of them were done before the motif, and in the first, *Still Life I (The Ear of Grain)* (p. 108), vestiges of real space remain while reference to Cubist practice is more obvious than in the others. The skewed gray-green rectangle rising toward the right inevitably reads, however elliptically, as physical support for the bowl, strainer, and ear of grain — the Cubist tabletop accommodated. And the ground lines of *The Farm* have not been entirely subsumed into an enveloping spatiality, for they reappear here under the bowl and head of the strainer.

While Cubism, and more particularly its then current offshoot, Purism, is certainly an ingredient of the next

two still lifes, *Still Life II (The Carbide Lamp)* (p. 109) and *Still Life III (Grill and Carbide Lamp)* (p. 110), it is buried in a content and conception that are Miró's own. If, as has been plausibly suggested, the rectangles of ocher paint in one, and white in the other, are symbols of cast light,[44] they do not function to illusion a real spatiality; in each, the inversion of the shape of the carbide lamp does not so much evoke the shadow of a depicted object as echo the shape of the support. While the rigidly frontal, ocher trapezoid of *Still Life II (The Carbide Lamp)* locks the tomato, lamp, and iron stand in a fixed relationship on the flat plane of the canvas, in the later *Still Life III (Grill and Carbide Lamp)* a relative fluidity prevails. The unattached hook on the lamp directly posits a state of ambivalent suspension, but it is more a sly sign of that condition than its agent. Miró's deceptively simple composition and his choice of blue, one of the "colors" of air, are what enable the flat, uninflected surface to act not merely as a ground on which, but also as a container *in* which, objects float. The suggestion is not of volume as such, but of that potential for reversibility which is always present in the real space of the world; the eye is invited to flip the slightly tilted white rectangle of the left half into alignment with its ghost outline on the right, and to execute the same maneuver from right to left with the grill and its corresponding opposite outline. In *The Kerosene Lamp* (p. 114) of about a year later, in which a hand is poised to turn the plane of the picture from right to left, Miró makes the picture-flipping principle wittily explicit.

After completing the still lifes, begun at Montroig in 1922, in Paris the following year, Miró would not make a recognizable return to the genre until 1937, in *Still Life with Old Shoe* (p. 227). But his deep love for these "humble objects" shows in their metamorphosis into such living creatures as the sugar-bowl-shaped woman at the right of *The Beautiful Bird Revealing the Unknown to a Pair of Lovers* (p. 258) and, years later, in the actual incorporation of such objects into sculpture (p. 304). What Marcel Proust said of Chardin — "since [his] art is the expression of what was closest to him in his life," it is "our life that it makes contact with"[45] — applies to the pictorial tour of Montroig and its objects that Miró gives us.

Surface Strategies

On June 20, 1923, in Paris, Miró consigned six still lifes to Léonce Rosenberg of the Galerie L'Effort Moderne,[46] and two weeks later was writing from Montroig that he had launched a new "offensive."[47] It was certainly nothing less than that, as many commentators have observed: the three canvases begun that summer — *The Tilled Field* (p. 111), *The Hunter (Catalan Landscape)* (p. 113), and *Pastorale* (p. 112) — were, as Dupin writes, "the revelation"; they show "the union of the real and the imaginary" that would be a constant in Miró's work thereafter.[48]

Virtually everyone who has tried to describe or analyze these paintings has invoked poetry, not so much because it is known that Miró was a voracious reader of Baudelaire, Rimbaud, Jarry, and Apollinaire, among others, and that his closest friends at the time were poets, but because the paintings themselves speak with the metaphors of poetry.[49] His subject is the same as that of the previous summer — the everydayness of life at the farm in Montroig; but now he renders it with a new intensity, with what French schoolchildren were taught was the special gift of Rimbaud: "What he sees, he transfigures; what he doesn't, he creates."[50]

While Miró said that he worked on several canvases at once in Montroig in 1923, there can be little doubt that he began his work of that summer with *The Tilled Field*. This poetic re-creation of *The Farm* is laid out with such precision that it makes the tight construction of the earlier picture look almost random.[51] Along the bottom of *The Tilled Field*, the canvas is divided at three equidistant points by vertical markers, which, along with certain other marks, are mostly invisible in reproduction, but may be revealed under infra-red examination. Figure 3 shows the actual location of these lines in the picture: on the right, rising through the trunk of the pine tree; in the center, just at the junction of the lizard's tail and the bucket that contains him; and on the left, the middle vertical of three Miró used to control the curving bulges of the furrows. These perpendicular directives are strictly obeyed in the right half of the picture, and just as deliberately modified in the left. The line at the right, the only one obvious without close scrutiny, dictates the center of the pine tree, its eye, and the division of earth, sky, and water into a yellow-gold trapezoid on the left and an inverted triangle of muted earth colors on the far right. The middle line, though interrupted, reappears (under infra-red), emerging from the top of the dog's head and rising from the left side of the chimney of the house, and by implication to the exact center of the top of the painting. At the left, an imaginary extension of the middle furrow line gives Miró, as would his grids of a year later, a diagrammatic means of deciding just how to distribute the elements of his composition. Here, his decision to move the base of the fig tree's trunk off-plumb reestablishes equilibrium in the narrow middle band of the three that divide the picture laterally. In that thin yellow strip, where water separates earth from sky, the forking branch of the fig tree, now aligned with the bottom marker, balances in virtually perfect spatial equipoise with the left edge of the chimney and the middle of the pine tree.[52]

The Tilled Field abounds with other careful structural calibrations, and the rhythms these set up are complemented by robust rhymes of geometric and biomorphic forms in a play of color that makes dramatic use of black. The extraordinary attention to detail that characterizes *The Tilled Field* is also manifest in an application of paint

so painstaking that one conservator examining its structure declared it to be in places "like appliqué." Miró, who in his gridded pictures of the following year was to exploit with relish the pictorial effects of pentimenti, boasted that his paintings of 1923 were without any. They were, he said, "meticulously drawn . . . thought about at length . . . seen absolutely clearly in my mind . . . finished without retouching."[53] Nearly seventy years later, advanced conservation techniques support Miró's account of his working method — though with some considerable exceptions in *The Hunter (Catalan Landscape)*. What Miró meant when he said the 1923 paintings were "meticulously drawn" is, however, more difficult to know.

As mentioned, there are no known drawings for paintings finished between 1920 and the end of 1922. Until relatively recently, this was also true of other large areas of Miró's work — not only were the studies for most of the paintings unknown, but so too were those for drawings, early constructions, and sculpture. But Miró's extraordinary gift in the late seventies of his sketchbooks of a lifetime to the Fundació Joan Miró in Barcelona has made a reappraisal and a more accurate understanding of his working methods possible. Without doubt, he started using the earliest of his 1920s sketchbooks in the gift (which hereafter will be referred to as the Montroig Notebook) at about the time he began to conceive *The Tilled Field* and *The Hunter (Catalan Landscape)*, in July 1923, used it extensively through 1924, and then intermittently between the beginning of 1925 and early 1927. Because the problem of this notebook's chronology is so inextricably entwined with that of other notebooks from the mid-twenties and so tied to the dates of paintings he would finish during the four years after 1923, it can be considered only later, within that context.

All known drawings for *The Tilled Field* are in the Montroig Notebook, and they differ in several respects from those for *The Hunter (Catalan Landscape)*, *Pastorale*, and later works. There are more of them — some sixteen — than for any other work executed during the rest of the twenties; and whereas the drawings for all later works — with the partial exception of *The Hunter (Catalan Landscape)* — spring from the imagination, these are all done from nature. None shows more than a fragment of what will be the finished composition, while the majority of drawings for pictures executed the following year, and all of them for the paintings of 1925–27, wholly prefigure their finished states. Lastly, with the exception of the farmhouse and farm animals (figs. 4, 5), the motifs of the *Tilled Field* drawings become so stylized in the painting that their relationship to their studies is, at most, elliptical (figs. 6, 7). The differences between the *Tilled Field* drawings and those that came after illustrate the process behind Miró's triumphant announcement to J. F. Ràfols on September 26, 1923: "I have already managed to break absolutely free of nature, and the landscapes have nothing

3. **The Tilled Field** (p. 111), 1923–24, with drawing superimposed to indicate underlying lines

whatever to do with outer reality. Nevertheless, they are more *Montroig* than had they been painted *from nature*."[54] By the time Miró was ready to start *Pastorale*, a single drawing (see cat. 28), which would undergo only a slight elimination of detail, sufficed before he began to paint.[55]

Drawings for *The Tilled Field* also help clarify Miró's constant iteration that his art was based on reality. Although this picture turns Montroig into a most peculiar vivarium, it is still far from those works that would leave the artist open to the charge of abstraction. Nonetheless, an eye in a tree is oddity enough for most commentators, including this one, to conclude that it must derive from something other than a tree. We may justifiably continue to believe that Klee, Max Ernst, and medieval Catalan art, together or singly, help account for its presence;[56] but it must be acknowledged also that the tree in Miró's drawing from nature is alive with eyes (fig. 6). Similarly, another tree drawing for *The Tilled Field* (fig. 7) shows it to be the Ur-form of Miró's many figures with outstretched arms of the thirties — most particularly of the Catalan peasant with raised fist in Miró's anti-fascist stamp, *"Aidez l'Espagne"* of 1937 (fig. 8).

If *The Farm* can be thought of as symbolic of Miró's own person, *The Tilled Field* is more depersonalized. Where the earlier picture gave us a self-contained world of organic interrelations, the later one shows that world not as self-contained, but rather as synecdochic of a surrounding cosmos, in which analogy governs. In a passage from a work much admired by Miró, Baudelaire asks, "What is a poet . . . but a translator, a decoder" of a reality in which "everything — form, movement, number, color, perfume — in the *spiritual* as in the *natural* domain, is significant, reciprocal, converse, *corresponding*."[57] *The Tilled Field* is Miró's first full-fledged statement of this Baudelairean

23

4. Study related to **The Tilled Field** (p. 111), 1923–24. Pencil on paper, 7½ × 6½″ (19.1 × 16.5 cm). FJM 602b

5. Study related to **The Tilled Field** (p. 111), 1923–24. Pencil on paper, 6½ × 7½″ (16.5 × 19.1 cm). FJM 596a

6. Study related to **The Tilled Field** (p. 111), 1923–24. Pencil on paper, 7½ × 6½″ (19.1 × 16.5 cm). FJM 594b

7. Study related to **The Tilled Field** (p. 111), 1923–24. Pencil on paper, 7½ × 6½″ (19.1 × 16.5 cm). FJM 595b

theme, which was also very much his own. But he delivers this bit of ancient wisdom, this quasi-secular sermon, with the gravity of humor, that quality which Aragon claims to be "the negative condition of poetry. . . . In order for there to be poetry, humor must first get rid of anti-poetry."[58] After *The Tilled Field*, Miró's art abides in the domain of metaphor, where, according to his close friend Michel Leiris, "a man is a moving tree as much as a tree is a rooted man . . . the sky is a rarified earth, the earth a denser sky . . . and . . . a dog running . . . is just as much the run that is dogging."[59]

Meaning's upward spiral from *The Farm* to *The Tilled Field* makes another, decisive turn away from the concrete and particular toward the general in *The Hunter (Catalan Landscape)*. The specificity of place and thing stressed in the generically titled *Tilled Field* is replaced in the later picture by a somewhere/anywhere landscape scrupulously designated as Catalan,[60] whose objects — although years afterward minutely catalogued by Miró — are designed to exchange identities.[61] In both paintings, the zones of earth, sky, and sea are less separated than melded. With the exception of the area of the inverted triangle at the right of *The Tilled Field*, the fluid elements of air and water are materially identical with each other. Sharing color and touch, the two elements seem united rather than divided by a hair-fine line of demarcation. But that unity, unbroken in *The Hunter (Catalan Landscape)*, is disrupted at the right of *The Tilled Field* by an emphatic division of brownish-red sky from gray water; and another division, that between the water and the furrowed rows of reddish earth, cleaves the line between light yellow land and darker yellow water. In spite of this rupture, the earth and sea of *The Tilled Field* are differentiated through most of their extent by hue alone, whereas the earth and sea are given two contrasting colors, pink and yellow, in *The Hunter*, and from this it should follow that a sense of flowing spatial ubiquity would be more freely dispersed in the earlier picture. This, however, is not at all what happens. Instead, the rigid straight line between land and wa-

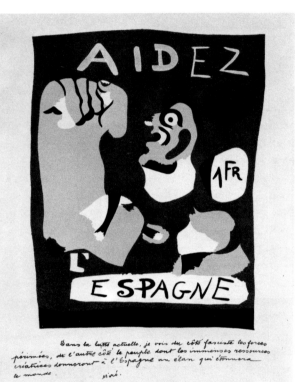

8. "Aidez l'Espagne." Paris, winter 1937. Pochoir, printed in color on cream smooth wove Arches paper; sheet, folded 12½ × 10″ (31.9 × 25.3 cm), composition 9¾ × 7⅝″ (24.8 × 19.4 cm). The Museum of Modern Art, New York. Gift of Pierre Matisse. Acq. no. 634.49

ter in *The Tilled Field* slices the yellow spatial envelope into a below and an above impervious to each other, and things, however exotic, remain earthbound, as is dramatically articulated by the farmhouse sitting four-square on the center of the land line. In *The Hunter*, on the contrary, the roll of land's pink edge against yellow water suggests the possibility of flux, posits an equivalence of matter between earth and sea. And the fact that the pinkness of the land is everywhere inflected by the yellow underpainting that lies beneath it reinforces the effect of enveloping spatial permeation.[62]

If, thanks to Miró's later exegesis, we can now know what each object represents, the givens of the painting itself are considerably less accessible; elements float on the land as in the sky, and all that is explicit is the remarkable similarity of their forms.[63] Indeed nearly everyone who has looked at this picture has remarked on the interchangeability of the sun-egg in the sky with the sex organs of the hunter and the sardine, and on the resemblance of all three to the mother's sex in *The Family* of spring 1924 (p. 115).[64] Miró's association of celestial and earthly procreation is confirmed by comparing a preliminary drawing for *The Family* (fig. 9) with the final picture. At the bottom of the preliminary drawing Miró lists: "1—Very luminous like the eyes of a cat | 2—Sky like a star; very mysterious | 3—like a tree | 4—like an onion." In the completed drawing (p. 115), the numeral *1* stands next to the eyes of the father, *3* next to the patently tree-like head of the child, and *4* next to the onion-like rump of the toy at the lower right; *2*, next to the root-like vagina of the mother, affirms *The Hunter*'s linking of the generative powers of earth and sky, just as the imagery of the painting illuminates what might otherwise seem a puzzling notation in the drawing.[65] If the transposition from sun to star appears to deviate from Miró's schema, another look at *The Hunter* will show it to be no more than a further move in the game of this-can-be-that; the star at the upper left is the scaled-down equivalent of sun-egg and hunter's sex.

What started out as a scene of a Catalan peasant about to barbecue his lunch (fig. 10) went through various mutations, including one that appears playfully to implement Miró's intention toward the Cubist guitar: at the upper right of one of *The Hunter*'s preliminary studies (fig. 11), what will become the horizontal cross-section of a carob tree grows a curved branch on the left and sprouts a straight one on the right that seems to terminate in the frets and scroll of a guitar. Ultimately, in the painting, Miró converted his initial vision of a sunny noon in Catalonia into a parable of cosmic and earthly union, generation and regeneration.

To call *The Hunter* a parable may perhaps seem too great a liberty, for the painting is far from a textual illustration. Rather, it is one of those pictures that presents itself as endowed with "the global property of corporeality," metaphorically displacing the lived experience of the body onto the canvas.[66] This may seem a peculiar claim for a picture that virtually strips its leading character, the hunter, of physicality. Yet this property is one of the tropes of pictorial rhetoric securing the presence of the canvas as a metaphorical body. If the hunter's body is deprived of mass, a compensatory sensuality is assigned to the earth, enveloped in a skin of flesh-pink paint. And the thin, straight lines adumbrating the hunter hover in isomorphic equivalency with the rectangular body of the canvas, just as his vital organs, his hairs, and the pipe he

9. PRELIMINARY DRAWING FOR **THE FAMILY** (P. 115), 1924. PENCIL AND COLORED PENCIL ON PAPER, 7½ × 6½" (19.2 × 16.6 CM). FJM 672A

smokes are multiplied into pictorial attributes throughout its whole extent. But his own eye is only a mute replica of the staring, flesh-englobed eye near the center — the eye, Miró said, of the picture, which gazes at me.[67] In this sense the picture is another sort of parable — of the power of sight. In its symbolic gaze the eye reveals to the mind the warmth of the world, "accomplishing," to borrow from Merleau-Ponty, "the prodigious work of opening the soul to what is not soul — the joyous realm of things, and their god, the sun."[68]

10. EARLY STUDY RELATED TO **THE HUNTER (CATALAN LANDSCAPE)** (P. 113), 1923–24. PENCIL ON PAPER, 5½ × 8" (14 × 20.5 CM). FJM 528. INSCRIBED: "TOULOUSE RABAT | GOS PETIT | FOGUERA | GRAELLES | PAELLA" (TOULOUSE RABAT | SMALL DOG | BONFIRE | GRILL | FRYING PAN)

11. PRELIMINARY STUDIES FOR **THE HUNTER (CATALAN LANDSCAPE)** (P. 113), 1923–24. PENCIL ON PAPER, 6½ × 7½" (16.5 × 19.1 CM). FJM 615A

12. **The Hunter (Catalan Landscape)** (p. 113), 1923–24, with
drawing superimposed to indicate the actual underlying
image, depicting Columbus's return to Spain, and lines
mimicking stretcher bars

A Sub-Surface Strategy, or the Relevance of Columbus

Miró, whose mother's family was from Mallorca, a place he
had often visited since childhood, was certainly familiar
with the ideas of its most famous figure, the thirteenth-
century philosopher Ramon Llull, whom Dupin calls
"poet, alchemist, traveler and mystic."[69] One of Llull's
teachings, later expanded by Leibniz, was that every indi-
vidual substance must contain a replica of the universe, as
a seed contains the totality of the being into which it will
develop.[70] The relevance of this to *The Hunter (Catalan
Landscape)* is obvious, but it is cited here less for that
pertinence than as a way, however oblique, into a recently
discovered conundrum. Examination of the picture with
infra-red vidicon reveals a neatly executed drawing
complete with trompe-l'oeil frame and identifying
inscription — "RETOUR DE COLOMB | en Espagne" — in the
upper left quadrant, under and extending on both sides of
the hunter's body (fig. 12). The drawing, depicting the re-
ception of Columbus by Ferdinand and Isabella at the
Sala del Tinell in Barcelona on the explorer's triumphant
return from his first voyage to the New World, has the
character of a copy, possibly of a nineteenth-century en-
graving. Similar casts of half-naked American Indians in
feathered headdress are shown in many illustrations of
this historic scene, but the model Miró presumably used
has not yet been found.

Once the existence of the drawing was discovered,
traces of it could be easily seen without technical aid: the
breasts of the woman holding the parrot, her left arm, the
frame, and letters inscribed under the sex of the hunter.
These traces were equally apparent in recent photographs
and in older ones taken before the painting was relined.
Laboratory analysis has ruled out the possibility that

Miró, using a secondhand canvas, might have innocently
painted over the image (concealed by some substance
such as a thick gesso ground), whose traces would emerge
only over time. Even without this scientific confirmation
that Miró had to be aware of the drawing he would sub-
merge beneath his hunter, close examination of the paint-
ing in a raking light yields the conclusion that he not only
knew of the drawing, but was himself the agent of its exe-
cution. Bordering the left and top edges of the canvas are
lines of a curious intaglio-like quality which mimic
stretcher-bar marks (fig. 12); integral to the composition,
these lines cannot be anything but the product of Miró's
hand. Since the traces of the drawing share the peculiar
pitted appearance of those delineating the left and top
edges, it is hard to imagine that anyone other than *The
Hunter*'s author was responsible for their presence. Given
how easily Miró could have effaced these clues to the un-
derlying drawing, it must be that he wanted them to be
seen. More than likely, the discovery in a well-known work
of something no one has previously noticed will change
little about why it is considered a masterpiece. Nonethe-
less, since Miró elected such a penetrable disguise, effec-
tively leaving clues to the secret image available to minute
scrutiny, it must have held some significance for him in
the making of *The Hunter*. On that basis, a speculative
excursion is justified.

First, assuming that the drawing is a copy, the original
would not have attracted Miró for aesthetic reasons. It
must then have been its content, along with an old-
fashioned imagery that may have triggered memories of
childhood. In discussing similarly dated images used by
Ernst, Theodor Adorno reflects on the impact of such vi-
sual stimulation on the child: "When we were children,
those illustrations, already archaic, must have jumped
out at us."[71] The original of the Columbus drawing may
best be thought of as a ready-made that vividly evoked
the child-self and appealed to the man fresh from
Dada-Surrealist Paris. Ernst's overpaintings, Duchamp's
L.H.O.O.Q., and an irresistible urge to skew the Surrealist
principle of bringing together different realities on the
same plane are some of the possible factors in Miró's deci-
sion to immure the return of Columbus behind his Cata-
lan hunter. Apollinaire's writings also may have provided
some impetus. Since Miró was especially fond of *Le Poète
assassiné*, which he had first read in 1917,[72] an episode
from its section called "Le Roi Lune" suggests itself as
particularly apposite. While wandering through a cavern
of exotic marvels, the hero discovers apparatuses that can
revivify — always for erotic purposes — the desirable bodies
of the illustrious dead. Apollinaire then speculates that a
more powerful machine, "more attuned to current moral-
ity, might serve to reconstitute historic scenes."[73]

To be an artist has always connoted the vocation of
discoverer, but never more so than in this century. Picasso
made the equation between the two explicit in 1912 with

"*Notre Avenir est dans l'air*" and its allusion to exploration through aviation. Apollinaire and the Surrealist writers Miró knew tended to focus instead on the sea; the idea of a voyage toward an unknown continent seemed to correlate with their search for the undiscovered territory of the unconscious. In his poem "Toujours," Apollinaire wonders where the next Christopher Columbus is to be found;[74] later, Miró's great friend Robert Desnos makes adventure at sea the central metaphor of his work. Breton, perhaps more than any other writer, invokes the ocean voyage, and often, specifically Columbus. In 1924, the year before he acquired *The Hunter*, he wrote in the first Surrealist manifesto that "Christopher Columbus should have set out to discover America with a boatload of madmen."[75] Seventeen years later, in 1941, Columbus becomes the prototype of the twentieth-century painter who has discovered a new world without knowing where he was bound.[76] In the preface to the catalogue of Miró's second one-artist exhibition in Paris, in June 1925, Benjamin Péret writes that "this little man with the strange look has seen in your body a fragment of bone from which a band of swallows announcing the discovery of America will soon emerge."[77]

In addition to the Surrealist equation of maritime adventure with the quest for the imaginative "beyond," there is another factor that might have led Miró to see a parallel between Columbus's adventure and his own. That was the belief, widespread in nineteenth-century Catalonia, that Columbus had been Catalan;[78] thus his arrival in Barcelona with exotica from the New World was a return not just to Spain, but to the land of his birth. The Columbus drawing — located just under the figure of the hunter, the artist's surrogate identity — would seem a pictorial pun on the commonality of their endeavors. Like Columbus, Miró, the native son, returns to Catalonia with treasures accumulated on his voyages of discovery to Paris.[79] If this is not how Miró was thinking, the fact remains that, fragmentary as it may be, he deliberately left one text to be read through another — the very definition of allegory, of which the palimpsest is the paradigm.

Aside from a very few contemporary writers, virtually the only Catalan of interest to the Parisian poets who were Miró's new companions was Ramon Llull. The relevance of the thirteenth-century mystic to Columbus may have eluded Miró's new friends, but it could not have been lost on any child of Catalonia. The claim that Columbus was Catalan arose in large part from his reputed knowledge of Llull's works, most of which were, in the fifteenth century, available only in Catalan. Even the insight, hardly original with Columbus, that the earth was a navigable sphere, was deemed in Catalonia to have been derived from Llull. Thus Llull, whose ideas often find something of a parallel in Miró — and especially in *The Hunter*, with its emphasis on the four elements, symbolic geometric forms, and man as microcosm — might have tickled Miró's fancy, as a common denominator between himself and Columbus, in

addition to providing a homespun link to Paris. The appearance of the Columbus drawing strongly suggests that Miró very likely regarded its incorporation into *The Hunter* as a good in-joke — along the lines, perhaps, of the alternative reading of the title of Breton's contemporary review, *Littérature*, as "Lis tes ratures."

Whether or not the Columbus drawing was an in-joke, it is now probably too late to ever know. If Breton, who acquired its host painting about a year after its completion, knew of the drawing, would he have refrained from mentioning it? So far as is known, Miró never spoke of it, even on such occasions as the one reported by Brassaï, when Miró took him to one of "the most beautiful and rarest examples of Catalan gothic, the Sala del Tinell," where "Ferdinand and Isabella received Christopher Columbus upon his first triumphal return from America."[80] Miró's close friend Michel Leiris perhaps drops a hint, in a collection of eighteen short poems published in 1961 titled "Marrons sculptés pour Miró." The sixteenth reads: "To cut the Gordian knot | or stand an egg on its end | by slicing off its point | is to prove that one knows nothing | in our game of who loses wins."[81] All one can say is that the poem is for Miró, and alludes to the well-known story about Columbus showing his detractors how to solve the puzzle of balancing an egg on end. (Coincidentally, Leiris's *Mots sans mémoire*, a book published in 1969 that includes the Miró poems, opens with a work of 1925 prefaced by a phrase from Llull: "From one place to another, without interval.")[82]

II. Thinking in Series

By early 1924, when Miró was finishing *The Tilled Field*, *The Hunter (Catalan Landscape)*, and *Pastorale*, he had finally reached a competence that would for the first time allow him sovereignty over his own art. According to Richard Wollheim in *Painting as an Art*, all great artists go through a period that is "pre-stylistic," when "their work passes through a phase before their style is formed."[83] The formation of an individual style has an individual history — in Miró's words, of "searching, and digging deeply and preparing"[84] for a maturity when style will become adequate to the negotiation of the artist's own demands. The "real art" Miró had dreamed of in 1919, in which "the spirit calmly strolls through the work,"[85] was at last within his grasp; at the beginning of 1924, his prestylistic, although often brilliant, apprenticeship was over.

The rest of this essay will investigate how Miró went about testing, exercising, and controlling his new creative freedom. The evolving logic of his serial practice, his extraordinary sensitivity to surface and materials, and his recycling of imagery and methods will be examined, insofar as possible, through a reconstruction of certain of his creative processes during the varying circumstances of his life from 1924 until 1945.

Whether or not the Columbus drawing was Miró's private acknowledgment of his newfound dominion, he was aware of the frontier he had crossed. Full of enthusiasm and excitement, he described his work to Leiris in August 1924, comparing his past canvases to "the screams of a whore in love." About his current work, he says it is "more profoundly moving," adding that he does not quite know how to characterize it: "This is hardly painting, but I don't give a damn."[86]

In 1931, as he recalled the early twenties in an interview with Francisco Melgar, Miró's response to the question of whether he had been one of the founders of Surrealism was: "No . . . my own development was very slow." Then, to a subsequent query, he replied: "The early days in Paris were really difficult"; after his first show at La Licorne there was "another very tough period, which I worked my way out of slowly, painfully, sweating blood, and then I entered a new period when I was very meticulous and paid a tremendous amount of attention to detail. Then I reacted violently to all that, and I wanted to go beyond painting. These reactions are the whole story of my work. They happen like clockwork and regulate the successive phases of my activity."[87] In spite of the fact that Miró's memory of events does not quite square with verifiable chronology, his remarks about going "beyond painting" probably refer to 1928 and 1929. Nonetheless, his description of those years is equally applicable to the period in 1924 coincident with his announcement to Leiris that his painting no longer seemed to fit conventional definition. That, indeed, is how Aragon was to remember the time many years later, when he wrote: "Already in 1924 (after canvases, which like Picasso's blue period, guaranteed what was to come after) canvases wholly of another character began to be born whose defiance kept growing, *The Kerosene Lamp, Carnival of Harlequin* . . . and *The Hermitage*. . . . Perhaps it's here that *anti-peinture* began."[88]

Within the rhetoric of Surrealism, Miró's "beyond painting" and Aragon's "anti-painting" were nearly interchangeable terms that carried heavy ideological weight. Both invoke the moral imperative of art to divest itself of an aesthetic compromised by social, historical ties to bourgeois convention. Miró often used these and similar terms with an oratorical truculence more than matching Aragon's most extreme formulations; but however much Miró may genuinely have believed in the extra-pictorial, social rationale behind such injunctions to scrap tradition, he had to know that these terms also denoted an ambition as old as art itself. "Beyond painting" lay the open expanse on the far side of the broken guitar, and past that, the unexplored territory forever receding from each fresh breakthrough.

Onset of the Serial Pattern

Picasso reportedly told Miró in 1924 that, after himself, the younger artist was the only one to have taken a step forward in painting.[89] Later, when Miró thought about the period during which he had started "eliminating, eliminating, until I got to the point where I was completely anti-Cubist and then I even eliminated Cubism from my work," he concluded that "maybe Picasso was right."[90] Picasso's remark was timely, if unduly exclusionary, for the step that Miró took in 1924 did lead to a way of working that would sustain him, with occasional interruption, for the rest of his life. The rhythm of "clockwork" reactions regulating the successive stages of his activity, which Miró would describe in 1931, was first prepared in the emerging pattern of working in series of 1924.

Miró had produced many paintings before 1924 that organize themselves into groups by common stylistic and/or thematic qualities, such as: the portraits of 1917–18 (pp. 91–93 are representative); the so-called "detaillist" pictures, including *Vegetable Garden and Donkey* (p. 96), the self-portrait of 1919 (p. 101), and *The Farm* (p. 107); the still lifes of 1920 (pp. 102, 103 are representative), and those of 1922–23 (pp. 108–10). Much of this work is magnificent, and had Miró never lifted a brush after early 1924, he would nonetheless be remembered. Like Klee before about 1918, and more than the Picasso of the Blue Period, Miró already had the ability to assert an individual intensity across an idiosyncratic mix of inherited pictorial codes. But in the actual making of his pictures this meant that each became a protracted wrestling match with tradition.[91] In August 1919, while at work on *The Village of Montroig (Montroig, the Church and the Village)* (p. 98) and *Vines and Olive Trees, Tarragona* (p. 99), he writes Ràfols: "I am . . . trying to solve as many problems as possible in order to reach a balance.—I don't know how the one of the olive trees will turn out: it started out being Cubist and is now becoming *pointilliste.* . . . What we have to do is learn to paint— look at that devil Picasso! We must forget about . . . doing '*interesting*' things . . . and keep on always searching . . . and preparing ourselves for the day we are mature enough to *start really interesting* things."[92] The routes Miró followed in this search are separately laid out by each of his groups of related works from before 1924.

And when, in early 1924, the day for which he had been preparing finally spread out before him, Miró was released into a freedom that he would have to learn how to manage. Suddenly, as the pace of his work accelerates dramatically, his notebooks and drawings indicate a consistent if rather ragtag attempt to keep track of his own activity. A certain amount of planning of blocks of work in advance becomes evident, as does a tendency to regard aspects of it in a serial way, although he was still far from the kind of calculated stratagems he would later employ.

But from Miró's ad hoc efforts to cope with the swerves and turns of those initial, nearly chaotic bursts of creativity in 1924 and 1925, a serial way of working did emerge that would become a basic pattern in his subsequent procedures. Seriality — understood as a fundamental phenomenon of the natural world, whether in its groups of related species or in its generative and regenerative cycles — was an especially congenial concept to someone of Miró's temperament. He was later to compare his own activity to that of a vegetable gardener, remarking that there are various crops, "here artichokes, there potatoes. . . . Things follow their natural course. They grow, they ripen; you have to graft."[93] This aptly describes the cyclical nature of Miró's art as well as the careful husbandry he brought to its articulation — its purposive planning in advance of results that can be only partially foreseen.

After 1924, the series is endemic to Miró's way of working; those phases of his art which fall somewhat outside its sway are exceptional, often evidencing some unusual stress or change of circumstances. But because the term "series" automatically evokes thoughts of such artists as Cézanne, Monet, and Mondrian, not to mention its built-in reference to latter-day practitioners of "serial imagery," including Jasper Johns, Frank Stella, and Kenneth Noland, its application to Miró risks confusion and misunderstanding. If, indeed, "series" were not the word Miró himself often used in referring to his work, it would be preferable to choose a more neutral term. About the only thing the various series within Miró's work have in common with those of artists whose names are virtually synonymous with "seriality" is the fact that they were thought out in advance as coherent groupings. Miró's series are never based on a single motif; they never rehearse the changes in a given object under optically different conditions, or the permutations in rearranging a fixed set of component elements. The subjects within each Miró series are often of a similar type, as in the Imaginary Portraits of 1929 (for example, pp. 170–71), but they can be as dissimilar as a bull (p. 269), a harbor (p. 266), and a Spanish dancer (p. 267) from a series of 1945. What actually defines each of Miró's series is his *conceptual* grouping, and his consistent technique. In an effort to defuse "series" of its art-historical charge, to "un-mark" it, the better to discuss Miró, the present essay will follow one of the word's more straightforward definitions, as given in the *Oxford English Dictionary:* "a number of things of one kind following upon each other in temporal succession or in the order of discourse or reasoning."[94]

Miró's notebooks, letters, and recorded remarks are replete with references to the various series he is working on or planning, or has already made. Sometime around January 1941, in the midst of the Constellations — a suite of twenty-three gouaches that Breton would characterize as constituting "a *series* in the most privileged sense of

the term . . . like the aromatic or cyclical series in chemistry"[95] — Miró is already plotting another sequence. The practice has so much become second nature to him that he confidently uses a rather acrobatic approach when jotting plans in his notebook for a future project: "To enrich them and make them more authentic, begin by drawing the last of them; that way the first will benefit from the last and will establish an equilibrium."[96] Commentators as diverse as René Gaffé, Jacques Dupin, and James Thrall Soby have remarked on Miró's serial tendencies.[97] Recounting an episode from the twenties, Gaffé remembers receiving a note from Miró, announcing, "I am going to make six small canvases, then eight very large pictures. Then, I am going to get married." When Miró had finished the "projected labor," Gaffé sent him a porcelain vase as a wedding present, only to receive a telegram from Miró saying that, no, he was not getting married, but was going to paint ten pictures *très poussés* and then make a series of twenty-four drawings.[98]

In 1924, the year that witnessed the onset of the serial pattern, Miró made, among other things, a large suite of drawings, which were preceded by work on two separate sets of pictures, each consisting of about ten, mostly large, radically experimental canvases. But Gaffé's account of the artist's clear pre-planning of groups of works, which is probably contemporaneous with Miró's matrimonial skirmish of 1928, does not fit the younger man of 1924. Far from being the seasoned campaigner of Gaffé's later profile, Miró was at this time plunged in an uncertain adventure that he was just beginning to sense he needed to master. Some insight into how he went about establishing control can be gained from studying his emerging serial procedures of that crucial year.

The Montroig Notebook

When from the rue Blomet Miró writes to Sebastià Gasch on May 3, 1924, that he is "in the middle of working feverishly, maybe as never before, and with the wind favoring all my things," he was almost certainly referring to his pictures characterized in the preceding pages as "gridded." In all, there are nine of these: four canvases — *Portrait of Mme K.* (p. 117), *Spanish Dancer* (p. 116), *Toys* (Dupin 89), and *The Kerosene Lamp* (p. 114) — and one large, complex drawing, *The Family* (p. 115), all largely in grisaille, were executed during Miró's stay in Paris in 1924, between about March and middle to late June; of the other four, none of them monochrome, *Head of Catalan Peasant, II* (Dupin 104) and *Carnival of Harlequin* (p. 128) were not completed until the beginning of the following year, when *Figure* (Dupin 106) and *Head of Catalan Peasant, III* (p. 129) were executed. But the preliminary drawing of at least one of these, *Head of Catalan Peasant, III*, is dated, in somewhat baroque script, March 10, 1924 (fig. 27). With only that evidence, it cannot be

demonstrated that the entire series was conceived during early 1924, but it is fair to assume this is a possibility, especially in light of certain evidence contained in the Montroig Notebook, which Miró appears to have used most during 1924.

Complicated by the loss of other sketchbooks and by still-open questions about Miró's travel, the task of unraveling the chronological puzzle of the Montroig Notebook and its some 140 unnumbered pages is neither simple nor completely feasible. Without doubt the notebook was begun in Montroig in mid-1923, with drawings for *The Tilled Field* and *The Hunter (Catalan Landscape)*, used extensively in 1924, and sporadically thereafter through early 1927. But aside from the first eleven pages, all devoted to studies for the just-mentioned landscapes, the rest

series of gridded pictures that he was then beginning and on which he would work until at least the latter part of May.[99] During this period, he appears to have shifted out of his accustomed notebook; instead, to judge from surviving studies, the gridded pictures were prepared by drawings on loose sheets and on the leaves he tore out of a tiny, now lost notebook and occasionally glued or pinned to the pages in other notebooks. The preparatory drawings for the gridded series not only are distanced from those for almost all other 1924 works by their displacement from the Montroig Notebook, but differ in kind as well. Where each of the other paintings and finished drawings of 1924 is usually preceded by one drawing that closely, if not exactly, prefigures it, a gridded picture could be prepared by several that develop from a naturalistic to

13. COVER OF THE MAGAZINE "LA UNION ILUSTRADA"; SOURCE IMAGE FOR **SPANISH DANCER** (P. 116), 1924. PRINTED PAPER, 11⅛ × 8⅛″ (28.4 × 20.8 CM). FJM 4479

14. PREPARATORY STUDY FOR **SPANISH DANCER** (P. 116), 1924. PENCIL ON PAPER, 4¾ × 2¾″ (12 × 7.2 CM). FJM 4477

15. PREPARATORY STUDY FOR **SPANISH DANCER** (P. 116), 1924. PENCIL AND WATERCOLOR ON PAPER, 8 × 5⅜″ (20.4 × 13.5 CM). FJM 4478

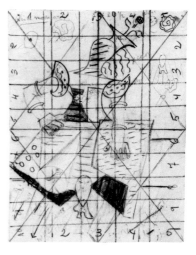

16. FINAL DRAWING FOR **SPANISH DANCER** (P. 116), 1924. PENCIL, COLORED PENCIL, AND PASTEL ON PAPER, 10½ × 8″ (26.8 × 20.5 CM). FJM 4480B

of the book at first appears a hopelessly promiscuous mix of places and times. Nonetheless, a rudimentary system, open to some exceptions, does prevail: until about the 36th page, all drawings are for works that will be executed in 1923 or 1924; almost all of those for the later year are on left-hand pages (if paginated, these would have even numbers); on the 36th, 38th, 40th, and 44th pages are lists and notes indicating a departure from Montroig; and thereafter, all drawings for works that will be completed after 1924 are on left-hand pages, whereas those for works of 1924 are on the right. The general conclusion must be that as Miró worked his way through the notebook, he tended to fill the right pages before the left.

When Miró arrived in Paris sometime in March 1924, he probably had the Montroig Notebook with him, but it is unlikely that he used it much for the next few months. Though it contains drawings for almost all of the known pictures of 1924, there are none whatever for any of the

a more fantastic presentation, as in *Spanish Dancer* (p. 116), which evolved from a magazine cover (figs. 13–16). The final drawing is recognizable by its red grid, which is retained in the finished picture even though the configuration of surrounding elements may have changed considerably.

When Miró picked up the Montroig Notebook again after at least three months, he would have found a number of empty left-hand pages toward the front. If his impulse was to begin again at the beginning, he would have started by filling in the blank left-hand pages of the first third or so of the book. The likelihood that this is what he did is supported by his memory of having painted *Portrait of Mme B.* of summer 1924 (p. 119) in Paris before leaving for Spain. Whether he actually painted the portrait then or whether he, years later, confused its conception (a drawing in the notebook) with its execution is an open question;[100] but whatever minor adjustments his memory may have

made, it is highly unlikely that he would have forgotten which of the summer 1924 paintings was the first to be conceived. If his recollection was correct about when the painting was conceived, and if he did indeed begin using the Montroig Notebook again at the beginning, then a study for *Portrait of Mme B.* should appear on a left-hand page early in the notebook; and so it does (fig. 17).

In this initial section, where studies for 1923 works appear on right-hand pages, *Mme B.* is preceded by only one drawing that is projected for a work of 1924 (fig. 18). This prior drawing, on a left-hand page, is the first of a suite of five that, like many others, are preparatory to final drawings; but as is not the case with most others, the final drawings will be executed on wood and seem to be guided by an obvious plan. Each preparatory drawing is divided into halves by a vertical or horizontal line; in the first the resulting rectangles are inscribed *1* and *2*, in the second *3* and *4*, and so on up to the fifth and last, inscribed *9* and *10*. The three finished drawings from this group that have been located all bear the date August 14, 1924, adding credence to the idea that they manifest an early series, thought out in advance. More important, the mid-August date implies what is elsewhere confirmed: that the positions of drawings within the notebook reveal an order of conception, but not of execution.

Miró was producing drawings at such a rate that it is not impossible for the contents of the notebook to have served as a kind of inventory or stockpile, from which he could chose at will. He hints at something like this in a letter of August 10, 1924, to Leiris, when he speaks of "leafing through my notebook" and "noticing the extremely disturbing quality of the dissociated drawings," adding, "I intend to do all these drawings."[101] With ideas piling up in his notebook, Miró seems to have needed a system to record whether he had converted a particular concept into a finished work; consequently, an *X* in brown crayon appears on each of the (otherwise all-pencil) drawings that he actually used, and none on those he never developed.[102]

With this in mind, we can go back to Miró's resumption of work in his notebook, sometime in the late spring: he would have filled the empty left-hand pages of the first third or so in no time. Then, in front of him would have been some hundred pages, all of them (with only four scattered exceptions) blank, enabling him to return to his old habit of working from right-hand page to right-hand page, which is what he appears to have done.[103]

Before leaving the farm in Montroig for Barcelona sometime shortly before Christmas, Miró did some end-of-the-year stocktaking in his notebook. Since the right-hand pages in the last two thirds were by now filled, he jotted down various lists and notes to himself just at the point, about a third of the way into the book, where the still-blank left-hand pages began. He would later continue using the left-hand pages, filling them with drawings for

17. PREPARATORY DRAWING FOR **PORTRAIT OF MME B.** (P. 119), 1924. PENCIL ON PAPER, 7½ × 6½" (19.1 × 16.5 CM). FJM 600B

18. PREPARATORY DRAWING FOR A LOST DRAWING ON WOOD, 1924. PENCIL ON PAPER, 7½ × 6½" (19.1 × 16.5 CM). FJM 597B

works he would execute in 1925, 1926, or early 1927. In the entire last two thirds, only two drawings projected for earlier work are on left-hand pages.[104]

Miró's pages of notes have an interest of their own, apart from the surrounding drawings. Meticulously preparing for the year to come, he made an inventory of the drawing and painting materials that were at the farm, and of the finished paintings there, including their sizes and prices; and he wrote a set of reminders about what he should take to Barcelona, what he should take from there, and what he would need in the new year. He did not indicate where he was going after Barcelona, but, if he was expecting to return to Montroig, it is hard to imagine why he listed white shoes and stockings and a cane as needed items; even more difficult to understand would be his planning to take recent paintings, among them *Portrait of Mme B.*, back to the farm. When he writes to Leiris on October 31, 1924 — "I am working a lot and still don't know when I will be back among you. Very encouraged and I hope that my latest works will amaze you a little"[105] — the clear implication is that he intends to bring his pictures to Paris, to show to his new friends. There is no reason why prices would be included in the list of paintings on hand if he was not expecting to have the works available in Paris.

Although Miró's experiences with the Parisian art market had thus far brought him almost nothing, the French capital was obviously the arena in which he wished to prove himself.[106] On his first trip to Paris, in 1920, he had written to Ràfols that "the important thing here is that people realize you *exist*."[107] By the end of 1924, Miró was known to the *bande* of the rue Blomet and a few discerning critics, but the "offensives" he had launched had not yet yielded wider recognition or an effective dealer. After the exhilaration and extraordinary productivity of the year just past, he must have been looking at 1925 with high hopes.

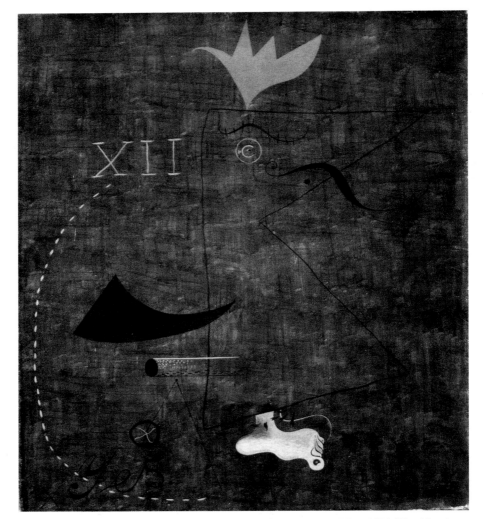

19. **THE GENTLEMAN.** MONTROIG, SUMMER–FALL 1924. OIL ON CANVAS, 20½ × 18⅛″ (52 × 46 CM). OEFFENTLICHE KUNSTSAMMLUNG BASEL, KUNSTMUSEUM. DUPIN 99

A Painter Named Miró

Reinstalling himself on the rue Blomet in early 1925, Miró would have had with him the work he hoped might "amaze you a little." Newly arrived would have been nearly all the work he had completed in Spain during 1924: the nineteen canvases on his list, including *The Tilled Field* and *The Hunter (Catalan Landscape)*, some fifteen drawings on wood and twenty on paper. In all, counting the five grid pictures of the previous spring, which he had most likely left in his Paris atelier, there would have been some sixty new works, only five of which could possibly have been seen before by anyone in Paris.[108] The pitch of excitement the making of this work had brought and the expectations it generated appear to have left Miró vulnerable to discouragement. At two o'clock in the afternoon on February 10, 1925, he wrote to Picasso: "My dear friend, You did me a lot of good this morning. Before going to see you, I was plunged in black ideas that you chased away. . . . Once again I follow the path of my imperious need to work. Thank you."

If not at the same hour, on the same day, Breton sent a note to his wife, Simone, telling her how impatient he was to see the sixty pictures that "a painter named Miró" had brought from Spain. Identifying Miró as André Masson's neighbor, he says the pictures seem to be quite extraordinary, that Aragon, Eluard, and Pierre Naville have just seen them and are unable to form a definite opinion.[109] Shortly thereafter, Breton must have visited Miró's studio on the rue Blomet and found himself sufficiently capable of making up his mind to become the owner of *The Hunter* and *The Gentleman* (fig. 19) by June 10, when Miró's second one-artist exhibition in Paris opened, with quite considerable brouhaha, at the Galerie Pierre. A month after Miró's show, Breton reproduced *The Hunter* and *Maternity* (p. 120) in *La Révolution surréaliste* of July 15, the issue with which he took over the magazine's direction. Given Breton's rather sudden discovery of the artist, the initial confusion the work prompted in the minds of Breton's friends, and the spectacular character of the opening at the Galerie Pierre, it is no wonder that he would later remember Miró's entry on the Surrealist scene as "turbulent."[110] But Breton's choice of adjective and the fact that he incorrectly places the event in 1924, instead of 1925, go beyond the circumstances of his encounter with Miró, to reflect his own first reactions to the pictures

painted mostly in 1924 and his entirely correct memory of their date.

In addition to the some sixty paintings and drawings that Miró had brought from Spain, Breton might have seen several other pictures on his first visit to Masson's neighbor. Since the meeting did not take place until after February 10, 1925, Miró could have already finished two canvases he had begun in Spain and brought with him to Paris — *Dialogue of the Insects* (Dupin 102) and *Landscape* (Dupin 103) — as well as *Carnival of Harlequin* (p. 128) and *Head of Catalan Peasant, II* (Dupin 104), which he had left incomplete in the rue Blomet atelier the previous spring. Since Breton's visit came after the fiery inspiration of Miró's meeting with Picasso, and in a year of prodigious activity, it may be that what were probably the last of the gridded pictures — *Head of Catalan Peasant, III* (p. 129) and *Figure* (Dupin 106) — were also available.[111]

Although it was 1928 when Breton wrote of Miró that "no one else has the same ability to bring together the incompatible, and to disrupt calmly what we do not dare even hope to see disrupted,"[112] he was undoubtedly referring to the work of 1924 and of 1924–25: he acquired for himself not only *The Hunter* and *The Gentleman* (fig. 19) but also *The Trap* (Dupin 95), and probably recommended to Jacques Doucet *Head of Catalan Peasant, II* (Dupin 104) and *Landscape* (Dupin 103). He does not seem to have liked so much the more abstract color-field paintings of the succeeding three years. The psychology of Breton's preference aside, he projects onto the art of Miró that joining of incompatible images which had first attracted him to Max Ernst. But Ernst's assaults upon convention consisted, as the artist put it in a paraphrase of Lautréamont, in "the chance meeting of two distant realities on an unfamiliar plane."[113] And where Lautréamont's formula, "beautiful as the chance encounter on a dissecting table of a sewing machine and an umbrella," could be translated by Ernst into the enigmatic co-presence of a bear, a sheep, and some fish in an otherwise quite ordinary bedroom (fig. 20), in Miró it is instead — contrary to Breton's reading — the marvelous unseen, immanent in everyday experience, that is imaged. However fantastic his personages and props may become, they are not incompatible with each other or their settings.[114]

It could be that one of the pictures Breton acquired, *The Gentleman* (fig. 19), with its inscribed English word "Yes," was made with Lautréamont's famous phrase in mind, which was, after all, formulated to describe the strange beauty of an Englishman.[115] The handsomeness of such a gentleman need not, however, subsist in a double umbrella silhouette, a coxcomb head, or a tracery of stitches connecting male member to fateful hour of encounter; but even if devoid of conscious reference to *Les Chants de Maldoror*, Miró's fancifully outfitted gentleman delivers poetry by way of humor in a manner fresh enough to match Lautréamont. Whatever the picture's source may

20. MAX ERNST. THE MASTER'S BEDROOM—IT'S WORTH SPENDING A NIGHT THERE. C. 1920. GOUACHE, PENCIL, AND INK ON PRINTED REPRODUCTION MOUNTED ON PAPERBOARD, 6½ × 8⅝" (16.3 × 21.9 CM). PRIVATE COLLECTION

have been, a fluid ambivalence between physical and mental events is realized. Miró claimed that pictures like this were "absolutely detached from the outer world (the world of men who have two eyes in the space below their foreheads)"[116] — a personal way of explaining how the circuit from perception to expression can emerge in painting to describe vision's "inward traces . . . the imaginary texture of the real."[117] *The Gentleman* depends not on incongruous juxtapositions for its effects, but on mapping out a boldly imagined, delicately executed departure from perceived reality.

Mapping the Surface

As early as *Vegetable Garden and Donkey* (p. 96), and with increasing urgency after *The Farm* (p. 107), Miró had been tinkering with his craft to find a spatial geometry that could approximate the feel of actual space, but without illusioning it or traducing the two-dimensionality of a planar support.[118] Once again, the imagery and structure of *The Hunter (Catalan Landscape)* (p. 113) show it to be among the most seminal works in Miró's career, not least in disclosing the kind of space he was searching for: the paintings of 1925–27, with their no less than revolutionary opening up of the pictorial field, were prepared for in the two kinds of paintings Miró made in 1924 — the gridded ones and those Dupin has called the "yellow-grounds"[119] — both of them foreseen in *The Hunter*.

Anticipating the gridded pictures, *The Hunter*, although not nearly as rigidly designed as *The Tilled Field* (p. 111), nonetheless shows a careful alignment of elements as well as a subtle delineation of edge in the form of the overly extended mock stretcher-bar lines running down the left edge and across the top (fig. 12). But despite their meticulous positioning, the objects and creatures in the picture appear in flux; and if the ground is not yet the

33

monochrome analogue of a universal anywhere, as it will become in later paintings, the pink and yellow are so closely valued that the sense of a spatial continuum is barely disrupted. By these means, Miró constructed for himself in *The Hunter* a pictorial model of the anarchic within the law-abiding, and he would thereafter make each function in the other's terms.

In the gridded pictures of spring 1924 (pp. 114–17 and Dupin 89), painted just after *The Hunter*, Miró diagrams the predetermined spatiality of the support. No punches are pulled: this is a flat-out declaration of the arbitrary nature of the two-dimensional, rectangular ground. But Miró does not dramatize these "skeletal aspects"[120] of the space of painting to assert a purely aesthetic order, apart from the order of the world. Even as his grid goes about its formalist modern function of subduing volume and facilitating a type of drawing integral to the formal space of painting, it finds itself participating in the creation of a sensuously and spiritually evocative art.

For if the grid defines limitations, it also opens up possibilities, becoming an exercise bar to show off the dynamics of painting and drawing. Like the discordant perspectives of de Chirico, it makes explicit the split reference of the picture — to the world outside, and internal to art. Its coordinates are the pictorial counterpart of an ideal of stasis and order that time and accidentality will inevitably confound. Behind the formal strategies of *The Family* (p. 115), for instance, is Miró's desire to reenact our quotidian experience of how existence constantly shifts between emerging and fading realities. An old Mallorcan tradition of storytelling begins every tale with the formula "It was and it was not."[121] The ambiguous poetry of time in this invocation suggests T. S. Eliot's lines from "Burnt Norton": "Time present and time past | Are both perhaps present in time future, | And time future contained in time past."[122] Both Eliot and the Mallorcan storyteller set up an imaginary precinct, like that of *The Family*, where "the deep structures of reality to which we are related as mortals who are born into this world and who *dwell* in it for a while" will be "unconcealed."[123] The space in which what *is* can mingle with what was and will be, is the space of mysterious domesticity where Miró's father, mother, and son coexist in *The Family*.

Meaning in any work of art, of course, arises from the physical materials the artist chooses and how he or she manipulates them. Self-evident as this is, the explanatory power to be gained in the conservation laboratory is sometimes overlooked. *The Family* has been closely examined by The Museum of Modern Art's conservators, with revealing results. Miró made this drawing with vine charcoal, white pastel, red conté, and oatmeal paper. Because the last was generally used for wallpaper, Miró would probably have had to begin with a trip to a household supplier to obtain a sheet of the size he wanted. This link between *The Family* and the real world of domesticity may have

21. **THE ARTIST WORKING.** AUGUST 25, 1977. PENCIL ON PAPER, 9⅛ × 10¾″ (23.4 × 27.5 CM). FJM 7826

amused him, but his real interest was the suitability of this particular paper to his purposes; because the paper's component materials are somewhat transparent, light is refracted from deep within its structure, creating the possibility of gentle luminosity. Once he had this paper in hand, Miró applied all the major grid lines in red conté. Thereafter, he would have picked up alternately his white pastel and his vine charcoal (which, according to a laboratory report, "sits on the paper in tiny, sparkling jewel-like particles" yielding deep, rich blacks). Initially, there was a different accommodation of figures to grid lines, as the ghost gray or white outlines of their former states attest. To create clear, unblemished pentimenti that could suggest evanescent experiences of emerging and changing, Miró did not erase the lines of his original images, but chose the less harsh method of stumping.[124] This is especially effective in the spectral radiance of the vanished but still-present eye exactly on the center line, near the top of the upper half of the sheet. Equally, the gently tamped lines of white surrounding the eye at the right emanate from its gaze as quivers of light. An omniscient beacon in a world of shadows, the eye of the artist animates his creation.

Miró's fascination with his own activity, his insistence upon directing attention to materials and process, as seen here, was at least as great as that of any other leading modernist. But never, until the end of his life, in one tiny drawing (fig. 21), was it expressed — as so often in the work of Matisse, Picasso, or even Klee — in a studio picture or in an image of himself working. Rather, as in *The Family* or *The Hunter*, he uses the disembodied eye, or hand, to signal his authorial function. These, like every other sign in Miró's pictorial vocabulary, are subject to contextual metamorphosis; in the twenties, however, both eye and hand are recognizably the declaration of the artist's presiding presence. In *The Kerosene Lamp* (p. 114), probably the last of the grisaille grids of 1924, and cer-

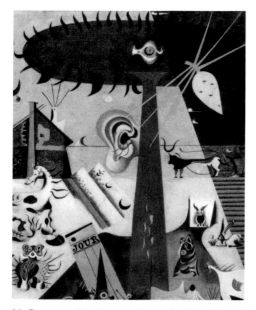

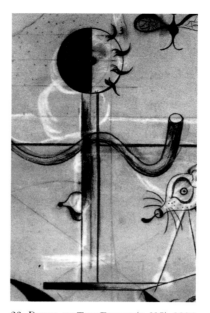

22. Detail of **The Tilled Field** (P. 111), 1923–24

23. Detail of **The Family** (P. 115), 1924

24. Study related to **The Tilled Field** (P. 111), 1923–24. Pencil on paper, 7½ × 6½″ (19.1 × 16.5 cm). FJM 603A

25. Detail of **Aviat l'Instant** (Hayward 1986, cat. 274, repr., color, p. 244), 1919. Oil on cardboard, 42⅛ × 30″ (107 × 76 cm). Private collection

26. **Portrait of Mlle K.** 1924. Pencil on paper, 7½ × 6½″ (19.1 × 16.5 cm). FJM 650A

tainly the funniest, Miró's hand appears with the panache of a carnival barker's as it seems to flip back the edge of a canvas to reveal a topsy-turvy world of marvels — among other things, counterclockwise from the top left: a hairy baton born as a tree in *The Tilled Field* (fig. 22), and most recently become a boy in *The Family* (fig. 23); a year-old swarm of flies (fig. 24), now in a kerosene lamp that is also descended from a tree (fig. 25) and about to double reincarnate as desirable matron (p. 119) and chaste maiden (fig. 26); the hand itself, whose helix-shaped thumb is an enlarged fly and an unrealized kiss (p. 118);[125] a mustachioed portrait that may be a hunter in Sunday best, a father in bourgeois uniform, or a dandy in spats who paints in Paris; and for initiated lovers of puns, the French word for "tea" (*thé*) — already associated with dice by Picasso in a 1912 collage where a newspaper frag-

ment reads "UN COUP DE THÉ," in a wordplay on Stéphane Mallarmé's *Un Coup de dés jamais n'abolira le hasard* — identifies what looks like a building borrowed from de Chirico as a sliced, enlarged die.

The Kerosene Lamp reads as an exuberant primer of Miró's pictorial language instated by the work of 1924, just as, some seven months later, *Carnival of Harlequin* will furnish a basic index to motifs of his subsequent career. Perhaps the most frequently remarked aspect of Miró's oeuvre is its reserve of pictographic signs used with the interchangeability of alphabetic letters in a vast range of permutations. As the context of each work alters the semantic charge of a sign, so the participation of that work in a series governs the formal manner of the sign's presentation. But in 1924 and 1925, while signs were still being formulated, Miró's different ways of working were spilling

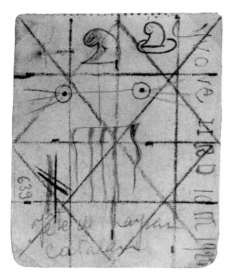

27. Preparatory drawing for **Head of Catalan Peasant, III** (p. 129), 1925. March 10, 1924. Colored pencil on paper, 2¾ × 2¼″ (7 × 5.7 cm). FJM 639

28. Preparatory drawing for **Head of Catalan Peasant, I** (p. 121), 1924. Pencil on paper, 6½ × 7½″ (16.5 × 19.1 cm). FJM 638a. The drawing is reproduced here to correspond to the orientation of the painting made after it.

29. Preparatory drawing for **The Hunter (Catalan Landscape)** (p. 113), 1923–24. Pencil on paper, 7½ × 6½″ (19.1 × 16.5 cm). FJM 654a

into each other, and perhaps the semantic sign most fundamental to his being evolves from *The Hunter*, crossing and recrossing the permeable borders between the gridded and the yellow-ground pictures, emerging finally in an early group of "dream" paintings from the summer of 1925.

The geometric stick-figure of the hunter incorporates the first appearance of the schematized head of a peasant coessential with the space of air. Like the four points of a compass, torso and limbs indicate the four edges of the canvas. Shortly after this debut, in a gridded drawing whose elaborately inscribed date seems to be March 10, 1924 (fig. 27), the hunter reappears, even more diagrammatically rendered, as the head of a Catalan peasant. To convert the earlier full figure into a head, Miró retains and amplifies the cap, the Catalan *barretina*, but it may not sit on anything even so insubstantial as the tip of the transparent triangle that was its former perch; it floats on an imaginary horizontal. With bodily contour abolished, the head, now coextensive with the sheet, is further described by an inverted, crossed *T*, suspended from the hat and adapted from the vertical and horizontal intersections of the hunter's body in *The Hunter*. The horizontal line from which the hunter's legs had been dropped becomes the bottom of the *T*, from which is suspended a vine-like beard; above, a parallel line, transposed from the horizon line running through the hunter's torso, connects a pair of star-like eyes. Within just over a year Miró would paint four versions of his Catalan peasant's head (p. 121, Dupin 104, p. 129, and p. 135); although the March 10 drawing (fig. 27) is the first individual conception of the subject, it would be the penultimate one executed (p. 129) — sometime in the early part of 1925.

In general, Miró's work of 1924 until the inception of

what are sometimes called the "dream" paintings of early 1925 through 1927 follows a course of increasing simplification. Going from the compositionally intricate grids of the spring (pp. 114–17 and Dupin 89) to the pared-down, semi-anecdotal open yellow-grounds of the summer (pp. 118–23 are representative), it detours sharply in the completion of the two grid pictures that span 1924–25, *Carnival of Harlequin* (p. 128) and *Head of Catalan Peasant, II* (Dupin 104), and emphatically resumes its reductive trajectory in the two canvases, *Head of Catalan Peasant, III* (p. 129) and *Figure* (Dupin 106), directly preceding the first of the "dream" paintings in 1925, which include *Head of Catalan Peasant, IV* (p. 135).

Prominent constitutive parts of this progression are the four Catalan heads, but they fit somewhat uneasily within its logic; with the exception only of the last, it is actually the first (p. 121) that is the sparest. While this may be explained by its execution during the period when Miró was noticing that his "canvases that are simply drawn . . . are more profoundly moving,"[126] it is so radically simplified that it could seem to belong to 1925. Like virtually every other painting from mid-1924 until mid-1927, this first painted version of the head is preceded by a drawing (fig. 28); but all four of the different finished paintings as well as their intimate ties to the hunter are already manifest in what is most probably the final drawing of 1923 (fig. 29) for *The Hunter* (p. 113), where his persona is doubled, once prefiguring the hunter and again in a cross-like form very close to the final head of 1925.

When, in the summer of 1924, Miró made the drawing (fig. 28) for *Head of Catalan Peasant, I*, he had three prior concepts to guide him: the cross-like figure from the 1923 study for *The Hunter* (fig. 29); the hunter as he appears in that painting (p. 113); and the drawing of March

30. Miró's signature from a letter, dated August, 19, 1973, to William Rubin. Department of Painting and Sculpture, The Museum of Modern Art, New York

31. Detail of inscription on the verso of **Ciphers and Constellations in Love with a Woman** (p. 257), 1941

32. Preparatory drawing for **Head of Catalan Peasant, IV** (p. 135), newspaper dated March 23, 1925. Ink on newspaper, 12⅜ × 8¼″ (31.4 × 21 cm). FJM 552

10, 1924 (fig. 27), which would be the basis in early 1925 for *Head of Catalan Peasant, III* (p. 129). Conflating elements from all of these, Miró's *Head of Catalan Peasant, I* (p. 121) is a hybrid of the peasant's past and future guises. Miró seems to have wanted to preserve a record of his chronological hopscotch, as he carefully pasted the drawing of March 10, 1924, on the right-hand page of the Montroig Notebook directly following the right-hand page where the study for *Head of Catalan Peasant, I* appears. Beyond this rather special treatment, the March 10 sketch must have held unusual significance for Miró; not only did he sign and date it — an almost unheard-of practice for preparatory studies — but he did so in an extraordinarily elaborate manner. The near fetishistic care Miró customarily took in signing his paintings is here, most unusually, carried over in the stencil-like quality of the letters and in their strategic placements along grid lines. The inscription itself is curious; the signature and date are relatively straightforward, but what to make of the first word? We will probably never know for certain, but given the interchangeable identity of hunter and peasant, and Miró's known fondness for Apollinaire, a reference could be intended to a memorable character from *L'Hérésiarque et Cie*, Qu'vlov? (i.e., "Que voulez-vous?"), "the companion of wild boars, the cousin of hares and squirrels," whose guitar was the always murmuring wind.[127]

With *Head of Catalan Peasant, IV* of 1925 (p. 135), Miró veers close to its 1923 conception as the cross-like figure in his most complete drawing for *The Hunter* (fig. 29). As in the three other Catalan peasant paintings, the coordinates of the figure map the field of the canvas; but here, like the intersecting dotted lines of the *Hunter* drawing, the hair-thin cross that is now the peasant's entire substance reads not as head but as bodily extension. The equation of body with pictorial support is expressed directly; more covert, but open to empathetic intuition, is

Miró's identification with the persona of his Catalan peasant. If intuition craves the gratification of proof, it can be found in Miró's signature during the last years of his life (fig. 30), where its first letter, *J*, replicates the cross and *barretina* of *Head of Catalan Peasant, IV*. Perhaps the most ubiquitous of signs in Miró's subsequent pictorial vocabulary, a kind of barbell pictograph (fig. 31), is a riff on the line that connects the eyes in *Head of Catalan Peasant, I* and in *IV*. The almost musical syncopation of the gouaches in the 1940–41 series of Constellations (pp. 238–60) arises in large part from the strategic deployment of this sign. Again, we have Miró's word as verification; in the early forties, when jotting down his thoughts about revising his self-portrait of 1937–38 (p. 228), he considers using the signs that come from the first and fourth Catalan peasant canvases — and if he does so, he tells himself, he will render them schematically, as he did in the Constellations of 1940–41.[128] Gerard de Nerval's line "Le moi a une force hiéroglyphique" would seem to have an application to much of Miró's work, but in this instance its relevance is serendipitously literal.

Consolidating a System: The Series, *A* to *J*

Sometime in early 1925, Miró instituted a system of rather confusing simplicity that he would use to keep track of his work in progress. Thanks to that system, illuminated by additional supporting evidence, the fourth version of the Catalan peasant's head, like other works of 1925 and 1926, can be assigned to a particular group having a common approximate date; in this case, *Head of Catalan Peasant, IV* belongs with five other works painted in Montroig between July and late September 1925. What Miró's system does not reveal (and in fact muddles) is the interval between conception and execution. That it often could be quite extended seems confirmed by the existence of a pre-

liminary sketch for the fourth head on a fragment from a Paris newspaper dated March 23, 1925 (fig. 32).

The feelings of discouragement that Miró had confided to Picasso early in the year were soon dissipated by increasing recognition and the support of a dealer committed to his work. By September 28, he could write to Gasch: "My life has changed radically, from both moral and material viewpoints. On April 1, I signed a contract with Monsieur Jacques Viot. . . . The only obligation I have is that all my work belongs to him; apart from that, absolute freedom in both work and production." At the moment of his association with Viot, Miró found his ideas for paintings multiplying more rapidly than ever; most likely, his old device of putting a brown *X* on a drawing once he had converted it to a finished work now seemed an inadequate means of representing to himself what would be in his dealer's hands.

The system Miró inaugurated in 1925 — and changed at the beginning of 1927 — can be traced in five notebooks, four of which began their service within the new regime in 1925; these are the already discussed Montroig Notebook, two others, bought in Paris, and a fourth, in Barcelona. The fifth was used in 1927 only. For clarity's sake, a way of referring to them is needed: accordingly, the earliest has already been designated the Montroig Notebook; the two from Paris can adopt the names of the shops where Miró purchased them, Charbo and Moreaux; similarly, the fourth can take the name of its city of origin, Barcelona; and for the fifth, the designation 1927 should suffice. Scattered throughout these notebooks are drawings for virtually every known painting executed between sometime after early 1925 and the beginning of what are called the "summer" paintings of 1927.[129] With the sole exception of drawings for the summer paintings of the year 1926, each drawing in these notebooks that actually resulted in a painting is marked with a letter from *A* to *J*. Additionally, almost every drawing for a pre-1927 work is inscribed with a French canvas size,[130] which, without exception, corresponds to the dimensions of the painting made after it; beginning in 1927, the size indication is dropped, and the inscribed letter is followed by a (superscript) number; for instance, the drawing for *Personage* of 1925 (see cat. 43) is inscribed *A/60F* and that for *"Un Oiseau poursuit une abeille et la baisse"* of 1927 (see cat. 61) is marked *G 11*.

Study of the notebook drawings and the paintings made after them yields these findings: all drawings, with one exception, inscribed with the letters *A* to *F* are for paintings of 1925; all marked *F2* are for canvases of 1926; every drawing bearing a letter from *G* to *J* is for a work of 1927. The *A* to *G* drawings are scattered through the Montroig, Charbo, and Moreaux notebooks; the only lettered drawings in the Barcelona Notebook are *G*s and *H*s. Nothing discernible in the drawings made for pre-1927 work either links them with others in their own letter-

33. PREPARATORY DRAWING MARKED "A" FOR "PHOTO—CECI EST LA COULEUR DE MES RÊVES" (P. 131), 1925. PENCIL AND WATERCOLOR ON PAPER, 7¾ × 10⅜″ (19.8 × 26.4 CM). FJM 720. THE DRAWING IS REPRODUCED HERE AS ORIENTED WITHIN THE CHARBO NOTEBOOK.

34. PREPARATORY DRAWING MARKED "E" FROM THE CHARBO NOTEBOOK FOR PAINTING (THE CHECK) (DUPIN 128), 1925. CHARCOAL ON PAPER, 10⅜ × 7¾″ (26.4 × 19.8 CM). FJM 721

group or differentiates them from those in different letter-groups; only in 1927, with the *G* series, and the substitution of a superscript number for canvas size, does a perceptible unity start to appear, which becomes progressively established in the series *H* to *J*.[131]

Given that all but one of the *A* to *F* drawings are for paintings of 1925, all *F2*s for 1926, and all *G* to *J* drawings for 1927, the conclusion is inevitable that the letter-groups provide a chronological guide to the execution of paintings during those years. But the conceptions behind the paintings — the notebook drawings for pre-1927 work — are mixed up higgledy-piggledy with one another. For example, in group *A* are six drawings (in three notebooks), for *The Siesta* (fig. 43), *Personage* (p. 130), *"Photo — Ceci est la couleur de mes rêves"* (p. 131), *Painting* (Dupin 140), and two lost canvases. The one for *The Siesta* appears on page 76 of the Montroig Notebook,[132] after drawings inscribed *B*, *C*, and *E*; *Personage* is on the first page of the Moreaux Notebook, and the drawing for one of the lost pictures on the last; *"Photo"* is in the middle of the Charbo Notebook, whose first page is a *B* drawing and whose second is the drawing marked *G 11*, for *"Un Oiseau poursuit une abeille et la baisse"* of 1927.

35. Preparatory drawing marked "D" from the Charbo Notebook for **The Birth of the World** (p. 133), 1925. Pencil on paper, 10⅜ × 7¾" (26.4 × 19.8 cm). FJM 701

36. Preparatory drawing marked "F2" for **Painting** (Dupin 160), 1926. Pencil on paper, 10⅜ × 7¾" (26.4 × 19.8 cm). FJM 702a. Right page in notebook, directly following the page reproduced in fig. 35.

37. Preparatory drawing marked "F2" for **Painting** (Dupin 162), 1926. Pencil on paper, 7¾ × 10⅜" (19.8 × 26.4 cm). FJM 702b. Left page in notebook, verso of the page reproduced in fig. 36; faces the page reproduced in fig. 38.

38. Unmarked drawing; never executed as a painting. 1925. Pencil on paper, 10⅜ × 7¾" (26.4 × 19.8 cm). FJM 703. Right page in notebook; faces the page reproduced in fig. 37.

39. Preparatory drawing marked "F2" for a lost painting. [1925]. Pencil on paper, 10⅜ × 7¾" (26.4 × 19.8 cm). FJM 704. Right page in notebook, directly following the page reproduced in fig. 38.

40. Preparatory drawing marked "D" for **Painting** (Saint-Paul-de-Vence 1990, cat. 22, repr., color, p. 61), 1925. Pencil on paper, 10⅜ × 7¾" (26.4 × 19.8 cm). FJM 705. Right page in notebook, directly following the page reproduced in fig. 39.

The drawing for *"Photo"* in particular gives some idea of how complex the relation between a notebook's contents can become. The Charbo Notebook, with its thin pages, especially favored the generation of further drawings from the impressions of others. *"Photo"* (fig. 33) is one of the primary drawings that led to further ones; in the drawing for *Painting (The Check)* (fig. 34), which directly follows, the outline of the little creature in the lower left, who has been identified as Mercueil, Alfred Jarry's super-male,[133] traces the configuration of the word "Photo," whose capital P accounts for his ithyphallic con-

dition, just as the tally of completed copulations follows the traces of "Ceci est la couleur de mes rêves." The blue spot on the *"Photo"* drawing left a particularly strong impression, giving rise to the three drawings succeeding the one for *Painting (The Check)*; but these four drawings, though they share a common origin in the imprint left by *"Photo,"* are lettered, respectively, *E, A, D,* and *C.* Similarly, eighteen pages before the *A* drawing for *"Photo"* is the *D* drawing for *The Birth of the World* (fig. 35), which generated five further drawings of its own, in this order: *F2, F2,* unmarked,[134] *F2,* and *D* (figs. 36–40).

If we are to posit that Miró painted the canvases of the *A* series (or any other until *G*) quite soon after making their drawings, we have to imagine that the decision to create a series was accompanied by another — to sketch in four different notebooks, wherever their pages might open. To bring the drawings generated by impressions of others into a close chronological relation with their paintings, we have to think that, having made the *A* drawing for "*Photo*," Miró skipped a page to make another *A* drawing, then skipped again to make a *C*, and returned later to fill in with a *D* and then an *E* on the intervening blank sides. With the *D* drawing for *The Birth of the World*, such a methodology would mean hopping four pages to use the drawing's traces on the fifth. Not only would such a procedure be ludicrously impracticable, it is manifestly not what happened with the five *Birth of the World* drawings, each of which, after the first, changes configuration in closer conformity to the one it follows than to the originary drawing.[135] The conclusion must be that Miró made drawings in such teeming profusion during the first part of 1925 that most, if not all, at least until those marked *G*, were in his notebooks as part of an image-bank, ready for selection when he started making his first lettered series.

A comparison of lists Miró made in the Moreaux and Barcelona notebooks with two letters written to Gasch in the fall of 1925 strongly suggests that the great cycle of "dream" paintings was not begun until July 1925. Unusually — probably because of the planned opening of the first Surrealist exhibition in Paris in November — Miró was preparing to break the rhythm of his work with a short trip to Paris.[136] On September 28, 1925, he writes: "I am working a lot. I will go back to Barcelona with around sixty canvases, some of them so big that I have to use a ladder to work on them." He says that this is a completely new situation for him; he has never before had so many canvases, and their transportation worries him. Twelve days later the outlook has changed, as he tells Gasch on October 10: "I packed all the canvases which are finished, that is, thirty-five, some of them of incredible size, which, of course, I shall have to check through. Sorry that I won't be able to show them to you, but don't worry. For Christmas I will finish a series of twenty-five canvases, which I am leaving here."

In the middle of the Barcelona Notebook are two lists very like those Miró had written to himself in the Montroig Notebook before leaving for Paris the previous year. The first, headed "Lo que falta (1925)," or "What is lacking," totes up what pigments are still at the farm, what he must take from Barcelona to Paris, and what materials he must have to finish the series *D* and *E*. On the facing page is a list, arranged by size, of thirty-five canvases, exactly the number he told Gasch he has completed and packed. The canvas sizes correspond to those in the *A*, *B*, and *C* series, but are incommensurate with those of the series *D* and *E*.[137] But an inventory near the back of the Moreaux

Notebook, which must have been made sometime in 1926 (as it includes *F2*s), lists — under *D* and *E* — twenty-seven canvases, with size and color notations that match up with the paintings in those series as we now know them. Virtually the only scenario that can be pieced together from the foregoing is that Miró was unable to work quite as quickly as he had thought possible when he first wrote to Gasch; consequently, when it came time to leave for Paris, some two weeks after his October 10 letter, he was forced to leave his *D* and *E* series incomplete and take with him only the finished series of *A*s, *B*s, and *C*s. Discarding the unlikely possibility that Miró began his first series in Paris, then took the paintings to Montroig, and then back to Paris, the only remaining interpretation is that — contrary to the widespread opinion that they were realized in Paris — the "dream" paintings of 1925 were all executed in Montroig.[138]

As the Gasch correspondence provides the key to dating the lists in the middle of the Barcelona Notebook, it helps also to unlock what had been the mystery of their occurrence in a notebook devoid of any drawings for work completed in 1925. Its first page, inscribed "1926," is another of those inventories of what is needed, and what is left. Thereafter, until the list of "what is lacking" in 1925, most drawings are for the summer landscapes of 1926, interspersed with others for drawings of the same year. Following the two 1925 lists are drawings for the 1927 *G* and *H* series, sequentially ordered by superscript number. The most plausible explanation for the sudden appearance in this particular notebook of Miró's plans of October 1925 for a trip to Paris is that the notebook was the one he had been working in. Reconstructing his progress in 1925, we have to think that when he arrived in Barcelona in July on his way to Montroig, he probably needed a new notebook. By then Miró would have filled the right-hand pages of the Moreaux and Charbo notebooks almost completely, and must have had some reluctance to use the left-hand pages, as they were to remain largely untouched. Aside from whatever now lost notebooks he may have drawn in, the only available blank pages in his old notebooks he would use were left-hand sides from the veteran Montroig Notebook. If he did pick up a new notebook in Barcelona, presumably he started, as he preferred, by drawing on the right side of its first two-page spread. The drawing he made there (see cat. 57) almost exactly prefigures *Landscape (The Grasshopper)* (p. 153), one of the summer landscapes of 1926, but providentially for our purposes, Miró did what he very rarely did with preparatory drawings: he dated it — 1925. The fact that he was painting furiously did not dissipate his urge to draw, and what he drew were sketches and preparatory studies for the seven landscapes (pp. 152–57 and Dupin 175) that he would paint in the following summer and for some drawings of the next year; where he drew them was in the first half of the Barcelona Notebook and on a cluster of pages

in the Montroig. His other notebooks already contained such a wealth of ideas for the paintings he projected in 1925 that—as he would find out, first with the *D* and *E* series, and then when he had to extend the *F*s into 1926 and label them *F2*s—he could not complete them within his planned schedule. But in the full enthusiasm of the summer of 1925, this was not yet apparent, and Miró evidently for a brief moment attempted to incorporate this new kind of drawing—and hence different way of painting—into the groups of 1925 within the larger series of "dream" paintings.

Although there are several sketches for summer 1926 paintings in the Montroig Notebook—sketches whose placement and imagery suggest that the whole series was inspired by drawings of 1924 or even earlier—only one fully prefigures a subsequent painting. That one is for *Person Throwing a Stone at a Bird* (see cat. 54), and it is inscribed *B*, followed by the canvas size, *30F*. When Miró began one of the series *A* to *F2*, he almost undoubtedly first wrote the appropriate letter on the drawings selected for that series, then, as he started to make each painting, went back and inscribed the relevant drawing with the size of the canvas to which it was transferred.[139] That being the case, Miró must have actually begun painting *Person Throwing a Stone at a Bird* (p. 152) around July 1925; the realization probably came rather quickly that he did not want to paint in such incompatible ways at once, and that there were still a multitude of drawings in another style that he felt driven to convert into paintings. Work on that picture was then put off until the following summer, when he would paint it along with the six others being planned in the pages of the Barcelona Notebook.[140]

With this scenario, it is entirely logical that the 1925 lists should appear in the middle of the Barcelona Notebook. By October, when Miró wrote to Gasch, he had finished the drawings for his summer 1926 landscapes, and he simply scribbled his lists at the point where he found himself in the notebook. As usual, before beginning to work the next summer, he inventoried what was needed and what remained at the farm, and the most natural place to add it up was the blank first page of the Barcelona Notebook, preceding the drawings he was then ready to start converting to paintings.

When, exactly, the drawings for the 1927 *G* and *H* series that follow the lists were made is not, on present evidence, possible to determine. But the paintings made after them had to have been executed in early 1927 on the rue Tourlaque, where Miró had moved the previous year. Beginning with the *G* drawings, the inscription of canvas size is eliminated, replaced by a number representing order of execution. Initially, the *G* campaign seems to have been something of a clean-up operation; the first two *G* paintings come from widely separated drawings in the Moreaux Notebook, the second batch from the Montroig, and the third—which is the trio of "*Un Oiseau poursuit*

une abeille et la baisse" (p. 142),[141] "*Beaucoup de monde*" (p. 144), and "*Musique—Seine—Michel, Bataille et moi*" (p. 145)—from the Charbo. After these first *G* drawings had been assigned to a series, the two notebooks from Paris and the one from Montroig were abandoned for many years.

Once the thirteen *G*s from his old notebooks were rounded up, Miró turned to the Barcelona Notebook, where the first drawing following the 1925 lists is numbered *G 14*, and the pages remaining complete the series *G* and *H*. The last of the drawings for the cycle of "dream" paintings are all in the 1927 Notebook, given over exclusively to *I* and *J*.

Miró's astonishing rate of production in the *A* to *F2* series—no fewer than eighty paintings were executed during a scant ten months[142]—was exceeded by the more than seventy pictures resulting from his January to July campaign of 1927 on the *G* to *J* series.[143] Had Miró basically changed his procedures, it would have been difficult, if not impossible, to sustain (much less, quicken) his pace. Because of the drying times that the grounds of most of his paintings required, he had to begin several at once, and he could do so with confidence only if a store of images was already in reserve. It is most unlikely that Miró would even have looked for a way to surmount this practical necessity. When he began the *G* paintings, he was not stepping outside the formal and psychological unity that binds all the paintings done after a letter-group of drawings into a single, if subdivided, large series; thus the possibility of a rupture in his methodology would not have occurred to him. The significance of his change of system, the substitution of superscript number for canvas size with the *G* drawings, signals the point at which Miró's thinking ahead *en bloc* brings conception and execution into one-to-one balance.

No longer would he leaf through his notebooks to choose drawings for the next projected series of paintings; after the clean-up operation of the first half of *G*, he made his paintings in the order in which he had done his drawings. When one drawing generated another—as *H 15* did *H 16* (figs. 41, 42)—the new system quite naturally eliminated the gap that had prevailed between the execution of paintings made from earlier studies so related. Not only does the superscript-number series introduce a sequential way of producing paintings from drawings, it also shows an increasing orderliness in Miró's advance planning. Where no demonstrable common feature such as theme or color governs the particular placement of drawings and their related paintings within the seven groups of *A* to *F2*, the series *G* to *J* show a progressive coherence; within the *G* and *H* series are clusters of obviously related drawings, but those in the *I* and *J* groups were conceived for paintings that have evident common characteristics. The intense blue ground "circus" paintings (pp. 147–49, 151) derive from the plans in *I*, while *J* accounts for all the

41. PREPARATORY DRAWING MARKED "H 15" FROM THE BARCELONA NOTEBOOK FOR **CIRCUS HORSE** (DUPIN 205), 1927. PENCIL ON PAPER, 5⅞ × 7⅜″ (14.9 × 18.6 CM). FJM 784

42. PREPARATORY DRAWING MARKED "H 16" FROM THE BARCELONA NOTEBOOK FOR "**TIC TIC**" (DUPIN 222), 1927. PENCIL ON PAPER, 5⅞ × 7⅜″ (14.9 × 18.6 CM). FJM 785

"white-ground" paintings,[144] the last and distinctly transitional group of the 1925–27 open-field pictures (Dupin 226–33).

The Logic of the Stretcher Bar

A curiously little-remarked phenomenon characterizes the majority of paintings done after drawings of the *A* to *E* series. Sometimes subtly, sometimes brazenly, their surface films of scumbled paint are applied so as to show the traces of underlying stretcher bars.[145] When Miró observed, "I have always evaluated the poetic content according to its plastic possibilities,"[146] his reference was not specifically to these paintings of 1925, but they illustrate his point. His unorthodox exploitation of the basic constituent fact of traditional easel painting—that, before all else, the field of operation is a canvas supported by a rectangle of wood and one or more crossbars—paralleled the ways his poet friends used the very arbitrariness of language to open it to new meanings. Syntax, Aragon admonished, exists as grapes do, to be trampled.[147]

If a simple incident of paint accumulation along the resistant edge of a stretcher bar was the immediate impulse behind Miró's new way of structuring paintings, he was probably delighted by the idea that order can result from chance. Once more, he was primed to use it; like the mock impress of stretcher bars and the palimpsest traces of the Columbus drawing in *The Hunter*, or the obvious red grids of 1924 and 1925, or the pentimenti in *The Family*, the indexical traces of stretcher bars in the 1925 pictures give evidence of Miró's physical engagement with making the object, and thus pull the viewer into a relationship of complicity. Looking at the picture, its observer is invited to think of the artist himself looking at it and calculating the effect of its markings—of how that act

determined its ultimate physiognomy.

Miró rarely, if ever, allowed the complete outline of an underlying stretcher to appear on his canvases. It is diagrammed most fully in the earliest of the paintings made after *A* to *E* drawings, for example *Personage* (p. 130), *The Siesta* (fig. 43), and *Painting* (Dupin 140), all of which derive from the *A* series. In these the stretcher marks frame the painting, divide it symmetrically into two interior rectangles, and follow a pattern that will prevail throughout the series: when the orientation of the canvas is vertical, the horizontal bar is emphasized; and when it is horizontal, the vertical axis is stressed.[148] In later works the frame is only partially delineated, and only occasionally is the horizontal or vertical bar apparent in its full extent. By the end of 1925, the stretcher bars cease acting as misbehaving syntax and reassume their customary, more discreet role. But Miró does not seem to have forgotten them just because they are not in evidence; in pictures like *Painting (Fratellini; Three Personages)* of 1927 (p. 149), paint is built up or thinned out to suggest their underlying presence. Miró was advancing on a formal tightrope in executing the *A* to *J* paintings, constantly running the risk that the lines and shapes of drawing would dissociate from their monochrome fields. The almost unerring sureness with which Miró holds the rhythms of drawing in organic suspension within the space of painting is the genius of this series. As his notebook drawings were the repositories of imagery, the diagram of stretcher shape, visible or invisible, was the basis of an always delicate equilibrium between drawing and painting.

Depending on how, and the degree to which, Miró emphasized the impress of stretcher bars, its function can vary from picture to picture. Invariably, however, these traces are evidentiary, "advertising," as Clement Greenberg said of collage, "the literal nature of the *support*,"[149] and

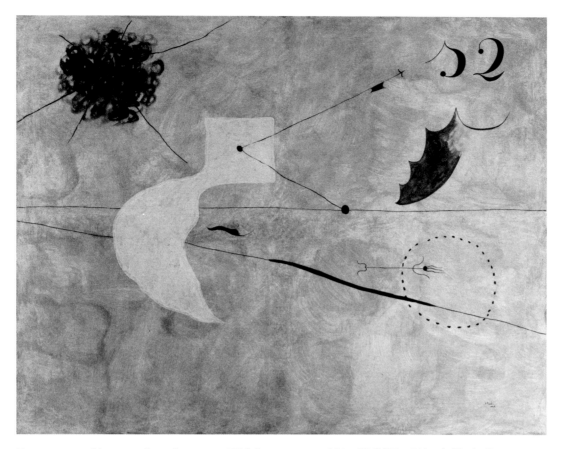

43. **THE SIESTA**. MONTROIG, JULY–SEPTEMBER 1925. OIL ON CANVAS, 44½ × 57½″ (113 × 146 CM). MUSÉE NATIONAL D'ART MODERNE, CENTRE GEORGES POMPIDOU, PARIS. DUPIN 119

its objectness, its existence as the conventional "ready-made" of easel painting. Like the hand in *The Kerosene Lamp*, or the one in Duchamp's *Tu m'*, the stretcher-bar trace is a pointer directing you, the viewer, to pay attention to me, the object before you.[150]

In the same year Miró was pulling his brush over canvas to produce the line of stretcher edge, Max Ernst had the revelation of frottage. Other than technique, the two processes have nothing in common save the fact that within the work of each artist the practice relates to collage. That relationship in Ernst appears to depend on a conflation of his understanding of Freud and Leonardo;[151] in Miró it is much simpler, and has to do with how the materials of art can be assertively self-reflexive yet remain coherently expressive. Where the additive process of paint accumulation produces line from underlying structure in 1925, a reductive removal of surface flocking in his 1929 collages creates line from the color of the paper beneath it.[152]

Miró's play with stretcher-bar marks may well have led him to make line emerge from ground in his later collages, but the stakes were not the same in this earlier game. Because of its layering, collage must tend to manifest itself as flat plane, whereas the nature of paint, its color and substance, is to suggest volume. This is especially true of the lightly brushed and poured glazes of pig-

ment that lie on the surfaces of Miró's paintings of 1925; and there can be no doubt that Miró wanted to produce sensations of shifting depth and atmospheric oscillation. Nonetheless, he was a painter of his time, and was not trying to create a Symbolist, Whistlerian fog. In countering such an effect, the stretcher imprint had a double utility: as a diagram of surface, it visually binds the luminous veils of paint to a condition of planarity; and as line, the imprint acts most peculiarly — heretical to its normal function, it deprives ground of recessive retreat by moving it in *front* of mark. Pictures like *Personage* (p. 130) make it easy to imagine that Miró relished the window-like aspect of the stretcher diagram, offering an implicit invitation to a transparent "beyond," yet combined with an ultimate, obdurate opacity of surface.

Approximate to the way that marks which compose words inscribed in paintings carry doubled meaning, the stretcher's traces are at once elements within a composition and signifiers of something outside it. But the comparison is not a smooth fit. The appearance of words in pictures combines two normally distinct cognitive functions — reading and looking — whereas the surface outline of stretcher provokes no more than a confrontation with orthodox ideas about the single utility of subtending frame. Miró extends the uses of the stretcher's trace to include a richly flexible variety of interpretative associations.

Where the outside edge is emphasized, the canvas becomes a container that displays its defining form as clothes reveal the body. To a more or less obvious degree, the stretcher traces are the up, down, left, and right of internal, pictorial space as well as the mirror of the points of the compass in real space. For instance, the impress of the middle bar across the center of *The Birth of the World* (p. 133) becomes, as in all the vertically oriented works in the series, a horizon; however, since the line is not drawn, but emerges from the fabric of the canvas, it can conjure zones of earth and sky without visually interrupting the continuity of ground. Only subtly apparent in *Head of Catalan Peasant, IV* (p. 135), the marks of crossed bars schematize an order of natural phenomena — the apparent orbit of the sun in relation to the vertical orientation of the human body, figured here in a skewed echo of stretcher shape as our old friend the Catalan peasant. Even where bars are only minimally in evidence, their

44. René Magritte. **The Treachery of Images ("Ceci n'est pas une pipe.")**. c. 1928–29. Oil on canvas, 25⅜ × 37" (64.5 × 94 cm). Los Angeles County Museum of Art. Purchased with funds provided by the Mr. and Mrs. William Preston Harrison Collection

presence serves notice of the material limits governing any painted ground that aspires to convey a limitless, swirling void. In this sense they furnish a model of contemporary thought rather like the one Meyer Schapiro found in Mondrian: "the conception of the world as law-bound in the relation of simple elementary components, yet open, unbounded and contingent as a whole."[153] The specificity of stretcher bar within its fluid, polysemous ambience contributes to a poetic spatiality simultaneously filled and emptied of possibility. According to Leiris, what Miró discovered in his mid-twenties open-field paintings was a kind of sorcery, an "understanding of emptiness . . . that was not the negative notion of nothingness but the posi-

tive understanding of a term at once identical and contrary to nothingness."[154]

If Miró identified with his Catalan hunter, it was, at least partially, and humorously, on the level of vocational metaphor; where the hunter pursued the beasts of the field, Miró's prey was plastic poetry. And similarly, when Michel Leiris gathered together a collection of writings under the title *Brisées*, he too sought a metaphor for his own vocation, but within a single word's dictionary definition. No less aptly does that definition describe Miró's vocation, especially in the uses to which he put the passage of paint over wood stretcher bars in 1925. As given by Leiris, *brisées* is a plural noun with the following meanings: branches broken by a hunter to show the area where an animal is; marks made on trees by the passage of an animal; cut branches marking the limits of a stand of trees to be felled. *"Each stand forms a rectangle whose four angles are bordered by ditches, by broken branches."*[155]

Of the six paintings after *A drawings*, one, *"Photo— Ceci est la couleur de mes rêves"* (p. 131), conspicuously lacks any trace of stretcher mark. Since the work calls itself *"Photo,"* it is entirely logical that Miró would not want to emphasize, at least in the same way, its material identity as a painting. Differently, however, *"Photo"* skews conventional pictorial syntax to explore the ontology of painting. Both the stretcher pictures and *"Photo"* obviously fulfill the conditions of two-dimensionality and pigmented surface necessary to qualify as examples of traditional Western easel painting, but by extreme structural candor in the stretcher-bar pictures, and blatantly transparent deception in *"Photo,"* each demands that the viewer examine the modes of its being. If the stretcher-impress means to force an awareness that pictorial illusionism is grounded in physical fact, *"Photo"* insists that only the reality of its nature as painting gives it power. Its message might be put: "I am not what I say I am (a photo). If I were, I could not present the color of dreams." To continue this fantasy of a "speaking picture," *"Photo"* might add: "And that other mode of communication, writing, couldn't either. What would a word, *blue,* show?"

Some four years after Miró made *"Photo,"* Magritte painted his first work to carry the inscription "Ceci n'est pas une pipe" (fig. 44). Although the two pictures share certain strategies, there is a level on which their meanings are almost diametrically opposed. Magritte's stresses what Miró's stretcher paintings merely concede, that the nature of pictures is to *re*-present the world; but *"Photo"* takes a stance contradictory to both — its blob of blue claims for painting a unique power as the only possible means to present the texture, color, and character of interior experience. In elaborately inscribing the word "Photo" on his canvas, Miró claims something of the evidentiary authority of photography. Like a photograph, the painting certifies that what is seen exists or has existed, its specimen

blue spot becoming, as well, the indexical equivalent of a thumbprint on a sworn document.[156]

The stretcher paintings and *"Photo"* are instances, among many in the 1925–27 "dream" series, of a double-sided game Miró plays with conventions of pictorial function — its goal, to reanimate painting's metaphorical power by openly displaying its character as artifice. Throughout the series, the emphasis on surface, on its planarity, as the primary defining condition of painting, is so emphatically stressed that a sort of reverse trompe-l'oeil obtains. In his 1930 essay on collage, Aragon would remark: "A funny man, Miró. Many things in his paintings recall what is not painted; he makes paintings on colored canvas, painting there only a white patch, as though he had not painted in that spot, as though the canvas were the painting. He deliberately draws the lines of the stretcher on the painting, as though the stretcher were crooked on the canvas."[157] Aragon was talking specifically about paintings of 1927 such as *Painting (Untitled; The Bullfighter)* (p. 146); by this time Miró no longer used the actual trace of stretcher bar but retained its axial structure to suggest the same rich variety of external and internal associative possibilities discovered in *Head of Catalan Peasant, IV* (p. 135). But as can be seen in *Painting*, a strategy to bend the role of structure is still at work. Where in the earlier paintings, paint coaxed line from underlying support, it now imitates the surface assumed to lie beneath it. Because, as Aragon points out, the canvas itself is colored, it takes on the appearance of being painted, whereas the areas of white pigment suggest canvas as yet untouched. *Painting*'s structural ambiguities, its latencies of meaning, are compounded by the black rectangle in the upper right; like the drawn lines echoing stretcher bars, it exists in a relation of skewed reciprocity with the material structure of the canvas, while behaving with the duck-and-rabbit agility of overlying shape and black hole.[158] This type of subversion from within, which characterizes the *A* to *J* series, their radical, if gently executed assault on conventional systems of picture-making, adds up to a severe critique of past painting. Yet by that very concentration on criticizing the technique of earlier art, Miró is more than ever vulnerable to the charges of immodest involvement with craft leveled against him by Breton and Aragon.

Miró, Picasso, and Painting as Collage

By 1930, when Aragon wrote *La Peinture au défi*, he was still quite suspicious about Miró's motivations, accusing him, along with Arp, of the "technical defect of liking too much what they do," and taking an oblique swipe in Miró's direction with the comment that "the style of the Café du Dôme or of bourgeois apartments can only be complemented by a Brancusi or a Miró."[159] But even within that essay, which is a diatribe against painting and

a sermon on collage, Aragon seems to have found some virtue in Miró's 1925–27 series of "dream" paintings.

Referring to Miró's collages of 1929, Aragon rather quirkily expresses this thought: "Last year, [Miró] happened, quite naturally, to make nothing but collages, which are closer to Picasso's collages and to Miró's paintings than to anything else. . . . It is difficult to say whether Miró's collages imitate his painting or whether his paintings imitated in advance the effects of collage, as Miró gradually came to practice it. I am inclined toward the latter interpretation."[160] Given the emphasis on surface, on effects of layering, and the repositioning of signs from work to work in the 1925–27 paintings, Aragon's conjecture that they had played a role in the evolution of Miró's collages makes a good deal of sense. Two other contemporaries of Miró — E. Tériade and Leiris — also noticed the affiliation between the mid-twenties paintings and the subsequent collages;[161] but only Aragon found structural parallels connecting them, and only he brought Picasso into the equation. In the paragraph just preceding his remarks about Miró, Aragon discusses Picasso's 1926 *Guitar* (fig. 45), making plain that this is the particular kind of Picasso collage he has in mind.[162]

If three of Miró's peers noticed the collage-like quality of the 1925–27 paintings, and one saw their structural resemblance to a certain kind of Picasso collage, it is difficult to imagine that Picasso himself, the possessor of the most acute visual apparatus of his time, had not also noticed the similarity. More than likely, Picasso had recognized the collage potential of Miró's paintings long before their author or anyone else. In that event, the trigger was probably the paintings of the *A* to *C* groups; since Miró shipped those series to Paris around mid-October 1925, and *Guitar* was reproduced in the June 15, 1926, issue of *La Révolution surréaliste*, there would have been little time for the *D* to *F2* paintings — which at the earliest could have been seen in Paris in winter or spring 1926 — to have influenced Picasso's conception. On visual evidence alone, *Personage* (p. 130), *The Siesta* (fig. 43), and *Head of Catalan Peasant, IV* (p. 135) are the most probable candidates for a kinship with *Guitar* — the first two from the *A* series and the third from *C*. In *The Siesta* the large white form, with its triangularly radiating lines, has some obvious affinities with the shape of Picasso's guitar, but nothing so incidental would have spurred Picasso to a new bout with collage. What could, however, have held Picasso's attention was the declaration that painting is, first of all, a form of collage; asserted by the stretcher impress in *Personage* and *The Siesta*, and murmured by the subtle imprint in *Head of Catalan Peasant, IV*, is the defining fact that one material (canvas) has been laid on and tacked to another (wood stretcher).

Even if the stretcher imprint may not unfailingly lead the average viewer to think about pictorial structure, nonetheless it is fair to assume that it would have imme-

45. PABLO PICASSO. **GUITAR**. PARIS, SPRING 1926. ASSEMBLAGE OF
CANVAS, NAILS, STRING, AND KNITTING NEEDLE ON PAINTED WOOD,
51¼×38⅛″ (130×97 CM). MUSÉE PICASSO, PARIS

diately engaged the mind of Picasso, an immoderately un-
average viewer. He would have grasped at once the collage
aspect of these paintings, as he would have instantly per-
ceived and probably relished the implicit role-reversal,
whereby physical structure is redeployed as line. With the
artistic "cannibalism" for which he is famous, Picasso
might have seized on hints he found in the Mirós, con-
verting them to his own more aggressive ends. In any
event, his *Guitar*, constructed as a collage, brutally inverts
accustomed procedures of painting: normally, tacks are
concealed at a picture's back, where they affix canvas to
stretcher and thus create a taut plane ready to receive im-
agery; but here, the tacks holding canvas to support are
the defining lines of an imagery formed of canvas itself.

A comment by Maurice Jardot, a friend and an astute
scholar of Picasso, on a very similar collage, conceived
and executed almost in tandem with *Guitar*,[163] lends
credibility to the notion that Picasso may indeed have
borrowed ideas from Miró's collage-like paintings. Jardot

remarks: "Like all works born of a lightning-quick imag-
ination, this one defies explication. It simply seems a
game of oppositions in which the sign has been made the
reverse [*negatif*] of the thing signified."[164]

By the time Picasso could have seen Miró's stretcher-
bar paintings, Surrealist evangelism had made it almost
an article of faith that the artist's route to the marvelous
lay in bringing together two distant realities on an incon-
gruous plane. It may in addition have crossed Miró's
mind—and Picasso's, too—that the juxtaposition of quite
proximate realities, and on an expected, but altered, plane
could also be a marvelous joke, and not incidentally a
high road to the marvelous itself.

If Miró's paintings had some share in the conception
of *Guitar*, there may have been additional grounds for
Picasso to find this amusing. At least two commentators
have suggested that *Personage* may borrow certain of its
features from Picasso's *Harlequin* of 1915 (fig. 46);[165] if
this was the case, Picasso cannot have failed to recognize
those borrowed features or to enjoy upping the ante on
the exchange in making *Guitar*. And in the event that
Head of Catalan Peasant, IV was indeed a source for *Gui-
tar*, Picasso must have been quite pleased to have the gui-
tar, his personal symbol, reenact the gesture of Miró's
emblematic peasant, pointing to the edges of his pictorial
field.

The Reception of the Work

More than half a century after the extended adventure of
the 1925–27 *A* to *J* series, an interviewer asked Miró
about the period: "You were attacking pictorial illusion-
ism, representation and collage. How was this aggression
received?" Miró's response, "With total indifference,"[166]
must have been compounded of a remembered impatience
and the fact that the "dream" paintings were relatively ne-
glected in the Miró criticism of a later period. At the time
of their making, however, they were hardly greeted with
indifference, and their appearance certainly contributed
to the rapid expansion of Miró's reputation between 1925
and 1929. Corresponding to the initial phase of Surreal-
ism's bid to incorporate art into its unruly utopian pro-
gram, those years provided a vexed context for the rise to
prominence of Miró's art.

Surrealism's "will to the displacement of everything,"
as Breton put it, would ultimately overturn all conven-
tions, social and aesthetic.[167] Alternately seductive and
belligerent, Surrealist oratory exhorted the artist to "go
beyond" *beau métier* tradition to the territory of the
marvelous—a higher moral ground, where bourgeois
standards of permanence and value would somehow be
collapsed into a larger synthesis of art and life. This pro-
gram paralleled Miró's own, which he often announced in
terms every bit as flamboyant as the movement's "official"
rhetoric. But between what Miró declared in 1927 as his

desire to "assassinate painting" and the Surrealist sense of going "beyond" painting was an intractable wedge of difference.[168] What Miró's murderously expressed intent actually described was his urge not to kill painting but to revivify it, through new expressive means—fundamentally little different from van Gogh's drive to go "further on" or Cézanne's struggle to forge a "new link." Throughout his life, Miró would resort to a tendentiously aggressive tone when describing certain of his aesthetic strategies; but its particular stridency in the middle to late twenties, when he was striving for wider recognition, was probably somewhat of a calculated defense.

Since his first visit to Paris in 1920, when he had written to Ràfols that "the important thing here is that people realize you *exist*,"[169] Miró had been acutely conscious of the importance of a degree of self-promotion if he wanted the French capital to notice his art. Although some critical recognition had come his way with his first exhibition at the Galerie La Licorne in 1921,[170] and his reputation was established within the rue Blomet group by 1924, it was not until the next year that *tout Paris* began to take notice. A review of his June 1925 exhibition at the Galerie Pierre comments that the crowd at the opening was overwhelming, and included "all the Surrealists," along with such contemporary luminaries as the Duchess of Clermont Tonnerre, Count Elie de Gaigneron, Miss Nathalie Clifford-Barney, Carl Einstein, and the Crown Prince of Sweden.[171] Miró was probably referring in part to this event when on September 28 he wrote Gasch that Viot's contract and purchase of previous works now allowed him "to live for a long time by my own means, and carry on the social life that I am more and more obliged to do. It is not reasonable for the artist to live like a hermit without doing anything provocative. Always more *outrageous* will be a man dressed in a tuxedo doing or saying *aggressive* things." In the same spirit, Miró later wrote to Gasch from Paris after the opening of the first Surrealist group exhibition that he was "very pleased by the tempest I provoke. The opening day of this exhibition (at midnight), rue Bonaparte was militarily occupied by pairs of policemen, within the gallery, too. Pictures had to be insured. Despite the fact that it snowed in the morning, more than a thousand people came."

However Miró may have intended to follow through on his new tactic of provocative behavior, he could not have anticipated the avalanche of attention that would greet his first venture into the world of theater design. On Picasso's recommendation, Sergei Diaghilev had commissioned Miró and Max Ernst to design costumes and sets for the ballet *Romeo and Juliet*, which opened at the Théâtre Sarah Bernhardt in Paris on May 18, 1926. According to one account, the Surrealists had initially welcomed the collaboration of two of "their" artists with Diaghilev, seeing it as a potential source of publicity. But Picasso, who delighted in teasing them, reportedly remarked, probably

46. PABLO PICASSO. **HARLEQUIN.** PARIS, LATE 1915. OIL ON CANVAS, 6' ¼" × 41⅜" (183.5 × 105.1 CM). THE MUSEUM OF MODERN ART, NEW YORK. ACQUIRED THROUGH THE LILLIE P. BLISS BEQUEST. ACQ. NO. 76.50

to Breton or Aragon: "I hear that your colleagues are working for Diaghilev? That's a fine state of affairs. The moment you see a cheque you collaborate with reactionary white Russians. So much for that famous rigor of yours!"[172]

Picasso's words hit their target; Breton and Aragon prepared a broadsheet, denouncing Ernst and Miró, that was distributed on the opening night of the ballet amid a violent demonstration instigated by the Surrealists. The Paris press had been presented with an irresistible subject. Under the heading "The Brawl at the Ballets Russes," one of the many reviews reported: "The moment the curtain went up on *Romeo and Juliet* an eruption of whistles burst forth while white leaflets swirled down from

the balconies to the orchestra. . . . This morning we saw M. André Berton [sic] who deigned to explain to us the reason for his group's demonstration. 'Max Ernst and Jean [sic] Miró . . . have negotiated with the powers of money.' "[173] Almost all accounts in the press concentrated, with colorful detail, on the demonstration, to the relative exclusion of either the performance or decor. But, assuming that the representative of Le Figaro had not been privy to the plans of Aragon and Breton, he seems to have felt that the event merited attention on its own, as he alerted his readers nearly a week in advance of the opening that attendance was de rigueur. Those who cannot say "I was there," he warns, will have no conversational future in the drawing rooms of Paris — adding, in a reference to Picasso's 1917 debut in the theater, that the entry of Miró and Ernst will mark a date in the history of contemporary art like that one.[174]

Both Miró and Ernst were unhappily surprised by the demonstration, and it left in the mind of each an increased wariness toward "orthodox" Surrealism. The movement, however, having rebuked the two wayward artists, wanted them back; Breton reproduced paintings by each in the December issue of La Révolution surréaliste, but with a pronounced favoring of Ernst. If Surrealism was happier with Ernst than with Miró, influential critics such as Tériade, Maurice Raynal, and Christian Zervos, who took exception to the literary character of its art, were far better disposed toward Miró.

In his important Anthologie de la peinture en France de 1906 à nos jours, published in 1927, Raynal dismisses Surrealism as a sort of literary romanticism more German than French and, in clear reference to Breton and probably Aragon, says that whatever might be sympathetic in it has been spoiled by "the rules of an insolent confidence game, making its followers generally intolerable."[175] He reproduces "Amour" of 1926 (p. 141),[176] and devotes more discussion to Miró than to any other Surrealist. What he has to say about Miró is in curious counterpoint to the views Breton would express in Le Surréalisme et la peinture the following year. Breton grudgingly admits that Miró may be "the most 'Surrealist' of us all"; he has no doubts about Miró's ability as a painter, and hopes only that he will disentangle himself from too great an allegiance to the medium. Raynal unhesitatingly dubs Miró "chef de l'école Surréaliste"; though he thinks Miró's painting is still too weak, he has no doubt that once Miró matures he will become sufficiently a painter to forget Surrealism's anti-pictorial spirit.[177]

By 1927, when Raynal's book appeared, Miró's enthusiasm for the strategic social foray seems to have waned considerably. On February 24, in the midst of intense work on his G to J paintings, a period he would later refer to as a "laboratory experiment,"[178] Miró wrote to Gasch from the rue Tourlaque: "I request you to abstain absolutely from talking about me in Paris. . . . I need at all costs to defend my moral position. . . . I work a lot, see very few people, only from time to time to show that I am alive. . . . There is a big panic around me, and I see my name appearing constantly for no reason at all." About two weeks later, Miró would write, again to Gasch, "You know my terror of success and how I detest fashion. These are huge dangers in Paris." To underscore his point, Miró adds about Picasso, "Think about his morality. He is a man who exhibited at the Salon pour la hausse du franc! . . . Moreover, he frequents people and receives cons from whom I turn my face. . . . A fatal microbe flies in the atmosphere. If you are thick-skinned, the poison won't affect you; otherwise, no matter how many vaccinations and shots they give you, it will be useless. . . . Think about Picasso — coming from Barcelona — and about the mystery I present being also from Barcelona."[179] These remarks about Picasso echo Miró's first criticisms of him in 1920, when he had written J. F. Ràfols that "Catalonia's rough way . . . might be the Calvary of redemption. — The French (and Picasso) are doomed because they have an easy road and they paint to sell."[180]

Miró's own road was never as easy as Picasso's, but by early 1927, when he was writing to Gasch, it had become a great deal smoother. Throughout his life, material success seemed to cause Miró a psychic discomfort beyond the usual artist's fear of contamination by the world of commerce. Even as he needed commercial recognition, strongly believed he merited it — and indeed, welcomed it — there was, nonetheless, a deep-seated reluctance to admit of any connection between inspiration and monetary reward. That this feeling was especially intense during the turbulent first years of growing fame seems obvious. But however uneasy his new prominence may have made him, he must have been pleased when the Vicomte Charles de Noailles and his wife, Marie-Laure — arguably the most influential collectors in Paris, and active supporters of Picasso — bought one of his paintings, in 1927. By the time they bought another in the following year,[181] one of Miró's hometown journals, L'Amic de les arts, had reported proudly on the Parisian success of Barcelona's native son. The article it ran pronounced Miró's May 1928 exhibition at the Galerie Georges Bernheim one of the most important events of the season just passed, and went on to note that canvases which had sold for 300 francs on Miró's first arrival in Paris were now bringing 20,000. Further, it claimed, with a touch of exaggeration, that "our painter" had become the favorite of the most important European and American collectors.[182]

The exhibition that prompted the Amic de les arts piece, although held at an elegant Right Bank gallery, had actually been organized by Pierre Loeb, who had replaced Jacques Viot as Miró's dealer.[183] Shortly after the show closed, Miró gave a version of its planning to an interviewer from Barcelona's leading newspaper, La Publicitat:

In the summer of 1926 I went back to Montroig . . . and I de-

cided on a plan of attack. Pierre and I decided that I would shut myself up completely and not let anyone see my work, and I'd prepare a major exhibition showing all the formal innovations and the aggressiveness I had inside me. . . . And so I spent the winter of 1927 closed up in Paris, and I didn't show anyone anything I was doing. . . . That summer I went back to Montroig again, where I painted seven huge canvases, and I felt that I had come to the end of that period. Naturally, the time had come to have that show. . . . I had told Pierre I wouldn't enter the ring unless it was for a championship bout, that I didn't want any friendly sparring match, and that now was the time to go for the title. I wasn't interested in fighting unless I could win the prize.[184]

Of the forty-one canvases that Miró goes on to say were in the exhibition, fourteen were almost certainly the complete series of what are known as the "summer" landscapes of 1926 and 1927, and the rest were probably made up largely of canvases from the G to J groups, which Miró had painted "closed up" in Paris in 1927.[185] A thorough success both critically and commercially, the show was reviewed widely in the press. Tériade in L'Intransigeant judged it "incontestably interesting," contrasting what he saw as the richly imaginative conception of Miró's canvases with their highly "reasoned" execution.[186] In La Presse, Waldemar George devoted a long, thoughtful article to the exhibition. In addition to specific remarks on "huge, bare surfaces covered with a uniform color and scattered hieroglyphics" and a space that evokes "the void or the infinite," George reflects on Miró's place in twentieth-century art in a way that suggests the overall reception then starting to be accorded to his work:

Miró comes after Picasso, but far from being dependent on the painter of the Saltimbanques, he seems to want to react against the expressive mode inaugurated by his compatriot. Without doubt, the origins of Miró and Picasso have points in common. Both began in a semi-realist style. Both reacted against naturalism. It is true that Picasso struggled for long years before he could impose [on the public] an art which ran counter to acquired taste and . . . a still-homogenous tradition, whereas Miró found before him a path already prepared and a public disposed to accept research and experimentation. This public, is it more liberal, cultivated, understanding than that which barred the way for Picasso and H. Matisse? Not at all. But the bases of its aesthetic faith have been so deeply shaken that it cannot oppose revolutionaries with any effective resistance. I said revolutionaries, even in comparison with Cubism. In fact, Cubism (at least Cubism such as it was practiced until 1920) is a constructive style. The attacks mounted on realism by Picasso and Braque conform to the laws which govern the mechanism of the eye and are only licenses — poetic, pictorial licenses. Whatever liberties the masters of Cubism took with appearances, they never departed from the logic of understanding. Miró leaves the level of painting as image or equivalence of the universe. From now on, he acts in the world of magic.[187]

The Politics of Bafflement

The terms in which George asserts that Miró is going beyond painting as an end in itself effectively ratify Breton's judgment, published in Le Surréalisme et la peinture the previous February, that Miró is devoted too exclusively to painting. However Miró's endeavors may have struck the radical ideologue and the conservative art critic, neither is likely to have known that in the interval between their comments, Miró had bid a brief farewell to painting.

The series of four collages Miró made in this period were, in all probability, Miró's response to Breton's charge that he had no "means at his disposal" other than painting.[188] The collages, each titled Spanish Dancer, make the most minimal use of line and paint, substituting, among other things, string, a nail, a hatpin, a feather, a drafting triangle, a printed image of a shoe, and an actual doll's shoe (fig. 47 and pp. 167–69). Dupin sees these Spanish Dancers as "anti-Miró"; their "sardonic humor" deliberately casts "a new magic spell that shatters the magic spell of the works it derives from."[189] That Miró himself intended these collage-objects to demonstrate his ample ability to command means other than painting seems confirmed by his gift, sometime around July 1928, of two of the most radical of them to Breton and Aragon.[190]

The "anti-Miró" quality observed in the Spanish Dancers, their estrangement from his previous painting, must also be explained in a larger context. If Breton's criticism was an immediate instigation, the fractious climate of the times was a constant in Miró's increasingly consistent pattern of working tactics. The stylistic distancing between the gridded pictures and yellow-ground paintings of 1924 had not been fully deliberate; but as we have seen, by mid-1925 Miró had begun to draw plans for two contrasting series: the A to J paintings and the fourteen "summer" landscapes of 1926 and 1927. If we find the majority of pictures in these two series successful, moving works of art, then we have to think that their pronounced formal differences result from an internal psychic pressure to express differing states of mind. Common sense might then ask how Miró could anticipate what his feelings might be from one year to the next. The answer surely is that he sometimes could not, and there are many instances in his career in which he failed to execute a planned series; however, between 1925 and 1927 his work on the A to J series was so intense and scheduled he probably could anticipate that his returns to Montroig in 1926 and 1927 would bring fresh expressive needs — to work slowly, to celebrate once more the Catalan earth.[191]

Whether in the thick of activity of these years, or after completing the last Montroig landscape in late 1927, Miró must have remarked how the two series reflected on each other — how the differences between them made more perceptible the distinctive characteristics of each. This juxtaposition of competing and complementary modes of

47. SPANISH DANCER (WITH DOLL'S SHOE). PARIS, MID-FEBRUARY–
SPRING 1928. COLLAGE-OBJECT: NAIL, STRING, AND DOLL'S SHOE,
41 × 26⅜″ (104 × 67 CM). WHEREABOUTS UNKNOWN. DUPIN 245

course facilitated creativity, provoking the emergence of
new ideas. It had tactical uses as well. Given Miró's intense
concern about the way his art was received, it is unlikely
that he had not also observed that to create distinct clus-
ters of work was to raise a preemptive defense against the
inevitable classification of his work by outsiders.[192] Some-
thing of this nature must be behind his mid-July 1928
statement: "Right now the opposition I'm getting from
dealers and 'art lovers' is spurring me even harder to go
straight ahead without worrying about anything else. And
it's such a luxurious feeling to baffle the people who be-
lieve in me!"[193]

The pleasure Miró took in "baffling" people with un-
expected changes in his work was vehemently indulged
during 1928 and 1929. The startling stylistic break be-
tween the Spanish Dancers and the subsequent series —
beginning with the Dutch Interiors (pp. 162–64) and in-
cluding *Potato* (p. 166) and *Still Life (Still Life with
Lamp)* (p. 165) of 1928 — is equaled by that of the follow-
ing year between the Imaginary Portraits (pp. 170, 171 and
Dupin 240, 242) and the later large suite of collages
(pp. 172–75 are representative). For all their surface dif-
ferences, however, the works of these four series connect to
each other, to Miró's previous painting, and to traditional
modes of composition through their origins in preparatory
drawings; further, they extend the supple interchanges of

imagery prevalent in Miró's art from 1923 onward.[194]

When Dalí in June 1928 favorably contrasts Miró's
procedure — the passive state of automatism — with Hie-
ronymous Bosch's frankly imaginative, additive, active
methodology, he lays the groundwork for his future criti-
cism of the docility of Surrealist practice;[195] but more rel-
evant to the present discussion, the comparison, like so
many others, turns fact upside down. That Miró rarely did
or said anything to contradict the false image of himself
encouraged by words like Dalí's probably has to do with
his personal politics of bafflement. Although Miró would
much later make publicly available all the evidence of his
procedures, there is nothing to suggest that he was willing
to do so at the time. At the height of Surrealism's call for
anti-peinture, and Miró's own expressed contempt for
painting, he was defiantly having it both ways: although
he asks Leiris to publish a preparatory drawing that pre-
ceded *La Fornarina* (Dupin 242) in an article being pre-
pared for *Documents*, he appears to have been as little
inclined to disclose the careful plans behind the Spanish
Dancers as he was to reveal the drawings for his *A* to *J*
series.

On August 16, 1928, Miró wrote Gasch from Montroig:

I am working very hard — I intend to finish a canvas by the
middle of next week, the first to be finished since I have been
here — a month and a half — with unprecedented preparation,
and after thoroughly systematic daily work. . . . My aim is to exe-
cute five canvases here, all of the same caliber as the one I am
finishing. . . . I imagine attacking every day more and more thor-
oughly, making my victims die cleanly, without nerve shivers in
their agony, a dry blow like lightning.

In projecting these works, which would become the series
starting with the three Dutch Interiors and ending with
Potato and *Still Life (Still Life with Lamp)*, Miró exactly
predicts the number of canvases he will produce before
the end of the year, and passes some rather puzzling re-
marks. Making allowance for vivid rhetoric, the "clean"
demise of his "victims" could be equated with the sur-
gically neat facture of the pictures in this series, or the
exactitude with which the final squared-off drawing is
transferred to canvas and then hidden under overlying
paint (see cats. 77–81). Previously, Miró had used the
grid only to pervert its traditional function; where now,
in 1928, it is deployed with classical discretion, in 1924
it had been undisguised, often more a network for the
nervous impulses of pictorial decision-making than
a priori compositional guide.

If Miró's "clean" attack may have this sort of reference,
it is more difficult to imagine what he meant by "unprec-
edented preparation." Perhaps his meaning has to do with
the very large number of drawings that preceded each
work. Alternatively, "unprecedented preparation" may re-
fer to the sources he was using. At the time of his August
1928 letter to Gasch, he was beginning the three Dutch

Interiors, the first two of which are based on postcards of seventeenth-century Dutch genre paintings, brought back from a trip to Holland the previous May. With the sole prior exception of *Spanish Dancer* from the 1924 grid series, which evolved from an image on a magazine cover (fig. 13), all his work since 1923 had been prepared by drawings based on the play of the imagination.[196] As we shall soon see, the 1924 *Spanish Dancer* (p. 116) had played a prominent role in the Spanish Dancer series just completed. It would therefore be not unlikely that Miró was referring specifically to it, as a unique precedent. Moreover, his reengagement with the 1924 *Spanish Dancer* may have furnished some impetus for his decision to make found images the basis for the two Dutch Interiors and then for his Imaginary Portraits.[197]

Radically opposed as the four 1928 Spanish Dancers seem to anything Miró had done previously, they do draw on earlier conceptions. For example, two of them (fig. 47 and p. 168) are stripped-down versions of the 1924 *Spanish Dancer* (p. 116), whose close relative, *Portrait of Mme K.* (p. 117), is subjected to a similar disrobing before being reclothed in the other two (pp. 167, 169). And notebook sketches (for example, fig. 48) show that the idea for two of the 1928 Spanish Dancers—the one given to Aragon (fig. 47) and another (p. 168) now in the collection of the Reina Sofía—began as a shoe within a cone, almost exactly replicating that figuration as it appears at the lower right of the 1924 *Spanish Dancer;* the succeeding drawings show Miró refining his initial conception until he came up with the image he would convert into the final works.[198] Since Miró was an avid reader of his own press clippings, he may have taken particular pleasure in giving prominence to the lowly shoe in these two ostensibly anti-bourgeois collages; earlier, when his *Spanish Dancer* of 1927[199] appeared in an exhibition in Brussels, it had provoked one observer—who found Miró's titles confusingly specific, contradicting what he saw as their abstract imagery—to comment: "The Spanish Dancer . . . nonetheless shows the heel of her shoes, something that seems to us an unpardonable concession to bourgeois taste."[200]

The link between the Spanish Dancer given to Breton (p. 169)—described by Eluard as the barest painting ever conceived—and *Portrait of Mme K.* is not as tight as that between the other 1928 Spanish Dancers and the 1924 *Spanish Dancer.* It might, indeed, be argued that the hatpin piercing the "virgin"[201] canvas owes as much to the instrument projecting from the neck of the 1924 *Spanish Dancer* as to the arrow-pin of *Portrait of Mme K.* However, given the orientation of the hatpin it seems more probable that it, like the vertical configuration of sandpaper, string, and drafting triangle in the fourth Spanish Dancer, is the metonymic equivalent of *Portrait of Mme K.,* with this one attribute standing for the whole figure. Reinforcing this interpretation is a note on one

48. PREPARATORY STUDIES FOR VARIOUS SPANISH DANCERS, 1928. PENCIL ON PAPER, OVERALL 7 × 5⅜″ (18 × 13.6 CM). FJM 535 (WITH 571 ATTACHED)

of the early drawings for the Breton collage: "Portrait de Mme —."[202]

The Spanish Dancers are not only beneficiaries in Miró's game of bartered identities; at least one of them makes a different kind of exchange, with one of Miró's subsequent and most sublime creatures, *Potato* (p. 116). As is hinted in the 1922–23 still lifes, explicitly stated in *The Kerosene Lamp* (p. 114), and put into practice in the drawing for *Landscape (Landscape with Rabbit and Flower)* of 1927 (p. 160)—where the cross of the Catalan peasant is reoriented (fig. 49)—Miró likes to reinvigorate pictorial elements by switching their alignments from one work to another. If the broad outline of the potato-figure's

49. PREPARATORY DRAWING FOR **LANDSCAPE (LANDSCAPE WITH RABBIT AND FLOWER)** (P. 160), 1927. PENCIL ON PAPER, 8⅜″ × 10¾″ (21.2 × 27.3 CM). FJM 790

50. Tracing of forms in **Potato** (fig. 52), 1928, reversed and reoriented to relate to **Spanish Dancer** (fig. 51), 1928

51. **Spanish Dancer** (p. 167), 1928

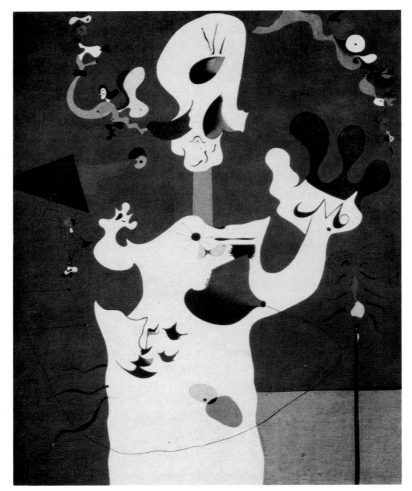

52. **Potato** (p. 166), 1928

head is traced, then joined to a tracing of the nearby triangle and its attached stem, and the sheet reversed (fig. 50), the close kinship between *Spanish Dancer* from the Neumann collection (fig. 51) and *Potato* (fig. 52) becomes clear. And where, in this instance, Miró borrows and repositions his own motifs, on other occasions he practices another form of self-appropriation. As he had earlier miniaturized *Painting (Untitled; The Bullfighter)* of 1927 (p. 146) to insert it into the upper left of *Animated Landscape* of the same year (p. 161), in the exchanges of 1928–29 he magnifies a study for *Dutch Interior (I)* (fig. 53) to transmute it into a collage (p. 172) in the following year.[203]

53. STUDY FOR **DUTCH INTERIOR (I)** (P. 162), 1928, AND RELATED TO **COLLAGE** (P. 172), 1929. PENCIL AND WHITE CHALK ON PAPER, 6 × 4¾″ (15.3 × 12 CM). THE MUSEUM OF MODERN ART, NEW YORK. GIFT OF THE ARTIST. ACQ. NO. 123.73

III. New Directions

The last two years of Miró's first full decade of artistic activity as an "international Catalan" brought him great personal joy, despite some disturbing outside events. In a letter written from Montroig near the end of July 1929, Miró sums up his situation: "Things in Mallorca were wonderful. Request of the hand in marriage and wedding on the 12th of October in Palma with: Pilar Juncosa, who is the most beautiful and sweetest bride in the world. . . . Apart from that . . . annoying stories in Paris, pretty annoying, which, however, I hope will turn out well."[204]

Although Miró's hopes were largely to be deceived as regarded events in Paris, his other news was a true herald of future happiness. Throughout his long life with Pilar Juncosa, Miró spoke of her with a lyrical devotion equal to the ardor of the words announcing his engagement.

By midsummer 1929, strife within the Surrealist movement had become intolerable: Bataille, Leiris, Desnos, Artaud, and Masson, among others of Miró's good friends, had broken off relations with Breton. Miró himself, in response to Breton's widely circulated letter demanding its recipients' views on collective versus individual action, had declared that even if it was only collective effort that would effect action, he was convinced that "individuals whose personalities are strong or excessive, unhealthy perhaps, deadly if you like — that is not the question here — these people will never be able to give in to the military-like discipline that communal action necessarily demands."[205] While Miró never completely broke with Breton, and did not join the attacks on him following the publication in December of the second Surrealist manifesto, his sympathies lay more with those around Bataille and his magazine *Documents*.

Just as the first great schism within Surrealism was opening up, the American stock market crashed in October. Thereafter, the Parisian art market was to go into a tailspin from which it would not recover for years.[206] At the time of the disaster on Wall Street, Miró was probably still honeymooning near Formentor, Mallorca. By sometime in November, however, he was back in Paris with his young bride, in an apartment on the rue François-Mouthon. Years earlier, Miró had sent a brief note to Picasso with the message: "In pursuit of a Mme Miró, of a studio, and a dealer! *C'est une drôle d'affaire!*"[207] While two of these goals had been achieved, Miró could not afford both a studio and an apartment, and repercussions of the economic depression were to be factors in depriving him of a satisfactory studio for some years.

Vicissitudes of a "Good-bye to Painting"

The work Miró produced in the two years after his marriage stands to that succeeding it somewhat as his pre-1924 paintings do to those executed from that year until 1930. While in the late teens and early twenties his energies had been directed toward finding his own voice, in 1930 and 1931 he was bent on a redirection of his art. In January 1930 he told Gasch: "I have taken up normal life again, working pretty much on the canvases I already mentioned to you, which will be, I think, my good-bye to painting, at least for some time, in order to attack new means of expression, bas-relief, sculpture, etc., using new vocabularies and elements of expression of which I am still ignorant." Where Miró's struggle with tradition is manifest in his pre-1924 work, a restlessness seems to pervade much of his output in 1930 and 1931. Often de-

54. **FEMALE TORSO.** MONTROIG, AUGUST 1931. OIL AND
WATERCOLOR ON LAID PAPER, 18¼ × 24⅝″ (46.4 × 62.7 CM).
PHILADELPHIA MUSEUM OF ART. THE LOUISE AND WALTER
ARENSBERG COLLECTION. DUPIN 307

scribed in dramatic terms borrowed from Miró's own
threat to "murder painting," this period was without
doubt the first real creative crisis of his mature career. As
Dupin has pointed out, Miró's professed battle with paint-
ing was first and foremost one waged with himself.[208] This
conflict was rendered especially difficult by at least two
interrelated factors: a natural, if temporary, loss of creative
steam after the uninterrupted flow of energy of the pre-
ceding six years, and a susceptibility to the agendas of
competing intellectual and aesthetic factions.

In 1928 and 1929, Miró had nimbly turned the divi-
sive spirit of the times to his own ends in a double
counterpoint of paintings and collages; but in the first two
years of the next decade, that agility appears to have been
partially impaired. Had there been no strident calls for an
anti-peinture, if the dissidents around Bataille had not
championed an attack directed against Surrealist ideal-
ism, if the Abstraction-Création group had not tried to
force its hegemony, Miró might nonetheless have faced a
need to reform his art. But those things did happen, and
there can be little question that the cultural horizon of
the period had an effect on the changes in Miró's art dur-
ing 1930 and 1931.

The six canvases — all titled *Painting* — described by
Miró as his farewell to painting are uncharacteristically
tentative, and as uneven in quality as those first executed
in Paris in 1921.[209] Miró's past, almost uncanny ability to
hold formally disparate elements in elastic balance failed
him momentarily, and an awkward tension between illu-
sionism and abstraction seems to grip these pictures. Per-
haps not fortuitously, the one superb painting from this
series (p. 181) allows the impulse toward abstraction an
immense freedom checked only by the fusion of color and

ambiguous shape, a restraint Miró knew would suffice
when he inscribed the painting's preparatory drawing "La
magie de la couleur" (see cat. 90). If the most abstract of
these pictures is the only one that can fully hold its own
against the best of Miró's other work, the most representa-
tional comes close to the same standard (p. 180). Oddly, it
does so because it skirts failure so narrowly; its almost
palpable quality of having been snatched from the brink
vividly annexes the precarious nature of the world beyond
the canvas to the world within.

Except for a few tiny pictures, which look to be re-
prises of the work of the first half of 1927,[210] Miró held
true to his prediction to give up painting. When he did go
back to brushes and paint, in 1931, much of what he pro-
duced looked more "anti-Miró" than anything known ei-
ther before or after. The wobble of indecision between the
conflicting demands of abstraction and representation that
had afflicted the six pictures of early 1930 is nearly elimi-
nated in a large series of oils on Ingres paper (fig. 54 is
representative).[211] If the Spanish Dancers of 1928 were, in
part, intended as a response to outside criticism, the
Ingres-paper oils mostly of 1931 may be a riposte to the
claims of the Abstraction-Création group, whose intransi-
gent championing of abstraction particularly aroused
Miró's ire. But where Miró had brilliantly beaten Surreal-
ism's *anti-peinture* at its own game with the Spanish
Dancers, the quasi-abstraction initiated in the Ingres-
paper oils went too much against the grain of his own
nature to be thoroughly successful. Deliberately excluding
virtually all recognizable imagery, Miró narrowed his pos-
sibilities too much, closing the doors to the place where
his creativity came from.[212] That Miró sensed this is sug-
gested by his later saying he had felt an "emptiness" in the
work of this period;[213] he had tried, he said, to compen-
sate for the fact that "the subjects of the paintings weren't
clear enough" by "giving them realistic titles."[214]

While the aesthetic politics of Abstraction-Création
may have been the chief external stimulus behind the
Ingres-paper oils, on a deeper level these works are fur-
ther evidence of Miró's attempt to revamp his painting
from within. Describing what he was doing, in a letter to
Ràfols, he says, "I am working very hard, trying to do
things worse from day to day, creating more difficulties
and fleeing from good taste."[215] Miró was probably the
only one to know that this was his first practice of any-
thing close to an automatist procedure, at least as defined
by Breton, and it was undertaken not under the sign of
Surrealism, but in response to the advice of an artist who
knew something about the art of painting. He would later
relate how he had made the Ingres-paper oils "without
any preliminary sketching. I took the sheet of paper, wet
my brush and unconsciously drew a motif in black. I did
exactly what Matisse said to do and more profoundly than
the Surrealists did: I let myself be guided by my hand. I
put the color in later."[216] Without doubt the Ingres-paper

55. DRAWING FROM A NOTEBOOK. 1930.
PENCIL ON PAPER, 6¾ × 8⅛″ (17.3 × 20.6 CM).
FJM 901

56. DRAWING FROM A NOTEBOOK. 1930.
PENCIL ON PAPER, 9⅜ × 6¼″ (23.6 × 15.8
CM). FJM 881

57. DRAWING FROM A NOTEBOOK. 1930. PENCIL ON PAPER,
6¼ × 9⅜″ (15.8 × 23.6 CM). FJM 869

oils were a necessary step in Miró's effort to "clear the ground," but the methodology that produced them would be largely discarded in any important works until the middle to late seventies.[217]

Miró's painting may have suffered during the period of experimentation of 1930 and 1931, but those "new vocabularies" he had planned to "attack" yielded with happy results to his assault. He apparently had little trouble establishing an effective syntax for the mostly low-relief constructions he made—often from prefabricated elements in 1930 (pp. 178, 179) and scavenged materials the following year (pp. 182, 183). Although his medium had changed, his old preference for working out his ideas in preliminary drawings remained.[218] The exuberant constructions of 1931 are perhaps more individual than the austere reliefs of 1930, but in both he is very much the master of his craft. In the for the most part tiny assemblages of 1931, such as *Man and Woman* (p. 182), painting combines with odd fragments of familiar objects to suggest erotic encounters at once portentous and banal. Playful, enigmatic, savage, and humorous, these painting-objects have a poetic bite that was often sharpened in the succeeding years of the decade.

Just prior to the constructions of 1931, Miró had made "a very large series of drawings" (those on p. 176 are representative) which show his touch in that familiar medium to have remained sure. Like the drawings in the suite of 1924, and a later one from 1926, each is prepared by a single notebook sketch; but unlike the earlier ones, these are not interspersed with any studies for paintings, and they deviate in only the most minor details from the finished drawings made after them. They run in an uninterrupted flow in two notebooks—some twenty-seven in one and fifty-two in another (see the Appendix to the Catalogue, app. 9, 10, 11). Whether all sketchbook studies were converted to finished drawings is unknown, and Miró's account leaves the question unresolved. He says only that he

made large drawings after them and that they have been dispersed.[219] Both notebooks are dated November 1930 and dedicated to Miró's wife of a year, Pilar.

The seamless way one sketch appears to emerge from another suggests that like those in the notebooks of 1925–27, they were made in one extended burst of creative energy that again provided Miró with a bank of preexistent images. But now his system is more orderly than it had been in the twenties; when it came time to turn the sketches into "presentation" drawings, Miró simply began with the first notebook sketch and continued to the last, inscribing the finished drawing with the day, month, and year of execution.[220] To judge by the dates of surviving drawings, Miró was occupied with this series between August and sometime near the end of November 1930, when he gave the notebooks to Pilar. If little time had elapsed between the completion of the notebook sketches and the beginning of work on the drawings, Miró probably was making the notebook sketches sometime around the birth of his only child, Dolores, on July 17, 1930.

The drawings of this series, especially as they appear in their preliminary states, in a sequential turning of notebook pages, are a wild, tender narrative of prelapsarian bliss. The story is not, however, of two discrete beings, but unfolds across the collapse and fusion of individual identities; in image after image, fragments of ungendered human anatomy, such as eyes and feet, meet to play games of exchange with male and female sexual organs, the moon and the sun within the bursiform outlines of a single startling—and sometimes, it appears, startled—creature. Sharing attributes of both sexes, half celestial, half terrestrial, these little figures at times are in a state of balloon-like levitation, occasionally touching down to rest on a schematically rendered beach (figs. 55–57). Perhaps the experience of sexual ecstasy as described by the American artist David Wojnarowicz conveys something of what is celebrated in Miró's two notebooks: "It's

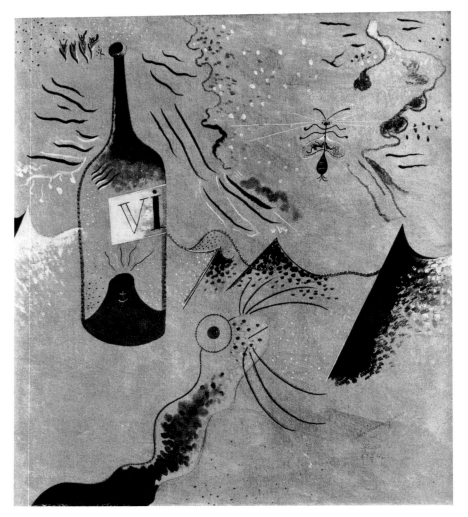

58. **The Bottle of Wine.** Montroig, summer–fall 1924. Oil on canvas, 28⅞ × 25¾″ (73.3 × 65.5 cm). Fundació Joan Miró, Barcelona. Dupin 90

like this loss of time and space and identity . . . [a way] of trying to get outside of the physical confines of our body vehicles. It's really about spirituality; we're trying to find this 'presence' — or the location of this presence, and really it's something we contain."[221]

Miró had earlier used the homologous relationship of male and female attributes and the morphological correspondences of body parts in a variety of images; but until the drawings of 1930, only in *The Bottle of Wine* of 1924 (fig. 58) are the binary oppositions of sexual difference collapsed in a single form. Thereafter, the androgynous being, barely hinted at in *The Bottle of Wine*, becomes a staple character of Miró's art; its most imposing and literal embodiment may be in the large sculpture *Moonbird* of 1966 (p. 300), at once "rampantly male" and "gently female."[222] The interlocking crescent forms that make up *Moonbird*'s body allude to the moon, but by that reference they are also intimately related to the most ubiquitous image in the 1930 drawings, the nail of the big toe. The toenail's presence in the drawings is virtually constant, its half-moon shape pictorially rhymed with the contours of eyes, vaginas, saccate curves of body parts, and, of course,

the moon and the sun; the undoing of gender difference in these drawings is brought about more than anything else by the crescent nail of the great toe.

Miró seems always to have had an affectionate regard for the human foot, as a drawing from his childhood testifies (fig. 60). In his adult work, the foot appears prominently, in exaggerated proportions, from 1922–23 on in paintings such as *Interior (The Farmer's Wife)* (p. 106), *Bouquet of Flowers ("Sourire de ma blonde")* (p. 122), *The Statue* (fig. 59), and *Person Throwing a Stone at a Bird* (p. 152). If Bataille in his 1929 article "Le Gros Orteil" had recommended "opening one's eyes wide before a big toe,"[223] Miró had already been doing so for a long time. The interests of Bataille and Miró in the big toe were — to borrow a children's locution — "the same but different." Bataille's was part of an articulated theory, Miró's of an otherwise largely unexplicated artistic praxis. On that basis, however, it would seem that Miró shared Bataille's understanding of the big toe as the most human part of the human body, its peculiar structure enabling the verticality that separates us from other animals. But, as Bataille said, and Miró's imagery corroborates, the toe that

59. **The Statue.** 1925. Oil on canvas, 31½ × 25⅝″ (80 × 65 cm). Private collection.
Dupin 123

makes possible the "noble" uprightness of human posture is nonetheless not just literally the lowest part of the body, but the most ludicrous, mired in the earth, the part that least fits idealization of the human form. For Bataille, "the toe's refusal to enter into a system of idealizing values"[224] had the utility of undoing that system and its binary opposition of noble versus ignoble. Miró's usage had less to

do with theory and more to do with poetic vision; for him, the toe was emblematic of our common humanity, male or female — the support that connects the terrestrial and the celestial. One widely quoted remark makes his view quite clear: "You must always plant your feet firmly on the ground if you want to be able to jump up in the air."[225]

Revised Methods

Miró did not lack for attention, or a growing international reputation, in 1930 and 1931; he participated in several important group exhibitions and had six one-artist shows, three of them in the United States.[226] But economically, times were still grim and, mainly because he could no longer afford to live in Paris, he remained in Barcelona at the beginning of 1932.

Alliances, too, had shifted, and although Miró continued to keep up his old contacts on an individual basis, he had little further to do with any Paris-based group activities. Christian Zervos, who had been militantly anti-Surrealist in the twenties, and had particularly irritated Miró at that time, was now reconciled, if not to Surreal-

60. Childhood drawing. c. 1901. Pencil, watercolor, and ink on paper, 4½ × 7″ (11.6 × 17.7 cm). FJM 22

ism, at least to some of the artists who had been identified with it, including Miró. In late January 1932, shortly after Zervos published an article in *Cahiers d'art* that featured a segment on Miró,[227] the artist wrote to thank his new ally, coincidentally informing him about his current living arrangements and his plans for future work. "I can't refrain from telling you that the room which will henceforth serve as my studio is the one in which I was born — after an active life and having more or less succeeded, it seems very curious." In spite of these somewhat disheartening circumstances, Miró is poised for work and just about ready, he tells Zervos, to begin some small pictures that will be as concentrated as he can make them.

Miró was, however, detoured from his plans to focus on the small pictures by a commission from Léonide Massine to design all the decor and costumes for the Ballets Russes production of *Jeux d'enfants*. Miró was delighted with the project from start to finish; beginning work on it in mid-February, he predicts that it will be "as sensational as a bullfight or heavyweight match," the equal of the company's famous ballets *Parade, Mercure,* and *Le Sacre du printemps* — all with decor by Picasso. And after its opening in Paris in June, he writes his friend George Antheil's wife that it has been "a magnificent success."[228]

Miró may possibly have begun work on his projected series of small pictures before receiving Massine's commission, but it was not until the summer at Montroig that he was truly able to fulfill his plans. The realization of this group of twelve tiny oils (pp. 184–87)[229] marked the end of the period, begun in 1930, when painting seemed to be the only medium that eluded Miró's mastery. Once again fully in command of his gifts, Miró returned to painting with a peculiar vengeance; both in technique and appearance, the twelve pictures have an Old Master quality. Cabinet-size, on wood panels, these miniaturized oil paintings are exquisitely crafted, each biomorphic form delineated with a hair-fine precision in colors of jewel-like brilliance. The figures in these paintings are as resistant to exact morphological reading as those in most of the drawings done from the 1930 notebooks, but Miró provided titles to instruct us in their interpretation. For the most part, the protagonists are women — their gender both explicit and ambiguous — in quotidian situations which often look as if set in an interior. Effectively, these paintings are a modern equivalent of seventeenth-century Dutch genre painting — as if Gerard Dou had received a Surrealist education.

Though Miró made his triumphant return to painting by way of the transformation of an Old Master style, his preliminary procedures at this point have less in common with the elaborate preparatory methods of most older art than any previous series except the Ingres-paper oils. As far as can be ascertained, the twelve wood panels were not preceded by drawings; the contours of forms in these paintings were probably drawn on an initial ground of white pigment and then meticulously painted over. While Miró by no means abandoned drawing, he does not seem to have used it directly in preparing any still-extant paintings from 1932 until 1935, when it was employed only sporadically; thereafter, toward the middle of 1936, it would once again become the standard way of getting a painting started.

Something else changed with the panel pictures of 1932. Before this time, Miró had rarely, if ever, precisely dated his paintings, inscribing them only with his signature and the year of execution, whereas he had always more exactly dated his works on paper, often — as in the series of drawings of 1924 and 1930 — noting both the day and month of their making. Why he made this distinction between mediums is open to speculation, as is the reason why most of the panel paintings, deviating from his previous practice, have the month as well as the year of execution written on their versos. Beginning with the series of collage-based paintings of the next year, Miró would become even more precise in the dating of his paintings; only rarely thereafter does a painting not bear an exact date. Comments scattered through letters of the thirties show him increasingly concerned with his place in history, and concomitantly at pains to leave material that would serve as future documentation of his work. This interest in preserving a record of his oeuvre may have contributed to Miró's new accuracy in dating the panel paintings of 1932.

On January 26 of the following year, in a makeshift studio in his mother's home, Miró initiated the first phase of a unique two-part experiment. Between that date and February 11, at an average rate of one per day, he made eighteen collages on uniformly sized sheets of Ingres paper. To each he glued elements clipped from advertisements, catalogues, and newspapers; very occasionally the images show parts of human anatomy and, once, a horse's head on a brandmark — otherwise, they range freely over the whole domain of objects created by the human mind and hand for the physical convenience of the species. Deadpan, they imply no hierarchical classification of human activities, neutrally representing them through such diverse objects as industrial machinery, airplane parts, a tennis racket, a toilet, cutlery, pots and pans, a crutch, umbrellas, a coin bank, furniture, combs, shoes, and gloves. As compositions these collages are rather unrewarding, yet they afford a glimpse of Miró's delight in mundane life, his recognition of its absurdities, and an ironic humor about the picture-making process. In one in particular (fig. 61), he seems to have enjoyed a sly joke directed at his own pictorial practices; as the word "Photo" had served a double purpose in 1925, when its impress had generated another image, or as the drafting triangle and string of the 1928 *Spanish Dancer* were recycled in *Potato,* the cutout from the interior of the coin bank functions to elucidate just how easily a single form

61. Preparatory collage of February 2, 1933, for **Painting** (Thwaites 1936, repr., detail, p. 25), April 6, 1933. Pencil and collage on paper, 18½ × 24¾″ (47.1 × 63 cm). FJM 1295

can assume at least a double value, or, in Miró's unsubtle cutout, "DOBLE VAL."

Miró went about compiling his collection of collaged cultural artifacts systematically; when a sheet held whatever he deemed to be its proper complement of glued images, he carefully dated it, set it aside, and moved on to the next. This phase of his enterprise was finished with the execution of the eighteenth collage, dated February 11, 1933 (see cat. 109); he was then ready to begin the second phase, the execution of eighteen large-scale canvases to be based on the collages and to follow them in exact chronological sequence (for representative examples, see cats. 106–09).[230] As he finished each painting, he inscribed the collage that had been its impetus with the canvas size and date of completion; thus the first collage bears the inscription *26.1.33. (60f. 3.3.33)*. Unbroken throughout the series, this methodical annotation makes it possible to chart Miró's progress: the collage of January 26 spawns the painting of March 3; the collage dated January 27–28 is followed by a painting on March 4; on March 8, a painting is finished based on the collage of January 28, and so on until the eighteenth painting is finished on June 13.

Miró never made a secret of the relationship between the collages and the paintings; neither, however, did he advertise it. When the paintings were first shown, at the Galerie Georges Bernheim in Paris at the end of 1933 and almost immediately afterward at the Pierre Matisse Gallery in New York, they were not accompanied by the collages. And when Zervos discussed the collage-to-painting nexus at some length in the 1934 issue of *Cahiers d'art* largely devoted to Miró, he nonetheless reproduced only the paintings;[231] earlier, Miró had wanted to have a preparatory sketch for *La Fornarina* appear in Leiris's article in *Documents*, but this does not seem to have been a concern in the case of the 1933 collages.[232] Since the publication of the Zervos article, almost all subsequent discussions of the 1933 paintings note their relationship to the collages,

but the full scope and obsessive nature of Miró's 1933 project were — like so much else in his oeuvre — impossible to know before the late seventies, when the artist gave his sketches and notebooks to the Fundació Joan Miró in Barcelona.

The transformation Miró effected in converting the small, orderly collages, with their recognizable if incongruously arranged elements, into large-scale canvases of elusive mystery has been discussed so comprehensively elsewhere that a rehearsal here would be redundant.[233] Yet the question of why Miró elected to use this unusual, not to say virtually unprecedented, procedure does merit some further attention.

Miró had, of course, often used mechanically reproduced images as inspiration before — in the *Spanish Dancer* of 1924, the Dutch Interiors of 1928, and the Imaginary Portraits of 1929. But in no previous instance did collage as such play a role, and, always before, any number of mediating drawings bridged the distance from reproduction to painting. In economy of preparation, the collage-based paintings are closest to those of the mid-twenties that were usually preceded by only one drawing; in similarity of source — and distance from it — their nearest relative is *Portrait of Queen Louise of Prussia* (p. 171). Unlike the other Imaginary Portraits based on images found in older art, *Portrait of Queen Louise of Prussia* is the transformation of a found collage, a newspaper advertisement for a German diesel engine juxtaposed with another for a shirt collar (fig. 62). In the final painting, the traces of these objects are as thoroughly removed from their origins as are the forms in the 1933 paintings from those in the collages; but, where the collages directly precede the final paintings, *Portrait of Queen Louise of Prussia* required at least twelve mediating drawings, in-

62. Advertisements that served as source images for **Portrait of Queen Louise of Prussia** (p. 171), 1929. Printed paper with pencil, irregular sheet; overall 8 × 8″ (20.5 × 20.5 cm). FJM 943

59

spired by the adjacently positioned advertisements. If this intermediate step was required in 1929 and could be dispensed with in 1933, in either case we see the radicality of Miró's leap from precise technical image to a loose biomorphic form rich in associative suggestion. It is not freedom of execution as such that distinguishes *Portrait of Queen Louise of Prussia* and the 1933 paintings, but the license Miró grants himself to depart from his source. Nowhere else in his oeuvre does he take such liberties; where a work is prepared by a drawing, it never shifts so sharply from the original conception. It would seem that it was the very absence of his hand in preparation, the impersonality of the source, that allowed for broader creativity in execution. Confirming this is a comment Miró jotted down in one of his notebooks in the early forties about a series of pictures he was planning: "Have someone else draw these canvases by a mechanical process . . . [then] draw them over with great freedom. . . . It's not important if the drawings that serve as point of departure are very much changed."[234]

If the hand played a role, by abdication, in the collages, the series as a whole meditates on its usages. In an article on the images of Diderot's *Encyclopédie*, Roland Barthes remarks: "The essence of the human is that the hands are inevitably the sign of inductive capacity [*signe inducteur*]. . . . The civilization of the hand is not one easily finished with."[235] The contraptions of twentieth-century Western culture that Miró ironically catalogues in his collages imply the agency of the hand in their making and functioning no less than do the tools and machinery of a pre-industrial era illustrated in the *Encyclopédie* (fig. 63). But in the collages — Miró's Dada-like equivalent of Enlightenment rationalism as displayed in the pages of the *Encyclopédie* — the creative power of man symbolized by the hand's dominion over a world of utilitarian objects is treated with a somewhat amazed and skeptical humor. The hands that have made or will wield Miró's collection of artifacts seem at the mercy of a quixotically pragmatic intelligence whose priorities are in need of rearrangement. From collage to painting, the ironic transformation of a staged, mechanistic order of reality into a reality of the marvelous turns the symbol system of the commonplace upside down, by fiat of Miró's hand in the act of painting.

Less than a year after the last collage-based painting had been finished, Zervos remarked in *Cahiers d'art* that Miró "seeks to make the world of things relive in his world."[236] This statement is sufficiently general to apply to almost the whole of Miró's work, but its emphasis on "the world of things" points to the singularity of Miró's procedure in the recently completed series. The similarity of spirit and method informing Miró's curiously set-up endeavor to what has been called "ethnographic Surrealism" is so strong that it may not be wholly coincidental. As explained by James Clifford, the collaboration between Surrealism and ethnography was exemplified in Georges

63. Plate from Diderot's **Encyclopédie** of 1751

Bataille's journal, *Documents*,[237] which published articles by Miró's close friends and apostate Bretonians, Desnos, Leiris, Artaud, and Queneau, along with such ethnographic field-workers as Marcel Griaule and André Schaeffner. *Documents* had published three articles on Miró in the two short years of its existence, and he was vividly aware of its intellectual and aesthetic positions. The ethnographic attitude, according to Clifford, "denoted a radical questioning of norms and an appeal to the exotic, the paradoxical, the *insolite*. It implied too a leveling and a reclassification of familiar categories."[238] Two of its "key attitudes" were "the corrosive analysis of a reality now identified as local and artificial; and . . . the supplying of exotic alternatives."[239] *Documents* itself is described by Clifford as a "playful museum that simultaneously collects and reclassifies its specimens."[240] A more appropriate description of Miró's activities, in assembling his collaged artifacts of Western culture for conversion to a strange realm of the exotic, could hardly be found. Indeed one wonders if Miró did not savor the contrast (and similarity) between his domestically based endeavor and the adventures of his friend Michel Leiris in Africa with the Mission Dakar-Djibouti.[241]

The six months of sustained effort Miró demanded of himself to produce his collage-based paintings seem to

have been followed by a period of relative relaxation. Sometime during midsummer 1933, he began a series of works combining cursive drawing, collaged postcards "in delectable bad taste"[242] and cutout images of subjects as diverse as flayed anatomy, birds, and fish (pp. 192, 193). In these, the supple rhythms of harmonically interlacing line move to link and surround the collaged elements in a manner that can recall the graceful play of ironwork in the art-nouveau lattice decorating a Barcelona shop-front window (fig. 64). The lines themselves were not created, as they often had been in Miró's 1929 collages, by gouging away at the flocking of the pastel-paper support, but by the flow of crayon or pencil over surface. Yet Miró's old impulse to enlist the physical nature of materials in his

64. Postcard of a Barcelona storefront

design was not gone, and he sometimes enriched the variety of drawn incident with clusters of tiny nail holes made by piercing the support from the reverse.

The collage-drawings were Miró's principal extended project following the completion of the eighteen large paintings of 1933, but they were by no means his sole occupation. In response to a commission from Marie Cuttoli for tapestry cartoons, he made four large paintings in the winter of 1933–34 (pp. 194–97); drawing directly on a base color applied to unprimed, glue-sized canvas, he filled in the contours he had brushed on quite carefully. Yet the resulting canvases, especially *"Hirondelle — Amour,"* soar with an exultant freedom that embodies Giacometti's remark, "For me, Miró was . . . more aerial, more liberated than anything I had ever seen before."[243]

For all the mastery displayed in the four paintings made on Marie Cuttoli's commission, Miró apparently regarded them as apart from his ongoing projects; in an April 29, 1934, letter to his dealer in the United States, Pierre Matisse,[244] Miró does not list them among the series he designates as *a* through *e*, finished since completion of his collage-based paintings. As he would often do in his subsequent voluminous correspondence with Pierre Matisse, Miró outlines what work he is planning for the future. Sometimes he specifically details his projected

schedule, but his April letter notes only general ideas, which, he says, have "the maximum probability of being realized," but which, he warns, must be considered subject to variation. In any case, all his activities, he makes clear, will culminate in a final series of paintings that will, like the collage-based pictures before them, be "the brilliant flowering of a new stage."

The "brilliant flowering" Miró anticipates is probably represented by the extraordinary series of small paintings on copper or masonite that he worked on intensively between fall 1935 and spring 1936. During 1934, Miró seems to have adhered to the program sketched out earlier, assuring Matisse in mid-July, "My work follows very closely the rhythm that I indicated to you."[245] In contrasting his approach to art-making with that of Picasso, Miró was later to say that where Picasso had "le goût de l'instrument,"[246] his own was for the support; and where that taste had led to experimentation with the givens of easel painting in the twenties, in 1934 it found expression in Miró's choice of a wide variety of paper grounds; one series is in gouache on black paper, while differing kinds of abrasive paper served as the support for two others, one in oil and collage, the other in pastel. With the exception of a brief episode in mid-1935, he evidently did not return to a sustained use of canvas until 1938.

The most important suite of works of 1934 is the pastels, which Miró appears to have regarded as equivalent to painting (pp. 198–200 are representative). He describes them as "very painted,"[247] and in a casual echo of his old fierce resolve to "go beyond painting," he says: "I wanted to stay with pure painting, while, at the same time, of course, transcending it."[248] No doubt these pastels are, as Dupin calls them, "the first manifestation" of Miró's "tableaux sauvages."[249] As with the small paintings of the following year, the sense of unease they almost palpably exude reflects a mood provoked by the ominous political climate in Spain. At the very moment he was making the last of the pastels, the Spanish federal army was arresting members of the Catalan government;[250] Miró himself judged the situation too dangerous to make a planned trip to the opening of an exhibition featuring his work at the Zurich Kunsthaus.[251] But deeply disturbing as were events in Spain, Miró did not neglect a proper concern about the fate of his art. In October he counsels Pierre Matisse to take photos of his work, or, at the very least, to keep records of the locations of the most representative examples, against that time when "something serious would be done about me";[252] in December he writes again, expressing concern about neglecting his European audience and allowing the American to imagine he depends exclusively on it. In the same letter, he recounts that he and his Paris dealer, Pierre Loeb — who shared Miró's production with Matisse in return for a monthly stipend — had, for reasons "de bonne politique," given one of the pastels to Breton, explaining: "It seemed

to me good policy to be on good terms with him, since the Surrealists have become *official personalities* in Paris."[253]

Growing Reputation

Although Miró still did not find himself in comfortable economic circumstances, his popular and critical success on both sides of the Atlantic was considerable. During 1934, he had participated in no fewer than five group shows in Paris, as well as others in Barcelona, Marseille, Brussels, Zurich, and Copenhagen; on the other side of the Atlantic he had had one-artist exhibitions in New York, Chicago, and San Francisco, and had been included in The Museum of Modern Art's fifth anniversary celebration. The first of *Cahiers d'art*'s 1934 issues had been devoted to him, reproducing some forty works from all periods and featuring articles by an international roster of authors — Christian Zervos, Maurice Raynal, Robert Desnos, Benjamin Péret, Ernest Hemingway, René Gaffé, Ragnar Hoppe, George Antheil, Vicente Huidobro, Pierre Guéguen, James Johnson Sweeney, Léonide Massine, Herbert Read, J. V. Foix, Jacques Viot, and Anatole Jakovsky.[254] Then in its first year of publication, the influential new magazine *Minotaure*, under the direction of Albert Skira and Tériade, did not neglect him.[255] Indeed one commentator, in *Le Témoin* of February 4, 1934, found his renown all too pervasive, remarking: "Miró, painter of hermetic modernism . . . [is] on all the walls of Paris; posters influenced by his work carry his mark. Advertisements for pasta, stoves, grills look like Miró's paintings copied by a clown with a sense for commerce."[256]

In America, the pioneering collectors A. E. Gallatin and Katherine Dreier, along with the critic Henry McBride, had supported Miró's work since the late twenties, but it was largely through the efforts of Pierre Matisse that Miró's reputation expanded in the thirties. McBride had featured Miró's *Dog Barking at the Moon* (p. 156) in a 1928 article in *The Dial*;[257] shortly afterward, Gallatin bought the painting and put it on public display with the rest of his collection in the Gallery of Living Art at New York University, where it attracted much notice, admiring and otherwise. As a result, to the degree that Miró was known, it was as a one-shot artist, with this painting standing for everything that was good and bad about Miró and modern art in general.

It was only in 1932, when Pierre Matisse began to hold yearly exhibitions of Miró's work, that the public really had a chance to assess it. On Matisse's exhibition of Miró's 1933 collage-based paintings and the panels of 1932, an *Art News* reviewer wrote: "Joan Miró has heretofore enjoyed fame in America as a 'one painting' artist and his *Dog Barking at the Moon* aroused a special curiosity that was in itself a tribute to the artist. Now through the good offices of Pierre Matisse we may enjoy his sophisticated

talent in all of its manifestations."[258] Much of the American audience was still quite unready to cope with either Miró or modern art itself, but Matisse's exhibitions would build on an already extant interest to generate an ever-growing positive response. Miró was by now sufficiently known to provoke an extended review in *Time* magazine's art section of January 22, 1934; the *Time* correspondent also invokes the famous dog and moon, but does so to point out that when the picture had been shown the previous summer in Chicago's "A Century of Progress" exhibition, it had been remarked by critics along with "Rembrandts, El Grecos and Manets as one of the greatest paintings"; about the show at Matisse, the reviewer judges that "Miró is . . . an abstract painter . . . interested in getting emotions on canvas. . . . But in late years, critics hardened to modernists have come to realize that he is also a serious, thoughtful painter with a vast grasp of the technique of his craft and an uncanny sense of color. His strange designs have the quality of holding attention and spurring imagination which, in its essence, is the final aim of surrealism."[259]

Although the press often associated Miró with Surrealism, and frequently, in fact, cited him as its leader, the movement itself was far from being an active force in his life. He expressed his attitude clearly to Pierre Loeb in a letter of April 12, 1934; Loeb must have made some negative comments about certain Surrealists, for Miró responds: "I completely share your judgment about certain persons . . . but that doesn't prevent them from being useful to us at certain moments." "I have the highest regard for Breton, as for some of his friends," Miró goes on. "But I have a greater and greater need to safeguard a fierce independence," the better, he says, to preserve his own "purity" and momentum.

"Auto-Revision" in a Mixed Series

Just where that momentum would carry Miró in 1935 is the subject of a December letter to Matisse. He foresees three general lines of endeavor. One: he will do several middle-size paintings (*peintures*), which, like the pastels, will be "very painted," and possibly one or two pictures (*grands tableaux*); two: in the summer, he says, "I will surely make some very small paintings *très poussés*"; three: he will make studies for some very important canvases (*toiles*), which will demand long consideration and great discipline. He will, he declares, push them to the last limit, but has no idea when they will be realized.[260] The first plan Miró outlines would result in some thirteen paintings on cardboard and a small number on canvas which he would execute in the first half of 1935 (pp. 201–09 and Dupin 403, 404, 406, 411, 413, 414); the second announces a suite of highly worked oils on copper or masonite (pp. 210–15 and Dupin 430); and the third probably refers to a group of canvases that two years later

he would be forced to leave in Barcelona unfinished, and to which he would not be able to return until the end of World War II (such as pp. 266–67, 269).

If in 1930 and 1931 Miró's art betrayed an indecisiveness that sometimes caused interruptions in his customary serial patterns of work, the first half of 1935 would seem, for parallel reasons, to offer another exceptional example. The diversity of subject and technique in the pictures Miró made between January and late spring 1935 (pp. 201–09 and Dupin 403, 404, 406, 411, 413, 414) is so extreme that these works obviously fail to meet any useful definition of seriality. If they meet the dictionary requirement of "following upon each other in temporal succession," they cannot meet its primary condition of being "things of one kind"; but equally, they do not seem united, as Miró's works in series are, by a common "conceptual grouping" and certainly do not exhibit a "consistent technique." Miró himself called this stage an "auto-revision of my work."[261] As such, its diversity is the product of a quasi-scientific experiment whose aim is self-instruction. The thirteen *peintures* are executed under controlled conditions, which are then abandoned in the *tableaux* that follow. It is as though Miró had posed two questions to himself: "If I permit myself to work on nothing other than a cardboard panel of a certain size, what varieties will come out of it?"; and then, "If, after that exercise, I let the constraints go, what will happen?" That Miró wanted something like a confrontational relation between pictures within the cardboard group is evidenced by their differences of style and content; that he also wanted to contrast the cardboards with the canvases that followed is at least implicit in his distinction between *peintures*, meaning for him, in this instance, paintings *not* on canvas grounds, as opposed to *tableaux*, which would be. If this mixed group of pictures defies all notions of serial relationship, it was nonetheless conceived as a single block of work — the cardboards united by identical size, and the whole by the instructive utility of contraposed treatments and materials.

There is much less unevenness of quality in the paintings of the first half of 1935 than there had been in the somewhat parallel period of 1930–31. Two of the most successful, *Portrait of a Young Girl* (p. 202) and *The Farmers' Meal* (p. 203), are respectively the third and fourth of the group of cardboards to have been completed, and they appear to have similar sources. A few years later Miró was to explain, "The drawings I sometimes do before doing certain paintings are an *intimate* document. . . . Once the paintings are finished, I destroy these drawings or else hold on to them to use as a springboard for other works."[262] We now know that Miró preserved many preparatory studies, but just how often he consulted them is a matter for speculation.[263] It is, however, clear that his 1935 process of auto-revision sent him back to his old Montroig Notebook; toward the middle of the notebook is

65. DRAWING FROM THE MONTROIG NOTEBOOK, 1924, USED FOR **THE FARMERS' MEAL** (P. 203), 1935. PENCIL ON PAPER, 6½ × 7½″ (16.5 × 19.1 CM). FJM 620A

66. PREPARATORY DRAWING MARKED "E" FROM THE MONTROIG NOTEBOOK FOR **THE FARMERS' MEAL** (FIG. 67), 1925. PENCIL ON PAPER, 6½ × 7½″ (16.5 × 19.1 CM). FJM 635B

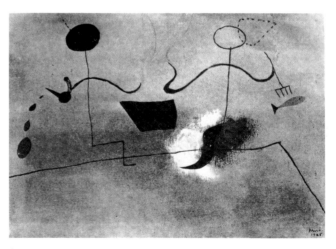

67. **THE FARMERS' MEAL.** MONTROIG, LATE SUMMER–FALL 1925. OIL ON CANVAS, 18⅛ × 15″ (46 × 38 CM). PRIVATE COLLECTION. DUPIN 112

a drawing (fig. 65) from 1924 that unquestionably served as the basis for the 1935 painting *The Farmers' Meal* (p. 203). In 1925 Miró had used the figures of farmer and wife at their meal for a less anecdotal study (fig. 66) in preparation for a painting of that year (fig. 67), but the

68. PREPARATORY DRAWING FOR **PORTRAIT OF A YOUNG GIRL** (P. 202), 1935, ON PAGE FROM A LOST NOTEBOOK ATTACHED IN THE MONTROIG NOTEBOOK. PENCIL ON PAPER, OVERALL SHEET 6½ × 7½" (16.5 × 19.1 CM); ATTACHED SHEET 2¾ × 2⅛" (7 × 5.6 CM). FJM 654B (WITH 3130 ATTACHED)

69. STUDIES ON THE LEFT PAGE OF THE MONTROIG NOTEBOOK FACING THE PAGE REPRODUCED IN FIG. 65. 1925. PENCIL ON PAPER, 6½ × 7½" (16.5 × 19.1 CM). FJM 619B

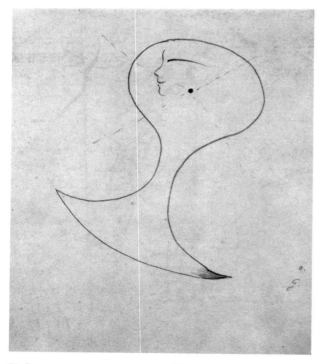

70. PREPARATORY DRAWING MARKED "G 9" FROM THE MONTROIG NOTEBOOK FOR **HEAD** (DUPIN 188), 1927. PENCIL ON PAPER, 7½ × 6½" (19.1 × 16.5 CM). FJM 656B

composition as a whole had not been utilized previously. The 1935 painting, which converts a playful interior into a domestic orgy, is probably somewhat further from the original 1924 study than it might appear: to judge by differences of line in the drawing, Miró, after drawing the original study, probably added the demonically grinning peasant to it, before transplanting him to the eerie green luminescence of his final context.

While it is not possible to fix an exact source for the

1935 *Portrait of a Young Girl*, Miró left evidence that it is also in the Montroig Notebook; glued to a page near the end is its study, on a tiny sheet from a lost thumb-size notebook (fig. 68). The young girl's forms seem to conflate those familiar in the *A* to *J* series with others from the Imaginary Portraits, but her pasted-in presence in the Montroig Notebook would indicate that Miró thought her origins were there. Adjacent to the page holding the study for *The Farmers' Meal* is one (fig. 69) whose scattered sketches make clear that the floating, bulb-like form appearing frequently in the *A* to *J* paintings is none other than the Catalan *barretina*, pressed into varieties of versatile service. One such is its use in a *G* drawing (fig. 70)[264] a few pages after the drawing for the young girl; here, the basic cap-form becomes a containing outline suggesting at once a head and the curving body of a woman. The configuration of the young girl of 1935 fuses head and body in a manner so similar, it may not be entirely wrong to adduce that her presence in the Montroig Notebook owes to her connections to the *barretina* family.

On concluding his foray into auto-revision in midsummer 1935, Miró had an eclectic body of work that recalled earlier pictorial expeditions, as well as foreshadowing directions he would not pursue until very much later. Some of his future directions are seen particularly in the two large works on canvas from the last stages of his selfimposed critique; both *Animated Landscape* (p. 208) and *Animated Forms* (p. 209) deploy open and closed forms with dissociated planes of color on an expansive light ground in a way that would not reappear until 1945. For a more immediately useful model, Miró had only to look at the second of his paintings on cardboard, *Person in the Presence of Nature* (Dupin 404). In subject and treatment, if not size, it directly prefigures his next important series.

Surface and Perversity

Although somewhat more loosely painted than the twelve tiny paintings on copper or masonite that Miró would work on between summer 1935 and mid-May of the following year,[265] *Person in the Presence of Nature* (Dupin 404), like them, converts the peaceful landscape of Montroig into savage theater. In affective intensity those paintings surpass the already great expressive power of the first of Miró's *tableaux sauvages*, the pastels of the preceding summer; for precision of execution they rival the panel paintings of 1932, which they recall in other respects as well.

This relation of the paintings of 1935–36 to the panel paintings of 1932 is one manifestation of a recurring phenomenon in Miró's working procedures: throughout his oeuvre, he sometimes set himself the task of addressing one problem of expression in the material terms previously used to address another. Instances of these non-parallel parallelisms are to be found in such series as the Ingres-paper oils of 1930–31, as contrasted with the Constellations of 1940–41; within the group of thirteen cardboards of 1935; and in the differences and similarities between the 1935 cardboard sequence and the masonite series of 1936.

While both the Ingres-paper oils and the Constellations are large suites of closely related paintings on sheets of uniform size, the nearly total abstraction and austere geometry of the earlier series could not be at a greater expressive remove from the effulgent lyricism of the Constellations. This parallel but contrastive model is, as we have seen, the operative principle within the sequence of thirteen cardboards of 1935. Whether Miró was thinking of his experiment with the thirteen cardboards when he launched his masonite series in the following year or not, in size and resistant nature of support they approximately resume the physical properties of the cardboards; but where the earlier group manifests great stylistic variation, the series of 1936 displays a similarity of treatment consonant with a consistent expressive intent. In each of the preceding, like givens of physical limitation are made to yield strongly contrasting modes. To the degree that Miró's choice of resistant grounds, small formats, and final number for the twelve paintings of 1935–36 rehearses the series of 1932 for purposes of another kind of expression, it places the 1935–36 series within the general model—but with a deviating quirk. This time the works show not only material similarities to but also close stylistic affinities with the earlier contrastive series; holding the formal variable to a relative constant, Miró introduced a refinement to his self-imposed conditions—effectively forcing himself in 1935–36 to bring forth a pictorial world of sinister, impending violence with little other means than a technique, now only slightly altered, that earlier had served to express a lighthearted domesticity.

Miró was also up to other tricks whose origins may lie in prior stratagems. Where in 1928 and 1929 he had juxtaposed strongly differing modes of collage and painting, he now bets on his ability to make an expressively cohesive series from materials of almost opposite physical qualities. Whether painted in oil on copper or in tempera on masonite, the twelve *tableaux sauvages* (pp. 210–15 and Dupin 430) are united each to each by their equal poetic intensity and common subject matter. Yet their unity of effect is achieved through a methodology close to the perverse. The series divides evenly into six works on masonite and six on copper; from its inception to its completion, Miró tended to work first on one ground, then on the other, going back and forth between them. He thus charged himself with bringing forth a common expressive content from alternating bouts with materials of seemingly intractable difference. When he opted to use first oil on copper—whose properties virtually ensure slick surfaces and heightened color[266]—and then tempera on masonite, nearly guaranteed to produce dry, mat effects and blunted hues, the poet was putting the craftsman to a severe test.

Miró frequently wrote to Pierre Matisse about the nature of his progress on the copper and masonite paintings, telling him in February 1936, "They demand to be worked on very slowly," and advising him to "have no fear about the solidity [*solidité*] of these works."[267] Miró applied himself with great intensity to this series, often with no interval between the completion of one painting and the beginning of another, yet, as he explained to Matisse, "to avoid any fatigue that would spoil freshness of inspiration," he was also making all sorts of other things relatively quickly.[268]

Before Matisse had seen the small-format paintings, the descriptions of them had made him want to have some on hand in his New York gallery. Miró, however, adamantly refused to part with any until the series was complete. In a letter of November 16, 1935, he follows up a remark about his hopes that the small size and meticulous technique of the paintings will make them very salable (*negociable*) with the repeated plea that Matisse not press him. He cannot, he says, "give up any part of the group, because in working I consult them all to remain in a certain state of spirit and to find a place [*point d'appui*] and a springboard to launch myself from," and, he adds, "it would be a great error to exhibit only a part of these works."

On his annual summer visits to Paris, Matisse was always eager to see Miró's new works and, when possible, to decide with Loeb and Miró which would be for New York and which for Paris. Miró and Matisse tried to plan these visits in advance, although they sometimes missed each other. On April 28, 1936, before he had begun the last two of his small paintings, Miró sent Matisse an outline of what he could expect to see when he arrived in Paris that summer. Using his customary format, Miró groups his

works in a list that runs from series *a* through *f*, and very briefly explicates what each comprises. Only his tiny *tableaux sauvages* merit additional comment; they are, he says, "the culmination of diverse explorations . . . and of capital importance." Having concluded his list, Miró draws a line across the paper, and immediately follows it with: "For the exhibition you are planning for next winter, I am taking the liberty of advising you to wait for the paintings I expect to finish in the beginning of autumn. . . . I think I will make about twenty-five in a format of about size 40."

Endowing Painting with the Presence of the Object

As it turned out, Miró executed some twenty-seven mixed-medium paintings on uniformly sized masonite panels (approximately corresponding to canvas size 40) between early summer and late October 1936 (pp. 216, 217 are representative). The series as a whole is not one of the most successful, but for what it reveals about Miró's thinking, it is one of the most interesting. Specifically based on ideas that came to him during the preparation of *Jeux d'enfants* in early 1932,[269] the masonite pictures are the clearest manifestation of Miró's fascination with materials and the objectness of painting.[270] What most appealed to him about the assemblages he had been constructing from homely, familiar materials off and on since 1930 was their "thingness"; he saw in them a talismanic presence, a power to arouse response more directly than the high art of painting. Since he had virtually abandoned canvas in 1933, his various shifts of medium reflect a resolve to endow painting with the presence of the object—in effect, rethinking painting's earlier treatment as collage, or his play with stretcher bars. The effort is at its most concentrated in the masonite panels, where a raw, almost ugly assertiveness of handling and materials makes an immediate impact that, more often than not, subsequently forces a deeper scrutiny.

Many years later Miró pointed out that in making the masonite series, "the *matière* commanded the execution. . . . The whole thing came from *Jeux d'enfants*, the ballet for which I had designed the curtains, costumes, and especially the *objets* that the dancers played with. A passionate experience for me that allowed me to go beyond the picture, to explode the surface."[271] Miró's ultimately impractical intent to realize the interactive experience of ballet in his masonite paintings is expressed in a note scribbled on the drawing for the thirteenth: "Put all these canvases [*sic*] together, joined like a film, *prise de roule*."[272] And on the same drawing, his desire to rid painting of overrefinement is expressed in the injunction to himself, "Make everything with a compass to kill all exterior sensibility." In the enthusiasm of the moment, Miró probably saw no irony in this notation, yet precisely in the "finest" of his paintings, from *The Tilled Field* on,

he had habitually used a compass to make the circular forms.

By the time the thought passed through his head to use a compass, Miró was already halfway through the series, which he had been attacking with a freedom of facture that would hardly accommodate precision instruments. In spite of their obvious spontaneity of execution, however, the masonites are the product of an old and rather careful way of working. As he had earlier returned to the Montroig Notebook, Miró clearly found inspiration for the masonite series in a notebook used in 1932; its pages intermingle several drawings for earlier constructions with many related to *Jeux d'enfants*. Either a great many pages have been lost or Miró used a second, unknown notebook in making his studies for the masonites.[273] Nonetheless, the evidence available allows a reconstruction of his procedures, which, in essence, simply extended previous practices.

When he returned to his 1932 notebook in the summer of 1936, Miró first made the studies for most of the masonites on blank left-hand pages, refiguring basic forms previously drawn on right-hand pages for constructions and the ballet. With this initial step complete, he then appears to have executed the paintings in the order in which he had made the studies, marking each drawing with a number in a circle when he began work on the relevant masonite. The collage/construction ethos so prevailed during the making of this series that Miró adapted its techniques to the composition of his paintings. In at least two instances, the sixth (p. 216) and seventh (Dupin 465) paintings, the final configuration of a painting results from its assembly of separate drawings. To build the compositions of the sixth and seventh paintings, in each case Miró combined two drawings (figs. 71, 72 and 73, 74), inscribing one drawing first with an uncircled, identifying number, then with a parenthetical instruction to himself to conjoin it with the other—thus the circled number, indicating order of execution, appears twice (i.e., once on each study), for paintings six and seven, along with the uncircled numbers and the respective notations "3 (join with 2)," "2 (join with 3)" and "5 (join with 4)," "4 (join with 5)." Reinforcing the conceptual link between constructions and the masonites is a drawing for a projected sculpture of c. 1932 (fig. 75) facing the page for the study of the left half of the sixth painting (fig. 71). Added to the sculpture study, at its upper left corner, is another drawing, with a border around it; this later drawing shows the completed configuration of painting six (p. 216) and makes clear how Miró has disassembled elements conceived as three-dimensional to redistribute them on a two-dimensional surface.

Although readable imagery occurs more frequently in the drawings than the paintings, both can come very close to abstraction; but behind them often lurks a surprisingly specific reference. For example, the configuration of in-

71. DRAWING FOR THE LEFT SIDE OF **PAINTING** (P. 216), 1936.
PENCIL ON PAPER, 5¼×6¾″ (13.4×17.1 CM). FJM 1448B

72. DRAWING FOR THE RIGHT SIDE OF **PAINTING** (P. 216), 1936.
PENCIL ON PAPER, 5¼×6¾″ (13.4×17.1 CM). FJM 1449B

73. DRAWING FOR THE LEFT SIDE OF **PAINTING** (DUPIN 465), 1936.
PENCIL ON PAPER, 5¼×6¾″ (13.4×17.1 CM). FJM 1450B

74. DRAWING FOR THE RIGHT SIDE OF **PAINTING** (DUPIN 465), 1936.
PENCIL ON PAPER, 5¼×6¾″ (13.4×17.1 CM). FJM 1455B

75. DRAWING FOR A PROJECTED SCULPTURE OF C. 1932, WITH ADDED
DRAWING AFTER THE SIXTH PAINTING OF THE MASONITE SERIES,
PAINTING (P. 216), 1936. PENCIL ON PAPER, 5¼×6¾″ (13.4×17.1
CM). FJM 1449A

76. STUDY FOR SET DESIGN OF **JEUX D'ENFANTS**, PRODUCED 1932. PENCIL ON PAPER, 7⅛×8¼″ (18.1×21 CM). FJM 975

77. DRAWING FOR A CONSTRUCTION. [1931]. PENCIL ON PAPER, 5¼×6¾″ (13.4×17.1 CM). FJM 1439A

78. PREPARATORY DRAWING FOR **PAINTING** (DUPIN 452), 1936. PENCIL ON NEWSPAPER, 3⅛×4½″ (8.1×11.5 CM). FJM 1416

79. PREPARATORY DRAWING FOR **PAINTING** (DUPIN 472), 1936. PENCIL AND COLORED PENCIL ON NEWSPAPER AND PAPER, OVERALL SHEET 5¼×6¾″ (13.4×17.1 CM). FJM 1455A (WITH 1456 ATTACHED)

clined phallic shape in conjunction with a circle—which first appears in studies for *Jeux d'enfants* (fig. 76) and is elaborated in various forms in studies for constructions (fig. 77), in independent drawings, and in varied guises throughout the masonite series—frequently appears with the inscription "Bonheur conjugal" (fig. 78). A veiled eroticism is operative also in the eighth painting (Dupin 472), intended, as its study makes clear, as an evocation of "lovers in ecstasy" (fig. 79). "Lovers," Miró would later explain, are "forms that struggle, that devour each other."[274]

IV. The Reality of the Times

Just after the completion of the masonite series in early fall 1936, events in Spain brought a halt to the measured cadences of Miró's working patterns. Although the Spanish Civil War had begun in earnest in the middle of that summer, Miró scarcely mentions it in his frequent letters to Pierre Matisse. Yet by late November, during the course of a visit to Paris, the situation had become so personally critical that Miró found himself in involuntary exile; for approximately the next four years he, with his wife and daughter, was forced to improvise ways of coping with the disruption of accustomed living arrangements.

On November 16, 1936, in his first letter to Matisse from Paris, Miró sticks to his old habit of laying out the projects he is planning for the next period of work, but he does not conclude with customary optimism. "Unfortunately," he says, "I'm afraid that this time I won't be able to accomplish these projects with the same almost mathematical rhythm I always work with, and that I will have to give in to the demands of the current drama."[275] By January 1937 he reports having finished the drawings for a series of large canvases that he had actually already begun in Barcelona, but had left there, along with some hundred other things in progress. Much as he does not yet "despair" of finishing them by midyear, he laments that he cannot "improvise" the materials and working atmosphere of the studio he has lost. In the face of the uncertainties posed by the times, he says, he will "plunge" into a new investigation of "the reality of things," a course he had already contemplated but had not, he underscores, expected to pursue until a later time.[276]

In spite of the new worries and the logistical difficulties of finding studio and living space, Miró used the unwelcome interruption of his habits to brilliant effect in 1937. The plunge into reality brought forth *Still Life with Old Shoe* (p. 227), painted between January and May 1937, and the drawing on canvas *Self-Portrait I* (p. 228), executed in a campaign extending from October 1937 to March 1938 in the tower studio of the apartment building on the boulevard Auguste-Blanqui to which Miró had moved in March 1937. Masterpieces of a poetically conceived realism, these two pictures could hardly be more stylistically unlike each other, or indeed anything else in Miró's prior or subsequent oeuvre. If some affinities can, nonetheless, be found between each painting and certain other works by Miró,[277] their strongest kinship is to each other; yet this relation between them has nothing at all to do with execution, but is founded exclusively on the singularity of each within the oeuvre. Their peculiar status is implicit in the comparison Miró made of both with *The Farm* (p. 107);[278] like that early painting, each was the culmination of an exceptionally long, intensive effort to embody in a single work the essential nature of his identity.

Between *Still Life with Old Shoe* and *Self-Portrait I* Miró painted his monumental *The Reaper (Catalan Peasant in Revolt)* (fig. 80), which, with Picasso's *Guernica*, represented the Spanish Republic at the Paris World's Fair of 1937. Unfortunately lost sometime after the closing of the fair, *The Reaper* was as emblematic of Miró's being as are the two paintings that bracket it, but it did not breach his own stylistic traditions as they do. Shortly after Miró had first realized that a return to Catalonia might have to be indefinitely postponed, he had written, "I find myself uprooted [*très dépaysé*], and I long for my own country."[279] The making of these three paintings must have constituted a catharsis, helping Miró to cease thinking of

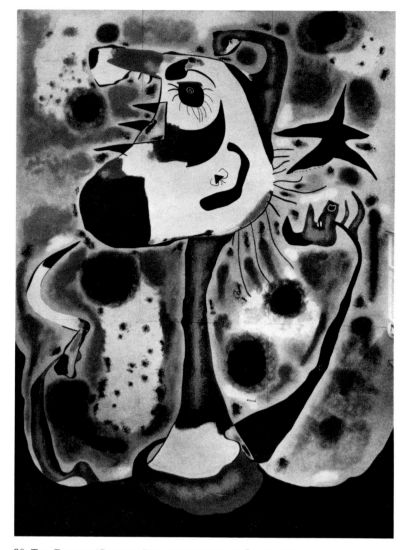

80. **The Reaper (Catalan Peasant in Revolt)**. Paris, 1937. Oil on celotex, 18′ ½″ × 11′ 11¾″ (550 × 365 cm). Whereabouts unknown. Dupin 474

the abandoned works-in-progress still in Barcelona.

Although it would endure only through the completion of his self-portrait, another change in Miró's working methods occurred during his first year of displacement. For the first time since the earliest of his drawings for *The Hunter (Catalan Landscape)* in 1923, he was working from the model. Not only did he set up all the elements of *Still Life with Old Shoe* on a table before him, and use his mirrored reflection for the self-portrait,[280] he also went frequently to the Académie de la Grande Chaumière, making a very large suite of drawings after the nude model (pp. 220, 221 are representative). But customary procedures were not wholly abandoned. On March 7, 1937, after expressing his hope that the still life he is working on will stand up next to a Zurbarán or Velázquez, Miró writes: "Once this canvas is finished, I am going to do a series of very free paintings in a state of complete evasion."[281] His timetable was thrown off slightly by the Spanish Pavilion commission, received sometime in April; but upon completion of *The Reaper* he spent the next few

months concentrating on a series of some eight oils on uniform-size celotex panels, each prepared by a drawing conceived from imagination.[282]

During the following two years, Miró found himself more at ease and able to resume his old congenial studio habits. The work, however, sorts itself out somewhat differently now than it had in the past. While the facade of daily life had regained a reassuring measure of normality, uncertainty and a sense of impending catastrophe were nonetheless ever present below the surface. This atmosphere of the times and the particular precariousness of Miró's position surely account for the shift observable in his working patterns. No less than previously, the greater part of his output falls together in pre-planned sequences, but now Miró does not seem to want to commit to any effort dependent on long-term stability. When he undertakes an extended series, the works tend to be of small size; if he chooses large formats, the number of paintings related to one another is limited to a few, as in the four portraits of 1938 (pp. 234, 235)[283] and the two seated women of 1938 and 1939 (pp. 236, 237).

If Miró's nostalgia for Catalonia had lost its sharpest edge, his longing for an adequate studio had become increasingly intense. On March 4, 1938, he writes to Matisse, "We are still living in the same apartment, fortunately, waiting for the damn day when we can make a decision and have a very large studio, which is the first thing I want to take care of." Soon afterward, in the May issue of XXe Siècle, his now famous article, "I Dream of a Large Studio," appeared. In it Miró explained, "My dream, once I am able to settle down somewhere, is to have a large studio, not so much for reasons of brightness, northern light, and so on . . . but in order to have enough room to hold many canvases, because the more I work the more I want to work. I would like to try my hand at sculpture, pottery, engraving, and have a press, to try also, inasmuch as possible, to go beyond easel painting."[284] While he would have to wait nearly two decades for the full realization of his dream, the new activities he contemplates were shortly to become almost all-consuming. But before that new cycle of creativity would come the astounding achievement of the Constellations.

The Constellations

The twenty-three paintings, mostly in gouache and oil, on uniform-size sheets of paper, collectively known as the Constellations (pp. 238–60) were begun in January 1940, during a period of deceptive tranquility. Between that time and the completion of the last, *The Passage of the Divine Bird*, on September 12, 1941, there took place Miró's own passage through the most harrowing episode of his life.

From January through May 1940, Miró finished the first ten Constellations at Varengeville, in Normandy,

where he believed he and his family would be safe from the threat of a German attack. Suddenly—as Miró would say later, "from one day to the next"[285]—German forces were advancing on France through Flanders, and the Mirós had no option but flight. Pilar Juncosa de Miró remembers they hesitated between a second exile—this time to America—or trying their luck and returning to Spain. But believing that her husband would be able to work more easily in his native land, she urged their return; she would, she said, take care of young Dolores during the trip, and he could watch over the Constellations.[286] After a hazardous journey through a France that was in complete panic, and then an anxious border crossing, they were once again in Spain by sometime in mid-June. There, however, they did not dare go to Barcelona, but settled in Palma with members of his wife's family; initially, even in Mallorca, Miró felt his situation so precarious that he used his mother's maiden name, Ferrà.

In the years preceding the Constellations, two words, "revolt" and "escape" (*évasion*), had appeared repeatedly in Miró's titles; the former does not appear at all in the sometimes poetically elaborate titles of the Constellations, and the latter only once, specifically, and a second time by implication.[287] Yet the Constellations are a sublime expression of the spirit of revolt, understood as unconstrained freedom, and of escape as transcendence of the external world, with its passing human catastrophe. The sense of immensity within intimacy that inhabits these small works comes from a concentrated state that Gaston Bachelard describes as a "philosophical category of daydream." In this state, Bachelard says, "we are not 'cast into the world,' since we open the world . . . by transcending the world seen as it is. . . . And even if we are aware of our own paltry selves—through the effects of harsh dialectics—we become aware of grandeur. . . . Immensity is within ourselves . . . attached to a sort of expansion of being that life curbs and caution arrests, but which starts again when we are alone."[288]

The Constellations, as a group and singly, are among the miracles that art occasionally bestows, and no more do we need to know the context of their making to be moved by them than we need to know that Picasso's *Tomato Plant* of 1944 is fraught with allusions to the war to find fascination in it.[289] Nonetheless, the act of self-extrication accomplished by the creation of the Constellations is an example of triumphant moral courage and unwavering will whose repercussions reach beyond the group. Writing in 1958 about the Constellations, Breton was quite clear on this point. After evoking the situation in May and June 1940 through the image of "cars bedecked with the heavy stripes of mattresses drifting helplessly along all the roads of France," he goes on:

The situation in art (the art of high adventure and discovery) has never been so precarious as it was in Europe during the summer

of 1940, when its doom appeared to be sealed. . . . The annihilation of such art, which was both the product and the generative force of liberty, featured prominently among the invader's plans. . . . We feared . . . the same defections that had occurred, under far less pressure, during the First World War, when some of the greatest names in art abandoned their advanced positions and took refuge in alignment. . . . It is to the glory of a new generation of artists that nothing of the sort happened this time, and in this respect Joan Miró offers us one of the most outstanding examples of *character*. *Resistance* on this plane can be considered an integral part of the whole Resistance movement. . . . Miró, at this hour of extreme anguish . . . unfurl[ed] the full range of his voice.[290]

Like, Breton adds, "the note of wild defiance of the hunter expressed by the grouse's love song."

Concluding his text, Breton comments on the fact that the Constellations were the "first message" about the state of art in Europe to reach America at the end of the war.[291] Shown at Pierre Matisse's gallery in 1945,[292] they were for Breton and the many European artists also then in exile in New York "a window opened wide onto all the flowering trees that the distant storm might have spared."[293] For an emergent generation of American painters, they were, as has been widely remarked, a revelation. Their particular message for the Americans, especially Pollock, has justifiably been seen to consist in "the all-over articulation" of surface, which was the result partly of the "process of painting itself,"[294] and partly of an initial sketching out in charcoal of principal compositional elements over subtly brushed, often abraded grounds.[295] Excluding the long hiatus between the last Constellation to be made in Varengeville and the first made in Palma, the intervals from finished painting to finished painting ranged from three days to almost two months. The immense moral, intuitive, and physical concentration Miró imposed on himself in making these little paintings sparked what is arguably the most brilliant expression of his inner vision. Nowhere else do the aerial and the earthly, the familiar and the cosmic, so seamlessly interweave. In the twenty-three sheets of this series, Miró does what Bachelard attributes to the poet Jules Supervielle: locating the "center of gravity . . . both in heaven and earth . . . he restores to the imagination a suppleness so miraculous that the image can be said to represent the sum of the direction that enlarges and the direction that concentrates."[296]

A Wartime Hiatus and the Resumption of Painting

Unlike those Surrealist and other European artists and writers who had taken refuge in America, Miró spent the war years in isolation, dividing his time among Palma, Montroig, and Barcelona. In a notebook of 1940–41 filled with ideas for future projects, Miró reflects: "One must be ready to work amidst total indifference and in the most

profound obscurity."[297] If necessity held Miró to this precept, the work already launched into the world was receiving unprecedented attention in America. In February 1941 several paintings were shown at The New School for Social Research in New York; his first major museum retrospective was held, at The Museum of Modern Art, in November of the same year; and in the following year, the first two exhibitions at Peggy Guggenheim's Art of This Century gallery featured his work. None of these events could alter Miró's actual situation; although the news he received from Pierre Matisse of the success of The Museum of Modern Art's exhibition pleased him greatly, he nonetheless remained mindful of the uncertain future. Writing to Matisse in July 1942 that "in these times . . . it is so difficult to send new paintings,"[298] he encourages the dealer to sustain interest in his work by now and again giving illustrated catalogues to collectors.

With the difficulty of obtaining materials and the unsettled nature of the times, Miró did little major painting between the completion of the Constellations and sometime in 1944. But his notebooks from the period reveal a flow of ideas about future work, as he jots down instructions to himself in an unedited stream. Although many projects were never realized, activities that were to preoccupy him after the war — almost to the exclusion of painting between 1950 and 1960 — such as printmaking, ceramics, and sculpture, are all meditated on at length.[299] By 1944, he was again at work with a vengeance — beginning his first ceramics with Josep Llorens Artigas, doing the important sequence of fifty lithographs known as the *Barcelona Series*, and commencing a cycle of large paintings that would not be completed until the following year.

Between late January and mid-October 1945, Miró finished some nineteen big paintings; the first important sequel to the Constellations, these canvases, like most of his work thereafter, extend and modify the language of signs so brilliantly codified in the earlier series. Pervading Miró's notebook ruminations are ideas for the large canvases of 1945, but they appear amid such a profusion of ideas for future work that it is not always possible to sort out their specific references. Nonetheless, it is clear that he often thought of them in relation to the Constellations; although often contradictory, his notebook jottings reveal a consistent will to synthesize and simplify the pictorial dynamics brought together in the gouaches of 1940–41, in the new series that he identifies alternatively as Evasion-Musique and as Femmes et Danseuses. At one point, he tells himself "not to think of invisible things" as he had in the gouaches, yet to allow the projected canvases to be "influenced by the poetic signs of 1940";[300] elsewhere, he resolves to jettison the detailed poetic titles of the gouaches for such general ones as "Personnages et oiseaux." Both the admonition not to think of the invisible and the decision to use straightforward titles represent a

81. **The Harbor.** [1934–35]. Pencil on paper, 6⅛×8¼″ (15.5×21 cm). FJM 1340. Antecedent to **The Harbor** (p. 266), 1945

82. **Spanish Dancer.** [1934–35]. Pencil on paper, 8¼×6⅛″ (21×15.5). FJM 1345. Antecedent to **Spanish Dancer** (p. 267), 1945

83. **The Bullfight.** [1934–35]. Pencil on paper, 6⅛×8¼″ (15.5×21 cm). FJM 1346. Antecedent to **Bullfight** (p. 269), 1945

move away from strategies of pictorial complexity rather than any fundamental imaginative shift. Just as the spare still lifes of 1922–23 can be regarded as blown-up details from *The Farm*, many of the 1945 paintings, such as *Spanish Dancer* (p. 267), may be seen as pointed-up, barer versions of imagery in the Constellations. For all their apparent abstraction, the Constellations are full of such grotesque beings as the woman beloved by ciphers and constellations (p. 257); even without Miró's instruction to himself—"for the *Spanish Dancer*, think of the monsters made in 1940"[301]—the link between the figure of 1940 and that of 1945 is readily apparent.

Monsters older than those of 1940 also lurk behind at least three of the large paintings of 1945. Miró's return to Spain had finally made resumption of work possible on the canvases he had been forced to leave in Barcelona and Montroig. His notes of the early forties show him unsure about when he will actually be able to begin work on his series of Femmes et Danseuses, and they are shot through with references to canvases, started and abandoned, that he may incorporate into it. His references are sometimes vague, but one passage names some of the works he has in mind:[302] all are from a suite begun sometime in the mid-thirties, and each of them was prepared by a detailed, still-surviving drawing marked with a canvas size.[303] Miró's ideas for the 1945 paintings changed often before the point in 1944 when he probably began work on them; while he originally planned to rework at least nine of the mid-thirties series, he did not do so, at least for inclusion in the sequence finished in 1945. From the series of Femmes et Danseuses, only three paintings, *The Harbor, Spanish Dancer,* and *Bullfight* (pp. 266, 267, 269), can be positively identified as reincarnations of mid-thirties conceptions.

Although *Spanish Dancer* was the only picture of the

above available for laboratory examination, evidence supporting the identification of each as a canvas actually begun in the mid-thirties is available from other sources. First, we are alerted by Miró's remarks in his notebooks of their intended conversion; then there is the obvious link between the imagery of the mid-thirties drawings (figs. 81–83) and the 1945 paintings. Additionally, in each case the size of the 1945 oil corresponds exactly to the size inscribed on its decade-old "preparatory" drawing. Most telling, perhaps, is proof Miró deliberately made accessible to the eye; each of the mid-thirties drawings is quite elaborately gridded for transfer—in each of the three 1945 paintings, a network of abraded lines displays a grid con-

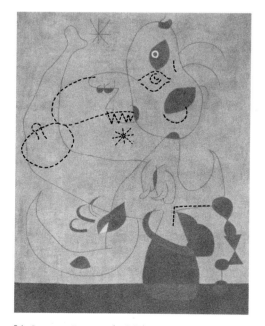

84. **Spanish Dancer** (p. 267), 1945, with drawing superimposed to indicate pentimenti from an intermediate stage of realization visible on the painting's surface

forming almost perfectly to that in the relevant earlier drawing. Not unlike the ghost traces of stumped line in *The Family* (p. 115), here the phantom presence of erasure is used to summon time past. Once again, as in the stretcher-bar paintings, or the collages of 1929, the fabric of the ground becomes the means of creating a mark.

Some other old tricks were up Miró's sleeve — at least in making *Spanish Dancer*. Obvious to the eye before the picture, or in a transparency, are pentimenti — not, however, from whatever may have been the work's appearance in the mid-thirties, but from an intermediate stage. Along with other motifs just visible under the surface film of paint are traces of three jagged, tooth-like elements hanging from a bulbous form over a star (the superimposed dotted lines in fig. 84 indicate the contours and position of pentimenti). Thanks to the fact that Miró had photographs taken of *Spanish Dancer*, along with *The Harbor* and *Bullfight* (figs. 85–87), sometime in 1944, during the course of working on them, *Spanish Dancer*'s pentimenti can be correlated with the state of the painting at that time. Where the shadow imagery in *The Family* serves largely to evoke imaginative encounters with time's passage, it may be that the successive stages of work recorded on the surface of *Spanish Dancer* held a more direct, sharper relevance to Miró's own experience of the immediate past — its abrasions and masked motifs embodying the frustration and despair endured when he had been forced to abandon his work in Barcelona.

86. PHOTOGRAPH INSCRIBED ON VERSO, POSSIBLY IN MIRÓ'S HAND: "'LE PORT' | — EN COURS DE RÉALISATION — | 1944" ("THE HARBOR" | — IN PROGRESS — | 1944). SEE **THE HARBOR** (P. 266), 1945

87. PHOTOGRAPH INSCRIBED ON VERSO, POSSIBLY IN MIRÓ'S HAND: "'LA COURSE DE TAUREAUX' | — EN COURS DE RÉALISATION — | 1944" ("BULLFIGHT" | — IN PROGRESS — | 1944). SEE **BULLFIGHT** (P. 269), 1945

New Mediums and Old Goals

Nowhere in the early forties notebooks does Miró appear confident about when he will be able to get his many projects under way, but he lets himself spin out ideas that will cover the full range of his subsequent work, even in such eccentric directions as pyrography and working on animal hides. While the notes are full of references to varied series of future paintings, their emphasis on sculpture, ceramics, printmaking, and book illustration accurately

85. PHOTOGRAPH INSCRIBED ON VERSO, POSSIBLY IN MIRÓ'S HAND: "'DANSEUSE ESPAGNOLE' | — EN COURS DE RÉALISATION — | 1944" ("SPANISH DANCER" | — IN PROGRESS — | 1944). SEE **SPANISH DANCER** (P. 267), 1945

predicts major areas of creative activity that Miró would explore extensively in the next three decades. Where the years between 1920 and 1941 were for the most part devoted to an intensive engagement with the energies of painting and drawing, those from 1945 to the late seventies saw exuberant explorations of variety in expressive form. But Miró's foray into new areas of action does not reflect a fundamental shift in his working methodology; rather, the exploration of new mediums logically extended old practices. Just as he had virtually abandoned canvas between 1934 and 1938 in favor of grounds that would present other challenges, for some twenty years after the war he chose to try his mettle in fired clay, assembled sculpture, and a breathtaking variety of printmaking and book illustration.

As in the past, what engaged Miró were the physical properties of his materials, and how, by a subversion from within, he could release their expressive potential. In a passage about printmaking from the early forties notebooks, this obsessive perfectionist tells himself to "remain a self-taught amateur as for technique."[304] In his early years Miró had been an avid student in art schools in Barcelona, and "amateur" would hardly be the word to characterize his subsequent career. The sense of this injunction must have to do with an attitude — pervasively evident in his work from 1923 on — toward the nature of the substance that his intercessions translate into expressive form; one perceptive critic discussing his post-1945 sculpture characterized this aspect of Miró's approach as "literalism," defined as "the principled use of materials as and for themselves."[305] Dubbing himself a "self-taught amateur," Miró, the consummate professional, likens his transgressions of traditional technique to their accidental manifestations in the work of a novice. What Miró's self-applied metaphor describes is a mind-set which, although vital to progress in any field, has been singled out as crucial to science.

Pitting poet against craftsman, Miró's varied strategies aim, more often than not, at surprising existing aesthetic orders by discovering possibilities latent within them. Had Miró been a scientist, Albert Einstein might have approvingly classed him as one of those "unscrupulous opportunists" who "in the construction of his conceptual world does not let himself be too restricted by adherence to a system."[306] Whether in the gridded pictures, the stretcher bars, the varied aspects of the painting-collage nexus, the deliberate setting of one mode against another, or the use of pentimenti — even in the Columbus drawing — Miró scrutinized his materials with the intensity of a lover who would rid the beloved of the vestments of convention. To suggest that an approach which can be so described might parallel the routes of discovery in science may seem farfetched. Yet Miró's ardent interest in his materials opened onto a counterinductive consideration of a set of assumed facts about picture-making and facilitated the creative, intuitive flash — what he called the "shock." This is fundamentally little different from the way progress in science has been seen — "as much a matter of . . . intuition and counterinduction . . . as of methodical observation and information gathering"[307] — or, put another way, which Breton might not have censured: " 'Experiment is not just passive observation but the invention of a *new kind of experience*,' made possible by a willingness to let 'reason . . . affirm what sensible experience seemed to contradict.' "[308] Miró's bracketing of his various artistic experiments within the controlling limits of the series extends — if, in this regard, only metaphorically — the analogy between his procedures and those of science.

After the immense variety of his adventures in pictorial form and the enforced slowdown of the war years, Miró's basic creative attitude fairly drove expansion of his activity into new realms. If *matière* had commanded the execution in the past, it would continue to do so; its potential for what Miró called "beautiful surprises"[309] would simply be enlarged. Miró had always known that to "make it new" had no meaning beyond revealing an unsuspected dimension in the familiar — that the materials of art must always be shaped into a medium that would shunt us back to the world of human experience. His ceramics, his sculpture, his prints, his books were, like his paintings and drawings, a constant attempt to surprise meaning from matter. The techniques he used were often designed to deflect expectation, and if at a given historical moment these had a tactical use, or if their purpose seems to record process, their poetic aim was to distill intuition into essence. In whatever medium he worked, Miró's intent was — as he said, with the limpid directness that was basic to his explorations into the domain of earthly complexity — "to rediscover the sources of human feeling."[310] What drove Miró's art, declared his old friend Tzara,[311] was the underlying question of its *raison d'être*, "posed with an obstinacy like that of the living body's circulation of blood."

Notes to the Text

For publications cited here in abbreviated form, full bibliographical data can be found in the Reference List. Exhibitions, cited here by city and year, can be found in the Exhibition History.

For the sources of unpublished correspondence cited, see the headnote to the Chronology.

Miró's letters and interviews are, for the most part, in either Catalan or French. Unless otherwise noted, translations from Catalan are by Cristina Portell and Mary Ann Newman. Translations from French are the author's, unless otherwise noted.

In the figure captions, drawings in the collection of the Fundació Joan Miró, Barcelona, are identified by the abbreviation *FJM*, followed by the Fundació's catalogue number. Within the essay text, plates are cited by page number; drawings that appear only in the Catalogue section are cited by the relevant catalogue (*cat.*) number; and drawings appearing only in the Appendix to the Catalogue are cited by appendix (*app.*) number. Works mentioned in the text but not reproduced in the present volume are identified by Dupin number (see Dupin 1962).

1. Masson exhibition files, The Museum of Modern Art, New York; in Rowell 1986, pp. 79–80.
2. Ibid., p. 79.
3. Wallace Stevens, *The Relations Between Poetry and Painting: A Lecture Delivered at The Museum of Modern Art on January 15, 1951*, brochure (New York: The Museum of Modern Art, 1951), p. 6. Revised version published in Stevens, *The Necessary Angel: Essays on Reality and the Imagination* (New York: Alfred A. Knopf, 1951).
4. Rubin 1968, p. 64.
5. The most complete and illuminating account of Miró's work remains that contained in Dupin 1962.
6. Miró 1977, p. 79.
7. Breton 1972, p. 70. French ed., *Le Surréalisme et la peinture* (Paris: Gallimard, 1965). Originally published in English in Peggy Guggenheim, ed., *Art of This Century* (New York: Art of This Century, 1942). Breton's identification of 1924 as the year of Miró's entry would imply that he had become acquainted with Miró in that year, when, in fact, he did not meet him until early 1925 (see note 110, below, and related text).
8. Ibid.
9. André Breton, *Manifeste du surréalisme/Poisson soluble* (Paris: Editions du Sagittaire chez Simon Kra, 1924), p. 42. Reprinted in Lucy R. Lippard, ed., *Surrealists on Art* (Englewood Cliffs, N.J.: Prentice-Hall, 1970), p. 20.

10. This and preceding quotations of Breton are from Breton 1972, pp. 36 ff.
11. Dupin 1962, pp. 137–38.
12. Rowell 1986, p. 82.
13. Translated from the French as given in Miró 1977, p. 201 (n. 1). Originally published, in English, in *The Collection of the Société Anonyme: The Museum of Modern Art, 1920* (New Haven, Conn.: Associates in Fine Art at Yale University, 1950), p. 108. Reprinted in Lippard, ed., *Surrealists on Art*, p. 116.
14. Greenberg 1948, p. 35.
15. Ibid., p. 23.
16. Duthuit 1936a, p. 261; in Rowell 1986, pp. 150–51.
17. "Eye and Mind," trans. Carleton Dallery, in Merleau-Ponty, *The Primacy of Perception: And Other Essays on Phenomenological Psychology, the Philosophy of Art, History and Politics*, ed. James M. Edie (Evanston, Ill.: Northwestern University Press, 1964), p. 180.
18. Quoted in William Rubin, *Picasso in the Collection of The Museum of Modern Art* (New York: The Museum of Modern Art, 1972), p. 72.
19. See Lanchner 1987, pp. 86–87, 109 (nn. 32, 33). In spite of the many inconsistencies surrounding accounts of the discovery of Klee by Miró, there is no disagreement that Klee was brought to Miró's attention by André Masson, and there is a consensus that the first encounter was by means of a book of reproductions. Because Masson, in a conversation with me in January 1975, very positively identified the book he had shown Miró as one published in Munich, I have always assumed it to have been Wilhelm Hausenstein, *Kairuan, oder eine Geschichte vom Maler Klee und von der Kunst dieses Zeitalters* (Munich: Kurt Wolff, 1921); however, the Cassanyes/Miró correspondence in the Fundació Pilar i Joan Miró a Mallorca would seem to establish that Miró knew, or was at least in contact with, H. V. Wedderkop. (In a letter of October 8, 1924, Cassanyes writes to Miró, "I have received your letter, in which you ask if I could speak with your good friend H. V. Welderkop [sic] in your place." On November 17, 1924, Cassanyes writes: "I have answered Mr. V. Wedderkop and I am currently still waiting for his answer. Attached to the present letter I enclose the one he sent you.") Virtually the only Klee book besides Hausenstein's published early enough to have been the one Masson showed Miró is Wedderkop's *Paul Klee*, published in Leipzig by Klinkhardt & Biermann in 1920. Although Miró's apparent interest in Wedderkop casts doubt on which book Masson had shown him, the illustrations in either would have served to provoke new ideas about pictorial space.
20. Miró 1977, p. 18.

21. For an excellent, thorough discussion of Miró and his Catalan roots, see Lubar 1988. For a superb summary of Miró's Catalan background, see Rowell 1986, p. 4 and passim.
22. For an illuminating discussion of this and related issues, see Lubar 1988, pp. 167–248.
23. The three surviving still lifes from the group of five are inscribed on the reverse as follows: "Nature Morte I" (*Still Life I [The Ear of Grain]*, p. 108); "Nature Morte II" (*Still Life II [The Carbide Lamp]*, p. 109); and "Nature morte III" (*Still Life III [Grill and Carbide Lamp]*, p. 110). The fourth must have been the one, now lost, that Dupin 1962, p. 132, describes as having shown a newspaper and a doorknob. The canvas supporting *Head of Catalan Peasant, II* (Dupin 104; whereabouts unknown) is inscribed on the reverse "Joan Miró | 'Nature morte V' | 1922–23," alongside "Joan Miró | 'Tête de paysan catalan' | 1924–25," and corresponds to the dimensions of one of a group of pictures, including at least three of the other five still lifes, that Miró consigned to Léonce Rosenberg in June 1923 (see note 46, below). Thus, it would appear that Miró painted over his fifth still life to convert it into *Head of Catalan Peasant, II*.
24. Dupin 1962, p. 131, reports that Miró painted the figure of the farm wife after a *santon* (one of the little clay figures used to group round the Christmas crèche in Provence).
25. For a thorough consideration of Miró's "stylistic pluralism" before his first trip to Paris, see Lubar 1988, p. 76 and passim.
26. Letter to J. F. Ràfols, May 8, 1920, sent from Paris; in Rowell 1986, p. 73.
27. Letter to J. F. Ràfols, July 25, 1920; in Rowell 1986, p. 74.
28. Undated letter (assigned by Rowell to March 1920) to J. F. Ràfols; in Rowell 1986, p. 72.
29. For an extended discussion of these still lifes, see Lubar 1988, pp. 190 ff.
30. Lubar (ibid., pp. 193–94) explains the content of Cocteau's book and its significance for Miró, and points out (p. 193, n. 78) that the identification of the book was first made by Rory Doepel (Doepel 1967, pp. 36–37), and later independently by Robert Rosenblum in *Cubism and Twentieth-Century Art* (New York: Harry N. Abrams, 1976), p. 289.
31. Dupin 1962, p. 129.
32. For a discussion of Miró and Purism, see Lubar 1988, pp. 215 ff.
33. Miró 1977, pp. 66–67.
34. Paris 1921.
35. For example, see Dupin 1962, pp. 100–04. *The Farm* is discussed extensively in Lubar 1988, pp. 224 ff.

36. Sweeney 1948, p. 208; in Rowell 1986, p. 207.
37. The grid lines shown in fig. 1 were reconstructed by Dan Kushel, Associate Professor, Art Conservation Department, Buffalo State College, Buffalo, N.Y., from those still visible in the painting. Of the nine gridded works from 1924–25, only in *Carnival of Harlequin* are the red grid lines not fully apparent upon even a casual viewing. Nonetheless, after examination of the picture, Kushel reported, in a letter of May 15, 1992, to the author, that "portions of all the lines could be seen by careful inspection under the brighter illumination used for the examination and photography and with the painting out from under its protective glazing."
38. Miró 1977, p. 57.
39. Aragon 1930, p. 5.
40. Interview with Yvon Taillandier; in Rowell 1986, p. 248. Miró cites Kant as his source for this expression.
41. "Starting from Paumanok," in *Leaves of Grass* (New York: New American Library, 1980), p. 45.
Miró mentions Whitman in a letter to E. C. Ricart, July 9, 1919; in Rowell 1986, p. 61. On p. 310 (n. 62), Rowell provides the information that Whitman's *Leaves of Grass* was translated into Catalan in 1909.
42. Letter to Pierre Matisse, September 28, 1936.
43. See note 23, above.
44. Rubin 1973, p. 20. Because Rubin's suggestion is made in the context of a discussion of objects in the collection of The Museum of Modern Art, the ocher shape in *Still Life II (The Carbide Lamp)* is the only one likened to cast light: nonetheless, the white rectangular form in *Still Life III (Grill and Carbide Lamp)* parallels the ideographic function specifically attributed to the ocher trapezoid in the earlier picture.
45. "Chardin," in *Contre Sainte-Beuve, suivi de Nouveaux Mélanges*; as cited in Richard Wollheim, *Painting as an Art*, Bollingen Series XXXV, 33 (Princeton, N.J.: Princeton University Press, 1987), p. 98.
46. A note written by Miró, now in the archives of the Musée National d'Art Moderne, Centre Georges Pompidou, Paris, reads as follows:
Je confie à M. Rosenberg: 1 nature morte de no. 30 | 1 nature morte de no. 25 | 1 nature morte de no. 15 | 1 nature morte de no. 9 | 2 natures mortes de no. 8 | au prix de 25 fois le numéro | 20 juin 1923 | Joan Miró | 45 rue Blomet (XVè) | Espagne | Tarragone | Montroig.

In the course of her research for the Catalogue section of this volume, Lilian Tone has identified all but the first (size 30) canvas on Miró's list, as follows: size 25, *Flowers and Butterfly* (Dupin 78); size

15, *Still Life III (Grill and Carbide Lamp)* (p. 110); the two size 8s, *Still Life I (The Ear of Grain)* (p. 108) and *Still Life II (The Carbide Lamp)* (p. 109). The canvas Miró lists as size 9 is almost certainly the one he painted over in 1924 and 1925 to make *Head of Catalan Peasant, II* (see note 23, above).

47. Postcard to Rosenberg, July 6, 1923.

48. Dupin 1962, p. 140.

49. On the relevance of Apollinaire's *L'Enchanteur pourrissant* to *The Tilled Field*, see Rowell 1972, p. 53, and Krauss/ Rowell 1972, p. 74. See also Margit Rowell, "Miró, Apollinaire and *L'Enchanteur pourrissant*," *The Art News* (New York), vol. 71, no. 6 (October 1972), pp. 64–67.

50. Pierre-Georges Castex and Paul Surer, *Manuel des études littéraires françaises: XIXᵉ Siècle* (Paris: Classiques Hachette, 1950), p. 277.

51. Dupin 1962, p. 140, remarks that the layout of *The Tilled Field* "has the accuracy of a surveyor's plan."

52. I am grateful to the staff of the Solomon R. Guggenheim Museum for allowing *The Tilled Field* to be examined in the painting conservation laboratory of The Museum of Modern Art; and I am especially indebted to James Coddington, Conservator of Painting at The Museum of Modern Art, whose depth of expertise and acute observations were invaluable in the examination of this picture.

53. Letter to J. F. Ràfols, September 26, 1923; in Rowell 1986, p. 82. The exactitude Miró required of himself is exemplified in his practice of using a compass to make his round forms, even when — as in *The Hunter (Catalan Landscape)* of 1923–24, *The Family* of 1924, or *Dutch Interior (I)* of 1928 — he deliberately skews the perfect geometry of his circles. We have been unable to examine enough paintings to determine just when Miró initiated this practice, but it was, on and off, in operation at least from *The Tilled Field* of 1923–24 until the mid-thirties.

54. Rowell 1986, p. 82.

55. From the time Miró made *Pastorale*, his preparatory drawings for what Dupin has called the "yellow-ground" paintings of 1924 (see note 119, below), like all the preparatory drawings for what are known as the "dream" paintings of 1925–27, differ very little from the final composition of the finished works. Where they do differ, it is more often the drawing that shows some element not present in completed work. For a brief discussion of the differences between drawings and the paintings made after them, see Green 1987, p. 269.

Rudenstine 1985, p. 537, speculates that drawings such as those for the "dream" paintings of 1925 "emerged while Miró was actually working on the painting and not in advance." Apart from the fact that Miró himself many times specified that these drawings were preparatory (see, for example, Picon 1976, vol. 1, p. 72 and passim, and a letter to Jacques Dupin of January 2, 1958, in which Miró expresses his excitement at finding "old preparatory

documents"), it will, I trust, become clear from what follows that these drawings were indeed preparatory.

56. On the relevance of Klee to Miró's depiction of the eye in a landscape, see Lanchner 1987, p. 88. Krauss/Rowell 1972, pp. 71, 73, relate the eyes on the pine cone hanging from the right side of the tree to Catalan Romanesque art, and the eye in the tree to an extrapolation from Max Ernst's uses of a disembodied ear.

57. "Réflexions sur quelques-uns de mes contemporains: Victor Hugo," from *L'Art romantique*; in *Oeuvres complètes de Baudelaire*, ed. Y. G. Le Dantec (Tours: Bibliothèque de la Pléiade; NRF; Gallimard, 1956), pp. 1,085–86; cited in Roger Shattuck, "Art and Ideas," *Salmagundi* (Saratoga Springs, N.Y.), nos. 78–79 (Spring–Summer 1988), p. 11. Miró's feeling about this work by Baudelaire is expressed in a letter of March 4, 1930, to Sebastià Gasch, whom he asks: "Do you know *L'Art romantique* by Baudelaire? It is wonderful." (Gasch was a Barcelona author and critic with whom Miró formed a warm friendship.)

58. *Treatise on Style*, trans. Alyson Waters (Lincoln, Nebr., and London: University of Nebraska Press, 1987), p. 68. Originally published as *Traité du style* (Paris: Gallimard, 1928).

59. "Metaphor," in *Brisées/Broken Branches*, trans. Lydia Davis (San Francisco: North Point Press, 1989), p. 18. Originally published as "Métaphore," *Documents* (Paris), vol. 1, no. 3 (June 1929), p. 170; reprinted in *Brisées* (Paris: Mercure de France, 1966).

60. Although the canvas is inscribed on the reverse "Joan Miró | 'Paysage Catalan' | 1923–24," a November 12, 1962, memorandum in the files of The Museum of Modern Art indicates that Miró had asked Alfred H. Barr, Jr., to have the title changed to *The Hunter (Catalan Landscape)*.

61. See Rubin 1973, p. 22, for Miró's iconographical chart of *The Hunter (Catalan Landscape)*.

62. For a discussion of the spatial structure of *The Tilled Field* and *The Hunter (Catalan Landscape)*, see Krauss 1972, pp. 16, 18.

63. Dupin 1962, p. 141, points out that the schematization of forms in *The Hunter* follows "two divergent tendencies. Some of the forms tend to the geometrical," whereas "the other simplifying tendency consists in reducing objects to lines." Krauss 1972, p. 18, notes that the "solid elements" — those described as "geometrical" by Dupin — "all seem to have the same visual weight."

64. For example, Krauss/Rowell 1972, p. 78, and Rubin 1973, p. 24. See Rubin (p. 22) for Miró's identification of the egg-shaped form sprouting tentacular rays at the upper right center as "sun-egg" and of the two similar forms — one at the base of the hunter's stick-like torso and the other to the right of the sardine's triangu-

lar tail — as, respectively, "hunter's sex organ" and "sardine's eggs (reproductive organ)."

65. In Miró 1977, p. 88, the artist explained his imagery of the vulva: "For me, the sex of the woman, it's like planets, or shooting stars; it's an element of my vocabulary."

66. On painting as metaphorical of the body, see Wollheim, *Painting as an Art*, pp. 308–15.

67. Miró's response to a question put to him in the mid-1970s about the presence of the eye in both his early and his recent work was, "It's the picture which gazes at me"; Miró 1977, p. 145.

68. Merleau-Ponty, "Eye and Mind," p. 186.

69. Dupin 1962, p. 35.

70. J. E. Cirlot, *A Dictionary of Symbols*, trans. Jack Sage (New York: Philosophical Library, 1971), p. 198. Originally published as *Diccionario de símbolos tradicionales*.

71. Quoted in Rosalind Krauss, "The Master's Bedroom," *Representations* (Berkeley), no. 28 (Fall 1989), p. 62.

72. In Miró 1977, p. 49, the artist remembers reading *Le Poète assassiné* during his military service. Raillard, in remarks made in a symposium held at the University of Barcelona, April 19, 1993, maintained that Miró could not have read *Le Poète assassiné* as early as he claimed since it was not published until after he had completed his military service; Raillard was mistaken in this, however, as the book was published in 1916 and Miró finished his service on December 31, 1917. Cf. Rowell 1986, p. 23.

73. *Oeuvres complètes de Guillaume Apollinaire*, ed. Michel Décaudin (Paris: André Balland et Jacques Lecat, n.d.), vol. 1, p. 303 and passim.

74. *Apollinaire: Oeuvres poétiques*, ed. Marcel Adéma and Michel Décaudin, preface by André Billy (Paris: Bibliothèque de la Pléiade; Gallimard, 1956), p. 237.

75. Breton, *Manifeste du surréalisme*, p. 11.

76. Breton 1972, p. 51.

77. Benjamin Péret, "Les Cheveux dans les yeux," preface to *Exposition Joan Miró* (Paris: Galerie Pierre, 1925), n.p.

78. For arguments on which this belief was based, see Luis Ulloa, *Christophe Colomb, catalan: La Vraie Genèse de la découverte de l'Amérique* (Paris: Librairie Orientale et Américaine, Maisonneuve Frères, 1927).

79. In a letter dated October 31, 1923, Miró congratulated his friend Vicente Huidobro on an article titled "Espagne" that he had published in *L'Esprit nouveau* (no. 18), in which Miró is cited as a young painter who, by implication, is worthy of representing Spain along with Picasso, Juan Gris, and Pau Gargallo. While the mention of Miró is very brief, both Columbus and Ramon Llull receive more extended treatment, and the two are linked by their common importance to the discovery of America. There is thus

little doubt that Miró was well aware of both figures at a moment coincident with his work on *The Hunter (Catalan Landscape)*. Miró's letter and the Huidobro article came to my attention through Lubar 1988, p. 217 (n. 34).

An additional factor that may have caused Miró to link his adventures with Columbus's is the fact that Columbus reportedly arrived back in Barcelona between April 15 and 20 of 1493, thereby providing a numerological parallel with Miró's birthdate, April 20, 1893. For the date of Columbus's arrival in Barcelona, see John Noble Wilford, *The Mysterious History of Columbus* (New York: Alfred A. Knopf, 1991), p. 24.

80. *The Artists of My Life* (New York: Viking Press, 1982), p. 144.

81. In Michel Leiris, *Mots sans mémoire* (Paris: NRF; Gallimard, 1982), p. 150. "Marrons sculptés pour Miró" was originally published as Leiris 1961.

82. Leiris, *Mots sans mémoire*, p. 9.

83. Chapter 1, "What the Artist Does," p. 29.

84. Letter to J. F. Ràfols, August 10, 1919; in Rowell 1986, p. 62.

85. Letter to E. C. Ricart, July 9, 1919; in Rowell 1986, p. 61.

86. Letter to Michel Leiris, August 10, 1924; in Rowell 1986, pp. 86, 87.

87. Melgar 1931; in Rowell 1986, pp. 116–17.

88. Aragon 1969, p. 1.

89. Trabal 1928, p. 4; in Rowell 1986, pp. 94–95. Although Miró seriously confuses dates in this interview, the context of the Picasso remark would locate it just before Miró began working on the *Spanish Dancer* of 1924 — therefore, sometime between March and late June.

90. Ibid.

91. For an excellent, thorough discussion of Miró's early period, see Lubar 1988.

92. Letter to J. F. Ràfols, August 10, 1919; in Rowell 1986, p. 62.

93. Interview with Yvon Taillandier; in Rowell 1986, p. 250.

94. *The Compact Edition of the Oxford English Dictionary* (Oxford: The Clarendon Press, 1971), vol. 2, p. 2,737.

95. Pierre Matisse 1959, p. 5. Reprinted in English in Breton 1972, p. 257.

96. Picon 1976, vol. 2, p. 46. As given in Picon, these notes appear to be dated "Palma de Majorque 18 janvier 1940," but they more likely date from 1941, as in January 1940 Miró was in Varengeville.

97. Since Dupin 1962 was written before Miró's gift of his preparatory drawings and notebooks to the Fundació Joan Miró in Barcelona, Dupin was unaware of how systematic Miró's procedures often were. Thus, he could make claims such as: "Alternations and shifts in the character of the artist's work — 'changeovers of regime,' as it were — are rarely calculated" (p. 256); yet the statement itself acknowledges a serial working pattern, and beginning with 1924, Dupin organizes his book according to the distinct sequences of Miró's work.

Soby 1959, p. 32, remarks: "Miró . . . often has planned many of his pictures ahead as components of series."

98. Gaffé 1934, p. 32. Given that Miró came very close to marriage in 1928, the ten paintings he foresees were probably realized in the nine canvases of the related series of Dutch Interiors and Imaginary Portraits. Although he speaks of following his projected paintings with a large suite of drawings, Miró very frequently used terms for mediums loosely; what he probably foresaw in his letter to Gaffé was the large suite of collages of summer 1929. (Dupin 1962, pp. 231, 521, reproduces only thirteen collages, but in preparation for a revised edition of his book, Dupin's research assistant, Ariane Lelong-Mainaud, had, as of February 1993, found a total of twenty-nine.)

99. The chronological sequence of the five gridded pictures of spring 1924 is not known, but the date inscribed on *The Family*—May 16, 1924—establishes that Miró was working on this kind of picture at least until that time.

That we know this drawing to be precisely dated is owed to Lilian Tone. Although the drawing has been in the collection of The Museum of Modern Art since 1961, its faint inscription, "16/5/24," at the upper left, went unremarked until Tone spotted it during examination of the picture in the Museum's conservation laboratory in spring 1992.

100. Dupin 1962, p. 145. Many of Miró's later published memories of the 1920s are at variance with demonstrable fact and, indeed, sometimes conflict with one another. Given the cohesiveness of the series of gridded pictures he worked on in Paris in spring 1924, and that of the yellow-ground series (see note 119, below), as well as the following summer in Montroig, as well as the fact that *Portrait of Mme B.* was one of the pictures Miró would take from Montroig to Paris in early 1925 (as will be discussed in the text, below), it may be that this is one of those instances of memory lapse.

101. Rowell 1986, p. 86.

102. This assertion rests on the fact that there are no known finished works after any of the notebook drawings not marked with the brown crayon X. No doubt some completed works have been lost; however, comments Miró made in the mid-1970s support the contention that the X represents a drawing's conversion into a finished work. Miró pointed out four drawings to Picon as not having been executed. Three are without an X, and no completed work after any is known; the fourth, marked with an X, served—despite Miró's contrary memory of some fifty years later—as the study for a known drawing. See Picon 1976, vol. 1, pp. 100–01. The notebook drawing illustrated in Picon and marked with the X is the study for a final drawing—signed and dated "Miró | 10-11-24"—formerly in the Charles Collingwood collection.

103. All four pre-1924 drawings on right pages following page 36 are related, if not exclusively, to *The Hunter (Catalan Landscape)*. They are as follows:

Page 43, a drawing (fig. 11; FJM 615a) inscribed "Paysan Catalan" and "Paysage Catalan," divided into two vertical rectangles, the left showing the figure of the hunter both as a rounded body and as the stick-figure of the final painting. Comparison of the hunter's gun in this drawing with the drawing (reproduced in Fundació Joan Miró 1988, p. 82, no. 230) for the 1924 painting *Olée* (Dupin 93) and the study (FJM 658b), facing the *Olée* drawing in the notebook, for a lost painting of 1925, strongly suggests that the gun's stick-and-triangle form was at the root of later conceptions of some Spanish Dancers, and probably of *Maternity* (p. 120).

Page 47, a drawing (FJM 617a) irregularly divided into seven sections, one of which is for *The Tilled Field*, and another for *The Hunter (Catalan Landscape)*.

Page 55, a drawing (FJM 622) divided into sections and now torn, inscribed "Paysan Catalan" on the left above the rounded hunter figure.

Page 111, the most developed drawing (fig. 29; FJM 654a) for *The Hunter (Catalan Landscape)*, showing the hunter as the triangle-headed stick-figure personage of the painting, and schematized even further as crossed, dotted lines surmounted by a *barretina*; very close in conception to *Head of Catalan Peasant, IV* (p. 135).

104. The two drawings are near the end of the notebook, on pages 128 (FJM 662b) and 130 (FJM 663b). The first is for a drawing dated November 24, 1924, originally given by Miró to Michel Leiris, now in the Musée Nationale d'Art Moderne, Centre Georges Pompidou, Paris (p. 127); and the second is for a drawing dated October 23, 1924, now in the Bareiss collection and reproduced in Dupin 1962, p. 169, fig. 18.

105. Rowell 1986, p. 87.

106. Miró's letters from August 1919 onward are filled with expectations and doubts about his fate in the Paris art world. For a brief moment in February 1921, he had hopes of forming a connection with Paul Rosenberg through Picasso's intercession, or even of making an impression on D.-H. Kahnweiler (letter to Josep Dalmau, c. February 25, 1921), but disappointment soon took over. His first one-artist exhibition in Paris, at the Galerie La Licorne, April 29–May 14, 1921, was organized by Dalmau, his Barcelona dealer, and it brought him some notice but virtually no financial return. From 1922 to 1924, Miró had a loose and, from his point of view, unsatisfactory arrangement with Léonce Rosenberg. There is no documentation to confirm when Miró ceased consigning works to Rosenberg, but it is logical that this connection would have ended at least by the time of the contract Miró made with Jacques Viot on April 1, 1925, and perhaps as early as late winter or spring 1924 (see the Chro-

nology, under those dates).

107. Letter to J. F. Ràfols, May 8, 1920; in Rowell 1986, p. 73.

108. The page in the Montroig Notebook on which Miró lists the pictures completed in 1924 is catalogued by the Fundació Joan Miró as 613b, Quadern 591–668 i 3129–3130. While Miró's list actually refers to twenty paintings, the first listed appears as "(Regal)" (in Catalan, *regal* means "gift") and represents *The Bottle of Wine* (fig. 58), which Miró did not take to Paris, but gave as a present to his parents.

Although Miró could have gone to Paris in March 1924 with *The Tilled Field*, *The Hunter (Catalan Landscape)*, and *Pastorale*, and finished these pictures there, as Krauss/Rowell 1972, p. 71, claim, it is difficult to understand why he would have taken them back to Spain some three months later, only to bring them to Paris again early the next year—especially as he seems to have had a place in Paris to store other of his pictures (the nine gridded ones) until his return there in early 1925. Given that Miró left Paris in mid-June 1924 from the rue Blomet studio and returned directly there without any of the changes of Paris address so frequent in the early twenties (see the Chronology), and that Gasch, in postcards to Miró of August 27 and October 2, 1924, refers to money being sent to Paris, it seems likely that Miró was able to rent the studio or retain some rights to it during his absence from Paris between mid-June 1924 and early 1925.

109. Beaumelle 1991, p. 175.

110. Marguerite Bonnet's Breton chronology in *André Breton: Oeuvres complètes*, vol. 1, ed. by Bonnet with the collaboration of Philippe Bernier, Etienne-Alain Hubert, and José Pierre (Dijon: Bibliothèque de la Pléiade; NRF; Gallimard, 1988), p. L, quotes a brief excerpt from Breton's letter to his wife regarding Miró. It was not, however, until a larger excerpt was published in Beaumelle 1991, p. 175, that the assumption, generally prevalent, that Breton had met Miró through Masson sometime in 1924 was shown to be incorrect. If Breton's letter to his wife establishes a date shortly after February 10, 1925, for his first introduction to Miró, it also, by identifying Miró as Masson's neighbor, corroborates the widespread belief that Masson was the intermediary. Bonnet's chronology places the initial meeting between Breton and Masson in early October 1924 (p. XLIX); supporting this claim is an October 1, 1924, letter from Breton to Kahnweiler, published in Beaumelle 1991, p. 171, in which Breton expresses his pleasure at having just met Masson. Thus the first encounter between Breton and Masson took place when Miró was in Spain, where he remained until early 1925.

111. Since *Carnival of Harlequin* and *Head of Catalan Peasant, II* are both inscribed "1924–25," and all evidence points to their execution in Paris, they

must have been begun during Miró's stay in Paris during spring 1924 and completed on his return to Paris in early 1925 (see the Chronology, under 1924 and 1925).

Five other pictures that may have been in evidence in Miró's studio at the time are *Souvenir of Barcelona* (not in Dupin; exhibited in New York 1987a, cat. 37, and reproduced on p. 101 of the catalogue), *Rouge et noir* (not in Dupin; now lost), *Bather* (Dupin 105), *Music Hall Usher* (Dupin 141), and *Circus Horse* (Dupin 203). All dated 1925, these paintings were each prepared by a drawing (respectively, FJM 659b, 661a, 658a, 667b–668, 648b) marked with a brown X. Since this was the system Miró used in his Montroig Notebook during 1924, to indicate which drawings had been converted into finished works, and which he ceased using sometime around April 1925, the just-mentioned pictures must have been completed during early 1925.

112. See note 10, above.

113. *Max Ernst: Beyond Painting*, The Documents of Modern Art series, ed. Robert Motherwell (New York: Wittenborn, Schultz, 1948), p. 13.

114. In Miró 1977, p. 83, the artist is quoted: "I have always been suspicious of the tendency to juxtapose contradictory objects."

115. Isidore Ducasse/Le Comte de Lautréamont, "Chant sixième," *Les Chants de Maldoror: Lettres poésies, I et II*, preface by J. M. G. Le Clézio, ed. Hubert Juin (Paris: Gallimard; NRF, 1973), p. 234. The beauty of the English youth, Mervyn, is likened not only to the sewing-machine/umbrella encounter, but to several other dubiously beautiful and unlikely phenomena.

116. Letter to Michel Leiris, August 10, 1924; in Rowell 1986, p. 86.

117. Merleau-Ponty, "Eye and Mind," p. 165.

118. For an excellent discussion of Miró and pictorial structure, see Krauss 1972, especially pp. 16–20.

119. Dupin 1962, p. 145. The term "yellow-grounds" here and in Dupin 1962 refers to the paintings made between late June and mid-December 1924 in Montroig. Although the majority of these paintings are on yellow grounds, there are exceptions, such as *Maternity* (p. 120), on a grayish ground, and *The Kiss* (p. 118), on a green ground.

120. John Elderfield, "Grids," *Artforum* (New York), vol. 10, no. 9 (May 1972), p. 53.

121. This injunction of the Mallorcan storyteller came to my attention in Paul Ricoeur's "The Metaphorical Process as Cognition, Imagination, and Feeling," in Sheldon Sacks, ed., *On Metaphor* (Chicago and London: University of Chicago Press, 1979), p. 151.

122. *The Collected Poems, 1909–1962* (New York: Harcourt, Brace & World, 1963), p. 175.

123. Ricoeur, "The Metaphorical

Process as Cognition, Imagination, and Feeling," p. 151.

124. For this discussion of materials, I am completely indebted to Antoinette King, Director of the Department of Conservation at The Museum of Modern Art, and have, in fact, borrowed some phrases from her memorandum to me of March 10, 1992, about the component elements of *The Family*.

125. Although the painting, *The Kiss*, was not executed until sometime between late June and mid-December 1924, Miró may have had the concept in mind since the previous summer; a fragmentary drawing (FJM 525) shows its helix-shape, along with a study for the tree in *The Hunter (Catalan Landscape)*.

126. Letter to Michel Leiris, August 10, 1924; in Rowell 1986, p. 86.

127. *Oeuvres complètes de Guillaume Apollinaire*, vol. 1, p. 163. R. T. Doepel, "Zoharic Imagery in the Work of Miró, 1924–1933," *South African Journal of Culture and Art History* (Pretoria), vol. 1, no. 1 (March 1987), p. 68, reads Miró's inscription as "YUOVE, a free transliteration of YHVH (Hebrew), that is, Jehova."

128. Picon 1976, vol. 2, pp. 70–71.

129. The five notebooks were all given to the Fundació Joan Miró, Barcelona, by Miró. The Fundació's catalogue numbers correspond as follows to the notebook designations given above, in the text: Montroig Notebook (FJM 591–668 i 3129–3130); Charbo Notebook (FJM 697–743); Moreaux Notebook (FJM 558–570 i 579–590); Barcelona Notebook (FJM 744–787); 1927 Notebook (FJM 677–696).

Two lists in Miró's notebooks (one in the middle of the Barcelona Notebook and one at the back of the Moreaux) make clear that Miró had produced some eighty paintings between mid-July 1925 and sometime before mid-1926; the number system he switched to in 1927 (see above) shows that he had made at least seventy paintings between early 1927 and mid-July of that year. Thus the original total of what are called his "dream" paintings of 1925–27 amounted to at least 150. Dupin 1962 catalogues 104 pictures of this enormous output. At the beginning of work on the present volume, it appeared that Dupin's catalogue contained twenty-eight paintings for which drawings were lacking in Miró's notebooks, and that the notebooks contained thirty-three lettered drawings for unknown paintings; since that time, we have found six drawings that had been detached from the notebooks, corresponding to six of the twenty-eight paintings in Dupin that had seemed to have no drawing. Additionally, it has become clear that ten of the paintings in Dupin without notebook studies are almost undoubtedly from the 1927 Notebook, containing the *I* and *J* series (see above), from which at least ten drawings are demonstrably missing. Of the thirty-three lettered drawings, paintings for seventeen have been found (with enormous help from Dupin and Ariane Lelong-Mainaud). No doubt some

paintings and some drawings are irretrievably lost, but the pattern that emerges from the above would indicate that drawings and paintings corresponding to each other will continue to turn up. See note 134, below.

130. For an explanation of French canvas sizes, see Ralph Mayer, *A Dictionary of Art Terms and Techniques* (New York: Thomas Y. Crowell Co., 1975), p. 59. Mayer gives the three categories of French sizes as Portrait, Paysage, and Marine, whereas Miró followed the more common designations of Figure, Paysage, and Marine (abbreviated as F, P, and M).

131. All *I* and *J* drawings are in the 1927 Notebook.

132. Some fifty years after painting *The Siesta*, Miró explained that the *A* on its drawing represented the color *azul* ("blue") of the canvas done after it (Picon 1976, vol. 1, p. 77). Even though, as far as is known, Miró never inscribed his drawings in Spanish (always in Catalan or French), the four known canvases done after *A* drawings (two paintings are lost, and it is almost certain that there were originally more than six drawings in the *A* series) might seem to support Miró's explanation, since blue is either featured or the predominant color. It may also be that, as he was beginning to conceive the open-format, sparsely drawn paintings which would be so profusely multiplied in the series *A* to *J*, he was thinking of putting his new ideas into execution in blue-ground canvases. As we have seen, the first conception for the blue-ground *Head of Catalan Peasant, IV* (p. 135) was sketched on a fragment of a Paris newspaper of March 23, 1925 (fig. 32); the picture was later executed in the summer at Montroig after a drawing in the Montroig Notebook from the *C* group, but its early conception on the newspaper fragment is inscribed *A 80f*. Since in March 1925 he probably had no notion of how far he would take the new way of painting he was planning, it could be that the *A* was meant as a notation that the canvas should be blue. If that was the case, then his later memory of *A* for *azul* is more easily explained.

It is, however, not possible that the letter designates canvas color in the progression *A* to *J*. Drawings for blue paintings are to be found inscribed with every letter designation other than *J*, whose drawings all seem to be for white paintings (see note 144, below). Additionally, there are considerable varieties in the color of canvases within series; for example, the series *B* encompasses canvases that are blue, brown, and ocher, and as much or more variation prevails in the paintings of each letter group until *I* and *J*, when a thematic and conceptual unity takes over.

Another refutation of the *A*-for-*azul* explanation is provided by the painting now known as *Swallow Dazzled by the Flash of the Red Pupil*, dated 1925–60 (Dupin 892), which was partially destroyed during World War II. Originally done after an *A* drawing, this painting was, before and af-

ter Miró reworked it in 1960, brown. In its 1925 state, the picture was one of the canvases Miró refers to in his September 28 and October 10, 1925, letters to Gasch (cited above) as being of incredible size. The drawing for the 1925 version of *Swallow* is marked "2,45 × 3,45 | A 2½ × 3½ | 30f F2." This is the only known instance of Miró's using a single study for two different works within the *A* to *J* series. The first two lines of this inscription refer to the subsequently partially destroyed painting (Miró did not mark a canvas size on this drawing, as he did not on those for *The Birth of the World* and *The Policeman [Figure and Horse]*; because each was for a painting that would exceed even the largest standard size, he noted the actual dimensions of each painting on its drawing); the last line refers to a smaller version that Miró incorporated into his later *F2* series (Dupin 170).

133. Rowell 1972, pp. 44–45, offers a persuasive reading of *Painting (The Check)* as derived from the superhuman lovemaking of Mercueil, the hero of Alfred Jarry's *Le Surmâle*, and sees the column of numbers as the tally of his "performances."

134. Drawings without a letter designation or a brown *X* in the notebooks under consideration do not seem to have been realized as paintings during the period from mid-1925 to mid-1927. The two exceptions I have found are:

1. A rather peculiar drawing, inside the back cover of the Montroig Notebook, for a painting dated May 1926 (sold at Sotheby's, London, December 1, 1976, lot 218, reproduced in the auction catalogue). Stylistically, this painting does not seem wholly to fit with the others of 1925–27, and with the exception of the oversize canvases, it is virtually the only picture made during this period not on a standard size.

2. A study in the Montroig Notebook (FJM 661b; reproduced in Fundació Joan Miró 1988, p. 101, no. 329), the blocked-off lower left corner of which is the preparatory drawing for a painting of 1925 (fig. 59). The drawing's main composition is the study for a drawing of May 1926 in the collection of The Museum of Modern Art (reproduced in Rubin 1973, p. 34), and the lower right corner of the drawing contains a figure repeated in a now lost painting of 1925. (The drawing, FJM 621b, for this last-mentioned painting is in the Montroig Notebook and is inscribed *E/25F*.)

135. Green 1987, p. 269, asserts that the drawing for *The Birth of the World* was based on a more realistic image of a figure reclining under a tree (fig. 38). In fact, the drawing is the unmarked one of the group of five generated by the impress of the drawing for *The Birth of the World*. Green thus reverses the process by which the drawing represented by fig. 38 actually came into being.

136. After his first trip to Paris, in spring 1920, and through 1931, Miró gen-

erally spent the first half of the year in Paris and the second in Spain, largely in Montroig (see the Chronology). This fall trip to Paris in 1925 is one of the very few exceptions to the pattern.

137. Miró lists: twelve canvases size 80, three size 60, nine size 50, three size 40, four size 30, and two whose dimensions (2.45 × 3.45 m and 2 × 2.5 m) are larger than standard size. All known paintings after *A*, *B*, and *C* drawings fall within this range, including the two oversize canvases, which represent, respectively, the enormous painting partially destroyed during World War II (see note 132, above) and *The Policeman (Figure and Horse)* (p. 132). Existing *A*, *B*, and *C* drawings sort out as follows: seven of size 80, two size 60, six size 50, two size 40, two size 30, and the two oversize just mentioned. The discrepancies between Miró's list and the numbers of existing drawings always show the larger number to be in his list; in no case does the present number of any size category exceed Miró's. That Miró's list must represent the *A*, *B*, and *C* series is supported by the fact that were it extended to include *D* and *E*, at least one size category (60) would exceed by three Miró's count, and the *D* and *E* sequence has categories (8, 15, 25, and 120) that do not appear in Miró's tally.

138. The statement in Dupin 1962, p. 157, that the "dream" paintings of 1925, 1926, and 1927 were all executed in Paris has been the basis for a widely held belief that they, as opposed to the "summer" landscapes of 1926 and 1927, were all products of Paris. It is, indeed, more than likely that the conceptions (i.e., the notebook drawings) for the paintings of 1925 were formulated in Paris. Since Dupin's statement was based on what Miró told him, the probability is that Miró—speaking generally—confused conception with execution. In at least two instances when questioned about specific works, Miró remembered having executed them in Montroig. Rubin 1973, p. 116 (n. 1), reports that "Miró distinctly recalls painting *The Birth of the World* in Montroig during the summer," and Rudenstine 1976, vol. 2, p. 519, says, "Miró specifically remembers that the present work [*Personage*, p. 130] was painted during the summer at Montroig." *Personage* was done from an *A* drawing—in other words, from the first group of dream paintings executed—which would confirm that Miró began *painting* his 1925 suite of dream pictures in Montroig. *The Birth of the World* was made after a *D* drawing, and most likely therefore painted sometime between the latter part of September and the end of October.

In Miró's September 28 letter to Gasch, he writes: "Within a month I will be back in Barcelona to leave in fifteen days for Paris," yet in his letter of October 10, he mentions that he will be in Barcelona on the 14th to send his canvases to Paris and to insure them. Since he had been confident in the September 28 letter that he

would have sixty canvases, but by October 10 finds that he has only thirty-five ready for transport, the probability is that on September 28 he had counted on having the month of October to complete his *D* and *E* series, which would then be ready to ship to Paris around October 28, the approximate date he had told Gasch he would arrive in Barcelona before leaving for Paris. Miró's worries about his inexperience in shipping so many canvases (see the September 28 letter, above) were most likely justified; the most plausible scenario is that he had discovered that he would have to arrange for shipment of his canvases to Paris some two weeks before he had expected it would be necessary, therefore precluding sending the *D* and *E* series still in progress, and necessitating a brief interruption of his work in Montroig for a short trip to Barcelona in mid-October. Following this logic, the *A* to *C* series would have been completed by the time of Miró's September 28 letter to Gasch, and the *D* to *E* series started, but not near completion until his departure for the opening of the Surrealist exhibition in Paris (November 14) sometime toward the beginning of November. (Even then, there were still seven drawings marked *E* that he had not yet begun to convert to paintings, which he would later make part of his *F2* series: see note 139, below.) Upon his return to Montroig—probably in the latter part of November—Miró would then have been able to begin painting the canvases made from *F* drawings. That this is what happened is supported by comparing the numbers of the extant drawings for the series *A* to *F* with Miró's accounts to Gasch in his letters of September 28 and October 10. The total of surviving drawings of the *A* to *E* series (including the seven drawings projected as *E*s, but converted to *F2*s) is fifty-three; given the fact that some drawings have been lost, the sum is significantly close to the sixty that Miró tells Gasch on September 28 he will send to Paris. The total of surviving drawings of the *F* and *F2* series (see note 139) is twenty-seven, proximate to the twenty-five that Miró promises Gasch on October 10 he will finish by Christmas. For the places of execution of the dream paintings of 1926 and 1927, see the Catalogue section of the present volume (cats. 53, 60–69) and the Chronology.

139. That this must have been so is confirmed by comparing the inscriptions on the seven drawings of the *F2* series that are marked *E* (crossed out), *F2*, and canvas size with those on the other drawings of series *A* to *F2*. In every case, the letter designating the series is in close proximity to the canvas-size designation; this proximity is maintained in the seven drawings with crossed-out *E*s. In other words, the inscription *F2* is close to the canvas-size designation, whereas the crossed-out *E* is not, thus indicating that Miró did not inscribe the canvas size on the drawing until he had changed its

letter designation and actually begun painting.

That Miró elected to create an *F2* category, rather than use the next letter of the alphabet, may be explained on the basis of his once again overestimating the amount of work he could get done in a given time. When he returned to Montroig, probably in the latter part of November, the task before Miró was the completion of any canvases of the *D* and *E* series still unfinished and the conversion into paintings of the drawings of his *F* series.

Since the eight canvases done after drawings marked *F* are all dated 1925, and the nineteen after drawings inscribed *F2* (exclusive of the seven after drawings with crossed-out *E*s) are dated 1926, the likelihood is that Miró found himself unable to complete the whole series of some twenty-seven *F*s projected in 1925, and changed those uncompleted to *F2*s, thereby preserving their continuity with the *F*s planned in 1925, while simultaneously recognizing their execution in the new year.

In a letter of January 7, 1926, to his parents, Miró wrote that he intended to leave Montroig by the following week. If he followed these plans, it seems implausible that he could have finished the entire *F2* series—some twenty-six canvases—in the period between January 1 and about January 14. More than likely, some part of the *F2* series was painted during Miró's stay in Paris—from sometime early in 1926 until April, when he was in Monte Carlo—and again during the period from early May to early July, when he was again in Paris (see the Chronology). My speculation is that it was the seven or so canvases done after drawings marked with a crossed-out *E* followed by an *F2* that Miró painted in early 1926 while still in Montroig, and that the rest of the series after *F2* drawings was done during his two stays in Paris in the first half of 1926.

140. Miró probably felt no necessity to cross out the *B* on the drawing because, unlike the *E*s that would become *F2*s, here there was no possibility of confusion. The painting itself unequivocally belonged to the series of "summer" landscapes of 1926 and 1927, which were so clearly distinct from the surrounding canvases after *A* to *J* drawings that their studies required no letter designation.

141. Green 1987, p. 271, states that the drawing for *"Un Oiseau poursuit une abeille et la baisse"* is opposite that for *"Oh! Un de ces messieurs qui a fait tout ça"* (reproduced, ibid.). While Green's assertion that the "rhythmic strokes" of the latter drawing echo the "wavering calligraphy" of the marks forming the word *poursuit* may be valid, the echo is not, as he says, the result of their positioning facing each other on opposite pages in the notebook; they are, in fact, on successive right-hand pages.

142. As argued above, Miró worked on the *A* to *E* series through at least half of

July, and during August, September, October, and perhaps early November 1925, resuming work on the *D*, *E*, and *F* sequences toward late November until just before Christmas. Given Miró's work on *Romeo and Juliet* and his move from the rue Blomet to the rue Tourlaque (see the Chronology), he could have worked on the *F2* series only episodically from January through March, and might again have continued it from May to early July 1926 (see note 139, above).

143. Miró's gift in July 1927 of the last known drawing of the *I* series—*I 16* (Fundació Joan Miró 1988, p. 112, no. 388)—to his friend Joan Prats indicates that he had finished the *I* series by that time. That he had also completed the *J* series is implied in letters he wrote on July 21, 1927, to Ricart and Ràfols. To Ricart he said, "Do you work? I will start now myself," and to Ràfols, "I have been in the country for fifteen days. I will begin to work this week." Both letters would indicate that Miró had spent some time relaxing after the intensive work of the preceding months and was about to undertake the effort of producing the seven large landscapes of the "summer" series of 1927. These seven landscapes of 1927 are mostly much larger than the seven of 1926, and Miró would have needed at least as much time to complete the 1927 group as he had required to execute the seven of the year before.

Surviving evidence of the *G* to *J* groups shows that eighteen were *G*s, sixteen *H*s, sixteen *I*s, and twenty *J*s. Since Miró began work on the canvases made from them at the beginning of January and seems to have completed the whole series at least fifteen days before his July 21 letter to Ràfols, it seems logical—if his working pace was more or less constant—that he would have devoted approximately a month and a half to each sequence, and thus the approximate dates of the paintings would run as follows: after *G* drawings, January to mid-February; after *H*s, mid-February through March; after *I*s, April through mid-May; after *J*s, mid-May through June.

144. While the drawing for *Painting (Fratellini; Personage)* (p. 148) has been lost, its close relationship to such canvases as *Painting (Fratellini; Three Personages)* (p. 149), as well as others of the blue-ground "circus" pictures, all done after *I* drawings, makes it virtually certain that its preparatory drawing must have been part of the *I* group.

Although at least eleven of the *J* drawings have been lost, the assertion that they were all intended for white- or gray-ground paintings is supported by the fact that, of the extant *J* drawings, both the one with the lowest number (2) and that with the highest (20) are, like the other remaining *J* drawings (3, 4, 10, 11, 13, 17, and 18), for white- or gray-ground paintings.

145. To my knowledge, only Jean-Louis Prat, in Saint-Paul-de-Vence 1990, p. 62,

cat. 23, in reference to *Composition* of 1925, has discussed the stretcher-bar trace as a consciously employed structural, compositional device. Ross Neher, "Dennis Masback's Paintings," *Artforum* (New York), vol. 16, no. 7 (March 1978), p. 51, reproduced *Personage* (p. 130) in connection with Masback's use of stretcher imprints, but did not discuss Miró.

146. Cf. Picon 1976, vol. 1, p. 60.

147. *Treatise on Style*, p. 17.

148. This is undoubtedly a consequence of Miró's habit of using canvas stretched on a strainer that has only one crossbar.

149. "Collage" (1961), in Greenberg, *Art and Culture: Critical Essays* (Boston: Beacon Press, 1972), p. 72.

150. I am here indebted to Rosalind Krauss's discussion of the "shifter" in "Notes on the Index: Part I," in *The Originality of the Avant-Garde and Other Modernist Myths* (Cambridge, Mass., and London: MIT Press, 1986), pp. 196 ff.

151. Krauss, "The Master's Bedroom," pp. 69–70.

152. For an excellent discussion of this technique and its relation to Miró's "dream" paintings, see Umland 1992, p. 58.

153. "On Some Problems in the Semiotics of Visual Art: Field and Vehicle in Image Signs," *Simiolus* (Amsterdam), vol. 6, no. 1 (1972–73), p. 19. This paper was originally presented at the Second International Colloquium on Semiotics, Kazimierz, Poland, September 1966.

154. "Joan Miró," in *Brisées/Broken Branches*, p. 26.

155. In *Brisées/Broken Branches*, p. ix, Leiris gives the source of this definition as Emile Littré, *Dictionnaire de la langue française* (Paris: Librairie Hachette et Cie, 1878).

156. This discussion is indebted to Krauss, "Notes on the Index: Part I," especially p. 203.

157. Aragon 1930, pp. 26–27; in Lippard, ed., *Surrealists on Art*, pp. 49–50.

158. Acute commentaries on the structure of this painting are to be found in Krauss 1972, p. 33, and Umland 1992, pp. 56–57.

159. Aragon 1930, pp. 28 and 19 (the passage on p. 19 is in Lippard, ed., *Surrealists on Art*, p. 44).

160. Aragon 1930, pp. 26–27; in Lippard, ed., *Surrealists on Art*, pp. 49–50. For a superb examination of Miró's collages of 1929, and the political/aesthetic context of the time, especially Miró's relations with Aragon and Breton, see Umland 1992.

161. Leiris 1929, p. 264; trans. in Leiris, "Joan Miró," pp. 27–28. Tériade 1930a, p. 76. Cf. Umland 1992, p. 56.

162. See Umland 1992, p. 54.

163. Reproduced in Christian Zervos, *Pablo Picasso*, vol. 7: *Oeuvres de 1926–1932* (Paris: Editions Cahiers d'Art, 1955), p. 6, no. 9.

164. *Picasso: Peintures, 1900–1955* (Paris: Musée des Arts Décoratifs, 1955), no. 68, n.p.

165. Angelica Zander Rudenstine (Rudenstine 1976, vol. 2, p. 522) finds a "striking resemblance" between what she sees as the mouth and teeth of *Personage* and the same motif in Picasso's *Harlequin* of 1915. Rudenstine credits Linda Shearer with pointing out this similarity.

166. Miró 1977, p. 81.

167. Quoted in Aragon 1930, p. 9 (note), from "Avis au lecteur de la Femme 100 têtes."

168. As far as is known, the desire to "assassinate painting" was first attributed to Miró by Maurice Raynal; see Raynal 1927, p. 34. On Raynal as the source for Miró's statement, see Jeffett 1989a, pp. 29, 38 (n. 10). Other commentators have cited sources subsequent to Raynal; for these attributions, see Umland 1992, p. 67 (n. 2).

169. See note 107, above.

170. Although Miró was dismissed by Gybal 1921, p. 2 (in Combalía 1990, pp. 135–36), as "a kind of *nègre*" from the heart of Africa, who, wholly ignorant of painting, had the nerve to try to teach Paris boulevard manners, most reviewers were much kinder. René-Jean 1921, p. 2 (in Combalía 1990, pp. 139–40), wrote of his undeniable gift as a painter. Fels 1921, p. 2 (in Combalía 1990, p. 140), and the reviewer in *Art et travail* 1921 (in Combalía 1990, p. 140), echoed René-Jean's views, while Salmon 1921, pp. 733–34 (in Combalía 1990, pp. 140–41), asked if Miró "was not a disciple of Picasso that Matisse would be able to like," and concluded that he was definitely a painter who would be noticed by critics.

171. *Action* 1925 (in Miró 1977, pp. 196–97).

172. This account of the origins of Breton's and Aragon's opposition to the participation of Miró and Ernst in the production of *Romeo and Juliet* is given by John Russell in *Max Ernst: Life and Work* (New York: Harry N. Abrams, 1967), p. 87.

173. "La Bagarre aux Ballets Russes: M. André Breton nous expose le point de vue des surréalistes," *Paris-Midi* (Paris), May 19, 1926, p. 1.

174. Laloy 1926, p. 1.

175. Raynal 1927, p. 37.

176. Ibid., p. 237.

177. Ibid., p. 238.

178. Trabal 1928, p. 4; in Rowell, p. 96.

179. Letter to Sebastià Gasch, March 7, 1927, sent from the rue Tourlaque.

180. See note 28, above.

181. The 1927 sale of a Miró to the de Noailleses is reported by Malcolm Gee (Gee 1981, p. 187), and their purchase of another, in 1928, was confirmed by Gee in a letter of October 10, 1992, to Lilian Tone.

182. "L'Exposició Joan Miró," in *Amic de les arts* 1928, p. 203.

183. See the Chronology, under 1926.

184. Trabal 1928, p. 4; in Rowell 1986, p. 96.

185. Although no catalogue has been located for Miró's May 1928 exhibition at the Galerie Georges Bernheim & Cie, it seems safe to assume that it included all fourteen of the 1926 and 1927 "summer" landscapes as well as many others. First, there is Miró's recollection, as published in the Trabal interview (Rowell 1986, p. 96; quoted above), only eight weeks after the closing of the Bernheim exhibition, that the show included forty-one works, and his implication that the show was comprised of the work he had been doing since summer 1926. The assertion in Dupin 1962, p. 180, that all fourteen "summer" landscapes were included in the Bernheim exhibition is certainly based on Miró's recollection; some forty years after the fact, it is likely that Miró would have been much clearer about the inclusion of his fourteen "summer" landscapes in the exhibition than he would have been about which of the more than seventy works of the *G* to *J* series had been shown. Rudenstine 1976, vol. 2, p. 527 (n. 1), reports Miró's confirmation, in a November 1966 letter to the Solomon R. Guggenheim Museum, of the inclusion of all fourteen "summer" landscapes in the Bernheim exhibition. (While Rudenstine says the show was limited to the fourteen landscapes, she probably bases this on Dupin's statement that "the fourteen large canvases done during the summers of 1926 and 1927 were exhibited at the Georges Bernheim gallery," which does not, in fact, rule out the inclusion of other pictures in the exhibition.)

Given Miró's intense involvement with the preparations for the Bernheim exhibition, it is doubtful that he would have misremembered the number of canvases included, in his almost contemporaneous interview with Trabal. If, however, he was mistaken, evidence that more than the fourteen landscapes were included is to be found in the May 25, 1928, issue of *La Veu de Catalunya* (see Z. 1928), which reports a total of some thirty canvases. Additionally, reviews of the exhibition, such as George 1928, include descriptions that can be made to fit only the so-called "dream" series. At least one of these, *Painting (Fratellini; Three Personages)* (p. 149), is documented in the Gallatin archives as having been included in the Bernheim exhibition; see Stavitsky 1990, vol. 8, p. 190.

186. Tériade 1928a, p. 4.

187. George 1928, p. 2.

188. That Miró's collages of 1928 were a specific response to Breton's criticism is persuasively argued in Umland 1992, pp. 53–54.

189. Dupin 1962, p. 203.

190. For Miró's response to Breton's charge than he lacked means beyond painting, and the gifts of the two collages to Breton and Aragon, see Umland 1992, p. 52. Subsequent to the publication of her article, a letter from Pierre Loeb to Miró of July 31, 1928, was made available to Umland by the Fundació Pilar i Joan Miró a Mallorca. The letter — which reads, in part, "Aragon has just left here with one of your *collages-cloutage*s that I gave him. He is delighted. I will give another to Breton"— suggests that Miró's dealer may have instigated these politically astute gifts.

191. In the middle of work on his seven "summer" landscapes of 1926, Miró wrote to Gasch, on September 23: "I am working a lot, although very slowly this time. . . . I would like to leave a drawn canvas here for the next year; first of a series of big canvases I intend to execute next summer."

192. This discussion draws on Philip Fisher's chapter "Sequence, Drift, Copy, Invention" in his *Making and Effacing Art: Modern American Art in a Culture of Museums* (New York and Oxford: Oxford University Press, 1991), especially pp. 97–98.

193. Trabal 1928, p. 4; in Rowell 1986, p. 96.

194. For the migration of motifs in Miró's oeuvre c. 1929, see Umland 1992, p. 61.

195. Salvador Dalí, "Les Arts: Joan Miró," *L'Amic de les arts* (Sitges) vol. 3, no. 26 (June 30, 1928), p. 202; reprinted in Dalí 1929, p. 208, and Combalía 1990, pp. 200–01.

196. A found image may have served as the source for at least one painting prior to 1923. Dupin 1962, p. 130, states that *Portrait of a Spanish Dancer* of 1921 (p. 104) was "painted from a color print."

197. *Dutch Interior (I)* (p. 162) derives from H. M. Sorgh's *The Lutanist* of 1661, and *Dutch Interior (II)* (p. 163) from Jan Steen's *The Cat's Dancing Lesson*, both in the Rijksmuseum, Amsterdam. When Monroe Wheeler asked Miró if *Dutch Interior (III)* (p. 164) had a similar source, Miró replied, in a letter of June 30, 1965, that it had no relation to any specific painting, but was a "sort of resumé of the series" (collection files, Department of Painting and Sculpture, The Museum of Modern Art, New York). According, however, to Maria Lluïsa Borràs, "Imaginación y realidad," *La Vanguardia* (Barcelona), April 17, 1993, p. 3, the Rijksmuseum has proposed that the third Dutch Interior was inspired by Jan Steen's *Woman at Her Toilet*, in its collection. Since *Woman at Her Toilet* did not enter the Rijksmuseum collection until 1961, and, according to Frick Art Reference Library records, was shown only in Leyden in 1926 at a time prior, but proximate, to Miró's execution of the third Dutch Interior in 1928, he could not, in all probability, have known the picture.

A letter of September 22, 1928, from Pierre Loeb to Miró makes it appear more than likely that Miró, while still painting his Dutch Interior series, was planning its closely related sequel, the Imaginary Portraits. In his letter, Loeb assures Miró that he will sell nothing until the series of portraits is finished.

198. Two other drawings for these Spanish Dancers are reproduced in Fundació Joan Miró 1988, p. 118, nos. 425, 426. For other preparatory drawings, see the note-book identified as Quadern 534–545 i 571–578 in the collection of the Fundació Joan Miró, Barcelona.

199. Reproduced in *Surrealism in Art* (New York: M. Knoedler & Co., 1975), as the frontispiece.

200. C.B. 1927, pp. 1–2.

201. The use of the word "virgin" is from Eluard's description (quoting his wife) of the collage, which also calls it "the barest painting ever conceived"; in Eluard 1937, p. 80.

202. Reproduced in Fundació Joan Miró 1988, p. 364, no. 1327.

203. See Umland 1992, pp. 61, 51.

204. Letter to Sebastià Gasch, July 23, 1929.

205. Published in *Variétés* 1929; in Rowell 1986, p. 108.

206. For the effect of the stock market crash on the Parisian art market, see Gee 1981, pp. 283–87.

207. Note to Picasso, written from 10, rue Berthollet and dated May 15, 1923.

208. Dupin 1962, p. 201.

209. Reproduced in Dupin 1962, nos. 260–65.

210. Dupin 1962 reproduces three of these: nos. 266–68.

211. Dupin 1962 reproduces sixteen of the Ingres-paper oils (nos. 294–309) and lists eight others. Dupin's colleague, Ariane Lelong-Mainaud, reported in a letter to the author, January 6, 1993, that she has located seven more of these oils.

212. I owe this expression to Ken Kiff's discussion of Miró's need to retain representational imagery, in "Joan Miró: Profound Explorations," *Modern Painters* (London), vol. 2, no. 2 (Spring 1989), p. 14.

213. Miró 1977, p. 118.

214. Permanyer 1978b; in Rowell 1986, p. 291.

215. Letter to J. F. Ràfols, February 5, 1931, sent from 3, rue François-Mouthon. Since this letter was written in February and the Ingres-paper oils were probably not begun until mid-July (see the Chronology), the works Miró refers to are most likely those reproduced in Dupin 1962, nos. 269–84, 286. The Ingres-paper oils, however, clearly issue from a state of mind such as Miró describes in his February 5 letter to Ràfols.

216. Permanyer 1978b; in Rowell 1986, p. 291.

217. Not until works of the middle to late 1970s (for example, pp. 308–15) would Miró seem to have permitted himself a comparable freedom in allowing immediate impulse to guide his brush.

218. See the Catalogue section of the present volume (cats. 91, 92).

219. Picon 1976, vol. 1, pp. 32–33. Ariane Lelong-Mainaud, who is working with Dupin on a catalogue raisonné of Miró's drawings, reported to the author, January 6, 1993, that she had thus far located fifty-one of these drawings.

220. All the finished drawings of this series that I have been able to locate run in the chronological order of their se-

quencing, from first to last page, within the two notebooks.

221. "The Compression of Time" (interview with Barry Blinderman), in *David Wojnarowicz: Tongues of Flame* (Normal, Ill.: University Galleries, Illinois State University, 1990), p. 63.

222. Sylvester 1972, p. 15. Although the large bronze version of *Moonbird* was cast in 1966, the work was first conceived around December 1945, as a tiny object in modeled clay.

223. "Le Gros Orteil," *Documents* (Paris), vol. 1, no. 6 (November 1929), p. 302.

224. Rosalind Krauss, in a classroom lecture at the Graduate School and University Center, City University of New York, fall 1991.

225. Sweeney 1948, p. 212; in Rowell 1986, pp. 207–11.

226. See the Exhibition History, under 1930–31.

227. Zervos 1931, pp. 424–26.

228. Letter to Böske Antheil, June 14, 1932, sent from the Hôtel Récamier, Paris.

229. Reproduced in Dupin 1962, nos. 318–29. I rely on Dupin's statement, "Miró executed twelve small paintings on wood panels" (p. 249), for the number of panel paintings of 1932.

230. Dupin 1962 reproduces fourteen of the paintings (out of chronological order) and lists the other four (nos. 331–48). Seventeen of the collages belong to the Fundació Joan Miró, Barcelona, and are reproduced in Fundació Joan Miró 1988, pp. 155–58. Miró gave the eighteenth and last collage (see the Catalogue section of the present volume, cat. 109) to The Museum of Modern Art, which owns the painting made after it (p. 191).

231. *Cahiers d'art* 1934, pp. 18, 54–55.

232. In a letter to Michel Leiris, September 25, 1929, Miró had written: "Perhaps it would be interesting to publish a drawing that I gave to Pierre [Loeb] — a sketch for the 'Portrait of the Fornarina' — with inscriptions."

233. Among the many sources discussing the collage-based paintings are Dupin 1962, pp. 252–55; Rubin 1973, pp. 58–60; and Jeffett 1989, pp. 30–31.

234. Picon 1976, vol. 2, p. 55.

235. "Les Planches de *L'Encyclopédie*," in *Roland Barthes: Le Texte et l'image* (Paris: Pavillon des Arts, 1986), p. 44. Originally published in "Image, raison, déraison," *L'Univers de l'Encyclopédie: 130 Planches de l'Encyclopédie* (Libraires Associés, 1964).

236. *Cahiers d'art* 1934, p. 13.

237. "On Ethnographic Surrealism," in Clifford, *The Predicament of Culture: Twentieth-Century Ethnography, Literature, and Art* (Cambridge, Mass., and London: Harvard University Press, 1988), p. 132.

238. Ibid., p. 129.

239. Ibid., p. 130.

240. Ibid., p. 132.

241. Michel Leiris was Secretary-Archivist of the ethnographic expedition

to Africa known as "La Mission Dakar-Djibouti" from May 1931 to February 1933. See Jamin 1992, p. 866 (n. 1). For a discussion of the Mission Dakar-Djibouti, see Clifford, *The Predicament of Culture*, pp. 136–38. For contemporary accounts by participants, see *Minotaure* (Paris), no. 2 (June 1, 1933).

242. Dupin 1962, p. 255.

243. Cited in Pierre Schneider, "Miró," *Horizon* (New York), vol. 1, no. 4 (March 1959), p. 72. Dupin 1962, p. 255, and Rubin 1973, p. 64, cite Giacometti's remark in the context of the paintings commissioned by Marie Cuttoli.

244. Miró had the first of his one-artist exhibitions at the Pierre Matisse Gallery, New York, November 1–25, 1932; thereafter, Matisse would be Miró's dealer in the United States.

245. Letter to Pierre Matisse, July 16, 1934.

246. Miró 1977, p. 121.

247. Letter to Pierre Matisse, November 11, 1934.

248. Letter to Pierre Matisse, December 17, 1934.

249. Dupin 1962, p. 264.

250. See Julia Engelhardt, Michael Raeburn, and Pilar Sada, "Chronology," in Hayward 1986, p. 307.

251. See the Exhibition History, under 1934.

252. Letter to Pierre Matisse, October 12, 1934.

253. Letter to Pierre Matisse, December 17, 1934; in Rowell 1986, p. 125, in a slightly different translation.

254. *Cahiers d'art* 1934. According to a letter from Miró to Michel Leiris, July 15, 1933, this issue was to have served as the catalogue of Miró's exhibition at the Galerie Georges Bernheim & Cie, October 30–November 13, 1933, but as things turned out, Zervos spent a protracted period in Greece, and was not ready to begin work until late November 1933 (letter from Miró to Leiris, November 21, 1933). The issue was not confined to Miró's recent work, as it might have been had it doubled as a catalogue, but covered the range of Miró's career.

255. Tériade reproduced one of the drawing-collages (Dupin 363) in "Aspects actuels de l'expression plastique," *Minotaure* (Paris), vol. 1, no. 5 (February 1934), pp. 33–44. In the following year Miró would design the cover for the magazine's June issue (vol. 2, no. 7).

256. "Arts des rues," *Le Témoin*, February 4, 1934 (in Palma II).

257. McBride 1928a, pp. 526–28.

258. M.M. 1934, p. 4 [Mary Morsell].

259. *Time* 1934, p. 34.

260. Letter to Pierre Matisse, December 20, 1934.

261. Letter to Pierre Matisse, October 6, 1935.

262. Letter to Pierre Matisse, March 7, 1937; in Rowell 1986, p. 148.

263. In addition to returning to his mid-1920s notebooks in 1935 in the process of his "auto-revision," Miró consulted

one of them at least once again in somewhat similar circumstances. In early 1958, when he wished to resume painting, after a period of its virtual abandonment in favor of printmaking, sculpture, ceramics, and other projects, Miró returned to the Montroig Notebook. Inserted into its pages and juxtaposed with his 1925 drawing for *Head of Catalan Peasant, IV* are drawings dated "4/1/58" unequivocally inspired by the earlier drawing and evidently intended as studies for paintings. A few pages further on are several other drawings, all inscribed with the same date, and reworking ideas from the mid-twenties. All held by the Fundació Joan Miró, Barcelona, these drawings are catalogued, respectively, as FJM 618a, 618b, 624a, 624b, 625, and 626.

264. The drawing resulted in the painting *Head* of 1927 (Dupin 188), now in the collection of the Philadelphia Museum of Art.

265. I rely on Dupin 1962, p. 285, for the number of copper and masonite paintings. Dupin reproduces eleven of the twelve as nos. 420–30.

266. The conservation staff of the Fundació Joan Miró, Barcelona, has noted that Miró used an encaustic technique for at least the Fundació's painting on copper from this series, *Man and Woman in Front of a Pile of Excrement* (p. 210). But the traces of wax they found may well be explained by Miró's use of "extenders." For a discussion of extenders, see Mayer, *A Dictionary of Art Terms and Techniques*, p. 140.

267. Letter to Pierre Matisse, February 5, 1936. Miró's concern about the "solidity" of these works is reflected in the research that must have gone into his decision to work on copper. Miró observed with care the Old Master technique of treating the copper grounds with garlic before applying any pigment, in order to prevent future deleterious reaction between metal and paint.

268. Letter to Pierre Matisse, February 5, 1936.

269. Picon 1976, vol. 1, p. 125.

270. Miró's interest in constructed objects and materials was no doubt heightened by what Rubin 1973, p. 143, has called "the tremendous vogue object-making enjoyed in Surrealist circles during the 1930s." Indeed, Miró's turn of mind at the beginning of the summer of 1936 was probably influenced by the widely talked-about exhibition of Surrealist objects that had just closed at the Galerie Charles Ratton in Paris ("Exposition surréaliste d'objets," May 22–29, 1936).

271. Picon 1976, vol. 1, p. 125.

272. Ibid., p. 124.

273. Dupin 1962 reproduces twenty-seven masonite paintings, while the extant notebook (FJM 1415–1463) holding their preparatory drawings contains only sixteen studies, many of which are on now detached pages.

274. Miró 1977, p. 168.

275. In Rowell 1986, p. 130.

276. Letter to Pierre Matisse, January 12, 1937; excerpt in Rowell 1986, p. 146.

277. One of the more interesting ways in which *Self-Portrait I* relates to prior work is the configuration of the eyes, which is an extrapolation of the sun in one of the preparatory drawings for *The Hunter (Catalan Landscape)* (fig. 11); this is virtually the only element that will carry over into *Self-Portrait II* (p. 229), done almost immediately thereafter. While only the eye directly relates the second self-portrait to the first, the second harks back more obviously to *The Hunter (Catalan Landscape)* in the stick-figure at the lower right, and in the delineation of the two fish.

278. Miró's first comparison of *Still Life with Old Shoe* to *The Farm* occurs in a letter to Pierre Matisse, February 12, 1937 (Rowell 1986, p. 147), but here the comparison seems to rest on its realism, which, says Miró, is "profound and fascinating." The second time that Miró connects the earlier picture with the new still life, it is to place it historically, as "with *The Farm, la pièce capitale* of my work" (letter to Matisse, March 21, 1937; excerpt in Rowell 1986, p. 157).

Miró compares *The Farm* to *Self-Portrait I* in a letter to Matisse of December 5, 1937, saying: "I am working a lot. Every morning I work on my portrait, which will be more important and representative than *The Farm* if I manage to succeed as I hope. It's a very ambitious goal that I am setting myself, but by dint of sweat, I hope to realize it."

279. Letter to Pierre Matisse, January 12, 1937; in Rowell 1986, p. 146, in a slightly different translation.

280. For a discussion of *Self-Portrait I* and its making, see Dupin 1962, p. 303, and Rubin 1973, p. 76.

281. Letter to Pierre Matisse, March 7, 1937.

282. Reproduced in Dupin 1962, nos. 475–81, 485. Drawings for four of the celotex panels are reproduced in Fundació Joan Miró 1988, p. 199, nos. 766–70.

283. The two others are reproduced in Dupin 1962, nos. 494, 495.

284. This and the previous quotation, in Rowell 1986, pp. 159, 162.

285. Miró 1977, p. 30.

286. In conversation with the author and A. Umland, July 1991.

287. The second Constellation is titled *The Escape Ladder*, and the twelfth *On the 13th, the Ladder Brushed the Firmament*. The ladder, symbolic of the link between earthly and celestial, was also evocative of escape.

288. *The Poetics of Space*, trans. Maria Jolas (Boston: Beacon Press, 1969), pp. 183–84. Originally published as *La Poétique de l'espace* (Paris: Presses Universitaires de France, 1958).

289. For a reproduction of Picasso's *Tomato Plant* and a discussion of its connection with World War II, see Jean Sutherland Boggs et al., *Picasso and Things* (Cleveland: The Cleveland Museum of

Art, 1992), p. 286, no. 117.

290. In Pierre Matisse 1959, pp. 6 ff. Reprinted in English in Breton 1972, pp. 259 ff.

291. Pierre Matisse 1959, p. 8. Reprinted in English in Breton 1972, p. 263.

292. It was originally projected that the Constellations be shown at The Museum of Modern Art, but for various reasons the plan was abandoned, and the series was shown at the Pierre Matisse Gallery (documents in the collection files, Department of Painting and Sculpture, The Museum of Modern Art, New York). While it is generally believed that the entire series was on view at the Matisse Gallery, Miró retained one work, *Morning Star* (p. 243), for himself. Of the twenty-two consigned to Matisse, only sixteen were shown at any one time. The gouaches on view were, however, rotated, so that virtually the entire set could possibly have been seen by viewers who visited the gallery more than once.

293. Pierre Matisse 1959, p. 13.

294. Rubin 1973, p. 81.

295. The surfaces of all of the Constellations we have been able to examine have been rubbed to produce effects of texture. The high shine of some of the blacks, which, observed under a microscope, appear as tiny gleaming black particles, was duplicated in the paper conservation laboratory of The Museum of Modern Art. A dab of Mars black oil paint was dropped into a beaker of turpentine; immediately thereafter the conservator dipped a brush into the beaker and made a few strokes on a rough-surfaced paper. Since the oil particles tend to settle quickly, the laboratory report emphasizes that the brush must be dipped quickly, while the mixture still has an even distribution of oil and turpentine. This laboratory reconstruction of a facet of Miró's methodology in painting the Constellations seems confirmed by a letter Miró wrote to Roland Penrose on March 22, 1969; at the beginning of work on the Constellations, Miró had just finished some oil paintings, and he tells Penrose that he then dipped his brushes in turpentine and wiped them on sheets of white paper, thus discovering a technique that he seems to have used throughout the series. (Penrose 1969, p. 100, publishes an excerpt from this letter and translates Miró's sentence "*Je trempais mes pinceaux à l'essence*" as "I dipped my brushes in petrol." It seems more likely that Miró meant *essence de térébenthine*—in English, "turpentine.") For Miró's making of the Constellations, see Penrose 1969, pp. 100 ff.

296. Bachelard, *The Poetics of Space*, p. 171.

297. Picon 1976, vol. 2, p. 50.

298. Letter to Pierre Matisse, July 11, 1942.

299. Extended extracts from these notebooks are to be found in Picon 1976, vol. 2, pp. 8–84. The entire contents of one notebook that Miró kept between July 1941 and the summer of the following year are published in Rowell 1986, pp. 175–95. The notebooks themselves were given by Miró to the Fundació Joan Miró, Barcelona, where they are now preserved.

300. Picon 1976, vol. 2, p. 35.

301. Ibid., p. 56.

302. Ibid., p. 60 and passim.

303. The drawings are reproduced in Fundació Joan Miró 1988, pp. 163–67. Following the practice initiated with the *A* to *F2* series of 1925–27, Miró tended to inscribe his preparatory drawings with a canvas size only as he actually began painting; it is, therefore, more than likely that canvases after these drawings had been begun sometime in the mid-1930s and, given their large sizes, were those that Miró so often lamented having been forced to abandon.

304. Rowell 1986, p. 177.

305. Peter Schjeldahl, "Toward a New Miró," in *Miró: Sculpture* (New York: The Pace Gallery, 1984), p. 5.

306. Cited in Paul Feyerabend, *Against Method: Outline of an Anarchistic Theory of Knowledge* (London: NLB, 1979), p. 18.

307. W. J. T. Mitchell, *Iconology: Image, Text, Ideology* (Chicago and London: University of Chicago Press, 1986), pp. 38–39.

308. Feyerabend, *Against Method*, pp. 92, 101, as cited in Mitchell, *Iconology*, p. 39.

309. Rowell 1986, p. 178.

310. Lee 1947; in Rowell 1986, p. 204.

311. "L'Interrogation naissante," in *Poétique de Miró*, special issue of *Opus international* (Paris), no. 58 (February 1976), p. 26.

Plates

THE CLOCK AND THE LANTERN. [BARCELONA, AFTER EARLY MARCH] 1915. (CAT. 1)
OIL ON CARDBOARD, 20½ × 25⅜″ (52 × 64.5 CM)
PRIVATE COLLECTION, SWITZERLAND

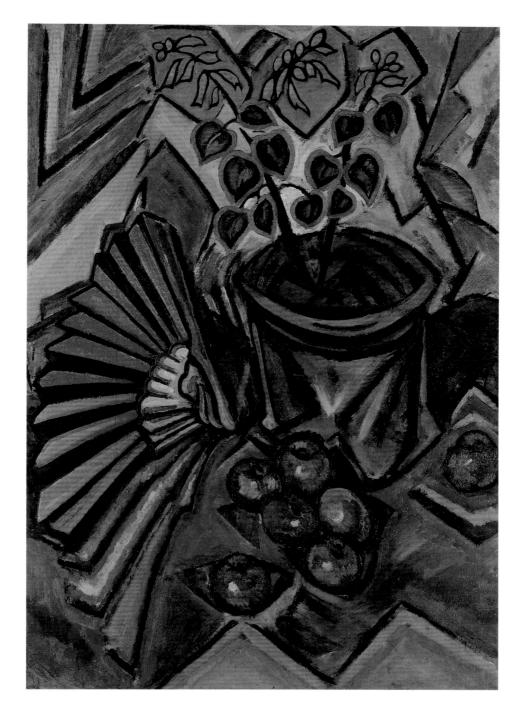

THE RED FAN. BARCELONA, FALL 1916. (CAT. 3)
OIL ON CARDBOARD, 40½ × 28¾″ (103 × 73 CM)
THE HAKONE OPEN-AIR MUSEUM, TOKYO

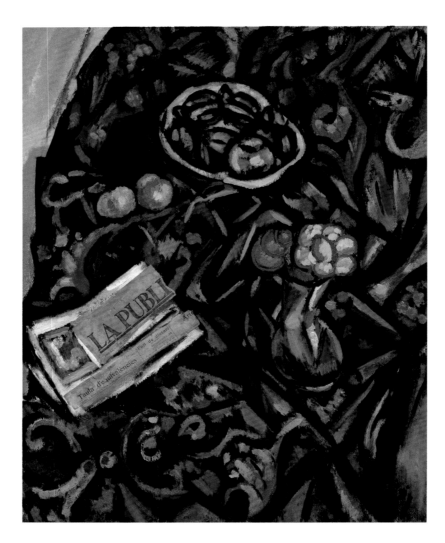

"La Publicidad" and Flower Vase. [Barcelona], winter 1917. (Cat. 5)
Oil and newspaper collage on linen, $28 \times 23''$ (71×58.5 cm)
Alsdorf Collection, Chicago

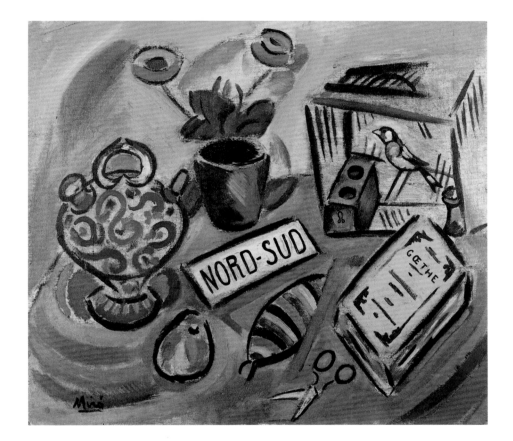

"Nord-Sud." [Barcelona], spring 1917. (Cat. 7)
Oil on canvas, 24⅜ × 27⅝″ (62 × 70 cm)
Galerie Maeght, Paris

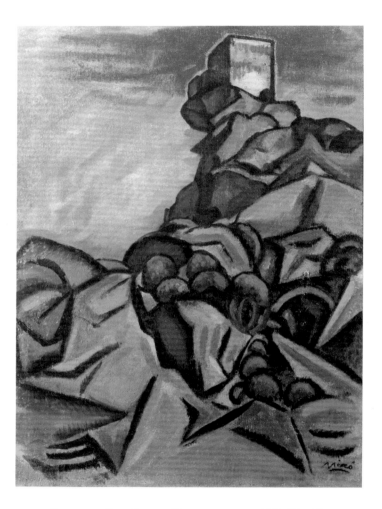

Montroig, Sant Ramon. Montroig, summer 1916. (Cat. 2)
Oil on canvas, 24¼ × 18⅞″ (61.5 × 47.9 cm)
Kouros Gallery, New York

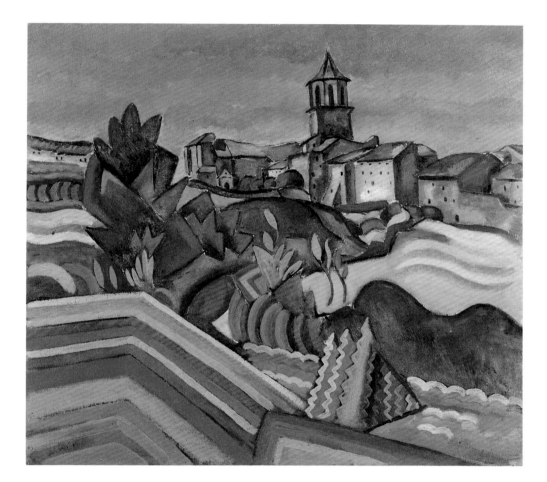

Prades, the Village. Prades, summer 1917. (Cat. 8)
Oil on canvas, 25⅝ × 28⅝″ (65 × 72.6 cm)
Solomon R. Guggenheim Museum, New York

DRAWING FROM THE CÍRCOL ARTÍSTIC DE SANT LLUC.
BARCELONA, [AFTER EARLY MARCH] 1915
WATERCOLOR AND CHARCOAL ON PAPER, 12⅛ × 8¼″ (31 × 21 CM)
GALERIE LELONG ZÜRICH

DRAWING FROM THE CÍRCOL ARTÍSTIC DE SANT LLUC.
BARCELONA, 1917
PENCIL ON PAPER, 12⅛ × 7⅞″ (31 × 20 CM)
GALERIE LELONG ZÜRICH

RECLINING NUDE. 1921
PENCIL ON PAPER, 8 × 10⅝″ (20.5 × 27 CM)
PERLS GALLERIES, NEW YORK

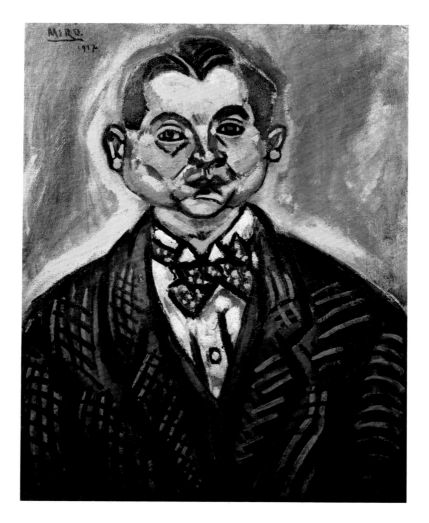

SELF-PORTRAIT. [BARCELONA], WINTER 1917. (CAT. 4)
OIL ON CANVAS, 24½ × 19½″ (62.2 × 49.5)
PRIVATE COLLECTION

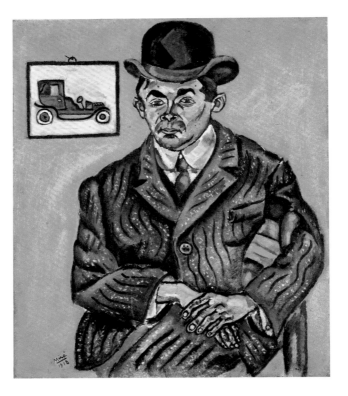

PORTRAIT OF HERIBERTO CASANY (THE CHAUFFEUR).
BARCELONA, WINTER OR EARLY SPRING 1918. (CAT. 9)
OIL ON CANVAS, 27½ × 24½″ (69.8 × 62.2 CM)
KIMBELL ART MUSEUM, FORT WORTH

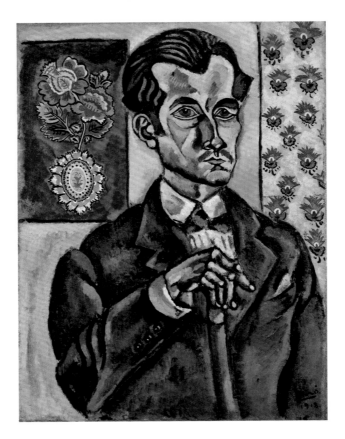

PORTRAIT OF RAMON SUNYER (THE GOLDSMITH).
BARCELONA, WINTER OR EARLY SPRING 1918. (CAT. 10)
OIL ON CANVAS, 27⅛ × 20⅛″ (68.8 × 51.1 CM)
PRIVATE COLLECTION

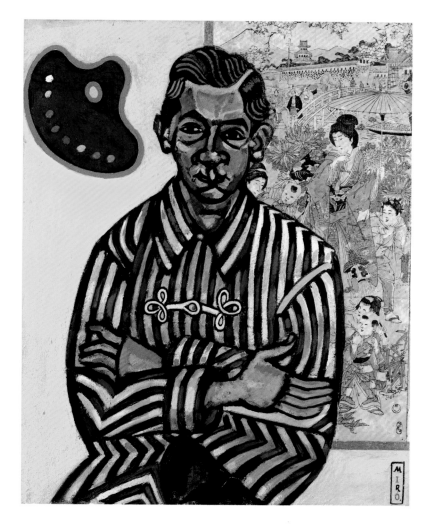

PORTRAIT OF E. C. RICART. [BARCELONA], WINTER OR EARLY SPRING 1917. (CAT. 6)
OIL AND PASTED PAPER ON CANVAS, 32¼×25⅞″ (81.9×65.7 CM)
THE METROPOLITAN MUSEUM OF ART, NEW YORK. ANONYMOUS LOAN

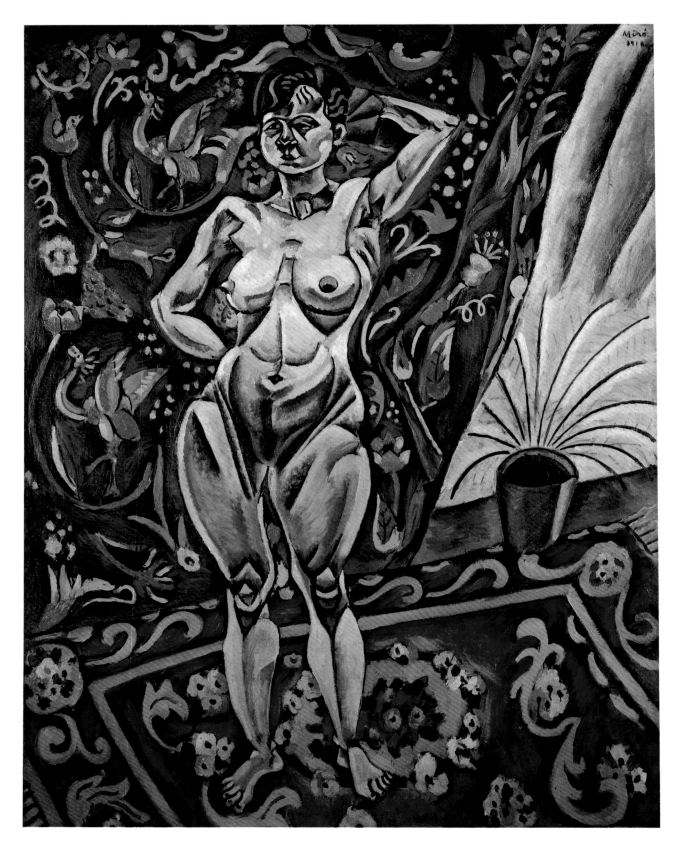

STANDING NUDE. BARCELONA, MID-MAY–JUNE 1918. (CAT. 11)
OIL ON CANVAS, 60¼ × 47½″ (153 × 120.6 CM)
THE SAINT LOUIS ART MUSEUM. PURCHASE, FRIENDS FUND

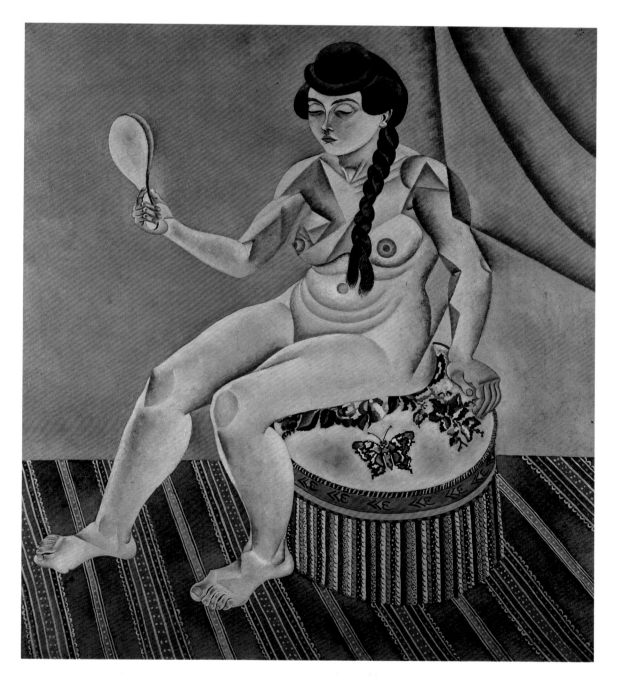

NUDE WITH MIRROR. BARCELONA, SPRING AND [FALL] 1919. (CAT. 17)
OIL ON CANVAS, 44½ × 40⅛″ (113 × 102 CM)
KUNSTSAMMLUNG NORDRHEIN-WESTFALEN, DÜSSELDORF

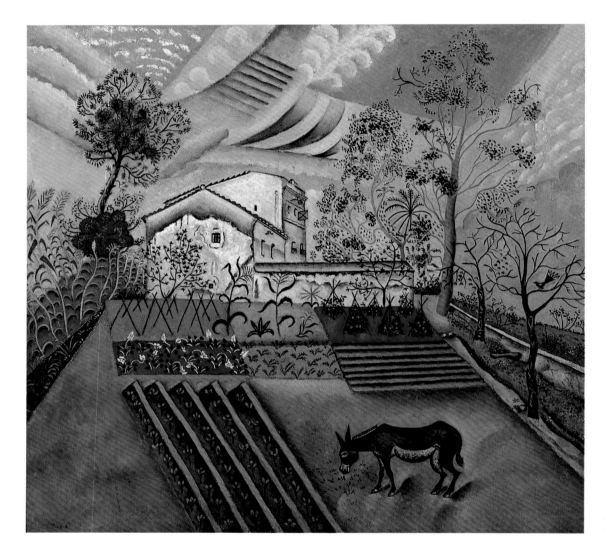

VEGETABLE GARDEN AND DONKEY. MONTROIG, [SUMMER AND/OR FALL] 1918. (CAT. 12)
OIL ON CANVAS, 25⅛ × 27½″ (64 × 70 CM)
MODERNA MUSEET, STOCKHOLM

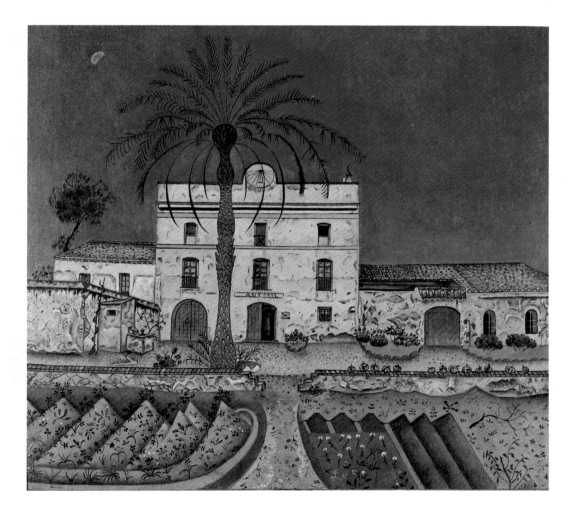

HOUSE WITH PALM TREE. MONTROIG, FALL 1918. (CAT. 13)
OIL ON CANVAS, 25½ × 28¾″ (65 × 73 CM)
PRIVATE COLLECTION

THE VILLAGE OF MONTROIG (MONTROIG, THE CHURCH AND THE VILLAGE).
MONTROIG, [SUMMER AND/OR FALL] 1918, AND MONTROIG AND BARCELONA, JULY–LATE FALL 1919. (CAT. 16)
OIL ON CANVAS, 28¾ × 23⅞" (73.1 × 60.7 CM)
COLLECTION MARIA DOLORES MIRÓ DE PUNYET

VINES AND OLIVE TREES, TARRAGONA. MONTROIG AND BARCELONA, JULY–LATE FALL 1919. (CAT. 15)
OIL ON CANVAS, 28½ × 35⅝″ (72.5 × 90.5 CM)
THE JACQUES AND NATASHA GELMAN COLLECTION

MALE NUDE. BARCELONA, JANUARY 1920
PENCIL ON THIN CARDBOARD, 9¼ × 5⅞″ (23.5 × 15 CM)
FUNDACIÓ JOAN MIRÓ, BARCELONA

MALE NUDE. BARCELONA, DECEMBER 1919
PENCIL ON THIN CARDBOARD, 9⅛ × 5⅞″ (23.2 × 15 CM)
FUNDACIÓ JOAN MIRÓ, BARCELONA

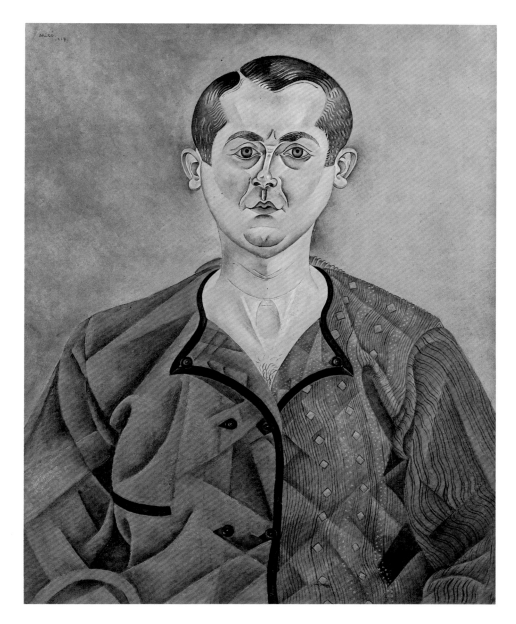

SELF-PORTRAIT. BARCELONA, WINTER–SPRING 1919. (CAT. 14)
OIL ON CANVAS, 28¾ × 23⅝″ (73 × 60 CM)
MUSÉE PICASSO, PARIS

HORSE, PIPE, AND RED FLOWER (STILL LIFE WITH HORSE). MONTROIG, JULY–OCTOBER 1920. (CAT. 18)
OIL ON CANVAS, 32½ × 29½″ (82.6 × 74.9 CM)
PHILADELPHIA MUSEUM OF ART. GIFT OF MR. AND MRS. C. EARLE MILLER

Still Life with Rabbit (The Table). Montroig and Barcelona, August 1920–January 1921. (Cat. 19)
Oil on canvas, 51⅛ × 43¼″ (130 × 110 cm)
Collection Gustav Zumsteg

PORTRAIT OF A SPANISH DANCER. PARIS, MARCH–SPRING 1921. (CAT. 21)
OIL ON CANVAS, 26 × 22″ (66 × 56 CM)
MUSÉE PICASSO, PARIS

STILL LIFE—GLOVE AND NEWSPAPER (TABLE WITH GLOVE). PARIS, FEBRUARY–MARCH 1921. (CAT. 20)
OIL ON CANVAS, 46 × 35¼″ (116.8 × 89.5 CM)
THE MUSEUM OF MODERN ART, NEW YORK. GIFT OF ARMAND G. ERPF

Interior (The Farmer's Wife). Montroig and Paris, July 1922–spring 1923. (Cat. 23)
Oil on canvas, 31⅞ × 25⅞″ (81 × 65.5 cm)
Private collection, Villiers-sous-Grez

THE FARM. MONTROIG, BARCELONA, AND PARIS, JULY 1921–C. EARLY MAY 1922. (CAT. 22)
OIL ON CANVAS, 48¾ × 55⅝″ (123.8 × 141.3 CM)
NATIONAL GALLERY OF ART, WASHINGTON, D.C. GIFT OF MARY HEMINGWAY

107

Still Life I (The Ear of Grain). Montroig and Paris, July 1922–spring 1923. (Cat. 24)
Oil on canvas, 14⅞ × 18⅛″ (37.8 × 46 cm)
The Museum of Modern Art, New York. Purchase

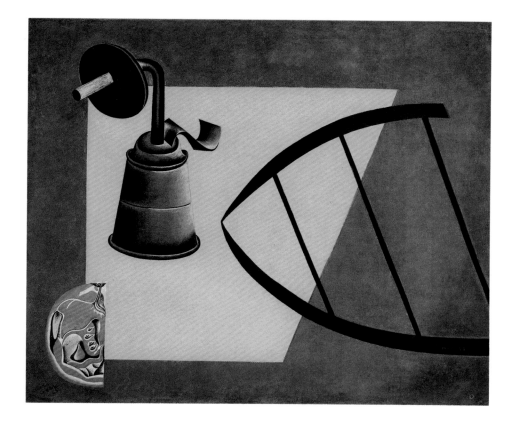

STILL LIFE II (THE CARBIDE LAMP). MONTROIG AND PARIS, JULY 1922–SPRING 1923. (CAT. 25)
OIL ON CANVAS, 15×18″ (38.1×45.7 CM)
THE MUSEUM OF MODERN ART, NEW YORK. PURCHASE

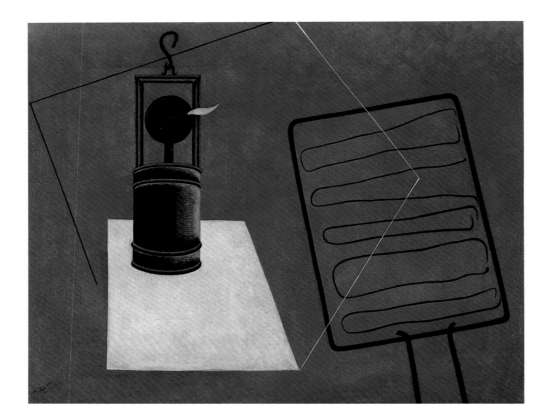

STILL LIFE III (GRILL AND CARBIDE LAMP). MONTROIG AND PARIS, JULY 1922–SPRING 1923. (CAT. 26)
OIL ON CANVAS, 19⅞ × 25½″ (50.5 × 65 CM)
PRIVATE COLLECTION

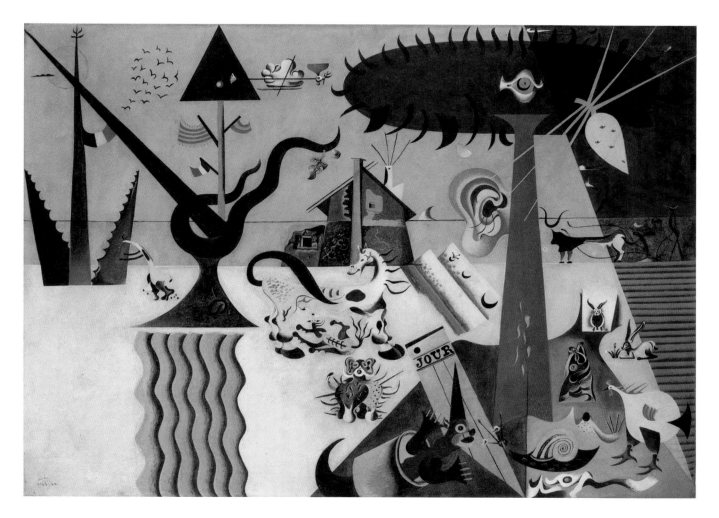

The Tilled Field. Montroig, July 1923–winter 1924. (Cat. 27)
Oil on canvas, 26 × 36½″ (66 × 92.7 cm)
Solomon R. Guggenheim Museum, New York

Pastorale. Montroig, July 1923—winter 1924. (Cat. 28)
Oil and pencil on canvas, 23⅝ × 36⅜″ (60 × 92.2 cm)
Collection Stefan T. Edlis

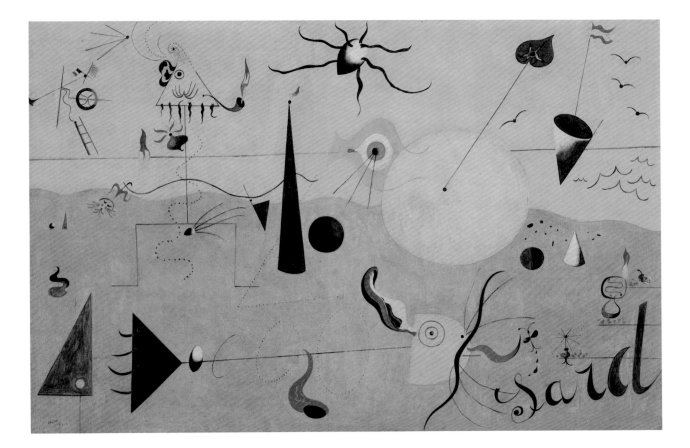

The Hunter (Catalan Landscape). Montroig, July 1923–winter 1924. (Cat. 29)
Oil on canvas, 25½ × 39½″ (64.8 × 100.3 cm)
The Museum of Modern Art, New York. Purchase

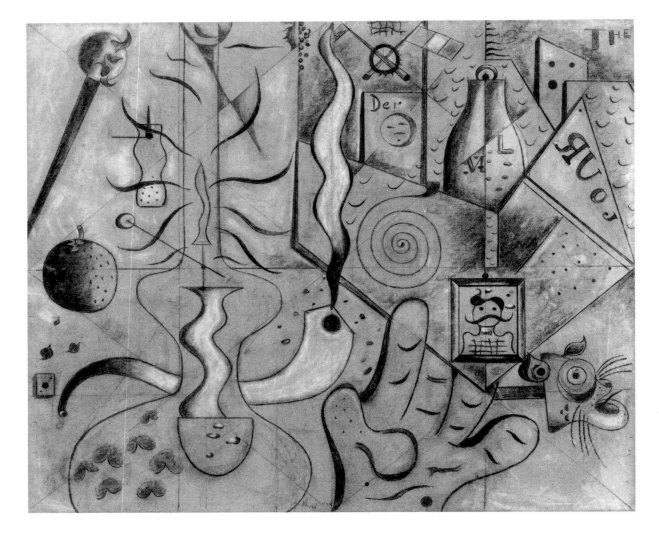

THE KEROSENE LAMP. PARIS, SPRING 1924. (CAT. 33)
CHARCOAL WITH RED CONTÉ AND COLORED CRAYON HIGHLIGHTED WITH WHITE OIL PAINT ON CANVAS
PREPARED WITH A GLUE GROUND, 31⅞ × 39½″ (81 × 100.3 CM)
THE ART INSTITUTE OF CHICAGO. GIFTS OF MRS. HENRY C. WOODS, MEMBERS OF THE COMMITTEE ON PRINTS AND DRAWINGS,
AND FRIENDS OF THE DEPARTMENT; JOSEPH AND HELEN REGENSTEIN FOUNDATION, HELEN L. KELLOGG TRUST,
BLUM-KOVLER FOUNDATION, AND MAJOR ACQUISITIONS FUND

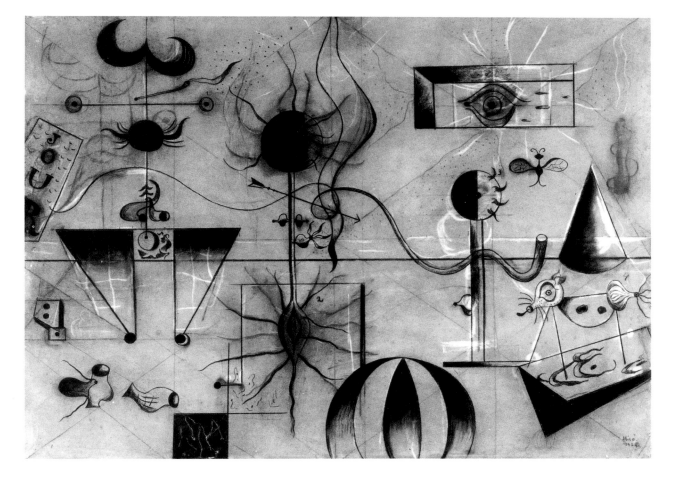

THE FAMILY. PARIS, MAY 16, 1924. (CAT. 32)
VINE CHARCOAL, WHITE PASTEL, AND RED CONTÉ ON OATMEAL PAPER, 29½×41″ (74.9×104.1 CM)
THE MUSEUM OF MODERN ART, NEW YORK. GIFT OF MR. AND MRS. JAN MITCHELL

Spanish Dancer. Paris, spring 1924. (Cat. 31)
Oil, charcoal, and tempera on canvas, 36¼ × 28¾″ (92 × 73 cm)
Private collection

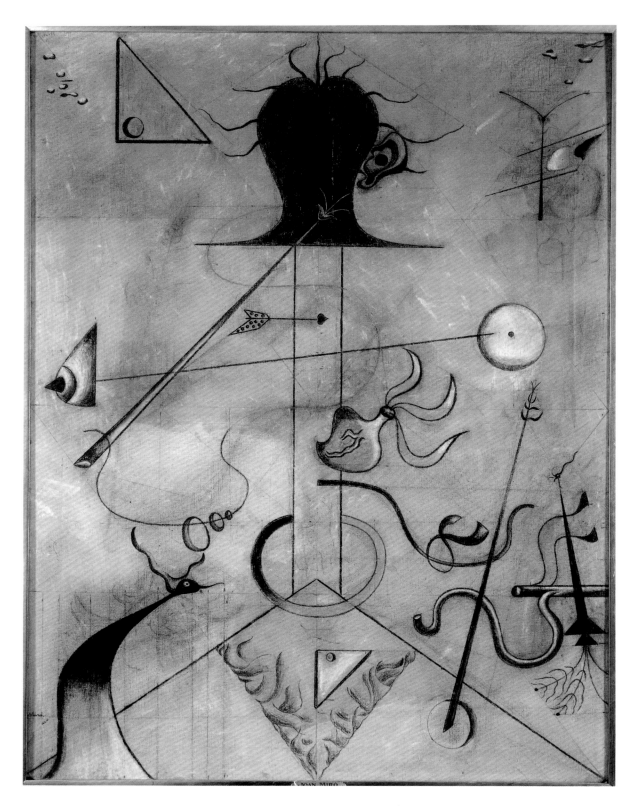

PORTRAIT OF MME K. PARIS, SPRING 1924. (CAT. 30)
OIL AND CHARCOAL ON CANVAS, 45¼×35″ (115×89 CM)
PRIVATE COLLECTION

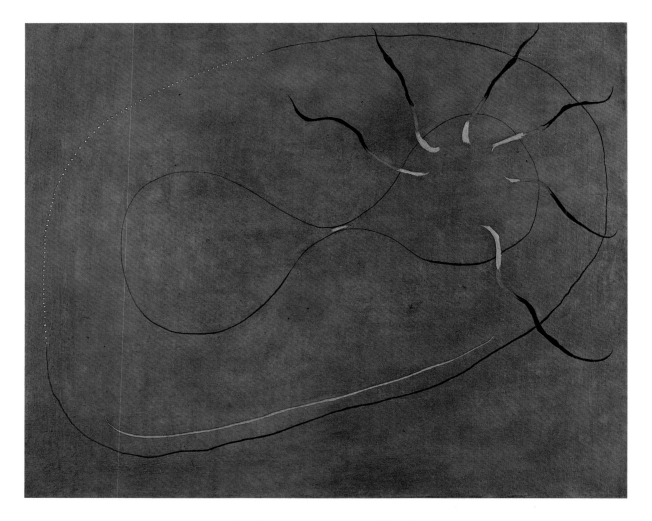

THE KISS. MONTROIG, SUMMER–FALL 1924. (CAT. 38)
OIL ON CANVAS, 28¾ × 36¼″ (73 × 92 CM)
COLLECTION JOSE MUGRABI

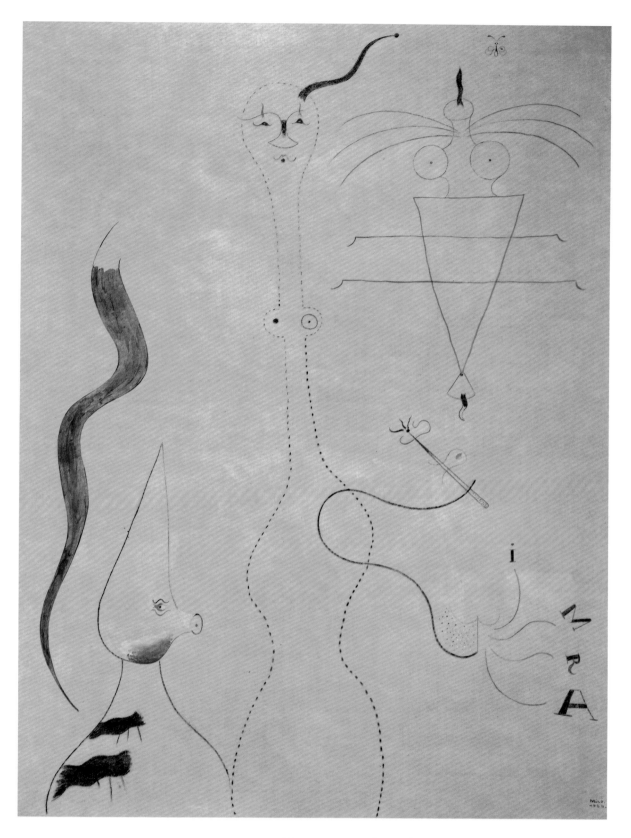

Portrait of Mme B. [Montroig, summer] 1924. (Cat. 34)
Oil and charcoal on canvas, 50¾ × 37⅝″ (129 × 95.5 cm)
Private collection, courtesy Berry-Hill Galleries, New York

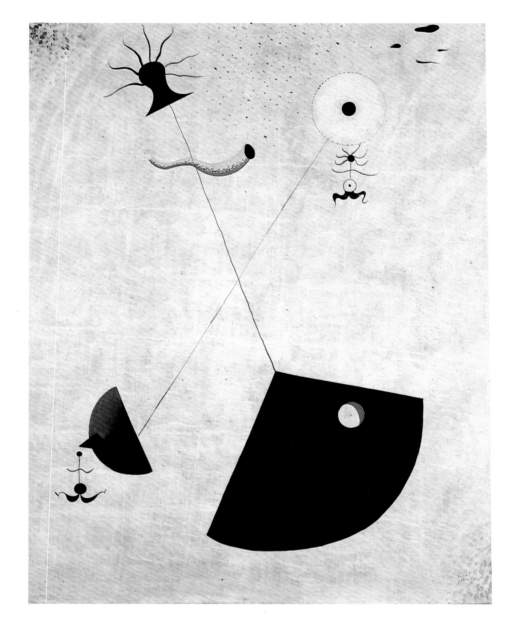

MATERNITY. MONTROIG, SUMMER–FALL 1924. (CAT. 35)
OIL ON CANVAS, 36¼ × 28¾″ (92.1 × 73.1 CM)
SCOTTISH NATIONAL GALLERY OF MODERN ART, EDINBURGH. PURCHASED WITH ASSISTANCE FROM
THE NATIONAL HERITAGE MEMORIAL FUND, THE NATIONAL ART COLLECTIONS FUND
AND DONATIONS FROM MEMBERS OF THE PUBLIC, 1991–1993

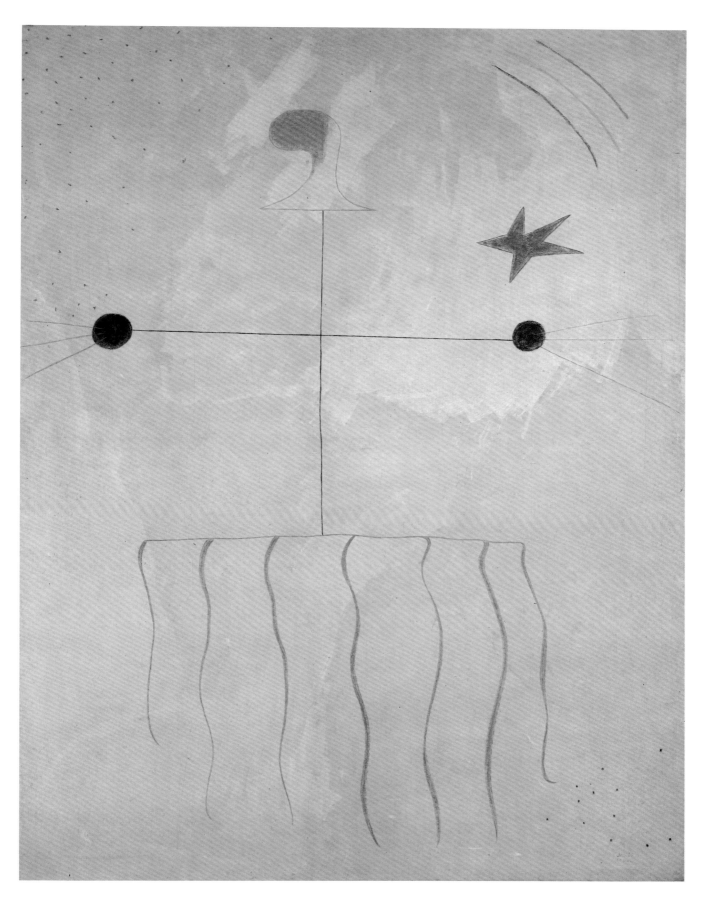

HEAD OF CATALAN PEASANT, I. MONTROIG, SUMMER–FALL 1924. (CAT. 39)
OIL ON CANVAS, 57½×45″ (146×114.2 CM)
NATIONAL GALLERY OF ART, WASHINGTON, D.C. GIFT OF THE COLLECTORS COMMITTEE, 1981

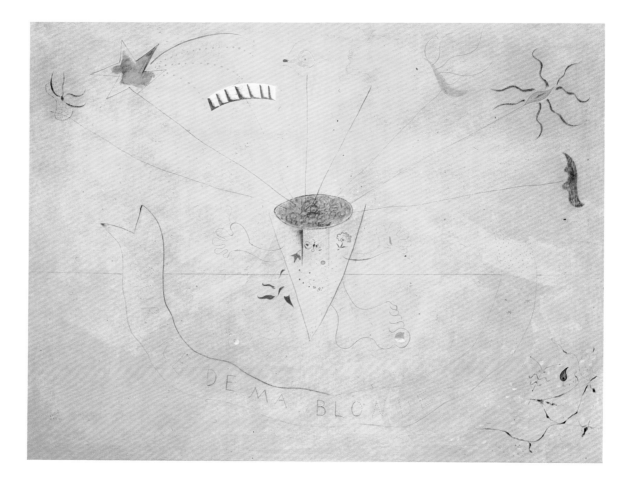

Bouquet of Flowers ("Sourire de ma blonde"). Montroig, summer–fall 1924. (Cat. 37)
Oil on canvas, 34⅝ × 45¼″ (88 × 115 cm)
Private collection, Paris

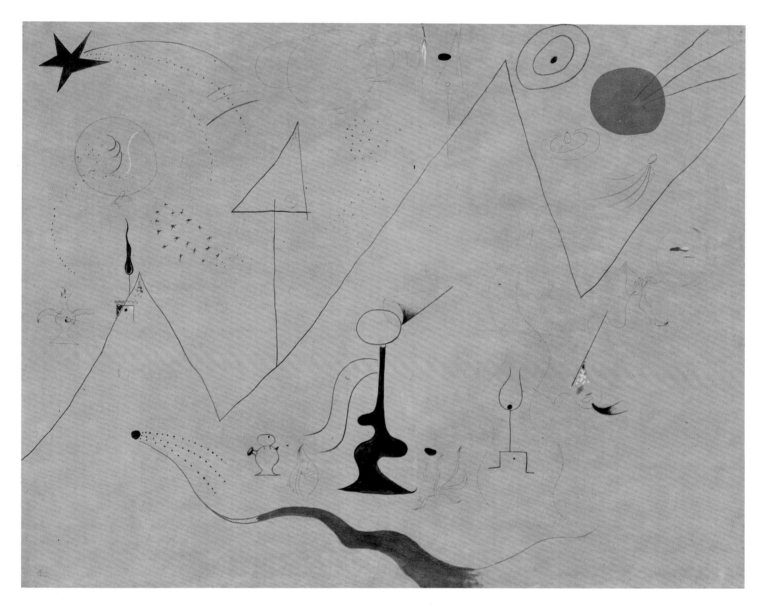

THE HERMITAGE. MONTROIG, SUMMER–FALL 1924. (CAT. 36)
OIL AND/OR AQUEOUS MEDIUM, CRAYON, AND PENCIL ON CANVAS, 45 × 57⅞″ (114.3 × 147 CM)
PHILADELPHIA MUSEUM OF ART. THE LOUISE AND WALTER ARENSBERG COLLECTION

Nude Descending a Staircase. Montroig, September 4, 1924. (App. 1)
Pencil and chalk on paper with collaged stamp, 23⅝ × 18⅛″ (60 × 46 cm)
Private collection

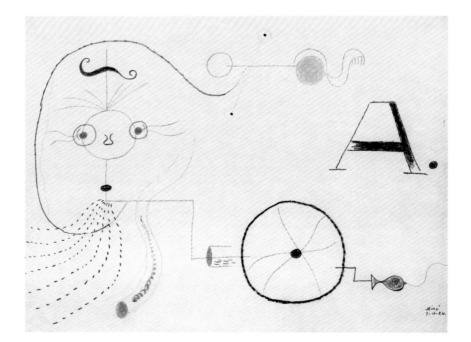

Automaton. Montroig, November 7, 1924. (App. 5)
Pencil and colored crayon on paper, 18¼ × 24″ (46.3 × 60.9 cm)
The Morton G. Neumann Family Collection

SPANISH DANCER. MONTROIG, OCTOBER 20, 1924. (APP. 3)
CONTÉ, CRAYON, PAINT, AND PENCIL ON PAPER, 23⅝ × 18⅜″ (60 × 46.6 CM)
COLLECTION KAY HILLMAN

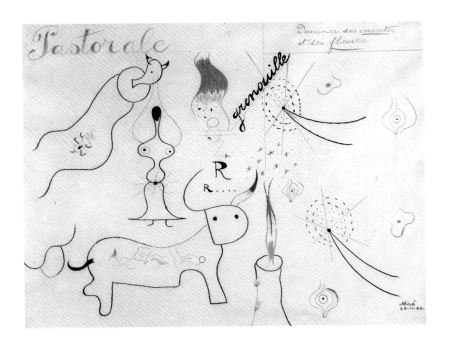

PASTORALE. MONTROIG, OCTOBER 23, 1924. (APP. 4)
PASTEL, BLACK CRAYON, INDIA INK, AND PENCIL ON PAPER, 18¼ × 24¼″ (46.3 × 61.5 CM)
PRIVATE COLLECTION, NEW YORK

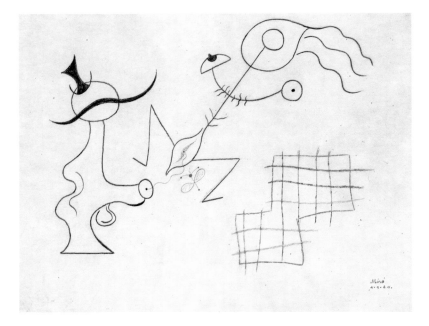

Untitled. Montroig, September 4, 1924. (App. 2)
Colored pencil, charcoal, and pencil on paper, 17⅞ × 23½″ (45.5 × 59.7 cm)
Collection Artcurial, Paris

The Kerosene Lamp. Montroig, November 10, 1924. (App. 6)
Pencil, graphite, and watercolor on watermarked wove paper, 22¾ × 17⅝″ (58 × 45 cm)
Musée National d'Art Moderne, Centre Georges Pompidou, Paris, 1990

THE WIND. MONTROIG, NOVEMBER 11, 1924. (APP. 7)
WATERCOLOR, CONTÉ, PENCIL, AND FOIL ON PAPER, 23⅝ × 18¼″ (60 × 46.4 CM)
PRIVATE COLLECTION

UNTITLED. MONTROIG, NOVEMBER 24, 1924. (APP. 8)
PENCIL, GOUACHE, AND FEATHER ON PAPER, 19⅜ × 25⅜″ (49 × 64.5 CM)
MUSÉE NATIONAL D'ART MODERNE, CENTRE GEORGES POMPIDOU, PARIS. GIFT OF LOUISE AND MICHEL LEIRIS, 1984

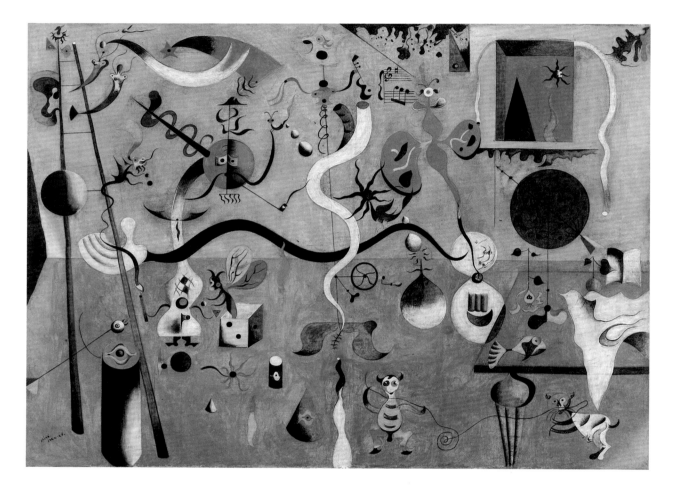

CARNIVAL OF HARLEQUIN. Paris, spring 1924–winter or spring 1925. (Cat. 40)
Oil on canvas, 26 × 36⅝″ (66 × 93 cm)
Albright-Knox Art Gallery, Buffalo. Room of Contemporary Art Fund, 1940

HEAD OF CATALAN PEASANT, III. PARIS, WINTER–SPRING 1925. (CAT. 41)
OIL ON CANVAS, 36⅜ × 28¾″ (92.4 × 73 CM)
SCOTTISH NATIONAL GALLERY OF MODERN ART, EDINBURGH. ON LOAN FROM A PRIVATE COLLECTION, ENGLAND

Personage. Montroig, July–September 1925. (Cat. 43)
Oil and egg tempera (?) on canvas, 51¼ × 37⅞″ (130 × 96.2 cm)
Solomon R. Guggenheim Museum, New York

"Photo—Ceci est la couleur de mes rêves." Montroig, July–September 1925. (Cat. 42)
Oil on canvas, 38 × 51″ (96.5 × 129.5 cm)
Private collection

The Policeman (Figure and Horse). Montroig, July–September 1925. (Cat. 44)
Oil on canvas, 8′ 1⅝″ × 6′ 4¾″ (248 × 195 cm)
The Art Institute of Chicago. Bequest of Claire Zeisler Trust

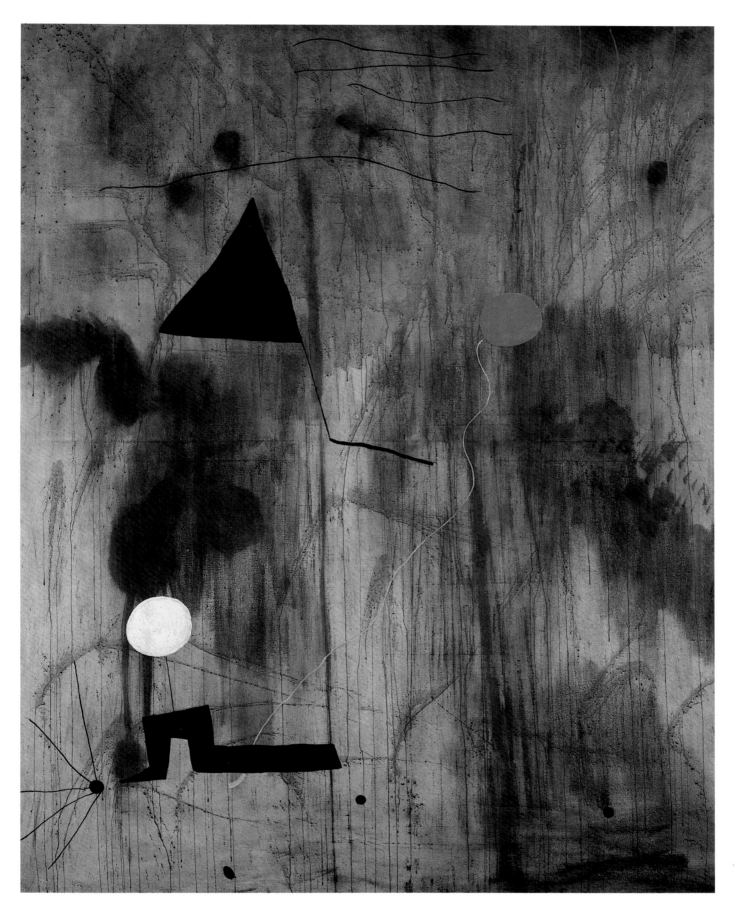

The Birth of the World. Montroig, late summer–fall 1925. (Cat. 49)
Oil on canvas, 8′ 2¾″ × 6′ 6¾″ (250.8 × 200 cm)
The Museum of Modern Art, New York. Acquired through an anonymous fund, the Mr. and Mrs. Joseph Slifka and
Armand G. Erpf Funds, and by gift of the artist

133

PAINTING (BLUE). MONTROIG, JULY–SEPTEMBER 1925. (CAT. 45)
OIL ON CANVAS, 24⅜ × 35¼″ (62 × 92 CM)
GALERIE MAEGHT, PARIS

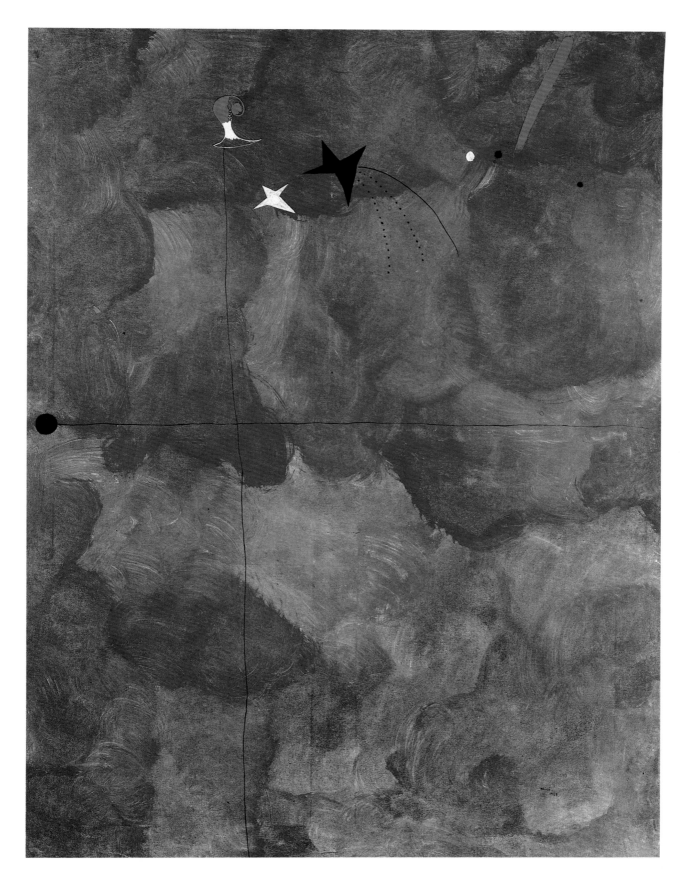

HEAD OF CATALAN PEASANT, IV. MONTROIG, JULY–SEPTEMBER 1925. (CAT. 46)
OIL ON CANVAS, 57 × 44⅞″ (145 × 114 CM)
MODERNA MUSEET, STOCKHOLM

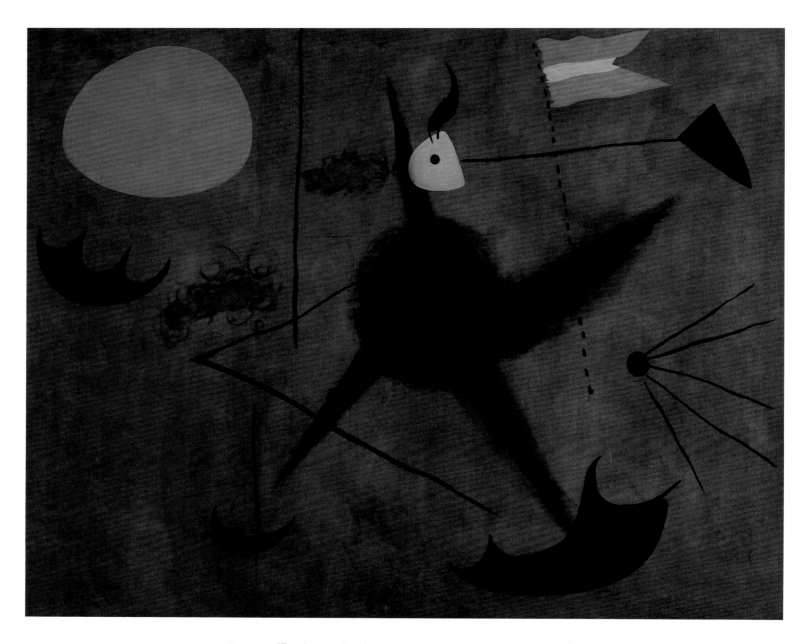

PAINTING (THE SPANISH FLAG). MONTROIG, JULY–SEPTEMBER 1925. (CAT. 47)
OIL ON CANVAS, 45¼ × 57½″ (115 × 146 CM)
PRIVATE COLLECTION, SWITZERLAND

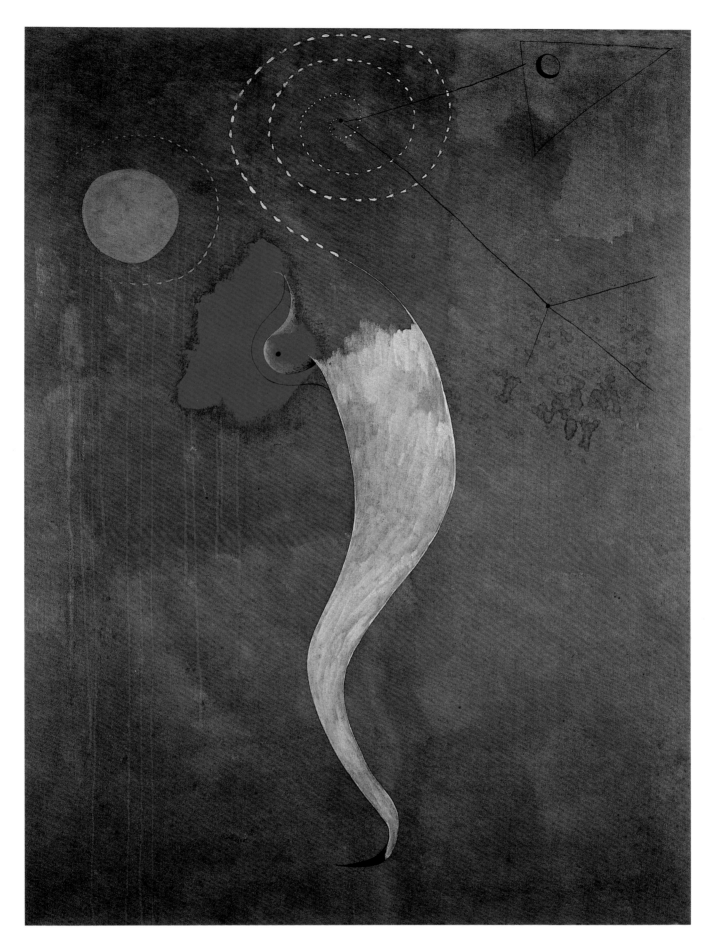

Lady Strolling on the Rambla in Barcelona. Montroig, [summer–fall] 1925. (Cat. 48)
Oil on canvas, 51¼ × 38⅜″ (132 × 97 cm)
New Orleans Museum of Art. Bequest of Victor K. Kiam

137

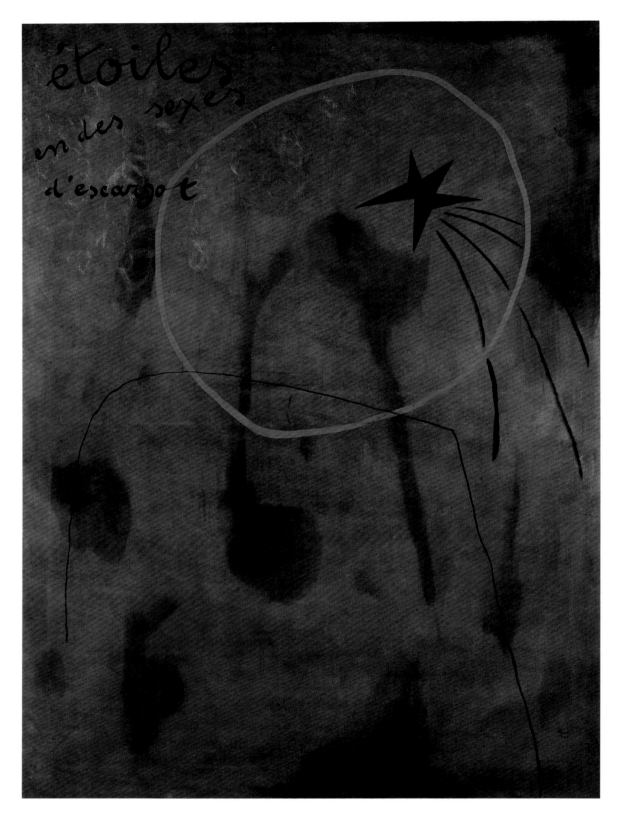

"**Étoiles en des sexes d'escargot.**" Montroig, late summer–fall 1925. (Cat. 50)
Oil on canvas, 51⅛ × 38⅛″ (129.5 × 97 cm)
Kunstsammlung Nordrhein-Westfalen, Düsseldorf

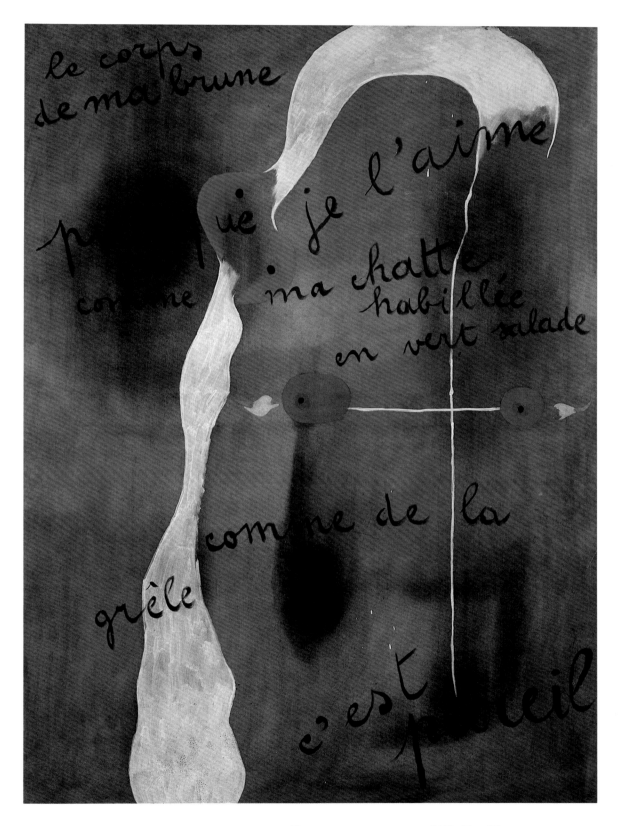

"Le Corps de ma brune . . ." Montroig, late summer–fall 1925. (Cat. 51)
Oil on canvas, 51⅛ × 37¾″ (129.8 × 95.8 cm)
Private collection

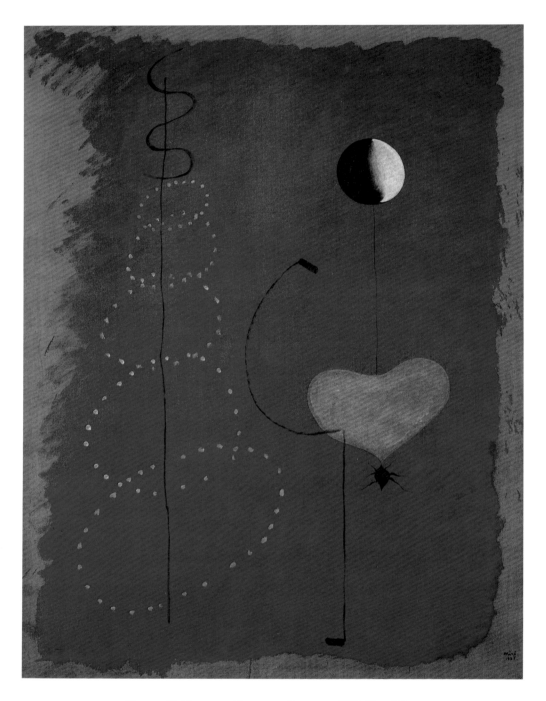

DANCER II. MONTROIG, NOVEMBER−DECEMBER 1925. (CAT. 52)
OIL ON CANVAS, 45½ × 34¾″ (115.5 × 88.5 CM)
COLLECTION A. ROSENGART

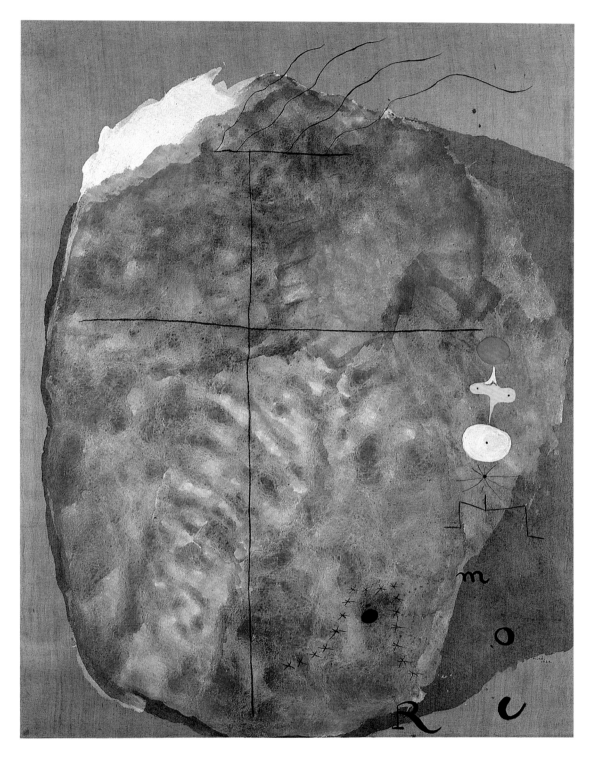

"Amour." Montroig or Paris, January–June 1926. (Cat. 53)
Oil on canvas, 57½ × 44⅞" (146 × 114 cm)
Museum Ludwig, Cologne

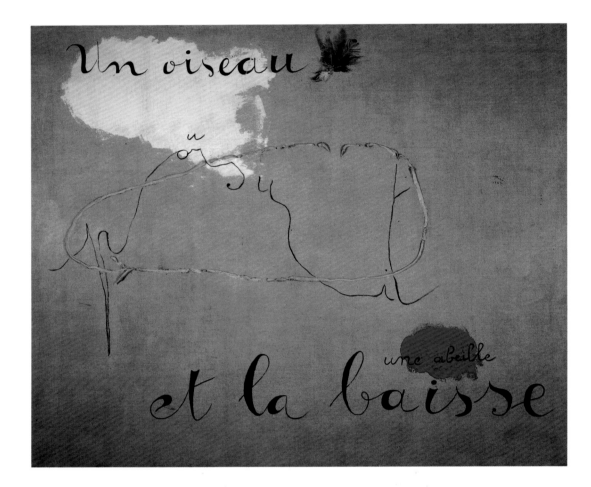

"Un Oiseau poursuit une abeille et la baisse." Paris, January–mid-February 1927. (Cat. 61)
Oil and feather on canvas, 32⅞ × 40¼″ (83.5 × 102 cm)
Private collection

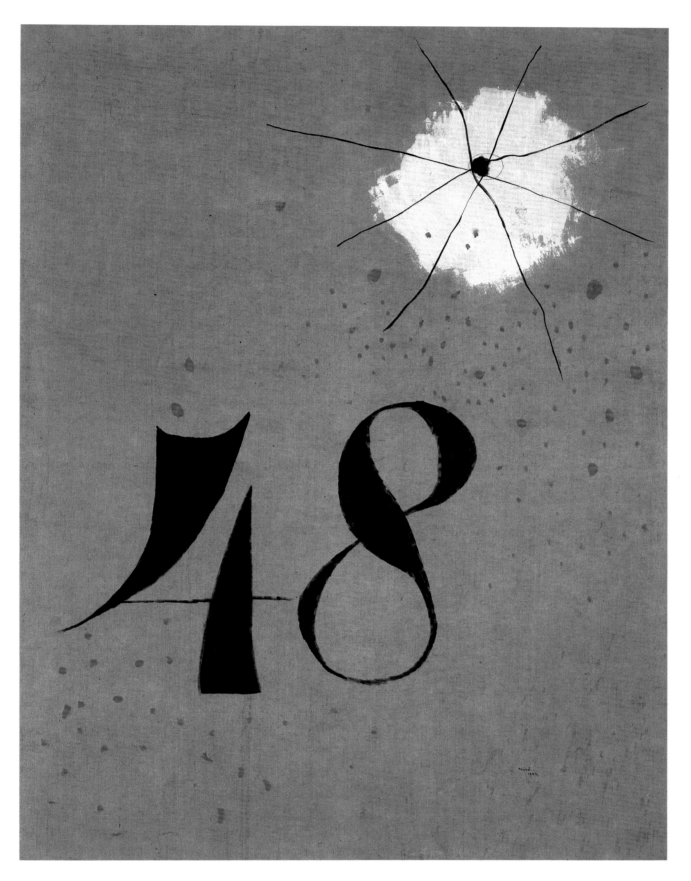

"48." Paris, January–mid-February 1927. (Cat. 60)
Oil and water-soluble paint on glue-sized canvas, 57½×45″ (146.1×114.2 cm)
Private collection

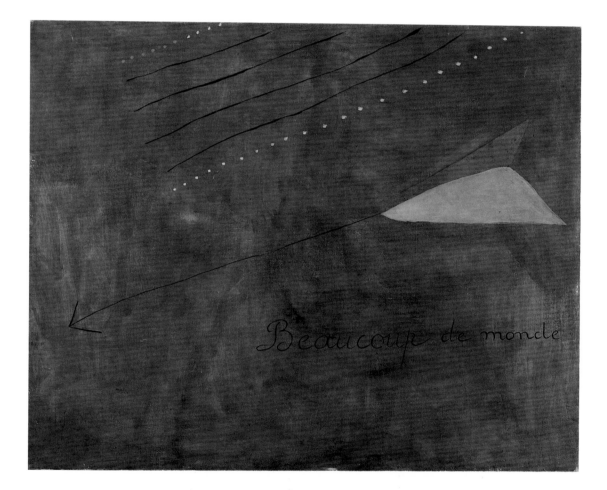

"Beaucoup de monde." Paris, January–mid-February 1927. (Cat. 63)
Oil and tempera on canvas, 32⅜ × 39⅜″ (82 × 100 cm)
Private collection, Switzerland

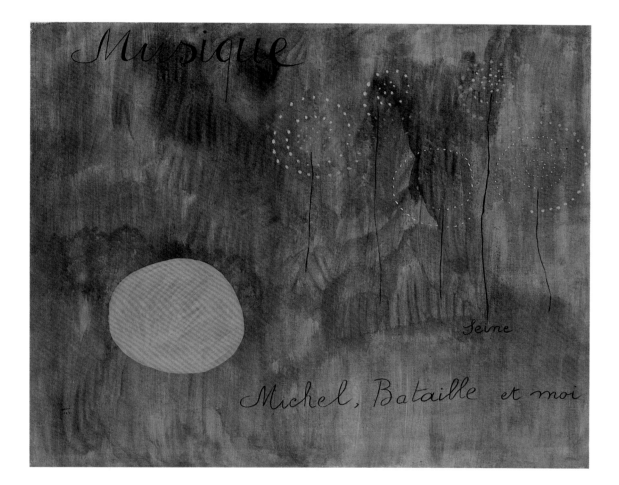

"Musique—Seine—Michel, Bataille et moi." Paris, January–mid-February 1927. (Cat. 62)
Oil on canvas, 31⅜ × 39½″ (79.5 × 100.5 cm)
Kunstmuseum Winterthur. Permanent loan from the Volkart Foundation since 1969

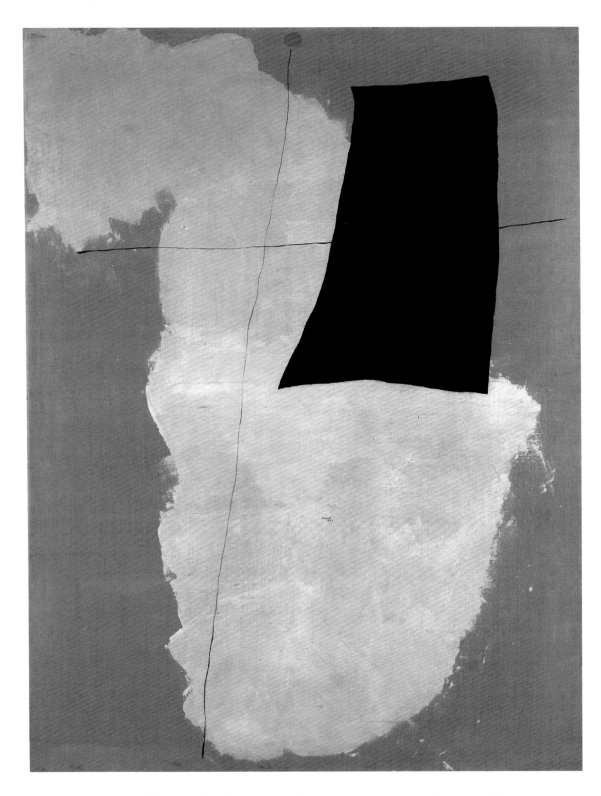

Painting (Untitled; The Bullfighter). Paris, January–mid-February 1927. (Cat. 64)
Oil on canvas, 50¾ × 38⅛″ (129 × 97 cm)
Musée d'Art Moderne, Villeneuve d'Ascq. Gift of Geneviève and Jean Masurel

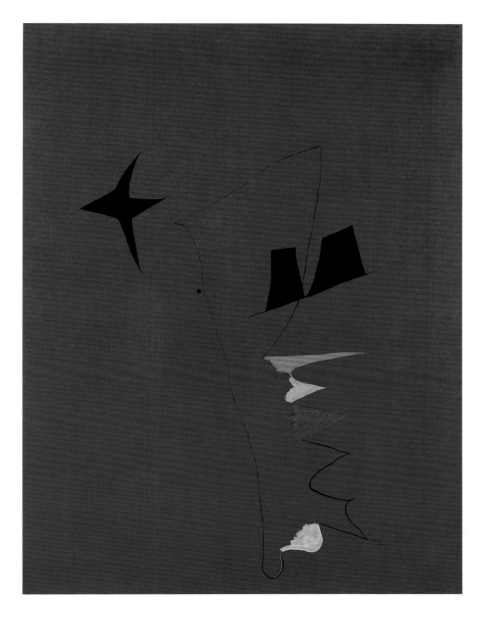

Painting (Blue). Paris, April–mid-May 1927. (Cat. 65)
Oil on canvas, 45⅝ × 35⅜″ (116 × 90 cm)
Collection Alfred Richet, Paris

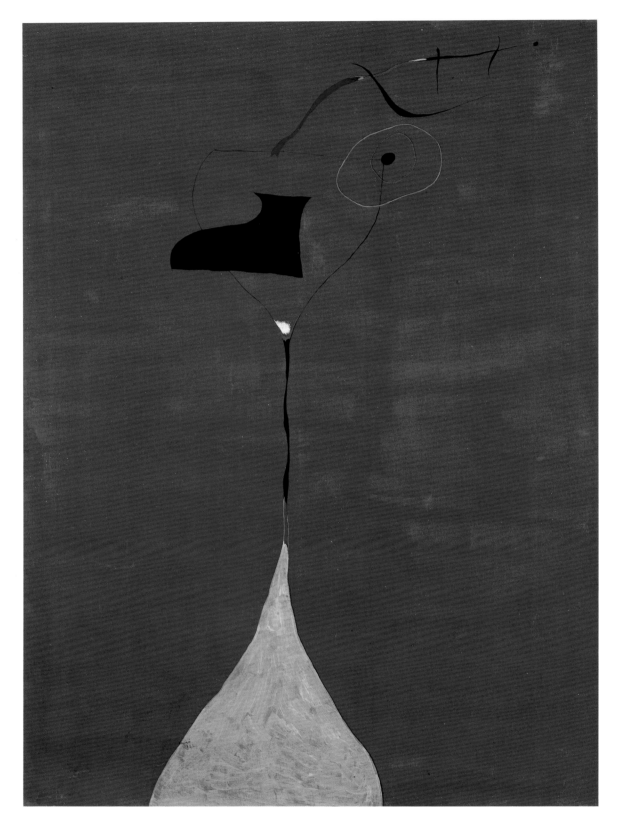

PAINTING (FRATELLINI; PERSONAGE). PARIS, APRIL–MID-MAY 1927. (CAT. 68)
OIL ON CANVAS, 51¼ × 38⅜″ (130 × 97.5 CM)
COLLECTION BEYELER, BASEL

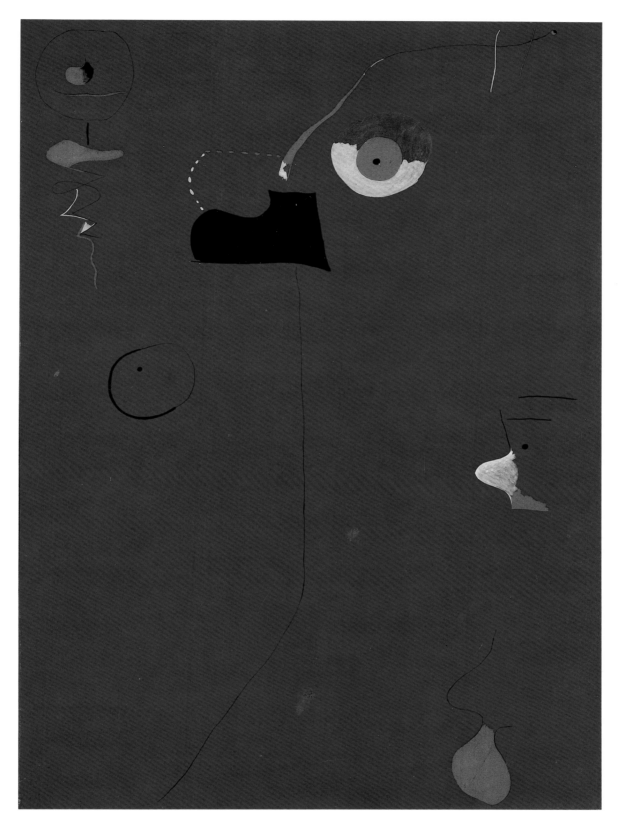

Painting (Fratellini; Three Personages). Paris, April–mid-May 1927. (Cat. 66)
Oil and aqueous medium on canvas, 51⅜ × 38⅜″ (130.5 × 97.5 cm)
Philadelphia Museum of Art. A. E. Gallatin Collection

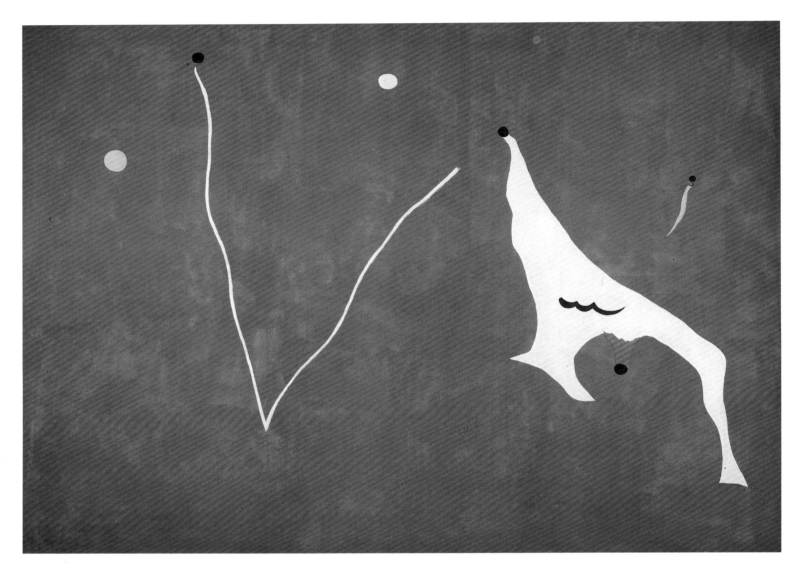

Painting (Circus Horse). Paris, winter or spring 1927. (Cat. 69)
Oil and pencil on burlap, 6′ 4¾″ × 9′ 2⅜″ (195 × 280.2 cm)
Hirshhorn Museum and Sculpture Garden, Smithsonian Institution, Washington, D.C.
Gift of the Joseph H. Hirshhorn Foundation, 1972

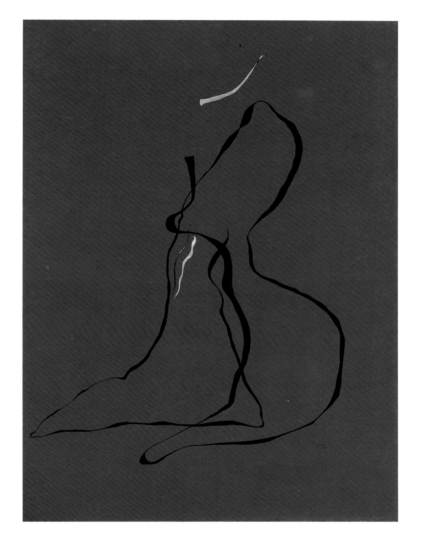

PAINTING (THE LASSO; CIRCUS HORSE). PARIS, APRIL–MID-MAY 1927. (CAT. 67)
OIL ON CANVAS, 51×38″ (129.5×96.5 CM)
FOGG ART MUSEUM, HARVARD UNIVERSITY ART MUSEUMS, CAMBRIDGE, MASSACHUSETTS.
GIFT OF MR. AND MRS. JOSEPH PULITZER, JR.

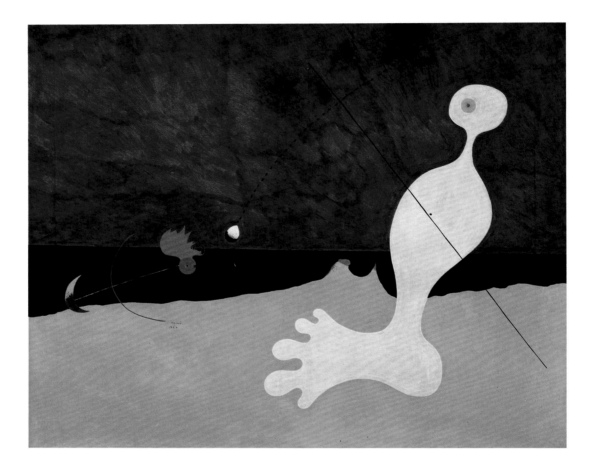

PERSON THROWING A STONE AT A BIRD. MONTROIG, MID-AUGUST–DECEMBER 1926. (CAT. 54)
OIL ON CANVAS, 29 × 36¼″ (73.7 × 92.1 CM)
THE MUSEUM OF MODERN ART, NEW YORK. PURCHASE

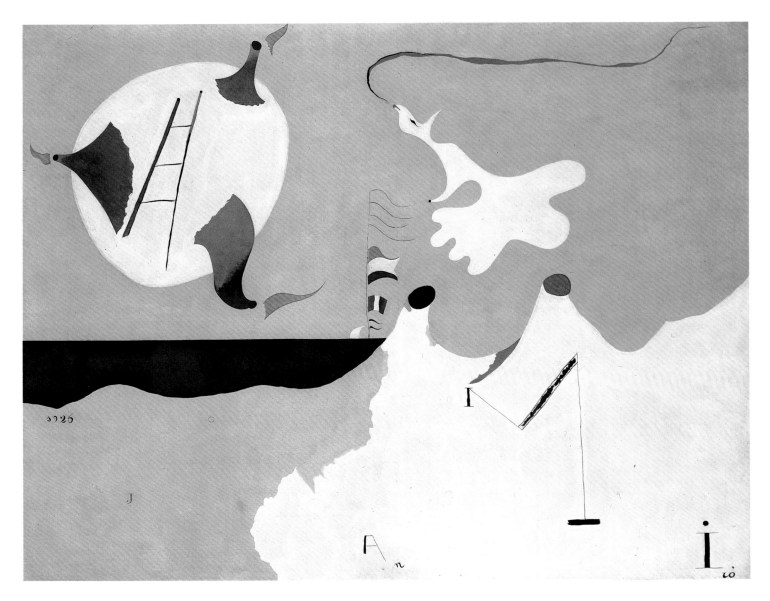

LANDSCAPE (THE GRASSHOPPER). MONTROIG, MID-AUGUST–DECEMBER 1926. (CAT. 57)
OIL ON CANVAS, 44⅞ × 57½″ (114 × 146 CM)
PRIVATE COLLECTION

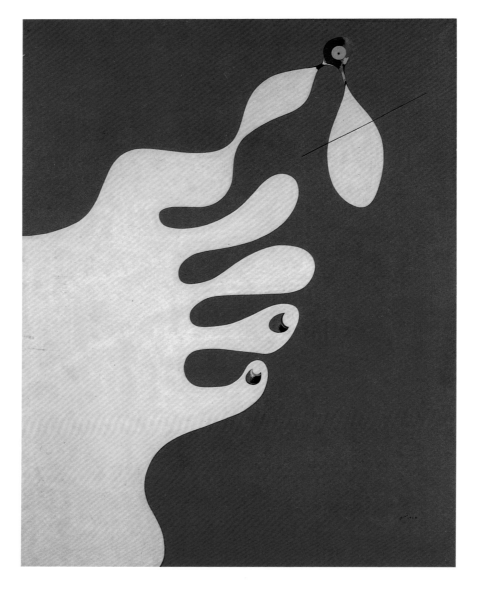

HAND CATCHING A BIRD. MONTROIG, MID-AUGUST–DECEMBER 1926. (CAT. 56)
OIL ON CANVAS, 36⅜ × 28¾″ (92.3 × 73 CM)
PRIVATE COLLECTION

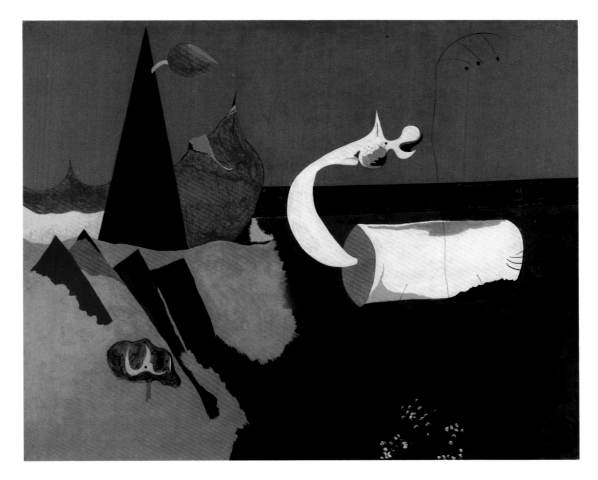

LANDSCAPE BY THE SEA (HORSE AT SEASHORE). MONTROIG, MID-AUGUST–DECEMBER 1926. (CAT. 55)
OIL ON CANVAS, 26 × 36⅝″ (66 × 93 CM)
PRIVATE COLLECTION

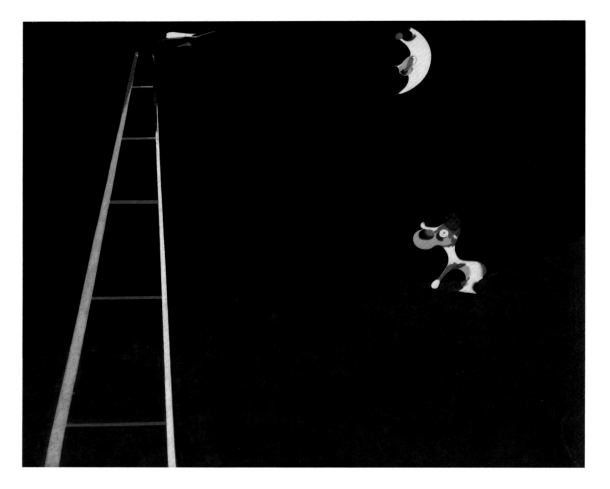

Dog Barking at the Moon. Montroig, mid-August–December 1926. (Cat. 58)
Oil on canvas, 28⅞ × 36½″ (73.3 × 92.7 cm)
Philadelphia Museum of Art. A. E. Gallatin Collection

NUDE. MONTROIG, MID-AUGUST–DECEMBER 1926. (CAT. 59)
OIL ON CANVAS, 36¼ × 28⅝″ (92 × 73.6 CM)
PHILADELPHIA MUSEUM OF ART. THE LOUISE AND WALTER ARENSBERG COLLECTION

LANDSCAPE (THE HARE). MONTROIG, LATE JULY–DECEMBER 1927. (CAT. 73)
OIL ON CANVAS, 51″ × 6′ 4⅝″ (129.6 × 194.6 CM)
SOLOMON R. GUGGENHEIM MUSEUM, NEW YORK

LANDSCAPE (LANDSCAPE WITH ROOSTER). MONTROIG, LATE JULY–DECEMBER 1927. (CAT. 70)
OIL ON CANVAS, 51⅛″ × 6′ 4¾″ (130×195 CM)
COLLECTION STEPHEN HAHN, NEW YORK

LANDSCAPE (LANDSCAPE WITH RABBIT AND FLOWER). MONTROIG, LATE JULY–DECEMBER 1927. (CAT. 72)
OIL ON CANVAS, 51⅛″ × 6′ 5″ (130 × 195.5 CM)
NATIONAL GALLERY OF AUSTRALIA, CANBERRA. PURCHASED 1983

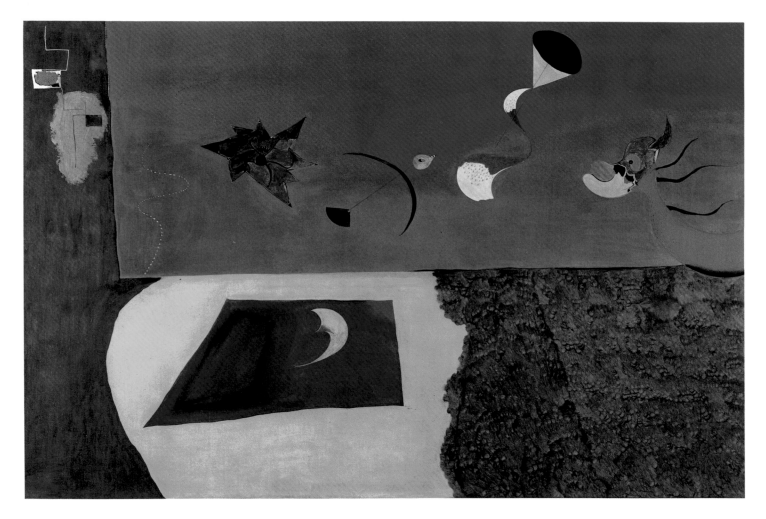

ANIMATED LANDSCAPE. MONTROIG, LATE JULY–DECEMBER 1927. (CAT. 71)
OIL ON CANVAS, 51″ × 6′ 4¾″ (129.5 × 195 CM)
THE JACQUES AND NATASHA GELMAN COLLECTION

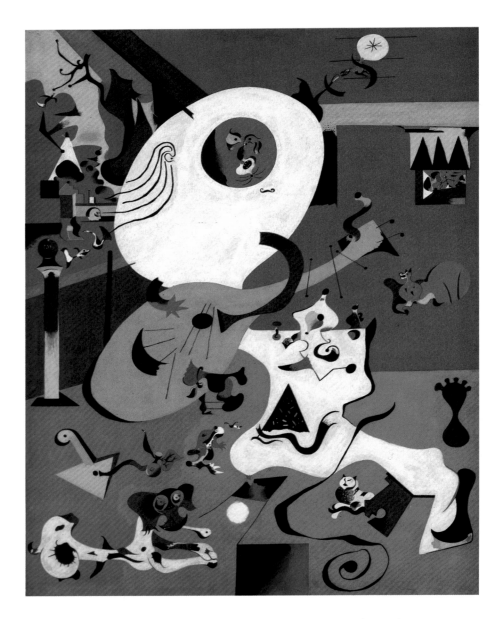

Dutch Interior (I). Montroig, July–December 1928. (Cat. 77)
Oil on canvas, 36⅛ × 28¾″ (91.8 × 73 cm)
The Museum of Modern Art, New York. Mrs. Simon Guggenheim Fund

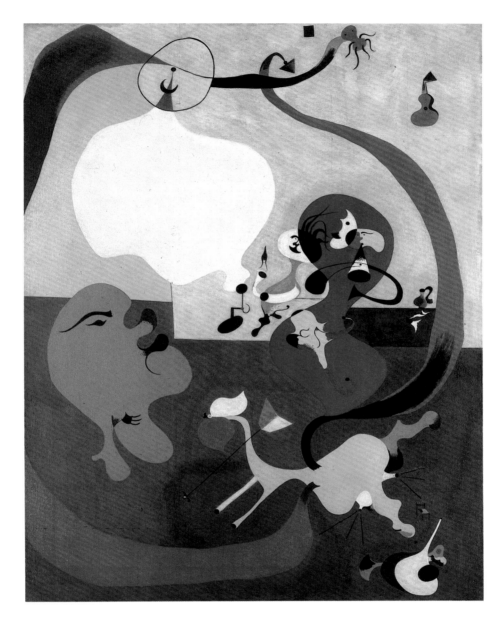

Dutch Interior (II). Montroig, July–December 1928. (Cat. 78)
Oil on canvas, 36¼ × 28¾″ (92 × 73 cm)
Solomon R. Guggenheim Museum, New York; Peggy Guggenheim Collection, Venice, 1976

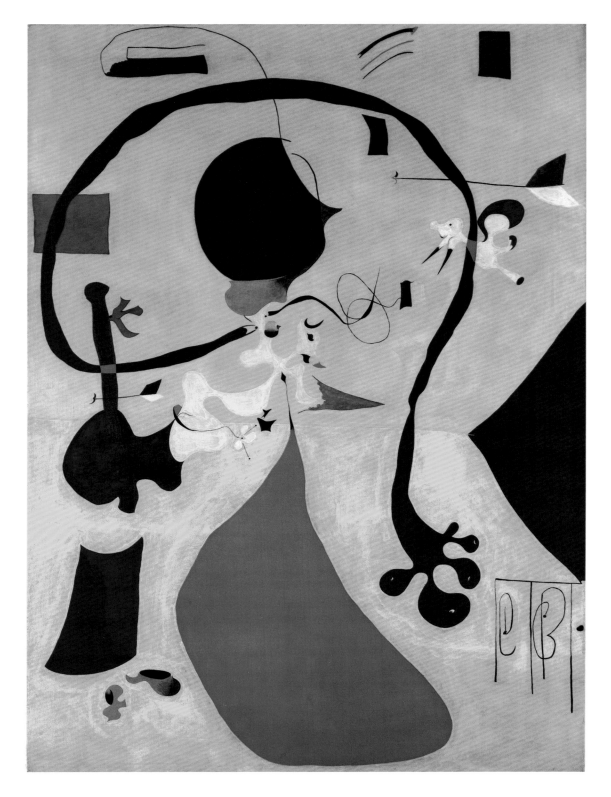

Dutch Interior (III). Montroig, July–December 1928. (Cat. 79)
Oil on canvas, 50¾ × 37⅞″ (128.9 × 96.2 cm)
The Metropolitan Museum of Art, New York. Anonymous loan

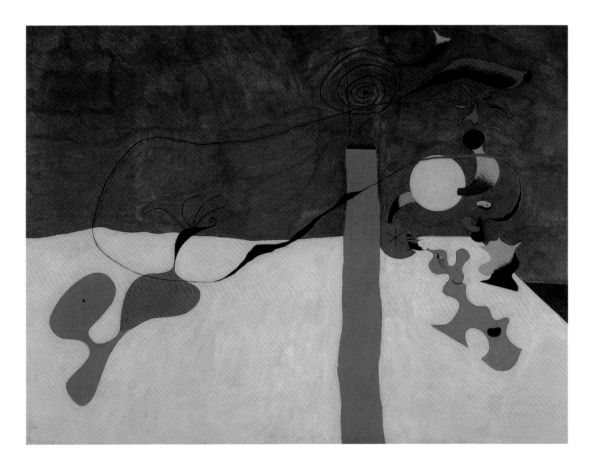

STILL LIFE (STILL LIFE WITH LAMP). MONTROIG, JULY–DECEMBER 1928. (CAT. 81)
OIL ON CANVAS, 35 × 44⅞″ (89 × 114 CM)
PRIVATE COLLECTION

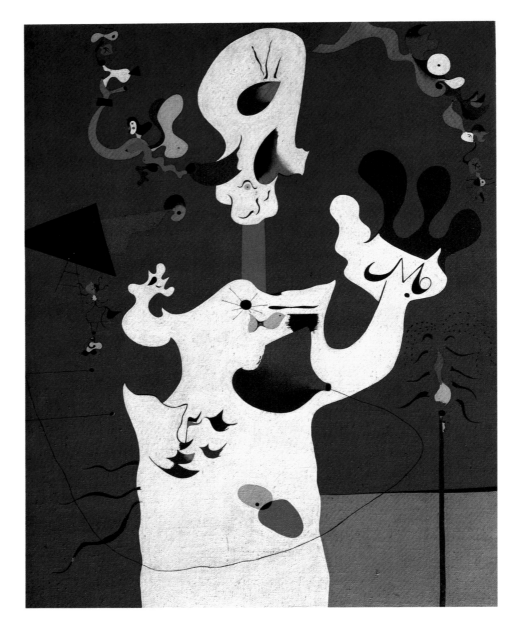

POTATO. MONTROIG, JULY−DECEMBER 1928. (CAT. 80)
OIL ON CANVAS, 39¾×32⅛″ (101×81.7 CM)
THE JACQUES AND NATASHA GELMAN COLLECTION

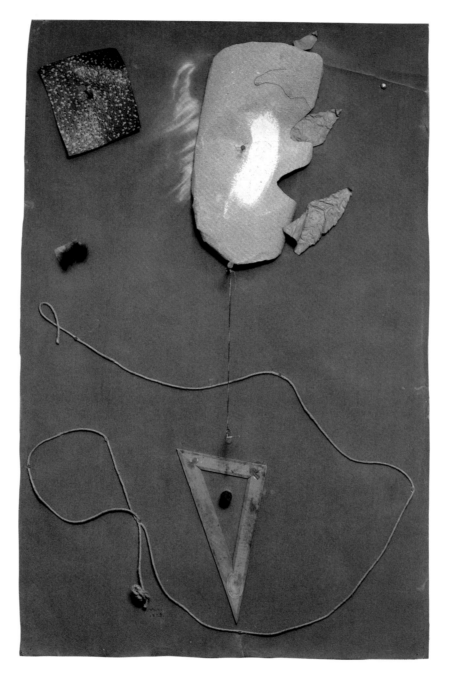

Spanish Dancer. Paris, mid-February–spring 1928. (Cat. 75)
Sandpaper, paper, string, nails, hair, architect's triangle, and paint on sandpaper
mounted on linoleum, 43⅛ × 28″ (109.5 × 71.1 cm)
The Morton G. Neumann Family Collection

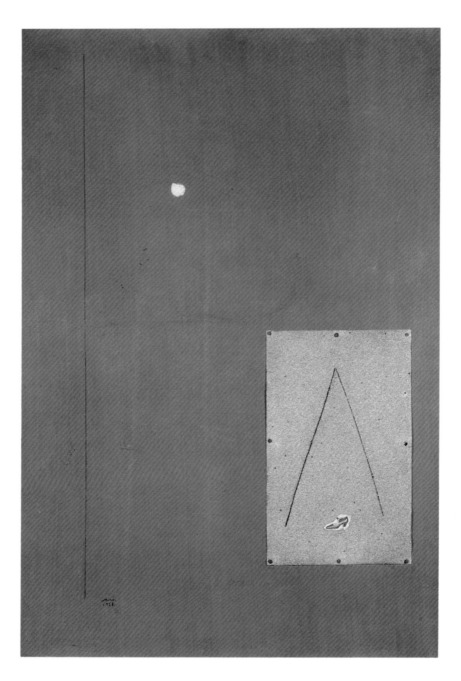

Spanish Dancer I. Paris, mid-February–spring 1928. (Cat. 74)
Collage, sandpaper, and oil on wood, 41⅜ × 29″ (105 × 73.5 cm)
Museo Nacional Reina Sofía, Madrid

Spanish Dancer. Paris, mid-February–spring 1928. (Cat. 76)
Collage-object with feather and hatpin, 39⅜ × 31½″ (100 × 80 cm)
Private collection

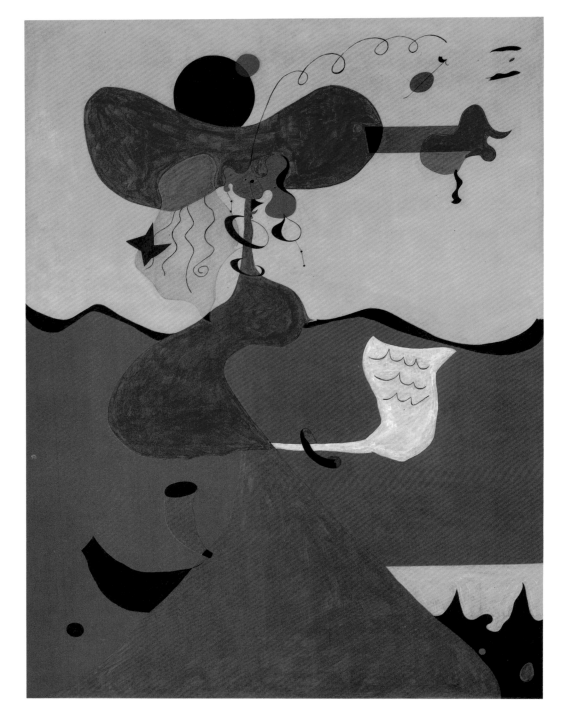

PORTRAIT OF MISTRESS MILLS IN 1750. PARIS, WINTER–SPRING 1929. (CAT. 82)
OIL ON CANVAS, 46 × 35¼″ (116.7 × 89.6 CM)
THE MUSEUM OF MODERN ART, NEW YORK. JAMES THRALL SOBY BEQUEST

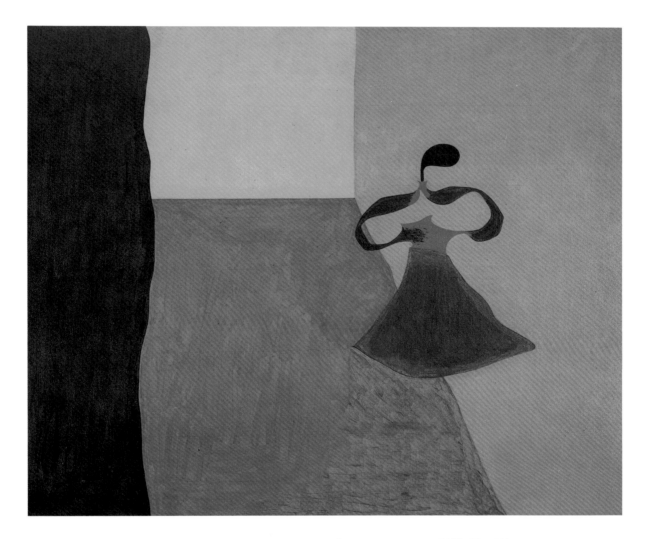

PORTRAIT OF QUEEN LOUISE OF PRUSSIA. PARIS, WINTER–SPRING 1929. (CAT. 83)
OIL ON CANVAS, 31¾ × 39¼″ (80.6 × 99.6 CM)
ALGUR H. MEADOWS COLLECTION, MEADOWS MUSEUM, SOUTHERN METHODIST UNIVERSITY, DALLAS

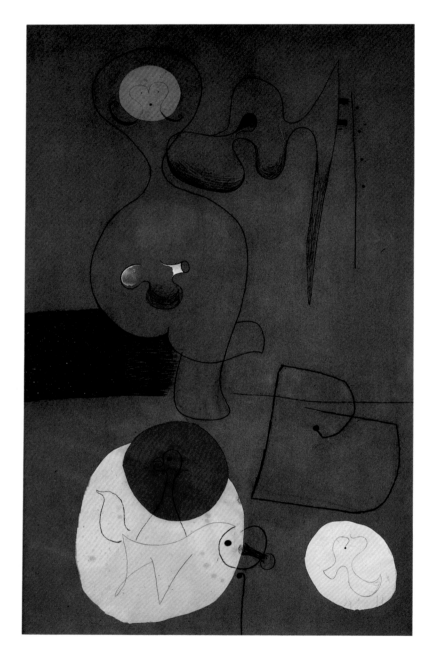

COLLAGE. MONTROIG, LATE JULY–EARLY OCTOBER 1929. (CAT. 87)
INK, CHARCOAL, PASTEL, PENCIL, AND PASTED PAPERS ON PAPER, 42⅛ × 28″ (107 × 71 CM)
PRIVATE COLLECTION, PARIS

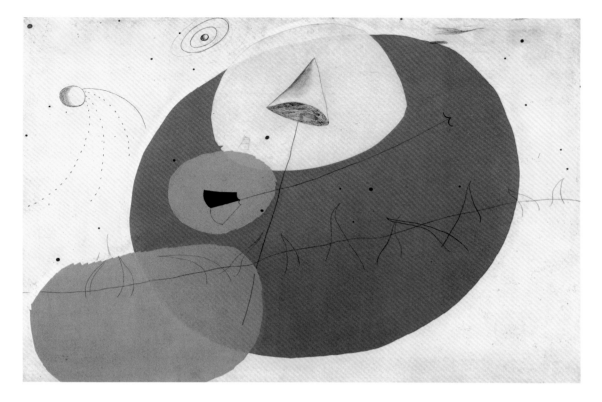

COLLAGE. Montroig, late July–early October 1929. (Cat. 85)
Pencil, ink, and collage on paper, 25 × 38⅝″ (63.5 × 98.1 cm)
Collection Richard and Mary L. Gray

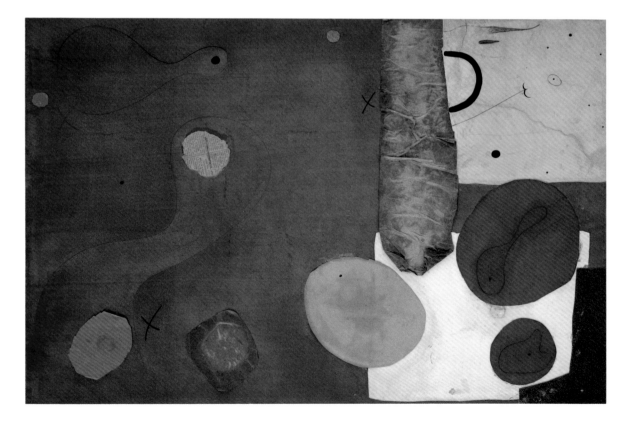

COLLAGE. Montroig, late July–early October 1929. (Cat. 86)
Pastel, ink, watercolor, crayon, and pasted papers on paper, 28⅝ × 42¾″ (72.7 × 108.4 cm)
The Museum of Modern Art, New York. James Thrall Soby Fund

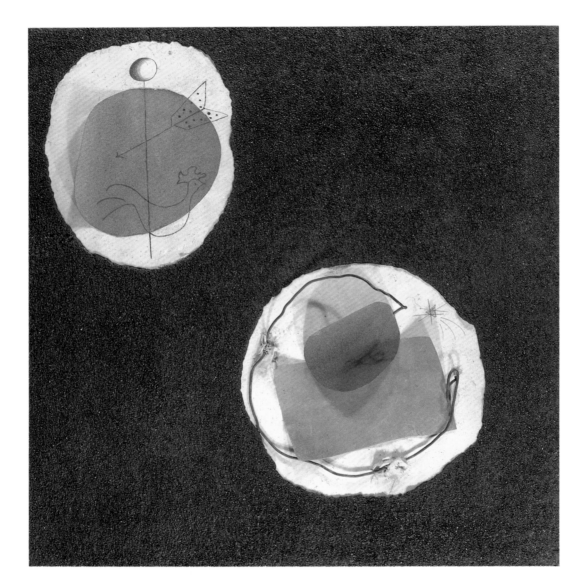

COLLAGE. MONTROIG, LATE JULY–EARLY OCTOBER 1929. (CAT. 84)
INK, BLACK SANDPAPER, INGRES PAPER, WIRE, AND FABRIC ON PLYWOOD, $42\frac{1}{8} \times 42\frac{1}{8}''$ (107×107 CM)
PRIVATE COLLECTION

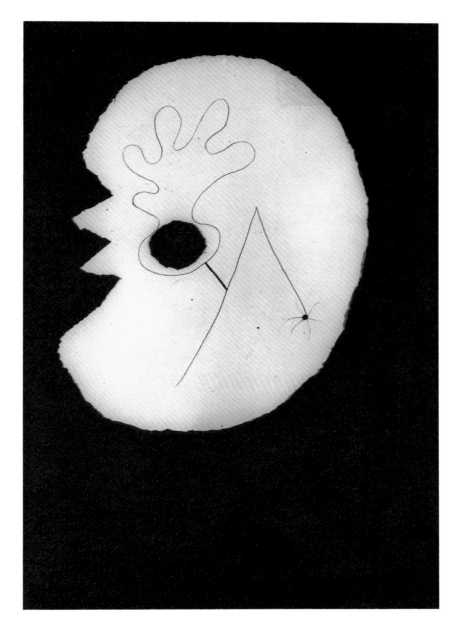

COLLAGE (HEAD OF GEORGES AURIC). MONTROIG, LATE JULY–EARLY OCTOBER 1929. (CAT. 88)
TARBOARD, CHALK, AND PENCIL ON PAPER, 43⅜ × 29½″ (110 × 75 CM)
KUNSTHAUS ZÜRICH. GIFT OF DR. GEORGES AND JOSI GUGGENHEIM, 1976

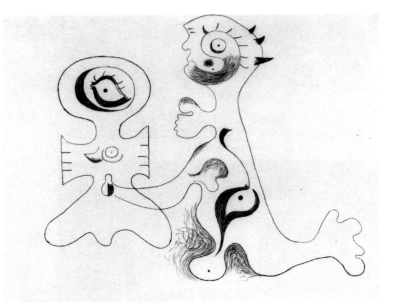

THE LOVERS. 1930. (APP. 9)
PENCIL AND INK ON PAPER, 18¾×24½″ (47.6×62.2 CM)
THE MORTON G. NEUMANN FAMILY COLLECTION

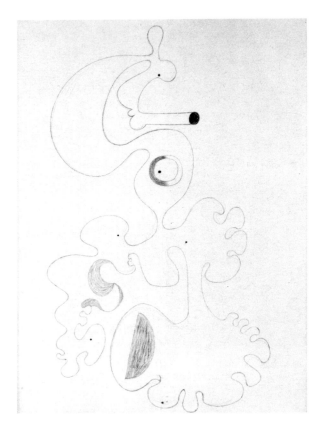

UNTITLED. MONTROIG, AUGUST 23–25, 1930. (APP. 10)
PENCIL ON INGRES PAPER, 24¾×18⅜″ (63×46.5 CM)
PRIVATE COLLECTION, FRANCE

UNTITLED. MONTROIG, AUGUST 30, 1930. (APP. 11)
PENCIL ON PAPER, 24×17½″ (61×44.5 CM)
OHARA MUSEUM OF ART, KURASHIKI, JAPAN

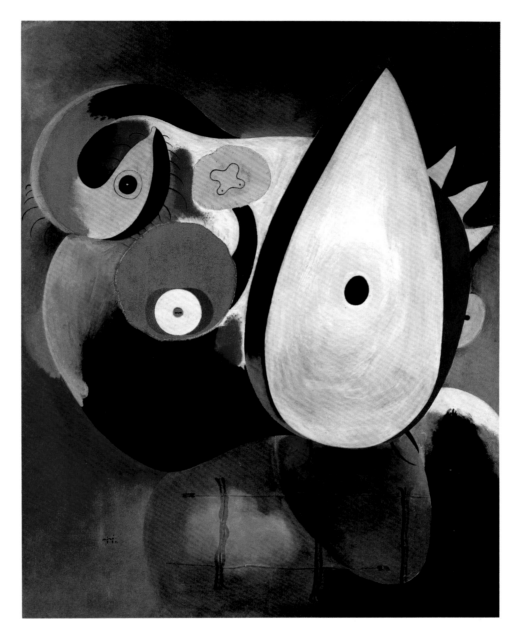

Human Head. Paris, May 1931. (Cat. 94)
Oil and collage on canvas, 31⅞ × 25⅝″ (81 × 65 cm)
Private collection

Construction. Montroig, August–November 1930. (Cat. 91)
Wood and metal, 35¾ × 28 × 14½″ (91 × 71 × 37 cm)
Private collection, Paris

RELIEF CONSTRUCTION. MONTROIG, AUGUST–NOVEMBER 1930. (CAT. 92)
WOOD AND METAL, 35⅞ × 27⅝ × 6⅜″ (91.1 × 70.2 × 16.2 CM)
THE MUSEUM OF MODERN ART, NEW YORK. PURCHASE

PAINTING. PARIS, JANUARY–APRIL 1930. (CAT. 89)
OIL, PLASTER, AND CHARCOAL ON CANVAS, 7′ 6½″ × 59″ (230 × 150 CM)
COLLECTION BEYELER, BASEL

PAINTING (UNTITLED). PARIS, JANUARY–APRIL 1930. (CAT. 90)
OIL ON CANVAS, 59⅛″ × 7′ 4⅝″ (150.5 × 225 CM)
THE MENIL COLLECTION, HOUSTON

OBJECT. [MONTROIG, MID-SUMMER–MID-FALL] 1931. (CAT. 95)
ASSEMBLAGE: PAINTED WOOD, STEEL, STRING, BONE, AND A BEAD, 15¾ × 11¾ × 8⅝″ (40 × 29.7 × 22 CM)
THE MUSEUM OF MODERN ART, NEW YORK. GIFT OF MR. AND MRS. HAROLD X. WEINSTEIN

OBJECT. [MONTROIG,
MID-SUMMER–MID-FALL]
1931. (CAT. 96)
PAINTED WOOD, INSULATOR, SCREW,
BURNT WOOD, SAND, AND CLOCKWORKS,
10⅝ × 5⅜ × 2⅝″ (26.9 × 13.6 × 6.6 CM)
PRIVATE COLLECTION, PARIS

MAN AND WOMAN. PARIS, MARCH 1931. (CAT. 93)
OIL ON WOOD, WITH METAL PARTS, 13⅜ × 7¼ × 2¼″ (33.9 × 18.4 × 5.7 CM)
PRIVATE COLLECTION

OBJECT (The Door). [Montroig, mid-summer–mid-fall 1931]. (Cat. 97)
Painted wood, metal, feathers, and other found objects, 44⅞×28¾″ (113.9×73 cm)
Collection Mr. and Mrs. A. Alfred Taubman

OBJECT. 1932. (Cat. 105)
Painted stone, shell, wood, mirror, and sequins, 9¾×22″ (24.8×55.9 cm)
Philadelphia Museum of Art. A. E. Gallatin Collection

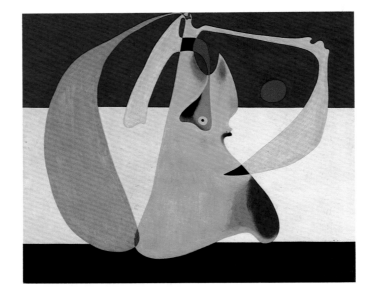

BATHER. [MONTROIG], OCTOBER 1932. (CAT. 102)
OIL AND PENCIL ON WOOD, 14½ × 18″ (35.8 × 45.7 CM)
THE MUSEUM OF MODERN ART, NEW YORK. FRACTIONAL GIFT OF CELESTE AND ARMAND P. BARTOS

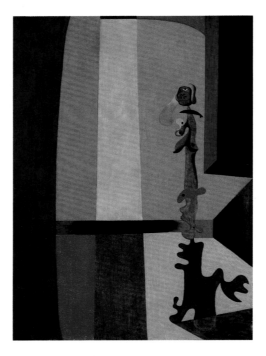

PERSONAGE. MONTROIG, AUGUST 1932. (CAT. 99)
OIL ON WOOD, 10¾ × 7⅞″ (27 × 20 CM)
THE ART INSTITUTE OF CHICAGO. GIFT OF MARY AND LEIGH BLOCK

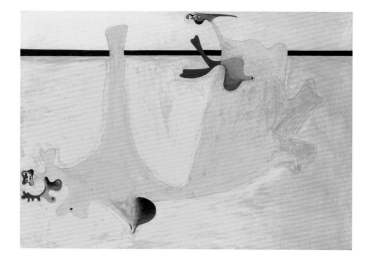

WOMEN RESTING. MONTROIG, AUGUST 1932. (CAT. 98)
OIL ON WOOD, 9½ × 13⅛″ (24.1 × 33.3 CM)
PRIVATE COLLECTION

FLAME IN SPACE AND NUDE WOMAN. 1932. (CAT. 103)
OIL ON WOOD, 16⅛ × 12⅝″ (41 × 32 CM)
FUNDACIÓ JOAN MIRÓ, BARCELONA

Right:
SEATED WOMAN. [MONTROIG], OCTOBER 1932. (CAT. 101)
OIL ON WOOD, 18¼ × 15″ (46 × 38.1 CM)
PRIVATE COLLECTION

Below:
GIRL PRACTICING PHYSICAL CULTURE. 1932. (CAT. 104)
OIL ON WOOD, 16⅛ × 12⅝″ (41 × 32 CM)
COLLECTION ERNA AND CURT BURGAUER

HEAD OF A MAN. MONTROIG, SEPTEMBER 1932. (CAT. 100)
OIL ON WOOD, 13¾ × 10⅝″ (35 × 27 CM)
PRIVATE COLLECTION, BARCELONA

Painting (Composition). Barcelona, March 8, 1933. (Cat. 106)
Oil and aqueous medium on canvas, 51⅜ × 64¼″ (130.5 × 163.2 cm)
Philadelphia Museum of Art. A. E. Gallatin Collection

PAINTING (COMPOSITION). BARCELONA, MARCH 31, 1933. (CAT. 107)
OIL ON CANVAS, 51×63½″ (129.5×161.5 CM)
KUNSTMUSEUM BERN

Painting (Composition). Barcelona, April 12, 1933. (Cat. 108)
Oil on canvas, 51⅛ × 64″ (130 × 162.5 cm)
National Gallery, Prague

PAINTING (COMPOSITION). BARCELONA, JUNE 13, 1933. (CAT. 109)
OIL ON CANVAS, 68½″ × 6′ 5¼″ (174 × 196.2 CM)
THE MUSEUM OF MODERN ART, NEW YORK. LOULA D. LASKER BEQUEST (BY EXCHANGE)

COLLAGE. BARCELONA, JANUARY 20, 1934. (CAT. 116)
CORRUGATED CARDBOARD, FELT, GOUACHE, AND
PENCIL ON SANDPAPER, 14½ × 9¼″ (36.9 × 23.6 CM)
THE MUSEUM OF MODERN ART, NEW YORK.
JAMES THRALL SOBY BEQUEST

DRAWING-COLLAGE. [MONTROIG], SEPTEMBER 22, 1933. (CAT. 110)
BLACK CHALK WITH COLLAGED POSTCARD AND BOTANICAL PRINTS
ON CREAM LAID PAPER, 24¾ × 18½″ (62.8 × 46.9 CM)
PRIVATE COLLECTION

DRAWING-COLLAGE. [MONTROIG], SEPTEMBER 25, 1933. (CAT. 111)
CONTÉ AND PASTED PAPER ON TAN PASTEL PAPER, 42 × 27½″ (106.7 × 69.9 CM)
THE MORTON G. NEUMANN FAMILY COLLECTION

COLLAGE (HOMAGE TO PRATS). MONTROIG, AUGUST 1934. (CAT. 117)
COLLAGE AND PENCIL ON PAPER, 25 × 18½″ (63.3 × 47 CM)
FUNDACIÓ JOAN MIRÓ, BARCELONA

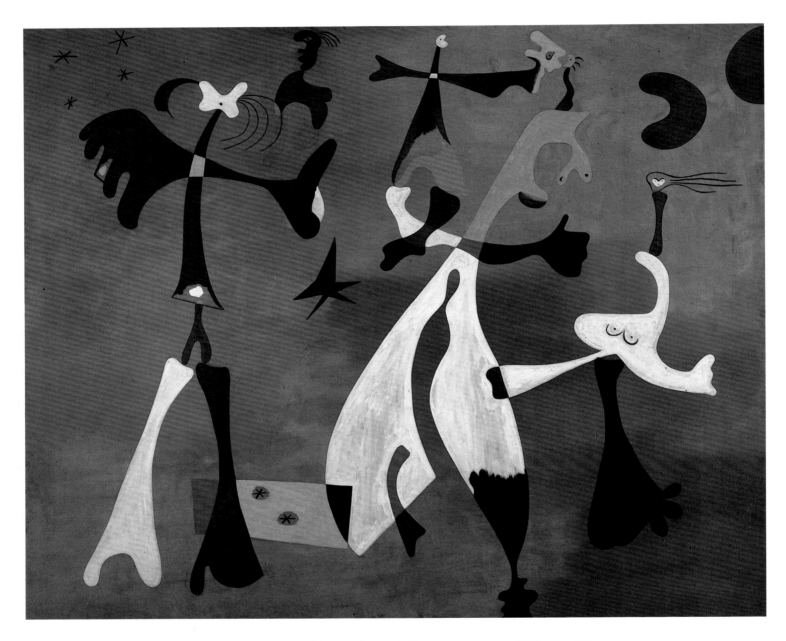

Personages with Star (Tapestry Cartoon). [Barcelona, late fall 1933]. (Cat. 112)
Oil on canvas, 6′ 6¼″ × 8′ 1½″ (198.8 × 247.7 cm)
The Art Institute of Chicago. Gift of Mr. and Mrs. Maurice E. Culberg

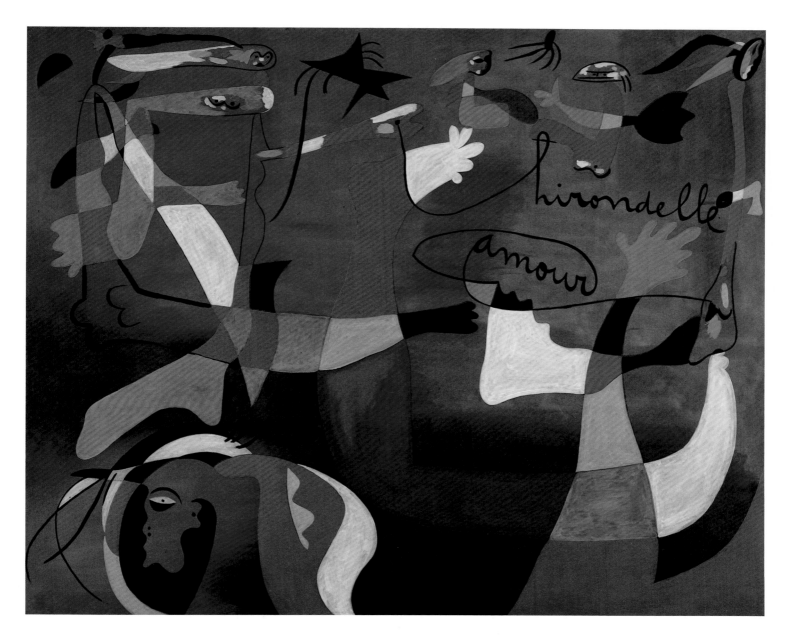

"Hirondelle—Amour" (Tapestry Cartoon). [Barcelona, late fall 1933–winter 1934]. (Cat. 114)
Oil on canvas, 6′ 6½″ × 8′ 1½″ (199.3 × 247.6 cm)
The Museum of Modern Art, New York. Gift of Nelson A. Rockefeller

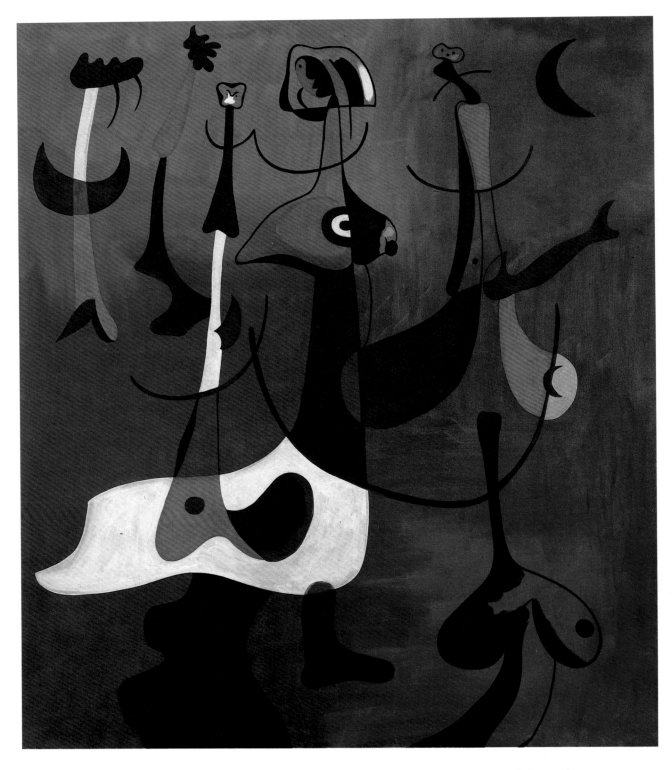

RHYTHMIC PERSONAGES (TAPESTRY CARTOON). [BARCELONA, LATE FALL 1933–WINTER 1934]. (CAT. 113)
OIL ON CANVAS, 6′ 4″ × 67⅜″ (193 × 171 CM)
KUNSTSAMMLUNG NORDRHEIN-WESTFALEN, DÜSSELDORF

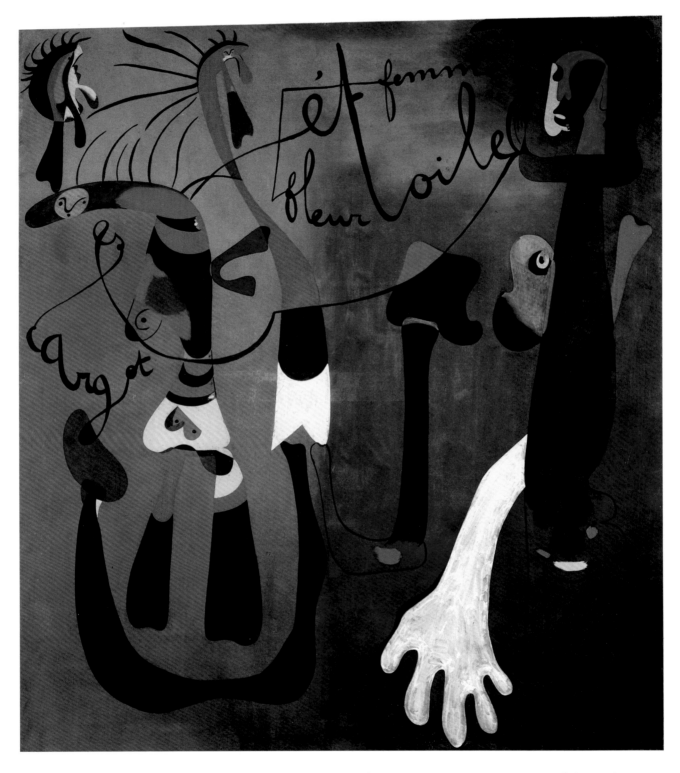

"Escargot—Femme—Fleur—Etoile" (Tapestry Cartoon). [Barcelona, late fall 1933–winter 1934]. (Cat. 115)
Oil on canvas, 6′ 4¾″ × 67⅝″ (195 × 172 cm)
Museo del Prado, Madrid

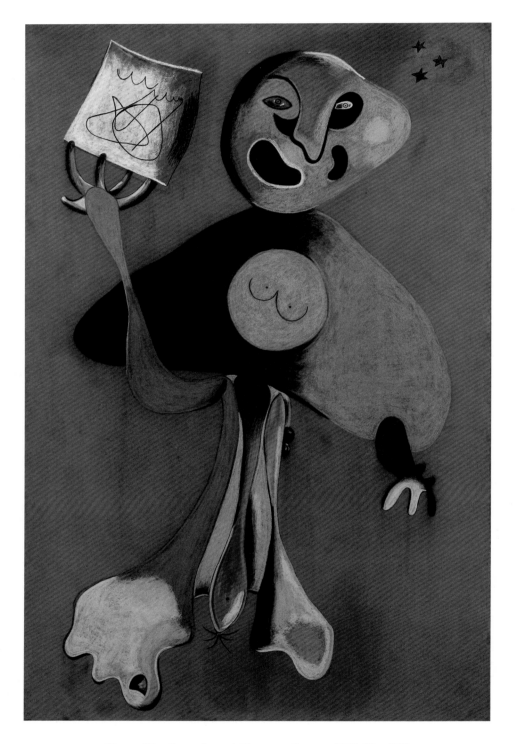

WOMAN (THE OPERA SINGER). MONTROIG, OCTOBER 1934. (CAT. 119)
PASTEL AND PENCIL ON ABRASIVE PAPER, 41⅜ × 29⅛″ (105.1 × 74.2 CM)
THE MUSEUM OF MODERN ART, NEW YORK. GIFT OF WILLIAM H. WEINTRAUB

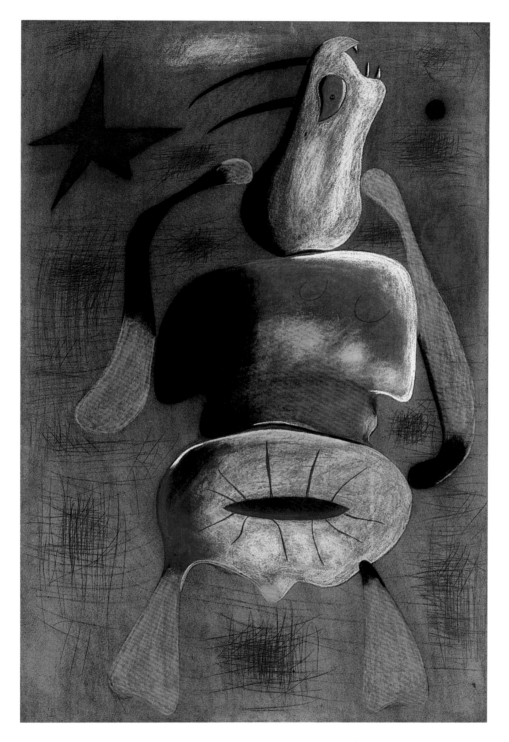

WOMAN. MONTROIG, OCTOBER 1934. (CAT. 118)
PASTEL ON ABRASIVE PAPER, 41⅜ × 29½″ (105 × 74.9 CM)
COLLECTION RICHARD S. ZEISLER

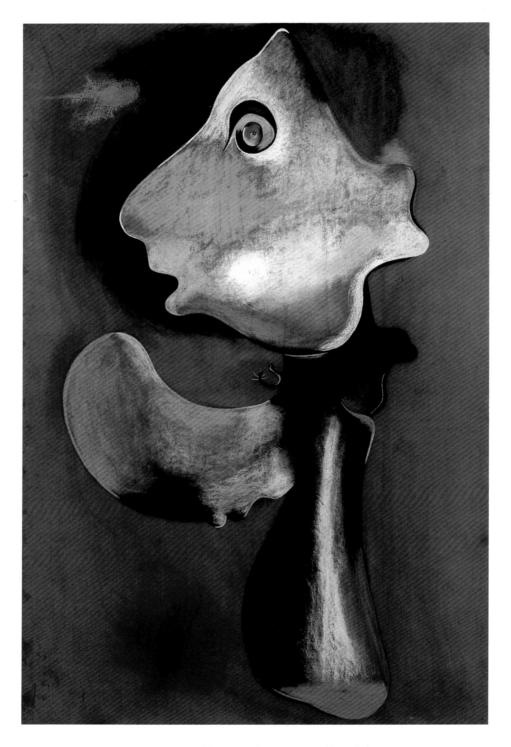

PERSONAGE. MONTROIG, OCTOBER 1934. (CAT. 120)
PASTEL ON ABRASIVE PAPER, 41¾×27⅞″ (106×69.5 CM)
PRIVATE COLLECTION

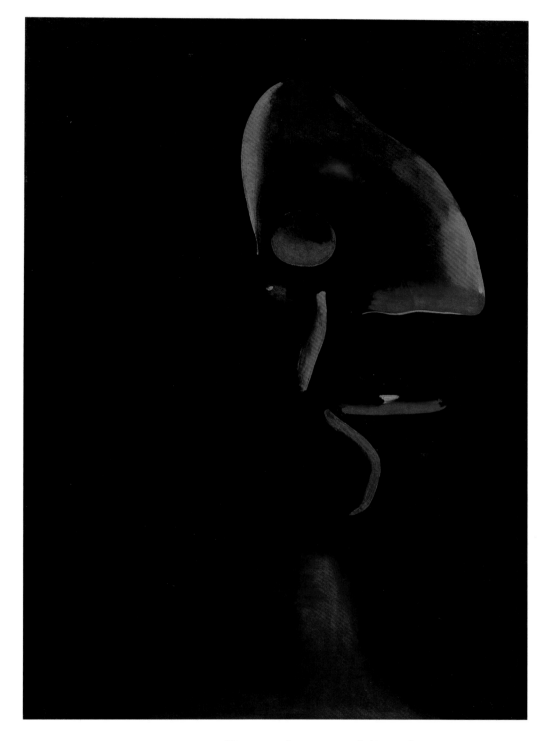

HEAD OF A MAN. [BARCELONA, JANUARY 2, 1935]. (CAT. 121)
OIL ON CARDBOARD MOUNTED ON WOOD, 41½ × 29⅝″ (105.5 × 75.3 CM)
MUSÉE NATIONAL D'ART MODERNE, CENTRE GEORGES POMPIDOU, PARIS. GIFT, 1991

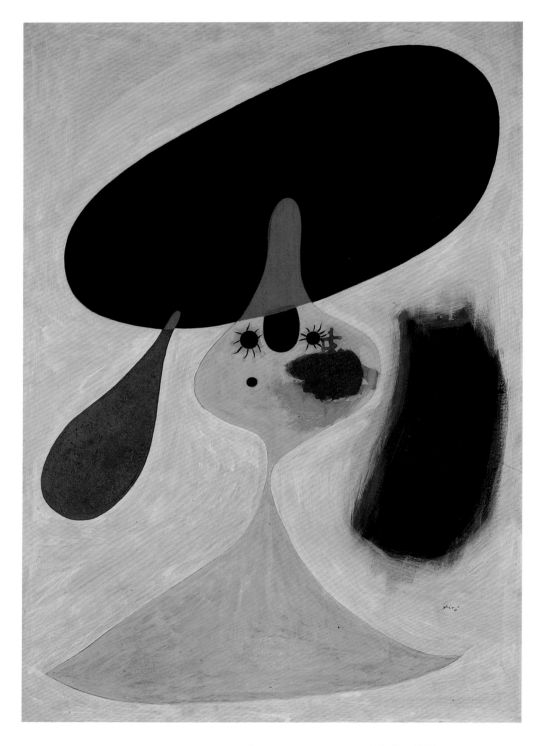

Portrait of a Young Girl. Barcelona, February 1, 1935. (Cat. 122)
Oil with sand on cardboard, 41⅜ × 29⅜″ (104.6 × 74.6 cm)
New Orleans Museum of Art. Bequest of Victor K. Kiam

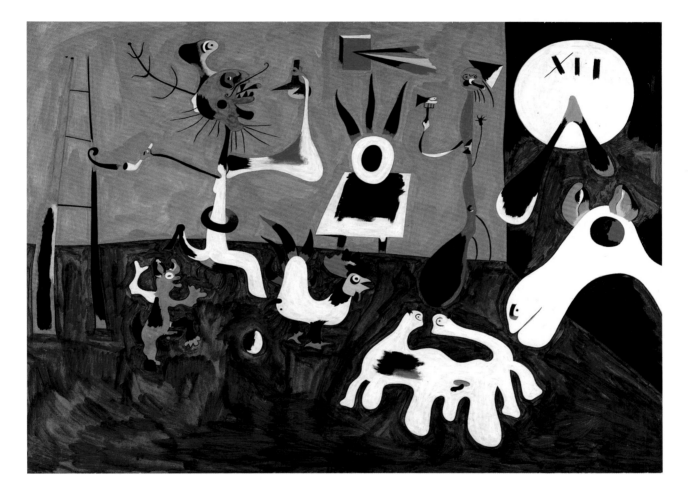

THE FARMERS' MEAL. [BARCELONA, MARCH 3, 1935]. (CAT. 123)
OIL ON CARDBOARD, 28¾ × 41″ (73 × 104.2 CM)
PRIVATE COLLECTION

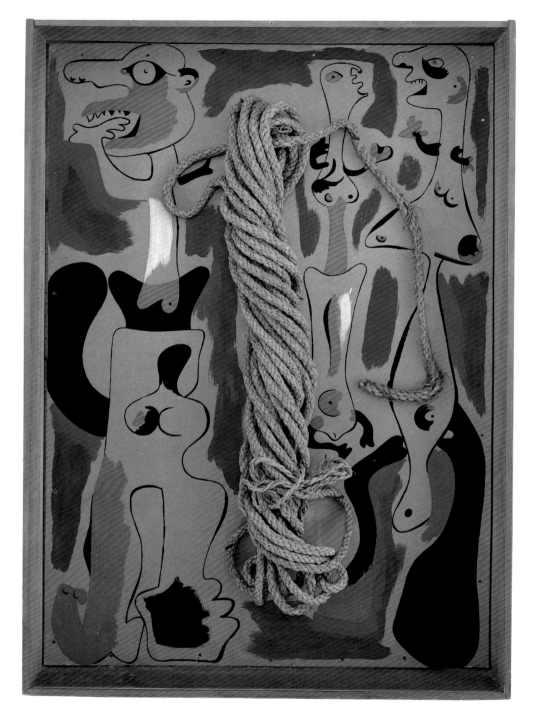

Rope and People, I. Barcelona, March 27, 1935. (Cat. 124)
Oil on cardboard mounted on wood, with coil of rope, 41¼ × 29⅜″ (104.7 × 74.6 cm)
The Museum of Modern Art, New York. Gift of the Pierre Matisse Gallery

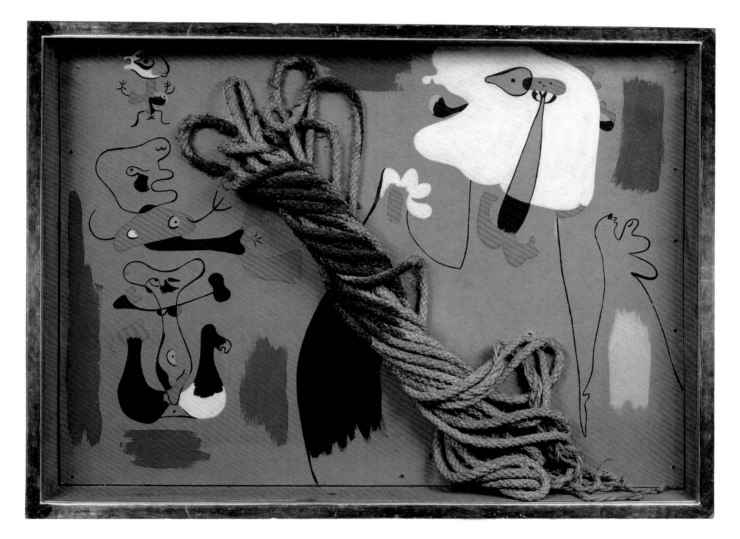

ROPE AND PEOPLE, II. BARCELONA, MARCH 29, 1935. (CAT. 125)
OIL AND ROPE ON CARDBOARD, 29⅜×41¾″ (74.6×106.1 CM)
THE MORTON G. NEUMANN FAMILY COLLECTION

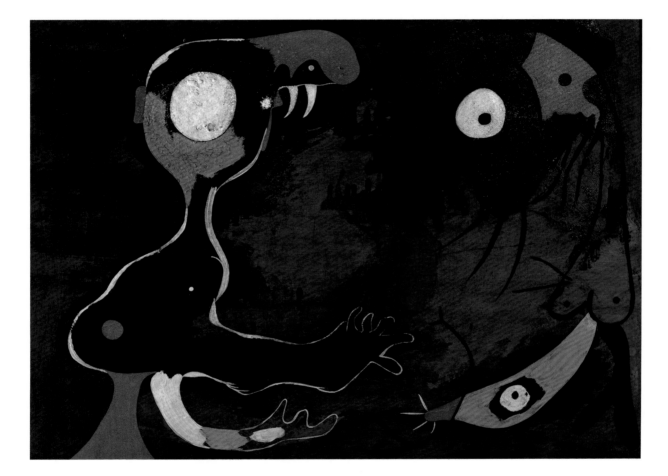

Two Women. [Barcelona, April 13, 1935]. (Cat. 127)
Oil and sand on cardboard, 29½×41⅜″ (75×105 cm)
Sprengel Museum, Hannover

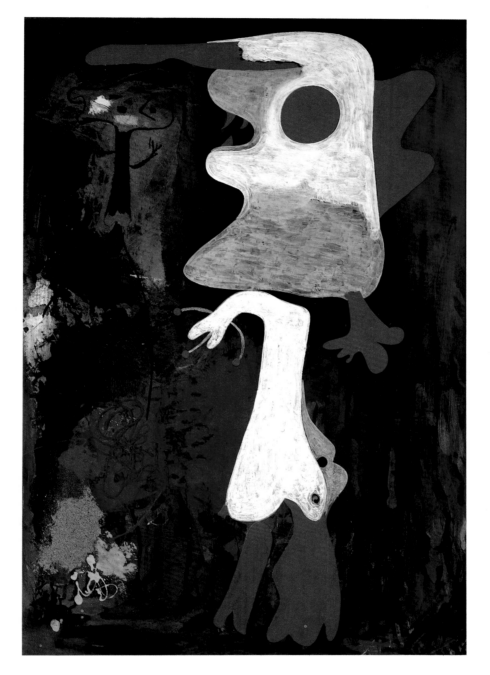

TWO PERSONAGES. [BARCELONA, APRIL 10, 1935]. (CAT. 126)
OIL, NAILS, CHEESECLOTH, STRING, AND SAND ON CARDBOARD, 41½ × 29⅜″ (105.4 × 74.6 CM)
THE KREEGER FOUNDATION

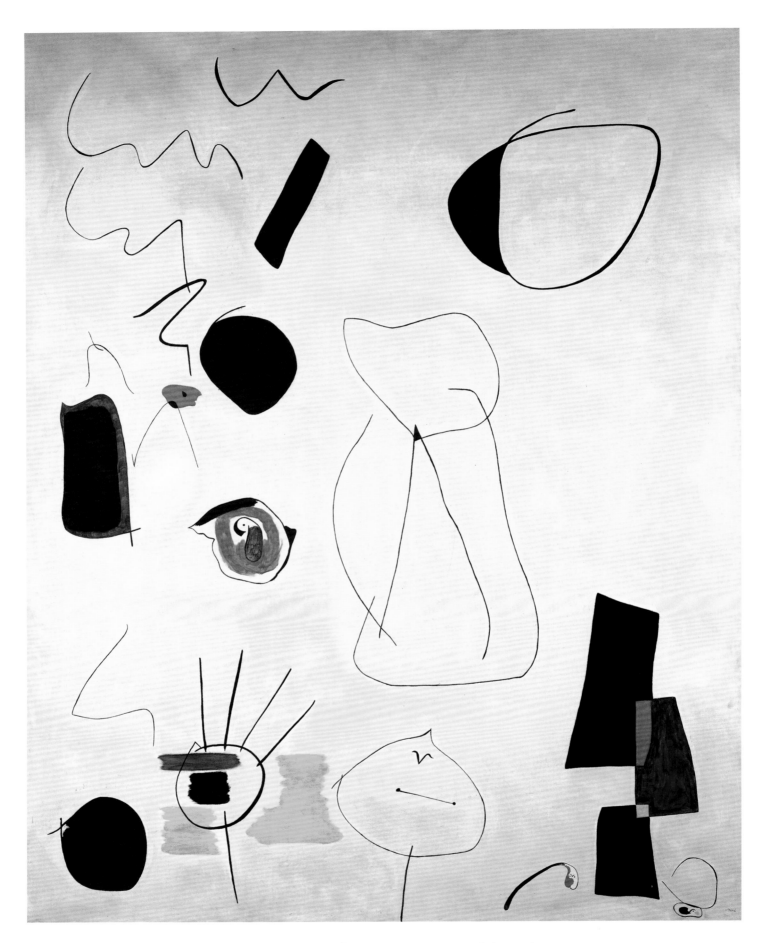

ANIMATED LANDSCAPE. [BARCELONA, LATE SPRING 1935]. (CAT. 128)
OIL ON CANVAS, 8′ 2¼″ × 6′ 6¾″ (250 × 200 CM)
PRIVATE COLLECTION

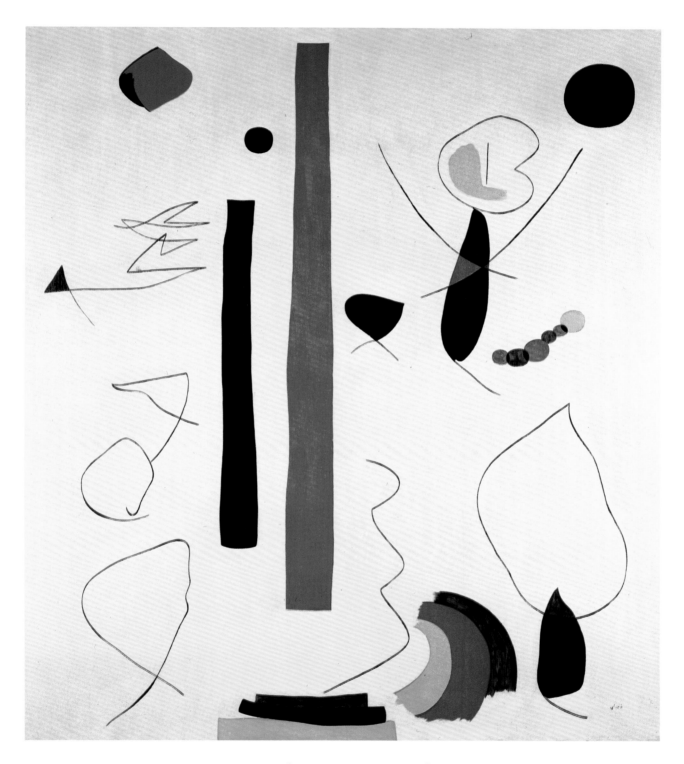

ANIMATED FORMS. [BARCELONA, LATE SPRING 1935]. (CAT. 129)
OIL ON CANVAS, 6′ 4½″ × 68¼″ (194.3 × 173.3 CM)
LOS ANGELES COUNTY MUSEUM OF ART. DAVID E. BRIGHT BEQUEST

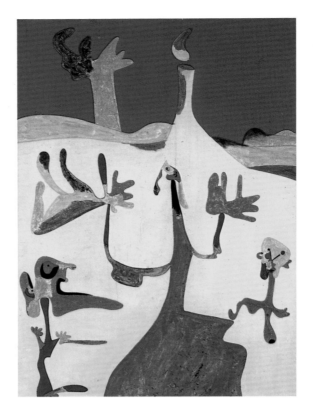

PERSONAGES IN FRONT OF A VOLCANO.
MONTROIG, OCTOBER 9–14, 1935. (CAT. 130)
TEMPERA ON MASONITE, 15¾×11¾″ (40×30 CM)
COLLECTION MRS. ROY J. FRIEDMAN

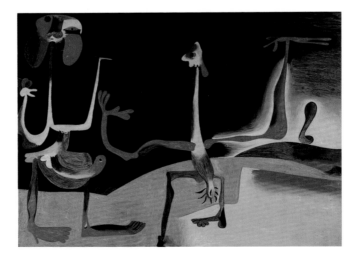

MAN AND WOMAN IN FRONT OF A PILE OF EXCREMENT.
MONTROIG, OCTOBER 15–22, 1935. (CAT. 131)
OIL ON COPPER, 9⅛×12⅝″ (23.2×32 CM)
FUNDACIÓ JOAN MIRÓ, BARCELONA

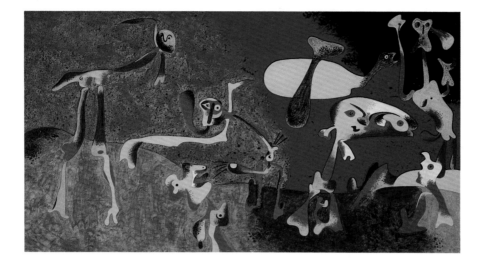

Figures and Birds in a Landscape. [Montroig and Barcelona], October 23–November 8, 1935. (Cat. 132)
Tempera on masonite, 10⅞ × 19½″ (27.6 × 49.5 cm)
The Baltimore Museum of Art. Bequest of Saidie A. May, BMA 1951.340

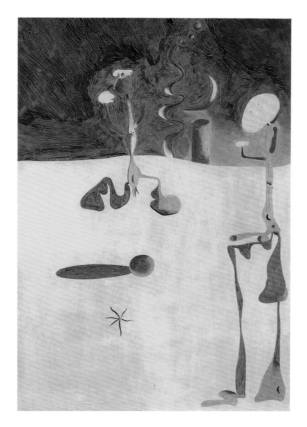

Nocturne. [Barcelona], November 9–16, 1935. (Cat. 133)
Oil on copper, 16½ × 11½″ (42 × 29.2 cm)
The Cleveland Museum of Art. Mr. and Mrs. William H. Marlatt Fund

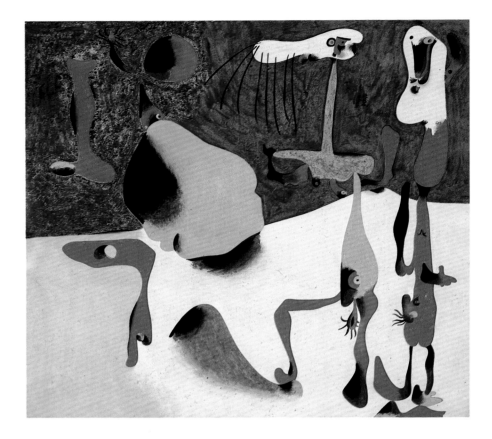

PERSONAGES IN THE PRESENCE OF A METAMORPHOSIS. BARCELONA, JANUARY 20–31, 1936. (CAT. 134)
TEMPERA ON MASONITE, 19¾ × 22⅝″ (50.2 × 57.5 CM)
NEW ORLEANS MUSEUM OF ART. BEQUEST OF VICTOR K. KIAM

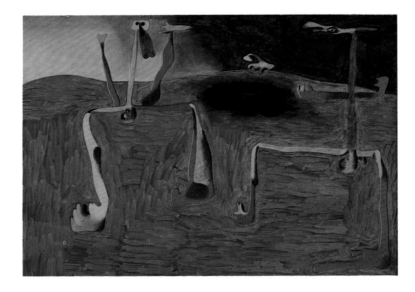

THE TWO PHILOSOPHERS. BARCELONA, FEBRUARY 4–12, 1936. (CAT. 135)
OIL ON COPPER, 14 × 19⅝″ (35.6 × 49.8 CM)
THE ART INSTITUTE OF CHICAGO. GIFT OF MARY AND LEIGH BLOCK

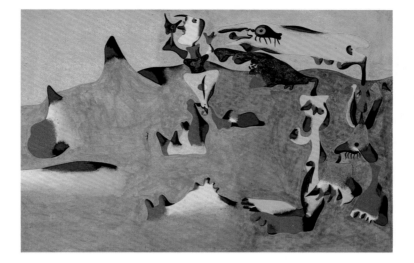

PERSONS ATTRACTED BY THE FORM OF A MOUNTAIN. [BARCELONA, FEBRUARY 15–29, 1936]. (CAT. 136)
TEMPERA ON MASONITE, 12¾ × 19½″ (32.3 × 49.5 CM)
THE BALTIMORE MUSEUM OF ART. BEQUEST OF SAIDIE A. MAY, BMA 1951.338

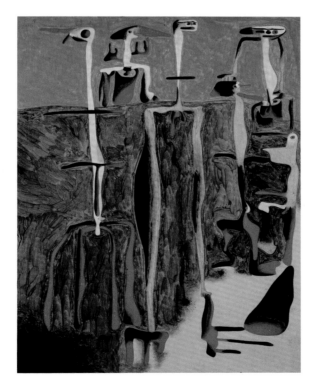

SEATED PERSONAGES. BARCELONA, MARCH 10–21, 1936. (CAT. 137)
OIL ON COPPER, 17⅜ × 13¾″ (44 × 35 CM)
PRIVATE COLLECTION

213

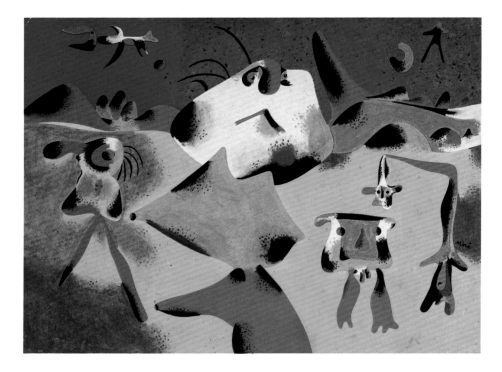

Personages, Mountains, Sky, Star, and Bird. Barcelona, April 6–16, 1936. (Cat. 138)
Tempera on masonite, 11¾×15¾″ (30×40 cm)
Private collection

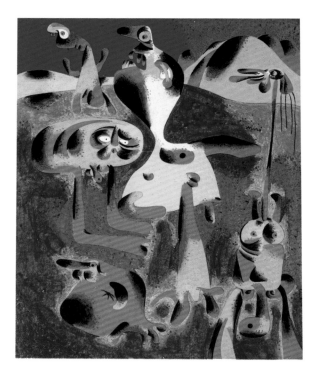

Personages and Mountains. [Barcelona, May 11–22, 1936]. (Cat. 140)
Tempera on masonite, 11⅞×9⅞″ (30.2×25.1 cm)
Private collection

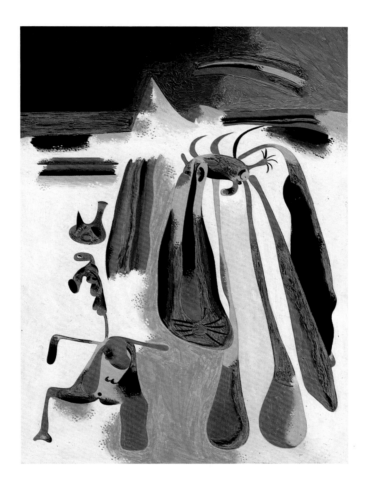

Catalan Peasant at Rest. Barcelona, April 17–25, 1936. (Cat. 139)
Oil on copper, 13¾×10¼″ (35×26 cm)
Collection Masaveu, Spain

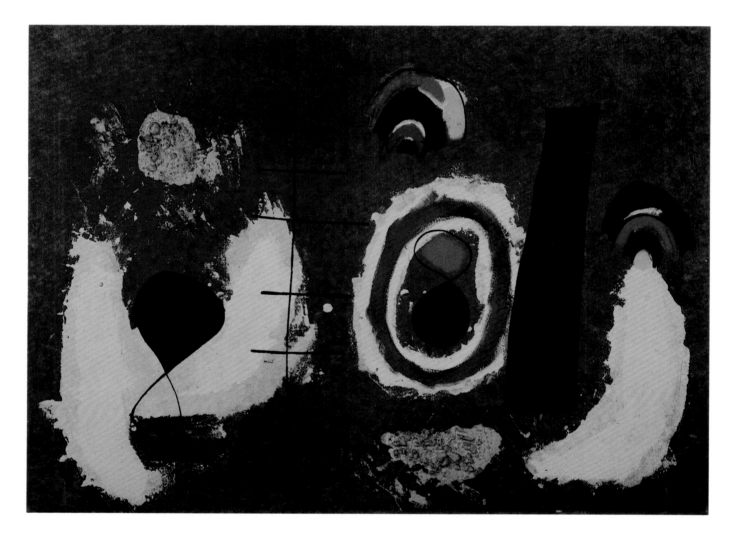

PAINTING. MONTROIG AND BARCELONA, JULY–OCTOBER 1936. (CAT. 141)
OIL, CASEIN, TAR, AND SAND ON MASONITE, 30¼ × 42⅛″ (77 × 107 CM)
PRIVATE COLLECTION

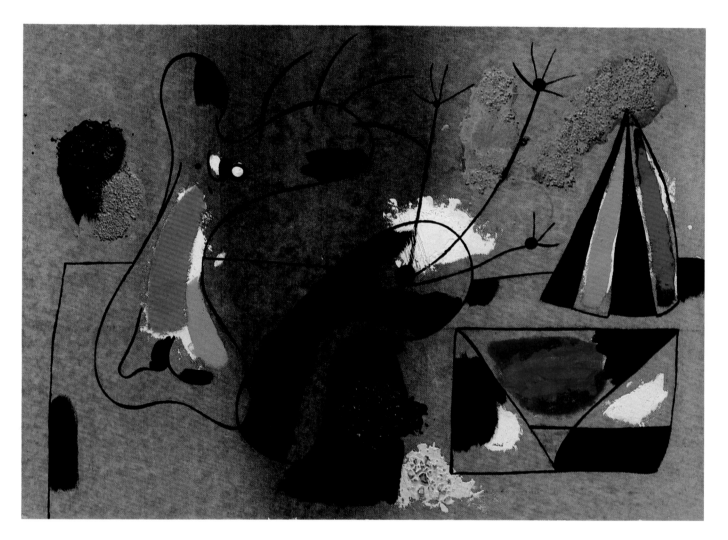

Painting. Montroig and Barcelona, July–October 1936. (Cat. 142)
Oil, gravel, and pebbles on masonite, 31 × 42⅝″ (78.7 × 108.3 cm)
The Art Institute of Chicago. Gift of Florene May Schoenborn and Samuel A. Marx

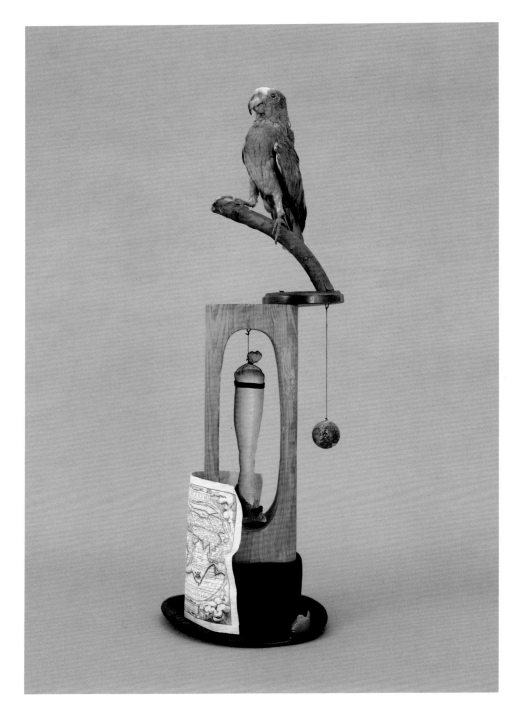

OBJECT. [1936]. (CAT. 143)
ASSEMBLAGE: STUFFED PARROT ON WOOD PERCH, STUFFED SILK STOCKING WITH VELVET GARTER
AND DOLL'S PAPER SHOE SUSPENDED IN HOLLOW WOOD FRAME, DERBY HAT, HANGING CORK BALL,
CELLULOID FISH, AND ENGRAVED MAP, 31⅞ × 11⅞ × 10¼″ (81 × 30.1 × 26 CM)
THE MUSEUM OF MODERN ART, NEW YORK. GIFT OF MR. AND MRS. PIERRE MATISSE

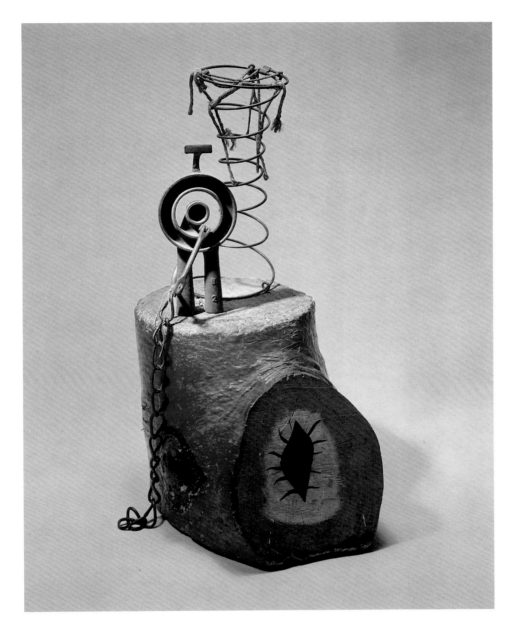

OBJECT OF SUNSET. [1936]. (CAT. 144)
ASSEMBLAGE: PAINTED WOOD, METAL, AND STRING, 26¾ × 17⅜ × 10¼″ (68 × 44 × 26 CM)
MUSÉE NATIONAL D'ART MODERNE, CENTRE GEORGES POMPIDOU, PARIS, 1975

DRAWING FROM LA GRANDE CHAUMIÈRE. PARIS, [WINTER OR SPRING] 1937
PENCIL ON PAPER, 12¼×9″ (31×23 CM)
GALERIE LELONG ZÜRICH

DRAWING FROM LA GRANDE CHAUMIÈRE. PARIS, [WINTER OR SPRING] 1937
PENCIL ON PAPER, 9½×12⅝″ (24×32 CM)
GALERIE MAEGHT, PARIS

DRAWING FROM LA GRANDE CHAUMIÈRE. PARIS, [WINTER OR SPRING] 1937
PENCIL ON PAPER, 13 × 10″ (33 × 25.5 CM)
GALERIE LELONG ZÜRICH

DRAWING FROM LA GRANDE CHAUMIÈRE. PARIS, [WINTER OR SPRING] 1937
PENCIL ON PAPER, 12⅛ × 9″ (30.9 × 23 CM)
FUNDACIÓ JOAN MIRÓ, BARCELONA

THREE PERSONAGES. 1937
INK AND GOUACHE ON PAPER, 29½ × 41⅜″ (75 × 105 CM)
PRIVATE COLLECTION

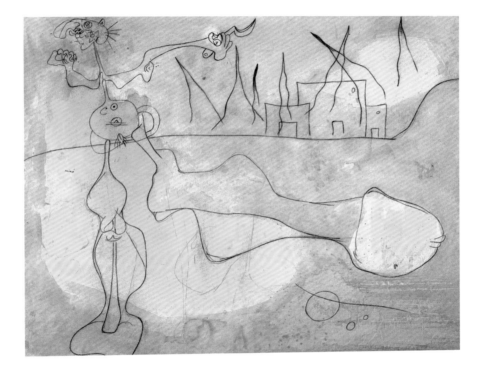

WOMAN IN REVOLT. PARIS, FEBRUARY 26, 1938
WATERCOLOR, PENCIL, AND CHARCOAL ON PAPER, 22⅝ × 29¼″ (57.4 × 74.3 CM)
MUSÉE NATIONAL D'ART MODERNE, CENTRE GEORGES POMPIDOU, PARIS, 1984

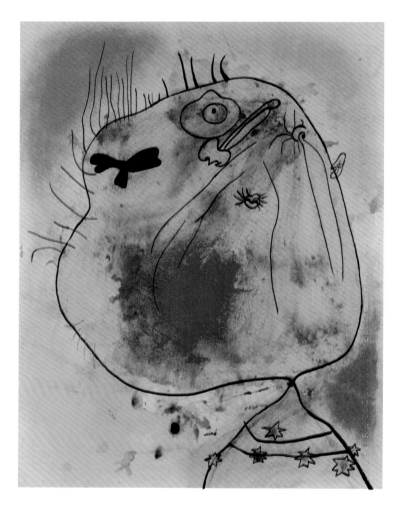

Head. [1937]
Pastel, gouache, India ink, and pencil on paper
laid down on paper, 25¼ × 19⅝″ (64.2 × 50 cm)
Collection Judy and Michael Steinhardt

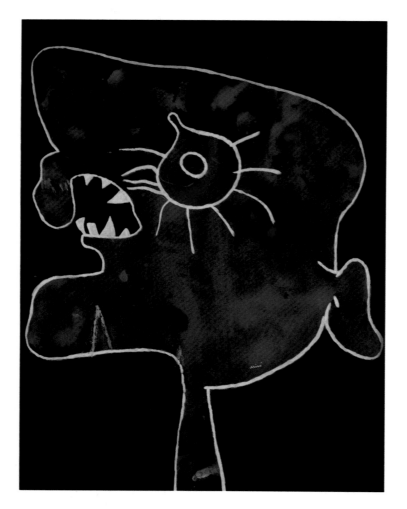

HEAD OF A MAN. [1937]
GOUACHE AND INDIA INK ON BLACK PAPER, 25⅝ × 19¾″ (65 × 50.1 CM)
COLLECTION RICHARD S. ZEISLER

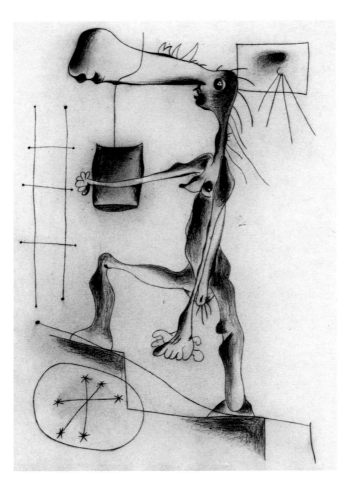

Nude Ascending the Staircase. Paris, March 1937
Charcoal on thin cardboard, 30⅝ × 22″ (77.9 × 55.8 cm)
Fundació Joan Miró, Barcelona

STILL LIFE WITH OLD SHOE. PARIS, JANUARY 24–MAY 29, 1937. (CAT. 145)
OIL ON CANVAS, 32 × 46″ (81.3 × 116.8 CM)
THE MUSEUM OF MODERN ART, NEW YORK. GIFT OF JAMES THRALL SOBY

Self-Portrait I. Paris, October 1937–March 1938. (Cat. 146)
Pencil, crayon, and oil on canvas, 57½ × 38¼″ (146.1 × 97.2 cm)
The Museum of Modern Art, New York. James Thrall Soby Bequest

Self-Portrait II. Paris, April 1938. (Cat. 147)
Oil on burlap, 51″×6′ 5″ (129.5×195.5 cm)
The Detroit Institute of Arts. Gift of W. Hawkins Ferry

AIR. [PARIS, APRIL 1938]. (CAT. 150)
OIL ON CANVAS, 21⅝ × 18⅛″ (55 × 46 CM)
PRIVATE COLLECTION

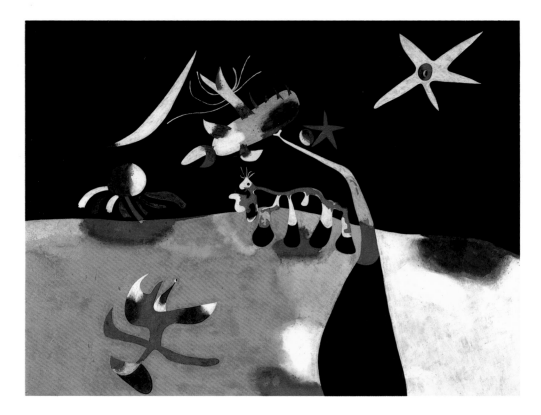

NOCTURNE. PARIS, APRIL 1938. (CAT. 149)
OIL ON CARDBOARD, 21¼ × 29⅛″ (54 × 74 CM)
PRIVATE COLLECTION

"UNE ETOILE CARESSE LE SEIN D'UNE NÉGRESSE" (PAINTING-POEM). PARIS, APRIL 1938. (CAT. 148)
OIL ON CANVAS, 51″ × 6′ 4½″ (129.5 × 194.3 CM)
TATE GALLERY, LONDON. PURCHASED 1983

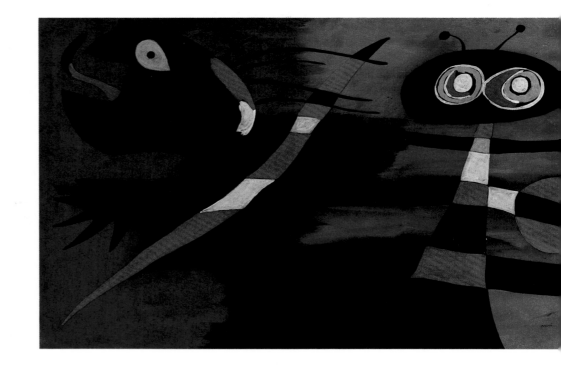

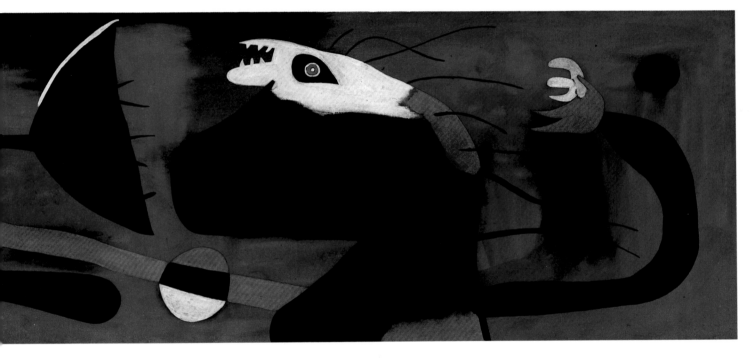

Woman Haunted by the Passage of the Bird-Dragonfly, Omen of Bad News (Nursery Decoration). Paris, September 1938. (Cat. 153)
Oil on canvas, 31½″ × 10′ 4″ (80 × 315 cm)
The Toledo Museum of Art, Ohio. Purchased with funds from the Libbey Endowment, Gift of Edward Drummond Libbey

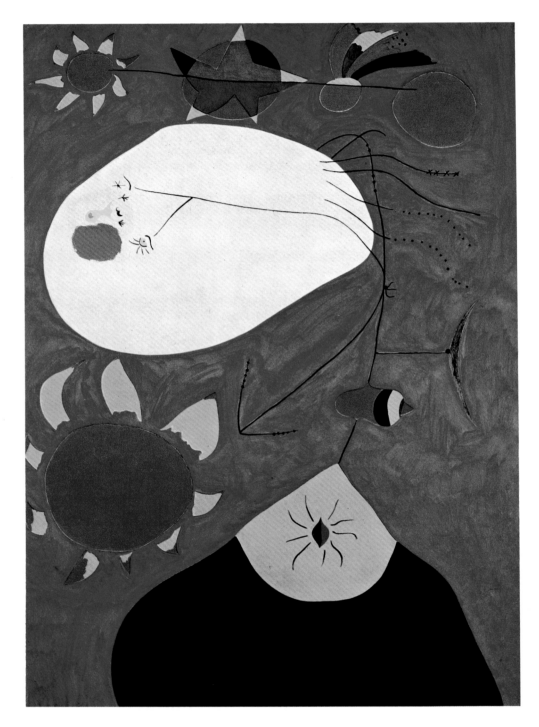

PORTRAIT IV. PARIS, JUNE 1938. (CAT. 152)
OIL ON CANVAS, 51⅛ × 37¾″ (129.8 × 95.8 CM)
PRIVATE COLLECTION

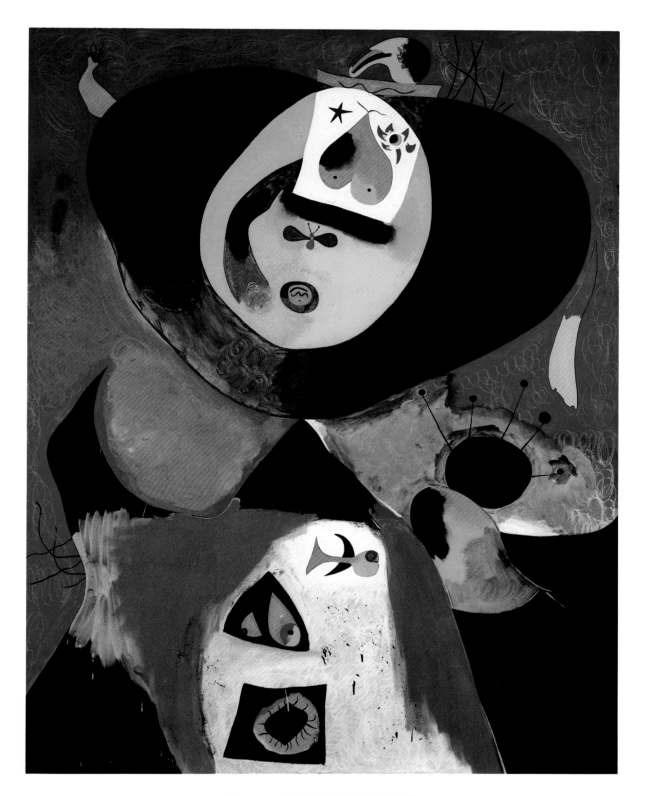

PORTRAIT I. PARIS, MAY 1938. (CAT. 151)
OIL ON CANVAS, 64¼ × 51¼″ (163.1 × 130.1 CM)
THE BALTIMORE MUSEUM OF ART. BEQUEST OF SAIDIE A. MAY, BMA 1951.339

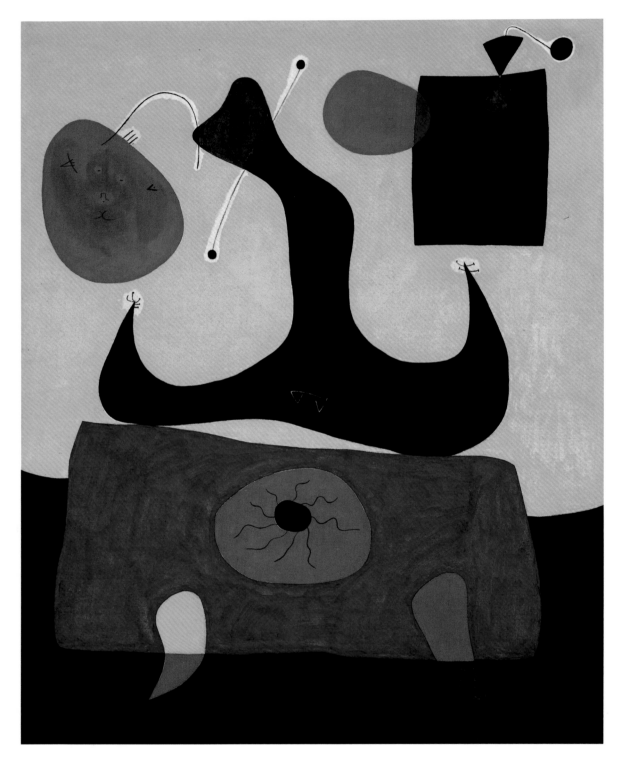

Seated Woman I. Paris, December 24, 1938. (Cat. 154)
Oil on canvas, 64⅜ × 51⅝″ (163.4 × 131 cm)
The Museum of Modern Art, New York. Gift of Mr. and Mrs. William H. Weintraub

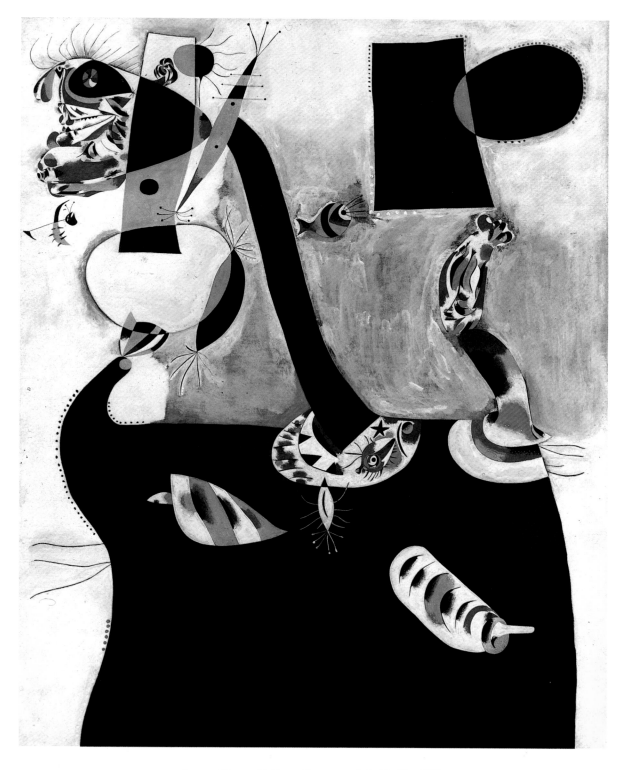

Seated Woman II. Paris, February 27, 1939. (Cat. 155)
Oil on canvas, 63¾ × 51⅛″ (162 × 130 cm)
Solomon R. Guggenheim Museum, New York; Peggy Guggenheim Collection, Venice, 1976

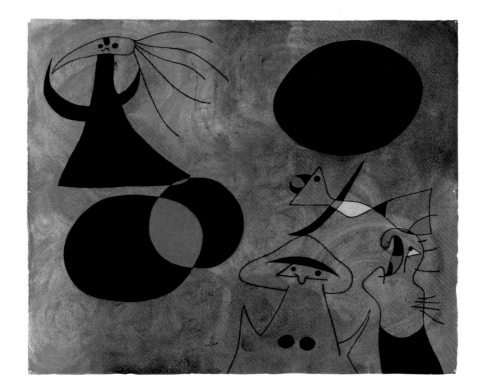

SUNRISE. FROM THE CONSTELLATION SERIES.
VARENGEVILLE, JANUARY 21, 1940. (CAT. 156)
GOUACHE AND OIL WASH ON PAPER, $15 \times 18\frac{1}{8}''$ (38×46 CM)
PRIVATE COLLECTION, UNITED STATES

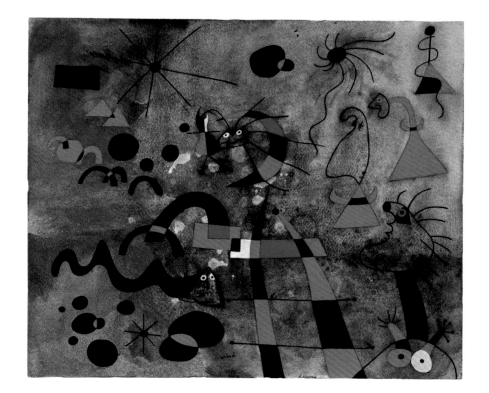

THE ESCAPE LADDER. FROM THE CONSTELLATION SERIES.
VARENGEVILLE, JANUARY 31, 1940. (CAT. 157)
GOUACHE, WATERCOLOR, AND INK ON PAPER, 15¾ × 18¾″ (40 × 47.6 CM)
THE MUSEUM OF MODERN ART, NEW YORK. HELEN ACHESON BEQUEST

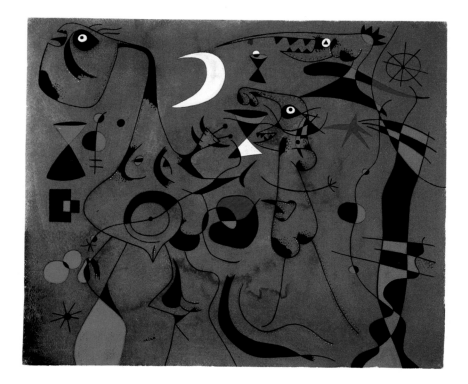

People at Night, Guided by the Phosphorescent Tracks of Snails.
From the Constellation series. Varengeville, February 12, 1940. (Cat. 158)
Gouache on wove paper, 15×18″ (37.9×45.7 cm)
Philadelphia Museum of Art. Louis E. Stern Collection

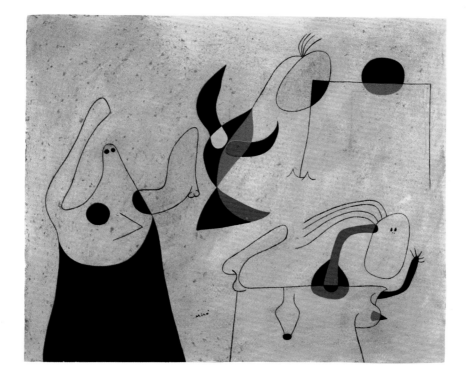

WOMEN ON THE BEACH. FROM THE CONSTELLATION SERIES.
VARENGEVILLE, FEBRUARY 15, 1940. (CAT. 159)
GOUACHE AND OIL WASH ON PAPER, 15 × 18 (38.1 × 45.8 CM)
THE JACQUES AND NATASHA GELMAN COLLECTION

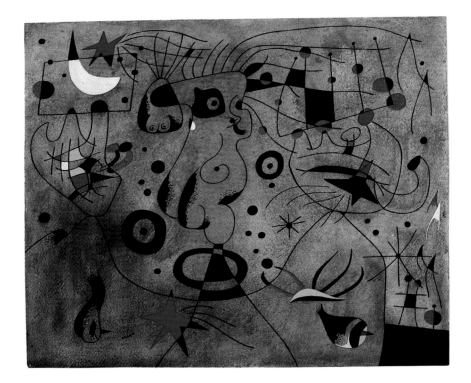

WOMAN WITH BLOND ARMPIT COMBING HER HAIR BY THE LIGHT OF THE STARS.
FROM THE CONSTELLATION SERIES. VARENGEVILLE, MARCH 5, 1940. (CAT. 160)
GOUACHE AND OIL WASH ON PAPER, 15 × 18⅛″ (38.1 × 46 CM)
THE CLEVELAND MUSEUM OF ART. CONTEMPORARY COLLECTION

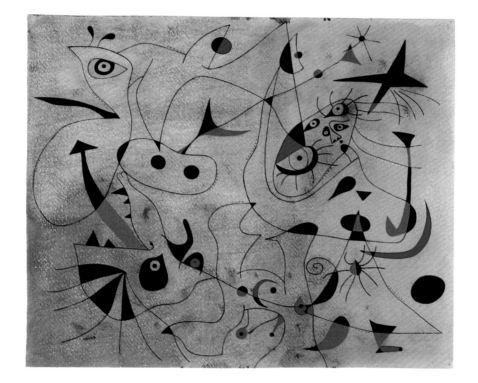

Morning Star. From the Constellation series.
Varengeville, March 16, 1940. (Cat. 161)
Tempera, gouache, egg, oil, and pastel on paper, $15 \times 18\frac{1}{8}''$ (38×46 cm)
Fundació Joan Miró, Barcelona

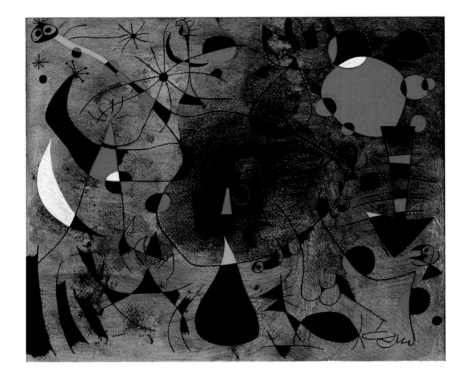

WOUNDED PERSONAGE. FROM THE CONSTELLATION SERIES.
VARENGEVILLE, MARCH 27, 1940. (CAT. 162)
GOUACHE AND OIL WASH ON PAPER, 15 × 18⅛″ (38 × 46 CM)
PRIVATE COLLECTION, SAN FRANCISCO

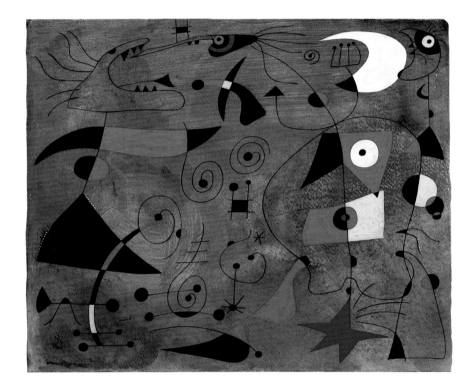

WOMAN AND BIRDS. FROM THE CONSTELLATION SERIES.
VARENGEVILLE, APRIL 13, 1940. (CAT. 163)
GOUACHE AND OIL WASH ON PAPER, 15 × 18½″ (38 × 46 CM)
COLLECTION MRS. GUSTAVO CISNEROS, CARACAS

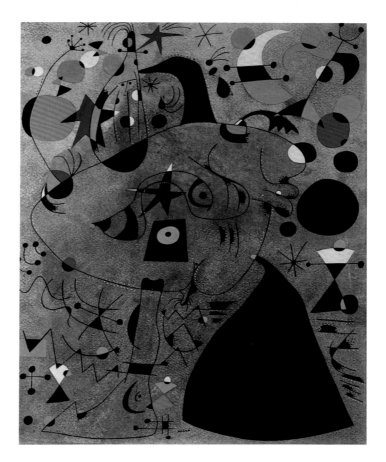

WOMAN IN THE NIGHT. FROM THE CONSTELLATION SERIES.
VARENGEVILLE, APRIL 27, 1940. (CAT. 164)
GOUACHE AND OIL WASH ON PAPER, 18¼×15″ (46.3×38.1 CM)
THE MARGULIES FAMILY COLLECTION

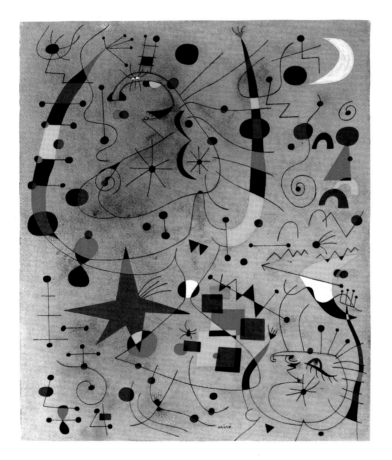

ACROBATIC DANCERS. FROM THE CONSTELLATION SERIES.
VARENGEVILLE, MAY 14, 1940. (CAT. 165)
WATERCOLOR ON PAPER, 18⅛ × 15″ (46 × 38.1 CM)
WADSWORTH ATHENEUM, HARTFORD. GIFT OF PHILIP L. GOODWIN COLLECTION

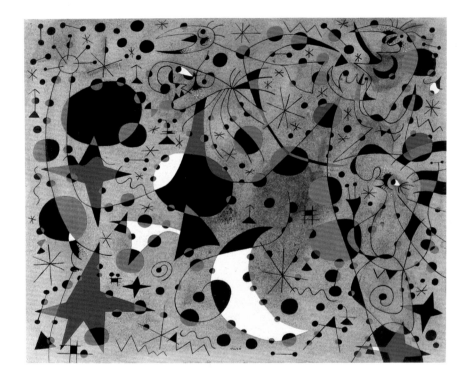

THE NIGHTINGALE'S SONG AT MIDNIGHT AND MORNING RAIN.
FROM THE CONSTELLATION SERIES. PALMA DE MALLORCA, SEPTEMBER 4, 1940. (CAT. 166)
GOUACHE AND OIL WASH ON PAPER, $15 \times 18\frac{1}{8}''$ (38×46 CM)
PERLS GALLERIES, NEW YORK

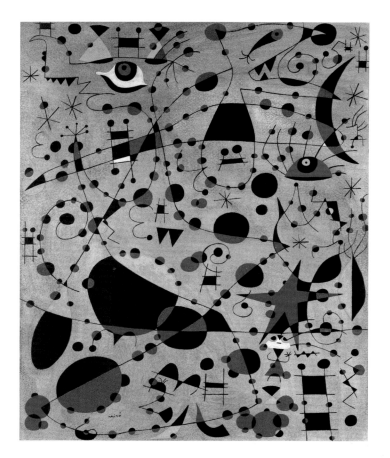

ON THE 13TH, THE LADDER BRUSHED THE FIRMAMENT.
FROM THE CONSTELLATION SERIES. PALMA DE MALLORCA, OCTOBER 14, 1940. (CAT. 167)
GOUACHE AND OIL WASH ON PAPER, 18×15″ (45.7×38.1 CM)
COLLECTION H. GATES LLOYD

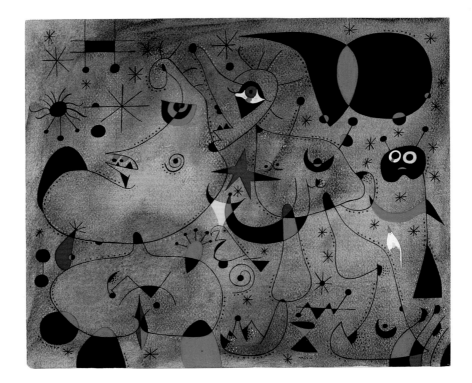

Nocturne. From the Constellation series.
Palma de Mallorca, November 2, 1940. (Cat. 168)
Gouache and oil wash on wove paper, $15 \times 18\frac{1}{8}''$ (38×46 cm)
Private collection

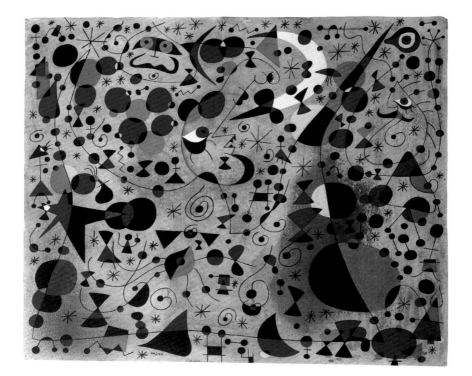

THE POETESS. FROM THE CONSTELLATION SERIES.
PALMA DE MALLORCA, DECEMBER 31, 1940. (CAT. 169)
GOUACHE AND OIL WASH ON PAPER, $15 \times 18''$ (38.1×45.7 CM)
PRIVATE COLLECTION, NEW YORK

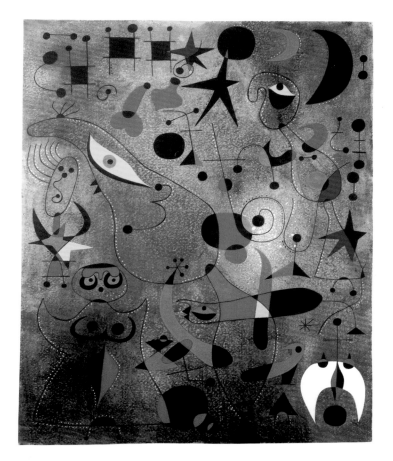

Awakening in the Early Morning.
From the Constellation series. Palma de Mallorca, January 27, 1941. (Cat. 170)
Gouache and oil wash on paper, 18×15″ (45.7×38.1 cm)
Private collection, New York

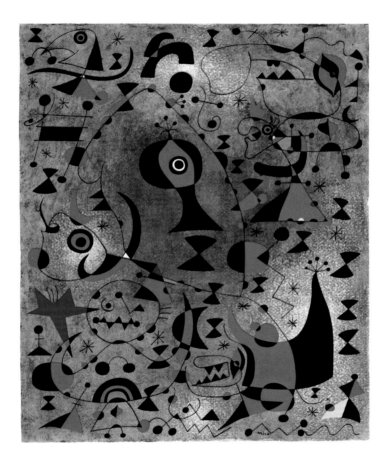

Toward the Rainbow.
From the Constellation series. Palma de Mallorca, March 11, 1941. (Cat. 171)
Gouache and oil wash on paper, 18×15″ (45.8×38 cm)
The Jacques and Natasha Gelman Collection

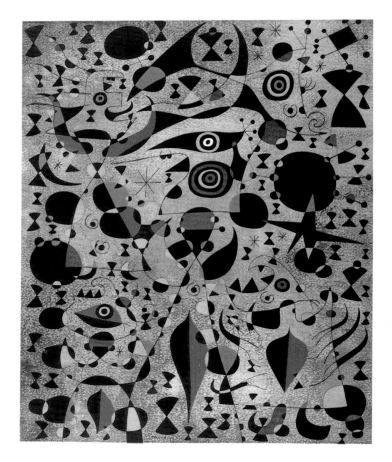

Women Encircled by the Flight of a Bird.
From the Constellation series. Palma de Mallorca, April 26, 1941. (Cat. 172)
Gouache and oil wash on paper, 18⅛×15″ (46×38 cm)
Private collection

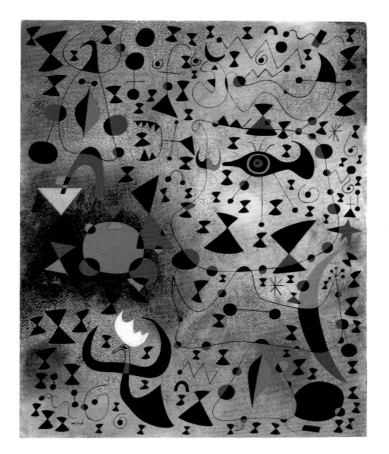

WOMEN AT THE BORDER OF A LAKE IRRADIATED BY THE PASSAGE OF A SWAN.
FROM THE CONSTELLATION SERIES. PALMA DE MALLORCA, MAY 14, 1941. (CAT. 173)
GOUACHE AND OIL WASH ON PAPER, 18⅛×15″ (46×38.1 CM)
PRIVATE COLLECTION

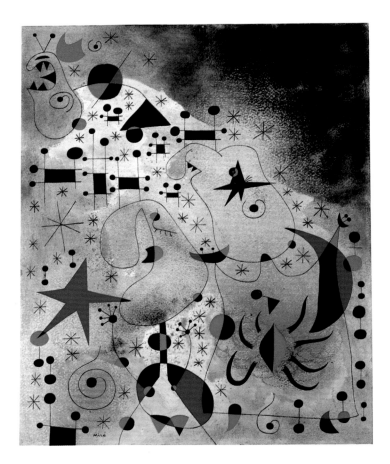

The Migratory Bird.
From the Constellation series. Palma de Mallorca, May 26, 1941. (Cat. 174)
Gouache and oil wash on paper, 18⅛ × 15″ (46.1 × 38.1 cm)
Private collection

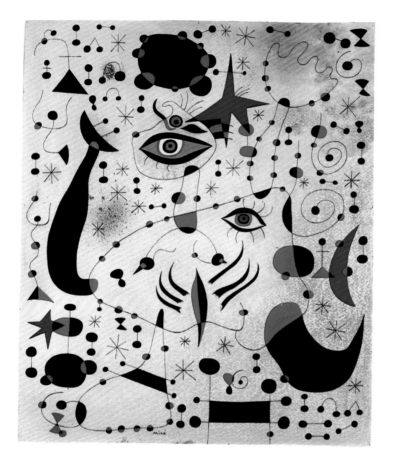

Ciphers and Constellations in Love with a Woman.
From the Constellation series. Palma de Mallorca, June 12, 1941. (Cat. 175)
Gouache and ink on ivory wove paper, $18 \times 15''$ (45.7×38.1 cm)
The Art Institute of Chicago. Gift of Mrs. Gilbert W. Chapman

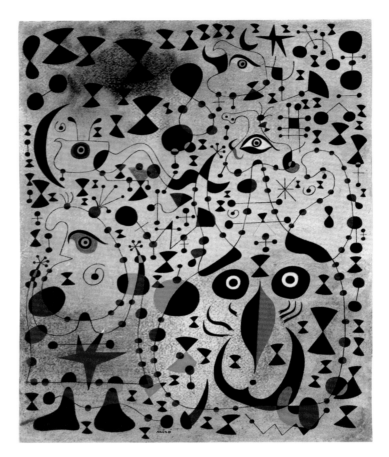

THE BEAUTIFUL BIRD REVEALING THE UNKNOWN TO A PAIR OF LOVERS.
FROM THE CONSTELLATION SERIES. MONTROIG, JULY 23, 1941. (CAT. 176)
GOUACHE AND OIL WASH ON PAPER, 18×15″ (45.7×38.1 CM)
THE MUSEUM OF MODERN ART, NEW YORK. ACQUIRED THROUGH THE LILLIE P. BLISS BEQUEST

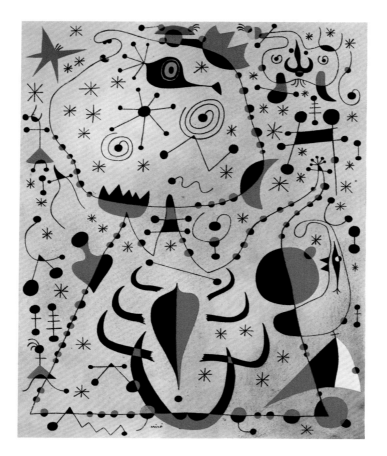

THE ROSE DUSK CARESSES THE SEX OF WOMEN AND OF BIRDS.
FROM THE CONSTELLATION SERIES. MONTROIG, AUGUST 14, 1941. (CAT. 177)
GOUACHE AND OIL WASH ON PAPER, 18⅛×15″ (46×38 CM)
PRIVATE COLLECTION

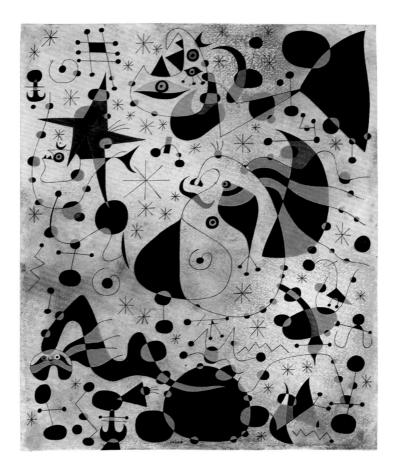

THE PASSAGE OF THE DIVINE BIRD.
FROM THE CONSTELLATION SERIES. MONTROIG, SEPTEMBER 12, 1941. (CAT. 178)
GOUACHE AND OIL WASH ON PAPER, 18⅛×15″ (46×38 CM)
PRIVATE COLLECTION, UNITED STATES

VERSO OF **THE PASSAGE OF THE DIVINE BIRD.**
FROM THE CONSTELLATION SERIES. MONTROIG, SEPTEMBER 12, 1941
INK ON PAPER, 18⅛×15″ (46×38 CM)
PRIVATE COLLECTION, UNITED STATES

BROWN PERSONAGE. 1944–46. (App. 13)
CERAMIC, 9 × 8¼ × 7⅞″ (23 × 21 × 20 CM)
GALERIE MAEGHT, PARIS

LIGHT BLUE HEAD. 1944–46. (App. 12)
CERAMIC, 7 × 9 × 7½″ (18 × 23 × 19 CM)
GALERIE MAEGHT, PARIS

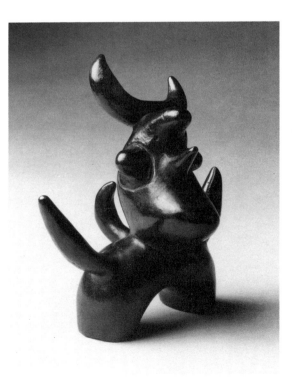

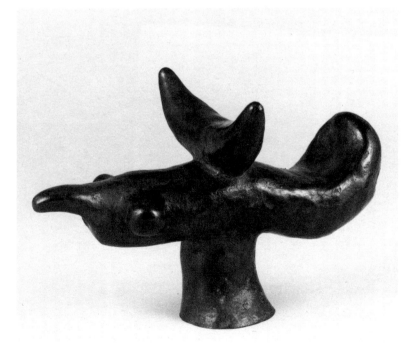

BIRD. 1946. (App. 14)
BRONZE, 7⅞ × 6½ × 2″ (20 × 16.5 × 5 CM)
GALERIE MAEGHT, PARIS

BIRD. 1946. (App. 15)
BRONZE, 5″ (12.7 CM) HIGH × 7½″ (19 CM) LONG
THE BALTIMORE MUSEUM OF ART. BEQUEST OF SAIDIE A. MAY, BMA 1951.386

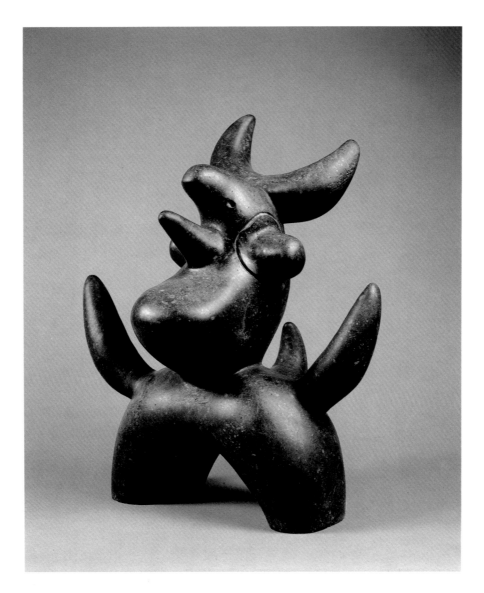

MOONBIRD. 1947
STONE, 18⅞ × 17⅝ × 12⅝″ (48 × 45 × 32 CM)
PRIVATE COLLECTION, NEW YORK

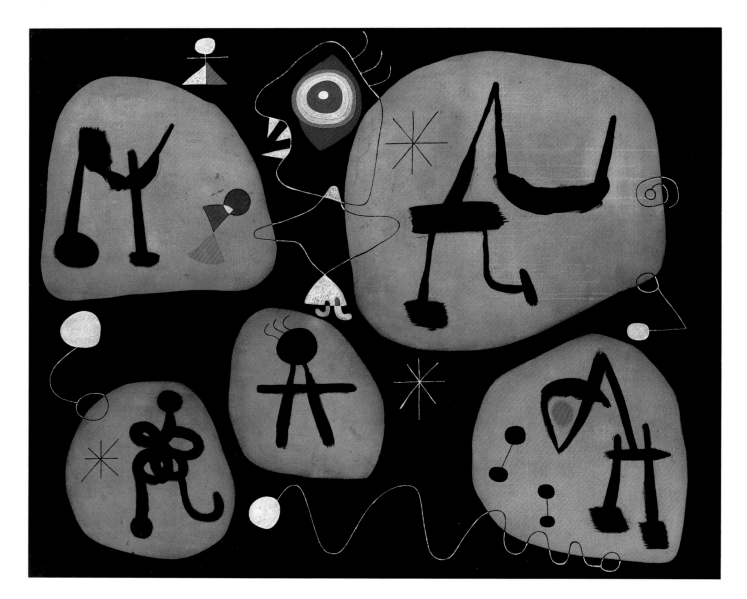

WOMEN LISTENING TO MUSIC. BARCELONA, MAY 11, 1945. (CAT. 180)
OIL ON CANVAS, 51×63¾″ (129.5×162 CM)
PRIVATE COLLECTION

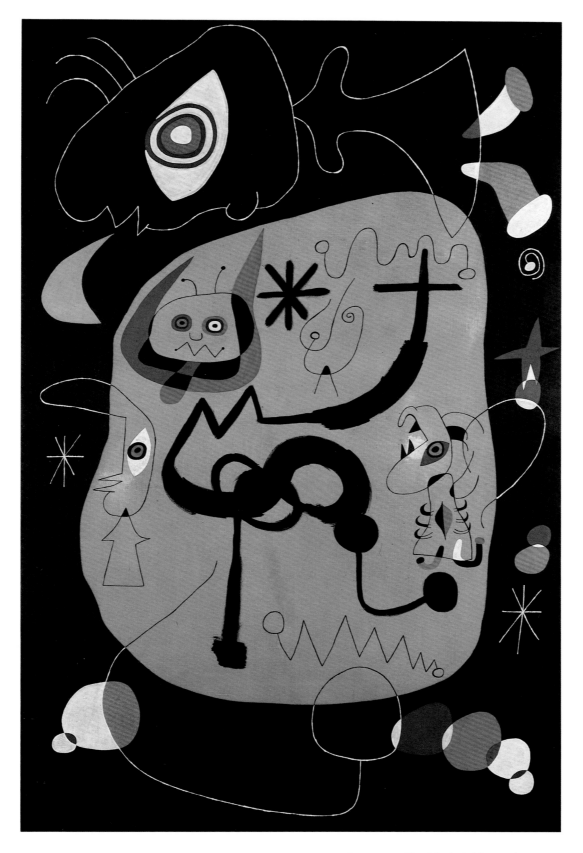

DANCER LISTENING TO THE ORGAN IN A GOTHIC CATHEDRAL. BARCELONA, MAY 26, 1945. (CAT. 181)
OIL ON CANVAS, 6′ 5⅝″ × 51½″ (197.1 × 130.6 CM)
FUKUOKA ART MUSEUM

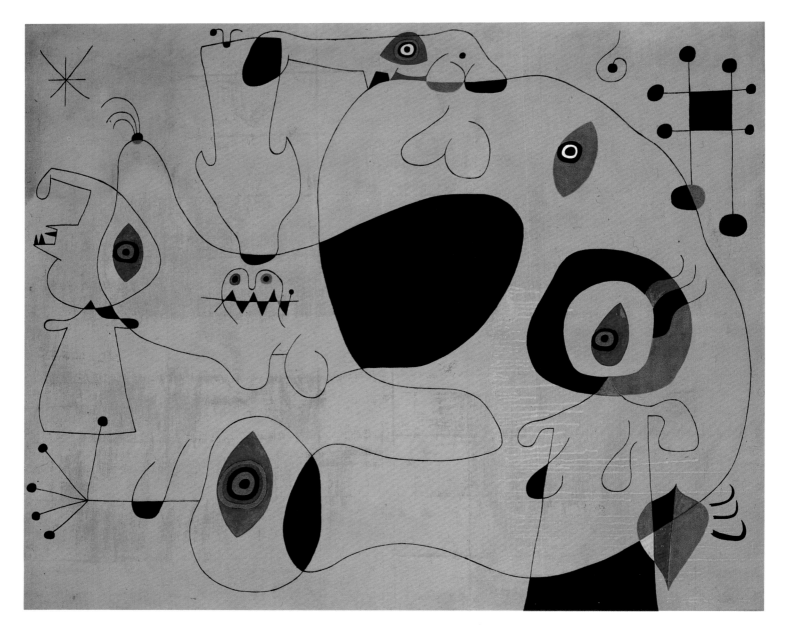

THE HARBOR. [BARCELONA], JULY 2, 1945. (CAT. 182)
OIL ON CANVAS, 51¼×63¾″ (130×162 CM)
PRIVATE COLLECTION

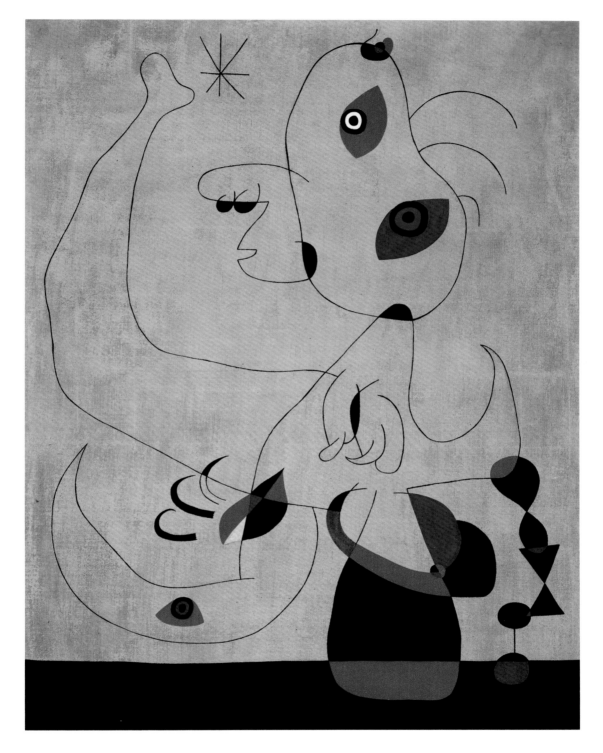

SPANISH DANCER. [BARCELONA], JULY 7, 1945. (CAT. 183)
OIL ON CANVAS, 57½ × 44⅞″ (146 × 114 CM)
COLLECTION BEYELER, BASEL

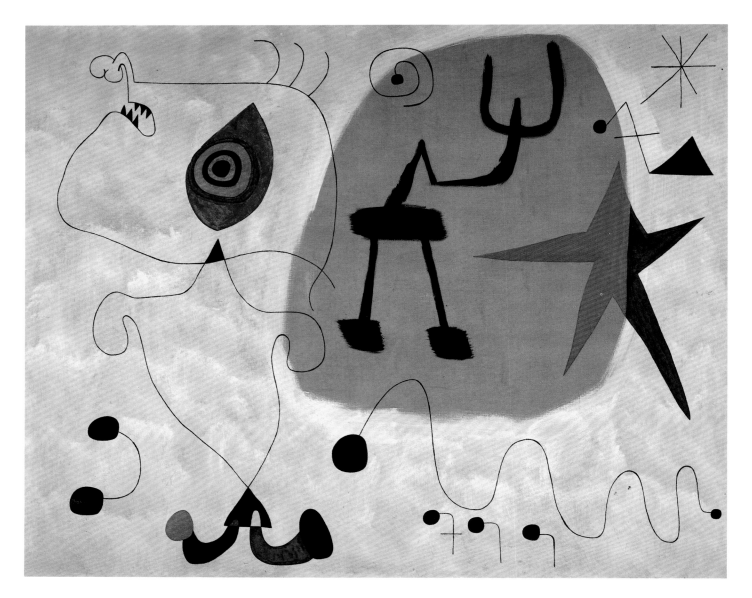

WOMAN, STARS. BARCELONA, MAY 7, 1945. (CAT. 179)
OIL ON CANVAS, 44⅞×57½″ (114×146 CM)
PRIVATE COLLECTION, NEW YORK

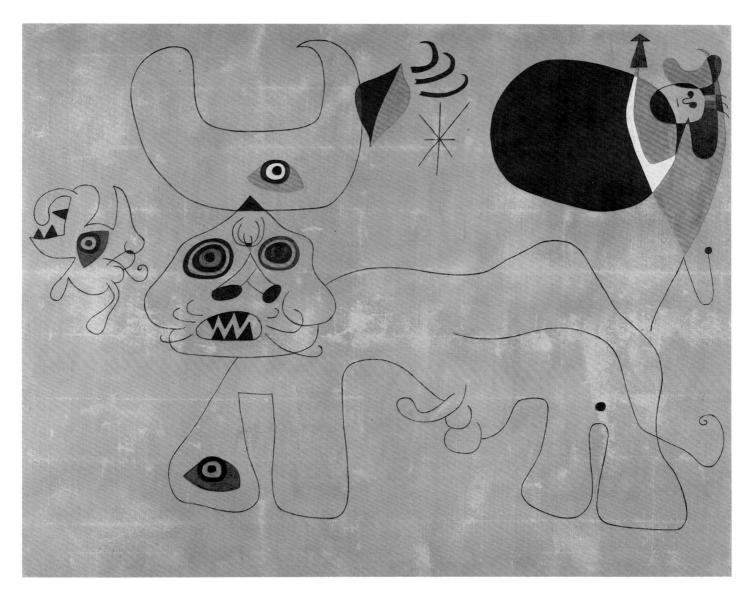

BULLFIGHT. BARCELONA, OCTOBER 8, 1945. (CAT. 184)
OIL ON CANVAS, 44⅞ × 56⅝″ (114 × 144 CM)
MUSÉE NATIONAL D'ART MODERNE, CENTRE GEORGES POMPIDOU, PARIS. GIFT OF THE ARTIST AND PIERRE LOEB, 1947

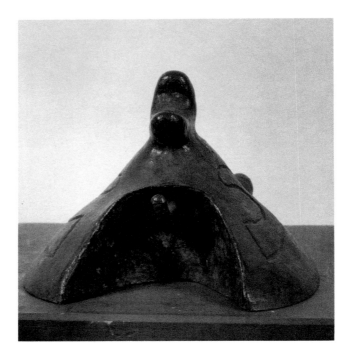

Woman. 1949. (App. 16)
Bronze, 7¼ × 10¼ × 9″ (18.4 × 26 × 22.8 cm)
Acquavella Modern Art

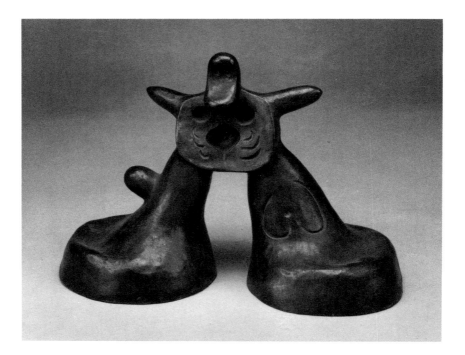

Woman. 1949. (App. 17)
Bronze, 11 × 16 × 6½″ (27.9 × 40.6 × 16.5 cm)
Acquavella Modern Art

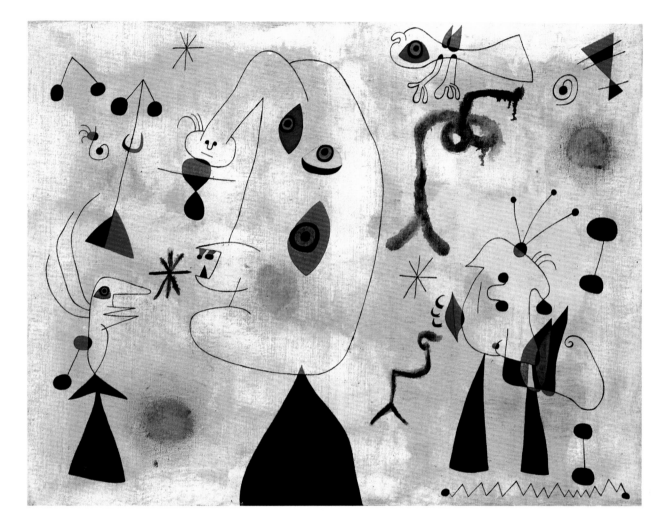

PERSONAGES, BIRDS, STARS. [BARCELONA, MARCH 1, 1946]. (CAT. 185)
OIL ON CANVAS, 28⅜ × 36⅝″ (72 × 93 CM)
PRIVATE COLLECTION, ZURICH

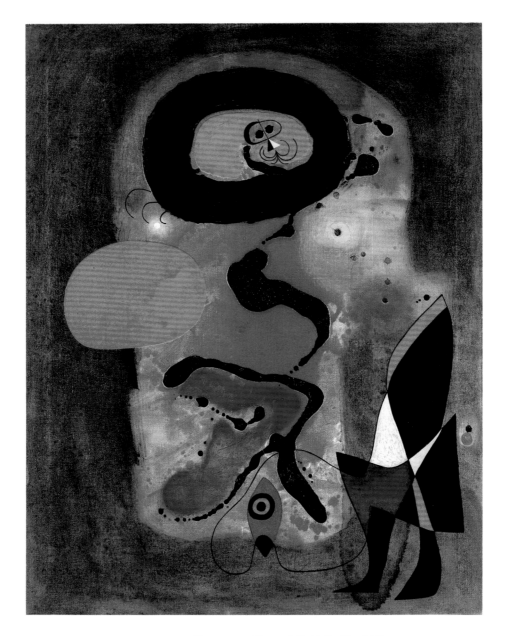

THE RED SUN. [BARCELONA, MARCH 20], 1948. (CAT. 186)
OIL AND GOUACHE ON CANVAS, 36⅛ × 28⅛″ (91.7 × 71.4 CM)
THE PHILLIPS COLLECTION, WASHINGTON, D.C.

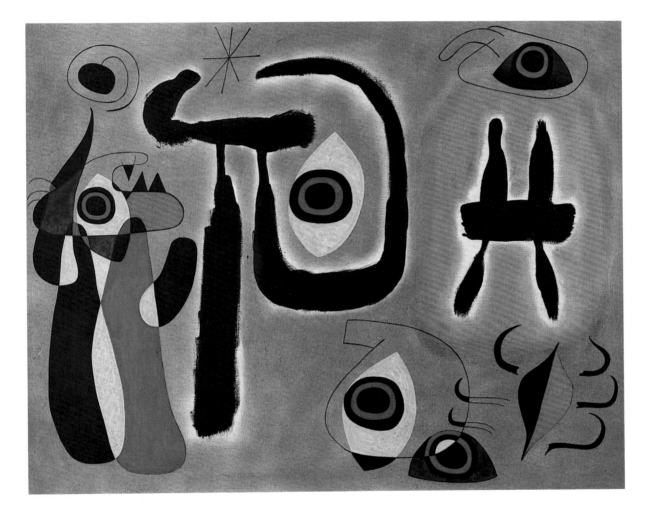

THE RED SUN GNAWS AT THE SPIDER. [BARCELONA, APRIL 2], 1948. (CAT. 187)
OIL ON CANVAS, 29½ × 37⅛″ (75 × 94.5 CM)
COLLECTION KAZUMASA KATSUTA

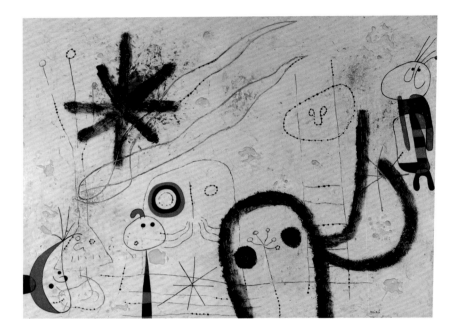

Sunburst Wounds the Tardy Star. 1951. (Cat. 192)
Oil and casein on canvas, 23⅝ × 31⅞″ (60 × 81 cm)
Collection Gustav Zumsteg

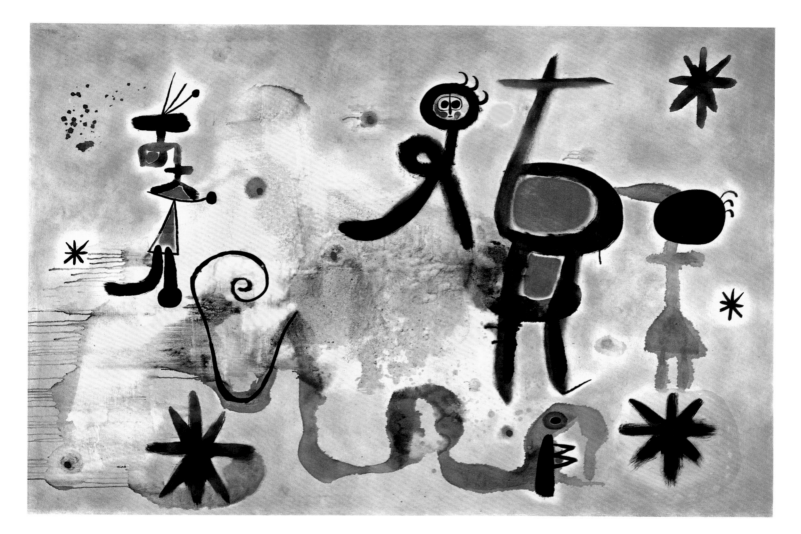

PAINTING. 1949. (CAT. 188)
OIL ON CANVAS, 50⅛″×6′ 4″ (127.3×193 CM)
THE MORTON G. NEUMANN FAMILY COLLECTION

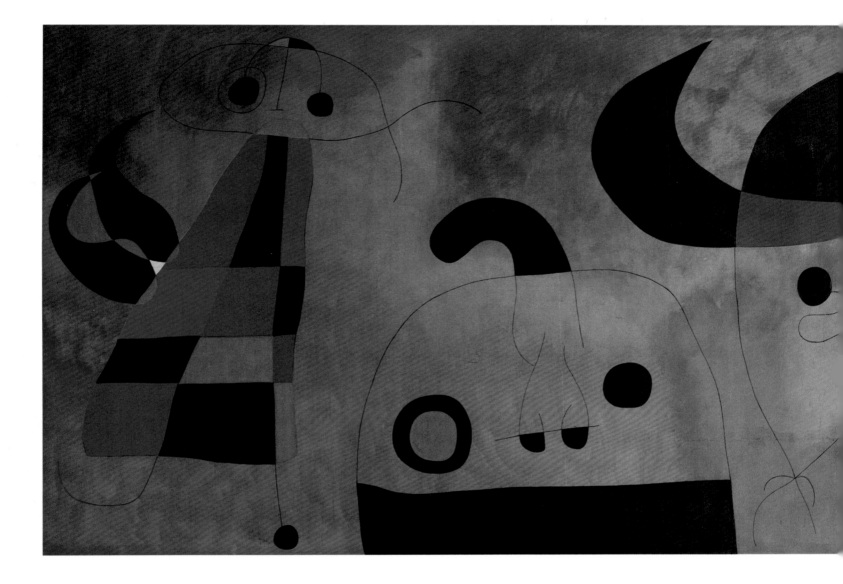

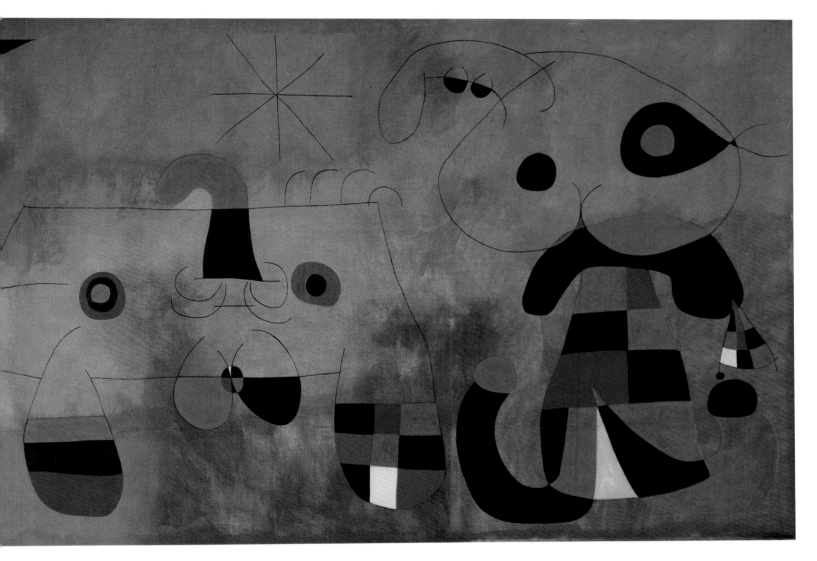

MURAL PAINTING. BARCELONA, OCTOBER 18, 1950–JANUARY 26, 1951. (CAT. 191)
OIL ON CANVAS, 6′ 2¾″ × 19′ 5¾″ (188.8 × 593.8 CM)
THE MUSEUM OF MODERN ART, NEW YORK. MRS. SIMON GUGGENHEIM FUND

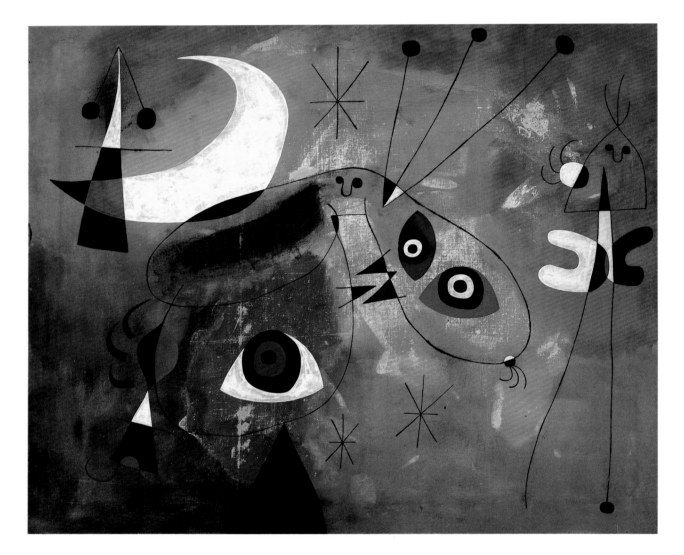

Painting (Personage and Moon). [Barcelona, February 25], 1950. (Cat. 189)
Oil on canvas, 32 × 39½″ (81.3 × 100.3 cm)
The Museum of Modern Art, New York. Fractional gift of Nina and Gordon Bunshaft

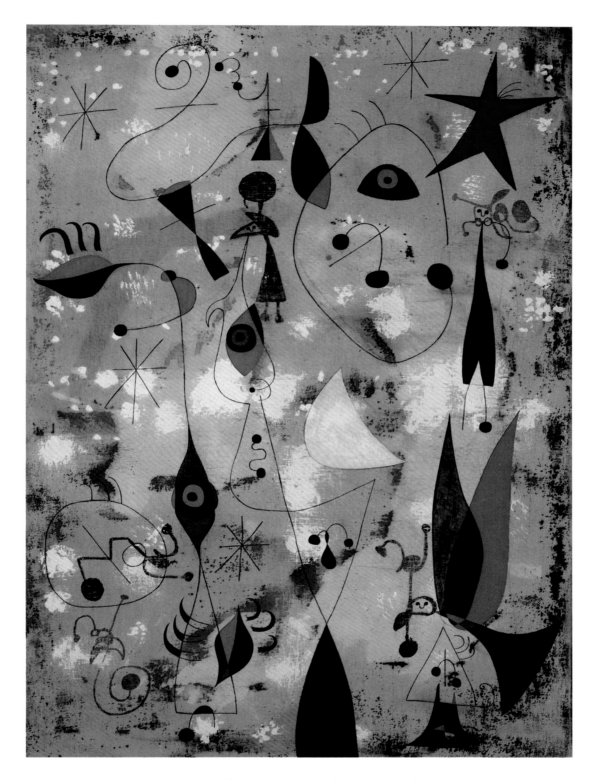

Painting. [Barcelona, March 17], 1950. (Cat. 190)
Oil and casein on canvas, 51⅛ × 38⅛″ (129.8 × 96.8 cm)
Vassar College Art Gallery, Poughkeepsie, New York.
From the collection of the late Katherine S. Deutsch, Class of 1940

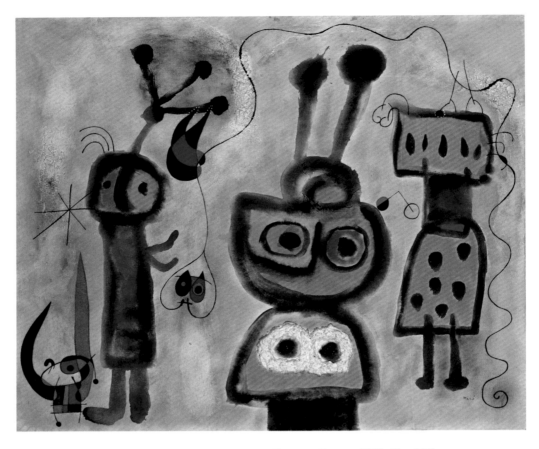

THE BIRD WITH A CALM LOOK, ITS WINGS IN FLAMES. 1952. (CAT. 193)
OIL AND PLASTER ON CANVAS, 31⅞ × 39⅜" (81 × 100 CM)
STAATSGALERIE STUTTGART

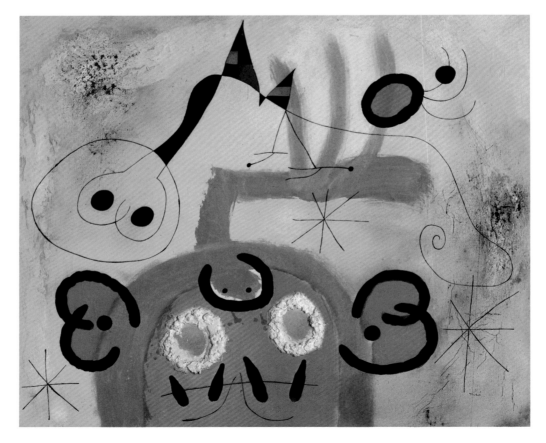

THE BIRD BOOM-BOOM MAKES HIS APPEAL TO THE HEAD ONION PEEL. 1952. (CAT. 194)
OIL ON CANVAS, 31⅞ × 39⅜" (81 × 100 CM)
COLLECTION MR. AND MRS. HERBERT KLAPPER, NEW YORK

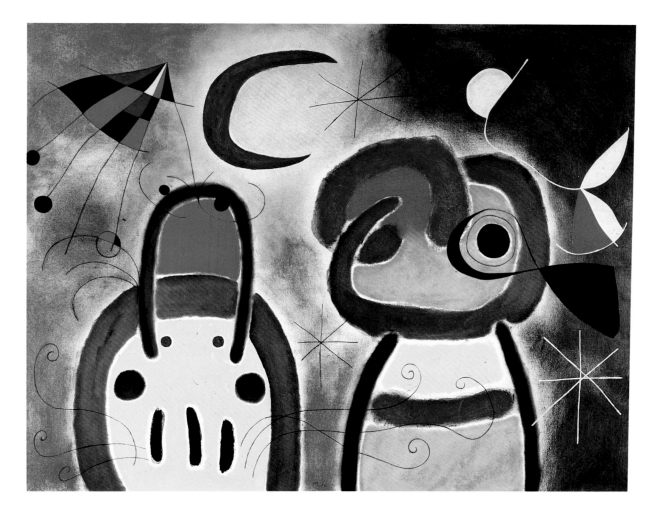

THE BIRD WITH PLUMAGE SPREAD FLIES TOWARD THE SILVERY TREE. 1953. (CAT. 195)
OIL ON CANVAS, 35¼ × 45¾″ (89.5 × 116.2 CM)
PRIVATE COLLECTION

PERSONAGE. 1955–56
CERAMIC, 14½ × 7¼ × 5″ (36.8 × 18.4 × 12.7 CM)
ACQUAVELLA MODERN ART

HEAD. [1954]
CERAMIC SUPPORTED BY A ROD AND WOODEN BASE, 9½ × 18 × 5½″ (23.5 × 45.7 × 14 CM)
THE MUSEUM OF MODERN ART, NEW YORK. GIFT OF RICHARD S. ZEISLER

HAIR DISHEVELED BY THE FLEEING CONSTELLATIONS. [BARCELONA, JANUARY 19], 1954. (CAT. 196)
OIL AND TEMPERA OR GOUACHE (?) ON MACHINE-WOVEN FABRIC PRINTED TO LOOK LIKE TAPESTRY, 51 × 70½″ (129.5 × 179 CM)
COLLECTION JOSEPH HOLTZMAN

Plaque. 1956
Ceramic, 19⅝ × 31½ × 9¾″ (50 × 80 × 25 cm)
Galerie Maeght, Paris

Disk. 1956
Ceramic, ¾″ (2 cm) high × 9¼″ (23.5 cm) diameter
Galerie Maeght, Paris

Round Plaque with Red Necklace. 1956
Ceramic, ⅜″ (1 cm) high × 12⅝″ (32 cm) diameter
Galerie Maeght, Paris

Plate. 1956
Ceramic, 2″ (5 cm) high × 14½″ (37 cm) diameter
Galerie Maeght, Paris

Above, left:
GOURD. 1956
CERAMIC,
19⅝″ (50 CM) HIGH × 7⅞″ (20 CM) DIAMETER
GALERIE MAEGHT, PARIS

Above, center:
VASE. 1956
CERAMIC,
20″ (51 CM) HIGH × 10⅝″ (27 CM) DIAMETER
GALERIE MAEGHT, PARIS

Above, right:
COLOCYNTH OBJECT. 1956
CERAMIC,
17¾ × 11 × 11″ (45 × 28 × 28 CM)
GALERIE MAEGHT, PARIS

Left:
TRIPOD OBJECT (IN TWO PARTS). 1956
CERAMIC,
31⅛ × 16½ × 18½″ (79 × 42 × 47 CM)
GALERIE MAEGHT, PARIS

PERSONAGE. [1956]
CERAMIC, 31¼ × 9⅞ × 8½″ (79.4 × 25.1 × 21.6 CM);
AT BASE, 11½″ (29.3 CM) WIDE × 11¼″ (28.6 CM) DEEP
THE MUSEUM OF MODERN ART, NEW YORK.
GIFT OF MR. AND MRS. EDWIN A. BERGMAN

MONUMENT. 1956
CERAMIC, 28¼ × 12¾ × 12¾″ (71.7 × 32.3 × 32.3 CM)
COLLECTION ALVIN S. LANE

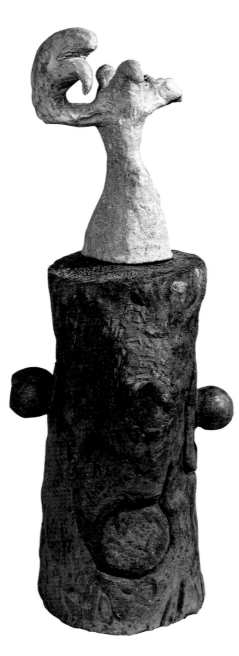

BIRD ON A TREE TRUNK. 1956
CERAMIC, $32 \times 9 \times 9\frac{3}{4}''$ ($81.2 \times 22.8 \times 24.7$ CM)
COURTESY THE PACE GALLERY, NEW YORK

BLUE I. PALMA DE MALLORCA, MARCH 4, 1961. (CAT. 198)
OIL ON CANVAS, 8′ 10¼″ × 11′ 7¾″ (270 × 355 CM)
COLLECTION HUBERT DE GIVENCHY

Blue II. Palma de Mallorca, March 4, 1961. (Cat. 199)
Oil on canvas, 8′ 10¼″×11′ 7¾″ (270×355 cm)
Musée National d'Art Moderne, Centre Georges Pompidou, Paris. Gift of the Menil Foundation, 1984

MURAL PAINTING II. PALMA DE MALLORCA, MAY 21, 1962. (CAT. 202)
OIL ON CANVAS, 8′ 10¼″ × 11′ 7¾″ (270 × 355 CM)
PRIVATE COLLECTION

MURAL PAINTING I. PALMA DE MALLORCA, MAY 18, 1962. (CAT. 201)
OIL ON CANVAS, 8' 10¼" × 11' 7¾" (270 × 355 CM)
PRIVATE COLLECTION

BLUE III. PALMA DE MALLORCA, MARCH 4, 1961. (CAT. 200)
OIL ON CANVAS, 8′ 9½″ × 11′ 5⅜″ (268 × 349 CM)
MUSÉE NATIONAL D'ART MODERNE, CENTRE GEORGES POMPIDOU, PARIS, 1988

MURAL PAINTING III. PALMA DE MALLORCA, MAY 22, 1962. (CAT. 203)
OIL ON CANVAS, 8′ 10¼″ × 11′ 7¾″ (270 × 355 CM)
PRIVATE COLLECTION

THE RED DISK. [PALMA DE MALLORCA], APRIL 19, 1960. (CAT. 197)
OIL ON CANVAS, 51¼ × 63⅜″ (130.2 × 161 CM)
NEW ORLEANS MUSEUM OF ART. BEQUEST OF VICTOR K. KIAM

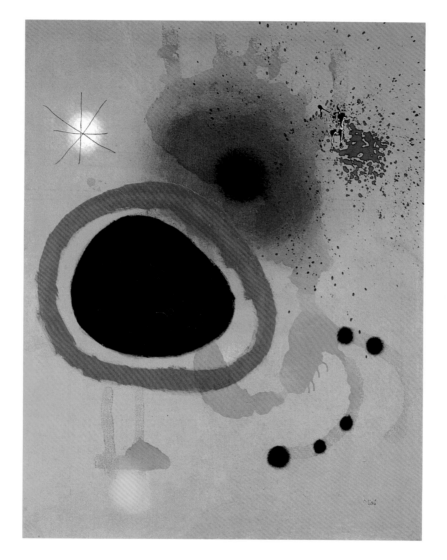

RED CIRCLE, STAR. Palma de Mallorca, July 13, 1965. (Cat. 204)
Oil on canvas, 45⅝×35″ (116×89 cm)
Private collection

THE SONG OF THE VOWELS.
PALMA DE MALLORCA, APRIL 24, 1966. (CAT. 205)
OIL ON CANVAS, 12′ ⅛″ × 45¼″ (366 × 114.8 CM)
THE MUSEUM OF MODERN ART, NEW YORK.
MRS. SIMON GUGGENHEIM FUND, SPECIAL
CONTRIBUTION IN HONOR OF DOROTHY C. MILLER

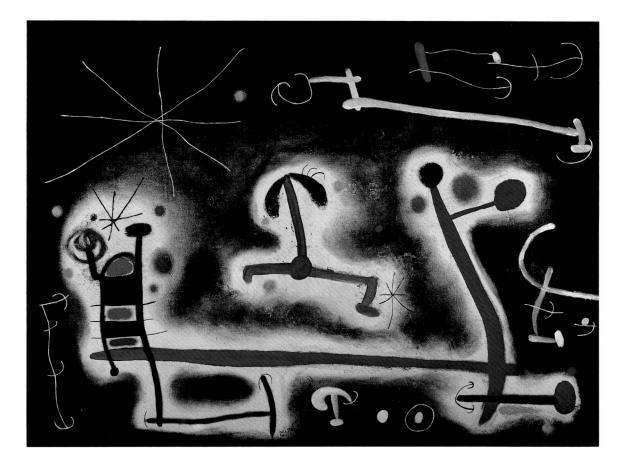

PERSONAGES AND BIRDS REJOICING AT THE ARRIVAL OF THE NIGHT. PALMA DE MALLORCA, [FEBRUARY 15, 1968]. (CAT. 206)
OIL ON CANVAS, 38⅝ × 51⅛″ (98 × 130 CM)
PRIVATE COLLECTION, BARCELONA

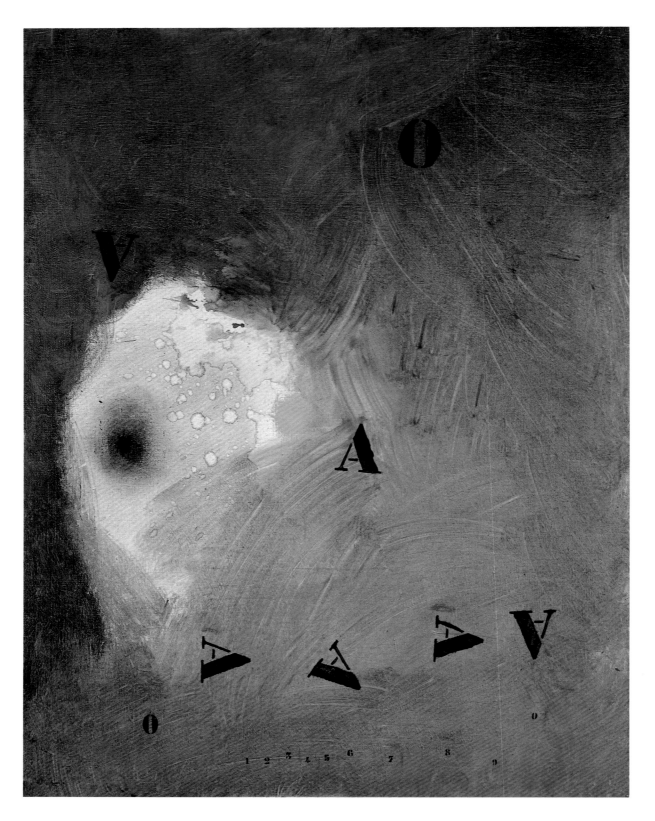

LETTERS AND NUMBERS ATTRACTED BY A SPARK (V). PALMA DE MALLORCA, JUNE 5, 1968. (CAT. 207)
OIL ON CANVAS, 57½ × 44⅞″ (146 × 114 CM)
COLLECTION KAZUMASA KATSUTA

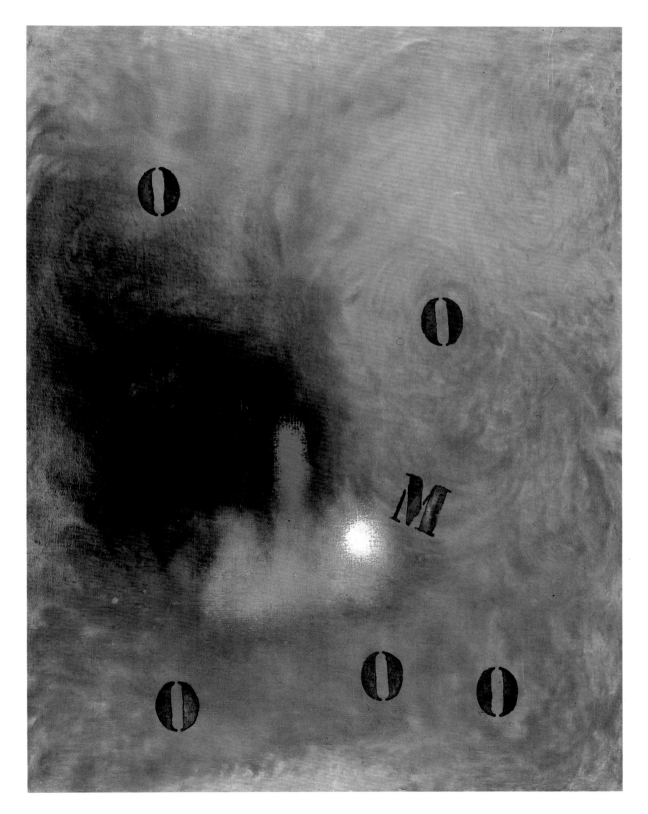

Letters and Numbers Attracted by a Spark (VI). Palma de Mallorca, June 5, 1968. (Cat. 208)
Oil on canvas, 57½ × 44⅞″ (146 × 114 cm)
Galerie Maeght, Paris

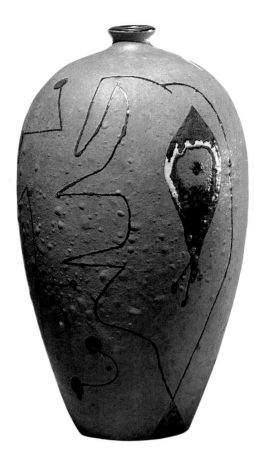

Vase. 1941
Ceramic, 15¾″ (40 cm) high × 8⅝″ (22 cm) diameter
Galerie Maeght, Paris

Blue Vase. 1962
Ceramic, 5⅛″ (13 cm) high × 3½″ (9 cm) diameter
Galerie Maeght, Paris

Blue Vase. 1962
Ceramic, 6⅛″ (15.5 cm) high × 4⅜″ (11 cm) diameter
Galerie Maeght, Paris

MAN AND WOMAN. 1962
BRONZE AND CERAMIC ON WOOD BASE,
7′ 11″ × 23″ × 30″ (241.3 × 58.4 × 76.2 CM)
ACQUAVELLA MODERN ART

MOONBIRD. 1966. (APP. 18)
BRONZE, 7′ 8⅛″ × 6′ 9¼″ × 59⅛″ (228.8 × 206.4 × 150.1 CM)
THE MUSEUM OF MODERN ART, NEW YORK. ACQUIRED THROUGH THE LILLIE P. BLISS BEQUEST

SOLAR BIRD. 1966. (APP. 19)
BRONZE, 48 × 71 × 40″ (121.9 × 180.3 × 101.6 CM)
THE ART INSTITUTE OF CHICAGO. GRANT J. PICK FUND

WOMAN. 1968
TERRA-COTTA, 41⅜ × 15¾ × 13¾″ (105 × 40 × 35 CM)
GALERIE MAEGHT, PARIS

WOMAN. 1968. (APP. 20)
BRONZE, $68 \times 28 \times 8''$ ($172.7 \times 71.1 \times 20.3$ CM)
ACQUAVELLA MODERN ART

WOMAN WITH PITCHER. 1970. (APP. 26)
BRONZE, 33¼×27½×14½″ (84.4×69.8×36.8 CM)
ACQUAVELLA MODERN ART

PERSONAGE. 1969. (APP. 21)
BRONZE, 56¾×14×12½″ (144.1×35.5×31.7 CM)
ACQUAVELLA MODERN ART

WOMAN. 1970. (APP. 22)
BRONZE, 24 × 12 × 5½″ (60.9 × 30.4 × 13.9 CM)
ACQUAVELLA MODERN ART

BIRD. 1970. (APP. 24)
BRONZE AND CONCRETE BLOCK, 24½ × 16¼ × 15″ (62.2 × 41.2 × 38.1 CM)
ACQUAVELLA MODERN ART

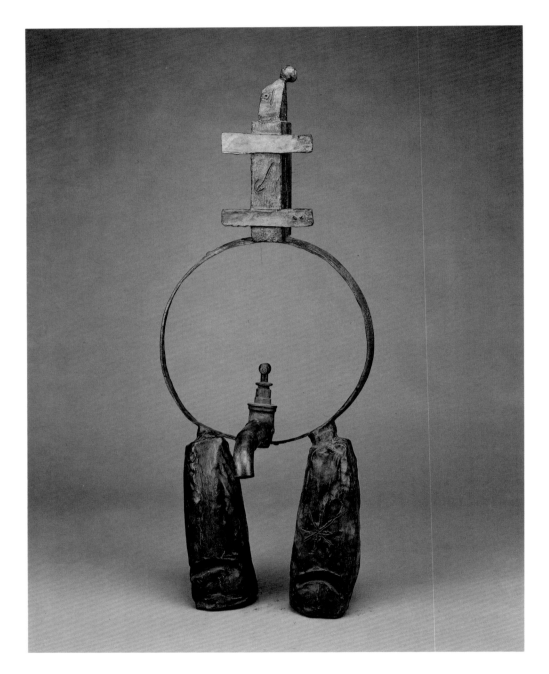

PERSONAGE. 1970. (APP. 23)
BRONZE, 46½ × 19 × 13″ (118.1 × 48.2 × 33 CM)
ACQUAVELLA MODERN ART

Opposite:
PERSONAGE. 1970. (APP. 25)
BRONZE, 6′ 6¾″ × 47¼″ × 39⅜″ (200 × 120 × 100 CM)
FONDATION MARGUERITE ET AIMÉ MAEGHT, SAINT-PAUL, FRANCE

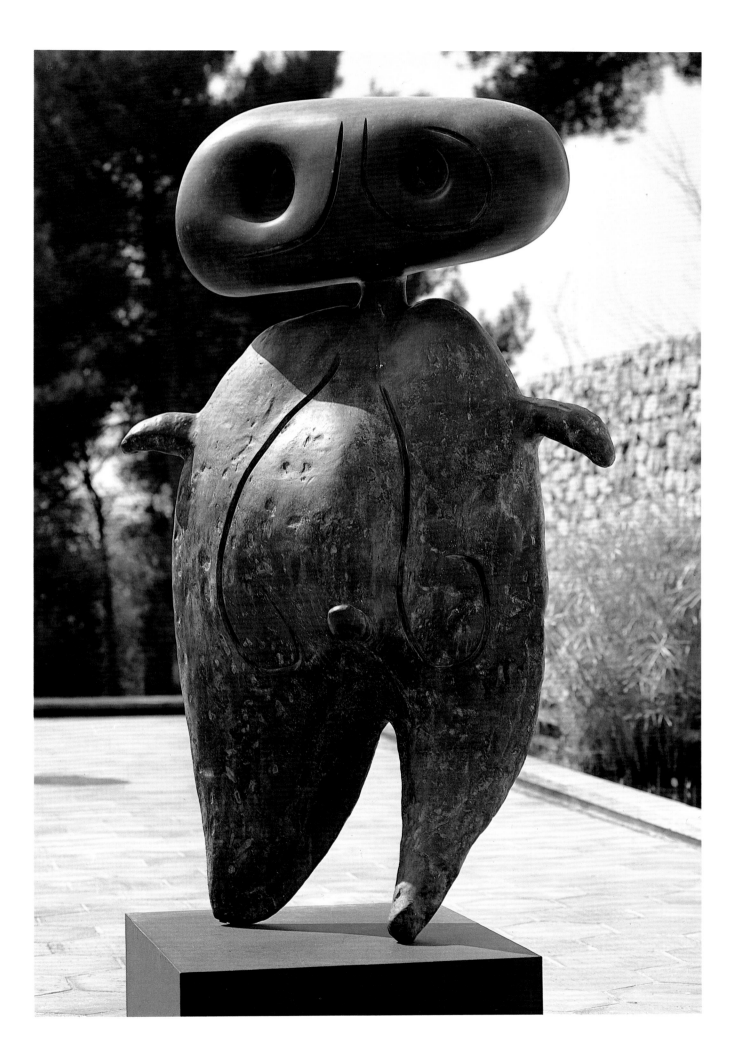

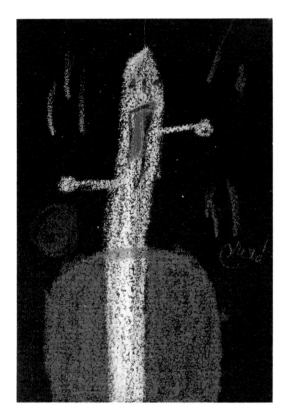

PERSONAGE. [PALMA DE MALLORCA], AUGUST 10, 1977
CHARCOAL, INK, AND CRAYON ON BLACK SANDPAPER,
11¼ × 7½″ (28.5 × 19 CM)
MUSÉE NATIONAL D'ART MODERNE,
CENTRE GEORGES POMPIDOU, PARIS.
GIFT OF THE ARTIST, 1979

UNTITLED. PALMA DE MALLORCA, C. 1970–80. (CAT. 213)
OIL ON CARDBOARD, 19⅞ × 14⅜″ (50.5 × 36.5 CM)
FUNDACIÓ PILAR I JOAN MIRÓ A MALLORCA

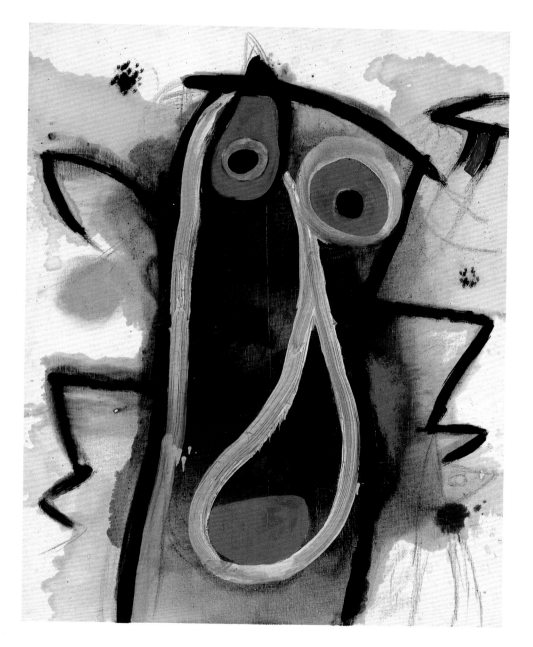

UNTITLED. PALMA DE MALLORCA, C. 1970–80. (CAT. 214)
OIL AND CHARCOAL ON CANVAS, 39⅜ × 31½″ (100 × 80 CM)
FUNDACIÓ PILAR I JOAN MIRÓ A MALLORCA

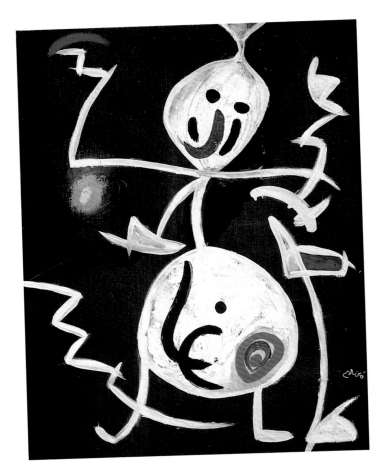

WOMAN, BIRD. PALMA DE MALLORCA, APRIL 29, 1976. (CAT. 209)
OIL ON CANVAS, 36¼×28⅜″ (92×72 CM)
COLLECTION PILAR JUNCOSA DE MIRÓ

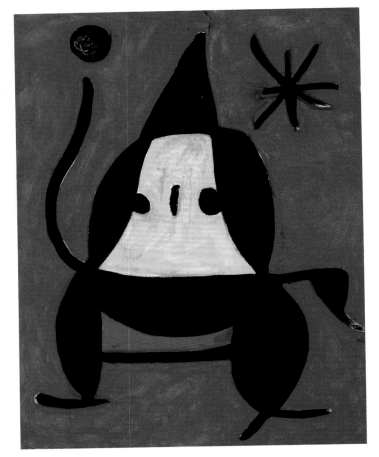

UNTITLED. PALMA DE MALLORCA, [JULY 31, 1978]. (CAT. 210)
OIL ON CANVAS, 36¼×28¾″ (92×73 CM)
FUNDACIÓ PILAR I JOAN MIRÓ A MALLORCA

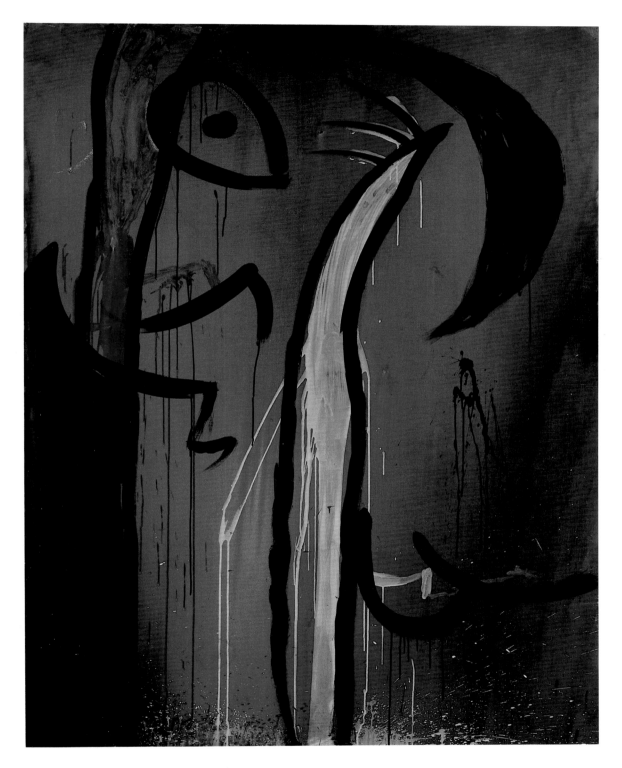

Untitled. Palma de Mallorca, c. 1970–80. (Cat. 215)
Oil on canvas, 64 × 51⅛″ (162.5 × 130 cm)
Fundació Pilar i Joan Miró a Mallorca

Untitled. Palma de Mallorca, c. 1970–80. (Cat. 211)
Oil on canvas, 64⅜ × 51⅝″ (163.5 × 131 cm)
Fundació Pilar i Joan Miró a Mallorca

UNTITLED. PALMA DE MALLORCA, C. 1970–80. (CAT. 212)
OIL ON CANVAS, 64⅜ × 51⅝″ (163.5 × 131 CM)
FUNDACIÓ PILAR I JOAN MIRÓ A MALLORCA

Untitled. Palma de Mallorca, c. 1970–80. (Cat. 216)
Oil and chalk on canvas, 8′ 10⅜″ × 11′ 7¾″ (270 × 355 cm)
Fundació Pilar i Joan Miró a Mallorca

Chronology

Compiled by Anne Umland

In 1957, Miró wrote to his friend and longtime dealer, Pierre Matisse, regarding plans to publish a facsimile edition of the gouaches now known as the Constellations (pp. 238–60). He told Matisse, "It is very important to date them exactly, in each case mentioning the place where they were made." Upon completing each of the gouaches, Miró had carefully recorded this information: on their versos are inscribed the date (day, month, and year) and place of execution (Varengeville, Palma de Mallorca, or Montroig), surrounded by a drawing (see p. 261).

Miró wanted the versos of the Constellations to be reproduced full-scale. Dry documentation, in other words, was to feature as prominently as visionary imagery. To turn one of the Constellations over is to flip from limitless cosmos to terrestrial fact, and to understand how in Miró's work the visionary and the pedestrian are inextricably intertwined. It also serves to highlight his concern with the significance of place and with the precise dating of his works, first evident in 1924 and continued throughout his life (though at some times more intensively than others).

Given the importance Miró attached to chronological sequence and to place of execution, the primary aim of the Chronology is to establish, as accurately as possible, the artist's movements and to determine where and when the works included in the exhibition were created. It seeks also to consolidate and resolve, wherever possible, conflicting information from previous chronologies, through careful examination of both primary and secondary sources, while at the same time bringing new information to light.

Due to constraints of space, the vast topic of Miró's post–World War II production (prints, illustrated books, ceramics, sculpture, textiles, and public commissions) is dealt with only cursorily. Beginning in the late 1940s, air travel enabled Miró to move about with increasing frequency; concurrently, the number of projects he was involved in multiplied, as did the number of exhibitions. As a result, the Chronology becomes more general at this point, although important projects and major exhibitions are recorded.

ABBREVIATIONS: Press-clipping volumes housed at the Fundació Pilar i Joan Miró a Mallorca, Palma de Mallorca, are cited as *Palma*, followed by a Roman numeral indicating the volume number.

Works discussed in the Chronology are, in general, those included in the plates (cited by page number), the Catalogue, or the Appendix to the Catalogue (cited by *cat.* or *app.* number). Other works are identified by the following numbers: *Dupin*, referring to the catalogue numbers in Dupin 1962; *FJM*, referring to the catalogue numbers assigned to individual works in the collection of the Fundació Joan Miró, Barcelona; *MoMA*, referring to

the accession numbers assigned to individual works in the collection of The Museum of Modern Art, New York.

ADDRESSES: In the case of correspondence with Miró located in the Fundació Pilar i Joan Miró a Mallorca, Palma de Mallorca, it is not always possible to discriminate between addresses noted by the correspondent on the envelope and forwarding addresses added by postal services. In those cases where an address is known to be a forwarding address, it is so noted in the endnotes.

DATES: Dates inscribed by Miró on works are considered primary documentation in establishing the artist's whereabouts, as are dates written by the artist in his notebooks, those inscribed on correspondence to and from the artist, and those based on contemporaneous press notices and on records found in the Registre Civil, Barcelona.

Unless otherwise noted, correspondence dates are those inscribed by the writers. Dating by postmark is indicated in the endnotes.

Dates based on religious days (such as saints' days) named in correspondence are given in square brackets at the beginning of Chronology entries.

Square brackets indicate also dates which, while not inscribed or printed on primary documents or works, are based on primary or secondary sources cited in the endnotes.

The use of a question mark with a bracketed date is reserved for speculative information that remains unconfirmed by either primary or secondary documentation.

Circa (abbreviated *c.*) indicates close proximity of an event to a date or span of dates, and functions independently of brackets and question marks.

A span of dates separated by a dash indicates a continuous interval of time; the word *or* is used for alternative possible dates.

A date qualified by the word *by* represents the earliest documented date of an arrival, departure, or encounter; when qualified by *before*, it represents the end of a time period during which a given event might have occurred (*terminus ante quem*); when qualified by *after*, it represents the beginning of such a period (*terminus post quem*).

The spans of the seasons are understood as: winter, January–March; spring, April–June; summer, July–September; fall, October–December.

General information that applies to an entire year or which is not dated precisely appears at the beginning of the year. Information that applies to only part of the year appears under the earliest relevant month or season.

ENDNOTES: Supporting data for information in the

Chronology is found in the endnotes, along with explanations of revisions to, or discrepancies with, existing Miró literature.

Conflicting information from other sources is sometimes also noted, parenthetically and in abbreviated form.

Abbreviations used in the endnotes refer to the Exhibition History (cited by city) and the Reference List (cited by author, title, or institution).

Correspondence *to* Miró is identified by name of sender, mailing address, and date.

Correspondence *from* Miró is identified by name of recipient, return address, and date.

In the case of undated correspondence to E. C. Ricart or J. F. Ràfols, an inventory or other identifying number is provided. For example, *Balaguer 476* identifies an undated letter from Miró to Ricart in the Biblioteca-Museu Balaguer, Vilanova i la Geltrú, and *Catalunya 16* identifies an undated letter to Ràfols in the Biblioteca de Catalunya, Barcelona.

EXHIBITIONS: The listing of Miró's one-artist exhibitions is virtually complete through the 1940s. For other exhibitions, the reader is referred to the Exhibition History.

ORTHOGRAPHY: Although the Catalan language was standardized in 1916, new grammatical and orthographic norms were not immediately adopted. Irregularities in spelling, therefore, abound in both primary and secondary sources. They are preserved here only in instances of direct quotations from primary documents.

The spelling of personal names is based, whenever possible, on the subject's known preference and/or common usage.

The spelling of names of institutions and of addresses has been standardized insofar as possible to conform with current usage in the language of origin (Catalan, French, Spanish). Exceptions are identified in the endnotes.

QUOTATIONS: Miró's letters and interviews are, for the most part, in either Catalan or French.

Translations from Catalan are by Cristina Portell and Mary Ann Newman, unless otherwise noted. Translations from French are the author's, unless otherwise noted. In some cases, the English translation is followed by its foreign-language equivalent.

Untranslatable phrases or expressions are retained within the body of translated texts and italicized, as are foreign words used by the original writer.

Generally, with quotations from published materials, the source of first publication is given and

subsequent publications omitted. Unless otherwise noted, excerpts from correspondence are unpublished.

Square brackets in the text indicate editorial interpolations.

SOURCES: Primary sources include: correspondence; records found in the Registre Civil, Barcelona; press-clipping volumes from the Fundació Pilar i Joan Miró a Mallorca, Palma de Mallorca; note-books and preparatory sketches housed in the Fundació Joan Miró, Barcelona; inscriptions on completed works; and contemporaneous exhibition catalogues and reviews.

Essential secondary sources include: Dupin 1962 (Jacques Dupin worked closely with Miró during the late 1950s in preparing this monograph); Rowell 1986 (Margit Rowell first published critical revisions to accepted Miró chronologies, along with a valuable anthology of letters, interviews, and statements); and Lubar 1988 (Robert Lubar's dissertation and other publications on Miró's early years in Catalonia provide the basis for much of the information that appears here concerning this period). Other secondary sources are cited in the endnotes and the Reference List.

Unless otherwise noted, correspondence cited in the Chronology comes from the following sources: Archives of the History of Art, The Getty Center for the History of Art and the Humanities, Los Angeles (letters to Douglas Cooper, E. Tériade); Biblioteca de Catalunya, Barcelona (letters to J. F. Ràfols); Biblioteca-Museu Balaguer, Vilanova i la Geltrú (letters to E. C. Ricart); Bibliothèque Littéraire Jacques Doucet, Paris (letters to André Breton, Robert Desnos, Michel Leiris, Benjamin Péret, Francis Picabia, Tristan Tzara, Patrick Waldberg); Jacques Dupin, Paris (letters to Jacques Dupin); Fundació J. V. Foix, Barcelona (letters to Foix); Fundació Pilar i Joan Miró a Mallorca, Palma de Mallorca (letters to Miró); Galerie Maeght, Paris (letters to Aimé Maeght); Caritat Grau Sala, Barcelona (letters to Sebastià Gasch); Albert Loeb, Paris (letters to Edouard Loeb); Pierre Matisse Foundation, New York (letters to Patricia Matisse; letters to and from Pierre Matisse); Musée National d'Art Moderne, Centre Georges Pompidou, Paris (letters to Jean Cocteau, Marie Cuttoli, Dr. Girardin, Valentine Hugo, Vasily Kandinsky, Pierre Loeb, Man Ray, Rebeyrol, Léonce Rosenberg, Christian Zervos); Musée Picasso, Paris (letters to Pablo Picasso); The Museum of Modern Art, New York (letters to Gérald Cramer, William Rubin; letters to and from James Thrall Soby); The New-York Historical Society (letters to A. E. Gallatin, Jacques Mauny); Roland Penrose Archives, East Sussex (letter to Pierre Loeb; letters to Roland Penrose); George Antheil Papers, Rare Book and Manuscript Library, Columbia University, New York (letters to George and Böske Antheil); The Josep Lluís Sert Collection, Frances Loeb Library, Graduate School of Design, Harvard University, Cambridge, Mass. (letters to Josep Lluís Sert); and Jaume Vallcorba, Barcelona (letters to J. M. Junoy).

Two particularly important caches of information were inaccessible: the Josep Dalmau Archives (in the possession of Rafael Santos Torroella, Barcelona) and the Pierre Loeb Archives (believed to have been lost during World War II).

The Miró family tree (artist unknown). Courtesy the Miró family, Palma de Mallorca. The names of Joan Miró and his sister, Dolores, are inscribed on the shoot at the lower right.

1893

APRIL 20: Birth of Joan Miró Ferrà, at 9 P.M. at Passatge del Crèdit, 4, Barcelona. First child of Miquel Miró Adzerias, a watchmaker, native of Cornudella, and Dolores Ferrà Oromí, a native of Palma de Mallorca. Paternal grandparents Joan Miró and Isabel Adzerias, natives of Cornudella. Maternal grandparents Joan Ferrà and Josefa Oromí, natives of Palma and Barcelona, respectively.[1]

1894

DECEMBER 9: Birth of a brother, Miquel Miró Ferrà, at 3 P.M. at Passatge del Crèdit, 4, Barcelona.[2] He dies on May 12, 1895, at the age of five months.[3]

1896

MARCH 16: Birth of a sister, Josefa Miró Ferrà, at 1 A.M. at Passatge del Crèdit, 4, Barcelona. She dies at an early age.[4]

1897

MAY 2: Birth of sister, Dolores Miró Ferrà, at 5 P.M. at Passatge del Crèdit, 4, Barcelona.[5]

1900

Miró begins primary schooling at Carrer Regomir, 13. Takes drawing lessons with a professor named Civil.[6]

Starting this year, summers with paternal grandparents in Cornudella and with maternal grandmother in Mallorca.[7]

1901

Makes earliest extant drawings.[8]

1906

Begins first surviving sketchbook; mostly landscape drawings made near Cornudella, and on Mallorca.[9]

1907

Attends both business classes and La Lonja's Escuela Superior de Artes Industriales y Bellas Artes, through 1910.[10] Studies with Modesto Urgell, a landscape painter, and José Pascó, professor of decorative arts.[11]

1910-11

Works as bookkeeper for Dalmau Oliveres, a hardware and chemicals firm.[12]

Family purchases farm in Montroig, in the province of Tarragona.[13]

1911

Suffers minor nervous breakdown, followed by typhoid fever. Convalesces in Montroig.[14]

JULY 20: Exhibits in the "VI Exposición Internacional de Arte," Barcelona. Under his name, the catalogue lists one painting, titled *Roquis de Miramar (Mallorca)*.[15]

1912

Studies (through 1915) at Francesc Galí's Escola d'Art, on the Carrer de la Cucurulla, Barcelona.[16] During his years with Galí, meets Josep Aragay, Rafel Benet, Heriberto Casany, Marià Espinal, Jaume Mercadé, Joan Prats, J. F. Ràfols, E. C. Ricart, and possibly Josep Llorens Artigas.[17] Artigas, Prats, Ràfols, and Ricart will be his lifelong friends.

[APRIL 20—MAY 10]: Visits "Exposició d'art cubista" at the Galeries Dalmau, Barcelona.[18]

1913

[OCTOBER 15]: Enrolls in the Círcol Artístic de Sant Lluc, Carrer Montsió, 3, Barcelona, for drawing classes.[19]

[DECEMBER 6—27]: Exhibits three paintings in "VIII*a* Exposició del Círcol Artístic de Sant Lluc," Cán Parés, Barcelona.[20]

1914

AUGUST: World War I begins. Spain remains neutral.

[FALL]: In Barcelona, living at Passatge del Crèdit, 4, with his family.[21]

[FALL?]: Possibly shares a studio with Ricart on the Carrer Arc de Jonqueres. At times, Ràfols works in this studio.[22]

[LATE NOVEMBER]: Miró's mother is stricken with typhoid fever. He spends three weeks caring for her and does not go to Galí's.[23]

1915

[JANUARY—MID-MARCH]: Stays with his mother in Caldetes during her convalescence.[24]

BEFORE JANUARY 31: Called for military service. Is assigned to cover for absentees and temporarily excused from duty.[25]

Miró with his parents and his sister, Dolores

BY MARCH 15: Returns to Barcelona from Caldetes.[26] Lives at home and possibly paints in studio shared with Ricart (Carrer Arc de Jonqueres).[27]

During this period, continues studies with Galí;[28] frequents the Círcol Artístic de Sant Lluc, where he attends modeling sessions, executing a number of drawings (p. 90).[29]

MARCH 15: Writes to Bartomeu Ferrà: "[N]ow, back in Barcelona, I am working hard; all my efforts are directed toward constructing properly; it is my struggle to achieve what I have not got. My work will be stronger if, in addition to beauty of color, it has a well-constructed form."[30] His interest in Cézanne and compositional structure at this time is evident in paintings such as *The Clock and the Lantern* (p. 84).[31]

[BY JUNE?]: Galí closes the Escola d'Art to accept directorship of the new Escola Superior dels Bells Oficis, Barcelona, a school of decorative arts and design.[32]

BEFORE JUNE 10: Miró is called for military service.[33]

[SUMMER?]: Possibly is in Barcelona; military service.[34]

[FALL?]: In Barcelona. Lives at home and possibly paints in studio shared with Ricart (Carrer Arc de Jonqueres).[35]

[DECEMBER 23—JANUARY 6, 1916]: Possibly attends an exhibition of Kees van Dongen's work at the Galeries Dalmau in Barcelona with Ricart and Ràfols.[36]

1916

[WINTER—SPRING?]: In Barcelona. Lives at home and paints in a studio (Carrer Arc de Jonqueres) shared with Ricart and, at times, possibly Ràfols.[37]

[AFTER JANUARY 6?]: Meets the dealer Josep Dalmau, owner of the Galeries Dalmau, a center of avant-garde artistic activity in Barcelona.[38]

[SUMMER]: In Montroig.[39]

BEFORE JULY 25: Leaves Montroig briefly to join his regiment because of a train strike.[40]

SAINT JAMES'S DAY [JULY 25]: From Montroig, writes to Ricart: "I will be able to spend all summer here working without having to go to serve [in the army] until the winter. . . . The period during which I will have to serve has the worst weather for painting (little light and very variable weather), so I was very lucky. . . . I am very happy because I am working a lot and this is a very pure joy." A painting from summer 1916 is *Montroig, Sant Ramon* (p. 88).

[OCTOBER 1—DECEMBER 31]: Military service, in Barcelona.[41]

[AFTER OCTOBER 7?]: Shares a studio with Ricart on Carrer Sant Pere Més Baix, Barcelona. At times, Ràfols works in this studio.[42] Possibly paints *The Red Fan* (p. 85).

1917

[WINTER—SPRING?]: In Barcelona. Lives at home and paints in a studio shared with Ricart (Carrer Sant Pere Més Baix).[43] Probably works on *Self-Portrait* (p. 91), *"La Publicidad" and Flower Vase* (p. 86), *Portrait of E. C. Ricart* (p. 93), and *"Nord-Sud"* (p. 87).

E. C. Ricart. *Joan Miró in the Studio He Shared with Ricart.* 1917. Oil on canvas, 18½×23¼" (47×59 cm). Collection F. X. Puig Rovira, Vilanova i la Geltrú

Develops an interest in poetry and begins reading avant-garde Catalan and French literary journals, including Pierre Reverdy's *Nord-Sud* and Pierre Albert-Birot's *SIC*.[44]

Attends soirées at Dalmau's.[45] Through Dalmau, is possibly introduced to Maurice Raynal and perhaps to Francis Picabia.[46]

[**APRIL 23—JULY 1**]: Visits a large exhibition of late nineteenth- and early twentieth-century French art in Barcelona.[47]

[**SUMMER**]: In Montroig; visits Siurana, Prades, Cornudella, and Cambrils.[48] During these months, begins fourteen canvases, including *Prades, The Village* (p. 89).[49]

AUGUST 13—20: General strike and uprising in Sabadell. State of emergency declared in Barcelona. Miró is called to Barcelona to rejoin his regiment.[50]

[**AUGUST 18**]: Arrives in Barcelona.[51]

[**AFTER AUGUST 19?**]: To Sabadell with his regiment.[52]

[**AUGUST 25?**]: Returns to Montroig.[53]

[**AFTER AUGUST 26?**]: To Cambrils.[54]

SEPTEMBER 13: From Montroig, writes to Ràfols about the paintings he has worked on during the summer, almost all of which are landscapes: "[T]he feeling of each one is very different and so is the execution."[55]

[**SEPTEMBER 30?**]: Arrives in Barcelona by train at midnight and meets his friend Ramon Sunyer on the Passeig de Gràcia.[56]

[**OCTOBER 1—DECEMBER 31**]: Military service, in Barcelona.[57] Paints in studio shared with Ricart (Carrer Sant Pere Més Baix).[58] Reads Apollinaire's poetry during military service period.[59]

[**OCTOBER 1?**]: From Barcelona, writes to Ricart: "[E]verything I have will fit in Dalmau's. . . . The fourteen canvases I did this summer [are] interesting although not all of them are complete. . . . I plan to exhibit in February."[60]

OCTOBER 19: Reads van Gogh letters at the Ateneu Barcelonès.[61]

[**NOVEMBER 10**]: Attends a performance of *Parade* (a collaboration by Jean Cocteau, Erik Satie, Picasso, and Léonide Massine) at the Gran Teatre del Liceu, Barcelona.[62]

[**DECEMBER 31**]: End of military service.[63]

1918

[**WINTER—SPRING?**]: In Barcelona. Lives at home and paints in a studio shared with Ricart (Carrer Sant Pere Més Baix).[64]

JANUARY: In *Almanac de la revista* (Barcelona) publishes a line drawing of a donkey, made the previous summer in Siurana.[65]

[**FEBRUARY**]: The Agrupació Courbet is constituted in reaction to more conservative elements of the Círcol

Cover of the catalogue of Miró's first one-artist exhibition, held at the Galeries Dalmau, Barcelona, February 1918. Calligram by J. M. Junoy

Artístic de Sant Lluc. Members include: Artigas, Francesc Domingo, Espinal, Miró, Ràfols, Ricart, and Rafel Sala.[66]

Publication of Miró's drawing of a female nude for the cover of the first and only issue of *Arc-voltaic*, directed by Joan Salvat Papasseit.[67]

FEBRUARY 16—MARCH 3: Has his first one-artist exhibition, at the Galeries Dalmau, Carrer Portaferrissa, Barcelona. Exhibits sixty-four paintings and drawings from 1914 to 1917.[68]

MARCH: Publishes a drawing in J. M. Junoy's magazine *Trossos*, a journal of advanced art and literature directed at the time by Josep Vicenç Foix.[69]

[**BEFORE APRIL 8**]: Probably completes *Portrait of Heriberto Casany* (p. 92) and *Portrait of Ramon Sunyer* (p. 92).[70]

BEFORE APRIL 14: To Mallorca; visits Palma, sees Bartomeu Ferrà.[71]

APRIL 14: In Pollensa.[72]

c. APRIL 15: Recent paintings by Miró, Ricart, and others shown at the Galeries Dalmau.[73]

MAY 10—JUNE 30: Exhibits with the Agrupació Courbet at the first "Exposició d'art del Palacio de Bellas Artes," in one of the rooms of the Círcol Artístic de Sant Lluc.[74]

MAY 11: From Barcelona, writes to Ricart: "At the beginning of next week Ràfols and I will start a nude of Trini. I am going to do a 1.20m × 1.52m canvas [*Standing Nude*, p. 94]. We shall see what comes out."[75]

[**JUNE 11**]: From Barcelona, writes to Ricart: "As soon as I finish . . . the life-size nude [*Standing Nude*, p. 94] . . . I will leave for Montroig to work very hard."[76]

In the evening attends Stravinsky's ballet *Petrouchka* at the Gran Teatre del Liceu, Barcelona.[77]

[**EARLY JULY—EARLY DECEMBER**]: In Montroig.[78] New pictorial style is visible in *Vegetable Garden and Donkey* (p. 96) and *House with Palm Tree* (p. 97), two of four canvases completed during this period.[79]

Miró's interest in going to Paris is evident in correspondence of this period.[80]

JULY 16: From Montroig, writes to Ricart: "No simplifications or abstractions. . . . Right now what interests me most is the calligraphy of a tree or a rooftop, leaf by leaf, twig by twig, blade of grass by blade of grass, tile by tile."[81]

AUGUST 11: From Montroig, writes to Ràfols: "This week I hope to finish two landscapes [possibly including *Vegetable Garden and Donkey*, p. 96]. . . . As you see, I work very slowly."[82]

OCTOBER 27: From Montroig, writes to Ricart: "Right now, I am doing a canvas with a house with a sundial, a palm tree, and a bird cage hanging in the doorway [*House with Palm Tree*, p. 97]."[83]

ALL SAINTS' DAY [NOVEMBER 1]: From Montroig, writes to Ràfols: "I am working a lot now. . . . I . . . spend the whole day in front of the easel. I had to leave off the painting of the village of Montroig [p. 98], which you will see half finished, in order to avoid going to the village, which is absolutely overrun by the flu."[84]

[**EARLY DECEMBER**]: Returns to Barcelona with family.[85] Allows Ricart to use his studio on the Carrer Sant Pere Més Baix.[86]

Sixth page of a letter from Miró to E. C. Ricart, November 10, 1918. Courtesy Biblioteca-Museu Balaguer, Vilanova i la Geltrú

1919

[WINTER–SPRING?]: In Barcelona. Lives at home and paints in studio on the Carrer Sant Pere Més Baix.

[JANUARY 22]: Sebastià Gasch joins the Círcol Artístic de Sant Lluc, through which he later befriends Miró.[87]

[SPRING?]: Miró begins *Nude with Mirror* (p. 95), working from a life model, possibly at the Círcol Artístic de Sant Lluc.[88]

MAY 17–30: Participates in the Agrupació Courbet's drawing exhibition at the Galeries Laietanes, Barcelona.[89]

MAY 28–JUNE 30: Exhibits with the Agrupació Courbet in the second Exposició d'Art, Barcelona, in one of the rooms of the Círcol Artístic de Sant Lluc.[90]

[BEFORE JUNE 29?]: Designs a poster for the second series of the Franco-Catalan journal *L'Instant*.[91]

[JUNE 29–OCTOBER 22]: In Montroig.

JULY 9: From Montroig, writes to Ricart: "I have been here at the farm since Saint Peter's Day [June 29]. . . . [T]his afternoon or tomorrow morning I will begin to work like a slave. In the early mornings I will continue the canvas of the village of Montroig begun last year [*The Village of Montroig*, p. 98], in the afternoons a large canvas with a landscape of olive trees, carobs, vines, mountains (a torrent of light) [*Vines and Olive Trees, Tarragona*, p. 99]."[92]

In the same letter, tells Ricart: "The self-portrait [p. 101] is already finished. . . . I was not able to finish the nude [*Nude with Mirror*, p. 95]."[93]

AUGUST 10: From Montroig, writes to Ràfols: "Ricart must have told you that he is determined to go to Paris in a few months. I am *definitely* going at the end of November. . . ."[94]

AUGUST 15: From Montroig, writes to Ricart: "Let me know what you find out about the cost of living in Paris. I have heard confidentially that my economic problems will be resolved in a dignified way, without wounding my scruples, and leaving a margin for freedom which at the same time will create *responsibility*."[95]

[AUGUST 24?]: From Montroig, writes to Ricart: "Upon my arrival in Barcelona, I am determined to talk to Dalmau about the proposition he made to me of sending some of my works to a dealer there [in Paris] in order to prepare my arrival there. Or to let myself be utterly exploited, telling him [Dalmau] to speak with Manyac [Pere Mañach] about the important reduction in my request. I would give all my work, without thinking, for 1,000 pesetas, *with the requirement that he organize an exhibition of my work within a fixed period of time*, plus a percentage upon sale."[96]

[OCTOBER 22]: Returns to Barcelona.[97] Lives at home and paints in studio on the Carrer Sant Pere Més Baix.

[AFTER OCTOBER 22]: In Barcelona, meets with Dalmau and possibly Mañach. Writes to Ricart: "I

can talk about going to Paris. My dealers (!) from Barcelona have accepted my propositions, which you already know."[98]

Also tells Ricart that the models are on strike, but that once it is settled he will "take up again (ten or twelve sessions) the nude from last summer [probably *Nude with Mirror*, p. 95] to complete it and take it with me."[99]

[NOVEMBER–JANUARY 1920]: Is involved in activities related to his planned trip to Paris.[100]

[NOVEMBER 15]: Probably attends his uncle's wedding in Barcelona.[101]

[MID-NOVEMBER OR DECEMBER?]: Probably completes landscapes from the summer (*The Village of Montroig*, p. 98, and *Vines and Olive Trees, Tarragona*, p. 99). Resumes work on *Nude with Mirror* (p. 95). At the same time, draws at the Círcol Artístic de Sant Lluc (*Male Nude*, p. 100).[102]

The Agrupació Courbet is by now virtually dissolved.[103]

1920

[JANUARY–LATE FEBRUARY]: In Barcelona. Lives at Passatge del Crèdit, 4.[104] Gives up studio in Barcelona.[105]

[BY FEBRUARY 20]: Ricart arrives in Paris.[106]

[LATE FEBRUARY?]: Miró goes to Paris.[107] Stays at the Hôtel de Rouen, 13, rue Notre-Dame-des-Victoires, as do Ricart and other Catalans.[108]

MARCH 2: Visits Picasso with Ricart.[109]

MARCH 5: Ricart writes to Ràfols from Paris that Miró is "enthusiastic and anxious to paint and draw."[110]

[MARCH 14?]: Miró writes to Ràfols from the Hôtel de Rouen, describing all he has seen in Paris.[111]

BEFORE MARCH 27: Meets with Josep Dalmau in Paris to discuss plans for his exhibition.[112]

APRIL 26: On a visit to Reims, sends a postcard to Ràfols.

[MAY 5]: Members of his family, who have been in Paris visiting, now leave.[113]

[MAY 26]: Miró possibly attends Dada festival, Salle Gaveau.[114]

[MID-JUNE]: From Paris, returns to Barcelona, where he stays for about two weeks before leaving for Montroig.[115]

[BY JUNE 27–MID-OCTOBER]: In Montroig,[116] where he completes three paintings marked by late Cubist influence, including *Horse, Pipe, and Red Flower* (p. 102).[117]

JUNE 27: From Montroig, writes to Picasso: "I agree with you that to be a painter you must remain in Paris. . . . Europe and the country. . . . Our actions abroad are more patriotic than those of people who act within their home, *without seeing the world*. I've just arrived in the countryside, ready to begin working fiercely; some months here, and afterward back again to Paris."[118]

JULY 18: From Montroig, writes to Ricart, telling him he has received an invitation to submit something to the Salon d'Automne.[119]

AUGUST 8: From Montroig, writes to Ferrà: "My stay in Paris opened up a whole world of ideas and now, with the *exciting* tranquility of the country, I've hurled myself into my work with abandon. . . . I've put off my Paris exhibition until next season; I'll have a better chance of succeeding then, with more doors open, and I'll be able to show things done after having been in Paris."[120]

AUGUST 22: From Montroig, writes to Ricart: "Now I am going to nail up two stretchers that I want to start: one is 1.40 × 1.12 [unidentified] and the other 1.30 × 1.12 [probably *Still Life with Rabbit*, p. 103]."[121]

[SEPTEMBER 1–8]: Possibly in Cambrils.[122]

OCTOBER 15–DECEMBER 12: Exhibits *Self-Portrait* (p. 101) and *The Village of Montroig* (p. 98) in the Catalan section of the Salon d'Automne in Paris.[123]

[MID-OCTOBER?]: Returns to Barcelona from Montroig.[124] Lives at Passatge del Crèdit, 4. Works on *Still Life with Rabbit* (p. 103), completed at the end of January 1921, in Dalmau's studio on the Carrer Perot lo Lladre.[125]

OCTOBER 26–NOVEMBER 15: Exhibits three paintings, including *Horse, Pipe, and Red Flower* (p. 102) in "Exposició d'art francès d'avantguarda," at the Galeries Dalmau, Barcelona.[126] Catalogue preface is by Maurice Raynal. Miró possibly meets with Raynal in Barcelona.[127]

NOVEMBER 18: From Barcelona, writes to Ràfols: "I am waiting to finish a 1.40m × 1.12m canvas before going to Paris. — I do not want to finish it there because I have a feeling I will experience another jolt in Paris. May God continue to give me these jolts!"[128]

DECEMBER 28: From Barcelona, sends Picasso a postcard, noting that he plans to return to Paris in early February and will visit Picasso's mother in Barcelona before then.[129]

1921

JANUARY 28: From Barcelona, Miró writes to Ràfols: "Tomorrow I will finish the painting [*Still Life with Rabbit*, p. 103] (finally!). . . . I will leave for Paris between the 8th and 10th of February; two or three days earlier I will take the painting off the stretcher and roll it up."[130]

[FEBRUARY 8–10]: Leaves Barcelona.[131]

FEBRUARY 11: Visits the Musée Ingres in Montauban, France; accompanied by Espinal.[132]

[AFTER FEBRUARY 11]: Arrives in Paris.[133] Stays at the Hôtel Innova, 32, boulevard Pasteur.[134]

[FEBRUARY 22?]: Picasso visits Miró at the Hôtel Innova. Sees *Still Life with Rabbit* (p. 103).[135]

[FEBRUARY 25]: From the Hôtel Innova, Miró sends Dalmau an angry letter regarding the lack of pro-

gress with plans for his exhibition. Threatens to cancel agreement with Dalmau, noting that the dealers Paul Rosenberg and Daniel-Henry Kahnweiler both intend to visit him.[136]

[FEBRUARY 26]: At Picasso's suggestion, Paul Rosenberg visits Miró at the Hôtel Innova. Sees *Still Life with Rabbit* (p. 103).[137]

[EARLY MARCH?]: Miró works in the studio of the sculptor Pau Gargallo, 45, rue Blomet. Lives at the Hôtel Innova and by June, at the Hôtel Namur, 39, rue Delambre.[138] Paints *Still Life — Glove and Newspaper* (p. 105) and later, *Portrait of a Spanish Dancer* (p. 104).[139]

BEFORE MARCH 10: Dalmau arrives in Paris.[140]

BY MARCH 20: Negotiations for Miró's first Parisian exhibition are completed.[141]

MARCH 26: From 32, boulevard Pasteur, writes to Ràfols: "I am working very hard; now I am working on the head of a girl [*Portrait of a Spanish Dancer*, p. 104]; I did a very big still life [*Still Life — Glove and Newspaper*, p. 105], and when I am finished with all this I want to start two big figure paintings [probably *Spanish Dancer*, Dupin 74, and *Standing Nude*, Dupin 75]. At night I make drawings of nudes. My exhibition will open on *April 29* at *La Licorne* (rue de la Boétie). . . . I've met many people; I've become a friend of Max Jacob's. . . . I don't know if I already mentioned that I am working in Gargallo's studio [45, rue Blomet] and I sleep in a hotel; this is a very good arrangement for me."

At this time, is acquainted with Pierre Reverdy and perhaps Tristan Tzara.[142]

MARCH 31: Friendship with Ricart becomes strained. Writing to Ràfols, Ricart characterizes Jacob, Picasso, Raynal, and Reverdy as Miró's "*arrivés* — and some, *arrivistes* — friends."[143]

[SPRING?]: Miró possibly meets André Masson through Max Jacob at the Café Savoyarde and discovers they are neighbors at 45, rue Blomet.[144]

APRIL 26: Dalmau writes from Barcelona concerning final arrangements for Miró's exhibition at the Galerie La Licorne.[145]

[BEFORE APRIL 29]: Dalmau presents Picasso with Miró's *Self-Portrait* (p. 101).[146]

APRIL 29—MAY 14: Miró's first one-artist exhibition in Paris, at Galerie La Licorne, 110, rue de La Boétie, organized by Dalmau. The catalogue preface is by Maurice Raynal. The exhibition includes twenty-nine paintings and fifteen drawings.[147]

MAY 3: From 45, rue Blomet, Miró writes to Junoy: "I suppose that by now you will have received the catalogue of my exhibition in Paris. . . . I am very happy and feel very encouraged. . . ."

[JUNE 12 OR 13]: Leaves Paris for Barcelona.[148]

[JUNE 27]: Leaves Barcelona for Montroig.[149]

[JUNE 27—LATE DECEMBER?]: In Montroig, begins work on *The Farm* (p. 107).[150]

JULY 31: From Montroig, writes to Ràfols: "I don't have to tell you that I am working all day long, as usual. I am working on two . . . landscapes which

will keep me busy until the winter, until it is time to go back to Paris."[151]

OCTOBER 2: From Montroig, writes to Ràfols: "My two paintings continue to be absolutely invisible. I imagine you will be surprised when you see the big canvas [probably *The Farm*, p. 107]; that is, when it is *finished*. . . . I have rented the same studio as Gargallo in Paris, and I will be able to live there — so I will be able to work really intensely this winter."[152]

BY DECEMBER 25: In Barcelona.[153]

1922

[JANUARY—LATE MARCH?]: Probably in Barcelona, living at Passatge del Crèdit, 4. Works on *The Farm*.[154]

MARCH 17: From Barcelona, sends Ràfols a postcard addressed to Florence, Italy: "I am planning to finish the painting [probably *The Farm*, p. 107] next week."[155]

[LATE MARCH OR EARLY APRIL?]: Leaves Barcelona for Paris.[156]

[EARLY APRIL?—LATE JUNE]: In Paris. Lives and works at 45, rue Blomet.[157] Friendship with André Masson and Roland Tual.[158] Continues painting *The Farm* (p. 107).[159]

[C. EARLY MAY]: Completes *The Farm* (p. 107).[160] Begins intense campaign to promote his first chef d'oeuvre among friends, critics, and art dealers.[161]

[MAY 28?]: The art dealer Léonce Rosenberg visits 45, rue Blomet, probably to see *The Farm* (p. 107).[162]

JUNE 1: Miró consigns *The Farm* (p. 107) to Rosenberg.[163]

[LATE JUNE]: Leaves Paris; returns to Barcelona. Visits Picasso's mother in Barcelona.[164]

JUNE 30: From Barcelona, writes to Ràfols: "My painting is at Léonce Rosenberg's and it has quite a success. If you go to Paris, let me know."[165]

[C. JULY 3—LATE DECEMBER]: In Montroig; takes trips to Barcelona.[166] Begins several paintings, including *Interior* (p. 106), *Still Life I* (p. 108), *Still Life II* (p. 109), and *Still Life III* (p. 110), the last of his so-called realist period.[167]

JULY 31: From Montroig, writes to Roland Tual: "I am working on figures and still lifes, and I put in seven hours of labor every day. . . . I look through the kitchen for humble things . . . an ear of corn, a grill, and make a picture from them."[168]

SEPTEMBER 7: Writes to Léonce Rosenberg, asking him to have *The Farm* framed and to submit it to the Salon d'Automne.[169]

SEPTEMBER 23: Rosenberg submits *The Farm* to the Salon d'Automne.[170]

[OCTOBER]: In Paris, Tual introduces the poet Michel Leiris to André Masson at 45, rue Blomet. It is possibly soon after this time that Leiris also meets Georges Limbour at the rue Blomet and through him Robert Desnos.[171]

OCTOBER 1: Miró returns to Barcelona for the wedding of his sister.[172]

Writes to Ràfols from Passatge del Crèdit, 4: "I'm working with . . . several . . . very simple . . . things at the same time, in order to rest from the great effort that the last canvas [most likely *The Farm*, p. 107] cost me."

OCTOBER 10: *The Farm* is accepted for the 1922 Salon d'Automne.[173]

OCTOBER 12: Miró attends the wedding of his sister, Dolores Miró Ferrà, to Jaime Galobart Sanmartí, in the church of Sant Jaume, Barcelona.[174]

[AFTER OCTOBER 12]: Returns to Montroig, where he remains until the Christmas holidays.[175]

OCTOBER 16: From Montroig, writes to Léonce Rosenberg: "I have not finished a single painting. I am concerned only with resolving them, and that done, I will finish them in Paris. . . . It would be an honor for me to show you these paintings first, and you can be sure I will not say a word and no one will see them before you."

NOVEMBER 1—DECEMBER 17: Exhibits *The Farm* (p. 107) at the Salon d'Automne, Paris. His name is given in the catalogue as "MIRO-FERRA (JEAN)."[176]

[NOVEMBER 17]: André Breton, in Barcelona on the occasion of a Picabia exhibition at the Galeries Dalmau (November 18—December 8), gives a lecture at the Ateneu. During his visit, Breton sees works by Miró for the first time.[177]

[BY DECEMBER 25]: Miró returns to Barcelona to spend the holidays with his family.[178]

DECEMBER 28: From Passatge del Crèdit, 4, writes to Léonce Rosenberg, mentioning that he has recently arrived in Barcelona and plans to return to Paris during the first half of January. A day later, writes to Picasso with the same information. His return to Paris is delayed, however, by his mother's illness.[179]

1923

[JANUARY—FEBRUARY]: In Barcelona. Lives at Passatge del Crèdit, 4.[180]

BY MARCH 4: In Paris. Works at 45, rue Blomet.[181] Lives at the Hôtel de la Haute-Loire, 203, boulevard Raspail, by March 9, and at 10, rue Berthollet, by April 7.[182]

Through Masson, meets Michel Leiris and possibly Antonin Artaud, Robert Desnos, Jean Dubuffet, Paul Eluard, Marcel Jouhandeau, Georges Limbour, Raymond Queneau, and Armand Salacrou.[183]

APRIL 9: Exhibits *The Farm* at the Caméléon, 146, boulevard Montparnasse on the occasion of A. Schneeberger's lecture "The Evolution of Catalan Poetry" at 9:00 P.M.[184]

[BEFORE MID-MAY?]: Possibly leaves studio at 45, rue Blomet.[185]

MAY 15: From 10, rue Berthollet, writes to Picasso announcing that he is "in pursuit of a Mme Miró, of a studio, and a dealer! It's a funny affair!"[186]

[MAY 16–31]: Exhibits *The Farm* again at the Caméléon, 146, boulevard Montparnasse.[187]

BEFORE JUNE 20: Completes *Interior* (p. 106), *Still Life I* (p. 108), *Still Life II* (p. 109), and *Still Life III* (p. 110).

JUNE 20: Consigns six still lifes (*nature mortes*) to Léonce Rosenberg.[188]

JUNE 21: Visits Nemours Seine-et-Marne with Michel Leiris, André Masson, and Odette Masson.[189] Sometime after June 21, returns to Spain.

[JULY–LATE DECEMBER]: In Montroig.[190]

JULY 6: From Montroig, sends postcards to both Ràfols and Léonce Rosenberg announcing that he is beginning a new "offensive."

Begins *The Tilled Field* (p. 111).[191] This painting, along with *The Hunter* (p. 113) and *Pastorale* (p. 112), marks a turning point in Miró's oeuvre.[192]

SEPTEMBER 26: From Montroig, writes to Ràfols: "I am working really a lot, with absolute regularity and method. . . . I have already managed to break absolutely free of nature, and the landscapes have nothing whatever to do with outer reality. Nevertheless, they are more *Montroig* than if they had been painted *from nature*."[193] In a postscript, notes: "I have now definitely been able to rent the studio at the rue Blomet; this is very important for its quiet and convenience."[194]

OCTOBER 7: From Montroig, writes to Ràfols and includes a description of *The Tilled Field* (p. 111) and *The Hunter* (p. 113): "Hard at work and full of enthusiasm. Monstrous animals and angelic animals. Trees with eyes and ears (and a peasant with his *barretina* and rifle, smoking a pipe). All the pictorial problems resolved. We must explore all the golden sparks of our souls."[195]

[BY DECEMBER 25]: To Barcelona.[196]

DECEMBER 31: From Passatge del Crèdit, 4, writes to Picasso: "Back from the country, I'm preparing for my return to Paris around the 15th of January."

1924

[JANUARY 1]: In Barcelona. Possibly returns to Montroig and remains through February.[197]

JANUARY 17: Léonce Rosenberg writes to Miró in Barcelona at Passatge del Crèdit, 4: "I await with impatient curiosity the pleasure of seeing your new works as you so kindly offered. I've shown the few paintings [*les quelques tableaux*] of yours that I have on deposit here to various *amateurs* who sincerely admired them but who are waiting to see more conclusive works, that is to say more mature, before making any definite pronouncements."[198]

FEBRUARY 25–MARCH 8: Masson exhibition at the Galerie Simon, Paris. André Breton sees the exhibition but still does not know Masson personally.[199]

[MARCH?–LATE JUNE?]: Miró is in Paris. Lives and works at 45, rue Blomet.[200]

Many of the leading avant-garde poets and writers of the day congregate at the rue Blomet. During this "heroic" period, Miró's friends include Max Jacob, Michel Leiris, Georges Limbour, Benjamin Péret, Armand Salacrou, and Roland Tual.[201] Miró is introduced by Masson to the work of Paul Klee.[202]

Begins an important series of large gridded pictures, executed in charcoal, chalk, pencil, and oil (see pp. 114–17). During the same period, probably begins work on *Carnival of Harlequin* (p. 128), and *Head of Catalan Peasant, II* (Dupin 104).[203]

Probably retrieves paintings on consignment to Léonce Rosenberg.[204]

[APRIL 22]: Writes to his friend Magí A. Cassanyes, probably from Paris.[205]

MAY 3: From 45, rue Blomet, writes to Gasch: "In the middle of working feverishly, maybe as never before and with the wind favoring all my things, I thank you for your good wishes. . . ."[206]

[MAY 5]: Attends the premiere performance of Raymond Roussel's *Etoile au front*, with Desnos and others.[207]

MAY 16: Completes *The Family* (p. 115).

JUNE 14: Attends performance of the ballet *Mercure* at the Théâtre de la Cigale; stage sets by Picasso, music by Erik Satie, and choreography by Léonide Massine.[208]

Sometime after June 14, leaves Paris and returns to Spain.

[LATE JUNE?–MID-DECEMBER]: In Montroig.[209] Completes a number of small drawings on painted wood grounds, paintings on monochromatic grounds (see pp. 118–23), and a series of drawings on Ingres paper (see pp. 124–27).

AUGUST 10: From Montroig, writes to Michel Leiris. The letter, which details many of Miró's objectives, reveals the impact of the poets on his work and makes reference to Breton's writings.[210]

[LATE SEPTEMBER]: In Paris, Breton meets André Masson for the first time.[211]

OCTOBER 15: Publication of the first *Manifeste du surréalisme*.

OCTOBER 31: From Montroig, Miró sends a poetic letter to Leiris. The language evokes a recently completed drawing, *Spanish Dancer* (dated October 20, 1924; p. 125).[212]

NOVEMBER 7–11: In Montroig, completes a number of drawings on Ingres paper, including *Automaton* (November 7, 1924; p. 124), *The Kerosene Lamp* (November 10, 1924; p. 126), and *The Wind* (November 11, 1924; p. 127).

NOVEMBER 15: From Montroig, writes to Picasso: "I'm working very energetically — very encouraged. I'll be back, as usual, after the Christmas holidays."

DECEMBER 1: Publication of the first issue of *La Révolution surréaliste*, edited by Pierre Naville and Benjamin Péret.

BEFORE DECEMBER 20: Miró returns to Barcelona, bringing his new work (the small drawings on painted wood grounds, the paintings on monochromatic grounds, and the drawings on Ingres paper) along with *The Tilled Field*, *The Hunter*, and *Pastorale*.[213]

[DECEMBER 23]: Cassanyes visits Miró in Barcelona and sees his new work.[214]

[DECEMBER 25]: In Barcelona, at Passatge del Crèdit, 4; spends the Christmas holidays with his family.[215]

DECEMBER 31: From Passatge del Crèdit, 4, writes to Picasso: "I will be back around the 12th — if you want anything tell me!"

1925

During this year, Hans Arp arrives in Paris; probably becomes acquainted with Miró late in the year.[216]

[C. MID-JANUARY?–EARLY JULY]: Miró is in Paris. Lives and works at 45, rue Blomet.[217]

Has arrived in Paris with some sixty works.[218] Included in this group are three paintings from 1923–24 (*The Tilled Field*, p. 111; *The Hunter*, p. 113; and *Pastorale*, p. 112), along with the 1924 drawings on wood and on Ingres paper (pp. 124–27 are representative), and 1924 paintings such as *The Kiss* (p. 118), *Portrait of Mme B.* (p. 119), *Maternity* (p. 120), *Head of Catalan Peasant, I* (p. 121), *Bouquet of Flowers* (p. 122), and *The Hermitage* (p. 123).[219]

Will later describe this period as one of "intense work. I filled up notebooks and drawings, and these served as the starting points for canvases."[220]

Continues working on *Carnival of Harlequin* (p. 128) and other paintings, including *Head of Catalan Peasant, II* (Dupin 104) and *Head of Catalan Peasant, III* (p. 129).[221]

[FEBRUARY]: The couturier and collector Jacques Doucet, along with Breton, visits Masson at the rue Blomet in this month and in May. Doucet will later purchase paintings from Miró.[222]

BEFORE FEBRUARY 10: Louis Aragon,[223] Paul Eluard, and Pierre Naville visit Miró's studio, 45, rue Blomet, to see the works he has brought from Spain, but are said to be "unable to form a definite opinion of them."[224]

AFTER FEBRUARY 10: Breton meets Miró for the first time, at 45, rue Blomet, and sees his recent works.[225] By the time of Miró's June exhibition at the Galerie Pierre, Breton will have purchased *The Hunter* (p. 113) and *The Gentleman* (Dupin 99).[226]

[BEFORE APRIL 1]: Evan Shipman brings Jacques Viot to see Miró. Viot is managing the recently opened Galerie Pierre.[227]

Miró possibly meets Ernest Hemingway around this time, as well as Ezra Pound.[228]

[APRIL 1]: Miró signs a contract with Viot.[229]

JUNE 10: From 45, rue Blomet, writes to Picabia, enclosing a catalogue of his upcoming exhibition at the Galerie Pierre: "I've often asked my friend Desnos for news of you, awaiting the time when you'll be in Paris to have the honor of making your acquaintance."

VOUS
INVITENT
A VISITER
L'EXPOSITION
JOAN MIRO

qui aura lieu
à la Galerie Pierre
15, RUE BONAPARTE - DU VENDREDI 12 JUIN AU SAMEDI 27 JUIN 1925

VERNISSAGE VENDREDI 12 JUIN A MINUIT

Invitation to the first of Miró's one-artist exhibitions at the Galerie Pierre, Paris, June 1925. The design of the invitation incorporates the signatures of the Surrealists.

JUNE 12–27: Miró's first one-artist exhibition at the Galerie Pierre, 13, rue Bonaparte, organized by Jacques Viot. Catalogue preface by Benjamin Péret, "Les Cheveux dans les yeux." Invitation is signed by many of the Surrealists. Fifteen drawings and sixteen paintings are shown.[230]

Miró is derided by conservative critics, who had found promise in his 1921 exhibition at the Galerie La Licorne.[231] Among the visitors to the exhibition is Raymond Roussel, who purchases a work.[232]

[AFTER JUNE 12]: André Masson writes to Michel Leiris: "[H]as Miró left? I've heard echoes of his exhibition from [Dr. Théodore] Fraenkel and a letter from him which testifies to his perfect joy."[233]

[JULY 2]: Miró probably attends the Surrealists' banquet at the Closerie des Lilas honoring the poet Saint-Pol-Roux. Violent incidents at this event cause an outcry in the press against the Surrealists' subversive activities.[234]

[AFTER JULY 5]: Miró arrives in Barcelona, en route to Montroig.[235]

[AFTER JULY 5–MID-NOVEMBER]: In Montroig; around mid-October returns briefly to Barcelona.[236]

Begins his great cycle of "dream" paintings in Montroig, including *Personage* (p. 130), *"Photo—Ceci est la couleur de mes rêves"* (p. 131), *The Policeman* (p. 132), *Painting* (p. 134), and *Head of Catalan Peasant, IV* (p. 135).[237] Through spring 1927, produces paintings at an astonishing rate.

JULY 15: First publication of Miró's work in *La Révolution surréaliste*; *Maternity* (p. 120) and *The Hunter* (p. 113) are reproduced.[238]

JULY 26: Writes to Picasso, apologizing for not having said good-bye: "When I left, you had already gone. This time I left very late, because of my exhibition, which kept me in Paris; it went very well, much better than I ever would have supposed. I hardly saw you at all this winter. Breton and my friends have told me a lot about a large painting you have made—it seems it is something unprecedented [*une chose inouïe*]. I went to see your mother in Barcelona; they are all doing very well."[239]

[LATE SUMMER–FALL]: Continues working on "dream" paintings, including *The Birth of the World* (p. 133), *"Etoiles en des sexes d'escargot"* (p. 138), and *"Le Corps de ma brune . . ."* (p. 139).[240]

SEPTEMBER 28: From Montroig, writes to Gasch: "I am working a lot. I will go back to Barcelona with around sixty canvases, some of them so big that I have to use a ladder to work on them."

OCTOBER 10: From Montroig, writes to Gasch: "I packed all the canvases that are finished, that is, thirty-five, some of them of incredible size. . . . For Christmas I will finish another series, of twenty-five canvases, which I am leaving here. . . ."

[AFTER OCTOBER 10]: Miró leaves Montroig; briefly returns to Barcelona and possibly ships thirty-five new paintings to Paris.[241]

[AFTER OCTOBER 14?]: Returns to Montroig to continue "dream" paintings. During the first half of November, leaves for Paris.[242]

[OCTOBER 24–NOVEMBER 14]: Paul Klee exhibition at the Galerie Vavin-Raspail impresses Miró.[243]

[BY NOVEMBER 9]: Following the publication of *In*

Our Time (October 5), Ernest Hemingway purchases *The Farm* from Evan Shipman as a birthday present for his wife, Hadley Hemingway.[244]

NOVEMBER 13: At midnight, the first Surrealist painting exhibition opens at the Galerie Pierre, 13, rue Bonaparte.[245]

NOVEMBER 14–25: *Carnival of Harlequin* (p. 128) and *Dialogue of the Insects* (Dupin 102) are shown in "Exposition: La Peinture surréaliste," along with works by Giorgio de Chirico, Hans Arp, Max Ernst, Paul Klee, Man Ray, André Masson, Picasso, and Pierre Roy. Catalogue preface is by André Breton and Robert Desnos.[246]

NOVEMBER 15: From 45, rue Blomet, Miró writes to Gasch, reporting on the opening of the Surrealist exhibition: "Very glad of the tempest I provoke. It is our *specialty*."

[AFTER NOVEMBER 15?]: Returns to Montroig; there continues "dream" paintings, including *Dancer II* (p. 140).

DECEMBER 15: Gasch's first article on Miró in *Gaseta de les arts* declares: "[T]he work of Miró represents, in the development of modern painting, the most original and important effort after Picasso."[247]

[BY DECEMBER 25]: In Barcelona for Christmas.[248] Possibly returns to Montroig shortly thereafter.[249]

1926

[JANUARY]: In Montroig, continuing the "dream" paintings.[250]

JANUARY 3: André Masson writes to Jacques Doucet: "Our friend Miró is in Spain—he is finishing paintings begun last summer."[251]

[JANUARY 7]: From Montroig, Miró writes to his parents in Barcelona that he plans to finish his work the following week.[252]

[FEBRUARY?]: Possibly returns to Paris, bringing new paintings with him.

Possibly moves into new studio, leased under Jacques Viot's name, at 22, rue Tourlaque, Cité des Fusains. Max Ernst is his neighbor.[253]

Probably sells first paintings to the Belgian businessman and journalist René Gaffé, including *Spanish Dancer* (p. 116) and *The Birth of the World* (p. 133).[254]

[MARCH?]: At Picasso's suggestion, Sergei Diaghilev sends Boris Kochno and Serge Lifar to Montmartre to visit Ernst's and Miró's studios. Subsequently, Diaghilev visits the two artists and commissions each of them to design the scenic devices for *Romeo and Juliet*, a ballet then in preparation by the Ballets Russes.[255]

[APRIL 1?]: The sculptor André de la Rivière moves into Miró's former studio at 45, rue Blomet.[256]

BY APRIL 20: Miró and Ernst are in Monte Carlo, working on *Romeo and Juliet* with the Ballets Russes.[257]

[MAY 4]: Premiere of the Ballets Russes production of *Romeo and Juliet*, in Monte Carlo;[258] music by Constant Lambert, decor by Max Ernst and Joan Miró, choreography by Bronislava Nijinska; Serge Lifar dances Romeo.[259]

BY MAY 8: Miró is in Paris, living and working at 22, rue Tourlaque. Neighbors include Ernst, Arp, and possibly Paul Eluard and Camille Goemans.[260]

Continues the series of "dream" paintings, possibly including *"Amour"* (p. 141).[261]

MAY 8: Sees Ernst's exhibition at the Galerie Jeanne Bucher, 5, rue du Cherche-Midi.[262]

MAY 12: A notice in *Le Figaro* announces the return of the Ballets Russes to Paris, and predicts that Ernst's and Miró's contributions to *Romeo and Juliet* will mark a date in the history of contemporary art comparable to 1917 (referring to Picasso's designs for *Parade*).[263]

Around the same time, the Paris police inform Diaghilev that the Surrealists intend to stage a demonstration on opening night to protest Ernst and Miró's collaboration with the "bourgeois" Diaghilev and the Ballets Russes.[264]

MAY 18: Opening of *Romeo and Juliet* at the Théâtre Sarah Bernhardt, Paris.[265] Surrealists disrupt the performance. Louis Aragon and André Breton have written a "Protestation," denouncing Miró and Ernst; the text, printed in red ink on small white sheets, is scattered throughout the audience.[266]

MAY 19: The incident at the Théâtre Sarah Bernhardt captures the attention of the press. As a result, Miró for the first time receives widespread international publicity. Serge Lifar later recalls that all the hullabaloo "had but one result, that Paris did nothing but talk of the new ballet, so that [when] it was given [again] (May 20th and 27th), we played to crammed houses."[267]

JUNE 15: Breton and Aragon's "Protestation" is published in *La Révolution surréaliste*. In an advertisement in the same issue, Miró, along with Masson, Yves Tanguy, de Chirico, Man Ray, Rrose Sélavy [Marcel Duchamp], Picabia, Georges Malkine, Picasso, and Ernst, is listed as an artist featured by the newly opened Galerie Surréaliste, 16, rue Jacques Callot.[268]

JULY 4: The New Chenil Galleries, London, presents the exhibition "Serge Lifar's Collection of Modern Painting," including works by Miró. *Romeo and Juliet* is performed during the course of the London season of the Ballets Russes, June 14–July 23.[269]

JULY 9: Death of Miró's father, Miquel Miró Adzerias, at Montroig.[270] Miró leaves Paris; returns to Barcelona.[271]

JULY 14: From Barcelona, writes to Picasso: "You will be astonished that I left without saying good-bye. Unfortunately, I had to leave unexpectedly after receiving a telegram with news of my father's sudden death at Montroig."

JULY 28: Pierre Loeb writes to Miró: "A fine bit of news: Viot has run off after having taken me for 40,000 francs' worth of paintings and owing money to the entire world. A warrant will no doubt be issued for his arrest. As he owes me for more than

500 *numéros* of paintings of yours, which I paid him for in advance because we were in business together, I propose to take over your entire production if in fifteen days we haven't heard news; I count on you in any case to give me priority."

BY JULY 29: Miró is in Girona, staying at the Casa Fugarolas, with his mother.[272]

AFTER AUGUST 2: Returns to Barcelona with his mother; then goes to Montroig.[273]

AUGUST 6: Pierre Loeb writes to Miró (addressed to Passatge del Crèdit, 4): "I am happy to hear that you are working in peace and with joy, and I thank you for what you told me on the subject of the 40 percent of your production which belongs to you. I am certain that we understand each other well and that you will have, I think, satisfaction from me. Your works will not be randomly dispersed; I will *place* them, according to my taste, with people worthy of them."[274]

[MID-AUGUST–MID-DECEMBER?]: In Montroig, with brief trips to Barcelona.[275] Works on Imaginary Landscapes (see pp. 152–57).[276]

AUGUST 27: Max Ernst writes to Miró in Montroig about Viot's disappearance; says that because the rue Tourlaque studio was leased in Viot's name, Miró must quickly put his own name on the lease, as otherwise the authorities might seal the studio and seize the contents.[277]

SEPTEMBER 23: From Montroig, Miró writes to Gasch: "I am working a lot, although very slowly this time. I will probably work for the entire month of October, which, of course, I will spend here in the countryside. . . . I would like to leave a drawn canvas here for the next year, the first of a series of big canvases I intend to execute next summer."

BEFORE OCTOBER 7: Is briefly in Barcelona. Visits the Paral·lel with Picasso and his wife, Olga Koklova.[278]

OCTOBER 26: Ernst writes to Miró: "[N]othing new about this sordid affair [i.e., Viot]. But I will send you a note once you can stay in your studio, which, I hope, won't be too long from now."[279]

NOVEMBER 19–JANUARY 1, 1927: Miró's work shown for the first time in the United States, in the Société Anonyme's "International Exhibition of Modern Art." Two paintings are exhibited, including *The Upset (Le Renversement)* (Dupin 94).[280]

DECEMBER 5: From Montroig, writes to Foix about a drawing he has completed for Foix's book *Gertrudis*.[281]

[MID-DECEMBER?]: Returns to Barcelona, probably bringing the Imaginary Landscapes (see pp. 152–57) with him.[282]

[LATE DECEMBER?]: Leaves Barcelona for Paris, probably with new work.[283]

1927

Sometime during the year, meets James Johnson Sweeney.[284]

JANUARY 1–[LATE JUNE]: In Paris; brief visit to Barcelona. Lives and works in Arp's old studio at 22, rue Tourlaque;[285] Max Ernst's studio is across from his.[286]

Completes another cycle of "dream" paintings, including *"48"* (p. 143), *"Un Oiseau poursuit une abeille et la baisse"* (p. 142), *"Musique — Seine — Michel, Bataille et moi"* (p. 145), *"Beaucoup de monde"* (p. 144), and *Painting* (p. 146). Permits no one to see his recent work.[287]

JANUARY 4: *La Publicitat* announces the forthcoming publication of Foix's *Gertrudis* with an original drawing by Miró.[288]

FEBRUARY 24: From 22, rue Tourlaque, writes to Gasch, asking him "*to abstain absolutely*" from publishing anything in the Paris press about his work. Also tells Gasch: "I work a lot. I see very few people, only from time to time to show that I am alive. Nobody has seen what I did this past summer [the 1926 Imaginary Landscapes, pp. 152–57] nor what I am doing now. It is very likely that we will do a very important exhibition when I've finished the series of canvases that I want to do this coming summer."

BY MARCH 29: In Barcelona; plans for engagement to Maria Pilar [Joy].[289]

[AFTER APRIL 2?]: Returns to Paris.[290] Continues to work on the last series of "dream" paintings, including *Painting* (p. 147), *Painting* (p. 148), and *Painting* (p. 149).[291]

[AFTER APRIL 15]: Gasch writes to Miró at 22, rue Tourlaque, mentioning Salvador Dalí's request that Gasch convey the younger artist's greetings and admiration to Miró.[292]

[BEFORE MAY 13]: The Ballets Russes performs *Romeo and Juliet* in Barcelona at the Gran Teatre del Liceu.[293]

[C. JULY 6–LATE NOVEMBER]: Is in Montroig; takes trips to Barcelona.[294]

AFTER JULY 21: Begins work on a second series of Imaginary Landscapes (pp. 158–61).[295]

AUGUST 6: Paul Eluard writes to Miró from Mallorca: "I truly regretted not having seen you . . . in Barcelona, but I had very little time and Montroig was too far away. I saw M. Dalmau and bought from him a big painting of yours: a nude woman set against a tapestry with Spanish flowers and birds [*Standing Nude*, p. 94]. . . . During my visit I had wanted to give you a letter from Breton along with poems by his great friend Lise Hirtz. It would give him great pleasure to have these little poems illustrated."[296]

AUGUST 21: Miró writes to Gasch from Montroig: "I expect Pierre [Loeb] to be here at the beginning of the month. As you know, I would like to introduce him to both Dalí's and [Francesc] Domingo's works. Is there anybody else interesting? . . . I will write to Dalí, asking him if he will allow me to visit him with a *friend* (no one must know this person is Pierre), so that he can be prepared to show us enough things to give an idea of his work."[297]

AUGUST 25: From Sitges, Cassanyes writes to Miró: "I have already seen the book by my ex-friend Raynal; poor devil! What a regrettable thing it is to see a man . . . obliged to talk about things he doesn't un-

derstand! You can see him, taken aback, dodging the issue, astonished by the fact that there are things, so many things, that he doesn't understand. . . . I read that he made you *chef du Surréalisme*; what a shame, since you have more to lose than to gain from it. . . ."298

September 1: Dalí writes to Miró from Figueres: "I am delighted at the prospect of a visit from you and your friend."

[Before September 18]: Miró visits Dalí in Figueres with Pierre Loeb.299

[October]: Executes gouaches on which *pochoir* illustrations for Lise Hirtz's book *Il était une petite pie* (published in November 1928) are based. Sends gouaches to Breton.300

October 11–25: Exhibits in Brussels for the first time, at the Galerie Le Centaure. Three paintings are included.301

November: Charles and Marie-Laure de Noailles purchase a large painting by Miró from the Galerie Pierre for 5,000 francs.302

November 1: Breton writes to Miró in Montroig: "Your drawings have arrived and I do not know how to thank you. They could not be better suited to the work I entrusted to you. They are admirably beautiful and stunning."303

[Late November]: Miró returns to Barcelona.304

December 1: The *Paris Times* reports: "Much interest is being displayed by connoisseurs in the work of the young French painter Jean Miró [*sic*], who at the age of thirty-two [*sic*] has attained a position of considerable prominence in the local scene. M. Pierre's large collection of the paintings of Miro is a testimony of confidence in his future."305

[Late December]: Returns to Montroig.306

1928

[January–February]: In Montroig; takes trips to Barcelona.307

February 7: From Montroig, writes to Ràfols: "I am still in the country, which at this time of year is a beautiful miracle of God, working hard for the exhibition that will open on the first of May at Hodebert (Barbazanges, Faubourg Saint-Honoré) and where I want to push things to the limit. . . . I would like to show you the recent paintings I did here [the 1927 Imaginary Landscapes; see pp. 158–61], but I am afraid that once they're in Barcelona, already rolled, it would be dangerous to unpack them. They are big canvases of 120. . . ."308

February 11: Breton's *Le Surréalisme et la peinture* is published; his comments on Miró, Arp, and Tanguy appear here for the first time.309

Before February 19: Miró returns to Barcelona, bringing the 1927 Imaginary Landscapes (see pp. 158–61). Leaves for Paris.310

By February 19: Is in Paris, at 22, rue Tourlaque.311 Possibly executes his first collage-objects, all titled *Spanish Dancer* (see pp. 167–69).312

Camille Goemans, Miró, Hans Arp (in front), E. L. T. Mesens, and P. G. van Hecke, Galerie l'Epoque, Brussels, May 1928. Archives Succession Miró

April 15: Writes to Picasso from 22, rue Tourlaque: "I'd prefer that you wait until my exhibition to see my paintings. At this moment I am very depressed. From now on things will go better, I hope. Pierre [Loeb] has asked you for my portrait [*Self-Portrait*, p. 101] for the exhibition. . . . For the moment, I think it is too early a work — it would give the impression of conceding to those people who think I can't draw a nose. Later, yes, I will ask you for it."

May 1–May 15: Has a one-artist exhibition at the Galerie Georges Bernheim & Cie, 109, rue du Faubourg-Saint-Honoré, organized by Pierre Loeb. The exhibition is a critical and commercial success.313

By May 5–May 17: Travels to Belgium and Holland; visits Brussels, The Hague, and Amsterdam.314

May 5: In Brussels.315

Visits Arp exhibition at Galerie L'Epoque and is photographed with Camille Goemans, Arp, E. L. T. Mesens, and P. G. van Hecke.316

May 11: In The Hague.317

May 14: In Amsterdam.318

By May 17: Is back in Paris, at 22, rue Tourlaque.319 Possibly begins work on sketches and drawings for the series of Dutch Interiors, based on postcards brought back from museums in Belgium and Holland.320

Before June 5: Leaves Paris for Barcelona.321

June 5: From Passatge del Crèdit, 4, writes to Ràfols, saying he has just arrived from Paris: "I would very much like to see you before getting married, on June 21, if God wills it." Asks Ràfols: "Do you know anything about Goya's centennial, whether it is in Madrid or Aragón? I would be grateful if you could

tell me, if you know, what exhibitions are planned and furthermore, *what their closing dates are*."322

[Early–mid-June?]: Is interviewed in Barcelona by the journalist Francesc Trabal. The interview is published in the Catalan nationalist paper *La Publicitat*, July 14, 1928.323

[By June 21?]: Engagement broken off. René Gaffé later recalls: "A telegram announced he no longer planned to marry, but was planning ten highly finished [*très poussés*] paintings, then a series of twenty-four drawings."324

By June 22: Miró's first trip to Madrid.325

July 1: First published interview with Miró appears in *La Gaceta literaria* (Madrid).326

[Before July 9?]: To Montroig.327 Stays there through mid-November, then visits Barcelona; possibly returns to Montroig before leaving for Paris sometime in December.328

Works on five paintings in an elaborate, detailed style: *Dutch Interior (I)* (p. 162), *Dutch Interior (II)* (p. 163), *Dutch Interior (III)* (p. 164), *Potato* (p. 166), and *Still Life* (p. 165).329

July 14: First extensive interview appears in *La Publicitat*. Following on the success of his May exhibition at the Galerie Georges Bernheim, Miró provides an account of his early artistic development and his years in Paris, speaks of his new work, and stresses his contempt for the conventions of painting and the pitfalls of success.330

July 21: From Montroig, writes to Gasch: "I am working a lot, with things that might be the beginning of a new phase of my work, but parallel to my former work."

July 31: Pierre Loeb writes to Miró: "What are you working on, and how far along are you? Aragon has

just left here with one of your *collages-cloutages* [*Spanish Dancer*, Dupin 245] that I gave to him. He is delighted. I will give another to Breton."[331]

AUGUST 2: From Montroig, Miró writes to Gasch: "What I am doing now is different from the past — *Enormément poussé* — however, it is parallel to *The Tilled Field* [p. 111] and to the *Carnival of Harlequin* [p. 128]. . . ."

AUGUST 16: From Montroig, writes to Gasch: "I intend to finish a canvas [probably *Dutch Interior (I)*, p. 162] by the middle of next week, the first to be finished since I've been here — a month and a half — with unprecedented preparation [*amb menos* (sic) *precedents de preparació*] and after thoroughly systematic daily work. . . . What I am doing now requires an endurance comparable perhaps to the time I was doing *The Farm* [p. 107]. . . . My aim is to execute five canvases here, all of the same caliber as the one I am finishing. I believe it will be a pretty impressive effort."[332]

AUGUST 22: From Brussels, Camille Goemans, Pierre Janlet, and the Arps send Miró a joint postcard.[333]

[C. AUGUST 25]: Pierre and Edouard Loeb arrive in Montroig.[334]

SEPTEMBER 2: Pierre Loeb writes to Miró from Palma: "I wrote in my letter to your mother that your painting [possibly *Dutch Interior (I)*, p. 162] had pleased me greatly. It contains almost all your researches up to the present moment, and summarizes them while at the same time suggesting a departure in a new direction, after shedding all the influences which up until your last paintings remained a bit too visible and literary. I think that now you are going to make a more important statement. . . ."

SEPTEMBER 22: Pierre Loeb, back in Paris, writes to Miró in Montroig: "I will await . . . the completion of the series of portraits before making any sales, and I will tell all interested parties that all your paintings are in Spain and that you will not give them to me until next July because you need to have them near you to work. At that time I will hold a little exhibition here to group them and show them together."[335]

NOVEMBER: Lise Hirtz's book *Il était une petite pie* is printed, with *pochoir* illustrations by Miró.[336]

[MID-NOVEMBER?]: Miró goes to Barcelona.[337]

[AFTER NOVEMBER 21?]: Possibly returns to Montroig.[338]

DECEMBER 10: Alexander Calder writes to Miró for the first time.[339]

BEFORE DECEMBER 26: Miró goes to Paris, with recent paintings (pp. 162–66).[340]

1929

[JANUARY–JUNE?]: In Paris, living and working at 22, rue Tourlaque. Visits Barcelona in late February and late March.[341]

Works on series of four paintings known as the Imaginary Portraits, including *Portrait of Mistress Mills in 1750* (p. 170) and *Portrait of Queen Louise of Prussia* (p. 171).[342]

[JANUARY 15–31]: Possibly attends Vasily Kandinsky's first one-artist exhibition in Paris, at the Galerie Zak.[343]

JANUARY 30: The critic Carl Einstein writes to Miró at 92 (sic), rue Tourlaque: "Would it be convenient for you if I come by on Sunday [February 3] to see your new paintings and to talk with you about the article which is to appear on you in *Documents?*"[344]

FEBRUARY 12: Breton, Aragon, and Raymond Queneau send out a circular to approximately seventy-five people, including Miró, requesting a statement regarding the efficacy of group action.[345]

FEBRUARY 21: Gaffé writes to Miró: "It is curious, the spiritual affiliation between your large Spanish dancer [*Spanish Dancer*, p. 116] and the young girl with mandolin by Picasso. They are, *chez moi*, almost literally juxtaposed: the same breath crosses them, the same spirit animates them."

BY FEBRUARY 26: Miró is in Barcelona for a few days.[346]

[MARCH 10]: In a letter of March 22, [1929], to Henry McBride, A. E. Gallatin wrote: "[T]he day after I arrived [i.e., March 10] I found three paintings *chez* Pierre which I at once bought [including] one of Miró's best things: *The Dog Barking at the Moon* [p. 156]. This last was sold in his exhibition last spring but was on the market again."[347]

MARCH 13: From 22, rue Tourlaque, Miró writes to Gasch: "Yesterday I met [Luis] Buñuel, who is very nice and very interesting. . . . We talked about both Dalí and you, and he likes you both very much. I have seen no Catalans since I've been here. They are, undeniably, the most disagreeable people in the world, aside from their stupidity and arrogance."

[BY MARCH 22?]: Returns briefly to Barcelona.[348]

BY APRIL 5: In Paris, at 22, rue Tourlaque.[349]

BEFORE APRIL 9: Dalí arrives in Paris.[350] Is introduced to the Surrealist group by Miró.[351]

APRIL 15: Georges Hugnet writes to Miró at 22, rue Tourlaque, about the lithographs Miró was to design for Tristan Tzara's book *L'Arbre des voyageurs*.[352]

APRIL 18: Breton writes to Miró at 22, rue Tourlaque, soliciting materials for a special issue of the Belgian periodical *Variétés* devoted to "Surrealism in 1929." Remarks: "I greatly admired your latest works at Pierre's and I never tire of looking at the marvelous *Nude* of 1926 [p. 157], which I've coveted for a long time."[353]

MAY 11–22: Miró has a one-artist exhibition, Galerie Le Centaure, Brussels, organized by Pierre Loeb.[354] Possibly attends opening.[355]

MAY 13: In Antwerp. Possibly visits the Musée de Steen.[356]

MAY 25: Writes to Desnos from 22, rue Tourlaque, arranging to meet the following Monday [May 27] at 7:30 P.M. at La Coupole to discuss the book Desnos wants Miró to illustrate.

[AFTER MAY 25?]: Possibly visits Massimo Campigli exhibition held at the Galerie Jeanne Bucher between May 24 and sometime in June.[357]

Miró and Pilar Juncosa at the time of their engagement, Palma, summer 1929. Archives Succession Miró

MAY 28: From 22, rue Tourlaque, writes to Desnos, arranging to meet again on Friday [May 31] at 7:45 P.M. at La Coupole. Decides to illustrate Desnos's *L'Aumonyme*.[358]

JUNE: Special issue of *Variétés* edited by Breton and Aragon appears. Includes responses to Breton, Aragon, and Queneau's letter of February 12, 1929, regarding potential of group action, among them Miró's equivocal statement.[359]

[LATE JUNE?]: Miró returns to Barcelona.[360]

[BEFORE JULY 17]: Visits Mallorca; is engaged to Pilar Juncosa, a native of Mallorca and the daughter of old family friends.[361]

[JULY 17]: Arrives in Montroig.[362]

[BEFORE JULY 23?]: Pauline and Ernest Hemingway visit Miró in Montroig.[363]

JULY 23: From Montroig, Miró writes to Gasch: "Now I start to work, and I believe I will be in top form very soon."

Begins work on series of large and austere collages that employ a wide variety of paper types (see pp. 172–75).[364]

[SEPTEMBER]: In Montroig, Barcelona, Palma.[365]

[SEPTEMBER 7]: Travels from Barcelona to Palma.[366]

[SEPTEMBER 22]: Returns to Montroig from Palma.[367]

SEPTEMBER 24: From Montroig, writes to Gasch, telling him that once married and back from Palma he will show Gasch the "drawings" he has done.[368]

OCTOBER 12: Marries Pilar Juncosa, in the church of San Nicolás, Palma.[369]

[AFTER OCTOBER 12]: The two go to Formentor, on Mallorca, then to Barcelona. Miró shows his recent collages (see pp. 172–75) to Gasch.[370]

BY NOVEMBER 22: Returns to Paris with his bride, Pilar Juncosa de Miró; they move into an apartment at 3, rue François-Mouthon.[371] Miró uses one room of the apartment as a studio.[372]

NOVEMBER 29: In La Publicitat, Gasch describes Miró's most recent works as "large drawings where the most diverse materials play an important role: sandpaper, wire, and wrapping paper."[373]

DECEMBER 15: The last issue of La Révolution surréaliste is published; includes Breton's "Second Manifeste du surréalisme."

[BY DECEMBER 25]: Miró is back in Barcelona for the Christmas and New Year holidays.[374]

1930

During the year, meets Pierre Matisse.[375]

[EARLY JANUARY?]: Returns to Paris with Pilar Juncosa de Miró; lives and works at 3, rue François-Mouthon.[376]

Paints a series of large canvases in an erratic, uneven style, including Painting (p. 180) and Painting (p. 181).[377]

JANUARY 28: From 3, rue François-Mouthon, writes to Gasch: "[I am] working pretty much on the canvases I already mentioned to you, which will be, I think, my good-bye to painting, at least for some time, in order to attack new means of expression, bas-relief, sculpture, etc., using new vocabularies and elements of expression of which I am still ignorant."

MARCH 7–14: One-artist exhibition, Galerie Pierre, Paris, featuring the Dutch Interiors and the Imaginary Portraits.[378]

BEFORE MARCH 15: Attends a reception at the Musée du Trocadéro. Paris-Midi reports numerous invités de marque including Miró and Masson and the poets Robert Desnos and Roger Vitrac.[379]

MARCH 15–22: One-artist exhibition, Galerie Pierre, Paris, featuring the summer 1929 collages.[380]

MARCH 28–APRIL 12: Included in the exhibition "La Peinture au défi," Galerie Goemans, Paris. Catalogue essay is by Louis Aragon.[381]

APRIL 5: From 3, rue François-Mouthon, sends Desnos a note, inviting him to a soirée on Thursday, April 10, at 9:00 P.M.

APRIL 9: Alberto Giacometti sends Miró a note, thanking him for his invitation and promising to visit on Thursday night [possibly April 10].[382]

[APRIL 10]: Desnos and possibly Giacometti along with André Masson and Paule Vézelay attend a soirée at the Mirós, 3, rue François-Mouthon.[383]

BEFORE MAY 14: Miró and Pilar leave Paris; are in Barcelona for two days, then go to Palma.[384]

MAY 14: From Palma, Miró writes to Gasch: "My life

here is devoted exclusively to rest and getting healthy, so as to have the strength later on to take up my work again with the maximum force."

Begins two notebooks with sketches on which he will base a series of drawings on Ingres paper (see p. 176).[385]

MAY 26: From Palma, writes to Jacques Mauny, an associate of A. E. Gallatin, with information concerning his paintings in the Gallatin collection. By about this time, has three works on regular exhibition at Gallatin's Gallery of Living Art, New York University, including Painting (p. 149) and Dog Barking at the Moon (p. 156).[386]

[BY MID-JUNE]: Returns to Barcelona with Pilar Juncosa de Miró.[387]

JULY 17: Birth of daughter, Maria Dolores, in Barcelona.[388]

JULY 25: From Barcelona, writes to Ràfols: "I am happy to tell you that, as of last Thursday, my wife has made me the father of a girl; both are fine."

[BY MID-AUGUST?–LATE NOVEMBER]: To Montroig with his family.[389]

Works on series of drawings on Ingres paper (see p. 176) and executes his first three-dimensional works, including Construction (p. 178) and Relief Construction (p. 179).[390]

AUGUST 23–25: Completes Untitled (p. 176).

AUGUST 30: Completes Untitled (p. 176).

OCTOBER 19: Writes to Gasch from Montroig: "I am working very hard, and it is a shame it won't be possible for me to show you all these sculptures properly finished and set up; but on the other hand, you will see the very large series of drawings [see p. 176], which will also be something very important."

OCTOBER 20–NOVEMBER 8: Has first one-artist

exhibition in the United States, Valentine Gallery, New York.[391]

NOVEMBER 18: From Montroig, writes to Tzara about two additional lithographs for L'Arbre des voyageurs.[392] L'Arbre des voyageurs is published later in the year.[393]

NOVEMBER 28–DECEMBER 3: Exhibits with Arp, Dalí, Ernst, Man Ray, and Tanguy on the occasion of the screening of Luis Buñuel and Dalí's film L'Age d'or at Studio 28, Paris. Three of Miró's collages are shown.[394] On December 3, members of the right-wing Ligue des Patriotes and the Ligue Anti-Juive riot during a showing of the film, slashing the artworks on view in the foyer.[395]

[LATE NOVEMBER OR EARLY DECEMBER?]: Goes to Barcelona for about two weeks.[396]

[DECEMBER 7?]: Gasch, Prats, and possibly Ràfols visit Miró in Barcelona to see a new series of drawings made in Montroig (see p. 176).[397]

BY DECEMBER 15: In Palma for the holidays.[398]

BY DECEMBER 31: In Barcelona.[399]

1931

[EARLY JANUARY–EARLY JUNE]: In Paris, living and working at 3, rue François-Mouthon.[400] Period of creative and financial difficulties.

JANUARY 17: From Paris, writes to Gasch: "There is a terrible crisis here. . . . I have managed to make an arrangement with Pierre, if not a brilliant one, at least adequate enough to be able to weather . . . this tough period. I am lucky, since almost everyone from my generation has had his neck broken."[401]

BEFORE JANUARY 24: Is interviewed in his studio at 3, rue François-Mouthon, by the Madrid journalist

Miró with his wife, Pilar Juncosa de Miró, and their baby daughter, Maria Dolores, Paris, March 1931. Archives Succession Miró

Francisco Melgar.[402] In the interview, as published in the January 24 issue of the periodical *Ahora* (Madrid), Miró expresses fundamental differences with the Surrealists and reviles the rule-bound conventions of traditional painting.[403]

JANUARY 27–FEBRUARY 17: One-artist exhibition, The Arts Club of Chicago, organized by the Valentine Gallery, New York.[404]

[JANUARY 30–FEBRUARY 14]: Visits Joaquín Torres-García exhibition at the Galerie Jeanne Bucher, Paris.[405]

FEBRUARY 5: From 3, rue François-Mouthon, writes to Ràfols: "I am working very hard . . . fleeing from good taste, which I believe is the way to avoid becoming like the riffraff we were talking about earlier."[406]

FEBRUARY 12: Writes to Léonce Rosenberg, inviting him to view his paintings at the Galerie Pierre on Saturday [February 14], rather than at his studio as previously planned.[407]

MARCH: Completes *Man and Woman* (p. 182), an early instance of the type of painting-objects that will occupy him in 1931 and 1932.[408]

MARCH 18: From 3, rue François-Mouthon, writes to Gaffé: "I have learned with joy that you already had a copy of *L'Arbre des voyageurs*. . . . I have long considered [Tzara's] poetry to be of great spiritual value and his *Dada* position has always been extremely appealing to me, as *clairvoyance* and as a method of action."[409]

APRIL 2: From 3, rue François-Mouthon, writes to Tzara: "Would you be able to give us the pleasure of coming with Greta next Tuesday [April 7] to take tea at the house? Our good friend Hans Arp and his wife will also be there."

APRIL 6: From 3, rue François-Mouthon, writes to Gasch, recommending that he read Tzara's article "Le Papier collé, ou le proverbe en peinture" and Aragon's essay "La Peinture au défi."[410]

APRIL 8: From 3, rue François-Mouthon, writes to Ràfols: "I continue working very hard, beating the canvases with hammer blows."

MAY: Completes painting titled *Human Head* (p. 177).

[EARLY JUNE]: Goes to Barcelona.[411]

BY JULY 1: In Palma.[412]

[MID- OR LATE JULY?–LATE NOVEMBER]: In Montroig.[413]

Begins a series of paintings on Ingres paper,[414] along with a number of painting-objects (pp. 182–83 are representative) incorporating found materials.[415]

BEFORE AUGUST 29: Douglas Cooper visits Montroig; sees the latest paintings on Ingres paper.[416]

[SEPTEMBER 27]: Prats and Gasch visit Montroig.[417]

OCTOBER 25: From Montroig, Miró writes to Gasch: "I am finishing the objects and once they are ready, I will consider this series of activities complete. . . ."

[NOVEMBER?] 25: From Barcelona, writes to Foix: "My wife and I would be very pleased if you and

Caricature of Miró by Abin, published in *Le Populaire*, December 1931. Courtesy Fundació Pilar i Joan Miró a Mallorca

your wife could come next *Friday* [November 27] at *10 at night* to our house; at the same time I would be very interested in showing you my recent works. I take the liberty of asking you to be on time, because there will be other friends to whom I will also show the paintings and painting-objects I've brought from Montroig."[418]

[NOVEMBER 27?]: Private exhibition of Miró's paintings on Ingres paper and painting-objects, at Passatge del Crèdit, 4, Barcelona.[419]

[AFTER NOVEMBER 27?]: To Paris with recent work.[420]

[NOVEMBER 27–DECEMBER 12]: Visits Serge Brignoni's exhibition at the Galerie Jeanne Bucher, Paris.[421]

DECEMBER 9: From 3, rue François-Mouthon, writes to Foix: "This morning I sent the drawing for your book to you by certified mail. . . . On *Friday 18*, there is an exhibition of my sculptures (from 1930) and of recent objects . . . at the Galerie Pierre; in this exhibition there will not be one single painting."[422]

DECEMBER 18–JANUARY 8, 1932: One-artist exhibition, Galerie Pierre, Paris.[423] Harry Dunham, Paul Bowles's companion at the time, possibly visits the exhibition and perhaps purchases two objects.[424]

[BEFORE DECEMBER 24]: Miró returns to Barcelona.[425]

1932

During the year, is introduced to Josep Lluís Sert by Joan Prats.[426]

[JANUARY]–FEBRUARY 14: Remains in Barcelona rather than, as usual, returning to Paris. Gives up apartment at 3, rue François-Mouthon. Lives and works at Passatge del Crèdit, 4;[427] uses the room in which he was born as a studio.[428]

JANUARY 20: Writes to Christian Zervos, from Passatge del Crèdit, 4: "I'm working with a great deal of enthusiasm on a new series of objects, and as soon as they are finished will begin to make small paintings, as concentrated as possible. . . ." In the same letter, notes that he will write to the New York dealer Valentine Dudensing "to tell him that Pierre [Loeb] is no longer looking after me and to see if I can do some business with him. . . . I am also going to write to Pierre Matisse."

FEBRUARY 12: From Passatge del Crèdit, 4, writes to Zervos, thanking him "from the bottom of my heart" for having approached Pierre Matisse on his behalf.[429] Also notes: "The times are still very hard and it doesn't look like things are falling back into place. . . . I'm in negotiations with the Ballets Russes company for a production; I hope we'll arrive at an agreement, and in this case I will leave immediately for Monte Carlo, to see to its realization."

[BEFORE FEBRUARY 14?]: Private viewing in Barcelona of his new series of objects.[430]

FEBRUARY 14: Leaves Barcelona for Monte Carlo.[431]

[MID-FEBRUARY–AFTER APRIL 15]: Is in Monte Carlo, at the Bristol Hotel. Designs curtain, costumes, sets, and props for the Ballets Russes de Monte Carlo production of *Jeux d'enfants*, commissioned and choreographed by Léonide Massine.[432]

FEBRUARY 23: From Monte Carlo, writes to Gasch, with news of his work on the ballet: "I am treating everything the same way as my latest work . . . with the same aggressiveness and violence. . . . [T]hroughout the entire event—a round that lasts about twenty minutes—objects keep appearing, moving, and being dismantled on stage."[433]

APRIL 9: From Monte Carlo, writes to Gasch: "I am pleased with the objects; now I am working on them personally. . . . What worries me most are the costumes. . . . I am afraid the costume maker, despite not being French—a Russian—had she been French, it would have been impossible, will have *too much taste*, so in order to obtain something lively I intend to unstitch many things and to tell her to thread a needle for me so I can sew them up myself, despite never having done it."

APRIL 14: Premiere of *Jeux d'enfants*, Théâtre de Monte Carlo. Ballet in one act; music by Georges Bizet; libretto by Boris Kochno; choreography by Léonide Massine; set design by Joan Miró, executed by Prince A. Schervashidzé; costume design by Joan Miró, executed by Madame Karinska; curtain designed and executed by Joan Miró; orchestra conducted by Marc-César Scotto.[434]

APRIL 15: From Monte Carlo, Miró writes to Gasch: "Yesterday there was the opening of my ballet, which

René Blum, Miró, and Colonel Wassily de Basil (all seated), with the company of the Ballets Russes de Monte Carlo, Monte Carlo, 1932

was a big success. I must, however, work a little on it to change some things that will allow me to attain an even greater violence. . . ."

AFTER APRIL 15: Returns to Barcelona.

JUNE 1: Schervashidzé writes to Miró: "Madame [Riabouchinska] wrote to me from Brussels that *Jeux d'enfants* was immensely successful, formidable, more than the other ballets."[435]

BY JUNE 4: To Paris; stays at the Hôtel Récamier, 3 bis, place Saint-Sulpice.[436]

[JUNE 11]: Paris premiere of *Jeux d'enfants* at the Théâtre des Champs-Elysées.[437]

JUNE 14: From the Hôtel Récamier, writes to Foix: "My ballet *Jeux d'enfants* was a great success. I think they [the Ballets Russes de Monte Carlo] will be in Barcelona at the end of September. It might be of interest for you to know, from the all-encompassing Catalan nationalist point of view, the *Catalan* activities here [in Paris] during June: Dalí exhibition, *Jeux d'enfants*, Picasso exhibition (250 paintings). *Catalan* activities that make a hit."

[C. JUNE 20]: Returns to Barcelona.[438]

BY JULY 8—[LATE OCTOBER OR NOVEMBER?]: In Montroig.[439] Executes twelve paintings on small wood panels, including *Flame in Space and Nude Woman* (p. 185), *Girl Practicing Physical Culture* (p. 186), *Personage* (p. 184), *Women Resting* (p. 185), *Head of a Man* (p. 187), *Seated Woman* (p. 186), and *Bather* (p. 184).[440]

AUGUST: Completes *Personage* (p. 184) and *Women Resting* (p. 185).

SEPTEMBER: Completes *Head of a Man* (p. 187).

SEPTEMBER 12: From Montroig, writes to Gasch: "The Calders arrived today. . . . I would love for you

to come visit us . . . it will be fun and we will wait for you to have a circus performance, so you can have an idea and it could be a scoop for an interesting article. [The Calders] will stay here eight to ten days. . . ."[441]

[BEFORE SEPTEMBER 29]: Calder performs his *Circus* in Barcelona, on the premises of GATCPAC (Grup d'Arquitectes i Tècnics Catalans per al Progrés de l'Arquitectura Contemporània).[442]

OCTOBER: Miró completes *Bather* (p. 184) and *Seated Woman* (p. 186).

NOVEMBER 1—25: Has his first one-artist exhibition at the Pierre Matisse Gallery, 51 East Fifty-seventh Street, New York.[443]

[BY NOVEMBER 18]: In Barcelona. Attends private viewing of recent work at the Galeries Syra for members of ADLAN (Amics de l'Art Nou), a newly formed association interested in the achievements of the Catalan avant-garde.[444]

The Ballets Russes de Monte Carlo performing *Jeux d'enfants*, Monte Carlo, 1932. Photograph by Raoul Barbà. Collection Nicolas Hugnet, Paris

[BEFORE DECEMBER 13]: To Paris, with the series of paintings on small wood panels (pp. 184–87 are representative) and objects (possibly including p. 183).[445]

DECEMBER 13—16: One-artist exhibition of recent paintings and objects, Galerie Pierre Colle, 29, rue Cambacérès, Paris.[446]

BY DECEMBER 25: In Barcelona.[447]

1933

JANUARY 1—C. APRIL 22: Miró is in Barcelona, living and working at Passatge del Crèdit, 4.[448]

During the first half of the year, Paule Vézelay sees Miró fairly frequently in Spain.[449]

JANUARY 26—FEBRUARY 11: Miró executes a series of eighteen collages on which he will base a series of eighteen paintings. The first of these collages is completed on January 26, the last on February 11.[450]

MARCH 3: Completes the first painting (Dupin 346), based on the earliest of the eighteen collages. The paintings are executed sequentially between March 3 and June 13 (see, for example, pp. 188–91), often at intervals of just a few days, with the second collage serving as basis for the second painting, the third collage as the basis for the third painting, and so on, through the eighteenth.[451]

APRIL 15: Jean Hélion writes to Miró, inviting him to participate in a group exhibition along with Antoine Pevsner, Arp, Calder, Kurt Seligmann, and Hélion himself.[452]

BY APRIL 22: Goes to Montroig.[453] Returns to Barcelona by April 26; remains there until leaving for Paris, sometime prior to June 22.[454]

[MAY 21]: Members of ADLAN attend a performance of *Jeux d'enfants* by the Ballets Russes de Monte Carlo in Barcelona's Gran Teatre del Liceu.[455]

JUNE 7—18: Miró exhibits four works, among them *Human Head* (p. 177), in the "Exposition surréaliste" at the Galerie Pierre Colle, Paris. Also shown are paintings, drawings, sculptures, objects, and collages by artists and poets including Arp, Breton, Dalí, Duchamp, Eluard, Ernst, Giacometti, Hugnet, Magritte, Picasso, Man Ray, and Tanguy.[456]

JUNE 9—24: Exhibits in "Arp, Calder, Hélion, Miró, Pevsner, Seligmann" at the Galerie Pierre, Paris.[457]

JUNE 13: Completes the last of eighteen paintings based on collages (p. 191).

[JUNE 15]: Writes to Ràfols: "Next Sunday [June 18], I am having an exhibition of my recent paintings before taking them to Paris; [the exhibition] is organized by ADLAN and will be in the same building, in the apartments Sert has for rent. It will start in the morning, from 11 to 2, and I would be very happy if you could come."[458]

[JUNE 18]: Private exhibition of his most recent paintings, the series of eighteen works based on collages, in Barcelona.[459]

[BY JUNE 22]: To Paris with series of recent paint-

ings. Stays in Alexander Calder's apartment at 14, rue de la Colonie.[460]

JULY: One-artist exhibition at The Mayor Gallery, London, organized by Douglas Cooper.[461]

[EARLY JULY?]: Returns to Barcelona.[462]

BY JULY 14: In Palma.[463]

JULY 15: From Palma, writes to Michel Leiris: "I am here only for a few days to rest a little, and will be leaving soon to start working again. From October 30 to November 13 there will be an important exhibition of my recent paintings at Georges Bernheim; for this date, Zervos wants to devote an issue of *Cahiers d'art* to me, which will also serve as a catalogue. I would be very pleased if you, who have known my work since the wonderful time of the rue Blomet, would write something about it. . . ."[464]

JULY 19: From Palma, writes to Foix: "Through our friend Prats you may know the results of my last trip to Paris, for which I think I can be happy. As he may have told you, Zervos wants to devote an issue of *Cahiers d'art* to me. . . . For Catalonia, I would like you to write something about me; you know my painting in depth, and you are a great Catalan and a great poet, things that will enable you to deal with my painting from these two perspectives."[465]

[C. JULY 24]: Returns from Palma to Barcelona.[466]

[EARLY AUGUST?—EARLY OCTOBER?]: In Montroig.[467] Works on a series of drawing-collages (pp. 192—93 are representative) that incorporate postcards, advertisements, anatomical diagrams, and illustrations of machines.[468]

[AFTER AUGUST 27]: Spends two days in Sitges, possibly with Douglas Cooper.[469]

AUGUST 31: From Montroig, writes to Foix: "*Enfances* by Georges Hugnet, illustrated by me and published by *Cahiers d'art*, has already come out. . . ."[470]

SEPTEMBER 22: Completes *Drawing-Collage* (p. 192).

SEPTEMBER 25: Completes *Drawing-Collage* (p. 193).

[BY OCTOBER 14]: In Barcelona at Passatge del Crèdit, 4.[471]

[BEFORE OCTOBER 27—MID-NOVEMBER?]: In Paris, at the Hôtel Récamier, 3 bis, place Saint-Sulpice.[472]

OCTOBER 27—NOVEMBER 26: Exhibits in the Salon des Surindépendants with the Surrealist group. Probably attends the opening.[473]

OCTOBER 30—NOVEMBER 13: One-artist exhibition, Galerie Georges Bernheim, 109, rue du Faubourg-Saint-Honoré, Paris, organized by Pierre Loeb. Shows the entire series of eighteen paintings based on collages.[474]

NOVEMBER 5: From the Hôtel Récamier, writes to Pierre Matisse: "I suppose you will have received the announcement I sent you for my exhibition at Georges Bernheim. Pierre [Loeb] and I are very pleased; if from the business point of view one cannot say much for the moment, from the morale standpoint it was a great success. . . . Pierre has told me that, as soon as this exhibition is over, you want

to organize one in New York, which will give me great pleasure and flatters me greatly."[475]

[AFTER NOVEMBER 9]—DECEMBER 31: In Barcelona, at Passatge del Crèdit, 4.[476]

[LATE FALL?]: Possibly begins work on four cartoons for tapestries: *Personages with Star* (p. 194), "*Hirondelle — Amour*" (p. 195), *Rhythmic Personages* (p. 196), and "*Escargot — Femme — Fleur — Etoile*" (p. 197).[477]

DECEMBER 29—JANUARY 18, 1934: Second one-artist exhibition at the Pierre Matisse Gallery, New York.[478]

1934

[JANUARY 1—LATE FEBRUARY]: Miró is in Barcelona, living and working at Passatge del Crèdit, 4.[479]

Possibly continues to work on three of the tapestry cartoons (see pp. 195—97). At the same time experiments with a wide variety of mediums and paper types, creating numerous drawings and at least one collage (see p. 192).[480]

JANUARY 20: Completes *Collage* (p. 192).

[LATE FEBRUARY?—MID-MARCH]: To Paris, possibly with the 1933 series of drawing-collages.[481]

[FEBRUARY 23—MARCH 10]: Possibly visits Seligmann exhibition at the Galerie Jeanne Bucher.[482]

[MARCH?]: Meets Vasily Kandinsky in Paris.[483]

BEFORE MARCH 16—[EARLY MAY]: In Barcelona, at Passatge del Crèdit, 4; travels to Montroig around April 19.[484]

MARCH 16—30: One-artist exhibition at The Arts Club of Chicago, organized by the Pierre Matisse Gallery, New York.[485]

[APRIL 1]: First contract with Pierre Matisse.[486]

APRIL 12: From Passatge del Crèdit, 4, writes to Breton: "[I]f you are free one day . . . go to Pierre's so he can show you the latest [*derniers*] collages . . . I would very much like to know what you think of them."[487]

[C. MAY 2]: To Paris for two days; returns afterward to Barcelona.[488]

MAY 3—MAY 19: One-artist exhibition, Galerie des Cahiers d'Art, Paris.[489]

MAY 14—JUNE: One-artist exhibition, East-West Gallery, San Francisco, organized by Howard Putzel.[490]

BY JULY 16: Briefly visits Palma.[491]

[JULY 20?]: Leaves Palma; arrives in Montroig.[492]

[JULY 25—BEFORE AUGUST 11]: In Paris to meet with Loeb, Pierre Matisse, and Zervos; returns thereafter to Montroig.[493]

AUGUST: Executes *Collage* (p. 193) for his friend Joan Prats.[494]

AUGUST 19: Writes to Cooper from Montroig, regarding his planned trip to Spain.[495]

OCTOBER—NOVEMBER: Works on a series of fifteen large pastels on paper, including *Woman* (p. 198), *Woman* (p. 199), and *Personage* (p. 200).[496]

OCTOBER 11—NOVEMBER 4: Included in group exhibition at the Kunsthaus Zürich, along with Arp, Ernst, Giacometti, and González. Catalogue essay is by Ernst.[497]

NOVEMBER 11: From Passatge del Crèdit, 4, writes to Pierre Matisse: "I am now finishing the last pastels, the final stage of this season. They will be ready in a few days, at which time I will go to Paris. I'm planning to go toward the end of November and can ship them to New York right at the beginning of December."[498]

NOVEMBER 19: Louis Marcoussis writes to Miró from Chicago, mentioning that he has dined "with some new American friends. Across from me I found your big painting *The Farm* [p. 107], which made me happy."[499]

[NOVEMBER 25]: Leaves Barcelona for Paris with recent work, including *Woman* (p. 198), *Woman* (p. 199), and *Personage* (p. 200).[500]

BY DECEMBER 17: Returns to Barcelona.[501]

DECEMBER 17: From Passatge del Crèdit, 4, writes to Pierre Matisse, regarding the reception of his recent works in Paris: "Before shipping them I wanted to show them to a number of people, in Paris, whose opinions I greatly value; also to create an ambiance and to not neglect the *European* side. The way in which I went about this was more than sufficient to ensure that all of Paris was talking. . . . I saw Mr. Sweeney a number of times. . . . There was one pastel that André Breton liked very much. It seemed like good politics to me to be on good terms with him, for the Surrealists have become *official personalities* in Paris. Pierre agreed with me and I gave him a pastel as a present. I think I did the right thing."[502]

[LATE DECEMBER?]: In Barcelona, Miró and Georges Duthuit witness the wedding of Rose and André Masson.[503]

1935

JANUARY 1—[MID-JUNE]: Miró is in Barcelona, living and working at Passatge del Crèdit, 4.[504]

[JANUARY 2]: Probably completes *Head of a Man* (p. 201), the first of a group of paintings, on cardboard panels of uniform size, which will occupy him through late May.[505]

JANUARY 10—FEBRUARY 9: One-artist exhibition, Pierre Matisse Gallery, New York.[506]

JANUARY 11: A. E. Gallatin acquires *Painting* (p. 188) from the Pierre Matisse Gallery.[507]

FEBRUARY 1: Miró completes *Portrait of a Young Girl* (p. 202).

[MARCH 3—APRIL 13]: Completes five paintings on cardboard: *The Farmers' Meal* (p. 203), *Rope and People, I* (p. 204), *Rope and People, II* (p. 205), *Two Personages* (p. 207), and *Two Women* (p. 206).

APRIL 14: From Passatge del Crèdit, 4, writes to Pierre Matisse: "I will be in Paris during the first week of June and will bring my recent paintings. . . . [T]hese last things . . . are becoming stronger and stronger."

MAY 11–21: Exhibits in "Exposición surrealista," Santa Cruz de Tenerife, organized by *Gaceta de arte*. Catalogue preface is by André Breton.[508]

BEFORE JUNE 18: To Paris, with recent paintings on cardboard.[509] Describes these paintings to Matisse as "an auto-revision of my work."[510]

While in Paris, visits Kandinsky in company with Josep Lluís Sert.[511]

[JUNE 25]: Possibly sees André Breton.[512]

[AFTER JUNE 26?–BEFORE JULY 2]: Visits Brussels; returns to Paris.[513]

[JULY 2]: Dines at Tanguy's, with Breton, Ernst, and Man Ray.[514]

JULY 2–20: One-artist exhibition, Galerie Pierre, Paris; shows recent work.[515]

BY JULY 12–[LATE OCTOBER?]: In Montroig.[516] During this period, begins a series of twelve small paintings, six on copper and six on masonite, which will occupy him through mid-May 1936.[517]

JULY 21: Issue of *Minotaure* (Paris; vol. 2, no. 7 [June 5, 1935]) with a color cover designed by Miró is reviewed in *Comoedia*.[518]

OCTOBER 9–14: Completes the first of the series of twelve paintings on copper and masonite, *Personages in Front of a Volcano* (p. 210). Other paintings from this series are finished October 15–22 (p. 210), October 23–November 8 (p. 211), and November 9–16 (p. 211).

[OCTOBER 14–NOVEMBER 2]: One-artist exhibition, Stanley Rose Gallery, Los Angeles, organized by Howard Putzel.[519]

[LATE OCTOBER?]: Returns to Barcelona from Montroig.[520]

NOVEMBER 13: Fernand Léger, Calder, Gallatin, and others send Miró a postcard at Passatge del Crèdit, 4.[521]

NOVEMBER 16: From Passatge del Crèdit, 4, writes to Pierre Matisse, explaining that he cannot part with any of his copper and masonite paintings until he has finished the series.[522]

AFTER NOVEMBER 16: Goes to Prague for a group exhibition, November 29–January 2, 1936, in which he participates.[523]

NOVEMBER 20: From Prague, sends Picasso a postcard.

[AFTER NOVEMBER 29?]: Visits museums in Germany. Goes to Paris, where he sees Pierre Loeb.[524]

BY DECEMBER 11: Returns to Barcelona from Paris.[525]

DECEMBER 13–31: Participates in "Exposition de dessins surréalistes," organized by André Breton, at the gallery Aux Quatre Chemins.[526]

1936

Collaborates with J. V. Foix and Robert Gerhard on the ballet *Ariel* (never produced).[527]

JANUARY 1–[EARLY JUNE?]: Is still in Barcelona, living and working at Passatge del Crèdit, 4.[528]

Continues the series of paintings on copper and masonite. Completes works from this group January 20–31 (p. 212); February 4–12 (p. 212); [February 15–29] (p. 213); March 10–21 (p. 213); April 6–16 (p. 214); April 17–25 (p. 215); [April 29–May 9] (Dupin 430); [May 11–22] (p. 214).[529]

JANUARY 1: From Passatge del Crèdit, 4, writes to Matisse, noting that he is working according to plan and will bring the results to Paris in June.

Miró with *Personages in the Presence of a Metamorphosis* (p. 212), Paris, 1936. Photograph by A. E. Gallatin. Private collection, Milford, New Jersey

[JANUARY 13–18]: ADLAN organizes a Picasso exhibition in Barcelona that attracts some eight thousand visitors. The exhibition opening is broadcast on the radio and features Miró, along with González, Dalí, Luis Fernández, and Jaime Sabartés.[530]

[JANUARY 24]: Paul Eluard lectures on Surrealism in Barcelona; sees Miró during his stay.[531]

FEBRUARY 19: From Passatge del Crèdit, 4, writes to Matisse: "The work continues. In the end, I believe it will transport you into a world of *real unreality*."[532]

MARCH 2–APRIL 19: Is included in the exhibition "Cubism and Abstract Art," The Museum of Modern Art, New York, organized by Alfred H. Barr, Jr.[533]

[SPRING?]: Possibly works on *Object* (p. 218) and *Object of Sunset* (p. 219).[534]

[BEFORE MAY 21]: Paints a small, irregularly shaped panel (Dupin 418) for the wall of an interior de-

signed by Sert for the "I Saló d'artistes decoradors," Barcelona.[535]

MAY 22–29: Exhibits *Object* of 1932 (p. 183) in "Exposition surréaliste d'objets," Galerie Charles Ratton, Paris. Catalogue preface is by André Breton.[536]

[EARLY JUNE]: To Paris, with recent work.[537] Miró is photographed by A. E. Gallatin in Paris, probably at the Galerie Pierre. Several of the small paintings on copper and masonite appear in the background in some of these photographs.

[EARLY OR MID-JUNE?]: To London.[538]

JUNE 11–JULY 4: Exhibits in "International Surrealist Exhibition," New Burlington Galleries, London. Catalogue preface is by André Breton; introduction by Herbert Read.[539]

BY JULY 14: In Montroig.[540] Remains there through late September, briefly visiting Barcelona.[541] Begins a series of some twenty-seven paintings on masonite, including *Painting* (p. 216) and *Painting* (p. 217).[542]

JULY 17–18: Outbreak of the Spanish Civil War.[543]

AUGUST 9: From Montroig, writes to Matisse regarding the effect of the war on his family: "Luckily, we are all in good health and nothing has happened to us; despite the current events, my work has followed an almost regular rhythm. . . . My financial situation will be greatly affected as a result of these circumstances."[544]

BEFORE AUGUST 15: To Barcelona briefly; returns to Montroig. Expects there to be a complete change in the political and economic climate.[545]

BEFORE SEPTEMBER 28: To Barcelona.[546]

SEPTEMBER 28: From Barcelona, writes to Matisse, reporting that he will finish his masonite paintings by about October 15, then will bring them to Paris himself toward the end of October and subsequently ship them to New York.[547]

BEFORE OCTOBER 28: To Paris, with recent work.[548] Leaves about a hundred works-in-progress in Barcelona.[549]

BEFORE NOVEMBER 16: With the James Johnson Sweeneys, joins some five hundred others in a demonstration of sympathy for Catalonia and for Spain.[550]

NOVEMBER 16: From the Hôtel Récamier, 3 bis, place Saint-Sulpice, writes to Matisse; describes his current work and plans for the future, but is worried that the "mathematical rhythm" he always works with will be broken by the "demands of the current drama."[551]

[LATE NOVEMBER?]: Because of the political situation in Spain, decides to remain in Paris.[552]

NOVEMBER 30–DECEMBER 26: One-artist exhibition, Pierre Matisse Gallery, New York.[553]

[DECEMBER 3–19]: Sees Kandinsky's exhibition at the Galerie Jeanne Bucher, Paris.[554]

DECEMBER 7–JANUARY 17, 1937: Included in the exhibition "Fantastic Art, Dada, Surrealism," The Museum of Modern Art, New York, organized by

Alfred H. Barr, Jr. Catalogue includes essays by Georges Hugnet.[555]

[DECEMBER 16]: Miró's wife, Pilar Juncosa de Miró, and daughter, Dolores, join him in Paris.[556]

DECEMBER 18: From the Hôtel Récamier, writes to Matisse: "My wife and child arrived in Paris two days ago, which has reassured me, since I was extremely worried. We are going to remain in Paris until life returns to normal in Catalonia." Miró then tells Matisse about his plans for future work and concludes: "Will I be able to carry them out?"[557]

1937

[JANUARY—FEBRUARY]: In Paris, living with his wife and daughter at the Hôtel Récamier, 3 bis, place Saint-Sulpice and perhaps briefly at the Hôtel Chaplain, 11 bis, rue Jules-Chaplain.[558]

JANUARY 12: From the Hôtel Récamier, writes to Matisse: "Given the impossibility of going on with my works-in-progress [those left in Barcelona], I have decided to do something absolutely different; I am going to begin doing *very realistic* still lifes."[559]

JANUARY 24: Begins work on *Still Life with Old Shoe* (p. 227), painting on the mezzanine at the Galerie Pierre from a still-life arrangement he has prepared on a table.[560]

BEFORE FEBRUARY 12: Is interviewed by Georges Duthuit for a forthcoming issue of *Cahiers d'art*.[561]

FEBRUARY 12: From the Hôtel Récamier, writes to Matisse, describing *Still Life with Old Shoe* (p. 227): "I am going to push this painting to the limit, for *I want* it to hold up against a good still life by Velázquez. It is somewhat reminiscent of *The Farm* [p. 107] and *Table with Glove* [*Still Life—Glove and Newspaper*, p. 105]. . . ."[562]

MARCH: Draws *Nude Ascending the Staircase* (p. 226).

[MARCH 4—17]: Visits Paule Vézelay's exhibition at the Galerie Jeanne Bucher. Others who also see the exhibition include Piet Mondrian, Hans Hartung, the Arps, the Kandinskys, Giacometti, P. G. Bruguière, and Marcoussis.[563]

BEFORE MARCH 7: Moves to an apartment at 98, boulevard Auguste-Blanqui. The architect Paul Nelson lives in the same building.[564] Miró is able to use a room in the apartment as a studio.[565]

Continues work on *Still Life with Old Shoe* (p. 227) and at times attends modeling sessions at the Académie de la Grande Chaumière, making a large number of drawings (pp. 220–21 are representative).[566]

Designs a stamp in support of Republican resistance in Spain: it proclaims *"Aidez l'Espagne."*[567]

BEFORE APRIL 25: Commissioned by the Spanish Republican government to paint a monumental work for the Spanish Pavilion at the Paris World's Fair ("Exposition internationale").[568] The pavilion is designed by Luis Lacasa and Miró's friend Josep Lluís Sert.[569]

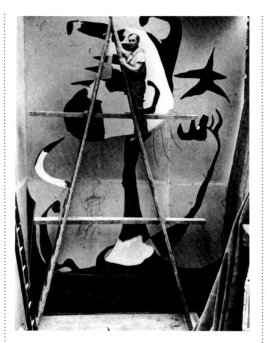

Miró painting *The Reaper* for the Spanish Pavilion, Paris World's Fair, 1937

APRIL 25: From 98, boulevard Auguste-Blanqui, sends Matisse news of the commission: "Calder is already here; we've talked about you and New York a lot. . . . The Spanish government has just commissioned me to decorate the Spanish Pavilion at the 1937 Exposition. Only Picasso and I have been asked; he will decorate a wall seven meters long; mine measures six. That's a big *job!* Once the Exposition is over, this painting can be taken off the wall and will belong to us. The stamp ["*Aidez l'Espagne*"] has still not been printed."[570]

[LATE APRIL?]: With Calder, visits the Spanish Pavilion, then under construction.[571]

MAY: Georges Duthuit's interview "Où allez-vous Miró?" appears in *Cahiers d'art*, the first major text on Miró published in French.[572]

MAY 6—JUNE 2: One-artist exhibition, Zwemmer Gallery, London.[573]

[MAY 20—JUNE 2]: Sees John Storrs exhibition at the Galerie Jeanne Bucher, Paris.[574]

MAY 28—JUNE 15: One-artist exhibition, Galerie Pierre, Paris, of early paintings exhibited in 1921 at the Galerie La Licorne and bought up by Loeb at a later date from Docteur Girardin.[575]

MAY 29: Completes *Still Life with Old Shoe* (p. 227).

[JUNE?—EARLY JULY?]: Paints *The Reaper (Catalan Peasant in Revolt)* (now lost) for the Spanish Pavilion.[576] The work is executed *in situ* in oil on six celotex panels that cover the wall of a stairway in the northeast corner of the building.[577]

[JULY 12]: Inauguration of the Spanish Pavilion at the Paris World's Fair; on view are *The Reaper*, Picasso's *Guernica*, and Calder's *Mercury Fountain*.[578]

[SUMMER?]: Makes numerous works on paper, possibly including *Three Personages* (p. 222), *Head* (p. 224), and *Head of a Man* (p. 225).[579]

[MID-OCTOBER]: Begins work on *Self-Portrait I* (p. 228).[580] Around the same time, sits for Balthus's portrait of him and his daughter, Dolores (completed January 1938).[581]

[NOVEMBER 5—20]: Visits the exhibition of Man Ray's drawings at the Galerie Jeanne Bucher, Paris.[582]

[NOVEMBER 25]: The Paris World's Fair closes. *The Reaper* is subsequently dismantled and possibly, at a later date, shipped to Valencia. (All traces of it have vanished.)[583]

DECEMBER: One-artist exhibition, Galerie Pierre, Paris.[584]

DECEMBER 5: From 98, boulevard Auguste-Blanqui, writes to Matisse: "I am working a lot. Every morning I work on my portrait, which will be more important and representative than *The Farm*. . . ."

1938

[JANUARY—JUNE OR JULY?]: In Paris. Living and working at 98, boulevard Auguste-Blanqui.[585] Continues work on *Self-Portrait I* (p. 228).

Learns etching and drypoint in Marcoussis's studio and with Roger Lacourière and Stanley William Hayter.[586]

JANUARY—FEBRUARY: Exhibits in the "Exposition internationale du surréalisme" at the Galerie Beaux-Arts, organized by André Breton and Paul Eluard.[587]

FEBRUARY 5: From 98, boulevard Auguste-Blanqui, writes to Matisse: "I have destroyed my portrait several times; I now feel that I am on the right track. . . . It will be a work that sums up my life, and it will be very representative in the history of painting. Besides that, I am doing drawings, gouaches, etc. I am going to etch on copper now, something that will open up new possibilities for me. Also, I am working on a series of drawings of nudes, which I started a year ago with the models at the academy and which I am now continuing in the studio."[588]

FEBRUARY 26: Completes *Woman in Revolt* (p. 223).

[LATE MARCH?]: Completes *Self-Portrait I* (p. 228).[589]

APRIL: Completes *Self-Portrait II* (p. 229).

BEFORE APRIL 7: Visits Paul Nelson's home in Varengeville, Normandy. Tells Matisse: "I'd wanted to try mural painting in Nelson's dining room, which could be interesting."[590]

APRIL 7: From 98, boulevard Auguste-Blanqui, writes to Matisse: "The situation in Spain is very agonizing, but far from being desperate; we have the firm hope that some event will take place to tip the balance in our favor. In this same mail I am sending you a photo of the drawn portrait [*Self-Portrait I*, p. 228]. . . . I am going to save this canvas, drawn on a very fine material, and later I will do a tracing on another canvas to paint it, making further changes in the formal conception. It's a good idea, for it would be too bad to lose this first stage as it is now. . . . Luckily, I have managed to keep my working enthusiasm and discipline."[591]

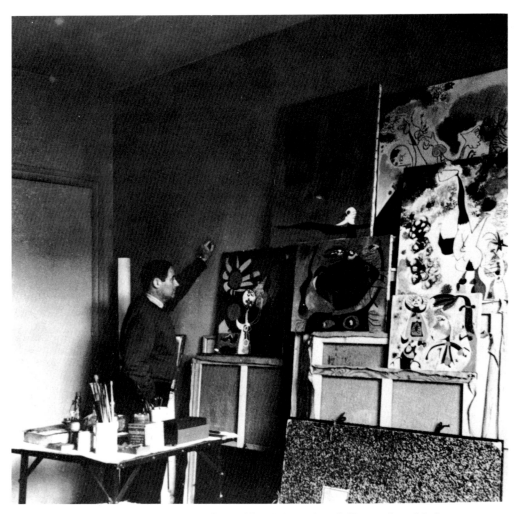

Miró in his studio at 98, boulevard Auguste-Blanqui, Paris, c. fall 1938. Against the wall: *Woman in Front of the Sun* (Dupin 507), left; *The Flight of a Bird over a Plain I* (Dupin 520), top; *Woman's Head* (Dupin 503), center; *Group of Personages* (Dupin 509), upper right, partially visible; and *Group of Personages* (Dupin 504), bottom right. Photograph by D. Bellon. Collection Nicolas Hugnet, Paris

APRIL 18—MAY 7: One-artist exhibition, Pierre Matisse Gallery, New York.[592]

MAY: Completes *Portrait I* (p. 235).

MAY 4—28: One-artist exhibition, The Mayor Gallery, London.[593]

JUNE: Completes *Portrait IV* (p. 234).

BEFORE JUNE 21: Attends the opening of a memorial exhibition for Guillaume Apollinaire (who died in 1918) at the Galerie de Beaune, Paris. Also present are Margaret Scolari Barr, Mrs. Paul Guillaume, Serge Lifar, Louis Marcoussis, Léopold Survage, Ossip Zadkine, Paul Rosenberg, and Dr. and Mrs. Girardin.[594]

[SUMMER?]: Possibly in Varengeville, Normandy, in house lent by Paul Nelson. Possibly begins mural paintings in Nelson's house.[595]

BEFORE AUGUST 10—[C. AUGUST 17]: Goes to Cassis, Bouches du Rhône, in southern France, for a vacation. Georges Braque is there at the same time.[596]

[SEPTEMBER?—DECEMBER?]: In Paris, living and working at 98, boulevard Auguste-Blanqui. Possibly

visits Varengeville to complete the murals in Paul Nelson's house.[597]

SEPTEMBER: Completes painting for Pierre Matisse's three children, *Woman Haunted by the Passage of the Bird-Dragonfly, Omen of Bad News* (pp. 232–33).

OCTOBER 31: From Paris, writes to Matisse, telling him they have survived "days of terrible nightmares."

NOVEMBER 24—DECEMBER 7: One-artist exhibition, Galerie Pierre, Paris.[598]

DECEMBER 24: Completes *Seated Woman I* (p. 236).

1939

[JANUARY—JULY?]: In Paris, living and working at 98, boulevard Auguste-Blanqui.[599]

JANUARY 2: From 98, boulevard Auguste-Blanqui, writes to Matisse, expressing concern for the safety of his mother, who is in Catalonia: "[T]he rebels' offensive . . . is drawing nearer and nearer to Montroig, where my mother still remains."

[JANUARY 20—30]: Sees Willi Baumeister's exhibition at the Galerie Jeanne Bucher, Paris, as do Arp, Kandinsky, Sophie Taeuber-Arp, Nina Kandinsky, Tanguy, Hans Bellmer, Max Ernst, Gertrude Stein, Braque, and Giacometti.[600]

JANUARY 26: Franco's troops occupy Barcelona.[601]

[FEBRUARY 14]: Miró learns that his old friend Joan Prats is in a concentration camp.[602]

FEBRUARY 27: Completes *Seated Woman II* (p. 237).

MARCH 8—12: One-artist exhibition, Galerie Pierre, Paris.[603]

[MARCH 16—APRIL 7]: Sees Dolli P. Chareau exhibition at the Galerie Jeanne Bucher, Paris.[604]

MARCH 24—APRIL 5: One-artist exhibition, Galerie d'Anjou, Paris. At the opening, Georges Duthuit discusses Miró's work and issues in contemporary painting.[605]

APRIL 10—MAY 6: One-artist exhibition, Pierre Matisse Gallery, New York.[606]

APRIL 14—27: Exhibits a series of etched self-portraits, executed with Louis Marcoussis, at the London Gallery, London.[607]

[MAY 2—16]: Sees exhibition of work by Hans Arp and Sophie Taeuber-Arp at the Galerie Jeanne Bucher, Paris.[608]

[JUNE 2—17]: Attends Kandinsky's exhibition at the Galerie Jeanne Bucher, along with Pilar Juncosa de Miró and Dolores.[609]

JUNE 20—30: Exhibits a series of etched self-portraits, executed with Marcoussis, at the Galerie Jeanne Bucher, Paris.[610]

[JULY?]: Prepares to leave Paris; possibly stores a number of canvases at Lefebvre-Foinet's (an artists' supply store and warehouse).[611]

BEFORE AUGUST 25: Rents a cottage, Clos des Sansonettes, on the Route de l'Eglise, Varengeville; stays there through late May 1940.[612] Georges Braque lives nearby.[613] Kandinsky visits before the end of 1939.[614]

AUGUST 25: From Clos des Sansonettes, writes to Matisse: "I was working very-well in this beautiful country [*pays*], and here we are, now plunged into this nightmare."

[LATE AUGUST—DECEMBER]: In Varengeville, makes two series of small paintings, the first with red grounds, the second on burlap.[615]

SEPTEMBER 1: On this date, Germany invades Poland. Great Britain and France declare war on Germany on September 3, and World War II begins.

SEPTEMBER 15: From Clos des Sansonettes, writes to Matisse: "I've entirely resumed my regular life and am very satisfied with my work."

1940

[JANUARY—LATE MAY]: In Varengeville, living and working at Clos des Sansonettes.[616] Makes trips to Paris.

Begins a series of twenty-three small gouaches with poetic titles, now known as the Constellations.[617]

JANUARY—FEBRUARY: Included in "Exposición internacional del surrealismo," Galería de Arte Mexicano, Mexico City, organized by André Breton, Wolfgang Paalen, and César Moro.[618]

BEFORE JANUARY 12: To Paris; sees Pierre Loeb.[619]

JANUARY 12: From Clos des Sansonettes, writes to Matisse, describing the Constellations: "I am now doing very elaborate paintings and feel I have reached a high degree of poetry—a product of the concentration made possible by the life we are living here."[620]

JANUARY 21: Completes the first Constellation, *Sunrise* (p. 238).

JANUARY 31: Completes the second Constellation, *The Escape Ladder* (p. 239).

BEFORE FEBRUARY 4: Christian and Yvonne Zervos visit Miró in Varengeville.[621]

FEBRUARY 4: From Clos des Sansonettes, Miró writes to Matisse: "Here is a detailed list of the finished paintings in landscape formats, the series on coarse [*grosse*] canvas.... Dimensions 0 — 1 — 3 — 10 — 12 — 15 — 20 — 25 — 30.... Braque and Zervos have seen them and found them very strong.... I am now working on a series of fifteen to twenty paintings in tempera and oil, dimensions 38 × 46.... [I]t is one of the most important things I have done, and even though the formats are small, they give the impression of large frescoes.... With the series of 38 × 46 canvases [*sic*] I am working on now, I can't even send you the finished ones, since I must have them all in front of me the whole time...."[622]

FEBRUARY 12: Completes the Constellation *People at Night, Guided by the Phosphorescent Tracks of Snails* (p. 240).

FEBRUARY 15: Completes the Constellation *Women on the Beach* (p. 241).

BEFORE FEBRUARY 25: To Paris; has paintings on burlap shipped to Matisse.[623]

MARCH 5: Completes the Constellation *Woman with Blond Armpit Combing Her Hair by the Light of the Stars* (p. 242).

MARCH 12—31: One-artist exhibition, Pierre Matisse Gallery, New York.[624]

MARCH 16: Completes the Constellation *Morning Star* (p. 243).

MARCH 27: Completes the Constellation *Wounded Personage* (p. 244).

APRIL: Germany invades Denmark and Norway.

APRIL 13: Miró completes the Constellation *Woman with Birds* (p. 245).

APRIL 14: From Clos des Sansonettes, writes to Matisse: "I am still working on the little paintings ... I hope I will be ... able to maintain the necessary spiritual tension until the end of this series.... This long stay in the country has done me a world of good, this solitude has greatly enriched me. I want to have enough years of life ahead of me to realize the most important part of my projects."

Detail of the first page of a letter from Miró to Pierre Matisse, sent from Perpignan on Hôtel de France stationery, June 6, 1940. Courtesy of the Pierre Matisse Foundation, New York

APRIL 27: Completes the Constellation *Woman in the Night* (p. 246).

MAY: New German offensive overruns the Low Countries; France is invaded and the Allied forces are trapped at Dunkirk.

MAY 2: From Clos des Sansonettes, Miró writes to Matisse: "I received a letter from Sweeney in which he told me that he is to write a monograph on me. ... The countryside is marvelous here now; the apple trees are beginning to flower and the light is very soft."[625]

MAY 14: Completes the Constellation *Acrobatic Dancers* (p. 247).

LATE MAY: The Nazis bomb Normandy. Miró leaves Varengeville with his family; travels to Perpignan via Dieppe, Rouen, and Paris.[626]

BY JUNE 1: Is in Perpignan.[627]

JUNE 6: From the Hôtel de France, quai Sadi-Carnot, in Perpignan, Miró writes to Matisse: "We have been in this lovely little village for several days. Where we were was, alas, hardly tranquil. Our journey up to now has been full of anxieties and unforeseen events, but here we are now safe and sound.... I've decided to return home. I think that this is the wisest thing to do at the moment to safeguard Pilar and the little one.... I know that this entails very great sacrifices on my part, but I cannot allow my little family to remain in the midst of a tempest. We are thinking of leaving on the 8th.... I do not know what will await me upon arrival ... but I hope once this has passed, I will be able to concentrate once again and to set to work.... This new contact with the Catalan countryside and with the very important works which I'd begun before my departure will undoubtedly do me a lot of good, though at the cost of dramatic sacrifices."

[JUNE 8?]: Leaves Perpignan; possibly goes to Figueres, Girona, and Vic. Subsequently goes to Palma.[628]

JUNE 14: Paris falls to the Nazis; on June 22 France signs an armistice.

[BY LATE JULY]: Miró is in Palma, living with his wife's family.[629]

AUGUST 22: From Palma, Carrer de Sant Nicolau, 22, Pilar Juncosa de Miró writes to Matisse: "The house where we now live is near Palma; the air is very fresh and does good for the health of my husband, who spends the day working in his room, which looks out on the bay of Palma...."

SEPTEMBER 4: Completes the first Constellation to be executed in Palma, *The Nightingale's Song at Midnight and Morning Rain* (p. 248).

OCTOBER 14: Completes the Constellation *On the 13th, the Ladder Brushed the Firmament* (p. 249).

NOVEMBER 2: Completes the Constellation *Nocturne* (p. 250).

DECEMBER 31: Completes the Constellation *The Poetess* (p. 251).

1941

[JANUARY—MID-JUNE]: In Palma, living and working at Carrer de Sant Nicolau, 22.[630]

JANUARY 27: Completes the Constellation *Awakening in the Early Morning* (p. 252).

MARCH 4—29: One-artist exhibition, Pierre Matisse Gallery, New York.[631]

MARCH 11: Completes the Constellation *Toward the Rainbow* (p. 253).

MARCH 25: From Carrer de Sant Nicolau, 22, Pilar Juncosa de Miró writes to Matisse: "[Miró] is entirely immersed in his work and studies."

APRIL 26: Completes the Constellation *Women Encircled by the Flight of a Bird* (p. 254).

APRIL 28: From Palma, Pilar writes to Matisse that Miró: "is working now in an extremely minute and elaborate fashion and is very content.... [T]hese works are very precious to him and for a certain period he needs to have them at all times beneath his eye, to use as a material of control, comparison, and study."

MAY 14: Completes the Constellation *Women at the Border of a Lake Irradiated by the Passage of a Swan* (p. 255).

MAY 26: Completes the Constellation *The Migratory Bird* (p. 256).

JUNE 12: Completes the Constellation *Ciphers and Constellations in Love with a Woman* (p. 257).

[AFTER JUNE 12–OCTOBER?]: Goes to Montroig for the first time since 1936.[632]

JULY: In Montroig, begins a journal of notations and projects.[633]

JULY 23: Completes the first Constellation to be done in Montroig, *The Beautiful Bird Revealing the Unknown to a Pair of Lovers* (p. 258).

AUGUST 14: Completes the Constellation *The Rose Dusk Caresses the Sex of Women and of Birds* (p. 259).

SEPTEMBER 12: Completes the twenty-third and last Constellation, *The Passage of the Divine Bird* (p. 260).[634]

BEFORE NOVEMBER 15: To Barcelona.[635]

BY NOVEMBER 15: Is in Palma, living at Carrer de les Minyones, 11.[636]

NOVEMBER 18–JANUARY 11, 1942: Has his first major museum retrospective, at The Museum of Modern Art, New York, organized by James Johnson Sweeney, who also writes the catalogue.[637] A retrospective of Salvador Dalí's work, organized by James Thrall Soby, is shown at The Museum of Modern Art at the same time.

1942

[JANUARY–JUNE?]: In Palma, at Carrer de les Minyones, 11, except for a trip to Barcelona in late February.[638] Many works on paper through 1944.[639]

FEBRUARY 15: From Palma, Carrer de les Minyones, 11, writes to Ricart, describing his current situation: "I considered it convenient for me to spend some time here in Palma. . . . I am planning to spend the summer in Montroig and I would be very happy to see you, to talk a little, and to bring back the old times of the studio at Baix de Sant Pere street. . . . I spend all my time here working . . . I see almost no one, and in this way I can escape without being engulfed by the terrible tragedy of the entire world."

BY FEBRUARY 26: In Barcelona, at Passatge del Crèdit, 4. Visits his mother, who is very ill.[640] Returns to Palma.

BEFORE JULY 11: Leaves Palma; visits Barcelona.[641]

JULY 11: From Barcelona, Passatge del Crèdit, 4, writes to Matisse: "We are all doing very well and are leaving in several days for Montroig (Tarragone) for a vacation. We already intend to spend next winter in Barcelona, where I've had a large studio set up."

[MID-JULY]: To Montroig.[642]

OCTOBER 14–NOVEMBER 7: Included in the exhibition "First Papers of Surrealism," Coordinating Council of French Relief Societies, New York, organized by André Breton and Marcel Duchamp.[643]

OCTOBER 20: Peggy Guggenheim's gallery, Art of This Century, opens in New York; thousands visit the gallery to view Frederick Kiesler's installation.[644] Among the many paintings, sculptures, drawings, collages, photographs, and objects are included Miró's *Dutch Interior (II)* (p. 163) and *Seated Woman II* (p. 237).[645]

[BEFORE OCTOBER 29?]: Miró moves back to Barcelona, Passatge del Crèdit, 4.[646] Works in a large studio on the top floor.[647]

[NOVEMBER–DECEMBER]: Possibly visits an exhibition of ceramics by Josep Llorens Artigas at the Galerías Argos, Barcelona. He subsequently asks Artigas to collaborate with him.[648]

DECEMBER 8–31: One-artist exhibition, Pierre Matisse Gallery, New York.[649]

1943

[JANUARY?–JUNE?]: In Barcelona, at Passatge del Crèdit, 4.[650] Works in studio on the top floor.[651]

MARCH 10: From Passatge del Crèdit, 4, writes to Sert: "We are fine; now we live in Barcelona. I took the top apartment of the building for myself and turned it into a magnificent studio. . . ."

MARCH 24–APRIL 7: One-artist exhibition, The Arts Club of Chicago.[652]

[JUNE?]: Writes to James Johnson Sweeney: "Besides painting, I am working now on a series of lithographs. I am also going to begin to work in ceramics with Artigas. . . . Also, I have been giving a great deal of thought to sculpture. . . . I am going to try my hand at it this summer. . . . All these means of expression greatly enrich the language of my painting. . . ."[653]

JUNE 1: From Passatge del Crèdit, 4, writes to Matisse: "During vacations I intend to make sculptures, at Montroig. . . ."[654]

[SUMMER]: In Montroig.[655]

[FALL?]: In Barcelona, at Passatge del Crèdit, 4.[656]

OCTOBER 19–NOVEMBER 15: One-artist exhibition, Galerie Jeanne Bucher, Paris.[657] Kandinsky visits the exhibition.[658]

1944

[JANUARY–JUNE?]: In Barcelona, at Passatge del Crèdit, 4. Works in studio on the top floor.[659]

Makes first ceramics, with Josep Llorens Artigas.[660]

[FEBRUARY?]: Writes to Sweeney: "We are already working at the ceramics. The fire produces exciting surprises. . . . I am drawing further and further away from conventional picture-making. . . ."[661]

MARCH 5: From Lisbon, Paulo Duarte writes to Philip L. Goodwin at The Museum of Modern Art, New York, on Miró's behalf, proposing that the Museum exhibit the Constellations and quoting Miró's instructions regarding their display: " '1 — These paintings must be shown together; on no account

are they to be separated from each other; 2 — I think they should be shown in strictly chronological order, which will explain my evolution and my state of mind; 3 — They are to be framed with double plate glass, so that one can see the title; 4 — They are to be framed in a very simple manner, hung on a plain white background and widely spaced. . . .' "[662]

[MARCH 7]: From Barcelona, writes to Valentine Dudensing: "I've entrusted to the Museum of Modern Art several paintings which I consider very important — from the 1940–41 period. I think they will hold an exhibition this spring."[663]

MAY: Joaquim Gomis documents Miró's varied activities in a series of photographs, including pictures of Miró and Artigas working on ceramics, Miró and Prats examining a lithograph in a print shop, and views of the studio at Passatge del Crèdit, 4.[664]

At this time, Miró possibly completes the group of lithographs known as the *Barcelona Series*.[665]

MAY 2–JUNE 3: One-artist exhibition, Pierre Matisse Gallery, New York.[666]

MAY 27: Death of Miró's mother, Dolores Ferrà Oromí.[667]

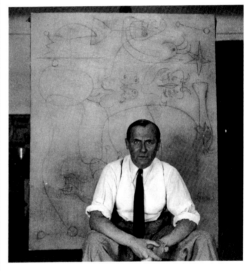

Miró with an early state of *The Harbor* (p. 266), Barcelona, 1944. Photograph by Joaquim Gomis

JUNE 6: Allied invasion of Normandy.

JUNE 17: From Passatge del Crèdit, 4, writes to Matisse, apparently responding to the dealer's concern that he is no longer interested in painting: "I work as always a lot; if I've made ceramics and lithographs, as this summer I am going to make sculpture, it is not to abandon painting . . . on the contrary, it is to enrich it with new possibilities and to take it up with a new enthusiasm."

JULY 10: Duarte writes to Goodwin from Lisbon, telling him he has succeeded in dispatching twenty-two paintings (the Constellations), seven ceramics, and 250 lithographs to the United States aboard the S.S. *Pero de Alenquer*, due to arrive in Philadelphia between July 23 and 30.[668]

[SUMMER?]: Probably goes to Montroig. Designs four ceramic sculptures (see p. 262 for two of them).[669]

Miró with Joan Prats, supervising the printing of *Barcelona Series XXXVI*, Barcelona, May 1944. Photograph by Joaquim Gomis. Courtesy of the Pierre Matisse Foundation, New York

AUGUST 25: The Allies liberate Paris.

[FALL?]: Miró is probably in Barcelona, living and working at Passatge del Crèdit, 4.

BY NOVEMBER 28: Pierre Matisse arranges to take over the entire shipment of Miró material (Constellations, ceramics, and lithographs) from The Museum of Modern Art.[670]

1945

[JANUARY—EARLY JULY?]: Miró is in Barcelona, living and working at Passatge del Crèdit, 4. Works on series of large paintings on black or white grounds (pp. 264–69 are representative).[671]

JANUARY 9—FEBRUARY 3: One-artist exhibition, Pierre Matisse Gallery, New York. The Constellations, lithographs, and ceramics are included.[672] Despite Miró's instructions, only sixteen of the twenty-two gouaches are shown at one time.[673]

JANUARY 17: Matisse writes to Miró: "It was a great joy for us to see your works again after these long years of silence. The opinion was unanimous and the public has found your exhibition very moving. You have attained an unprecedented degree of poetic intensity, and in the color as in the line a dazzling mastery."[674]

FEBRUARY 5—25: One-artist exhibition of lithographs, Pierre Matisse Gallery, New York.[675]

MARCH 26: From Passatge del Crèdit, 4, writes to Duarte: "Thank you, my friend, for all that you have done to organize my exhibition. . . . I'm working a lot on large canvases. This summer I made sculptures, and in addition to that have done ceramics with Artigas."[676]

MARCH 27—APRIL 28: One-artist exhibition, Galerie Vendôme, Paris.[677] No recent work is included.

MAY 7: Germany surrenders to the Allied forces.

MAY 8: Henri Matisse writes to Miró: "At last! Let us rejoice together."

MAY 11: Miró completes *Women Listening to Music* (p. 264).[678]

MAY 13: From Passatge del Crèdit, 4, writes to Zervos, mentioning plans for a Paris exhibition "of my work from the war years . . . during this period of time one had to enter into action in one manner or another, or blow one's brains out; there was no choice to make. I worked on entirely new aspects of my oeuvre. . . . [T]his exhibition should be considered not as a simple artistic event, but as an act of human import. . . ."[679]

MAY 26: Completes *Dancer Listening to the Organ in a Gothic Cathedral* (p. 265).

JUNE 18: From Passatge del Crèdit, 4, writes to Pierre Matisse: "I am entirely committed to risking it all. Either I find a way to live like men of my age (fifty-two years) from the preceding generation — Picasso, Matisse, Braque — or I find a way to settle my debts . . . [and go] to live in Montroig, where I will continue to work with the same passion and enthusiasm as always — which constitutes a need for me and my reason for living. . . . Excuse me for speaking to you in this tone, but life has been too hard for me these past years for me to do otherwise. I have to plan my future in a clear and courageous way, one that is worthy of my age."

JULY 2: Completes *The Harbor* (p. 266).

JULY 7: Completes *Spanish Dancer* (p. 267).

[AFTER JULY 7?]: To Montroig;[680] remains there through the end of September.[681]

BY OCTOBER 3: In Barcelona, at Passatge del Crèdit, 4.[682] Remains in Barcelona through December.[683]

OCTOBER 8: Completes *Bullfight* (p. 269).

DECEMBER: Makes terra-cotta maquettes for the first bronze *Birds* (see p. 262).[684]

1946

[JANUARY—LATE JULY]: In Barcelona, at Passatge del Crèdit, 4.[685]

[MARCH 1]: Completes *Personages, Birds, Stars* (p. 271).

[APRIL—NOVEMBER]: Makes first bronze sculptures (see p. 262).[686]

JULY: Alexina Matisse, Pierre Matisse's wife, visits Barcelona to discuss a new contract with Miró.[687]

JULY 20: From Barcelona, Miró writes to Tzara regarding his invitation for Miró to illustrate a new edition of Tzara's *L'Antitête*.[688]

[LATE JULY?—EARLY OCTOBER]: In Montroig.[689]

AUGUST 16: Pierre Matisse writes to Miró, offering to purchase Miró's entire production from 1942–46 and to contract for that of 1947–49; he adds, "Pierre Loeb is with me all the way."[690]

SEPTEMBER 3: From Montroig, Miró writes to Matisse regarding plans for an exhibition in New York: "In the future world, America, full of dynamism and vitality, will play a primary role. It follows that, at the time of my exhibition, I should be in New York to make direct and personal contact with your country; besides, my work will benefit from the shock."

[EARLY OCTOBER]: Returns to Barcelona, Passatge del Crèdit, 4.[691] Remains in Barcelona through December.[692]

[DECEMBER]: Matisse concludes arrangements for a commission for Miró to paint a mural in the Gourmet Room of the new Terrace Plaza Hotel in Cincinnati, built by Thomas Emery's Sons and designed by Skidmore, Owings, & Merrill.[693]

1947

[JANUARY—FEBRUARY 5]: In Barcelona, at Passatge del Crèdit, 4.[694]

JANUARY 26: From Barcelona, writes to Pierre Matisse: "One has to keep in mind that this is not simply a case of making a big painting. . . . I will have to go to Cincinnati beforehand, as early as possible, to see the building and the space, otherwise I'd only make an easel painting on a grand scale. . . ."[695]

[FEBRUARY 5]: Miró, Pilar Juncosa de Miró, and Dolores fly from Barcelona to Lisbon. They stay at the Hotel Borges, rua Garrett.[696]

[FEBRUARY 8]: Flies from Lisbon to New York with Pilar and Dolores. This is his first visit to the United States.[697]

[FEBRUARY 8—OCTOBER 15]: Is in New York, with trips to Cincinnati and to Connecticut.[698]

After years of isolation, sees a great many people during his stay, including Thomas Bouchard, Louise Bourgeois, Alexander Calder, Katherine S. Dreier, Dorothea and Max Ernst, Clement Greenberg, Peggy Guggenheim, Stanley William Hayter, Frederick Kiesler, Pierre Matisse, Arnold Newman, Josep Lluís Sert, James Johnson Sweeney, and Kay and Yves Tanguy.[699]

Works at Hayter's Atelier 17, 41 East Eighth Street, in Greenwich Village, on a number of projects in-

Arnold Newman, Stanley William Hayter, and Miró, New York, June 1947. Photograph © Arnold Newman

cluding illustrations for Tzara's *L'Antitête*.[700] Possibly meets Jackson Pollock at Hayter's.[701]

Executes his mural painting for the Terrace Plaza Hotel, Cincinnati, in Carl Holty's studio at 149 East 119th Street, New York.[702]

Thomas Bouchard films Miró working at Atelier 17 and in Holty's studio.[703]

[**MARCH 8**]: The Geneva-based publisher Gérald Cramer asks Miró to illustrate a bibliophile edition of Paul Eluard's *A toute épreuve* (originally published in 1930).[704]

BEFORE APRIL 11: Travels with Matisse to Cincinnati to inspect the site for the mural painting.[705]

MAY 13—JUNE 7: One-artist exhibition, Pierre Matisse Gallery, New York.[706]

MAY 26: Purchases paints for the Cincinnati mural.[707]

[**BEFORE MAY 27**]: Possibly meets with Frederick Kiesler to discuss the latter's installation plans for Breton and Duchamp's "Le Surréalisme en 1947: Exposition internationale du surréalisme." Designs a banner (Dupin 703) for the Salle de Superstition, based on Kiesler's specifications.[708]

JUNE 27: Arnold Newman photographs Miró at Hayter's studio in Greenwich Village.[709]

JUNE 30: Miró is interviewed by Francis Lee for the New York periodical *Possibilities*.[710]

JULY 7: Opening at the Galerie Maeght, Paris, of "Le Surréalisme en 1947: Exposition internationale du surréalisme," organized by Breton and Duchamp.[711]

Miró with Louise Bourgeois, his wife, Pilar Juncosa de Miró, and his daughter, Maria Dolores, in New York with a banner for "Le Surréalisme en 1947: Exposition internationale du surréalisme," 1947. Photographer unknown. Courtesy Louise Bourgeois, New York

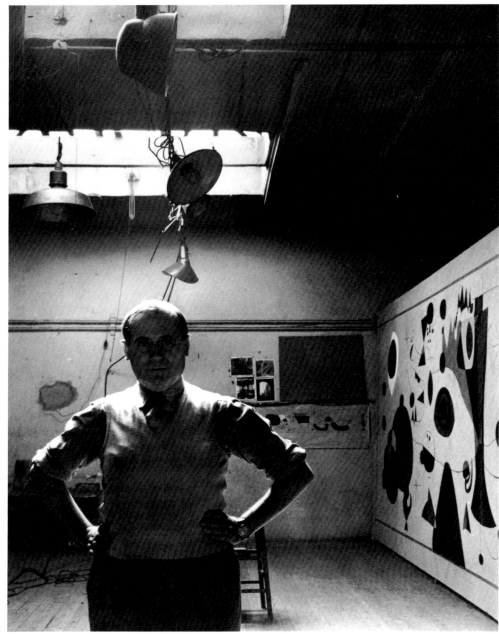

Miró in Carl Holty's studio, New York, with the Cincinnati mural painting (Dupin 706), September 1947. Photograph © Arnold Newman

[**C. AUGUST**]: Miró moves into Josep Lluís Sert's apartment, 15 East Fifty-ninth Street, for the rest of his stay in New York.[712]

SEPTEMBER: Arnold Newman photographs Miró with the Cincinnati mural in Carl Holty's studio. The mural is essentially complete at the time the photographs are taken.[713]

William Baziotes will later recall watching Miró "unveiling the mural in his studio, watching for the reaction of the onlookers, walking rapidly and excitedly all over the place, upset and very nervous."[714] Annalee Newman will also recall visiting Miró's studio while he was working on the mural.[715]

OCTOBER 14: From New York, Miró writes to Josep Lluís Sert: "The mural painting is already finished; it made a strong impression. It will be exhibited at the museum at the end of January."

[**OCTOBER 15**]: Sails from New York for Barcelona aboard the *Habana*.[716]

[**LATE OCTOBER?**]: Arrives in Barcelona. Briefly visits Montroig.[717]

DECEMBER 1: From Barcelona, Passatge del Crèdit, 4, writes to Matisse: "[A]fter this *séjour* in America, which I liked so much . . . I go as often as possible to Montroig and to the museum, to see the great Romanesque frescoes, which . . . make me forget, in the complete isolation in which I work, all the misfortunes of Europe. . . ."

DECEMBER 12: Pierre Loeb writes to Miró, telling him that he and Pierre Matisse have decided to annul their agreement made in 1946.[718]

1948

[JANUARY—EARLY FEBRUARY]: Miró is in Barcelona, living and working at Passatge del Crèdit, 4.[719]

FEBRUARY: James Johnson Sweeney's interview with Miró appears in *Partisan Review* (New York).[720]

BY FEBRUARY 11: To Geneva.[721]

BY FEBRUARY 18: Goes to Paris for the first time in eight years. Stays through early March.[722]

FEBRUARY 21: From the Hôtel Pont-Royal, Paris, writes to Pierre Matisse: "I leave at the end of next week. . . . You will receive a letter from Mr. Megh [Maeght]. He wants to organize a major exhibition of my works next June. . . . I am in complete agreement."[723]

MARCH 2—APRIL 4: Miró's mural for the Cincinnati Terrace Plaza Hotel is exhibited at The Museum of Modern Art, New York, installed by Alfred H. Barr, Jr.[724]

[c. MARCH 4 OR 5]: To Golfe-Juan, Antibes. Visits Picasso and Henri Matisse.[725]

AFTER MARCH 8: Returns to Spain, possibly to Montroig.[726]

MARCH 16—APRIL 10: One-artist exhibition, Pierre Matisse Gallery, New York.[727]

[BY MARCH 20?]: In Barcelona, at Passatge del Crèdit, 4. Possibly completes *The Red Sun* (p. 272).[728]

[APRIL 2]: Possibly completes *The Red Sun Gnaws at the Spider* (p. 273).[729]

JULY 12: From the Hôtel Pont-Royal, Paris, writes to Sert: "I am organizing an exhibition for next fall, and at the same time I am working on important book illustrations" (probably Tzara's *Parler seul* and Eluard's *A toute épreuve*).

AUGUST 30: Pierre Matisse writes to Miró; reports he has spoken with Aimé Maeght about picking up the part of the contract abandoned by Pierre Loeb.

[c. SEPTEMBER]: Irving Penn photographs Miró and Dolores in Montroig.[730]

[c. OCTOBER 7]: To Paris. Works on upcoming exhibition at the Galerie Maeght and on illustrations for Tzara's *Parler seul*.[731]

NOVEMBER 19—DECEMBER 18: Has first one-artist exhibition at the Galerie Maeght, Paris. It includes paintings and ceramics,[732] and marks his reemergence on the Paris scene.[733]

[DECEMBER 22—24]: Pierre Matisse and Aimé Maeght, who is now Miró's representative in France, go to Barcelona to meet with Miró.[734]

1949

Miró is in Barcelona, at Passatge del Crèdit, 4, throughout much of the year; makes frequent trips to Paris and visits Montroig and Palma. In the coming years, becomes increasingly involved in printmaking, book illustration, ceramics, and bronze

sculpture, in addition to painting. His principal residence is in Barcelona until 1956, although he travels frequently. Exhibitions of his work multiply.

APRIL 19—MAY 14: One-artist exhibition at Pierre Matisse Gallery, New York, of early paintings, 1923–27.[735]

APRIL 23—MAY 6: Has first one-artist exhibition in Barcelona since 1918, at the Galerías Layetanas.[736] It is organized by Rafael Santos Torroella, a Catalan art historian and critic.[737]

[OCTOBER]: Finishes layout for Eluard's *A toute épreuve*.[738]

OCTOBER 31: From Barcelona, writes to Matisse: "At the moment I'm having several sculptures cast that I finished this summer [possibly *Woman* and *Woman*, both p. 270]; I hope they will be successful."

DECEMBER 6—31: One-artist exhibition, Pierre Matisse Gallery, New York.[739]

1950

[JANUARY—MAY]: Miró is in Barcelona, living and working at Passatge del Crèdit, 4.

[EARLY JANUARY]: Matisse and Aimé Maeght go to Barcelona to see Miró.[740]

At Walter Gropius's suggestion, Miró is commissioned by Harvard University to execute a mural for the Harkness Commons dining room (*Mural Painting*, pp. 276–77).[741]

FEBRUARY 22: From Passatge del Crèdit 4, Miró writes to Sert: "I have just sent the model [of the Harvard *Mural Painting*] to Gropius and I put all my heart and enthusiasm into it. . . ."[742]

[FEBRUARY 25]: Possibly completes *Painting* (p. 278).[743]

MARCH 14: Sketch of the Harvard *Mural Painting* is approved.[744]

[MARCH 17]: Possibly completes *Painting* (p. 279).[745]

JUNE 2: An exhibition of Miró's recent work opens at the Galerie Maeght, Paris.[746]

[FALL?]: Moves from apartment at Passatge del Crèdit, 4, to Carrer Folgaroles, 9;[747] retains studio at Passatge del Crèdit, 4.[748]

OCTOBER 18: Begins work on *Mural Painting* (pp. 276–77) for Harvard University, in the studio at Passatge del Crèdit, 4.[749]

1951

In Barcelona, living at Carrer Folgaroles, 9. Works both at Carrer Folgaroles, 9, and at Passatge del Crèdit, 4, studio.[750]

JANUARY 26: Completes the Harvard *Mural Painting* (pp. 276–77).

JANUARY 29: From Carrer Folgaroles, 9, writes to Sert: "I have just finished this canvas [Harvard

Miró at work on the Harvard University *Mural Painting* (pp. 276–77), Barcelona, fall 1950

Mural Painting] . . . I think it is the most powerful thing I have ever done. . . ."

[LATE FEBRUARY]: To Paris with the Harvard *Mural Painting*.[751]

MARCH—MAY: The Harvard *Mural Painting* is exhibited in "Sur quatre murs," Galerie Maeght, Paris.[752] Large-scale works by Picasso, Braque, Rouault, Léger, Chagall, and Matisse were also included.[753]

MARCH 6—31: One-artist exhibition, Pierre Matisse Gallery, New York.[754]

MARCH 15: His interview with Rafael Santos Torroella is published in *Correo literario* (Madrid),[755] one of the few interviews he gives in Spain during the Franco years.

[JUNE]: *Mural Painting* is delivered to Harvard University, Cambridge, Massachusetts. It is subsequently installed in Harkness Commons.[756]

JULY 17: From Montroig, writes to Sert: "Montroig is magnificent. Now, in the summer, I am working on a series of sculptures in a big studio I had built for me."

NOVEMBER 20—DECEMBER 15: One-artist exhibition, Pierre Matisse Gallery, New York.[757]

1952

In Barcelona, living at Carrer Folgaroles, 9; works there and at Passatge del Crèdit, 4.

[MARCH 7—31]: Visits Jackson Pollock's first Parisian one-artist exhibition, Studio Paul Facchetti, 17, rue de Lille.[758]

APRIL 15—MAY 17: One-artist exhibition, Pierre Matisse Gallery, New York.[759]

[JUNE 1]: Departs from Barcelona, by plane, for New York.[760]

[JUNE 2]: Arrives in New York.[761]

[JUNE 4]: To Cincinnati, to see his mural painting at the Terrace Plaza Hotel.[762]

[JUNE 5]: To Cambridge, to see his *Mural Painting* at Harvard University.[763]

[JUNE 6—9?]: To Long Island. Visits Sert; works on preliminary model for a United Nations mural (never realized).[764]

[JUNE 10]: Returns to Barcelona.[765]

Miró in his studio, Montroig, c. early 1950s. Left foreground: *Man and Woman* (p. 299) in progress. Photograph by Ernst Scheidegger. Photography Study Collection, The Museum of Modern Art, New York

1953

[JANUARY—MAY]: In Barcelona, living at Carrer Folgaroles, 9; works there and at Passatge del Crèdit, 4.

[FEBRUARY—MARCH]: Thomas Bouchard is in Barcelona, continuing work on film begun in 1947, *Around and About Miró*.

JUNE 19: Opening of one-artist exhibition, Galerie Maeght, Paris.[766]

NOVEMBER 17—DECEMBER 12: One-artist exhibition, Pierre Matisse Gallery, New York.[767]

1954

Begins work in the village of Gallifa with Artigas on a large series of ceramics.[768] Over the next two years, the two of them conceive and execute more than two hundred ceramics, including dishes, vases, decorated plaques, and a number of sculpture-objects.[769]

JANUARY 10—FEBRUARY 14: Retrospective exhibition, Kaiser-Wilhelm Museum, Krefeld.[770]

[FEBRUARY 25]: First group of large series of ceramics fired in the kiln at Gallifa.[771]

APRIL 17: From Palma, writes to Matisse, mentioning for the first time his plans to move to Palma: "This country is marvelous. . . . We are about to buy a house near Palma on a splendid piece of land. Dividing my time between here and Paris, and from time to time making a trip to New York will be ideal for both work and health."

[C. JUNE 10—13]: To Palma. Purchases property on which he will build a large studio to be designed by Sert.[772]

JUNE 19—OCTOBER 17: Exhibits in the Venice Biennale. Awarded grand prize for graphic work.[773]

1955

During the years while the new studio is under construction in Palma and through the late 1950s, produces very few paintings. Continues work in ceramics.[774]

JULY 15—SEPTEMBER 18: Exhibits in the first Documenta, Museum Fridericianum, Kassel.[775]

AUGUST [16]: From Palma, Calamajor, Son Abrines, writes to Matisse: "My frequent escapes to Artigas's serve to calm my nerves; ceramics demand a great deal of concentration."

BY OCTOBER 20: Invited to design two ceramic walls for the new UNESCO headquarters, place de Fontenoy, Paris.[776]

DECEMBER 9: Thomas Bouchard's film *Around and About Miró* premieres at Harvard University.[777]

1956

[JANUARY—MAY]: In Barcelona; makes frequent trips to Gallifa to continue work on ceramics.[778]

JANUARY 6—FEBRUARY 7: Retrospective exhibition, Palais des Beaux-Arts, Brussels.[779]

MAY: Discusses new ceramic series in an interview with Rosamond Bernier published in *L'Oeil*.[780]

[MAY 10]: Last group of large series of ceramics fired in Gallifa. Since 1954, over two hundred works have been executed (see, for example, pp. 282, 284—87).[781]

JUNE 15: Exhibition of ceramics by Miró and Artigas opens at the Galerie Maeght, Paris.[782]

[FALL?]: Miró gives up his studio at Passatge del Crèdit, 4, and apartment at Carrer Folgaroles, 9. Moves to Palma, into the villa Son Abrines and a large studio designed by Sert.[783]

[SEPTEMBER]: Begins work with Artigas on ceramic walls for UNESCO building.[784]

DECEMBER 4—31: Exhibition of ceramics by Miró and Artigas, Pierre Matisse Gallery, New York.[785]

1957

Begins process of organizing new studio in Palma and reassessing his oeuvre. Makes frequent trips to Gallifa to work on UNESCO walls.[786]

[MARCH]: Visits the Altamira cave paintings with Artigas in preparation for UNESCO walls.[787]

MARCH 8: Pierre Matisse writes to Miró: "[O]ne of your UNESCO friends . . . brought me up to date on the text Jacques Dupin is to write on your oeuvre. . . . I am happy to learn of this new enterprise, which . . . will at last reveal your work fully. . . ."[788]

APRIL: Exhibition of his graphic work, Museum Haus Lange, Krefeld.[789]

[AUGUST]: In Palma, begins work with Jacques Dupin on the latter's major monograph.[790]

AUGUST 9: Matisse writes to Miró about publishing a facsimile edition of the Constellations: "I was very happy to have your consent for the work I am planning on the series of twenty-two prestigious gouaches known as the Constellations of 1940 and 1941."[791]

Miró at work on ceramics with Joan Gardy Artigas and Josep Llorens Artigas (facing left), Gallifa, April 1956. Photograph by Sabine Weiss. Courtesy of the Pierre Matisse Foundation, New York

OCTOBER 3: Matisse writes to Miró, thanking him for his suggestions about the Constellations, noting, "I am glad you yourself advanced André Breton's name for the text."

1958

In Palma, continues to organize new studio. Rediscovers sketchbooks, drawings, and projects accumulated over his entire career.[792]

JANUARY 21: From Palma, writes to Breton, telling him he is *"happy and proud"* that Breton has agreed to write the text for the Constellations.

JANUARY 28: James Thrall Soby, Chairman of the Department of Painting and Sculpture, The Museum of Modern Art, writes to Miró with plans for a major retrospective of his work.

APRIL 25—JUNE 5: Exhibition of *A toute épreuve*, Galerie Berggruen, Paris.[793]

MAY 19: From Palma, writes to Matisse: "The work for UNESCO is, so to speak, finished; I'm awaiting word from Artigas for the final revision. . . ."

[MAY 29]: Last firing of ceramic walls for UNESCO.[794]

[LATE AUGUST?]: Miró is told he has won the Guggenheim International Award for the UNESCO walls.[795]

[NOVEMBER?]: Inauguration of his two ceramic walls for the new UNESCO headquarters, place de Fontenoy, Paris.[796]

NOVEMBER 4—29: One-artist exhibition, of *"peintures sauvages,"* 1934–1953, at Pierre Matisse Gallery, New York.[797]

NOVEMBER 11: From Palma, writes to Matisse: "UNESCO mural—Guggenheim prize—*Sauvage* exhibition—Constellations book—Museum of Modern Art exhibition. All this strikes me as a magnificent strategy."

1959

JANUARY 20—MARCH: Exhibition of the facsimile edition of the Constellations, along with a number of the original gouaches, Galerie Berggruen, Paris.[798]

MARCH 17—APRIL 11: Exhibition of the facsimile edition of the Constellations, along with some of the original gouaches and with photographs from the book *The Miró Atmosphere*, Pierre Matisse Gallery, New York.[799]

MARCH 18—MAY 10: Retrospective exhibition, The Museum of Modern Art, New York, organized by William S. Lieberman. Catalogue is by James Thrall Soby.[800]

MARCH 30: From Palma, writes to Matisse: "I am eager to see the exhibition, not only for the rigorous self-criticism of my work which I plan and which will do me a great deal of good, but because there I will see my entire life unfold."

APRIL 14: From Palma, writes to Matisse regarding plans for a trip to the United States: "I will stay in

Morton G. Neumann, Pilar Juncosa de Miró, Rose Neumann, Miró, and Joan Prats, aboard the S.S. *Liberté*, June 1, 1959. Courtesy Hubert Neumann, New York

New York until the close of my exhibition; after that several little trips: Sert, Calder, Chicago, Philadelphia. I would also like you to arrange a visit to the Barnes Collection. I am also thinking of contacting the American painters. . . ."[801]

[APRIL 21]: For his third trip to the United States,[802] flies from Barcelona to New York.[803] Stays briefly at the Sherry Netherland Hotel, Fifth Avenue at Fifty-ninth Street, and then at the Hotel Gladstone, 114–122 East Fifty-second Street.[804]

APRIL 27: Matisse hosts a party in Miró's honor. Among the invited guests are Dorothy Miller, Armand and Celeste Bartos, James Johnson Sweeney, James Thrall Soby, Margaret Scolari and Alfred H. Barr, Jr., William S. Lieberman, Clement Greenberg, Thomas Bouchard, I. M. Pei, Loren MacIver, Leo Castelli, and Theodore Roszak.[805]

MAY 18: President Eisenhower presents Miró with the 1958 Guggenheim International Award, in Washington, D.C.[806]

[C. MAY 21—22]: Miró travels to Boston and Philadelphia.[807] Visits his *Mural Painting* at Harvard University; distressed by its condition, he proposes that it be replaced by a ceramic version.[808]

[MAY 29]: Leaves New York on the S.S. *Liberté*.[809]

1960

FEBRUARY 27: Executes a small study for *Blue I* (p. 288).[810]

MARCH 13: Writes to Aimé Maeght, suggesting that they postpone an exhibition they had planned: "Numerically, I have enough material for an exhibition, but . . . these works are only rapidly sketched because what interests me *underneath everything* is, at the moment when a spark strikes my spirit, to record it, even in a practically invisible manner. Several months have had to pass for them to mature and for me to be disposed to give them *form* and make them *physically strong*. . . . There are only a few exhibitions left to me in my life, and each one must be justified by its strength. . . ."

APRIL 19: Completes *The Red Disk* (p. 292).

MAY 6: Executes small studies for *Blue II* and *Blue III* (p. 289).[811]

[SUMMER?]: Works on ceramic mural with Artigas for Harkness Commons, Harvard University, to replace *Mural Painting* (pp. 276–77).[812]

[SEPTEMBER]: Acquires Son Boter, a seventeenth-century house near his home and studio in Palma, to be used as a second studio.[813]

1961

[JANUARY 31—FEBRUARY 16]: Exhibition of Harvard ceramic mural, Sala Gaspar, Barcelona. Also shown at the Galerie Maeght, Paris, in February, and at the Solomon R. Guggenheim Museum, New York, March 30–April 16.[814]

MARCH 4: Completes three large-scale paintings in the Palma studio, *Blue I*, *Blue II*, and *Blue III* (see pp. 288–89).[815]

In an interview with Rosamond Bernier, describes these "three large blue canvases. They took me a long time. Not to paint, but to think them through. . . . This struggle exhausted me. I have not painted anything since. These canvases are the culmination of everything I had tried to do up to then."[816]

APRIL: One-artist exhibition opens at the Galerie Maeght, Paris.[817]

JUNE 23—JULY 31: One-artist exhibition (mural paintings), Galerie Maeght, Paris. Includes *Blue I*, *Blue II*, and *Blue III* (pp. 288–89).[818]

OCTOBER 31—NOVEMBER 25: One-artist exhibition, Pierre Matisse Gallery, New York.[819]

[NOVEMBER 17]: Goes to Paris; followed by a trip to New York. Possibly visits Cambridge to see the new ceramic mural installed.[820]

1962

Jacques Dupin's monograph, *Joan Miró: Life and Work*, is published.[821]

MAY 18: Completes *Mural Painting I* (p. 290).

MAY 21: Completes *Mural Painting II* (p. 290).

MAY 22: Completes *Mural Painting III* (p. 291).

MAY 27: Writes to Dupin, mentioning plans to set up a print studio in Palma.

JUNE—NOVEMBER: Has his first major museum retrospective in Paris, Musée National d'Art Moderne.[822]

[JULY?]: To Saint-Paul-de-Vence. Meets with Sert to discuss plans for the Fondation Maeght.[823]

1963

[EARLY MARCH?]: To Gallifa; works on sculptures for the Fondation Maeght.[824]

[JUNE 13]: Exhibition of Miró and Artigas ceramics opens at the Galerie Maeght, Paris.[825]

Miró at work on *Mural Painting I* (p. 290) in his Palma studio, 1962. To its right: *Mural Painting II* (p. 290). Against right wall: *Mural Painting III* (p. 291). Photograph by F. Català-Roca

[AUGUST 14]: Thomas M. Messer, Director of the Solomon R. Guggenheim Museum, proposes a ceramic-mural commission for the museum, in memory of Alicia Patterson Guggenheim.[826]

NOVEMBER 5–30: Exhibition of Miró and Artigas ceramics, Pierre Matisse Gallery, New York.[827]

1964

[EARLY MARCH]: To Saint-Paul-de-Vence to work on installation of his sculptures at the Fondation Maeght.[828]

[MID-APRIL]: To Gallifa; works with Artigas on a ceramic mural for the Ecole Supérieure de Sciences Economiques, Commerce et Administration Publique, Saint-Gall, Switzerland.[829]

JULY 28: Inauguration of the Fondation Maeght, Saint-Paul-de-Vence; sculptures and labyrinth by Miró.[830]

AUGUST 27–OCTOBER 11: Retrospective exhibition, Tate Gallery, London, organized by Roland Penrose.[831]

[SEPTEMBER 12]: Flies to London from Barcelona to see the Tate retrospective.[832]

1965

MAY: One-artist exhibition, of paintings on cardboard, Galerie Maeght, Paris.[833]

JULY 13: Completes *Red Circle, Star* (p. 293).

[OCTOBER 23]: Flies to New York from Paris.[834]

OCTOBER 26–NOVEMBER 20: One-artist exhibition, of paintings on cardboard, Pierre Matisse Gallery, New York.[835]

Visits Chicago; sees Seurat's *La Grande Jatte* at the Art Institute.[836]

1966

Makes first monumental bronze sculptures (see pp. 300–01).[837]

APRIL 24: Completes *The Song of the Vowels* (p. 294).[838]

APRIL 26–MAY 26: One-artist exhibition, Marlborough Fine Art, London.[839]

AUGUST 26–OCTOBER 9: Retrospective exhibition, National Museum of Modern Art, Tokyo.[840]

[SEPTEMBER 20]: First trip to Japan.[841] Meets the poet Shuzo Takiguchi for the first time.[842]

OCTOBER 23: From Palma, writes to Dupin, remarking that the trip to Japan had turned him upside down, "almost as much, if I dare say it, as when I went to Paris for the first time. . . ."

1967

APRIL–MAY: One-artist exhibition, Galerie Maeght, Paris. Includes *Moonbird* (p. 300) and *Solar Bird* (p. 301).

[MAY 17]: Flies from Paris to New York.[843]

[MAY 18]: Dedication of ceramic mural at the So-

Miró at the Fondation Maeght, Saint-Paul-de-Vence, during construction of *Great Arch*, c. 1963–64. Courtesy The Josep Lluís Sert Collection, Frances Loeb Library, Graduate School of Design, Harvard University, Cambridge, Massachusetts

lomon R. Guggenheim Museum, New York. Miró attends ceremony and dinner in his honor.[844]

JULY 4: Writes to Matisse: "I spent several days in Barcelona working at my foundry. This last series is very beautiful; I am going to send them to Paris after vacation to see and study what must be done with the patinas and to finish them."[845]

[OCTOBER]: Awarded the Carnegie International Grand Prize for Painting.[846]

NOVEMBER 14—DECEMBER 9: One-artist exhibition, Pierre Matisse Gallery, New York. Includes *Moonbird* (p. 300) and *Solar Bird* (p. 301).[847]

DECEMBER 25: From Palma, writes to Matisse: "I now see things on a grand scale, the moonbird and many of my recent sculptures not only hold up, but *demand* to be set outdoors and enlarged to an *unlimited scale*, in the middle of the crowd."

1968

[LATE FEBRUARY]: To Gallifa to work on ceramic mural for the Fondation Maeght, Saint-Paul-de-Vence.[848]

MARCH 18: From Palma, writes to Sert with news of a commission for a ceramic mural for the Barcelona airport.

MARCH 27—JUNE 9: Is included in the exhibition "Dada, Surrealism, and Their Heritage," The Museum of Modern Art, New York, organized by William Rubin.[849]

JUNE 5: Miró completes *Letters and Numbers Attracted by a Spark (V)* (p. 296) and *Letters and Numbers Attracted by a Spark (VI)* (p. 297).

[AFTER JUNE 5]: Last trip to the United States.[850] Awarded an honorary degree at Harvard University on commencement day.[851] Visits The Museum of Modern Art, New York.

JULY 21: Attends party for Alexander Calder's seventieth birthday, in Saint-Paul-de-Vence.[852]

JULY 22: Fondation Maeght hosts dinner for Miró to celebrate his seventy-fifth-birthday retrospective.[853]

JULY 23—SEPTEMBER 30: Retrospective exhibition, Fondation Maeght, Saint-Paul-de-Vence. Catalogue preface is by Jacques Dupin.[854]

NOVEMBER—JANUARY 1969: Retrospective exhibition, Recinto del Antiguo Hospital de la Santa Cruz, Barcelona.[855]

1969

MARCH 15—MAY 11: Retrospective exhibition, Haus der Kunst, Munich.[856]

APRIL 10: From Palma, writes to Roland Penrose: "[M]y printed work occupies a more and more important and central place in my production and in the message I want it to have."

[EARLY NOVEMBER]: Travels to Osaka. Probably works on monumental ceramic murals and water

Miró, his wife, Pilar Juncosa de Miró, and Pablo Picasso at Notre-Dame-de-Vie, c. 1960s. Photograph by Jacqueline Picasso. Courtesy Catherine Hutin-Blay

garden for the Osaka World's Fair, which will open in 1970.[857]

1970

Monumental ceramic mural for the Barcelona airport.[858]

[JANUARY]: Sert produces first sketches for what will become the Centre d'Estudis d'Art Contemporani, Fundació Joan Miró, Barcelona.[859]

APRIL 16: In Barcelona, works on sculpture at Parellada foundry.[860]

MAY 5—JUNE 5: One-artist exhibition of bronze sculptures, ceramics, etchings, and lithographs, Pierre Matisse Gallery, New York.[861]

MAY 25: In Meudon, works on sculpture at Clementi foundry.[862]

JUNE: One-artist exhibition of sculptures, Galerie Maeght, Paris.[863]

AUGUST 18: Sert writes to Miró, suggesting they meet to discuss preliminary plans for the Centre d'Estudis d'Art Contemporani (CEAC).

1971

OCTOBER 3—NOVEMBER 28: "Miró Sculptures," Walker Art Center, Minneapolis.[864]

OCTOBER—NOVEMBER: One-artist exhibition, Galerie Maeght, Paris.[865]

1972

FEBRUARY 1—MARCH 12: "Miró Bronzes," Hayward Gallery, London.[866] Miró possibly visits London in March.[867]

MARCH 21—APRIL 15: One-artist exhibition of works on paper, Pierre Matisse Gallery, New York.[868]

[SPRING?]: Completes first of a series of woven pieces, known as *sobreteixims*. Executed in collaboration with Josep Royo, Tarragona.[869]

[EARLY APRIL]: To Barcelona and Gallifa; completes work on a ceramic mural for Kunsthaus Zürich.[870]

MAY: One-artist exhibition, of *sobreteixims* and sculpture, Sala Gaspar, Barcelona.[871]

MAY 17: Matisse writes to Miró mentioning the possibility of a commission for the new wing of the National Gallery of Art in Washington, D.C.[872]

JUNE 4—JULY 30: Retrospective exhibition of sculpture, Kunsthaus Zürich.[873]

[JUNE 27]: The Spanish Minister of Education grants official recognition to the Centre d'Estudis d'Art Contemporani, Fundació Joan Miró.[874]

OCTOBER 27—JANUARY 21, 1973: "Joan Miró: Magnetic Fields," Solomon R. Guggenheim Museum, New York, organized by Rosalind Krauss and Margit Rowell.[875]

1973

APRIL: One-artist exhibition of paintings on burlap and *sobreteixims*, Galerie Maeght, Paris.[876]

APRIL 14—JUNE 30: One-artist exhibition of sculptures and ceramics, Fondation Maeght, Saint-Paul-de-Vence.[877]

MAY 1—25: One-artist exhibition, of paintings, gouaches, *sobreteixims*, sculpture, and etchings, at the Pierre Matisse Gallery, New York.[878]

[LATE JUNE OR JULY]: To Paris and probably Saint-Paul-de-Vence.[879] Costume rehearsal for the ballet *L'Oeil-oiseau*, at the Fondation Maeght; scenario by Jacques Dupin, music by Patrice Mestral, sets by Miró.[880]

OCTOBER 10—JANUARY 27, 1974: "Miró in the Collection of The Museum of Modern Art," The Museum of Modern Art, New York, organized by William Rubin.[881]

OCTOBER 19—NOVEMBER 9: "Miró: Sobreteixims," Pierre Matisse Gallery, New York.[882]

NOVEMBER 15—JANUARY 15, 1974: Exhibition "Miró vuitanta: Joan Miró, catalitzador de la joventut," Col·legi d'Arquitectes, Palma.[883]

1974

Dedication of *Moonbird* at the site of the former 45, rue Blomet, Paris.[884]

[MAY?]: To Paris for installation of his retrospective at the Grand Palais.[885]

MAY 17—OCTOBER 13: Retrospective exhibition, Grand Palais, Paris, organized by Jean Leymarie, Jacques Dupin, and Isabelle Fontaine.[886] At the same time, "Miró: L'Oeuvre graphique" shown at the Musée d'Art Moderne de la Ville de Paris.[887]

1975

APRIL—MAY: One-artist exhibition, of paintings and sculpture, at the Pierre Matisse Gallery, New York.[888]

JUNE 10: Unofficial opening of the Centre d'Estudis d'Art Contemporani, Fundació Joan Miró, in a building designed by Sert, Parc de Montjuïc, Barcelona;[889] inaugural exhibition of paintings, sculpture, and *sobreteixims*.[890]

NOVEMBER 20: Death of General Franco.

DECEMBER 5—JANUARY 1976: Miró retrospective exhibition, Galería Maeght, Barcelona.[891]

1976

Pavement *Pla de l'Os*, on Les Rambles, Barcelona.[892]

Ceramic mural for IBM Laboratories, Barcelona.[893]

Prepares ceramic mural for the Wilhelm Hack Museum, Ludwigshafen.[894]

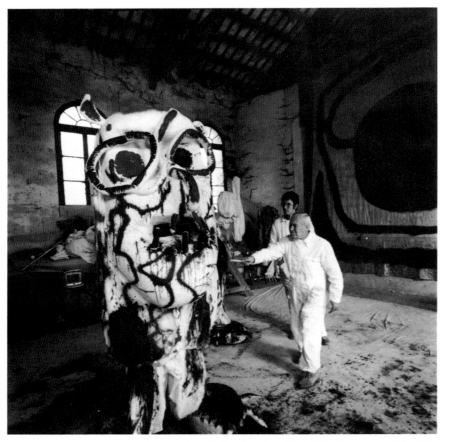

Miró at work on *Mori el Merma*, Sant Esteve de Palau Tordera, Barcelona, March 1977. Photograph by F. Català-Roca

APRIL: Donates nearly five thousand drawings, sketches, and notebooks to the Fundació Joan Miró, Barcelona.[895]

APRIL 13—MAY: "Miró: Sculpture," Pierre Matisse Gallery, New York.[896]

APRIL 29: Completes *Woman, Bird* (p. 310).

JUNE 18: Official inauguration of the Fundació Joan Miró, Barcelona; exhibition of drawings donated from the artist's collection.[897]

NOVEMBER 16—DECEMBER 16: "Miró: Aquatintes, Grands formats, 1974–75," Pierre Matisse Gallery, New York.[898]

[DECEMBER?]: Beginning of collaboration with La Claca theater group on *Mori el Merma*.[899] This troupe had been prohibited from performing in Spain during Franco's regime.[900]

1977

Ceramic mural for the Edwin A. Ulrich Museum of Art, Wichita State University, Kansas.[901]

Large wall tapestry (with Josep Royo) for the East Building, National Gallery of Art, Washington, D.C.[902]

[MARCH]: Paints costumes and sets for *Mori el Merma*.[903]

JULY—SEPTEMBER: One-artist exhibition of paint-ings, sculpture, and prints, Musée d'Art Moderne, Céret.[904]

AUGUST 10: Completes *Personage* (p. 308).

1978

Monumental sculpture, *Couple d'amoureux*, for La Défense, Paris.[905]

Ceramic mural for the Victoria Museum, The Netherlands.[906]

[FEBRUARY]: The BBC films Miró in his Palma studio with Roland Penrose and at work on *Mori el Merma*.[907]

MARCH 5: From Palma, writes to William Rubin: "A big exhibition of my works for Madrid is being organized, which I consider a major event. . . . [T]his exhibition can help to build a new Spain, which we are all working for. . . ."

MARCH 7: World premiere of *Mori el Merma*, Teatre Principal, Palma.[908] Monstrous puppets parody bourgeois values; veiled but precise references to the Franco era.[909]

MAY 4—JULY 23: Has his first museum retrospective in Madrid, at the Museo Español de Arte Contemporáneo.[910] Goes to Madrid for the opening.[911]

At the same time, "Joan Miró: Obra gráfica" held at the Dirección General del Patrimonio Artístico, Madrid.[912]

JUNE 7: Premiere of *Mori el Merma* at Gran Teatre del Liceu, Barcelona.[913] Miró is seated next to the President of the Generalitat of Catalonia.[914]

[JULY 31]: Completes *Untitled* (p. 310).

[SEPTEMBER 4?]: Decorated with the Grand Cross of Isabel la Católica by King Juan Carlos and Queen Sofía of Spain.[915]

SEPTEMBER 20—JANUARY 22, 1979: "Dessins de Miró provenant de l'atelier de l'artiste et de la Fondation Joan Miró de Barcelone," Musée National d'Art Moderne, Centre Georges Pompidou, Paris.[916]

OCTOBER 19—DECEMBER 17: "Miró: Cent Sculptures, 1962–1978," Musée d'Art Moderne de la Ville de Paris.[917]

NOVEMBER: One-artist exhibition of paintings, Galerie Maeght, Paris.[918]

NOVEMBER 21—DECEMBER 16: "Joan Miró: Recent Paintings, Gouaches and Drawings from 1969 to 1978," Pierre Matisse Gallery, New York.[919]

1979

Stained-glass windows for Chapelle de Saint-Frambourg, Fondation Cziffra, Senlis.[920]

JANUARY: One-artist exhibition, Seibu Art Museum, Tokyo.[921]

MARCH 21—22: Arnold Newman photographs Miró in his Palma studio.[922] Visible in the photo-

graphs are many of his last paintings, in progress (see pp. 308–15).

APRIL 10—MAY 13: "Drawings by Joan Miró from the Artist's Studio and the Joan Miró Foundation, Barcelona," Hayward Gallery, London.[923]

MAY 26 OR 27—SEPTEMBER 30: Retrospective exhibition, Orsanmichele, Florence (paintings); Museo Civico, Siena (prints); Palazzo Pretorio, Prato (sculpture).[924]

JUNE—JULY: One-artist exhibition, Galería Maeght, Barcelona.[925]

JULY 7—SEPTEMBER 30: Retrospective exhibition, Fondation Maeght, Saint-Paul-de-Vence.[926]

[OCTOBER 2]: Awarded degree of *Doctor honoris causa*, Universitat de Barcelona.[927]

1980

Ceramic mural for Palacio de Congresos y Exposiciones, Madrid.[928]

Awarded Bellas Artes gold medal by King Juan Carlos.[929]

MARCH 19—APRIL 27: "Joan Miró: The Development of a Sign Language," Washington University Gallery of Art, Saint Louis, organized by Sidra Stich.[930]

MARCH 20—JUNE 8: Retrospective exhibition, Hirshhorn Museum and Sculpture Garden, Smithsonian Institution, Washington, D.C.[931]

MAY—AUGUST: Retrospective exhibition, Museo de Arte Moderno, Mexico City.[932]

MAY 13—JUNE 7: One-artist exhibition, of painted sculpture and ceramics, at the Pierre Matisse Gallery, New York.[933]

MAY 15: His sister, Dolores Miró Ferrà, dies in Barcelona at age eighty-three.[934]

1981

The Fundació Pilar i Joan Miró a Mallorca is established in Palma.[935]

[APRIL 20]: Monumental sculpture *Miss Chicago* unveiled in Chicago.[936]

[SEPTEMBER]: Costumes and sets for the ballet *Miró: L'Uccello-luce*, Venice (scenario by Jacques Dupin, music by Sylvano Bussotti, choreography by Joseph Russillo).[937] Premiere given at La Fenice, Venice; subsequently performed at the Teatro Municipale, Florence.[938]

OCTOBER 26—DECEMBER 6: "Miró Milano," seven simultaneous exhibitions in museums and galleries in Milan.[939]

[NOVEMBER 6]: Two monumental sculptures unveiled, in Plaça de Pius XII and the gardens of S'Hort del Rei, Palma.[940]

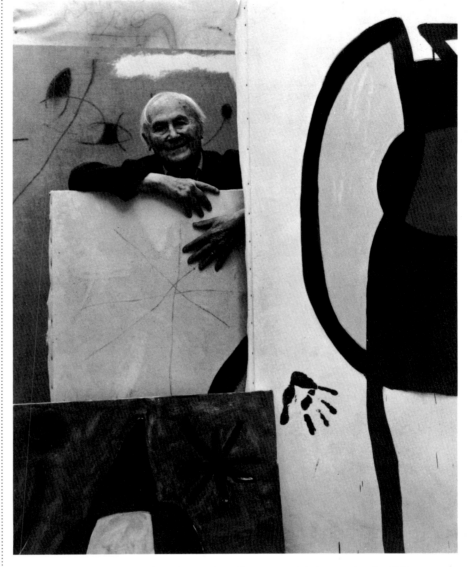

Miró in Palma, March 1979. *Untitled* (p. 310) is partially visible in the lower left. Photograph © Arnold Newman

1982

[APRIL 20]: Unveiling of the monumental sculpture *Personage and Birds*, Texas Commerce Bank, United Energy Plaza, Houston.[941]

APRIL 21—JUNE 27: "Miró in America," The Museum of Fine Arts, Houston.[942]

[JUNE 24]: Unveiling of the monumental sculpture *Woman and Bird*, Parc Escorxador, Barcelona.[943]

1983

[APRIL]: Unveiling of a monumental sculpture on the patio of the Ajuntament de Barcelona.[944]

APRIL 14—26: "Joan Miró: A Ninetieth-Birthday Tribute," The Museum of Modern Art, New York.[945]

MAY 10—JUNE 18: "Miró: Ninety Years," Pierre Matisse Gallery, New York.[946]

DECEMBER 25: Death of Joan Miró, in Palma.

DECEMBER 27: Private memorial service, church of San Nicolás, Palma. In accordance with Miró's wishes, the service is conducted in Catalan, the language of Catalonia and of Spain's Mediterranean islands. In Barcelona and the rest of Catalonia, flags on government buildings are ordered flown at half-mast for three days.[947]

DECEMBER 29: Funeral; Miró is buried in the family vault in Montjuïc Cemetery, Barcelona, the city of his birth.[948]

Notes to the Chronology

1. Birth Registration. April 22, 1893. Perucho 1968, p. 10, reproduces Miró's father's business card, which indicates he was a watchmaker and a jeweler. Miró inherited both his father's and his mother's family names, as is common in Spain. Although he would at times use his full name, he more frequently chose to retain his father's patronym (Miró) and to drop his mother's (Ferrà).
2. Birth Registration. December 12, 1894.
3. Death Registration. May 12, 1895.
4. Birth Registration. March 18, 1896.
5. Birth Registration. May 5, 1897.
6. Rowell 1986, p. 21; based on Miró's letter to Dupin, October 9, 1959, ibid., p. 44 (as 1957). Miró's own recollections as recorded for Dupin provide the basis for much information concerning his education and events during his early years.
7. Rowell 1986, p. 21. See also Dupin 1962, pp. 33–35, and Fundació Joan Miró 1988, p. 464. For possible other visits to his grandparents, see Miró 1977, p. 151.
8. Dupin 1962, pp. 40–42 (reproduced), 494, and Fundació Joan Miró 1988, pp. 35–36 (reproduced).
9. Notebook FJM 44–94. See Fundació Joan Miró 1988, pp. 39–45, and Picon 1976, vol. 1, pp. 22, 24–25.
10. La Lonja is now called La Llotja. Cf. Dupin 1962, pp. 44–45, 494; Rowell 1986, p. 21; Hirschfeld/Lubar 1987, p. 249; Fundació Joan Miró 1988, p. 464; Lubar 1988, pp. 23, 254; and Combalía 1990, p. 29.
11. Dupin 1962, pp. 45–47, 494; Rowell 1986, pp. 21, 44; and Lubar 1988, p. 254. On classes taught by Urgell and Pascó, see Marés Deulovol 1964, p. 272.
12. Dupin 1962, p. 47; Rowell 1986, pp. 22, 44; Fundació Joan Miró 1988, p. 464; and Lubar 1988, pp. 23, 254.
13. Rowell 1986, p. 22. The exact date of the farm's purchase is unknown. Cf. Dupin 1962, pp. 33, 48.
14. Dupin 1962, pp. 47–48, 494, is the primary source for this information. Cf. Rowell 1986, p. 22; Hirschfeld/Lubar 1987, p. 249; Lubar 1988, pp. 23, 255; and Combalía 1990, p. 28.
15. Barcelona 1911. Both Lubar 1988, pp. 58 (n. 45), 254, and Combalía 1990, p. 29 (n. 4), suggest that Miró exhibited two paintings.
16. Rowell 1986, p. 22. For the address of Galí's school and an informative description, see López Rodríguez 1985, pp. 74–78.
17. Lubar 1988, pp. 25–26 (n. 41), 27 (n. 44), 255. Dupin 1962, p. 466, notes that Miró and Artigas met around 1917 at the Círcol Artístic de Sant Lluc, although on p. 494 he dates the start of their

friendship to 1912, as does Rowell 1986, p. 22.
18. See Dupin 1962, p. 52, and Lubar 1988, pp. 61 (n. 51), 255.
19. Rowell 1986, p. 22; Lubar 1988, pp. 27, 28 (n. 46), 255; and Jardí 1976, pp. 83–84. There were no life models at Galí's school, but models were available at the Círcol Artístic de Sant Lluc (now called the Cercle Artístic de Sant Lluc).
20. Barcelona 1913. See Rowell 1986, p. 22; Lubar 1988, p. 28 (n. 46); and Combalía 1990, p. 29.
21. Letter to Ricart. From Barcelona, Passatge del Crèdit, 4, December 11, 1914.
22. There is disagreement as to the location and dates of occupancy of the studio Miró and Ricart shared. Dupin 1962, pp. 62, 494, states that Miró rented his first studio with Ricart in 1915 at Baja San Pedro, 51 (Carrer Sant Pere Més Baix). Rowell 1986, p. 22, proposes that Miró rented this studio with Ricart in fall 1914. Lubar agrees with Rowell's date (see Hirschfeld/Lubar 1987, p. 249, and Lubar 1988, pp. 255, 283–84, including notes) but suggests that the two artists first shared a studio on the Carrer Arc de Jonqueres and that Ràfols used this studio as well. Only after summer 1916, according to Lubar, did Ricart and Miró move to a studio on the Carrer Sant Pere Més Baix.
23. Letter to Ricart. From Barcelona, Passatge del Crèdit, 4, December 11, 1914.
24. Although the date of Miró's trip to Caldetes has been given as December 1914 (Rowell 1986, p. 22, and Lubar 1988, p. 255), it seems more likely, from his letters to Ricart (from Barcelona, December 11 and 22, 1914), that Miró's mother would have been unable to travel before late December and that they planned to spend the holidays in Barcelona. On the length of the stay, see the letters to Ricart, from Caldetes, January 31, 1915, and to Bartomeu Ferrà, from Barcelona, March 15, 1915 (in Serra 1986, pp. 226–27).
25. Letter to Ricart. From Caldetes, January 31, 1915.
26. See note 24, above.
27. Rowell 1986, p. 22. Rowell refers to the studio at Carrer Sant Pere Més Baix, 51, as does Dupin 1962, pp. 62, 494. See note 22, above, and Hirschfeld/Lubar 1987, p. 249; Lubar 1988, pp. 255, 284; and Jeffett 1989b, p. 120.
28. Rowell 1986, p. 22.
29. Dupin 1962, pp. 54–56; Hayward 1986, p. 298; Fundació Joan Miró 1988, p. 466; and Lubar 1988, p. 267.
30. Letter to Bartomeu Ferrà. From Barcelona, March 15, 1915. In Serra 1986, p. 226.
31. See Lubar 1988, pp. 60–61.
32. Hayward 1986, p. 298, and Lubar

1988, pp. 33–36, 34 (n. 57). Although Dupin 1962, pp. 62, 494, and Jeffett 1989b, p. 120, suggest that Miró "graduated" from Galí's academy in 1915, it seems more likely that the school simply closed and that Miró did not choose to follow Galí to the new school in fall 1915.
33. Although Rowell 1986, p. 22, states that beginning in 1915 and through 1917 Miró would fulfill military service requirements for three months (October 1–December 31), in a letter to Ricart, sent from Barcelona, June 10, 1915, Miró states: "I am now a soldier of the 57th Infantry Regiment. . . ." In 1916, Miró made arrangements with the military allowing him to serve during a period beginning in October (see Miró's letter to Ricart, from Montroig, Saint James's Day [July 25], 1916), as opposed to the summer months. In 1915, however, as witnessed not only by his June 10, 1915, letter to Ricart but also by an earlier one, January 31, 1915, he was called to serve briefly in January and for a longer period beginning sometime before June 10, 1915.
34. See note 33, above. (Rowell 1986, p. 22, says Miró was in Montroig during summer 1915.)
35. See note 33, above.
36. Lubar 1988, pp. 78–79, including notes.
37. Miró's whereabouts during winter–spring 1916 are undocumented aside from a postcard to Ricart, postmarked Barcelona, and dated April 25, 1916. For his studio address, see Miró's letter to Ricart (Balaguer 417), possibly from summer 1916.
38. Lubar 1988, p. 109 (n. 37), notes that according to Melià 1975, pp. 118–19, Miró met Dalmau shortly after the van Dongen exhibition closed, on January 6, 1916. Cf. Dupin 1962, pp. 65, 494, and Rowell 1986, p. 22.
39. Balaguer 417. From Montroig, Tuesday. An excerpt is quoted in Dupin 1962, p. 65, as "July 1916." Lubar 1988, p. 283 (n. 4), dates the letter to summer 1916.
40. Letter to Ricart. From Montroig, Saint James's Day [July 25], 1916.
41. Rowell 1986, p. 22. Confirmed by letters to Ricart, sent from Montroig and Barcelona, respectively, Saint James's Day [July 25] and October 7, 1916.
42. Lubar 1988, p. 284, suggests that Miró and Ricart shared a studio on the Carrer Més Baix de Sant Pere (Carrer Sant Pere Més Baix) from 1916 to 1918 and that subsequently, Miró allowed Ricart to use his studio there until 1920. In Miró's letter to Ricart, from Barcelona, October 7, 1916, he seems to refer to the loss of their studio on the Carrer Arc de Jonqueres and the need to find a new one. On Ràfols's

use of the studio, see Miró's letter to Ràfols, from Montroig, September 13, 1917 (in Rowell 1986, p. 52).
43. As yet, no documentation exists to establish Miró's whereabouts in winter–spring 1917. An undated postcard to Ricart (Balaguer 453, postmarked Barcelona, possibly June or July 1917) and an undated letter (Balaguer 452, from Barcelona, possibly October 1, 1917) suggest that Miró and Ricart shared a studio on the Carrer Sant Pere Més Baix in winter–spring 1917.
44. Rowell 1986, p. 7, and Lubar 1988, p. 256.
45. Lubar 1988, p. 73 (and n. 32). Lubar bases this statement on Melià 1975, p. 119. See also Miró 1977, p. 19.
46. The dates of Miró's first encounters with both Raynal and Picabia are open to question. Rowell 1986, p. 22, suggests Miró met Raynal in Barcelona in 1917 and notes it was through Dalmau. Dupin 1962, p. 64, also says Dalmau introduced the two but suggests (p. 494) that they met during the year of Miró's first trip to Paris, as do Hirschfeld/Lubar 1987, pp. 249–50. Miró told Brassaï that Picasso had introduced him to Raynal; see Brassaï 1982, p. 143. Certainly Raynal and Miró had met by winter–spring 1921, when Raynal wrote the catalogue preface for the latter's first Paris exhibition.

Picabia was in Barcelona during January–March 1917 and published the first four numbers of his Dada magazine *391* with Dalmau; see Lubar 1988, pp. 67 (n. 12), 69 (nn. 17–19). Although numerous sources suggest the two met in 1917 (see, for example, Dupin 1962, p. 494; Rubin 1973, p. 113, n. 24; Rose 1982a, p. 13; Rowell 1986, p. 22; and Fundació Joan Miró 1988, p. 466), it is unlikely that Miró's acquaintance with Picabia in Barcelona went beyond a brief introduction. As noted in Lubar 1988, p. 73 (n. 32), in a letter to Picabia, June 10, 1925, Miró mentioned he hoped to make Picabia's acquaintance. Given this remark, it is difficult to conclude that Miró and Picabia even knew each other prior to 1925. Jacques Dupin (in conversation with A. Umland, March 1992) noted that Miró said only that he had "seen" Picabia in Barcelona in the late teens. Others who have expressed skepticism concerning the date of Miró's first meeting with Picabia include Jeffett 1989b, p. 120; Combalía 1990, p. 45; and Maria Lluïsa Borràs, in conversation with C. Lanchner.
47. Rowell 1986, pp. 22–23, and Lubar 1988, pp. 88, 256.
48. Rowell 1986, p. 23. See also Lubar 1988, pp. 256, 293. On the trip to Cornudella, see an undated letter to Ricart

(Balaguer 449, from Montroig, possibly August 26, 1917).

49. Letter to Ricart (Balaguer 452). From Barcelona, Monday (possibly October 1, 1917). In Rowell 1986, p. 52. It is unclear when *Prades, The Village* (p. 89) was completed; cf. Rudenstine 1976, vol. 2, p. 518, and an undated letter to Ricart (Balaguer 448, from Barcelona, possibly August 19, 1917).

50. Hayward 1986, p. 299, and Lubar 1988, pp. 64 (n. 2), 256. Regarding the strike, see M. Sarmiento, "En Sabadell," *La Publicidad* (Barcelona), vol. 40, no. 13785 (August 19, 1917), p. 4; and "La Huelga general," *La Publicidad* (Barcelona), vol. 40, no. 13787 (August 21, 1917), p. 3.

51. Letter to Ricart (Balaguer 448). From Barcelona, Sunday. The only Sunday between August 13 and 20, 1917, the beginning and ending dates of the general strike, is August 19, therefore Miró must have arrived in Barcelona on August 18.

52. Letter to Ricart (Balaguer 449). From Montroig, Sunday (possibly August 26, 1917). See note 53, below, for a discussion of dating.

53. Letter to Ricart (Balaguer 449). From Montroig, Sunday. Since this letter, which notes that Miró returned to Montroig the day before, refers to the one sent to Ricart during the strike (Balaguer 448, possibly August 19, 1917), it most probably dates to August 26 (the only Sunday in August 1917 after August 19).

54. Letter to Ricart (Balaguer 449). From Montroig, Sunday. Cf. Lubar 1988, pp. 256, 308. See note 53, above.

55. Rowell 1986, p. 50. See Dupin 29–44.

56. Letter to Ricart (Balaguer 452). From Barcelona, Monday (possibly October 1, 1917). In Rowell 1986, p. 52. On the letter's date, see Rowell 1986, p. 308 (n. 15). Combalía 1990, pp. 39–40, 40–41 (n. 24), quotes extensively from this letter but suggests its date is February 1918; it contains, however, a reference to Miró's current military service (completed on December 31, 1917).

57. Rowell 1986, pp. 22–23. Confirmed by letters to Ràfols, September 13, 1917, and to Ricart (Balaguer 452); see note 56, above.

58. Lubar 1988, p. 284. Confirmed by letter to Ricart (Balaguer 452) sent from Barcelona, Monday (possibly October 1, 1917); see note 56, above, for date of letter.

59. Miró 1977, p. 49, and Rowell 1986, p. 23.

60. Letter to Ricart (Balaguer 452). From Barcelona, Monday (possibly October 1, 1917); see note 56, above, for date of letter. Cf. Rowell 1986, pp. 52–53, and Dupin 1962, p. 81, for slightly different translations.

61. Lubar 1988, pp. 79–80 (n. 47); based on a letter to Ricart from Ràfols, October 19, 1917.

62. Lubar 1988, pp. 142, 256. For the

suggestion that Miró met Picasso at this performance, see Brassaï 1982, pp. 142–43, and also Cabanne 1977, p. 193. Elsewhere, Miró said he did not dare approach Picasso at the time (see Melià 1975, p. 131, and Miró 1977, p. 50). As suggested in Lubar 1988, p. 176 (n. 29), Miró probably first met Picasso in Paris.

63. Rowell 1986, p. 23. Confirmed by letter to Ricart, from Barcelona, postmarked December 30, 1917.

64. Few documents establish Miró's whereabouts in winter–spring 1918, although he did send a letter to Ferrà, from Barcelona, on February 18 (in Serra 1986, pp. 228–29), and one to Ricart, from Barcelona, on May 11.

65. Lubar 1988, pp. 107, 256.

66. Rowell 1986, p. 23, and Lubar 1988, pp. 118–20, 256.

67. Hayward 1986, p. 190 (fig. 201), and Lubar 1987, p. 17 (fig. 5).

68. Barcelona 1918a. For a list of works included, see Lubar 1988, pp. 288–89. For an overview of the critics' reactions, see Lubar 1987, pp. 14–16; Lubar 1988, pp. 109–18 (including notes); and Combalía 1990, pp. 46–48.

69. Lubar 1987, pp. 17 (fig. 6), 18; Lubar 1988, pp. 105–06 (including notes).

70. According to the *Feuilles d'admission* for the 1918 "Exposició d'art," Miró submitted these works on April 8; see Lubar 1988, pp. 124–25 (n. 75).

71. Postcard to Ràfols and Ricart. From the Carrer de les Minyones, 11, Palma, April 14, 1918.

72. Ibid.

73. Barcelona 1918b. On the basis of a notice in *Vell i nou* 1918, Combalía 1990, pp. 48–49 (n. 42), implies an association between Miró and a group known as the Evolucionistes. In fact, however, this group had exhibited at Dalmau's March 9–24, 1918 (Miró was *not* listed in the catalogue), and the commentator in *Vell i nou* made clear that while some of the Evolucionistes' paintings were still on display at the same time at which those of Miró, Ricart, et al. were installed, the relationship between Miró and this group went no further.

74. Barcelona 1918c. See Lubar 1988, pp. 124–27 ff. Rowell 1986, p. 23, suggests that Miró exhibited on May 10 with the Agrupació Courbet at the "Salon de Primavera in Sant Lluc room," and that on May 25 he exhibited in the "Exposició d'Art, Palau de Belles Arts in Sant Lluc room." In fact, the "Salon de Primavera" *was* the "Exposició d'art."

75. Rowell 1986, p. 54. Trini was a model who often posed for Miró; see Rowell 1986, p. 309 (n. 29).

76. Balaguer 476. Tuesday (probably June 11, 1918). See note 77, below, regarding dating.

77. Balaguer 476. Tuesday. Lubar 1988, p. 311, suggests this letter can be dated June 16, and on p. 257 that Miró attended *Petrouchka* on that date. In 1918, however, June 16 fell on a Sunday, whereas Miró

indicated his letter was written on a Tuesday. In 1918, *Petrouchka* was performed in Barcelona at the Gran Teatre del Liceu on June 11, 14, 15, and 16; of these dates, only June 11 was a Tuesday.

78. Letter to Ricart. From Montroig, July 16, 1918. In Rowell 1986, p. 54. See note 85, below, regarding return to Barcelona in early December.

79. The other two are *The Tileworks at Montroig* (Dupin 62) and *The Trail* (Dupin 61). Ràfols called works from this period *detallista* (see Ràfols 1948, p. 499). Combalía 1990, p. 52, believes Artigas was the first to apply the term *detallismo* to Miró's paintings of summer 1918.

80. See, for example, letters to Ferrà, from Montroig, July 25, 1918 (in Serra 1986, p. 230), and to Ricart, from Montroig, November 10, 1918 (in Rowell 1986, p. 60).

81. Rowell 1986, p. 54.

82. Ibid., p. 57.

83. Ibid., pp. 58, 309 (n. 50).

84. Lubar 1988, p. 315, dates this letter October 31, 1918.

85. Letter to Ricart. From Montroig, November 10, 1918.

86. Lubar 1988, p. 284. Confirmed by letters to Ricart, from Montroig, October 18 and November 10, 1918.

87. Lubar 1988, p. 277.

88. Ibid., p. 315; based on letter to Ricart, from Montroig, July 9, 1919 (in Rowell 1986, p. 62).

89. Barcelona 1919a. (Rowell 1986, p. 23, as June 1918.) See Lubar 1988, pp. 159–61, 159 (n. 74).

90. Barcelona 1919b. (Rowell 1986, p. 23, as June–July, described as the "Salon Primavera.") See Lubar 1988, pp. 130–32, and Combalía 1990, pp. 51–53.

91. According to Lubar 1988, pp. 149–51, 151 (n. 59), the second series of *L'Instant* (August 15–October 15, 1919) was published in Barcelona, rather than Paris. See Hayward 1986, p. 244, fig. 274. The poster may have been completed before he arrived in Montroig on June 29, 1919.

92. Rowell 1986, pp. 60, 309 (nn. 56, 57).

93. Ibid., pp. 62, 310 (nn. 64, 65). *Self-Portrait* (p. 101) and *The Village of Montroig* (p. 98) were shown in Paris, at the Salon d'Automne, October 15–December 12, 1920.

94. Rowell 1986, p. 62.

95. Cf. an undated letter to Ricart (Balaguer 472, Sunday, possibly August 24, 1919), where Miró mentions "the pension that my family will give me."

96. Balaguer 472, Sunday. The paragraph describing Miró's plans for negotiations with Dalmau is similar to that found in his letter to Ràfols of August 21, 1919 (in Rowell 1986, p. 63), and August 24 was the first Sunday following the 21st. Moreover, Miró mentions he will be writing to his friend Josep de Togores, who was in Paris, and in a subsequent letter to Ricart, August 31, 1919, notes that Togores has not responded. Therefore the Sunday letter was probably written be-

tween August 21 and 31 — thus August 24, 1919.

Dupin 1962, p. 96, dates this letter "winter" 1919 and provides a different translation, changing the tense from future to past, thereby presenting Miró's proposed course of action as a fait accompli. Lubar (1987, p. 23, n. 45; 1988, p. 116, n. 52) follows Dupin's lead. Because Miró worked closely with Dupin and provided him with the translations of his correspondence with Ricart and Ràfols, the final terms of his arrangement with Dalmau may have been similar to those described. Pere Mañach was a banker, a friend, and Picasso's first dealer.

97. Letter to Ricart (Balaguer 486). From Montroig, Monday. Here Miró states, "Wednesday 22, we are going to Barcelona." Rowell 1986, p. 23, suggests Miró remained in Montroig through November 22. Because Rowell (notes to A. Umland, January 1993) believes the undated letter (Balaguer 486) dates from 1920, she did not consider it when determining the date of Miró's return to Barcelona in 1919. On the basis of Miró's references to Sala's departure and to his studio, however, this letter must date from 1919 and Miró must have returned to Barcelona on Wednesday, October 22; see Lubar 1988, p. 167 (n. 1).

98. Balaguer 474. From Barcelona, Sunday. Lubar dates this letter "January or early February 1920" (Lubar 1988, p. 315). It seems unlikely, however, that Miró would have delayed so long in presenting his proposal to his "dealers."

99. Balaguer 474. From Barcelona, Sunday. Because Lubar 1988, p. 315, dates this letter "January or early February 1920," he concludes that *Nude with Mirror* (p. 95) probably was not completed until early 1920. However, based on two sketchbooks including sketches after the model, dated November 13, 1919 (FJM 419–508), and December 12 [1919] (FJM 266–365), and at least two drawings dated December 1919 (*Male Nude*, p. 100, and FJM 510), also apparently after the model, the models must have come to an agreement before 1920. If these studies do not preclude Miró's working on *Nude with Mirror* through 1920, they do establish that he could have resumed working on it in fall 1919, completing it before 1920. (According to the Círcol Artístic de Sant Lluc's records, the models requested a wage raise on October 29, 1919; these records do not, however, mention a strike.)

100. Rowell 1986, p. 69, and undated correspondence with Ricart (see Balaguer 461, 473, 479, and 480).

101. Letter to Ricart (Balaguer 472). Sunday (possibly August 24, 1919).

102. Letter to Ricart (Balaguer 479). Since Miró had not planned to go to his studio regularly at the beginning of his stay in Barcelona (see letter to Ricart, Balaguer 486), and given the models' strike (see note 99, above), this letter possibly dates from mid-November or December 1919.

103. Rowell 1986, p. 23.

104. Postcards addressed to Passatge del Crèdit, 4, from Togores, February 4, 1920, and Espinal, February 18, 1920.

105. Letter to Ricart (Balaguer 478). Undated. See Rowell 1986, p. 23, where the date is given as 1919; cf. Lubar 1988, p. 284.

106. Lubar 1988, p. 170 (n. 12).

107. Postcard from Espinal. Addressed to Passatge del Crèdit, 4, February 18, 1920. Here Espinal tells Miró, "I was happy to learn that at the end of the month you are going to Paris."

108. Miró 1977, p. 66, and Rowell 1986, p. 23.

109. Postcard to Ràfols (Catalunya 18). From Paris, Tuesday. This card is postmarked March 2, 1920 (a Tuesday). Lubar 1988, pp. 176 (n. 29), 257, suggests the postmark reads March 20, 1920 (a Saturday), and assigns this date to Miró and Ricart's visit to Picasso. Miró told Trabal, "Dalmau introduced me to Picasso" (Trabal 1928, translated in Rowell 1986, p. 92); cf. Dupin 1962, p. 90, and Miró 1977, p. 51.

110. Lubar 1988, p. 171 (n. 15).

111. Catalunya 16. Sunday. In Rowell 1986, pp. 71–72. Rowell 1986, p. 71, dates this letter "[March 1920?]," and on p. 310 (n. 4), suggests it was written slightly before March 19, since, in closing, Miró wishes his friend a happy saint's day (Saint Joseph, March 19). The immediately preceding Sunday was March 14. Other correspondence from Paris includes a letter of May 8, 1920, to Ràfols (in Rowell 1986, pp. 72–73) and a postcard to Ràfols, May 28, 1920.

112. Letter to Dalmau. From Paris, March 27, 1920. Courtesy of the Pierre Matisse Foundation, New York. As Lubar 1988, p. 172 (n. 19), suggests, Miró expected to exhibit in Paris sometime during spring 1920. He did not, in fact, have an exhibition there until 1921.

113. Letter to Ràfols. From the Hôtel de Rouen, May 8, 1920.

114. Lubar 1988, pp. 188 (n. 64), 257. Both Dupin 1962, p. 96, and Rowell 1986, p. 23, state that Miró attended, but this has proved impossible to confirm. Miró was certainly aware of the Dadaists; see his letter to Ràfols, from Barcelona, November 18, 1920 (in Rowell 1986, p. 75).

115. Letter to Ràfols. From the Hôtel de Rouen, May 8, 1920. Confirmed by a postcard to Ràfols, from Paris, May 28, 1920. Regarding the stay in Barcelona, see letter to Ricart, from Montroig, July 18, 1920 (in Rowell 1986, p. 73).

116. Letter to Picasso. Although inscribed "'Mas Miró' Montroig 27-6-20," this letter is postmarked Barcelona, June 27, 1920, which suggests Miró may have left Barcelona for Montroig on this date. In another letter, from Montroig, July 25, 1920 (in Rowell 1986, p. 74), Miró told Ràfols he expected to be in Montroig until the middle of October.

117. Dupin 1962, pp. 98, 104, mentions four still lifes completed over the summer: *Spanish Playing Cards* (Dupin 69), *Horse, Pipe, and Red Flower* (p. 102), *Still Life with Rabbit* (p. 103), and a canvas titled *The Grapes* (not in Dupin). It is clear from subsequent correspondence, however, that *Still Life with Rabbit* was not completed until January 1921, in Barcelona.

118. Letter to Picasso. Inscribed "'Mas Miró' Montroig 27-6-20." Postmarked Barcelona, June 27, 1920. See note 116, above.

119. Regarding the works Miró submitted, see Lubar 1988, pp. 201–03, including notes.

120. Serra 1986, pp. 234–35.

121. The 1.40 × 1.12 meter canvas may have been abandoned, repainted, or lost; there is no known work dated 1920 with these dimensions, although they correspond closely to those of *The Farm* (p. 107), begun in 1921. Subsequent letters make clear that Miró worked on *Still Life with Rabbit* (p. 103) through January 1921, and his July 31, 1921, letter to Ràfols establishes that it was *Still Life with Rabbit* that he had finished before going to Paris. For further discussion of the dating of this work, see Lubar 1988, p. 316.

122. Letter to Ricart. August 22, 1920. See Rowell 1986, p. 23.

123. Paris 1920, and see the entries for *Self-Portrait* and *The Village of Montroig* in the Catalogue section of the present volume (cats. 14, 16). Cf. Lubar 1988, pp. 201–03 (including notes), 258, and Dupin 1962, p. 495, who suggests this exhibition took place in 1923.

124. Letter to Ràfols. From Montroig, July 25, 1920. Rowell 1986, p. 23, suggests Miró left Montroig on October 22, on the basis of an undated letter to Ricart (Balaguer 486), which she believes dates from 1920 rather than 1919; see note 97, above.

125. Letters to Ràfols. From Barcelona and Montroig, respectively January 28 and August 15, 1921. Cf. Lubar 1988, p. 204 (n. 2).

126. Barcelona 1920 and the Catalogue section of the present volume (cat. 18). See Lubar 1988, p. 194 (and n. 81). Elsewhere, Lubar suggests that *Still Life with Rabbit* was also shown (Lubar 1988, p. 258), but this must be a typographical error, since he clearly establishes that the painting was not completed at this time.

127. In a letter to Miró of June 12, 1934, Raynal mentioned it would be good to see Miró and to talk about their old memories of Paris *and* Barcelona. By November 12, 1920, Miró was interested in Raynal as on that date (as well as in another undated letter, Balaguer 488), he asked Ricart to get him Raynal's book on Lipchitz.

128. From Passatge del Crèdit, 4. In Rowell 1986, p. 75. Probably *Still Life with Rabbit*, despite discrepancy in dimensions; see Rowell 1986, p. 311 (n. 14), and note 121, above.

129. Date based on postmark.

130. A letter to Ràfols, from Montroig, July 31, 1921, makes clear that Ràfols saw *Still Life with Rabbit* in late January or early February 1921.

131. Letter to Ràfols. From Barcelona, January 28, 1921.

132. Postcard to Ràfols from Miró and Espinal. From Montauban, February 11, 1921.

133. (Rowell 1986, p. 24; to Paris in late March 1921.) As Lubar points out, Ricart sent a postcard to Ràfols from Paris on March 10, 1921, and mentioned he had lunched with Miró and Dalmau. And Miró himself told Ràfols (see the January 28, 1921, letter, above) that he planned to leave for Paris between February 8 and 10. Consequently, it is likely that Miró visited the Musée Ingres en route to Paris and arrived there soon after February 11, 1921. See Lubar 1988, pp. 204–05 (and n. 5).

134. Note to Picasso. From 32, boulevard Pasteur, undated. Miró mentions he arrived the day before.

135. Note from Picasso. Postmarked February 21, 1921. In Miró's letter [February 25, 1921] to Dalmau, he mentions Picasso had visited a few days ago. See also Trabal 1928 (in Rowell 1986, p. 92).

136. Reproduced in Colegio de Arquitectos 1969, n.p. Friday. This letter can be dated Friday, February 25, 1921, based on Miró's reference to Paul Rosenberg's forthcoming visit. See the letter from Rosenberg to Miró, [Thursday], February 24, 1921, arranging for a visit on Saturday, February 26, 1921. Rowell 1986, p. 24, notes that Miró received visits from Paul Rosenberg *and* Daniel-Henry Kahnweiler in 1921.

137. Letter from Rosenberg. Addressed to 32, boulevard Pasteur, February 24, 1921. Based on Miró's unreliable text "Je rêve d'un grand atelier" (Miró 1938, in Rowell 1986, p. 161), Rosenberg seems to have visited Miró at the Hôtel Innova, and Miró told Raillard (Miró 1977, p. 67) that Rosenberg saw *The Table* (i.e., *Still Life with Rabbit*, p. 103).

138. In "Je rêve d'un grand atelier" (Miró 1938, in Rowell 1986, p. 161), Miró recalled he began working at 45, rue Blomet soon after Rosenberg's visit; in other words, probably in early March. The earliest known letter that mentions the studio at 45, rue Blomet is to Ràfols, dated March 26, 1921, and it confirms Miró's 1938 account. Miró's letter to Junoy of May 3, 1921, gives his address as "45, rue Blomet | (chez Mr. Gargallo) | Paris (XVme)." On Miró's arrangement with Gargallo, see Dupin 1962, p. 98; Miró 1977, p. 67; Rowell 1986, p. 24; Lubar 1988, p. 285; and Jeffett 1989b, p. 120. Pau Gargallo is also known as "Pablo." He was raised, lived, and worked in Barcelona, however, and in Catalan his name is "Pau."

Miró's living arrangements during this period are difficult to pinpoint: in February he seems to have been at the Hôtel In-

nova, 32, boulevard Pasteur. He was still at this address on March 26, 1921 (the date of a letter to Ràfols), and may have remained there through April (postcard to Ricart, postmarked April 9, 1921, sent from 32, boulevard Pasteur) and possibly even May. By June 7, 1921, he had moved to the Hôtel Namur, 39, rue Delambre (letter to Dalmau of this date). By June 12 or 13, 1921, Miró left Paris (see below).

139. Mentioned in a letter to Ràfols, from 32, boulevard Pasteur, March 26, 1921. Both Dupin 1962, p. 130, and Doepel 1967, pp. 25–26, suggest that *Portrait of a Spanish Dancer* is based on a color print.

140. Postcard from Ricart to Ràfols. From Paris, March 10, 1921. Cited in Lubar 1988, pp. 204–05.

141. Letter to Joaquim Sunyer. From Paris, March 20, 1921. Cited in Lubar 1988, p. 205 (n. 7).

142. Rowell 1986, p. 24; Hirschfeld/Lubar 1987, p. 250; and Dupin 1962, p. 96, without date. Lubar 1988, pp. 205–06, also mentions that Miró met Pierre Reverdy in 1921. See Combalía 1990, pp. 65–66 (n. 62), 70 (n. 69), for a review of various dates assigned to Miró's first meeting with Tzara.

143. Lubar 1988, p. 206 (and n. 11).

144. The date of Miró's first meeting with Masson and subsequent involvement with the rue Blomet group is open to question. According to Frances Beatty, Masson did not move into the rue Blomet studio until late in 1921; see Beatty 1981, p. 64. Miró 1938 (in Rowell 1986, p. 161) recalled that Masson was there when he began working at 45, rue Blomet. Masson remembered meeting Miró in 1922 or early 1923, while elsewhere recalling they met at the Café Savoyarde around 1921–22; see Will-Levaillant 1976, pp. 104–05 (n. 47), 86–88. Cf. Dupin 1962, p. 98.

Assuming Masson was in residence on the rue Blomet by spring 1921, it is plausible that the two artists met in spring 1921. This is the time period assigned by both Rowell 1986, p. 24, and Lubar 1988, pp. 258, 286. The two artists did not become intimate friends until the following year (1922), when both resided at 45, rue Blomet. See Lubar 1988, pp. 285–87.

145. Typewritten and unsigned, although it must have been written by Dalmau. Courtesy Pierre Matisse Foundation, New York.

146. Years later, Miró told Raillard that Picasso had not purchased his *Self-Portrait* (p. 101); rather, "Dalmau . . . needed to open doors. He thought that Picasso was well positioned, and offered Picasso this painting in order to please him." See Miró 1977, p. 52. By the time of Miró's first Paris exhibition at La Licorne (April 29–May 14, 1921) the *Self-Portrait* was exhibited as belonging to Picasso. Lubar 1988, p. 258, suggests Picasso acquired this work late in 1920; cf. Dupin 1962, pp. 87, 91.

147. Paris 1921.

148. Letter to Dalmau. From the Hôtel Namur, 39, rue Delambre, June 7, 1921. Courtesy of the Pierre Matisse Foundation, New York. Mentions, "I will leave here next Monday *the 13*." In a letter to Docteur Girardin, from the Hôtel Namur, 39, rue Delambre, Thursday (possibly June 9, 1921), Miró suggests he will leave for Spain on June 12. Sunday (June 12) is also the date given in a letter to Picasso, from this same address, postmarked June 8, 1921. (Rowell 1986, p. 24; leaves Paris May–June 1921.)

149. Postcard from Ricart. Addressed to Montroig, June 28, 1921.

150. Although Rowell 1986, p. 24, notes that Miró stayed in Montroig only through October–November, and Lubar 1988, p. 258, has him returning to Barcelona in November, Miró said, in a letter to Ràfols, from Montroig, October 2, 1921, "My family will leave soon. I will stay here on my own until I finish what I am doing, and then go right away to Paris." Miró was in Barcelona on December 25, 1921 (see postcard to Ràfols, sent from Barcelona), but there is no evidence that he returned much before the Christmas holidays. Regarding *The Farm*, see Miró 1977, p. 57.

151. One of the landscapes Miró mentions is certainly *The Farm*. The other has not been identified. As Lubar suggests, it is possible that Miró discarded the second landscape, or temporarily abandoned it. See Lubar 1988, pp. 224 (n. 2), 318.

152. Rowell 1986, p. 76; cf. p. 24, where Rowell notes that Miró continued to live at a hotel and work in the rue Blomet studio in early April–late June 1922. See Lubar 1988, p. 285 (and n. 10).

153. Postcard to Ràfols. On December 30, 1921, he sends Picasso a postcard, from Passatge del Crèdit, 4.

154. Miró's whereabouts between December 30, 1921, and March 17, 1922, are unknown. Since he mentioned having worked on *The Farm* in Barcelona (Miró 1977, p. 57), it is likely that he was in Barcelona from January through March, before returning to Paris.

155. Inscribed "Barcelona, 17-3-21." Despite the date Miró inscribed on this postcard, it is postmarked March 17, 1922. Furthermore, Ràfols did not go to Italy until 1922, which confirms that Miró most probably wrote this card on March 17, 1922.

156. Lubar 1988, pp. 259, 318, places Miró in Paris by "early March," but a postcard to Ràfols, mailed from Barcelona, is postmarked March 17, 1922 (see note 155, above), and it seems unlikely Miró would have left for Paris early in the month, only to return by the 17th.

157. See note 152, above, and related text regarding Miró's residence at the rue Blomet studio during his *third* stay in Paris, in 1922.

158. Lubar 1988, p. 259. See letter to Roland Tual, July 31, 1922 (in Rowell 1986, pp. 79–80). Although Rowell (1986, p. 24) suggests that "Georges Limbour,

Antonin Artaud, Armand Salacrou, Michel Leiris, Roland Tual are almost daily visitors" to the rue Blomet at this time, Leiris did not meet Masson until October 1922 (see below), and it is uncertain when Limbour, Artaud, and Salacrou began to frequent the rue Blomet. Dupin (1962, pp. 494–95) also suggests that it was in 1922 that the rue Blomet group, including Tual, Leiris, Limbour, Artaud, and Salacrou, began to form—as does Miró himself (see Chevalier 1962, in Rowell 1986, p. 265), along with many Miró biographers. In all probability, however, most of these friendships date to 1923 or 1924.

159. Letter to Ràfols. From Barcelona, June 30, 1922. In Rowell 1986, p. 76.

160. Lubar 1988, p. 225 (and n. 5), suggests Miró worked on *The Farm* in Montroig and Barcelona from early July 1921 through February 1922, and that he completed the picture in Paris during the month of March. It seems, however, that Miró did not arrive in Paris until late March or early April and that the month he spent working on *The Farm* in Paris was that of *April*. He must have finished *The Farm* sometime in May, since he later told Léonce Rosenberg, in a letter from Montroig of October 16, 1922, that a photograph of the painting had been taken by "M. Lemarc [or Lemare] (45, rue Jacob 6ème)" around the month of *May*, presumably upon its completion.

161. See letter to Ràfols, from Barcelona, June 30, 1922 (in Rowell 1986, pp. 76–77); Trabal 1928 (in Rowell 1986, p. 94); and Miró 1977, p. 53.

162. Letter from Rosenberg. May 26, 1922.

163. Receipt of June 1, 1922. In Léonce Rosenberg's handwriting, the document states: "Please return to the bearer the painting 'The Pleasures of the Countryside.'" Although *The Farm* is inscribed on the verso "La Ferme," it seems highly probable, given the date of the receipt and Miró's subsequent letter to Ràfols, June 30, 1922 (in Rowell 1986, p. 77), that "The Pleasures of the Countryside" refers to *The Farm*. Miró would later provide more dramatic accounts of this transaction; see, for instance, Trabal 1928 (in Rowell 1986, p. 94) and Miró 1977, p. 53. *The Farm* stayed with Rosenberg at least through April 1923, and probably through early 1924 (a letter from Rosenberg to Miró, January 17, 1924, mentions that Rosenberg has several paintings of Miró's *en dépôt*).

164. Letter to Ràfols. From Barcelona, June 30, 1922. On June 16, 1922, from 45, rue Blomet, Miró sent Picasso a letter, postmarked June 18, 1922, which places him in Paris through at least mid-June. See Rowell 1986, p. 24, and Lubar 1988, p. 259. Regarding the visit to Picasso's mother, see Miró's letter to Picasso, from Montroig, July 23, 1922.

165. Rowell 1986, p. 77.

166. Letters to Ràfols. From Barcelona, June 30, 1922, and October 1, 1922. See

Rowell 1986, p. 24.

167. Letter to Rosenberg, from Montroig, July 10, 1922; and Dupin 1962, p. 131.

168. Masson exhibition files, The Museum of Modern Art, New York. In Rowell 1986, p. 79.

169. Despite the fact that Miró later told Trabal (see Trabal 1928, translated in Rowell 1986, p. 93), "No matter where you see my name, it's always 'Joan' and that's more than you can say of other painters from Barcelona who have gone abroad," he instructed Rosenberg to list him as "Jean Miró Ferra." The address he gave was 45, rue Blomet, and the price to be asked for *The Farm* was 4,000 francs. Miró also instructed Rosenberg to bill him for all costs involved.

170. Postcard from Rosenberg. Addressed to Montroig; forwarded to Passatge del Crèdit, 4, October 6, 1922.

171. Letter from Michel Leiris to C. Lanchner. April 23, 1975. Masson exhibition file, The Museum of Modern Art, New York. Françoise Levaillant, in conversation with C. Lanchner, February 1993, confirms that Masson met Leiris in October 1922, and notes that according to Jamin 1992, p. 27, Leiris met Masson at dinner. See also Rowell 1986, p. 85. If Leiris did not meet Masson until October 1922, he probably did not meet Miró until the latter's return to Paris in 1923, and in all probability, the same holds true for Miró's first encounter with Limbour and Desnos. See note 183, below.

172. Letter to Ràfols. From Passatge del Crèdit, 4, October 1, 1922.

173. Letter from Rosenberg. Addressed to Montroig, forwarded to Passatge del Crèdit, 4. October 10, 1922.

174. Wedding Certificate. October 12, 1922.

175. Letter to Ràfols. From Passatge del Crèdit, 4, October 1, 1922.

176. Paris 1922, and see the entry for *The Farm* in the Catalogue section of the present volume (cat. 22).

177. Beaumelle 1991, p. 110. Although Miró's friend M. A. Cassanyes attended Breton's lecture and reviewed both the lecture and the Picabia exhibition in *La Publicitat* (see Borràs 1985, p. 246, n. 20), it does not appear likely, based on Cassanyes's letters to Miró dating from 1923, 1924, and 1925, that Miró attended either the lecture or the exhibition.

178. Letter to Ràfols. From Passatge del Crèdit, 4, October 1, 1922.

179. Letter to Ràfols. From 45, rue Blomet, Sunday, postmarked March 4, 1923.

180. Ibid.

181. Ibid. Rowell 1986, p. 24, states that Miró arrived in Paris in January (as he had, indeed, planned to do before his mother fell ill). In subsequent correspondence, Miró continued to give 45, rue Blomet as his return address (April 2, 1923, to Ràfols; April 7, 1923, to Léonce Rosenberg; April 7, 1923, to Tristan

Tzara; June 20, 1923, to Léonce Rosenberg).

182. Letter to Picasso. From the Hôtel de la Haute-Loire, postmarked March 9, 1923, although Miró dates this letter March 9, 1922. By April 7, 1923 (postcard to Picasso, postmarked with this date), Miró had taken up residence at 10, rue Berthollet, although he must have continued to use the rue Blomet studio, as on this same day he wrote to Tzara, giving his return address as 45, rue Blomet.

Presumably, the Hôtel de la Haute-Loire (203, boulevard Raspail) and 10, rue Berthollet, are the residences referred to in Miró's often unreliable text "Je rêve d'un grand atelier" (Miró 1938, in Rowell 1986, p. 161). Here Miró recalled: "The next year, I couldn't have Gargallo's studio again. At first, I stayed at a small hotel on the boulevard Raspail, where I finished *The Farmer's Wife*, *Ear of Grain*, and other pictures. I left the hotel for a furnished room on the rue Berthollet. *The Carbide Lamp*."

The year referred to is presumably 1923, based on Miró's reference to *Interior (The Farmer's Wife)*, *Still Life I (The Ear of Grain)*, and *Still Life II (The Carbide Lamp)*. But contrary to Miró's recollection, it seems he *did* work at 45, rue Blomet (Gargallo's studio) in 1923, through at least April 7, and possibly through June (see note 181, above). To further complicate matters, in 1976 Miró told Jan Krugier (letter to L. Tone) that he had "reworked [*Still Life III (Grill and Carbide Lamp)*] a number of times during this period, in either 1922 or 1923. This canvas was painted in a hotel on the rue de l'Ombre [probably rue Delambre]." Miró is not known to have stayed on the rue Delambre in 1923.

183. The chronology of friendships formed by Miró at the rue Blomet needs further investigation; see notes 158 and 171, above. Because Masson did not meet Leiris until *October* 1922 (see above), at which point Miró was in Spain, it is likely that Miró's friendship with Leiris, and most probably with other habitués of the rue Blomet, dates from his return to Paris in 1923 at the earliest.

184. Paris 1923a, and see the entry for *The Farm* in the Catalogue section of the present volume (cat. 22). In 1922, A. Schneeberger had published an article in *La Nervie* discussing three Catalan painters, Joaquim Sunyer, Joaquim Biosca, and Miró (see Schneeberger 1922).

185. According to Dupin 1962, p. 131, at some unspecified date, "Artigas had taken his studio in the Rue Blomet, Miró stayed in a hotel on the Boulevard Raspail, then in a furnished room in the Rue Berthollet, and finally in the flat of the painter Dubuffet (who had gone to Argentina) in the Rue Gay-Lussac." It is possible that Dupin's account applies to 1923.

186. Cf. postcard from L. Garriga. Ad-

dressed to Montroig, July 20, 1923.

187. Paris 1923b, and see the entry for *The Farm* in the Catalogue section of the present volume (cat. 22). Mentioned in a letter to Picasso, from 10, rue Berthollet, May 15, 1923.

188. Handwritten receipt from Miró to Léonce Rosenberg. Two addresses given: 45, rue Blomet, and Montroig. Paris, June 20, 1923. For identification of works consigned, see essay note 46.

189. Postcard addressed to the Kahnweilers. Date based on postmark. Reproduced in Levaillant 1990, p. 36.

190. (Rowell 1986, p. 24; in Montroig in July–October.) In a letter of September 26, 1923, from Montroig, Miró told Ràfols, "I will actually be here until around Christmas."

191. Dupin 1962, p. 139.

192. According to Krauss/Rowell 1972, p. 71, *The Tilled Field*, *The Hunter*, and *Pastorale* were completed in Paris in 1924. There is, however, no evidence that Miró brought these paintings with him to Paris in 1924, and it is more likely that they were completed in Montroig and remained in Spain until Miró's return to Paris in early 1925. See essay note 108.

193. Rowell 1986, p. 82.

194. Cf. Lubar 1988, p. 285 (n. 10).

195. Rowell 1986, p. 83. Reference to *The Hunter* (p. 113) is inserted into the text and appears to have been added at the same time as a postscript in which Miró asks after Gasch.

196. Letter to Ràfols. From Montroig, September 26, 1923.

197. See the letter from Cassanyes to Miró, January 29, 1924, in which Cassanyes responds to Miró's January 1, 1924, letter, sent from Barcelona. In the absence of Miró's letter, it is difficult to know whether Miró planned to stay in Barcelona or return to Montroig, although it seems Cassanyes expected him to be in Spain until some time after January 29, 1924, as he mentioned the possibility of seeing Miró's works. Miró's letter to Picasso, December 31, 1923, however, suggests he planned to return to Paris in mid-January.

198. From this letter, it appears Miró intended to bring his new works (*The Tilled Field*, *The Hunter*, and *Pastorale*) to Paris on his next trip. From a list in one of Miró's notebooks (FJM 613b), however, it seems unlikely that he brought these paintings to Paris before 1925. See essay note 108.

Although the "few works" Rosenberg refers to presumably include the six still lifes Miró had consigned to him on June 20, 1923, it is unclear whether he still possessed *The Farm* at this time. The next known correspondence from Miró to Rosenberg dates from June 11, 1925. It therefore seems likely that, at some point after this letter of January 17, 1924, Miró discontinued his relationship with Rosenberg.

199. Beaumelle 1991, p. 170. Doepel

1967, p. 50, states that Miró met André Breton, Paul Eluard, and Louis Aragon at the opening of Masson's exhibition at the Galerie Simon. In light of new research published in Beaumelle 1991, this appears highly unlikely; according to this source, Breton did not meet Masson until the end of September 1924 (see p. 171) and still had not met Miró by February 10, 1925 (see p. 175). See essay note 110.

200. Although the date of Miró's return to Paris is uncertain, based on his letter to Ràfols, September 26, 1923, it seems certain he was both living and working at the rue Blomet in 1924. See Rowell 1986, p. 24.

201. Rowell 1986, p. 9. Although Rowell suggests that the writers and poets began to congregate at rue Blomet in 1922, it was undoubtedly late in the year, at a time when Miró was in Spain. In 1923, Miró's time at the rue Blomet may have been limited, and it seems more likely that his intense participation in the "heroic" period of the rue Blomet referred to by Rowell was actually in 1924. By August 10, 1924, he would tell Michel Leiris: "I am working furiously; you and all my other writer friends have given me much help and improved my understanding of many things." In Rowell 1986, p. 86. For a discussion of the impact of poetry on Miró's work of 1924–27, see Rowell 1972, pp. 45 ff.

202. Dupin 1962, p. 137, and Krauss 1972, p. 21, suggest that Masson showed Miró a book of Klee reproductions in 1924, although the date is far from secure. Cf. Miró 1977, p. 68; Brassaï 1982, p. 143; Temkin 1987a, p. 24; and Lanchner 1987, p. 88. It was not until October 1925 that they would see a full-scale exhibition of Klee's work at the Galerie Vavin-Raspail, Paris. See Temkin 1987a, pp. 24–25, and essay note 19.

203. See essay notes 99 and 111. Cf. Miró 1938 (in Rowell 1986, p. 161) and Miró 1977, pp. 34, 69.

204. Judging from Rosenberg's letter to Miró, January 17, 1924 (see above), he still had some of Miró's paintings, possibly including *The Farm* and the six still lifes in his possession at that date. Among the still lifes, however, *Still Life V* was reworked in 1924–25, and became *Head of Catalan Peasant, II* (Dupin 104). It is one of the gridded paintings probably begun in spring 1924, which suggests Miró retrieved all his paintings from Rosenberg at that time. By April 1, 1925, the date of Miró's first contract with Viot, he must certainly have taken his works back.

205. Letter from Cassanyes. May 7, 1924. Mentions receipt of Miró's letter of April 22, 1924.

206. This is the earliest known correspondence sent by Miró from Paris in 1924.

207. Raillard 1977, p. 23, and Rowell 1986, p. 24.

208. Note from Picasso. Addressed to 45, rue Blomet, postmarked June 14,

1924. Regarding the impact of *Mercure* on Miró, see Krauss 1972, pp. 21, 29, 31, 32 (fig. 12), and Miró's letter to Picasso, from Montroig, November 15, 1924.

209. In his letter to Picasso, from Montroig, November 15, 1924, Miró implies he left Paris not long after attending *Mercure*. By July 13, 1924, he sent Picasso a postcard from Montroig. Rowell 1986, p. 24, suggests that Miró was in Montroig by July and remained there only through October, returning afterward to Paris. It seems evident, however, from Miró's letters to Leiris, from Montroig, October 31, 1924, in Rowell 1986, p. 87, and to Picasso, from Montroig, November 15, 1924, that he remained in Montroig through sometime in mid-December.

210. Rowell 1986, p. 86.

211. Beaumelle 1991, p. 171. Since Breton did not visit Masson on the rue Blomet until September 1924 and Miró did not return to Paris until 1925, the date of his first encounter with Breton must have been in 1925 (see below, following February 10, 1925, and essay note 110).

212. Rowell 1986, p. 87.

213. Letter from Cassanyes. Addressed to Passatge del Crèdit, 4, December 20, 1924. For works Miró brought from Montroig, see FJM 613b (in notebook FJM 591–668 i 3129–3130).

214. See Cassanyes's letters to Miró of December 20 and 24, 1924.

215. Based on correspondence from Cassanyes; letter to Picasso, November 15, 1924; and on the patterns of past years.

216. Beaumelle 1991, p. 178. It is unclear when Arp first met Miró. Both artists exhibited in the first Surrealist exhibition (November 14–25, 1925), at the Galerie Pierre.

217. (Rowell 1986, p. 24, Paris in March–late June.) Miró's letter to Picasso, from Passatge del Crèdit, 4, December 31, 1924, suggests he planned to return around the "12th," probably of January, and a letter from André Breton to Simone Breton, February 10, 1925, establishes that Miró had returned to the rue Blomet before that date; see Beaumelle 1991, p. 175. A letter to Miró from his parents, July 5, 1925, suggests he remained in Paris through early July. Few letters from Miró seem to have survived from this period, but those that have were all sent from 45, rue Blomet, Paris.

218. Letter from André Breton to Simone Breton, February 10, 1925; in Beaumelle 1991, p. 175. See essay note 109 and related text.

219. In one of Miró's notebooks in the collection of the Fundació Joan Miró, Barcelona (notebook FJM 591–668 i 3129–3130), is a list of approximately sixty works, which can most probably be identified as those Miró planned to bring to Paris in 1925. The list includes titles of paintings and canvas sizes, although the drawings are not individually identified. This page from the notebook (FJM 613b)

is reproduced in Fundació Joan Miró 1988, p. 87, no. 259.

220. In "Memories of the Rue Blomet" (1977), in Rowell 1986, p. 103. Cf. Picon 1976, vol. 1, p. 72.

221. Dupin 1962, pp. 147–48, notes that *Carnival of Harlequin* "was executed in the Rue Blomet during the winter of 1924–25 at the same time as three smaller paintings closely related to it in spirit and manner"; that is, *Landscape* (Dupin 103), *Head of Catalan Peasant, II* (Dupin 104), and *Dialogue of the Insects* (Dupin 102). According to C. Lanchner, *Carnival of Harlequin* and *Head of Catalan Peasant, II* were probably begun in Paris during spring 1924; *Landscape* and *Dialogue of the Insects* were brought back from Spain; see essay note 111 and related text.

222. Beaumelle 1991, p. 175, and Chapon 1984, p. 301. Doucet owned Miró's *Landscape* of 1924–25 (Dupin 103) and another painting known as *Joie* (not in Dupin; collection Washington University Gallery of Art, Saint Louis). *Landscape* appears in a photograph taken of Doucet's apartment in Neuilly, reproduced in *L'Illustration* (May 3, 1930); see Joubin 1930, p. 18. Cf. Miró, "Memories of the Rue Blomet," 1977 (in Rowell 1986, p. 103).

223. Aragon 1969, p. 1, dates this visit to 1924.

224. André Breton, letter to Simone Breton. February 10, 1925. See Beaumelle 1991, p. 175. Cf. Trabal 1928 (in Rowell 1986, p. 95) and "Memories of the Rue Blomet," 1977 (in Rowell 1986, p. 102).

225. According to Beaumelle 1991, p. 175, Breton's letter to Simone, February 10, 1925, indicated that he was very impatient to see Miró's work, and he undoubtedly paid Miró a call soon thereafter. Based on this source, it would have been the first time Breton met Miró.

Miró is almost invariably said to have met André Breton, Louis Aragon, and Paul Eluard in 1924, as previous Miró biographers lacked the documentation published in Beaumelle 1991 (see essay note 110) and relied on Miró's and Breton's own (inaccurate) recollections. See, for instance, Dupin 1962, p. 495; Rowell 1986, p. 24; Hirschfeld/Lubar 1987, p. 250; Fundació Joan Miró 1988, p. 468; Jeffett 1989b, p. 121; and Combalía 1990, p. 70, although Combalía 1990, p. 70 (n. 70), does suggest that the date of Miró's meeting with Breton is doubtful.

226. In the catalogue of the exhibition (Paris 1925a), both "Le Chasseur" (*The Hunter*) and "Le Gentleman" were listed as belonging to "M. André Breton." Gee 1981, p. 93, suggests that Breton purchased *The Hunter (Catalan Landscape)* in 1924, which seems unlikely, given that the painting was still in Spain and Breton had not met Miró.

227. Miró to Trabal; see Trabal 1928 (in Rowell 1986, p. 95). Although Miró is often a less than reliable source, it is clear

that Shipman was involved in his affairs; he was listed as the owner of *The Farm* in the catalogue of Miró's exhibition at the Galerie Pierre in June 1925. See Meyers 1985, pp. 150–51, 592 (n. 53), for an account of Shipman.

228. Miró to Trabal; see Trabal 1928 (in Rowell 1986, p. 94). Meyers 1985, p. 165, suggests that Hemingway probably met Miró through Gertrude Stein sometime in the early 1920s. Dupin 1962, p. 495, dates Miró's friendship with Hemingway to 1923, as do Hirschfeld/Lubar 1987, p. 250. There are two notes to Miró from Pound, July 31, 1926, and May 16, 1927; the latter suggests Pound may have visited Miró at 45, rue Blomet at some earlier date.

229. Letter to Gasch. From Montroig, September 28, 1925. Cf. Trabal 1928 (in Rowell 1986, p. 95) and Miró 1977, p. 162. Miró suggests that Viot severed his ties with the Galerie Pierre, where he had previously worked, upon signing this contract. He must, nonetheless, have retained some sort of relationship with the gallery, since Miró's June 1925 exhibition was held there.

230. Paris 1925a. For descriptions of the opening, see *Action* 1925 (reprinted in Miró 1977, pp. 196–97, with slight variations in spelling); and Viot 1936 (in Dupin 1962, p. 154).

231. See, for example, Pinturrichio 1925 and Fels 1925b (cf. Fels 1921). Regarding commentary in the Catalan press on the exhibition, see Combalía 1990, p. 73.

232. Undated *carte-de-visite* from Raymond Roussel to Michel Leiris, in the Bibliothèque Littéraire Jacques Doucet, Paris. Cf. Miró 1977, p. 23.

233. Letter from Masson to Leiris. [June 1925]. Published in Levaillant 1990, p. 80.

234. Date for this event based on Beaumelle 1991, p. 177. Rowell 1986, p. 25, notes Miró attended, but does not provide a date; Jeffett 1989b, p. 121, suggests the banquet was held in May; see also Roditi 1958, p. 43, and Miró 1977, p. 117. For a general description of this event, see Nadeau 1989, pp. 112–15.

235. Letter to Miró from his parents. Addressed to Paris, July 5, 1925.

236. Letter to Gasch. From Montroig, October 10, 1925.

237. Dupin 1962, p. 157, used the term "dream painting" to describe Miró's work of 1925–27 (not including the "summer" landscapes of 1926–27). Dupin, however, states that all of these works were produced in Paris, when in fact many were executed in Montroig. See essay note 138.

238. *Révolution surréaliste* 1925a, pp. 4, 15.

239. Miró refers no doubt to Picasso's 1925 painting *The Dance*, which Breton had reproduced in the same issue of *La Révolution surréaliste* (July 15, 1925) as *Les Demoiselles d'Avignon* (and Miró's paintings *Maternity* and *The Hunter*). On *The Dance*, see Silver 1989, p. 397. It is

unclear whether or not Picasso attended Miró's opening at the Galerie Pierre on June 12, 1925.

240. See essay notes 137 and 138 and related text.

241. Letter to Gasch. From Montroig, October 10, 1925.

242. Letters to Gasch. From Montroig, September 28 and October 10, 1925. Although he told Gasch in his letter of the 28th he planned to return to Barcelona from Montroig toward the end of the month [of October] and to leave fifteen days after that for Paris, he may have remained in Montroig through mid-November. See also essay note 137 and related text.

243. Rowell 1986, p. 25, and Miró 1977, p. 68.

244. Meyers 1985, pp. 165–67. Hadley Hemingway was born on November 9, 1891. The story of Hemingway's purchase of *The Farm* has been so often told that fundamental (albeit less colorful) details of chronology have been lost. Most accounts suggest that the painting passed directly from Miró to Hemingway, omitting the period of time it must have spent with Evan Shipman (from at least June 1925 through October 1925), and imply that the transaction took place at a much earlier date. In addition, few seem to mention that, from sometime after August 1926 through late 1934, *The Farm* was not even in Hemingway's possession. Rather, it was kept by his wife Hadley after the two separated in August 1926 and Hemingway brought it to her new apartment at 35, rue Fleurus sometime in late October–November 1926. Ironically, when Hemingway published his paean to *The Farm* (in *Cahiers d'art* 1934), the painting had been with Hadley for a number of years.

245. Beaumelle 1991, p. 178.

246. Paris 1925b, and see the entry for *Carnival of Harlequin* in the Catalogue section of the present volume (cat. 40). See also Trabal 1928 (in Rowell 1986, p. 96).

247. Gasch 1925, p. 5. In Spanish translation in Combalía 1990, pp. 158–59.

248. Letter to Ràfols. From 45, rue Blomet, November 15, 1925. Cf. Rowell 1986, p. 25.

249. There is no documentation that establishes whether Miró returned to Montroig in late December 1925 or early January 1926.

250. It is not clear whether Miró returned to Montroig in late December 1925 or soon after New Year's Day. He sent a card to Gasch, from Montroig, on January 8, 1926. His parents' letter to him of January 10, 1926, suggests Miró planned to return to Barcelona in middle to late January.

251. Levaillant 1990, p. 111.

252. The whereabouts of Miró's letter are unknown, but Miró's father wrote back to him on January 10, 1926: "We have received your letter of the 7th. . . . Accord-

ing to what you told us, you will finish your work this week."

253. The date of Miró's move to 22, rue Tourlaque is commonly given as 1927; see Dupin 1962, pp. 189, 495; Rubin 1973, p. 122 (n. 6); Rowell 1986, p. 25; Hirschfeld/Lubar 1987, p. 250; and Jeffett 1989b, p. 121. Rowell 1986, p. 25, proposes that Miró was still at 45, rue Blomet in 1926.

Doepel 1967, pp. 52–53, suggests, however, that the move took place at the end of 1925 or in early 1926. The former date is unlikely (during Miró's brief stay in Paris in late 1925 he was at 45, rue Blomet, and in early 1926 Miró was still in Spain); but by April 1, 1926, Robert Desnos had moved into Masson's former studio at 45, rue Blomet, and the sculptor André de la Rivière had taken possession of Miró's studio. See Levaillant 1990, p. 113 (n. 1); Jeffett 1989b, p. 121; and Desnos 1934, p. 25.

On *May 8, 1926*, Miró inscribed his address as "22 rue Tourlaque" in the Galerie Jeanne Bucher's guestbook, on the occasion of an exhibition of Max Ernst's work. Because the date of Miró's return to Paris in spring 1926 (if indeed he returned to Paris at all prior to May) is unknown, the exact date of his move to the rue Tourlaque cannot now be ascertained. What is certain is that the move took place in *1926* and not in 1927.

254. Rowell 1986, p. 25, and Gaffé 1963, p. 108. According to Rowell, Gaffé was a close friend of André Breton and Paul Eluard who, beginning in the 1920s, assembled one of the earliest and greatest collections of Surrealist painting; see Rowell 1986, p. 112.

Gaffé recalled in 1963 that he had bought *The Birth of the World* (p. 133) "as soon as it was finished," mentioning his admiration for the pictures hanging on Miró's studio walls at 22, rue Tourlaque. William Rubin, however, has said Miró told him that the painting was in his studio for "at least a year" after he finished it and, relying on previous chronologies which place Miró's move to the rue Tourlaque in 1927, suggests that Gaffé may actually have purchased the painting in 1927; see Rubin 1973, p. 116 (n. 2).

255. Picasso is generally credited with having recommended Miró and Ernst to Diaghilev. See Russell 1967, p. 87, and Hansen 1985, p. 98. According to Russell, the date of the commission fell sometime around Ernst's exhibition (March 10–24, 1926) at the Galerie Van Leer. Serge Lifar, who danced the role of Romeo, provides a description of his encounter with Ernst and Miró (see Lifar 1940, p. 309). Kochno's memoirs (see Kochno 1970, 236) mention only Diaghilev's visit to Miró and Ernst, and not his own. There are two paintings by Miró in the Serge Lifar Collection at the Wadsworth Atheneum, Hartford, believed to relate to the Ballets Russes *Romeo and Juliet* (see Dupin 152, *Romeo and Juliet: Decorative Project*, and Dupin 153, *Romeo and Juliet:

Project for a Stage Curtain*). Confusingly, however, both of these paintings are signed and dated 1925, and Dupin 153 is inscribed on the verso in the artist's hand "Joan Miró | 'Amour' | 1925"; how they became associated with the *Romeo and Juliet* project has thus far been impossible to determine.

The foregoing does suggest that Ernst and Miró lived in close proximity when they received the commission to work on *Romeo and Juliet*; this in turn suggests Miró's presence at 22, rue Tourlaque by March 1926.

256. See note 253, above.

257. Postcard to Picasso. From Monte Carlo, April 20, 1926. As noted in Hansen 1985, p. 99, there is much confusion about exactly which elements in *Romeo and Juliet* Miró and Ernst were, respectively, responsible for. For other references to Miró's designs, see Grigoriev 1953, pp. 219–20; Dupin 1962, pp. 189, 249; and Krauss/Rowell 1972, p. 106. See *Daily Mail* 1926 for a firsthand description of the artists' work.

258. Rowell 1986, p. 25.

259. Kochno 1970, pp. 234, 236. See also Grigoriev 1953, pp. 219–20, 270. It is not known if Miró and Ernst attended opening night in Monte Carlo.

260. See note 253, above. On the question of Miró's neighbors, see his unreliable text "Je rêve d'un grand atelier" (Miró 1938, in Rowell 1986, pp. 161–62); Rowell 1986, pp. 25, 316 (n. 6); Dupin 1962, p. 189; and Ernst's letter to Miró, December 9, 1926.

261. Because the chronology of Miró's movements during winter and spring 1926 is relatively undocumented, it is difficult to determine exactly when he worked on the series of "dream" paintings designated *F2* in the notebooks. See essay note 139.

262. See note 253, above. According to the Galerie Jeanne Bucher guestbook, Max Ernst and Jean Cocteau visited Ernst's exhibition on the same day.

263. Laloy 1926, p. 1.

264. Lifar 1940, p. 312. Cf. Russell 1967, p. 87, who suggests that Picasso instigated the Surrealists' protest. See essay note 172 and related text.

265. Rowell 1986, p. 25, and Kochno 1970, p. 234. According to Russell 1967, p. 87, Ernst was in the Pyrenees at the time of the opening. It is not known whether Miró was present on opening night, or whether he attended subsequent performances on May 20 and 27, 1926.

266. In Lifar 1940, p. 378, Appendix B, and in Combalía 1990, pp. 162–63. Original copy in Palma I. On Miró's reaction to the Surrealists' protest, see Miró 1977, p. 26, and Brassaï 1982, pp. 143–44. For a vivid account of the demonstration on opening night, see Lifar 1940, pp. 312–13.

267. Lifar 1940, p. 313. In Palma I, there are over sixty articles, dated between May 18 and 28, 1926, which mention the Surrealists' protest; a number are pub-

lished in Spanish translation in Combalía 1990, pp. 163–71.

268. *Révolution surréaliste* 1926a, p. 31.
269. London 1926; Grigoriev 1953, p. 223; and Lifar 1940, p. 314.
270. Rowell 1986, p. 25.
271. Rowell (ibid.) suggests that Miró went to Montroig after Barcelona and spent the summer there, aside from an excursion to Girona with his mother in August. Miró may, however, have gone to Girona directly from Barcelona (he was in Girona by July 29), not arriving in Montroig until sometime in mid-August.
272. Postcard to Gasch. From Casa Fugarolas, Carrer Montsoliu, 26, S. Hilari de Sacalm (Girona), July 29, 1926. Cf. Rowell 1986, p. 25.
273. Letter to Ràfols. From Girona, August 2, 1926.
274. Loeb's reference to the "40 percent" of Miró's production which belongs to the artist is unclear, since Miró's earlier letter to Gasch (September 28, 1925) suggested Viot had contracted for "all" his works.
275. In Miró's letter to Ràfols from Girona, August 2, 1926, he remarks, "By the second half of August . . . we will be able to go to Montroig." On December 5, 1926, Miró wrote a postcard to Foix from Montroig, but a letter of December 9, 1926, from Ernst was forwarded from Montroig to Passatge del Crèdit, 4. Miró's letter to Gasch, October 7, 1926, from Montroig, suggests he had been in Barcelona prior to that date. And on October 26, 1926, Ernst sent Miró a letter addressed to Montroig that was forwarded to Passatge del Crèdit, 4.
276. Dupin 1962, p. 495, describes this series as "imaginary landscapes" and notes they were executed in Montroig. See also Trabal 1928 (in Rowell 1986, p. 96).
277. According to the Fundació Pilar i Joan Miró a Mallorca, this letter is postmarked August 27, 1928. It appears, however, that the postmark has been misread, since all the other letters received by Miró regarding the Viot affair date from 1926.
278. Letter to Gasch. From Montroig, October 7, 1926. The Paral·lel is a street in Barcelona lined with many theaters and cabarets.
279. Addressed to Montroig, forwarded to Passatge del Crèdit, 4. Date based on postmark. By this point, it seems, Ernst had managed to gain access to Miró's studio and remove both furniture and artworks.
280. New York 1926.
281. For a brief mention of *Gertrudis*, see Combalía 1990, p. 88. Rowell 1986, p. 25, dates Miró's first book illustration for *Gertrudis* to 1927, which was the year of publication, not execution.
282. Ernst's letter to Miró, December 9, 1926, was forwarded from Montroig to Passatge del Crèdit, 4, which suggests that by mid-December, Miró had left the farm.
283. By January 1, 1927, Miró was back in Paris (see postcard from Miró to Ricart,

January 1, 1927, sent from 22, rue Tourlaque); this suggests he left Barcelona sometime in late December.
284. Rowell 1986, pp. 25, 206, 318 (n. 2); based on Sweeney's recollections.
285. Ernst's letter to Miró, December 9, 1926, makes it seem highly probable that Miró moved into the studio vacated by Arp. This letter suggests that up until late 1926, Arp had worked at the rue Tourlaque and that during his time in Paris in 1926, Miró had worked in a studio which Ernst identified as "No. 7" at 22, rue Tourlaque. It also appears to confirm Miró's recollection, in his text "Je rêve d'un grand atelier," that he had not kept "a larger studio in the same villa on the ground floor" for long; Miró 1938, in Rowell 1986, p. 162. Dupin 1962, p. 189, also notes that Miró occupied two studios at 22, rue Tourlaque.

On January 1, 1927, Miró sent postcards to both Ricart and Gasch from 22, rue Tourlaque. On March 29, 1927, he wrote to Ràfols from Barcelona (see below, following March 29). By early July he was back in Montroig, which suggests he left Paris sometime in late June. See Miró's letter to Ràfols, July 21, 1927, in which he mentions he had been in Montroig for fifteen days.
286. See letter from Ernst to Miró, December 9, 1926, which mentions that Arp's studio is "across from mine [*en face du mien*]." Regarding Miró's other neighbors at rue Tourlaque, see Dupin 1962, p. 189, and Rowell 1986, pp. 12, 25. With the exception of Ernst, the questions of who lived at the rue Tourlaque during Miró's years there, and exactly when, require further research.
287. Dupin 1962, p. 189. On the dating of these paintings, see essay note 143. On the issue of secrecy concerning new works, see the letters to Gasch, from 22, rue Tourlaque, February 24 and March 7, 1927; Trabal 1928 (in Rowell 1986, p. 96); and Penrose 1969, pp. 57–60.
288. *Publicitat* 1927. Cf. Rowell 1986, p. 25.
289. Letters to Ràfols and Ricart. From Barcelona, March 29, 1927. By June 1928, this engagement appears to have been broken. The spelling of Miró's fiancée's last name remains unconfirmed.
290. Letter to Gasch. March 31, 1927.
291. On the dating of these paintings, see essay note 143. In "Je rêve d'un grand atelier" (Miró 1938, in Rowell 1986, p. 162), Miró recalled that he "had painted a whole series of blue canvases" while living at Villa des Fusains, 22, rue Tourlaque.
292. Although this letter is undated, it refers to an article Gasch had published on Miró in *La Gaceta literaria* of April 15, 1927 (Gasch 1927a). Gasch's reference to Dalí is the first found in the Miró correspondence examined so far. See Miró's letter to Gasch, from 22, rue Tourlaque, May 11, 1927, for more regarding Dalí.
293. A number of reviews appeared in the local press; the earliest is dated May

13, 1927, indicating the performance must have taken place sometime before that date. Combalía 1990, pp. 184–86, reprints some of the reviews in Spanish translation. Gasch mentioned, in a letter to Miró, May 23, 1927, that he had seen *Romeo and Juliet*, as did Prats (letter of May [31], 1927) and Cassanyes (letter of June 11, 1927).
294. The exact date of Miró's return to Spain is unknown; he may well have remained in Paris through June, as suggested in Rowell 1986, p. 25. In a letter of July 21, 1927, sent from Montroig, Miró told Ràfols, "I have been in the country for 15 days," and in a letter of August 11, 1927, sent from Montroig, to Ricart, he mentioned that due "to an excess of work during the winter I have to take a medical treatment" that obliged him to go to Barcelona frequently. To judge from letters to and from Miró, and from the pattern of the past, it seems he was probably in Barcelona from late November through the Christmas holidays. Cf. Rowell 1986, p. 25.
295. Letters to Ricart and Ràfols. From Montroig, July 21, 1927. See Trabal 1928 (in Rowell 1986, p. 96) and Rudenstine 1976, vol. 2, p. 525 (n. 1).
296. Date based on postmark. Lise Hirtz's book *Il était une petite pie* was published in 1928 with *pochoir* illustrations by Miró.
297. Miró does not seem to have corresponded with Dalí up to this point, since he asks Gasch for Dalí's address.
298. The book by Raynal which Cassanyes refers to is undoubtedly *Anthologie de la peinture en France de 1906 à nos jours* (Raynal 1927). On p. 34, Raynal wrote: "The Catalan Joan Miró, leader of the Surrealist school, would later say, 'I want to assassinate painting.' " Cassanyes's reaction suggests Raynal's statement was far from well received at this time, certainly not by Cassanyes and probably not by Miró. For a discussion of the frequent quotation of Miró's alleged statement, see Combalía 1990, pp. 84–86 (including notes); regarding its relation to Miró's 1929 collage series, see Umland 1992.
299. The visit appears to have been made by September 18, 1927; see Gasch's letter to Miró of that date. On this visit, see Combalía 1990, p. 83 (n. 84), and probably Gols 1927, p. 1 (although Loeb is not mentioned by name). On Miró's opinion of Dalí, see Miró 1977, pp. 83, 86. Figueres was formerly spelled Figueras.
300. See Eluard's letter to Miró of August 6, 1927 (above), and the letter from Breton to Miró, November 1, 192[7], acknowledging receipt of the gouaches.
301. Brussels 1927a.
302. Letter from Malcolm Gee to L. Tone, October 10, 1992.
303. November 1, 192[?]. The last numeral of the year is cut off but the content of the letter places it in 1927.
304. See Miró's letter to Ricart, November 26, 1927, in which he mentions that

he will be in Barcelona for "a few days." These days seem to have extended well into the month of December, judging from letters addressed to Miró at Passatge del Crèdit, 4: November 29 (from Domingo), December 2 (from Ràfols), December 6 (from Ricart), and December 20, 1927 (from Trabal).
305. *Paris Times* 1927, p. 3.
306. Letter to Ricart. From Montroig, December 30, 1927.
307. Letter to Ràfols. From Montroig, February 7, 1928.
308. Regarding the exhibition referred to, see Paris 1928c. According to Z. 1928, the Galerie Georges Bernheim took over the Galerie Barbazanges's space in spring 1928.
309. Beaumelle 1991, pp. 186–87 (does not mention that comments on Miró and Tanguy had not been published previously). For an English translation of Breton's text on Miró, see Breton 1972, p. 36. For Miró's reaction to Breton's text, see Miró 1977, pp. 77–78.
310. Postcard to Ràfols, February 19, 1928, mailed from 22, rue Tourlaque, Paris, and Miró's letter to Ràfols, from Montroig, February 7, 1928. Cf. Rowell 1986, p. 25.
311. Postcard to Ràfols. From 22, rue Tourlaque, February 19, 1928.
312. For a discussion of the dating of these works, see Umland 1992, pp. 73–74 (n. 56). On July 31, 1928, Pierre Loeb wrote to Miró (who was by that date in Montroig), reporting that he had given one of Miró's *collages-cloutages* to Aragon (*Spanish Dancer*, Dupin 245) and planned to give another to Breton (*Spanish Dancer*, p. 169), which establishes a *terminus ante quem* for the date of this series.
313. Paris 1928c and essay note 185. According to Albert Loeb (Pierre Loeb's son), interview with L. Tone and A. Umland, February 1992, Loeb rented the Bernheim gallery space for this exhibition.
314. Postcard to Ràfols, from Brussels, May 5; letter to Gasch, from The Hague, on May 11; postcard to Ràfols, from Amsterdam, May 14, 1928. On May 17 Miró wrote to Ràfols, saying he had just arrived at 22, rue Tourlaque from Amsterdam. For Miró's reactions to his trip, see Dupin 1962, pp. 189–90.
315. See note 314, above.
316. Caption of photograph reproduced following p. 106 of *Variétés* (Brussels), vol. 1, no. 2 (June 15, 1928). The same photograph is reproduced in Dupin 1962, p. 22, captioned "about 1927."
317. See note 314, above.
318. Ibid.
319. Ibid.
320. See Rubin 1973, pp. 40–41 (including foldout), for reproductions of drawings related to *Dutch Interior (I)*; see Fundació Joan Miró 1988, pp. 115–18, for drawings related to other paintings in this series. Rowell 1986, p. 319 (n. 3), states that Miró painted the series of Dutch

Interiors upon his return to Paris, but subsequent correspondence (see, in particular, Miró's letters to Gasch, July 21, August 2, and August 16, 1928) proves that these works, along with *Potato* and *Still Life*, were actually painted in Montroig. Dupin 1962, p. 189, confirms that this series of works was painted during the course of the summer (although on p. 495 he suggests they were painted in Paris). Dupin also points out (pp. 189–91) that *Dutch Interior (I)* is based on H. M. Sorgh's *Lute Player* and that *Dutch Interior (II)* derives directly from Jan Steen's *The Cat's Dancing Lesson*. According to Miró (note to Monroe Wheeler, June 30, 1965; collection files, Department of Painting and Sculpture, The Museum of Modern Art, New York), there was no source for *Dutch Interior (III)*. See essay note 196.

321. Letter to Ràfols. From Passatge del Crèdit, 4, June 5, 1928.

322. On interest in Goya, see *Gaceta literaria* 1928, and Trabal 1928 (in Rowell 1986, p. 98).

323. Trabal 1928. Rowell 1986, p. 91, suggests that the interview probably took place at this time. Another interview (see *Gaceta literaria* 1928) establishes that Miró's interview with Trabal took place prior to his departure for Madrid.

324. See Gaffé 1934, p. 32. For a possible identification of the works Miró was planning, see essay note 98 and related text.

325. Rowell 1986, p. 25. From Madrid, Miró sent at least three postcards to friends on June 22, 1928 (see postcards to Picasso, Ricart, and Ràfols).

326. See *Gaceta literaria* 1928; I am grateful to L. Tone for bringing this interview to my attention. Rowell 1986, p. 91, incorrectly identifies Miró's interview with Trabal (see Trabal 1928) as the "first" published.

327. A letter from Gasch, which most probably was written on Monday, July 9, 1928, was sent to Miró in Montroig.

328. (Rowell 1986, p. 26; Montroig during July and August.) In a letter to Gasch, from Montroig, October 31, 1928, Miró mentioned, "Around the middle of the month [November] I will go to Barcelona to spend a few days there, coming back to the country afterwards." On November 20, 1928, Ràfols sent Miró a postcard addressed to Passatge del Crèdit, 4, inviting him to dinner the next night. What is not clear is whether he returned to Montroig afterward, as he had told Gasch he intended to do, or whether he left Barcelona for Paris sometime between late November and mid-December. By December 26, 1928, he sent a postcard to Ràfols from 22, rue Tourlaque. Cf. Rowell 1986, p. 26.

329. Although Miró did not number the Dutch Interiors, he told Jacques Dupin which of them was the first, the second, and the third completed. At the same time, he stated these three paintings were followed by *Potato* and *Still Life*. Letter

from Ariane Lelong-Mainaud to A. Umland, January 6, 1993.

330. See Trabal 1928. Most of this interview is in Rowell 1986, pp. 92–98.

331. *Collages-cloutages* can be translated somewhat literally as "nailed-collages." The *collage-cloutage* which Loeb gave to Breton can be identified as *Spanish Dancer* (p. 169); cf. Umland 1992, pp. 52–54.

332. The five canvases referred to are probably *Dutch Interior (I)* (p. 162), *Dutch Interior (II)* (p. 163), *Dutch Interior (III)* (p. 164), *Potato* (p. 166), and *Still Life* (p. 165). Although it is possible that Miró was about to complete a work other than *Dutch Interior (I)*, he told Jacques Dupin that it was the first of the Dutch Interior series. See note 329, above.

333. Date based on postmark.

334. See Pierre Loeb's letter to Miró, postmarked August 14, 1928, on a planned arrival date of August 25 or earlier. For a description of Loeb's visit, see Loeb 1946, pp. 82–83 (without mention of a specific year).

335. This letter confirms the suggestion that Miró thought of the Dutch Interiors and the Imaginary Portraits as related series; see essay note 197 and related text. It also provides early evidence of an inclination that would become increasingly marked in Miró in the 1930s and early 1940s, that is, of needing to keep all the works of a given series around him while he worked on the individual paintings comprising the group.

336. See Hirtz 1928.

337. Letter to Gasch. From Montroig, October 31, 1928.

338. See note 328, above.

339. Addressed to Montroig, forwarded to Passatge del Crèdit, 4. According to Rowell 1986, pp. 26, 320 (n. 2), Calder met Miró probably in 1928, although Calder's December 10, 1928, letter suggests they had yet to meet. They would become lifelong friends. See Rowell 1986, p. 255, for a poem Miró wrote for Calder on November 12, 1960. Cf. Miró 1977, pp. 201–02 (n. 2).

340. Cf. Rowell 1986, p. 26. On December 26, 1928, Miró sent Ràfols a postcard from 22, rue Tourlaque, but it is unclear exactly when he left Barcelona for Paris.

341. Miró's earliest known letter from Paris this year is dated January 24, 1929. Presumably, he had been in Paris since at least December 26, 1928 (see note 328, above). Except for visiting Barcelona in late February and late March, Miró was in Paris through late May (see letter to Desnos, from 22, rue Tourlaque, May 28, 1929) and probably left sometime in June. See below, under February 26 and March 22, 1929, regarding trips to Barcelona.

342. Dupin 1962, pp. 192–94, refers to these paintings as "imaginary portraits." Two other paintings are known from this series: *Portrait of a Lady in 1820* (Dupin 240) and *La Fornarina* (Dupin 242). Several of these portraits were based on re-

productions; all were preceded by preliminary drawings. Dupin 1962, p. 194, proposes that *Portrait of Mistress Mills in 1750* was the first of this series. See also Rubin 1973, p. 121 (n. 2), and Miró 1977, p. 185, for sources.

343. See Barnett 1985, p. 256, for the dates of this exhibition. See also Miró 1977, pp. 68–69.

344. *Documents*, a review directed by Georges Bataille, brought together a number of former Surrealists: Boiffard, Desnos, Leiris, Limbour, Masson, Vitrac. Einstein did not publish an article on Miró in *Documents* until 1930 (see Einstein 1930); Michel Leiris, however, did publish an article on Miró in this journal in 1929 (see Leiris 1929).

345. For the contents of this letter, see Rowell 1986, p. 107.

346. Postcard to Ràfols. From Barcelona, February 26, 1929. (Rowell 1986, p. 26; Barcelona in February.) Miró does not seem to have spent the entire month of February in Barcelona, but rather a few days at the end of the month. See letter to Gasch, from 22, rue Tourlaque, February 22, 1929. Lubar 1988, pp. 17–18 (n. 26), mentions that Miró was in Barcelona on February 2, 1929, and Jeffett 1989b, p. 123, suggests that Miró "remained in Barcelona during the spring of 1929," but thus far no evidence appears to support either statement.

347. Stavitsky 1990, vol. 8, p. 183. See Gallatin's letter to McBride, Archives of American Art, New York, NMcB, frame 357.

348. Miró's letter to Gasch, March 13, 1929, sent from 22, rue Tourlaque, says he hopes to see Gasch in Barcelona on "Friday the 22nd." Miró may have remained in Barcelona through Friday, March 29, 1929; see René Gaffé's letter to Miró, April 4, 1929.

349. Postcard to Ràfols. From 22, rue Tourlaque, April 5, 1929. Cf. Rowell 1986, p. 26.

350. Beaumelle 1991, p. 189, puts Dalí's arrival in March and Breton's meeting with him in April. On April 9, 1929, Miró wrote to Gasch, from 22, rue Tourlaque, mentioning that Dalí was in Paris.

351. According to Schiffman 1985, p. 206, Miró introduced Dalí to Arp, Camille Goemans, Magritte, and Paul Eluard. Miró later told Raillard that he was the one who introduced not only Dalí but also Buñuel to Breton; see Miró 1977, p. 83. A letter from Dalí's father to Miró, May 17, 1929, thanks him for his help in securing Dalí's contract with the art dealer Goemans.

352. The exact chronology of this project (Tzara 1930) is unclear. A letter from Miró to Tzara, from Montroig, November 18, 1930, indicates that initially Miró had planned two lithographs for the book, but that Tzara had thought there should be more. When the book was printed, on December 31, 1930, four lithographs were included and the fourth, following p. 64, was signed and dated "Miró. | 3·29" (for

sketches related to this project, see Fundació Joan Miró 1988, p. 124, nos. 461–65). Rowell 1986, p. 26, suggests that Miró's first lithographs for Tzara's *L'Arbre des voyageurs* are dated 1930. Based on the evidence of the lithographs themselves, however, and Hugnet's letter of April 15, 1929 (date based on postmark), it seems the project was initiated in 1929. On Hugnet, see Schiffman 1985, p. 212.

353. Reproduced in Beaumelle 1991, p. 191. The recent works Breton refers to are probably the three Dutch Interiors, along with *Potato* and *Still Life*.

354. Brussels 1929.

355. On May 13, 1929, Miró was in Antwerp (see below), so he could have attended his opening in Brussels on May 11.

356. Postcard to Picasso. From Antwerp, May 13, 1929.

357. Galerie Jeanne Bucher guestbook. In the guestbook, Miró's name is next to that of the Vte de Noailles and although not in his handwriting, appears to be in the same hand that recorded Noailles's.

358. This project apparently was not published.

359. See *Variétés* 1929a (in Rowell 1986, p. 108), and essay note 205 and related text.

360. Miró was in Paris through late May (see letter to Desnos, May 28, 1929, from 22, rue Tourlaque) and received letters addressed to 22, rue Tourlaque dated as late as June 25, 1929 (see postcard from Dalí).

361. Miró's letter to Gasch, July 23, 1929, announced his arrival in Montroig from Mallorca on July 17, 1929, and his engagement to Pilar Juncosa. Perhaps Miró's trips to Barcelona in late February and late March had something to do with his seemingly quick engagement, although Pilar Juncosa de Miró, in an interview with C. Lanchner and A. Umland, July 1991, recalled that their engagement was sudden.

362. Letter to Gasch. From Montroig, July 23, 1929.

363. Ibid. Combalía 1990, pp. 98–99, quotes part of this letter but erroneously suggests that Miró saw the Hemingways in Mallorca, rather than Montroig. There is an undated postcard from Pauline Hemingway to George Antheil, inscribed as sent from "Montroig (Tarragona)," which refers to this visit and is signed also by Miró. Cf. Meyers 1985, p. 215.

364. Regarding this series, see Umland 1992. The versos of most of these collages are inscribed "Summer 1929."

365. In his letter to Gasch of July 23, 1929, Miró mentioned he would have to go back to Palma. On September 1, 1929, he was still in Montroig (postcard to Tzara). On September 3, 1929, he sent a letter to Ràfols from Barcelona, where he remained through Saturday [September 7], traveling afterward to Palma. Cf. Rowell 1986, p. 26.

366. See note 365, above.

367. Letter to Gasch. From Montroig,

September 24, 1929.

368. By "drawings" Miró probably means the collages executed during the summer of 1929 (see pp. 172–75).

369. See Miró's letter to Gasch, from Montroig, July 23, 1929; also Dupin 1962, pp. 198, 495, and Rowell 1986, p. 26.

370. Dupin 1962, p. 198, reports that the couple honeymooned at Formentor, Mallorca. Gasch's article in *La Publicitat* (Gasch 1929h) identifies Miró's most recent work as the collages of summer 1929.

371. Note to Desnos. From 3, rue François-Mouthon, November 22, 1929.

372. Dupin 1962, p. 198.

373. Gasch 1929h. Miró commented in a letter to Gasch, January 28, 1930, that he was both honored by and interested in this article.

374. Note to Gasch, from Barcelona, December 26, 1929, and letter to Ràfols, from 3, rue François-Mouthon, March 10, 1930.

375. Rowell 1986, pp. 26, 123. It is unclear when, exactly, during 1930, Matisse met Miró.

376. Letter to Gasch. From Barcelona, December 26, 1929. Mentions they will stay in Barcelona one week. Unless Miró and his wife went to Mallorca after Barcelona, it is likely they arrived in Paris in early January. Rowell 1986, p. 26, places Miró in Paris, March–May.

377. Dupin 1962, p. 238, suggests that *Painting* (p. 180) was painted in summer 1930 at Montroig. Miró, however, in a letter to Gasch, January 17, 1931, notes that all the paintings in this series (reproduced in Bataille 1930) were from "last winter." For other works from this group of paintings, see Dupin 261–62, 264–65.

378. Paris 1930a. For list of works shown, see Joffroy 1979, p. 118.

379. Omer 1930, p. 2.

380. Paris 1930b. Dupin 1962, p. 581, and Rowell 1986, p. 26, suggest that the summer 1929 collages were shown at the Galerie Pierre, May 7–22, 1930. In fact, this May exhibition never took place; see Umland 1992, p. 72 (n. 42).

381. Paris 1930c. On two different occasions Miró asked Gasch if he had read Aragon's introductory essay, "La Peinture au défi" (see the letters of October 19, 1930, and April 6, 1931).

382. As noted in Dupin 1962, p. 247, Miró did not leave the Surrealist group, but saw its members on an individual basis, as friends; among them, according to Dupin, Miró was especially close to Giacometti.

383. Levaillant 1990, p. 172. Vézelay was an English painter involved with André Masson from spring 1929 through spring 1933.

384. Letter to Gasch. From Villa Enriqueta, Son Armadans, Terreno, Palma, May 14, 1930.

385. See FJM notebooks 882–942 and 854–881. In Fundació Joan Miró 1988, pp. 132–43. While Miró dedicated the two notebooks to Pilar in November 1930 (the

date is inscribed in each book), the large-drawings executed after sketches in these notebooks date from August–November 1930. Miró told Picon that the drawings in these notebooks were made in Palma, the year after his marriage; see Picon 1976, vol. 1, pp. 32–33.

386. See Gallatin 1930. The third work was *Painting* of 1926, now in the Philadelphia Museum of Art. Both Dupin 1962, p. 581, and Rowell 1986, p. 26, suggest that Miró had six works on regular exhibition at the Gallery of Living Art in 1930, but Gallatin 1930 lists only three.

387. Letter to Gasch. From Palma, May 14, 1930.

388. Birth Registration. July 18, 1930.

389. On August 19, 1930, Miró completed the earliest known large drawing on Ingres paper, based on one of the Palma notebooks (see FJM notebook 882–942; this drawing relates to FJM 894). Presumably, he had arrived in Montroig by that date, and perhaps somewhat earlier. Miró planned to remain in Montroig through the end of November; see letter to Gasch, from Montroig, October 19, 1930.

390. Dupin 1962, pp. 238, 242, states that both drawings and constructions were executed during the summer of 1930 at Montroig (although on p. 444 he mistakenly notes that the constructions date from 1929). The latest known drawing from the series on Ingres paper (there may, of course, be others) is dated November 22, 1930, suggesting that Miró worked on drawings and, by implication, constructions through November 1930.

391. New York 1930c. See also Melgar 1931 (in Rowell 1986, p. 117).

392. As mentioned earlier (see note 352, above), this project seems to have been initiated in 1929, so it is puzzling that Miró did not send the two additional lithographs to Tzara sooner. Both Rowell 1986, p. 26, and Combalía 1990, p. 100, suggest that Miró worked on this project with Tzara in 1930.

393. See Tzara 1930; printed December 31, 1930.

394. Paris 1930f. According to Rowell (notes to L. Tone and A. Umland, January 1993), the Noailles Archive, Musée National d'Art Moderne, Centre Georges Pompidou, Paris, contains documentation which establishes that the three Miró collages were lent by Pierre Loeb.

395. Ades 1982, p. 194, and Beaumelle 1991, p. 195. See also Miró 1977, p. 175.

396. Letters to Gasch, from Montroig, October 19, 1930, and to Ràfols, from Barcelona, December 3, 1930. Cf. Rowell 1986, p. 26.

397. Letter to Ràfols. From Barcelona, December 3, 1930.

398. Postcard to Ràfols. From Villa Enriqueta, Son Armadans, Terreno, Palma, December 15, 1930. See also Miró's letter to Gasch, from Montroig, October 19, 1930.

399. Letter to Ràfols. From Barcelona,

December 31, 1930.

400. See letters to Böske Antheil, from Montroig, October 15, 1930, and Gasch, from Montroig, October 19, 1930. In a subsequent letter to Gasch, from Paris, May 6, 1931, Miró said, "We are coming [to Barcelona] at the beginning of June." Cf. Rowell 1986, p. 26.

401. The crisis Miró refers to is most likely financial. This is Miró's earliest known allusion to the effects of the Depression in Paris.

402. Rowell 1986, p. 114.

403. Melgar 1931. Most of this interview is in Rowell 1986, pp. 116–17. It seems to have displeased Miró; see the letter to Ràfols, from 3, rue François-Mouthon, February 5, 1931.

404. Chicago 1931.

405. Galerie Jeanne Bucher guestbook.

406. Miró's reference to "riffraff" is unclear; his works from this period are remarkably uneven and largely unpublished, aside from the paintings mentioned by Dupin 1962, pp. 243–45.

407. From 3, rue François-Mouthon. Possibly Miró was casting about for means of support other than Loeb and chose to renew contact with Rosenberg at this time.

408. Although Dupin 1962, p. 248, dates most of Miró's first painted and assembled objects to summer 1931, in Montroig, *Man and Woman* (p. 182) seems to have been an exception and is inscribed with the date March 1931. Roger Vitrac referred to "recent objects" of Miró in an article published in 1931; see Vitrac, "L'Esprit moderne," *L'Intransigeant* (Paris), March 17, 1931, p. 5. It is not clear, however, whether Vitrac refers to the constructions of 1930 or the assembled objects of 1931.

409. Rowell 1986, p. 113.

410. See Tzara 1931 and Aragon 1930.

411. Letter to Gasch. From Paris, May 6, 1931.

412. Postcard to Ràfols. From Villa Enriqueta, Son Armadans, Terreno, Palma, July 1, 1931. Rowell 1986, p. 26, suggests Miró remained in Palma for the entire month of July. Until August 26, 1931, however, when he writes to Ràfols from Montroig, his movements are undocumented.

413. (Rowell 1986, p. 26; in Montroig from August to October.) Miró must have arrived in Montroig before his letter of August 26, 1931, to Ràfols. Three of the 1931 paintings on Ingres paper are dated July (letter to A. Umland from Ariane Lelong-Mainaud, March 19, 1993), suggesting he may have arrived in Montroig sometime during that month. He most probably left late in November (letter to Ràfols, from Montroig, October 2, 1931).

414. See Dupin 294–307 and Dupin 1962, pp. 245–46. According to Dupin the paintings on Ingres paper are not gouaches, although frequently described as such, but oil thinned with turpentine. Of those works in this series which are known to be specifically dated, the ear-

liest are from July 1931 (letter to A. Umland from Ariane Lelong-Mainaud, March 19, 1993).

415. Dupin 1962, p. 248, suggests that *Personnage au parapluie* also was executed during summer 1931 in Montroig, as does Rubin 1973, p. 54.

416. Postcard from Cooper. Addressed to Montroig, postmarked August 29, 1931.

417. Letter to Ràfols. From Montroig, October 2, 1931.

418. In the date of this letter, the month is illegible.

419. See Ràfols 1931b. Published on December 2, 1931. Ràfols's article states this event took place on Friday; the Friday preceding December 2, 1931, was November 27.

420. (Rowell 1986, p. 27; Paris during November and December.) The earliest known letter mailed from Paris is to Foix, December 9, 1931.

421. Galerie Jeanne Bucher guestbook.

422. The drawing is illustrated in Hayward 1986, p. 286 (fig. 319).

423. Paris 1931e.

424. See Bowles's postcard to Miró, January 20, postmarked 1932; and Sawyer-Laucanno 1989, pp. 120–21, 124.

425. Letter to Foix. From 3, rue François-Mouthon, December 9, 1931.

426. Freedberg 1986, vol. 1, p. 580 (n. 3).

427. Miró had returned to Barcelona before December 24, 1931, and probably stayed there until leaving for Monte Carlo, on February 14, 1932; see the letter to Gasch, February 14, 1932. According to Rowell 1986, p. 13, Miró's decision to remain in Barcelona was probably motivated by his precarious financial situation. Miró told Zervos, in a letter from Barcelona, January 20, 1932, that Pierre Loeb was no longer handling his affairs. See also Dupin 1962, p. 247.

428. Dupin 1962, p. 39, notes, without providing a date, that Miró rented the floor above his mother's apartment and that he lived there with his wife and daughter for several years, keeping an attic studio in the same building; and Rowell 1986, p. 27, suggests Miró began using a studio on the top floor in 1932. Miró, however, was using as a studio the room in which he was born (letter to Zervos, January 20, 1932). It was not until the 1940s that the top floor, or attic, of Passatge del Crèdit, 4, would serve as studio.

429. The Pierre Matisse Foundation, New York, could not locate any letters from Zervos to Matisse from this period. According to Rowell 1986, p. 123, Pierre Loeb initiated contact with Pierre Matisse. Miró's February 12, 1932, letter to Zervos, however, and another, of January 20, 1932, suggest Zervos made first contact, and at Miró's, rather than Loeb's, urging.

430. Foix reviewed this event in an article published in *La Publicitat* on April 21, 1932 (see Foix 1932), and noted it had taken place "some weeks ago." Miró left for Monte Carlo on February 14, 1932, and

is not known to have returned to Barcelona until after April 15; therefore his new objects were probably shown prior to his departure on February 14.

431. Letter to Gasch. February 14, 1932. (Rowell 1986, p. 27; in Monte Carlo, March and April.) From this letter, it seems he arrived in February.

432. Rowell 1986, p. 27, suggests that Miró began work on this project in January, as does Dupin 1962, p. 248, although this remains unverified. Most of Miró's letters from Monte Carlo were written on Bristol & Majestic Hotels letterhead; a postcard to Ràfols, April 9, 1932, specified the Bristol Hotel. Dupin 1962, p. 248; Rowell 1986, pp. 27, 118; and Hirschfeld/Lubar 1987, p. 251, suggest Massine commissioned Miró. García-Márquez 1990, p. 35, suggests that it was Boris Kochno and that his first choice had been Giacometti, who rejected the commission. Many of Miró's sketches and drawings for this project, along with a maquette for the stage decoration, are reproduced in Fundació Joan Miró 1988, pp. 147–53. The Ballets Russes de Monte Carlo was founded in January 1932 to succeed the Ballets Russes de Diaghilev; Sergei Diaghilev had died in 1929.

433. Rowell 1986, p. 119, as "[March–April 1932]." The actual date of this letter is February 23, 1932. See also García-Márquez 1990, pp. 34–35.

434. García-Márquez 1990, p. 28. See Dupin 1962, p. 248, and García-Márquez 1990, p. 35, for descriptions of Miró's designs for *Jeux d'enfants*.

435. Although the name mentioned is unclear, it might possibly be that of Tatiana Riabouchinska, who danced the role of "L'Enfant" in *Jeux d'enfants*; see García-Márquez 1990, p. 28.

436. Note to Böske Antheil. June 4, 1932.

437. Ibid., for date of the premiere. Rowell 1986, p. 27, and García-Márquez 1990, p. xiii, identify the theater.

438. Letter to Böske Antheil. From the Hôtel Récamier, June 14, 1932.

439. Letter to Böske Antheil. From Montroig, July 8, 1932. The date of Miró's return to Barcelona is unknown; several of the small paintings on wood which occupied him during this period in Montroig are inscribed October (see *Bather*, p. 184, and *Seated Woman*, p. 186), suggesting he may have remained in Montroig through the month of October, if not later.

440. Dupin 1962, p. 249, notes that during the same period, Miró constructed six poetic "objects," although the objects he refers to may be those Miró had executed earlier that year (see letters to Zervos, January 20 and February 12, 1932).

441. Cf. Rowell 1986, p. 27, and Miró 1977, pp. 114, 202 (n. 2).

442. Hayward 1986, pp. 212, 225 (n. 4), suggests the performance was held in September, on the basis of an article by Gasch, published in *Mirador*, on September 29, 1932. According to the chronology published in the exhibition catalogue for Barcelona 1992, p. 697, however, the performance took place in November. See Hayward 1986, p. 305, on GATCPAC (Grup d'Arquitectes i Tècnics Catalans per al Progrés de l'Arquitectura Contemporània), formed in 1930.

443. New York 1932. Pierre Matisse told Albert Loeb (Pierre Loeb's son), in a letter of March 21, 1988, that the works in his first Miró exhibition were lent by the Galerie Pierre, which suggests that Miró must still have had some connection with Pierre Loeb at the time, despite having told Zervos in his letter of January 20, 1932, that "Pierre [Loeb] is no longer looking after me." Letter from Matisse to Albert Loeb, courtesy Albert Loeb, Paris.

444. Jardí 1983, p. 194, but at a different location; see Barcelona 1932b. According to Hayward 1986, pp. 306–07, ADLAN was founded in November 1932, on the initiative of Joan Prats, to promote avant-garde art in Barcelona.

445. Letter to Pierre Colle. From Passatge del Crèdit, 4, December 25, 1932. Courtesy Sylvia Lorant, Paris.

446. Paris 1932b.

447. Letter to Pierre Colle. From Passatge del Crèdit, 4, December 25, 1932. Courtesy Sylvia Lorant, Paris.

448. Postcard to Ràfols. From Passatge del Crèdit, 4, January 1, 1933. On April 22, 1933, when Miró completed the ninth painting of the 1933 series of paintings based on collages (date based on inscription on related collage, FJM 1297), he sent Ràfols a postcard from Montroig.

449. Levaillant 1990, p. 533.

450. The first collage corresponds to FJM 1289; the last to MoMA 131.73 (see cat. 109). With the exception of MoMA 131.73, all of these collages are reproduced in Fundació Joan Miró 1988, pp. 155–58. Each is inscribed by the artist with two dates, the first corresponding to the collage, the second to the painting based on the collage. The canvas size of each painting from this series is also inscribed on its related collage. The collage date inscribed on FJM 1293 is "31.1.33" (incorrectly recorded in Fundació Joan Miró 1988, p. 156, as "31.3.33").

451. For a general discussion of this series, see Dupin 1962, pp. 252–53, and Rubin 1973, p. 60.

452. Addressed to Montroig. Although Miró agreed to participate in this show, by 1934 he would refuse to exhibit with Hélion and Arp, because of their association with the Abstraction-Création group; see letter to Zervos, from Barcelona, June 2, 1934. Despite this, Miró's work was later included in "Abstract and Concrete: An Exhibition of Abstract Painting and Sculpture, 1934 and 1935," held in Oxford, February 15–22, 1936 (see Oxford 1936), although he may have had nothing to do with the loans.

453. Postcard to Ràfols. From Montroig, April 22, 1933.

454. If all of the 1933 paintings based on collages were executed at Passatge del Crèdit, 4, Miró must have returned to Barcelona by April 26, as he completed a painting from this series on that date (Dupin 334). See note 460, below, for the date of his departure for Paris.

455. Hayward 1986, p. 212. Cf. García-Márquez 1990, p. 45. Rowell 1986, p. 27, and Hayward 1986, p. 307, suggest that *Jeux d'enfants* was first presented in Barcelona on May 3, 1933; this remains unconfirmed.

456. Paris 1933a. See Beaumelle 1991, p. 207, for installation photographs.

457. Paris 1933b.

458. Catalunya 96. On a *carte-de-visite*. Thursday. In this note, Miró refers to a local review of *Jeux d'enfants*, which establishes that the year is 1933. Given this, the "recent paintings" must be the 1933 series based on collages. Because the last painting of this series was completed on June 13 and Miró was in Paris by June 22, "Thursday" must be June 15 and "Sunday" June 18.

459. Ibid. See Hayward 1986, p. 212, for the suggestion that this exhibition took place at Passatge del Crèdit, 4.

460. Letter from Miró's mother, June 29, 1933, mentioning a letter received from Miró, *from Paris*, dated June 22.

461. London 1933b.

462. By July 14, 1933, he was in Palma (see below), having, presumably, stopped in Barcelona on his way back from Paris.

463. Letter to Douglas Cooper. From Palma, July 14, 1933.

464. This project was subsequently delayed, and the issue of *Cahiers d'art* largely devoted to Miró was not published until 1934; see *Cahiers d'art* 1934.

465. See Foix 1934.

466. Letter to Foix. From Palma, July 19, 1933. He notes, "We will be here until the beginning of next week [c. Monday, July 24]. . . ."

467. (Rowell 1986, p. 27; Montroig in August.) During the summer in Montroig, Miró worked on a series of drawing-collages. One of the earliest of these is inscribed August 8, 1933, suggesting he may have arrived in Montroig before that date; see Rubin 1973, pp. 61, 125.

468. Most of these drawing-collages are dated by day, month, and year. See Dupin 1962, p. 255, and Dupin 352, 354–63.

469. Letters from Cooper, July 18, 1933, and to Ricart, from Passatge del Crèdit, 4, December 4, 1933.

470. Miró's first etchings were for Hugnet's *Enfances*; see Rowell 1986, p. 27.

471. On October 14, 1933, Georges Duthuit was in Barcelona and wrote to Miró at Passatge del Crèdit, 4.

472. Letter to Douglas Cooper. From the Hôtel Récamier, October 28, 1933. This letter suggests Miró had been in Paris for at least a few days already and had probably attended the opening of the Salon des Surindépendants on October 27. By November 21, 1933, Miró was in Barcelona, at which time he wrote to Michel Leiris.

473. Paris 1933c, and note 472, above. See P.I. 1933. Miró may have shown *Personnage au parapluie*, executed during summer 1931 in Montroig, and first reproduced in *Surréalisme au service de la révolution* 1931, p. 38. Rubin 1973, p. 54, suggests this object was shown in the Salon des Surindépendants in 1931, rather than in 1933, but no evidence has been found to support the earlier date.

474. Paris 1933d. According to Warnod 1933, all eighteen paintings were shown.

475. This is the earliest letter from Miró to Pierre Matisse found in the archives of the Pierre Matisse Foundation, New York.

476. Although Seligmann's letter to Miró, postmarked November 9, 1933, does not securely establish that Miró was still in Paris at this date, it strongly suggests that he was. On December 31, 1933, Miró wrote to Leiris from Passatge del Crèdit, 4.

477. Despite the importance of these paintings within Miró's oeuvre, very little is known about them. Unlike Miró's other works from 1933 (which are inscribed with day, month, and year), they are all undated, and Miró does not seem to have regarded them as major works on canvas: in a letter dated May 5, 1952, to Matisse he said, "The big canvas does not have a title, because it was a *carton* for a tapestry. . . ."

Dupin 1962, p. 255, suggests that they were painted during the winter of 1933–34, and in the absence of further documentation, there is no basis for assigning other dates. Rubin 1973, p. 125, notes these tapestry cartoons were commissioned by Marie Cuttoli, but unfortunately, the only correspondence between Miró and Cuttoli that has been found so far is a letter from Cuttoli, postmarked January 22, 1929, and one from Miró, June 18, 1945. In a letter of December 7, 1951, Miró told Pierre Matisse that "Maeght was able to recover from Mme Cuttoli's two large maquettes (*hors de mesure*) realized in 1933 for tapestries," which confirms Cuttoli's involvement and, in a very general way, Dupin's dating.

478. New York 1933. Installation photographs and an annotated catalogue are included in the Pierre Matisse Gallery Scrapbook, in microfilm at the Archives of American Art, New York.

479. Letter to Leiris. From Passatge del Crèdit, 4, December 31, 1933. In a letter of February 7, 1934, Miró told Pierre Matisse he would leave for Paris in a few days, but an ink and pastel drawing in the Philadelphia Museum of Art is dated February 22, 1934, suggesting that Miró's departure was delayed until sometime in late February. See Temkin 1987b, p. 42.

480. Dupin 1962, p. 256. A number of these works are reproduced in Yokohama Museum of Art 1992, pp. 58–61. See also Miró's letter to Pierre Matisse, from Passatge del Crèdit, 4, April 29, 1934, for

a description of work during this period.

481. For dating of Miró's departure for Paris, see note 479, above. He must have returned to Barcelona in mid-March, as in a letter to Ràfols, from Passatge del Crèdit, 4, March 16, 1934, he wrote, "I arrived from Paris a few days ago. . . ." In a letter to Breton, April 12, 1934, he mentioned he had brought his "latest [*derniers*] collages" to Paris; see Beaumelle 1991, p. 214.

482. Galerie Jeanne Bucher guestbook. Miró's name is entered in the guestbook, but the signature does not appear to be in his handwriting.

483. Barnett 1985, p. 256, notes that Kandinsky met Miró in March 1934, presumably in Paris. Albert Loeb, in conversation with L. Tone and A. Umland, March 1992, Paris, said that Kandinsky had met Miró at a dinner at Pierre Loeb's. Rowell 1986, p. 28, however, suggests they met in 1933; and according to Barnett 1985, p. 256, Kandinsky was the guest of honor at the 1933 Salon des Surindépendants, which opened on October 27, 1933, and which Miró probably attended, so it is possible the two were introduced prior to March 1934. Kandinsky's first known postcard to Miró, of April 8, 1934, provides a *terminus ante quem* for their encounter. According to Derouet 1985, p. 59, the two artists were close.

484. See note 481, above. Miró went back to Paris for a few days in early May, around the time of his exhibition at the Galerie des Cahiers d'Art, May 3–19, 1934 (Paris 1934c); see letter to Matisse, April 29, 1934. On April 19, 1934, Miró sent a letter to Douglas Cooper from Montroig.

485. Chicago 1934a.

486. On April 29, 1934, Miró wrote to Pierre Matisse, asking him to confirm an agreement whereby, as of April 1, 1934, in return for a monthly stipend, Matisse would have one half of his work, the remaining half then to be evenly divided between Miró and Pierre Loeb, with the understanding that Loeb might have the full half if he so chose. By February 19, 1936 (letter from Miró to Matisse), Loeb apparently was solvent enough to have asked to take over half of the contract. Although Rowell 1986, p. 123, suggests it was in 1932 that "Loeb asked Matisse to take on half the artist's production and give Miró a monthly stipend," Miró's 1934 letter is the first known to mention any such arrangement.

487. In Beaumelle 1991, p. 214. The collages Miró refers to may be the series of drawing-collages he executed in the latter half of 1933. According to Beaumelle, Breton probably bought a collage from this series, known as *The Beach* (Dupin 356), at this time.

488. Letter to Pierre Matisse. From Passatge del Crèdit, 4, April 29, 1934.

489. Paris 1934c.

490. San Francisco 1934a.

491. Letter to Pierre Matisse. From Villa Enriqueta, Son Armadans, Terreno, Palma, July 16, 1934.

492. Miró wrote at least two letters on July 20, 1934. In the absence of postmarks, it is difficult to determine where these letters were actually mailed from. The first was sent to Pierre Matisse, with Palma noted as the return address. The second, sent to Douglas Cooper, was headed "Montroig."

493. Letter to Pierre Matisse. From Palma, July 20, 1934. Cf. letter to Douglas Cooper, also of July 20, 1934. By August 11, 1934, Miró was back in Montroig, and told Cooper in a letter of that date, "I was in Paris."

494. Miró 1977, pp. 116–17.

495. On the evidence of Miró's letter to him, from Passatge del Crèdit, 4, December 18, 1934, Cooper did visit in summer 1934, as Miró notes in December, "Since you came to see me in the country, I've worked a lot more. . . ."

496. Dupin 371–85. Dupin mentions fifteen of these pastels, but in Miró's letter to Matisse of November 24, 1934, he refers to only fourteen; perhaps he retained one for himself.

497. Zurich 1934. Rowell 1986, p. 28, suggests this was a one-artist exhibition. Miró's correspondence from summer 1934 makes clear that he had hoped to visit Zurich during this exhibition; according to Rowell 1986, p. 28, current events in Spain prevented him from leaving.

498. Although the three pastels from this series included in the present catalogue (*Woman*, p. 198, *Woman*, p. 199, and *Personage*, p. 200) are all dated October, some works from this series were apparently completed in November, and in Barcelona rather than Montroig.

499. Addressed to Passatge del Crèdit, 4. Hadley Mowrer, formerly Hadley Hemingway, also signed this postcard. The return address given was "Paul Scott Mowrer, 1320 N. State, Chicago." This postcard proves that *The Farm* remained with Hadley through the late 1920s and early 1930s. By January 10, 1935, however, when Pierre Matisse opened his new Miró exhibition, *The Farm* was included and the catalogue noted "Collection Ernest Hemingway." According to Meyers 1985, p. 166, Hemingway borrowed *The Farm* in 1934 for five years and then never returned it to Hadley.

500. Letter to Matisse. From Passatge del Crèdit, 4, November 24, 1934.

501. Letter to Matisse. From Passatge del Crèdit, 4, December 17, 1934.

502. Excerpts in Rowell 1986, p. 125.

503. Levaillant 1990, p. 231 (n. 2).

504. Correspondence from this period is invariably addressed to or from Passatge del Crèdit, 4. By June 18, Miró was in Paris (letter to Gallatin, from the Hôtel Récamier, June 18, 1935).

505. See Dupin 402–12. The date of *Head of a Man* (p. 201) is based on Dupin 1962, p. 532. There is no longer any inscription visible on the verso of this work.

506. New York 1935. Installation photo-graphs included in the Pierre Matisse Gallery Scrapbook, in microfilm at the Archives of American Art, New York.

507. Stavitsky 1990, vol. 8, p. 193. Date of sales receipt.

508. Tenerife 1935. An installation view including *Nude* (p. 157) is reproduced in Beaumelle 1991, p. 221.

509. Letters to Matisse, from Barcelona, April 14 and 27, 1935, and to Gallatin, from the Hôtel Récamier, June 18, 1935. (Rowell 1986, p. 28; Paris in late June.)

510. Letter to Matisse. From Montroig, October 6, 1935. See essay note 261 and related text.

511. Letter to Kandinsky. From Montroig, July 31, 1935. Reproduced in Centre Pompidou 1984, p. 50.

512. Letter to Breton. From the Hôtel Récamier, June 26, 1935.

513. Letter to Kandinsky, from Montroig, July 12, 1935 (reproduced in Centre Pompidou 1984, p. 34), and postcard from Hélion and Gallatin, July 18, 1935. (Rowell 1986, p. 28, has Miró in Brussels in the spring.)

514. Beaumelle 1991, p. 221.

515. Paris 1935e.

516. Letter to Kandinsky. From Montroig, July 12, 1935. Reproduced in Centre Pompidou 1984, p. 34. On October 27, 1935, Miró sent a postcard to Tériade; while the return address is indicated as Passatge del Crèdit, 4, the postmark is from "Cambrils . . . (Tarragona)," suggesting it was mailed from Cambrils, close to the time Miró planned to leave Montroig for Barcelona. (Rowell 1986, p. 28, has Miró in Montroig in October.)

517. Dupin 1962, p. 285, suggests that Miró worked on this series between October 23, 1935, and May 22, 1936 (see Dupin 419–30). Two paintings, however, are now known to date prior to October 23: specifically *Personages in Front of a Volcano*, October 9–14 (p. 210), and *Man and Woman in Front of a Pile of Excrement*, October 15–22 (p. 210). To judge from his letter to Matisse, from Montroig, October 6, 1935, Miró worked on this series over the summer, prior to October 9–14, which is, presumably, when he completed the first painting of the series. Each painting in this series is inscribed with a span of dates, which probably refer to the period when Miró added finishing touches.

518. Serge 1935, p. 3.

519. Los Angeles 1935b.

520. See note 516, above.

521. Signatures only. Date based on postmark.

522. Apparently, Matisse had asked Miró to send him some of the small-format copper and masonite paintings to exhibit in New York.

523. Letter to Matisse. From Passatge del Crèdit, 4, November 16, 1935. See Prague 1935. Cf. Rowell 1986, p. 28.

524. Letter to Matisse. From Passatge del Crèdit, 4, January 1, 1936. See also note from Georges Braque, January 7, 1936.

525. Letter to Valentine Hugo. From Passatge del Crèdit, 4, December 11, 1935. Cf. Rowell 1986, p. 28.

526. Paris 1935f.

527. Rowell 1986, p. 29.

528. Letter to Matisse. From Passatge del Crèdit, 4, January 1, 1936.

529. Bracketed dates are based on Dupin 1962, p. 533, but no verifying inscriptions appear on the works. For Miró's comments on the progress of his work during this period, see letters to Matisse, all from Passatge del Crèdit, 4, of February 5 and 19 and April 28, 1936.

530. Hayward 1986, p. 219.

531. Ibid., and letter to Breton, from Passatge del Crèdit, 4, February 6, 1936.

532. Rowell 1986, p. 125.

533. New York 1936b.

534. Miró mentioned he was working on objects during 1936 in at least two letters to Matisse, from Passatge del Crèdit, 4, the earlier of February 5 and the other of April 28, 1936. The exact dating of *Object* (p. 218) and *Object of Sunset* (p. 219) remains, however, open to question. Rubin 1973, p. 70, suggests that the flurry of activity leading up to the "Exposition surréaliste d'objets," held at the Galerie Charles Ratton, Paris, May 22–29, 1936, may have inspired Miró to execute *Object*, although this work is not known to have been included in the Ratton exhibition.

About *Object of Sunset*, Miró later recalled that the work was executed in Montroig, taken to Paris (to the Hôtel Récamier), where it was shown to Pierre Matisse and Pierre Loeb; see Beaumelle 1987, pp. 433–34. According to Beaumelle 1987, p. 434, *Object of Sunset* went to Loeb, while *Object* went to Matisse. *Object of Sunset* was, at some subsequent point, acquired by Breton. Matisse's letter to Dupin of May 15, 1959, however, suggests he owned *Object of Sunset* prior to Breton, although he gives its date as 1934.

535. Barcelona 1936. Cf. Jardí 1983, p. 223 (which reproduces a photograph of the installation); Macmillan 1982, p. 101 (which incorrectly dates the exhibition to 1934); and Freedberg 1986, vol. 1, pp. 597–98 (n. 95).

536. Paris 1936b. *Object 1932* (p. 183) can be identified in photographs of the installation provided by the gallery Charles Ratton & Guy Ladrière, Paris.

537. Miró told Matisse he planned to come to Paris in June in at least two letters, from Passatge del Crèdit, 4, January 1 and February 5, 1936; see also the letter to Breton, from Passatge del Crèdit, 4, of April 28, 1936. Presumably, he would not have left Barcelona before completing *Personages and Mountains* (possibly on May 22).

Joffroy 1979, p. 123, suggests that Miró attended the opening of Wolfgang Paalen's exhibition at the Galerie Pierre. Because the dates of the exhibition were May 15–29, 1936, this seems implausible if the dates recorded by Dupin (May 11–22) for *Personages and Mountains* are correct.

538. Rowell 1986, p. 28, notes Miró went to London at the time of the "International Surrealist Exhibition," held at the New Burlington Galleries, June 11–July 4, 1936. Scant documentation has been found so far concerning this trip. Miró briefly alludes to having been in London in a letter to Matisse of July 14, 1936. Roland Penrose briefly refers to Miró's 1936 trip to London in *Joan Miró: Theater of Dreams*, a program he wrote and narrated for BBC Television in 1978; the Penrose Archives contain no additional information about this visit (letter to A. Umland from Michael Sweeney, February 8, 1993). Cf. *Intransigeant* 1936.

539. London 1936c.

540. Letter to Matisse. From Montroig, July 14, 1936.

541. Judging from letters to Matisse, Miró remained in Montroig through late September (see letters of July 14, August 9, and August 15, 1936). In the August 15 letter, he mentioned he had just returned from Barcelona. By September 28, 1936, he wrote to Matisse from Barcelona, where he remained through late October, prior to leaving for Paris. (Rowell 1986, p. 29, has Miró in Montroig during July.)

542. Letter to Matisse. From Montroig, July 14, 1936. Although Miró told Matisse in a letter of September 28, 1936, that there were twenty-six paintings on masonite, Dupin 1962, pp. 287, 535–36, catalogues twenty-seven (Dupin 446–72). Miró probably retained one of these paintings for himself, most likely *Painting* (p. 216). While Dupin 1962, p. 495, suggests these works were executed entirely in Montroig, Miró's letter to Matisse (September 28, 1936) suggests they were completed in Barcelona.

543. Rowell 1986, p. 29, and Hayward 1986, p. 308.

544. In later years, Miró provided Raillard with a dramatic account of his situation at the outbreak of the war, suggesting he had to leave Spain immediately; see Miró 1977, p. 112.

545. Letter to Matisse. From Montroig, August 15, 1936.

546. Letter to Matisse. From Barcelona, September 28, 1936. Excerpts in Rowell 1986, p. 126.

547. Excerpts in Rowell 1986, p. 126. The envelope which contained this letter was stamped by the Spanish censor.

548. Letter from Matisse. October 28, 1936. Here Matisse mentions he has heard that Miró is in Paris. (Rowell 1986, p. 29, has Miró going to Paris in November.)

549. Letter to Matisse. From the Hôtel Récamier, January 12, 1937. In Rowell 1986, p. 146. See essay note 276 and related text.

550. Letter to Matisse. From the Hôtel Récamier, November 16, 1936. In Rowell 1986, p. 130 (mention of Sweeneys omitted).

551. Rowell 1986, p. 130.

552. Ibid., pp. 13–14, 29. At the time of Miró's letter to Matisse, from the Hôtel Ré-

camier, November 16, 1936 (in Rowell 1986, pp. 131–32), he still did not know whether he would remain in Paris, because his wife and daughter were having trouble leaving Spain. On Miró's decision to live in exile, see the letters to Matisse, from the Hôtel Récamier, December 18, 1936, and January 12, 1937 (in Rowell 1986, pp. 133–34, 146).

553. New York 1936c. Installation photographs included in the Pierre Matisse Gallery Scrapbook, in microfilm at the Archives of American Art, New York.

554. Galerie Jeanne Bucher guestbook. Miró's name appears in the guestbook below Giacometti's and is followed soon thereafter by Sert's.

555. New York 1936d.

556. Letters to Matisse. From the Hôtel Récamier, December 14 and 18, 1936. In Rowell 1986, p. 133.

557. Rowell 1986, pp. 133–34.

558. Ibid., p. 29. With one exception, Miró listed the Hôtel Récamier, 3 bis, place Saint-Sulpice, as his return address during January and February 1937 (see the letters to Matisse of January 12 and February 12, and to Gallatin of February 17). Dupin 1962, pp. 290, 495, however, suggests Miró lived in a hotel on the rue Jules-Chaplain, and there is, indeed, one letter from Miró to Matisse of January 22, 1937, in which the return address is that of the Hôtel Chaplain.

559. Rowell 1986, p. 146.

560. Letter from Pierre Loeb to James Thrall Soby, October 28, 1958. James Thrall Soby Papers, The Museum of Modern Art Archives, New York. See also letter from Matisse, February 15, 1937.

561. See Duthuit 1936a. As remarked in Rowell 1986, p. 315 (n. 1), although this issue of *Cahiers d'art* was dated 1936, it appeared in May 1937. Miró's description of the interview and the planned contents of the issue are found in a letter to Matisse, February 12, 1937 (in Rowell 1986, p. 147).

562. Rowell 1986, p. 147.

563. Galerie Jeanne Bucher guestbook. In this and other cases, names are given in the order in which they appear in the guestbook.

564. Letter to Matisse. From 98, boulevard Auguste-Blanqui, March 7, 1937. Cf. Rowell 1986, p. 29.

565. Letter to Matisse. From 98, boulevard Auguste-Blanqui, March 7, 1937. Rowell 1986, pp. 29, 160, states that Miró painted at the Galerie Pierre from January through *May* 1937, and that in 1938 he would occasionally use a room at the Galerie Pierre for larger works; she also, on p. 156, notes that he completed both *Still Life with Old Shoe* (p. 227) and *Self-Portrait I* (p. 228) there. By March 7, 1937, however, Miró told Matisse he had a place to work in the apartment he had moved into at 98, boulevard Auguste-Blanqui, and in another letter, from that address, April 6, 1937, he described the space as "large" and with "good light." It

seems unlikely, then, that Miró would have continued to paint in the far from ideal conditions afforded by the Galerie Pierre any longer than he had to. Once settled at 98, boulevard Auguste-Blanqui, he most probably continued working on *Still Life with Old Shoe* there. Freedberg 1986, vol. 1, p. 580 (n. 8), draws similar conclusions. Relevant also is Loeb's 1958 recollection that Miró painted in his gallery for a "month"; see letter from Loeb to Soby, October 28, 1958, James Thrall Soby Papers, The Museum of Modern Art Archives, New York.

566. Dupin 1962, pp. 292–94, and Rowell 1986, p. 29. It is unclear exactly when Miró began attending sessions at the Académie de la Grande Chaumière. Two letters to Matisse, from 98, boulevard Auguste-Blanqui, March 21 and April 6, 1937, mention going to the Académie.

567. Letter to Matisse. From 98, boulevard Auguste-Blanqui, March 7, 1937. See Permanyer 1978b (in Rowell 1986, pp. 292–93) and Rowell 1986, p. 315 (n. 6).

568. Letter to Matisse. From 98, boulevard Auguste-Blanqui, April 25, 1937. In Rowell 1986, p. 157.

569. Fluegel 1980, p. 309.

570. Excerpts in Rowell 1986, p. 157. Regarding the commission, see Dupin 1962, pp. 296–97, and Freedberg 1986, vol. 1, chap. 7, pp. 525–601.

571. Freedberg 1986, vol. 1, pp. 526–27, 580 (n. 6). According to Freedberg 1986, vol. 1, p. 596 (n. 88), Miró was responsible for Calder's involvement in the Spanish Pavilion project.

572. Duthuit 1936a. On the significance of this text, see Rowell 1986, p. 149.

573. London 1937b.

574. Galerie Jeanne Bucher guestbook. Roland Penrose, Paule Vézelay, and Douglas Cooper also attended this exhibition.

575. Paris 1937c and Rowell 1986, p. 29.

576. The exact dates of Miró's work on the mural are open to question. Photographs taken at the time establish that the work was painted *in situ*, so presumably, Miró was unable to begin until construction of the pavilion was more or less complete.

Rowell 1986, p. 29, suggests Miró worked on the mural from April through July 1937. Given Calder's recollection (see Freedberg 1986, vol. 1, pp. 526–27) that the site was still under construction in late April, and Miró's letter to Matisse, April 25, 1937, which suggests he had only recently been commissioned to execute the mural, it seems unlikely that he could have begun as early as April.

Freedberg argues that Miró would have begun the mural only upon completing *Still Life with Old Shoe* on May 29, 1937; see Freedberg 1986, vol. 1, pp. 527–28. Although Miró was surely capable of working on a variety of projects simultaneously, apparently there were construction delays which forced postponement of

the pavilion's opening from mid-June to July 12. If Picasso's *Guernica* was installed in the pavilion by mid-June (see Fluegel 1980, p. 309), Miró would certainly have been able to work on *The Reaper* by that point.

This, combined with Sert's recollection that the execution of the mural took around two weeks and that Miró worked on it until just a few days before the opening, suggest the period of execution can be approximately dated to sometime during June through perhaps early July. See Freedberg 1986, vol. 1, pp. 527–28, 581 (nn. 10, 11), for Sert's comments on the project.

577. According to Dupin 1962, p. 296, and Rowell 1986, p. 156, the overall dimensions of the mural were approximately 18' ½" × 11' 11¾" (5.50 × 3.65 m). For a detailed description of the site, see Freedberg 1986, vol. 1, pp. 529, 534–36. For a discussion of other aspects of the painting (title, theme, possible color scheme), see Freedberg 1986, vol. 1, chap. 7.

578. Reina Sofía 1987, p. 32.

579. Dupin 1962, pp. 299–300, as following *The Reaper*. Dupin does not mention *Three Personages* as among this group of works.

580. Letter to Matisse. From 98, boulevard Auguste-Blanqui, November 3, 1937. In Rowell 1986, pp. 157–58. See also Miró 1961 (in Rowell 1986, p. 257); Dupin 1962, p. 303; and Rubin 1973, p. 76.

581. In the collection of The Museum of Modern Art, New York, this portrait is inscribed "October 1937–January 1938." Cf. letters to Matisse, from 98, boulevard Auguste-Blanqui, November 3, 1937, and February 5, 1938 (in Rowell 1986, p. 158).

582. Galerie Jeanne Bucher guestbook. Others who attended this exhibition included Georges Hugnet, Hayter, Roland Penrose, Hans Arp and Sophie Taeuber-Arp, Max Ernst, and Francis Picabia.

583. Reina Sofía 1987, p. 164. The most detailed consideration of *The Reaper*'s fate is found in Freedberg 1986, vol. 1, pp. 576–78, 600 (and nn. 101–08), based largely on Sert's recollections.

584. Paris 1937g.

585. Letters to Matisse. From 98, boulevard Auguste-Blanqui, December 5, 1937, and February 5, 1938. According to Rowell 1986, p. 29, Miró remained at this address through at least April 1938. He was probably there even longer, to judge from dates inscribed on *Portrait I* (May 1938) and *Portrait IV* (June 1938), which presumably were painted in Paris.

Rowell 1986, p. 30, suggests Miró spent the summer at Varengeville. If so, he had left Varengeville by August 10, 1938, for Cassis, Bouches du Rhône.

586. Rowell 1986, p. 30. For mention of Marcoussis and Hayter, see Miró 1977, pp. 161–62 (without specific date).

587. Paris 1938a. According to Beaumelle 1991, p. 237, the exhibition opened on January 17, 1938.

588. Rowell 1986, p. 158.

589. Letter to Matisse. From 98, boulevard Auguste-Blanqui, April 7, 1938. In Rowell 1986, p. 159.

590. Letter to Matisse. From 98, boulevard Auguste-Blanqui, April 7, 1938. Cf. Rowell 1986, p. 30, and Freedberg 1986, vol. 2, pp. 897–98. Miró's only subsequent reference to this project found so far is in a letter to Matisse, from Paris, October 31, 1938.

591. Rowell 1986, p. 159. Miró did have a tracing made of *Self-Portrait I*, possibly by a draftsman in Paul Nelson's architectural firm named Freiss (spelling unconfirmed). It was only years later, however, that Miró "attacked" his portrait again, painting a head in very heavy contours over the tracing (Dupin 897). See also letter from Soby to Dorothy C. Miller and Alfred H. Barr, Jr., December 8, 1961, James Thrall Soby Papers, The Museum of Modern Art Archives, New York; Miró 1961, in Rowell 1986, pp. 257–58; and Picon 1976, vol. 2, p. 70.

592. New York 1938b.

593. London 1938a.

594. Lannes 1938.

595. Rowell 1986, p. 30, states that Miró spent his first summer at Varengeville in 1938 and suggests he painted a "fresco" for Nelson's living room around that time; cf. Dupin 1962, pp. 345–46. Freedberg 1986, vol. 2, pp. 897–98, provides a detailed description of the mural project along with illustrations (figs. M19, M19a) which establish that Miró painted a series of murals; she suggests, however, that they date to late 1938. Miró's letter to Matisse, from Paris, October 31, 1938, establishes he had worked on the paintings prior to that date.

596. Postcard to Matisse. From Cassis, Bouches du Rhône, August 10, 1938.

597. On October 31, 1938, Miró wrote to Matisse, from Paris, and on November 17, 1938, he wrote again, this time giving his full return address as 98, boulevard Auguste-Blanqui. The letter of October 31 suggests he might recently have been in Varengeville, as he reports the "frieze" in the Nelsons' house in Varengeville is complete but will not dry. He most probably was back in Paris by September, the date inscribed on the back of the nursery decoration (pp. 232–33). *Seated Woman I* (p. 236) is dated December 24, 1938, which suggests that Miró was still in Paris through that date.

598. Paris 1938b.

599. Miró's correspondence places him in Paris through late March 1939. The Galerie Jeanne Bucher guestbook indicates he was still in Paris at the time of Kandinsky's exhibition, June 2–17, 1939. According to Dupin 1962, pp. 348–52, in July Miró executed a series of paintings titled *Flight of a Bird over a Plain* (Dupin 520–23) in Paris prior to his move to Varengeville in August 1939. It should be noted, however, that at least one painting from this series, Dupin 520, is inscribed with the date September 10, 1938 (I am

grateful to Daniel Schulman of The Art Institute of Chicago for providing this information). Dupin also mentions these works were painted on the boulevard Garibaldi; this is the only reference found to Miró's having worked at such an address. Hirschfeld/Lubar 1987, p. 252, assign these works to Varengeville.

600. Galerie Jeanne Bucher guestbook.

601. Rowell 1986, p. 30.

602. Letter to Tzara. From 98, boulevard Auguste-Blanqui, February 15, 1939. See also Miró 1977, p. 31.

603. Paris 1939a.

604. Galerie Jeanne Bucher guestbook. Other names listed include Lipchitz, the Arps, and Jeannine Picabia.

605. Paris 1939b and "A l'Association des Peintres," *Beaux-Arts* (Paris), vol. 76, no. 325 (March 24, 1939), p. 8.

606. New York 1939b.

607. London 1939a and Warnod 1939.

608. Galerie Jeanne Bucher guestbook. Others who signed the guestbook include Kandinsky, Raoul Hausmann, Bellmer, Freundlich, S. W. Hayter, Giacometti, Eluard, and Tristan Tzara.

609. Galerie Jeanne Bucher guestbook. Léonce Rosenberg's signature also appears, as do those of the Arps.

610. Paris 1939f.

611. (Rowell 1986, p. 320, n. 2, has Miró storing works at Lefebvre-Foinet in the spring.) Miró did not retrieve his stored work until at least 1956, when he moved into his new studio in Palma.

612. Letter to Matisse. August 25, 1939. See also Dupin 1962, p. 346; Rowell 1986, p. 30; and Miró 1977, p. 129.

613. Dupin 1962, p. 352; Miró 1977, p. 129; and Rowell 1986, p. 30.

614. Derouet 1985, p. 15.

615. Dupin 1962, p. 354. Dupin 524–28 and 529–37.

616. Miró's correspondence with Matisse establishes he was in Varengeville through May 2; the last Constellation completed in Varengeville, *Acrobatic Dancers* (p. 247), was completed on May 14, 1940.

617. Regarding this series and what Rowell describes as Miró's "'constellated' structure," see Rowell 1993, pp. 14–41. See also Rowell 1986, pp. 167, 169, 228.

618. Mexico City 1940.

619. Letter to Matisse. From Varengeville, January 12, 1940.

620. Rowell 1986, p. 168.

621. Letter to Matisse. From Varengeville, February 4, 1940.

622. Rowell 1986, p. 168. Rowell translates "*série sur la grosse toile*" as "series of large canvases" but omits the dimensions of these works, which correspond to those of the series of paintings on burlap (Dupin 529–37); the word *grosse*, then, might be translated as "coarse," rather than "large." The series of 38 × 46 paintings that Miró refers to is clearly the Constellations.

623. Letter to Matisse. From Varengeville. February 25, 1940.

624. New York 1940b.

625. Sweeney 1941 is the monograph referred to in this letter.

626. Dupin 1962, p. 356, suggests Miró left Varengeville on May 20, 1940; this date remains unconfirmed. He also mentions that Miró caught a train to Paris from Dieppe. Pilar Juncosa de Miró, in conversation with C. Lanchner and A. Umland, Palma, July 1991, mentioned they had stopped in Rouen and Paris, and although she and Miró had discussed the possibility of going to America, they ultimately decided to return to Spain. Miró's own version of the story, as told to Raillard, closely parallels his wife's recollections; see Miró 1977, pp. 30–31. Miró's letter to Matisse, June 6, 1940, sent from Perpignan, confirms they had stopped in Paris.

627. Postcard to Tzara. From Perpignan, June 1, 1940.

628. It is not known whether Miró left Perpignan on June 8 as planned. Nor is his subsequent itinerary certain. According to Dupin 1962, p. 356, Prats met them at the frontier and dissuaded them from going to Barcelona; because of this they went to Vic, a town west of Girona, where Miró's sister lived, and after that, to Palma to stay with Pilar's family. For a slightly different version, see Miró 1977, pp. 30–31. Miró did not mention Vic in this account, although he was undoubtedly the source of Dupin's information.

629. On July 7, 1940, Matisse wrote to Pilar, telling her they had been happy to hear from them; there is no indication whether this letter was addressed to Barcelona or to Palma, where the Mirós eventually settled. By July 31, 1940, Miró would inscribe and date a number of sketches in a notebook (FJM 1774–1841) "Palma Mallorca. | 31/7/40"; see Fundació Joan Miró 1988, pp. 213–15. Dupin 1962, p. 356, states that Miró was in Palma by August 1, 1940, and resumed work on the Constellations at that time. By August 22, 1940, Pilar wrote to Matisse providing the following return address: "Pilar Juncosa de Miró, c. San Nicolas 22, Palma Mallorca, (Baleares) *Spain*," which was her parents' home.

630. Miró's whereabouts are established by Pilar Juncosa de Miró's letters to Matisse (January 7, March 25, and April 28) and by the dates and locations inscribed on the versos of the Constellations Miró completed during this period. The last Constellation completed in Mallorca (p. 257) is dated June 12, 1941.

631. New York 1941b.

632. He remained in Montroig through at least September 12, 1941, when he completed the twenty-third and final Constellation. By November 15, 1941, he was back in Palma and had visited Barcelona sometime prior to that date (see letter from Pilar Juncosa de Miró to Matisse, from Carrer de les Minyones, 11, November 15, 1941). Picon 1976, vol. 2, p. 17, transcribes an entry from one of Miró's notebooks as "Montroig, 9 April 1941."

Because he does not reproduce the page, it is unclear if this is an error in transcription. There is no other evidence that Miró was in Montroig prior to summer 1941.

633. This notebook is translated in its entirety in Rowell 1986, pp. 175–98, and is in the collection of the Fundació Joan Miró, Barcelona.

634. Although Miró carefully noted on the verso the place in which each Constellation was completed (Varengeville, Palma, Montroig), he told Permanyer in 1978 that he had "painted the Constellation series in Varengeville, Palma, Barcelona, Montroig, and again in Barcelona, where I finished it." See Permanyer 1978b (in Rowell 1986, p. 294). It has proved impossible to verify this statement.

635. Letter to Matisse (Miró's handwriting, signed by Pilar Juncosa de Miró). From Palma, Carrer de les Minyones, 11 entresol, November 15, 1941.

636. Ibid. For some reason, the Mirós seem not to have returned to Carrer de Sant Nicolau, 22, or at least, noted a different return address on this letter, Carrer de les Minyones, 11 entresol. Years earlier, Miró had sent a postcard to Ricart and Ràfols from this same street address (see above, under April 14, 1918).

637. New York 1941g.

638. Postcard to Foix. From Carrer de les Minyones, 11, January 5, 1942. Miró's signature is clearly legible on this card, suggesting he was no longer concerned with anonymity at this point. By February 26, 1942, Miró was in Barcelona (letter to Matisse). (Rowell 1986, p. 30, has Miró in Palma during the entire month of February.) A drawing executed in Palma is dated June 2, 1942 (see Yokohama Museum of Art 1992, p. 92), suggesting that he remained there through June before leaving for Barcelona and Montroig.

639. Miró produced numerous works on paper in 1942; see Centre Pompidou 1978, pp. 77–82, and Yokohama Museum of Art 1992, pp. 92–96. A number of miscellaneous sketches and notes dated 1942 are reproduced in Fundació Joan Miró 1988, pp. 231–38. Cf. Dupin 1962, pp. 372, 496.

640. Letter to Matisse. From Passatge del Crèdit, 4, February 26, 1942.

641. Letter to Matisse. From Passatge del Crèdit, 4, July 11, 1942.

642. Ibid. Cf. Rowell 1986, p. 31.

643. New York 1942d.

644. New York 1942a; Whitney 1989, p. 150; and Beaumelle 1991, p. 352.

645. Both are visible in photographs of Kiesler's installation; see Goodman 1989, p. 62.

646. He was in Montroig through September 8, 1942 (letter from Pilar Juncosa de Miró to Moncha Sert), but may have been in Barcelona by October, in time for his daughter to start school. A drawing in Yokohama Museum of Art 1992, p. 95, is inscribed "Barcelone, 29-10-1942," suggesting that he had settled in Barcelona by late October. Rowell 1986, p. 30, states that in 1942 Miró took an apartment at

Carrer Folgaroles, 9, and kept a studio at Passatge del Crèdit, 4. Miró does not, however, seem to have moved to the Folgaroles address until 1950.

647. Letters to Matisse and Sert. From Passatge del Crèdit, 4, respectively July 11, 1942, and March 10, 1943.

648. Dupin 1962, p. 466, based on Artigas's own recollections published in *Derrière le miroir* 1956. Nineteen forty-two is commonly given as the year in which Miró first invited Artigas to work with him. The Galerie Adrien Maeght owns a Miró-Artigas *Vase* (p. 298) that they date as 1941 (see note 660, below, for dating of Miró and Artigas's first realized collaborative efforts).

649. New York 1942g.

650. Miró's whereabouts during the war years are difficult to trace; his letter to Matisse, from Passatge del Crèdit, 4, July 11, 1942, suggests he intended to stay in Barcelona through the winter of 1942–43, just as another letter to Matisse, from Passatge del Crèdit, 4, June 1, 1943, sent from Barcelona, suggests they plan to spend the summer in Montroig. Based on Miró's past habits, he may have remained in Barcelona through June and left for Montroig in July.

651. Letter to Sert. From Passatge del Crèdit, 4, March 10, 1943.

652. Chicago 1943.

653. Published in excerpted form in Sweeney 1945, p. 126, where it is dated November 1943. Despite Miró's penchant for planning in advance, it seems odd that he would refer to "this summer" (presumably the summer of 1944) at such an early date. Because Sweeney's papers are unavailable to researchers, we have been unable to examine the date inscribed on this letter. It seems plausible that it might have been written in June 1943, from around the same time as Miró's letter to Matisse of June 1, 1943, which also refers to plans to make sculpture during the summer. Dupin 1962, p. 375, and Rowell 1986, p. 173, suggest Miró did not resume painting until 1944; there is, however, at least one painting dated 1943, found in the collection of the Fundació Joan Miró, Barcelona (FJM 4680).

654. There are no sculptures dated 1943 in Jouffroy/Teixidor 1974.

655. Letter to Matisse. From Passatge del Crèdit, 4, June 1, 1943. Here, Miró mentions he intends to vacation in Montroig; he most likely referred to the summer months of July, August, and September.

656. On November 24, 1943, Miró wrote to Matisse from Passatge del Crèdit, 4, and on December 22, 1943, he wrote to Ricart from Barcelona.

657. Paris 1943.

658. Derouet 1985, p. 59.

659. On March 7 he wrote to Valentine Dudensing, from Barcelona; in May, Joaquim Gomis took many photographs of Miró in Barcelona, including some of the studio at Passatge del Crèdit, 4; and on

May 15 and June 17, 1944, Miró sent letters from Barcelona to Paulo Duarte and Pierre Matisse, respectively. All of the above suggests that Miró was probably in Barcelona from January through June 1944.

660. Nineteen forty-four is the year commonly assigned to Miró and Artigas's first realized collaborative efforts; see, for example, Dupin 1962, pp. 466, 468; Rubin 1973, p. 90; Rowell 1986, pp. 31, 233; and Jeffett 1989b, p. 127.

661. In excerpted form in Sweeney 1945, p. 126; dated February 1944.

662. Courtesy of the Pierre Matisse Foundation, New York. An English transcription of this letter is in the Museum Collection Files (Miró—General), The Museum of Modern Art, New York. There are errors in the English translation. (Notably, the dimensions of the "twenty-two" pictures referred to are given as 38 × 46 *inches*, and the date of the last of this series is given as December 9, 1941. In fact, the Constellations' dimensions are 38 × 46 centimeters, and the last is inscribed "12-9-41"—in other words, 12 September 1941.) The original French version of this letter provides accurate information which securely identifies the Constellations. The location of Miró's original letter quoted by Duarte is unknown.

663. The location of the original of this letter is unknown. It is quoted in a letter from Dudensing to Monroe Wheeler, October 30, 1944, and Dudensing noted that it was sent from Barcelona and dated March 7. For various reasons, the Museum decided not to exhibit this series of works and turned them all over to Pierre Matisse, who exhibited them in 1945.

664. Many of these photographs are found in the Pierre Matisse Foundation, New York, dated May 1944.

665. Rowell 1986, pp. 31, 173, dates these lithographs to 1944, whereas Jeffett 1989b, pp. 126–27, states they were begun in 1939 (thus in Paris) and completed in 1944. A letter to Duarte, from Passatge del Crèdit, 4, May 15, 1944, mentions a series of fifty lithographs, mostly measuring 70 × 50 centimeters, completed sometime in May 1944.

666. New York 1944d.

667. Death Announcement. Courtesy Biblioteca de Catalunya, Barcelona.

668. The original of this letter was probably in French. A translated and transcribed copy is in the Museum Collection Files (Miró—General), The Museum of Modern Art, New York.

669. There are four sketches in a notebook at the Fundació Joan Miró, Barcelona (FJM notebook 3509–3533) which relate to ceramics executed during the following two years. They are dated August 7, 1944 (FJM 3510), August 22, 1944 (FJM 3511), August 31, 1944 (FJM 3512), and September 20, 1944 (FJM 3513). FJM 3512 relates to *Light Blue Head* (p. 262), and FJM 3511 relates to *Brown Personage* (p. 262).

670. Letter from Matisse to James Thrall Soby. November 28, 1944. Museum Collection Files (Miró—General), The Museum of Modern Art, New York.

671. See Dupin 643–61. These works were most probably executed in the studio at Passatge del Crèdit, 4, and their dates (inscribed by day, month, and year) span a period from January 26, 1945, through July 7, 1945, which suggests that Miró was in Barcelona during this period, as does his correspondence (the earliest known letter is to Michel Leiris, March 20, 1945; the latest to Rebeyrol, June 19, 1945). The last painting of this series was completed on October 8, 1945.

672. New York 1945a. For general comments on the impact of this exhibition, see Dupin 1962, p. 360; Rubin 1973, pp. 81–82; Miró 1977, p. 22; and Rose 1982a, pp. 5, 33.

673. Letter from Matisse. January 17, 1945. Here he told Miró, "On the advice of a number of people, [Sert], Sweeney, Breton and Duarte, I decided to display only sixteen of the twenty[-two] gouaches. . . ." Matisse did, however, plan to rotate the sixteen Constellations, so that each would be on view at one time or another. This same excerpt is published in Beaumelle 1991, p. 363, although Sert's name is omitted.

674. In this letter, Matisse makes a very early reference to a project that would come to fruition only in 1959: the publication of a portfolio of facsimiles of the gouaches.

675. New York 1945b.

676. Courtesy of the Pierre Matisse Foundation, New York.

677. Paris 1945a.

678. See Dupin 1962, p. 378, regarding the series of large paintings on black or white grounds.

679. The organizers of this exhibition, which did not take place, were Monsieur Rebeyrol and Docteur Laugier; see Rowell 1986, p. 317 (n. 4).

680. Although Miró was in Barcelona through June 19, 1945 (letter to Rebeyrol, from Passatge del Crèdit, 4), it is unclear when he left for Montroig. It is probable that he went after completing *Spanish Dancer* (p. 267) on July 7, 1945.

681. Letter to Matisse. From Montroig, September 14, 1945.

682. Letter to Matisse. From Passatge del Crèdit, 4, October 3, 1945.

683. Miró wrote to Matisse from Passatge del Crèdit, 4, on the following dates in fall 1945: October 30, November 7, 8, and 18; he wrote to Breton on December 19. This suggests he was continuously in residence at this address through December.

684. For a terra-cotta version of *Bird* (p. 262), see Gomis/Prats 1959, pl. 29, dated 1945. Although the two bronze *Birds* (p. 262) are often dated 1944 (see, for example, Sylvester 1972, p. 9), sketches for them appear in a notebook in the Fundació Joan Miró, Barcelona (see FJM

3520a, FJM 3521) dated December 1945. On both of these notebook pages appears a note suggesting the bronze versions were completed in 1946.

685. Letters to Loeb, from Passatge del Crèdit, 4, January 27, 1946, and to Tzara, from Barcelona, July 20, 1946, mentioning plans to leave for the country in a few days.

686. See note 684, above. According to Fundació Joan Miró 1988, p. 474, Miró's first bronzes were made in 1946.

687. Pictures taken of Alexina Matisse, Miró, Prats, and Gomis are dated July 1946 (Pierre Matisse Foundation, New York). See also letter to Matisse, from Barcelona, July 20, 1946.

688. This letter and others related to *L'Antitête* are published in Jeffett 1993, pp. 89–93.

689. Letter to Matisse. From Montroig, September 22, 1946.

690. In the archives of the Pierre Matisse Foundation, New York, is a contract between Miró and Matisse that arranges for the disposition of his "oeuvre de guerre" (works from 1942–46), signed by Miró and dated as "Barcelona, July 30, 1946." Perhaps the contract was backdated, as it is evident not only from Matisse's letter to Miró of August 16 but also from Miró's to Matisse of September 3, 1946, that many details were ironed out after July 30, 1946.

691. Letter to Matisse. From Montroig, September 22, 1946.

692. Miró's correspondence establishes he was in Barcelona from early October through December 1946: see letters to Tzara, October 10; to Matisse, October 13, November 21 and 29; to Sert, November 29; to Matisse, December 18 and 22; and to Sert, December 22. Pilar Juncosa de Miró wrote to Sert's wife, Moncha, on December 29, 1946, also from Barcelona.

693. Letter from Matisse. December 20, 1946.

694. Letter to Sert. From Barcelona, January 15, 1947.

695. Miró painted the Cincinnati mural in Carl Holty's studio, 149 East 119th Street (at Lexington Avenue); see letter to Sert, from New York, October 14, 1947.

696. Letter to Matisse. From Barcelona, January 26, 1947. On Miró's stay in Lisbon, see *Diário de Lisboa* 1947 and *Século* 1947.

697. Letter to Matisse. From Barcelona, January 26, 1947. Jeffett 1989b, p. 127, erroneously suggests Miró first visited the United States in 1946.

698. Correspondence to and from Miró indicates the family resided at a number of different addresses during their stay in New York: initially their address was 950 First Avenue; followed by 235 East Forty-sixth Street, c/o Richard de Rochemont; then 320 East Seventy-second Street, c/o Pierre Matisse, and 230 East Fifty-seventh Street, c/o Pierre Matisse; and finally 15 East Fifty-ninth Street, c/o J. L. Sert. Miró's letter to Sert of October 14, 1947,

makes clear they remained in the latter's apartment through the end of their stay.

Regarding Miró's trip to New York, see Dupin 1962, pp. 385–88; Miró 1977, p. 162; McCandless 1982, p. 58; Rose 1982a, p. 35; Rose 1982b, p. 120; and Rowell 1986, pp. 31, 201, 279.

699. Largely based on correspondence to and from Miró, along with photographs from the period. See also Greenberg 1948, p. 38, and Whitney 1989, p. 152.

700. Dupin 1962, p. 496; Rose 1982a, p. 35; and Rowell 1986, p. 31. For detailed discussion of *L'Antitête*, see Jeffett 1993, pp. 81–93. Hayter's Atelier 17 had been temporarily moved from Paris to New York during the war.

701. In a 1981 interview with Barbara Rose, Miró said he met Jackson Pollock at Hayter's Atelier 17; see Rose 1982b, p. 120. Rowell 1986, p. 31, and Hirschfeld/Lubar 1987, p. 252, agree Miró met Pollock in 1947 although so far no other evidence has been found to confirm this encounter.

702. Miró provided Sert with this address in a letter of October 14, 1947. Rose 1982a, p. 35, mistakenly notes that Holty's studio was in the East Nineties.

703. A. Umland, interview with Diane Bouchard, Cape Cod, Mass., August 1992. Bouchard produced two films on Miró, the first titled *Miró Makes a Print*, released in 1948, and the second, longer film, titled *Around and About Joan Miró*, released in 1955.

704. Letter to Gérald Cramer. From [9]50 First Avenue, March 19, 1947.

705. Letter from Matisse to E. F. Ireland, Vice President of Thomas Emery's Sons (the company that commissioned the mural), April 11, 1947. Cf. Dupin 1962, p. 386.

706. New York 1947b.

707. Receipt made out to J. Miró, C.O.D. Gallery Pierre Matisse. From Robert Rosenthal, Inc., New York, May 26, 1947.

708. Whitney 1989, p. 152, and Goodman 1989, p. 73. Illustrated *in situ* in Beaumelle 1991, p. 397.

709. Letters from Arnold Newman to Kristin L. Spangenberg, Cincinnati Art Museum, December 12, 1975, and December 24, 1986. Courtesy Jean Feinberg, Curator, Cincinnati Art Museum.

710. Lee 1947, p. 67.

711. Paris 1947b. Opening date based on Beaumelle 1991, p. 396. Rowell 1986, p. 31, suggests this exhibition was held in spring 1947.

712. On August 8, 1947, Cartier-Bresson sent Miró a letter, addressed to 320 East Seventy-second Street, which was forwarded to Sert's at 15 East Fifty-ninth Street.

713. Letter from Arnold Newman to Kristin L. Spangenberg, Cincinnati Art Museum. December 12, 1975. Courtesy Jean Feinberg, Curator, Cincinnati Art Museum.

714. Quoted in Rose 1982a, p. 35. According to the chronology in Houston

1982, p. 127, Miró met Adolph Gottlieb during his stay in New York, but it is not indicated where or when.

715. Letter from Jean Feinberg to C. Lanchner, October 9, 1991.

716. Letter to Sert. October 14, 1947.

717. On November 19, 1947, he wrote to Sert from Barcelona, mentioning he had been in Montroig.

718. Courtesy of the Pierre Matisse Foundation, New York.

719. Miró cabled Pierre Matisse on January 15, 1948, from Barcelona and wrote to Matisse again on February 2, 1948, again from Barcelona. By February 11, 1948, Miró was in Geneva (see postcard to Tzara, from Geneva).

720. Sweeney 1948.

721. Postcard to Tzara. From Geneva, February 11, 1948.

722. Letter to Matisse. From the Hôtel Pont-Royal, rue Montalembert, February 18, 1948.

723. Although Miró refers to Maeght as "Mr. Megh," there is little question that Aimé Maeght is indeed the person in question. Cf. Dupin 1962, p. 392. Miró's first one-artist exhibition at the Galerie Maeght, Paris, was held November 19–December 18, 1948 (Paris 1948b). From then on, Aimé Maeght represented Miró's work in France and published many of his prints and illustrated books.

724. New York 1948a and Rubin 1973, p. 10.

725. Letters to Sert and Matisse. From Paris and Golfe-Juan, respectively March 2 and 8, 1948.

726. Ibid.

727. New York 1948b.

728. According to Dupin 1962, p. 555, *The Red Sun* (p. 272) is dated March 20, 1948, but no verifying inscription appears on the work itself. By April 5, 1948, Miró sent a note to Tzara, from Passatge del Crèdit, 4.

729. Dupin 1962, p. 555, provides this date for *The Red Sun Gnaws at the Spider*, but no verifying inscription appears on the work itself.

730. See *Destino* 1948. Cf. Szarkowski 1984, pp. 23–24 and pl. 11.

731. Letters to Sert and Matisse. From the Hôtel Pont-Royal, respectively October 14 and 19, 1948.

732. Paris 1948b.

733. Dupin 1962, p. 392.

734. Letters from Matisse, November 23, 1948, and to Matisse, December 3, 1948.

735. New York 1949a.

736. Barcelona 1949. For installation views, see C. 1949. Miró exhibited infrequently in Spain during Franco's regime; see the Exhibition History, passim.

737. Rowell 1986, p. 225. In 1949, Santos Torroella published an important monograph on Miró (written by J. E. Cirlot) and a special issue of his magazine *Cobalto* in homage to Miró.

738. Letter to Cramer. October 2, 1949. In Rowell 1986, p. 215.

739. New York 1949e.

740. Cable from Matisse, December 19, 1949, and letter to Sert, from Passatge del Crèdit, 4, January 23, 1950.

741. According to the Fogg Art Museum Archives, Harvard University, Cambridge, Mass., Miró was chosen by Walter Gropius, with the support of Alfred H. Barr, Jr., of The Museum of Modern Art, and professors John Coolidge and Fred Deknatel.

742. Cf. letter to Matisse. February 22, 1950.

743. Dupin 1962, p. 556, provides this date for the painting, but no verifying inscription appears on the work itself.

744. Fogg Art Museum Archives, Harvard University, Cambridge, Mass. Cf. Rubin 1973, p. 87. Macmillan 1982, p. 102, erroneously suggests Miró *sent* the sketch on March 15, 1950.

745. Dupin 1962, p. 556, provides this date for *Painting*, but no verifying inscription appears on the work itself.

746. Paris 1950. Opening date based on an exhibition invitation found in the Miró Scrapbook, The Museum of Modern Art, New York. According to *Derrière le miroir* 1950 and Rowell 1986, p. 32, the exhibition opened in May. See also Rowell 1986, p. 319 (n. 3), and Dupin 1962, p. 393.

747. On November 22, 1950, he would write to Breton, giving Carrer Folgaroles, 9, as the return address. Presumably, he moved sometime after his letter to Tzara from Passatge del Crèdit, 4, July 12, 1950. Cf. note 646, above.

748. Dupin 1962, p. 39, and letter to Sert, from Carrer Folgaroles, 9, January 29, 1951.

749. On a Museum of Modern Art Artist's Questionnaire (March 16, 1964), Miró noted this work was executed in "Barcelona (Pasaje Crédito 4)."

750. Letter to Sert. From Carrer Folgaroles, 9, January 29, 1951. Mentions he will work at Carrer Folgaroles, 9, and on large paintings at Passatge del Crèdit, 4.

751. Letter to Sert. From Carrer Folgaroles, 9, January 29, 1951.

752. Paris 1951; and see the entry for the Harvard University *Mural Painting* in the Catalogue section of the present volume (cat. 191).

753. Conlan 1951.

754. New York 1951a.

755. Santos Torroella 1951 (in Rowell 1986, pp. 226–27).

756. Collection records (former accession number 1950.168), Fogg Art Museum, Harvard University, Cambridge, Mass., and *Harvard Alumni Bulletin* 1951.

757. New York 1951c.

758. See the Studio Paul Facchetti guestbook for the Pollock exhibition, reproduced in Centre Pompidou 1982, pp. 294–95. For comments on Miró's visit to Pollock's exhibition and the impact of American painting on his work, see Krauss 1972, pp. 36–37; Rowell 1972, p. 64; Miró 1977, p. 97; Rose 1982b, p. 120; and Rowell 1986, p. 279.

759. New York 1952b.

760. Letter to Matisse. From Barcelona, May 13, 1952.

761. Matisse sent Miró a cable in Paris on May 21, 1952, which outlined the following itinerary: "Arrive Monday [June 2] Cincinnati Wednesday [June 4] Boston Thursday [June 5] Depart 10 June Please cable to confirm." Miró cabled Matisse (the cable was stamped May 23, 1952) telling him he agreed to the proposed schedule.

762. See note 761, above. Cf. Macmillan 1982, p. 102.

763. See note 761, above.

764. Letter to Sert. From Barcelona, December 22, 1952.

765. See note 761, above.

766. Paris 1953.

767. New York 1953b.

768. Dupin 1962, p. 470, notes that the vast program developed by Miró and Artigas was not carried out until 1954 and 1955. This is supported by a letter from Miró to Aimé Maeght, June 7, 1954, and another from Miró to Breton, January 18, 1955. Cf. Rowell 1986, pp. 33, 233; Hirschfeld/Lubar 1987, p. 253; and Jeffett 1989b, p. 127, who all suggest that Miró's renewed collaboration with Artigas began in 1953.

769. Dupin 1962, pp. 470–73, based on *Derrière le miroir* 1956.

770. Krefeld 1954.

771. Dupin 1962, p. 473.

772. Letter to Matisse. From Barcelona, June 8, 1954.

773. Venice 1954. Miró was clearly upset that the grand prize for painting went to Max Ernst rather than himself; see letters to Aimé Maeght and Matisse, respectively July 27 and September 14, 1954.

774. Dupin 1962, pp. 439, 478; Rowell 1986, p. 33.

775. Kassel 1955.

776. Letter to Matisse. From Montroig, October 20, 1955. For descriptions of this project, see *Derrière le miroir* 1958; Dupin 1962, pp. 473–74; Rowell 1986, pp. 33, 242; and an article by Deborah Goldberg forthcoming in *Apollo* (London).

777. Telegram from Matisse. Addressed to Carrer Folgaroles, 9, December 9, 1955.

778. Letters to Matisse, January 16 and February 1, 1956, and Sert, February 22, March 15, and May 21, 1956.

779. Brussels 1956.

780. Bernier 1956.

781. Dupin 1962, p. 473.

782. Paris 1956. See the announcement in the Miró Scrapbook, The Museum of Modern Art, New York, for the opening date.

783. Rowell 1986, p. 33.

784. Ibid. Cf. *Derrière le miroir* 1958 (in Rowell 1986, pp. 242–45).

785. New York 1956.

786. See letter from Artigas to Matisse, from Gallifa, March 28; postcard to Sert, from Gallifa, July 23; letter to Matisse, from Palma, September 6; and letter to Dupin, from Palma, September 19, 1957.

787. Rowell 1986, p. 33; see also *Der-*

rière le miroir 1958 (in Rowell 1986, p. 243).

788. According to Rowell 1986, p. 43, the French poet and critic Jacques Dupin was commissioned by Harry N. Abrams to write a monograph on Miró in 1956.

789. Krefeld 1957.

790. Rowell 1986, p. 34. Cf. letter to Matisse, from Palma, August 11, 1957.

791. Miró and Matisse discussed this project extensively in subsequent letters, and in 1959 an edition containing twenty-two facsimiles of the Constellations, along with texts by André Breton, was published in a limited edition of 350 copies. See Dupin 1962, p. 580.

792. Letter to Dupin. From Palma, January 2, 1958.

793. Paris 1958.

794. *Derrière le miroir* 1958 (in Rowell 1986, p. 245).

795. Letter to Matisse. From Palma, August 25, 1958.

796. See Cooper 1958 and Rowell 1986, p. 34.

797. New York 1958d.

798. Paris 1959a.

799. New York 1959a. Cf. letter from Matisse, March 18, 1959.

800. New York 1959b.

801. On the impact of Miró's visit to the United States in 1959 on his later work, see Rowell 1986, pp. 278–79.

802. Letter to Matisse. From Palma, April 14, 1959. Rowell 1986, p. 34, suggests this was Miró's second trip.

803. Letter to Matisse. From Palma, March 30, 1959.

804. Archives of the Pierre Matisse Foundation, New York.

805. Ibid. Names appear in the order of the guest list.

806. *New York Times* 1959, p. 15. (Dupin 1962, p. 475, as May 19.)

807. Archives of the Pierre Matisse Foundation, New York.

808. Letter from Agnes Mongan to Soby. May 29, 1959. Courtesy Fogg Art Museum Archives, Harvard University, Cambridge, Mass.

809. Letter to Matisse. From Palma, March 6, 1959.

810. FJM 2446. See the entry in the Catalogue section of the present volume (cat. 198).

811. FJM 2444 and 2445. See the entries in the Catalogue section (cats. 199, 200).

812. Rowell 1986, p. 34, without specific date. See letters to Matisse, December 19, 1959, and to Sert, September 18, 1960.

813. Letter to Sert. From Montroig, September 18, 1960. See also Miró 1961 (in Rowell 1986, p. 260).

814. Barcelona 1961. See also *Derrière le miroir* 1961a.

815. See entries for February 27 and May 6, 1960.

816. Miró 1961 (in Rowell 1986, pp. 258–59).

817. Paris 1961a.

818. Paris 1961b.

819. New York 1961d.

820. Letter to Sert. From Palma, October 31, 1961.

821. The French edition of Dupin's book was published in 1961; the English edition in 1962. For Miró's comments on the book, see letter to Dupin, from Montroig, September 26, 1962.

822. Paris 1962b.

823. Letter to Sert, from Palma, February 28, 1962; letter to Dupin, May 27, 1962; and telegram to Picasso, from Saint-Paul-de-Vence, July 21, 1962. See also Freedberg 1986, vol. 1, p. 598.

824. Letter to Sert. From Palma, March 17, 1963.

825. Paris 1963. For the opening date, see letter to Sert, from Palma, May 24, 1963.

826. Messer 1987, p. 226.

827. New York 1963a.

828. Letters to Sert. From Saint-Paul-de-Vence and Palma, respectively March 5 and March 16, 1964.

829. Letter to Patricia Matisse. From Palma, April 5, 1964. Cf. Rowell 1986, p. 35.

830. See Rowell 1986, p. 35. See also Macmillan 1982, p. 108.

831. London 1964b.

832. Letters to Penrose, from Palma, August 6, 1964, and to Patricia Matisse, September 26, 1964. See also Perucho 1968, p. 196, and Penrose 1981, p. 277 (figs. 668, 670, 671).

833. Paris 1965.

834. Letter to Patricia Matisse. From Palma, October 6, 1965. Rowell 1986, p. 35, dates this trip to November.

835. New York 1965a.

836. Rowell 1986, pp. 35, 273, 321 (n. 3).

837. Ibid., p. 35.

838. Rowell 1986, p. 274, puts this work in 1966, after Miró's fall 1966 trip to Japan.

839. London 1966.

840. Tokyo 1966.

841. Letters to Matisse and Dupin. From Montroig, respectively August 25 and 26, 1966. According to Rowell 1972, p. 64, Miró visited both Tokyo and Kyoto in 1966. For Miró's general comments on his trip to Japan, see Miró 1977, p. 36, and Rowell 1986, p. 279.

842. Rowell 1986, p. 35.

843. Cable from Matisse. To Paris, May 8, 1967.

844. Cable from Matisse. To Paris, May 6, 1967.

845. Miró possibly refers here to the Parellada foundry, located outside Barcelona.

846. Cable from Matisse, to Palma, stamped with date October 26, 1967; and Rowell 1986, p. 35 (without specific date).

847. New York 1967b.

848. Letter to Dupin. February 23, 1968. See also Macmillan 1982, p. 106. In a letter to Sert, from Palma, October 19, 1968, Miró mentioned that this mural had been completed.

849. New York 1968a.

850. Rowell 1986, p. 35 (without specific date).

851. Ibid. (as June).

852. Schwartz 1968, p. L7.

853. Ibid.

854. Saint-Paul-de-Vence 1968.

855. Barcelona 1968.

856. Munich 1969.

857. Cf. Rowell 1986, p. 36.

858. Ibid. See also Macmillan 1982, p. 106.

859. See Fundació Joan Miró 1988, pp. 542, 480. The Fundació opened to the public on June 10, 1975. As its full name suggests, the foundation was conceived by Miró not only as an institution for the preservation and study of his own work but also as a center whose support of the arts would stimulate creativity of artists both in Catalonia and around the world.

860. Letter to Matisse. April 16, 1970.

861. New York 1970c.

862. Letter to Matisse. May 25, 1970.

863. Paris 1970a.

864. Minneapolis 1971.

865. Paris 1971.

866. London 1972.

867. Letter to Matisse. From Palma, February 5, 1972.

868. New York 1972a.

869. See, for example, Rubin 1973, pp. 104–05, 135. Cf. Hirschfeld/Lubar 1987, p. 255.

870. Letter to Sert. From Palma, March 26, 1972.

871. Barcelona 1972.

872. Regarding this project, see Miró 1977, p. 95.

873. Zurich 1972.

874. Letter to Matisse from Joaquim Gomis. August 9, 1972.

875. New York 1972d.

876. Paris 1973.

877. Saint-Paul-de-Vence 1973a.

878. New York 1973a.

879. Letters to Rubin. From Palma, June 10 and July 20, 1973.

880. Rowell 1986, p. 37, suggests that this ballet was performed at the Fondation Maeght during summer 1973. According to Jacques Dupin (conversation with C. Lanchner, February 1993), only the costumes were tried out at the Fondation; the actual performance was given at the Venice Biennale in 1980.

881. New York 1973b.

882. New York 1973c.

883. Rowell 1986, p. 37.

884. Ibid.

885. Taillandier 1974 (in Rowell 1986, p. 283).

886. Paris 1974b.

887. Paris 1974c.

888. New York 1975b.

889. Rowell 1986, p. 37.

890. Barcelona 1975a.

891. Barcelona 1975b. For the opening date, see Miró 1977, p. 91.

892. Rowell 1986, p. 37.

893. Ibid.

894. Ibid.

895. Fundació Joan Miró 1988, pp. 543–44 and passim.

896. New York 1976a.

897. Rowell 1986, p. 37.

898. New York 1976c.

899. Larose 1979, p. 48, and Armengaud 1979, p. 47.

900. Rowell 1986, p. 302.

901. Ibid., p. 37 (for the University of Kansas, Wichita).

902. Hirschfeld/Lubar 1987, p. 256.

903. Larose 1979, p. 48.

904. Rowell 1986, p. 37.

905. Ibid., p. 38. See Miró 1977, p. 114, for comments on this project.

906. Rowell 1986, p. 38.

907. Penrose 1981, p. 276 (fig. 665). This film is available in video form as *Joan Miró: Theatre of Dreams* (London: RM Arts/BBC Television Co-Production, 1978).

908. Vilà i Folch 1978, pp. 51–53, and Permanyer 1978a, p. 70.

909. See Rowell 1986, p. 302, regarding the sources and significance of this work.

910. Madrid 1978a.

911. Bernard 1978 (in Rowell 1986, p. 304).

912. Madrid 1978b.

913. Vilà i Folch 1978, p. 52, and Penrose 1981, p. 276. According to Rowell 1986, p. 37, *Mori el Merma* was also performed in Berlin, Rome, and Belgrade during the spring and summer of 1978.

914. Penrose 1981, p. 276.

915. Ibid., p. 277 (without specific date).

916. Paris 1978a.

917. Paris 1978b.

918. Paris 1978c.

919. New York 1978.

920. Hirschfeld/Lubar 1987, p. 256, and Permanyer 1978b (in Rowell 1986, p. 294).

921. Rowell 1986, p. 38.

922. Interview with Arnold Newman, February 1993.

923. London 1979.

924. Florence 1979, Siena 1979, and Prato 1979.

925. Barcelona 1979.

926. Saint-Paul-de-Vence 1979.

927. Hirschfeld/Lubar 1987, p. 256.

928. Rowell 1986, p. 38.

929. Fundació Joan Miró 1988, p. 481.

930. Saint Louis 1980.

931. Washington 1980a.

932. Mexico City 1980.

933. New York 1980a.

934. Death Announcement. Courtesy Miró family, Palma de Mallorca.

935. Bradley 1993, p. 31.

936. Rowell 1986, p. 39.

937. Ibid., p. 39.

938. Hirschfeld/Lubar 1987, p. 256.

939. Milan 1981.

940. Rowell 1986, p. 39.

941. Rose 1982a, p. 43. See also Macmillan 1982, p. 112.

942. Houston 1982.

943. Rowell 1986, p. 39.

944. Ibid. Cf. Hirschfeld/Lubar 1987, p. 256.

945. New York 1983b.

946. New York 1983c.

947. *New York Times* 1983, p. A20.

948. Ibid.

Catalogue

Compiled by Lilian Tone

The Catalogue documents all of the paintings as well as certain of the objects and series of works on paper included in the exhibition "Joan Miró," held at The Museum of Modern Art, New York, October 17, 1993–January 11, 1994. A complete checklist, including all the sculptures, ceramics, and drawings in the exhibition, is available from the Museum.

TITLES

The titles used here are generally those inscribed by Miró on the reverse of the works, unless superseded by titles expressly assigned by the artist at a later date. For the painting-poems, the inscription appearing on the front of the canvas has been adopted as the title, and is given within quotation marks. An additional title, especially one in common use, may be given as an alternative, in parentheses; when more than one is given, such titles are separated by a semicolon.

Roman numerals following a comma or enclosed in parentheses are not part of the original title. When following a comma, they indicate the documented order in which the works in a series were executed. When enclosed in parentheses, they indicate the order of execution that is commonly accepted for the designated works but which, to our knowledge, is not confirmed by primary documentation.

PLACE AND DATE OF EXECUTION

The year of execution is preceded by the month or season, when known. (For the sake of simplicity, the spans of the seasons are understood as: winter, January–March; spring, April–June; summer, July–September; and fall, October–December). More precise dates, including day and month, are based on the artist's inscriptions on the works, and on Dupin 1962 (see the Reference List); these are understood as dates of completion, except for cats. 145 and 191, where they indicate the period of execution. In the absence of other documentation, dates for works from the teens are based on Lubar 1988, and for sculptures and ceramics on Jouffroy/Teixidor 1974 and on information provided by the owners or custodians. Supporting evidence concerning places and dates of execution can be found in the Chronology.

Information on either the place or the date of execution is enclosed in square brackets when not founded on primary documentation, such as inscriptions on the works themselves, or evidence from Miró's correspondence, or from his notebooks at the Fundació Joan Miró in Barcelona. Approximate dates are preceded by c., for circa. A span of dates separated by a dash indicates a more or less continuous period of execution for either the individual work or the series to which it belongs, while use of the word or indicates alternative possible dates.

MEDIUMS AND DIMENSIONS

The information on mediums and dimensions has been provided by the owners or custodians of the works. Dimensions are given in inches (and feet, when greater than 72 inches), followed in parentheses by centimeters; height precedes width, followed, when applicable, by depth, unless otherwise noted.

INSCRIPTIONS

For the most part, inscriptions that appear on the reverse of the works are given as transcribed by the owners or custodians. Inscriptions on the reverse of some works are no longer visible, because of relining or the presence of backing; when records are available, those inscriptions are also provided. In the entries, a vertical bar denotes the beginning of a new line within the inscription.

REFERENCE NUMBERS

Works catalogued in Dupin 1962 are identified by the word *Dupin* followed by the reference number assigned in that book.

PROVENANCE

When known, names of former owners are followed by the relevant acquisition dates. Approximate acquisition dates are preceded by c. In the absence of a secure date of acquisition, a date preceded by the word *by* indicates the earliest recorded instance in which the work appeared credited to that collection. Speculative dates are followed by a question mark.

The word *to* indicates a direct transfer from one owner to the next, while its absence indicates a possible gap. Names of former owners enclosed in square brackets indicate that ownership is not verified by firm documentation.

SELECTED EXHIBITIONS

Exhibitions are listed in abbreviated form; full references appear in the Exhibition History. The precise title of a given work adopted in each exhibition is provided, unless it is the same as the one printed in boldface in the present Catalogue. If the title adopted in a given exhibition is not known, a question mark, enclosed in parentheses, appears instead. The cited reproductions (indicated by *repr.*, in the absence of a plate number or figure number) are in black and white, unless color is noted. For exhibitions presented at more than one venue, the work in question was shown at all venues unless otherwise noted. When available, the relevant exhibition-catalogue or checklist number is given, indicated by *cat.*

SELECTED REFERENCES

Published references to a work are given in abbreviated form; full citations appear in the Reference List. Early references, especially exhibition reviews, are emphasized over monographs, as the latter are widely available. References to exhibition catalogues given in the present list under the heading Selected Exhibitions are not repeated under Selected References.

STUDIES AND APPENDIX

Whenever a study is known for a work included in the Catalogue, it is reproduced adjacent to the entry for the relevant work. Studies for those drawings and sculpture in the present book and exhibition that are not included in the Catalogue section can be found in the Appendix to the Catalogue, which immediately follows. Whenever several studies exist for a single work, it is the final study that is reproduced.

Unless another medium or support is indicated, all studies are pencil on paper. Most of the studies illustrated in the present Catalogue and in the Appendix are also reproduced in Fundació Joan Miró 1988, which also includes further information concerning mediums and inscriptions and the notebooks in which many of them are found. In the captions, those studies are identified by the Fundació's catalogue numbers, which include the abbreviation *FJM*. Studies in the collection of The Museum of Modern Art, New York, are identified by the Museum's acquisition numbers, preceded by the abbreviation *MoMA*. Dates in the study captions are inscribed.

1. THE CLOCK AND THE LANTERN. [Barcelona, after early March] 1915. (Plate, p. 84)

Oil on cardboard, 20½×25⅜″ (52×64.5 cm). Signed and dated lower left: *Miró | 1915*. Private collection, Switzerland. Dupin 7

PROVENANCE
Perls Galleries, New York; to present owner, by 1956.

SELECTED EXHIBITIONS
Barcelona 1918a, cat. 6
Paris 1921, cat. 1, as *La Pendule*
Basel 1956, cat. 1, as *Nature morte à l'horloge*

London 1964b, cat. 4, p. 17, as *Clock and Lantern*

SELECTED REFERENCES
Artigas 1918, p. 3. Hüttinger 1957, p. 9, fig. 2. Dupin 1962, pp. 61, 73–74, no. 7, repr. pp. 63 (color), 502. Picon 1971, p. 8. Picon 1981, p. 38. Lubar 1988, pp. 60, 114, 295, fig. 5. Combalía 1990, pp. 105, 283, 285.

2. MONTROIG, SANT RAMON. Montroig, summer 1916. (Plate, p. 88)

Oil on canvas, 24¼×18⅞″ (61.5×47.9 cm). Signed lower right: *Miró*. Kouros Gallery, New York. Dupin 12

PROVENANCE
Saidenberg Gallery, New York, early 1950s; to Stephen Hahn, New York; private collection; to Kouros Gallery, New York.

SELECTED EXHIBITIONS
Barcelona 1918a, cat. 31
Nice 1957, cat. 3, repr. n.p., as *Le Rocher* (incorrectly dated 1912)

New York 1991a, cat. 19, repr. (color) n.p.

SELECTED REFERENCES
Queneau 1949, fig. 2 (color). Verdet 1957a, n.p. Verdet 1957b, pl. 5. Dupin 1962, pp. 21, 68, no. 12, repr. pp. 108, 502. Bonnefoy 1964, p. 6. Lubar 1988, pp. 92 (n. 75), 299, fig. 20. Combalía 1990, pp. 9, 284.

3. THE RED FAN. Barcelona, fall 1916. (Plate, p. 85)

Oil on cardboard, 40½×28¾″ (103×73 cm). Signed and (incorrectly) dated lower left: *Miró. 1915*. The Hakone Open-Air Museum, Tokyo. Dupin 25

PROVENANCE
Anne Burnett Tandy, Fort Worth; to Estate of Anne Burnett Tandy (consigned to Sotheby's, New York; sold November 18, 1986, lot 38); to David Nehmed (Davlyn Gallery), New York; to private collection, Japan, November 1986; to private collection, Japan, March 1991; to The Hakone Open-Air Museum, Tokyo, c. April 1992.

SELECTED EXHIBITIONS
Barcelona 1918a, cat. 35
Paris 1921, cat. 2, as *L'Eventail et les fleurs*

Possibly Paris 1939c, as (?)

SELECTED REFERENCES
Beaux-Arts 1939a, repr. p. 4. Dupin 1962, p. 74, no. 25, repr. pp. 111, 503. Rowell 1976, repr. p. 26. Lubar 1988, p. 300, fig. 23. Combalía 1990, pp. 284, 285.

4. SELF-PORTRAIT. [Barcelona], winter 1917. (Plate, p. 91)

Oil on canvas, 24½×19½″ (62.2×49.5). Signed and dated upper left: *Miró. | 1917*. Private collection. Dupin 49

PROVENANCE
The artist to Galerie Käte Perls, Paris; to Walter P. Chrysler, Jr., New York and Warrenton, Va., by January 1941 (consigned to Parke-Bernet Galleries, New York; sold February 16, 1950, lot 56); Edward A. Bragaline, New York, by November 1951; present owner.

SELECTED EXHIBITIONS
Barcelona 1918a, cat. 37, as *Retrat*
Possibly Paris 1921, cat. 6, as *Portrait*
Richmond 1941, cat. 137, p. 77, repr. n.p.
New York 1951c, cat. 5
New York 1953a, cat. 26

New York 1959b, cat. 5 (New York venue only)
New York 1963b, cat. 20, repr. n.p.
Sydney 1975, cat. 74, p. 220, repr. p. 221
New York 1984c, cat. 10, repr. (color) p. 23
Charleroi 1985, cat. 5, repr. (color) p. 177

SELECTED REFERENCES

Frankfurter 1941, p. 16, repr. p. 16. Whiting 1941, repr. p. 93. Sweeney 1953, repr. p. 63. Canaday 1959, repr. p. 28. Dupin 1962, pp. 78, 87, no. 49, repr. pp. 116, 505. Lassaigne 1963, p. 21. Penrose 1969, p. 22. Miró 1977, p. 209. Gimferrer 1978, fig. 180 (color). Malet 1983b, p. 9, fig. 11 (color). Bouret 1986, n.p. Lubar 1988, pp. 78, 79, 300, fig. 24. Combalía 1990, repr. (color) n.p.

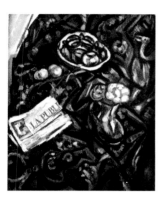

5. "LA PUBLICIDAD" AND FLOWER VASE. [Barcelona], winter 1917. (Plate, p. 86)

Oil and newspaper collage on linen, 28 × 23″ (71 × 58.5 cm). Signed lower right: *Miró.* Alsdorf Collection, Chicago. Dupin 27

PROVENANCE

Klaus Perls (Perls Galleries), New York; to Alsdorf Collection, Chicago, October 1957.

SELECTED EXHIBITIONS

Barcelona 1918a, cat. 38
Chicago 1961, cat. 1, repr. n.p., as *Nature morte au journal*

Washington 1980a, cat. 3, repr. (color) p. 52, as *Newspaper and Flower Vase*

SELECTED REFERENCES

Dupin 1962, p. 73, no. 27, repr. p. 503 (dated 1916–17). Wescher 1971, p. 188. Lubar 1988, pp. 17–18 (n. 26), 60, 237 (n. 30), 300–01, fig. 25. Combalía 1990, p. 284. Umland 1992, p. 76 (n. 94).

6. PORTRAIT OF E. C. RICART. [Barcelona], winter or early spring 1917. (Plate, p. 93)

Oil and pasted paper on canvas, 32¼ × 25⅞″ (81.9 × 65.7 cm). Signed lower right: *M | I | R | Ó.* The Metropolitan Museum of Art, New York. Anonymous loan. Dupin 50

PROVENANCE

The artist to E. C. Ricart, Vilanova i la Geltrú, by February 1918; to Pierre Matisse Gallery, New York, by November 1950; to Florene and Samuel A. Marx, Chicago, 1950; to present owner, January 1964.

SELECTED EXHIBITIONS

Barcelona 1918a, cat. 42, as *Retrat de E.C.R.*
Barcelona 1949, cat. 5
New York 1950b, cat. 9, repr. n.p.
New York 1951c, cat. 8, as *Portrait of the Engraver E. C. Ricart*

New York 1955, cat. 96
New York 1959b, cat. 6 (Los Angeles venue, cat. 5)
Chicago 1961, cat. 4, repr. n.p.
New York 1965b, pp. 9, 47, repr. (color) p. 46

SELECTED REFERENCES

Ràfols 1948, p. 499. C. 1949, repr. p. 9 [17] (installation view). Cirici-Pellicer 1949, p. 13, repr. (color) n.p. *Art News* 1950, p. 48, repr. p. 48. Duthuit 1953, fig. 1 (repr. p. 29; incorrectly identified as *Portrait de J. F. Rafols [sic]*). *MoMA Bulletin* 1955, repr. p. 27 (installation view). Prévert/Ribemont-Dessaignes 1956, repr. p. 12. Erben 1959, p. 101, pl. 39. Soby 1959, p. 14, repr. (color) p. 15. Canaday 1959, repr. p. 28. Rubin 1959, p. 35. Dupin 1962, pp. 64, 76, 78, 80, no. 50, repr. pp. 77 (color), 505. Gasch 1963, p. 30. Lassaigne 1963, p. 21, repr. (color) p. 22. Gasser 1965, p. 10, repr. (color) p. 19. Dupin 1966, p. 20. Walton 1966, pp. 10, 30, pl. 50 (color). Penrose 1969, pp. 16, 20, pl. 8 (repr. p. 17). Wescher 1971, p. 188. Rowell 1972, p. 64. Okada 1974, pl. 1 (color). Teixidor 1974, p. 94. Rowell 1976, p. 189 (n. 53). Varnedoe 1976, p. 107. Miró 1977, pp. 66, 209. Gimferrer 1978, pp. 30, 72, 206, fig. 73. Millard 1980, p. 16. Jardí 1983, p. 64. Malet 1983b, p. 9. Dupin 1985, p. 49. Bouret 1986, n.p. Erben 1988, repr. (color) p. 15. Lubar 1988, pp. 78, 79, 124–25 (n. 75), 302, fig. 29. Raillard 1989, pp. 18, 52, repr. (color) p. 53. Saura 1989, p. 18. Llorca 1990, repr. p. 162. Combalía 1990, p. 284. Umland 1992, p. 47.

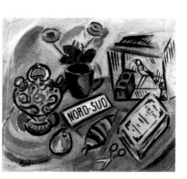

7. "NORD-SUD." [Barcelona], spring 1917. (Plate, p. 87)

Oil on canvas, 24⅜ × 27⅝″ (62 × 70 cm). Signed lower left: *Miró.* Galerie Maeght, Paris. Dupin 28

PROVENANCE

Mrs. [Pere] Mañach, Barcelona, by April 1949; Pierre Matisse Gallery, New York, by 1951; to G. David Thompson, Pittsburgh; Galerie Maeght, Paris, by July 1958.

SELECTED EXHIBITIONS

Barcelona 1918a, cat. 48
Barcelona 1949, cat. 12
New York 1951c, cat. 4, as *Still Life with Bird (Nord-Sud)*
Liège 1958, cat. 1, repr. n.p.
Paris 1962b, cat. 3
London 1964b, cat. 9, p. 18, pl. 1c
Tokyo 1966, cat. 7, repr. (color) p. 27
Saint-Paul-de-Vence 1968, cat. 6, repr. (color) p. 16
Barcelona 1968, cat. 3, pl. I (repr., color, p. 19)
Munich 1969, cat. 3, repr. n.p.
Paris 1974b, cat. 2, p. 110, repr. p. 110
Humlebaek 1974, cat. 1

Barcelona 1975b, cat. 5, repr. (color) n.p.
Madrid 1978a, cat. 5, p. 89, repr. (color) p. 34
Florence 1979, cat. 3, repr. (color) n.p.
Milan 1981, repr. (color) p. 49
Villeneuve d'Ascq 1986, cat. 3, repr. (color) n.p.
Tokyo 1986, cat. 3, repr. (color) p. 39
Paris 1989, repr. pp. 6, 16 (installation view)
Saint-Paul-de-Vence 1990, cat. 2, p. 20, repr. (color) p. 21
Frankfurt 1991, cat. 85, repr. (color) p. 202
Osaka 1991, cat. 40, repr. (color) n.p.

SELECTED REFERENCES

Duthuit 1953, repr. (color) p. 5. Dupin 1962, pp. 64, 74, no. 28, repr. pp. 75 (color), 503. Lassaigne 1963, p. 20. *Mainichi Shinbun* 1966c, repr. p. 1. Wescher 1971, p. 188. Marchiori 1972, p. 18. Lemayrie 1974a, p. 10. Lemayrie 1974b, p. 4.

Gimferrer 1975, n.p. Rudenstine 1976, p. 518. Miró 1977, p. 183. Dorfles 1981, p. 15.
Rose 1982a, p. 14. Schmalenbach 1982, repr. p. 32. Malet 1983b, p. 9, fig. 9 (color).
Bouret 1986, n.p. Lubar 1987, p. 22 (n. 40). Erben 1988, repr. (color) p. 14. Lubar
1988, pp. 76, 77, 80–81, 82 (n. 51), 91, 128, 133, 237 (n. 30), 293, 303, fig. 34.
Raillard 1989, pp. 18, 48, repr. (color) p. 49. Combalía 1990, pp. 46, 284, repr.
(color) n.p.

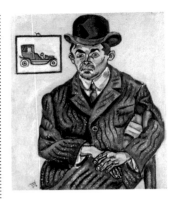

8. PRADES, THE VILLAGE. Prades, summer 1917. (Plate, p. 89)
Oil on canvas, 25⅝ × 28⅝″ (65 × 72.6 cm). Signed lower left: *Miró*. Solomon R.
Guggenheim Museum, New York. Dupin 38

PROVENANCE
The artist to Galeries Dalmau, Barcelona; to Pere Mañach, Barcelona, 1918; to Mrs.
Pere Mañach, Barcelona, 1940s; Pierre Matisse Gallery, New York, 1951; to Robert
Elkon, New York, with Albert Loeb, Paris, and Galerie Jan Krugier, Geneva, 1969; to
Solomon R. Guggenheim Museum, New York, 1969.

SELECTED EXHIBITIONS
Barcelona 1918a, cat. 58
Possibly Paris 1921, cat. 10, as *Paysage*
New York 1951c, cat. 6, repr. n.p., as
 View of Montroig
New York 1959b, cat. 4, as *View of
 Montroig*
Paris 1962b, cat. 4
Tokyo 1966, cat. 12, repr. p. 91
New York 1972b, cat. 4, repr. (color) n.p.,
 as *The Village, Prades*
Berlin 1977, cat. 4/120, repr. p. 186
Washington 1980a, cat. 4, repr. (color)
 p. 53, as *The Village, Prades*
São Paulo 1981, p. 96, repr. p. 97

Houston 1982
New York 1983a, cat. 1
Charleroi 1985, cat. 4, repr. (color)
 p. 176
Zurich 1986, cat. 5, repr. (color) n.p.
New York 1987a, cat. 3, repr. (color)
 p. 60
On view at the Solomon R. Guggenheim
 Museum, New York: December 1969–
 January 1970; May–September 1970;
 June–September 1971; August–
 September 1973; December 1977–
 February 1978; July–October 1978;
 March–August 1979; May–September
 1986; February–April 1990

SELECTED REFERENCES
Duthuit 1953, fig. 3 (repr. p. 29). Soby 1959, repr. p. 12. Dupin 1962, p. 73, no. 38,
repr. p. 504. Cooper 1972, n.p. Rowell 1976, repr. p. 27. Rudenstine 1976, no. 183,
pp. 516–18, repr. (color) p. 517. Millard 1980, p. 15. Robert Elkon Gallery 1981, repr.
p. 21. Lubar 1987, pp. 14, 15, 16 (n. 25), 22. Rowell 1987a, fig. 1 (repr. p. 3). Erben
1988, repr. (color) p. 13. Lubar 1988, pp. 81, 88, 89, 90, 306, fig. 43. Combalía
1990, pp. 46, 51, 284, repr. n.p.

9. PORTRAIT OF HERIBERTO CASANY (The Chauffeur). Barcelona,
winter or early spring 1918. (Plate, p. 92)
Oil on canvas, 27½ × 24½″ (69.8 × 62.2 cm). Signed and dated lower left: *Miró.* |
1918. Kimbell Art Museum, Fort Worth. Dupin 52

PROVENANCE
René Gaffé, Brussels, 1929?; to Pierre Matisse Gallery, New York, February 1937; to
Walter P. Chrysler, Jr., New York and Warrenton, Va., 1939 (consigned to Parke-
Bernet Galleries, New York; sold February 16, 1950, lot 57); Edward A. Bragaline,
New York, by November 1951; to Kimbell Art Museum, Fort Worth, 1984.

SELECTED EXHIBITIONS
Barcelona 1918c, cat. 450, as *L'Home del
 berret*
Paris 1921, cat. 15 or 16, repr. n.p., as
 Portrait
Brussels 1929, as (?)
New York 1936c, cat. 1, as *Man with a
 Derby* (not exhibited)
New York 1937a, cat. 14, as *Man with a
 Derby Hat* (not exhibited)
New York 1939a, cat. 12, as *Portrait du
 chauffeur*
New York 1940b, cat. 1, repr. n.p., as
 Portrait du chauffeur
Richmond 1941, cat. 138, pp. 77–78,
 repr. n.p., as *Chauffeur*

New York 1951c, cat. 11, as *The
 Chauffeur*
New York 1959b, cat. 7, as *The
 Chauffeur* (Los Angeles venue, cat. 6)
New York 1963b, cat. 5, repr. (color) n.p.,
 as *Le Chauffeur*
New York 1976b, cat. 79, repr. p. 108, as
 The Chauffeur
London 1985, cat. 135, fig. 219 (repr.,
 color, p. 206), as *Retrat d'Heribert
 Casany: El Xofer* (Barcelona venue
 only)
New York 1987a, cat. 8, repr. (color)
 p. 65

SELECTED REFERENCES
Junoy 1918, p. 3. O.F. 1918, repr. p. 508. George 1929a, repr. p. 203. Eggermont
1929, p. 194. Ràfols 1929, repr. p. 9. Charensol 1930, repr. p. 971 (detail, as
L'Automobile). Melgar 1931, repr. p. 16. Ràfols 1931a, repr. p. 10. Ràfols 1933, p. 18.
Devree 1937a, p. 60. *Art News* 1939, repr. p. 17. Klein 1939a, p. 5. Genauer 1939a,
repr. McBride 1939a, p. 15. Devree 1939, p. 10X. Lowe 1939, p. 13. *Art Digest*
1939a, p. 6. J.W.L. 1940, p. 13. *New York World Telegram* 1940. *Brooklyn Daily
Eagle* 1940. *Art Digest* 1940, p. 9. Watson 1941, pl. 2 (repr. between pp. 132 and
133). Sweeney 1941, pp. 15, 19, repr. p. 15. Greenberg 1948, p. 12, pl. I (repr. p. 47).
Ràfols 1948, p. 499. Read 1948, p. 89. Cirici-Pellicer 1949, p. 15, ill. 8. Cirlot 1949,
pp. 18, 20, fig. 2. Elgar 1954, n.p. Erben 1959, p. 101. Soby 1959, p. 14, repr. p. 17.
Dupin 1962, pp. 64, 78, no. 52, repr. p. 505. Gasch 1963, p. 30. Lassaigne 1963,
p. 21. Teixidor 1974, p. 94. Varnedoe 1976, pp. 107–08, 191. Jardí 1983, pp. 64, 70.
Dupin 1985, p. 49. Lubar 1988, pp. 124–25, 257, 309–10, fig. 54. Combalía 1990,
p. 49, repr. (color) n.p. Combalía 1992, p. 184. Umland 1992, fig. 24 (repr. p. 65).

10. PORTRAIT OF RAMON SUNYER (The Goldsmith). Barcelona,
winter or early spring 1918. (Plate, p. 92)
Oil on canvas, 27⅛ × 20⅛″ (68.8 × 51.1 cm). Signed and dated lower right: *Miró.* |
1918. Private collection. Dupin 54

PROVENANCE

[Dr. Girardin (Galerie La Licorne), Paris]; to Galerie Pierre, Paris, c. April 1937?; Mr. and Mrs. Lee Ault, New York, by March 1940; to Pierre Matisse Gallery, New York, October 1941; to Mr. and Mrs. Sydney M. Shoenberg, Saint Louis, November 1950; to Stephen Hahn, New York, after 1976; to present owner, November 26, 1979.

SELECTED EXHIBITIONS

Barcelona 1918c, cat. 451, as *L'Home del bastó*
Possibly Paris 1921, cat. 15 or 16, as *Portrait*
Paris 1937c, as (?)
New York 1940b, cat. 3, repr. n.p., as *Portrait d'un orfèvre*

New York 1943e, cat. 36, as *Portrait of a Goldsmith*
Saint Louis 1965
Washington 1980a, cat. 6, repr. (color) p. 55
Zurich 1986, repr. (color) p. 36

SELECTED REFERENCES

Junoy 1918, p. 3. E.M.P. 1918, p. 210. Ràfols 1933, p. 18. Eluard 1937, repr. p. 82. Greenberg 1948, p. 12, pl. II (repr. p. 48). Ràfols 1948, p. 499, repr. between pp. 500 and 501. Soby 1959, p. 14, repr. p. 16. Dupin 1962, pp. 64, 78, no. 54, repr. pp. 117, 505. Gasch 1963, p. 30. Lassaigne 1963, p. 21. Teixidor 1974, p. 94. Varnedoe 1976, p. 107. Millard 1980, p. 16. Jardí 1983, pp. 64, 70. Dupin 1985, p. 49. Bouret 1986, n.p. Lubar 1988, pp. 124–25 (n. 75), 257, 310, fig. 55. Combalía 1990, pp. 49, 117.

11. STANDING NUDE. Barcelona, mid-May–June 1918. (Plate, p. 94)

Oil on canvas, 60¼×47½" (153×120.6 cm). Signed and dated upper right: *Miró. | 1918*. The Saint Louis Art Museum. Purchase, Friends Fund. Dupin 55

PROVENANCE

The artist to Josep Dalmau (Galeries Dalmau), Barcelona; to Paul Eluard, Paris, c. August 1927; Galerie Pierre, Paris, by October 1934; Max Broder, Paris, after 1949; to Sidney Janis Gallery, New York, [and Pierre Matisse Gallery, New York], 1957; to William Rubin, New York, November 8, 1957; to Mr. and Mrs. Joseph Slifka, New York, c. January 1959; Pierre Matisse Gallery, New York, by 1961; to The Saint Louis Art Museum, 1965.

SELECTED EXHIBITIONS

Zurich 1934, cat. 83, as *Grand Nu*
New York 1953c, as *Odalisque*
New York 1958b, cat. 45, repr. n.p., as *Odalisque*
New York 1959b, cat. 8 (Los Angeles venue, cat. 7)
Paris 1962b, cat. 8

London 1964b, cat. 17, p. 19, pl. 2a
Saint Louis 1965
Paris 1974b, cat. 5, p. 110, repr. p. 111
Washington 1980a, cat. 8, repr. (color) p. 57
Zurich 1986, cat. 14, repr. (color) n.p.

SELECTED REFERENCES

Carreres 1929, repr. p. 2. Zervos 1934, fig. 2 (repr. p. 15). Ràfols 1948, p. 498. Cirici-Pellicer 1949, ill. 6. Cirlot 1949, p. 18. B.G. 1953, p. 42, repr. p. 42. Soby 1959, p. 26, repr. (color) p. 18. Rubin 1959, p. 35. Brookner 1962, p. 364. Dupin 1962, pp. 80, 94, 95, no. 55, repr. pp. 79 (color), 505. Nordland 1962a, p. 67. Nordland 1962b, p. 55. Lassaigne 1963, p. 20. Bonnefoy 1964, pl. 6. Roberts 1964, p. 478. *City Art Museum of Saint Louis Bulletin* 1965a, p. 1, repr. p. 2. *City Art Museum of Saint Louis Bulletin* 1965b, p. 8. *Burlington Magazine* 1966a, p. 89, fig. 45 (repr. p. 92). *Chronique des arts* 1966, fig. 271 bis (repr. p. 69). Penrose 1969, p. 20, pl. 9 (repr.

color, p. 18). Picon 1971, p. 9. Cooper 1972, n.p. Marchiori 1972, p. 18, repr. p. 17. Okada 1974, repr. p. 74. Lemayrie 1974a, p. 10. Lemayrie 1974b, p. 4. Picon 1976, vol. 1, p. 27. Millard 1980, pp. 17, 18, 20, fig. 7 (repr. p. 17). Picon 1981, p. 38. Dupin 1985, p. 57. Bouret 1986, n.p. Rowell 1986, pp. 52, 309 (n. 29). Lubar 1987, pp. 21, 26, fig. 11 (repr. p. 21). Erben 1988, repr. (color) p. 19. Lubar 1988, pp. 129, 133 (n. 12), 311, fig. 59. Raillard 1989, p. 54, repr. (color) p. 55. Combalía 1990, repr. (color) n.p. Yokohama Museum of Art 1992, fig. 1 (repr. p. 24). Combalía 1992, p. 184.

12. VEGETABLE GARDEN AND DONKEY. Montroig, [summer and/or fall] 1918. (Plate, p. 96)

Oil on canvas, 25⅛×27½" (64×70 cm). Signed and dated lower left: *Miró. | 1918*. Moderna Museet, Stockholm. Dupin 60

PROVENANCE

The artist to Josep Dalmau (Galeries Dalmau), Barcelona, by April 1921; [to Dr. Girardin (Galerie La Licorne), Paris]; to Pierre Loeb (Galerie Pierre), Paris, c. April 1937?; through Rose Fried Gallery, New York, to Mr. and Mrs. Irvin Shapiro, New York, by November 1953; The Hanover Gallery, London, by December 1961; Galerie Wilhelm Grosshennig, Düsseldorf, after August 1964; to Moderna Museet, Stockholm, 1965.

SELECTED EXHIBITIONS

Barcelona 1919b, cat. 370, as *L'Hort*
Paris 1921, cat. 21, as *Catalogne: Le Verger*
Paris 1937c, as (?)
Avignon 1947, cat. 134, as *Paysage*
New York 1959b, cat. 9a, as *Kitchen Garden with Donkey* (New York venue only)
Paris 1962b, cat. 10
London 1964b, cat. 18, p. 19, pl. 3b
Barcelona 1968, cat. 8, pl. IV (repr., color, p. 22), as *L'Hort*
Paris 1974b, cat. 8, p. 111, repr. pp. 33 (color), 111

Humlebaek 1974, cat. 3
Berlin 1977, cat. 4/121, repr. p. 187
London 1985, cat. 151, fig. 219 (repr., color, p. 206), as *Garden with Donkey* (London venue only)
Zurich 1986, cat. 15, repr. (color) n.p.
New York 1987a, cat. 10, repr. (color) p. 68
Frankfurt 1991, cat. 97, repr. frontispiece (color) and p. 212 (color), as *La Huerta del asno*

SELECTED REFERENCES

J.F.R. 1919b, p. 177. Cheronnet 1937a, repr. p. 5. Eluard 1937, repr. p. 80. Sweeney 1941, pp. 15, 16, 19, 22, repr. p. 16. Greenberg 1948, pp. 12, 13. Ràfols 1948, p. 500. Cirici-Pellicer 1949, pp. 15, 16, ill. 9. Sweeney 1953, repr. p. 65. Elgar 1954, n.p. Prévert/Ribemont-Dessaignes 1956, pp. 75, 76, repr. p. 21. Soby 1959, pp. 14, 19, repr. p. 21. *Burlington Magazine* 1961, pl. XXXIII. Frigerio 1962, p. 54. Dupin 1962, pp. 83, 84, 86, no. 60, repr. pp. 118, 506. Gasch 1963, p. 32. Lassaigne 1963, p. 27. Bonnefoy 1964, pp. 14, 18, pl. 9. Miró 1964, repr. (color) frontispiece. Penrose 1969, pl. 12 (repr. p. 21). Marchiori 1972, repr. p. 15. Lemayrie 1974a, p. 11. Lemayrie 1974b, p. 4, repr. (color) p. 17. Okada 1974, repr. p. 75. Miró 1977, pp. 168, 190. Gimferrer 1978, pp. 64, 182, fig. 61 (color). Gateau 1982, repr. p. 346. McCandless 1982, p. 60. Jardí 1983, p. 70. Malet 1983b, p. 9, fig. 16 (color). Gimferrer 1985, pp. 61, 62, repr. p. 61. Bouret 1986, n.p. Rowell 1986, p. 309 (n. 30). Lubar 1987, pp. 18, 26, 27. Erben 1988, repr. (color) p. 21. Lubar 1988, pp. 128–29, 133 (n. 12), 162, 232, 238, 257, 312–13, fig. 63. Malet 1988a, p. 18. Raillard 1989, p. 56, repr. (color) p. 57. Combalía 1990, pp. 51, 58, 119, repr. (color) n.p.

13. HOUSE WITH PALM TREE. Montroig, fall 1918. (Plate, p. 97)
Oil on canvas, 25½ × 28¾″ (65 × 73 cm). Signed and dated lower left: *Miró.* | *1918.*
Private collection. Dupin 59

PROVENANCE
[Dr. Girardin (Galerie La Licorne), Paris]; to Pierre Loeb (Galerie Pierre), Paris, c.
April 1937?; to Collection Hanson-Dyer, Paris; Vera Espirito Santo, Estoril, by May
1974; auctioned at Sotheby's, London, June 27, 1977, lot 49; to Lee Vandervelde,
New York; to L. Vandervelde Inc., Los Angeles, 1987; present owner.

SELECTED EXHIBITIONS
Barcelona 1919b, cat. 371, as *La Casa* Brisbane 1959, cat. 58, as *Spanish*
 de la palmera *House*
Paris 1921, cat. 18, repr. n.p. as Paris 1974b, cat. 7, p. 111, repr. p. 111
 Catalogue: La Maison et le palmier Charleroi 1985, cat. 6, repr. (color)
Paris 1937c, as (?) p. 178

SELECTED REFERENCES
Espàtula 1919, p. 504. J.F.R. 1919b, p. 177. Folch 1919, p. 6,878. Ràfols 1931a, p. 10.
Beaux-Arts 1937b, repr. p. 7. Loeb 1946, pl. XIV. Ràfols 1948, p. 500, repr. between
pp. 500 and 501. Prévert/Ribemont-Dessaignes 1956, repr. p. 105. Erben 1959, p.
102, pl. 42. Dupin 1962, pp. 83, 86, no. 59, repr. pp. 119, 506. Gasch 1963, p. 32,
repr. p. 13. Gasser 1965, pp. 10, 13, repr. p. 20. Krauss/Rowell 1972, p. 80. Marchiori
1972, p. 18. Lemayrie 1974a, p. 11. Lemayrie 1974b, p. 4. Miró 1977, pp. 168, 210.
Dorfles 1981, repr. p. 2. Jardí 1983, p. 70. Malet 1983b, p. 9. Gimferrer 1985, pp. 61,
62. Bouret 1986, n.p. Rowell 1986, pp. 58, 309 (n. 50). Lubar 1988, pp. 128–29,
162, 232, 238, 257, 313, fig. 64. Combalía 1990, pp. 51, 52, 60, 119, 124, 285.

14. SELF-PORTRAIT. Barcelona, winter–spring 1919. (Plate, p. 101)
Oil on canvas, 28¾ × 23⅝″ (73 × 60 cm). Signed and dated upper left: *Miró.* | *1919.*
Musée Picasso, Paris. Dupin 67

PROVENANCE
The artist to Josep Dalmau (Galeries Dalmau), Barcelona; to Pablo Picasso, Paris,
by April 1921; to Estate of Pablo Picasso, 1973; to Musée Picasso, Paris, September
1985.

SELECTED EXHIBITIONS
Paris 1920, cat. 2565, as *Portrait de* Paris 1937c, as (?)
 l'artiste Venice 1954 (not in catalogue)
Paris 1921, cat. 22, as *Portrait de* Paris 1962b, cat. 15
 l'artiste London 1964b, cat. 22, pp. 19–20, pl. 3a

Barcelona 1968, cat. 12, pl. VI (repr., Zurich 1986, cat. 17, repr. (color) n.p.
 color, p. 24), as *El Jove de la* Saint-Paul-de-Vence 1990, cat. 6, p. 26,
 garibaldina vermella repr. (color) p. 27
Paris 1974b, cat. 11, p. 112, repr. pp. 31
 (color), 112

SELECTED REFERENCES
Marcial 1920a, p. 6. Marcial 1920b, p. 3. Pérez-Jorba 1921, p. 4. Schneeberger 1922,
repr. between pp. 108 and 109. *Amic de les arts* 1927, repr. p. 1. Trabal 1928, p. 4.
Ràfols 1931a, p. 10. Zervos 1934, fig. 3 (repr. p. 16). Cheronnet 1937a, repr. p. 5.
Daily Sketch 1938. Sweeney 1941, pp. 16, 21, repr. p. 18. Raymer 1942, p. 6B.
Greenberg 1948, pp. 13–14. Read 1948, p. 89. Ràfols 1948, pp. 500, 501. Cirici-
Pellicer 1949, p. 16, ill. 10. Cirlot 1949, p. 18, fig. 5. Gasch 1950, repr. p. 21.
Sweeney 1953, repr. p. 68. Prévert/Ribemont-Dessaignes 1956, repr. p. 31. Erben
1959, p. 107, pl. 43. Soby 1959, p. 28, repr. p. 26. Dupin 1962, pp. 87, 88, 91, 495,
no. 67, repr. pp. 121, 506. Frigerio 1962, p. 54. Chevalier 1962, repr. p. 6. Gasch
1963, p. 33, repr. p. 41. Lassaigne 1963, p. 35. Bonnefoy 1964, pl. 10 (color). Russell
1964, p. 10. Gasser 1965, pp. 12, 76, repr. p. 52. Walton 1966, pp. 10, 30, pl. 47
(color). Penrose 1969, pp. 22, 96, pl. 13 (repr., color, p. 23). Cooper 1972, n.p.
Marchiori 1972, p. 18, repr. (color) p. 19. Rubin 1973, p. 76, fig. 58 (repr. p. 129).
Lemayrie 1974a, p. 11. Lemayrie 1974b, p. 4. Okada 1974, repr. p. 88. Rowell 1976,
repr. p. 8. Miró 1977, pp. 52, 87. Gimferrer 1978, p. 99, fig. 95 (color). Fundació
Joan Miró 1983, repr. p. 97. Malet 1983b, p. 9, fig. 15 (color). Bouret 1986, n.p.
Rowell 1986, pp. 92, 310 (n. 64), 312 (n. 2), ill. 1 (repr. opp. p. 48), repr. (color)
cover. Green 1987, p. 289. Lubar 1987, p. 21 (n. 38), fig. 10 (repr. p. 20). Erben
1988, repr. (color) p. 6. Lubar 1988, pp. 157, 167–68, 210, 258, 313–14, fig. 65.
Raillard 1989, pp. 35, 122. Combalía 1990, pp. 58, 59–60, 62, 74, 127, 128, 139,
285, repr. (color) n.p. Combalía 1992, p. 185.

15. VINES AND OLIVE TREES, TARRAGONA. Montroig and
Barcelona, July–late fall 1919. (Plate, p. 99)
Oil on canvas, 28½ × 35⅝″ (72.5 × 90.5 cm). Signed and dated lower left: *Miró.* |
1919. The Jacques and Natasha Gelman Collection. Dupin 64

PROVENANCE
Pierre Matisse Gallery, New York, 1937; Mary and Leigh B. Block, Chicago, 1951;
E. V. Thaw & Co., New York, c. 1985–86; to The Jacques and Natasha Gelman
Collection, 1987.

SELECTED EXHIBITIONS
Possibly Paris 1921, cat. 24, as New York 1959b, cat. 12, as *The Olive*
 Catalogue: Arbres et montagnes à *Grove* (Los Angeles venue, cat. 11)
 Tarragone Chicago 1961, cat. 6, as *Olive Grove*
New York 1940b, cat. 4, repr. n.p., as Paris 1962b, cat. 13, repr. n.p., as
 Paysage aux oliviers *Montroig, vignes et oliviers par temps*
New York 1941g, as *Landscape with* *de pluie*
 Olive Trees (New York venue only) London 1964b, cat. 24, p. 20, pl. 4c
San Francisco 1948, cat. 42, repr. p. 97, New York 1989
 as *Landscape with Olive Trees* Saint-Paul-de-Vence 1990, cat. 8, p. 32,
New York 1949d, cat. 8, repr. n.p., as *The* repr. (color) p. 33, as *Vignes et oliviers*
 Olive Grove *à Tarragona*
New York 1951c, cat. 12, as *The Olive*
 Grove (Montroig)

SELECTED REFERENCES

Sweeney 1941, pp. 15, 16, 22, repr. p. 17. *New York Herald Tribune* 1941b. Loeb 1946, pp. 82–83. Greenberg 1948, p. 15, pl. IV (repr. p. 50). Ràfols 1948, repr. between pp. 500 and 501. Cirici-Pellicer 1949, p. 16. Hess 1952, repr. p. 40. Prévert/Ribemont-Dessaignes 1956, pp. 75, 76. Devree 1959, repr. p. X15. Rubin 1959, p. 36. Soby 1959, p. 28, repr. p. 23. Dupin 1962, pp. 92, 94, 139, 495, no. 64, repr. pp. 89 (color), 506. Lassaigne 1963, pp. 27, 28, repr. (color) p. 25. Barrett 1964, p. 27. Penrose 1969, p. 24, pl. 16 (repr., color, p. 27). Krauss 1972, p. 16. Rubin 1973, fig. 6 (repr. p. 112). Okada 1974, pl. 3 (color). Rowell 1976, pp. 23, 33, repr. (color) p. 22. Bouret 1986, n.p. Rowell 1986, pp. 60, 62, 63, 263, 309 (n. 57), ill. 6. Erben 1988, repr. (color) p. 22. Lubar 1988, pp. 164, 167, 210, 314, fig. 67. Lieberman 1989, pp. 156–59, 306, repr. pp. 157 (color), 306. Combalía 1990, p. 58, repr. (color) n.p. Combalía 1992, p. 185.

16. THE VILLAGE OF MONTROIG (Montroig, the Church and the Village). Montroig, [summer and/or fall] 1918, and Montroig and Barcelona, July–late fall 1919. (Plate, p. 98)

Oil on canvas, 28¾ × 23⅞″ (73.1 × 60.7 cm). Signed and dated lower left: *Miró | 1919.* Collection Maria Dolores Miró de Punyet. Dupin 63

PROVENANCE

The artist and Pilar Juncosa de Miró; to Maria Dolores Miró de Punyet, October 12, 1954.

SELECTED EXHIBITIONS

Paris 1920, cat. 2566, as *Paysage*
Possibly Paris 1921, cat. 25, as *Catalogne: Village catalan*
Venice 1954, cat. 5
New York 1959b, cat. 11 (Los Angeles venue, cat. 10)
Paris 1962b, cat. 12, as *Montroig, l'église et le village*
London 1964b, cat. 23, p. 20, pl. 5a, as *Montroig, the Village and Church*
Tokyo 1966, cat. 17, repr. p. 92, as *Montroig, l'église et le village*
Saint-Paul-de-Vence 1968, cat. 9, repr. (color) p. 12, as *Montroig, église et village*
Barcelona 1968, cat. 11, pl. 6 (repr. p. 94), as *Montroig, la iglesia y el pueblo*
Munich 1969, cat. 12, repr. n.p., as *Montroig, Kirche und Dorf*
Paris 1974b, cat. 10, p. 112, repr. p. 112, as *Montroig, l'église et le village*

Barcelona 1975b, cat. 8, as *Montroig, l'église et le village*
Madrid 1978a, cat. 10, p. 90, repr. (color) p. 38, as *Montroig, la iglesia y el pueblo*
Florence 1979, cat. 5, repr. (color) n.p., as *Montroig, l'église et le village* (not exhibited)
Milan 1981, repr. (color) p. 49, as *Montroig, l'église et le village*
Charleroi 1985, cat. 7, repr. (color) p. 179, as *Montroig, l'église et le village*
Zurich 1986, cat. 16, repr. (color) n.p., as *Montroig, l'église et le village*
New York 1987a, cat. 11, repr. (color) p. 69, as *Montroig, the Church and the Village*
Frankfurt 1991, cat. 98, repr. (color) p. 214, as *Montroig, la iglesia y el pueblo*

SELECTED REFERENCES

Marcial 1920a, p. 6. Marcial 1920b, p. 3. Gasch 1950, repr. p. 24. Sweeney 1953, repr. p. 64. Erben 1959, p. 99, repr. (color) p. 97. Gomis/Prats 1959, pl. 74. Soby 1959, repr. p. 22. Dupin 1962, pp. 20, 92, no. 63, repr. pp. 120, 506. Lassaigne 1963, p. 27. Bonnefoy 1964, pl. 8. Walton 1966, p. 31, pl. 53 (color). Penrose 1969, p. 24. Marchiori 1972, p. 18, repr. p. 23. Lemayrie 1974a, p. 11. Lemayrie 1974b, p.

4. Gimferrer 1975, n.p. Miró 1977, pp. 92, 210. Gimferrer 1978, p. 72, fig. 70 (color). Malet 1983b, p. 9, fig. 17 (color). Rowell 1986, pp. 60, 62, 63, 309 (n. 56). Fernández Miró 1987, p. 46. Lubar 1987, p. 18 (n. 31). Erben 1988, repr. (color) p. 23. Lubar 1988, pp. 164, 167, 258, 314–15, fig. 68. Porcel 1989, p. 16. Llorca 1990, repr. p. 163. Combalía 1990, pp. 127, 128–29, repr. (color) n.p. Yokohama Museum of Art 1992, ill. 3 (repr. p. 45).

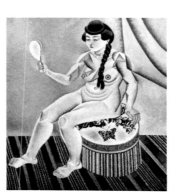

17. NUDE WITH MIRROR. Barcelona, spring [and fall] 1919. (Plate, p. 95)

Oil on canvas, 44½ × 40⅛″ (113 × 102 cm). Signed and dated upper right: *Miró | 1919.* Kunstsammlung Nordrhein-Westfalen, Düsseldorf. Dupin 68

PROVENANCE

The artist to Josep Dalmau (Galeries Dalmau), Barcelona, by April 1921; [Galerie La Licorne, Paris]; [Galerie Pierre, Paris]; Pierre Matisse Gallery, New York, by March 1940; Galerie L'Oeil, Paris, after June 1962; to Kunstsammlung Nordrhein-Westfalen, Düsseldorf, 1964.

SELECTED EXHIBITIONS

Paris 1921, cat. 23, repr. n.p., as *Nu de la jeune fille au miroir*
New York 1940b, cat. 5, repr. n.p.
New York 1941g (New York venue only)
New York 1945c, as *Le Miroir*
San Francisco 1948, cat. 43, repr. p. 97
New York 1951c, cat. 13
Venice 1954, cat. 4
New York 1959b, cat. 13, as *Seated Nude* (Los Angeles venue, cat. 12)

Paris 1962b, cat. 14
Düsseldorf 1973, repr. n.p.
Paris 1974b, cat. 12, pp. 112–13, repr. pp. 37 (color), 113
London 1974, cat. 85, p. 192, repr. p. 193
Madrid 1978a, cat. 11, pp. 90–91, repr. (color) p. 39
Saint-Paul-de-Vence 1990, cat. 7, p. 28, repr. (color) p. 29

SELECTED REFERENCES

Pérez-Jorba 1921, p. 4. Coates 1941, p. 59. Sweeney 1941, pp. 15, 19, repr. p. 17. *Art News* 1945c, repr. p. 29. Greenberg 1948, p. 15, pl. V (repr. p. 51). Ràfols 1948, p. 500. Read 1948, p. 89. Cirici-Pellicer 1949, p. 16. Cirlot 1949, fig. 3. Duthuit 1953, repr. p. 6. Sweeney 1953, repr. p. 68. Prévert/Ribemont-Dessaignes 1956, p. 75, repr. p. 11. Soby 1959, pp. 24, 31, repr. (color) p. 27. Rubin 1959, repr. p. 36. Dupin 1962, pp. 94–95, 130, 495, no. 68, repr. pp. 93 (color), 506. Chevalier 1962, p. 8. Nordland 1962a, p. 67. Bonnefoy 1964, pl. 11 (color). *Quadrum* 1965, fig. 36 (repr. p. 165). Hodin 1966, repr. p. 29. Russell 1966, p. 93, repr. p. 91. Walton 1966, pp. 10, 30, pl. 52 (color). Juin 1967, repr. (color) p. 13. Penrose 1969, p. 20, pl. 10 (repr., color, p. 19). Picon 1971, p. 9. Marchiori 1972, p. 18, repr. p. 16. Lemayrie 1974a, p. 12. Lemayrie 1974b, p. 5. Picon 1976, vol. 1, p. 27. Gimferrer 1978, p. 99, fig. 94. Picon 1981, p. 38. Schmalenbach 1982, repr. p. 30. Schmalenbach 1986, p. 391. Bouret 1986, n.p. Rowell 1986, pp. 62, 263, 310 (n. 65). Green 1987, p. 66, pl. 84 (repr. p. 66). Erben 1988, repr. (color) p. 25. Lubar 1988, pp. 167–68, 192 (n. 77), 210, 219 (n. 38), 315, fig. 69. Combalía 1990, pp. 138, 285. Combalía 1992, p. 184.

18. HORSE, PIPE, AND RED FLOWER (Still Life with Horse). Montroig, July–October 1920. (Plate, p. 102)

Oil on canvas, 32½ × 29½″ (82.6 × 74.9 cm). Signed and dated lower right: *Miró | 1920.* Philadelphia Museum of Art. Gift of Mr. and Mrs. C. Earle Miller. Dupin 70

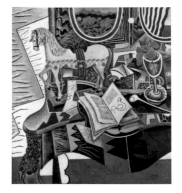

PROVENANCE

The artist to Galeries Dalmau, Barcelona, by October 1920; to Pierre Matisse Gallery, by January 1939; to Mr. and Mrs. C. Earle Miller, Downingtown, Pa., by November 1951; to Philadelphia Museum of Art, 1986.

SELECTED EXHIBITIONS

Barcelona 1920, cat. 53, repr. n.p., as *La Cònsola*
Paris 1921, cat. 26, as *Le Cheval, la pipe et la fleur rouge*
New York 1939a, cat. 11, as *Nature morte au cheval*
New York 1939e, cat. 3, as *Still Life with Horse*
New York 1940b, cat. 6, repr. n.p., as *Nature morte au cheval*
New York 1951c, cat. 15, as *Still Life with a Horse*
New York 1959b, cat. 15, as *Still Life*
with *Toy Horse* (Los Angeles venue, cat. 14)
Paris 1962b, cat. 16, as *Le Cheval, la pipe et la fleur rouge*
London 1964b, cat. 25, p. 20, pl. 5c, as *Still-Life With Toy Horse*
New York 1972b, cat. 9, repr. (color) n.p.
New York 1987a, cat. 12, repr. (color) p. 71
Philadelphia 1987a, cat. 1
Saint-Paul-de-Vence 1990, cat. 9, p. 30, repr. (color) p. 31

SELECTED REFERENCES

Xenius 1920, p. 4. Gasch 1925, repr. p. 5, as *Natura morta* (incorrectly dated 1925). Raynal 1934a, fig. 8 (repr. p. 23). Devree 1939, p. 10X. Lowe 1939, p. 13. Bille 1945, repr. p. 151. Greenberg 1948, p. 16, pl. VII (repr. p. 53). Cirici-Pellicer 1949, ill. 13. Cirlot 1949, p. 19, fig. 6. Prévert/Ribemont-Dessaignes 1956, p. 76. Guéguen 1957, p. 40. Soby 1959, repr. p. 25. Schwartz 1959, p. 151. Dupin 1962, pp. 104, 129, no. 70, repr. pp. 101 (color), 507. Lassaigne 1963, p. 28. Penrose 1969, p. 24, pl. 15 (repr., color, p. 26). Cooper 1972, n.p. Marchiori 1972, p. 18. Rubin 1973, p. 110 (n. 3). Millard 1980, p. 19. Jardí 1983, p. 79. Malet 1983b, p. 9. Bouret 1986, n.p. D'Harnoncourt 1987, p. 2. Lubar 1987, p. 25. Rowell 1987a, pp. 4, 6, repr. (color) p. 5. Temkin 1987b, p. 39. Lubar 1988, pp. 182, 190, 191, 192, 193, 194, 198, 210, 212, 222, 223, 233 (n. 21), 238, 258, 315–16, fig. 70. Raillard 1989, p. 20. Combalía 1990, p. 285.

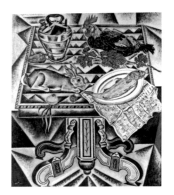

19. STILL LIFE WITH RABBIT (The Table). Montroig and Barcelona, August 1920–January 1921. (Plate, p. 103)
Oil on canvas, 51⅛ × 43¼″ (130 × 110 cm). Signed and dated lower left: *Miró. | 1920.*
Collection Gustav Zumsteg. Dupin 71

PROVENANCE

The artist to Josep Dalmau (Galeries Dalmau), Barcelona, by April 1921; [to Mr. Demotte, Paris, June 1921?]; Mrs. Demotte, Paris, by October 1925; Pierre Loeb (Galerie Pierre), Paris, by October 1934; to Gustav Zumsteg by April 1949.

SELECTED EXHIBITIONS

Paris 1921, cat. 29, as *La Table*
Zurich 1934, cat. 84, as *Table au coq*
Lucerne 1935, cat. 70, as *Nature morte*
London 1936c, cat. 211, as *The Table*
Bern 1949, cat. 1, p. 2, repr. n.p.
Basel 1949, cat. 113
Venice 1954, cat. 7, as *Il Tavolo di cucina*
Brussels 1956, cat. 6a, repr. n.p.
Basel 1956, cat. 7, repr. n.p.
Nice 1957, cat. 5, repr. n.p.
New York 1959b, cat. 16, as *The Table (Still Life with Rabbit)* (Los Angeles venue, cat. 15)
Paris 1962b, cat. 17, as *La Table (Nature morte au lapin)*
Lausanne 1964, cat. 334, repr. n.p., as *La Table, Nature morte au lapin*
London 1964b, not in checklist (Zurich venue only)
Tokyo 1966, cat. 18, p. 21, repr. (color) p. 33, as *La Table (Nature morte au lapin)*
Paris 1967a, cat. 197, repr. (color) n.p., as *La Table, Nature morte au lapin*
Saint-Paul-de-Vence 1968, cat. 10, repr.
p. 55, as *La Table (Nature morte au lapin)*
Barcelona 1968, cat. 13, as *La Taula*
Munich 1969, cat. 14, repr. n.p., as *Der Tisch*
Paris 1974b, cat. 13, p. 113, repr. p. 113, as *La Table au lapin*
Barcelona 1975b, cat. 9, repr. (color) n.p., as *La Table (Nature morte au lapin)*
New York 1976d, p. 154, repr. (color) p. 155, as *The Table (Still Life with Rabbit)*
Berlin 1977, cat. 4/122, repr. (color) n.p., as *Der Tisch (Stilleben mit Kaninchen)*
Madrid 1978a, cat. 12, p. 91, repr. (color) p. 40
Zurich 1986, cat. 18, repr. (color) n.p., as *La Table (Nature morte au lapin)*
Saint-Paul-de-Vence 1990, cat. 10, p. 34, repr. (color) p. 35, as *La Table (Nature morte au lapin)*
Frankfurt 1991, cat. 99, repr. (color) p. 215, as *La Mesa (Naturaleza muerta con conejo)*

SELECTED REFERENCES

Pérez-Jorba 1921, p. 4. Gasch 1926b, repr. p. 7. Trabal 1928, p. 4. Ràfols 1931a, p. 10. Raynal 1934a, fig. 8 (repr. p. 22). Guéguen 1934, p. 44. Erni 1935, p. 27. Sweeney 1941, pp. 22, 26, repr. p. 20. Greenberg 1948, p. 16. Ràfols 1948, p. 501, repr. between pp. 500 and 501. C.G.W. 1949, p. 76. Cirici-Pellicer 1949, ill. 12. Cirlot 1949, p. 19, fig. 8. Dorfles 1949, p. 332. Dégand 1956, p. 28. Caso 1956, p. 5. Dupin 1956, p. 96. Guéguen 1957, p. 40. Hüttinger 1957, pp. 11–12, 13, 16, fig. 7 (color). Verdet 1957b, pl. 5. Erben 1959, pp. 107–08, pl. 44. Soby 1959, p. 28, repr. (color) p. 29. Schwartz 1959, p. 151. Rubin 1959, pp. 35–36, repr. p. 35. Borchert 1961, p. 4, pl. 1 (repr., color, p. 5). Dupin 1962, pp. 104, 129, 130, no. 71, repr. pp. 125, 507. Frigerio 1962, p. 54. Chevalier 1962, repr. p. 7. Gasch 1963, pp. 33, 34, repr. p. 24. Lassaigne 1963, p. 28, repr. (color) p. 29. Bonnefoy 1964, pl. 14. H.C. 1964, p. 289. Gasser 1965, p. 12, repr. (color) p. 23. Penrose 1969, p. 24, pl. 14 (repr. p. 25). Krauss/Rowell 1972, p. 75. Marchiori 1972, p. 18. Rubin 1973, pp. 16, 110 (n. 3), fig. 1 (repr. p. 109). Leymarie 1974a, p. 12. Melià 1975, repr. n.p. Gimferrer 1975, n.p. Rowell 1976, pp. 17, 21, 23, 33, repr. p. 18. Miró 1977, pp. 67, 87, 136, 183. Fundació Joan Miró 1983, repr. p. 98. Malet 1983b, p. 9, fig. 19 (color). Rowell 1986, pp. 75, 76, 92, 297, 311 (nn. 14, 16), 312 (nn. 2, 3). Bouret 1986, n.p. Green 1987, p. 66, pl. 85 (repr. p. 66). Lubar 1987, pp. 25, 26, fig. 12 (repr. p. 24). Rowell 1987a, p. 4. Centre d'Art Santa Mònica 1988, repro. p. 203, no. 12 (installation view). Erben 1988, repr. (color) p. 26. Lubar 1988, pp. 182, 190, 192 (n. 77), 207–08, 210, 222, 224 (n. 2), 238, 258, 316–17, fig. 72. Raillard 1989, p. 20. Llorca 1990, repr. p. 163. Combalía 1990, pp. 8, 58, 60, 62, 74, 93, 94, 138, 286, repr. (color) n.p. Combalía 1992, p. 185.

20. STILL LIFE—GLOVE AND NEWSPAPER (Table with Glove). Paris, February–March 1921. (Plate, p. 105)
Oil on canvas, 46 × 35¼″ (116.8 × 89.5 cm). Signed and dated lower left: *Miró | 1921.* Inscribed on verso, on stretcher: *Miró Nature Morte—Le gant et le journal.* The Museum of Modern Art, New York. Gift of Armand G. Erpf. Acq. no. 18.55. Dupin 72

PROVENANCE

The artist [to Dr. Girardin (Galerie La Licorne), Paris, c. September 1921?]; Galerie

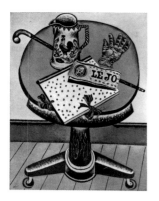

Pierre, Paris, by October 1934; Pierre Matisse Gallery, New York, by November 1936; to Alexina Matisse (later Alexina Duchamp), New York, 1949; to Sidney Janis Gallery, New York; to Armand G. Erpf, New York, April 1955; to The Museum of Modern Art, New York, April 1955.

SELECTED EXHIBITIONS

Possibly Brussels 1929, as (?)
Zurich 1934, cat. 85, as *Table au gant*
New York 1936c, cat. 4, as *Still Life with Glove*
New York 1940b, cat. 8, repr. n.p., as *La Table au gant*
New York 1941g, as *Glove and Newspaper* (New York venue only)
New York 1955, cat. 97, as *Glove and Newspaper*
New York 1958b, cat. 46, repr. n.p., as *Glove on the Table*

New York 1959b, cat. 17, as *Table with Glove (Glove and Newspaper)* (Los Angeles venue, cat. 16)
Paris 1962b, cat. 18, as *La Table au gant*
New York 1973b, as *Table with Glove*
Paris 1974b, cat. 14, p. 113, repr. p. 113, as *La Table au gant*
Humlebaek 1974, cat. 4, as *La Table au gant*
On view at The Museum of Modern Art, New York: May 27–October 19, 1964

SELECTED REFERENCES

George 1929a, repr. p. 200. Gasch 1931b, repr. p. 7. *Cahiers d'art* 1934, fig. 11 (repr. p. 27). Davidson 1936, p. 11. Genauer 1936. Miró 1938, p. 26. J.W.L. 1940, p. 13. *New York Herald Tribune* 1941b. Sweeney 1941, p. 80. Greenberg 1948, p. 17, repr. p. 8. Cirici-Pellicer 1949, p. 17, ill. 16. Duthuit 1953, fig. 2 (repr. p. 29). *MoMA Bulletin* 1955, repr. pp. 7, 28 (installation view). Knox 1955, p. 47, repr. p. 47. *MoMA Bulletin* 1956, p. 37, no. 1187. Prévert/Ribemont-Dessaignes 1956, repr. p. 17. Schwartz 1958, p. 223, repr. p. 224. Soby 1959, pp. 28, 31, repr. p. 30. Frigerio 1962, p. 54. Dupin 1962, pp. 130, 134, no. 72, repr. pp. 126, 507. Lassaigne 1963, pp. 30–31. Gasser 1965, p. 13, repr. p. 22. Wescher 1971, p. 188. Rubin 1973, pp. 8, 16, 109–10, repr. (color) p. 17. Leymarie 1974a, p. 5, repr. (color) p. 17. Okada 1974, repr. p. 88. Carmean 1980, p. 37. Bouret 1986, n.p. Rowell 1986, pp. 147, 161. Green 1987, pp. 67, 102, 297, pl. 86 (repr. p. 67). Lubar 1988, pp. 215, 218, 220–23, 237 (n. 30), 239, 252, 317, fig. 73. Raillard 1989, p. 20. Combalía 1990, p. 58, repr. (color, detail) cover, (color, detail) back cover, and (color) n.p.

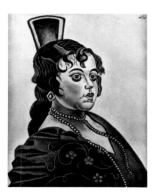

21. PORTRAIT OF A SPANISH DANCER. Paris, March–spring 1921. (Plate, p. 104)
Oil on canvas, 26×22″ (66×56 cm). Signed and dated upper right: *Miró | 1921.*
Musée Picasso, Paris. Dupin 73

PROVENANCE

The artist to Josep Dalmau (Galeries Dalmau), Barcelona; to Dr. Girardin (Galerie La Licorne), Paris; to Pierre Loeb (Galerie Pierre), Paris, April 1937?; to Pablo Picasso, Paris, by June 1937; to Estate of Pablo Picasso, 1973; to Musée Picasso, Paris, September 1985.

SELECTED EXHIBITIONS

Paris 1937c, as (?)
Paris 1962b, cat. 19
London 1964b, cat. 26, p. 20, pl. 4a
Barcelona 1968, cat. 14, pl. VII (repr., color, p. 25)

Paris 1974b, cat. 15, pp. 113–14
Castres 1990, cat. 1, p. 20, repr. cover (color), pp. 20, 49 (color)
Frankfurt 1991, cat. 100, repr. (color) p. 216

SELECTED REFERENCES

Beaux-Arts 1937, p. 7. Cheronnet 1937a, repr. p. 5. Eluard 1937, repr. p. 83. Miró 1938, p. 26, repr. p. 26. Sweeney 1941, pp. 22, 26, repr. p. 21. Greenberg 1948, pp. 16–17. Cirici-Pellicer 1949, p. 21 (incorrectly identified as ill. 17). Cirlot 1949, p. 20, fig. 9. Prévert/Ribemont-Dessaignes 1956, repr. p. 106. Soby 1959, pp. 28, 31, repr. p. 31. Dupin 1962, pp. 91, 130, no. 73, repr. p. 507. Lassaigne 1963, p. 36. Bonnefoy 1964, p. 10, repr. p. 11. Aragon 1969, p. 1. Cooper 1972, n.p. Rubin 1973, p. 109 (n. 1). Leymarie 1974a, p. 11. Lemayrie 1974b, p. 4. Mortensen 1974, p. 34. Miró 1977, pp. 51, 52, 199, 201. Malet 1983b, p. 10, fig. 18 (color). Bouret 1986, n.p. Rowell 1986, p. 161. Lubar 1988, pp. 215, 218, 220, 239, 317, fig. 74. Raillard 1989, p. 35. Combalía 1990, pp. 60, 62, 72, 93, repr. (color) n.p. Combalía 1992, p. 185.

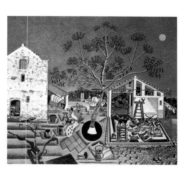

22. THE FARM. Montroig, Barcelona, and Paris, July 1921–c. early May 1922. (Plate, p. 107)
Oil on canvas, 48¾×55⅝″ (123.8×141.3 cm). Signed and dated lower left: *Miró | 1921–22.* Inscribed on verso, upper left: *Joan Miró | "La Ferme" | 1921–22.*
National Gallery of Art, Washington, D.C. Gift of Mary Hemingway. Dupin 76

PROVENANCE

The artist (on consignment to Léonce Rosenberg, Galerie L'Effort Moderne, Paris, June 1, 1922–spring 1924?) to Jacques Viot (Galerie Pierre), Paris (on consignment?); to Evan Shipman, Paris, by June 1925; to Hadley and Ernest Hemingway, Paris, by November 9, 1925; to Hadley Richardson Hemingway (later Hadley Mowrer), Paris and Chicago, c. October–November 1926; to Ernest Hemingway, Key West, Fla., and Havana, February 18, 1935 (on extended loan to The Museum of Modern Art, New York, September 15, 1959–January 17, 1964); to Mary Hemingway, New York, 1964; to National Gallery of Art, Washington, D.C., 1987.

SELECTED EXHIBITIONS

Paris 1922, cat. 1754
Paris 1923a
Paris 1923b
Paris 1925a, cat. 1
New York 1935, cat. 1
New York 1959b, cat. 18 (New York venue only)
London 1964b, cat. 28, p. 21, repr. (color) opp. p. 16
Washington 1980a, cat. 9, repr. (color)

p. 58 (Washington venue only)
Zurich 1986, cat. 20, repr. (color) n.p.
New York 1987a, cat. 14, repr. (color) p. 74
Paris 1987b, cat. 22, repr. (color) p. 70
Saint-Paul-de-Vence 1990, cat. 12, pp. 38, 40, repr. (color) p. 39
On view at The Museum of Modern Art, New York: July 21–September 27, 1960; October 4, 1960–October 26, 1962

SELECTED REFERENCES

Raynal 1922, p. 5. Pérez-Jorba 1922, p. 3. *Jahrbuch der Jungen Kunst* 1923, repr.

p. 330. Roh 1925, repr. n.p. Charensol 1925a, p. 2. Ràfols 1925, repr. p. 243. Gasch 1925, repr. p. 5 (incorrectly dated 1925). CH. 1927, p. 387. Gasch 1927b, p. 92. Gasch 1928a, p. 3. Cassanyes 1928, p. 202. Trabal 1928, p. 4, repr. p. 4. Benet 1928, p. 6. Dalí 1928, p. 7. Baiarola 1930a, p. 4. Baiarola 1930b, p. 4. Ràfols 1931a, p. 10. Ràfols 1933, p. 18. Hemingway 1933, n.p. Zervos 1934, p. 13. Desnos 1934, p. 26. Hemingway 1934, p. 28, repr. p. 29. Gaffé 1934, p. 32. M.M. 1935, p. 9. Read 1935, p. C6. J.W.L. 1935, p. 21. Sweeney 1935, p. 360. *Cahiers d'art* 1935, repr. p. 95 (installation view). Westerdahl 1936, pp. 6, 7, 8. Davidson 1936, p. 11. West 1937, p. 19. *Chicago Daily News* 1938b. Zervos 1938, repr. p. 419 (detail). Miró 1938, pp. 26, 27, 28. Watson 1941, pl. 1 (detail, repr. between pp. 132 and 133). Sweeney 1941, pp. 16, 22, 26, 28, 32, 35, 53, repr. p. 23. Bille 1945, repr. p. 152. Parrot 1945, p. 4. Gasch 1948, p. 34, repr. p. 32. Greenberg 1948, pp. 5, 17–18, 37, pl. X (repr. p. 55), repr. p. 4. Read 1948, p. 89. Sicre 1948, p. 6. Ràfols 1948, p. 501, repr. between pp. 500 and 501. Sweeney 1948, pp. 208, 209. Faison 1949, p. 4. Cirici-Pellicer 1949, pp. 20–21, 22, 27, 29, ills. 14, 15 (detail). Cirlot 1949, pp. 19, 20, 24, 32, 41, fig. 10. Gasch 1950, p. 22. C.G.W. 1950, p. 52. Gasch 1953, pp. 93–94, 100. Duthuit 1953, repr. p. 45. Sweeney 1953, pp. 67–68, 71, 74, 80, 185, repr. p. 66. Elgar 1954, n.p. Jouffroy 1955, p. 34. Dupin 1956, p. 97. Prévert/Ribemont-Dessaignes 1956, pp. 76, 77, 78, repr. p. 49. Hüttinger 1957, p. 13. Verdet 1957a, n.p. Verdet 1957b, n.p. Guéguen 1957, p. 40. Erben 1959, pp. 102–03, 104, 108, 109, 111, 116, 124, 125, pl. 46. Gomis/Prats 1959, n.p. Soby 1959, pp. 4, 14, 34, 36, 45, repr. (color) p. 33. Knox 1959, p. L26, repr. p. L26. Canaday 1959, p. 23, repr. p. 22. Schwartz 1959, p. 151. Rubin 1959, p. 36, repr. p. 34. Clark 1959, p. 59, repr. p. 59. R.F.C. 1959, p. 220. Vallier 1960, pp. 164, 168, repr. p. 163. Erben 1961, p. 23. Dupin 1962, pp. 33, 34, 83, 87, 92, 99–100, 102, 104, 131, 132, 138, 139, 140, 141, 151, 152, 153–54, 190, 265, 268, 392, 393, 495, no. 76, repr. pp. 97 (color), 507. Chevalier 1962, p. 8. Gasch 1963, pp. 34–37, 38. Lassaigne 1963, pp. 27, 28, 33, 36, 43, repr. (color) p. 26. Bonnefoy 1964, pp. 14, 18, 20, 24, repr. p. 13. Penrose 1964, pp. 6, 7. Burr 1964, p. 238. Russell 1964, p. 10. Roberts 1964, pp. 478–79, fig. 45. Lynton 1964, p. 44. Barrett 1964, p. 27. Whittet 1964, pp. 224–25. H.C. 1964, p. 289. Gasser 1965, pp. 13–14, 18, repr. (color) p. 25. Walton 1966, pp. 11, 31, pl. 54 (color). Juin 1967, pp. 11, 14, 15, 24, 27, repr. (color) p. 9. Aragon 1969, p. 1. Penrose 1969, pp. 27–29, 34, 44, 45, 47, 113, 186, 193, 200, pl. 17 (repr., color, p. 30). Vidal Alcover 1970, pp. 25, 26, 29. Picon 1971, pp. 11, 12. Wescher 1971, p. 188. Marchiori 1972, p. 18. Schneider 1972, n.p. Cooper 1972, n.p. Krauss/Rowell 1972, pp. 39, 71, 73, 74, 92, fig. 22 (repr. p. 71). Krauss 1972, p. 16. Rowell 1972, p. 39. Tamir 1973, n.p., repr. n.p. (detail, i.e., *L'Intransigeant* masthead) and n.p. (incorrectly dated 1921). Rubin 1973, pp. 18, 19, 20, 21, 24, 43, 110, 111, fig. 3 (repr. p. 110). Leymarie 1974a, p. 11. Mortensen 1974, p. 34. Okada 1974, pl. 4 (color). Teixidor 1974, p. 94. Picon 1976, vol. 1, pp. 22, 59, repr. p. 58. Rowell 1976, pp. 23, 25, 33, 37, 53, 131, repr. p. 24. Rudenstine 1976, p. 517. Miró 1977, pp. 39–40, 53, 54, 57–58, 60, 65, 73, 211, repr. p. 59. Gimferrer 1978, pp. 70, 72, 182, fig. 36 (color). Carmean 1980, pp. 35, 41. Millard 1980, pp. 20, 21. Freeman 1980, p. 35. Dorfles 1981, pp. 9, 10, 15. Benincasa 1981, p. 31. Picon 1981, pp. 41, 42, 43. Gee 1981, p. 17. Gateau 1982, p. 140. Rose 1982a, pp. 7, 8–9, 10. Rose 1982b, p. 119. McCandless 1982, pp. 53, 59, fig. 49 (repr. p. 53). Jardí 1983, pp. 98, 150. Rolnik 1983, n.p. Fundació Joan Miró 1983, repr. p. 100. Malet 1983b, pp. 10, 11, fig. 20 (color). Dupin 1983, pp. 125, 126. Malet 1983a, p. 128. Dupin 1985, pp. 51–52, repr. p. 51. Gimferrer 1985, p. 75. Rowell 1986, pp. 24, 75, 76, 77, 78, 81, 93–94, 102, 103–04, 147, 156, 157, 161, 162, 207, 208, 264, 290, 292, 311 (nn. 15, 17, 20, 22), 312 (n. 7), ill. 7. Théberge 1986, pp. 42, 43. Bouret 1986, n.p. Malet 1986, pp. 17–18. Dupin 1987a, pp. 34, 35, 42, 43. Fernández Miró 1987, p. 46. Lubar 1987, pp. 10, 26 (n. 58), 27 (n. 62), 28. Miró 1987, pp. 30, 31–32. Serra 1987, p. 59. Rowell 1987a, p. 6, fig. 2 (repr. p. 6). Erben 1988, repr. (color) p. 29. Malet 1988a, pp. 18, 20, repr. pp. 19, 177. Lubar 1988, pp. xv–xix, 223, 224, 225–48, 249, 252, 258, 259, 287 (n. 18), 318, fig. 77. Malet 1988b, p. 8. Malet 1989, p. 12, repr. p. 13. Jeffett 1989b, pp. 120, 121. Porcel 1989, p. 16. Raillard 1989, pp. 8, 20, 21, 32, 46, 60, 62, repr. (color) p. 61. Combalía 1990, pp. 8, 45, 50, 52, 60, 65, 66, 67, 68, 74, 76, 85, 142, 193, 219, 272, 273, 286, repr. (color) n.p. Llorca 1990, repr. p. 163. Bouisset 1990, p. 129, repr. (color) p. 129. Yokohama Museum of Art 1992, fig. 2 (repr. p. 25). Combalía 1992, pp. 185, 186.

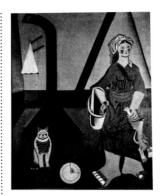

PROVENANCE

René Gaffé, Brussels, by June 19, 1929?; to Pierre Matisse Gallery, New York, February 1937; to present owner, by September 1948.

SELECTED EXHIBITIONS

Paris 1925a, cat. 4
New York 1936c, cat. 3, as *The Farmer's Wife* (not exhibited)
New York 1937a, cat. 15, as *The Farm's Kitchen* (not exhibited)
Possibly Paris 1937e, cat. 122
New York 1940b, cat. 9, repr. cover (detail), n.p., as *La Fermière*
New York 1941g, as *The Farmer's Wife*
Boston 1946, cat. 34, as *The Farmer's Wife*
San Francisco 1948, cat. 44, repr. p. 98, as *Farmer's Wife*
New York 1953a, cat. 25, repr. n.p., as *"Intérieur"—The Farmer's Wife*
Venice 1954, cat. 8, as *La Moglie del fattore*
New York 1959b, cat. 20, as *The Farmer's*
Wife (Los Angeles venue, cat. 19)
Paris 1962b, cat. 22, as *La Fermière*
London 1964b, cat. 30, p. 21, pl. 6a, as *The Farmer's Wife*
Saint-Paul-de-Vence 1968, cat. 12, repr. p. 61, as *La Fermière*
Barcelona 1968, cat. 16, pl. 8 (repr. p. 96), as *La Masovera*
Munich 1969, cat. 15, repr. n.p., as *Die Bäuerin*
Paris 1974b, cat. 16, p. 114, repr. pp. 35 (color), 114, as *La Fermière*
Madrid 1978a, cat. 13, pp. 91–92, repr. (color) p. 41, as *La Granjera*
Zurich 1986, cat. 22, repr. (color) n.p., as *La Fermière*
Saint-Paul-de-Vence 1990, cat. 13, p. 40, repr. (color) p. 41, as *La Fermière*

SELECTED REFERENCES

Bosschère 1928, repr. n.p. *Vooruit* 1937, repr. Miró 1938, p. 26. J.W.L. 1940, p. 13, repr. p. 3. *New York World Telegram* 1940, repr. *Art Digest* 1940, p. 9, repr. p. 9. Genauer 1941, repr. Watson 1941, pl. 3 (repr. between pp. 132 and 133). Sweeney 1941, p. 26, repr. p. 25. Loeb 1946, pl. XV (detail). Greenberg 1948, p. 18, pl. XII (repr. p. 57). Sweeney 1948, p. 208. Read 1948, p. 90. Cirici-Pellicer 1949, p. 22, ill. 20. Cirlot 1949, fig. 11. Duthuit 1953, fig. 8 (repr. p. 30). Sweeney 1953, pp. 68, 71, repr. p. 71. F.P. 1953, repr. p. 55. Dégand 1956, p. 28. Prévert/Ribemont-Dessaignes 1956, p. 77. Hüttinger 1957, p. 14. Erben 1959, pp. 109, 110, pl. 45. R.F.C. 1959, repr. p. 221. Soby 1959, p. 34, repr. p. 35. Dupin 1962, pp. 131, 132, no. 77, repr. pp. 103 (color), 507. Chevalier 1962, p. 8. Lassaigne 1963, p. 33, repr. (color) p. 32. Bonnefoy 1964, pp. 14, 18, pl. 13 (color). Penrose 1964, p. 7. Russell 1964, p. 10. Gasser 1965, p. 14, repr. (color) p. 24. Aragon 1969, p. 1. Penrose 1969, pp. 29, 30, pl. 18 (repr., color, p. 31). Picon 1971, pp. 9, 12. Cirici 1972, repr. (color) p. 54. Marchiori 1972, pp. 18, 21. Leymarie 1974a, p. 12. Melià 1975, repr. n.p. Rowell 1976, pp. 21, 23, 33, repr. (color) p. 20. Gimferrer 1978, pp. 26, 30, 164, 182, 206, fig. 30 (color), fig. 154 (color, detail). Carmean 1980, p. 37. Millard 1980, p. 19. Picon 1981, pp. 38, 43. Rose 1982a, p. 9. McCandless 1982, p. 60. Malet 1983b, p. 10, fig. 21 (color). Rolnik 1983, ill. 1. Bouret 1986, n.p. Rowell 1986, pp. 101, 113, 161, 207, 263, 297, 312 (n. 17). Dupin 1987a, p. 34. Erben 1988, repr. (color) p. 31. Lubar 1988, p. 240 (n. 35).

23. **INTERIOR** (The Farmer's Wife). Montroig and Paris, July 1922– spring 1923. (Plate, p. 106)

Oil on canvas, 31⅞ × 25⅞″ (81 × 65.5 cm). Signed and dated lower left: *Miró | 1922–23*. Inscribed on verso: *Miró | "Intérieur" | 1922–23*. Private collection, Villiers-sous-Grez. Dupin 77

24. **STILL LIFE I** (The Ear of Grain). Montroig and Paris, July 1922– spring 1923. (Plate, p. 108)

Oil on canvas, 14⅞ × 18⅛″ (37.8 × 46 cm). Signed and dated twice, lower left: *Miró. | 1922–23*. Inscribed on verso: *Joan Miró | "Nature Morte I" | 1922–23*. The Museum of Modern Art, New York. Purchase. Acq. no. 11.39. Dupin 81

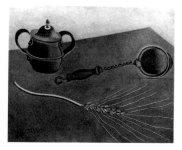

PROVENANCE

The artist (on consignment to Léonce Rosenberg, Galerie L'Effort Moderne, Paris, June 20, 1923–spring 1924?); Pierre Loeb (Galerie Pierre), Paris; to The Museum of Modern Art, New York, January 1939.

SELECTED EXHIBITIONS

Possibly Paris 1925a, cat. 2, as *Nature morte*
Possibly Paris 1937c, as (?)
Paris 1938a, cat. 132, as *L'Epi de blé*
New York 1940b, cat. 11, repr. n.p., as *L'Epi de blé*
New York 1941d, as *The Ear of Grain*
New York 1941g, as *The Ear of Grain*
New York 1943c, cat. 223, as *The Ear of Grain*
Minneapolis 1954, cat. 110, as *The Ear of Grain*
New York 1954, as *The Ear of Grain*
London 1964b, cat. 20, p. 21, pl. 5b, as *The Ear of Corn*
Munich 1969, cat. 17, repr. n.p., as *Die Kornähre*
Knokke 1971, cat. 3, repr. p. 25, as *L'Epi de blé*

New York 1973b, as *The Ear of Grain*
Tokyo 1975, cat. 48, repr. n.p., as *The Ear of Grain*
Berlin 1977, cat. 4/123, repr. p. 189, as *Die Kornähre*
Houston 1982, as *Ear of Grain*
Zurich 1986, cat. 21, repr. (color) n.p., as *L'Epi de blé*
New York 1987a, cat. 15, repr. (color) p. 75, as *The Ear of Grain*
Saint-Paul-de-Vence 1990, cat. 15, p. 44, repr. (color) p. 45, as *L'Epi de blé*
On view at The Museum of Modern Art, New York: July–November 1941; January–February 1955; October 1955–June 1957; October 1958–October 1962; June 1965–February 1969; April–November 1974.

SELECTED REFERENCES

Eluard 1937, repr. p. 81. Miró 1938, p. 26. Sweeney 1941, p. 26, repr. p. 24. Greenberg 1948, p. 18, pl. VIII (repr. p. 54). Cirici-Pellicer 1949, p. 21, ill. 18. Cirlot 1949, p. 20. Elgar 1954, n.p. Prévert/Ribemont-Dessaignes 1956, p. 76. Erben 1959, p. 109. Soby 1959, p. 34, repr. p. 34. Lassaigne 1963, p. 33, repr. (color) p. 31. Gasser 1965, p. 14, repr. p. 26. Rubin 1973, pp. 18–20, 111, repr. p. 19. Okada 1974, pl. 5 (color). Millard 1980, pp. 19, 20. Rose 1982a, pp. 7, 8, 9, fig. 4 (repr. p. 8). Malet 1983b, p. 10. Rowell 1986, pp. 78, 79, 161. Dupin 1987a, pp. 33, 34. Miró 1987, p. 29.

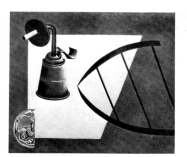

25. STILL LIFE II (The Carbide Lamp). Montroig and Paris, July 1922–spring 1923. (Plate, p. 109)

Oil on canvas, 15 × 18″ (38.1 × 45.7 cm). Signed and dated lower left: *Miró | 1922/23* and lower right: *Miró | 1922–23*. Inscribed on verso: *Joan Miró | "Nature Morte II" | 1922–23*. The Museum of Modern Art, New York. Purchase. Acq. no. 12.39. Dupin 80

PROVENANCE

The artist (on consignment to Léonce Rosenberg, Galerie L'Effort Moderne, Paris,

June 20, 1923–spring 1924?); Pierre Loeb (Galerie Pierre), Paris; to The Museum of Modern Art, New York, January 1939.

SELECTED EXHIBITIONS

Possibly Paris 1925a, cat. 2, as *Nature morte*
New York 1940b, cat. 10, as *La Lampe à Carbure*
New York 1941d, as *The Carbide Lamp*
New York 1941g, as *The Carbide Lamp*
San Francisco 1948, cat. 45, repr. p. 98, as *The Carbide Lamp*
Houston 1951, cat. 2, as *The Carbide Lamp*
New York 1951c, cat. 16, as *The Carbide Lamp*
Palm Beach 1952, cat. 29, repr. n.p., as *The Carbide Lamp*
New York 1954, as *The Carbide Lamp*
New York 1959b, not in checklist (Los Angeles venue, cat. 18, as *The Carbide Lamp*)
Knokke 1971, cat. 2, repr. p. 24, as *La Lampe à carbure*
New York 1973b, as *The Carbide Lamp*
Tokyo 1975, cat. 47, repr. n.p., as *The Carbide Lamp*
New York 1979b, repr. p. 70, as *The Carbide Lamp*

São Paulo 1981, pp. 98–99, repr. p. 99, as *The Carbide Lamp* (Calgary venue only)
Houston 1982, as *Carbide Lamp*
Tokyo 1983, cat. 65, repr. n.p., as *The Carbide Lamp*
Zurich 1986, cat. 23, repr. (color) n.p., as *La Lampe à carbure*
New York 1987a, cat. 16, repr. (color) p. 76, as *The Carbide Lamp*
Saint-Paul-de-Vence 1990, cat. 14, p. 42, repr. (color) p. 43, as *La Lampe à carbure*
Cologne 1991, cat. 111, repr. (color) p. 131, as *La Lampe à carbure*
On view at The Museum of Modern Art, New York: July–November 1941; June 1945–January 1946; October 1954–January 1955; October 1958–October 1962; October–November 1964; June 1965–June 1968; October 1968–May 1969; April–November 1974

SELECTED REFERENCES

Dictionnaire abrégé 1938, repr. p. 48. Miró 1938, p. 26. Sweeney 1941, p. 26. Greenberg 1948, pl. IX (repr. p. 54). Read 1948, p. 90. Prévert/Ribemont-Dessaignes 1956, repr. p. 109. Dupin 1962, pp. 131, 132, 134, 136, 137, 139, no. 80, repr. pp. 127, 507. Lassaigne 1963, p. 33, repr. (color) p. 30. Bonnefoy 1964, pl. 15 (color). Walton 1966, p. 31, pl. 55 (color). Juin 1967, p. 26. Marchiori 1972, repr. (color) p. 20. Rubin 1973, pp. 18–20, 110–11, repr. p. 18. Rose 1982a, pp. 7, 8, 9, 33. Gateau 1982, p. 140. Malet 1983b, p. 10. Rowell 1986, pp. 78, 79, 101, 161, 312 (n. 17). Erben 1988, repr. (color) p. 28. Lubar 1988, p. 240 (n. 35). Malet 1988a, p. 18. Combalía 1990, p. 60.

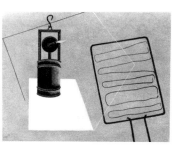

26. STILL LIFE III (Grill and Carbide Lamp). Montroig and Paris, July 1922–spring 1923. (Plate, p. 110)

Oil on canvas, 19⅞ × 25½″ (50.5 × 65 cm). Signed and dated twice, lower left: *Miró | 1922–23*. Inscribed on verso, upper left: *Joan Miró | "Nature morte III." | 1922–23*. Private collection. Dupin 79

PROVENANCE

The artist (on consignment to Léonce Rosenberg, Galerie L'Effort Moderne, Paris, June 20, 1923–spring 1924?); Charles and Marie-Laure de Noailles, Paris; to Nathalie de Noailles, Fontainebleau; private collection, Italy; to Mr. and Mrs. Jan Krugier, Geneva, March 1976; to Galerie Jan Krugier, Geneva; to present owner, May 1977.

SELECTED EXHIBITIONS
Possibly Paris 1925a, cat. 2, as *Nature
morte*
Zurich 1986, cat. 24, repr. (color) n.p., as
Gril et lampe à carbure
New York 1987a, cat. 17, repr. (color) p.
77, as *Grill and Carbide Lamp*

SELECTED REFERENCES
Dupin 1962, no. 79, repr. p. 507. Lassaigne 1963, p. 33. Rubin 1973, pp. 18, 19, fig.
4 (repr. p. 110). Gimferrer 1978, fig. 113 (color). Gateau 1982, p. 140. Bouret 1986,
n.p. Rowell 1986, pp. 78, 79, 101. Lubar 1988, p. 240 (n. 35). Raillard 1989, p. 20.

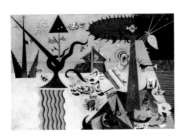

27. THE TILLED FIELD. Montroig, July 1923–winter 1924. (Plate,
p. 111)

Oil on canvas, 26 × 36½″ (66 × 92.7 cm). Signed and dated lower left: *Miró. | 1923–
24.* Inscribed on verso: *Joan Miró | "La Terre Labourée" | 1923–24.* Solomon R.
Guggenheim Museum, New York. Dupin 82
(Note: For a number of studies related to *The Tilled Field*, see FJM 192–98.)

PROVENANCE
The artist to Jacques Viot, Paris, by June 1925; André Breton, Paris; to René Gaffé,
Brussels, by October 1928; to Roland Penrose, London, July 15, 1937; to Zwemmer
Gallery, London, end of July 1937; Valerie Cooper, London, by May 1938; Pierre
Matisse Gallery, New York, 1940; to Mr. and Mrs. Henry Clifford, Radnor, Pa., 1941;
to Harold and Hester Diamond, New York, 1972; to Solomon R. Guggenheim
Museum, New York, 1972.

SELECTED EXHIBITIONS
Paris 1925a, cat. 9

Paris 1927c

London 1936c, cat. 215

London 1937b, cat. 3, repr. n.p.

New York 1940b, cat. 2, repr. n.p.

New York 1941g

Houston 1951, cat. 3

Venice 1954, cat. 9

Brussels 1958, cat. 219, repr. p. 113

New York 1959b, cat. 21 (Los Angeles
venue, cat. 20)

Paris 1962b, cat. 23

London 1964b, cat. 31, pp. 21–22, pl. 6b

New York 1968a, cat. 223 (New York
venue only)

New York 1972d, cat. 1, pp. 70–75, 77,
80, 82, 86, 92, 110, 147, repr. p. 70

Paris 1974b, cat. 17, p. 114

Humlebaek 1974, cat. 5

Madrid 1978a, cat. 14, p. 92, repr. (color)
p. 42

Washington 1980a, cat. 10, repr. (color)
p. 59 (at Washington venue, shown
until April 29 only)

New York 1983a, cat. 2

New York 1987a, cat. 18, repr. (color)
p. 78

On view at the Solomon R. Guggenheim
Museum, New York: April–October
1976; April–July 1981; May–
September 1986; November 1987–
March 1988; February–April 1990

SELECTED REFERENCES
Pinturrichio 1925, p. 7. Fels 1925a, p. 25. *Révolution surréaliste* 1925b, repr. p. 10.
Leiris 1926, repr. between pp. 8 and 9. Trabal 1928, p. 4. Breton 1928, pl. 58. Gaffé
1929, repr. p. 55. Focius 1930a, repr. p. 4 (detail). Einstein 1930, p. 241. Zervos
1934, pp. 13–14. Gaffé 1934, p. 32, fig. 13 (repr. p. 30). Grohmann 1934, p. 38. Frey
1936, pp. 13, 14. Duthuit 1937, repr. p. 442. Zervos 1938, repr. p. 421. *London
Bulletin* 1938, repr. p. 5. *Art Digest* 1940, p. 9. Sweeney 1941, pp. 22, 26, 28, 35,
repr. p. 27. Greenberg 1948, pp. 20–21, 23, 28, 37, pl. XIV (repr. p. 59). Cirici-
Pellicer 1949, pp. 22–23, ill. 21. Cirlot 1949, pp. 20, 23, 28, fig. 12. C.G.W. 1950, p.
52. Gasch 1953, p. 100. Duthuit 1953, fig. 6 (repr. p. 30). Elgar 1954, n.p. Jouffroy

1955, p. 34. Dupin 1956, p. 97. Prévert/Ribemont-Dessaignes 1956, p. 77, repr. p.
110. Erben 1959, pp. 111, 112, pl. 47. Schwartz 1959, p. 151. Rubin 1959, pp. 36–37,
repr. p. 34. R.F.C. 1959, repr. p. 220. Soby 1959, pp. 36, 37–38, 45, repr. p. 37.
Vallier 1960, p. 168. Dupin 1962, pp. 94, 134, 136, 140, 141, 196, 495, no. 82, repr.
pp. 135 (color), 508. Chevalier 1962, p. 8. Rykwert 1962, repr. p. 37. Gaffé 1963,
repr. p. 150. Gasch 1963, pp. 38, 39–40. Lassaigne 1963, pp. 37, 40. Bonnefoy
1964, pp. 14, 18, 24, pl. 17 (color). Roberts 1964, p. 479. Gasser 1965, pp. 15, 17,
repr. (color) p. 27. Rubin 1966, repr. p. 47. Juin 1967, p. 18, repr. (color) p. 16.
Rubin 1968, pp. 66, 68, fig. 83 (repr. p. 66). Aragon 1969, p. 1. Penrose 1969, p. 34,
pl. 19 (repr., color, p. 35). Picon 1971, pp. 11, 12. Cooper 1972, n.p. Krauss 1972, pp.
13, 16, 31, 33. Marchiori 1972, p. 21. Rowell 1972, pp. 39, 60. Schneider 1972, n.p.
Golding 1973, p. 91. Rubin 1973, pp. 20, 21, 26, 112 (n. 20), fig. 5 (repr. p. 110).
Leymarie 1974a, p. 13. Leymarie 1974b, p. 5, repr. (color) p. 18. Okada 1974, repr. p.
77. Picon 1976, vol. 1, pp. 59, 62, repr. (color) p. 58. Rowell 1976, pp. 33, 37, 117,
129, 131, 161, 185 (n. 24), repr. (color) p. 128. Rudenstine 1976, p. 517, repr. p. 724.
Miró 1977, pp. 26, 57, 60, 61, 65, 187, 211. Gimferrer 1978, pp. 6, 62, 94, 106, 110,
118, 182, fig. 1 (color). Millard 1980, pp. 20, 21. Dorfles 1981, p. 10. Benincasa 1981,
p. 31. Picon 1981, pp. 41, 42, 43. Gateau 1982, pp. 140, 141. Rose 1982a, pp. 9, 10,
17, fig. 5 (repr. p. 9). McCandless 1982, pp. 49, 59. Rolnik 1983, n.p. Fundació Joan
Miró 1983, repr. p. 101. Dupin 1983, p. 125. Malet 1983b, p. 11, fig. 24 (color). Ooka
1984, repr. p. 14. Gimferrer 1985, pp. 62, 75, repr. p. 76. Bouret 1986, n.p. Rowell
1986, pp. 11, 81, 82, 94, 95, 102, 263, 282, 311 (n. 3), ill. 10. Beaumelle 1987, p.
430. Dupin 1987a, p. 35. Fernández Miró 1987, p. 46. Green 1987, pp. 102, 283.
Lubar 1987, p. 26. Miró 1987, p. 30. Pierre 1987, pp. 144, 203. Rowell 1987a, pp. 7,
8, fig. 3 (repr. p. 7). Erben 1988, repr. (color) p. 32. Lubar 1988, p. 224 (n. 2). Malet
1988a, p. 20. Jeffett 1989b, p. 121, repr. p. 120. Raillard 1989, pp. 21, 22, 25, 62, 64,
repr. (color) p. 63. Combalía 1990, pp. 68, 71–72, 80, 286, repr. (color) n.p. Rowell
1991, p. 180, repr. p. 179. Halliday 1991, pp. 155, 156 (n. 35), 157, repr. p. 156.
Combalía 1992, p. 186. Umland 1992, p. 54.

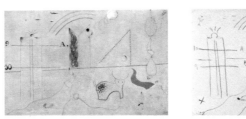
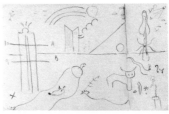

FJM 4352. Charcoal on paper, 5⅞ × 9⅛″
(15 × 23.4 cm)

28. PASTORALE. Montroig, July 1923–winter 1924. (Plate, p. 112)

Oil and pencil on canvas, 23⅝ × 36⅜″ (60 × 92.2 cm). Signed and dated lower right:
Miró. | 1923–24. Inscribed on verso: *Joan Miró | "Pastorale" | 1923–24.* Collection
Stefan T. Edlis. Dupin 83

PROVENANCE
Pierre Matisse Gallery, New York; to Alexina Matisse (later Alexina Duchamp), New
York and Villiers-sous-Grez, 1949; to Harold and Hester Diamond, New York, after
1972; to Mr. and Mrs. A. Richard Benedek, New York, by May 1974; auctioned at
Sotheby Parke Bernet, New York, November 7, 1979, lot 567; to Stefan T. Edlis.

SELECTED EXHIBITIONS
Paris 1925a, cat. 8

Paris 1938a, cat. 133

New York 1940b, cat. 14

New York 1941g (all venues except
New York)

New York 1948b, cat. 1

New York 1949a, cat. 1

New York 1972d, cat. 3, pp. 71, 79–80,
95, repr. p. 79

Paris 1974b, cat. 18, p. 114, repr. p. 114

Humlebaek 1974, cat. 6

Saint Louis 1980

Houston 1982

Barcelona 1983, cat. 27, repr. (color)
p. 41

Chicago 1984, p. 196, repr. (color) p. 25

Charleroi 1985, cat. 8, repr. (color)
p. 180

Zurich 1986, cat. 27, repr. (color) n.p.

New York 1987a, cat. 21, repr. (color)
p. 81

Paris 1987b, cat. 23, repr. (color) p. 71

Los Angeles 1989, fig. 34 (repr. p. 41)

Saint-Paul-de-Vence 1990, cat. 16, p. 46,
repr. (color) p. 47

SELECTED REFERENCES
Sweeney 1941, p. 32, repr. p. 30. Greenberg 1948, p. 23. Cirici-Pellicer 1949, p. 23. Dupin 1962, pp. 139, 142, no. 83, repr. p. 508. Lassaigne 1963, pp. 37–38. Krauss 1972, p. 18. Leymarie 1974a, p. 13. Picon 1976, vol. 1, p. 62. Rowell 1976, repr. p. 32. Stich 1980, p. 16, fig. 5 (repr. p. 16). Gateau 1982, p. 140. Rose 1982a, pp. 9, 13, 15, 17, fig. 6 (repr. p. 9). Dupin 1983, p. 125. Malet 1983b, p. 11. Rolnik 1983, n.p. Gimferrer 1985, p. 75. Rowell 1986, pp. 11, 81, 82, 311 (n. 3). Dupin 1987a, p. 35. Rowell 1987a, p. 7. Lubar 1988, p. 224 (n. 2). Freeman 1989, p. 42. Combalía 1990, repr. (color) n.p.

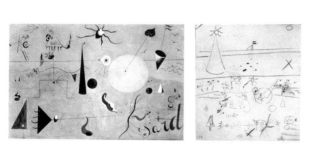

FJM 654a. 7½ × 6½″ (19.1 × 16.5 cm)

29. THE HUNTER (Catalan Landscape). Montroig, July 1923–winter 1924. (Plate, p. 113)

Oil on canvas, 25½ × 39½″ (64.8 × 100.3 cm). Signed and dated lower left: *Miró. | 1923–24*. Inscribed on verso: *Joan Miró | "Paysage Catalan" | 1923–24*. The Museum of Modern Art, New York. Purchase. Acq. no. 95.36. Dupin 84

PROVENANCE
The artist [to Jacques Viot (Galerie Pierre), Paris]; to André Breton, Paris, by June 1925; to Simone Breton (later Simone Collinet), Paris, 1929; through Pierre Matisse Gallery, New York, to The Museum of Modern Art, New York, December 1936.

SELECTED EXHIBITIONS
Paris 1925a, cat. 10
New York 1936d, cat. 430, repr. p. 138, as *Catalan Landscape*
Grand Rapids 1938, cat. 430, as *Catalan Landscape*
New York 1941a, as (?)
New York 1941g, as *Catalan Landscape (The Hunter)*
San Francisco 1948, cat. 46, repr. p. 99, as *Catalan Landscape*
New York 1949a, cat. 2, as *Catalan Landscape*
Houston 1951, cat. 4, as *Catalan Landscape (The Hunter)*
New York 1954, as *Catalan Landscape (The Hunter)*
New York 1959b, cat. 22, as *Catalan Landscape (The Hunter)* (Los Angeles venue, cat. 21)
New York 1972d, cat. 2, pp. 71, 74, 76–78, 80, 82, 86, 95, 102, 106, 114, repr. p. 76
New York 1973b
Paris 1974b, cat. 19, p. 114, repr. p. 36
Madrid 1978a, cat. 15, pp. 92–97, repr. pp. 43 (color), 93 (with iconographical chart), as *Paisaje catalan (El Cazador)*

Cleveland 1979, cat. 25, repr. p. 73
Houston 1982, pl. 3 (color)
Barcelona 1983, cat. 23, repr. (color) p. 39, as *Paisatge català (El Caçador)*
Zurich 1986, cat. 25, repr. (color, detail) cover and (color) n.p., as *Paysage catalan (Le Chasseur)*
New York 1987a, cat. 19, repr. (color) p. 79, as *Catalan Landscape (The Hunter)*
On view at the Albright Art Gallery, Buffalo: February 13–March 13, 1939
On view at The Museum of Modern Art, New York: May–September 1940; May–November 1941; November 1944–May 1945; June 1945–January 1946; May 1949–February 1950; November 1952–September 1954; October 1955–April 1958; October 1958–October 1962; May 1964–March 1967; July 1969–July 1971; November 1971–October 1972; January–September 1973; January–April 1974; November 1974–March 1978; August 1978–August 1979; February–March 1980; April 1981–January 1982; May 1984–November 1986; September 1987–August 1992

SELECTED REFERENCES
Révolution surréaliste 1925a, repr. p. 15. *Heraldo de Madrid* 1926, repr. (line drawing). Desnos 1926, repr. p. 213. Leiris 1926, repr. between pp. 8 and 9. Planas 1928, repr. p. 1. Breton 1928, pl. 59. Frey 1936, pp. 13, 14. Hugnet 1936, p. 21.

Beaux-Arts 1939b, p. 4. Coates 1941, p. 59. Sweeney 1941, pp. 28, 30, 32, 35, repr. p. 29. Arbois 1945, p. 3. Greenberg 1948, p. 23, pl. XIII (repr. p. 58). Cirici-Pellicer 1949, pp. 22–23, ill. 22. Cirlot 1949, fig. 13. Gibbs 1949, p. 17. Queneau 1949, n.p. Jouffroy 1955, p. 34. Prévert/Ribemont-Dessaignes 1956, p. 77. Clark 1957, pp. 84–85, repr. p. 85. Hüttinger 1957, p. 20. Soby 1959, pp. 37, 45, repr. (color) p. 39. Schwartz 1959, p. 151. Rubin 1959, p. 37. Borchert 1961, p. 6, pl. 2 (repr., color, p. 7). Dupin 1962, pp. 139, 140, 141, 508, no. 84, repr. p. 205. Lassaigne 1963, pp. 37, 38. Bonnefoy 1964, p. 18, pl. 16. Penrose 1969, pp. 37–39, pl. 22 (repr., color, p. 38). Krauss 1972, pp. 16, 18, 33. Rowell 1972, p. 46. Rubin 1973, pp. 7, 20–26, 27, 29, 30, 32, 38, 44, 62, 111–14, 130 (n. 2), repr. pp. 22 (with iconographical chart), 23 (color). Leymarie 1974a, p. 13 Lemayrie 1974b, p. 5. Okada 1974, repr. p. 76. Picon 1976, vol. 1, pp. 56, 59–60, 62, 93, repr. (color) p. 59. Rowell 1976, pp. 33, 35, 37, 39, 119, 185 (n. 24), repr. p. 34. Rudenstine 1976, p. 523. Miró 1977, pp. 160–61. Henning 1979, p. 238, fig. 5 (repr. p. 238). Carmean 1980, pp. 35, 36, 38, 39, 43, fig. 1 (repr. p. 36). Stich 1980, pp. 12–16, 19, 42, 48, fig. 2 (repr. p. 12). Gee 1981, p. 93. Gateau 1982, pp. 140, 141. Rose 1982a, pp. 9, 10, 11, 15, 16. McCandless 1982, p. 49, fig. 46 (repr. p. 49). Schmalenbach 1982, repr. p. 32. Dupin 1983, p. 125. Malet 1983a, pp. 128, 129. Malet 1983b, p. 11, fig. 25 (color). Rolnik 1983, ill. 2. Gimferrer 1985, p. 75. Bouret 1986, n.p. Malet 1986, p. 18. Rowell 1986, pp. 11, 81, 82, 83, 284, 298, 309 (n. 48), 311 (nn. 3, 4), ill. 9. Dupin 1987a, p. 35. Green 1987, pp. 102, 103, 258, 267, 278, 283, 288, pl. 133 (repr. p. 104). Lubar 1987, p. 26. Pierre 1987, pp. 144, 203, 341, fig. 49. Rowell 1987a, pp. 7, 8, fig. 4 (repr. p. 7). Erben 1988, repr. (color) p. 33. Malet 1988a, p. 20, repr. p. 19. Lubar 1988, pp. 224 (n. 2), 238 (n. 31). Freeman 1989, pp. 39–40, 42, fig. 33 (repr. p. 40). Jeffett 1989b, p. 121, repr. p. 121. Jeffett 1989c, p. 15 (n. 12). Raillard 1989, pp. 21, 64, repr. (color) p. 65. Welchman 1989, p. 87. Combalía 1990, pp. 68, 71–72, 79, 80, 286, repr. (color) n.p. Llorca 1990, repr. p. 164. Rowell 1991, p. 180, repr. p. 181. Beaumelle 1991, pp. 176, 177. Yokohama Museum of Art 1992, p. 186, fig. 3 (repr. p. 26).

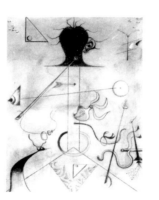

30. PORTRAIT OF MME K. Paris, spring 1924. (Plate, p. 117)

Oil and charcoal on canvas, 45¼ × 35″ (115 × 89 cm). Signed and dated lower left: *Miró. | 1924*. Private collection. Dupin 86

PROVENANCE
René Gaffé, Brussels and Cagnes-sur-Mer; to present owner, November 1968.

SELECTED EXHIBITIONS
Brussels 1956, cat. 10
London 1964b, cat. 36, p. 22, pl. 7a

SELECTED REFERENCES
Trabal 1928, p. 4. Dupin 1956, p. 97. Prévert/Ribemont-Dessaignes 1956, repr. p. 111. Guéguen 1957, repr. p. 40. Erben 1959, pp. 112, 115–16, 123, 125, pl. 48. Chevalier 1960, p. 32. Dupin 1962, pp. 144, 146–47, 152, 508, no. 86, repr. p. 207. Gaffé 1963, repr. p. 151. Gasch 1963, p. 39. Lassaigne 1963, p. 38. Bonnefoy 1964, p. 18. Gasser 1965, repr. p. 38. Dorival 1966, fig. 12 (repr. p. 119). Aragon 1969, p. 2. Penrose 1969, pp. 39–41, pl. 23 (repr. p. 40). Krauss 1972, pp. 19, 106. Rubin 1973, pp. 27, 34, 113 (n. 28), fig. 18 (repr. p. 115). Picon 1976, vol. 1, p. 91, repr. p. 90. Miró 1977, p. 88. Carmean 1980, pp. 36, 37, 39. Schmalenbach 1982, repr. p. 33. Malet 1983b, p. 11, fig. 27 (color). Rolnik 1983, ill. 3. Rowell 1986, p. 95. Green 1987, pp. 102, 258, 267, 275, 276, 278, 284, pl. 290 (repr. p. 277). Erben 1988, repr. p. 178 (upside down). Combalía 1990, pp. 93–94. Umland 1992, p. 69 (n. 21).

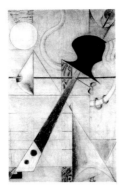

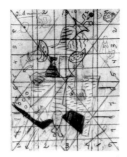

FJM 4480b. Pencil, colored pencil, and pastel on paper, 10½ × 8″ (26.8 × 20.5 cm)

31. **SPANISH DANCER.** Paris, spring 1924. (Plate, p. 116)
Oil, charcoal, and tempera on canvas, 36¼ × 28¾″ (92 × 73 cm). Signed and dated lower right: *Miró.* | *1924*. Private collection. Dupin 87

PROVENANCE
The artist [to Paul Eluard, Paris, by October 26, 1926]; René Gaffé, Brussels and Cagnes-sur-Mer, 1926?; to present owner, November 1968.

SELECTED EXHIBITIONS
Paris 1925a, cat. 7
Brussels 1956, cat. 9

SELECTED REFERENCES
Trabal 1928, p. 4. Gaffé 1934, fig. 14 (repr. p. 31). Zervos 1938, repr. p. 420. Miró 1938, p. 27. Greenberg 1948, pp. 23–24. Cirici-Pellicer 1949, ill. 17. Dupin 1956, p. 97. Chevalier 1960, repr. p. 32. Dupin 1962, pp. 144, 152, no. 87, repr. p. 508. Gaffé 1963, p. 108, repr. p. 154. Lassaigne 1963, p. 38. Picon 1976, vol. 1, pp. 87–88, 91, repr. p. 89. Rowell 1986, pp. 94, 102, 161, 313 (n. 20). Bouret 1986, n.p. Raillard 1989, pp. 35, 37. Umland 1992, p. 69 (n. 21).

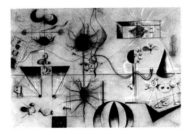

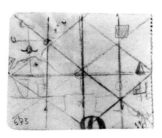

FJM 673a. Pencil and colored pencil on paper, 2¼ × 2¾″ (5.7 × 7 cm)

32. **THE FAMILY.** Paris, May 16, 1924. (Plate, p. 115)
Vine charcoal, white pastel, and red conté on oatmeal paper, 29½ × 41″ (74.9 × 104.1 cm). Signed and dated lower right: *Miró.* | *1924*. Inscribed upper left, near edge: *16/5/24*. The Museum of Modern Art, New York. Gift of Mr. and Mrs. Jan Mitchell. Acq. no. 395.61. No Dupin number

PROVENANCE
René Gaffé, Brussels; to Roland Penrose, London, July 15, 1937; to Zwemmer Gallery, London, end of July 1937; [Minneapolis Institute of Arts, by 1959]; [Pierre Matisse Gallery, New York]; Mr. and Mrs. Jan Mitchell, New York; to The Museum of Modern Art, New York, December 1961.

SELECTED EXHIBITIONS
Possibly Paris 1925b
London 1937b, cat. 5
London 1939c, cat. 2
London 1940, cat. 21
New York 1941a
London 1964b, cat. 37, p. 22, repr. n.p.
New York 1973b
New York 1974, cat. 116, repr. p. 65
New York 1982 (New York venue only)
New York 1983b
New York 1983e, p. 154, repr. (color) p. 155
New York 1987c

On view at The Museum of Modern Art, New York: December 1961–February 1962; April–August 1962; January 1965–January 1966; October 1966–May 1967; May–October 1971; March 1972–May 1973; November 1974–June 1975; February 1976–March 1980; October 1980–January 1982; November 1986–September 1987; July 1990–September 1991

SELECTED REFERENCES
Basler 1926, repr. p. 64. Breton 1928, pl. 60. *Hèlix* 1929, repr. p. 7. García y Bellido 1929, repr. p. 1. Gaffé 1934, p. 32. Grohmann 1934, p. 38. Frey 1936, p. 13. Tériade 1936, repr. p. 15. Sweeney 1941, pp. 22, 32, repr. p. 32. Bille 1945, repr. p. 153. Greenberg 1948, p. 23. Cirici-Pellicer 1949, p. 23. Prévert/Ribemont-Dessaignes 1956, p. 78. Soby 1959, repr. p. 38. *Park Avenue Social Review* 1961, repr. p. 30. *MoMA Bulletin* 1962a, repr. p. 14. Dupin 1962, pp. 144–45, repr. p. 206. Gaffé 1963, repr. p. 153. Bonnefoy 1964, pp. 20, 26. Miró 1965, repr. p. 106. Penrose 1969, pp. 40–41, pl. 24 (repr. p. 41). Krauss/Rowell 1972, pp. 75, 78, 82, 90, 106. Rowell 1972, p. 61. Rubin 1973, pp. 8, 24, 27–30, 32, 34, 44, 116, repr. pp. 28 (with iconographical chart), 29. Rowell 1976, p. 163. Miró 1977, pp. 34, 71, 88, 187. Rose 1982a, pp. 6, 29–30, fig. 1 (repr. p. 6). Lader 1982, p. 89. Rolnik 1983, n.p. Fundació Joan Miró 1983, repr. p. 44. Gimferrer 1985, p. 78, repr. p. 77. Raillard 1989, p. 112. Halliday 1991, pp. 155, 157, 166, 315.

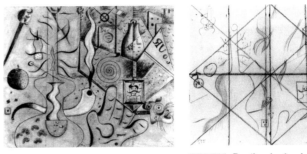

FJM 555. Pencil and colored pencil on paper, 6½ × 7½″ (16.6 × 19.2 cm)

33. **THE KEROSENE LAMP.** Paris, spring 1924. (Plate, p. 114)
Charcoal with red conté and colored crayon highlighted with white oil paint on canvas prepared with a glue ground, 31⅞ × 39½″ (81 × 100.3 cm). Signed and dated lower center: *Miró 1924*. Inscribed on verso: *Joan Miró* | *"La Lampe à Petrole"* | *1924*. The Art Institute of Chicago. Gifts of Mrs. Henry C. Woods, Members of the Committee on Prints and Drawings, and Friends of the Department; Joseph and Helen Regenstein Foundation, Helen L. Kellogg Trust, Blum-Kovler Foundation, and Major Acquisitions Fund. Dupin 88

PROVENANCE
[Paul Eluard, Paris]; Marie Cuttoli, Paris, by March 1945; auctioned at Sotheby's, London, July 4–5, 1962, lot 246; to Richard L. Feigen & Co., New York; Ellen J. Myers, New York; to The Art Institute of Chicago, 1978.

SELECTED EXHIBITIONS
Possibly Paris 1925a, cat. 5
Paris 1945a, cat. 9
Paris 1946a, cat. 136
Brussels 1956, cat. 14, repr. n.p.
Basel 1956, cat. 8
Aix-en-Provence 1958, cat. 27, repr. n.p.

SELECTED REFERENCES
Amic de les arts 1926, repr. p. 17. Croizard 1945, p. 4. Caso 1956, p. 5. *Burlington Magazine* 1962, repr. p. xxxiv. Dupin 1962, p. 144, no. 88, repr. p. 508. Aragon 1969, p. 1. Miró 1977, p. 204. Carmean 1980, p. 38. Gateau 1982, pp. 140–41. Fundació Joan Miró 1983, repr. p. 40. Gimferrer 1985, pp. 62–65, repr. p. 65.

34. **PORTRAIT OF MME B.** [Montroig, summer] 1924. (Plate, p. 119)
Oil and charcoal on canvas, 50¾ × 37⅝″ (129 × 95.5 cm). Signed and dated lower right: *Miró.* | *1924*. Private collection, courtesy Berry-Hill Galleries, New York. Dupin 91

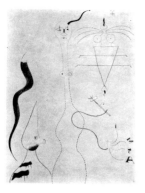

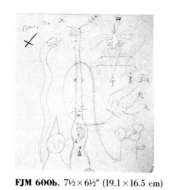

FJM 600b. 7½ × 6½″ (19.1 × 16.5 cm)

PROVENANCE
René Gaffé, Brussels; to Roland Penrose, London, July 15, 1937; to Pierre Matisse Gallery, New York, 1959; to William R. Copley, Longpont-sur-Orge and New York (consigned to Sotheby's, New York; sold November 13, 1983, lot 64); CPLY Art Trust, New York (consigned to Sotheby's, New York; sold May 13, 1986, lot 39); to present owner.

SELECTED EXHIBITIONS
Paris 1925a, cat. 11
London 1937b, cat. 7
London 1939a, cat. 6
New York 1949a, cat. 3
London 1964b, cat. 34, p. 22, repr. n.p.
 (London venue only)

New York 1972d, cat. 4, p. 81, repr. p. 81
Paris 1974b, cat. II, p. 173
London 1978, cat. 9.52
Washington 1980a, cat. 11, repr. (color)
 p. 60

SELECTED REFERENCES
Greenberg 1948, pl. XVI (repr. p. 60). Gibbs 1949, p. 17. Dupin 1962, p. 145, no. 91, repr. p. 508. Aragon 1969, p. 2. Rowell 1972, pp. 41, 43. Rowell 1976, pp. 133, 135, repr. p. 134. Millard 1980, p. 21. Gateau 1982, p. 140. Gimferrer 1985, p. 74, repr. p. 74. Rowell 1987a, p. 7. Combalía 1990, p. 286.

Antwerp 1956, cat. 11
New York 1959b, cat. 23 (Los Angeles
 venue, cat. 22)
Paris 1962b, cat. 26
London 1964b, cat. 33, p. 22, pl. 7b
Tokyo 1966, cat. 23, repr. (color) p. 39
Exeter 1967, cat. 94
Saint-Paul-de-Vence 1968, cat. 14, repr.
 p. 65
Barcelona 1968, cat. 18, pl. 10 (repr.
 p. 98)
Munich 1969, cat. 21, repr. n.p.

Munich 1972, cat. 320, repr. n.p.
Paris 1972, cat. 305, repr. n.p.
Sydney 1975, cat. 75, p. 184, repr. p. 185
London 1978, cat. 9.49, repr. p. 217
Madrid 1978a, cat. 17, p. 97, repr. (color)
 p. 45
Edinburgh 1982, cat. 4, repr. (color)
 p. 18
Barcelona 1983, cat. 42, repr. (color)
 p. 45
Liverpool 1988, p. 28, repr. (color) p. 28

SELECTED REFERENCES
Révolution surréaliste 1925a, repr. p. 4. Breton 1928, pl. 61. Gasch 1929b, repr. p. 205. Taylor 1932, repr. p. 7 (upside down). Gaffé 1934, p. 32. *Petite Anthologie* 1934, repr. opp. p. 144. Frey 1936, p. 14. *Beaux-Arts* 1937c, p. 8. Sweeney 1941, p. 32, repr. p. 31. Cirici-Pellicer 1949, p. 23, ill. 19 (incorrectly credited to Collection René Gaffé, Brussels). Cirlot 1949, fig. 14. Dégand 1956, p. 28. Prévert/Ribemont-Dessaignes 1956, p. 78. Verdet 1957a, n.p. Verdet 1957b, n.p. Erben 1959, p. 123. Soby 1959, p. 39, repr. (color) p. 41. Dupin 1962, pp. 146–47, 509, no. 100, repr. p. 209. Gaffé 1963, repr. p. 152. Lassaigne 1963, pp. 39–40, repr. (color) p. 34. Bonnefoy 1964, pp. 18, 21. Gasser 1965, pp. 17–18, repr. p. 32. Walton 1966, p. 31, pl. 57 (color). *Sunday Times Magazine* 1967, repr. p. 25. Penrose 1969, pp. 40–43, 45, pl. 25 (repr., color, p. 42). Penrose 1970, pp. 40–43, pl. 25 (color). Krauss 1972, p. 46. Okada 1974, pl. 6 (color). Picon 1976, vol. 1, pp. 45, 85–87, repr. (color) p. 86. Rowell 1976, pp. 39, 185 (n. 23), repr. p. 38. Carmean 1980, p. 37. Penrose 1981, pl. 419 (repr., color, p. 167). Gateau 1982, p. 141. Rose 1982a, pp. 6, 10. Lader 1982, p. 89. Malet 1983b, p. 11, fig. 31 (color). Ooka 1984, repr. p. 14. Gimferrer 1985, pp. 72–74, repr. p. 73. Malet 1986, p. 18. Rowell 1987a, p. 19, fig. 9 (repr. p. 19). Centre d'Art Santa Mònica 1988, p. 177, repr. p. 203 (installation view). Erben 1988, repr. (color) p. 34. Combalía 1990, p. 286. Halliday 1991, pp. 155, 156. Rowell 1991, pp. 177, 180, repr. p. 181.

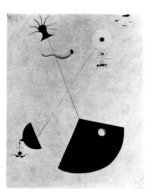

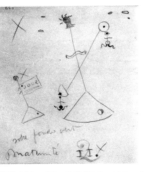

FJM 640a. 7½ × 6½″ (19.1 × 16.5 cm)

35. MATERNITY. Montroig, summer–fall 1924. (Plate, p. 120)

Oil on canvas, 36¼ × 28¾″ (92.1 × 73.1 cm). Signed and dated lower right: *Miró | 1924.* Inscribed on verso: *Joan Miró | "Maternité" | 1924.* Scottish National Gallery of Modern Art, Edinburgh. Purchased with assistance from the National Heritage Memorial Fund, the National Art Collections Fund and donations from Members of the Public, 1991–1993. Dupin 100

PROVENANCE
The artist to Jacques Viot, Paris, by June 1925; [André Breton, Paris]; René Gaffé, Brussels, by June 1929; to Roland Penrose, London, July 15, 1937; to Lee Miller-Penrose, London, 1984; to Antony Penrose; to Scottish National Gallery of Modern Art, Edinburgh, 1991.

SELECTED EXHIBITIONS
Paris 1925a, cat. 13
London 1936c, cat. 216
London 1937b, cat. 6

London 1939a, cat. 5
New York 1941a
Brussels 1956, cat. 11, repr. n.p.

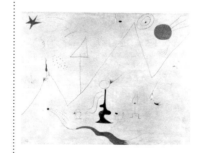

FJM 662a. 6½ × 7½″ (16.5 × 19.1 cm)

36. THE HERMITAGE. Montroig, summer–fall 1924. (Plate, p. 123)

Oil and/or aqueous medium, crayon, and pencil on canvas, 45 × 57⅞″ (114.3 × 147 cm). Signed and dated lower left: *Miró. | 1924.* Inscribed on verso: *Joan Miró | L'Ermitage | 1924.* Philadelphia Museum of Art. The Louise and Walter Arensberg Collection. Dupin 92

PROVENANCE
Louis Aragon, Paris; Louise and Walter Arensberg, Hollywood, by June 1934; to Philadelphia Museum of Art, 1950.

SELECTED EXHIBITIONS
Paris 1925a, cat. 16
San Francisco 1934b, cat. 212
Chicago 1949, cat. 147
New York 1961e
New York 1972c, cat. 59

Zurich 1986, cat. 31, repr. (color) n.p.
New York 1987a, cat. 25, repr. (color)
 p. 85
Philadelphia 1987a, cat. 2

SELECTED REFERENCES
Philadelphia Museum of Art 1954, no. 144, repr. n.p. Dupin 1962, p. 145, no. 92, repr. p. 508. Aragon 1969, p. 1. Krauss/Rowell 1972, p. 88. Miró 1977, p. 205.

Gimferrer 1985, pp. 65–67, 68, 69, repr. p. 67. Rowell 1987a, p. 8, repr. (color) p. 9. Temkin 1987b, p. 39. Umland 1992, pp. 56, 75 (n. 72).

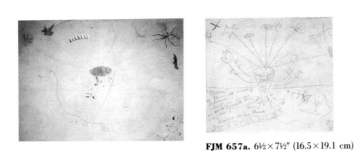

FJM 657a. 6½ × 7½″ (16.5 × 19.1 cm)

37. BOUQUET OF FLOWERS ("Sourire de ma blonde"). Montroig, summer–fall 1924. (Plate, p. 122)

Oil on canvas, 34⅝ × 45¼″ (88 × 115 cm). Signed and dated lower left: *Miró.* | *1924.* Inscribed on verso: *Joan Miró* | *"Bouquet de fleurs"* | *1924.* Private collection, Paris. Dupin 97

PROVENANCE
The artist to Max Morise, Paris; to Simone Breton (later Simone Collinet), Paris, c. 1932; to present owner.

SELECTED EXHIBITIONS
Paris 1945a, cat. 5
Saarbrücken 1952, cat. 65, as *Souvenir de ma blonde*
Basel 1952, cat. 136, as *Sourire de ma blonde*
Stockholm 1963, cat. 119, repr. p. 58, as *Sourire de ma blonde*
Paris 1964, cat. 227, as *Sourire de ma blonde*

Knokke 1968, cat. 98, repr. p. 58, as *Le Sourire de ma blonde*
New York 1972d, cat. 5, pp. 77 (n. 3), 82, 88, 147, repr. (color) p. 82, as *Sourire de ma blonde*
Paris 1991, repr. (color) p. 256, as *Sourire de ma blonde*

SELECTED REFERENCES
Marc 1945. Dupin 1962, p. 146, no. 97, repr. p. 509. Wescher 1971, p. 190. Rowell 1972, pp. 45, 46–47, 50. Picon 1976, vol. 1, pp. 68–70, repr. p. 69. Rowell 1976, pp. 141, 143, repr. (color) p. 140. Rose 1982a, p. 16. Gimferrer 1985, pp. 71–72, repr. p. 71. Rowell 1986, p. 90. Rowell 1987a, p. 7. Freeman 1989, p. 42, fig. 35 (repr. p. 42). Raillard 1989, p. 68, repr. (color) p. 69. Rowell 1991, p. 180.

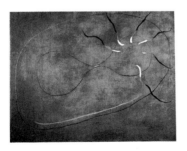 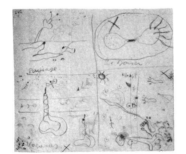

FJM 642a. Pencil and crayon on paper, 6⅜ × 7½″ (16 × 19.1 cm)

38. THE KISS. Montroig, summer–fall 1924. (Plate, p. 118)

Oil on canvas, 28¾ × 36¼″ (73 × 92 cm). Signed and dated lower left: *Miró.* | *1924.* Inscribed on verso: *Joan Miró* | *"Le baiser"* | *1924.* Collection Jose Mugrabi. Dupin 98

PROVENANCE
The artist to Galerie Pierre, Paris, until 1925; Mrs. Stanley Resor, Greenwich, Conn.; to Ann Resor (later Mrs. James Laughlin), Norfolk, Conn.; to G. David Thompson, Pittsburgh, 1954; to Harold and Hester Diamond, New York, c. 1959–60; to Richard

L. Feigen & Co., New York, June 1965; to Barry R. Peril, Rydale, Pa., March 1967; auctioned at Sotheby's, London, June 24, 1986, lot 52; to Jose Mugrabi.

SELECTED EXHIBITIONS
Paris 1925a, cat. 15
Tokyo 1966, cat. 22, repr. p. 94
New York 1972d, pp. 83, 106, cat. 6, repr. (color) p. 83

SELECTED REFERENCES
Dupin 1962, pp. 147, 509, no. 98, repr. p. 211. Krauss 1972, p. 14. Rowell 1976, pp. 141, 143, 145, repr. (color) p. 140. Miró 1977, p. 72. Rolnik 1983, n.p. Gimferrer 1985, pp. 75–76, repr. p. 77. Dupin 1987a, pp. 33, 34, 37, 39, fig. 1 (repr. p. 33). Combalía 1990, p. 286.

FJM 638a. 7½ × 6½″ (19.1 × 16.5 cm)

39. HEAD OF CATALAN PEASANT, I. Montroig, summer–fall 1924. (Plate, p. 121)

Oil on canvas, 57½ × 45″ (146 × 114.2 cm). Signed and dated lower right: *Miró* | *1924.* Inscribed on verso, upper left: *Joan Miró* | *"Tête de Paysan Catalan"* | *1924.* National Gallery of Art, Washington, D.C. Gift of the Collectors Committee, 1981. No Dupin number

PROVENANCE
Galerie Pierre, Paris, by October 1934; private collection, Switzerland; Galerie Marie-Louise Jeanneret, Geneva; Acquavella Galleries, New York; to National Gallery of Art, Washington, D.C., 1981.

SELECTED EXHIBITIONS
Zurich 1934, cat. 86, as *Tête de paysan catalan*
London 1936c, cat. 210, as *Head of a Catalan Peasant*
New York 1980c, cat. 13, repr. (color) p.
31, as *Catalonian Peasant*
Houston 1982, pl. 5 (color), as *Head of a Catalan Peasant* (incorrectly dated 1925)

SELECTED REFERENCES
Dupin 1962, pp. 162, 166. Dupin 1987a, p. 36, fig. 3 (repr. p. 37; incorrectly dated 1925). Green 1987, p. 289, pl. 305 (repr. p. 289).

40. CARNIVAL OF HARLEQUIN. Paris, spring 1924–winter or spring 1925. (Plate, p. 128)

Oil on canvas, 26 × 36⅝″ (66 × 93 cm). Signed and dated lower left: *Miró.* | *1924–25.* Inscribed on verso: *Joan Miró* | *"Carnaval d'Arlequin"* | *1924–25.* Albright-Knox Art Gallery, Buffalo. Room of Contemporary Art Fund, 1940. Dupin 101

PROVENANCE
M.P.E. [Monsieur Paul Eluard?], by November 1925; [André Breton, Paris]; René Gaffé, Brussels, by June 1929; to Zwemmer Gallery, London, July 1936; to Mr. and Mrs. Jonathan Griffin, July 22, 1936; through Zwemmer Gallery, London, to Douglas Cooper (The Mayor Gallery), London, 1937; to Pierre Matisse Gallery, New York, March 5, 1937; to Albright-Knox Art Gallery, Buffalo, 1940.

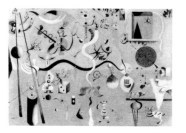

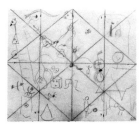

FJM 669. Pencil and colored pencil on paper, 6½ × 7½″ (16.6 × 19.2 cm)

SELECTED EXHIBITIONS

Paris 1925b, cat. 7
Brussels 1934, cat. 94
London 1936c, cat. 217
London 1936e, cat. 33
New York 1937c
Paris 1937e, cat. 118
New York 1938d, cat. 30
New York 1940b, cat. 13, repr. n.p.
New York 1941g
Boston 1946, cat. 36
Ann Arbor 1948, cat. 23
Cincinnati 1951, cat. 44
Houston 1951, cat. 5
Paris 1952, cat. 62
Denver 1954, cat. 1
Venice 1954, cat. 10, repr. n.p.
Boston 1957b, cat. 94, pl. 56
Brussels 1958, cat. 220, pl. XXII (color)
New York 1959b, cat. 25 (New York venue only)
Bennington 1960, cat. 22
New Haven 1961, cat. 49
Paris 1962b, cat. 28
London 1964b, cat. 39, p. 23, pl. 8a
Cleveland 1966, cat. 31, repr. (color) n.p.

Montreal 1967, cat. 58, p. 120, repr. p. 121
New York 1968a, cat. 225 (New York and Chicago venues only)
Washington 1968b, repr. p. 39
Buenos Aires 1969, cat. 17, repr. p. 28
New York 1972b, cat. 11, repr. (color) n.p.
Paris 1974b, cat. 21, p. 115, repr. pp. 39, 115
New York 1975c, repr. n.p.
London 1978, cat. 9.50, repr. p. 217
Madrid 1978a, cat. 18, pp. 97–98, repr. (color) p. 46
Washington 1980a, cat. 12, repr. (color) p. 61
New York 1981a, as (?)
Barcelona 1983, cat. 51, repr. (color) p. 47
New York 1984b, repr. p. 576
New York 1987a, cat. 26, repr. (color) p. 86
Saint-Paul-de-Vence 1990, cat. 18, pp. 52, 53, repr. (color) p. 53

SELECTED REFERENCES

Révolution surréaliste 1926b, repr. p. 19. Trabal, 1928, p. 4. Gasch 1929b, repr. p. 202. Einstein 1931, repr. p. 430. Gaffé 1934, fig. 15 (repr. p. 32). Grohmann 1934, p. 38. Westerdahl 1936, p. 8, repr. p. 18. Zervos 1938, repr. p. 421. Miró 1938, p. 27, repr. p. 25. *Art News* 1938, p. 16, repr. p. 16. Miró 1939, p. 85, repr. p. 85. *Brooklyn Daily Eagle* 1940. *Art Digest* 1940, p. 9. Watson 1941, p. 131. Sweeney 1941, pp. 22, 28, 32, 33, 35, 47, repr. (color) p. 33. *New York Herald Tribune* 1941b. *Boston Herald* 1941. *Art News* 1942a, p. 17, repr. (color) p. 17. D.B. 1942, p. 21. Hayter 1945, p. 178, repr. p. 179. Loeb 1946, p. 49, pl. XLIII. *Art News* 1947, p. 23. Greenberg 1948, pp. 23, 28, 30, 32, 33, repr. (color) n.p. Read 1948, p. 90. *Art News Annual* 1949, repr. (color) p. 37. Cirici-Pellicer 1949, pp. 23, 27, ill. 24 (incorrectly credited to Collection Pierre Matisse, New York). Cirlot 1949, pp. 23, 24, 28, 34, fig. 15. Breton 1952, repr. *Libre Belgique* 1952. Gasch 1953, p. 100. Clarac-Sérou 1954, p. 6. Elgar 1954, n.p. Jouffroy 1955, p. 34. *Arts* 1956, repr. (color) p. 36. Prévert/Ribemont-Dessaignes 1956, p. 78, repr. p. 112. Devree 1959, p. X15. Erben 1959, pp. 116–19, 126, 139, pl. 49. Rubin 1959, pp. 37, 41, repr. p. 36. Schwartz 1959, p. 151. Soby 1959, p. 45, repr. (color) p. 44. Vallier 1960, p. 168. Erben 1961, p. 23. Frigerio 1962, p. 54. Dupin 1962, pp. 83, 147–48, 150–52, 154, 162, 176, 190, 495, no. 101, repr. pp. 210, 509. Gaffé 1963, repr. p. 150. Gasch 1963, p. 44. Lassaigne 1963, pp. 40, 42, 43, 58, 61, repr. (color) p. 39. Bonnefoy 1964, pp. 18, 20, 24, 26, pl. 19 (color). Roberts 1964, p. 479. Gasser 1965, p. 18, repr. (color) p. 30. Rubin 1966, pp. 48, 53, 55, repr. p. 47. Walton 1966, pp. 11, 12, 31, pl. 56 (color). Juin 1967, pp. 18, 19, 20, 22, repr. p. 11. Rubin 1967, pp. 26–27, repr. p. 25. Rubin 1968, p. 132, fig. 86 (repr. p. 68). Aragon 1969, p. 1. Penrose 1969, pp. 36, 37, 80, 193, pl. 20 (repr., color, p. 35). Vidal Alcover 1970, pp. 25, 30, 32. Cooper 1972, n.p. Krauss 1972, pp. 13, 14, 36. Krauss/Rowell 1972, pp. 75, 78, 86, 90, 106. Rowell 1972, pp. 46, 61. Marchiori 1972, pp. 18, 21, repr. p. 24. Golding 1973, pl. 195 (repr. p. 111). Rubin 1973, pp. 21, 24, 25, 26, 43, 44, fig. 10 (repro. p. 113), repr. p. 11 (installation view). Jouffroy 1974, p. 56. Lemayrie 1974a, p. 14. Lemayrie 1974b, p. 5. Okada 1974, pl. 7 (color). Picon 1976, vol. 1, pp. 93, 97, 98, repr. (color) pp. 94–95. Rowell 1976, pp. 39, 163, repr. (color) p. 36. Miró 1977, pp. 62, 69–72, 192, 193, 204, 211, repr. p. 37. Gimferrer 1978, pp. 19, 44, 72, 124, 126, fig. 23 (color). Joffroy 1979, p. 9. Nash 1979, pp. 415–17, repr. pp. 414, 416 (detail). Henning 1979, p. 235, fig. 1 (repr. p. 234). Carmean 1980, pp. 35, 36, 39, fig. 2 (repr. p. 37). Millard 1980, pp. 20, 21. Malet 1983b, pp. 11, 12, fig. 23 (color). Rolnik 1983, n.p. Fundació Joan Miró 1983, repr. p. 102. Dupin 1983, pp. 126, 127. Théberge 1986, p. 52. Bouret 1986, n.p. Rowell 1986, pp. 96, 102, 161, 163–64, 284, 290–91, ill. 11. Dupin 1987a, p. 37. Green 1987, pp. 283, 284. Fernández Miró 1987, p. 47. Miró 1987, p. 30. Pierre 1987, pp. 138, 203, fig. 150. Erben 1988, repr. (color) pp. 36–37. Malet 1988a, p. 20. Malet 1988b, p. 9. Jeffett 1989c, p. 15 (n. 12). Malet 1989, p. 12, repr. p. 13. Raillard 1989, p. 72, repr. (color) p. 73. Saura 1989, p. 31. Llorca 1990, repr. p. 164. Combalía 1990, pp. 72, 76, repr. (color) n.p. Halliday 1991, pp. 156–57, 174. Rowell 1991, p. 180, repr. p. 179. Yokohama Museum of Art 1992, fig. 4 (repr. p. 27). Combalía 1992, p. 186. Umland 1992, p. 54.

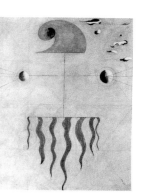

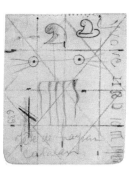

FJM 639. March 10, 1924. Colored pencil on paper, 2¾ × 2¼″ (7 × 5.7 cm)

41. HEAD OF CATALAN PEASANT, III. Paris, winter–spring 1925. (Plate, p. 129)

Oil on canvas, 36⅜ × 28¾″ (92.4 × 73 cm). Signed and dated lower right: *Miró.* | *1925.* Inscribed on verso, upper left: *Joan Miró* | *"Tête de paysan catalan"* | *1925.* Scottish National Gallery of Modern Art, Edinburgh. On loan from a private collection, England. Dupin 110

PROVENANCE

Pierre Loeb (Galerie Pierre), Paris; René Gaffé, Brussels; to Roland Penrose, London, July 15, 1937; to present owner, 1984.

SELECTED EXHIBITIONS

London 1937b, cat. 8, as *Tête d'un paysan catalan*
London 1939a, cat. 7, as *Tête de paysan catalan*
London 1950, cat. 2, as *Tête de paysan catalan*
Brussels 1956, cat. 21, as *Tête de paysan catalan*
Antwerp 1956, cat. 12, repr. p. 9, as *Tête de paysan catalan*
London 1964b, cat. 43, p. 23, as *Head of a Catalan Peasant*
Turin 1967, cat. 246, repr. p. 182, as *Testa di contadino* (incorrectly dated 1924)
Barcelona 1968, cat. 21, as *Cabeza de payés*
Munich 1969, cat. 24, repr. n.p., as *Katalanischer Bauerkopf*
Knokke 1971, cat. 6, as *Tête de paysan catalan*
Munich 1972, cat. 323, repr. n.p., as *Tête de paysan catalan*
Paris 1972, cat. 308, repr. n.p., as *Tête de paysan catalan*

New York 1972d, cat. 8, pp. 85–86, repr. p. 85, as *Head of a Catalan Peasant*
Paris 1974b, cat. 23, p. 116, repr. p. 117, as *Tête de paysan catalan*
Humlebaek 1974, cat. 7, as *Tête de paysan catalan*
London 1978, cat. 9.51, as *Tête de paysan catalan*
Edinburgh 1982, cat. 7, repr. (color) p. 19, as *Head of a Catalan Peasant*
Barcelona 1983, cat. 56, repr. (color) p. 48, as *Cap de pagès català*
London 1985, cat. 153, fig. 274 (repr., color, p. 69), as *Head of a Catalan Peasant* (London venue only)
Leeds 1986, cat. 156, repr. (color) p. 98, as *Head of a Catalan Peasant*
Zurich 1986, cat. 45, repr. (color) n.p., as *Tête de paysan catalan*
Paris 1987b, cat. 24, repr. (color) p. 72, as *Tête de paysan catalan*
New York 1987a, cat. 38, repr. (color) p. 103, as *Head of a Catalan Peasant*
Barcelona 1992, cat. 185, repr. (color) p. 265, as *Cap de pagès català*

SELECTED REFERENCES
Dupin 1956, p. 98. Soby 1959, repr. p. 42. Dupin 1962, pp. 162, 166, no. 110, repr. p. 509. Dorival 1966, fig. 10 (repr. p. 118). Penrose 1969, pl. 26 (repr., color, p. 43). Rowell 1972, p. 46. Rubin 1973, p. 27, fig. 23 (repr. p. 116). Leymarie 1974a, p. 13. Rowell 1976, pp. 53, 185 (n. 23), repr. p. 54. Rudenstine 1976, p. 523. Gimferrer 1978, fig. 136 (color). Penrose 1981, fig. 672 (repr. p. 277). Malet 1983b, fig. 29 (color). Erben 1988, repr. (color) p. 43. Halliday 1991, p. 155 (n. 33). Yokohama Museum of Art 1992, ill. 4 (repr. p. 46).

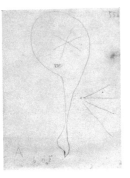

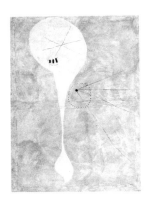

FJM 558. 4⅜ × 3⅛″ (11 × 8.1 cm)

FJM 720. Pencil and watercolor on paper, 7¾ × 10⅜″ (19.8 × 26.4 cm)

42. "PHOTO—CECI EST LA COULEUR DE MES RÊVES." Montroig, July–September 1925. (Plate, p. 131)

Oil on canvas, 38 × 51″ (96.5 × 129.5 cm). Signed and dated lower right: *Miró.* | *1925.* Private collection. Dupin 125

PROVENANCE
The artist [to Jacques Viot (Galerie Pierre), Paris, late October–early November 1925]; Max Ernst; Meret Oppenheim; James Johnson Sweeney, New York; to Pierre Matisse Gallery, New York, December 1968; to present owner.

SELECTED EXHIBITIONS
London 1964b, cat. 48, p. 24, as *Ceci est la couleur de mes rêves*
Knokke 1971, as *Ceci est la couleur de mes rêves. Tableau-poème* (replaced cat. 7, *Peinture (L'Addition)*)
Munich 1972, cat. 325, repr. n.p., as *Ceci est la couleur de mes rêves*
Paris 1972, cat. 310, repr. n.p., as *Ceci est la couleur de mes rêves*
New York 1972d, cat. 14, pp. 96–97, repr. p. 97, as *Photo: Ceci est la couleur de mes rêves*
Paris 1974b, cat. 25, p. 116, as *Photo: Ceci est la couleur de mes rêves*
Humlebaek 1974, cat. 8, as *Photo: Ceci est la couleur de mes rêves*
London 1978, cat. 9.54, repr. p. 218, as *Photo: Ceci est la couleur de mes rêves*

Madrid 1978a, cat. 21, pp. 98–99, as *Este es el color de mis sueños*
Houston 1982, pl. 7 (color), as *Photo: Ceci est la couleur de mes rêves*
Barcelona 1983, cat. 69, repr. (color) p. 53, as *Ceci est la couleur de mes rêves*
Zurich 1986, cat. 42, repr. (color) n.p., as *Ceci est la couleur de mes rêves*
New York 1987a, cat. 35, repr. (color) p. 97, as *Photo: Ceci est la couleur de mes rêves*
Los Angeles 1989, repr. p. 12, as *Ceci est la couleur de mes rêves* (Los Angeles venue only)
Saint-Paul-de-Vence 1990, cat. 20, p. 56, repr. (color) p. 57, as *Photo: Ceci est la couleur de mes rêves*

SELECTED REFERENCES
Dupin 1962, no. 125, pp. 168, 510. Penrose 1964, p. 7. Penrose 1969, p. 44, pl. 27 (repr., color, p. 46). Wescher 1971, p. 190. Krauss 1972, p. 15. Rowell 1972, pp. 60–61, 65. Rubin 1973, p. 126 (n. 3), fig. 47 (repr. p. 125). Rowell 1976, pp. 161, 163, 171, 189 (n. 55), repr. p. 160. Rudenstine 1976, p. 522. Miró 1977, pp. 69, 81, repr. p. 21. Gimferrer 1978, p. 122. Rose 1982a, p. 16. Malet 1983a, p. 129. Rowell 1985, p. 56, fig. 12 (repr. p. 55). Rowell 1986, p. 90. Green 1987, p. 289. Freeman 1989, p. 43. Raillard 1989, pp. 7, 80, repr. (color) p. 81. Combalía 1990, repr. (color) n.p. Bouisset 1990, p. 129.

43. PERSONAGE. Montroig, July–September 1925. (Plate, p. 130)

Oil and egg tempera (?) on canvas, 51¼ × 37⅞″ (130 × 96.2 cm). Signed and dated lower left: *Miró.* | *1925.* Inscribed on verso: *Joan Miró.* | *1925.* Solomon R. Guggenheim Museum, New York. Dupin 139

PROVENANCE
The artist to Jacques Viot (Galerie Pierre), Paris, late October–early November 1925; Galerie de Beaune, Paris; Walter P. Chrysler, Jr., New York and Warrenton, Va., 1938 (consigned to Parke-Bernet Galleries, New York; sold April 11, 1946, lot 36); to Karl Nierendorf, New York; to Estate of Karl Nierendorf, 1948; to Solomon R. Guggenheim Museum, New York, 1948.

SELECTED EXHIBITIONS
Possibly Paris 1937e, cat. 117
Richmond 1941, cat. 140, as *Abstraction*
New York 1967c, repr. p. 68
New York 1968b
New York 1972d, cat. 17, pp. 100–01, 106, repr. p. 100, as *Painting (Personage)*
Washington 1980a (Buffalo venue only)
New York 1983a, cat. 3
Zurich 1986, cat. 36, repr. (color) n.p., as *Peinture*
New York 1987a, cat. 30, repr. (color) p. 91

On view at the Solomon R. Guggenheim Museum, New York: May–November 1953; July–September 1962; June–October 1966; May–October 1967; December 1969–January 1970; May–September 1970; June–September 1971; August–September 1973; April–October 1976; December 1977–February 1978; July–October 1978; March–August 1979; April–July 1981; July–September 1986

SELECTED REFERENCES
Dupin 1962, no. 139, repr. p. 512. Rowell 1976, repr. p. 42. Rudenstine 1976, cat. 184, pp. 519–24, repr. p. 521. Rowell 1987a, p. 12, fig. 5 (repr. p. 12).

FJM 715. 10⅜ × 7¾″ (26.4 × 19.8 cm)

44. THE POLICEMAN (Figure and Horse). Montroig, July–September 1925. (Plate, p. 132)

Oil on canvas, 8′ 1⅝″ × 6′ 4¾″ (248 × 195 cm). Signed and dated lower left: *Miró* | *1925.* The Art Institute of Chicago. Bequest of Claire Zeisler Trust. Dupin 121

PROVENANCE
The artist to Jacques Viot (Galerie Pierre), Paris, late October–early November 1925; René Gaffé, Brussels, by June 7, 1928?; Norman Granz (Galerie Verve), Breganz, Switzerland, c. 1962–63; to Richard L. Feigen & Co., Chicago, April 1963; to Claire Zeisler, Chicago, April 1963; to The Art Institute of Chicago, October 1991.

SELECTED EXHIBITIONS
Brussels 1956, cat. 14, repr. (color) n.p.
New York 1968a, cat. 227 (New York
 venue only)

SELECTED REFERENCES
Dégand 1956, p. 28, repr. p. 28. Dupin 1956, p. 98, repr. (color) p. 99. Chevalier
1960, p. 32. Dupin 1962, p. 164, no. 121, repr. p. 510. Gaffé 1963, repr. p. 152.
Rubin 1968, p. 68, fig. 85 (repr. p. 67). Penrose 1969, p. 51. Rudenstine 1976, p.
523. Stuckey 1991, repr. (color) p. 267. Russell 1991, repr. p. H35.

FJM 616b. 6½ × 7½″ (16.5 × 19.1 cm)

45. PAINTING (Blue). Montroig, July–September 1925. (Plate, p. 134)
Oil on canvas, 24⅜ × 35¼″ (62 × 92 cm). Signed lower right: *Miró.* Inscribed on
verso: *Miró | 1925.* Galerie Maeght, Paris. Dupin 149

PROVENANCE
The artist to Jacques Viot (Galerie Pierre), Paris, late October–early November
1925; René Mendès-France, Paris, by June 17, 1955; Galerie Maeght, Paris, by
March 1959.

SELECTED EXHIBITIONS
New York 1959b, cat. 26 (Los Angeles
 venue, cat. 24)
London 1964b, cat. 57, p. 25
New York 1972d, cat. 18, pp. 102–03,
 133, 155, repr. (color) p. 103
Barcelona 1975b, cat. 12

Lyon 1988, repr. pp. 120, 320
 (installation view), 321 (installation
 view), as *Petit Bleu*
Osaka 1991, cat. 3, repr. (color) n.p., as
 Petit Bleu

SELECTED REFERENCES
Motherwell 1959, p. 65. Volboudt 1961, p. 7. Taillandier 1962, p. 38. Dupin 1962, pp.
160, 161, 510, no. 149, repr. p. 216. Penrose 1964, p. 7. H.C. 1964, p. 289. Krauss
1972, pp. 33–34, 37. Sylvester 1972, p. 16. Rowell 1976, p. 171, repr. (color) p. 164.
Miró 1977, pp. 44, 83, 185. Gimferrer 1978, fig. 117 (color). Gateau 1982, p. 142.
Bouret 1986, n.p. McEvilley 1988, p. 20.

FJM 617b. 7½ × 6½″ (19.1 × 16.5 cm)

46. HEAD OF CATALAN PEASANT, IV. Montroig, July–September
1925. (Plate, p. 135)
Oil on canvas, 57 × 44⅞″ (145 × 114 cm). Signed and dated lower right: *Miró. | 1925.*
Moderna Museet, Stockholm. Dupin 111

PROVENANCE
The artist to Jacques Viot (Galerie Pierre), Paris, late October–early November
1925; private collection, Bern, by April 1949; Marcel Mabille, Brussels, by January
1956; Svensk-Franska Konstgalleriet, Stockholm; Gerard Bonnier, Stockholm, by
1961; to Moderna Museet, Stockholm, 1989.

SELECTED EXHIBITIONS
Brussels 1927a, cat. 61, as *Tête de
 paysan catalan*
Bern 1949, cat. 10, as *Tête de paysan
 catalan*
Basel 1949, cat. 156, as *Tête de paysan
 catalan*
Brussels 1956, cat. 16, repr. n.p., as *Tête
 de paysan catalan*
Basel 1956, cat. 10, as *Tête de paysan
 catalan*

Stockholm 1968, cat. 44, as *Tête de
 paysan catalan*
New York 1972d, cat. 9, pp. 87–88, 110,
 121, 133, repr. (color) p. 87, as *Head of
 a Catalan Peasant*
Barcelona 1983, cat. 59, repr. (color) p.
 49, as *Cap de pagès català*

SELECTED REFERENCES
C.B. 1927, p. 2. Schmitz 1927. Apollonio 1959, p. 173. Dupin 1962, pp. 162, 166,
510, no. 111, repr. (color) p. 155. Gasser 1965, repr. (color) p. 33. Dorival 1966, fig. 9
(repr. p. 118). Walton 1966, p. 32, pl. 59 (color). Krauss 1972, pp. 14, 18–19, 23, 25,
33, 37. Rowell 1976, repr. (color) p. 4. Miró 1977, p. 80. Gimferrer 1978, fig. 140.
Stich 1980, p. 17. Gimferrer 1985, pp. 62, 79, repr. p. 63. Dupin 1987a, p. 36, fig. 4
(repr. p. 37; incorrectly credited to private collection, Brussels). Erben 1988, repr.
(color) p. 42.

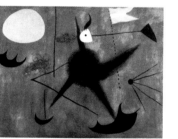

FJM 718. 7¾ × 10⅜″ (19.8 × 26.4 cm)

47. PAINTING (The Spanish Flag). Montroig, July–September 1925.
(Plate, p. 136)
Oil on canvas, 45¼ × 57½″ (115 × 146 cm). Signed and dated lower right: *Miró |
1925.* Private collection, Switzerland. Dupin 157

PROVENANCE
The artist to Jacques Viot (Galerie Pierre), Paris, late October–early November
1925; Alexander Iolas Gallery, New York; to Mr. and Mrs. Joseph Randall Shapiro,
Chicago, by February 1961; to present owner, 1990.

SELECTED EXHIBITIONS
Chicago 1961, cat. 9, repr. n.p., as
 Spanish Flag
Chicago 1969, cat. 57, repr. n.p., as
 Spanish Flag
Chicago 1984, p. 196, repr. (color) p. 96,

as *Spanish Flag*
Chicago 1985, cat. 119, fig. 89 (repr.,
 color, p. 90), as *Spanish Flag*
Basel 1992, cat. 35, repr. (color) n.p.

SELECTED REFERENCES
Dupin 1962, no. 157, repr. p. 513.

48. LADY STROLLING ON THE RAMBLA IN BARCELONA. Montroig,
[summer–fall] 1925. (Plate, p. 137)
Oil on canvas, 51¼ × 38⅜″ (132 × 97 cm). Signed and dated lower left: *Miró | 1925.*
Inscribed on verso: *Joan Miró | "Dame se Promenant sur La Rambla de Barcelona" |
1925.* New Orleans Museum of Art. Bequest of Victor K. Kiam. Dupin 148

PROVENANCE
Pierre Matisse Gallery, New York; to Mr. and Mrs. Walter Bareiss, New York, after 1954; [Sidney Janis Gallery, New York]; Victor K. Kiam, New York; to New Orleans Museum of Art, August 1977.

SELECTED EXHIBITIONS
New York 1949a, cat. 6
Minneapolis 1952
Denver 1954, cat. 53, as *Women Walking on the Rambla in Barcelona*
Houston 1982
Zurich 1986, cat. 37, repr. (color) n.p.
New York 1987a, cat. 31, repr. (color) p. 92

SELECTED REFERENCES
Dupin 1962, pp. 166, 168, 510, no. 148, repr. p. 214. Krauss/Rowell 1972, p. 116.

FJM 701. 10⅜ × 7¾″ (26.4 × 19.8 cm)

49. THE BIRTH OF THE WORLD. Montroig, late summer–fall 1925. (Plate, p. 133)

Oil on canvas, 8′ 2¾″ × 6′ 6¾″ (250.8 × 200 cm). Signed and dated lower right: *Miró | 1925*. Inscribed on verso: *Joan Miró | 1925*. The Museum of Modern Art, New York. Acquired through an anonymous fund, the Mr. and Mrs. Joseph Slifka and Armand G. Erpf Funds, and by gift of the artist. Acq. no. 262.72. Dupin 150

PROVENANCE
René Gaffé, Brussels and Cagnes-sur-Mer, 1926?; to Jeanne Gaffé, Cagnes-sur-Mer, November 1968; to The Museum of Modern Art, New York, October 1972.

SELECTED EXHIBITIONS
Brussels 1953, cat. 71, repr. n.p.
Brussels 1956, cat. 15, repr. n.p.
New York 1968a, cat. 226 (New York venue only)
New York 1973b
Paris 1974b, cat. 28, p. 116, repr. p. 117
Humlebaek 1974, cat. 11
Washington 1980a, cat. 13, repr. (color) p. 62 (Washington venue only)
New York 1987a, cat. 28, repr. (color) p. 89

On view at The Museum of Modern Art, New York: September–November 1972; December 1972–September 1973; January–April 1974; February 1975–February 1980; October 1980–January 1982; March 1982–February 1983; June–September 1983; December 1983–January 1984; April 1984–May 1987; September 1987–April 1992; December 1992

SELECTED REFERENCES
Gaffé 1934, pp. 30-32. Dupin 1956, p. 9, repr. n.p. Chevalier 1960, p. 32. Dupin 1962, pp. 161, 238, 510, no. 150, repr. p. 217. Gaffé 1963, pp. 108, 172, repr. p. 149. Taillandier 1964, repr. p. 107. Rubin 1967b, p. 29, repr. p. 28. Mandelbaum 1968, p. 33. Ashbery 1968, p. 65. Rubin 1968, p. 68, fig. 87 (repr. p. 69). Penrose 1969, p. 49, pl. 31 (repr., color, p. 50). Rubin 1973, pp. 7, 30–33, 37, 50, 60, 116–17, repr. (color) p. 31. Leymarie 1974a, p. 14. Picon 1976, vol. 1, p. 72, repr. (color) p. 71. Rudenstine 1976, pp. 522, 523. Gimferrer 1978, fig. 170. Millard 1980, p. 22. Stich 1980, pp. 17–19, fig. 7 (repr. p. 18). Gateau 1982, p. 142, repr. p. 143. Dupin 1985, repr. p. 52. Bouret 1986, n.p. Gohr 1986b, p. 170. Green 1987, pp. 258, 267, 269, 288–89, pl. 256 (repr., color, p. 252). McEvilley 1988, p. 20. Raillard 1989, p. 82. Saura 1989, p. 32. Combalía 1990, p. 97, repr. (color) n.p. Stich 1990, pp. 80–81, pl. 97 (repr. p. 80). Yokohama Museum of Art 1992, ill. 5 (repr. p. 46). Combalía 1992, p. 187. Umland 1992, pp. 57, 59, 75 (n. 82), fig. 10 (repr. p. 58).

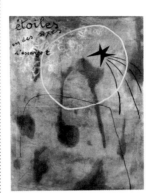

FJM 587a. 4⅜ × 3⅛″ (11 × 8.1 cm)

50. "ETOILES EN DES SEXES D'ESCARGOT." Montroig, late summer–fall 1925. (Plate, p. 138)

Oil on canvas, 51⅛ × 38⅛″ (129.5 × 97 cm). Signed and dated lower right: *Miró. | 1925*. Inscribed on verso: *Joan Miró 1925*. Kunstsammlung Nordrhein-Westfalen, Düsseldorf. Dupin 108

PROVENANCE
Galerie de Beaune, Paris; to Walter P. Chrysler, Jr., New York and Warrenton, Va., by January 1941; Pierre Matisse Gallery, New York, by 1961; to Kunstsammlung Nordrhein-Westfalen, Düsseldorf, 1969.

SELECTED EXHIBITIONS
Richmond 1941, cat. 139, p. 78
London 1964b, cat. 51, p. 24
Tokyo 1966, cat. 25, repr. p. 94
New York 1967c, repr. p. 70
New York 1972d, cat. 11, pp. 88, 92–93, repr. (color) p. 93
Düsseldorf 1973, repr. n.p.
Paris 1974b, cat. 22, p. 116
London 1974, cat. 86, p. 194, repr. p. 195
Barcelona 1983, cat. 77, repr. (color) p. 58
Saint-Paul-de-Vence 1990, cat. 19, p. 54, repr. (color) p. 55

SELECTED REFERENCES
Dupin 1962, no. 108, repr. p. 509. *Chronique des arts* 1970, fig. 146 (repr. p. 31). Krauss 1972, p. 31. Rowell 1972, pp. 57, 58. Champa 1973, repr. (color) p. 57. Rubin 1973, p. 126 (n. 3), fig. 48 (repr. p. 126). Rowell 1976, pp. 155, 157, repr. (color) p. 156. Miró 1977, p. 80. Schmalenbach 1982, repr. p. 32. Malet 1983a, p. 129. Rowell 1986, p. 90. Schmalenbach 1986, pp. 391–92.

51. "LE CORPS DE MA BRUNE . . ." Montroig, late summer–fall 1925. (Plate, p. 139)

Oil on canvas, 51⅛ × 37¾″ (129.8 × 95.8 cm). Signed and dated lower right: *Miró. | 1925*. Private collection. Dupin 126

PROVENANCE
[Galerie Pierre, Paris]; Galerie Vignon, Paris, by 1931; Henri Laugier, Paris, by January 1938; Marie Cuttoli, Paris, by January 1956; Cordier Warren Gallery, New

FJM 567b. 4⅜ × 3⅛″ (11 × 8.1 cm)

York; to Selma and Maxime Hermanos, New York, 1960 (consigned to Christie's, New York; sold November 12, 1985, lot 59); to present owner.

SELECTED EXHIBITIONS
Prague 1931, cat. 343
Possibly Paris 1935g, as (?)
Paris 1938a, cat. 135 (incorrectly dated 1927)
Brussels 1956, cat. 24, repr. n.p.
Basel 1956, cat. 13
Aix-en-Provence 1958, cat. 28, repr. n.p.
New York 1959b, cat. 27 (Los Angeles venue, cat. 25)

London 1964b, cat. 52, pp. 24–25, pl. 10b
New York 1972d, pp. 82, 98, 121, 147, cat. 15, repr. (color) p. 98
Zurich 1986, repro. (color) frontispiece (Düsseldorf venue only)
New York 1987a, cat. 36, repr. (color) p. 99
Los Angeles 1989, fig. 36 (repr. p. 43) (Los Angeles venue only)

SELECTED REFERENCES
Eluard 1937, repr. p. 58. Guetta 1938, p. 13. Elgar 1954, pl. 7 (color). Dupin 1956, p. 98. Hüttinger 1957, pp. 18–19, fig. 10. Soby 1959, p. 48, repr. p. 46. R.F.C. 1959, p. 221. Dupin 1962, pp. 164, 510, no. 126, repr. p. 218. Bonnefoy 1964, p. 18. Gasser 1965, repr. p. 39. Penrose 1969, pp. 53, 177, pl. 32 (repr., color, p. 51). Krauss 1972, p. 14. Rowell 1972, pp. 46, 50, 53–54, 55, 57–58. Rowell 1976, pp. 53, 147, 149, 153, 157, 185 (n. 22), repr. (color) p. 148. Miró 1977, p. 80. Gimferrer 1978, p. 122. Millard 1980, p. 25. Bouret 1986, n.p. Rowell 1986, p. 90. Green 1987, pp. 267, 278, 280, 284, 286, pl. 278 (repr. p. 268). Erben 1988, repr. (color) p. 45. Freeman 1989, p. 42. Raillard 1989, p. 20. Combalía 1990, repr. (color) n.p.

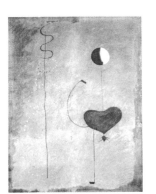

FJM 655b. 7½ × 6½″ (19.1 × 16.5 cm)

52. DANCER II. Montroig, November–December 1925. (Plate, p. 140)
Oil on canvas, 45½ × 34¾″ (115.5 × 88.5 cm). Signed and dated lower right: *Miró. | 1925.* Inscribed on verso: *Joan Miró. | "Danseuse II." | 1925.* Collection A. Rosengart. No Dupin number

PROVENANCE
Mr. and Mrs. R. Sturgis Ingersoll, Philadelphia and Penllyn, Pa., by January 1946; A. Rosengart, 1980.

SELECTED EXHIBITIONS
Boston 1946, cat. 35, as *Spanish Dancer* (incorrectly dated 1924)
Stuttgart 1985, cat. 382, repr. (color) p. 243

Zurich 1986, cat. 39, repr. (color) n.p., as *Danseuse*
New York 1987a, cat. 33, repr. (color) p. 95, as *Dancer*

Sankt Gallen 1988, repr. (color) p. 81, as *Danseuse*
Lucerne 1988, cat. 47, pp. 194, 195, repr. (color) p. 140
Saint-Paul-de-Vence 1990, cat. 24, p. 64, repr. (color) p. 65

SELECTED REFERENCES
Erben 1988, repr. (color) p. 47.

FJM 732b. 10⅜ × 7¾″ (26.4 × 19.8 cm)

53. "AMOUR." Montroig or Paris, January–June 1926. (Plate, p. 141)
Oil on canvas, 57½ × 44⅞″ (146 × 114 cm). Signed and dated lower right: *Miró | 1926.* Inscribed on verso: *Joan Miró 1926.* Museum Ludwig, Cologne. Dupin 166

PROVENANCE
The artist to Pierre Loeb (Galerie Pierre), Paris, by 1927; Collection Decagne, Belgium; Galerie Europe, Brussels; to Galerie Rosengart, Lucerne, 1958; to Wallraf-Richartz-Museum, Cologne, 1965; incorporated into the collection of Museum Ludwig, Cologne, 1976.

SELECTED EXHIBITIONS
New York 1959b, cat. 32 (Los Angeles venue, cat. 31)
London 1964b, cat. 62, p. 26, pl. 13a
Cologne 1965, cat. 75, repr. (color) cover

New York 1967c, repr. (color) p. 2
Munich 1969, cat. 28, repr. n.p.
Lucerne 1988, cat. 48, repr. (color) p. 143 (not exhibited)

SELECTED REFERENCES
Raynal 1927, repr. p. 237. Giménez Caballero 1928, p. 329, fig. 8 (repr. between pp. 328 and 329). Soby 1959, repr. p. 48. Rubin 1959, p. 37, repr. p. 37. Kramer 1959, p. 50, repr. p. 51. Dupin 1962, p. 168, no. 166, repr. p. 514. Rubin 1967b, p. 29. Penrose 1969, p. 55, pl. 33 (repr. p. 52). Krauss 1972, p. 29. Rowell 1972, pp. 47, 121, fig. 17 (repr. p. 46). Rowell 1976, p. 143, repr. p. 142. Miró 1977, p. 80. Gohr 1986a, p. 120, pl. 99 (repr., color, p. 127). Gohr 1986b, p. 170. Kunz 1988, pp. 194, 195.

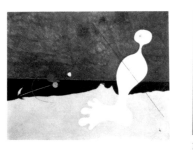

FJM 631b. 6½ × 7½″ (16.5 × 19.1 cm)

54. PERSON THROWING A STONE AT A BIRD. Montroig, mid-August–December 1926. (Plate, p. 152)
Oil on canvas, 29 × 36¼″ (73.7 × 92.1 cm). Signed and dated lower left: *Miró | 1926.* The Museum of Modern Art, New York. Purchase. Acq. no. 271.37. Dupin 172

PROVENANCE
René Gaffé, Brussels, by June 7, 1928?; to The Museum of Modern Art, New York, December 1937.

SELECTED EXHIBITIONS

Paris 1928c, as (?)
New York 1936d, cat. 434, repr. p. 139
New York 1939d, cat. 196, repr. n.p.
New York 1941a
New York 1941g
New Orleans 1944 (New Orleans, Poughkeepsie, N.Y., Newark, Cincinnati, and Bloomington, Ind., venues only)
New York 1949c
Venice 1954, cat. 11
New York 1954
New York 1959b, cat. 32 (Los Angeles venue only)
Boston 1960, cat. 19, repr. p. 7
Paris 1962b, cat. 38
San Diego 1969, repr. n.p.
Bogotá 1971, cat. 59, repr. (color) n.p.
New York 1973b
Paris 1974b, cat. 30, p. 117, repr. p. 40
Humlebaek 1974, cat. 15

Cincinnati 1977, repr. (color) n.p.
Vienna 1978, cat. 49, repr. (color) p. 131
La Jolla 1980, repr. p. 104
São Paulo 1981, p. 102, repr. p. 103
Atlanta 1982
On view at The Museum of Modern Art, New York: January–July 1940; May–June 1941; December 1942–July 1943; June 1945–May 1946; July–December 1946; January 1948–January 1949; December 1949–November 1952; October 1956–June 1957; January–March 1958; April–May 1959; May 1964–December 1968; November 1969–May 1971; March–September 1973; January–April 1974; February 1975–February 1976; November–December 1977; May–October 1979; October 1980–April 1981; April 1984–August 1992

SELECTED REFERENCES

Révolution surréaliste 1927, repr. p. 62. Desnos 1929, repr. p. 206. Einstein 1931, repr. p. 432. Grohmann 1934, p. 38. Gascoyne 1935, repr. p. 118. *Star* 1936. Hugnet 1936, pp. 21, 22. *New York Herald Tribune* 1936b, p. 23. *Beaux-Arts* 1937a, repr. p. 3 (installation view). Sweeney 1941, p. 36, repr. (color) p. 39. *New York Herald Tribune* 1941b. Greenberg 1948, p. 32. Read 1948, p. 90. Davenport 1948, p. 61, repr. p. 58. Cirici-Pellicer 1949, p. 26. Goldwater/d'Harnoncourt 1949, pp. 30–31, repr. p. 30. Lancaster 1952, repr. p. 121. Prévert/Ribemont-Dessaignes 1956, p. 81. Dupin 1962, p. 176, no. 172, repr. pp. 163 (color), 514. Chevalier 1962, p. 9. Gaffé 1963, repr. p. 153. Lassaigne 1963, pp. 53–54. Gasser 1965, repr. (color) p. 31. Walton 1966, pp. 12, 32, pl. 63 (color). Penrose 1969, p. 56, pl. 37 (repr., color, p. 55). Sylvester 1972, p. 9. Rubin 1973, pp. 7, 37, 38, 118, repr. (color) cover and p. 36. Leymarie 1974a, p. 14. *Louisiana Revy* 1974, repr. (color) p. 19. Okada 1974, pl. 8 (color). Teixidor 1974, p. 94. Picon 1976, vol. 1, pp. 83–84, repr. p. 84. Rudenstine 1976, pp. 522, 525. Miró 1977, pp. 72, 201. Gimferrer 1978, p. 128, fig. 124. Rose 1982a, pp. 10–11. Fundació Joan Miró 1983, repr. p. 104. Rowell 1986, p. 265. Green 1987, p. 287, pl. 303 (repr. p. 287). Erben 1988, repr. (color) p. 49. Saura 1989, p. 32. Stich 1990, p. 132, pl. 170 (repr. p. 132).

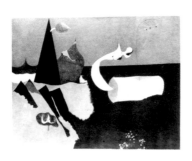

FJM 760. 5⅞ × 7⅜″ (14.9 × 18.6 cm)

55. LANDSCAPE BY THE SEA (Horse at Seashore). Montroig, mid-August–December 1926. (Plate, p. 155)

Oil on canvas, 26 × 36⅝″ (66 × 93 cm). Signed and dated lower center: *Miró | 1926*. Inscribed on verso: *Joan Miró | Paysage près de la Mer | 1926*. Private collection. Dupin 173

PROVENANCE

Galerie Pierre, Paris, by October 1934; Howard Putzel (Stanley Rose Gallery), Hollywood (on consignment?), sold by January 22, 1936; Pierre Matisse Gallery, New York, by 1936; Thomas Laughlin, New York, by November 1941; private collection, South Carolina; present owner.

SELECTED EXHIBITIONS

Paris 1928c, as (?)
Paris 1928d, cat. 23, repr. n.p., as *Paysage*
New York 1930c, cat. 1, as *Paysage au bord de la mer*
Chicago 1931, cat. 1, as *Paysage au bord de la mer*
London 1933b, cat. 1
Zurich 1934, cat. 88, as *Paysage au bord de la mer*
San Francisco 1935a, as *Landscape near the Sea*
Los Angeles 1935b
New York 1936c, cat. 8, repr. n.p.

New York 1941g
Saint Paul 1946
New York 1972b, cat. 16, repr. (color) n.p., as *Horse at Seashore*
Cleveland 1979, cat. 28, repr. p. 76, as *Horse at the Seashore*
Houston 1982, pl. 10 (color), as *Cheval au bord de la mer*
Barcelona 1983, cat. 80, repr. (color) p. 60, as *Cavall a la vora del mar*
Saint-Paul-de-Vence 1990, cat. 25, p. 68, repr. (color) p. 69, as *Cheval au bord de la mer*

SELECTED REFERENCES

Centaure 1928, repr. p. 51. *Amic de les arts* 1928, repr. p. 200. Gantenys 1929, p. 2. Gasch 1929b, repr. p. 203. Davidson 1936, p. 11, repr. p. 11. Watson 1941, pl. 4 (repr. between pp. 132 and 133). Sweeney 1941, repr. p. 42. Ayrton 1946, repr. p. 110. Cirici-Pellicer 1949, p. 27, ill. 27. Cirlot 1949, pp. 24, 32. Prévert/Ribemont-Dessaignes 1956, p. 81. Erben 1959, p. 123. Dupin 1962, p. 178, no. 173, repr. p. 514. Cooper 1972, n.p. Rudenstine 1976, p. 525. McCandless 1982, pp. 54, 65 (n. 29), fig. 50 (repr. p. 55). Malet 1983a, p. 129. Rose 1992, p. 194.

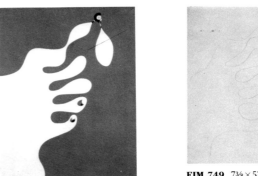

FJM 749. 7⅜ × 5⅞″ (18.6 × 14.9 cm)

56. HAND CATCHING A BIRD. Montroig, mid-August–December 1926. (Plate, p. 154)

Oil on canvas, 36⅜ × 28¾″ (92.3 × 73 cm). Signed and dated lower right: *Miró. | 1926*. Inscribed on verso: *Joan Miró | "Main à la poursuite d'un oiseau" | 1926*. Private collection. Dupin 174

PROVENANCE

[Galerie Pierre, Paris]; Charles and Marie-Laure de Noailles, Paris; to present owner.

SELECTED EXHIBITIONS

Paris 1928c, as (?)
Paris 1962b, cat. 39, repr. n.p.

London 1964b, cat. 61, p. 26, pl. 11b
New York 1968a, cat. 230

SELECTED REFERENCES

Trabal 1928, repr. p. 4. Breton 1928, pl. 63. *Variétés* 1929b, repr. n.p. Tériade 1930a, repr. p. 84. Grohmann 1934, p. 38. Frey 1936, p. 14. Queneau 1949, n.p. Brookner 1962, p. 364. Dupin 1962, p. 180, no. 174, repr. pp. 223, 514. Rubin 1968, p. 68, fig. 84 (repr. p. 67). Waldberg 1970, pl. 28 (color). Sylvester 1972, p. 9. Rubin 1973, p. 118 (n. 1). Picon 1976, vol. 1, p. 45, repr. (color) p. 46. Rowell 1976, repr. (color) p. 45. Miró 1977, p. 201. Picon 1981, p. 43. Dupin 1983, p. 127. Gimferrer 1985, p. 64. Green 1987, p. 283.

57. LANDSCAPE (The Grasshopper). Montroig, mid-August–December 1926. (Plate, p. 153)

Oil on canvas, 44⅞ × 57½″ (114 × 146 cm). Signed lower half: *Joan Miró*. Dated lower left: *1926*. Private collection. Dupin 176

FJM 746. 5⅞ × 7⅜″ (14.9 × 18.6 cm)

PROVENANCE
Galerie Surréaliste, Paris, by 1928?; Galerie Le Centaure, Brussels; to Pierre Janlet, Brussels, 1932; Daniel Varenne, Paris; to present owner, 1973.

SELECTED EXHIBITIONS

Paris 1928a, as *La Sauterelle*	Tokyo 1966, cat. 30, repr. (color) p. 47
Paris 1928c, as (?)	Turin 1967, cat. 254, repr. p. 186, as
Possibly Brussels 1930, as (?)	*La Cavalletta*
Brussels 1931, cat. 499, as *La Sauterelle*	Munich 1969, cat. 29, repr. n.p., as
Brussels 1956, cat. 26, repr. n.p., as *La Sauterelle*	*Die Heuschrecke*
	Knokke 1971, cat. 12, repr. p. 30
Brussels 1958, cat. 221, repr. 115, as *La Sauterelle*	Munich 1972, cat. 327, repr. n.p.
	Paris 1972, cat. 312, repr. n.p.
Paris 1959b, cat. 108, pl. 18, as *La Sauterelle*	New York 1972d, cat. 24, pp. 110–11, 122, 128, repr. (color) p. 111
Paris 1962b, cat. 40, as *La Sauterelle*	Paris 1974b, cat. IV, p. 173, repr. p. 173
London 1964b, cat. 63, p. 29, pl. 12c	(upside down), as *La Sauterelle*

SELECTED REFERENCES
Révolution surréaliste 1928, repr. back cover. Gasch 1928b, repr. p. 203. Tériade 1929, repr. p. 364. Centaure 1929, repr. p. 74. *Cahiers d'art* 1934, fig. 19 (repr. p. 37). Cassou 1934, fig. 446 (repr. p. 339). Prévert/Ribemont-Dessaignes 1956, repr. p. 114. Hüttinger 1957, fig. 14 (color). Erben 1959, pl. 51. Taillandier 1962, repr. (color) p. 41. Dupin 1962, p. 178, no. 176, repr. p. 514. Picon 1976, vol. 1, pp. 78–79, repr. (color) p. 79; vol. 2, p. 60. Rowell 1976, repr. (color) p. 144. Dupin 1985, repr. p. 53. Bouret 1986, n.p. Raillard 1989, p. 84.

FJM 759. 5⅞ × 7⅜″ (14.9 × 18.6 cm)

58. DOG BARKING AT THE MOON. Montroig, mid-August–December 1926. (Plate, p. 156)

Oil on canvas, 28⅞ × 36½″ (73.3 × 92.7 cm). Signed and dated lower left: *Miró. | 1926.* Inscribed on verso: *Joan Miró. | Chien aboyant la lune. | 1926.* Philadelphia Museum of Art. A. E. Gallatin Collection. Dupin 177

PROVENANCE
The artist to Galerie Pierre, Paris; to private collection, spring 1928; to Galerie Pierre, Paris, by December 1928; to A. E. Gallatin, New York, March 10, 1929; to Philadelphia Museum of Art, 1952.

SELECTED EXHIBITIONS

Paris 1928c, as (?)	Chicago 1933, cat. 785, p. 84, pl.
New York 1929b, cat. 4	LXXVII
New York 1930a, cat. 62, repr. n.p.	New York 1936c, cat. 7

New York 1941g (New York venue only)	London 1985, cat. 154, fig. 220 (repr., color, p. 207) (London venue only)
New York 1959b, cat. 34 (Los Angeles venue, cat. 33)	Zurich 1986, cat. 49, repr. (color) n.p.
New York 1961e, repr. n.p.	New York 1987a, cat. 41, repr. (color) p. 109
Paris 1962b, cat. 41	Philadelphia 1987a, cat. 9
London 1964b, cat. 64, p. 26, pl. 12b	Paris 1987b (Madrid venue only)
Cleveland 1966, cat. 37, repr. (color) n.p.	Saint-Paul-de-Vence 1990, cat. 26, p. 70, repr. (color) p. 71
New York 1968b	New York 1990b, fig. 37 (repr., color, p. 175)
New York 1972c, cat. 60	
Paris 1974b, cat. V, p. 173	On view at the Museum of Living Art, New York University, New York: 1929–43
Madrid 1978a, cat. 22, pp. 99–100, repr. (color) p. 49	
Washington 1980a, cat. 15, repr. (color) p. 64	
Houston 1982, pl. 9 (color)	
Barcelona 1983, cat. 82, repr. (color) p. 61	

SELECTED REFERENCES
Breton 1928, pl. 64. Trabal 1928, repr. p. 4. Planas 1928, p. 1. McBride 1928a, p. 527. McBride 1928b, p. 9. Gantenys 1929, p. 2. *Hèlix* 1929, repr. p. 8. Gasch 1929e, p. 4. Burnett 1929. *New York Times* 1929, p. 29. *Art News* 1929a, p. 10. *Art News* 1929b, repr. p. 5. *Art Digest* 1929, pp. 5, 10, repr. p. 5. Rivière 1930, repr. p. 374. Gallatin 1930, repr. n.p. Barr 1930, pp. 15, 35. McBride 1930a, p. sup10, repr. p. sup11. Mauny 1930, repr. p. 22b. *Art News* 1930, p. 11. McBride 1930b, p. 8. Melgar 1931, repr. p. 17. Jewell 1931a, repr. p. 13. *Bulletin of The Art Institute of Chicago* 1933, repr. p. 80. Gallatin 1933, no. 90, repr. n.p. Schwob 1933, p. 223. *Art Digest* 1933, repr. p. 33. Jewell 1933, p. L11. M.M. 1934, p. 4. *Art Digest* 1934, p. 13. Hoppe 1934, fig. 17 (repr. p. 34). Grohmann 1934, p. 38. *Time* 1934, p. 34. Morsell 1936, p. 3. Cary 1936, p. X9. Thwaites 1936, p. 23. Frey 1936, p. 14. *Art Digest* 1936, p. 13. Davidson 1936, p. 11. McBride 1936c, p. 43. Klein 1936b, p. 12. Genauer 1936. *New York Times* 1936, p. 12. Gallatin 1936, no. 86, repr. n.p. Bjerke-Petersen 1937, repr. p. 53. Devree 1937a, p. 60. Gilbert 1938. *Chicago Daily News* 1938b. Jewett 1938b. Zervos 1938, repr. p. 424. Jewell 1938b, p. L22. Devree 1939, p. 10X. Gallatin 1940, no. 88, repr. n.p. Lane 1941, p. 11. Sweeney 1941, p. 36, repr. p. 38. Jewell 1941b. *New York Herald Tribune* 1941b. *New York Herald Tribune* 1941c. *New York Journal American* 1941. Frost 1943, p. 28, repr. p. 14. Clifford 1943, p. 4, repr. p. 11. Bille 1945, repr. p. 154. *Pictures on Exhibit* 1945, p. 14. Arbois 1945, p. 3. Wolf 1947, p. 10. Greenberg 1948, p. 32. Read 1948, pl. 90. Cirici-Pellicer 1949, p. 26, ill. 25. Queneau 1949, n.p. Prévert/Ribemont-Dessaignes 1956, p. 81. Verdet 1957a. n.p. Verdet 1957b, pl. 9. Roditi 1958, p. 40. Erben 1959, pp. 124, 135, pl. 52. Soby 1959, p. 53, repr. p. 53. Canaday 1959, pp. 22, 23, repr. pp. 22–23. Devree 1959, p. X15. Rubin 1959, p. 37. R.F.C. 1959, p. 221, repr. p. 222. Dupin 1962, pp. 176, 178, no. 177, repr. pp. 222, 515. Lassaigne 1963, p. 54, repr. (color) p. 55. Bonnefoy 1964, pp. 5, 26, pl. 22 (color). Penrose 1964, p. 8. Gasser 1965, repr. p. 40. Walton 1966, p. 32, pl. 62 (color). Juin 1967, p. 15, repr. p. 12. Penrose 1969, pp. 56, 186, 193, pl. 36 (repr., color, p. 54). Marchiori 1972, p. 21. Rubin 1973, pp. 24, 118 (n. 1), fig. 16 (repr. p. 115), repr. p. 11 (installation view). Leymarie 1974a, p. 14. Okada 1974, pl. 9 (color). Teixidor 1974, p. 94. Picon 1976, vol. 1, pp. 45, 72, repr. (color) p. 73. Rudenstine 1976, p. 525. Gimferrer 1978, p. 128, fig. 123 (color). Carmean 1980, p. 41. Lerner 1980, p. 9. Millard 1980, p. 22. Freeman 1980, p. 36. Rose 1982a, p. 10. McCandless 1982, pp. 50, 52, 54, 56, fig. 47 (repr. p. 51). Schmalenbach 1982, repr. p. 21. Malet 1983a, p. 129. Ooka 1984, repr. p. 14. Bouret 1986, n.p. Rowell 1986, pp. 189, 317 (n. 30). D'Harnoncourt 1987, p. 2. Rowell 1987a, pp. 19, 20, repr. (color) p. 19. Temkin 1987b, pp. 40–41. Erben 1988, repr. (color) p. 48. Jeffett 1989c, p. 15 (n. 12). Llorca 1990, repr. p. 165. Combalía 1990, pp. 97, 215, repr. (color) n.p. Stavitsky 1990, vol. 8, p. 183. Yokohama Museum of Art 1992, fig. 5 (repr. p. 27). Combalía 1992, p. 187. Umland 1992, fig. 24 (repr. p. 65).

59. NUDE. Montroig, mid-August–December 1926. (Plate, p. 157)

Oil on canvas, 36¼ × 28⅝″ (92 × 73.6 cm). Signed and dated lower right: *Miró | 1926.* Inscribed on verso: *Joan Miró | Nu | 1926.* Philadelphia Museum of Art. The Louise and Walter Arensberg Collection. Dupin 178

PROVENANCE
The artist to Galerie Pierre, Paris, by May 1928; Howard Putzel (Stanley Rose

FJM 752. 7⅜ × 5⅞″ (18.6 × 14.9 cm)

Gallery), Hollywood (on consignment?), by October 1935; to Louise and Walter Arensberg, Hollywood, by January 22, 1936?; to Philadelphia Museum of Art, 1950.

SELECTED EXHIBITIONS

Paris 1928c, as (?)	New York 1959b, cat. 33 (New York
Possibly Brussels 1929, as (?)	venue only)
New York 1930c, cat. 4	Paris 1962b, cat. 42
Chicago 1931, cat. 4	London 1964b, cat. 65, p. 26, pl. 12a
London 1933b, cat. 4	New York 1972c, cat. 61
Brussels 1934, cat. 90	Washington 1980a, cat. 14, repr. (color)
Copenhagen 1934, cat. 354, repr. p. 1, as	p. 63
Abstraction	Houston 1982
Tenerife 1935, cat. 20	Barcelona 1983, cat. 84, repr. (color) p. 62
Los Angeles 1935b	Philadelphia 1987a, cat. 8
New York 1941g (New York venue only)	On view at the Galerie Pierre, Paris:
Chicago 1949, cat. 149, repr. n.p.	c. April 1929

SELECTED REFERENCES

Breton 1928, pl. 65. *Feuilles volantes* 1928, repr. n.p. Benet 1928, repr. p. 6. Ozenfant 1928, repr. p. 135. Mycho 1929, repr. n.p. George 1929a, repr. p. 202. Gasch 1929c, repr. p. 5 (incorrectly dated 1927). Tériade 1930a, repr. p. 84. Hoppe 1934, fig. 18 (repr. p. 35). Terents 1934, repr. p. 1. Zervos 1938, repr. p. 423. *Dictionnaire abrégé* 1938, repr. p. 76 (installation view). Sweeney 1941, p. 36, repr. p. 37. Cirlot 1949, fig. 16. Philadelphia Museum of Art 1954, no. 146, repr. n.p. Prévert/Ribemont-Dessaignes 1956, p. 81. Erben 1959, p. 125, pl. 53. Soby 1959, p. 53, repr. p. 52. Cordier 1959, repr. p. 7. R.F.C. 1959, p. 221. Dupin 1962, pp. 180, 196, 308, no. 178, repr. pp. 165 (color), 515. Rubin 1966, repr. p. 38. Juin 1967, repr. (color) p. 8. Krauss/Rowell 1972, p. 75. Okada 1974, pl. 10 (color). Rudenstine 1976, p. 523. Millard 1980, p. 22. Dupin 1983, p. 127. Green 1987, pp. 103, 278, 284, pl. 300 (repr. p. 285). Pierre 1987, fig. 51. Rowell 1987a, p. 19, repr. (color) p. 18. Temkin 1987b, p. 40. Erben 1988, repr. (color) p. 56. Raillard 1989, p. 92. Combalía 1990, repr. (color) n.p. Beaumelle 1991, pp. 189, 191, repr. p. 221 (installation view). Combalía 1992, p. 187.

FJM 569a. 4⅜ × 3⅛″ (11 × 8.1 cm)

60. "48." Paris, January–mid-February 1927. (Plate, p. 143)
Oil and water-soluble paint on glue-sized canvas, 57½ × 45″ (146.1 × 114.2 cm). Signed and dated lower right: *Miró | 1927*. Inscribed on verso: *Joan Miró | 1927*. Private collection. Dupin 216

PROVENANCE

The artist to Galerie Pierre, Paris; Marie Cuttoli, Paris, by 1952; Robert Elkon Gallery, New York, by 1967; to Arthur and Elaine Lustig Cohen, New York, 1969 (consigned to Christie's, New York; sold May 15, 1979, lot 50); to present owner.

SELECTED EXHIBITIONS

Saarbrücken 1952, cat. 66, as *Peinture 48*	New York 1967a, cat. 16, repr. n.p.
	New York 1972d, cat. 35, p. 125, repr.
Brussels 1956, cat. 73	p. 125
Basel 1956, cat. 23	New York 1975a, cat. 107, repr. p. 49
Paris 1962b, cat. 47	London 1978, cat. 9.58, repr. (color) n.p.
London 1964b, cat. 75, p. 27	Saint Louis 1980

SELECTED REFERENCES

Taillandier 1962, p. 38, repr. p. 39. Frigerio 1962, p. 54. Dupin 1962, no. 216, repr. p. 518. Bonnefoy 1964, pl. 24 (color). Marchiori 1972, repr. (color) p. 25. Champa 1973, repr. p. 58. Rowell 1976, repr. p. 146. Rudenstine 1976, p. 523. Stich 1980, pp. 23–24, fig. 14 (repr. p. 23). Rowell 1986, pp. 101, 313 (n. 8). Miró 1987, p. 29. Rudenstine 1988, no. 284, pp. 782–87, repr. p. 783. Freeman 1989, pp. 43–44, fig. 37 (repr. p. 44).

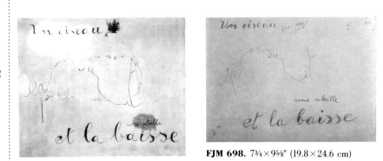

FJM 698. 7¾ × 9⅝″ (19.8 × 24.6 cm)

61. "UN OISEAU POURSUIT UNE ABEILLE ET LA BAISSE." Paris, January–mid-February 1927. (Plate, p. 142)
Oil and feather on canvas, 32⅞ × 40¼″ (83.5 × 102 cm). Signed and dated upper right: *Miró. | 1927*. Private collection. Dupin 161

PROVENANCE

The artist to Alberto Magnelli, Paris; to Nelly van Doesburg, mid-1950s; Mrs. M. Pasquier, Paris; to William N. Copley, Longpont-sur-Orge and New York (consigned to Sotheby Parke Bernet, New York; sold November 6, 1979, lot 18); private collection, New York; present owner.

SELECTED EXHIBITIONS

New York 1968a, cat. 231, as *A Bird Pursues a Bee and "Kisses" It*	New York 1972d, cat. 25, pp. 112–13, 128, 144, 147, repr. p. 113

SELECTED REFERENCES

Dupin 1962, pp. 164, 491 (n. 49), no. 161, repr. p. 513 (incorrectly dated 1926). Rubin 1968, p. 94, fig. 132 (repr. p. 98). Dienst 1968, repr. p. 31. Penrose 1969, pp. 55, 94, pl. 33 (repr. p. 52). Wescher 1971, p. 190. Krauss 1972, pp. 23, 25, 26, 34. Rowell 1972, pp. 57, 58–60. Rubin 1973, p. 126 (n. 3), fig. 49 (repr. p. 126). Rowell 1976, pp. 155, 157, repr. p. 158. Miró 1977, p. 81. Carmean 1980, p. 38. Millard 1980, p. 25. Rowell 1986, p. 90. Freeman 1989, p. 44, fig. 39 (repr. p. 45). Umland 1992, pp. 70 (n. 28), 75 (n. 75).

62. "MUSIQUE—SEINE—MICHEL, BATAILLE ET MOI." Paris, January–mid-February 1927. (Plate, p. 145)
Oil on canvas, 31⅜ × 39½″ (79.5 × 100.5 cm). Signed and dated lower left: *Miró. | 1927*. Inscribed on verso: *Joan Miró 1927*. Kunstmuseum Winterthur. Permanent loan from the Volkart Foundation since 1969. Dupin 192

PROVENANCE

[René Gaffé, Brussels]; [Zwemmer Gallery, London]; Roland Penrose, London, by

FJM 742. 7¾ × 10⅜″ (19.8 × 26.4 cm)

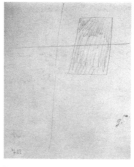

FJM 763. 7⅜ × 5⅞″ (18.6 × 14.9 cm)

December 1939; [H. U. Gasser, Zurich]; Dr. Heinz Keller, Winterthur; to Volkart Foundation, Winterthur, 1969; on permanent loan to Kunstmuseum Winterthur, January 1969.

SELECTED EXHIBITIONS

London 1937b, cat. 13, as *Musique*
London 1950, cat. 8, as *Musique*
Basel 1956, cat. 26
London 1964b, cat. 73, p. 27

New York 1972d, cat. 28, p. 118, repr. p. 118
Stuttgart 1985, cat. 383, repr. (color) p. 244

SELECTED REFERENCES

Hüttinger 1957, fig. 18. Dupin 1962, p. 168, no. 192, repr. p. 516. Rubin 1973, p. 126 (n. 3), fig. 50 (repr. p. 126). Kunstmuseum Winterthur 1976, no. 603. Rowell 1976, repr. p. 130. Rowell 1986, pp. 90, 103, 313 (n. 23). Miró 1987, p. 31. Freeman 1989, pp. 43–44, fig. 38 (repr. p. 45). Jeffett 1989b, p. 121, repr. p. 121. Raillard 1989, p. 84. Koella 1992, pp. 152–53, repr. (color) p. 153.

PROVENANCE

Roger Dutilleul, Paris; to Geneviève and Jean Masurel; to Musée d'Art Moderne, Villeneuve d'Ascq.

SELECTED EXHIBITIONS

New York 1972d, cat. 31, p. 121, repr. p. 121
Paris 1974b, cat. 33, p. 118, repr. pp. 45 (color), 118
Humlebaek 1974, cat. 16
Madrid 1978a, cat. 23, p. 100
Paris 1980, cat. 81, as *Composition*

Charleroi 1985, cat. 14, repr. (color) p. 186
Villeneuve d'Ascq 1986, cat. 6, repr. (color) n.p., as *Sans titre*
Tokyo 1986, cat. 7, repr. (color) p. 43, as *Sans titre*
Saint-Paul-de-Vence 1990, cat. 31, p. 74, repr. (color) p. 75, as *Composition*

SELECTED REFERENCES

Dupin 1962, no. 197, repr. p. 516. Krauss 1972, p. 33. *Louisiana Revy* 1974, repr. (color) p. 21. Rowell 1976, repr. p. 192. Rowell 1987a, p. 15, fig. 8 (repr. p. 16). Umland 1992, pp. 56–57, 75 (n. 75), fig. 9 (repr., color, p. 55).

FJM 743. 7¾ × 10⅜″ (19.8 × 26.4 cm)

63. "BEAUCOUP DE MONDE." Paris, January–mid-February 1927. (Plate, p. 144)

Oil and tempera on canvas, 32⅜ × 39⅜″ (82 × 100 cm). Signed and dated lower left: *Miró.* | *1927*. Private collection, Switzerland. Dupin 193

PROVENANCE

Galerie Pierre, Paris; Edouard Loeb, Paris; Rasmussen Collection, Paris; to Mr. and Mrs. J. Berthod Urvater, Brussels and Rhode-Saint-Genèse; present owner.

SELECTED EXHIBITIONS

Otterlo 1957, cat. 93, repr. n.p.
Paris 1959b, cat. 109
Knokke 1971, cat. 14, repr. p. 32

New York 1972d, cat. 29, pp. 119, 133, repr. p. 119

SELECTED REFERENCES

Dupin 1962, p. 168, no. 193, repr. p. 516. Krauss 1972, p. 33. Rowell 1976, repr. p. 154.

64. PAINTING (Untitled; The Bullfighter). Paris, January–mid-February 1927. (Plate, p. 146)

Oil on canvas, 50¾ × 38⅛″ (129 × 97 cm). Signed and dated lower center: *Miró.* | *1927*. Inscribed on verso: *Joan Miró 1927*. Musée d'Art Moderne, Villeneuve d'Ascq. Gift of Geneviève and Jean Masurel. Dupin 197

65. PAINTING (Blue). Paris, April–mid-May 1927. (Plate, p. 147)

Oil on canvas, 45⅝ × 35⅜″ (116 × 90 cm). Signed and dated lower right: *Miró* | *1927*. Collection Alfred Richet, Paris. Dupin 218

PROVENANCE

Galerie Pierre, Paris, by May 1938; Alfred Richet, Paris.

SELECTED EXHIBITIONS

London 1964b, cat. 71, p. 27, as *Painting, Blue Ground*

SELECTED REFERENCES

Miró 1938, repr. p. 27. Grenier 1960, repr. (color) p. 37. Dupin 1962, no. 218, repr. p. 518. Miró 1964, repr. (color) p. 13.

66. PAINTING (Fratellini; Three Personages). Paris, April–mid-May 1927. (Plate, p. 149)

Oil and aqueous medium on canvas, 51⅜ × 38⅜″ (130.5 × 97.5 cm). Signed and dated lower center: *Miró.* | *1927*. Inscribed on verso, upper right: *Joan Miró.* | *1927*. Philadelphia Museum of Art. A. E. Gallatin Collection. Dupin 189

FJM 679. 10⅝ × 8½″ (27 × 21.6 cm)

PROVENANCE
The artist to Galerie Pierre, Paris; to A. E. Gallatin, New York, by fall 1928; to Philadelphia Museum of Art, 1952.

SELECTED EXHIBITIONS
Paris 1928c, as (?)
New York 1929a, as *The Signature*
New York 1936c, cat. 9, as *The Fratellini*
New York 1941g, as *The Fratellini* (New York venue only)
New York 1967c, repr. p. 70
San Diego 1969, repr. n.p., as *The*

Fratellini
New York 1972c, cat. 62
Philadelphia 1987a, cat. 6
On view at the Museum of Living Art, New York University, New York: December 1928 to 1943

SELECTED REFERENCES
McBride 1928b, p. 9. McBride 1930a, p. sup10. Gallatin 1930. Gallatin 1933, no. 91. McBride 1936c, p. 43. Gallatin 1936, no. 88. McBride 1940, p. 8. Gallatin 1940, no. 90, repr. n.p. Sweeney 1941, repr. p. 45. Clifford 1943, p. 4. Cirici-Pellicer 1949, p. 27. *Philadelphia Museum Bulletin* 1952, repr. p. 58. Prévert/Ribemont-Dessaignes 1956, p. 81. Dupin 1962, pp. 166, 168, no. 189, repr. p. 516. Krauss/Rowell 1972, p. 104. Rowell 1987a, p. 15, repr. (color) p. 14. Temkin 1987b, p. 41. Stavitsky 1990, vol. 8, p. 190.

FJM 682. 10⅝ × 8½″ (27 × 21.6 cm)

67. PAINTING (The Lasso; Circus Horse). Paris, April–mid-May 1927. (Plate, p. 151)
Oil on canvas, 51 × 38″ (129.5 × 96.5 cm). Signed and dated lower right: *Miró | 1927*. Fogg Art Museum, Harvard University Art Museums, Cambridge, Mass. Gift of Mr. and Mrs. Joseph Pulitzer, Jr. Dupin 202

PROVENANCE
René Gaffé, Brussels; to Roland Penrose, London, July 15, 1937; to Zwemmer Gallery, London, end of July 1937; Pierre Matisse Gallery, New York; to Mr. and Mrs. Joseph Pulitzer, Jr., Saint Louis, January 1947; to Fogg Art Museum, Harvard University, Cambridge, Mass., 1954.

SELECTED EXHIBITIONS
London 1937b, cat. 11, as *Le Lasso*
San Francisco 1948, cat. 49, repr. p. 100, as *The Lasso*

New York 1957b, cat. 43, pp. 59–60, ill. 14b, as *The Lasso*
Saint Louis 1965, as *The Lasso*

Munich 1972, cat. 329, repr. n.p., as *Lasso*
Paris 1972, cat. 314, repr. n.p., as *Lasso*

Saint Louis 1980, as *The Lasso* (Saint Louis venue only)

SELECTED REFERENCES
Duthuit 1936b, pl. 59 (repr. p. 160). Sweeney 1941, repr. p. 44. Read 1948, p. 92. Cirici-Pellicer 1949, ill. 30 (incorrectly credited to Collection René Gaffé, Brussels). Dupin 1962, pp. 168, 173, 517, no. 202, repr. p. 221. Krauss/Rowell 1972, p. 104. Picon 1976, vol. 1, repr. p. 45. Stich 1980, pp. 25, 26, fig. 16 (repr. p. 25). Halliday 1991, p. 157.

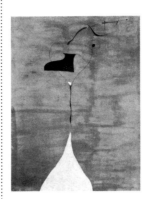

68. PAINTING (Fratellini; Personage). Paris, April–mid-May 1927. (Plate, p. 148)
Oil on canvas, 51¼ × 38⅜″ (130 × 97.5 cm). Signed and dated lower left: *Miró | 1927*. Inscribed on verso: *Joan Miró | 1927*. Collection Beyeler, Basel. Dupin 190

PROVENANCE
Pierre Loeb (Galerie Pierre), Paris; Pierre Chadourne, Paris; Theodore Schemmp & Co., New York; to Lydia Winston (later Mrs. Barnett Malbin) and Harry Lewis Winston, Birmingham, Mich., 1952 (consigned to Sotheby's, New York; sold May 16, 1990, lot 67); to Collection Beyeler, Basel.

SELECTED EXHIBITIONS
Ann Arbor 1955, cat. 45, as *The Brothers Fratellini*
Detroit 1957, p. 64, repr. (color)

frontispiece, as *The Brothers Fratellini*
New York 1959b, cat. 35, as *The Fratellini* (New York venue only)

SELECTED REFERENCES
Prévert/Ribemont-Dessaignes 1956, p. 81. Saarinen 1957, repr. (color) cover and p. 5. Rubin 1959, repr. p. 37. Soby 1959, p. 53, repr. p. 51. R.F.C. 1959, p. 221. Dupin 1962, p. 166, no. 190, repr. p. 516. Krauss/Rowell 1972, p. 108. Rowell 1987a, p. 15, fig. 6 (repr. p. 15). Alden 1991, repr. p. 80 (detail, color, repr. of Louise Lawler's *Blue Nall*, 1990).

69. PAINTING (Circus Horse). Paris, winter or spring 1927. (Plate, p. 150)
Oil and pencil on burlap, 6′ 4¾″ × 9′ 2⅜″ (195 × 280.2 cm). Signed and dated lower right: *Miró. | 1927*. Inscribed on verso, upper left: *Joan Miró | 1927*. Hirshhorn Museum and Sculpture Garden, Smithsonian Institution, Washington, D.C. Gift of the Joseph H. Hirshhorn Foundation, 1972. Dupin 206

PROVENANCE
Collection Decagne, Belgium; Galerie Europe, Brussels; to Galerie Rosengart, Lucerne, 1958; to Philippe Dotremont, Brussels, August 1960 (consigned to Parke-Bernet Galleries, New York; sold April 14, 1965, lot 18); to Pierre Matisse Gallery, New York; to Joseph H. Hirshhorn, New York, June 10, 1968; to Hirshhorn Museum and Sculpture Garden, Smithsonian Institution, Washington, D.C., 1972.

SELECTED EXHIBITIONS
Düsseldorf 1961, cat. 51, repr. n.p., as *Le Cirque*
Paris 1962b, cat. 45, as *Le Cheval de cirque*
London 1964b, cat. 67, p. 27, pl. 14a, as *Circus Horse*
New York 1968a, cat. 232, as *Circus Horse* (Los Angeles and Chicago venues only)
New York 1972d, cat. 34, pp. 104, 120, 122, 124, repr. p. 124, as *Circus Horse*
Washington 1980a, cat. 17, repr. (color) p. 66, as *Circus Horse*
Zurich 1986, cat. 54, repr. (color) n.p., as *Le Cheval de cirque*
New York 1987a, cat. 46, repr. (color) p. 114, as *Circus Horse*
Saint-Paul-de-Vence 1990, cat. 32, p. 76, repr. (color) p. 77, as *Le Cheval de cirque*

SELECTED REFERENCES
Amic de les arts 1928, repr. p. 202. Gasch 1929a, repr. p. 68. Gasch 1929b, repr. p. 204. Gasch 1929g, repr. p. 3. Frigerio 1961, p. 55. Dupin 1962, p. 168, no. 206, repr. p. 517. Chevalier 1962, repr. p. 10. *Apollo* 1965, repr. p. ciii. Krauss 1972, p. 37. Rowell 1976, repr. p. 56. Millard 1980, p. 23. Rowell 1987a, p. 15, fig. 7 (repr. p. 15).

Private collection, New York. 7½ × 9¾″ (19 × 24.7 cm)

70. LANDSCAPE (Landscape with Rooster). Montroig, late July–December 1927. (Plate, p. 159)

Oil on canvas, 51⅛″ × 6′ 4¾″ (130 × 195 cm). Signed and dated lower center: *Miró. | 1927.* Inscribed on verso: *Joan Miró | Paysage | 1927.* Collection Stephen Hahn, New York. Dupin 181

PROVENANCE
Galerie Pierre, Paris, by 1934; Pierre Matisse Gallery, New York, by November 1941; Ruth McC. Maitland, Santa Monica, Calif., by September 1948; Mr. and Mrs. John Gilbert Dean, North Scituate, R.I., by August 1966; to Richard L. Feigen & Co., Chicago/New York, February 1973; to Stephen Hahn, New York, March 1973.

SELECTED EXHIBITIONS
Paris 1928c, as (?)
Possibly New York 1930c, cat. 2 or 3, as *Grand Paysage*
Possibly Chicago 1931, cat. 2 or 3, as *Grand Paysage*
Zurich 1934, cat. 92, as *Paysage au coq*
New York 1941g, as *Landscape with Rooster* (New York, Northampton, Mass., and Poughkeepsie, N.Y., venues only)
San Francisco 1948, cat. 48, repr. p. 100, as *Landscape with Rooster and Butterfly*
Tokyo 1966, cat. 31, repr. p. 96, as *Paysage au coq*
New York 1968a, cat. 233, as *Landscape with Rooster*
New York 1987a, cat. 42, repr. (color) p. 110, as *Landscape with Rooster*
New York 1990b, fig. 38 (repr., color, p. 176) (New York venue only)

SELECTED REFERENCES
Tériade 1930a, repr. p. 84. Gasch 1930d, repr. p. 197. *Cahiers d'art* 1934, fig. 21 (repr. p. 39). Greenberg 1948, pl. XIX (repr. p. 62). Cirici-Pellicer 1949, ill. 28. Dupin 1962, no. 181, repr. p. 515. Bonnefoy 1964, p. 26. *Mainichi Shinbun* 1966b, repr. p. 1. Rubin 1968, p. 68, repr. (color) p. 65. Leider 1968, repr. p. 23. Krauss

1972, p. 14. Rubin 1973, pp. 24, 112 (n. 23), 118 (n. 1), fig. 12 (repr. p. 114). Rudenstine 1976, p. 525. Raillard 1989, p. 86, repr. (color) p. 87.

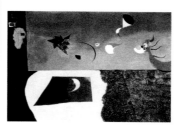

71. ANIMATED LANDSCAPE. Montroig, late July–December 1927. (Plate, p. 161)

Oil on canvas, 51″ × 6′ 4¾″ (129.5 × 195 cm). Signed and dated lower center: *Miró | 1927.** The Jacques and Natasha Gelman Collection. Dupin 182
(*Note: The Museum of Modern Art's records indicate that, at the time of the 1941 Miró retrospective at the Museum, this work was signed, titled, and dated on the verso; no further description was provided, however.)

PROVENANCE
The artist to Galerie Pierre, Paris, c. 1928; Pierre Matisse Gallery, New York, c. 1935; to Alexina Matisse (later Alexina Duchamp), New York and Villiers-sous-Grez, 1949; The New Gallery, New York, 1959; to The Jacques and Natasha Gelman Collection, 1959.

SELECTED EXHIBITIONS
Paris 1928c, as (?)
Possibly New York 1930c, cat. 2 or 3, as *Grand Paysage*
Possibly Chicago 1931, cat. 2 or 3, as *Grand Paysage*
New York 1936a, cat. 4
New York 1941b, cat. 1
New York 1941g (Portland and San Francisco venues only)
New York 1947a, cat. 15
New York 1948b, cat. 2
New York 1949a, cat. 9, as *Landscape*
Dallas 1959, p. 41, repr. p. 40
London 1964b, cat. 72, p. 27, pl. 13b
New York 1989
Saint-Paul-de-Vence 1990, cat. 30, p. 72, repr. (color) pp. 72–73

SELECTED REFERENCES
Amic de les arts 1928, repr. p. 201. Tériade 1930a, repr. p. 84. McBride 1936a, p. 16. Morsell 1936, p. 5. Cary 1936, p. X9. *Dictionnaire abrégé* 1938, repr. p. 49. Greenberg 1948, pl. XVIII (repr. p. 61). Hess 1948, p. 33. Gibbs 1949, p. 17, repr. p. 17. *Art News* 1959, repr. p. 51. Kramer 1959, p. 49. Rubin 1959, p. 37. Dupin 1962, no. 182, repr. p. 515. Bonnefoy 1964, pl. 23. Marchiori 1972, repr. p. 29. Rubin 1973, p. 118 (n. 1). Rudenstine 1976, p. 525. Lieberman 1989, pp. 180–82, 307, repr. pp. 181 (color), 307. Combalía 1992, p. 187

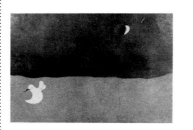

FJM 790. 8⅜ × 10¾″ (21.2 × 27.3 cm)

72. LANDSCAPE (Landscape with Rabbit and Flower). Montroig, late July–December 1927. (Plate, p. 160)

Oil on canvas, 51⅛″ × 6′ 5″ (130 × 195.5 cm). Signed and dated lower left: *Miró | 1927.* Inscribed on verso: *Joan Miró | "Paysage" | 1927.* National Gallery of Australia, Canberra. Purchased 1983. Dupin 180

PROVENANCE

The artist [to Galerie Pierre, Paris]; A. Mavrogordato, Paris, by February 1930; Pierre Colle, Paris; Pierre Matisse Gallery, New York; to Gordon and Nina Bunshaft, New York, November 1, 1958; to National Gallery of Australia, Canberra, March 1983.

SELECTED EXHIBITIONS

Paris 1928c, as (?)
Possibly New York 1930c, cat. 2 or 3, as *Grand Paysage*
Possibly Chicago 1931, cat. 2 or 3, as *Grand Paysage*

New York 1972d, cat. 26, pp. 114–15, 116, 120, 133, 140, repr. (color) p. 115
New York 1973b
Washington 1980a, cat. 16, repr. (color) p. 65

SELECTED REFERENCES

Tériade 1930a, repr. p. 84. *Art et industrie* 1930, repr. p. 11. Duthuit 1936b, pl. 58 (repr. p. 161). Dupin 1962, pp. 179–80, no. 180, repr. p. 515. Krauss 1972, pp. 34, 37. Rubin 1973, pp. 8, 38, 119, repr. (color) p. 39. Rowell 1976, repr. (color) cover, p. 51. Rudenstine 1976, pp. 525, 526. Millard 1980, p. 22. Lloyd/Desmond 1992, pp. 170, 172, repr. (color) p. 171.

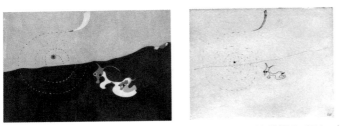

FJM 675. 8⅜ × 10¾″ (21.2 × 27.4 cm)

73. LANDSCAPE (The Hare). Montroig, late July–December 1927. (Plate, p. 158)

Oil on canvas, 51″ × 6′ 4⅝″ (129.6 × 194.6 cm). Signed and dated lower right: *Miró | 1927*. Inscribed on verso: *Joan Miró. | "Paysage" | 1927*. Solomon R. Guggenheim Museum, New York. Dupin 184

PROVENANCE

The artist to Galerie Pierre, Paris, 1927; to Max Pellequer, Paris, after January 1933; to Galerie Maeght, Paris, c. 1950; to Solomon R. Guggenheim Museum, New York, 1957.

SELECTED EXHIBITIONS

Paris 1928c, as (?)
Possibly Brussels 1929, as (?)
Possibly New York 1930c, cat. 2 or 3, as *Grand Paysage*
Possibly Chicago 1931, cat. 2 or 3, as *Grand Paysage*
Worcester 1933, cat. 216, as *Scene*
Krefeld 1954, cat. 3, as *Le Lièvre/ Der Hase*
Brussels 1956, cat. 32, repr. n.p., as *Le Lièvre*
Basel 1956, cat. 22, as *Le Lièvre*
Paris 1962b, cat. 43
London 1964b, cat. 70, p. 27
Tokyo 1966, cat. 32, repr. p. 96
New York 1967c, repr. p. 69
New York 1968b
New York 1972d, cat. 27, pp. 116–17, 120, repr. p. 117
Paris 1974b, cat. 32, pp. 117–18, repr. pp. 43 (color), 118
Humlebaek 1974, cat. 17

London 1978, cat. 9.59, repr. p. 219
Cleveland 1979, cat. 27, repr. p. 75
New York 1983a, cat. 4
Barcelona 1983, cat. 88, repr. (color) p. 64
Charleroi 1985, cat. 13, repr. (color) p. 185
Zurich 1986, cat. 51, repr. (color) n.p.
New York 1987a, cat. 43, repr. (color, detail) cover and (color) p. 111
On view at the Solomon R. Guggenheim Museum, New York: June–December 1957; October 1959–June 1960; April–October 1965; May–June 1967; December 1969–January 1970; May–September 1970; June–September 1971; August–September 1973; April–October 1976; July–October 1978; March–August 1979; May–November 1980; April–July 1981; November 1987–March 1988; February–April 1990

SELECTED REFERENCES

McBride 1928a, p. 527. George 1929a, repr. p. 205. Dalí 1929, repr. p. 207. Gasch 1929e, p. 4. Gasch 1929f, repr. p. 4. Schwob 1933, p. 223, repr. p. 223. Dupin 1956, p. 99. Prévert/Ribemont-Dessaignes 1956, repr. (color) p. 116. Hüttinger 1957, p. 22, fig. 16. Dupin 1962, pp. 178–79, no. 184, repr. pp. 225, 515. Gasser 1965, repr. p. 41. Krauss 1972, p. 37. Leymarie 1974a, p. 14. Leymarie 1974b, p. 6, repr. (color) p. 18. Rowell 1976, repr. p. 50. Rudenstine 1976, no. 185, pp. 524–27, repr. p. 524. Miró 1977, p. 72, repr. p. 93. Henning 1979, pp. 237, 238, fig. 2 (repr. p. 236). Millard 1980, p. 22. Dupin 1983, p. 127. Malet 1983a, p. 129. Bouret 1986, n.p. Erben 1988, repr. (color) p. 53. Raillard 1989, p. 86. Combalía 1990, repr. (color) n.p. Combalía 1992, p. 187.

FJM 542. 7 × 5⅜″ (18 × 13.6 cm)

74. SPANISH DANCER I. Paris, mid-February–spring 1928. (Plate, p. 168)

Collage, sandpaper, and oil on wood, 41⅜ × 29″ (105 × 73.5 cm). Signed and dated lower left: *Miró | 1928*. Inscribed on verso: *Joan Miró | Danseuse Espagno | le I | 1928*. Museo Nacional Reina Sofía, Madrid. Dupin 246

PROVENANCE

Galerie Percier, Paris; to Mr. and Mrs. Alfred Richet, Paris, 1951; to Galerie Daniel Malingue, Paris, 1984; to Acquavella Galleries, New York; to Museo Nacional Reina Sofía, Madrid, 1989.

SELECTED EXHIBITIONS

Berlin 1952, cat. 49, as *Spanische Tänzerin*
New York 1968a, cat. 235, as *Spanish Dancer*
Paris 1974b, cat. 36, p. 119, as *Danseuse espagnole*

Zurich 1986, cat. 59, repr. (color) n.p., as *Danseuse espagnole*
New York 1987a, cat. 50, repr. (color) p. 119, as *Spanish Dancer*
Paris 1991

SELECTED REFERENCES

Abend 1952. Dupin 1962, pp. 202, 203, no. 246, repr. p. 520. Rubin 1968, p. 68, fig. 90 (repr. p. 71). Wescher 1971, p. 190. Combalía 1990, pp. 85, 97–98, repr. (color) n.p.

75. SPANISH DANCER. Paris, mid-February–spring 1928. (Plate, p. 167)

Sandpaper, paper, string, nails, hair, architect's triangle, and paint on sandpaper mounted on linoleum, 43⅛ × 28″ (109.5 × 71.1 cm). Signed and dated lower left: *Miró | 1928*. The Morton G. Neumann Family Collection. Dupin 243

SELECTED EXHIBITIONS

Possibly Paris 1930c, cat. 22
New York 1959b, cat. 38 (New York venue only)

Chicago 1961, cat. 12, repr. n.p.
New York 1968a, cat. 236
Washington 1980b, cat. 52

SELECTED REFERENCES

Aragon 1930, pl. XIX. Sweeney 1941, p. 47, repr. p. 52. Rubin 1959, p. 37. Soby 1959, repr. p. 61. Dupin 1962, pp. 202–03, 520, no. 243, repr. p. 230. Aragon 1965,

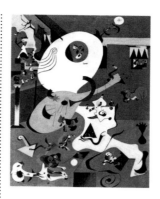

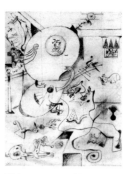

repr. (upside down) p. 56. Gasser 1965, repr. p. 44. Rubin 1968, p. 68, fig. 91 (repr. p. 71). Wescher 1971, p. 190, pl. 152 (repr. p. 365). Rubin 1973, p. 52, fig. 39 (repr. p. 122), repr. p. 12 (installation view). Jouffroy 1974, pp. 34, 43. Jouffroy/Teixidor 1974, no. 2, repr. p. 8. Carmean 1980, pp. 36, 39, 40, 42, repr. p. 62. Stich 1980, pp. 25–26, fig. 17 (repr. p. 26). Théberge 1986, p. 43. Malet 1988a, p. 21. Combalía 1990, pp. 85, 97–98. Umland 1992, pp. 54, 73 (n. 40), 74 (n. 56), fig. 8 (repr. p. 54).

FJM 9927b (9928, 9929a, 9930 attached). Pencil and ink on paper, 7 × 5⅜″ (18 × 13.6 cm)

76. SPANISH DANCER. Paris, mid-February–spring 1928. (Plate, p. 169)

Collage-object with feather and hatpin, 39⅜ × 31½″ (100 × 80 cm). Signed and dated lower left: *Miró | 1928*. Private collection. Dupin 247

PROVENANCE

The artist to Galerie Pierre, Paris, by July 1928; to André Breton, Paris, c. July 31, 1928; to present owner, 1966.

SELECTED EXHIBITIONS

Possibly Paris 1930c, cat. 23, as *Danseuse*

Paris 1974b, cat. 36, p. 119, repr. p. 49

Paris 1991, repr. p. 259 (Paris venue only)

SELECTED REFERENCES

Variétés 1929a, repr. p. 23. Gasch 1929d, p. 4. Gasch 1930b, p. 8. Hugnet 1931b, p. 338. Eluard 1937, p. 80. *Dictionnaire abrégé* 1938, repr. p. 9. Dupin 1962, pp. 202, 203, no. 247, repr. p. 520. Lassaigne 1963, p. 66. Penrose 1969, p. 67, pl. 42 (repr. p. 66). Wescher 1971, p. 190. Krauss 1972, p. 34. Sweeney 1973, n.p. Jouffroy/Teixidor 1974, no. 3, repr. p. 8. Leymarie 1974a, p. 15. Lemayrie 1974b, p. 6. Rowell 1976, repr. p. 58. Miró 1977, p. 199. Gimferrer 1978, pp. 48, 104, fig. 48. Carmean 1980, p. 39. Gateau 1982, p. 347 (n. 20). Bouret 1986, n.p. Rowell 1986, p. 13. Rowell 1987a, p. 23. Malet 1988a, p. 21. Raillard 1989, pp. 22, 32, 34–35, repr. p. 35. Combalía 1990, pp. 85, 97–98, 248. Rowell 1991, p. 180. Beaumelle 1991, p. 191. Umland 1992, pp. 47, 52, 53, 72 (n. 40), 73 (nn. 55, 56), 74 (n. 61), fig. 7 (repr. p. 53).

77. DUTCH INTERIOR (I). Montroig, July–December 1928. (Plate, p. 162)

Oil on canvas, 36⅛ × 28¾″ (91.8 × 73 cm). Inscribed on verso: *Joan Miró | "Intérieur Hollandais" | 1928*. The Museum of Modern Art, New York. Mrs. Simon Guggenheim Fund. Acq. no. 163.45. Dupin 234

PROVENANCE

The artist to Galerie Pierre, Paris, by 1929; [Zwemmer Gallery, London]; Galerie Pierre, Paris, by May 1934 (on consignment to Pierre Matisse Gallery, New York, October 1934–June 1936); to Georges Keller (Bignou Gallery), New York, by October 1941; to The Museum of Modern Art, New York, December 1945.

SELECTED EXHIBITIONS

Paris 1930a, cat. 1, 2, or 3, as *Intérieur hollandais*

Possibly New York 1930c, cat. 8 or 9, as *Interieur* [*sic*] *hollandais*

Possibly Chicago 1931, cat. 8 or 9, as *Interieur* [*sic*] *hollandais*

Possibly Paris 1931d, as *Intérieur hollandais*

London 1933b, cat. 2 or 3, as *Intérieur hollandais*

Brussels 1934, cat. 91, as *Interieur* [*sic*] *hollandais*

San Francisco 1935b, as *Intérieur hollandais*

Los Angeles 1935a, as *Interior* [*sic*] *hollandais.*

Cambridge 1936, cat. 23, as *Dutch Interior*

London 1936c, cat. 209, as *Dutch Interior*

New York 1941f, cat. 15, as *Interieur* [*sic*] *hollandais*

New York 1941g, as *Dutch Interior* (New York venue only)

New York 1944e, repr. p. 93, as *Dutch Interior*

Paris 1952, cat. 63, pl. VIII, as *Dutch Interior*

New York 1954, as *Dutch Interior*

New York 1959b, cat. 36, as *Dutch Interior* (Los Angeles venue, cat. 34)

Washington 1963, repr. p. 72, as *Dutch Interior*

London 1964b, cat. 79, p. 28, pl. 16a, as *Dutch Interior I*

Saint-Paul-de-Vence 1968, cat. 21, repr. (color) p. 36, as *Intérieur hollandais I*

Barcelona 1968, cat. 26, pl. IX (repr., color, p. 27), as *Interior holandés I*

New York 1973b, as *Dutch Interior I*

Paris 1974b, cat. 34, p. 118, repr. pp. 47 (color), 118, as *Intérieur hollandais I*

Madrid 1978a, cat. 23, pp. 100–03, repr. pp. 51 (color), 101 (with iconographical chart), as *Interior holandes I*

New York 1979b, repr. p. 125, as *Dutch Interior, I*

New York 1980b, cat. 37, pp. 60–62, repr. p. 61, as *Dutch Interior, I*

New York 1983b, as *Dutch Interior I*

Saint-Paul-de-Vence 1990, cat. 34, p. 80, repr. (color) cover and (color) p. 81, as *Intérieur hollandais I*

On view at The Museum of Modern Art, New York: February 1946; July 1946–March 1952; November 1952–September 1954; October 1955–April 1958; October 1958–February 1959; August 1959–October 1959; January–November 1963; May–July 1964; November 1964–June 1968; May 1969–September 1973; February–April 1974; November 1974–March 1978; August 1978–May 1980; October 1980–January 1982; April 1983; June–September 1983; December 1983–January 1984; April 1984–May 1990; November 1990–August 1992

SELECTED REFERENCES

Leiris 1929, repr. p. 264. Focius 1930b, p. 6. Gasch 1930c, repr. p. 9. Einstein 1931, repr. p. 428. Huidobro 1934, fig. 26 (repr. p. 43). De Maeght 1934, p. 3. Westerdahl 1936, p. 8, repr. p. 18. *Dictionnaire abrégé* 1938, repr. p. 54 (installation view). Sweeney 1941, pp. 22, 47, repr. p. 48. *New Masses* 1941, repr. *Diario de la Marina*

1941, repr. Bille 1945, repr. p. 157. Greenberg 1948, p. 33, pl. XX (repr. p. 65). Cirici-Pellicer 1949, pp. 27, 40, ill. 32. Cirlot 1949, pp. 6, 25, 32, fig. 17. Breton 1952. Duthuit 1953, fig. 9 (repr. p. 30). Prévert/Ribemont-Dessaignes 1956, repr. p. 118. Guéguen 1957, p. 42. Roditi 1958, p. 40. Erben 1959, pp. 125–26, pl. 55. Soby 1959, p. 58, repr. (color) p. 57. Vallier 1960, p. 168. Erben 1961, p. 22, repr. (color) p. 23. Dupin 1962, pp. 191, 192, no. 234, repr. pp. 227, 519. Lassaigne 1963, pp. 54, 61, repr. (color) p. 56. Bonnefoy 1964, pl. 18. Penrose 1964, p. 8. Roberts 1964, p. 479, fig. 47. Gasser 1965, p. 73, repr. (color) p. 29. Tillim 1966, p. 69, repr. p. 68. Juin 1967, p. 22. Aragon 1969, p. 2. Penrose 1969, p. 63, pl. 39 (repr., color, p. 59). Marchiori 1972, repr. p. 31. Rubin 1973, pp. 8, 43–45, 49, 50, 96, repr. pp. 42 (color, foldout), 42 (with iconographical chart). Leymarie 1974a, p. 15. Okada 1974, pl. 12 (color). Rowell 1976, p. 53, repr. p. 57. Rudenstine 1976, p. 523. Gimferrer 1978, pp. 68, 142, fig. 67 (color). Fundació Joan Miró 1983, repr. p. 106. Malet 1983b, p. 13, fig. 39 (color). Rudenstine 1985, pp. 542, 545, fig. h (repr. p. 544). Rowell 1986, pp. 292, 298. Erben 1988, repr. (color) p. 50. Malet 1988b, p. 9, fig. 1 (repr. p. 10). Llorca 1990, repr. p. 166. Yokohama Museum of Art 1992, ill. 4 (repr. p. 53). Umland 1992, pp. 48, 61, fig. 5 (repr., color, p. 50).

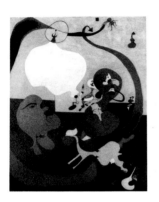

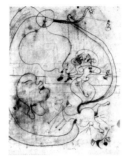

FJM 802. Charcoal on paper, 24¼ × 18⅝″ (61.6 × 47.5 cm)

78. DUTCH INTERIOR (II). Montroig, July–December 1928. (Plate, p. 163)

Oil on canvas, 36¼ × 28¾″ (92 × 73 cm). Inscribed on verso: *Joan Miró | "Intérieur Hollandais" | 1928*. Solomon R. Guggenheim Museum, New York; Peggy Guggenheim Collection, Venice, 1976. Dupin 235

PROVENANCE

The artist, until 1937?; Peggy Guggenheim, Paris, New York, and Venice, 1940; to Solomon R. Guggenheim Museum, New York, Peggy Guggenheim Collection, Venice, 1976.

SELECTED EXHIBITIONS

Paris 1930a, cat. 1, 2, or 3, as *Intérieur hollandais*
New York 1930c, cat. 8 or 9, as *Interieur [sic] hollandais*
Chicago 1931, cat. 8 or 9, repr. cover, as *Interieur [sic] hollandais*
Possibly Paris 1931d, as *Intérieur hollandais*
Possibly London 1933b, cat. 2 or 3, as *Intérieur hollandais*
Possibly Prague 1935, cat. 44, as *Holandsk Interiér*
Tokyo 1937, cat. 82, repr. n.p., as *Peinture* (incorrectly dated 1925)
New York 1942a, p. 112, repr. p. 113, as *Dutch Interior*
Venice 1948, cat. 87, as *Interno olandese*

Florence 1949, cat. 93, as *Interno olandese*
Zurich 1951, cat. 102, as *Holländisches Interieur*
London 1964c, cat. 82, pp. 55–56, repr. p. 55, as *Dutch Interior II*
Turin 1967, cat. 255, repr. p. 187, as *Interno olandese II*
New York 1969a, p. 102, repr. p. 103, as *Dutch Interior II*
Paris 1974d, cat. 84, p. 74, repr. p. 75, as *Intérieur hollandais II*
New York 1987a, cat. 51, repr. (color) p. 121, as *Dutch Interior II*
On view at Art of This Century, New York: 1942–47

SELECTED REFERENCES

Tériade 1929, repr. p. 364. Focius 1930b, p. 6. Gasch 1930c, repr. p. 9. McBride 1930b, p. 8. Sweeney 1949, pp. 39, 40, repr. p. 41. Sweeney 1953, p. 186, repr. p. 71 (incorrectly credited to Samuel Marx Collection, Chicago). Dupin 1956, repr. p. 102.

Roditi 1958, p. 40. Soby 1959, p. 55, repr. p. 54. Vallier 1960, pp. 165, 166, 168, repr. p. 167. Dupin 1962, p. 190, no. 235, fig. 25 (repr. p. 172), repro. p. 519. Lassaigne 1963, pp. 54, 55, 58–59, repr. (color) p. 57. Bonnefoy 1964, p. 22. Juin 1967, p. 22. Rubin 1968, p. 165, fig. 254 (installation view). Marchiori 1972, p. 21. Rubin 1973, p. 119 (n. 1). Rose 1982a, p. 21. Schmalenbach 1982, repr. p. 25. Fundació Joan Miró 1983, repr. p. 73. Malet 1983b, p. 13. Rudenstine 1985, no. 117, pp. 540–45, repr. p. 541. Bouret 1986, n.p. Erben 1988, repr. (color) p. 54. Malet 1989, repr. p. 12. Raillard 1989, p. 88, repr. (color) p. 89. Umland 1992, pp. 48, 61, fig. 17 (repr. p. 62).

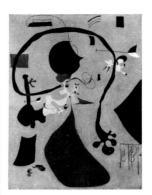

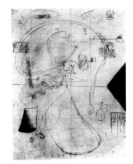

FJM 796. Charcoal, pencil, and pastel on paper, 24⅛ × 18⅝″ (61.5 × 47.5 cm)

79. DUTCH INTERIOR (III). Montroig, July–December 1928. (Plate, p. 164)

Oil on canvas, 50¾ × 37⅞″ (128.9 × 96.2 cm). The Metropolitan Museum of Art, New York. Anonymous loan. Dupin 236

PROVENANCE

The artist to Galerie Pierre, Paris; [René Gaffé, Brussels]; Marie Cuttoli, Paris, by January 1938; Mr. and Mrs. Samuel A. Marx, Chicago, 1950; to present owner, January 1964.

SELECTED EXHIBITIONS

Paris 1930a, cat. 1, 2, or 3, as *Intérieur hollandais*
Possibly New York 1930c, cat. 8 or 9, as *Interieur [sic] hollandais*
Possibly Chicago 1931, cat. 8 or 9, as *Interieur [sic] hollandais*
Possibly Paris 1931d, as *Intérieur hollandais*
London 1933b, cat. 2 or 3, as *Intérieur hollandais*
Possibly Prague 1935, cat. 44, as

Holandsk Interiér
Paris 1938a, cat. 137, as *Intérieur hollandais*
New York 1941g, as *Dutch Interior*
Chicago 1961, cat. 11, as *The Dutch Interior*
New York 1965b, pp. 9, 49, repr. p. 48, as *Dutch Interior*
Buenos Aires 1968, repr. (color) p. 55, as *Interior holandés*

SELECTED REFERENCES

Tériade 1929, repr. p. 364. Focius 1930b, p. 6. Einstein 1931, repr. p. 429. *Times* 1933. *Observer* 1933. Blunt 1933. Prévert/Ribemont-Dessaignes 1956, repr. p. 119. Soby 1959, p. 58, repr. p. 56. Vallier 1960, p. 168. Dupin 1962, pp. 191–92, no. 236, repr. pp. 167 (color), 520. Gasser 1965, repr. p. 42. Walton 1966, pp. 12, 32, pl. 65 (color). Rubin 1973, p. 119 (n. 1). Malet 1983b, p. 13. Rudenstine 1985, pp. 542, 545. Rowell 1986, p. 112. Erben 1988, repr. (color) p. 55. Umland 1992, p. 48.

80. POTATO. Montroig, July–December 1928. (Plate, p. 166)

Oil on canvas, 39¾ × 32⅛″ (101 × 81.7 cm). Inscribed on verso: *Joan Miró | Pomme de Terre | 1928*. The Jacques and Natasha Gelman Collection. Dupin 237

PROVENANCE

The artist to Valentine Gallery, New York, c. 1930; Pierre Matisse, New York, 1931; Thomas Laughlin, New York, c. 1932; James B. Laughlin, New York, 1955; Pierre Matisse Gallery, New York, 1975; to The Jacques and Natasha Gelman Collection, 1975.

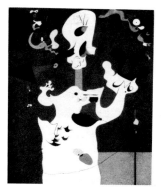

Private collection. Charcoal and pastel on paper, 25 × 18⅞″ (63.5 × 48 cm)

SELECTED EXHIBITIONS

Paris 1930a, cat. 4
New York 1930c, cat. 10, as *Pommes de terres* [sic]
Chicago 1931, cat. 10, as *Pommes de terres* [sic]
New York 1931b
Hartford 1931, cat. 33
New York 1936c, cat. 10
New York 1941g
Venice 1954, cat. 12
New York 1959b, cat. 37 (Los Angeles venue, cat. 35)

Paris 1962b, cat. 49
London 1964b, cat. 80, p. 28, pl. 17b
New York 1972b, cat. 19, repr. (color) n.p.
Paris 1974b, cat. 35, p. 119
London 1978, cat. 9.61, repr. (color) n.p.
New York 1989
Saint-Paul-de-Vence 1990, cat. 35, p. 82, repr. (color) p. 83

SELECTED REFERENCES

Focius 1930b, p. 6. McBride 1930b, p. 8. *New York Herald Tribune* 1931, p. 8. Jewell 1931b, p. XII. Huidobro 1934, fig. 25 (repr. p. 42). Davidson 1936, p. 11. *New York Times* 1936, p. 12. Zervos 1938, repr. p. 426. *Boston Herald* 1941. Sweeney 1941, p. 47, repr. (color) cover and (color) frontispiece. Tyler 1945, repr. (color) p. 16. Venturi 1947, pl. 210. Greenberg 1948, p. 33, repr. (color) n.p. Cirici-Pellicer 1949, pp. 27–28, ill. 33. Cirlot 1949, p. 42. Soby 1959, p. 58, repr. (color) p. 59. Dupin 1962, pp. 189, 192, no. 237, repr. pp. 226, 520. G.H. 1962, repr. p. 51. Juin 1967, repr. (color) p. 9. Penrose 1969, pp. 63–64, pl. 40 (repr. p. 63). Cooper 1972, n.p. Rowell 1972, p. 46. Rubin 1973, p. 119 (n. 1). Leymarie 1974a, p. 15. Lemayrie 1974b, p. 6. Rowell 1976, p. 185 (n. 24). Millard 1980, p. 23. Rose 1982a, p. 25. Fundació Joan Miró 1983, repr. p. 69. Lieberman 1989, pp. 183–85, 307, repr. (color) frontispiece, and pp. 184 (color), 307. Raillard 1989, p. 25. Umland 1992, pp. 48, 61, fig. 20 (repr. p. 63).

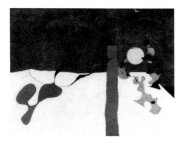

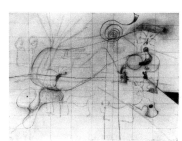

FJM 810. 19⅝ × 25⅝″ (50 × 65.1 cm)

81. STILL LIFE (Still Life with Lamp). Montroig, July–December 1928. (Plate, p. 165)

Oil on canvas, 35 × 45⅞″ (89 × 114 cm). Inscribed on verso: *Joan Miró | Nature Morte | 1928.* Private collection. Dupin 238

PROVENANCE

Pierre Matisse Gallery, New York, by November 1931; to Alexina Matisse (later Alexina Duchamp), New York and Villiers-sous-Grez, 1949; to Harold and Hester Diamond, New York, 1972; to present owner, 1981.

SELECTED EXHIBITIONS

Paris 1930a, cat. 5
New York 1930c, cat. 11
Chicago 1931, cat. 11
Hartford 1931, cat. 32

New York 1940c
Washington 1980a, cat. 18, repr. (color) p. 67, as *Still Life with Lamp*

SELECTED REFERENCES

Tériade 1929, repr. p. 361. Focius 1930a, p. 6. Jewell 1940, p. L13. Lane 1941, p. 11. Genauer 1941. Dupin 1962, pp. 189, 192, no. 238, repr. p. 520. Fundació Joan Miró 1983, repr. p. 70. Umland 1992, p. 48.

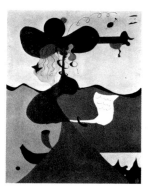

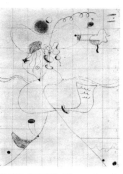

MoMA 130.73. Charcoal and pencil on paper, 24¾ × 19″ (62.1 × 41.8 cm)

82. PORTRAIT OF MISTRESS MILLS IN 1750. Paris, winter–spring 1929. (Plate, p. 170)

Oil on canvas, 46 × 35¼″ (116.7 × 89.6 cm). Inscribed on verso: *Joan Miró | 1929 | "Portrait de | Mistress Mills | en 1750."* The Museum of Modern Art, New York. James Thrall Soby Bequest. Acq. no. 1236.79. Dupin 239

PROVENANCE

The artist to Galerie Pierre, Paris, by October 1929; to Mrs. Valentine Dudensing, New York, 1930; to James Thrall Soby, New Canaan, Conn., November 17, 1943; to The Museum of Modern Art, New York, December 1979.

SELECTED EXHIBITIONS

Paris 1930a, cat. 6
New York 1930c, cat. 12, as *Portrait of Mrs. Mills*
Hartford 1931, cat. 34, as *Portrait of Mrs. Mills in Costume of 1750*
New York 1931c, as *Portrait de Mrs. Mills en costume de 1820*
New York 1941g (New York venue only)
New York 1946a
New York 1955, cat. 98
New York 1959b, cat. 39 (Los Angeles venue, cat. 36)
New York 1961a, cat. 49, pp. 16, 56, repr. p. 57
New York 1973b
Washington 1980a, cat. 19, repr. (color) p. 68

São Paulo 1981, p. 104, repr. (color) p. 105
Houston 1982, pl. 11 (color)
Barcelona 1983, cat. 133, repr. (color) p. 75
Miami 1984a, cat. 177, repr. p. 151
Zurich 1986, cat. 61, repr. (color) n.p., as *Portrait de Mrs. Mills en 1750 (d'après Constable)*
New York 1987a, cat. 53, repr. (color) p. 125
Villeneuve d'Ascq 1989, cat. 4, repr. (color) n.p.
On view at The Museum of Modern Art, New York: March–May 1979; August–September 1979; October 1980–April 1981; May 1990–October 1991

SELECTED REFERENCES

Leiris 1929, repr. p. 269. Gasch 1930a, repr. p. 7. Focius 1930b, p. 6. Monitor 1930, p. 10. Sweeney 1941, p. 47, repr. p. 50. Greenberg 1948, repr. p. 34. Cirici-Pellicer 1949, p. 29, ill. 34. Cirlot 1949, pp. 36, 42, fig. 18. *MoMA Bulletin* 1955, repr. p. 28 (installation view). Prévert/Ribemont-Dessaignes 1956, p. 82. Erben 1959, p. 127. Rubin 1959, pp. 37, 39. Soby 1959, pp. 4, 60, 62, 66, repr. p. 63. Vallier 1960, p. 168, repr. p. 173. Soby 1961, p. 71. Tyler 1961, p. 63. Dupin 1962, pp. 192, 193, 194, 195, 196, no. 239, repr. pp. 177 (color), 520. Lassaigne 1963, pp. 58, 61. Juin 1967, p. 22. Penrose 1969, p. 64, pl. 41 (repr. p. 64). Marchiori 1972, p. 21. Rubin 1973, pp. 8, 49–50, 78, 120–22, repr. (color) p. 48. Picon 1976, vol. 1, p. 44, repr. p. 44.

Gimferrer 1978, fig. 184 (color). Marie-Louise Jeanneret Art Moderne 1979, repr. p. 3. Millard 1980, p. 23. Rose 1982a, p. 39. Dupin 1983, p. 127. Malet 1983b, p. 13, fig. 41 (color). Théberge 1986, p. 56. Erben 1988, repr. (color) p. 57. Raillard 1989, p. 92, repr. (color) p. 93. Saura 1989, p. 49. Umland 1992, pp. 47, 48.

FJM 958. Charcoal on paper, 19⅛ × 24⅝″ (48.5 × 62.5 cm)

83. PORTRAIT OF QUEEN LOUISE OF PRUSSIA. Paris, winter–spring 1929. (Plate, p. 171)

Oil on canvas, 31¾ × 39¼″ (80.6 × 99.6 cm). Inscribed on verso: *Joan Miró 1929 | "Portrait de la Reine Louisse [sic] du Prusse."* Algur H. Meadows Collection, Meadows Museum, Southern Methodist University, Dallas. Dupin 241

PROVENANCE

The artist to Galerie Pierre, Paris, by October 1929; Pierre Matisse Gallery, New York, by March 1936; to Algur H. Meadows, Dallas, August 2, 1967; to Meadows Museum, Southern Methodist University, Dallas, August 2, 1967.

SELECTED EXHIBITIONS

Paris 1930a, cat. 9
New York 1930c, cat. 5, as *Portrait de la Reine Louise*
Chicago 1931, cat. 5, as *Portrait de la Reine Louise*
Copenhagen 1935, cat. 22, as *La Deine Louise de Prusse*
San Francisco 1935a
Los Angeles 1935b
New York 1936b (all venues except New York)
Paris 1945a, cat. 13
Minneapolis 1952
Paris 1962b, cat. 51

London 1964b, cat. 81, pp. 28–29, pl. 17a, as *Queen Louise of Prussia*
Tokyo 1966, cat. 35, p. 22, repr. p. 97, as *La Reine Louise de Prusse*
San Diego 1969, repr. n.p., as *Queen Louisa of Prussia*
Saint Louis 1980
Houston 1982, pl. 12 (color), as *Queen Louise of Prussia*
Barcelona 1983, cat. 155, repr. (color) p. 77, as *La Reina Lluïsa de Prússia*
London 1985, cat. 137, as *La Reina Lluïsa de Prússia* (Barcelona venue only)

SELECTED REFERENCES

Leiris 1929, p. 266, repr. p. 267. *Publicitat* 1929, repr. p. 5. Focius 1930b, p. 6. Tériade 1930b, repr. p. 6. Monitor 1930, p. 10. Einstein 1930, p. 243. Limbour 1947, p. 49. Erben 1959, p. 127. Dupin 1962, pp. 192, 193, 194, 195–96, no. 241, fig. 42 (repr. p. 185), repr. p. 520. Chevalier 1962, p. 9. Lassaigne 1963, pp. 58, 61, repr. (color) p. 59. Andrews 1966, p. B3. Juin 1967, p. 22. Wescher 1971, p. 191. Picon 1976, vol. 1, pp. 34, 44, 47–49, 50, repr. (color) p. 49. Miró 1977, pp. 38, 212. Gimferrer 1978, pp. 19, 144, 180, fig. 9. Stich 1980, p. 28, fig. 19 (repr. p. 29). Rose 1982a, p. 36. Malet 1983a, p. 129. Malet 1983b, p. 14. Malet 1986, p. 19. Rowell 1986, pp. 184, 266. Malet 1988b, pp. 10, 11, fig. 2 (repr. p. 11). Malet 1989, pp. 14, 15–16, repr. p. 14. Raillard 1989, pp. 90, 92, repr. (color) p. 91. Saura 1989, p. 49. Combalía 1990, repr. (color) n.p. Umland 1992, pp. 47, 48, 71 (n. 32).

84. COLLAGE. Montroig, late July–early October 1929. (Plate, p. 174)

Ink, black sandpaper, Ingres paper, wire, and fabric on plywood, 42⅛ × 42⅛″ (107 × 107 cm). Private collection. Dupin 251

PROVENANCE

Simone Breton (later Simone Collinet), Paris, by May 1930; Georges Hugnet, Paris; [Galerie Marie-Louise Jeanneret, Geneva]; Giovanni Traversa, Rivoli; present owner.

FJM 2582 and 2583. Overall sheet (no FJM number): 7 × 5⅜″ (18 × 13.5 cm)

SELECTED EXHIBITIONS

Paris 1930b, as (?)
Possibly Paris 1930c
Paris 1962b, cat. 110, repr. n.p., as

Collage en relief
Turin 1967, cat. 256, repr. p. 188

SELECTED REFERENCES

Aragon 1930, pl. XVII. Einstein 1930, repr. p. 241. Guéguen 1934, fig. 28, (repr. p. 45). Cirici-Pellicer 1949, ill. 35. Dupin 1962, pp. 203–04, no. 251, repr. p. 521. Bonnefoy 1964, pl. 26 (color). Walton 1966, pp. 13, 33, pl. 66 (color). Wescher 1971, pp. 190–91. Erben 1988, repr. (color) p. 59. Umland 1992, pp. 46, 72 (n. 40), 75 (n. 83), fig. 2 (repr. p. 46).

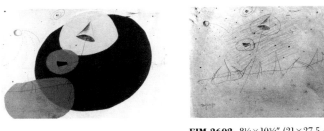

FJM 2602. 8¼ × 10¾″ (21 × 27.5 cm)

85. COLLAGE. Montroig, late July–early October 1929. (Plate, p. 173)

Pencil, ink, and collage on paper, 25 × 38⅝″ (63.5 × 98.1 cm). Signed and dated on verso: *Miró | Eté 1929.* Collection Richard and Mary L. Gray. Dupin 253

PROVENANCE

The artist to Galerie Pierre, Paris; Samuel Kootz, New York, by 1952; Harold Diamond, New York; Galerie Thomas Borgmann, Cologne; Galerie Paolo Sprovieri, Rome; Galerie Rudolf Zwirner, Cologne; to Richard and Mary L. Gray, June 1981.

SELECTED EXHIBITIONS

Possibly Paris 1930b, as (?)
New York 1952a, cat. 12
Chicago 1984, p. 197, repr. p. 197, as *Summer*
Zurich 1986, cat. 62, repr. (color) n.p., as *Dessin-collage*

New York 1987a, cat. 54, repr. (color) p. 126, as *Drawing-Collage*
Barcelona 1988b, cat. 3, repr. (color) p. 29, as *Papier collé*
London 1989, repr. (color) n.p., as *Papier collé*

SELECTED REFERENCES

Wescher 1955, repr. p. 56. Dupin 1962, pp. 203–04, no. 253, repr. p. 521. Wescher 1971, pp. 190–91, pl. 149 (repr. p. 364). Malet 1988b, p. 10. Umland 1992, p. 9, fig. 10 (repr. p. 58).

86. COLLAGE. Montroig, late July–early October 1929. (Plate, p. 173)

Pastel, ink, watercolor, crayon, and pasted papers on paper, 28⅝ × 42¾″ (72.7 × 108.4 cm). Signed and dated on verso: *Miró | Eté 1929.* The Museum of Modern Art, New York. James Thrall Soby Fund. Acq. no. 1307.68. Dupin 256

FJM 2601a. Pencil and watercolor on paper, 8×10½″ (20.5×26.7 cm)

PROVENANCE

Pierre Loeb (Galerie Pierre), Paris, by November 1930; Galerie Lawrence, Paris; Robert Elkon Gallery, New York; Maurice Rheims and Victor Hammer, Paris; Crane Kalman Gallery, London; to The Museum of Modern Art, New York, October 1968.

SELECTED EXHIBITIONS

Possibly Paris 1930b, as (?)
Paris 1930f, cat. 12, 13, or 14, as *Collage*
New York 1959b, cat. 38 (Los Angeles venue only)
Bogotá 1971, cat. 61 (Auckland, Sydney, Melbourne, Adelaide, and Mexico City venues only)

New York 1973b
São Paulo 1981, p. 106, repr. p. 107
Houston 1982
On view at The Museum of Modern Art, New York: April–November 1974; March–August 1978

SELECTED REFERENCES

Melgar 1931, repr. p. 17. Dupin 1962, pp. 103, 203–04, no. 256, repr. p. 521. Wescher 1971, pp. 190–91. Rubin 1973, pp. 8, 50, 122, repr. p. 51. Robert Elkon Gallery 1981, repr. (upside down) p. 17. Umland 1992, pp. 1, 48, 49, 65–66, 72 (n. 43), 75 (n. 83), fig. 1 (repr., color, p. 42), fig. 23 (repr. p. 64), fig. 24 (repr. p. 65), fig. 25 (detail; repr. p. 65).

MoMA 123.73. Pencil and white chalk on paper, 6×4¾″ (15.2×12 cm)

87. COLLAGE. Montroig, late July–early October 1929. (Plate, p. 172)

Ink, charcoal, pastel, pencil, and pasted papers on paper, 42⅛×28″ (107×71 cm). Signed and dated on verso: *Miró | été | 1929*. Private collection, Paris. Dupin 258

PROVENANCE

The artist to Galerie Pierre, Paris; to present owner, c. 1939.

SELECTED EXHIBITIONS

Possibly Paris 1930b, as (?)
Paris 1962b, cat. 112, as *Papier collé*
London 1964b, cat. 84, p. 29, pl. 16b
Tokyo 1966, cat. 37, repr. p. 98, as *Papier collé*
Paris 1970b, as *Eté*
Bordeaux 1971, cat. 191, repr. p. 104, as *Ete [sic]*

Paris 1974b, cat. 39, p. 119, repr. p. 119, as *Papier collé*
Humlebaek 1974, cat. 51
Paris 1979, cat. 138a, repr. n.p., as *Eté*
Paris 1987b, cat. 46, repr. (color) p. 101, as *Collage (Personnage)*
Saint-Paul-de-Vence 1990, cat. 89, p. 85, repr. (color) p. 85, as *Papier-collé*

SELECTED REFERENCES

Gasch 1948, repr. p. 33. Dupin 1962, pp. 203–04, no. 258, repr. p. 521. Lassaigne 1963, repr. (color) p. 67. Wescher 1971, pp. 190–91. Umland 1992, pp. 48, 75 (n. 83), fig. 6 (repr., color, p. 51).

FJM 2581a. 7⅜×5¾″ (18.6×14.8 cm)

88. COLLAGE (Head of Georges Auric). Montroig, late July–early October 1929. (Plate, p. 175)

Tarboard, chalk, and pencil on paper, 43⅜×29½″ (110×75 cm). Signed and dated on verso: *Miró | été 1929*. Kunsthaus Zürich. Gift of Dr. Georges and Josi Guggenheim, 1976. No Dupin number

PROVENANCE

Charles Zalber (Galerie Bellechasse), Paris; Galerie Arditti, Paris; to Georges and Josi Guggenheim, 1964; to Kunsthaus Zürich, 1976.

SELECTED EXHIBITIONS

Possibly Paris 1930b, as (?)
Possibly Paris 1930c, cat. 24, as *Tête*
London 1964b, cat. 82, p. 29
Edinburgh 1982, cat. 9, repr. p. 12, as *Head of Georges Auric*
Stuttgart 1985, cat. 384, repr. p. 244, as *Kopf Georges Auric*

Zurich 1986, cat. 63, repr. (color) n.p., as *Tête Georges Auric*
Barcelona 1988b, cat. 5, repr. (color) p. 31, as *Cap Georges Auric*
London 1989, repr. (color) n.p., as *Head of Georges Auric*

SELECTED REFERENCES

Dupin 1962, pp. 203–04. Waldberg 1967b, repr. p. 70. Billeter 1976, pp. 101–02. Umland 1992, p. 72 (n. 40).

FJM 4317. 8½×6½″ (21.7×16.7 cm)

89. PAINTING. Paris, January–April 1930. (Plate, p. 180)

Oil, plaster, and charcoal on canvas, 7′ 6½″×59″ (230×150 cm). Signed and dated on verso: *Joan Miró | 1930*. Collection Beyeler, Basel. Dupin 260

PROVENANCE

The artist to Galerie Pierre, Paris, 1930; Jean Arp, Paris; Emanuel Hoffmann Foundation, Basel; Galerie Maeght, Paris, by 1956; Jan Mitchell, New York, by March 1959; to Collection Beyeler, Basel, 1972.

FJM 842. 7⅝×6¾″ (19.5×17.3 cm)

SELECTED EXHIBITIONS
Brussels 1956, cat. 34, repr. n.p.
Basel 1956, cat. 31
New York 1959b, cat. 40 (Los Angeles
 venue, cat. 39)
Basel 1972, cat. 3, repr. (color)
 frontispiece
Basel 1974, cat. 26, repr. (color) n.p.
Basel 1979, cat. 62, repr. (color) n.p.
San Francisco 1981b, cat. 6, repr. (color)
 n.p.
Houston 1982, pl. 15 (color), as *Three*

Personages and Head (incorrectly
 dated 1934 and credited to Collection
 Harcourts Gallery, San Francisco)
Basel 1984, cat. 48, repr. (color) n.p.
Zurich 1986, cat. 66, repr. (color) n.p.
Paris 1987b (Madrid venue only)
Barcelona 1988b, cat. 6, repr. (color)
 p. 32
Madrid 1989, p. 95, repr. (color) p. 97
Saint-Paul-de-Vence 1990, p. 86, cat. 36,
 repr. (color) p. 87

SELECTED REFERENCES
Bataille 1930, repr. p. 398. Prévert/Ribemont-Dessaignes 1956, repr. p. 120. Dupin
1962, pp. 237, 238, 522, no. 260, repr. p. 234. Malet 1988b, p. 13.

Humlebaek 1974, cat. 56
New York 1979a, cat. 71, p. 106, repr.
 p. 106

Madrid 1986, cat. 1, pp. 30, 32, repr.
 p. 32

SELECTED REFERENCES
Hugnet 1931b, repr. p. 336. Dupin 1962, pp. 242, 243. Jouffroy/Teixidor 1974, no.
4, repr. p. 6. Umland 1992, p. 76 (n. 94).

FJM 4318. Pencil and gouache on paper,
6½×8½″ (16.7×21.7 cm)

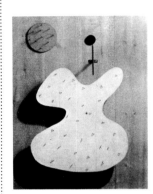

FJM 811. 7⅝×6¾″ (19.5×17.3 cm)

90. PAINTING (Untitled). Paris, January–April 1930. (Plate, p. 181)

Oil on canvas, 59⅛″×7′ 4⅝″ (150.5×225 cm). Signed and dated on verso: *Joan
Miró. | 1930*. The Menil Collection, Houston. Dupin 263

PROVENANCE
The artist to Galerie Pierre, Paris, 1930; Galerie Pierre, Paris, and Pierre Matisse
Gallery, New York; Hugo Gallery, New York; The Menil Collection, Houston.

SELECTED EXHIBITIONS
Bern 1949, cat. 13, as *Les Boules
 de couleur*
Basel 1949, cat. 158, as *Les Boules
 de couleur*
New York 1968a, cat. 238
New York 1972d, cat. 36, pp. 126, 153,
 repr. p. 126

Paris 1974b, cat. 40, pp. 119–20
London 1978, cat. 10.7, repr. (color) n.p.
Houston 1982, pl. 13 (color)
Paris 1984a, cat. 570, p. 98, repr. pp.
 135 (color), 409, as *Sans titre*

SELECTED REFERENCES
Bataille 1930, repr. p. 399. Dupin 1962, p. 237, no. 263, repr. p. 522. Bonnefoy
1964, pl. 28 (color). Walton 1966, p. 32, pl. 67 (color). Rubin 1968, p. 129, fig. 191
(repr. p. 132). Rubin 1973, fig. 40 (repr., upside down, p. 122). Picon 1976, vol. 1,
repr. p. 51. Rowell 1976, repr. p. 62. Erben 1988, repr. (color) p. 58.

91. CONSTRUCTION. Montroig, August–November 1930. (Plate, p. 178)

Wood and metal, 35¾×28×14½″ (91×71×37 cm). Signed and dated on back:
Joan Miró. | 1930. Private collection, Paris. No Dupin number

PROVENANCE
The artist to Georges Hugnet, Paris, by 1931?; to Jacques Tronche (Galerie Tronche),
Paris, c. 1965–66; to present owner.

SELECTED EXHIBITIONS
Possibly Paris 1931e, as (?)
Paris 1945a, cat. 123, as *Un Objet*
Paris 1962b, cat. 113, as *Tableau-objet*

Paris 1970b, as *Sculpture*
Saint-Paul-de-Vence 1973a, cat. 2
Paris 1974b, cat. 218, p. 150

92. RELIEF CONSTRUCTION. Montroig, August–November 1930.
(Plate, p. 179)

Wood and metal, 35⅞×27⅞×6⅜″ (91.1×70.2×16.2 cm). Signed and dated on
back: *Joan Miró | 1930*. The Museum of Modern Art, New York. Purchase. Acq. no.
259.37. No Dupin number

PROVENANCE
André Breton, Paris; to Paul Eluard, Paris; to The Museum of Modern Art, New
York, December 1937.

SELECTED EXHIBITIONS
Possibly Paris 1931e, as (?)
New York 1936b, cat. 170 (New York
 venue only)
New York 1936d, cat. 435, repr. p. 142
 (New York venue only)
New York 1941g (New York venue only)
New York 1942i
New York 1949c (not in checklist)
New York 1954
New York 1959b, cat. 41, as *Construction*
 (Los Angeles venue, cat. 40)
New York 1961c (Dallas and San
 Francisco venues only)
Saint-Paul-de-Vence 1973a, cat. 1, repr.
 p. 55, as *Construction*
New York 1973b
Paris 1974b, cat. 219, p. 150, repr. p.
 150, as *Construction*

Humlebaek 1974, cat. 57, as
 Construction
New York 1979a, cat. 70, p. 104, repr.
 p. 105
Paris 1986, cat. 100, repr. p. 90
Zurich 1986, cat. 67, repr. (color) n.p., as
 Construction
New York 1987a, cat. 55, repr. (color) p.
 127, as *Construction*
On view at The Museum of Modern Art,
 New York: December 1939–February
 1940; May–October 1940; January–
 August 1941; October–November
 1941; January–November 1942; April–
 June 1943; November 1944–March
 1945; June 1945–June 1948; October
 1948–October 1949; December 1949–
 April 1950; June–December 1950;

March–May 1951; July–October 1951;
November–December 1951; June
1953–January 1954; July–October
1955; December 1956–January 1957;
September 1957–April 1958; October
1958–October 1962; May 1964–May

1969; November 1969–March 1973;
January–April 1974; February 1975–
January 1979; June 1979–March
1980; June–September 1983; May
1984–May 1990; mid-June 1990–
August 1992

SELECTED REFERENCES
Barr 1936, p. 182, fig. 202 (repr. p. 184). Benson 1936, p. 257, repr. p. 257. Sweeney
1941, p. 47, repr. p. 51. *New York Herald Tribune* 1941b. Cirici-Pellicer 1949, ill. 59.
Cirlot 1949, p. 32. Soby 1959, repr. p. 64. Dupin 1962, pp. 242, 243, 461, repr. p.
232. Gasser 1965, repr. p. 45. Swanson 1971, repr. n.p. Sylvester 1972, p. 5, repr. p.
6. Rubin 1973, pp. 7, 52, 68, 122, repr. p. 53. Jouffroy/Teixidor 1974, no. 6, repr. p.
7. Lemayrie 1974b, repr. p. 5. Teixidor 1974, p. 96. Gimferrer 1978, fig. 5. Erben
1988, repr. (color) p. 61. Raillard 1989, p. 94, repr. (color) p. 95. Umland 1992,
p. 76 (n. 94).

SELECTED EXHIBITIONS
Possibly Paris 1931e, as (?)
Paris 1933a, cat. 52, 53, 54, or 55,
 as *Objet*
Tokyo 1937, cat. 84, repr. n.p.,
 as *Peinture*

New York 1950a, cat. 13
Chicago 1961, cat. 16, repr. n.p.
London 1964b, cat. 93, p. 30, pl. 19a
Basel 1969, cat. 19, repr. (color) p. 51

SELECTED REFERENCES
Sweeney 1934, fig. 30 (repr. p. 48). Dupin 1962, pp. 243, 245, 523, no. 284, repr. p.
236. Beaumelle 1991, repr. p. 207 (installation view).

93. MAN AND WOMAN. Paris, March 1931. (Plate, p. 182)
Oil on wood, with metal parts, 13⅜ × 7¼ × 2¼″ (33.9 × 18.4 × 5.7 cm). Signed lower
left: *Miró.* | *3-31.* Inscribed on back: *Homme et Femme.* Private collection.
Dupin 293

PROVENANCE
André Breton, Paris; to present owner, 1966.

SELECTED EXHIBITIONS
Possibly Paris 1931e, as (?)
London 1964b, cat. 100, p. 31, pl. 20a,
 as *Object—Man and Woman*
Paris 1974b, cat. VI, pp. 173–74
London 1978, cat. 11.29, as *Objet:*

Homme et femme
Madrid 1986, cat. 5, p. 36, repr. p. 36
Paris 1991, repr. (color) p. 307 (Paris
 venue only)

SELECTED REFERENCES
Dupin 1962, pp. 248, 462, no. 293, repr. p. 524. Penrose 1969, p. 70, pl. 105 (repr.
p. 142). Wescher 1971, p. 192. Sylvester 1972, p. 5, repr. p. 7. Jouffroy 1974, p. 16.
Jouffroy/Teixidor 1974, no. 14, repr. p. 11. Miró 1977, p. 136. Joffroy 1979, repr. p. 38
(photograph of Breton's apartment). Bouret 1986, n.p. Raillard 1989, p. 96. Fleck
1991, repr. (color) p. 96. Monod-Fontaine 1991, repr. p. 67 (photograph of Breton's
apartment).

95. OBJECT. [Montroig, mid-summer–mid-fall] 1931. (Plate, p. 182)
Assemblage: painted wood, steel, string, bone, and a bead, 15¾ × 11¾ × 8⅝″
(40 × 29.7 × 22 cm). Signed and dated under base: *Miró* | *1931.* The Museum of
Modern Art, New York. Gift of Mr. and Mrs. Harold X. Weinstein. Acq. no. 7.61.
No Dupin number

PROVENANCE
Georges Hugnet, Paris; to Richard L. Feigen & Co., Chicago; to Burt Kleiner,
Los Angeles; to Richard L. Feigen & Co., Chicago, by 1959; to Mr. and Mrs. Harold
X. Weinstein, Chicago, 1961; to The Museum of Modern Art, New York, October
1961.

SELECTED EXHIBITIONS
Possibly Paris 1931e, as (?)
New York 1959b, cat. 44 (Los Angeles
 venue, cat. 43)
New York 1961c (Dallas and San
 Francisco venues only)
Bogotá 1971, cat. 62, repr. n.p.
New York 1973b
Vienna 1978, cat. 48, repr. p. 129

Saint Louis 1980
São Paulo 1981, p. 108, repr. p. 109
Madrid 1986, cat. 2, pp. 30, 33, repr.
 p. 33
On view at The Museum of Modern Art,
 New York: November 1962–January
 1963; June–November 1965; March–
 June 1968

SELECTED REFERENCES
Jean 1936, repr. p. 58. *MoMA Bulletin* 1962b, p. 61, repr. p. 36. Dupin 1962, pp.
248, 462. Rubin 1973, pp. 8, 123, repr. pp. 12 (installation view), 55. Jouffroy/
Teixidor 1974, no. 7, repr. p. 192 (incorrectly dated 1930). Stich 1980, p. 27, fig. 18
(repr. p. 27).

94. HUMAN HEAD. Paris, May 1931. (Plate, p. 177)
Oil and collage on canvas, 31⅞ × 25⅝″ (81 × 65 cm). Signed and dated lower left:
Miró | *5.31.* Private collection. Dupin 284

PROVENANCE
The artist to Pierre Colle (Galerie Pierre Colle), Paris, December 1932; to Pierre
Matisse Gallery, New York, c. December 1937; to G. David Thompson, Pittsburgh,
January 1954; to Pierre Matisse Gallery, New York; Mr. and Mrs. Arnold H.
Maremont, Chicago, by February 1961; unidentified dealer, Paris; to Galerie Beyeler,
Basel, 1968; to unidentified dealer, Italy, 1969; Acquavella Galleries, New York; to
present owner.

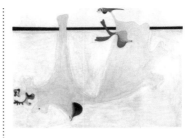

96. OBJECT. [Montroig, mid-summer–mid-fall] 1931. (Plate, p. 182)
Painted wood, insulator, screw, burnt wood, sand, and clockworks, 10⅝ × 5⅜ × 2⅝″ (26.9 × 13.6 × 6.6 cm). Signed and dated on back: *Miró | 1931.* Inscribed on back, on collaged paper: *M.* Private collection, Paris. No Dupin number

PROVENANCE
Galerie Pierre, Paris, by June 1936; to present owner, c. 1936–37.

SELECTED EXHIBITIONS
Possibly Paris 1931e, as (?)
London 1936c, cat. 227, 228, or 229
Paris 1964, cat. 229

Saint-Paul-de-Vence 1973a, cat. 5, repr. p. 56, as *Peinture-objet*

SELECTED REFERENCES
Jouffroy/Teixidor 1974, no. 10, repr. p. 9. Centre d'Art Santa Mònica 1988, p. 203 (installation view).

98. WOMEN RESTING. Montroig, August 1932. (Plate, p. 185)
Oil on wood, 9½ × 13⅛″ (24.1 × 33.3 cm). Inscribed on verso: *Joan Miró 8-32. "Femmes au repos."* Private collection. Dupin 321

PROVENANCE
The artist to Pierre Matisse (Pierre Matisse Gallery), New York, by December 1933; Dieter Keller, Stuttgart; to Galerie Beyeler, Basel, 1979; to Lawrence Rubin, New York, 1980; to Ted Ashley, New York, October 1980 (consigned to Christie's, New York; sold November 19, 1986, lot 49); to unidentified dealer, Paris; present owner (consigned to Sotheby's, New York; at auction May 13, 1992, lot 78).

SELECTED EXHIBITIONS
New York 1933 (not in checklist)
New York 1936c, cat. 11
New York 1948b, cat. 7

Basel 1979, cat. 66
Saint-Paul-de-Vence 1990, cat. 37, p. 88, repr. (color) p. 89

SELECTED REFERENCES
Jewell 1933, p. L11. Dupin 1962, pp. 247, 249, 250, no. 321, repr. p. 526. McCandless 1982, p. 52.

97. OBJECT (The Door). [Montroig, mid-summer–mid-fall 1931]. (Plate, p. 183)
Painted wood, metal, feathers, and other found objects, 44⅞ × 28¾″ (113.9 × 73 cm). Collection Mr. and Mrs. A. Alfred Taubman. No Dupin number

PROVENANCE
[Georges Hugnet, Paris]; to Claude Hersaint, Paris, c. 1950–55?; Mr. and Mrs. William N. Copley, Longpont-sur-Orge and New York, by March 1959 (consigned to Sotheby Parke Bernet, New York; sold May 17, 1978, lot 71); to Mr. and Mrs. A. Alfred Taubman.

SELECTED EXHIBITIONS
Possibly Paris 1931e, as (?)
New York 1959b, cat. 42 (Los Angeles venue, cat. 41)
London 1964b, cat. 96, p. 31
New York 1968a, cat. 239

Paris 1977, repr. p. 479, as *Table à moustaches* (incorrectly dated 1927)
London 1978, cat. 11.27a, repr. p. 273, as *Table moustache* (incorrectly dated 1927)

SELECTED REFERENCES
Soby 1959, repr. p. 77. Dupin 1962, pp. 248, 462. Walton 1966, p. 32, pl. 64 (color). Rubin 1968, p. 146, fig. 223 (repr. p. 147). Wescher 1971, p. 192. Rubin 1973, repr. p. 12 (installation view). Jouffroy/Teixidor 1974, no. 16, repr. p. 193.

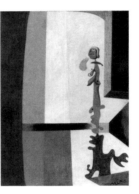

99. PERSONAGE. Montroig, August 1932. (Plate, p. 184)
Oil on wood, 10¾ × 7⅞″ (27 × 20 cm). Signed lower right: *Miró.* Inscribed on verso: *Joan Miró | 8-32 | "Figure."* The Art Institute of Chicago. Gift of Mary and Leigh Block. Dupin 326

PROVENANCE
The Mayor Gallery, London; Berggruen & Cie, Paris; Richard L. Feigen & Co., Chicago; to Mary and Leigh Block, Chicago, July 1960; to The Art Institute of Chicago, 1988.

SELECTED EXHIBITIONS
London 1933b, cat. 9, as *Figure*
New York 1933, cat. 4, as *Figure*

Chicago 1934a, cat. 3

SELECTED REFERENCES
M.M. 1934, p. 4. Jewett 1934. Dupin 1962, pp. 247, 249, 250, no. 326, repr. p. 526.

100. HEAD OF A MAN. Montroig, September 1932. (Plate, p. 187)
Oil on wood, 13¾ × 10⅝″ (35 × 27 cm). Inscribed on verso: *Joan Miró. | 9-32. | "Tête d'homme."* Private collection, Barcelona. Dupin 318

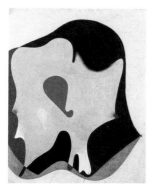

PROVENANCE
The artist to Pierre Matisse Gallery, New York; Galerie Maeght, Paris; present owner.

SELECTED EXHIBITIONS
Paris 1932b
London 1933b, cat. 8
New York 1933, cat. 7
Chicago 1934a, cat. 4
San Francisco 1935a
Los Angeles 1935b
New York 1936b, cat. 171 (New York
 venue only)

Brussels 1956, cat. 36
Basel 1956, cat. 33
Saint-Paul-de-Vence 1968, cat. 23
Munich 1969, cat. 35, repr. n.p.
Barcelona 1975b, cat. 21
Barcelona 1988b, cat. 17, repr. (color)
 p. 46

SELECTED REFERENCES
M.M. 1934, p. 4. Jewett 1934. Barr 1936, fig. 203 (repr. p. 184). Prévert/Ribemont-Dessaignes 1956, repr. (color) p. 125. Dupin 1962, pp. 247, 249, 250, 492, 526, no. 318, repr. p. 313. Gimferrer 1978, fig. 59 (color). Malet 1983b, p. 14, fig. 40 (color). Malet 1988b, p. 11.

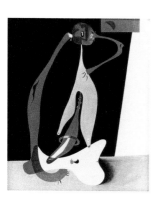

101. SEATED WOMAN. [Montroig], October 1932. (Plate, p. 186)
Oil on wood, 18¼×15″ (46×38.1 cm). Inscribed on verso: *Joan Miró | 10-32 | Femme Assise.* Private collection. Dupin 319

PROVENANCE
Pierre Matisse Gallery, New York; to Mr. and Mrs. James Johnson Sweeney, New York; to Estate of James Johnson Sweeney (consigned to Sotheby's, New York; sold November 18, 1986, lot 3); present owner.

SELECTED EXHIBITIONS
London 1933b, cat. 11
New York 1933, cat. 6
New York 1936c, cat. 12
New York 1941g (New York venue only)
New York 1942d, repr. n.p.
New York 1959b, cat. 47 (New York
 venue only)

London 1964b, cat. 103, p. 32, pl. 21a
Paris 1974b, p. 120, cat. 41, repr. pp. 50
 (color), 120
Humlebaek 1974, cat. 18
Washington 1980a, cat. 20, repr. (color)
 p. 69

SELECTED REFERENCES
Read 1933b, repr. *Art Digest* 1936, repr. p. 13. *New York Times* 1936, p. 12. Sweeney 1941, p. 53, repr. p. 54. Cirici-Pellicer 1949, p. 30. Soby 1959, p. 66, repr. p. 69. Dupin 1962, pp. 247, 249, 250, 252–55, 526, no. 319, repr. (color) p. 239. Gasser 1965, p. 74, repr. (color) p. 35. Penrose 1969, pl. 46 (repr. p. 71). *Louisiana Revy* 1974, repr. (color) p. 20. Miró 1977, p. 89. Gimferrer 1978, fig. 179. Willard 1980, p. 25, fig. 11 (repr. p. 25). Rose 1982a, p. 33. McCandless 1982, p. 52. Erben 1988, repr. (color) p. 62.

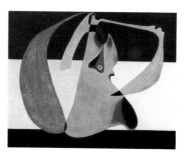

102. BATHER. [Montroig], October 1932. (Plate, p. 184)
Oil and pencil on wood, 14½×18″ (35.8×45.7 cm). Inscribed on verso, upper left: *Joan Miró | 10-32. | "Baigneuse."* The Museum of Modern Art, New York. Fractional gift of Celeste and Armand P. Bartos. Acq. no. 503.84. Dupin 324

PROVENANCE
The artist to Pierre Matisse Gallery, New York; to Mr. and Mrs. Henry Clifford, Radnor, Pa., c. December 1933; Samuel Kootz, New York; to Celeste and Armand P. Bartos, New York, 1954; to The Museum of Modern Art, New York, December 1984.

SELECTED EXHIBITIONS
Paris 1932b
London 1933b, cat. 6
New York 1933, cat. 5

New York 1973b
Paris 1974b, cat. XIV, p. 175

SELECTED REFERENCES
Times 1933. Jewell 1933, p. L11. Dupin 1962, pp. 247, 249, 250, no. 324, repr. p. 526 (incorrectly credited to collection Wadsworth Atheneum, Hartford). Rubin 1973, pp. 8, 56, 124, repr. (color) p. 57.

103. FLAME IN SPACE AND NUDE WOMAN. 1932. (Plate, p. 185)
Oil on wood, 16⅛×12⅝″ (41×32 cm). Inscribed on verso: *Joan Miró. | "Flama en l'espai | i dona nua." | 1932. | 6.* Fundació Joan Miró, Barcelona. Dupin 322

PROVENANCE
The artist to Joan Prats Vallés, Barcelona; to Fundació Joan Miró, Barcelona, June 1975.

SELECTED EXHIBITIONS

Barcelona 1949, cat. 20
Barcelona 1975a, cat. 14, repr. (color)
 p. 36
Madrid 1978a, cat. 27, pp. 103–04, repr.
 (color) p. 53
Florence 1979, cat. 7, repr. (color) n.p.
Lausanne 1986, cat. 62, repr. n.p.
 (color), p. 180

Paris 1987b, cat. 49, repr. (color) p. 104
 (incorrectly dated 1933) (Paris venue
 only)
Barcelona 1988b, cat. 18, repr. (color)
 p. 47
London 1989, repr. (color) n.p.
Barcelona 1992, cat. 190, repr. p. 273

SELECTED REFERENCES

Dupin 1962, pp. 247, 249, 250, no. 322, repr. p. 526. Malet 1983b, p. 14, fig. 49 (color). Erben 1988, repr. (color) p. 65. Fundació Joan Miró 1988, repr. pp. 126 (color), 155. Malet 1988b, p. 11. Malet 1989, p. 16. Jeffett 1989a, p. 30.

104. GIRL PRACTICING PHYSICAL CULTURE. 1932. (Plate, p. 186)

Oil on wood, 16⅛ × 12⅝″ (41 × 32 cm). Inscribed on verso: *Joan Miró | 1932 | "Jeune fille faisant la culture physique."* Collection Erna and Curt Burgauer. Dupin 323

PROVENANCE

Galerie Pierre, Paris, by January 1935; Collection Erna and Curt Burgauer.

SELECTED EXHIBITIONS

Paris 1932b
London 1933b, cat. 7
New York 1933, cat. 8
Chicago 1934a, cat. 5
Copenhagen 1935, cat. 23
Prague 1935, cat. 45
Basel 1952, cat. 143
Basel 1956, cat. 34, repr. n.p.

London 1964b, cat. 102, p. 31, repr. n.p.
Saint-Paul-de-Vence 1968, cat. 24
Barcelona 1968, cat. 28, pl. 11 (repr.
 p. 99)
Zurich 1985b, cat. 13, repr. (color) n.p.
Zurich 1986, cat. 70, repr. (color) n.p.
Lausanne 1987, ill. 1 (repr., color,
 p. 287)

SELECTED REFERENCES

Jewell 1933, p. L11. Jewett 1934. Dupin 1962, pp. 247, 249, 250, no. 323, repr. p. 526. McCandless 1982, p. 52. Erben 1988, repr. (color) p. 66.

105. OBJECT. 1932. (Plate, p. 183)

Painted stone, shell, wood, mirror, and sequins,* 9¾ × 22″ (24.8 × 55.9 cm). Signed and dated on wooden base, right rear corner: *Miró | 1932.* Philadelphia Museum of Art. A. E. Gallatin Collection. Dupin 330

(*Note: The original mirror and shell have been replaced.)

PROVENANCE

Galerie Pierre, Paris, by 1934; to A. E. Gallatin, New York, end of 1936; to Philadelphia Museum of Art, 1952.

SELECTED EXHIBITIONS

Paris 1932b
Paris 1936b, p. 7
New York 1961c, cat. 151, repr. p. 65
 (New York venue only)

Philadelphia 1987a, cat. 12
On view at the Museum of Living Art,
 New York University, New York:
 c. 1936–43

SELECTED REFERENCES

Tériade 1932, p. 7. *Cahiers d'art* 1934, fig. 33 (repr. p. 50). Bjerke-Petersen 1934, fig. 19 (repr. p. 93). Gallatin 1936, no. 89, repr. n.p. Zervos 1938, repr. p. 425. Gallatin 1940, no. 91, repr. n.p. Sweeney 1941, pp. 80, 81. Cirici-Pellicer 1949, ill. 56. Dupin 1962, no. 330, repr. p. 526. Jouffroy/Teixidor 1974, no. 18, repr. p. 11. Stich 1980, p. 27. Rowell 1987a, p. 24, repr. p. 25. Temkin 1987b, p. 42. Stavitsky 1990, vol. 8, p. 192.

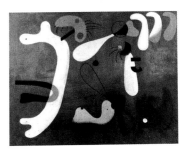

FJM 1291. January 28, 1933. Pencil and collage on paper, 18⅝ × 24¾″ (47.5 × 62.9 cm)

106. PAINTING (Composition). Barcelona, March 8, 1933. (Plate, p. 188)

Oil and aqueous medium on canvas, 51⅜ × 64¼″ (130.5 × 163.2 cm). Signed and dated on verso: *Joan Miró. | 8.3.33.* Philadelphia Museum of Art. A. E. Gallatin Collection. Dupin 335

PROVENANCE

The artist to Pierre Matisse Gallery, New York, by December 1933; to A. E. Gallatin, New York, January 11, 1935; to Philadelphia Museum of Art, 1952.

SELECTED EXHIBITIONS

Paris 1933d, as (?)
New York 1933, cat. 17, as *Composition*
New York 1961e
New York 1972c, cat. 63

Philadelphia 1987a, cat. 13
On view at the Museum of Living Art,
 New York University, New York:
 1935–43

SELECTED REFERENCES

Art News 1935, repr. p. 9. Gallatin 1936, no. 90, repr. n.p. Gallatin 1940, no. 92, repr. n.p. Clifford 1943, p. 4, repr. p. 12. Venturi 1947, pl. 211. Cirici-Pellicer 1949, ill. 42. Canaday 1959, repr. p. 30. Dupin 1962, pp. 252–55, no. 335, repr. p. 527. Okada 1974, pl. 14 (color). Rowell 1986, p. 125. Rowell 1987a, p. 26, repr. (color) p. 27. Temkin 1987b, p. 42. Stavitsky 1990, vol. 8, p. 193.

107. PAINTING (Composition). Barcelona, March 31, 1933. (Plate, p. 189)

Oil on canvas, 51 × 63½″ (129.5 × 161.5 cm). Signed and dated on verso: *Joan Miró. 31.3.33.* Kunstmuseum Bern. Dupin 333

PROVENANCE

The artist to Pierre Matisse Gallery, New York; Peliquer Collection; Max Kaganovitch, Paris; to Kunstmuseum Bern, March 1955.

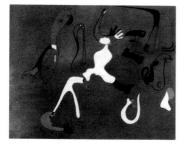

FJM 1293. January 31, 1933. Pencil and collage on paper, 18½ × 24¾″ (47.1 × 63.1 cm)

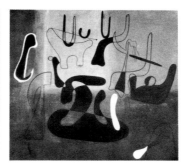

MoMA 131.73. February 11, 1933. Cut-and-pasted photomechanical reproductions and pencil on paper, 18½ × 24⅞″ (46.8 × 63 cm)

SELECTED EXHIBITIONS
Paris 1933d, as (?)
New York 1933, cat. 15, as *Composition*
Paris 1938a, cat. 139
Basel 1956, cat. 35, as *Composition*
Paris 1962b, cat. 56
London 1964b, cat. 108, p. 32, pl. 21b

Cologne 1965, cat. 76, repr. n.p., as *Komposition*
Tokyo 1966, cat. 39, repr. p. 99
Munich 1969, cat. 36, repr. n.p.
Zurich 1986, cat. 80, repr. (color) n.p. (Zurich venue only)

SELECTED REFERENCES
Breton/Duchamp 1947, repr. p. iii (installation view). Hüttinger 1957, fig. 20 (color). Kunstmuseum Bern 1960, pl. 177. Dupin 1962, pp. 252–55, no. 333, repr. p. 527. Juin 1967, repr. p. 12. Rowell 1986, p. 125. Erben 1988, repr. (color) p. 68.

PROVENANCE
The artist to Pierre Matisse Gallery, New York; to George L. K. Morris, New York; to The Museum of Modern Art, New York, September 1937.

SELECTED EXHIBITIONS
Paris 1933d, as (?)
Possibly Prague 1935, cat. (?), as *Obraz*
New York 1936b, cat. 173, as *Composition* (all venues except Baltimore, Providence, and Grand Rapids, Mich.)
Toledo 1938, cat. 76, as *Composition*
New York 1939d, cat. 197a, as *Composition*
San Francisco 1940, cat. 687, as *Composition*
New York 1941g, as *Composition*
Chicago 1943, cat. 4, as *Composition*
New York 1944e, as *Composition*
New York 1949c, as *Composition* (not exhibited)
New York 1954
New York 1958a, as *Composition*
New York 1959b, cat. 49 (Los Angeles venue, cat. 46)
Washington 1963, repr. p. 72, as *Composition*
New York 1968 (Chicago venue only)
New York 1973b
Paris 1974b, cat. 42, p. 120, repr. p. 120
Sydney 1975, cat. 76, p. 186, repr. p. 187
Paris 1977, repr. p. 425

Vienna 1978, cat. 50, repr. p. 133
São Paulo 1981, pp. 110–11, repr. p. 111
Atlanta 1982
New York 1983b
New York 1990b, fig. 127 (repr., color, p. 307)
On view at The Museum of Modern Art, New York: February–March 1937; January–March 1940; October 1940–January 1941; May–October 1941; November 1944–May 1945; June 1945–May 1946; July 1946–February 1951; April–November 1951; March 1952–September 1954; March–April 1955; October 1955–January 1958; March–April 1958; October 1958–February 1959; August–October 1959; August 1960–March 1961; May 1964–September 1968; January–November 1969; March 1972–September 1973; January–April 1974; November 1974–February 1975; October 1975–April 1977; May 1979–November 1979; October 1980–April 1981; June–September 1983; April 1984–August 1990; October 1991–August 1992

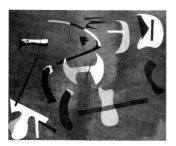

FJM 1296. February 3, 1933. Pencil and collage on paper, 18½ × 24¾″ (47.2 × 63.1 cm)

108. PAINTING (Composition). Barcelona, April 12, 1933. (Plate, p. 190)
Oil on canvas, 51⅛ × 64″ (130 × 162.5 cm). Signed and dated on verso: *Joan Miró 12.4.33.* National Gallery, Prague. Dupin 338

PROVENANCE
Association of Friends of the Modern Gallery, Prague, 1936; to National Gallery, Prague, 1960.

SELECTED EXHIBITIONS
Paris 1933d, as (?)
New York 1933, cat. 16, as *Composition*
Prague 1935, cat. (?), as *Obraz*
Bordeaux 1971, cat. 192, repr. p. 104, as *Composition*
Knokke 1971, cat. 16, repr. p. 34

Florence 1981, cat. 46, p. 159, repr. (color) p. 92, as *Composizione*
Zurich 1986, cat. 78, repr. (color) n.p.
New York 1987a, cat. 63, repr. (color) p. 136

SELECTED REFERENCES
Dupin 1962, pp. 252–55, no. 338, repr. p. 527. Penrose 1969, pl. 48 (repr., color, p. 75). Rowell 1986, p. 125. Erben 1988, repr. (color) p. 69.

SELECTED REFERENCES
Volné Smèry 1935, repr. p. 113. *Frie Udstillings Bygning* 1935, repr. p. 28. Barr 1936, pp. 180, 182, fig. 204 (repr. p. 185). McBride 1936b. Jewell 1937a, p. X9. Bjerke-Petersen 1937, repr. p. 52. Sweeney 1941, pp. 22, 54, repr. (color) p. 55. *Park Avenue Social Review* 1941. Jewell 1941c. Cirici-Pellicer 1949, p. 32, repr. (color) n.p. Goldwater/d'Harnoncourt 1949, repr. p. 28. Roditi 1958, p. 39, repr. p. 42. Rubin 1959, repr. p. 38. Soby 1959, p. 70, repr. (color) p. 73. Heller 1961, repr. p. 46. Dupin 1962, pp. 252–55, no. 336, repr. p. 527. Hellman 1964, repr. p. 54. Penrose 1969, pp. 73–74, 76, pl. 47 (repr., color, p. 74). Rubin 1973, pp. 7, 8, 58–60, 124, repr. (color) p. 59. Stich 1980, pp. 29, 31. Rowell 1986, p. 125.

109. PAINTING (Composition). Barcelona, June 13, 1933. (Plate, p. 191)
Oil on canvas, 68½″ × 6′ 5¼″ (174 × 196.2 cm). Signed and dated on verso, upper left: *Joan Miró | 13.6.33.* The Museum of Modern Art, New York. Loula D. Lasker Bequest (by exchange). Acq. no. 229.37. Dupin 336

110. DRAWING-COLLAGE. [Montroig], September 22, 1933. (Plate, p. 192)
Black chalk with collaged postcard and botanical prints on cream laid paper, 24¾ × 18½″ (62.8 × 46.9 cm). Signed and dated on verso: *Pour Pilar | Joan Miró. | 22.9.33.* Private collection. No Dupin number

SELECTED REFERENCES
Dupin 1962, pp. 255–56. Wescher 1971, p. 191.

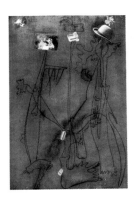

111. DRAWING-COLLAGE. [Montroig], September 25, 1933. (Plate, p. 193)

Conté crayon and pasted paper on tan pastel paper, 42×27½″ (106.7×69.9 cm). Signed and dated on verso: *Joan Miró | 25.9.33*. The Morton G. Neumann Family Collection. Dupin 360

SELECTED EXHIBITIONS
New York 1959b, cat. 52, as *Collage* Washington 1980b, cat. 54
 (Los Angeles venue, cat. 51) Chicago 1984, p. 199, repr. p. 199
Chicago 1961, cat. 18, repr. n.p., as
 Collage

SELECTED REFERENCES
Soby 1959, p. 70, repr. p. 75. Dupin 1962, pp. 255–56, no. 360, repr. p. 528. Wescher 1971, p. 191. Carmean 1980, p. 39, repr. p. 63.

112. PERSONAGES WITH STAR (Tapestry Cartoon). [Barcelona, late fall 1933]. (Plate, p. 194)

Oil on canvas, 6′ 6¼″×8′ 1½″ (198.8×247.7 cm). The Art Institute of Chicago. Gift of Mr. and Mrs. Maurice E. Culberg. Dupin 367

PROVENANCE
The artist (commissioned by Marie Cuttoli, Paris, and kept by her until end of

1951); to Galerie Maeght, Paris, December 1951; to Pierre Matisse Gallery, by March 1952; to Mr. and Mrs. Maurice E. Culberg, Chicago; to The Art Institute of Chicago, 1952.

SELECTED EXHIBITIONS
New York 1952b, cat. 1, as *Painting*

SELECTED REFERENCES
Lieberman 1948, pp. 142–43, 148. Fitzsimmons 1952, p. 16. Devree 1952. *Pictures on Exhibit* 1952, repr. *Messaggero di Roma* 1952, repr. Dupin 1962, pp. 255–56, no. 367, repr. p. 529.

113. RHYTHMIC PERSONAGES (Tapestry Cartoon). [Barcelona, late fall 1933–winter 1934]. (Plate, p. 196)

Oil on canvas, 6′ 4″×67⅜″ (193×171 cm). Kunstsammlung Nordrhein-Westfalen, Düsseldorf. Dupin 366

PROVENANCE
The artist (commissioned by Marie Cuttoli, Paris, and kept by her until end of 1951); to Galerie Maeght, Paris, December 1951; Fritz Heer, Zurich, by July 1955; Philippe Dotremont, Brussels, by April 1958; to Kunstsammlung Nordrhein-Westfalen, Düsseldorf, 1962.

SELECTED EXHIBITIONS
Kassel 1955, cat. 419, pl. IX (color), as as *Peinture, carton de tapisserie*
 Komposition *(Personnages rythmiques)*
Basel 1956, cat. 36, repr. n.p., as Humlebaek 1967, cat. 68, repr. n.p.
 Composition Saint-Paul-de-Vence 1968, cat. 27, repr.
Brussels 1958, cat. 222, repr. p. 114 p. 78
Düsseldorf 1961, cat. 52 Munich 1969, cat. 39, repr. n.p.
Basel 1961, cat. 46, repr. n.p. Munich 1972, cat. 331, repr. (color) n.p.
Paris 1962b, cat. 60, repr. n.p., as Paris 1972, cat. 316, repr. (color) n.p.
 Peinture, carton de tapisserie. Düsseldorf 1973, repr. n.p.
 Personnages rythmiques Paris 1974b, cat. 46, p. 121, repr. pp. 53
Recklinghausen 1963, cat. 162, repr. (color), 121, as *Peinture, carton de
 (color) n.p. tapisserie (Personnages rythmiques)*
London 1964b, cat. 116, p. 33, pl. 22a, London 1974, cat. 87, p. 196, repr. pp.
 as *Cartoon for Tapestry—* 197 (color), 20
 "Personnages rythmiques" Saint-Paul-de-Vence 1990, cat. 41, p. 94,
Tokyo 1966, cat. 44, p. 22, repr. p. 101, repr. (color) p. 95

SELECTED REFERENCES
Lieberman 1948, pp. 142–43, 148. Hüttinger 1957, p. 25, fig. 21. Erben 1959, repr. (color) p. 113. Dupin 1962, pp. 255–56, no. 366, repr. p. 529. Chevalier 1962, p. 11. Lassaigne 1963, p. 72, repr. (color) p. 73. *Quadrum* 1965, fig. 37 (repr. p. 166). Okada 1974, pl. 15 (color). Schmalenbach 1982, repr. p. 17. Rowell 1986, p. 268. Schmalenbach 1986, p. 392.

114. "HIRONDELLE—AMOUR" (Tapestry Cartoon). [Barcelona, late fall 1933–winter 1934]. (Plate, p. 195)

Oil on canvas, 6′ 6½″×8′ 1½″ (199.3×247.6 cm). The Museum of Modern Art, New York. Gift of Nelson A. Rockefeller. Acq. no. 723.76. Dupin 368

PROVENANCE

The artist (commissioned by Marie Cuttoli, Paris, and kept by her until 1946); to Galerie Maeght, Paris; to Nelson A. Rockefeller, New York, by May 1955; to The Museum of Modern Art, New York, March 1977.

SELECTED EXHIBITIONS

New York 1955, cat. 99
New York 1959b, cat. 56, as *L'Hirondelle d'amour*
New York 1967c, repr. (color) p. 25, as *L'Hirondelle d'amour*
New York 1969b, p. 134, repr. (color) p. 81, as *L'Hirondelle d'amour*
New York 1973b

On view at The Museum of Modern Art, New York: November 1974–March 1980; October 1980–January 1982; March 1982–February 1983; June–September 1983; December 1983–January 1984; April 1984–August 1992

SELECTED REFERENCES

Lieberman 1948, pp. 142–43, 148. *MoMA Bulletin* 1955, repr. p. 27 (installation view). Guéguen 1957, p. 43. Rubin 1959, p. 39, repr. p. 38. Soby 1959, p. 74, repr. (color) p. 81. R.F.C. 1959, p. 221. *Art in America* 1961, repr. p. 26. Dupin 1962, pp. 255–56, no. 368, repr. p. 529. Lassaigne 1963, p. 72. Plessix 1965, repr. p. 29 (installation view, photograph captioned "main reception hall of the Governor's Mansion"). Calas 1968, repr. (color) p. 35. Rubin 1973, pp. 8, 64, 68, 125–26, repr. (color) p. 65. Thevenon 1974, p. 19. Millard 1980, p. 26. Erben 1988, repr. (color) p. 73. Raillard 1989, repr. (color) cover.

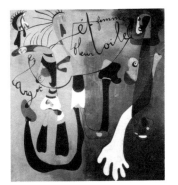

115. **"Escargot—Femme—Fleur—Etoile"** (Tapestry Cartoon). [Barcelona, late fall 1933–winter 1934]. (Plate, p. 197)
Oil on canvas, 6′ 4¾″ × 67⅝″ (195 × 172 cm). Signed lower right: *Miró*. Museo del Prado, Madrid. Dupin 369

PROVENANCE

The artist (commissioned by Marie Cuttoli, Paris); Pilar Juncosa de Miró; to Museo del Prado, Madrid, 1986.

SELECTED EXHIBITIONS

Krefeld 1954, cat. 5
Paris 1962b, cat. 61
London 1964b, cat. 115, p. 33, pl. 23b, as *Cartoon for Tapestry — "Escargot et femme, fleur, étoile"*
Tokyo 1966, cat. 45, p. 22, repr. (color) p. 55

New York 1968a, cat. 241 (at Chicago venue, shown for first week only)
Barcelona 1968, cat. 32, pl. 14 (repr. p. 102)
Munich 1969, cat. 40, repr. (color) n.p.
Paris 1974b, cat. 47, p. 121, repr. p. 121
Humlebaek 1974, cat. 21

Barcelona 1975a, cat. 19, repr. (color) p. 39
Madrid 1978a, cat. 30, p. 104, repr. (color) p. 55
Florence 1979, cat. 9, repr. (color) n.p.
Mexico City 1980, cat. 8, repr. (color) n.p.
Milan 1981, repr. (color) p. 53
Charleroi 1985, cat. 18, repr. (color) p. 190
Zurich 1986, cat. 90, repr. (color) n.p.

New York 1987a, cat. 74, repr. (color) p. 149
Madrid 1987, cat. 1, p. 17, repr. (color) p. 17
Paris 1987b, cat. 50, repr. (color) p. 105
Barcelona 1988b, cat. 27, repr. (color) p. 57
London 1989, repr. (color) n.p.
Saint-Paul-de-Vence 1990, cat. 42, p. 96, repr. (color) p. 97

SELECTED REFERENCES

Lieberman 1948, pp. 142–43, 148. Prévert/Ribemont-Dessaignes 1956, repr. p. 135. Erben 1959, p. 12. Dupin 1962, pp. 255–56, no. 369, repr. pp. 317, 529. Lassaigne 1963, p. 72. Bonnefoy 1964, pl. 32 (color). Roberts 1964, p. 479. Gasser 1965, repr. p. 50. Walton 1966, p. 13, 34, pl. 74 (color). Juin 1967, repr. (color) p. 16. Rubin 1968, pp. 129, 132, fig. 192 (repr. p. 133). Krauss/Rowell 1972, p. 92. Marchiori 1972, p. 29. *Louisiana Revy* 1974, repr. (color) cover. Rowell 1976, repr. (color) p. 65. Miró 1977, p. 213. Gimferrer 1978, fig. 151. Malet 1983b, fig. 44 (color). Beristain/Salazar 1987, p. 9. Erben 1988, repr. (color) p. 72. Hernández León 1988, p. 78. Malet 1988b, p. 11. Combalía 1992, p. 190. Yokohama Museum of Art 1992, fig. 7 (repr. p. 30).

116. **Collage.** Barcelona, January 20, 1934. (Plate, p. 192)
Corrugated cardboard, felt, gouache, and pencil on sandpaper, 14½ × 9¼″ (36.9 × 23.6 cm). Signed and dated on verso, upper center: *Joan Miró | 20/1/34*. The Museum of Modern Art, New York. James Thrall Soby Bequest. Acq. no. 109.79. Dupin 392

PROVENANCE

The artist to Pierre Matisse Gallery, New York; James Thrall Soby, Farmington and New Canaan, Conn., 1935; to The Museum of Modern Art, New York, May 1979.

SELECTED EXHIBITIONS

New York 1935, cat. 9, 10, 11, 12, or 13, as *Painting on Sand Paper*
New York 1961a, cat. 50, repr. p. 58, as *Untitled*
New York 1973b
New York 1982 (all venues except

New York)
New York 1987c
New York 1988
On view at The Museum of Modern Art, New York: March–June 1981; June–September 1983; April–September 1991

SELECTED REFERENCES

Cahiers d'art 1935, repr. p. 95 (installation view). Dupin 1962, pp. 256–58, no. 392, repr. p. 531. Rubin 1973, pp. 8, 126, repr. p. 66.

117. **Collage** (Homage to Prats). Montroig, August 1934. (Plate, p. 193)
Collage and pencil on paper, 25 × 18½″ (63.3 × 47 cm). Signed and dated lower right: *homenatge a | Prats is quality* [these three words in collaged printing] *| Miró | 8/34*. Fundació Joan Miró, Barcelona. Dupin 353

PROVENANCE
The artist to Joan Prats Vallés, Barcelona, August 1934?; to Fundació Joan Miró, Barcelona, June 1975.

SELECTED EXHIBITIONS
Barcelona 1949, cat. 23
London 1964, cat. 113, p. 33, as
 Drawing-Collage — Homage to Prats
Barcelona 1975a, cat. 20
Madrid 1978a, cat. 31, p. 104, as
 Homenaje a Joan Prats
Mexico City 1980, cat. 10, as Homenaje
 a Joan Prats

London 1985, cat. 160, fig. 235 (repr., color, p. 221), as Homage to Joan Prats (Barcelona venue cat. 143)
Barcelona 1988b, cat. 25, repr. (color) p. 55
London 1989, repr. (color) n.p.

SELECTED REFERENCES
Erben 1959, pp. 74–75. Dupin 1962, pp. 255–56, 528, no. 353, repr. p. 257. Arras Gallery 1971, n.p. Wescher 1971, p. 191. Miró 1977, p. 117. Penrose 1981, pl. 660 (repr. p. 274; photograph of Prats in his office). Fundació Joan Miró 1988, repr. pp. 173 (color), 174. Raillard 1989, p. 100, repr. (color) p. 101.

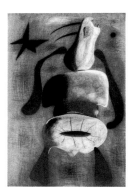

118. **WOMAN.** Montroig, October 1934. (Plate, p. 199)
Pastel on abrasive paper, 41⅜ × 29½″ (105 × 74.9 cm). Inscribed on verso: *Joan Miró Femme Octobre 1934.* Collection Richard S. Zeisler. Dupin 372

PROVENANCE
Pierre Matisse Gallery, New York; to Collection Richard S. Zeisler, December 1956.

SELECTED EXHIBITIONS
New York 1935, cat. 20, 21, 22, 23, or
 24, as Pastel
Waltham 1961, cat. 26, repr. n.p.
Paris 1962b, cat. 123
London 1964b, cat. 117, pp. 33–34,
 pl. 24a
New York 1972b, cat. 26, repr. (color)
 n.p.

Saint Louis 1980
Zurich 1986, cat. 92, repr. (color) n.p.
New York 1987a, cat. 76, repr. (color)
 p. 151
Berkeley 1990

SELECTED REFERENCES
Cahiers d'art 1935, repr. p. 95 (installation view). Greenberg 1948, pl. XXV (repr. p. 68). Dupin 1962, pp. 264–65, no. 372, repr. pp. 251 (color), 529. Gasser 1965, repr. (color) p. 36. Cooper 1972, n.p. Stich 1980, pp. 35–36, 37, fig. 26 (repr. p. 34). Schmalenbach 1982, repr. p. 34. Rowell 1986, p. 124. Erben 1988, repr. (color) p. 75. Stich 1990, pp. 61, 63, 67, pl. 71 (repr., color, p. 64).

119. **WOMAN** (The Opera Singer). Montroig, October 1934. (Plate, p. 198)
Pastel and pencil on abrasive paper, 41⅜ × 29⅛″ (105.1 × 74.2 cm). Inscribed on verso: *Joan Miró | "Femme" | Octobre 1934.* The Museum of Modern Art, New York. Gift of William H. Weintraub. Acq. no. 509.64. Dupin 378

PROVENANCE
The artist to Pierre Matisse Gallery, New York; to Mr. and Mrs. William H. Weintraub, New York; to The Museum of Modern Art, New York, June 1964.

SELECTED EXHIBITIONS
New York 1935, cat. 2, as The Singer
San Francisco 1935a, as Singer
Los Angeles 1935b, as Chanteuse
New York 1958d, cat. 1, repr. n.p., as
 Figure
Paris 1962b, cat. 133
New York 1973b, as Opera Singer

New York 1982, as Opera Singer (New
 York venue only)
New York 1987c, as Opera Singer
On view at The Museum of Modern Art,
 New York: September–November
 1972; July–September 1990; April–
 September 1991

SELECTED REFERENCES
M.M. 1935, p. 9. J.W.L. 1935, p. 21. *Art Digest* 1935, repr. p. 11. Greenberg 1948, repr. p. 18. Dupin 1962, pp. 264–65, no. 378, repr. p. 530. Rubin 1973, pp. 8, 68, 126, repr. p. 68. Rowell 1986, p. 124.

120. **PERSONAGE.** Montroig, October 1934. (Plate, p. 200)
Pastel on abrasive paper, 41¾ × 27⅞″ (106 × 69.5 cm). Inscribed on verso: *Joan Miró | "Figure" | Octobre 1934.* Private collection. Dupin 380

PROVENANCE
The artist to Pierre Matisse Gallery, New York; to A. Conger Goodyear, New York, by

1935; to Zaidee Bliss (later Mrs. A. Conger Goodyear), New York, by 1941; private collection, New York; present owner.

SELECTED EXHIBITIONS

New York 1935, cat. 20, 21, 22, 23, or 24, as *Pastel*
New York 1936d, cat. 437 (New York venue only)
New York 1941g, as *Figure* (New York venue only)
New York 1959b, cat. 55, as *Figure*

New York 1984c, cat. 13, repr. (color) p. 29
Zurich 1986, cat. 93, repr. (color) n.p., as *Femme*
New York 1987a, cat. 77, repr. (color) p. 152, as *Woman*

SELECTED REFERENCES

Cahiers d'art 1935, repr. p. 95 (installation view). Benson 1935, p. 299, repr. p. 299. Sweeney 1941, repr. p. 63. Soby 1959, p. 74, repr. (color) p. 79. Dupin 1962, pp. 264–65, no. 380, repr. p. 530. Rowell 1986, p. 124.

121. **HEAD OF A MAN.** [Barcelona, January 2, 1935]. (Plate, p. 201)

Oil on cardboard mounted on wood, 41½×29⅝″ (105.5×75.3 cm). Signed, in April 1959, lower left: *Miró*. Musée National d'Art Moderne, Centre Georges Pompidou, Paris. Gift, 1991. Dupin 402

PROVENANCE

Pierre Matisse Gallery, New York; to Musée National d'Art Moderne, Centre Georges Pompidou, Paris, 1991.

SELECTED EXHIBITIONS

Possibly Paris 1935e, as (?)
Possibly New York 1936c, cat. 17
New York 1958d, cat. 3, repr. n.p.
New York 1959b, cat. 57

London 1964b, cat. 233, p. 47
Saint-Paul-de-Vence 1990, cat. 43, p. 105, repr. (color) p. 105
Paris 1992, p. 86, repr. (color) p. 87

SELECTED REFERENCES

Westerdahl 1936, repr. p. 14. Prévert/Ribemont-Dessaignes 1956, repr. p. 129. F.P. 1958, p. 12. Erben 1959, p. 134, pl. 60. Soby 1959, p. 80, repr. (color) p. 82. Dupin 1962, p. 266, no. 402, repr. p. 532.

122. **PORTRAIT OF A YOUNG GIRL.** Barcelona, February 1, 1935. (Plate, p. 202)

Oil with sand on cardboard, 41⅜×29⅜″ (104.6×74.6 cm). Signed, in April 1959, lower right: *Miró*. Inscribed on verso: *Joan Miró | Portrait de jeune fille | 1-2-35*. New Orleans Museum of Art. Bequest of Victor K. Kiam. Dupin 405

PROVENANCE

Pierre Matisse Gallery, New York; to Mr. and Mrs. Victor K. Kiam, New York; to New Orleans Museum of Art, August 1977.

SELECTED EXHIBITIONS

San Francisco 1935a
Los Angeles 1935b
Chicago 1938, as (?)

New York 1944d, cat. 8
New York 1959b, cat. 58 (Los Angeles venue, cat. 58)

FJM 654b (3130 attached). 6½×7½″ (16.5×19.1 cm)

London 1964b, cat. 126, p. 35
Houston 1982
Barcelona 1988b, cat. 36, repr. (color) p. 67

London 1989, repr. (color) n.p.

SELECTED REFERENCES

Gilbert 1938. Jewett 1938a. *Chicago Daily News* 1938a. *Art News* 1944b, p. 21. Dupin 1962, p. 266, no. 405, repr. p. 532. Bonnefoy 1964, pl. 34 (color). Erben 1988, repr. (color) p. 76. Malet 1988b, p. 12. Malet 1989, p. 18.

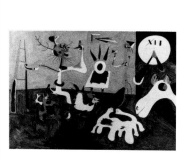

FJM 620a. 6½×7½″ (16.5×19.1 cm)

123. **THE FARMERS' MEAL.** [Barcelona, March 3, 1935]. (Plate, p. 203)

Oil on cardboard, 28¾×41″ (73×104.2 cm). Private collection. Dupin 407

PROVENANCE

The artist to Pierre Matisse Gallery, New York, 1935; to Thomas C. Adler, Cincinnati, 1944; present owner.

SELECTED EXHIBITIONS

Possibly Paris 1935e, as (?)
New York 1937c, as *The Farmer's Dinner*
Toledo 1938, cat. 75, as *Farmer's Dinner*
New York 1944d, cat. 7, as *The Farmer's Meal*
Cincinnati 1945, as *Farmer's Meal*
Cincinnati 1949, cat. 42, as *Farmer's Meal*

Cincinnati 1956, cat. 39, repr. n.p., as *Farmer's Meal*
New York 1961f, cat. 38, repr. n.p., as *Farmer's Meal*
London 1964b, cat. 127, p. 35, pl. 25a, as *The Farmer's Meal*

SELECTED REFERENCES

Cassanyes 1935, repr. p. 41. Breuning 1944, repr. p. 11. *Art News* 1944b, p. 21, repr. p. 21. Greenberg 1948, pl. XXXII (repr. p. 73). Faison 1949, repr. p. 4. *Cincinnati Art Museum News* 1949, repr. p. ii. Prévert/Ribemont-Dessaignes 1956, repr. p. 132. Guéguen 1957, repr. p. 41. Dupin 1962, p. 268, no. 407, repr. p. 532. Russell 1964, p. 10. Penrose 1969, p. 80, pl. 53 (repr. p. 80). Picon 1976, vol. 1, p. 103, repr. p. 103. Dupin 1985, p. 54.

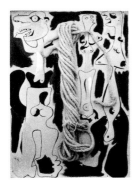

124. ROPE AND PEOPLE, I. Barcelona, March 27, 1935. (Plate, p. 204)

Oil on cardboard mounted on wood, with coil of rope, 41¼ × 29⅜″ (104.7 × 74.6 cm). Inscribed on verso: *Joan Miró | "Corde et personnages." | 27-3-35.* The Museum of Modern Art, New York. Gift of the Pierre Matisse Gallery. Acq. no. 71.36. Dupin 408

PROVENANCE
The artist to Pierre Matisse Gallery, New York, 1935; to The Museum of Modern Art, New York, October 1936.

SELECTED EXHIBITIONS
Possibly Paris 1935e, as (?)
New York 1936d, cat. 439, repr. p. 141, as *Rope and Personages*
New York 1941a, as (?)
New York 1941g, as *Rope and Persons* (New York venue only)
New York 1954, as *Rope and People*
New York 1970a, cat. 5, repr. n.p., as *Rope and People I*
New York 1973b, as *Rope and People I*
Paris 1974b, cat. 50, p. 122, repr. pp. 55 (color), 122, as *Corde et personnages I*

New York 1988
On view at The Museum of Modern Art, New York: January–February 1946; September 1957–April 1958; July 1964–June 1965; March–July 1967; June 1968–May 1969; September–December 1969; April 1970–December 1972; March–September 1973; January–April 1974; January 1975–November 1979; May 1984–August 1986; May–September 1990

SELECTED REFERENCES
Henry 1935, repr. p. 115. Westerdahl 1936, repr. p. 15. *Beaux-Arts* 1937a, repr. p. 3 (installation view). Devree 1937b, repr. p. 448. Jewell 1937c, repr. p. 10. Sweeney 1941, p. 62, repr. p. 64. Jewell 1941c, repr. (upside down). Jewell 1941d. *Aufbau* 1941b. *Boston Herald* 1941. *Art Digest* 1941c, p. 5. Greenberg 1948, pl. XXXV (repr. p. 75). Cirlot 1949, pp. 32, 36, 39. Duthuit 1953, fig. 10 (repr. p. 31). *Paris-Presse* 1954. Soby 1959, repr. p. 76. Taillandier 1962, p. 38, repr. p. 40. Dupin 1962, pp. 268, 281, 532, no. 408, repr. p. 321. Penrose 1969, pl. 58 (repr. p. 84). Wescher 1971, p. 192. Rubin 1973, pp. 7, 68, 127, repr. (color) p. 69. Gimferrer 1978, p. 26, fig. 25. Carmean 1980, pp. 40, 43, repr. p. 40. Rose 1982a, pp. 31, 32. McCandless 1982, p. 55. Dupin 1985, repr. p. 54. Rose 1992, p. 195.

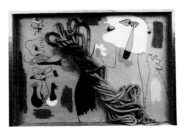

125. ROPE AND PEOPLE, II. Barcelona, March 29, 1935. (Plate, p. 205)

Oil and rope on cardboard, 29⅜ × 41¾″ (74.6 × 106.1 cm). Inscribed on verso: *Joan Miró | Corde et Personnages | 29.3.35.* The Morton G. Neumann Family Collection. Dupin 409

PROVENANCE
The artist to Pierre Matisse Gallery, New York, 1935; private collection, Paris, by March 1956; The Morton G. Neumann Family Collection.

SELECTED EXHIBITIONS
Paris 1935e, as (?)
Paris 1938a, cat. 140, as *Corde et personnage*
Basel 1956, cat. 40, repr. n.p., as *Corde et personnages*
Chicago 1961, cat. 20, repr. n.p., as *Cord*

[sic] *et personnages*
Madrid 1964, repr. n.p., as *Cuerda y personajes*
Washington 1980b, cat. 56, as *Rope and People II*

SELECTED REFERENCES
Cassanyes 1935, repr. p. 41. Raynal 1935, repr. p. 5. Cousin Pons 1935, p. 4. Cirlot 1949, pp. 32, 36, 39. *Paris-Presse* 1954. Courthion 1956, repr. (color) p. 44. Hüttinger 1957, pp. 23–24, fig. 25. Dupin 1962, pp. 268, 281, no. 409, repr. p. 532. Wescher 1971, p. 192. Carmean 1980, p. 40, repr. pp. 41 (color), 65. Rose 1982a, pp. 31, 32. Rose 1992, p. 195.

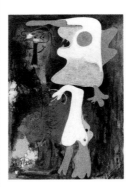

126. TWO PERSONAGES. [Barcelona, April 10, 1935]. (Plate, p. 207)

Oil, nails, cheesecloth, string, and sand on cardboard, 41½ × 29⅜″ (105.4 × 74.6 cm). The Kreeger Foundation. Dupin 410

PROVENANCE
The artist to Pierre Matisse Gallery, New York, 1935; Patricia Matta Echaurren, New York, by 1948; Jacques and Natasha Gelman, Mexico City; The New Gallery, New York; to Richard L. Feigen & Co., Chicago, and E. V. Thaw & Co., New York, May 1962; to Mr. and Mrs. David Lloyd Kreeger, Washington, D.C., May 1962; to The Kreeger Foundation.

SELECTED EXHIBITIONS
Possibly Paris 1935e, as (?)
New York 1958d, cat. 4, repr. n.p.
London 1964b, cat. 128, p. 35, pl. 25b, as *Two People*

Washington 1965, cat. 15, pp. 8, 37, repr. p. 25

SELECTED REFERENCES
Cassanyes 1935, repr. p. 40. Greenberg 1948, pl. XXX (repr. p. 71). Prévert/Ribemont-Dessaignes 1956, repr. p. 131. Dupin 1962, pp. 266, 268, 532, no. 410, repr. p. 322. Penrose 1969, p. 85, pl. 57 (repr., color, p. 83). Wescher 1971, p. 192. Stich 1980, pp. 38–39. Martín 1982, p. 178.

127. TWO WOMEN. [Barcelona, April 13, 1935]. (Plate, p. 206)

Oil and sand on cardboard, 29½ × 41⅜″ (75 × 105 cm). Sprengel Museum, Hannover. Dupin 412

PROVENANCE
Pierre Matisse Gallery, New York; to Douglas Cooper, London, March 2, 1937; to The Mayor Gallery, London, June 1938; to D. Mitronovic, London, 1938; J. Berthod Urvater, Brussels and Rhode-Saint-Genèse; to Galerie Rosengart, Lucerne, 1965; to Bernhard Sprengel, Hannover, 1969; to Sprengel Museum, Hannover, 1969.

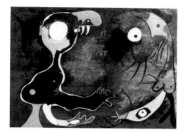

SELECTED EXHIBITIONS
Possibly Paris 1935e, as (?)
New York 1936a, cat. 5
London 1937b, cat. 20, as *Deux
 Personages* [*sic*]
London 1938a, cat. 9
London 1950, cat. 11 (incorrectly dated
 1925)

Brussels 1956, cat. 38, repr. n.p.
Otterlo 1957, cat. 97, repr. (color) n.p.
Munich 1969, cat. 45, repr. n.p.
Lucerne 1988, cat. 49, repr. (color)
 p. 144

SELECTED REFERENCES
McBride 1936a, p. 16. Morsell 1936, p. 5. Westerdahl 1936, repr. p. 16. Dupin 1956,
p. 103, repr. (color) n.p. J.L. 1958, p. 178. Miró 1959, repr. p. 29. Dupin 1962, p.
268, no. 412, repr. p. 532. Moeller 1985, no. 384, p. 412, repr. (color) p. 413.

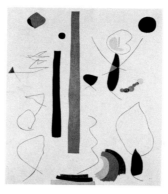

SELECTED EXHIBITIONS
Possibly Paris 1935e, as (?)
New York 1948b, cat. 6
Los Angeles 1967, p. 34, repr. (color)
 p. 35

New York 1968a, cat. 242
Los Angeles 1975, cat. 111, pp. 115, 213,
 repr. (color) p. 114

SELECTED REFERENCES
Hess 1948, p. 33. Dupin 1962, p. 282, no. 416, repr. (upside down) p. 533. Rubin
1968, p. 132, fig. 193 (repr. p. 134). Sandler 1968, repr. p. 26. Lader 1982, repr.
p. 86.

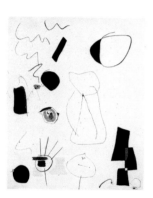

128. ANIMATED LANDSCAPE. [Barcelona, late spring 1935]. (Plate, p. 208)

Oil on canvas, 8' 2¼" × 6' 6¾" (250 × 200 cm). Signed lower right: *Miró.* Private
collection. Dupin 415

PROVENANCE
[Galerie Pierre, Paris]; Pierre Matisse Gallery, New York; Etablissement Vie des Arts,
Vaduz; to present owner, 1984.

SELECTED EXHIBITIONS
Possibly Paris 1935e, as (?)
Possibly London 1936c, cat. 212
Possibly Paris 1937e, cat. 120
London 1964b, cat. 129, p. 35, pl. 26a
Tokyo 1966, cat. 49, repr. p. 105

Knokke 1971, cat. 21, repr. p. 39
Zurich 1986, repr. (color) p. 41
Barcelona 1988b, cat. 40, repr. (color)
 p. 71

SELECTED REFERENCES
Dupin 1962, p. 282, no. 415, repr. p. 532. Malet 1988b, p. 13.

129. ANIMATED FORMS. [Barcelona, late spring 1935]. (Plate, p. 209)

Oil on canvas, 6' 4½" × 68¼" (194.3 × 173.3 cm). Signed lower right: *Miró.* Los
Angeles County Museum of Art. David E. Bright Bequest. Dupin 416

PROVENANCE
Pierre Matisse Gallery, New York; to David E. Bright, Los Angeles; to Los Angeles
County Museum of Art, July 1967.

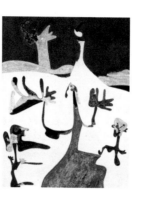

130. PERSONAGES IN FRONT OF A VOLCANO. Montroig, October 9–14, 1935. (Plate, p. 210)

Tempera on masonite, 15¾ × 11¾" (40 × 30 cm). Signed lower center: *Miró.*
Inscribed on verso: *Joan Miró | "Figures devant un volcan" | 9/10–14/10/35.*
Collection Mrs. Roy J. Friedman. Dupin 420

PROVENANCE
Pierre Matisse Gallery, New York; to Theodore Schemmp & Co., New York; to Mr.
and Mrs. Roy J. Friedman, Chicago.

SELECTED EXHIBITIONS
Chicago 1961, cat. 21, repr. n.p.

SELECTED REFERENCES
Greenberg 1948, pl. XXXIV (repr. p. 74). Dupin 1962, pp. 285, 533, no. 420, repr.
p. 323 (incorrectly dated December 9–14, 1935). Bonnefoy 1964, p. 5. Stich 1980,
p. 40.

131. MAN AND WOMAN IN FRONT OF A PILE OF EXCREMENT. Montroig, October 15–22, 1935. (Plate, p. 210)

Oil on copper, 9⅛ × 12⅝" (23.2 × 32 cm). Signed center right: *Miró.* Inscribed on
verso: *Joan Miró | "Homme et femme devant | un tas d'excréments" | 15/10–22/10/35.
| 140.* Fundació Joan Miró, Barcelona. Dupin 426

PROVENANCE
The artist to Pilar Juncosa de Miró; to Fundació Joan Miró, Barcelona, June 1975.

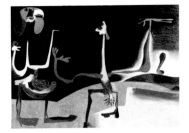

SELECTED EXHIBITIONS

London 1964b, cat. 135, p. 36, repr. n.p.
Tokyo 1966, cat. 52, p. 22, repr. p. 106
Saint-Paul-de-Vence 1968, cat. 29, repr.
 p. 82
Barcelona 1968, cat. 36
Munich 1969, cat. 47, repr. (color) n.p.
Paris 1974b, cat. 52, p. 122, repr. p. 122
Humlebaek 1974, cat. 23
Barcelona 1975a, cat. 22, repr. (color)
 p. 41
Madrid 1978a, cat. 33, pp. 104–05, repr.
 (color) p. 56
London 1978, cat. 12.96
Milan 1981, repr. (color) p. 53
Edinburgh 1982, cat. 12, repr. (color)
 p. 21

London 1985, cat. 155, fig. 73 (repr.
 p. 75)
Zurich 1986, cat. 100, repr. (color) n.p.
New York 1987a, cat. 85, repr. (color)
 p. 163
Paris 1987b, cat. 119, repr. (color) p. 178
 (Paris venue only)
Barcelona 1988a, p. 22, repr. (color)
 p. 71
Barcelona 1988b, cat. 41, repr. (color)
 p. 73
London 1989, repr. (color) n.p.
Berkeley 1990

SELECTED REFERENCES

Dupin 1962, pp. 285, 533, no. 426 (incorrectly dated 1936), repr. (color) p. 259.
Lassaigne 1963, pp. 76–77. Bonnefoy 1964, pp. 5, 22. Penrose 1969, pp. 82, 85, pl.
56 (repr., color, p. 82). Picon 1971, p. 14. Rowell 1976, repr. p. 68. Miró 1977, p. 89.
Gimferrer 1978, pp. 154, 202, fig. 148 (color). Stich 1980, pp. 41–42, fig. 35 (repr. p.
42). Dorfles 1981, p. 15. Picon 1981, p. 45. Malet 1983b, fig. 45 (color). Bouret 1986,
n.p. Rowell 1986, p. 292. Erben 1988, repr. (color) p. 80. Fundació Joan Miró 1988,
repr. pp. 131 (color), 182. Malet 1988b, pp. 12, 13. Jeffett 1988, p. 19. Malet 1989, pp.
18, 20. Jeffett 1989a, p. 31. Stich 1990, pp. 152, 154, pl. 192 (repr., color, p. 152).
Tamblyn 1991, p. 161, repr. n.p.

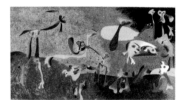

132. FIGURES AND BIRDS IN A LANDSCAPE. [Montroig and Barcelona], October 23–November 8, 1935. (Plate, p. 211)

Tempera on masonite, 10⅞ × 19½″ (27.6 × 49.5 cm). Signed upper center: *Miró*.
Inscribed on verso: *Joan Miró.* | *Figures et oiseaux dans un paysage* | *23/10–
8/11/35.* The Baltimore Museum of Art. Bequest of Saidie A. May, BMA 1951.340.
Dupin 419

PROVENANCE

Galerie Pierre, Paris; to Saidie A. May, Baltimore, 1938; to The Baltimore Museum
of Art, 1951.

SELECTED EXHIBITIONS

Baltimore 1950, cat. 83 Baltimore 1972, p. 77, repr. p. 77
Denver 1954, cat. 49

SELECTED REFERENCES

Gallatin 1936, repr. n.p. (photograph of Miró in his studio). Dupin 1962, p. 285, no.
419, repr. p. 533.

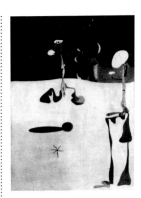

133. NOCTURNE. [Barcelona], November 9–16, 1935. (Plate, p. 211)

Oil on copper, 16½ × 11½″ (42 × 29.2 cm). Signed upper left: *Miró*. Inscribed on
verso: *Joan Miró* | *"Nocturne"* | *9/11–16/11/35.* The Cleveland Museum of Art. Mr.
and Mrs. William H. Marlatt Fund. Dupin 425

PROVENANCE

Paul Eluard, Paris; to Roland Penrose, London, June 27, 1938; to E. V. Thaw & Co.,
New York, September 1976; to The Cleveland Museum of Art, November 20, 1978.

SELECTED EXHIBITIONS

Paris 1938a, cat. 141, repr. p. 49 Exeter 1967, cat. 95, repr. n.p.
London 1939a, cat. 18 Barcelona 1968, cat. 33
London 1948, cat. 152 Munich 1969, cat. 46, repr. n.p.
Brussels 1956, cat. 39 Knokke 1971, cat. 22
New York 1959b, cat. 59 Munich 1972, cat. 332, repr. n.p.
Paris 1962b, cat. 62 Paris 1972, cat. 317, repr. n.p.
London 1964b, cat. 133, pp. 35–36, Paris 1974b, cat. 51, p. 122, repr. p. 122
 pl. 26b Humlebaek 1974, cat. 22
Tokyo 1966, cat. 50, repr. p. 105 Cleveland 1979, cat. 29, repr. p. 77

SELECTED REFERENCES

Soby 1959, repr. p. 84. Dupin 1962, p. 285, no. 425, repr. p. 533. Henning 1979,
pp. 237, 239, 240 (n. 3), repr. (color) cover, fig. 4 (repr., detail, p. 237). Gateau 1982,
p. 347.

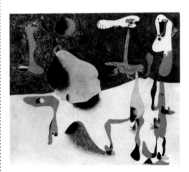

134. PERSONAGES IN THE PRESENCE OF A METAMORPHOSIS.
Barcelona, January 20–31, 1936. (Plate, p. 212)

Tempera on masonite, 19¾ × 22⅝″ (50.2 × 57.5 cm). Signed upper right: *Miró*.
Inscribed on verso: *Joan Miró* | *"Figures devant une métamorphose"* | *20/1–31/1/36.*
New Orleans Museum of Art. Bequest of Victor K. Kiam. Dupin 421

PROVENANCE

Dorothy Joralemon, Berkeley; Pierre Matisse Gallery, New York; to Victor K. Kiam,
New York, June 1957; to New Orleans Museum of Art, August 1977.

SELECTED EXHIBITIONS

New York 1936c, cat. 18, repr. n.p., as *Front of a Metamorphosis*
 Figures in the Presence of a New York 1958d, cat. 7, repr. n.p., as
 Metamorphosis *Personnages en présence d'une*
New York 1948b, cat. 7, as *Figures in* *métamorphose*

New York 1959b, cat. 60, as *Persons in the Presence of a Metamorphosis*
London 1964b, cat. 134, p. 35, as *People in the Presence of a Metamorphosis*
Washington 1980a, cat. 23, repr. (color) p. 72, as *Persons in the Presence of a Metamorphosis*
Houston 1982, as *Persons in the Presence of a Metamorphosis*
Edinburgh 1982, cat. 11, repr. (color) p. 20
Orléans 1984, cat. 42, pp. 92–94, repr. p. 93, as *Figures dans la présence*
d'une métamorphose
Zurich 1986, cat. 96, repr. (color) n.p., as *Personnages devant une métamorphose*
New York 1987a, cat. 81, repr. (color) p. 158
Barcelona 1988b, cat. 43, repr. (color) p. 75
London 1989, repr. (color) n.p., as *Figures in Front of a Metamorphosis*
Saint-Paul-de-Vence 1990, cat. 45, p. 110, repr. (color) p. 111, as *Personnages devant une métamorphose*

SELECTED REFERENCES
Davidson 1936, repr. p. 11. Gallatin 1940, repr. n.p. (photograph of Miró in his studio). Greenberg 1948, pl. XLI (repr. p. 79). Prévert/Ribemont-Dessaignes 1956, repr. p. 136. F.P. 1958, p. 12. Soby 1959, repr. p. 87. Schwartz 1959, p. 151. Dupin 1962, p. 285, no. 421, repr. p. 533. Lassaigne 1963, p. 77. Rubin 1973, repr. frontispiece (photograph of Miró in his studio). Millard 1980, p. 26. McCandless 1982, fig. 53 (repr. p. 61). D'Harnoncourt 1987, repr. p. 2 (photograph of Miró in his studio). Erben 1988, repr. (color) p. 78.

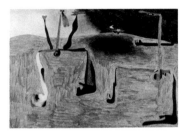

135. THE TWO PHILOSOPHERS. Barcelona, February 4–12, 1936. (Plate, p. 212)
Oil on copper, 14×19⅝″ (35.6×49.8 cm). Inscribed on verso: *Joan Miró | "Les Deux Philosophes" | 4/2–12/2/36.* The Art Institute of Chicago. Gift of Mary and Leigh Block. Dupin 427

PROVENANCE
The artist to Pierre Matisse Gallery, New York, 1936; to Mary and Leigh Block, Chicago, January 1960; to The Art Institute of Chicago, 1988.

SELECTED EXHIBITIONS
New York 1936c, cat. 22
New York 1958d, cat. 5, repr. n.p.
London 1964b, cat. 136, p. 36

SELECTED REFERENCES
Gallatin 1936, repr. n.p. (photograph of Miró in his studio). Dupin 1962, p. 285, no. 427, repr. p. 533. Penrose 1969, p. 80, pl. 54 (repr. p. 81).

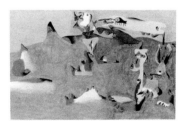

136. PERSONS ATTRACTED BY THE FORM OF A MOUNTAIN. [Barcelona, February 15–29, 1936]. (Plate, p. 213)
Tempera on masonite, 12¾×19½″ (32.3×49.5 cm). Signed center left: *Miró.* The Baltimore Museum of Art. Bequest of Saidie A. May, BMA 1951.338. Dupin 422

PROVENANCE
Pierre Matisse Gallery, New York; to Saidie A. May, Baltimore, 1938; to The Baltimore Museum of Art, 1951.

SELECTED EXHIBITIONS
New York 1936c, cat. 20, as *Figures Attracted by the Shape of a Mountain*
New York 1941g (New York venue only)
Baltimore 1950, cat. 81, as *Persons Attracted by the Form of a Mountain*
(Figures in the Presence of a Metamorphosis)
New York 1959b, cat. 63
Baltimore 1972, p. 78, repr. p. 78

SELECTED REFERENCES
Devree 1937a, p. 60. Sweeney 1941, p. 80. Rubin 1959, repr. p. 39. Soby 1959, p. 80, repr. p. 85. Dupin 1962, p. 285, no. 422, repr. p. 533. Lassaigne 1963, p. 77. Penrose 1969, p. 80.

137. SEATED PERSONAGES. Barcelona, March 10–21, 1936. (Plate, p. 213)
Oil on copper, 17⅜×13¾″ (44×35 cm). Signed center right: *Miró.* Inscribed on verso: *Joan Miró | Personnages Assis | 10/3–21/3/36.* Private collection. Dupin 428

PROVENANCE
Pierre Matisse Gallery, New York; private collection, Philadelphia; present owner.

SELECTED EXHIBITIONS
London 1964b, cat. 137, p. 36, as *Seated People*
Tokyo 1966, cat. 53, repr. p. 107
New York 1975a, cat. 109, repr. p. 51
Houston 1982
Zurich 1986, cat. 97, repr. (color) n.p.
New York 1987a, cat. 82, repr. (color) p. 159
Düsseldorf 1987, cat. 66, repr. p. 153
Berkeley 1990

SELECTED REFERENCES
Greenberg 1948, pl. XXXVIII (repr. p. 77). Dupin 1962, pp. 285, 533, no. 428, repr. p. 325. Rose 1982a, fig. 16 (repr. p. 20; incorrectly dated 1935–36). Erben 1988, repr. (color) p. 81. Stich 1990, p. 152, pl. 193 (repr., color, p. 153).

138. PERSONAGES, MOUNTAINS, SKY, STAR, AND BIRD. Barcelona, April 6–16, 1936. (Plate, p. 214)
Tempera on masonite, 11¾×15¾″ (30×40 cm). Signed center right: *Miró.* Inscribed on verso: *Joan Miró | "Personnages, montagnes, ciel, étoile et oiseau." | 6/4–16/4/36.* Private collection. Dupin 423

PROVENANCE
The artist to present owner, c. 1937.

SELECTED EXHIBITIONS
Paris 1937e, cat. 104, as *Personnages, montagnes, ciel étoilé, oiseau*
Paris 1974b, cat. VIII, p. 174, repr. p. 174, as *Personnages, montagnes, étoiles et oiseau*
Saint-Paul-de-Vence 1990, cat. 46, p. 106, repr. (color) p. 106, as *Personnages, montagnes, étoile et oiseau*

SELECTED REFERENCES
Raynal 1947, pl. 50 (color). Queneau 1949, fig. 7. Dupin 1962, p. 285, no. 423, repr. p. 533. Walton 1966, p. 33, pl. 68 (color).

SELECTED EXHIBITIONS
New York 1936c, cat. 19
New York 1959b, cat. 62
Tokyo 1966, cat. 51, repr. (color) p. 57
Houston 1982, pl. 17 (color)
Zurich 1986, cat. 98, repr. (color) n.p.
New York 1987a, cat. 83, repr. (color) p. 161
Saint-Paul-de-Vence 1990, cat. 44, p. 107, repr. (color) p. 107
Frankfurt 1991, cat. 102, repr. (color) p. 218

SELECTED REFERENCES
Viot 1936, repr. p. 260. Greenberg 1948, repr. (color) n.p. Duthuit 1953, repr. (color) p. 18. Soby 1959, repr. p. 86. Dupin 1962, pp. 285, 533, no. 424, repr. p. 324. Erben 1988, repr. (color) p. 79.

139. CATALAN PEASANT AT REST. Barcelona, April 17–25, 1936. (Plate, p. 215)

Oil on copper, 13¾×10¼″ (35×26 cm). Signed upper right: *Miró*. Inscribed on verso: *Joan Miró.* | *"Paysan catalan au repos"* | *17/4–25/4/36.* Collection Masaveu, Spain. Dupin 429

PROVENANCE
Pierre Matisse Gallery, New York; to Douglas Cooper, London, March 2, 1937 (on consignment to The Mayor Gallery, London, 1938, and to Galerie Melki, Paris, 1973); to the Douglas Cooper Estate (consigned to Christie's, London; sold March 28, 1988, lot 39); to Collection Masaveu, Spain.

SELECTED EXHIBITIONS
New York 1936c, cat. 21, as *Catalonian Peasant Resting*
London 1937b, cat. 23
London 1938a, cat. 17, as *Catalan Peasant Resting*
Paris 1974a, cat. 10, repr. pp. 27 (color), 63
Zurich 1986, cat. 99, repr. (color) n.p.
New York 1987a, cat. 84, repr. (color) p. 162
Barcelona 1988b, cat. 42, repr. (color) p. 74

SELECTED REFERENCES
Beaux-Arts 1937c, p. 8. Dupin 1962, p. 285, no. 429, repr. p. 533. Bonnefoy 1964, p. 22. Dupin 1985, p. 54. Erben 1988, repr. (color) p. 82.

FJM 1449b. 5¼×6¾″ (13.4×17.1 cm)

140. PERSONAGES AND MOUNTAINS. [Barcelona, May 11–22, 1936]. (Plate, p. 214)

Tempera on masonite, 11⅞×9⅞″ (30.2×25.1 cm). Signed upper right: *Miró.* Inscribed on verso: *Joan Miró* | *Personnages et montagnes.* Private collection. Dupin 424

PROVENANCE
The artist to Pierre Matisse Gallery, New York, 1936; to Mr. and Mrs. Lee Ault, New York, 1948; Perls Galleries, New York; to Richard L. Feigen & Co., New York, March 1965; to Mr. and Mrs. David Lloyd Kreeger, Washington, D.C., March 1965; through Richard L. Feigen & Co., New York, to present owner, January 1979.

141. PAINTING. Montroig and Barcelona, July–October 1936. (Plate, p. 216)

Oil, casein, tar, and sand on masonite, 30¼×42⅛″ (77×107 cm). Inscribed on verso: *Joan Miró.* | *"Peinture"* | *été 1936.* | *appartient à mlle. Dolores Miró.* Private collection. Dupin 448

SELECTED EXHIBITIONS
Possibly Paris 1937g, as (?)
Palma de Mallorca 1990a, repr. (color) p. 55

SELECTED REFERENCES
Dupin 1962, pp. 287–89, 535, no. 448, repr. p. 327.

142. PAINTING. Montroig and Barcelona, July–October 1936. (Plate, p. 217)

Oil, gravel, and pebbles on masonite, 31×42⅝″ (78.7×108.3 cm). Signed lower right: *Miró.* Inscribed on verso: *Joan Miró* | *"Peinture"* | *été 1936.* The Art Institute of Chicago. Gift of Florene May Schoenborn and Samuel A. Marx. Dupin 459

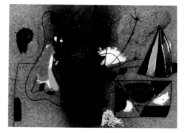

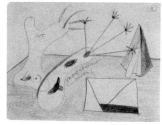

FJM 1441b. 5¼ × 6¾″ (13.4 × 17.1 cm)

PROVENANCE
The artist to Galerie Pierre, Paris, 1936; Pierre Matisse Gallery, New York; Florene and Samuel A. Marx, Chicago; to The Art Institute of Chicago, 1950.

SELECTED EXHIBITIONS
Possibly Paris 1937g, as (?)
New York 1965b, p. 49, repr. p. 49

SELECTED REFERENCES
Duthuit 1936a, repr. p. 265. Greenberg 1948, pl. XXXVI (repr. p. 76). Dupin 1962, pp. 287–89, no. 459, repr. p. 535.

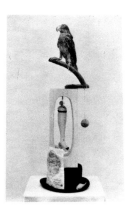

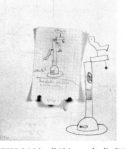

FJM 1403a (1404 attached). 8¼ × 6⅛″ (21 × 15.5 cm)

143. OBJECT. [1936]. (Plate, p. 218)

Assemblage: stuffed parrot on wood perch, stuffed silk stocking with velvet garter and doll's paper shoe suspended in hollow wood frame, derby hat, hanging cork ball, celluloid fish, and engraved map,* 31⅞ × 11⅞ × 10¼″ (81 × 30.1 × 26 cm). Signed bottom of parrot's stand: miró. The Museum of Modern Art, New York. Gift of Mr. and Mrs. Pierre Matisse. Acq. no. 940.65a–c. No Dupin number
(*Note: The original map disintegrated and the original fish disappeared; both have been replaced.)

PROVENANCE
The artist to Pierre Matisse Gallery, New York; to Mrs. Kenneth F. Simpson, New York; to Mr. and Mrs. Pierre Matisse, New York; to The Museum of Modern Art, New York, December 1965.

SELECTED EXHIBITIONS

New York 1936d, cat. 444, repr. p. 142 (New York venue only)
New York 1959b, cat. 64, as *Objet poétique* (New York venue only)
New York 1961c, cat. 153, repr. p. 63, as *Objet poétique* (New York venue only)
New York 1968a, cat. 243, as *Poetic Object*
New York 1973b
Paris 1974b, cat. 220, p. 150, repr. p. 150, as *Objet poétique*

New York 1987a, cat. 80, repr. (color) p. 157
On view at The Museum of Modern Art, New York: July–November 1971; May 1972–September 1973; January–April 1974; January 1975–March 1980; October 1980–January 1982; March 1982–January 1984; May 1984–May 1987; September 1987–August 1992; September 1992–February 1993

SELECTED REFERENCES
Hugnet 1936, p. 31. Jewell 1936a, p. L25. *New York Herald Tribune* 1936b, p. 23.

Jewell 1936b, repr. p. X11. *Gloversville Herald* 1937, repr. Connolly 1951, repr. (color) p. 152. Prévert/Ribemont-Dessaignes 1956, repr. p. 50. Soby 1959, repr. p. 77. Kramer 1959, p. 49, repr. p. 48. Revel 1964, repr. p. 3. Rubin 1968, p. 146, fig. 222 (repr. p. 147). Kramer 1968, repr. p. 109. Penrose 1969, pl. 106 (repr. p. 142). Wescher 1971, p. 215. Sylvester 1972, p. 9, repr. p. 4. Rubin 1973, pp. 8, 70–71, 127–28, repr. (color) p. 71. Jouffroy/Teixidor 1974, no. 19, repr. p. 12. Sylvester 1974, p. 10. Miró 1977, p. 183. Gimferrer 1978, pp. 26, 104, fig. 28. Théberge 1986, pp. 46–47, fig. 3 (repr. p. 47). Pierre 1987, p. 170, fig. 54. Jeffett 1989c, p. 8, repr. p. 4.

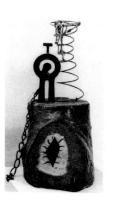

FJM 1402b. 8¼ × 6⅛″ (21 × 15.5 cm)

144. OBJECT OF SUNSET. [1936]. (Plate, p. 219)

Assemblage: painted wood, metal, and string, 26¾ × 17⅜ × 10¼″ (68 × 44 × 26 cm). Signed center right: *Miró*. Musée National d'Art Moderne, Centre Georges Pompidou, Paris, 1975. Dupin 488

PROVENANCE
The artist to Pierre Matisse Gallery, New York; to André Breton, Paris, 1937?; to Elisa Breton, Paris, 1966; to Musée National d'Art Moderne, Centre Georges Pompidou, Paris, 1975.

SELECTED EXHIBITIONS

Possibly Paris 1937b, as (?)
Possibly Paris 1938a, cat. 143, as (?)
Paris 1959c, as *Le Tronc d'arbre*
London 1964b, cat. 154, p. 39, pl. 29a
Saint-Paul-de-Vence 1973a, cat. 6, repr. (color) p. 57

Paris 1974b, cat. 221, p. 150
Paris 1976, p. 2
Madrid 1981, cat. 86, repr. (color) n.p.
Paris 1986, cat. 201, repr. (color) p. 176
Paris 1991, repr. p. 311

SELECTED REFERENCES
Dictionnaire abrégé 1938, repr. p. 70. Dupin 1962, no. 488, repr. p. 537. Penrose/Gomis/Prats 1966, pl. LXVI (color). Penrose 1969, pl. 107 (repr. p. 143). Sylvester 1972, p. 9, repr. p. 10. Rubin 1973, p. 130 (n. 2), fig. 61 (repr. p. 130). Jouffroy/Teixidor 1974, no. 21, repr. (color) p. 13. Sylvester 1974, p. 10. Miró 1977, pp. 135, 136, 182, 213, repr. p. 70. Joffroy 1979, repr. p. 38 (photograph of Breton's studio). Bouret 1986, n.p. Malet 1986, p. 20. Rowell 1986, ill. 15. Beaumelle 1987, pp. 433–34, repr. (color) p. 430. Jeffett 1989c, p. 8, repr. p. 8. Raillard 1989, p. 106, repr. (color) p. 107. Rowell 1991, p. 181. Combalía 1992, p. 189.

145. STILL LIFE WITH OLD SHOE. Paris, January 24–May 29, 1937. (Plate, p. 227)

Oil on canvas, 32 × 46″ (81.3 × 116.8 cm). Inscribed on verso, on stretcher: *Joan Miró | Nature Morte au Vieux Soulier | 24-I-29-V-1937*. The Museum of Modern Art, New York. Gift of James Thrall Soby. Acq. no. 1094.69. Dupin 473

PROVENANCE
Pierre Matisse Gallery, New York, by February 1938; to Mr. and Mrs. C. Earle Miller, Downingtown, Pa., by November 1941; to Pierre Matisse Gallery, New York, 1943?; to James Thrall Soby, Farmington and New Canaan, Conn., March 15, 1944; to The Museum of Modern Art, New York, February 1969.

SELECTED EXHIBITIONS

Paris 1937e, cat. 116
New York 1938a, cat. 8, as *Le Vieux Soulier*
New York 1938b, cat. 1
New York 1941g (New York venue only)
Chicago 1943, cat. 2
San Francisco 1948, cat. 55, repr. p. 103
Venice 1954, cat. 14, repr. n.p.
New York 1955, cat. 100
New York 1957a, cat. 56, as *Still Life: Old Shoes*
Boston 1957b, cat. 95, pl. 118
New York 1958c
New York 1959b, cat. 65 (Los Angeles venue, cat. 64)
New York 1961a, cat. 51, pp. 19, 56, repr. (color) p. 17
Paris 1962a, cat. 43, repr. n.p.
Paris 1962b, cat. 69
London 1964b, cat. 147, pp. 9, 37–38, pl. 28a
Tokyo 1966, cat. 57, p. 22, repr. (color) p. 59
New York 1968a, cat. 244 (New York venue only)
Saint-Paul-de-Vence 1968, cat. 32, repr. (color) p. 44

Barcelona 1968, cat. 37, pl. X (repr., color, p. 28), as *Bodegón del zapato viejo*
New York 1971, cat. 39
Saint-Paul-de-Vence 1973b, cat. 806, repr. (color) p. 300
New York 1973b
London 1978, cat. 12.97, repr. (color) n.p.
Washington 1980a, cat. 26, repr. (color) p. 75
São Paulo 1981, pp. 112–13, repr. p. 113
Houston 1982, pl. 19 (color)
London 1985, cat. 156, fig. 70 (repr., color, p. 71) (London venue only)
Zurich 1986, cat. 101, repr. (color) n.p.
New York 1987a, cat. 86, repr. (color) p. 165
Paris 1987b (Madrid venue only)
Barcelona 1988b, cat. 57, repr. (color) p. 89
London 1989, repr. (color) n.p.
On view at The Museum of Modern Art, New York: November 1970–February 1971; March–May 1979; September 1979–February 1980; June–September 1983

SELECTED REFERENCES

Cheronnet 1937b, p. 8. *Minotaure* 1937, repr. p. 31. Morris 1938, p. 33, repr. n.p. *New York Post* 1938a, repr. p. 12. *New York Post* 1938b, p. 12. A.M.F. 1938, p. 13. *New York Times* 1938b, p. X7. *Art Digest* 1938b, p. 21. Sweeney 1941, pp. 68, 70, 72, repr. p. 68. Jewell 1941c. Venturi 1947, pl. 212. Sweeney 1948, p. 210. Cirici-Pellicer 1949, p. 36, ill. 46 (incorrectly credited to collection C. Earle Miller, Downingtown, Pa.). Cirlot 1949, p. 32. *MoMA Bulletin* 1955, repr. p. 28 (installation view). Prévert/Ribemont-Dessaignes 1956, p. 82. *MoMA Bulletin* 1958, p. 30, repr. p. 30. *Art in America* 1958–59, fig. 2 (repr. p. 87). Erben 1959, p. 134. Rubin 1959, p. 39. Soby 1959, pp. 31, 80, 83, 88, repr. (color) p. 89. Soby 1961, p. 71, repr. p. 68. *Arts* 1961, repr. (color) p. 29. Revel 1962, repr. p. 72. Schneider 1962, p. 48. Dupin 1962, pp. 293–94, 296, 297, 303, 304, 495, 537, no. 473, repr. (color) p. 267. Lassaigne 1963, pp. 77–78. Bonnefoy 1964, p. 22, pl. 36 (color). Roberts 1964, p. 479. Gasser 1965, pp. 74, 76, repr. (color) p. 57. Walton 1966, p. 33, pl. 69 (color). Juin 1967, repr. p. 12. Rubin 1968, p. 132. Penrose 1969, pp. 85–86, 96, 187, pl. 60 (repr., color, p. 87). Picon 1971, p. 14. Marchiori 1972, p. 29. Rubin 1973, pp. 8, 19, 72–74, 76, 111, 128, 134 (n. 5), repr. (color) p. 73. Leymarie 1974a, p. 16. Teixidor 1974, p. 94. Rowell 1976, p. 61, repr. p. 70. Gimferrer 1978, pp. 154, 202, fig. 149 (color). Marie-Louise Jeanneret Art Moderne 1979, repr. p. 6. Millard 1980, pp. 27–28, 30. Picon 1981, p. 45. Rose 1982a, p. 33. Malet 1983b, fig. 51 (color). Dupin 1985, p. 54, repr. p. 54. Bouret 1986, n.p. Malet 1986, pp. 19–20. Rowell 1986, pp. 145, 146–47, 156, 157, 182, 183, 209, 231, 232, 292, 293–94, 307 (n. 6), 315 (n. 3), ill. 17. Beaumelle 1987, p. 430. Dupin 1987b, p. 42. Reina Sofía 1987, p. 95. Erben 1988, repr. (color) p. 83. Malet 1988a, p. 22, repr. Malet 1988b, p. 13. Jeffett 1988, p. 19. Malet 1989, pp. 18, 19. Jeffett 1989a, p. 31. Combalía 1992, p. 189. Yokohama Museum of Art 1992, fig. 9 (repr. p. 31).

146. SELF-PORTRAIT I. Paris, October 1937–March 1938. (Plate, p. 228)

Pencil, crayon, and oil on canvas, 57½ × 38¼″ (146.1 × 97.2 cm). Signed upper right: *Miró*. Inscribed on verso: *Joan Miró | Autoportrait I | 1937–38*. The Museum of Modern Art, New York. James Thrall Soby Bequest. Acq. no. 1238.79. Dupin 489

PROVENANCE

Pierre Matisse (Pierre Matisse Gallery), New York, by January 1939; to James Thrall Soby, New Canaan, Conn., July 1949; to The Museum of Modern Art, New York, December 1979.

SELECTED EXHIBITIONS

Possibly Paris 1939a, as (?)
New York 1939b, cat. 1
New York 1941g, as *Self-Portrait* (New York venue only)
Possibly New York 1942b, cat. 6, as *Auto-portrait*
New York 1942h, pp. 19, 140, repr. p. 102, as *Self-Portrait*
New York 1944a, p. 94, as *Self-Portrait* (New York venue only)
Boston 1946, cat. 40, as *Self-Portrait*
Paris 1952, cat. 64, as *Auto-portrait*
New York 1955, cat. 101, as *Self-Portrait*
New York 1958c, as *Self-Portrait*
New York 1959b, cat. 67, as *Self-Portrait*
New York 1961a, cat. 52, p. 59
Paris 1962b, cat. 71
London 1964b, cat. 153, pp. 38-39, pl. 30a (London venue only)

New York 1968a, cat. 245, as *Self-Portrait* (New York venue only)
New York 1973b
Washington 1980a, cat. 27, repr. (color) p. 76
New York 1982 (New York venue only)
Houston 1982
New York 1983b
New York 1983e, p. 164, repr. (color) p. 165, as *Self-Portrait, I*
Zurich 1986, cat. 102, repr. (color) n.p.
New York 1987a, cat. 90, repr. (color) p. 169
Paris 1987b, cat. 128, repr. (color) p. 187
On view at The Museum of Modern Art, New York: March–May 1979; August–November 1979; April 1981–January 1982; April 1983; June–September 1983; November 1985–April 1986; April–July 1989; June 1990–May 1991

SELECTED REFERENCES

Morris 1938, p. 33. D.B. 1939, p. 14. Genauer 1939b. Sweeney 1941, p. 70, repr. p. 71. Greenberg 1948, p. 27, pl. LI (repr. p. 89). Cirici-Pellicer 1949, ill. 49. Cirlot 1949, pp. 7, 32, fig. 24. *Libre Belgique* 1952. Breton 1952. Jeannerat 1952. Sweeney 1953, repr. p. 76. *MoMA Bulletin* 1955, repr. p. 28 (installation view). Prévert/Ribemont-Dessaignes 1956, p. 84. *MoMA Bulletin* 1958, p. 30, repr. p. 31. Hess 1958, repr. p. 37. Erben 1959, p. 135, pl. 61. Rubin 1959, p. 39, repr. p. 35. Soby 1959, pp. 93, 96, repr. p. 92. Soby 1961, p. 71. Tyler 1961, pp. 43, 62, repr. p. 42. Dupin 1961a, pp. 10, 17. Miró 1961, pp. 14–15. Dupin 1962, pp. 296, 303–04, 484, 495, 538, no. 489, repr. p. 330. Lassaigne 1963, pp. 78–79, 116. Bonnefoy 1964, p. 22, pl. 37. Hodin 1964, repr. p. 28. Gasser 1965, p. 76, repr. p. 53. Ferry 1966, n.p. Rubin 1968, p. 132, fig. 194 (repr. p. 134). Penrose 1969, pp. 96–97, 125, pl. 28 (repr. p. 98). Rubin 1973, pp. 8, 72, 76, 111, 126–27, repr. p. 77. Leymarie 1974a, p. 18. Picon 1976, vol. 2, repr. p. 69. Varnedoe 1976, pp. 97–98. Miró 1977, pp. 86–87. Marie-Louise Jeanneret Art Moderne 1979, repr. p. 5. Millard 1980, p. 28. McCandless 1982, pp. 42, 60, fig. 52 (repr. p. 60). Rowell 1986, pp. 145, 156, 157, 158, 159, 183, 189, 190, 232, 257–58, 270, 294, 307 (n. 6), 315 (n. 5), 317 (n. 31), 319 (n. 4), ill. 19. Erben 1988, repr. (color) p. 84. Jeffett 1988, pp. 21, 22, fig. 2 (repr. p. 21). Jeffett 1989a, pp. 34, 35, repr. p. 26. Jeffett 1989b, pp. 126, 128. Raillard 1989, p. 122. Combalía 1992, p. 190.

147. SELF-PORTRAIT II. Paris, April 1938. (Plate, p. 229)

Oil on burlap, 51″ × 6′ 5″ (129.5 × 195.5 cm). Signed center: *Miró*. Inscribed on verso: *JOAN MIRÓ. | auto-portrait II. | IV-938.* The Detroit Institute of Arts. Gift of W. Hawkins Ferry. Dupin 490

PROVENANCE
Pierre Matisse Gallery, New York, by 1939; Mr. and Mrs. William Beckett, by September 1950; Esther Robles Gallery, Los Angeles (on consignment?), by 1958; Stanley N. Barbee, Beverly Hills, Calif.; to E. V. Thaw & Co., New York; to G. David Thompson, Pittsburgh; to Estate of G. David Thompson (consigned to Parke-Bernet Galleries, New York; sold March 23, 1966, lot 63); to W. Hawkins Ferry, Detroit; to The Detroit Institute of Arts, 1966.

SELECTED EXHIBITIONS

Possibly Paris 1939a, as (?)
New York 1939b, cat. 2
Hartford 1940, cat. 70, as *Auto-Portrait Number 2*
Possibly New York 1942b, cat. 6, as *Auto-portrait*
New York 1946b, as *Autoportrait (Black Bkgrnd)*
Beverly Hills 1950, repr. n.p., as *Auto Portrait*

Detroit 1966, cat. 34, repr. (color) n.p.
Kalamazoo 1971, repr. p. 12
Paris 1974b, cat. XI, pp. 174–75
Washington 1980a, cat. 28, repr. (color) p. 77
Barcelona 1988b, cat. 68, repr. (color) p. 100
London 1989, repr. (color) n.p.

SELECTED REFERENCES
Duthuit 1939, repr. p. 73. D.B. 1939, p. 14. *Art News Annual* 1958, repr. p. 189. Dupin 1962, pp. 303, 304, 306, 307, 538, no. 490, repr. p. 331. *Art News* 1966, repr. p. 10. *Burlington Magazine* 1966b, p. xxv. *Apollo* 1966, repr. p. xcv. *Art in America* 1966, repr. p. 6. *Art Quarterly* 1966, repr. p. 186. Ferry 1966, n.p. *Bulletin of The Detroit Institute of Arts* 1967, repr. pp. 22, 26 (installation view). Penrose 1969, p. 97, pl. 69 (repr. p. 99). Rubin 1973, p. 76, fig. 59 (repr. p. 130). Jeffett 1988, pp. 21, 22. Jeffett 1989a, pp. 34, 35.

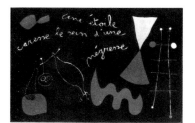

148. "UNE ETOILE CARESSE LE SEIN D'UNE NÉGRESSE" (Painting-Poem). Paris, April 1938. (Plate, p. 231)

Oil on canvas, 51″ × 6′ 4½″ (129.5 × 194.3 cm). Signed lower left: *Miró*. Inscribed on verso: *JOAN MIRÓ | peinture-poème. | IV-938.* Tate Gallery, London. Purchased 1983. Dupin 496a/496bis

PROVENANCE
The artist to Pierre Matisse Gallery, New York, by 1941; to Tate Gallery, London, 1983.

SELECTED EXHIBITIONS

Possibly Paris 1939a, as (?)
New York 1941g, as *Painting-Poem* (New York venue only)

Chicago 1943, cat. 10, as *Painting-Poem*
New York 1953a, cat. 29, as *Peinture Poème*

New York 1959b, cat. 70, as *Painting-Poem*
London 1964b, cat. 158, p. 39, as *Painting-Poem — "Une Etoile caresse le sein d'une négresse"*
Tokyo 1966, cat. 59, repr. (color) p. 63
Munich 1969, cat. 53, repr. n.p.
Knokke 1971, cat. 26, repr. p. 43
Munich 1972, cat. 333, repr. n.p.
Paris 1972, cat. 318, repr. n.p.
Paris 1974b, cat. 55, p. 123, repr. pp. 54, 123
Humlebaek 1974, cat. 25
London 1978, cat. 12.100, repr. p. 316
Madrid 1978a, cat. 38, p. 105, repr. (color) p. 60

Washington 1980a, cat. 29, repr. (color) p. 78
São Paulo 1981, pp. 114–15, repr. p. 115
Houston 1982, pl. 20 (color)
Edinburgh 1982, cat. 24, repr. (color) p. 24, as *Picture-Poem (A Star Caresses the Breast of a Negress)*
Zurich 1986, cat. 118, repr. (color) n.p.
Liverpool 1988, p. 28, repr. (color) p. 44
Barcelona 1988b, cat. 69, repr. (color) p. 101
London 1989, repr. (color) n.p.
Saint-Paul-de-Vence 1990, cat. 49, p. 120, repr. (color) pp. 120–21

SELECTED REFERENCES
Sweeney 1941, p. 72, repr. p. 74. Cirici-Pellicer 1949, p. 37, ill. 51. Sweeney 1953, p. 63, repr. p. 76. Soby 1959, p. 96, repr. p. 97. Dupin 1962, p. 307, no. 496a/496bis, repr. p. 538. Penrose 1969, pp. 91, 185, 193, pl. 65 (repr. p. 92). Mortensen 1974, repr. (color) p. 23. Gimferrer 1978, pp. 36, 122, fig. 118 (color). Millard 1980, p. 28. Malet 1983b, fig. 50 (color). Rowell 1986, p. 138. Fernández Miró 1987, p. 47. Erben 1988, repr. (color) p. 95. Tate Gallery 1988, pp. 533–36, repr. p. 533. Raillard 1989, p. 108, repr. (color) p. 109. Saura 1989, p. 49.

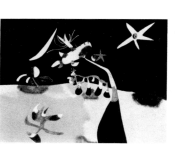

149. NOCTURNE. Paris, April 1938. (Plate, p. 230)

Oil on cardboard, 21¼ × 29⅛″ (54 × 74 cm). Signed center right: *Miró*. Inscribed on verso: *Joan Miró | Nocturne | IV-38.* Private collection. Dupin 497

PROVENANCE
The artist to Pierre Matisse Gallery, New York, 1938; to Thomas Laughlin, New York, December 1939; private collection; present owner.

SELECTED EXHIBITIONS

Possibly Paris 1939a, as (?)
New York 1941g
New York 1959b, cat. 69
London 1964b, cat. 155, p. 39, pl. 31c
New York 1972b, cat. 33, repr. (color) n.p.
New York 1975a, cat. 111, repr. p. 50
Houston 1982, pl. 21 (color)
Zurich 1986, cat. 116, repr. (color) n.p.

New York 1987a, cat. 100, repr. (color) p. 179
Düsseldorf 1987, cat. 68, repr. (color) p. 83
Barcelona 1988b, cat. 67, repr. (color) p. 99
London 1989, repr. (color) n.p.
Berkeley 1990

SELECTED REFERENCES
Sweeney 1941, p. 72, repr. p. 75. Greenberg 1948, pl. LVI (repr. p. 93). Cirici-Pellicer 1949, p. 37, ill. 50. Prévert/Ribemont-Dessaignes 1956, p. 84. Soby 1959, p. 96, repr. p. 96. Dupin 1962, pp. 306, 307, no. 497, repr. p. 538. Penrose 1969, p. 187, pl. 132 (repr. p. 187). Cooper 1972, n.p. Rose 1982a, fig. 35 (repr. p. 33). Stich 1990, pp. 160, 163, pl. 202 (repr., color, p. 161).

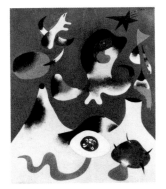

150. AIR. [Paris, April 1938]. (Plate, p. 230)
Oil on canvas, 21⅝ × 18⅛″ (55 × 46 cm). Signed lower center: *Miró.*
Private collection. Dupin 510

PROVENANCE
E. Tériade, Paris; Heinz Berggruen, Paris; to Acquavella Galleries, New York; to
present owner.

SELECTED EXHIBITIONS
Possibly Paris 1939a, as (?)
Paris 1974b, cat. 56, p. 123, repr. p. 123

SELECTED REFERENCES
Dupin 1962, no. 510, repr. p. 539.

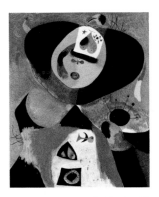

151. PORTRAIT I. Paris, May 1938. (Plate, p. 235)
Oil on canvas, 64¼ × 51¼″ (163.1 × 130.1 cm). Signed lower left: *Miró.* Inscribed on
verso: *Joan Miró | Portrait I | V-938.* The Baltimore Museum of Art. Bequest of
Saidie A. May, BMA 1951.339. Dupin 493

PROVENANCE
Galerie Pierre, Paris; to Saidie A. May, Baltimore, 1938; to The Baltimore Museum
of Art, 1951.

SELECTED EXHIBITIONS
Possibly Paris 1939a, as (?)
Baltimore 1940, as *Portrait No. 1*
Baltimore 1941, p. 95
New York 1941g (New York venue only)
Baltimore 1950, cat. 82, repr. p. 22, as
 Portrait No. 1
Denver 1954, cat. 2, repro. n.p., as
 Portrait Number I

New York 1959b, cat. 68
London 1964b, cat. 156, p. 39, pl. 31a,
 as *Portrait No. 1*
New York 1966, cat. 194, repr. (color) p.
 110, as *Portrait No. 1*
Baltimore 1972, pp. 17, 79, repr. pp. 16
 (color), 79
Pittsburgh 1974, cat. 70, repr. n.p.

SELECTED REFERENCES
Duthuit 1939, repr. p. 71. Sweeney 1941, p. 72, repr. p. 73. Cirlot 1949, fig. 25.
Perlman 1955, repr. p. 16. Prévert/Ribemont-Dessaignes 1956, p. 84. Rubin 1959, p.
39, repr. p. 39. Soby 1959, p. 96, repr. (color) p. 95. Dupin 1962, pp. 300, 307–08,
310–11, 433, no. 493, repr. p. 538. Lassaigne 1963, p. 79. Taillandier 1964, repr. p.

107. Piene 1966, repr. p. 109. Penrose 1969, pl. 63 (repr., color, p. 90). *BT 1978,*
repr. p. 2.

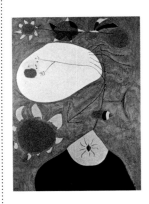

152. PORTRAIT IV. Paris, June 1938. (Plate, p. 234)
Oil on canvas, 51⅛ × 37¾″ (129.8 × 95.8 cm). Inscribed on verso, upper left: *JOAN
MIRÓ | portrait IV | VI-938.* Private collection. Dupin 496

PROVENANCE
Curt Valentin Gallery, New York; Pierre Matisse Gallery, New York; to James Thrall
Soby, Farmington and New Canaan, Conn., October 7, 1944; through Pierre Matisse
Gallery, New York, to G. David Thompson, Pittsburgh, January 1956; to Estate of G.
David Thompson; to present owner, 1965.

SELECTED EXHIBITIONS
Possibly Paris 1939a, as (?)
New York 1939b, cat. 3

Chicago 1943, cat. 9, as *Auto Portrait IV*

SELECTED REFERENCES
Greenberg 1948, pl. L (repr. p. 88). Soby 1959, p. 96, repr. p. 94. Dupin 1962, pp.
300, 307, 308, 310–11, 538, no. 496, repr. (color) p. 295. Chevalier 1962, repr. p. 12.
Lassaigne 1963, p. 79. Gasser 1965, repr. (color) p. 59. Erben 1988, repr. (color)
p. 91.

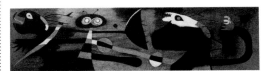

**153. WOMAN HAUNTED BY THE PASSAGE OF THE BIRD-
DRAGONFLY, OMEN OF BAD NEWS** (Nursery Decoration). Paris,
September 1938. (Plate, pp. 232–33)
Oil on canvas, 31½″ × 10′ 4″ (80 × 315 cm). Signed lower left: *Miró.* Inscribed on
verso, upper left: *Pour Jacky, Peter et Pauley | Matisse | JOAN MIRÓ. | IX-1938.* The
Toledo Museum of Art, Ohio. Purchased with funds from the Libbey Endowment,
Gift of Edward Drummond Libbey. Dupin 491

PROVENANCE
The artist to Jacqueline, Peter, and Paul Matisse (Pierre Matisse Gallery), New York,
1938; to Mr. and Mrs. Richard K. Weil, Saint Louis, 1958; to Galerie Beyeler, Basel,
1985; to The Toledo Museum of Art, Ohio, 1986.

SELECTED EXHIBITIONS
Paris 1938b, as *Panneau décoratif*
New York 1941b, cat. 15, as *Decorative
 Panel*
New York 1941g, as *Nursery Decoration
 "Pour Jackey, Peter and Pauley
 Matisse"* (New York venue only)
New York 1952c, as *Nursery Decoration*
New York 1958d, cat. 11, repr. n.p., as

Pour Jackey, Peter and Pauley Matisse
New York 1959b, cat. 72, as *Nursery
 Decoration* (New York venue only)
Saint Louis 1965, as *Nursery Decoration*
Saint Louis 1980 (Saint Louis venue
 only)
Basel 1986, cat. 30, repr. (color) n.p.
Berkeley 1990

SELECTED REFERENCES
Marianne 1938, p. 11. Vargas 1939, repr. p. 71. McCausland 1941. R.F. 1941, p. 43.
Greenberg 1941, p. 481. Sweeney 1941, p. 62, repr. p. 67. Raymer 1942, p. 6B.
Greenberg 1948, pl. XLVII (repr. p. 86). Cirlot 1949, fig. 23. Duthuit 1953, fig. 7
(repr. p. 30). Prévert/Ribemont-Dessaignes 1956, repr. p. 38. Munsterberg 1958, p.
53. Soby 1959, pp. 98–99, repr. (color) pp. 98–99. Dupin 1962, p. 345, no. 491,
repr. p. 538. Bonnefoy 1964, p. 22, pl. 39 (color, foldout). Stich 1980, pp. 42–44, fig.
37 (repr. p. 43). Millard 1980, p. 27. Erben 1988, repr. (color) pp. 92–93. Stich
1990, pp. 159–60, 175 (n. 45), pl. 200, repr. (color) pp. 158–59.

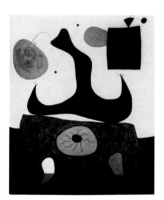

154. SEATED WOMAN I. Paris, December 24, 1938. (Plate, p. 236)

Oil on canvas, 64⅜ × 51⅝″ (163.4 × 131 cm). Signed upper right: *Miró*. Inscribed on
verso: *JOAN MIRÓ | Femme Assise I | 24/12/1938*. The Museum of Modern Art,
New York. Gift of Mr. and Mrs. William H. Weintraub. Acq. no. 1532.68. Dupin 518

PROVENANCE

The artist to Pierre Matisse Gallery, New York; to Mr. and Mrs. William H.
Weintraub, Westhampton Beach, N.Y., December 1959; to The Museum of Modern
Art, New York, December 1968.

SELECTED EXHIBITIONS

Possibly Paris 1939a, as (?)
New York 1939b, cat. 4, as *Woman
 Seated I*
New York 1941g
Chicago 1943, cat. 11, as *Femme assise*
 (incorrectly dated 1939)
New York 1944d, cat. 18, as *Woman
 Seated* (incorrectly dated 1939)
Possibly Prague 1947 (not in checklist);
 repr. n.p., as *Sedící Zena*
Houston 1951, cat. 12, as *Seated Woman,
 No. 1*
New York 1958d, cat. 14, repr. n.p., as
 Femme assise (incorrectly dated March
 8, 1939)
Tokyo 1966, cat. 60, p. 23, repr. p. 108,
 as *Femme assise II*
Bogotá 1971, not in checklist (Auckland,

Sydney, Melbourne, Adelaide, and
 Mexico City venues only)
New York 1973b
Paris 1974b, cat. XII, p. 175
Vienna 1978, cat. 51, repr. p. 135, as
 Sitzende Frau
Zurich 1986, cat. 114, repr. (color) n.p.,
 as *Femme assise*
Barcelona 1988b, cat. 71, repr. (color)
 cover and (color) p. 103
London 1989, repr. (color) n.p.
On view at The Museum of Modern Art,
 New York: June–September 1970;
 September–October 1986; August
 1987–January 1988; August–
 November 1988; May–December
 1989; February 1990–July 1991

SELECTED REFERENCES

F.P. 1958, p. 12. Dupin 1962, pp. 312, 345, no. 518, repr. p. 539 (incorrectly
identified as *Seated Woman II* and dated December 7, 1938). Rubin 1973, pp. 8, 78,
82, 130, repr. (color) p. 79. Rudenstine 1985, pp. 546, 548, 549, fig. a (repr. p. 546).
Erben 1988, repr. (color) p. 101. Malet 1988b, p. 14. Malet 1989, p. 20.

155. SEATED WOMAN II. Paris, February 27, 1939. (Plate, p. 237)

Oil on canvas, 63¾ × 51⅛″ (162 × 130 cm). Signed upper right: *Miró*. Inscribed on
verso: *JOAN MIRÓ | "Femme assise II" | 27/II/1939*. Solomon R. Guggenheim
Museum, New York; Peggy Guggenheim Collection, Venice, 1976. Dupin 517

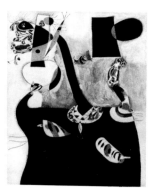

PROVENANCE

The artist to Pierre Matisse Gallery, New York, summer 1939; to Peggy Guggenheim,
New York and Venice, November 15, 1941; to Solomon R. Guggenheim Museum,
New York, Peggy Guggenheim Collection, Venice, 1976.

SELECTED EXHIBITIONS

Possibly Paris 1939a, as (?)
New York 1939b, cat. 5 (incorrectly
 dated 1938)
New York 1942a, p. 112, repr. p. 114, as
 The Seated Woman (incorrectly dated
 1938–39)
New York 1943c, cat. 224, as *Seated
 Woman* (incorrectly dated 1938–39)
Venice 1948, cat. 88, ill. 93, as *La
 Donna seduta*
Florence 1949, cat. 94, repr. p. xxxi, as
 La Donna seduta
Zurich 1951, cat. 103, repr. n.p., as
 Sitzende Frau
London 1964c, cat. 82, p. 56, repr. p. 56

Turin 1967, cat. 258, repr. p. 189, as
 Donna seduta
New York 1969a, p. 104, repr. (color)
 p. 105
Paris 1974d, cat. 85, p. 75, repr. (color)
 p. 17
Houston 1982
New York 1983a, cat. 5, repr. cover
Zurich 1986, cat. 115, repr. (color) n.p.,
 as *Femme assise*
New York 1987a, cat. 98, repr. (color) p.
 177, as *Seated Woman*
On view at Art of This Century, New
 York: 1942–47

SELECTED REFERENCES

Klein 1939b, p. 5. *Arts* 1948, repr. Greenberg 1948, pl. XLII (repr. p. 94). Rubin
1959, p. 40. Dupin 1962, pp. 312, 345, no. 517, repr. pp. 335, 539 (incorrectly
identified as *Seated Woman I* and dated December 4, 1938). Lassaigne 1963, p. 79.
Rubin 1968, p. 132, fig. 195 (repr. p. 135; incorrectly identified as *Seated Woman I*
and dated 1938). Penrose 1969, pp. 91, 94, pl. 66 (repr. p. 93; incorrectly identified
as *Seated Woman I* and dated 1938). Marchiori 1972, p. 30. Rubin 1973, pp. 78,
130, fig. 60 (repr. p. 130). Picon 1976, vol. 2, repr. p. 63. Rose 1982a, pp. 21, 22, 23,
fig. 17 (repr. p. 22) (installation view). Rudenstine 1985, pp. 546–49, no. 118, repr. p.
547. Erben 1988, repr. (color) p. 94.

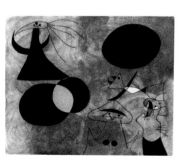

156. SUNRISE. From the Constellation series. Varengeville, January 21, 1940. (Plate, p. 238)

Gouache and oil wash on paper, 15 × 18⅛″ (38 × 46 cm). Signed lower center: *Miró*.
Inscribed on verso: *Joan Miró | Le léver du soleil | Varengeville s/mer | 21-I-1940*.
Private collection, United States. Dupin 538

PROVENANCE

The artist to Pierre Matisse Gallery, New York; Dwight Ripley, New York, Wappingers

Falls, N.Y., and Greenport, Long Island, N.Y., by December 1958; to Georges Bernier, Paris; to present owner, August 1965.

SELECTED EXHIBITIONS
Possibly New York 1945a, cat. 1
Paris 1959a
New York 1959a
Houston 1982

Barcelona 1988b, cat. 78, repr. (color) p. 110
London 1989, repr. (color) n.p.

SELECTED REFERENCES
B.B.N. 1945, repr. p. 64. Breton 1958, pp. 50–55. Pierre Matisse 1959, pl. 1 (color). Dupin 1962, pp. 355, 356, 357–60, no. 538, repr. p. 541. Bonnefoy 1964, p. 24. Penrose 1969, p. 106. Teixidor 1972, pp. 38, 41. Rolnik 1983, n.p. Malet 1988b, p. 14. Raillard 1989, p. 112, repr. (color) p. 113.

157. THE ESCAPE LADDER. From the Constellation series.
Varengeville, January 31, 1940. (Plate, p. 239)
Gouache, watercolor, and ink on paper, 15¾ × 18¾" (40 × 47.6 cm). Signed lower center: *Miró*. Inscribed on verso: *Joan Miró | L'échelle de l'évasion | Varengeville s/mer | 31-I-1940*. The Museum of Modern Art, New York. Helen Acheson Bequest. Acq. no. 743.78. Dupin 539

PROVENANCE
The artist to Pierre Matisse Gallery, New York; to Helen Acheson, New York, by December 1957; to The Museum of Modern Art, New York, October 1978.

SELECTED EXHIBITIONS
Possibly New York 1945a, cat. 2
Paris 1959a
New York 1959b, cat. 74 (Los Angeles venue, cat. 76)
Paris 1962b, cat. 135
London 1964b, cat. 167, p. 41, pl. 33c
Tokyo 1966, cat. 62, repr. (color) p. 65
Saint-Paul-de-Vence 1968, cat. 37
New York 1972b, cat. 38, repr. (color) n.p.
New York 1974, cat. 118
Cleveland 1979, cat. 33, repr. p. 80, as *The Ladder for Escape*

Saint Louis 1980
São Paulo 1981, pp. 116–17, repr. p. 117, as *The Ladder for Escape*
Houston 1982, as *Ladder for Escape*
New York 1985a, cat. 61, repr. p. 139
New York 1991b, p. 138, repr. (color) p. 55
On view at The Museum of Modern Art, New York: August–November 1979; June–September 1983; August 1986–February 1988; March 1989–January 1991; May 1991–July 1992

SELECTED REFERENCES
Breton 1958, pp. 50–55. Pierre Matisse 1959, pl. 2 (color). Dupin 1962, pp. 356, 357–60, 541, no. 539, repr. (color) p. 309. Lassaigne 1963, p. 89. Bonnefoy 1964, pp. 18, 24, pl. 42 (color). *Mainichi Shinbun* 1966a, repr. (color) p. 1. Penrose 1969, pp. 105, 185, pl. 78 (repr., color, p. 110). Marchiori 1972, p. 30. Teixidor 1972, pp. 38, 41, repr. (color) p. 40. Okada 1974, repr. p. 80. Teixidor 1974, p. 94. Miró 1977, pp. 61–62. Carmean 1980, p. 40 (incorrectly identified as Dupin 359). Stich 1980, pp. 46–47, fig. 41 (repr. p. 47). Rose 1982a, p. 34. Rolnik 1983, n.p. Pierre 1987, p. 231. Erben 1988, repr. (color) p. 107. Jeffett 1988, p. 23.

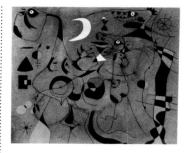

158. PEOPLE AT NIGHT, GUIDED BY THE PHOSPHORESCENT TRACKS OF SNAILS. From the Constellation series. Varengeville, February 12, 1940. (Plate, p. 240)
Gouache on wove paper, 15 × 18" (37.9 × 45.7 cm). Signed lower left: *Miró*. Inscribed on verso: *Joan Miró | Personnages dans la nuit guidés par les traces | phosphorescentes des escargots | Varengeville s/mer | 12/II/1940*. Philadelphia Museum of Art. Louis E. Stern Collection. Dupin 540

PROVENANCE
The artist to Pierre Matisse Gallery, New York; to Louis E. Stern, New York, February 1945; to Philadelphia Museum of Art, 1963.

SELECTED EXHIBITIONS
Possibly New York 1945a, cat. 3
New York 1962, cat. 62, repr. p. 11

Philadelphia 1987a, cat. 19

SELECTED REFERENCES
Breton 1958, pp. 50–55. Pierre Matisse 1959, pl. 3 (color). Dupin 1962, pp. 356, 357–60, 541, no. 540, repr. p. 343. Bonnefoy 1964, pl. 43 (color). Gasser 1965, repr. p. 56. Walton 1966, p. 34, pl. 75 (color). Penrose 1969, p. 106, pl. 76 (repr. p. 106). Krauss/Rowell 1972, p. 92. Teixidor 1972, pp. 38, 41. Picon 1976, vol. 2, repr. p. 36. Gimferrer 1978, fig. 187. Rolnik 1983, n.p. Rowell 1986, p. 170. Rowell 1987a, p. 35, repr. (color) p. 34. Temkin 1987b, p. 44. Erben 1988, repr. (color) p. 109. Raillard 1989, p. 70.

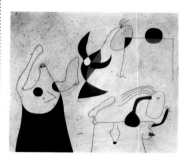

159. WOMEN ON THE BEACH. From the Constellation series.
Varengeville, February 15, 1940. (Plate, p. 241)
Gouache and oil wash on paper, 15 × 18" (38.1 × 45.8 cm). Signed lower center: *Miró*. Inscribed on verso: *Joan Miró | Femmes sur la plage | Varengeville s/mer | 15/II/1940*. The Jacques and Natasha Gelman Collection. Dupin 541

PROVENANCE
The artist to Pierre Matisse Gallery, New York; to The Jacques and Natasha Gelman Collection, 1968.

SELECTED EXHIBITIONS
Possibly New York 1945a, cat. 4
Venice 1954, cat. 17
Paris 1959a
New York 1959a

New York 1959b, cat. 75 (Los Angeles venue only)
London 1964b, cat. 168, p. 41
New York 1989

SELECTED REFERENCES
Breton 1958, pp. 50–55, repr. p. 52. Pierre Matisse 1959, pl. 4 (color). Dupin 1962, pp. 356, 357–60, no. 541, repr. p. 541. Burr 1964, pp. 238–40. Teixidor 1972, pp.

38, 41. Miró 1977, p. 89. Rolnik 1983, n.p. Lieberman 1989, pp. 218–21, 308, repr. pp. 219 (color), 220 (color, verso), 308. Raillard 1989, p. 112, repr. (color) p. 113.

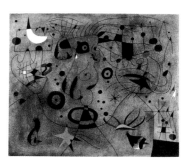

160. WOMAN WITH BLOND ARMPIT COMBING HER HAIR BY THE LIGHT OF THE STARS. From the Constellation series. Varengeville, March 5, 1940. (Plate, p. 242)

Gouache and oil wash on paper, 15 × 18⅛″ (38.1 × 46 cm). Signed lower left: *Miró*. Inscribed on verso: *Joan Miró | Femme à la blonde aisselle coiffant | sa chévelure à la lueur des étoiles | Varengeville s/mer | 5/III/1940*. The Cleveland Museum of Art. Contemporary Collection. Dupin 542

PROVENANCE
The artist to Pierre Matisse Gallery, New York; Dwight Ripley, New York, Wappingers Falls, N.Y., and Greenport, Long Island, N.Y., by December 1958; Mrs. Samuel S. White, Ardmore, Pa.; E. V. Thaw & Co., New York, and Pierre Matisse Gallery, New York; to The Cleveland Museum of Art, January 1966.

SELECTED EXHIBITIONS
Possibly New York 1945a, cat. 5
Paris 1959a
Possibly New York 1959a
Cleveland 1966, cat. 77, repr. (color) n.p.

Saint-Paul-de-Vence 1968, cat. 38
Barcelona 1968, cat. 42
Cleveland 1979, cat. 34, repr. p. 81
Houston 1982

SELECTED REFERENCES
Breton 1958, pp. 50–55. Pierre Matisse 1959, pl. 5 (color). Dupin 1962, pp. 356, 357–60, no. 542, repr. p. 541. Penrose 1969, p. 185. Teixidor 1972, pp. 38, 41. Okada 1974, pl. 20 (color). Henning 1979, pp. 239, 240 (n. 5), fig. 8 (repr. p. 240). Malet 1983b, fig. 57 (color). Rolnik 1983, n.p. Rowell 1986, p. 170.

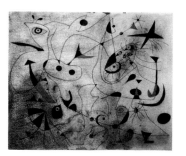

161. MORNING STAR. From the Constellation series. Varengeville, March 16, 1940. (Plate, p. 243)

Tempera, gouache, egg, oil, and pastel on paper, 15 × 18⅛″ (38 × 46 cm). Signed lower left: *Miró*. Inscribed on verso: *Joan Miró | L'étoile matinale | Varengeville s/mer | 16/III/1940 | appt. à mme. Miró*. Fundació Joan Miró, Barcelona. Dupin 543

PROVENANCE
The artist to Pilar Juncosa de Miró; to Fundació Joan Miró, Barcelona, November 4, 1986.

SELECTED EXHIBITIONS
Possibly Paris 1959a
Paris 1962b, cat. 137

London 1964b, cat. 169, p. 41
Tokyo 1966, cat. 63, repr. p. 109

Saint-Paul-de-Vence 1968, cat. 36
Barcelona 1968, cat. 41, pl. 17 (repr. p. 105)
Munich 1969, cat. 54, repr. n.p.
Madrid 1978a, cat. 39, p. 106, repr. (color) p. 62
Milan 1981, repr. (color) p. 56
Zurich 1986, cat. 122, repr. (color) n.p.
New York 1987a, cat. 105, repr. (color) p. 185

Barcelona 1988b, cat. 79, repr. (color) p. 111
London 1989, repr. (color) n.p.
Saint-Paul-de-Vence 1990, cat. 50, p. 118, repr. (color) p. 119
Paris 1991, repr. (color) p. 391 (Paris venue only)

SELECTED REFERENCES
Prévert/Ribemont-Dessaignes 1956, repr. p. 149. Breton 1958, pp. 50–55. Erben 1959, p. 139. Pierre Matisse 1959, pl. 6 (color). Dupin 1962, pp. 356, 357–60, no. 543, repr. p. 541. Chevalier 1962, p. 11. Bonnefoy 1964, p. 26. Teixidor 1972, pp. 38, 41. Rolnik 1983, n.p. Bouret 1986, n.p. Fundació Joan Miró 1988, repr. cover (color), pp. 206, 207 (color). Malet 1988b, p. 14.

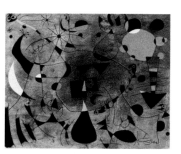

162. WOUNDED PERSONAGE. From the Constellation series. Varengeville, March 27, 1940. (Plate, p. 244)

Gouache and oil wash on paper, 15 × 18⅛″ (38 × 46 cm). Signed lower left: *Miró*. Inscribed on verso: *Joan Miró | Personnage blessé | Varengeville s/mer | 27/III/1940*. Private collection, San Francisco. Dupin 544

PROVENANCE
The artist to Pierre Matisse Gallery, New York; Mr. and Mrs. Ernst Zeisler, Chicago, by June 1958; to Richard L. Feigen & Co., New York; to Galleria Galatea, Turin; Count C. Cicogna, Milan; Alex Reid & Lefevre, London; present owner, by 1979.

SELECTED EXHIBITIONS
Possibly New York 1945a, cat. 6
Boston 1946, cat. 43
San Francisco 1948, cat. 57, repr. p. 104
Paris 1959a
New York 1959b, cat. 75 (Los Angeles

venue, cat. 77)
Chicago 1961, cat. 29
Cleveland 1966, cat. 76, repr. n.p.
Cleveland 1979, cat. 35, repr. p. 80

SELECTED REFERENCES
Breton 1958, pp. 50–55. Pierre Matisse 1959, pl. 7 (color). Soby 1959, repr. p. 104. Dupin 1962, pp. 356, 357–60, no. 544, repr. p. 542. Teixidor 1972, pp. 38, 41. Rolnik 1983, n.p.

163. WOMAN AND BIRDS. From the Constellation series. Varengeville, April 13, 1940. (Plate, p. 245)

Gouache and oil wash on paper, 15 × 18½″ (38 × 46 cm). Signed lower left: *Miró*. Inscribed on verso: *Joan Miró | Femme et oiseaux | Varengeville s/mer | 13/IV/1940*. Collection Mrs. Gustavo Cisneros, Caracas. Dupin 545

PROVENANCE
The artist to Pierre Matisse Gallery, New York; to Mr. and Mrs. Lee Ault, New Canaan, Conn., 1946; Mrs. George W. Helm, East Hampton, N.Y., by 1948; Mrs. Rolf Tjeder, New York, by April 1958; Mr. and Mrs. Jan Mitchell, New York, by August 1964; [Mr. and Mrs. Michael Helm]; private collection; Thomas Ammann Fine Arts, Zurich; to Mrs. Gustavo Cisneros, Caracas, 1987.

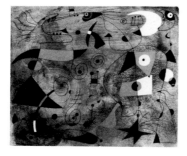

SELECTED EXHIBITIONS
Possibly New York 1945a, cat. 7
Paris 1959a
London 1964b, cat. 170, p. 41
New York 1972b, cat. 40, repr. (color)
n.p.

Zurich 1986, cat. 124, repr. (color) n.p.
New York 1987a, cat. 107, repr. (color)
p. 188

SELECTED REFERENCES
Greenberg 1948, pl. LXII (repr. p. 101). Breton 1958, pp. 50–55. Pierre Matisse
1959, pl. 8 (color). Dupin 1962, pp. 356, 357–60, no. 545, repr. p. 542. Bonnefoy
1964, p. 26. Teixidor 1972, pp. 38, 41. Rolnik 1983, n.p. Llorca 1990, repr. p. 170.

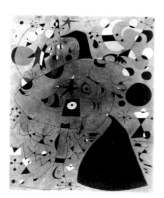

164. WOMAN IN THE NIGHT. From the Constellation series.
Varengeville, April 27, 1940. (Plate, p. 246)
Gouache and oil wash on paper, 18¼ × 15″ (46.3 × 38.1 cm). Signed lower center:
Miró. Inscribed on verso: *Joan Miró | Femme dans la nuit | Varengeville s/mer |
27/IV/1940*. The Margulies Family Collection. Dupin 546

PROVENANCE
The artist to Pierre Matisse Gallery, New York; to Alexina Matisse (later Alexina
Duchamp), New York, January 20, 1945; to World Arts Establishment, Liechtenstein;
to private collection, United States; to Matthiesen Fine Art Limited, London; to
Galerie Maeght, Paris; David Lloyd Kreeger, Washington, D.C.; to Richard L. Feigen
& Co., New York, October 1976; to Acquavella Galleries, New York, October 1976;
Cofinearte, Switzerland, by 1978; Art Advisory S.A., by 1979; Galerie Maeght, Paris;
to The Margulies Family Collection, June 16, 1980.

SELECTED EXHIBITIONS
Possibly New York 1945a, cat. 8
Paris 1959a
New York 1959a
London 1964b, cat. 171, p. 41, pl. 33b

London 1978, cat. 16.22, repr. p. 422
Cleveland 1979, cat. 36, repr. p. 81
Houston 1982
Miami 1984b, cat. 2, repr. (color) p. 9

SELECTED REFERENCES
Breton 1958, pp. 50–55, repr. (color; upside down) p. 54. Pierre Matisse 1959, pl. 9
(color). Dupin 1962, pp. 356, 357–60, no. 546, repr. p. 542. Teixidor 1972, pp. 38,
41. Rolnik 1983, n.p. Marck 1984, pp. 5, 6, 8.

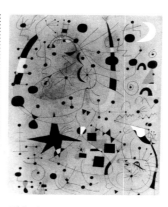

165. ACROBATIC DANCERS. From the Constellation series.
Varengeville, May 14, 1940. (Plate, p. 247)
Watercolor on paper, 18⅛ × 15″ (46 × 38.1 cm). Signed lower center: *Miró*. Inscribed
on verso: *Joan Miró | Danseuses acrobates | Varengeville s/mer | 14/V/1940*.
Wadsworth Atheneum, Hartford. Gift of Philip L. Goodwin Collection. Dupin 547

PROVENANCE
The artist to Pierre Matisse Gallery, New York; to Philip L. Goodwin, New York,
1944; to Estate of Philip L. Goodwin, February 1958; to Wadsworth Atheneum,
Hartford, 1958.

SELECTED EXHIBITIONS
Possibly New York 1945a, cat. 9
Paris 1959a
Possibly New York 1959a

New York 1968a, cat. 246
Washington 1980a, cat. 32, repr. (color)
p. 81

SELECTED REFERENCES
Breton 1958, pp. 50–55, repr. p. 50. Pierre Matisse 1959, pl. 10 (color). Dupin 1962,
pp. 356, 357–60, no. 547, repr. p. 542. Rubin 1968, p. 132, fig. 196 (repr. p. 135).
Teixidor 1972, pp. 38, 41. Millard 1980, p. 29. Rolnik 1983, n.p.

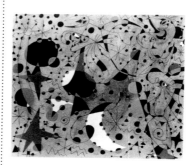

166. THE NIGHTINGALE'S SONG AT MIDNIGHT AND MORNING RAIN.
From the Constellation series. Palma de Mallorca, September 4, 1940.
(Plate, p. 248)
Gouache and oil wash on paper, 15 × 18⅛″ (38 × 46 cm). Signed lower center: *Miró*.
Inscribed on verso: *Joan Miró | Le chant du rossignol à minuit | et la pluie matinale
| Palma de majorque | 4/IX/1940*. Perls Galleries, New York. Dupin 548

PROVENANCE
The artist to Pierre Matisse Gallery, New York; Mrs. Herbert C. Morris, Mount Airy,
Pa.; Perls Galleries, New York, by 1979.

SELECTED EXHIBITIONS
Possibly New York 1945a, cat. 10
Possibly Paris 1959a
Possibly New York 1959a
New York 1972b, cat. 41, repr. (color)
n.p.
Cleveland 1979, cat. 37, repr. p. 82
Washington 1980a, cat. 31, repr. (color)
p. 80

Houston 1982, pl. 22 (color)
Tokyo 1984, cat. 15, repr. (color) p. 49
Stuttgart 1985, cat. 385, repr. (color)
p. 245
Zurich 1986, cat. 121, repr. (color) n.p.
New York 1987a, cat. 104, repr. (color)
p. 184

SELECTED REFERENCES

Breton 1958, pp. 50–55. Pierre Matisse 1959, pl. 11 (color). Dupin 1962, pp. 356, 357–60, no. 548, repr. p. 542. Lassaigne 1963, p. 89. Penrose 1969, pp. 105, 185, pl. 75 (repr. p. 105). Teixidor 1972, pp. 38, 41. Millard 1980, p. 29. Rolnik 1983, n.p. Rowell 1986, p. 170. Erben 1988, repr. (color) p. 108. Saura 1989, p. 50. Yokohama Museum of Art 1992, fig. 10 (repr. p. 31).

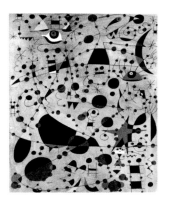

167. ON THE 13TH, THE LADDER BRUSHED THE FIRMAMENT.
From the Constellation series. Palma de Mallorca, October 14, 1940. (Plate, p. 249)

Gouache and oil wash on paper, 18 × 15″ (45.7 × 38.1 cm). Signed lower left: *Miró*. Inscribed on verso: *Joan Miró | Le 13 l'échelle a frôlé le firmament | Palma de majorque | 14/X/1940*. Collection H. Gates Lloyd. Dupin 549

PROVENANCE

The artist to Pierre Matisse Gallery, New York; to Mrs. H. Gates Lloyd, Washington, D.C., and Haverford, Pa., c. January–February 1945.

SELECTED EXHIBITIONS

Possibly New York 1945a, cat. 11
New York 1959a
New York 1972b, cat. 39, repr. (color) n.p., as *The 13th Ladder Brushes Against the Stars*
Cleveland 1979, cat. 32, repr. p. 79, as *The 13th Ladder Brushed Against the Heavens*

SELECTED REFERENCES

Breton 1958, pp. 50–55. Pierre Matisse 1959, pl. 12 (color). Dupin 1962, pp. 356, 357–60, 541, no. 549, repr. p. 342. Lassaigne 1963, p. 89. Penrose 1969, p. 105. Teixidor 1972, pp. 38, 41. Picon 1976, vol. 1, repr. p. 120. Gimferrer 1978, fig. 3. Rolnik 1983, n.p. Rowell 1986, p. 170.

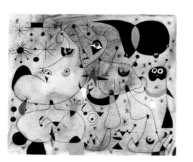

168. NOCTURNE.
From the Constellation series. Palma de Mallorca, November 2, 1940. (Plate, p. 250)

Gouache and oil wash on wove paper, 15 × 18⅛″ (38 × 46 cm). Signed lower right: *Miró*. Inscribed on verso: *Joan Miró | Nocturne | Palma de majorque | 2/XI/1940*. Private collection. Dupin 550

PROVENANCE

The artist to Pierre Matisse Gallery, New York; Stephen C. Clark, New York, 1945; Mrs. Cable Senior, New York, by May 1958; auctioned at Sotheby Parke Bernet, London; sold March 23, 1983, lot 52; to present owner.

SELECTED EXHIBITIONS

Possibly New York 1945a, cat. 12
Barcelona 1988b, cat. 80, repr. (color) p. 112
London 1989, repr. (color, detail) cover and (color) n.p.

SELECTED REFERENCES

Greenberg 1948, pl. LXI (repr. p. 98). Duthuit 1953, fig. 13 (repr. p. 31). Breton 1958, pp. 50–55. Dupin 1962, pp. 356, 357–60, no. 550, repr. p. 542. Teixidor 1972, pp. 38, 41. Miró 1977, p. 92. Rolnik 1983, n.p. Malet 1988b, p. 14. Jeffett 1989a, p. 37.

169. THE POETESS.
From the Constellation series. Palma de Mallorca, December 31, 1940. (Plate, p. 251)

Gouache and oil wash on paper, 15 × 18″ (38.1 × 45.7 cm). Signed lower left: *Miró*. Inscribed on verso: *Joan Miró | La Poétesse | Palma de majorque | 31/XII/1940*. Private collection, New York. Dupin 551

PROVENANCE

The artist to Pierre Matisse Gallery, New York; to present owner, by 1946.

SELECTED EXHIBITIONS

Possibly New York 1945a, cat. 13
Boston 1946, cat. 41
New York 1951b
Houston 1951, cat. 14
Paris 1959a
New York 1959b, cat. 76 (Los Angeles venue, cat. 78)
New York 1960, cat. 71, repr. n.p.
Tokyo 1966, cat. 64, repr. p. 110
Buenos Aires 1968, repr. p. 61
New York 1972b, cat. 42, repr. (color) n.p.
Paris 1974b, cat. 57, p. 123, repr. pp. 57 (color), 123
London 1978, cat. 16.23, repr. (color) n.p.
Cleveland 1979, cat. 38, repr. p. 82

SELECTED REFERENCES

Sweeney 1945, repr. (color) p. 93. Greenberg 1948, repr. (color) n.p. Duthuit 1953, repr. (color) p. 47. Breton 1958, pp. 50–55, repr. (color) p. 55. Kramer 1959, repr. p. 48. Pierre Matisse 1959, pl. 13 (color). Soby 1959, p. 106, repr. (color) p. 107. Dupin 1962, pp. 356, 357–60, no. 551, repr. p. 542. Volboudt 1962b, repr. p. 78. Lassaigne 1963, p. 89. Bonnefoy 1964, p. 26, pl. 44 (color). Rubin 1966, p. 53, repr. p. 53. Rubin 1967a, p. 26, repr. p. 25. Teixidor 1972, pp. 38, 41, repr. (color) p. 38. Martín 1982, p. 179. Rolnik 1983, n.p. Erben 1988, repr. (color) p. 111.

170. AWAKENING IN THE EARLY MORNING.
From the Constellation series. Palma de Mallorca, January 27, 1941. (Plate, p. 252)

Gouache and oil wash on paper, 18 × 15″ (45.7 × 38.1 cm). Signed lower left: *Miró*. Inscribed on verso: *Joan Miró | Le réveil au petit jour | Palma de majorque | 27/I/1941*. Private collection, New York. Dupin 552

PROVENANCE

The artist to Pierre Matisse Gallery, New York; to present owner, by 1946.

SELECTED EXHIBITIONS

Possibly New York 1945a, cat. 14
Boston 1946, cat. 42
Venice 1954, cat. 16
Paris 1959a
New York 1959b, cat. 77, as *Awakening at Dawn* (Los Angeles venue, cat. 79)

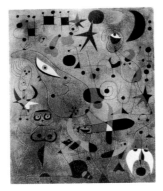

New York 1960, cat. 72, repr. n.p.
Paris 1962b, cat. 136
London 1964b, cat. 172, p. 41, pl. 33a
Cleveland 1966, cat. 78, repr. n.p., as
Constellation: Awakening at Dawn
Saint-Paul-de-Vence 1968, cat. 39, repr.
(color) p. 32
Barcelona 1968, cat. 43, pl. 18 (repr.

p. 106)
New York 1972b, cat. 45, repr. (color)
n.p.
Paris 1974b, cat. 58, pp. 123–24, repr.
p. 124
Cleveland 1979, cat. 30, repr. p. 78
New York 1985a, cat. 131, repr. p. 188

SELECTED REFERENCES
B.B.N. 1945, repr. p. 62. Greenberg 1948, pl. LXV (repr. p. 104). Prévert/Ribemont-
Dessaignes 1956, repr. p. 150. Breton 1958, pp. 50–55. Erben 1959, p. 139. Pierre
Matisse 1959, pl. 14 (color). Soby 1959, p. 106, repr. p. 104. Dupin 1962, pp. 356,
357–60, no. 552, repr. p. 542. Lassaigne 1963, p. 89. Miró 1964, repr. (color) p. 15.
Roberts 1964, p. 479. Teixidor 1972, pp. 38, 41. Rowell 1976, repr. p. 76.
Schmalenbach 1982, repr. p. 24. Malet 1983b, fig. 59 (color). Rolnik 1983, n.p.
Bouret 1986, n.p.

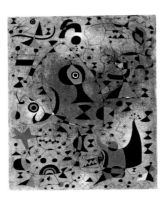

171. TOWARD THE RAINBOW. From the Constellation series. Palma de
Mallorca, March 11, 1941. (Plate, p. 253)
Gouache and oil wash on paper, 18 × 15″ (45.8 × 38 cm). Signed lower right: *Miró.*
Inscribed on verso: *Joan Miró | Vers l'arc-en-ciel | Palma de majorque | 11/III/1941.*
The Jacques and Natasha Gelman Collection. Dupin 553

PROVENANCE
The artist to Pierre Matisse Gallery, New York; to Patricia Matisse, New York, by
1951; to The Jacques and Natasha Gelman Collection, 1968.

SELECTED EXHIBITIONS
Possibly New York 1945a, cat. 15
Houston 1951, cat. 16
Venice 1954, cat. 19
Paris 1959a
New York 1959a

Paris 1962b, cat. 138
London 1964b, cat. 173, p. 41
Tokyo 1966, cat. 65, repr. (color) p. 67
New York 1989

SELECTED REFERENCES
Greenberg 1948, pl. LXIV (repr. p. 103). Breton 1958, pp. 50–55, repr. (color) p. 53.
Pierre Matisse 1959, pl. 15 (color). Dupin 1962, pp. 356, 357–60, 541, no. 553, repr.

p. 344. Teixidor 1972, pp. 38, 41. Picon 1976, vol. 2, repr. p. 30. Gimferrer 1978, fig.
188. Rolnik 1983, n.p. Lieberman 1989, pp. 222–25, 308, repr. pp. 223 (color,
recto), 224 (color, verso), 308.

172. WOMEN ENCIRCLED BY THE FLIGHT OF A BIRD. From the
Constellation series. Palma de Mallorca, April 26, 1941. (Plate, p. 254)
Gouache and oil wash on paper, 18⅛ × 15″ (46 × 38 cm). Signed lower left: *Miró.*
Inscribed on verso: *Joan Miró | Femmes encerclées par le vol d'un | oiseau | Palma
de majorque | 26/IV/1941.* Private collection. Dupin 554

PROVENANCE
The artist to Pierre Matisse Gallery, New York; to André Breton, New York and Paris,
c. January–February 1945; to present owner.

SELECTED EXHIBITIONS
Possibly New York 1945a, cat. 16
Venice 1954, cat. 18
Possibly Paris 1959a
Paris 1962b, cat. 139

London 1964b, cat. 174, p. 41
Paris 1974b, cat. 59, p. 124
Madrid 1978a, cat. 40, pp. 106–07
Paris 1991, repr. (color) p. 390

SELECTED REFERENCES
Greenberg 1948, pl. LXIII (repr. p. 102). Cirlot 1949, p. 38. Powys 1951, repr. p. 93.
Breton 1958, pp. 50–55. Pierre Matisse 1959, pl. 16 (color). Dupin 1962, pp. 356,
357–60, no. 554, repr. p. 542 (incorrectly dated April 27, 1941). Bonnefoy 1964, pl.
45 (color). Walton 1966, p. 34, pl. 76 (color). Penrose 1969, p. 104, pl. 74 (repr. p.
104). Teixidor 1972, pp. 38, 41, repr. (color) p. 39. Rowell 1976, repr. (color) p. 73.
Gimferrer 1978, fig. 189 (color). Martín 1982, p. 179. Schmalenbach 1982, repr. p.
36. Malet 1983b, fig. 58 (color). Rolnik 1983, n.p. Bouret 1986, n.p. Erben 1988,
repr. (color) p. 106. Raillard 1989, p. 112, repr. (color) p. 113. Monod-Fontaine 1991,
repr. p. 79 (photograph of Breton's apartment).

**173. WOMEN AT THE BORDER OF A LAKE IRRADIATED BY THE
PASSAGE OF A SWAN.** From the Constellation series. Palma de
Mallorca, May 14, 1941. (Plate, p. 255)
Gouache and oil wash on paper, 18⅛ × 15″ (46 × 38.1 cm). Signed lower left: *Miró.*
Inscribed on verso: *Joan Miró | Femmes au bord du lac à la surface | irisée par le
passage d'un cigne | Palma de majorque | 14/V/1941.* Private collection. Dupin 555

PROVENANCE
The artist to Pierre Matisse Gallery, New York; to Mrs. Stanley Resor, Greenwich, Conn., c. January–February 1945; to Helen Resor (later Mrs. Gabriel Hauge); to Ann Resor (later Mrs. James Laughlin), Norfolk, Conn., c. 1953; to present owner, 1974.

SELECTED EXHIBITIONS
Possibly New York 1945a, cat. 17
Possibly Paris 1959a
New York 1959b, cat. 78 (Los Angeles venue, cat. 80)
New York 1972b, cat. 44, repr. (color) n.p.
Cleveland 1979, cat. 39, repr. p. 83

SELECTED REFERENCES
Breton 1958, pp. 50–55. Pierre Matisse 1959, pl. 17 (color). Soby 1959, repr. p. 105. Dupin 1962, pp. 356, 357–60, no. 555, repr. p. 542. Lassaigne 1963, p. 89. Bonnefoy 1964, p. 26, pl. 46. Penrose 1969, p. 104, pl. 72 (repr. p. 103). Teixidor 1972, pp. 38, 41. Rolnik 1983, n.p. Rowell 1986, p. 170. Rowell 1991, p. 181.

174. THE MIGRATORY BIRD. From the Constellation series. Palma de Mallorca, May 26, 1941. (Plate, p. 256)

Gouache and oil wash on paper, 18⅛ × 15″ (46.1 × 38.1 cm). Signed lower left: *Miró*. Inscribed on verso: *Joan Miró | L'oiseau migrateur | Palma de majorque | 26/V/1941*. Private collection. Dupin 556

PROVENANCE
The artist to Pierre Matisse Gallery, New York; to Mr. and Mrs. William McKim, Palm Beach, Fla., c. January–February 1945; to present owner.

SELECTED EXHIBITIONS
Possibly New York 1945a, cat. 18
Paris 1959a
New York 1959a
Paris 1974b, cat. IX, p. 174, repr. p. 175
Cleveland 1979, cat. 31, repr. p. 79
Saint Louis 1980

SELECTED REFERENCES
Breton 1958, pp. 50–55. Pierre Matisse 1959, pl. 18 (color). Dupin 1962, pp. 356, 357–60, no. 556, repr. p. 542. Penrose 1969, p. 105. Teixidor 1972, pp. 38, 41. Rowell 1976, pp. 113, 169. Stich 1980, p. 8, fig. 1 (repr. p. 9). Rolnik 1983, n.p.

175. CIPHERS AND CONSTELLATIONS IN LOVE WITH A WOMAN. From the Constellation series. Palma de Mallorca, June 12, 1941. (Plate, p. 257)

Gouache and ink on ivory wove paper, 18 × 15″ (45.7 × 38.1 cm). Signed lower center: *Miró*. Inscribed on verso: *Joan Miró | Chiffres et constellations amoureux d'une femme | Palma de majorque | 12/VI/1941*. The Art Institute of Chicago. Gift of Mrs. Gilbert W. Chapman. Dupin 557

PROVENANCE
The artist to Pierre Matisse Gallery, New York; Mrs. Gilbert W. Chapman, New York, by December 1957; to The Art Institute of Chicago.

SELECTED EXHIBITIONS
New York 1945a, cat. 19
Possibly Paris 1959a
Possibly New York 1959a
New York 1972b, cat. 43, repr. (color) n.p.
Zurich 1986, cat. 123, repr. (color) n.p.
New York 1987a, cat. 106, repr. (color) p. 187

SELECTED REFERENCES
Pictures on Exhibit 1945, p. 16, repr. p. 25. Breton 1958, pp. 50–55. Pierre Matisse 1959, pl. 19 (color). Dupin 1962, pp. 356, 357–60, no. 557, repr. p. 542. Penrose 1969, p. 185. Teixidor 1972, pp. 38, 41. Stich 1980, p. 48. Rolnik 1983, n.p. Rowell 1986, p. 170. Erben 1988, repr. (color) p. 102. Jeffett 1989a, p. 37, repr. p. 37. Raillard 1989, p. 112, repr. (color) p. 113.

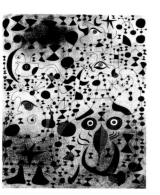

176. THE BEAUTIFUL BIRD REVEALING THE UNKNOWN TO A PAIR OF LOVERS. From the Constellation series. Montroig, July 23, 1941. (Plate, p. 258)

Gouache and oil wash on paper, 18 × 15″ (45.7 × 38.1 cm). Signed lower center: *Miró*. Inscribed on verso: *Joan Miró | Le bel oiseau déchiffrant l'inconnu | au couple d'amoureux | Montroig | 23/VII/1941*. The Museum of Modern Art, New York. Acquired through the Lillie P. Bliss Bequest. Acq. no. 7.45. Dupin 558

PROVENANCE
The artist to Pierre Matisse Gallery, New York; to The Museum of Modern Art, New York, January 1945.

SELECTED EXHIBITIONS
New York 1945a, cat. 20
Austin 1947
New York 1954
Paris 1959a
New York 1959b, cat. 79 (Los Angeles venue, cat. 81)
Saint-Paul-de-Vence 1968, cat. 40
Barcelona 1968, cat. 44, pl. 19 (repr. p. 107)
Munich 1969, cat. 55, repr. n.p.
Knokke 1971, cat. 27, repr. p. 44
New York 1973b
Paris 1974b, cat. 60, p. 124, repr. pp. 59 (color), 124
Cleveland 1979, cat. 40, repr. p. 83
New York 1982
New York 1983b
New York 1983e, p. 170, repr. (color) p. 171
New York 1991b, p. 138, repro. p. 54
On view at The Museum of Modern Art, New York: February–March 1945; June 1945–January 1946; July 1946–July 1947; January–May 1950; August

1950–November 1952; October 1955–
June 1957; November 1959–
September 1961; October 1962–
November 1963; May 1964–June
1968; November 1971–September

1973; January–April 1974; November
1974–August 1979; February–March
1980; April 1981–January 1982; May
1984–August 1986; February 1988–
August 1991

SELECTED REFERENCES
Art News 1945, repr. p. 27. Hayter 1945, p. 178, repr. p. 178. Zervos 1945–46, repr.
p. 422. Prévert/Ribemont-Dessaignes 1956, repr. p. 148. Breton 1958, pp. 50–55.
Erben 1959, p. 139, repr. (color) p. 121. Pierre Matisse 1959, pl. 20 (color). Soby
1959, p. 106, repr. p. 105. Dupin 1962, pp. 356, 357–60, no. 558, repr. p. 543. Clark
1962, repr. p. 31. Lassaigne 1963, repr. (color) p. 80. Juin 1967, p. 27. Marchiori
1972, p. 30. Teixidor 1972, pp. 38, 41. Rubin 1973, pp. 8, 81–82, 128 (n. 8), 131,
repr. (color) p. 80. Okada 1974, pl. 21 (color). Picon 1976, vol. 1, repr. p. 119. Rowell
1976, p. 71, repr. p. 74. *BT* 1978, repr. p. 3. Stich 1980, p. 48. Malet 1983b, fig. 60
(color). Rolnik 1983, n.p. Rowell 1986, pp. 170, 294–95, ill. 21. Pierre 1987, p. 231,
fig. 52. Saura 1989, p. 50.

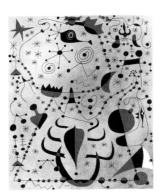

**177. THE ROSE DUSK CARESSES THE SEX OF WOMEN AND OF
BIRDS.** From the Constellation series. Montroig, August 14, 1941.
(Plate, p. 259)
Gouache and oil wash on paper, 18⅛ × 15″ (46 × 38 cm). Signed lower center: *Miró.*
Inscribed on verso: *Joan Miró | Le crépuscule rose caresse le sexe des | femmes et des
oiseaux | Montroig | 14/VIII/1941.* Private collection. Dupin 559

PROVENANCE
The artist to Pierre Matisse Gallery, New York; to Elizabeth L. Payne Card,
Fairhaven, Mass., c. January–February 1945; present owner.

SELECTED EXHIBITIONS
Possibly New York 1945a, cat. 21

SELECTED REFERENCES
B.B.N. 1945, repr. p. 65. Breton 1958, pp. 50–55. Pierre Matisse 1959, pl. 21 (color).
Dupin 1962, pp. 356, 357–60, no. 559, repr. p. 543. Penrose 1969, p. 104, pl. 73
(repr. p. 103). Teixidor 1972, pp. 38, 41. Rolnik 1983, n.p. Rowell 1986, p. 170.

178. THE PASSAGE OF THE DIVINE BIRD. From the Constellation
series. Montroig, September 12, 1941. (Plate, p. 260)
Gouache and oil wash on paper, 18⅛ × 15″ (46 × 38 cm). Signed lower center: *Miró.*
Inscribed on verso: *Joan Miró | Le passage de l'oiseau divin | Montroig | 12/IX/1941.*
Private collection, United States. Dupin 560

PROVENANCE
The artist to Pierre Matisse Gallery, New York; to Elizabeth Paepcke, Aspen, Colo.,
and Chicago; to present owner, May 1974.

SELECTED EXHIBITIONS
Possibly New York 1945a, cat. 22
Paris 1959a

Possibly New York 1959a
Houston 1982, pl. 23 (color)

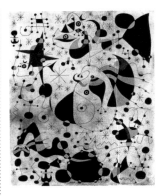

Barcelona 1988b, cat. 81, repr. (color)
p. 113

London 1989, repr. (color) n.p.

SELECTED REFERENCES
Breton 1958, pp. 50–55. Pierre Matisse 1959, pl. 23 (color). Dupin 1962, pp. 355,
356, 357–60, no. 560, repr. p. 543. Lassaigne 1963, p. 89. Juin 1967, repr. (color) p.
24. Penrose 1969, pp. 95, 106, 185. Teixidor 1972, pp. 38, 41. McCandless 1982, fig.
51 (repr. p. 57). Rolnik 1983, n.p. Rowell 1986, p. 187. Malet 1988b, p. 14. Jeffett
1989a, p. 36. Raillard 1989, p. 41.

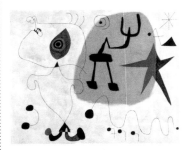

179. WOMAN, STARS. Barcelona, May 7, 1945. (Plate, p. 268)
Oil on canvas, 44⅞ × 57½″ (114 × 146 cm). Inscribed on verso: *Miró.* | 7-5-45 |
"femᵐe, étoiles." Private collection, New York. Dupin 656

PROVENANCE
Galerie Maeght, Paris; to present owner, May 1951.

SELECTED EXHIBITIONS
Paris 1948b, cat. 63, as *Femme et étoiles*
Stockholm 1949, cat. 6, as *Femme, étoile*

SELECTED REFERENCES
Tzara 1945–46, repr. p. 288. Gassier 1946, repr. p. 11. Dupin 1962, pp. 378–80,
no. 656, repr. p. 550.

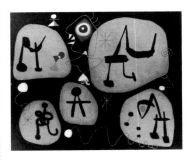

180. WOMEN LISTENING TO MUSIC. Barcelona, May 11, 1945. (Plate,
p. 264)
Oil on canvas, 51 × 63¾″ (129.5 × 162 cm). Inscribed on verso: *Miró 79 | 11-5-45 |
"femmes entendant de la musique."* Private collection. Dupin 657

PROVENANCE
Vladimir Golschmann, Saint Louis; [Grace Sharpe, New York]; Evelyn Sharp, New York; to Perls Galleries, New York; to Mr. and Mrs. Hans Neumann, Caracas (consigned to Christie's, New York; sold November 14, 1990, lot 31); to present owner.

SELECTED EXHIBITIONS
Paris 1948b, cat. 79, as *Femme entendant la musique* Nice 1957, cat. 9, repr. n.p., as *Femme entendant de la musique*

SELECTED REFERENCES
Art News 1947, p. 23. *Derrière le miroir* 1948, repr. Cirlot 1949, p. 39. Hoppe 1949, repr. p. 11. Queneau 1949, fig. 11 (color). *Art News* 1955, repr. p. 43. Prévert/Ribemont-Dessaignes 1956, repr. p. 157. Verdet 1957a, n.p. Verdet 1957b, pl. 9. Erben 1959, p. 143. Soby 1959, p. 118, repr. p. 112. Dupin 1962, pp. 378–80, no. 657, repr. p. 550. Lassaigne 1963, p. 93, repr. (color) p. 91. Penrose 1969, pp. 107, 180. Picon 1976, vol. 1, p. 118; vol. 2, repr. (color) p. 24. Rose 1982a, p. 34. Erben 1988, repr. (color) p. 115.

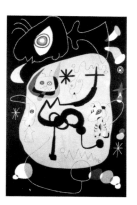

181. DANCER LISTENING TO THE ORGAN IN A GOTHIC CATHEDRAL.
Barcelona, May 26, 1945. (Plate, p. 265)
Oil on canvas, 6' 5⅝" × 51½" (197.1 × 130.6 cm). Inscribed on verso: *Miró.* | *26-5-45* | *"danseuse entendant jouer de l'orgue dans une cathédrale gothique."* Fukuoka Art Museum. Dupin 658

PROVENANCE
The artist to Pierre Matisse Gallery, New York, 1945; to Edna and Keith Warner, Norwich, Vt., March 1949; to Edna Warner (later Edna K. Allen), Fort Lauderdale, Fla., by January 1966; Fukuoka Art Museum.

SELECTED EXHIBITIONS
New York 1947b, cat. 21, as *Dancer Hearing Organ Music Played in a Cathedral* *Dancer Listening to Organ Music in a Gothic Cathedral* (New York venue only)
Paris 1952, cat. 65 Tokyo 1986, cat. 15, repr. (color) p. 48
New York 1959b, cat. 84, as *A Ballet*

SELECTED REFERENCES
Tzara 1945–46, repr. p. 285. Gassier 1946, repr. p. 11. *Art News* 1947, repr. p. 22. McBride 1947, p. 29. Burrows 1947, p. 7. Wolf 1947, p. 10. Greenberg 1948, repr. (color) n.p. Cirici-Pellicer 1949, p. 38, ill. 54. Cirlot 1949, pp. 28, 42, 53. Hess 1950, repr. (color) p. 149 (incorrectly identified as *"Figures and Mountains*, Lee A. Ault Collection, New Canaan, Conn."). *Libre Belgique* 1952, repr. Breton 1952. Mellquist 1952, p. 7, repr. p. 6. Sweeney 1953, p. 63. Soby 1959, p. 118, repr. p. 113. Dupin 1962, pp. 378–80, 549, no. 658, repr. (color) p. 359. Lassaigne 1963, p. 93. Gasser 1965, repr. (color) p. 65. Penrose 1969, pp. 107, 180, pl. 79 (repr., color, p. 111). Rubin 1973, repr. p. 11 (installation view). Picon 1976, vol. 1, p. 118; vol. 2, repr. (color) p. 25. Rose 1982a, p. 34.

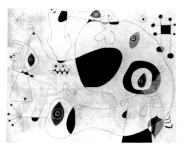

182. THE HARBOR. [Barcelona], July 2, 1945. (Plate, p. 266)
Oil on canvas, 51¼ × 63¾" (130 × 162 cm). Inscribed on verso: *Miró.* | *2-7-45.* | *"le port."* Private collection. Dupin 659

PROVENANCE
The artist to Pierre Matisse Gallery, New York, 1945; to Frank Perls Gallery, Beverly Hills, Calif., May 1950; Pierre Matisse Gallery, New York; to Celeste and Armand P. Bartos, New York, c. 1953 (consigned to Christie's, New York; sold June 27, 1983, lot 6); present owner.

SELECTED EXHIBITIONS
New York 1947b, cat. 20, as *The Port* Paris 1962b, cat. 78
New York 1957a, cat. 55 London 1964b, cat. 180, p. 42, pl. 35a
New York 1958a Washington 1980a, cat. 33, repr. (color) p. 82
New York 1959b, cat. 85 (Los Angeles venue, cat. 87)

SELECTED REFERENCES
McBride 1947, p. 29. Coates 1947, p. 74. Wolf 1947, p. 10, repr. p. 10. Greenberg 1948, pl. LXXV (repr. p. 116). Rubin 1959, p. 41. Soby 1959, p. 118, repr. (color) p. 115. Dupin 1962, p. 380, no. 659, repr. p. 550. Rubin 1973, repr. p. 11 (installation view). Rowell 1976, repr. (color) p. 194. Millard 1980, pp. 29–30. Castello di Rivoli 1988, repr. p. 33 (detail, in progress; photograph of Miró in his studio). Erben 1988, repr. (color) p. 116.

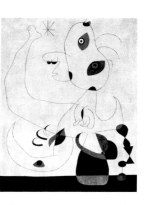

183. SPANISH DANCER. [Barcelona], July 7, 1945. (Plate, p. 267)
Oil on canvas, 57½ × 44⅞" (146 × 114 cm). Inscribed on verso: *Miró* | *7-7-45* | *"danseuse espagnole."* Collection Beyeler, Basel. Dupin 660

PROVENANCE
Mr. and Mrs. Lee A. Ault, New Canaan, Conn., by 1948; John L. Senior, Jr., New York and New Canaan, Conn.; through M. Knoedler & Co., New York, to Saidenberg Gallery, New York, June 1956; to Alex Reid & Lefevre, London, after 1966; Acquavella Galleries, New York; William Koch, Boston (consigned to Sotheby's, New York; sold November 13, 1990, lot 47A); to Collection Beyeler, Basel.

SELECTED EXHIBITIONS
New York 1959b, cat. 86 (Los Angeles venue, cat. 88) Zurich 1986, cat. 128, repr. (color) n.p.
New York 1966, cat. 266, repr. p. 145 New York 1987a, cat. 110, repr. (color) p. 193
New York 1972b, cat. 50, repr. (color) n.p.

SELECTED REFERENCES
Bruguière 1945–46, repr. p. 297. Greenberg 1948, pl. LXXVI (repr. p. 117). Soby 1959, p. 118, repr. p. 116. Dupin 1962, pp. 378–80, 549, no. 660, repr. p. 402. Gasser 1965, repr. p. 64. Raillard 1989, pp. 35, 37.

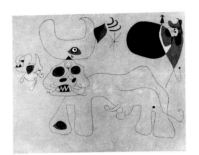

184. BULLFIGHT. Barcelona, October 8, 1945. (Plate, p. 269)
Oil on canvas, 44⅞ × 56⅝″ (114 × 144 cm). Inscribed on verso: *Miró 8-10-45 La course de taureaux.* Musée National d'Art Moderne, Centre Georges Pompidou, Paris. Gift of the artist and Pierre Loeb, 1947. Dupin 661

PROVENANCE
The artist and Pierre Loeb (Galerie Pierre), Paris; to Musée National d'Art Moderne, Centre Georges Pompidou, Paris, 1947.

SELECTED EXHIBITIONS
Basel 1952, cat. 152, as *La Course aux taureaux*
Boston 1957a, cat. 31, repr. n.p.
Paris 1962b, cat. 79, repr. n.p.
Washington 1968a, cat. 28, repr. p. 50
Bordeaux 1971, cat. 193, repr. p. 104
Paris 1974b, cat. 62, p. 125, repr. (color) p. 61
Humlebaek 1974, cat. 26

SELECTED REFERENCES
Tzara 1945–46, repr. pp. 279 (in progress), 290. Dorival 1948a, p. 30, repr. p. 30. Dorival 1948b, p. 178. Cirlot 1949, fig. 34. Gasch 1950, repr. p. 23. Prévert/Ribemont-Dessaignes 1956, repr. p. 156. Erben 1959, p. 141. Dupin 1962, pp. 378–80, 382, no. 661, repr. p. 550. Chevalier 1962, p. 11. *Louisiana Revy* 1974, repr. (color) p. 22. Okada 1974, pl. 23 (color). Picon 1976, vol. 1, p. 114; vol. 2, repr. (color) p. 11. Miró 1977, pp. 135, 170. *BT* 1978, repr. cover. Gimferrer 1978, p. 142. Macmillan 1982, pp. 104–05. Bouret 1986, n.p. Rowell 1986, p. 268.

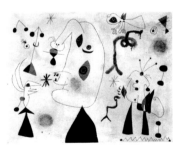

185. PERSONAGES, BIRDS, STARS. [Barcelona, March 1, 1946].
(Plate, p. 271)
Oil on canvas, 28⅜ × 36⅝″ (72 × 93 cm). Private collection, Zurich. Dupin 681

PROVENANCE
Galerie Maeght, Paris, by 1949; to Franz Meyer, Zurich, 1950; to present owner, June 1950.

SELECTED EXHIBITIONS
Paris 1948b, cat. 55, as *Personnage, oiseau, étoile*
Basel 1956, cat. 58
London 1964b (Zurich venue only)
Munich 1969, cat. 62, repr. n.p.
Paris 1974b, cat. 63, p. 125
Humlebaek 1974, cat. 27
Zurich 1986, cat. 131, repr. (color) n.p.
New York 1987a, cat. 114, repr. (color) p. 198

SELECTED REFERENCES
Derrière le miroir 1948, repr. n.p. Bouchet 1949, repr. n.p. Cirici-Pellicer 1949, ill. 55 (incorrectly dated 1941). Hoppe 1949, repr. p. 12. Prévert/Ribemont-Dessaignes 1956, repr. p. 162. Dupin 1962, p. 382, no. 681, repr. p. 552. Erben 1988, repr. back cover (color), p. 117 (color).

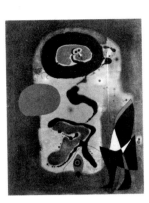

186. THE RED SUN. [Barcelona, March 20], 1948. (Plate, p. 272)
Oil and gouache on canvas, 36⅛ × 28⅛″ (91.7 × 71.4 cm). Inscribed on verso: *Miró | 1948 | LE SOLEIL ROUGE.* The Phillips Collection, Washington, D.C. Dupin 720

PROVENANCE
The artist to Pierre Matisse Gallery, New York; to The Phillips Collection, Washington, D.C., 1951.

SELECTED EXHIBITIONS
New York 1951a, cat. 5, repr. n.p.
Chapel Hill 1951
Washington 1952, cat. 11
Denver 1954, cat. 50
New York 1959b, cat. 90 (Los Angeles venue, cat. 96)
New York 1972b, cat. 52, repr. (color) n.p.
San Francisco 1981a, cat. 47, p. 176,
repr. (color) p. 177
New York 1983f, cat. 68
Washington 1986
Zurich 1986, cat. 133, repr. (color) n.p.
New York 1987a, cat. 116, repr. (color) p. 201
Madrid 1988, repr. (color) p. 187
Washington 1989

SELECTED REFERENCES
Zervos 1949, repr. p. 135. Soby 1959, p. 127, repr. (color) p. 125. Borchert 1961, p. 12, pl. 5 (repr., color, p. 13). Dupin 1962, pp. 388, 390, 392, 555, no. 720, repr. p. 409. Lippard 1965, p. 33. Okada 1974, pl. 25 (color). Erben 1988, repr. (color) p. 121.

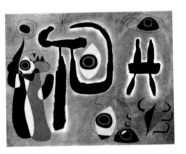

187. THE RED SUN GNAWS AT THE SPIDER. [Barcelona, April 2], 1948. (Plate, p. 273)
Oil on canvas, 29½ × 37⅛″ (75 × 94.5 cm). Inscribed on verso: <u>*MIRÓ | 1948 | LE SOLEIL ROUGE RONGE RONGE*</u> [crossed out] *L'ARAIGNÉE.* Collection Kazumasa Katsuta. Dupin 721

PROVENANCE
Mr. and Mrs. Fernand C. Graindorge, Liège, by May 1953; Galerie Maeght, Paris; to Stephen Hahn, New York; to Collection Kazumasa Katsuta, 1988.

SELECTED EXHIBITIONS

Stockholm 1949, cat. 25
Brussels 1953, cat. 70, repr. n.p.
Brussels 1956, cat. 75
Basel 1956, cat. 60
Liège 1958, cat. 8
Paris 1959b, cat. 111, pl. 19
Paris 1962b, cat. 83
Humlebaek 1967, cat. 70, repr. n.p.
Saint-Paul-de-Vence 1968, cat. 46, repr. p. 87
Barcelona 1968, cat. 51, pl. 21 (repr. p. 109)
Paris 1974b, cat. 64, p. 125, repr. p. 125
Humlebaek 1974, cat. 28
Basel 1979, cat. 72
Edinburgh 1982, cat. 28, repr. (color) p. 25
Zurich 1986, cat. 135, repr. (color) n.p.
New York 1987a, cat. 117, repr. (color) p. 203
Yokohama 1992, cat. 67, repr. (color) p. 104

SELECTED REFERENCES

Zervos 1949, repr. p. 126. Prévert/Ribemont-Dessaignes 1956, p. 93, repr. p. 47. Hüttinger 1957, fig. 36. Dupin 1962, pp. 388, 390, 555, no. 721, repr. (color) p. 373. Gasser 1965, repr. cover (color, detail) and p. 66 (color). *Louisiana Revy* 1974, repr. (color) p. 22. Gimferrer 1978, pp. 36, 110, fig. 44 (color). Malet 1983b, fig. 63 (color). Rowell 1986, p. 229. Erben 1988, repr. (color) p. 120. Saura 1989, p. 50.

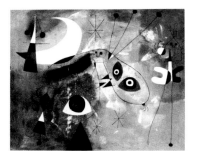

188. PAINTING. 1949. (Plate, p. 275)

Oil on canvas, 50⅛″ × 6′ 4″ (127.3 × 193 cm). Inscribed on verso: *Miró | 1949 | Monsieur et Madame Morton Neumann amicalement.* The Morton G. Neumann Family Collection. Dupin 744

PROVENANCE

[Pierre Matisse Gallery, New York]; to The Morton G. Neumann Family Collection, by October 1956?

SELECTED EXHIBITIONS

Possibly New York 1951a, cat. 10, as *Constellation with Figures*
Chicago 1961, cat. 36, repr. cover, as
Composition
Washington 1980b, cat. 60
Houston 1982 (dated May 20, 1949)

SELECTED REFERENCES

Dupin 1962, pp. 395–96, 556, no. 744, repr. p. 415. Bonnefoy 1964, pl. 47. Carmean 1980, p. 42, repr. (color) p. 69.

189. PAINTING (Personage and Moon). [Barcelona, February 25], 1950. (Plate, p. 278)

Oil on canvas, 32 × 39½″ (81.3 × 100.3 cm). Signed and dated on verso: *Miró | 1950.* The Museum of Modern Art, New York. Fractional gift of Nina and Gordon Bunshaft. Acq. no. 1239.79. Dupin 737

PROVENANCE

The artist to Pierre Matisse Gallery, New York; to Nina and Gordon Bunshaft, New York, January 27, 1955; to The Museum of Modern Art, New York, December 1979.

SELECTED EXHIBITIONS

New York 1951a, cat. 13, repr. n.p., as *Woman, Moon and Stars* (incorrectly dated 1949–50)
Minneapolis 1954, cat. 111, as *Woman, Moon and Stars*
New York 1959b, cat. 94 (Los Angeles venue, cat. 102)
New York 1973b
Washington 1980a, cat. 35, repr. (color) p. 84
Houston 1982, pl. 28 (color)
Saint-Paul-de-Vence 1990, cat. 54, p. 132, repr. (color) p. 133

SELECTED REFERENCES

Soby 1959, repr. (color) p. 128. Dupin 1962, pp. 393–95, no. 737, repr. p. 556. Rubin 1973, p. 131, repr. p. 83. Millard 1980, p. 30.

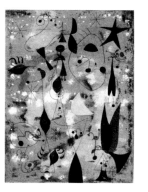

190. PAINTING. [Barcelona, March 17], 1950. (Plate, p. 279)

Oil and casein on canvas, 51⅛ × 38⅛″ (129.8 × 96.8 cm). Signed and dated on verso: *Miró. | 1950.* Vassar College Art Gallery, Poughkeepsie, N.Y. From the collection of the late Katherine S. Deutsch, Class of 1940. Dupin 740

PROVENANCE

The artist to Pierre Matisse Gallery, New York; to Katherine S. Deutsch, Greenwich, Conn., March 15, 1951; on extended loan to the Vassar College Art Gallery, Poughkeepsie, N.Y., January 3, 1991.

SELECTED EXHIBITIONS

New York 1959b, cat. 96, as *Birds, Figures and Blue Star* (Los Angeles venue, cat. 104)

SELECTED REFERENCES

Soby 1959, p. 130, repr. p. 132. Devree 1959, repr. p. X15. Kramer 1959, repr. cover. Dupin 1962, pp. 393–95, 429–30, no. 740, repr. p. 556.

191. MURAL PAINTING. Barcelona, October 18, 1950–January 26, 1951. (Plate, pp. 276–77)

Oil on canvas, 6′ 2¾″ × 19′ 5¾″ (188.8 × 593.8 cm). Signed lower left: *Miró.* Inscribed on verso: *"peinture murale" | Miró. | 18/10/1950 | 26/1/1951.* The Museum of Modern Art, New York. Mrs. Simon Guggenheim Fund. Acq. no. 592.63. Dupin 775

PROVENANCE

The artist to Harvard University, Cambridge, Mass. (commissioned by the Harvard Corporation for Harkness Commons, Graduate Center), June 1951; to the artist, May 19, 1961; to Pierre Matisse Gallery, New York, 1961; to The Museum of Modern Art, New York, December 1963.

Fundació Pilar i Joan Miró a Mallorca. Ink on tracing paper, 10½ × 24″ (26.5 × 61 cm)

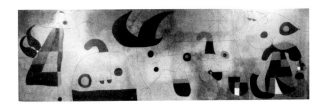

SELECTED EXHIBITIONS

Paris 1951, cat. 24, repr. (color) n.p.
New York 1963a, cat. 16, repr. n.p., as
 Grande Peinture murale
New York 1973b
Paris 1974b, cat. X, p. 174, repr. p. 175
New York 1980b, cat. 38, pp. 62–63
Houston 1982
On view at the Harkness Commons
 Dining Room, Graduate Center,
 Harvard University, Cambridge, Mass.:
 June 1951–c. 1960
On view at the Fogg Art Museum,
 Harvard University, Cambridge, Mass.:

c. 1960–May 19, 1961
On view at The Museum of Modern Art,
 New York: February 1965–September
 1967; January–July 1968; May 1969–
 October 1973; January–April 1974;
 November 1974–August 1975; October
 1975–December 1976; May 1984–
 September 1992
On view at The Metropolitan Museum of
 Art, New York: October 4, 1967–
 January 11, 1968; October 1980–
 March 1981; August 1982–March
 1984

SELECTED REFERENCES

Cahiers d'art 1951, p. 206, repr. p. 209. *Architecture d'Aujourd'hui* 1951, repr. (color)
p. 47. Warnod 1951. Conlan 1951. Gindertail 1951. *Observateur* 1951. Prévert/
Ribemont-Dessaignes 1956, repr. p. 87. Erben 1959, p. 144. Soby 1959, pp. 123–24,
127, repr. pp. 130–31. Gardy Artigas 1961, p. 3. Choay 1961, p. 35. Dupin 1962, pp.
430, 475, 496, 559, no. 775, repr. pp. 404–05. Lassaigne 1963, p. 96, repr. (color)
pp. 94–95. Lonngren 1964, p. 10. Juin 1967, p. 27. Penrose 1969, pp. 152–53, pl.
115 (repr. pp. 152–53). Rubin 1973, pp. 8, 87, 132, repr. pp. 86 (color, foldout), 132.
Macmillan 1982, pp. 103–04, 105, fig. 56 (repr. p. 103). Rowell 1985, p. 58.

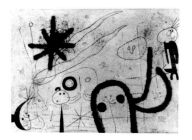

192. SUNBURST WOUNDS THE TARDY STAR. 1951. (Plate, p. 274)
Oil and casein on canvas, 23⅝ × 31⅞″ (60 × 81 cm). Signed lower right: *Miró*.
Inscribed on verso: *Joan Miró | "Les éclats du soleil blessent l'étoile tardive" | 1951*.
Collection Gustav Zumsteg. Dupin 783

PROVENANCE

Galerie Maeght, Paris; to Collection Gustav Zumsteg, 1953.

SELECTED EXHIBITIONS

Venice 1954, cat. 26 London 1964b (Zurich venue only)
Basel 1956, cat. 67 Zurich 1986, cat. 140, repr. (color) n.p.
Paris 1962b, cat. 90, repr. n.p.
Lausanne 1964, cat. 335, repr. (color) n.p.

SELECTED REFERENCES

Cahiers d'art 1952, repr. p. 32. Duthuit 1953, repr. pp. 34–35. Prévert/Ribemont-
Dessaignes 1956, p. 95. Dupin 1962, p. 431, no. 783, repr. p. 559. Lassaigne 1963,
repr. (color) p. 93. Penrose 1969, pl. 82 (repr. p. 117). Rowell 1986, p. 229. Saura
1989, p. 50.

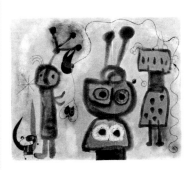

193. THE BIRD WITH A CALM LOOK, ITS WINGS IN FLAMES. 1952.
(Plate, p. 280)
Oil and plaster on canvas, 31⅞ × 39⅜″ (81 × 100 cm). Signed lower right: *Miró*.
Inscribed on verso: *Miró 1952. L'oiseau au regard calme les ailes en flames*.
Staatsgalerie Stuttgart. Dupin 786

PROVENANCE

Gustav Zumsteg, Zurich, by 1954; to Galerie Beyeler, Basel, 1956; to Ragnar
Moltzau, Oslo, 1956; G. David Thompson, Pittsburgh, by 1960; private collection,
Brussels; to Galerie Beyeler, Basel, 1960; to Staatsgalerie Stuttgart, 1966.

SELECTED EXHIBITIONS

Paris 1953, cat. 19 Basel 1960, cat. 55
New York 1953, cat. 18 Zurich 1960, cat. 143
Venice 1954, cat. 27 Hague 1961, cat. 136
Basel 1956, cat. 69 Kassel 1964, cat. 3, repr. p. 85
Zurich 1957, cat. 53 London 1964b, cat. 193, p. 44, pl. 37b
Hague 1957, cat. 54 (added to the exhibition on September
London 1958, cat. 54 3; London venue only)
London 1959, cat. 52, repr. p. 64

SELECTED REFERENCES

Estienne 1954, repr. p. 4. Kaiser-Wilhelm Museum 1954, repr. (color) n.p. Borchert
1961, p. 16, pl. 7 (repr., color, p. 17). Dupin 1962, pp. 433, 560, no. 786, repr. p. 419.
Lassaigne 1963, p. 100, repr. (color) p. 99. Roberts 1964, pp. 477, 478. Lynton 1964,
p. 44. Maur/Inboden 1982, p. 225, repr. p. 225. Rowell 1986, p. 229. Erben 1988,
repr. (color) p. 129.

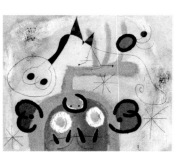

**194. THE BIRD BOOM-BOOM MAKES HIS APPEAL TO THE HEAD
ONION PEEL.** 1952. (Plate, p. 280)
Oil on canvas, 31⅞ × 39⅜″ (81 × 100 cm). Signed lower right: *Miró*. Inscribed on
verso: *Miró | 1952 | L'oiseau boum-boum fait sa prière à la tête pelure d'oignon*.
Collection Mr. and Mrs. Herbert Klapper, New York. Dupin 793

PROVENANCE

Galerie Maeght, Paris; Hans Schröder, Saarbrücken and Garmisch-Partenkirchen;
Acquavella Galleries, New York; to Mr. and Mrs. Herbert Klapper, New York.

SELECTED EXHIBITIONS
Munich 1969, cat. 67, repr. n.p.
Paris 1981, cat. 21, repr. (color) n.p.

New York 1981b, cat. 18, repr. (color) p. 39

SELECTED REFERENCES
Dupin 1962, p. 433, no. 793, repr. p. 560. Rowell 1986, p. 229.

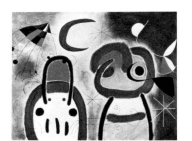

195. THE BIRD WITH PLUMAGE SPREAD FLIES TOWARD THE SILVERY TREE. 1953. (Plate, p. 281)

Oil on canvas, 35¼ × 45¾″ (89.5 × 116.2 cm). Signed lower center: *Miró*. Inscribed on verso: *Miró 1953 L'Oiseau au Plumage Déployé Vole Vers L'Arbre Argenté*. Private collection. Dupin 817

PROVENANCE
The artist to Pierre Matisse Gallery, New York; to Edgar J. Kaufmann, Jr., New York, 1953; to Estate of Edgar J. Kaufmann, Jr. (consigned to Sotheby's, New York; sold November 15, 1989, lot 6); to present owner.

SELECTED EXHIBITIONS
Paris 1953, cat. 21
New York 1953b, cat. 21, repr. n.p.

(incorrectly captioned as cat. 22)
New York 1958d, cat. 19, repr. n.p.

SELECTED REFERENCES
Dupin 1962, p. 433, no. 817, repr. p. 562.

196. HAIR DISHEVELED BY THE FLEEING CONSTELLATIONS. [Barcelona, January 19], 1954. (Plate, p. 283)

Oil and tempera or gouache (?) on machine-woven fabric printed to look like tapestry, 51 × 70½″ (129.5 × 179 cm). Signed lower left: *Miró*. Inscribed on verso: *Miró. | 1954 | LA CHÉVELURE DÉFAITE | À LA FUITE | DES CONSTELLATIONS*. Collection Joseph Holtzman. Dupin 850

PROVENANCE
Galerie Maeght, Paris, by October 1955; to Mr. and Mrs. Raoul Lévy, Paris (consigned to Sotheby's, London; sold June 23, 1965, lot 73); to Magnussen; Berggruen & Co, Paris; to Joseph Holtzman, 1966.

SELECTED EXHIBITIONS
Pittsburgh 1955, cat. 197, pl. 73, as *In the Trail of the Constellations*
New York 1959b, cat. 102, as *Coiffeur Disheveled by the Flight of Constellations* (Los Angeles venue, cat. 109)

Paris 1962b, cat. 96
London 1964b, cat. 200, p. 45, repr. (color) n.p., as *Hair Dishevelled in Pursuit of the Constellations*
On view at The Baltimore Museum of Art: December 10, 1990–September 16, 1991

SELECTED REFERENCES
Prévert/Ribemont-Dessaignes 1956, repr. (color) p. 179. Yanaihara 1957, repr. p. 17. Erben 1959, p. 151, pl. 68. Soby 1959, p. 139, repr. (color) p. 143. Dupin 1962, pp. 440, 564, no. 850, repr. p. 426. S.N.H. 1965, repr. p. 7. *Burlington Magazine* 1965, repr. p. vii.

197. THE RED DISK. [Palma de Mallorca], April 19, 1960. (Plate, p. 292)

Oil on canvas, 51¼ × 63⅜″ (130.2 × 161 cm). Signed lower right: *Miró*. Inscribed on verso: *19/4/1960 Le Disque Rouge*. New Orleans Museum of Art. Bequest of Victor K. Kiam. Dupin 896

PROVENANCE
Pierre Matisse Gallery, New York; Galerie Maeght, Paris; Victor K. Kiam, New York; to New Orleans Museum of Art, August 1977.

SELECTED EXHIBITIONS
Paris 1960, cat. 5
Paris 1961a, cat. 1
New York 1961d, pl. 22
Saint-Paul-de-Vence 1968, cat. 54
Barcelona 1968, cat. 57, pl. 24 (repr. p. 112)
Munich 1969, cat. 71, repr. n.p.

Washington 1980a, cat. 37, repr. (color) p. 86
Houston 1982
Zurich 1986, cat. 149, repr. (color) n.p.
New York 1987a, cat. 129, repr. (color) p. 219

SELECTED REFERENCES
Dupin 1961b, repr. (color) p. 33. Volboudt 1961, p. 7. Dupin 1962, pp. 482–83, 568, no. 896, repr. (color) p. 469. Gasch 1963, repr. p. 59. Penrose 1969, pl. 94 (repr. p. 129). Okada 1974, repr. p. 81. Millard 1980, p. 31. Malet 1983b, fig. 70 (color). Erben 1988, repr. (color) p. 156. Llorca 1990, repr. p. 175.

FJM 2446. Fountain pen and colored pencil on thin cardboard, 2¾ × 3¾″ (7.2 × 9.6 cm)

198. BLUE I. Palma de Mallorca, March 4, 1961. (Plate, p. 288)

Oil on canvas, 8′ 10¼″ × 11′ 7¾″ (270 × 355 cm). Inscribed on verso: *MIRÓ. | 4/3/61 | BLEU I/III*. Collection Hubert de Givenchy. Dupin 969

PROVENANCE
The artist to Galerie Maeght, Paris; to Hubert de Givenchy.

SELECTED EXHIBITIONS
Paris 1961b, cat. 3
New York 1961d, pl. 8

Houston 1962, p. 62
London 1966, cat. 22, repr. (color) n.p.

Tokyo 1966, cat. 89, repr. (color) p. 73
Saint-Paul-de-Vence 1968, cat. 58
Barcelona 1968, cat. 62
Munich 1969, cat. 74, repr. n.p.
New York 1972d, cat. 39, pp. 130, 133, repr. p. 130
Paris 1974b, cat. 78, p. 127, repr. p. 127
Barcelona 1975b, cat. 23, repr. (color) n.p.
Madrid 1978a, cat. 57, p. 109, repr. (color) p. 68
Saint-Paul-de-Vence 1979, cat. 3, repr. (color) p. 132

Paris 1983, cat. 1
Paris 1984b
Zurich 1986, cat. 150, repr. (color) n.p.
New York 1987a, cat. 130, repr. (color) p. 220 (not exhibited)
Lyon 1988, repr. pp. 121, 320 (installation view), 321 (installation view)
Saint-Paul-de-Vence 1990, cat. 60, p. 144, repr. (color) p. 145

SELECTED REFERENCES

Miró 1961, p. 18. Mastai 1961, p. 195. J.K. 1961, p. 10. Volboudt 1961, p. 7. S.T. 1962, p. 35. Ragon 1962, p. 60. Dupin 1962, p. 497, no. 969, repr. pp. 460, 574. Taillandier/Gomis/Prats 1962, pl. 58 (color). Volboudt 1962a, n.p. Ashton 1966, p. 42. Juin 1967, repr. (color; upside down) p. 20. Penrose 1969, pp. 132, 189. Krauss 1972, pp. 34, 37. Rowell 1972, p. 66. Gimferrer 1975, n.p. Rowell 1976, p. 171, repr. p. 120. Miró 1977, repr. p. 108 (installation view). Gimferrer 1978, pp. 36, 118, fig. 38 (color). Millard 1980, p. 31. Freeman 1980, p. 39. Schmalenbach 1982, repr. p. 22. Rowell 1985, pp. 48–49, 56–59, fig. 1 (repr. p. 50). Rowell 1986, pp. 258–59, 270, 320 (n. 10), 321 (n. 9). Beaumelle 1987, p. 434. Erben 1988, repr. (color) p. 158.

FJM 2444. Ballpoint pen and colored pencil on paper, 4 × 5¼″ (10 × 13.3 cm)

199. **BLUE II.** Palma de Mallorca, March 4, 1961. (Plate, p. 289)
Oil on canvas, 8′ 10¼″ × 11′ 7¾″ (270 × 355 cm). Inscribed on verso: *MIRÓ | 4/3/1961 | BLEU II/III.* Musée National d'Art Moderne, Centre Georges Pompidou, Paris. Gift of the Menil Foundation, 1984. Dupin 970

PROVENANCE

The artist to Pierre Matisse Gallery, Paris; to Musée National d'Art Moderne, Centre Georges Pompidou, Paris, 1984.

SELECTED EXHIBITIONS

Paris 1961b, cat. 3
New York 1961d, pl. IV (color)
Houston 1962
New York 1964, cat. 59, repr. (color) p. 35
London 1964b, cat. 212, p. 46, pl. 39b
Saint-Paul-de-Vence 1968, cat. 59, repr. p. 114
Barcelona 1968, cat. 63
Munich 1969, cat. 75, repr. n.p.
New York 1972d, cat. 40, pp. 131, 133, repr. (color) p. 131
Paris 1974b, cat. 79, p. 127, repr. pp. 67 (color), 127

Washington 1980a, cat. 38, repr. (color) p. 87
Houston 1982
Paris 1984b
Zurich 1986, cat. 151, repr. (color) n.p., (in progress) n.p.
New York 1987a, cat. 131, repr. (color) p. 221
Saint-Paul-de-Vence 1990, cat. 61, p. 144, repr. pp. 146 (color), 192 (in progress), 202 (in progress)

SELECTED REFERENCES

Miró 1961, p. 18, repr. (color) p. 18. Mastai 1961, p. 195. J.K. 1961, p. 10. Volboudt

1961, p. 7. Dupin 1962, p. 497, no. 970, repr. p. 574. Ragon 1962, p. 60, repr. p. 58. S.T. 1962, p. 35. Volboudt 1962a, n.p. Taillandier/Gomis/Prats 1962, pl. 59 (color). Ashton 1964, p. 7, repr. p. 7. Bonnefoy 1964, p. 171, pl. 61. Lynton 1964, p. 44. Barrett 1964, p. 27. H.C. 1964, p. 289. Ashton 1966, p. 42. Tillim 1966, p. 69, repr. p. 66. Penrose 1969, pp. 132, 189. Krauss 1972, pp. 34, 37. Rowell 1972, p. 66. Okada 1974, pl. 31 (color). Rowell 1976, repr. (color) p. 112. Miró 1977, repr. p. 63 (in progress). Gimferrer 1978, pp. 36, 118, fig. 39 (color). Millard 1980, p. 31. Freeman 1980, p. 39. McCandless 1982, p. 62, fig. 54 (repr. p. 63; upside down). Malet 1983b, fig. 68 (color). Rowell 1985, pp. 48–49, 56–59, fig. 3 (repr. p. 51). Bouret 1986, n.p. Rowell 1986, pp. 258–59, 270, 320 (n. 10), 321 (n. 9), ill. 25 (in progress). Beaumelle 1987, pp. 434–35, repr. (color) p. 435. Castello di Rivoli 1988, repr. pp. 67, 69 (detail, in progress). Erben 1988, repr. (color) p. 159. Stuckey 1991, repr. (color) p. 304. Yokohama Museum of Art 1992, repr. p. 15 (in progress).

FJM 2445. Ballpoint pen and colored pencil on paper, 3⅝ × 4½″ (9.4 × 11.3 cm)

200. **BLUE III.** Palma de Mallorca, March 4, 1961. (Plate, p. 289)
Oil on canvas, 8′ 9½″ × 11′ 5⅜″ (268 × 349 cm). Inscribed on verso: *MIRÓ. | 4/3/1961 | BLEU III/III.* Musée National d'Art Moderne, Centre Georges Pompidou, Paris, 1988. Dupin 971

PROVENANCE

The artist to Galerie Maeght, Paris; Pierre Matisse Gallery, New York; to Musée National d'Art Moderne, Centre Georges Pompidou, Paris, 1988.

SELECTED EXHIBITIONS

Paris 1961b, cat. 3
New York 1961d, pl. 11
Houston 1962, repr. n.p.
Saint-Paul-de-Vence 1968, cat. 60, repr. p. 118
Barcelona 1968, cat. 64
Munich 1969, cat. 76, repr. n.p.
Knokke 1971, cat. 43, repr. p. 53
New York 1972d, cat. 41, pp. 132–33, repr. p. 132

Paris 1974b, cat. 80, pp. 127–28, repr. p. 127
Houston 1982, pl. 30 (color)
Paris 1984b
Zurich 1986, cat. 152, repr. (color) n.p.
New York 1987a, cat. 132, repr. (color) p. 223
Saint-Paul-de-Vence 1990, cat. 62, p. 144, repr. (color) p. 147

SELECTED REFERENCES

Miró 1961, p. 18, repr. p. 16. Taillandier 1961, n.p. Mastai 1961, p. 195. J.K. 1961, p. 10. Volboudt 1961, p. 7, repr. pp. 8–9. Dupin 1962, p. 497, no. 971, repr. p. 574. Ragon 1962, p. 60. S.T. 1962, p. 35. Taillandier/Gomis/Prats 1962, pl. 60 (color). Volboudt 1962a, n.p. Miró 1964, repr. (color) p. 41. Ashton 1966, p. 42. Penrose 1969, pp. 132, 189, pl. 95 (repr., color, p. 130). Krauss 1972, pp. 34, 37. Rowell 1972, p. 66. Rowell 1976, p. 171, repr. p. 176. Gimferrer 1978, pp. 36, 118, fig. 40 (color). Millard 1980, p. 31. Freeman 1980, p. 39. McCandless 1982, p. 62. Malet 1983b, fig. 69 (color). Rowell 1985, pp. 48–49, 56–59, fig. 5 (repr. p. 52). Rowell 1986, pp. 258–59, 270, 320 (n. 10), 321 (n. 9). Beaumelle 1987, p. 434. Erben 1988, repr. (color) p. 160.

FJM 4621. Ink and pencil on paper,
2⅞ × 2⅞″ (7.3 × 7.3 cm)

201. MURAL PAINTING I. Palma de Mallorca, May 18, 1962. (Plate,
p. 290)
Oil on canvas, 8′ 10¼″ × 11′ 7¾″ (270 × 355 cm). Inscribed lower left corner: *M.*
Inscribed on verso: *MIRÓ | I. PEINTURE | MURALE | JAUNE ORANGE |
18/V/62.* Private collection. No Dupin number

PROVENANCE
The artist to Galerie Maeght, Paris; to present owner, January 27, 1981.

SELECTED EXHIBITIONS
Paris 1962b, cat. 106
London 1964b, cat. 213, p. 47, as *Yellow*
Saint-Paul-de-Vence 1968, cat. 61
London 1972, cat. 49, as *Mural Painting
I: Yellow-Orange*
New York 1972d, cat. 42, p. 134, repr.
(color) p. 134, as *Mural Painting for a
Temple I*
New York 1990a, as *Mural Painting for a
Temple I*
On view at the National Gallery of Art,
Washington, D.C.: June 1988–
December 1990

SELECTED REFERENCES
Chevalier 1962, pp. 12–13. Lassaigne 1963, repr. (color) pp. 114–15 (incorrectly
identified as *Mural Painting III*). Lynton 1964, p. 44. Barrett 1964, p. 27. Penrose
1969, p. 133. Krauss 1972, pp. 34, 37. Rowell 1972, p. 66. Sylvester 1972, pp. 16–
17. Rowell 1976, p. 171. Gimferrer 1978, p. 154. Rowell 1986, ill. 26 (in progress).
McEvilley 1988, p. 21.

FJM 4622. Ink and pencil on thin
cardboard, 2½ × 3″ (6.5 × 7.8 cm)

202. MURAL PAINTING II. Palma de Mallorca, May 21, 1962. (Plate,
p. 290)
Oil on canvas, 8′ 10¼″ × 11′ 7¾″ (270 × 355 cm). Inscribed lower left corner: *M.*
Inscribed on verso: *MIRÓ | II. | PEINTURE | MURALE | VERT | 21/V/62.* Private
collection. No Dupin number

PROVENANCE
The artist to Galerie Maeght, Paris; to present owner, January 27, 1981.

SELECTED EXHIBITIONS
Paris 1962b, cat. 107
London 1964b, cat. 214, p. 47, as *Green*
Saint-Paul-de-Vence 1968, cat. 62
London 1972, cat. 50, as *Mural Painting
II: Green*
New York 1972d, p. 135, cat. 43, repr.
(color) p. 135, as *Mural Painting for a
Temple II*
New York 1990a, as *Mural Painting for a
Temple II*

On view at the National Gallery of Art,
Washington, D.C.: June 1988– December 1990

SELECTED REFERENCES
Chevalier 1962, pp. 12–13. Lynton 1964, p. 44. Barrett 1964, p. 27. Penrose 1969, p.
133. Krauss 1972, pp. 34, 37. Rowell 1972, p. 66. Sylvester 1972, pp. 16–17. Rowell
1976, p. 171. Gimferrer 1978, p. 154. Rowell 1986, ill. 26 (in progress).

FJM 4623. Ink and pencil on thin
cardboard, 2⅝ × 3″ (6.6 × 7.8 cm)

203. MURAL PAINTING III. Palma de Mallorca, May 22, 1962. (Plate,
p. 291)
Oil on canvas, 8′ 10¼″ × 11′ 7¾″ (270 × 355 cm). Inscribed lower left corner: *M.*
Inscribed on verso: *MIRÓ | III | PEINTURE | MURALE | ROUGE | 22/V/62.* Private
collection. No Dupin number

PROVENANCE
The artist to Galerie Maeght, Paris; to present owner, January 27, 1981.

SELECTED EXHIBITIONS
Paris 1962b, cat. 108
London 1964b, cat. 215, p. 47, as *Red*
Saint-Paul-de-Vence 1968, cat. 63
London 1972, cat. 51, as *Mural Painting
III: Red*
New York 1972d, pp. 133, 136, cat. 44,
repr. (color) p. 136, as *Mural Painting
for a Temple III*
New York 1990a, as *Mural Painting for a
Temple III*
On view at the National Gallery of Art,
Washington, D.C.: June 1988–
December 1990

SELECTED REFERENCES
Chevalier 1962, pp. 12–13. Lynton 1964, p. 44. Barrett 1964, p. 27. Penrose 1969, p.
133. Krauss 1972, pp. 34, 37. Rowell 1972, p. 66. Sylvester 1972, pp. 16–17. Rowell
1976, p. 171. Gimferrer 1978, p. 154. Rowell 1986, ill. 26 (in progress).

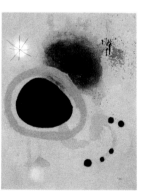

204. RED CIRCLE, STAR. Palma de Mallorca, July 13, 1965. (Plate,
p. 293)
Oil on canvas, 45⅝ × 35″ (116 × 89 cm). Signed lower right: *Miró.* Inscribed on
verso: *MIRÓ | 13-VII-65 | CERCLE ROUGE ÉTOILE.* Private collection

SELECTED EXHIBITIONS
Palma de Mallorca 1990a, repr. (color) p. 33.

205. THE SONG OF THE VOWELS. Palma de Mallorca, April 24, 1966. (Plate, p. 294)

Oil on canvas, 12′ ⅛″ × 45¼″ (366 × 114.8 cm). Inscribed on verso: *MIRÓ | 24/IV/66 | LA CHANSON DES VOYELLES*. The Museum of Modern Art, New York. Mrs. Simon Guggenheim Fund, special contribution in honor of Dorothy C. Miller. Acq. no. 57.70

PROVENANCE
The artist to Pierre Matisse Gallery, New York, c. January 1969; to The Museum of Modern Art, New York, February 1970.

SELECTED EXHIBITIONS
Saint-Paul-de-Vence 1968, cat. 105, repr. p. 156 (incorrectly dated 1967)
Barcelona 1968, cat. 111 (incorrectly dated 1967)
Minneapolis 1971 (not in checklist)
New York 1973b
Paris 1974b, cat. 83, p. 128

On view at The Museum of Modern Art, New York: May 1970–September 1971; October 1972–October 1973; January–April 1974; March 1975–March 1980; May 1984–April 1985; November 1986–March 1989; June 1989–June 1990

SELECTED REFERENCES
Rowell 1972, p. 65. Rubin 1973, pp. 8, 25, 45, 96, 133, repr. (color) p. 97. Leymarie 1974a, p. 18. Rowell 1976, p. 171, repr. p. 6. Gimferrer 1978, fig. 83 (color). Malet 1983b, fig. 80 (color). Rowell 1986, pp. 274, 275. Erben 1988, repr. (color) p. 184.

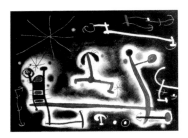

206. PERSONAGES AND BIRDS REJOICING AT THE ARRIVAL OF THE NIGHT. Palma de Mallorca, [February 15, 1968]. (Plate, p. 295)

Oil on canvas, 38⅝″ × 51⅛″ (98 × 130 cm). Signed lower center: *Miró*. Private collection, Barcelona

SELECTED EXHIBITIONS
Saint-Paul-de-Vence 1968, cat. 126, repr. (color) p. 142
Barcelona 1968, cat. 131, pl. 35 (repr. p. 123)
Madrid 1978a, cat. 69, p. 110

Charleroi 1985, cat. 26, repr. (color) p. 198, as *Personnage et oiseau en fête pour la nuit qui approche*
Saint-Paul-de-Vence 1990, cat. 60, p. 160, repr. (color) p. 161

SELECTED REFERENCES
Rowell 1976, repr. p. 114. Gimferrer 1978, fig. 152 (color). Malet 1983b, fig. 89 (color). Llorca 1990, repr. p. 177.

207. LETTERS AND NUMBERS ATTRACTED BY A SPARK (V). Palma de Mallorca, June 5, 1968. (Plate, p. 296)

Oil on canvas, 57½ × 44⅞″ (146 × 114 cm). Inscribed on verso: *MIRÓ 5/VI/68 | LETTRES ET CHIFFRES | ATTIRÉS PAR UNE | ÉTINCELLE*. Collection Kazumasa Katsuta

PROVENANCE
The artist to Pierre Matisse Gallery, New York; Mr. and Mrs. William R. Acquavella, New York; to Collection Kazumasa Katsuta.

SELECTED EXHIBITIONS
Saint-Paul-de-Vence 1968, cat. 156
New York 1972d, cat. 57, pp. 125, 152–53, repr. (color) p. 153

Yokohama 1992, cat. 100, repr. (color) p. 141

SELECTED REFERENCES
Rowell 1972, p. 65. Rowell 1976, pp. 113, 171, repr. (color) p. 173. Rowell 1986, p. 275.

208. LETTERS AND NUMBERS ATTRACTED BY A SPARK (VI). Palma de Mallorca, June 5, 1968. (Plate, p. 297)

Oil on canvas, 57½ × 44⅞″ (146 × 114 cm). Inscribed on verso: *MIRÓ | LETTRES ET CHIFFRES ATTIRÉS PAR UNE ÉTINCELLE | V/VI/68*. Galerie Maeght, Paris

PROVENANCE
The artist to Galerie Maeght, Paris.

SELECTED EXHIBITIONS
Barcelona 1968, cat. 157
Munich 1969, cat. 118
Knokke 1971, cat. 59, repr. p. 66
Villeneuve d'Ascq 1986, cat. 41, repr. (color) n.p.

Tokyo 1986, cat. 44, repr. (color) p. 66, as *Lettres et chiffres attirés par une étincelle*
Osaka 1991 (not in checklist)

SELECTED REFERENCES
Rowell 1976, pp. 113, 171. Rowell 1986, p. 275.

209. WOMAN, BIRD. Palma de Mallorca, April 29, 1976. (Plate, p. 310)

Oil on canvas, 36¼×28⅜″ (92×72 cm). Signed lower right: *Miró*. Inscribed on verso: *MIRÓ | 29-IV-76 | FEMME OISEAU*. Collection Pilar Juncosa de Miró

SELECTED EXHIBITIONS
Palma de Mallorca 1990a, repr. (color)
 p. 75.

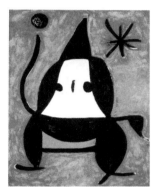

210. UNTITLED. Palma de Mallorca, [July 31, 1978]. (Plate, p. 310)

Oil on canvas, 36¼×28¾″ (92×73 cm). Fundació Pilar i Joan Miró a Mallorca

SELECTED EXHIBITIONS
Palma de Mallorca 1987, repr. (color) Barcelona 1989a, repr. (color) p. 29
 p. 171 Porto 1990, repr. (color) p. 61
Rome 1989, repr. (color) p. 85

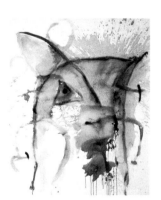

211. UNTITLED. Palma de Mallorca, c. 1970–80. (Plate, p. 312)

Oil on canvas, 64⅜×51⅝″ (163.5×131 cm). Fundació Pilar i Joan Miró a Mallorca

SELECTED EXHIBITIONS
Palma de Mallorca 1987, repr. (color) Barcelona 1989a, repr. (color) p. 30
 p. 127 Porto 1990, repr. (color) p. 51
Rome 1989, repr. (color) p. 74

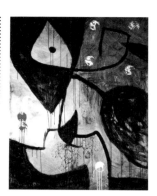

212. UNTITLED. Palma de Mallorca, c. 1970–80. (Plate, p. 313)

Oil on canvas, 64⅜×51⅝″ (163.5×131 cm). Fundació Pilar i Joan Miró a Mallorca

SELECTED EXHIBITIONS
Rome 1989, repr. (color) p. 63 Porto 1990, repr. (color) p. 54
Barcelona 1989a, repr. (color) p. 42

SELECTED REFERENCES
Fundació Pilar i Joan Miró 1987, repr. p. 41 (photograph of Miró's studio).

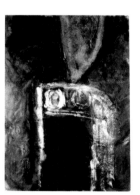

213. UNTITLED. Palma de Mallorca, c. 1970–80. (Plate, p. 308)

Oil on cardboard, 19⅞×14⅜″ (50.5×36.5 cm). Fundació Pilar i Joan Miró a Mallorca

SELECTED EXHIBITIONS
Rome 1989, repr. (color) p. 90 Porto 1990, repr. (color) p. 82
Barcelona 1989a, repr. (color) p. 61

214. UNTITLED. Palma de Mallorca, c. 1970–80. (Plate, p. 309)

Oil and charcoal on canvas, 39⅜×31½″ (100×80 cm). Fundació Pilar i Joan Miró a Mallorca

SELECTED EXHIBITIONS

Palma de Mallorca 1987, repr. (color) p.
253
Rome 1989, repr. (color) p. 51

Barcelona 1989a, repr. (color) p. 50
Porto 1990, repr. (color) p. 85

215. **UNTITLED.** Palma de Mallorca, c. 1970–80. (Plate, p. 311)
Oil on canvas, 64 × 51⅛″ (162.5 × 130 cm). Fundació Pilar i Joan Miró a Mallorca

SELECTED EXHIBITIONS

Palma de Mallorca 1987, repr. (color)
p. 177
São Paulo 1988, cat. 12, repr. (color)
p. 30

Rome 1989, repr. (color) p. 69
Barcelona 1989a, repr. (color) p. 24
Porto 1990, repr. (color) p. 49

216. **UNTITLED.** Palma de Mallorca, c. 1970–80. (Plate, p. 315)
Oil and chalk on canvas, 8′ 10⅜″ × 11′ 7¾″ (270 × 355 cm). Fundació Pilar i Joan
Miró a Mallorca

SELECTED EXHIBITIONS

Palma de Mallorca 1987, repr. (color;
upside down) p. 153
Rome 1989, repr. (color; upside down)
p. 55
Barcelona 1989a, repr. (color; upside
down) p. 55

Porto 1990, repr. (color) p. 45
Saint-Paul-de-Vence 1990, cat. 80, repr.
(color) pp. 182–83

SELECTED REFERENCES

Dupin 1974, repr. p. 20 (in progress; photograph of Miró's studio). Miró 1977, repr.
p. 194 (in progress; photograph of Miró's studio). Llorca 1990, repr. p. 178 (in
progress; photograph of Miró's studio).

Appendix to the Catalogue

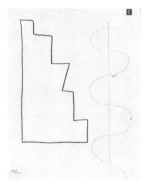

FJM 4345a. 4⅜ × 3⅜″ (10.9 × 8.5 cm)

1. NUDE DESCENDING A STAIRCASE. Montroig, September 4, 1924. (Plate, p. 124)
Pencil and chalk on paper with collaged stamp, 23⅝ × 18⅛″ (60 × 46 cm). Private collection

FJM 656a. 6½ × 7½″ (16.5 × 19.1 cm)

2. UNTITLED. Montroig, September 4, 1924. (Plate, p. 126)
Colored pencil, charcoal, and pencil on paper, 17⅞ × 23½″ (45.5 × 59.7 cm). Collection Artcurial, Paris

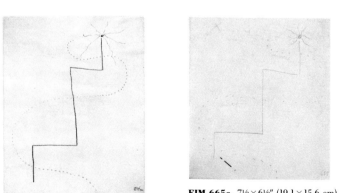

FJM 665a. 7½ × 6⅛″ (19.1 × 15.6 cm)

3. SPANISH DANCER. Montroig, October 20, 1924. (Plate, p. 125)
Conté, crayon, paint, and pencil on paper, 23⅝ × 18⅜″ (60 × 46.6 cm). Collection Kay Hillman

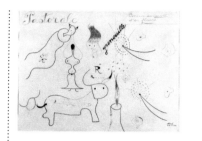

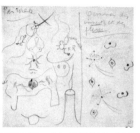

FJM 621a. 6½ × 7½″ (16.5 × 19.1 cm)

4. PASTORALE. Montroig, October 23, 1924. (Plate, p. 125)
Pastel, black crayon, India ink, and pencil on paper, 18¼ × 24¼″ (46.3 × 61.5 cm). Private collection, New York

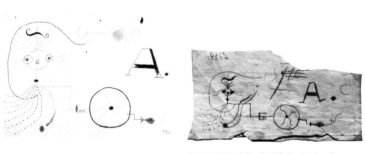

FJM 4347. 2¾ × 5½″ (7.2 × 13.9 cm)

5. AUTOMATON. Montroig, November 7, 1924. (Plate, p. 124)
Pencil and colored crayon on paper, 18¼ × 24″ (46.3 × 60.9 cm). The Morton G. Neumann Family Collection

FJM 619a. 7½ × 6½″ (19.1 × 16.5 cm)

6. THE KEROSENE LAMP. Montroig, November 10, 1924. (Plate, p. 126)
Pencil, graphite, and watercolor on watermarked wove paper, 22¾ × 17⅝″ (58 × 45 cm). Musée National d'Art Moderne, Centre Georges Pompidou, Paris, 1990

FJM 645a. 7½ × 6½″ (19.1 × 16.5 cm)

7. THE WIND. Montroig, November 11, 1924. (Plate, p. 127)
Watercolor, conté, pencil, and foil on paper, 23⅝ × 18¼″ (60 × 46.4 cm). Private collection

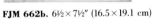

FJM 662b. 6½ × 7½″ (16.5 × 19.1 cm)

8. UNTITLED. Montroig, November 24, 1924. (Plate, p. 127)
Pencil, gouache, and feather on paper, 19⅜ × 25⅜″ (49 × 64.5 cm). Musée National d'Art Moderne, Centre Georges Pompidou, Paris. Gift of Louise and Michel Leiris, 1984

FJM 890. 6¾ × 8⅛″ (17.3 × 20.6 cm)

9. THE LOVERS. 1930. (Plate, p. 176)
Pencil and ink on paper, 18¾ × 24½″ (47.6 × 62.2 cm). The Morton G. Neumann Family Collection

FJM 899. 8⅛ × 6¾″ (20.6 × 17.3 cm)

10. UNTITLED. Montroig, August 23–25, 1930. (Plate, p. 176)
Pencil on Ingres paper, 24¾ × 18⅜″ (63 × 46.5 cm). Private collection, France

FJM 902. 8⅛ × 6¾″ (20.6 × 17.3 cm)

11. UNTITLED. Montroig, August 30, 1930. (Plate. p. 176)
Pencil on paper, 24 × 17½″ (61 × 44.5 cm). Ohara Museum of Art, Kurashiki, Japan

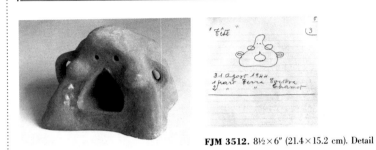

FJM 3512. 8½ × 6″ (21.4 × 15.2 cm). Detail

12. LIGHT BLUE HEAD. 1944–46. (Plate, p. 262)
Ceramic, 7 × 9 × 7½″ (18 × 23 × 19 cm). Galerie Maeght, Paris

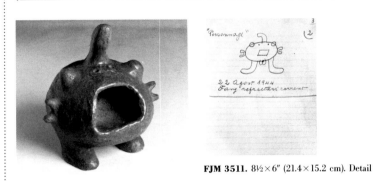

FJM 3511. 8½ × 6″ (21.4 × 15.2 cm). Detail

13. BROWN PERSONAGE. 1944–46. (Plate, p. 262)
Ceramic, 9 × 8¼ × 7⅞″ (23 × 21 × 20 cm). Galerie Maeght, Paris

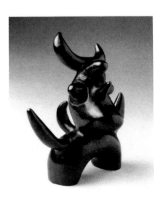

FJM 3520a. 8½ × 6″ (21.4 × 15.2 cm)

14. BIRD. 1946. (Plate, p. 262)
Bronze, 7⅞ × 6½ × 2″ (20 × 16.5 × 5 cm). Galerie Maeght, Paris

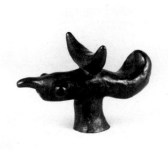

FJM 3521. 8½×6″ (21.4×15.2 cm)

15. BIRD. 1946. (Plate, p. 262)
Bronze, 5″ (12.7 cm) high × 7½″ (19 cm) long. The Baltimore Museum of Art.
Bequest of Saidie A. May, BMA 1951.386

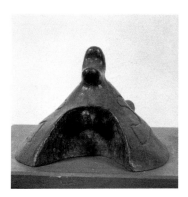

FJM 3517. 8½×6″ (21.4×15.2 cm)

16. WOMAN. 1949. (Plate, p. 270)
Bronze, 7¼×10¼×9″ (18.4×26×22.8 cm). Acquavella Modern Art

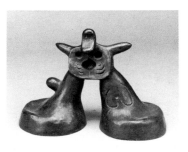

FJM 3519. 8½×6″ (21.4×15.2 cm). Detail

17. WOMAN. 1949. (Plate, p. 270)
Bronze, 11×16×6½″ (27.9×40.6×16.5 cm). Acquavella Modern Art

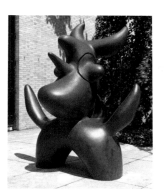

FJM 3535. Ballpoint pen on paper,
7½×5¾″ (19×14.8 cm)

18. MOONBIRD. 1966. (Plate, p. 300)
Bronze, 7′ 8⅛″×6′ 9¼″×59⅛″ (228.8×206.4×150.1 cm). The Museum of Modern
Art, New York. Acquired through the Lillie P. Bliss Bequest. Acq. no. 515.70

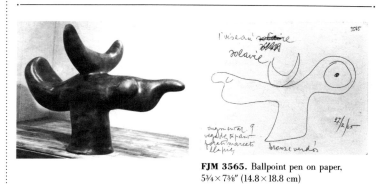

FJM 3565. Ballpoint pen on paper,
5¾×7⅜″ (14.8×18.8 cm)

19. SOLAR BIRD. 1966. (Plate, p. 301)
Bronze, 48×71×40″ (121.9×180.3×101.6 cm). The Art Institute of Chicago. Grant
J. Pick Fund

FJM 3577. Ballpoint pen on paper,
8×5⅞″ (20.5×15 cm)

20. WOMAN. 1968. (Plate, p. 303)
Bronze, 68×28×8″ (172.7×71.1×20.3 cm). Acquavella Modern Art

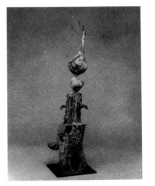

FJM 3615. Ballpoint pen on paper,
8½ × 6⅛″ (21.7 × 15.5 cm)

21. **PERSONAGE.** 1969. (Plate, p. 304)
Bronze, 56¾ × 14 × 12½″ (144.1 × 35.5 × 31.7 cm). Acquavella Modern Art

FJM 3569. Ballpoint pen on paper,
8⅜ × 12⅛″ (21.3 × 31 cm)

22. **WOMAN.** 1970. (Plate, p. 305)
Bronze, 24 × 12 × 5½″ (60.9 × 30.4 × 13.9 cm). Acquavella Modern Art

FJM 3569b. Ballpoint pen on paper,
8⅜ × 12⅛″ (21.3 × 31 cm)

23. **PERSONAGE.** 1970. (Plate, p. 306)
Bronze, 46½ × 19 × 13″ (118.1 × 48.2 × 33 cm). Acquavella Modern Art

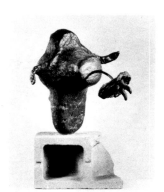

FJM 3563a. Ballpoint pen on paper,
8⅜ × 12⅛″ (21.3 × 31 cm)

24. **BIRD.** 1970. (Plate, p. 305)
Bronze and concrete block, 24½ × 16¼ × 15″ (62.2 × 41.2 × 38.1 cm). Acquavella
Modern Art

FJM 3650. Ballpoint pen on paper,
8⅜ × 12⅛″ (21.3 × 31 cm)

25. **PERSONAGE.** 1970. (Plate, p. 307)
Bronze, 6′ 6¾″ × 47¼″ × 39⅜″ (200 × 120 × 100 cm). Fondation Marguerite et Aimé
Maeght, Saint-Paul, France

FJM 3556b. Ballpoint pen on paper,
8⅜ × 12⅛″ (21.3 × 31 cm)

26. **WOMAN WITH PITCHER.** 1970. (Plate, p. 304)
Bronze, 33¼ × 27½ × 14½″ (84.4 × 69.8 × 36.8 cm). Acquavella Modern Art

Exhibition History

Compiled by Lilian Tone

The following list of exhibitions is in chronological order by opening date. The abbreviation *n.d.* indicates that precise opening and closing dates could not be found. When an exhibition was accompanied by a publication identifying the works shown, whether a book, brochure, or printed list, it is indicated by the word *catalogue*. In the absence of any such publication, the word *checklist* indicates the existence of an unpublished list of works shown.

Through 1945, the list is comprehensive, and includes abbreviated references to reviews mentioning Miró, listed in the order of their publication (full information appears in the Reference List). Organizers of exhibitions are identified, when known. Proper names generally are given as they appear in the original documents. Addresses of galleries and private institutions are given at the first listing, and do not subsequently appear except to note a change of address. Exhibition information is enclosed in square brackets when not founded on firm documentation.

After 1945, the list is restricted to exhibitions of particular significance and to those cited in the Catalogue.

1911

BARCELONA 1911
Barcelona, Ayuntamiento de Barcelona. "VI Exposición Internacional de Arte," opened July 20. Catalogue.

1913

BARCELONA 1913
Barcelona, Cân Parés. "VIIIa Exposició del Círcol Artístic de Sant Lluc," [December 6–27]. Catalogue.

1918

BARCELONA 1918A
Barcelona, Galeries Dalmau (Portaferrissa, 18). "Exposició Joan Miró," February 16–March 3. Catalogue: poem by J. M. Junoy. Reviews: Artigas 1918, Sacs 1918a, *Diario de Barcelona* 1918, Oliver 1918, Vallescá 1918, F.V. 1918.

BARCELONA 1918B
Barcelona, Galeries Dalmau. Group exhibition, c. April. Review: *Vell i nou* 1918.

BARCELONA 1918C
Barcelona, Palacio de Bellas Artes. "Exposició d'art del Palacio de Bellas Artes," May 10–June 30. Catalogue. Reviews: Junoy 1918, B. 1918, Sacs 1918b, O.F. 1918, E.M.P. 1918.

1919

BARCELONA 1919A
Barcelona, Galeries Laietanes. "Exposició de dibuixos," May 17–30. Reviews: *El Dia* 1919, Sacs 1919a, Artigas 1919a, J.F.R. 1919a.

BARCELONA 1919B
Barcelona, Palau Municipal de Belles Arts. "Exposició d'art," Círcol Artístic de Sant Lluc, May 28–June 30. Catalogue. Reviews: Espàtula 1919, Xenius 1919, Sacs 1919b, J.F.R. 1919b, Marinel·lo 1919, Folch 1919, Vallescá 1919, Artigas 1919b.

1920

PARIS 1920
Paris, Grand Palais des Champs-Elysées. "Salon d'Automne," section "Exposition des artistes catalans," October 15–December 12. Section organized by the Comité Municipal d'Expositions d'Art. Catalogue. Reviews: Mercereau 1920, Marcial 1920a, Pla 1920, Marcial 1920b, Pérez-Jorba 1920.

BARCELONA 1920
Barcelona, Galeries Dalmau. "Exposició d'art francès d'avantguarda," October 26–November 15. Catalogue: preface by Maurice Raynal. Reviews: Xenius 1920, R.B. 1920.

1921

PARIS 1921
Paris, Galerie La Licorne (110, rue de La Boétie). "Exposition de peintures et dessins de Joan Miró," April 29–May 14. Organized by Josep Dalmau. Catalogue: preface by Maurice Raynal. Reviews: Cassanyes 1921, Gybal 1921, Pérez-Jorba 1921, René-Jean 1921, Fels 1921, *Art et travail* 1921, Salmon 1921.

BARCELONA 1921
Barcelona, Galeries Dalmau. "Exposició de pintures i dibuixos de diversos artistes," June 23–July [16]. Catalogue. Review: R.B. 1921.

1922

PARIS 1922
Paris, Grand Palais des Champs-Elysées. "Salon d'Automne," November 1–December 17. Catalogue. Reviews: Raynal 1922, Pérez-Jorba 1922.

1923

PARIS 1923A
Paris, Au Caméléon (146, boulevard Montparnasse).

Group exhibition held on the occasion of the lecture "L'Evolution de la poésie catalane" by A. Schneeberger, April 9.

PARIS 1923B
Paris, Au Caméléon. Exhibition of paintings and drawings by Joan Miró and Francesc Domingo, May 16–31.

1925

PARIS 1925A
Paris, Galerie Pierre (13, rue Bonaparte). "Exposition Joan Miró," June 12–27. Organized by Jacques Viot. Catalogue: preface by Benjamin Péret. Reviews: Gros 1925, *Action* 1925, Charensol 1925a, Montpar. 1925a, Pinturrichio 1925, *Comoedia* 1925, Leon-Martin 1925, *Veu de Catalunya* 1925, Montpar. 1925b, Soldevila 1925, Junoy 1925, Fels 1925a, Fels 1925b, Curieux 1925.

PARIS 1925B
Paris, Galerie Pierre. "Exposition: La Peinture surréaliste," November 14–25. Catalogue: preface by André Breton and Robert Desnos. Reviews: Montpar. 1925c, M. 1925, Zenon 1925, Charensol 1925b, Basler 1926.

PARIS 1925C
Paris, Galerie de la Ville L'Evêque (rue de la Ville l'Evêque). "L'Art d'aujourd'hui," November 30–December. Catalogue. Review: Charensol 1926.

1926

MADRID 1926
Madrid, Círculo de Bellas Artes. "El Arte catalán moderno," opened January 16. Organized by the *Heraldo de Madrid*. Reviews: Marquina 1926a, Marquina 1926b.

LONDON 1926
London, The New Chenil Galleries (by the Town Hall, Chelsea). "Serge Lifar's Collection of Modern Painting," opened July 4. Catalogue. Review: *Times* 1926.

BARCELONA 1926
Barcelona, Galeries Dalmau (Passeig de Gràcia, 62). "Exposició de modernisme pictòric català confrontada amb una selecció d'obres d'artistes d'avantguarda extrangers [sic]," October 16–November 6. Catalogue: preface by Sebastià Gasch. Review: Benet 1926.

NEW YORK 1926
New York, The Brooklyn Museum. "International

Exhibition of Modern Art," November 19–January 1, 1927. Assembled by the Société Anonyme. Catalogue: foreword by W.H.E., introduction by Katherine S. Dreier.

PARIS 1926
Paris, Galerie Fermé la Nuit (41, quai de l'Horloge). Group exhibition, November 8–25. Reviews: Montpar. 1926a, *Chicago Tribune* 1926, Montpar. 1926b.

1927

NEW YORK 1927
New York, The Anderson Galleries. "The International Exhibition of Modern Art," January 25–February 5. Assembled by the Société Anonyme. Catalogue: preface by Katherine S. Dreier.

PARIS 1927A
Paris, Galerie Surréaliste (16, rue Jacques-Callot). Group exhibition, February–[May]. Review: *Chicago Tribune* 1927.

PARIS 1927B
Paris, Galerie Pierre (2, rue des Beaux-Arts). Group exhibition, May 23–August 15.

MONTPELLIER 1927A
Montpellier, Pavillon Populaire. "Exposition internationale de Montpellier," May 27–June 26. Organized by the Comité Montpelliérain de l'Art d'Aujourd'hui and the Société Artistique de l'Hérault. Catalogue.

MONTPELLIER 1927B
Montpellier, Théâtre Municipal. "Cinquante Ans de peinture française," c. June.

PARIS 1927C
Paris, Galerie Surréaliste. "Cadavre exquis," opened October 10.

BRUSSELS 1927A
Brussels, Galerie Le Centaure (62, avenue Louise). "Peinture française contemporaine," October 11–25. Catalogue. Reviews: Conrardy 1927, C.B. 1927, Devigne 1927, Schmitz 1927, A.D. 1927.

BARCELONA 1927
Barcelona, Galeries Dalmau. "Exposició de conjunt," October 20–November 4.

BRUSSELS 1927B
Brussels, Galerie L'Epoque (43, chaussée de Charleroi). Group exhibition, opened November 5. Catalogue.

PARIS 1927D
[Paris, Galerie Pierre. One-artist exhibition, November 13.]

PARIS 1927E
Paris, Galerie Quatre Chemins (8, rue Godot-de-Mauroy). "Borès, Bosschère, Joan Miró, Gomez de la Serna, Kristian [sic] Tonny," December 28–January 17, 1928. Catalogue. Reviews: *Patrie* 1928, P.F. 1928a,

Warnod 1928, *Pariser deutsche Zeitung* 1928, Montpar. 1928a, Charensol 1928a.

1928

BARCELONA 1928
[Barcelona, Teatro Tívoli. "Exposición homenaje a Marinetti," February. Organized by Josep Dalmau.]

PARIS 1928A
Paris, Galerie Surréaliste. Group exhibition, March.

PARIS 1928B
Paris, Galerie Au Sacre du Printemps (5, rue du Cherche-Midi). "Exposition surréaliste," April 2–15.

PARIS 1928C
Paris, Galerie Georges Bernheim & Cie (109, rue du Faubourg-Saint-Honoré). "Miró," May 1–15. Organized by Pierre Loeb. Reviews: Tériade 1928a, Colrat 1928, Pinturrichio 1928, P.F. 1928b, *Veu de Catalunya* 1928, George 1928, Veidle 1928, Z. 1928, *Feuilles volantes* 1928, Charensol 1928b, Fosca 1928, *Telegraaf* 1928, Harris 1928, Gasch 1928b.

BRUSSELS 1928A
Brussels, Galerie L'Epoque. Group exhibition, c. November. Reviews: *Cahiers de Belgique* 1928b.

PARIS 1928D
Paris, Galerie Danthon (29, rue de La Boétie). "Exposition d'oeuvres de maîtres de la peinture contemporaine," November. Catalogue: preface by André Salmon. Review: Tériade 1928b.

BRUSSELS 1928B
Brussels, Palais des Beaux-Arts. "Jeune Peinture espagnole," December 15–26. Catalogue. Reviews: *Meuse* 1928, C.B. 1928, Milo 1929.

1929

NEW YORK 1929A
New York, Gallery of Living Art (100 Washington Square East), New York University. Group exhibition, [January]. Catalogue.

PARIS 1929A
Paris, Salle de la Renaissance (11, rue Royale). "Exposition d'oeuvres des 19e et 20e siècles provenant de collections particulières," January 15–31. Organized by the Syndicat des Editeurs d'Art et Négociants en Tableaux Modernes to benefit the Pavillon des Beaux-Arts de la Fondation Nationale de la Cité Universitaire. Catalogue. Reviews: P.F. 1929, *Semaine à Paris* 1929, Fierens 1929.

PARIS 1929B
Paris, Editions Bonaparte (12, rue Bonaparte). "Panorama de l'art contemporain," January 17–February 16. Organized by Waldemar George. Catalogue: essay by Waldemar George. Reviews: Dumas 1929, *Crapouillot* 1929.

PARIS 1929C
[Paris, Galerie Jeanne Bucher (5, rue du Cherche-

Midi). Group exhibition, c. March–April.] Review: *Cahiers d'art* 1929a.

CAMBRIDGE 1929
Cambridge, Mass., Harvard Cooperative Building, Rooms 207-8 (1400 Massachusetts Avenue). "An Exhibition of the School of Paris, 1910–1928," March 20–April 12. Organized by The Harvard Society for Contemporary Art. Catalogue.

MADRID 1929
Madrid, Jardín Botánico. "Exposición de pinturas y esculturas de españoles residentes en París," March 20–25. Organized by the Sociedad de Cursos y Conferencias. Catalogue. Review: García y Bellido 1929.

BRUSSELS 1929
Brussels, Galerie Le Centaure. "Joan Miró," May 11–22. Organized by Pierre Loeb. Reviews: C.B. 1929, *Meuse* 1929, Eggermont 1929, Ràfols 1929, Wenneckers 1929.

ZURICH 1929
Zurich, Kunsthaus Zürich. "Ausstellung abstrakte und surrealistische Malerei und Plastik," October 6–November 3. Catalogue: preface by W. Wartmann. Reviews: *Intransigeant* 1929, Einstein 1929, *Cahiers d'art* 1929b.

BARCELONA 1929
[Barcelona, Galeries Dalmau. "Exposició d'art abstracte," October 19.]

NEW YORK 1929B
New York, Brummer Gallery (27 East Fifty-seventh Street). "Loan Exhibition Held by New York University Gallery of Living Art: Contemporary Paintings," November 30–December 13. Catalogue: preface by A. E. Gallatin. Reviews: *Art News* 1929b, Cary 1929, *Art Digest* 1929, McBride 1930a.

PARIS 1929D
Paris, Galerie Vignon. "Collection de peintures de nos jours appartenant à Serge Lifar," December. Catalogue: prefaces by Jean Cocteau, Waldemar George, Sergei Shchukin, and B.K.

PARIS 1929E
Paris, Galerie Goemans (49, rue de Seine). "Peintres surréalistes: Arp, Chirico, Dalí, Ernst, Magritte, Miró, Picabia, Picasso, Tanguy," December 6–25.

1930

NEW YORK 1930A
New York, The Museum of Modern Art. "Painting in Paris from American Collections," January 18–February 16 (extended to March 2), 1930. Catalogue: foreword by Alfred H. Barr, Jr. Reviews: McCormick 1930, Read 1930, *Amérique latine* 1930.

PARIS 1930A
Paris, Galerie Pierre. "Exposition Joan Miró," March 7–14. Catalogue. Reviews: Focius 1930b, Tériade 1930b, Monitor 1930.

PARIS 1930B
Paris, Galerie Pierre. "Exposition Joan Miró: Oeuvres récentes," March 15–22. Catalogue. Reviews: *Cahiers d'art* 1930, Tériade 1930b, Fierens 1930, Einstein 1930.

PARIS 1930C
Paris, Galerie Goemans. "La Peinture au défi," March 28–April 12, 1930. Catalogue: essay by Louis Aragon. Review: *Neue Pariser Zeitung* 1930.

PARIS 1930D
[Paris, Galerie Pierre. "Arp, Miró, Giacometti," spring.]

BRUSSELS 1930
Brussels, Galerie Le Centaure. "30 Ans de peinture française," May 31–June 30. Reviews: Courthion 1930, Ridder 1930, *Centaure* 1930.

NEW YORK 1930B
New York, The Museum of Modern Art. "Summer Exhibition," June 15–September 28. Catalogue.

SAN SEBASTIÁN 1930
[San Sebastián. "Exposición de arquitectura y pintura moderna," c. September.] Review: R.G. 1930.

PARIS 1930E
Paris, Galerie Billiet-Pierre Vorms (30, rue de La Boétie). "Exposition rétrospective de maquettes, décors et costumes exécutés pour la Compagnie des Ballets Russes de Serge de Diaghilew," October 14–28, 1930. Catalogue: preface by André Boll. Reviews: Dhérelle 1930, Warnod 1930, *Intransigeant* 1930, Dumas 1930, Lissim 1930.

NEW YORK 1930C
New York, Valentine Gallery (69 East Fifty-seventh Street). "Joan Miró," October 20–November 8. Catalogue. Reviews: McBride 1930b, *Art News* 1930, Goodrich 1930.

PARIS 1930F
Paris, Studio 28 (10, rue Tholozé). Group exhibition held on the occasion of the first showing of *L'Age d'or*, November 28–December 3. Catalogue.

1931

NEW YORK 1931A
New York, The New School for Social Research (66 West Twelfth Street). Group exhibition, January 1–February 10. Organized by the Société Anonyme. Checklist.

CHICAGO 1931
Chicago, The Arts Club of Chicago. "Paintings by Joan Miró," January 27–February 17. Organized by the Valentine Gallery, New York. Catalogue.

PARIS 1931A
Paris, Galerie Bernheim-Jeune (83, rue du Faubourg-Saint-Honoré). " 'Folle enchère': 7ᵉ Salon de la Société des Amateurs d'Art et des Collectionneurs," February 7–20. Catalogue: preface by André Salmon. Reviews: *Chicago Daily Tribune* 1931, Salmon 1931.

PARIS 1931B
Paris, Galerie Pierre. "Exposition concours de 'Palettes,' " April 5–30. Review: Deux Aveugles 1931.

BRUSSELS 1931
Brussels, Palais des Beaux-Arts. "L'Art vivant en Europe," April 25–May 24. Organized by the Société l'Art Vivant and the Société Auxiliaire des Expositions du Palais des Beaux-Arts. Catalogue. Reviews: Scauflaire 1931, C.B. 1931, Fleischman 1931.

PRAGUE 1931
Prague, V Obecním Domě, Výstava Umělecké Besedy. "L'Ecole de Paris," [May–June]. Catalogue.

PARIS 1931C
Paris, Galerie Pierre. "Où allons-nous?," June. Reviews: Tériade 1931, *Beaux-Arts* 1931, Uhde 1931.

PARIS 1931D
Paris, Galerie Billiet-Pierre Vorms. Group exhibition, July. Organized by Casa de Catalunya. Reviews: *Populaire* 1931, R.J. 1931, Falgairolle 1931, *Services publics* 1931.

NEW YORK 1931B
New York, Gallery L'Elan (50 West Fifty-second Street). "Modern Paintings and Sculpture for the Modern Home," September 22–October 15. Reviews: *New York Herald Tribune* 1931, Jewell 1931b.

HARTFORD 1931
Hartford, Wadsworth Atheneum. "Newer Super-Realism," November. Catalogue.

PARIS 1931E
Paris, Galerie Pierre. "Sculptures de Joan Miró," December 18–January 8, 1932. Reviews: N.D.L.R. 1931, Lesbats 1931, V. 1931, W.G. 1932.

NEW YORK 1931C
New York, Valentine Gallery. "Since Cézanne," December 28–January 16, 1932. Catalogue.

1932

BARCELONA 1932A
Barcelona, G.A.T.C.P.A.C. (Grup d'Arquitectes i Tècnics Catalans per al Progrés de l'Arquitectura Contemporània). Group exhibition, April. Review: Ràfols 1932.

PRAGUE 1932
Prague, S. V. U. Mánes. "Poesie 1932," October 27–November 7. Catalogue: introduction by Kamil Novotný.

NEW YORK 1932
New York, Pierre Matisse Gallery (51 East Fifty-seventh Street). "Joan Miró: Paintings on Paper, Drawings," November 1–25. Catalogue. Reviews: *Art News* 1932, Jewell 1932, *New York Sun* 1932, Breuning 1932, Mumford 1932, Stuyvesant 1932.

PARIS 1932A
Paris, Grand Palais des Champs-Elysées. "Salon d'Automne," section "Décoration théâtrale,"

November 1–December 11. Section organized by Raymond Cogniat. Catalogue.

BARCELONA 1932B
Barcelona, Galeries Syra. One-artist exhibition, November 18. Private viewing for members of A.D.L.A.N. (Amics de l'Art Nou). Review: Díaz-Plaja 1932.

PARIS 1932B
Paris, Galerie Pierre Colle (29, rue Cambacérès). "Exposition Miró," December 13–16. Reviews: *Formes* 1932, Tériade 1932.

BERLIN 1932
Berlin, Galerie Flechtheim. "Neuere spanische Kunst," December 18–end of January. Organized by the Sociedad de Artistas Ibéricos. Catalogue: preface by Manuel Abril. Reviews: *Intransigeant* 1932, M.A. 1933.

TOKYO 1932
Tokyo, Musée des Beaux-Arts. "Exposition de la confédération des artistes d'avant-garde Paris–Tokio," 1932–33. Also shown in Osaka, Kyoto, Fukuoka, Kanazawa, and Nagoya. Organized by André Breton, André Salmon, Riukow Kawaji, Kouni Matuwo, Giiti Minégisi, Tari Morigouti, Motoi Ogui, Ioé Saitow, Katué Sibata, and Koji Tanabé. Catalogue.

1933

WORCESTER 1933
Worcester, Mass., Worcester Art Museum. "International 1933," January 6–31. Also shown in New York, Rockefeller Center, February 5–26. Organized by the College Art Association. Catalogue. Reviews: Flint 1933, Schwob 1933.

LONDON 1933A
London, The Mayor Gallery (18 Cork Street). "Exhibition of Recent Paintings by English, French and German Artists," April. Catalogue.

CHICAGO 1933
Chicago, The Art Institute of Chicago. "A Century of Progress: Exhibition of Paintings and Sculpture," June 1–November 1. Catalogue. Reviews: *Art Digest* 1933.

PARIS 1933A
Paris, Galerie Pierre Colle. "Exposition surréaliste," June 7–18. Catalogue. Review: *Cahiers d'art* 1933a.

PARIS 1933B
Paris, Galerie Pierre. "Arp, Calder, Hélion, Miró, Pevsner, Seligmann," June 9–24. Organized by Jean Hélion. Review: *Cahiers d'art* 1933b.

LONDON 1933B
London, The Mayor Gallery. "Paintings by Joan Miró," July. Organized by Douglas Cooper. Checklist. Reviews: *Yorkshire Post* 1933, *Western Morning News* 1933, Read 1933a, *Times* 1933, *Observer* 1933, *Scotsman* 1933, *Bystander* 1933, Crankshaw 1933, *Sunday Referee* 1933, *Week End Review* 1933, Blunt 1933.

LONDON 1933C
London, The Mayor Gallery. "Art Now," October. Organized by Herbert Read. Catalogue.

PARIS 1933C
Paris, Parc des Expositions, Porte de Versailles. "Les Surindépendants," October 27–November 26. Catalogue. Reviews: Taylor 1933, Fierens 1933, P.I. 1933, Campagne 1933.

PARIS 1933D
Paris, Galerie Georges Bernheim & Cie. "Les Dernières Oeuvres de Joan Miró," October 30–November 13. Organized by Pierre Loeb. Reviews: *Art et industrie* 1933, Gros 1933, Warnod 1933.

NEW YORK 1933
New York, Pierre Matisse Gallery. "Joan Miró," December 29–January 18, 1934. Catalogue: excerpts from essays by Ernest Hemingway and James Johnson Sweeney. Reviews: Jewell 1933, McBride 1934, *Time* 1934, M.M. 1934, *Art Digest* 1934.

1934

PARIS 1934A
Paris, Galerie Pierre. Group exhibition, January 12–February 16.

BARCELONA 1934
[Barcelona, Galeria d'Art Catalònia. One-artist exhibition, February 16. Organized by A.D.L.A.N.]

CHICAGO 1934A
Chicago, The Arts Club of Chicago. "Paintings by Joan Miró," March 16–30. Organized by the Pierre Matisse Gallery, New York. Catalogue: excerpts from essays by James Johnson Sweeney and Ernest Hemingway. Review: Jewett 1934.

PARIS 1934B
Paris, Galerie Cardo. "Lucullus chez Cardo, menu d'un dîner," April 25–May 18. Review: Leon-Martin 1934.

PARIS 1934C
Paris, Galerie des Cahiers d'Art (14, rue du Dragon). "Joan Miró," May 3–19. Organized by Yvonne Zervos. Reviews: Raynal 1934b, Humeau 1934.

BRUSSELS 1934
Brussels, Palais des Beaux-Arts. "Exposition Minotaure," May 12–June 3. Organized by Editions Albert Skira. Catalogue: introductory note by Albert Skira and E. Tériade. Reviews: *Wallonie* 1934, De Maegt 1934, Koenig 1934, G.V. 1934.

SAN FRANCISCO 1934A
San Francisco, East-West Gallery. "Miró," May 14–June. Organized by Howard Putzel. Reviews: *San Francisco News* 1934, Cravens 1934, Fried 1934.

SAN FRANCISCO 1934B
San Francisco, The California Palace of the Legion of Honor. "Exhibition of French Painting from the Fifteenth Century to the Present Day," June 8–July 8. Catalogue: foreword by Walter Heil. Review: *Art et les artistes* 1934.

CHICAGO 1934B
Chicago, The Renaissance Society of the University of Chicago. "A Selection of Works by Twentieth-Century Artists," June 20–August 20. Organized by James Johnson Sweeney. Catalogue: foreword by E.W.S.

ZURICH 1934
Zurich, Kunsthaus Zürich. Group exhibition, October 11–November 4. Catalogue: essay by Max Ernst. Review: Kochnitzky 1934.

COPENHAGEN 1934
Copenhagen, Charlottenborg Palace. "Fransk Malerkunst gennem de sidste 20 Aar," November. Catalogue. Reviews: *Politiker* 1934, Terents 1934.

NEW YORK 1934
New York, The Museum of Modern Art. "Modern Works of Art: Fifth Anniversary Exhibition," November 20–January 20, 1935. Catalogue: preface by A. Conger Goodyear, introduction by Alfred H. Barr, Jr.

1935

PARIS 1935A
Paris, Gazette des Beaux-Arts (140, rue du Faubourg-Saint-Honoré). "Prestige du dessin," January 8–23. Catalogue: introduction by Raymond Cogniat. Review: Sarradin 1935.

PARIS 1935B
Paris, Galerie Charpentier. "Le Temps présent: Peinture, sculpture, gravure," January 10–28. Catalogue. Reviews: *Beaux-Arts* 1935a, René-Jean 1935.

NEW YORK 1935
New York, Pierre Matisse Gallery. "Joan Miró, 1933–1934: Paintings, Tempera, Pastels," January 10–February 9. Catalogue. Reviews: M.M. 1935, McBride 1935, *Springfield Sunday Union and Republican* 1935, Read 1935, Mumford 1935, J.W.L. 1935, *Art Digest* 1935, Sweeney 1935.

COPENHAGEN 1935
Copenhagen, Den Frie Udstillings Bygning. "International Kunstudstilling: Kubisme-Surrealisme," January 15–28. Organized by Vilhelm Bjerke-Petersen and André Breton. Catalogue: preface by André Breton. Review: Bille 1935.

LUCERNE 1935
Lucerne, Kunstmuseum Luzern. "These, Antithese, Sinthese," February 24–March 31. Catalogue: preface by Dr. Paul Hilber, essays by Dr. S. Giedion, Jean Hélion, Anatole Jakovski, Wassily Kandinsky, Fernand Léger, James Johnson Sweeney. Review: Erni 1935.

TENERIFE 1935
Santa Cruz de Tenerife, Ateneo de Santa Cruz de Tenerife. "Exposición surrealista," May 11–21. Organized by *Gaceta de arte*. Catalogue: preface by André Breton.

PARIS 1935C
Paris, Galerie Le Niveau (133, boulevard Montparnasse). "3e Exposition 'L'Oeuvre nouvelle': Nature morte, composition, sculpture," May 20–31. Catalogue. Review: *Beaux-Arts* 1935b.

PARIS 1935D
Paris, Collège d'Espagne, Cité Universitaire. "Exposition peinture et sculpture," May 24–June 3. Catalogue: preface by Jean Cassou. Review: Kunstler 1935.

SAN FRANCISCO 1935A
San Francisco, San Francisco Museum of Art. "Drawings and Pastels by Miró," June 30–August 12. Checklist.

PARIS 1935E
Paris, Galerie Pierre. "Oeuvres récentes de Joan Miró," July 2–20. Reviews: Raynal 1935, Cousin Pons 1935.

SAN FRANCISCO 1935B
San Francisco, San Francisco Museum of Art. "Selected Watercolors by Lurçat, Miró, and Dufy," August 4–September 2. Checklist.

LOS ANGELES 1935A
Los Angeles, Stendahl Galleries. One-artist exhibition, c. October. Checklist.

LOUVIÈRE 1935
La Louvière, Belgium, Salle d'Exposition de la Commune de La Louvière (2, rue Joseph Wauters). "Tendences contemporaines: Exposition surréaliste," October 13–27. Catalogue. Review: Milo 1935.

LOS ANGELES 1935B
Los Angeles, Stanley Rose Gallery (6661½ Hollywood Boulevard). "Joan Miró," [October 14–November 2]. Organized by Howard Putzel.

PRAGUE 1935
Prague, Spolek výtvarných umělců Mánes. "Mezinárodní Výstava I," November 29–January 2, 1936. Catalogue.

PARIS 1935F
Paris, Aux Quatre Chemins (99, boulevard Raspail). "Exposition de dessins surréalistes," December 13–31. Organized by André Breton. Catalogue.

PARIS 1935G
Paris, Galerie Jeanne Bucher (9, boulevard Montparnasse). "Exposition d'un collectionneur: Henri Laugier," December 19–January 20, 1936. Review: Fegdal 1936.

1936

NEW YORK 1936A
New York, Pierre Matisse Gallery. "Eight Moderns," January 14–February 8. Catalogue. Reviews: *New York American* 1936, Klein 1936a, McBride 1936a, Morsell 1936, Cary 1936, *New York Herald Tribune* 1936a.

PARIS 1936A
Paris, Musée des Ecoles Etrangères Contemporaines, Jeu de Paume des Tuileries. "L'Art espagnol contemporain (Peinture et sculpture)," February 12–March 31. Organized by Manuel Abril, Luis Blanco Soler, Pérez Rubio, and André Dezarrois. Catalogue: introduction by Juan de la Encina, essay by Jean Cassou. Review: Boll 1936.

OXFORD 1936
Oxford (41 Saint Giles). "Abstract and Concrete: An Exhibition of Abstract Painting and Sculpture, 1934 and 1935," February 15–22. Organized by Nicolette Gray in cooperation with Axis. Catalogue.

NEW YORK 1936B
New York, The Museum of Modern Art. "Cubism and Abstract Art," March 2–April 19. Also shown in San Francisco, San Francisco Museum of Art, July 27–August 24; Cincinnati, Cincinnati Art Museum, October 19–December 27; Minneapolis, Minneapolis Institute of Arts, November 29–December 27; Cleveland, The Cleveland Museum of Art, January 7–February 7, 1937; Baltimore, The Baltimore Museum of Art, February 17–March 17, 1937; Providence, Museum of Art, Rhode Island School of Design, March 24–April 21, 1937; Grand Rapids, Mich., Grand Rapids Art Gallery, April 29–May 26, 1937. Catalogue: by Alfred H. Barr, Jr. Reviews: McBride 1936b, Benson 1936.

CAMBRIDGE 1936
Cambridge, Mass., Dunster House. "Exhibition of Contemporary French Painting," March 10–April 1. Catalogue.

LONDON 1936A
London, Duncan Miller Gallery (10 Lower Grosvenor Place). "Modern Pictures for Modern Rooms," April. Organized by S. John Woods and Duncan Miller. Catalogue: preface by S. John Woods.

LOS ANGELES 1936
[Los Angeles, Stanley Rose Gallery. Group exhibition, April. Organized by Howard Putzel.]

LONDON 1936B
London, The Mayor Gallery. "Exhibition of Works by French and English Artists," May. Catalogue.

BARCELONA 1936
Barcelona, Cúpula del Coliseum (Carrer de les Corts). "I Saló d'artistes decoradors," May 21–June. Organized by the Foment de les Arts Decoratives. Catalogue: preface by Enric F. Gual. Review: Gifreda 1936.

PARIS 1936B
Paris, Galerie Charles Ratton (14, rue de Marignan). "Exposition surréaliste d'objets," May 22–29. Catalogue: preface by André Breton.

TENERIFE 1936
Santa Cruz de Tenerife, Círculo de Bellas Artes. "Exposición de arte contemporáneo," June 10–15. Organized by A.D.L.A.N. Catalogue: preface by Eduardo Westerdahl.

LONDON 1936C
London, New Burlington Galleries (Burlington Gardens). "International Surrealist Exhibition," June 11–July 4. Catalogue: preface by André Breton, introduction by Herbert Read. Review: Star 1936, Intransigeant 1936.

PARIS 1936C
[Paris, Galerie des Cahiers d'Art. Group exhibition, June 26–July 20.]

NEW YORK 1936C
New York, Pierre Matisse Gallery. "Joan Miró," November 30–December 26. Catalogue. Reviews: Art Digest 1936, Davidson 1936, Vaughan 1936a, Genauer 1936, McBride 1936c, Klein 1936b, New York Times 1936, McCausland 1936, Devree 1937a.

NEW YORK 1936D
New York, The Museum of Modern Art. "Fantastic Art, Dada, Surrealism," December 7–January 17, 1937. Also shown in Philadelphia, Pennsylvania Museum of Art, January 30–March 1, 1937; Boston, The Institute of Modern Art, March 6–April 3, 1937; Springfield, Mass., Springfield Museum of Fine Arts, April 12–May 10, 1937; Milwaukee, Milwaukee Art Institute, May 19–June 16, 1937; Minneapolis, University Gallery, University of Minnesota, June 26–July 24, 1937; San Francisco, San Francisco Museum of Art, August 6–September 3, 1937. Catalogue: edited by Alfred H. Barr, Jr., essays by Georges Hugnet. Reviews: New York Herald Tribune 1936b, Mumford 1936, Jewell 1936a, Vaughan 1936b, Jewell 1936b, McNeil 1936, Rochester Democrat and Chronicle 1937, Beaux-Arts 1937a, C.M. 1937, Devree 1937b.

LONDON 1936D
London, The Mayor Gallery. "Inexpensive Pictures," opened December 8. Catalogue.

LONDON 1936E
London, Zwemmer Gallery (26 Litchfield Street). "Christmas Exhibition," December 8–January 14, 1937. Catalogue.

1937

PARIS 1937A
Paris, Galerie Pierre. Group exhibition, n.d.

NEW YORK 1937A
New York, Pierre Matisse Gallery. "Masterpieces," January 5–30. Catalogue. Reviews: McBride 1937a, New York American 1937, Klein 1937.

LONDON 1937A
London, The Mayor Gallery. "A Collection of Paintings by French and English Artists," January 29–February 27. Catalogue.

LOS ANGELES 1937A
[Los Angeles, Stegel Antheil Gallery. One-artist exhibition, March.]

LOS ANGELES 1937B
[Los Angeles, Putzel Gallery (6729 Hollywood Boulevard). One-artist exhibition, opened March 15.]

CHICAGO 1937
Chicago, Quest Art Galleries (810 North Michigan Avenue). Group exhibition, March [24]–April 15. Review: Jewett 1937.

NEW YORK 1937B
New York, Pierre Matisse Gallery. "Pastels, Watercolors, Drawings," April 12–May 1. Catalogue. Reviews: McBride 1937c, Jewell 1937b, Davidson 1937.

NEW YORK 1937C
New York, The Museum of Modern Art. "Twelve Modern Paintings," April 28–May 30.

PARIS 1937B
Paris, Galerie Gradiva (31, rue de Seine). Group exhibition, May.

LONDON 1937B
London, Zwemmer Gallery. "Selected Early Paintings and Drawings by Joan Miró," May 6–June 2. Catalogue. Review: Beaux-Arts 1937c.

PARIS 1937C
Paris, Galerie Pierre. "Joan Miró: Peintures, 1915–1922," May 28–June 15. Reviews: Beaux-Arts 1937b, Cheronnet 1937a, Villeboeuf 1937, Zahar 1937, Boll 1937.

JAPAN 1937
Japan. "Surréalisme, 1937," June 10–14. Organized by Paul Eluard, Georges Hugnet, and Roland Penrose. Catalogue.

TOKYO 1937
Tokyo, Nippon Salon. "Album surréaliste," June 10–14. Organized by Mizue magazine. Catalogue: edited by Shuzo Takiguchi and Tiroux Yamanaka.

PARIS 1937D
Paris, Spanish Pavilion. "Exposition internationale," July 12–November 25. Reviews: Larrea 1937, Lhote 1937, Liseur 1937, Besson 1937.

PARIS 1937E
Paris, Musée du Jeu de Paume. "Origines et développement de l'art international indépendant." July 30–October 31. Catalogue. Reviews: Kosposth 1937, Cheronnet 1937b.

STOCKHOLM 1937
Stockholm, Svensk-Franska Konstgalleriet. "Textiles," September. Catalogue.

COPENHAGEN 1937
[Copenhagen, Den Frie Udstillings Bygning. Group exhibition, September 1–13. Organized by Ejler Bille, Vilhelm Bjerke-Petersen, and Richard Mortensen.]

PARIS 1937F
Paris, Club des Architectes (Pont des Invalides). "L'Art d'aujourd'hui," October 1–30. Review: Architecture d'aujourd'hui 1937.

LONDON 1937C
London, The Mayor Gallery. "Water Colours by Modern English and French Artists," opened November 10. Catalogue.

PARIS 1937G
Paris, Galerie Pierre. "Miró," December. Review: Bonjean 1938.

1938

PARIS 1938A
Paris, Galerie Beaux-Arts (140, rue du Faubourg-Saint-Honoré). "Exposition internationale du surréalisme," January–February. Organized by André Breton and Paul Eluard. Catalogue. Reviews: Charensol 1938, Rambosson 1938, Fegdal 1938, Guetta 1938, Westheim 1938, Mailfeet 1938, *New York Times* 1938a.

NEW YORK 1938A
New York, Pierre Matisse Gallery. "From Matisse to Miró," January 4–29. Catalogue. Reviews: Genauer 1938a, Klein 1938, McBride 1938a, Davidson 1938, *New York Herald Tribune* 1938, Jewell 1938a, *Art Digest* 1938a.

GRAND RAPIDS 1938
Grand Rapids, Mich., Grand Rapids Art Gallery. "Fantastic Art: Past and Present," January 26–February 16. Also shown in Middlebury, Vt., Middlebury College, February 23–March 16; Durham, N.C., Duke University, March 23–April 13; Binghampton, N.Y., Junior League of Binghampton, April 20–May 11. Organized by The Museum of Modern Art, New York. Checklist.

LOS ANGELES 1938
[Los Angeles, Putzel Gallery. Group exhibition, April.]

NEW YORK 1938B
New York, Pierre Matisse Gallery. "Joan Miró: Recent Works," April 18–May 7. Catalogue. Reviews: Jewell 1938b, *New York Post* 1938b, Genauer 1938b, McBride 1938b, *New York Times* 1938b, A.M.F. 1938, *Art Digest* 1938b, *Daily Sketch* 1938, Coates 1938.

LONDON 1938A
London, The Mayor Gallery. "Miró: Paintings and Gouaches," May 4–28. Catalogue: published in *London Bulletin* 1938. Reviews: Newton 1938, Gordon 1938, *New Statesman and Nation* 1938, *Times* 1938, *Liverpool Daily Post* 1938, *Cavalcade* 1938.

AMSTERDAM 1938
Amsterdam, Galerie Robert (527 Keizersgracht). "Exposition internationale du surréalisme," spring. Organized by André Breton, Paul Eluard, Georges Hugnet, Roland Penrose, E.L.T. Mesens, and Kristians Tonny. Catalogue.

LONDON 1938B
London, Gallery Guggenheim Jeune (30 Cork Street). "Contemporary Painting and Sculpture," June 21–July 2. Catalogue.

PITTSBURGH 1938
Pittsburgh, Carnegie Institute. "The 1938 International Exhibition of Paintings," October 13–December 4. Catalogue. Reviews: Jena 1938, Grafly 1938.

NEW YORK 1938C
New York, Pierre Matisse Gallery. "The Suspended House: Paul Nelson; Collaborators: Arp, Léger, Miró," October 25–November 12.

CHICAGO 1938
Chicago, Katherine Kuh Gallery (540 North Michigan Avenue). One-artist exhibition, November [1–30]. Reviews: Jewett 1938a, *Chicago Daily News* 1938a, *Chicago Daily News* 1938b, *Pictures on Exhibit* 1938, Jewett 1938b, Cooper 1938.

LONDON 1938C
London, Gallery Guggenheim Jeune. "Exhibition of Collages, Papiers-collés and Photo-montages," November 4–26. Catalogue.

TOLEDO 1938
Toledo, Ohio, The Toledo Museum of Art. "Contemporary Movements in European Painting," November 6–December 11. Catalogue.

PARIS 1938B
Paris, Galerie Pierre. "Joan Miró: Un Panneau décoratif et quelques gouaches," November 24–December 7. Reviews: *Beaux-Arts* 1938, *Marianne* 1938, *Reflets* 1938, *Arts et métiers graphiques* 1939.

NEW YORK 1938D
New York, Pierre Matisse Gallery. "Exhibition of Modern Painting and Colored Reproductions," December 12–31. Organized by *Verve*. Catalogue.

1939

NEW YORK 1939A
New York, Pierre Matisse Gallery. "Early Paintings by French Moderns," January 3–31. Catalogue. Reviews: *Pictures on Exhibit* 1939, *New York Herald Tribune* 1939, McBride 1939a, Klein 1939a, Genauer 1939a, Devree 1939, Lowe 1939, Coates 1939, *Art Digest* 1939a.

PARIS 1939A
Paris, Galerie Pierre. "Joan Miró," March 8–12.

PARIS 1939B
Paris, Galerie d'Anjou (29, rue d'Anjou). "Exposition de peintures de Joan Miró," March 24–April 5. Review: Besson 1939.

PARIS 1939C
Paris, Galerie Contemporaine (36, rue de Seine). "Le Rêve dans l'art et la littérature: De l'antiquité au surréalisme," March 24–April 12. Catalogue. Review: Fegdal 1939a.

PARIS 1939D
[Paris, Maison de la Culture. One-artist exhibition, April.] Review: C.T. 1939.

NEW YORK 1939B
New York, Pierre Matisse Gallery. "Joan Miró: Paintings, Gouaches," April 10–May 6. Catalogue. Reviews: Bird 1939, Genauer 1939b, Klein 1939b, D.B. 1939, McBride 1939b, Breuning 1939.

LONDON 1939A
London, The London Gallery (28 Cork Street). "An Exhibition of Paintings by Louis Marcoussis and Joan Miró," April 14–27. Catalogue: published in *London Bulletin* 1939. Review: Warnod 1939.

PARIS 1939E
Paris, Galerie de Beaune (25, rue de Beaune). "VIIe Exposition de gravures et plâtres gravés du groupe de l'Atelier 17," April 21–May 5. Catalogue.

NEW YORK 1939C
New York, Valentine Gallery (16 East Fifty-seventh Street). "Twenty Selected Paintings by Twentieth-Century French Moderns," April 24–June 1. Catalogue. Review: Jewell 1939.

NEW YORK 1939D
New York, The Museum of Modern Art. "Art in Our Time: Tenth Anniversary Exhibition," May 10–September 30. Catalogue: preface by A. Conger Goodyear, introduction by Alfred H. Barr, Jr.

NEW YORK 1939E
New York, Pierre Matisse Gallery. "Summer Exhibition by French Moderns," June–October. Catalogue.

LONDON 1939B
London, Gallery Guggenheim Jeune. "S. W. Hayter's Studio 17: Engravings, Etchings, Plaster, Prints," June 8–23. Catalogue.

PARIS 1939F
Paris, Galerie Jeanne Bucher. "Gravures de Marcoussis, Miró," June 20–30. Reviews: *Beaux-Arts* 1939c, Fegdal 1939b.

NEW YORK 1939F
New York, Pierre Matisse Gallery. Group exhibition, November. Catalogue. Reviews: *Art Digest* 1939b, McBride 1939c, Genauer 1939c, Klein 1939c, Lane 1939.

LONDON 1939C
London, Zwemmer Gallery. "Christmas 1939," December 1–January 15, 1940. Catalogue.

1940

MEXICO CITY 1940
Mexico City, Galería de Arte Mexicano (Milán, 18). "Exposición internacional del surrealismo," January–February. Organized by André Breton, Wolfgang Paalen, and César Moro. Catalogue: essays by César Moro and Wolfgang Paalen.

BALTIMORE 1940
Baltimore, The Baltimore Museum of Art. "Modern Painting Isms and How They Grew," January 12–February 11. Catalogue.

NEW YORK 1940A
New York, The Museum of Modern Art. "Modern Masters from European and American Collections," January 26–May 24. Catalogue: foreword by Dorothy Miller.

HARTFORD 1940
Hartford, Wadsworth Atheneum. "Night Scenes,"
February 15–March 7. Catalogue: foreword by
A. Everett Austin, Jr.

NEW YORK 1940B
New York, Pierre Matisse Gallery. "Joan Miró: Early
Paintings, 1918–1925," March 12–31. Catalogue:
reprint of text by Joan Miró. Reviews: McBride 1940,
J.W.L. 1940, *New York World Telegram* 1940, Klein
1940, *Brooklyn Daily Eagle* 1940, *Art Digest* 1940.

SAN FRANCISCO 1940
San Francisco, Palace of Fine Arts. "Golden Gate
International Exposition," [May 25–September 29].
Organized by Timothy L. Pflueger. Catalogue: texts
by various authors.

LONDON 1940
London, Zwemmer Gallery. "Summer Exhibition,"
July 13–August 15. Catalogue.

NEW YORK 1940C
New York, Pierre Matisse Gallery. "Landmarks in
Modern Art," December 30–January 25, 1941.
Catalogue. Reviews: *Cue* 1940, Jewell 1940, Lane
1941, Genauer 1941a, Breuning 1941a, Kruse 1941a,
Burrows 1941a, Coates 1941a, *Art Digest* 1941a.

1941

RICHMOND 1941
Richmond, The Virginia Museum of Fine Arts.
"Collection of Walter P. Chrysler, Jr.," January 16–
March 4. Also shown in Philadelphia, Philadelphia
Museum of Art, March 29–May 11. Catalogue:
foreword by Thomas Colt and Fiske Kimball, essay by
Henry McBride. Reviews: Frankfurter 1941, Whiting
1941.

NEW YORK 1941A
New York, The New School for Social Research.
"Surrealist Art," February 1–17. Exhibition
concurrent with lectures by Gordon Onslow-Ford.
Organized by Howard Putzel.

NEW YORK 1941B
New York, Pierre Matisse Gallery. "Miró: Paintings,
Gouaches," March 4–29. Catalogue. Reviews: Jewell
1941a, Genauer 1941b, McCausland 1941, Breuning
1941b, *Art Digest* 1941b, R.F. 1941, *Time* 1941,
Greenberg 1941, Brown 1941.

NEW YORK 1941C
New York, Pierre Matisse Gallery (41 East Fifty-
seventh Street). "Small Pictures by French Painters,"
April 15–May 3. Catalogue.

NEW YORK 1941D
New York, The Museum of Modern Art. "New
Acquisitions: European Paintings," June 3–July 18.
Checklist.

BALTIMORE 1941
Baltimore, The Baltimore Museum of Art. "A Century
of Baltimore Collecting, 1840–1940." June 6–
September 1. Organized by Adelyn D. Breeskin.
Catalogue: foreword by Leslie Cheek, Jr.

NEW YORK 1941E
New York, Pierre Matisse Gallery. "French Modern
Paintings," October 7–November 1. Catalogue.
Reviews: Upton 1941, Burrows 1941b, Devree 1941,
Breuning 1941c.

NEW YORK 1941F
New York, Bignou Gallery (32 East Fifty-seventh
Street). "A Selection of Twentieth-Century Paris
Painters," October 27–November 22. Catalogue.

NEW YORK 1941G
New York, The Museum of Modern Art. "Joan Miró,"
November 18–January 11, 1942. Also shown in
Northampton, Mass., Smith College Museum of Art,
February 1–28, 1942; Poughkeepsie, N.Y., Vassar
College, March 7–28, 1942; Portland, Oreg., Portland
Art Museum, April 8–May 6, 1942; San Francisco,
San Francisco Museum of Art, June 2–July 5, 1942.
Organized by James Johnson Sweeney. Catalogue: by
James Johnson Sweeney. Reviews: *Park Avenue Social
Review* 1941, *Mirror* 1941, *Vogue* 1941, Jewell 1941b,
New York Herald Tribune 1941a, *New York Herald
Tribune* 1941b, *Long Island Press* 1941, *Forest Hills*
1941, McBride 1941, *Cue* 1941a, *Times Dispatch* 1941,
Genauer 1941, *Springfield Sunday Union and
Republican* 1941, Jewell 1941c, *Women's Wear Daily*
1941, *New York Times* 1941, Rudkin 1941, *New York
Sun* 1941, *Aufbau* 1941a, *Cue* 1941b, Coates 1941b,
Kruse 1941b, *New York Herald Tribune* 1941c, *New
York Journal American* 1941, Jewell 1941d, *Art Digest*
1941c, *Design* 1941, *Aufbau* 1941b, Murray 1941,
Buffalo Evening News 1941, Shore 1941, *New Masses*
1941, *New Yorker* 1941, *Boston Herald* 1941, *Diario de
la Marina* 1941, *Architectural Forum* 1942, D.B.
1942, Byrne 1942, Kelly 1942, Morris 1942, Raymer
1942, Puccinelli 1942.

NEW YORK 1941H
New York, Buchholz Gallery (32 East Fifty-seventh
Street). "Seventy-five Selected Prints," December
8–27. Catalogue.

1942

NEW YORK 1942A
New York, Art of This Century (30 West Fifty-seventh
Street). "Objects, Drawings, Photographs, Paintings,
Sculpture, Collages, 1910–1942," n.d. Catalogue:
essays by André Breton, Jean Arp, and Piet
Mondrian.

PARIS 1942
Paris, Galerie Charpentier (76, rue du Faubourg-
Saint-Honoré). "La Quinzaine d'art espagnol," n.d.
Catalogue.

NEW YORK 1942B
New York, Pierre Matisse Gallery. "Figure Pieces in
Modern Painting," January 20–February 14.
Catalogue.

NEW YORK 1942C
New York, Buchholz Gallery. "Aspects of Modern
Drawing," May 5–30. Catalogue.

HAVANA 1942
[Havana, The Lyceum. One-artist exhibition, July
27–August 2.]

NEW YORK 1942D
New York, Coordinating Council of French Relief
Societies (451 Madison Avenue). "First Papers of
Surrealism," October 14–November 7. Organized by
André Breton and Marcel Duchamp. Catalogue.

NEW YORK 1942E
New York, Valentine Gallery (55 East Fifty-seventh
Street). "Picasso and Miró," November. Catalogue.

NEW YORK 1942F
New York, Buchholz Gallery. "Seventy-five Selected
Prints," December 8–26. Catalogue.

NEW YORK 1942G
New York, Pierre Matisse Gallery. "Miró," December
8–31. Catalogue. Reviews: *Art News* 1942b, *Art
Digest* 1942.

NEW YORK 1942H
New York, The Museum of Modern Art. "Twentieth-
Century Portraits," December 9–January 24, 1943.
Catalogue: by Monroe Wheeler.

NEW YORK 1942I
New York, The Museum of Modern Art. "Children's
Festival of Modern Art," December 16–January 17,
1943.

1943

NEW YORK 1943A
New York, Valentine Gallery. "Twenty Modern
Paintings and Sculptures by Leading American and
French Artists," n.d. Catalogue.

NEW YORK 1943B
New York, Pierre Matisse Gallery. "War and the
Artist," March 9–April 3. Catalogue. Reviews: M.R.
1943, *Art News* 1943.

NEW YORK 1943C
New York, Art of This Century. "Fifteen Early,
Fifteen Late Paintings," March 13–April 17.
Catalogue.

CHICAGO 1943
Chicago, The Arts Club of Chicago. "Joan Miró,"
March 24–April 7. Checklist.

NEW YORK 1943D
New York, Pierre Matisse Gallery. "Summer
Exhibition: Modern Pictures Under Five Hundred,"
June 15–July. Checklist.

PARIS 1943
Paris, Galerie Jeanne Bucher. "Peintures, gouaches et
dessins de Joan Miró," October 19–November 15.
Review: Paille 1943.

NEW YORK 1943E
New York, Buchholz Gallery. "Early Work by
Contemporary Artists," November 16–December 4.
Catalogue.

NEW YORK 1943F
New York, Buchholz Gallery. "Contemporary Prints: Etchings, Lithographs, Woodcuts," December 10–30. Catalogue.

1944

NEW YORK 1944A
New York, The Museum of Modern Art. "Modern Drawings," February 16–May 10. Also shown in Pittsburgh, Carnegie Institute, June 20–July 18; San Francisco, The California Palace of the Legion of Honor, August 1–29; Hagerstown, Md., Washington County Museum of Fine Arts, October 1–29; Saint Paul, The Saint Paul Gallery and School of Art, November 12–December 10; Minneapolis, Walker Art Center, January 3–31, 1945; Milwaukee, Milwaukee Art Institute, February 14–March 14, 1945; Worcester, Mass., Worcester Art Museum, March 28–April 25, 1945; Louisville, Ky., J. B. Speed Art Museum, May 9–June 7, 1945. Catalogue: edited by Monroe Wheeler.

NEW YORK 1944B
New York, Pierre Matisse Gallery. "Ivory Black in Modern Painting," March 21–April 15. Catalogue. Review: Art News 1944a.

NEW YORK 1944C
New York, Art of This Century. "First Exhibition in America of Twenty Paintings," April 11–30. Catalogue.

NEW YORK 1944D
New York, Pierre Matisse Gallery. "Joan Miró: Paintings and Gouaches," May 2–June 3. Catalogue. Reviews: Breuning 1944, Art News 1944b, Greenberg 1944.

NEW YORK 1944E
New York, The Museum of Modern Art. "Art in Progress: Fifteenth Anniversary Exhibition," May 24–October 15. Catalogue: essays by various authors.

PARIS 1944
Paris, Palais de Tokio. "Salon d'Automne," October 6–November 5. Catalogue. Reviews: Barotte 1944, Ce Soir 1944, Grenier 1944, Jakovsky 1944, Renne 1945.

NEW ORLEANS 1944
New Orleans, Isaac Delgado Museum of Art. "Variety in Abstraction," October 29–November 19. Also shown in Poughkeepsie, N.Y., Vassar College, November 27–December 18; Newark, Del., University of Delaware, January 2–23, 1945; Cincinnati, Cincinnati Art Museum, February 6–27, 1945; Bloomington, Ind., Indiana University, March 8–29, 1945; Hanover, N.H., Dartmouth College, April 12–May 3, 1945; Alfred, N.Y., College of Ceramics, Alfred University, November 2–December 11, 1945; Rochester, N.Y., Rochester Memorial Art Gallery, December 26, 1945–January 16, 1946; Ithaca, N.Y., College of Home Economics, Cornell University, January 30–February 20, 1946; Chicago, The Arts Club of Chicago, March 3–31, 1946; Bloomfield Hills, Mich., Cranbrook Academy of Art Museum,

April 14–May 5, 1946. Organized by The Museum of Modern Art, New York. Checklist.

NEW YORK 1944F
New York, Pierre Matisse Gallery. "Homage to the 'Salon d'Automne' 1944: 'Salon de la Libération,'" December 9–January 1, 1945. Catalogue.

1945

NEW YORK 1945A
New York, Pierre Matisse Gallery. "Joan Miró: Ceramics 1944, Tempera Paintings 1940 to 1941, Lithographs 1944," January 9–February 3. Catalogue. Reviews: Pictures on Exhibit 1945, Riley 1945a, Burrows 1945a, Art News 1945a, Sweeney 1945, B.B.N. 1945.

NEW YORK 1945B
New York, Pierre Matisse Gallery. "Joan Miró: 1944 Lithographs," February 5–25. Reviews: Art News 1945b, Breuning 1945.

PARIS 1945A
Paris, Galerie Vendôme (16, place Vendôme). "Exposition Joan Miró," March 27–April 28. Catalogue: essay by Louis Parrot. Reviews: Bouret 1945, Mornac 1945, Warnod 1945, Ferrier 1945, Arbois 1945, F.D. 1945, Florisoone 1945, Degand 1945, Elgar 1945, Marc 1945, Lassaigne 1945, Saint-André 1945, Croizard 1945.

NEW YORK 1945C
New York, Pierre Matisse Gallery. "Eleven Nudes by Twentieth-Century Artists," April 10–28. Catalogue. Review: Burrows 1945b.

LONDON 1945
London, The Lefevre Gallery (131–134 New Bond Street). "School of Paris: Picasso and His Contemporaries," May–June. Catalogue.

NEW YORK 1945D
New York, 67 Gallery. "A Problem for Critics," June (?)–30. Organized by Howard Putzel. Reviews: Burrows 1945c, Art News 1945d, Riley 1945b, Greenberg 1945.

PARIS 1945B
Paris, Galerie d'Art Altarriba (43, rue du Bac). "Art catalan moderne," June–July. Review: Monde 1945.

NEW YORK 1945E
New York, Pierre Matisse Gallery. "Group Show," September 20–November. Review: Arts 1945a.

CINCINNATI 1945
Cincinnati, Cincinnati Art Museum. "The Third Biennial Exhibition: Acquisitions of Modern Art Society Members," October 23–December 3. Catalogue.

PARIS 1945C
Paris, Galerie Denise René (124, rue de La Boétie). "D'Ingres à nos jours," December–January 1946. Reviews: Theroude 1945, New York Herald Tribune 1945, Arts 1945b.

NEW YORK 1945F
New York, Pierre Matisse Gallery. "Pictures Under Five Hundred," December 11–31. Catalogue.

PARIS 1945D
Paris, Galerie Jeanne Bucher. "20 Ans chez Jeanne Bucher: Aquarelles, dessins, gouaches, 1925–45," December 14–January 12, 1946.

1946

BOSTON 1946
Boston, The Institute of Modern Art. "Four Spaniards: Dalí, Gris, Miró, Picasso," January 24–March 3. Catalogue.

TOURS 1946
Tours, Musée de Tours. "De l'avènement du cubisme à nos jours," May 18–June 2. Catalogue: preface by P.G.B.

PARIS 1946A
Paris, Galerie Charpentier. "Cent Chefs-d'oeuvre des peintres de l'école de Paris," May 24–July. Catalogue: introduction by René Huyghe.

NEW YORK 1946A
New York, The Museum of Modern Art. "Paintings from New York Private Collections," July 2–September 22. Catalogue: preface by Monroe Wheeler.

NEW YORK 1946B
New York, Pierre Matisse Gallery. "Group Show," October 10–November 2. Checklist.

SAINT PAUL 1946
Saint Paul, Hamline University. "Landscapes: Real and Imaginary," October 29–November 19. Also shown in Chicago, The Arts Club of Chicago, December 2–28; 1946; Grand Rapids, Mich., Grand Rapids Art Gallery, January 7–28, 1947; West Palm Beach, Fla., Norton Gallery and School of Art, February 8–March 2, 1947; Bloomfield Hills, Mich., Cranbook Academy of Art Museum, March 16–April 6, 1947; Bloomington, Ind., Indiana University, April 22–May 13, 1947; San Francisco, San Francisco Museum of Art, June 3–24, 1947; Honolulu, Honolulu Academy of Arts, August 1–22, 1947. Organized by The Museum of Modern Art, New York. Checklist.

PARIS 1946B
Paris, Galerie Lucien Reyman. "Premier Salon d'art catalan," November 8–December 6. Organized by L'Amicale des Catalans de Paris, in collaboration with Cultura Catalana. Catalogue: preface by Jean Cassou, essays by Frédéric Saisset and André Marty.

1947

NEW YORK 1947A
New York, The Museum of Modern Art. "Large Scale Modern Paintings," April 1–May 4. Checklist.

PARIS 1947A
Paris, Galerie du Luxembourg. "Papiers collés et

collages: Arp, Brauner, Dalí, Ernst, Juan Gris, Klee, Laurens, Masson, Miró, Picasso, Styrski," opened May 2.

NEW YORK 1947B
New York, Pierre Matisse Gallery. "Joan Miró," May 13–June 7. Catalogue.

AVIGNON 1947
Avignon, Palais des Papes. "Exposition de peintures et sculptures contemporaines," June 27–September 30. Organized by Yvonne Zervos, Jacques Charpier, and René Girard. Catalogue.

PARIS 1947B
Paris, Galerie Maeght. "Le Surréalisme en 1947: Exposition internationale du surréalisme," opened July 7. Catalogue: by André Breton and Marcel Duchamp.

AUSTIN 1947
Austin, University of Texas. "Symbolism in Painting," September 22–October 13. Also shown in San Antonio, Witte Memorial Museum, October 25–November 15; Minneapolis, Minneapolis Institute of Arts, November 28–December 19; Saint Louis, City Art Museum of Saint Louis, December 31–January 21, 1948; Oberlin, Ohio, Dudley Peter Allen Memorial Museum, Oberlin College, February 2–23, 1948; Baltimore, Baltimore Museum of Art, March 6–27, 1948; Poughkeepsie, N.Y., Vassar College, April 8–29, 1948; Wellesley, Mass., Wellesley College, May 9–30, 1948; Baton Rouge, Louisiana State University, June 12–July 3, 1948; San Francisco, San Francisco Museum of Art, July 17–August 7, 1948; Portland, Oreg., Portland Art Museum, August 21–September 11, 1948; Evanston, Ill., Northwestern University, September 25–October 26, 1948; Muskegon, Mich., Hackley Art Gallery, October 30–November 20, 1948; Boston, School of the Museum of Fine Arts, December 3–24, 1948. Organized by The Museum of Modern Art, New York. Checklist.

POUGHKEEPSIE 1947
Poughkeepsie, N.Y., Vassar College. "Drawings from the Collection of The Museum of Modern Art," November 1–29. Also shown in Boston, The Institute of Modern Art, December 13–January 10, 1948; Minneapolis, Minneapolis Institute of Arts, January 24–February 21, 1948; Grand Rapids, Grand Rapids Art Gallery, March 6–April 3, 1948; Minneapolis, University Gallery, University of Minnesota, May 29–June 26, 1948. Organized by The Museum of Modern Art, New York. Checklist.

PRAGUE 1947
Prague. "Mezinárodní Surrealismus," November 4–December 3. Catalogue.

1948

NEW YORK 1948A
New York, The Museum of Modern Art. "Miró Mural," March 2–April 4.

NEW YORK 1948B
New York, Pierre Matisse Gallery. "Joan Miró," March 16–April 10. Catalogue.

VENICE 1948
Venice. "XXIV Biennale di Venezia: La Collezione Peggy Guggenheim," May 29–September 30. Catalogue.

SAN FRANCISCO 1948
San Francisco, San Francisco Museum of Art. "Picasso, Gris, Miró: The Spanish Masters of Twentieth-Century Painting," September 14–October 17. Also shown in Portland, Oreg., Portland Art Museum, October 26–November 28, 1948. Catalogue: essays by Donald Gallup, Juan Larrea, Man Ray, Sidney Janis, Daniel-Henry Kahnweiler, and Herbert Read.

PARIS 1948A
Paris, Galerie Nina Dausset (19, rue du Dragon). "Le Cadavre exquis," October 7–30. Catalogue: preface by André Breton.

ANN ARBOR 1948
Ann Arbor, Mich., Michigan Museum of Art, University of Michigan. "Contemporary Paintings from the Albright Art Gallery," November 4–24. Catalogue.

PARIS 1948B
Paris, Galerie Maeght. "Joan Miró," November 19–December 18. Catalogue: published in *Derrière le miroir* 1948.

LONDON 1948
London, Academy Hall. "40,000 Years of Modern Art: A Comparison Between Primitive and Modern," December 20–January 29, 1949. Organized by the Institute of Contemporary Arts, London. Catalogue.

1949

FLORENCE 1949
Florence, Palazzo Strozzi. "La Collezzione Guggenheim," February 19–March 10. Catalogue.

CINCINNATI 1949
Cincinnati, Cincinnati Art Museum. "Tenth Anniversary Exhibition," April 13–May 10. Catalogue.

NEW YORK 1949A
New York, Pierre Matisse Gallery. "Joan Miró, 1923–1927," April 19–May 14. Catalogue.

BERN 1949
Bern, Kunsthalle Bern. "Joan Miró, Margrit Linck, Oskar Dalvit," April 21–May 29. Catalogue.

BARCELONA 1949
Barcelona, Galerías Layetanas. "Exposición-homenaje Joan Miró," April 23–May 6. Organized by Ediciones Cobalto. Catalogue: published in *Cobalto* 1949.

NEW YORK 1949B
New York, Buchholz Gallery. "Léger, Matisse, Miró, Moore," May 4–28. Catalogue.

BASEL 1949
Basel, Kunsthalle Basel. "Joan Miró, Otto Abt," June 14–July 17. Catalogue.

NEW YORK 1949C
New York, The Museum of Modern Art. "Modern Art in Your Life," October 5–December 4. Catalogue: by Robert Goldwater and René d'Harnoncourt.

CHICAGO 1949
Chicago, The Art Institute of Chicago. "Twentieth-Century Art from the Louise and Walter Arensberg Collection," October 20–December 18. Catalogue: essays by Katherine Kuh and Daniel Catton Rich.

NEW YORK 1949D
New York, Pierre Matisse Gallery. "Selections," November 8–26. Catalogue.

NEW YORK 1949E
New York, Pierre Matisse Gallery. "Miró: Pastels, Gouaches, Drawings, Sculptures, 1933–1943," December 6–31. Catalogue.

1950

LONDON 1950
London, The London Gallery. "Joan Miró, Desmond Morris, and Cyril Hamersma," February 2–28. Organized by E. L. T. Mesens. Catalogue.

BALTIMORE 1950
Baltimore, The Baltimore Museum of Art. "Saidie A. May Collection of Modern Paintings and Sculpture," March 17–April 16. Catalogue: preface by Adelyn D. Breeskin, introduction by James Johnson Sweeney.

NEW YORK 1950A
New York, Pierre Matisse Gallery. "Contemporary Art: Painting and Sculpture," June. Catalogue.

PARIS 1950
Paris, Galerie Maeght. "Miró," June. Catalogue: published in *Derrière le miroir* 1950.

BEVERLY HILLS 1950
Beverly Hills, Frank Perls Gallery. "Miró: Thirty Paintings, Gouaches, Pastels, Bronzes," September 14–October 11.

NEW YORK 1950B
New York, Pierre Matisse Gallery. "Selections," November. Catalogue.

1951

CINCINNATI 1951
Cincinnati, Cincinnati Art Museum. "Paintings: 1900–1925," February 2–March 4. Catalogue.

PARIS 1951
Paris, Galerie Maeght. "Sur quatre murs," March–May. Catalogue: published in *Derrière le miroir* 1951.

NEW YORK 1951A
New York, Pierre Matisse Gallery. "Joan Miró," March 6–31. Held in honor of the Diamond Jubilee of the Philadelphia Museum of Art. Catalogue.

ZURICH 1951
Zurich, Kunsthaus Zürich. "Moderne Kunst aus der

Sammlung Peggy Guggenheim," April–May. Catalogue: introduction by Max Bill.

CHAPEL HILL 1951
Chapel Hill, N.C., Person Hall Art Gallery, University of North Carolina. "A Selection of Twentieth-Century European Paintings from The Phillips Collection," June 1–August. Checklist.

NEW YORK 1951B
New York, The Museum of Modern Art. "Selections from Five New York Private Collections," June 26–September 9. Catalogue.

SAN FRANCISCO 1951
San Francisco, The California Palace of the Legion of Honor. "Paintings by Joan Miró," August 4–September 9. Checklist.

HOUSTON 1951
Houston, Contemporary Arts Museum. "Exhibition of Painting and Sculpture: Calder, Miró," October 14–November 4. Catalogue: introduction by Mary Gershinowitz.

NEW YORK 1951C
New York, Pierre Matisse Gallery. "The Early Paintings of Joan Miró," November 20–December 15. Catalogue.

MILAN 1951
Milan, Galleria d'Arte del Naviglio. "Joan Miró," December 8–21. Catalogue: introduction by Gillo Dorfles.

1952

SAARBRÜCKEN 1952
Saarbrücken. "Peinture surréaliste en Europe," n.d. Catalogue: preface by André Breton.

PALM BEACH 1952
Palm Beach, Fla., Society of the Four Arts. "Spanish Painting," January 11–February 6. Catalogue.

NEW YORK 1952A
New York, Kootz Gallery. "Vlaminck, Léger, Miró," January 28–February 16. Catalogue.

MINNEAPOLIS 1952
Minneapolis, Walker Art Center. "Joan Miró," March 8–April 6. Checklist.

WASHINGTON 1952
Washington, D.C., The Phillips Gallery. "Painters of Expressionistic Abstractions," March 16–April 29. Checklist.

NEW YORK 1952B
New York, Pierre Matisse Gallery. "Joan Miró," April 15–May 17. Catalogue.

PARIS 1952
Paris, Musée d'Art Moderne. "L'Oeuvre du XXᵉ siècle," May 5–June 15. Also shown in London, Tate Gallery, July 15–August 17. Organized by James Johnson Sweeney. Catalogue: introduction by James Johnson Sweeney.

BASEL 1952
Basel, Kunsthalle Basel. "Phantastische Kunst des XX. Jahrhunderts," August 30–October 12. Catalogue: essays by H.P. and W.J.M.

BERLIN 1952
Berlin, Hochschule für Bildende Künste. "Werke französischer Meister der Gegenwart," September 11–October 12. Catalogue: preface by Maurice Jardot and Adolf Jannasch, essays by Maurice Jardot and Daniel-Henry Kahnweiler.

NEW YORK 1952C
New York, The Museum of Modern Art. "New Children's Holiday Carnival of Modern Art," December 9–January 11, 1953.

1953

NEW YORK 1953A
New York, Schaeffer Galleries. "Contemporary Spanish Paintings," January 20–February 7. Catalogue: foreword by Juan Larrea.

BRUSSELS 1953
Brussels, Palais des Beaux-Arts. "Panorama de l'art contemporain dans les musées et collections belges," May 29–June 24. Catalogue.

PARIS 1953
Paris, Galerie Maeght. "Miró," June–August. Catalogue: published in Derrière le miroir 1953.

NEW YORK 1953B
New York, Pierre Matisse Gallery. "Miró: Recent Paintings," November 17–December 12. Catalogue: preface by James Johnson Sweeney.

NEW YORK 1953C
New York, Sidney Janis Gallery. "Recent French Acquisitions," December 7–January 21, 1954. Checklist.

1954

DENVER 1954
Denver, Denver Art Museum. "Ten Directions by Ten Artists," January 7–February 14. Catalogue: by John Ulbricht.

KREFELD 1954
Krefeld, Kaiser-Wilhelm Museum. "Miró," January 10–February 14. Also shown in Stuttgart, Württembergische Staatsgalerie, February 21–March 28; West Berlin, Haus am Waldsee, April 8–May 2. Catalogue: essays by Paul Wember and Will Grohmann.

CHICAGO 1954
Chicago, The Arts Club of Chicago. "Recent Graphic Work by Joan Miró," May 5–June 9. Catalogue.

MINNEAPOLIS 1954
Minneapolis, Walker Art Center. "Reality and Fantasy, 1900–1954," May 23–July 2. Catalogue.

VENICE 1954
Venice, Palazzo Centrale. "XXVII Biennale di Venezia," June 19–October 17. Catalogue.

NEW YORK 1954
New York, The Museum of Modern Art. "Paintings from the Museum Collection: Twenty-fifth Anniversary Exhibition," October 19–January 2, 1955. Checklist.

1955

NEW YORK 1955
New York, The Museum of Modern Art. "Paintings from Private Collections: A Twenty-fifth Anniversary Exhibition," May 31–September 5. Catalogue: published in MoMA Bulletin 1955.

KASSEL 1955
Kassel, Museum Fridericianum. "Documenta," July 15–September 18. Catalogue.

PITTSBURGH 1955
Pittsburgh, Carnegie Institute. "The 1955 Pittsburgh International Exhibition of Contemporary Painting," October 13–December 18. Catalogue: foreword by Gordon Bailey Washburn.

ANN ARBOR 1955
Ann Arbor, Mich., University of Michigan Museum of Art, Alumni Memorial Hall. "Twentieth-Century Painting and Sculpture from the Collection of Mr. and Mrs. Harry L. Winston," October 30–November 27. Catalogue: essay by Jean Paul Slusser.

1956

BRUSSELS 1956
Brussels, Palais des Beaux-Arts. "Joan Miró," January 6–February 7. Also shown in Amsterdam, Stedelijk Museum, February–March. Catalogue: excerpts from texts and poems by René Gaffé, Jean Cassou, Tristan Tzara, Paul Eluard, Jacques Prévert, E. L. T. Mesens, Pierre Loeb, Georges Limbour, and Michel Leiris.

BASEL 1956
Basel, Kunsthalle Basel. "Joan Miró," March 24–April 29. Catalogue: preface by A. Rüdlinger.

ANTWERP 1956
Antwerp, Zaal C. A. W. "De vier Hoofdpunten van het surrealisme," April 15–26. Catalogue: introduction by E. L. T. Mesens.

CINCINNATI 1956
Cincinnati, Cincinnati Art Museum. "Modern Art in Evolution, 1900–1956," May 19–June 17. Catalogue.

PARIS 1956
Paris, Galerie Maeght. "Miró, Artigas," June–August. Catalogue: published in Derrière le miroir 1956.

NEW YORK 1956
New York, Pierre Matisse Gallery. "Sculpture in Ceramic by Miró and Artigas," December 4–31.

Catalogue: reprint of Rosamond Bernier's interview with Miró and Artigas.

1957

OTTERLO 1957
Otterlo, Museum Kröller-Müller. "Collection Urvater," n.d. Also shown in Liège, Musée des Beaux-Arts, n.d. Catalogue: introduction by Emile Langui.

BARCELONA 1957
Barcelona, Sala Gaspar. "Litografías originales de Joan Miró," January 9–25.

NEW YORK 1957A
New York, World House Galleries. "The Struggle for New Form," January 22–February 23. Catalogue: introduction by Frederick J. Kiesler and Armand P. Bartos.

ZURICH 1957
Zurich, Kunsthaus Zürich. "Sammlung Ragnar Moltzau," February 9–March 31. Catalogue: texts by René Wehrli and Henning Gran.

KREFELD 1957
Krefeld, Museum Haus Lange. "Miró: Das graphische Werk," April. Also shown in West Berlin, Haus am Waldsee, n.d. [1957]; Munich, Städtische Galerie, n.d. [1957]; Cologne, Kölnischer Kunstverein, n.d. [1957]; Hannover, Kestner-Gesellschaft, December 11–January 19, 1958; Hamburg, Kunsthalle, n.d. [1958]. Catalogue: by Paul Wember.

NEW YORK 1957B
New York, M. Knoedler & Co. "Modern Painting, Drawing and Sculpture Collected by Louise and Joseph Pulitzer, Jr.," April 9–May 4. Also shown in Cambridge, Mass., Fogg Art Museum, May 16–September 15. Catalogue.

HAGUE 1957
The Hague, Gemeentemuseum's-Gravenhage. "Collectie Ragnar Moltzau, Oslo," April 19–June 11. Catalogue: preface by L. J. F. Wijsenbeek, introduction by Henning Gran.

NICE 1957
Nice, Galerie Matarasso. "Joan Miró," May 17–June 17. Catalogue: essay by André Verdet.

DETROIT 1957
Detroit, The Detroit Institute of Arts. "Collecting Modern Art: Paintings, Sculpture and Drawings from the Collection of Mr. and Mrs. Harry Lewis Winston," September 27–November 3. Also shown in Richmond, Va., The Virginia Museum of Fine Arts, December 13–January 5, 1958; San Francisco, The San Francisco Museum of Art, January 23–March 3, 1958; Milwaukee, Milwaukee Art Institute, April 11–May 12, 1958. Exhibition circulated by The Institute of Contemporary Art, Boston. Organized by The Detroit Institute of Arts. Catalogue.

BOSTON 1957A
Boston, The Institute of Contemporary Art. "Painting from the Musée National d'Art Moderne," October 2–November 17. Also shown in Columbus, Ohio, The Columbus Gallery of Fine Arts, December 1–January 1, 1958; Pittsburgh, Carnegie Institute, January 10–February 9, 1958; Minneapolis, Walker Art Center, March 1–April 15, 1958. Catalogue: foreword by Bernard Dorival.

BOSTON 1957B
Boston, Museum of Fine Arts. "Masters of Our Time," October 10–November 17. Catalogue.

1958

HOUSTON 1958
Houston, Contemporary Arts Museum. "The Disquieting Muse: Surrealism," January 9–February 16. Catalogue: essays by Jermayne MacAgy and Julien Levy.

NEW YORK 1958A
New York, The Museum of Modern Art. "Three Painters as Printmakers: Braque, Miró, Morandi," January 29–March 18. Checklist.

BRUSSELS 1958
Brussels, Palais International des Beaux-Arts. "50 Ans d'art moderne: Exposition universelle et internationale de Bruxelles," April 17–July 21. Catalogue: preface by the Marquis de la Boëssière-Thiennes, essay by Emile Langui.

PARIS 1958
Paris, Galerie Berggruen. "Joan Miró: Bois gravés pour un poème de Paul Eluard," April 25–June 5. Catalogue: preface by Douglas Cooper.

LIÈGE 1958
Liège, Musée de l'Art Wallon. "Picasso, Miró, Laurens," July–September. Organized by the Société Royale des Beaux-Arts de Liège. Catalogue: preface by Jacques Dupin.

AIX-EN-PROVENCE 1958
Aix-en-Provence, Pavillon de Vendôme. "Collection d'un amateur parisien," July 15–September 28. Catalogue.

NEW YORK 1958B
New York, Sidney Janis Gallery. "Ten Years of Janis," September 29–November 1. Catalogue.

LONDON 1958
London, Tate Gallery. "The Moltzau Collection: From Cézanne to Picasso," October 3–November 2. Catalogue: introduction by David Baxandall.

NEW YORK 1958C
New York, The Museum of Modern Art. "Works of Art, Given or Promised," October 8–November 9. Catalogue: published in *MoMA Bulletin* 1958.

NEW YORK 1958D
New York, Pierre Matisse Gallery. "Miró: 'Peintures Sauvages,' 1934 to 1953," November 4–29. Catalogue: introduction by James Fitzsimmons.

1959

BRISBANE 1959
Brisbane, Queensland Art Gallery. "Exhibition of French Art from Australian Collections," n.d. Catalogue.

PARIS 1959A
Paris, Galerie Berggruen. "Constellations," January 20–March.

BEVERLY HILLS 1959
Beverly Hills, Frank Perls Gallery. "Constellations," opened March 17.

NEW YORK 1959A
New York, Pierre Matisse Gallery. "Constellations," March 17–April 11. Catalogue.

NEW YORK 1959B
New York, The Museum of Modern Art. "Joan Miró," March 18–May 10. Also shown in Los Angeles, Los Angeles County Museum of Art, June 10–July 21. Organized by William S. Lieberman. Catalogue: by James Thrall Soby.

LONDON 1959
London, Marlborough Fine Art Ltd. "Nineteenth- and Twentieth-Century European Masters," summer. Catalogue.

PARIS 1959B
Paris, Musée National d'Art Moderne. "L'Ecole de Paris dans les collections belges," opened July 9. Catalogue.

KASSEL 1959
Kassel, Museum Fridericianum. "II. Documenta, '59: Kunst nach 1945," July 11–October 11. Catalogue.

DALLAS 1959
Dallas, The Dallas Museum for Contemporary Arts. "Signposts of Twentieth-Century Art," October 28–December 7. Catalogue.

PARIS 1959C
Paris, Galerie Daniel Cordier. "Exposition internationale du surréalisme," December 15–February 29, 1960. Organized by André Breton and Marcel Duchamp. Catalogue: essays by various authors.

1960

BENNINGTON 1960
Bennington, Vt., Bennington College. "Surrealist Art: An Exhibition of Paintings and Sculpture, 1913–1946," April 7–29. Catalogue.

NEW YORK 1960
New York, M. Knoedler & Co. "The Colin Collection," April 12–May 14. Catalogue.

BASEL 1960
Basel, Galerie Beyeler. "La Femme," May–June. Catalogue.

BOSTON 1960
Boston, The Institute of Contemporary Art, Metropolitan Boston Center. "The Image Lost and Found," May–August. Catalogue.

PARIS 1960
Paris, Galerie Maeght. "Poètes, peintres, sculpteurs," July–September. Catalogue: published in *Derrière le miroir* 1960.

ZURICH 1960
Zurich, Kunsthaus Zürich. "Thompson Pittsburgh: Aus einer amerikanischen Privatsammlung," October 15–November 27. Catalogue: essays by G. David Thompson and Alfred H. Barr, Jr.

1961

BARCELONA 1961
Barcelona, Sala Gaspar. "Joan Miró," [January 31–February 16]. Also shown in Paris, Galerie Maeght, February; New York, Solomon R. Guggenheim Museum, March 30–April 16. Catalogue: published in *Derrière le miroir* 1961a.

NEW YORK 1961A
New York, M. Knoedler & Co. "The James Thrall Soby Collection of Works of Art Pledged or Given to The Museum of Modern Art," February 1–March 4. Catalogue: preface by Blanchette H. Rockefeller, essays by James Thrall Soby and Alfred H. Barr, Jr.

HAGUE 1961
The Hague, Haags Gemeentemuseum. "Collectie Thompson uit Pittsburgh," February 17–April 9. Catalogue: essays by G. David Thompson and Alfred H. Barr, Jr.

NEW YORK 1961B
New York, Perls Galleries. "Alexander Calder, Joan Miró," February 21–April 1. Catalogue.

CHICAGO 1961
Chicago, The Arts Club of Chicago. "Joan Miró: Works from Chicago Collections," February 22–March 25. Catalogue: preface by Everett McNear.

DÜSSELDORF 1961
Düsseldorf, Kunsthalle. "Aktuelle Kunst: Bilder und Plastiken aus der Sammlung Dotremont," March 3–April 9. Catalogue: essays by Karl-Heinz Hering and Julien Alvard.

PARIS 1961A
Paris, Galerie Maeght. "Miró," April. Catalogue: published in *Derrière le miroir* 1961b.

BASEL 1961
Basel, Kunsthalle Basel. "Moderne Malerei seit 1945 aus der Sammlung Dotremont," April 22–May 28. Catalogue: essay by Julien Alvard, interview with Philippe Dotremont.

NEW HAVEN 1961
New Haven, Conn., Yale University Art Gallery. "Paintings and Sculpture from the Albright Art Gallery," April 27–September 3. Catalogue: introduction by Andrew Carnduff Ritchie.

BOSTON 1961
Boston, Museum of Fine Arts. "The Artist and the Book, 1860–1960," May 4–July 16. Catalogue: introduction by Philip Hofer, catalogue of works by Eleanor M. Garvey.

WALTHAM 1961
Waltham, Mass., Rose Art Museum. "A Century of Modern European Painting," June 3–July 2. Catalogue: foreword by Sam Hunter.

GENEVA 1961
Geneva, Musée de l'Athénée. "Joan Miró: Oeuvre graphique original, céramiques," June 10–July 14. Catalogue: preface by Michel Leiris.

PARIS 1961B
Paris, Galerie Maeght. "Miró: Peintures murales," June 23–July 31. Catalogue: published in *Derrière le miroir* 1961c.

NEW YORK 1961C
New York, The Museum of Modern Art. "The Art of Assemblage," October 4–November 12. Also shown in Dallas, The Dallas Museum for Contemporary Arts, January 9–February 11, 1962; San Francisco, San Francisco Museum of Art, March 5–April 15, 1962. Catalogue: by William C. Seitz.

NEW YORK 1961D
New York, Pierre Matisse Gallery. "Miró, 1959–1961," October 31–November 25. Catalogue: essay by Yvon Taillandier.

NEW YORK 1961E
New York, Solomon R. Guggenheim Museum. "Paintings from the Arensberg and Gallatin Collections of the Philadelphia Museum of Art," November 1–January 7, 1962. Catalogue.

NEW YORK 1961F
New York, M. Knoedler & Co. "Cincinnati Collects," November 3–25. Catalogue: introduction by Allon T. Schoener.

1962

HOUSTON 1962
Houston, The Museum of Fine Arts. "Three Spaniards: Picasso, Miró, Chillida," February 6–March 4. Catalogue: introduction by James Johnson Sweeney.

PARIS 1962A
Paris, L'Oeil Galerie d'Art. "Minotaure," May 23–June 30. Catalogue: essay by Jean-François Revel, catalogue notes by Guy Habasque.

PARIS 1962B
Paris, Musée National d'Art Moderne. "Joan Miró," June–November. Catalogue: preface by Jean Cassou.

NEW YORK 1962
New York, The Brooklyn Museum. "The Louis E. Stern Collection," September 25–March 10, 1963. Catalogue: texts by Thomas S. Buechner, Meyer Schapiro, and Bernard Pincus.

TOKYO 1962
Tokyo, Musée National d'Art Occidental. "Miró: Art graphique," September 29–October 28. Catalogue.

1963

RECKLINGHAUSEN 1963
Recklinghausen, Germany. Städtische Kunsthalle Recklinghausen, "Gesammelt im Ruhrgebiet," n.d. Catalogue: essays by Thomas Grochowiak, Gert van der Osten, H. Winckelmann, Peter Leo, and others.

FRANKFURT 1963
Frankfurt, Galerie Olaf Hudtwalcher. "Grafik von Joan Miró," April 13–May 18. Checklist.

PARIS 1963
Paris, Galerie Maeght. "Miró, Artigas," June–July. Catalogue: published in *Derrière le miroir* 1963.

NEW YORK 1963A
New York, Pierre Matisse Gallery. "Miró: Artigas Ceramics," November 5–30. Catalogue: essay by André Pieyre de Mandiargues.

NEW YORK 1963B
New York, M. Knoedler & Co. "Twentieth-Century Masters from the Bragaline Collection," November 6–23. Organized for the benefit of the Museum of Early American Folk Arts. Catalogue.

WASHINGTON 1963
Washington, D.C., National Gallery of Art. "Paintings from The Museum of Modern Art, New York," December 17–March 1, 1964. Catalogue: preface by John Walker, foreword by René d'Harnoncourt, introduction by Alfred H. Barr, Jr.

STOCKHOLM 1963
Stockholm, Moderna Museet. "Önskemuseet," December 26–February 16, 1964. Organized by the Friends of the Moderna Museet. Catalogue.

1964

LAUSANNE 1964
Lausanne, Palais de Beaulieu. "Exposition nationale suisse Lausanne 1964: Chefs-d'oeuvres des collections suisses de Manet à Picasso," n.d. Catalogue: essay by Max Huggler, catalogue notes by François Daulte.

PARIS 1964
Paris, Galerie Charpentier. "Le Surréalisme: Sources, histoire, affinités," n.d. Catalogue: preface by Raymond Nacenta, essay by Patrick Waldberg.

NEW YORK 1964
New York, Solomon R. Guggenheim Museum. "Guggenheim International Award, 1964," January–March. Catalogue: introduction by Lawrence Alloway.

MADRID 1964
Madrid, Sala de la Cacharrería del Ateneo de Madrid. "Miró," March. Catalogue: preface by Carlos-Antonio Arean.

KASSEL 1964
Kassel, Alte Galerie. "Documenta III," June 27–October 5. Catalogue.

LONDON 1964A
London, The Institute of Contemporary Arts. "Joan Miró: Thirty Years of His Graphic Art," August 26–October 10. Directed by Roland Penrose. Organized in association with The Arts Council of Great Britain. Catalogue: introduction by Roland Penrose.

LONDON 1964B
London, Tate Gallery. "Joan Miró," August 27–October 11. Also shown in Zurich, Kunsthaus Zürich, October 31–December 6. Catalogue: preface by G.W., introduction by Roland Penrose.

LONDON 1964C
London, Tate Gallery. "The Peggy Guggenheim Collection," December 31–March 7, 1965. Catalogue: foreword by Gabriel White, preface by Herbert Read, introduction by Peggy Guggenheim.

1965

WASHINGTON 1965
Washington, D.C., The Corcoran Gallery of Art. "Paintings and Sculpture from the Collection of Mr. and Mrs. David Lloyd Kreeger," February 19–March 26. Also shown in Baltimore, The Baltimore Museum of Art, April 6–May 23. Catalogue.

PARIS 1965
Paris, Galerie Maeght. "Miró: Cartons," May. Catalogue: published in Derrière le miroir 1965.

SAINT LOUIS 1965
Saint Louis, City Art Museum of Saint Louis. "Miró in Saint Louis," October 1–November 7. Checklist.

COLOGNE 1965
Cologne, Wallraf-Richartz-Museum. "Traum-Zeichen-Raum: Kunst in den Jahren 1924 bis 1939," October 23–December 12. Catalogue.

NEW YORK 1965A
New York, Pierre Matisse Gallery. "Miró: 'Cartones,' 1959–1965," October 26–November 20. Catalogue: essay by Pierre Schneider.

NEW YORK 1965B
New York, The Museum of Modern Art. "The School of Paris: Paintings from the Florene May Schoenborn and Samuel A. Marx Collection," November 2–January 2, 1966. Also shown in Chicago, The Art Institute of Chicago, February 11–March 27, 1966; Saint Louis, City Art Museum of Saint Louis, April 26–June 13, 1966; Mexico City, Museo de Arte Moderno, July 2–August 7, 1966; San Francisco, San Francisco Museum of Art, September 2–October 2, 1966; Denver, Denver Art Museum, October 24–November 25, 1966. Organized by The Museum of Modern Art, in collaboration with The Art Institute of Chicago, City Art Museum of Saint Louis, San Francisco Museum of Art, and Museo de Arte Moderno, Mexico City. Catalogue: preface by Alfred

H. Barr, Jr., introduction by James Thrall Soby, catalogue notes by Lucy Lippard.

1966

LONDON 1966
London, Marlborough Fine Art Limited. "Joan Miró," April 26–May 26. Catalogue: preface by Roland Penrose.

NEW YORK 1966
New York, "Seven Decades, 1895–1965: Crosscurrents in Modern Art," April 26–May 21. Venues: Paul Rosenberg & Co. (for 1895–1904); M. Knoedler & Co. (1905–14); Perls Galleries and E. V. Thaw & Co. (1915–24); Saidenberg Gallery and Stephen Hahn Gallery (1925–34); Pierre Matisse Gallery (1935–44); André Emmerich Gallery and Galleria Odyssia (1945–1954); Cordier & Ekstrom (1955–65). Organized for the benefit of the Public Education Association. Catalogue: essay by Peter Selz.

CLEVELAND 1966
Cleveland, The Cleveland Museum of Art. "Fifty Years of Modern Art, 1916–1966," June 15–July 31. Catalogue: by Edward B. Henning.

TOKYO 1966
Tokyo, National Museum of Modern Art. "Joan Miró Exhibition, Japan 1966," August 26–October 9. Also shown in Kyoto, National Museum of Modern Art, October 20–November 30. Organized by the National Museum of Modern Art, Tokyo, in collaboration with Mainichi Newspapers. Catalogue: preface by Yukio Kobayashi and Tsunetaka Ueda, introduction by Jacques Dupin, essay by Shuzo Takiguchi.

PHILADELPHIA 1966
Philadelphia, Philadelphia Museum of Art. "Joan Miró: Prints and Books," September 15–October 23. Catalogue: introduction by Evan Turner, foreword by Kneeland McNulty.

DETROIT 1966
Detroit, The Detroit Institute of Arts. "The W. Hawkins Ferry Collection," October 11–November 20. Catalogue: introduction by Joshua Taylor, essay by W. Hawkins Ferry.

1967

EXETER 1967
Exeter, England, Exeter City Gallery. "The Enchanted Domain," n.d. Catalogue: preface by J. H. Mathews, introduction by George Melly, catalogue notes by Jacques Brunius, John Lyle, Conroy Maddox, and E. L. T. Mesens.

PARIS 1967A
Paris, Orangerie des Tuileries. "Chefs-d'oeuvres des collections suisses de Manet à Picasso," n.d. Catalogue: by François Daulte.

HUMLEBAEK 1967
Humlebaek, Louisiana Museum. "Six Peintres

surréalistes," March–April. Also shown in Brussels, Palais des Beaux-Arts, May 9–June 6. Catalogue.

PARIS 1967B
Paris, Galerie Maeght. "Miró: L'Oiseau solaire, l'oiseau lunaire, étincelles," April–May. Catalogue: published in Derrière le miroir 1967.

MONTREAL 1967
Montreal, National Gallery of Canada. "Man and His World: International Fine Arts Exhibition, Expo '67," April 28–October 27. Catalogue.

NEW YORK 1967A
New York, Robert Elkon Gallery. "Arp, Delaunay, Dubuffet, Giacometti, Kupka, Matisse, Miró, Picabia," September 26–October 26. Catalogue.

LOS ANGELES 1967
Los Angeles, Los Angeles County Museum of Art. "The David E. Bright Collection," October. Catalogue: foreword by Sidney F. Brody, introduction by Kenneth Donahue.

TURIN 1967
Turin, Galleria Civica d'Arte Moderna. "Le Muse inquietanti: Maestri del surrealismo," November–January 1968. Catalogue: essays by Luigi Mallé and Luigi Carluccio.

NEW YORK 1967B
New York, Pierre Matisse Gallery. "Miró: Oiseau lunaire, oiseau solaire, étincelles," November 14–December 9. Catalogue: essay by David Sylvester.

NEW YORK 1967C
New York, M. Knoedler & Co. "Space and Dream," December 5–29, 1967. Catalogue: essay by Robert Goldwater.

1968

WASHINGTON 1968A
Washington, D.C., National Gallery of Art. "Painting in France, 1900–1967," n.d. Also shown in New York, The Metropolitan Museum of Art; Boston, Museum of Fine Arts; Chicago, The Art Institute of Chicago; San Francisco, M. H. de Young Memorial Museum. Catalogue.

NEW YORK 1968A
New York, The Museum of Modern Art. "Dada, Surrealism, and Their Heritage," March 27–June 9. Also shown in Los Angeles, Los Angeles County Museum of Art, July 16–September 8; Chicago, The Art Institute of Chicago, October 19–December 8. Catalogue: by William Rubin.

LAUSANNE 1968
Lausanne, Galerie Bonnier. "Léger, Miró, Picasso," April 25–June 30.

BUENOS AIRES 1968
Buenos Aires, Museo Nacional de Bellas Artes. "De Cézanne a Miró," May 15–June 5. Also shown in Santiago, Museo de Arte Contemporáneo de la Universidad de Chile, June 26–July 17; Caracas, Museo de Bellas Artes, August 4–25; New York,

Center for Inter-American Relations, September 12–22. Organized by The International Council of The Museum of Modern Art, New York. Directed by Monroe Wheeler. Catalogue: preface by Mrs. Donald B. Straus, introduction by Monroe Wheeler.

WASHINGTON 1968B
Washington, D.C., National Gallery of Art. "Paintings from the Albright-Knox Art Gallery, Buffalo, New York," May 19–July 21. Catalogue: foreword by John Walker, introduction by Gordon Mackintosh Smith.

NEW YORK 1968B
New York, Solomon R. Guggenheim Museum. "Rousseau, Redon, and Fantasy," May 31–September 8. Catalogue: introduction by Louise Averill Svendsen.

KNOKKE 1968
Knokke, Belgium, Casino Communal. "Trésors du surréalisme," June–September. Catalogue: preface by Patrick Waldberg.

STOCKHOLM 1968
Stockholm, Moderna Museet. "Ur Gerard Bonniers samling," June 6–August 18. Catalogue: essay by K. G. Hultén, Gerard Bonnier, and Ulf Linde.

SAINT-PAUL-DE-VENCE 1968
Saint-Paul-de-Vence, Fondation Maeght. "Miró," July 23–September 30. Catalogue: preface by Jacques Dupin, excerpts from texts and poems by Paul Eluard, Tristan Tzara, René Char, Jacques Prévert, Raymond Queneau, André Frénaud, Michel Leiris, André Breton, and Shuzo Takiguchi.

BARCELONA 1968
Barcelona, Recinto del Antiguo Hospital de la Santa Cruz, Ayuntamiento de Barcelona. "Miró," November–January 1969. Catalogue: essays by José Ma. de Porcioles, J. Ainaud de Lasarte, Jacques Dupin, and Rosa Ma. Subirana; bibliographical notes by Rafael Santos Torroella.

1969

SAN DIEGO 1969
San Diego, Fine Arts Gallery of San Diego. "Legacy of Spain," January 2–March 4. Catalogue: introduction by Warren Beach.

NEW YORK 1969A
New York, Solomon R. Guggenheim Museum. "Works from the Peggy Guggenheim Foundation," January 16–March 23. Catalogue: introduction by Peggy Guggenheim.

BARCELONA 1969
Barcelona, Colegio Oficial de Arquitectos de Cataluña y Baleares. "Galerías Dalmau," February 22–March 12. Catalogue.

MUNICH 1969
Munich, Haus der Kunst. "Joan Miró," March 15–May 11. Catalogue: preface by Jacques Dupin.

BASEL 1969
Basel, Galerie Beyeler. "Spanish Artists," May–July. Catalogue.

NEW YORK 1969B
New York, The Museum of Modern Art. "Twentieth-Century Art from the Nelson Aldrich Rockefeller Collection," May 26–September 1. Catalogue: foreword by Monroe Wheeler, preface by Nelson A. Rockefeller, essay by William S. Lieberman.

GENEVA 1969
Geneva, Galerie Gérald Cramer. "Joan Miró: Oeuvre gravé et lithographié," June 9–September 27. Catalogue.

BUENOS AIRES 1969
Buenos Aires, Museo Nacional de Bellas Artes. "109 Obras de Albright-Knox Art Gallery," October 23–November 30. Catalogue: preface by Seymour H. Knox, introduction by Gordon M. Smith.

CHICAGO 1969
Chicago, Museum of Contemporary Art. "Selections from the Joseph Randall Shapiro Collection," December 20–February 1, 1970. Catalogue.

1970

NEW YORK 1970A
New York, Sidney Janis Gallery. "Exhibition: String and Rope," January 7–31. Catalogue.

NEW YORK 1970B
New York, The Museum of Modern Art. "Joan Miró: Fifty Recent Prints," March 9–May 11. Also shown in Río Piedras, Museo de la Universidad de Puerto Rico, September 14–October 14, 1971; Bogotá, Museo de Arte Moderno, November 18–December 15, 1971; Caracas, Estudio Actual, January 30–February 25, 1972; Maracaibo, Centro de Bellas Artes, March 5–31, 1972; Buenos Aires, Centro de Arte y Comunicación, June 6–July 6, 1972, in Montevideo, Museo Nacional de Bellas Artes, July 21–mid-August, 1972; Santiago, Museo Nacional de Bellas Artes, October 10–31, 1972. Organized by The International Council of The Museum of Modern Art. Catalogue: essay by Riva Castleman.

NEW YORK 1970C
New York, Pierre Matisse Gallery. "Miró: Sculpture in Bronze and Ceramic, 1967–1969, and Recent Etchings and Lithographs," May 5–June 5. Catalogue: introduction by John Russell.

PARIS 1970A
Paris, Galerie Maeght. "Miró: Sculptures," June. Catalogue: published in Derrière le miroir 1970.

PALMA DE MALLORCA 1970
Palma de Mallorca, Sala Pelaires. "Joan Miró," October 1970. Catalogue: preface by Jaume Vidal Alcover.

PARIS 1970B
Paris, Grand Palais. "Hommage à Christian et Yvonne Zervos," December 11–January 18, 1971. Catalogue.

1971

BORDEAUX 1971
Bordeaux, Galerie des Beaux-Arts, "XXIe Exposition de Mai: Surréalisme," May 2–September 1. Catalogue: essays by Patrick Waldberg, Philippe Roberts-Jones, and Gilberte Martin-Méry.

KALAMAZOO 1971
Kalamazoo, Mich., Genevieve and Donald Gilmore Art Center, Kalamazoo Institute of Arts. "The Surrealists," May 9–June 6. Catalogue.

KNOKKE 1971
Knokke, Belgium, Casino Communal. "Joan Miró," June 26–August 29. Catalogue: essay by Gaëtan Picon.

NEW YORK 1971
New York, The Museum of Modern Art. "The Artist as Adversary," July 1–September 27. Organized by Betsy Jones. Catalogue: introduction by Betsy Jones.

BOGOTÁ 1971
Bogotá, Museo de Arte Moderno. "Surrealism," August 26–October 3. Also shown in Buenos Aires, Museo Nacional de Bellas Artes, October 28–November 29; Montevideo, Museo Nacional de Artes Plásticas, December 2–January 4, 1972; Caracas, Museo de Bellas Artes, January 24–February 27, 1972; Lima, Instituto de Arte Contemporáneo, April 4–30, 1972; Santiago, Museo Nacional de Bellas Artes, May 15–June 11, 1972; Auckland, City of Auckland Art Gallery, July 18–August 20, 1972; Sydney, Art Gallery of New South Wales, September 1–October 1, 1972; Melbourne, National Gallery of Victoria, October 19–November 20, 1972; Adelaide, Art Gallery of South Australia, December 3, 1972–January 2, 1973; Mexico City, Museo de Arte Moderno, January 25–February 28, 1973. Organized by The International Council of The Museum of Modern Art, New York. Directed by Bernice Rose. Catalogue: preface by Richard Teller Hirsch, introduction by Bernice Rose.

PARIS 1971
Paris, Galerie Maeght. "Miró: Peintures sur papier—Dessins," October–November. Catalogue: published in Derrière le miroir 1971.

MINNEAPOLIS 1971
Minneapolis, Walker Art Center. "Miró Sculptures," October 3–November 28. Also shown in Cleveland, The Cleveland Museum of Art, February 2–March 12, 1972; Chicago, The Art Institute of Chicago, April 15–May 28, 1972. Catalogue: essays by Jacques Dupin and Dean Swanson.

1972

MADRID 1972
Madrid, Galería Vandrés. "Joan Miró: 15 Litografías Originales—Homenatge a Joan Prats," January 14–February 19. Catalogue.

MILAN 1972
Milan, Artelevi. "Joan Miró: Opere scelte dal 1924 al

1960," February. Catalogue: introduction by Franco Passoni.

LONDON 1972
London, Hayward Gallery. "Miró Bronzes," February 1–March 12. Catalogue: by David Sylvester.

MUNICH 1972
Munich, Haus der Kunst. "Der Surrealismus, 1922–1942," March 11–May 7. Catalogue: by Patrick Waldberg.

NEW YORK 1972A
New York, Pierre Matisse Gallery. "Miró: Sobre papel," March 21–April 15. Catalogue: preface by Pierre Schneider.

BARCELONA 1972
Barcelona, Sala Gaspar. "Joan Miró: Sobreteixims i escultures," May.

ZURICH 1972
Zurich, Kunsthaus Zürich. "Joan Miró: Das plastische Werk," June 4–July 30. Catalogue: essays by Jacques Dupin and David Sylvester.

PARIS 1972
Paris, Musée des Arts Décoratifs. "Le Surréalisme, 1922–1942," June 9–September 24. Catalogue: by Patrick Waldberg.

BALTIMORE 1972
Baltimore, The Baltimore Museum of Art. "Saidie A. May Collection," September 5–October 15. Catalogue: published in *Baltimore Museum of Art Record* 1972.

NEW YORK 1972B
New York, Acquavella Galleries. "Joan Miró," October 18–November 18. Catalogue: essay by Douglas Cooper.

NEW YORK 1972C
New York, The Museum of Modern Art. "Philadelphia in New York: Ninety Modern Works from the Philadelphia Museum of Art," October 18–January 7, 1973. Catalogue: preface by Betsy Jones.

NEW YORK 1972D
New York, Solomon R. Guggenheim Museum. "Joan Miró: Magnetic Fields," October 27–January 21, 1973. Organized by Rosalind Krauss and Margit Rowell. Catalogue: essays by Rosalind Krauss and Margit Rowell.

BASEL 1972
Basel, Galerie Beyeler. "Miró, Calder," December–February 1973. Catalogue.

1973

HAMBURG 1973
Hamburg, Kunstverein. "Joan Miró: Das graphische Werk," March 31–April 29. Catalogue: essays by Hans Gerd Tuchel, Castor Seibel, and Jacques Dupin, excerpts from poems and texts by various authors.

PARIS 1973
Paris, Galerie Maeght. "Miró," April. Catalogue: published in *Derrière le miroir* 1973.

SAINT-PAUL-DE-VENCE 1973A
Saint-Paul-de-Vence, Fondation Maeght. "Sculptures de Miró, céramiques de Miró et Llorens Artigas," April 14–June 30. Catalogue: essays by Joan Teixidor, Jacques Dupin, Dean Swanson, David Sylvester, and André Pieyre de Mandiargues.

NEW YORK 1973A
New York, Pierre Matisse Gallery. "Miró: Paintings, Gouaches, Sobreteixims, Sculpture, Etchings," May 1–25. Catalogue: excerpts from texts by Jacques Dupin, John Russell, Pierre Schneider, and James Johnson Sweeney.

TEL AVIV 1973
Tel Aviv, Tel Aviv Museum. "Joan Miró: His Graphic Work," June–July. Catalogue: introduction by Dr. Haim Gamzu, preface by Ilan Tamir, reprint of texts by Paul Eluard, Jacques Prévert, and Yvon Taillandier.

SAINT-PAUL-DE-VENCE 1973B
Saint-Paul-de-Vence, Fondation Maeght. "André Malraux," July 13–September 30. Catalogue: essays by André Masson and Roger Caillois.

NEW YORK 1973B
New York, The Museum of Modern Art. "Miró in the Collection of The Museum of Modern Art," October 10–January 27, 1974. Catalogue: by William Rubin.

GENEVA 1973
Geneva, Galerie Gérald Cramer. "Joan Miró: Livres illustrés, lithographies en couleur," October 16–November 10. Catalogue.

NEW YORK 1973C
New York, Pierre Matisse Gallery. "Miró: Sobreteixims," October 19–November 9. Catalogue: preface by James Johnson Sweeney.

DÜSSELDORF 1973
Düsseldorf, Kunstsammlung Nordrhein-Westfalen. "Surrealismus: Eine didaktische Schau," October 26–December 30. Catalogue.

1974

GENEVA 1974
Geneva, Galerie Gérald Cramer. "Chagall, Masson, Meckseper, Miró, Moore: Eaux-fortes et lithographies 1973–1974," n.d. Catalogue.

BASEL 1974
Basel, Galerie Beyeler. "Surréalisme et peinture," February–April. Catalogue: preface by Reinhold Hohl.

PARIS 1974A
Paris, Galerie Melki. "Miró," May–July. Catalogue: preface by Douglas Cooper.

PARIS 1974B
Paris, Grand Palais. "Joan Miró," May 17–October 13.

Organized by Jean Leymarie, Jacques Dupin, and Isabelle Fontaine. Catalogue: preface by Jean Leymarie, essay by Jacques Dupin, excerpts from essays and poems by various authors.

PARIS 1974C
Paris, Musée d'Art Moderne de la Ville de Paris. "Miró: L'Oeuvre graphique," May 17–October 13. Also shown in Lisbon, Fundação Calouste Gulbenkian, November 25–January 12, 1975. Catalogue: by Marguerite Benhoura, Anne de Rougemont, and Françoise Gaillard, preface by Jacques Lassaigne, essay by Alexandre Cirici.

NEW YORK 1974
New York, The Museum of Modern Art. "Seurat to Matisse: Drawing in France," June 13–September 8. Catalogue: edited by William S. Lieberman.

LONDON 1974
London, Tate Gallery. "Picasso to Lichtenstein: Masterpieces of Twentieth-Century Art from the Nordrhein-Westfalen Collection in Düsseldorf," October 2–November 24. Catalogue: by Werner Schmalenbach.

PITTSBURGH 1974
Pittsburgh, Museum of Art, Carnegie Institute. "Celebration," October 26–January 5, 1975. Catalogue: introduction by Leon Anthony Arkus.

HUMLEBAEK 1974
Humlebaek, Louisiana Museum. "Joan Miró," November 9–January 12, 1975. Catalogue: published in *Louisiana Revy* 1974.

PARIS 1974D
Paris, Orangerie des Tuileries. "Art du XX*e* siècle: Fondation Peggy Guggenheim, Venise," November 30–March 3, 1975. Catalogue: introduction by Peggy Guggenheim, catalogue notes by Jean Leymarie.

1975

NEW YORK 1975A
New York, M. Knoedler & Co. "Surrealism in Art," February 5–March 6. Catalogue.

NEW YORK 1975B
New York, Pierre Matisse Gallery. "Joan Miró: Paintings and Sculptures, 1969–1974," April–May. Catalogue: excerpt of essay by Jacques Dupin.

LOS ANGELES 1975
Los Angeles, Los Angeles County Museum of Art. "A Decade of Collecting, 1965–1975," April 8–June 29. Catalogue.

SYDNEY 1975
Sydney, Art Gallery of New South Wales. "Modern Masters: Manet to Matisse," April 10–May 11. Also shown in Melbourne, National Gallery of Victoria, May 28–June 22; New York, The Museum of Modern Art, August 4–September 1. Organized by The International Council of The Museum of Modern Art, New York. Catalogue: edited by William S. Lieberman.

BARCELONA 1975A
Barcelona, Fundació Joan Miró. "Pintura, escultura i sobreteixims de Miró a la Fundació," June. Catalogue: essays by Joan Teixidor and Francesc Vicens.

TOKYO 1975
Tokyo, National Museum of Modern Art. "Surrealism," September 27–November 16. Also shown in Kyoto, National Museum of Modern Art, November 26–January 11, 1976. Catalogue: essays by Roland Penrose and Tamon Miki.

NEW YORK 1975C
New York, Sidney Janis Gallery. "Twentieth-Century Masters," October 29–November 22. Catalogue.

BARCELONA 1975B
Barcelona, Galería Maeght. "Un Camí compartit: Miró–Maeght," December–January 1976. Catalogue: essay by Pere Gimferrer.

1976

NEW YORK 1976A
New York, Pierre Matisse Gallery. "Miró: Sculpture," April 13–May. Catalogue: essay by Josep Lluís Sert.

PARIS 1976
Paris, Musée National d'Art Moderne. "Assemblage," April 28–May 20. Catalogue.

NEW YORK 1976B
New York, Wildenstein Gallery. "Modern Portraits: The Self and Others," October 20–November 28. Catalogue: edited by Kirk Varnedoe.

NEW YORK 1976C
New York, Pierre Matisse Gallery. "Miró: Aquatintes, Grands Formats, 1974–75," November 16–December 16. Catalogue.

NEW YORK 1976D
New York, The Museum of Modern Art. "European Master Paintings from Swiss Collections," December 17–March 1, 1977. Catalogue.

1977

CINCINNATI 1977
Cincinnati, The Taft Museum. "Best of Fifty," March 24–May 8. Catalogue.

PARIS 1977
Paris, Musée National d'Art Moderne. "Paris–New York," June 1–September 19. Catalogue: essays by various authors.

BERLIN 1977
Berlin, Grosse Orangerie im Schloss Charlottenburg. "Tendenzen der zwanziger Jahre: 15. europäische Kunstaustellung, Berlin 1977," August 14–October 16. Catalogue.

1978

LONDON 1978
London, Hayward Gallery. "Dada and Surrealism Reviewed," January 11–March 27. Catalogue: by Dawn Ades, with essays by David Sylvester and Elizabeth Cowling.

VIENNA 1978
Vienna, Museum des 20. Jahrhunderts. "Surrealismus aus der Sammlung The Museum of Modern Art, New York," February–March. Also shown in Düsseldorf, Kunsthalle Düsseldorf, April–June; Brussels, Musées Royaux des Beaux-Arts de Belgique, June–July; Zurich, Kunsthaus Zürich, August–October; Oslo, Sonja Henie–Niels Onstad Foundations, October–December. Organized by The International Council of The Museum of Modern Art, New York. Catalogue: essays by Carolyn Lanchner, Alfred Schmeller, and André Breton.

MADRID 1978A
Madrid, Museo Español de Arte Contemporáneo. "Joan Miró: Pintura," May 4–July 23. Organized in collaboration with the Fundació Joan Miró. Catalogue: by María Angeles Dueñas, Rosa Maria Malet, and Francesc Vicens, with essays by Julián Gállego and excerpts from texts by Jacques Dupin, James Johnson Sweeney, Francesc Vicens, Alexandre Cirici, and Roland Penrose.

MADRID 1978B
Madrid, Salas de la Dirección General del Patrimonio Artístico. "Joan Miró: Obra gráfica," May 4–July 23. Catalogue.

BARCELONA 1978
Barcelona, Galería Maeght. "Miró: Dibuixos, gouaches, monotips," May 10–June 30. Catalogue: essay by Pere Gimferrer.

PARIS 1978A
Paris, Musée National d'Art Moderne, Centre Georges Pompidou. "Dessins de Miró provenant de l'atelier de l'artiste et de la Fondation Joan Miró de Barcelone," September 20–January 22, 1979. Exhibition and catalogue by Pierre Georgel and Isabelle Monod-Fontaine, with essays by Pierre Georgel, Isabelle Monod-Fontaine, and Rosa Maria Malet.

PARIS 1978B
Paris, Musée d'Art Moderne de la Ville de Paris. "Miró: Cent Sculptures, 1962–1978," October 19–December 17. Organized in collaboration with the Fondation Maeght. Catalogue: preface by Jacques Lassaigne, essays by Jacques Dupin and Dean Swanson (reprint).

PARIS 1978C
Paris, Galerie Maeght. "Miró," November. Catalogue: published in *Derrière le miroir* 1978.

NEW YORK 1978
New York, Pierre Matisse Gallery. "Joan Miró: Recent Paintings, Gouaches and Drawings from 1969 to 1978," November 21–December 16. Catalogue.

1979

NEW YORK 1979A
New York, Solomon R. Guggenheim Museum. "The Planar Dimension: Europe, 1912–1932," March 9–May 6. Catalogue: by Margit Rowell.

ZURICH 1979
Zurich, Galerie Maeght. "Zeichnungen und Malereien auf Papier von Joan Miró," April–May.

LONDON 1979
London, Hayward Gallery. "Drawings by Joan Miró from the Artist's Studio and the Joan Miró Foundation, Barcelona," April 10–May 13. Catalogue: introduction by Jim Hilton, essays by Pierre Georgel, Isabelle Monod-Fontaine, and Rosa Maria Malet.

GENEVA 1979A
Geneva, Galerie Patrick Cramer. "Joan Miró: 60 Livres illustrés," May 17–July 28. Catalogue.

FLORENCE 1979
Florence, Orsanmichele. "Joan Miró: Pittura, 1914–1978," May 26–September 30. Catalogue: essays by Giulio Carlo Argan, Francesc Vicens, Maurizio Calvesi, and Filiberto Menna.

SIENA 1979
Siena, Museo Civico. "Joan Miró: Grafica, 1930–1978," May 26–September 30. Catalogue: essays by Joan Teixidor and Aldo Cairola.

PRATO 1979
Prato, Palazzo Pretorio. "Joan Miró: Scultura, 1931–1972," May 27–September 30. Catalogue: edited by Sergio Salvi, with essays by Jacques Dupin and Vanni Bramanti.

BARCELONA 1979
Barcelona, Galería Maeght. "Joan Miró: Homenatge a Gaudí: 100 Gravats i 4 esculture recents, 1978–1979," June–July. Catalogue: essay by Lluís Permanyer.

BASEL 1979
Basel, Galerie Beyeler. "Jean Arp, Joan Miró," June–September. Catalogue.

PARIS 1979
Paris, Musée d'Art Moderne de la Ville de Paris. "L'Aventure de Pierre Loeb: La Galerie Pierre, Paris, 1924–1964," June 7–September 16. Also shown in Brussels, Musée d'Ixelles, October 4–December 23. Catalogue: essays by various authors.

SAINT-PAUL-DE-VENCE 1979
Saint-Paul-de-Vence, Fondation Maeght. "Joan Miró: Peintures, sculptures, dessins, céramiques, 1956–1979," July 7–September 30. Organized by Jean-Louis Prat. Catalogue: introduction by Jean-Louis Prat, reprints of essays by André Balthazar, Jean-Louis Prat, Jacques Dupin, David Sylvester, Marcelin Pleynet, and Lluís Permanyer.

CLEVELAND 1979
Cleveland, The Cleveland Museum of Art. "The

Spirit of Surrealism," October 3–November 25. Catalogue: by Edward B. Henning.

NEW YORK 1979B
New York, The Museum of Modern Art. "Art of the Twenties," November 17–January 22, 1980. Catalogue: edited by William S. Lieberman.

GENEVA 1979B
Geneva, Marie-Louise Jeanneret Art Moderne. "Hommage à James Thrall Soby," December 20–March 1, 1980. Catalogue: essays by Marzio Pinottini, Sergio Ruffino, and Marguerite Arp.

1980

PARIS 1980
Paris, Musée du Luxembourg. "Donation Geneviève et Jean Masurel à la Communauté Urbaine de Lille," March 14–May 25. Catalogue.

SAINT LOUIS 1980
Saint Louis, Washington University Gallery of Art. "Joan Miró: The Development of a Sign Language," March 19–April 27. Also shown in Chicago, The David and Alfred Smart Gallery, University of Chicago, May 15–June 18. Organized by Sidra Stich. Catalogue: by Sidra Stich.

WASHINGTON 1980A
Washington, D.C., Hirshhorn Museum and Sculpture Garden, Smithsonian Institution. "Miró: Selected Paintings," March 20–June 8. Also shown in Buffalo, Albright-Knox Art Gallery, June 27–August 17. Catalogue: foreword by Abram Lerner, essays by Charles W. Millard and Judi Freeman.

LA JOLLA 1980
La Jolla, La Jolla Museum of Contemporary Art. "Seven Decades of Twentieth-Century Art," March 29–May 11. Also shown in Santa Barbara, Santa Barbara Museum of Art, June 6–August 10. Catalogue: introduction by William Rubin, catalogue of the works from the Sidney Janis Gallery Collection by Marian Burleigh-Motley.

NEW YORK 1980A
New York, Pierre Matisse Gallery. "Miró: Painted Sculpture and Ceramics," May 13–June 7. Catalogue.

MEXICO CITY 1980
Mexico City, Museo de Arte Moderno. "Miró: Una Realidad, un arte," May–August. Also shown in Caracas, Museo de Bellas Artes, September 7–November 9. Catalogue: essays by various authors.

NEW YORK 1980B
New York, The Metropolitan Museum of Art. "Modern Masters: European Paintings from The Museum of Modern Art," June 6–September 21. Catalogue: edited by William S. Lieberman.

WASHINGTON 1980B
Washington, D.C., National Gallery of Art. "The Morton G. Neumann Family Collection," August 31–December 31. Catalogue.

NEW YORK 1980C
New York, Acquavella Galleries. "Nineteenth- and Twentieth-Century Master Paintings," October 15–November 15. Catalogue.

BARCELONA 1980
Barcelona, Fundació Joan Miró and Centre Cultural de la Caixa de Pensions. "Joan Miró: Obra gràfica," November 13–January 11, 1981. Catalogue: essay by Alexandre Cirici.

MADRID 1980
Madrid, Sala de Exposiciones del Centro de Servicios de la Caja de Pensiones. "Miró escultor," November 28–December 23. Catalogue: essay by Jacques Dupin.

1981

NEW YORK 1981A
New York, Sidney Janis Gallery. "The Picasso Generation," January 9–February 7. Catalogue.

PARIS 1981
Paris, Galerie Daniel Malingue. "Maîtres impressionnistes et modernes," April 29–June 6. Catalogue.

SÃO PAULO 1981
São Paulo, Museu de Arte de São Paulo. "Four Modern Masters: De Chirico, Ernst, Magritte, and Miró," May 18–June 28. Also shown in Buenos Aires, Museo Nacional de Bellas Artes, July 13–August 23; Caracas, Museo de Bellas Artes, September 7–October 11; Calgary, Glenbow Museum, November 23–January 10, 1982. Organized by The International Council of The Museum of Modern Art, New York. Catalogue: preface by Duncan F. Cameron, introduction by Carolyn Lanchner and Laura Rosenstock.

FLORENCE 1981
Florence, Palazzo Pitti. "Da Monet a Picasso: Cento Capolavori della Galleria Nazionale di Praga," June 27–September 20. Organized by Jiří Kotalík and Achille Bonito Oliva. Catalogue: introduction by Fulvio Abboni, essays by Luciano Berti, Jiří Kotalík, and Achille Bonito Oliva.

CANNES 1981
Cannes, Galerie Herbage. "Joan Miró: Retrospective de l'oeuvre gravé, 1964–1978," July 4–September 12. Catalogue: preface by Alexandre Cirici.

SAN FRANCISCO 1981A
San Francisco, The California Palace of the Legion of Honor, The Fine Arts Museums of San Francisco. "Impressionism and the Modern Vision: Master Paintings from The Phillips Collection," July 4–November 1. Also shown in Dallas, Dallas Museum of Fine Arts, November 22–February 16, 1982; Minneapolis, Minneapolis Institute of Arts, March 14–May 30, 1982; Atlanta, The High Museum of Art, June 24–September 5, 1982; Oklahoma City, The Oklahoma Art Center, October 17, 1982–January 9, 1983. Catalogue.

SAN FRANCISCO 1981B
San Francisco, Harcourts Gallery. "Joan Miró: Important Paintings, Sculpture and Graphic Works," October–November. Catalogue: introduction by Henry T. Hopkins.

MILAN 1981
Milan. "Miró Milano: Pittura, scultura, ceramica, disegni, sobreteixims, grafica," October 26–December 6. Venues: Castello Sforzesco, Sala della Balla (paintings, 1914–80), Rotonda di via Besana (prints and illustrated books), Palazzo del Senato (large sculptures and film), Palazzo Dugnani (sculpture), Galleria del Naviglio (ceramics), Galleria del Milione (drawings and gouaches), Studio Marconi (tapestries, posters, and works for the theater). Catalogue: essays by Gillo Dorfles, Carmine Benincasa, Gaëtan Picon, Jacques Dupin, André Pieyre de Mandiargues, Joan Teixidor, and Alexandre Cirici.

NEW YORK 1981B
New York, Acquavella Galleries. "Nineteenth- and Twentieth-Century Master Paintings," October 30–November 30. Catalogue.

MADRID 1981
Madrid, Fundación Juan March. "Medio siglo de escultura, 1900–1945," November–December. Catalogue: introduction by Jean-Louis Prat.

LONDON 1981
London, Waddington Galleries. "Joan Miró," December 1–23. Catalogue: essay by Richard Calvocoressi.

1982

ATLANTA 1982
Atlanta, The High Museum of Art. "Twentieth-Century Paintings from the Collection of The Museum of Modern Art," February 12–April 11. Also shown in Seattle, Seattle Art Museum, April 29–July 4; San Diego, San Diego Museum of Art, July 24–September 19; Kansas City, Mo., Nelson-Atkins Museum of Art, October 21–December 10; New Orleans, New Orleans Museum of Art, February 4–March 20, 1983; Denver, Denver Art Museum, April 22–July 3, 1983. Organized by The Museum of Modern Art, New York. Checklist.

NEW YORK 1982
New York, The Museum of Modern Art. "A Century of Modern Drawing," March 1–16. Also shown in London, The British Museum, June 9–September 12; Cleveland, The Cleveland Museum of Art, October 19–December 5; Boston, Museum of Fine Arts, January 25–April 3. Directed by Bernice Rose. Organized by The International Council of The Museum of Modern Art, New York. Checklist.

HOUSTON 1982
Houston, The Museum of Fine Arts. "Miró in America," April 21–June 27. Catalogue: essays by Barbara Rose, Judith McCandless, Duncan Macmillan, interview with Miró by Barbara Rose, reprints of texts by various authors.

EDINBURGH 1982
Edinburgh, Scottish National Gallery of Modern Art. "Miró's People: Joan Miró — Paintings and Graphics of the Human Figure, 1920–1980," August 12–October 3. Catalogue.

1983

PARIS 1983
Paris, Galerie Maeght. "Joan Miró: 90e Anniversaire," n.d. Catalogue: texts by Michel Leiris and Jacques Dupin.

NEW YORK 1983A
New York, Solomon R. Guggenheim Museum. "An Homage to Joan Miró at Ninety," January 21–February 27. Catalogue.

TOKYO 1983
Tokyo, Isetan Museum of Art. "Surrealism," February 27–March 22. Organized by Serge Sabarsky and Charles Byron. Catalogue: essay by Hilton Kramer.

NEW YORK 1983B
New York, The Museum of Modern Art. "Joan Miró: A Ninetieth-Birthday Tribute," April 14–26. Checklist.

BARCELONA 1983
Barcelona, Fundació Joan Miró. "Joan Miró: Anys vint — Mutació de la realitat," May–June. Also shown in Madrid, Museo Español de Arte Contemporáneo, June–July. Catalogue: essays by Joan Miró (reprint), Antoni Tàpies, Jacques Dupin, and Rosa Maria Malet.

NEW YORK 1983C
New York, Pierre Matisse Gallery. "Miró: Ninety Years," May 10–June 18.

NEW YORK 1983D
New York, The Museum of Modern Art. "Museum Collection: Miró and Picasso," June 9–September 12, 1983. Checklist.

KARLSRUHE 1983
Karlsruhe, Städtische Galerie im Prinz-Max-Palais. "Joan Miró: Skulpturen," September 24–November 13. Catalogue: essays by Andreas Franzke and Antoni Tàpies.

NEW YORK 1983E
New York, The Museum of Modern Art. "The Modern Drawing: 100 Works on Paper from The Museum of Modern Art." October 26–January 3, 1984. Catalogue: by John Elderfield.

NEW YORK 1983F
New York, IBM Gallery of Science and Art. "Paintings and Drawings from The Phillips Collection," December 9–January 21, 1984. Checklist.

1984

BARCELONA 1984
Barcelona, Casa Elizalde. "Joan Miró: Sèrie Barcelona," January–February. Catalogue: preface by Maria Lluïsa Borràs.

MIAMI 1984A
Miami, Center for the Fine Arts. "In Quest of Excellence," January 14–April 22. Catalogue: edited by Jan van der Marck.

SAINT-PAUL-DE-VENCE 1984
Saint-Paul-de-Vence, Fondation Maeght. "Hommage à Joan Miró," March 10–May 8. Catalogue: introduction by Jean-Louis Prat, reprints of texts by various authors.

TOKYO 1984
Tokyo, Grande Gallery Odakyu. "Retrospective Exhibition of Miró," April 6–18. Also shown in Nagano, Shinamo Museum of Fine Arts, April 21–May 20; Osaka, Hanshin Department Store Art Gallery, May 24–29; Chiba, Funabashi Seibu Museum of Arts, June 22–July 17; Miyagi, Miyagi Museum of Art, July 21–August 26; Fukushima, Fukushima Prefectural Museum of Modern Art, September 1–30. Catalogue: essays by Makoto Ooka, Yoshiaki Tono, Shuzo Takiguchi, Kojin Toneyama, J. Gardy Artigas, and Rosa Maria Malet.

PARIS 1984A
Paris, Galeries Nationales du Grand Palais. "La Rime et la raison: Les Collections Ménil (Houston–New York)," April 17–July 30. Organized by Walter Hopps and Jean-Yves Mock. Catalogue: preface by Hubert Landais, essays by Domenique de Ménil, Walter Hopps, Bertrand Davezac, and Jean-Yves Mock.

NEW YORK 1984A
New York, The Pace Gallery. "Miró Sculpture," April 27–June 9. Catalogue: essay by Peter Schjeldahl.

ORLÉANS 1984
Orléans, Musée des Beaux-Arts d'Orléans. "Peintures françaises du Museum of Art de la Nouvelle Orléans," May 9–September 15.

BASEL 1984
Basel, Galerie Beyeler. "Nudes, Nus, Nackte," June–August. Catalogue: preface by Margit Weinberg-Staber.

NEW YORK 1984B
New York, The Museum of Modern Art. " 'Primitivism' in Twentieth-Century Art: Affinity of the Tribal and the Modern," September 19–January 15, 1985. Also shown in Detroit, The Detroit Institute of Arts, February 23–May 19, 1985; Dallas, Dallas Museum of Art, June 15–September 8, 1985. Organized by William Rubin (director of the exhibition) and Kirk Varnedoe (co-director). Catalogue: edited by William Rubin.

MIAMI 1984B
Miami, Center for the Fine Arts. "Joan Miró in Miami," October 13–November 25. Catalogue: essay by Jan van der Marck.

NEW YORK 1984C
New York, Acquavella Galleries. "Nineteenth- and Twentieth-Century Master Paintings," November 7–December 8. Catalogue.

PARIS 1984B
Paris, Musée National d'Art Moderne, Centre Georges Pompidou. "Miró: Les 3 Bleu," November 21–January 28, 1985.

CHICAGO 1984
Chicago, Museum of Contemporary Art. "Dada and Surrealism in Chicago Collections," December 1–January 27, 1985. Catalogue: edited by Terry Ann R. Neff, essays by various authors.

1985

ZURICH 1985A
Zurich, Galerie Maeght Lelong. "Miró: Sculptures," n.d. Catalogue: preface by Jean-Christophe Bailly.

NEW YORK 1985A
New York, Solomon R. Guggenheim Museum. "Kandinsky in Paris," February 15–April 21. Also shown in Houston, The Museum of Fine Arts, June 8–August 11; Milan, Palazzo Reale, September 19–November 10; Vienna, Museum des 20. Jahrhunderts, December 5–January 26, 1986. Catalogue: preface by Thomas M. Messer, essays by Christian Derouet and Vivian Endicott Barnett.

CHICAGO 1985
Chicago, The Art Institute of Chicago. "The Mr. and Mrs. Joseph Randall Shapiro Collection," February 23–April 14. Catalogue: foreword by James Wood, introduction by Joseph Randall Schapiro, essays by Katherine Kuh and Dennis Adrian.

ZURICH 1985B
Zurich, Kunsthaus Zürich. "36 Werke aus der Sammlung Erna und Curt Burgauer: Geschenke und ein versprochenes Legat," March 9–May 5. Catalogue: preface by Felix Baumann, introduction by Curt Burgauer.

FERRARA 1985
Ferrara, Gallerie Civiche d'Arte Moderna, Palazzo dei Diamanti. "Joan Miró," March 16–June 15. Catalogue: introduction by Alexandre Cirici, reprints of texts by Joan Miró.

STUTTGART 1985
Stuttgart, Staatsgalerie Stuttgart. "Vom Klang der Bilder: Die Musik in der Kunst des 20. Jahrhunderts," July 6–September 22. Catalogue: by Karin v. Maur.

CHARLEROI 1985
Charleroi, Palais des Beaux-Arts. "Picasso, Miró, Dalí: Evocations d'Espagne," September 26–December 22. Catalogue: essays by various authors, including Jacques Dupin and Pere Gimferrer.

NORWICH 1985
Norwich, Sainsbury Centre of Visual Arts, University of East Anglia. "The Touch of Dreams: Joan Miró, Ceramics and Bronzes, 1949–1980," October 1–December 8. Catalogue: edited by Veronica Sekules,

essays by Dawn Ades, D. Barrass, and Michael Sweeney.

NEW YORK 1985B
New York, Pierre Matisse Gallery. "Miró, Artigas: Terres de grand feu," November 12—December 7. Catalogue: essays by Rosamond Bernier and Joan Gardy Artigas.

LONDON 1985
London, Hayward Gallery. "Homage to Barcelona: The City and Its Art, 1888—1936," November 14—February 23, 1986. Also shown in Barcelona, Palau de La Virreina, January 21—March 29. Catalogue: essays by various authors.

1986

BASEL 1986
Basel, Galerie Beyeler. "Aus privaten Sammlungen," n.d. Catalogue.

VILLENEUVE D'ASCQ 1986
Villeneuve d'Ascq, Musée d'Art Moderne. "Joan Miró," January 18—March 16. Organized by Daniel Gervis. Catalogue: essay by Blandine Bouret.

TOKYO 1986
Tokyo, Isetan Museum of Art. "Joan Miró," April 17—May 6. Also shown in Osaka, Daimaru Museum, May 21—June 9; Toyama, Museum of Modern Art, June 14—August 24; Fukuoka, Fukuoka Art Museum, September 4—28; Yokohama, Sogo Art Museum, October 10—26; Nagasaki, Nagasaki Prefectural Art Museum, October 31—November 24. Organized by Daniel Gervis and Brain Trust Inc. Catalogue.

WASHINGTON 1986
Washington, D.C., The Phillips Collection. "Duncan Phillips: Centennial Exhibition," June 14—August 31. Checklist.

MONTREAL 1986
Montreal, The Montreal Museum of Fine Arts. "Miró in Montreal," June 20—October 5. Catalogue: essays by Jean-Louis Prat and Pierre Théberge; reprints of texts by Joan Miró, Jacques Dupin, Roland Penrose, and Lluís Permanyer.

PARIS 1986
Paris, Musée National d'Art Moderne, Centre Georges Pompidou. "Qu'est-ce que la sculpture moderne?" July 3—October 13. Catalogue: by Margit Rowell.

LEEDS 1986
Leeds, Leeds City Art Galleries. "Surrealism in Britain in the Thirties," October 10—December 7. Catalogue: essays by Alexander Robertson, Michel Remy, and Mel Gooding.

LAUSANNE 1986
Lausanne, Fondation de l'Hermitage. "Trésors de Barcelone: Picasso, Miró, Dalí et leur temps," October 10—December 28. Catalogue: texts by François Daulte and Cesáreo Rodríguez-Aguilera.

MADRID 1986
Madrid, Museo Nacional Centro de Arte Reina Sofía. "Miró escultor," October 21—January 18, 1987. Also shown in Barcelona, Fundació Joan Miró, January 29—March 29, 1987; Cologne, Museum Ludwig, April 10—June 8, 1987. Organized by Gloria Moure. Catalogue: essays by Gloria Moure, Rosa Maria Malet, and Jacques Dupin.

ZURICH 1986
Zurich, Kunsthaus Zürich. "Joan Miró," November 21—February 1, 1987. Also shown in Düsseldorf, Städtische Kunsthalle Düsseldorf, February 14—April 20, 1987. Catalogue: essays by Robert S. Lubar, Joan Miró, Jacques Dupin, Werner Schmalenbach, Hans Heinz Holz, Hajo Düchting, and Barbara Rose.

1987

NEW YORK 1987A
New York, Solomon R. Guggenheim Museum. "Joan Miró: A Retrospective," May 15—August 23. Catalogue: essays by Robert S. Lubar, Joan Miró, Jacques Dupin, Werner Schmalenbach, and Thomas M. Messer.

NEW YORK 1987B
New York, Pierre Matisse Gallery. "Miró: The Last Bronze Sculptures 1981—1983," May 20—June 20. Catalogue: introduction by Margit Rowell.

PALMA DE MALLORCA 1987
Palma de Mallorca, Palau Solleric. "Joan Miró, Son Abrines i Son Boter—Olis, dibuixos i graffiti," opened May 29. Organized by the Fundació Pilar i Joan Miró. Catalogue: introduction by Ramon Aguiló, essays by Miquel Servera Blanes, Oriol Bohigas, Jean-Louis Prat, David Fernández Miró, and Pere A. Serra.

PARIS 1987A
Paris, Galerie Maeght Lelong. "Joan Miró: Les Dernières Estampes," June 27—July 30. Catalogue: preface by Jacques Dupin.

MADRID 1987
Madrid, Museo Nacional Centro de Arte Reina Sofía. "Miró en las colecciones del Estado," October—December. Organized by Ana Beristain and María José Salazar. Catalogue: by Ana Beristain and María José Salazar.

PHILADELPHIA 1987A
Philadelphia, Philadelphia Museum of Art. "Miró in the Philadelphia Collection," October 3—November 29, 1987. Catalogue: published in *Philadelphia Museum of Art Bulletin*; preface by Anne d'Harnoncourt, essay by Margit Rowell, catalogue of works by Ann Temkin.

PHILADELPHIA 1987B
Philadelphia, Philadelphia Museum of Art. "The Captured Imagination: Drawings by Joan Miró from the Fundació Joan Miró, Barcelona," October 4—November 29. Also shown in Fort Worth, The Fort Worth Art Museum, December 13—February 14, 1988; San Francisco, San Francisco Museum of

Modern Art, March 5—May 1, 1988. Catalogue: by Margit Rowell.

PARIS 1987B
Paris, Musée d'Art Moderne de la Ville de Paris. "Le Siècle de Picasso," October 10—January 3, 1988. Also shown in Madrid, Museo Nacional Centro de Arte Reina Sofía, January 29—March 13, 1988. Catalogue: essays by Pierre Daix, Francisco Calvo Serraller, and Tomás Llorens.

NEW YORK 1987C
New York, The Museum of Modern Art. "European Drawing Between the Wars," October 22—March 1, 1988. Checklist.

GENEVA 1987
Geneva, Galerie Patrick Cramer. "Joan Miró," November 2—January 30, 1988. Catalogue.

LAUSANNE 1987
Lausanne, Musée Cantonal des Beaux-Arts. "La Femme et le surréalisme," November 27—February 28, 1988. Catalogue: by Erika Billeter and José Pierre, with preface by André Pieyre de Mandiargues and essays by various authors.

DÜSSELDORF 1987
Düsseldorf, Kunstsammlung Nordrhein-Westfalen. "'. . . und nicht die leiseste Spur einer Vorschrift'—Positionen unabhängiger Kunst in Europa um 1937," December 4—January 31, 1988. Catalogue: preface by Werner Schmalenbach and Jörn Merkert, essays by Freya Mülhaupt, Thomas Brandt, Gladys C. Fabre, Andrei Nakov, Günter Metken, and Rita Bischof.

1988

SANKT GALLEN 1988
Sankt Gallen, Kunstmuseum St. Gallen. "Rot Gelb Blau," n.d. Organized by Bernhard Bürgi and Veit Loers. Catalogue: edited by Bernhard Bürgi.

BARCELONA 1988A
Barcelona, Centre d'Art Santa Mònica. "Surrealisme a Catalunya 1924—1936: De 'L'Amic de les arts' al Logicofobisme," May—June. Catalogue: essays by Rosa Maria Malet, Isabel Coll, Rosa Maria Subirana, Jaume Fàbrega, Josep Corredor-Matheos, and Josep-Miquel Garcia.

LIVERPOOL 1988
Liverpool, Tate Gallery Liverpool. "Surrealism in the Tate Gallery Collection," May 24—March 4, 1989. Catalogue: foreword by Sir Alan Bowness, essays by Dawn Ades and Michael Sweeney, catalogue notes by Joanne Bernstein.

RIVOLI 1988
Rivoli, Castello di Rivoli. "Joan Miró: Viaggio delle figure," June 4—September 18, 1988. Organized by Rudi Fuchs, Johannes Gachnang, and Cristina Mundici. Catalogue: essays by Vittorio Beltrami, Antonio Maria Marocco, Juan Miguel Hernández León, Rudi Fuchs, Antoni Tàpies, Francesc Trabal (reprint), and Joan Miró (reprint).

LUCERNE 1988
Lucerne, Kunstmuseum Luzern. "Von Matisse bis
Picasso: Hommage an Siegfried Rosengart," June
19–September 11. Catalogue: edited by Martin Kunz.

SÃO PAULO 1988
São Paulo, Museu de Arte de São Paulo. "Joan Miró:
Pintura, escultura, tapiz, cerâmica, obra gráfica,
cartazes." August–September. Also shown in Rio de
Janeiro, Paço Imperial, September–October.
Organized by Daniel Giralt-Miracle. Catalogue: essay
by Juan Perucho.

LYON 1988
Lyon, Musée Saint-Pierre Art Contemporain. "La
Couleur seule: L'Expérience du monochrome,"
October 7–December 5. Catalogue: essays by various
authors.

NEW YORK 1988
New York, The Museum of Modern Art. "Collage:
Selections from the Permanent Collection," November
3–February 28, 1989. Checklist.

BARCELONA 1988B
Barcelona, Fundació Joan Miró. "Impactes: Joan
Miró, 1929–1941," November 24–January 15, 1989.
Catalogue: essays by Rosa Maria Malet and William
Jeffett.

MADRID 1988
Madrid, Museo Nacional Centro de Arte Reina Sofía.
"Obras maestras de la Colección Phillips,
Washington," November 30–February 16, 1989.
Checklist.

1989

LONDON 1989
London, Whitechapel Art Gallery. "Joan Miró:
Paintings and Drawings, 1929–1941," February 3–
April 23. Catalogue: foreword by Catherine Lampert,
essays by Rosa Maria Malet and William Jeffett.

ROME 1989
Rome, Accademia Spagnola di Roma. "I Miró di
Miró," [March]. Catalogue: essays by Trinidad
Sánchez Pacheco, Sergio Morico, Miguel Servera
Blanes, Rosa Maria Malet, and Renato Minore.

WASHINGTON 1989
Washington, D.C., The Phillips Collection. "The
Return of Master Paintings," April 22–August 27.
Checklist.

MADRID 1989
Madrid, Museo Nacional Centro de Arte Reina Sofía.
"Colección Beyeler," May 24–July 24. Catalogue:
introduction and catalogue entries by Reinhold Hohl.

LOS ANGELES 1989
Los Angeles, Los Angeles County Museum of Art.
"The Dada and Surrealist Word-Image," June 15–
August 27. Also shown in Hartford, Wadsworth
Atheneum, October 8–December 31; Frankfurt,
Kunsthalle, February 22–May 13, 1990. Catalogue:
essays by Judi Freeman and John C. Welchman.

PARIS 1989
Paris, Galerie Adrien Maeght. "Miró," summer.
Catalogue: essays by Antonio Saura and Michel
Nuridsany.

VILLENEUVE D'ASCQ 1989
Villeneuve d'Ascq. Musée d'Art Moderne. "Blast:
Foyer et explosion," November. Catalogue: preface by
Joëlle Pijaudier.

BARCELONA 1989A
Barcelona, Palau Robert. "Els Tallers de Miró,"
November–December. Catalogue: essays by Miquel
Servera Blanes and Baltasar Porcel.

BARCELONA 1989B
Barcelona, Fundació Joan Miró. "109 Llibres amb
Joan Miró," November 30–January 28, 1990.
Catalogue: introduction by Rosa Maria Malet, essays
by Joan Brossa, João Cabral de Melo Neto, Jacques
Dupin, David Fernández Miró, and Pere Gimferrer,
catalogue notes by Rosa Maria Malet.

HANNOVER 1989
Hannover, Kestner-Gesellschaft. "Joan Miró: Arbeiten
aus Papier 1901–1977," December 8–February 19,
1990. Catalogue: edited by Carl Haenlein, with
reprints of texts by various authors.

SOUTHAMPTON 1989
Southampton, Southampton City Art Gallery. "Joan
Miró: Sculpture," December 8–January 1990. Also
shown in Birmingham, Ikon Gallery, January 20–
February 24, 1990; Aberdeen, Aberdeen Art Gallery,
March 10–April 8, 1990. Catalogue: essay by William
Jeffett.

NEW YORK 1989
New York, The Metropolitan Museum of Art.
"Twentieth-Century Modern Masters: The Jacques
and Natasha Gelman Collection," December 12–April
1, 1990. Catalogue: edited by William S. Lieberman.

1990

OVIEDO 1990
Oviedo, Caja de Ahorros de Asturias. "Miró en la
Caja," n.d. Catalogue: essays by David Fernández
Miró, Rosa Maria Malet, Inmaculada Julián, Julia
Barroso, and Blas Fernández Gallego.

PORTO 1990
Porto, Fundação de Serralves. "Os Mirós de Miró,"
March 2–April 22. Organized by Fernando Pernes.
Catalogue: essays by Fernando Pernes, Miguel
Servera Blanes, Baltasar Porcel (reprint), Sandra
Orienti, Maria João Fernandes, and Vicent Llorca.

MUNICH 1990
Munich, Kunsthalle de Hypo-Kulturstiftung. "Joan
Miró: Skulpturen," April 7–June 17. Catalogue:
essays by Jacques Dupin, Jean-Louis Prat, and Carla
Schulz-Hoffmann.

NEW YORK 1990A
New York, Solow Building Company. "Miró:
Important Works 1962–70," April 20–May 22.
Catalogue.

PALMA DE MALLORCA 1990A
Palma de Mallorca, Pelaires Centre Cultural
Contemporani. "Miró i Pelaires: Vint Anys després,"
June 1–August 10. Catalogue: essays by Lluís
Permanyer, Josep Melià, and Basilio Baltasar.

CASTRES 1990
Castres, Musée Goya. "Le Génie catalan: Miró,
Picasso, Dalí, Gaudí," June 22–September 2.
Organized by Jean-Louis Augé and Marie-Paule
Romanens. Catalogue.

SAINT-PAUL-DE-VENCE 1990
Saint-Paul-de-Vence, Fondation Maeght. "Joan Miró:
Rétrospective de l'oeuvre peint," July 4–October 7.
Exhibition and catalogue: by Jean-Louis Prat.

BERKELEY 1990
Berkeley, University Art Museum, University of
California. "Anxious Visions: Surrealist Art," October
3–December 30. Catalogue: by Sidra Stich.

NEW YORK 1990B
New York, The Museum of Modern Art. "High and
Low: Modern Art and Popular Culture," October 7–
January 15, 1991. Also shown in Chicago, The Art
Institute of Chicago, February 20–May 12, 1991; Los
Angeles, The Museum of Contemporary Art, June
21–September 15, 1991. Directed by Kirk Varnedoe
and Adam Gopnik. Catalogue: by Kirk Varnedoe and
Adam Gopnik.

PALMA DE MALLORCA 1990B
Palma de Mallorca, Llonja. "Escultures de Miró,"
December–February 1991. Catalogue: essays by
Joana M. Palou and Pilar Ortega.

1991

NEW YORK 1991A
New York, Kouros Galleries. "Perspectives:
Impressionist and Modern Masters," January.
Catalogue.

NEW YORK 1991B
New York, The Museum of Modern Art. "Art of the
Forties," February 24–April 30. Organized by Riva
Castleman. Catalogue: edited by Riva Castleman,
with an essay by Guy Davenport.

PARIS 1991
Paris, Musée National d'Art Moderne, Centre Georges
Pompidou. "André Breton: La Beauté convulsive,"
April 25–August 26. Also shown in Madrid, Museo
Nacional Centro de Arte Reina Sofía, October 1–
December 12. Organized by Dominique Bozo, Agnès
Angliviel de la Beaumelle, and Isabelle Monod-
Fontaine. Catalogue: edited by Agnès Angliviel de la
Beaumelle, Isabelle Monod-Fontaine, and Claude
Schweisguth, with essays by various authors,
including Isabelle Monod-Fontaine and Margit
Rowell.

COLOGNE 1991
Cologne, Museum Ludwig. "Max Ernst: Das
Rendezvous der Freunde," June 22–September 8.
Catalogue: essays by various authors.

Frankfurt, Schirn Kunsthalle Frankfurt. "Picasso, Miró, Dalí und der Beginn der spanischen Moderne, 1900–1936," September 6–November 10. Organized by the Museo Nacional Centro de Arte Reina Sofía. Catalogue: prefaces by María del Corral and Christoph Vitali, essay by Eugenio Carmona.

OSAKA 1991
Osaka, Museum of Art. "Oeuvres de Joan Miró: Collection Maeght," October 18–27. Also shown in Hyogo, Amagasaki Cultural Center, November 2–24; Tokyo, Isetan Museum of Art, January 14–February 17, 1992; Chiba, Chiba Sogo, March 20–25, 1992; Hakone, Hakone Open-Air Museum, April 11–May 5, 1992. Organized by the Sankei Shimbun. Catalogue.

1992

YOKOHAMA 1992
Yokohama, Yokohama Museum of Art. "Joan Miró Centennial Exhibition: The Pierre Matisse Collection," January 11–March 25. Catalogue: essays by Victoria Combalía, Jacques Dupin, and Barbara Rose.

BASEL 1992
Basel, Galerie Beyeler. "Homage to Francis Bacon," June–September. Catalogue.

PARIS 1992
Paris, Musée National d'Art Moderne, Centre Georges Pompidou. "Dation Pierre Matisse," June–September. Directed by Isabelle Monod-Fontaine and Claude Laugier. Catalogue.

BARCELONA 1992
Barcelona, La Pedrera. "Avantguardes a Catalunya, 1906–1939," July 16–September 30. Organized by J. Corredor-Matheos, Daniel Giralt-Miracle, and Joaquim Molas. Catalogue: essays by J. Corredor-Matheos, Daniel Giralt-Miracle, Joaquim Molas, Joan M. Minguet Batllori, and Jaume Vidal i Oliveras.

Reference List

The following list provides full references for the sources cited by abbreviation elsewhere in this volume. It includes books, exhibition catalogues, articles, reviews, special issues of periodicals, gallery and auction advertisements, and reproductions.

Within this list, *Palma* refers to the volumes of press clippings housed at the Fundació Pilar i Joan Miró a Mallorca, Palma de Mallorca (roman numerals indicate volume number). *Mayor* refers to press clippings in the archives of The Mayor Gallery, London. *Matisse* refers to press clippings from the Pierre Matisse Gallery. *Kuh* refers to press clippings from the Katherine Kuh Gallery. The Matisse and Kuh clippings are available on microfilm at the Archives of American Art, New York. In some cases, items cited from clippings may lack certain bibliographical data, as will those citations that refer, for example, only to reproductions.

For comprehensive bibliographies dedicated to Miró, see Dupin 1962, Santos Torroella 1968, Lubar/Martí/Escudero 1987, and Fundació Joan Miró 1988.

ABEND 1952
Der Abend (Berlin), September 11, 1952 (in Palma IV).

ACTION 1925
"La Boîte à couleurs." *Action* (Paris), June 15, 1925 (in Palma I).

A.D. 1927
A.D. "Les Tableaux et les livres." *L'Action nationale* (Brussels), October 23, 1927, p. 2.

ADES 1982
Ades, Dawn. *Dalí and Surrealism.* New York: Harper & Row, 1982.

ALDEN 1991
Alden, Todd. "Louise Lawler." *Arts Magazine* (New York), vol. 66, no. 2 (October 1991), p. 80.

AMÉRIQUE LATINE 1930
"La Peinture à Paris." *Amérique latine*, April 20, 1930 (in Palma I).

A.M.F. 1938
A.M.F. "Miró's Flight from Reality: Modern Spain to Cave Painting." *The Art News* (New York), vol. 36, no. 31 (April 30, 1938), p. 13.

AMIC DE LES ARTS 1926
L'Amic de les arts (Sitges), vol. 1, no. 5 (August 1926), p. 17.

AMIC DE LES ARTS 1927
L'Amic de les arts (Sitges), vol. 2, no. 19 (October 31, 1927), pp. 1, 98–102.

AMIC DE LES ARTS 1928
L'Amic de les arts (Sitges), vol. 3, no. 26 (June 30, 1928). Issue largely devoted to Miró.

ANDREWS 1966
Andrews, Terry. "Large Number of Foreigners Visit Joan Miró Exhibition." *Mainichi Daily News*, September 9, 1966, p. B3.

APOLLO 1965
Apollo (London), vol. 81, no. 37 (March 1965), p. ciii.

APOLLO 1966
Apollo (London), n.s., vol. 83, no. 49 (March 1966), pp. xcv, cix.

APOLLO 1973
"Art Across the U.S.A.: Catalan Calligrammes." *Apollo* (London), vol. 97, no. 131 (January 1973), pp. 105–06.

APOLLONIO 1959
Apollonio, Umbro. "La Collection Bonnier à Stockholm." *Quadrum* (Brussels), no. 6 (Summer 1959), p. 173.

ARAGON 1930
Aragon, Louis. *La Peinture au défi.* Paris: Galerie Goemans; Librairie José Corti, 1930.

ARAGON 1965
Aragon, Louis. *Les Collages.* Paris: Hermann, 1965.

ARAGON 1969
Aragon, Louis. "Barcelone à l'aube." *Les Lettres françaises* (Paris), June 11, 1969, pp. 1–2, back cover.

ARBOIS 1945
Arbois, Simone. "La Peinture: Joan Miró." *Volontés* (Paris), vol. 2, no. 19 (April 4, 1945), p. 3.

ARCHITECTURAL FORUM 1942
"Books: Joan Miró." *The Architectural Forum* (New York), vol. 76, no. 1 (January 1942), p. 20.

ARCHITECTURE D'AUJOURD'HUI 1937
"Exposition." *Architecture d'aujourd'hui*, September 1937 (in Palma II).

ARCHITECTURE D'AUJOURD'HUI 1951
"Centre Universitaire, Harward [*sic*]." *L'Architecture d'aujourd'hui* (Boulogne), vol. 22, no. 38 (December 1951), pp. 41–48.

ARMENGAUD 1979
Armengaud, Christian. "A propos de . . . 'Mori el Merma.'" *Actualité de la scénographie* (Paris), vol. 2, no. 9 (February 1979), p. 47.

ARRAS GALLERY 1971
"Joan Prats: The Friend." In *Joan Miró: Homenatge a Joan Prats.* New York: Arras Gallery Ltd. and Barney Weinger Gallery, 1971, n.p.

ART DIGEST 1929
"Miró's Dog Barks While McBride Bites." *The Art Digest* (New York), vol. 4, no. 6 (Mid-December 1929), pp. 5, 10.

ART DIGEST 1933
"Miró's Surrealist Dog Barks at the Moon." *The Art Digest* (New York), vol. 7, no. 16 (May 15, 1933), p. 33.

ART DIGEST 1934
"The Sincerity of Miró." *The Art Digest* (New York), vol. 8, no. 8 (January 15, 1934), p. 13.

ART DIGEST 1935
"Miró, Leader of Surrealists, Has Exhibit." *The Art Digest* (New York), vol. 9, no. 9 (February 1, 1935), p. 11.

ART DIGEST 1936
"A Retrospective of Introspective Miró, Whose Dog Barked at the Moon." *The Art Digest* (New York), vol. 11, no. 5 (December 1, 1936), p. 13.

ART DIGEST 1938A
"Matisse to Miró." *The Art Digest* (New York), vol. 12, no. 8 (January 15, 1938), p. 20.

ART DIGEST 1938B
"Do You Get It?" *The Art Digest* (New York), vol. 12, no. 15 (May 1, 1938), p. 21.

ART DIGEST 1939A
"Once Upon a Time." *The Art Digest* (New York), vol. 13, no. 8 (January 15, 1939), p. 6.

ART DIGEST 1939B
"Parisians in High and Muted Keys." *The Art Digest* (New York), vol. 14, no. 5 (November 1, 1939), p. 11.

ART DIGEST 1940
"The Four-Fold Evolution of Joan Miró." *The Art Digest* (New York), vol. 14, no. 13 (April 1, 1940), p. 9.

ART DIGEST 1941A
"Rouault Features Landmarks of Modern Art." *The Art Digest* (New York), vol. 15, no. 8 (January 15, 1941), p. 8.

ART DIGEST 1941B
"Abstract Shows Flood 57th Street: Miró's Whimsicality." *The Art Digest* (New York), vol. 15, no. 12 (March 15, 1941), pp. 8–9.

ART DIGEST 1941C
"Dalí and Miró Jar New York with Visions of the Subconscious." *The Art Digest* (New York), vol. 16, no. 5 (December 1, 1941), pp. 5–6.

ART DIGEST 1942
"Playful Paintings of Miró in New York." *The Art Digest* (New York), vol. 17, no. 6 (December 15, 1942), p. 13.

ART ET INDUSTRIE 1930
"Chez Mr. A. Mavrogordato," *Art et industrie* (Paris), February 1930, p. 11.

ART ET INDUSTRIE 1933
"L'Exposition Juan [*sic*] Miró (Galerie Georges Bernheim)." *Art et industrie* (Paris), November 1933, p. 24.

ART ET LES ARTISTES 1934
"La Peinture française à San Francisco." *Art et les artistes* (Paris), vol. 29, no. 150 (October 1934), pp. 32–33.

ART ET TRAVAIL 1921
Art et travail, May 21, 1921 (in Palma I).

ART IN AMERICA 1958–59
Art in America (New York), vol. 46, no. 4 (Winter 1958–59), p. 87.

ART IN AMERICA 1961
"What Should a Museum Be?" *Art in America* (New York), vol. 49, no. 2 (1961), p. 26.

ART IN AMERICA 1966
Art in America (New York), vol. 54, no. 2 (March–April 1966), p. 6.

ART NEWS 1929A
"N.Y.U. Announces Acquisitions." *The Art News* (New York), vol. 28, no. 5 (November 2, 1929), p. 10.

ART NEWS 1929B
The Art News (New York), vol. 28, no. 10 (December 7, 1929), p. 5.

ART NEWS 1930
"Miró Exhibition: Valentine Gallery." *The Art News* (New York), vol. 29, no. 4 (October 25, 1930), p. 11.

ART NEWS 1932
"Joan Miró: Pierre Matisse Gallery." *The Art News* (New York), vol. 31, no. 6 (November 5, 1932), p. 6.

ART NEWS 1935
"N.Y.U. Gallery Rehangs Exhibit." *The Art News* (New York), vol. 33, no. 18 (February 2, 1935), p. 9.

ART NEWS 1938
"Modern Works Reproduced by *Verve*—Pastels by Ferren." *The Art News* (New York), vol. 37, no. 13 (December 24, 1938), pp. 15–16.

ART NEWS 1939
The Art News (New York), vol. 37, no. 15 (January 7, 1939), p. 17.

ART NEWS 1942A
"Joan Miró: *The Harlequin's Carnival, 1924–25*." *The Art News* (New York), vol. 40, no. 18 (January 1–14, 1942), p. 17.

ART NEWS 1942B
"The Passing Shows." *The Art News* (New York), vol. 41, no. 15 (December 15–31, 1942), pp. 33–34.

ART NEWS 1943
"War and the Artist." *The Art News* (New York), vol. 42, no. 3 (March 15–31, 1943), p. 23.

ART NEWS 1944A
"The Passing Shows." *The Art News* (New York), vol. 43, no. 4 (April 1–24, 1944), p. 22.

ART NEWS 1944B
"The Passing Shows." *The Art News* (New York), vol. 43, no. 7 (May 15–31, 1944), p. 21.

ART NEWS 1945A
"The Passing Shows." *The Art News* (New York), vol. 43, no. 19 (January 15–31, 1945), p. 27.

ART NEWS 1945B
"The Passing Shows." *The Art News* (New York), vol. 44, no. 1 (February 15, 1945), p. 26.

ART NEWS 1945C
The Art News (New York), vol. 44, no. 5 (April 15, 1945), p. 29.

ART NEWS 1945D
"The Passing Shows." *The Art News* (New York), vol. 44, no. 8 (June 1–30, 1945), p. 6.

ART NEWS 1947
"Reviews and Previews." *The Art News* (New York), vol. 45, no. 13 (March 1947), pp. 22–23.

ART NEWS 1950
"Reviews and Previews: Contemporary French." *The Art News* (New York), vol. 49, no. 7 (November 1950), p. 48.

ART NEWS 1955
"Trying Abstraction on Fabrics." *The Art News* (New York), vol. 54, no. 7 (November 1955), p. 43.

ART NEWS 1959
The Art News (New York), vol. 58, no. 2 (April 1959), p. 51.

ART NEWS 1966
The Art News (New York), vol. 64, no. 10 (February 1966), p. 10.

ART NEWS ANNUAL 1949
"The Treasury of the Circus." *Art News Annual*, 19 (New York), vol. 48, no. 7 (November 1949), pp. 33–48.

ART NEWS ANNUAL 1958
Art News Annual, 28 (New York), vol. 57, no. 7 (November 1958), p. 189.

ART QUARTERLY 1966
"Accessions of American and Canadian Museums, January–March 1966." *Art Quarterly* (Barnham, England), vol. 29, no. 2 (1966), pp. 165–86.

ARTIGAS 1918
Artigas, Josep Llorens i. "Les Exposicions: Les Pintures d'En Joan Miró." *La Veu de Catalunya* (Barcelona), vol. 28, no. 6751 (February 25, 1918, evening ed.), p. 3.

ARTIGAS 1919A
Artigas, Josep Llorens i. "Partita VIII: Joan Miró." *La Veu de Catalunya* (Barcelona), vol. 29, no. 7225 (June 3, 1919, morning ed.), p. 10.

ARTIGAS 1919B
Artigas, Josep Llorens i. "El Darrer Saló: Barcelona, MCMXIX." *L'Instant: Revista quinzenal* (Barcelona and Paris), vol. 2, no. 1 (August 15, 1919), pp. 4–5.

ARTS 1945A
"A l'étranger." *Arts* (Lyon and Paris), November 23, 1945, p. 2.

ARTS 1945B
"Les Expositions: D'Ingres à nos jours." *Arts* (Lyon and Paris), December 28, 1945, p. 2.

ARTS 1948
"*Femme assise* (Coll. Guggenheim)." *Arts*, September 3, 1948 (in Palma III).

ARTS 1956
"The Albright Gallery." *Arts* (New York), vol. 31, no. 2 (November 1956), pp. 30–36.

ARTS 1961
"The Soby Collection at Knoedler's." *Arts* (New York), vol. 35, no. 5 (February 1961), p. 29.

ARTS ET MÉTIERS GRAPHIQUES 1939
"Joan Miró (Galerie Pierre)." *Arts et métiers graphiques* (Paris), no. 66 (January 1, 1939), p. 66.

ASHBERY 1968
Ashbery, John. "Growing Up Surreal." *The Art News* (New York), vol. 67, no. 3 (May 1968), pp. 40–44, 65.

ASHTON 1964
Ashton, Dore. "Art: Cosmos and Chaos at the Guggenheim." *Arts and Architecture* (Los Angeles), vol. 81, no. 3 (March 1964), pp. 6–7.

ASHTON 1966
Ashton, Dore. "Commentary from Houston and New York." *Studio International* (London), vol. 171, no. 873 (January 1966), pp. 40–42.

AUFBAU 1941A
Bindol, Ben. "Art Events." *Aufbau* (New York), November 28, 1941 (in The Museum of Modern Art Archives, Public Information Scrapbook no. 52).

AUFBAU 1941B
Aufbau (New York), December 5, 1941 (in The Museum of Modern Art Archives, Public Information Scrapbook no. 52).

AYRTON 1946
Ayrton, Michael. "The Heritage of British Painting, III: Cosmopolitanism." *The Studio* (New York and London), vol. 132, no. 643 (October 1946), pp. 102–10.

B. 1918
B. "Exposición de arte: Primavera de 1918." *El Correo catalán* (Barcelona), vol. 43, no. 14050 (June 7, 1918), pp. 21–24.

BAIAROLA 1930A
Baiarola. "Vida artística: Pessebres II." *La Veu de Catalunya* (Barcelona), vol. 40, no. 10476 (January 1, 1930, morning ed.), p. 4.

BAIAROLA 1930B
Baiarola, "Vida artística: Pessebres III." *La Veu de Catalunya* (Barcelona), vol. 40, no. 10479 (January 3, 1930, evening ed.), p. 4.

BALJEU 1958
Baljeu, Joost. *Mondrian or Miró.* Amsterdam: De Beuk, 1958.

BALTIMORE MUSEUM OF ART RECORD 1972
The Baltimore Museum of Art Record (Baltimore), vol. 3, no. 1 (1972).

BARNETT 1985
Barnett, Vivian Endicott, with Christian Derouet, Susan B. Hirschfeld, Lewis Kachur, Clark V. Poling, Jane Sharp, and Susan Alyson Stein. "Chronology." In *Kandinsky in Paris, 1934–1944.* New York: Solomon R. Guggenheim Museum, 1985.

BAROTTE 1944
Barotte, René. "Au Salon d'Automne." *Carrefour* (Paris), vol. 1, no. 7 (October 7, 1944), p. 5.

BARR 1930
Barr, Alfred H., Jr. *Painting in Paris from American Collections.* New York: The Museum of Modern Art, 1930.

BARR 1936
Barr, Alfred H., Jr. *Cubism and Abstract Art.* New York: The Museum of Modern Art, 1936.

BARRETT 1964
Barrett, Cyril. "London Report: Miró Exhibition in the Tate Gallery." *Das Kunstwerk* (Baden-Baden), vol. 18 (November 1964), p. 27.

BASLER 1926
Basler, Adolphe. "Pariser Chronik." *Der Cicerone* (Leipzig), vol. 18, no. 2 (1926), pp. 62, 64.

BATAILLE 1930
B[ataille], G[eorges]. "Joan Miró: Peintures récentes." *Documents* (Paris), vol. 2, no. 7 (1930), pp. 398–403.

B.B.N. 1945
B.B.N. "Los Ultimos Cuadros de Miró." *Revista belga* (New York), vol. 2, no. 6 (June 1945), pp. 62–66.

BEATTY 1981
Beatty, Frances. "André Masson and the Imagery of Surrealism." Ph.D. dissertation, Columbia University, New York, 1981.

BEAUMELLE 1987
Beaumelle, Agnès Angliviel de la, and Nadine Pouillon, eds. *La Collection du Musée National d'Art Moderne*. Paris: Editions du Centre Georges Pompidou, 1987.

BEAUMELLE 1991
Beaumelle, Agnès Angliviel de la, Isabelle Monod-Fontaine, and Claude Schweisguth, eds. *André Breton: La Beauté convulsive*. Paris: Editions du Centre Georges Pompidou, 1991.

BEAUX-ARTS 1931
"Où allons-nous?" *Beaux-Arts* (Paris), vol. 9, no. 6 (June 25, 1931), p. 24.

BEAUX-ARTS 1935A
"Le Temps présent." *Beaux-Arts* (Paris), vol. 73, no. 106 (January 11, 1935), pp. 1, 6.

BEAUX-ARTS 1935B
"L'Oeuvre nouvelle." *Beaux-Arts* (Paris), vol. 73, no. 126 (May 31, 1935), p. 8.

BEAUX-ARTS 1937A
"L'Art fantastique en Amérique." *Beaux-Arts* (Paris), vol. 75, no. 220 (March 19, 1937), p. 3.

BEAUX-ARTS 1937B
"Les Expositions: Joan Miró." *Beaux-Arts* (Paris), vol. 75, no. 231 (June 4, 1937), p. 7.

BEAUX-ARTS 1937C
"A l'étranger: A Londres." *Beaux-Arts* (Paris), vol. 75, no. 238 (July 23, 1937), p. 8.

BEAUX-ARTS 1938
"Les Expositions: Joan Miró." *Beaux-Arts* (Paris), vol. 75, no. 310 (December 9, 1938), p. 4.

BEAUX-ARTS 1939A
"Les Expositions." *Beaux-Arts* (Paris), vol. 76, no. 326 (March 31, 1939), p. 4.

BEAUX-ARTS 1939B
"Les Musées: Au Musée de Buffalo." *Beaux-Arts* (Paris), vol. 76, no. 329 (April 21, 1939), p. 4.

BEAUX-ARTS 1939C
"Pour un portrait gravé de Miró: Miró et Marcoussis collaborent." *Beaux-Arts* (Paris), vol. 76, no. 338 (June 23, 1939), p. 4.

BENET 1926
Benet, Raf[a]el. "El Saló 'Modernista,' i III." *La Veu de Catalunya* (Barcelona), vol. 36, no. 9499 (November 9, 1926, morning ed.), p. 7.

BENET 1928
Benet, Rafael. "Joan Miró." *La Veu de Catalunya* (Barcelona), vol. 38, no. 10046 (August 12, 1928, morning ed.), p. 6.

BENINCASA 1981
Benincasa, Carmine. "Uno Sguardo del mondo sulla pittura." In *Miró Milano: Pittura, scultura, ceramica, disegni, sobreteixims, grafica*. Milan: Mazzotta, 1981.

BENSON 1935
Benson, E. M. "Forms of Art, III: Phases of Fantasy." *The American Magazine of Art* (Washington, D.C.), vol. 28, no. 5 (May 1935), pp. 290–99.

BENSON 1936
Benson, E. M. "Exhibition Reviews." *The American Magazine of Art* (Washington, D.C.), vol. 29, no. 4 (April 1936), pp. 253–58.

BERISTAIN/SALAZAR 1987
Beristain, Ana, and María José Salazar. *Miró en las colecciones del Estado*. Madrid: Museo Nacional Centro de Arte Reina Sofía, 1987.

BERNARD 1978
Bernard, René. "Miró à *L'Express*: La Violence libère." *L'Express* (Paris), September 4–10, 1978, pp. 33, 35. Reprinted in Rowell 1986.

BERNIER 1956
Bernier, Rosamond. "Miró céramiste." *L'Oeil* (Paris), no. 17 (May 1956), pp. 46–53.

BESSON 1937
Besson, George. "Exposition: L'Art à l'exposition." *Commune* (Paris), December 1937, pp. 503–06 (in Palma II).

BESSON 1939
Besson, George. "Les Arts: Joan Miró." *Ce Soir* (Paris), vol. 3, no. 757 (March 30, 1939), p. 2.

B.G. 1953
B.G. "Reviews and Previews: School of Paris." *The Art News* (New York), vol. 52, no. 8 (December 1953), p. 42.

BILLE 1935
Bille, Ejler. "Den Internationale Kunstudstilling i København 1935 (Kubisme-Surrealisme)." *Linien* (Copenhagen), vol. 2, no. 10 (February 15, 1935), p. 2.

BILLE 1945
Bille, Ejler. *Picasso, surrealisme, abstrakt kunst*. Copenhagen: Forlaget Helios, 1945.

BILLETER 1976
Billeter, Erika. "Joan Miró: *Tête Georges Auric*, 1929. André Masson: *Coquillage*, 1928." In *Kunsthaus Zürich: Zürcher Kunstgesellschaft – Jahresbericht, 1976*. Zurich: Kunsthaus Zürich, 1976.

BIRD 1939
Bird, Paul. "The Fortnight in New York: Another Catalonian." *The Art Digest* (New York), vol. 13, no. 14 (April 15, 1939), pp. 18–19, 34.

BJERKE-PETERSEN 1934
Bjerke-Petersen, Vilhelm. *Surrealismen*. Copenhagen: Nordlundes Bogtrykkeri, [1934].

BJERKE-PETERSEN 1937
Bjerke-Petersen, Vilhelm. *Surrealismens Billedverden*. Copenhagen: Arthur Jensens Forlag, 1937.

BLUNT 1933
Blunt, Anthony. "Art: Tiepolo out of Context." *The Spectator* (London), no. 5484 (August 4, 1933), p. 157.

BOLL 1936
Boll, André. "Les Belles Expositions." *Notre Temps*, February 23, 1936 (in Palma II).

BOLL 1937
Boll, André. "Expositions." *La Flèche* (Paris), vol. 4, no. 70 (June 12, 1937), p. 3.

BONJEAN 1938
Bonjean, Jacques. "A propos de l'exposition Miró." *Beaux-Arts* (Paris), vol. 75, no. 262 (January 7, 1938), p. 4.

BONNEFOY 1964
Bonnefoy, Yves. *Miró*. Paris: La Bibliothèque des Arts, 1964.

BONNET 1988
Bonnet, Marguerite, ed. *André Breton: Oeuvres complètes*. Paris: Gallimard, 1988.

BORCHERT 1961
Borchert, Bernhard. *Joan Miró*. London: Faber & Faber, 1961.

BORRÀS 1985
Borràs, Maria Lluïsa. *Picabia*. New York: Rizzoli, 1985.

BOSSCHÈRE 1928
Bosschère, Jean de. "Notes sur la peinture et Miró." *Variétés* (Brussels), vol. 1, no. 3 (July 15, 1928), pp. 132–39.

BOSTON HERALD 1941
"Art Shows in New York: Surrealism by Dalí and Miró." *Boston Herald* (Boston), December 14, 1941 (in The Museum of Modern Art Archives, Public Information Scrapbook no. 52).

BOUCHET 1949
Bouchet, André du. "Three Exhibitions: Masson, Tal Coat, Miró." *Transition Forty-nine* (New York), no. 5 (December 1949), pp. 94–95.

BOUISSET 1990
Bouisset, Maïten. "La Ferme de Monsieur Miró." *Beaux-Arts* (Paris), no. 82 (September 1990), p. 129.

BOURET 1945
Bouret, Jean. "Dans le monde de Joan Miró." *Ce Soir* (Paris), vol. 9, no. 1101 (March 29, 1945), p. 2.

BOURET 1986
Bouret, Blandine. *Joan Miró*. Villeneuve d'Ascq: Musée d'Art Moderne, 1986.

BRADLEY 1993
Bradley, Kim. "Miró Foundation on Mallorca." *Art in America* (New York), vol. 81, no. 2 (February 1993), p. 31.

BRASSAÏ 1982
Brassaï. *The Artists of My Life*. Translated by Richard Miller. New York: Viking, 1982.

BRETON 1928
Breton, André. *Le Surréalisme et la peinture*. Paris: Gallimard, 1928.

BRETON 1952
Breton, André. "Ferments de libertés: 125 Oeuvres de haut vol au Musée d'Art Moderne." *Arts*, May 15, 1952 (in Palma IV).

BRETON 1958
Breton, André. "Constellations de Joan Miró." *L'Oeil* (Paris), no. 48 (December 1958), pp. 50–55.

BRETON 1972
Breton, André. *Surrealism and Painting*. Translated by Simon Watson Taylor. New York: Harper & Row, 1972.

BRETON/DUCHAMP 1947
Breton, André, and Marcel Duchamp. *Le Surréalisme en 1947*. Paris: Maeght Editeur, 1947.

BREUNING 1932
Breuning, Margaret. "Surrealiste Painters." *New York Evening Post* (New York), November 12, 1932, p. 8S.

BREUNING 1939
Breuning, Margaret. "Miró." *Magazine of Art* (Washington, D.C.), vol. 32, no. 5 (May 1939), p. 315.

BREUNING 1941A
Breuning, Margaret. *New York Journal American* (New York), January 5, 1941 (in Matisse).

BREUNING 1941B
Breuning, Margaret. *New York Journal American* (New York), March 9, 1941 (in Matisse).

BREUNING 1941C
Breuning, Margaret. *Smart Set* (London), October 12, 1941 (in Matisse).

BREUNING 1944
Breuning, Margaret. "Joan Miró's World of Subjective Imagery." *The Art Digest* (New York), vol. 18, no. 15 (May 1, 1944), p. 11.

BREUNING 1945
Breuning, Margaret. "Miró Lithographs." *The Art Digest* (New York), vol. 19, no. 10 (February 15, 1945), p. 16.

BROOKLYN DAILY EAGLE 1940
"Spanish Modern." *Brooklyn Daily Eagle* (New York), March 17, 1940 (in Matisse).

BROOKNER 1962
Brookner, Anita. "Current and Forthcoming Exhibitions: Paris." *The Burlington Magazine* (London), vol. 104, no. 713 (August 1962), pp. 361–64.

BROWN 1941
Brown, Milton. "Three Abstract Painters." *Parnassus* (New York), vol. 13, no. 4 (April 1941), pp. 154–55.

BRUGUIÈRE 1945–46
Bruguière, Paul. "Intelligence de l'art." *Cahiers d'art* (Paris), vols. 20–21 (1945–46), pp. 294–300.

BT 1978
BT: Bibliothèque de travail, no. 860 (April 15, 1978), pp. 1–28.

BUFFALO EVENING NEWS 1941
Buffalo Evening News (Buffalo), December 6, 1941 (in The Museum of Modern Art Archives, Public Information Scrapbook no. 52).

BULLETIN OF THE ART INSTITUTE OF CHICAGO 1933
Bulletin of The Art Institute of Chicago (Chicago), vol. 27, no. 4 (April–May 1933), p. 80.

BULLETIN OF THE DETROIT INSTITUTE OF ARTS 1967
"Appendix VI: Accessions." *Bulletin of The Detroit Institute of Arts* (Detroit), vol. 46, no. 1 (1967), pp. 18–25.

BURLINGTON MAGAZINE 1961
"Advertisement Supplement." *The Burlington Magazine* (London), vol. 103, no. 705 (December 1961), n.p.

BURLINGTON MAGAZINE 1962
The Burlington Magazine (London), vol. 104, no. 711 (June 1962), p. xxxiv.

BURLINGTON MAGAZINE 1965
The Burlington Magazine (London), vol. 107, no. 746 (May 1965), pp. ii, vii.

BURLINGTON MAGAZINE 1966A
"Recent Museum Acquisitions: Miró's *Standing Nude* (City Art Museum, St. Louis)." *The Burlington Magazine* (London), vol. 108, no. 755 (February 1966), p. 89.

BURLINGTON MAGAZINE 1966B
The Burlington Magazine (London), vol. 108, no. 755 (February 1966), pp. xxv, 89, 92.

BURNETT 1929
Burnett, Whit. "France Cuts Red Tape in Buying Works of Art." *New York Herald Tribune*, September 1, 1929 (in Palma I).

BURR 1964
Burr, James. "Round the London Galleries: The Catalan Magician." *Apollo* (London), vol. 80, no. 31 (September 1964), pp. 238–40.

BURROWS 1941A
Burrows, Carlyle. "Modern Art." *New York Herald Tribune* (New York), January 5, 1941, p. 8.

BURROWS 1941B
Burrows, Carlyle. "French Paintings." *New York Herald Tribune* (New York), October 12, 1941, p. 8.

BURROWS 1945A
Burrows, Carlyle. "Joan Miró." *New York Herald Tribune* (New York), January 14, 1945, p. 7.

BURROWS 1945B
Burrows, Carlyle. "Art of the Week: 'Eleven Nudes.'" *New York Herald Tribune* (New York), April 15, 1945, p. 7.

BURROWS 1945C
Burrows, Carlyle. "In the Art Galleries: French and American." *New York Herald Tribune* (New York), May 27, 1945, p. 5.

BURROWS 1947
Burrows, Carlyle. "Joan Miró." *New York Herald Tribune* (New York), May 18, 1947, p. 7.

BYRNE 1942
Byrne, Barry. "Art." *America* (New York), January 10, 1942 (in The Museum of Modern Art Archives, Public Information Scrapbook no. 52).

BYSTANDER 1933
The Bystander, July 19, 1933 (in Mayor).

C. 1949
C. "Tres Exposiciones de Joan Miró." *Cobalto* (Barcelona), vol. 2 (1949), p. 9 [17].

CABANNE 1977
Cabanne, Pierre. *Pablo Picasso: His Life and Times.* New York: Wm. Morrow & Co., 1977.

CAHIERS D'ART 1929A
"Exposition de peintres et sculpteurs contemporains (Galerie Jeanne Bucher)." *Cahiers d'art* (Paris), vol. 4, nos. 2–3 (March–April 1929), p. 120.

CAHIERS D'ART 1929B
"Exposition d'art abstrait surréaliste (Kunsthaus)." *Cahiers d'art* (Paris), vol. 4, no. 7 (November 1929), pp. xvii–xviii.

CAHIERS D'ART 1930
"Les Expositions à Paris et ailleurs: Joan Miró (Galerie Pierre)." *Cahiers d'art* (Paris), vol. 5, no. 2 (1930), p. 106.

CAHIERS D'ART 1933A
"Exposition surréaliste (Galerie Pierre Colle), 9–18 juin." *Cahiers d'art* (Paris), vol. 8, nos. 5–6 (1933), p. 251.

CAHIERS D'ART 1933B
"Arp, Calder, Hélion, Miró, Pevsner, Seligmann (Galerie Pierre), du 9 au 24 juin." *Cahiers d'art* (Paris), vol. 8, nos. 5–6 (1933), p. 252.

CAHIERS D'ART 1934
Cahiers d'art (Paris), vol. 9, nos. 1–4 (1934). Issue largely devoted to Miró.

CAHIERS D'ART 1935
"Les Expositions." *Cahiers d'art* (Paris), vol. 10, nos. 1–4 (1935), pp. 95–96.

CAHIERS D'ART 1951
"Les Expositions d'art ancien et moderne: Sur quatre murs (Galerie Maeght)." *Cahiers d'art* (Paris), vol. 26 (1951), pp. 206, 209.

CAHIERS D'ART 1952
"Miró: Peintures récentes." *Cahiers d'art* (Paris), vol. 27, no. 1 (July 1952), pp. 32–37.

CAHIERS DE BELGIQUE 1928A
"En marge: De Glozel à Joan Miró." *Cahiers de Belgique* (Brussels), no. 8 (October 1928), p. 310.

CAHIERS DE BELGIQUE 1928B
"Expositions: Un Groupe surréaliste (Galerie L'Epoque)." *Cahiers de Belgique* (Brussels), no. 9 (November 1928), pp. 356–57.

CALAS 1968
Calas, Nicholas (*sic*). "Surrealist Heritage?" *Arts Magazine* (New York), vol. 42, no. 5 (March 1968), pp. 24–29.

CAMPAGNE 1933
Campagne, J. M. "Les Arts: Les Surindépendants." *Germinal*, November 18, 1933 (in Palma II).

CANADAY 1959
Canaday, John. "Miró 'Barks' Merrily at His Critics." *The New York Times Magazine* (New York), March 15, 1959, pp. 22–23, 25, 27–28, 30.

CARMEAN 1980
Carmean, E. A., et al. *The Morton G. Neumann Family Collection.* Washington, D.C.: National Gallery of Art, 1980.

CARRERES 1929
Carreres, Agustí. "Joan Miró." *Hèlix* (Vilafranca del Penedès), no. 1 (February 1929), p. 2.

CARY 1929
Cary, Elizabeth Luther. "Gallery of Living Art Exhibits Work Up-town: British Art of Our Day Also Shown." *New York Times* (New York), December 8, 1929, p. 14X.

CARY 1936
Cary, Elizabeth Luther. "Paintings by Some of Our Older Modernists." *New York Times* (New York), January 19, 1936, p. X9.

CASO 1956
Caso, Paul. "Rétrospective Miró." *Le Soir* (Brussels), January 8, 1956, p. 5.

CASSANYES 1921
Cassanyes, M. A. "Les Exposicions: Exposició Joan Miró, a París." *Monitor* (Sitges), vol. 1, no. 4 (April 30, 1921), p. 28.

CASSANYES 1928
Cassanyes, M. A. "Les Arts: Joan Miró." *L'Amic de les arts* (Sitges), vol. 3, no. 26 (June 30, 1928), p. 202.

CASSANYES 1935
Cassanyes, M. A. "Joan Miró, el extraordinario." *A.C.* (Barcelona), vol. 5, no. 18 (1935), pp. 40–41.

CASSANYES 1936
Cassanyes, M. A. "Pintura catalana: Joan Miró." *La Publicitat* (Barcelona), vol. 58, no. 19196 (May 15, 1936), p. 2.

CASSOU 1934
Cassou, Jean. "Le Dadaïsme et le surréalisme." *L'Amour de l'art* (Paris), vol. 15 (March 1934), pp. 337–44.

CASTELLO DI RIVOLI 1988
Joan Miró: Viaggio delle figure. Rivoli: Castello di Rivoli, 1988.

CAVALCADE 1938
"First Onslaught." *Cavalcade* (London), May 21, 1938 (in Mayor).

C.B. 1927
C.B. In *La Nation belge* (Brussels), October 13, 1927, pp. 1–2.

C.B. 1928
C.B. "Les Expositions." *La Nation belge* (Brussels), December 20, 1928, p. 5.

C.B. 1929
C.B. "Les Expositions." *La Nation belge* (Brussels), May 13, 1929, p. 2.

C.B. 1931
C.B. "L'Art vivant en Europe." *La Nation belge* (Brussels), May 22, 1931, pp. 1–2.

CE SOIR 1944
"Le Salon d'Automne 1944: La Liberté de la peinture, la peinture de la liberté." *Ce Soir* (Paris), October 8–9, 1944 (in Palma II).

CENTAURE 1928
Le Centaure. "Surréalisme." *Le Centaure* (Brussels), vol. 2, no. 4 (January 1, 1928), pp. 51–55.

CENTAURE 1929
Le Centaure. "Le Problème du 'sujet.'" *Le Centaure* (Brussels), vol. 3, no. 4 (January 1, 1929), pp. 71–75.

CENTAURE 1930
"Trente Ans de peinture française." *Le Centaure* (Brussels), vol. 4, nos. 9–10 (June–July 1930), pp. 199–200, 204.

CENTRE D'ART SANTA MÒNICA 1988
Surrealisme a Catalunya, 1924–1936: De "L'Amic de les arts" al Logicofobisme. Barcelona: Centre d'Art Santa Mònica, 1988.

CENTRE POMPIDOU 1978
Dessins de Miró provenant de l'atelier de l'artiste et de la Fondation Joan Miró de Barcelone. Paris: Editions du Centre Georges Pompidou, 1978.

CENTRE POMPIDOU 1982
Jackson Pollock. Paris: Editions du Centre Georges Pompidou, 1982.

CENTRE POMPIDOU 1984
Kandinsky: Album de l'exposition. Paris: Editions du Centre Georges Pompidou, 1984.

C.G.W. 1949
C.G.W. "Ausstellungen: Joan Miró, Oskar Dalvit, Margrit Linck." *Werk* (Zurich), vol. 36, no. 6 (June 1949), pp. 76–77.

C.G.W. 1950
C.G.W. "Michel Leiris: The Prints of Joan Miró." *Werk* (Zurich), vol. 37, no. 4 (April 1950), pp. 51–52.

CH. 1927
CH. "Les Expositions: Kristians Tonny." *L'Art vivant* (Paris), vol. 3 (May 15, 1927), p. 387.

CHAMPA 1973
Champa, Kermit. "Miró." *Artforum* (New York), vol. 11, no. 6 (February 1973), pp. 57–61.

CHAPON 1984
Chapon, François. *Mystère et splendeurs de Jacques Doucet.* Paris: Editions J.-C. Lattès, 1984.

CHARENSOL 1925A
Charensol, [G.] "La Vie artistique: Quelques Expositions." *Le Soir* (Paris), vol. 39, no. 92 (June 17, 1925), p. 2.

CHARENSOL 1925B
Charensol, [G.] *Correspond. Méridionale*, December 3, 1925 (in Palma I).

CHARENSOL 1926
Charensol, [G.] "Les Expositions." *L'Art vivant* (Paris), vol. 2, no. 25 (January 1, 1926), pp. 35–36.

CHARENSOL 1928A
Charensol, [G.] "Les Expositions." *L'Art vivant* (Paris), vol. 4 (January 15, 1928), p. 76.

CHARENSOL 1928B
Charensol, [G.] "Les Expositions." *L'Art vivant* (Paris), vol. 4 (June 5, 1928), pp. 486–87.

CHARENSOL 1930
Charensol, G. "L'Auto et la peinture." *Vu* (Paris), no. 133 (October 1930), pp. 970–71, 986.

CHARENSOL 1938
Charensol, G. "Dans l'obscurité: Il faut munir d'une lampe électrique pour voir les tableaux de l'exposition surréaliste." *L'Intransigeant* (Paris), January 19, 1938 (in Palma II).

CHERONNET 1937A
Cheronnet, Louis. "Joan Miró." *Marianne* (Paris), vol. 5, no. 242 (June 9, 1937), p. 5.

CHERONNET 1937B
Cheronnet, Louis. "Histoire d'un art serpent." *Marianne* (Paris), vol. 5, no. 260 (October 13, 1937), p. 8.

CHEVALIER 1960
Chevalier, Denys. "La Collection de René Gaffé dans sa maison du Haut-de-Cagnes." *Aujourd'hui Art et Architecture* (Boulogne), vol. 5, no. 25 (February 1960), pp. 28–33.

CHEVALIER 1962
Chevalier, Denys. "Miró." *Aujourd'hui Art et Architecture* (Boulogne), vol. 7, no. 40 (November 1962), pp. 6–13.

CHICAGO DAILY NEWS 1938A
"Of Miró and the Shrieking Mandrake." *Chicago Daily News*, [November] 1938 (in Kuh).

CHICAGO DAILY NEWS 1938B
"Miró at Katherine Kuh's." *Chicago Daily News*, November 1938 (in Kuh).

CHICAGO DAILY TRIBUNE 1931
"Folle Enchère Art Exhibit On: Work of 1920 Is Compared with That of 1930." *Chicago Daily Tribune* (Paris), February 10, 1931, p. 2.

CHICAGO TRIBUNE 1926
"Art and Artists." *Chicago Tribune* (Paris), November 21, 1926, p. 5.

CHICAGO TRIBUNE 1927
"Art and Artists." *Chicago Tribune* (Paris), February 27, 1927, p. 5.

CHOAY 1961
Choay, Françoise. "Miró, Millares et les pictogrammes." *Art International* (Zurich), vol. 5, no. 3 (April 5, 1961), pp. 35–36.

CHRONIQUE DES ARTS 1966
La Chronique des arts, supplement to *Gazette des beaux-arts* (Paris), no. 1165 (February 1966), p. 69.

CHRONIQUE DES ARTS 1970
La Chronique des arts, supplement to *Gazette des beaux-arts* (Paris), no. 1213 (February 1970), p. 31.

CINCINNATI ART MUSEUM NEWS 1949
"Modern Art Society Celebrates Tenth Anniversary." *Cincinnati Art Museum News* (Cincinnati), vol. 4, no. 4 (April 1949), p. ii.

CIRICI 1972
Cirici, Alexandre. "Productive Exchanges Between Earth and Man." In G. di San Lazzaro, ed., *Homage to Miró.* New York: Tudor Publishing Co., 1972. Special issue of the review *XXe Siècle*.

CIRICI-PELLICER 1949
Cirici-Pellicer, A[lexandre]. *Miró y la imaginación.* Barcelona: Ediciones Omega, S.A., 1949.

CIRLOT 1949
Cirlot, J.-E. *Joan Miró.* Barcelona: Ediciones Cobalto, 1949.

CITY ART MUSEUM OF SAINT LOUIS BULLETIN 1965A
"Recent Acquisitions: *Standing Nude, 1918.*" *City Art Museum of Saint Louis Bulletin* (Saint Louis), vol. 1, no. 2 (July–August 1965), pp. 1–2.

CITY ART MUSEUM OF SAINT LOUIS BULLETIN 1965B
"Current Exhibitions: Miró in Saint Louis, October 1 to November 7." *City Art Museum of Saint Louis Bulletin* (Saint Louis), vol. 1, no. 3 (September–October 1965), p. 8.

CLARAC-SÉROU 1954
Clarac-Sérou, Max. "Twenty-eighth Venice Biennale." *Arts Digest* (New York), vol. 28, no. 19 (August 1, 1954), pp. 6–8.

CLARK 1957
Clark, Max. "Milestones in Modern Art: *Catalan Landscape (The Hunter)* by Joan Miró." *The Studio* (London and New York), vol. 154, no. 774 (September 1957), pp. 84–85.

CLARK 1959
Clark, Eliot. "New York Commentary." *The Studio* (London and New York), vol. 158, no. 797 (August–September 1959), p. 59.

CLARK 1962
Clark, Kenneth. "The Blot and the Diagram." *The Art News* (New York), vol. 61, no. 8 (December 1962), pp. 28–31, 70–75.

CLIFFORD 1943
Clifford, Henry. "The Gallatin Collection: Mirror of Our Time." *Philadelphia Museum Bulletin* (Philadelphia), vol. 38, no. 198 (May 1943), pp. 1–14.

C.M. 1937
C.M. "Carnet artistique: Le Surréalisme au musée." *La Nation belge* (Brussels), March 23, 1937, p. 2.

COATES 1938
Coates, Robert M. "May Wine — Modern Paintings — Independents — Miró." *The New Yorker* (New York), vol. 14, no. 12 (May 7, 1938), pp. 79–80.

COATES 1939
Coates, Robert M. "The Art Galleries: The Emperor Augustus — And Some Moderns." *The New Yorker* (New York), vol. 14, no. 48 (January 14, 1939), pp. 46–48.

COATES 1941A
Coates, Robert M. "The Art Galleries: Modern French — And Some Americans." *The New Yorker* (New York), vol. 16, no. 48 (January 11, 1941), pp. 57–58.

COATES 1941B
Coates, Robert M. "Had Any Good Dreams Lately?" *The New Yorker* (New York), vol. 17, no. 42 (November 29, 1941), pp. 58–59.

COATES 1947
Coates, Robert M. "New Mirós, New Museum, and New York." *The New Yorker* (New York), vol. 23, no. 14 (May 24, 1947), pp. 72, 74.

COBALTO 1949
Cobalto (Barcelona), vol. 1 (1949), n.p.

COLEGIO DE ARQUITECTOS 1969
Galerías Dalmau. Barcelona: Colegio de Arquitectos de Cataluña y Baleares, 1969.

COLRAT 1928
Colrat, Bernard. "Les Expositions." *La Renaissance* (Paris), vol. 16, no. 19 (May 12, 1928), p. 9.

COMBALÍA 1990
Combalía, Victoria, ed. *El Descubrimiento de Miró: Miró y sus críticos, 1918–1929.* Barcelona: Ediciones Destino, 1990.

COMBALÍA 1992
Combalía, Victoria. "Joan Miró: Su Etapa de formación y su madurez artística." In *Joan Miró Centennial Exhibition: The Pierre Matisse Collection.* Yokohama: Yokohama Museum of Art, 1992.

COMOEDIA 1925
"Nouvelles au fusain: S.A.R. le Prince Eugène chez les artistes." *Comoedia* (Paris), no. 4568 (June 22, 1925), p. 2.

CONNOLLY 1951
Connolly, Cyril. "Surrealism." *Art News Annual, 21* (New York), vol. 50, no. 7, part 2 (November 1951), pp. 131–70.

CONLAN 1951
Conlan, Barnett D. "Colour as Delicate as Fine Porcelain: A Remarkable Series of Pastels." *Daily Mail*, May 2, 1951 (in Palma III).

CONRARDY 1927
Conrardy, Charles. "Chronique des beaux-arts: Les Arts à Bruxelles — Galerie d'art 'Le Centaure,' Peinture française contemporaine." *La Meuse* (Liège), October 13, 1927, p. 6.

COOPER 1938
Cooper, Mary Frances. "Miró Display Produces Gala Impressionism." *Evanston*, November 1938 (in Kuh).

COOPER 1958
Cooper, Douglas. "Art in the New Unesco Building: Sacrifice of an Ideal." *The Sunday Times* (London),

October 26, 1958, magazine section, p. 23.

COOPER 1972
Cooper, Douglas. "Miró, Painter-Poet of Catalonia." In *Joan Miró.* New York: Acquavella Galleries, 1972.

CORDIER 1959
Exposition internationale du surréalisme. Paris: Galerie Daniel Cordier, 1959.

COURTHION 1930
Courthion, Pierre. "Trente Ans de peinture française." *Le Centaure* (Brussels), vol. 4, no. 8 (May 1, 1930), pp. 164–66.

COURTHION 1956
Courthion, Pierre. "Jeux et fantasie de Miró." *XXᵉ Siècle* (Paris), no. 6 (January 1956, double issue), pp. 41–44.

COUSIN PONS 1935
Le Cousin Pons. "Les Arts: Rue de Seine." *L'Intransigeant* (Paris), July 11, 1935, p. 4.

CRANKSHAW 1933
Crankshaw, Edward. "Art: Paintings by Joan Miró — The Mayor Gallery." *The Week End Review* (London), vol. 8, no. 176 (July 22, 1933), p. 87.

CRAPOUILLOT 1929
"Panorama de l'art contemporain." *Le Crapouillot* (Paris), March 1, 1929 (in Palma I).

CRAVENS 1934
Cravens, Junius. "Jean [sic] Miró's Abstractions Are Distorted Soul-Spasms over Which Dilettantes Can Rave." *San Francisco Examiner*, May 20, 1934 (in Palma II).

CROIZARD 1945
Croizard, Maurice. "Miró." *Libertés* (Paris), no. 76 (May 11, 1945), p. 4.

C.T. 1939
C.T. "Les Expositions: Juan Miro [sic]: Peintures (Maison de la Culture)." *Marianne* (Paris), April 5, 1939, p. 9.

CUE 1940
"Landmarks in Modern Art." *Cue*, December 28, 1940 (in Matisse).

CUE 1941A
"Dalí and Miró." *Cue* (New York), November 22, 1941 (in The Museum of Modern Art Archives, Public Information Scrapbook no. 52).

CUE 1941B
"Dalí and Miró." *Cue* (New York), November 29, 1941 (in The Museum of Modern Art Archives, Public Information Scrapbook no. 52).

CURIEUX 1925
Le Curieux. "Les Expositions." *La Renaissance* (Paris), vol. 7 (August 1925), n.p.

DAILY MAIL 1926
"Romeo and Juliet Again: Diaghilew Ballet's Success — Super-Realists Silent." *Daily Mail* (London), May 22, 1926 (in Palma I).

DAILY SKETCH 1938
"Joan, the Man." *Daily Sketch* (London and Manchester), May 5, 1938 (in Mayor).

DALÍ 1928
Dalí, Salvador. "Realidad y sobrerrealidad." *La Gaceta literaria* (Madrid), vol. 2, no. 44 (October 15, 1928), p. 7.

DALÍ 1929
Dalí, Salvador. "Joan Miró." *Cahiers de Belgique* (Brussels), vol. 2, no. 6 (June 1929), pp. 207–08. Originally published as "Les Arts: Joan Miró." *L'Amic de les arts* (Sitges), vol. 3, no. 26 (June 30, 1928), p. 202.

DAVENPORT 1948
Davenport, Russell W. "A *Life* Round Table on Modern Art." *Life* (New York), vol. 25, no. 15 (October 11, 1948), pp. 56–79.

DAVIDSON 1936
Davidson, Martha. "Subconscious Pictography by Joan Miró." *The Art News* (New York), vol. 35, no. 10 (December 5, 1936), pp. 11, 26.

DAVIDSON 1937
D[avidson], M[artha]. "Nineteenth Century and Modern French Artists." *The Art News* (New York), vol. 35, no. 30 (April 24, 1937), p. 16.

DAVIDSON 1938
Davidson, Martha. "View No. 2 of Modern French Art: Matisse to Miró in Another Current Show." *The Art News* (New York), vol. 36, no. 15 (January 8, 1938), pp. 11, 24.

D.B. 1939
D.B. "Recent Canvases by Joan Miró, a Non-Conforming Surrealist." *The Art News* (New York), vol. 37, no. 29 (April 15, 1939), p. 14.

D.B. 1942
D.B. "Double Image of Surrealism: Miró and Dalí." *The Art News* (New York), vol. 40, no. 18 (January 1–14, 1942), p. 21.

DEGAND 1945
Degand, Léon. "Joan Miró: Peintre de la réalité." *Les Lettres françaises* (Paris), vol. 5, no. 51 (April 14, 1945), p. 4.

DEGAND 1956
Degand, Léon. "Les Expositions à l'étranger: Joan Miró." *Aujourd'hui Art et Architecture* (Boulogne), vol. 1, no. 6 (January 1956), p. 28.

DE MAEGT 1934
De Maegt, Joh. "Surrealistische Tentoonstelling de Minotaure-Groep: In het Paleis voor Schoone Kunsten te Brussel." *Het Laatste Nieuws* (Brussels), vol. 47, no. 141 (May 21, 1934), p. 3.

DEROUET 1985
Derouet, Christian. "Kandinsky in Paris, 1934–1944." In *Kandinsky in Paris: 1934–1944.* New York: Solomon R. Guggenheim Museum, 1985.

DERRIÈRE LE MIROIR 1948
"Joan Miró." *Derrière le miroir* (Paris), nos. 14–15 (November–December 1948).

DERRIÈRE LE MIROIR 1950
"Miró." *Derrière le miroir* (Paris), nos. 29–30 (May–June 1950).

DERRIÈRE LE MIROIR 1951
"Sur quatre murs." *Derrière le miroir* (Paris), nos. 36–38 (March–May 1951).

DERRIÈRE LE MIROIR 1953
"Miró." *Derrière le miroir* (Paris), nos. 57–59 (June–August 1953).

DERRIÈRE LE MIROIR 1956
"Miró, Artigas." *Derrière le miroir* (Paris), nos. 87–89 (June–August 1956).

DERRIÈRE LE MIROIR 1958
"Sur quatre murs." *Derrière le miroir* (Paris), nos. 107–09 (1958).

DERRIÈRE LE MIROIR 1960
"Poètes, peintres, sculpteurs." *Derrière le miroir* (Paris), no. 119 (1960).

DERRIÈRE LE MIROIR 1961A
"Miró: Céramique murale pour Harvard." *Derrière le miroir* (Paris), no. 123 (February 1961).

DERRIÈRE LE MIROIR 1961B
Derrière le miroir (Paris), nos. 125–26 (April 1961).

DERRIÈRE LE MIROIR 1961C
"Miró: Peintures murales." *Derrière le miroir* (Paris), no. 128 (June 1961).

DERRIÈRE LE MIROIR 1963
Derrière le miroir (Paris), nos. 139–40 (June–July 1963).

DERRIÈRE LE MIROIR 1965
"Miró: Cartons." *Derrière le miroir* (Paris), nos. 151–52 (1965).

DERRIÈRE LE MIROIR 1967
"Miró: L'Oiseau solaire, l'oiseau lunaire, étincelles." *Derrière le miroir* (Paris), nos. 164–65 (April–May 1967).

DERRIÈRE LE MIROIR 1970
"Miró: Sculptures." *Derrière le miroir* (Paris), no. 186 (June 1970).

DERRIÈRE LE MIROIR 1971
"Miró: Peintures sur papier, dessins." *Derrière le miroir* (Paris), nos. 193–94 (October–November 1971).

DERRIÈRE LE MIROIR 1973
"Miró." *Derrière le miroir* (Paris), no. 203 (April 1973).

DERRIÈRE LE MIROIR 1978
"Miró." *Derrière le miroir* (Paris), no. 231 (November 1978).

DESIGN 1941
"Miró Exhibition." *Design* (Columbus), vol. 43, no. 4 (December 1941), pp. 27–28.

DESNOS 1926
Desnos, Robert. "Surréalisme." *Cahiers d'art* (Paris), vol. 1, no. 8 (October 1926), pp. 210–13.

DESNOS 1929
Desnos, Robert. "Miró." *Cahiers de Belgique* (Brussels), vol. 2, no. 6 (June 1929), p. 206.

DESNOS 1934
Desnos, Robert. *Cahiers d'art* (Paris), vol. 9, nos. 1–4 (1934), pp. 25–26.

DESTINO 1948
Destino. September 4, 1948 (in Palma III).

DEUX AVEUGLES 1931
Les Deux Aveugles. "Matériel pour artistes, ou la revanche des accessoires." *L'Intransigeant* (Paris), April 21, 1931, p. 7.

DEVIGNE 1927
Devigne, Marguerite. *L'Horizon*, October 15, 1927 (in Palma I).

DEVREE 1937A
Devree, Howard. "Seeing the Shows: Three Exotics—Chagall, Dalí, Miró." *Magazine of Art* (Washington, D.C.), vol. 30, no. 1 (January 1937), p. 60.

DEVREE 1937B
Devree, Howard. "Field Notes: New York Resumé." *Magazine of Art* (Washington, D.C.), vol. 30, no. 7 (July 1937), pp. 446–48, 450.

DEVREE 1939
Devree, Howard. "A Reviewer's Notebook: Brief Comment on Some of the Recently Opened Shows—Accent on Modernism." *New York Times* (New York), January 8, 1939, p. 10X.

DEVREE 1941
Devree, Howard. "A Reviewer's Notebook: Brief Comment on Some of the Recently Opened Shows." *New York Times* (New York), October 12, 1941, p. X10.

DEVREE 1952
Devree, Howard. "Kirchner and Expressionism—Joan Miró—Cézanne Exhibition a Great Success." *New York Times* (New York), April 30, 1952 (in Palma IV).

DEVREE 1959
Devree, Howard. "Paradox of Miró." *New York Times* (New York), March 22, 1959, p. X15.

D'HARNONCOURT 1987
d'Harnoncourt, Anne. "Preface." *Philadelphia Museum of Art Bulletin* (Philadelphia), vol. 83, nos. 356–57 (Fall 1987), p. 2.

DHÉRELLE 1930
Dhérelle. "Pour célébrer la mémoire de Serge de Diaghilew des fidèles exposent les maquettes des Ballets Russes: Des originaux des plus grands artistes seront exposés à Paris avant de partir pour les villes étrangères." *Paris-Midi* (Paris), n.s., vol. 20, no. 1658 (October 14, 1930), p. 2.

DIA 1919
"Els Dibuixos de la 'Agrupació Courbet.'" *El Dia* (Terrassa), vol. 2, no. 328 (May 20, 1919), pp. 4–5.

DIARIO DE BARCELONA 1918
"De arte." *Diario de Barcelona* (Barcelona), no. 59 (February 28, 1918, morning ed.), pp. 2,462–63.

DIARIO DE LA MARINA 1941
"Miró, antitesis de Dalí, exhibe sus obras en el Museo de Arte." *Diario de la Marina* (Havana), December 26, 1941 (in The Museum of Modern Art Archives, Public Information Scrapbook no. 52).

DIÁRIO DE LISBOA 1947
"Passou por Lisboa notável pintor catalan Joan Miró." *Diário de Lisboa* (Lisbon), February 8, 1947 (in Palma II).

DÍAZ-PLAJA 1932
Díaz-Plaja, Guillem. "Notes a un catàleg inexistent: Joan Miró a les catacumbes." *Mirador* (Barcelona), vol. 4, no. 199 (November 24, 1932), p. 7.

DICTIONNAIRE ABRÉGÉ 1938
Dictionnaire abrégé du surréalisme. Paris: Galerie Beaux-Arts, 1938.

DIENST 1968
Dienst, Rolf-Gunter. "Ausstellungen in New York." *Das Kunstwerk* (Baden-Baden), vol. 21 (April–May 1968), p. 31.

DOEPEL 1967
Doepel, R. T. "Aspects of Joan Miró's Stylistic Development, 1920 to 1925." M.A. thesis, Courtauld Institute of Art, University of London, May 1967.

DORFLES 1949
Dorfles, Gillo. "Per Joan Miró." *Critica d'arte* (Florence), vol. 8, no. 4 (November 1, 1949), pp. 332–34.

DORFLES 1981
Dorfles, Gillo. "Miró—Milano." In *Miró Milano: Pittura, scultura, ceramica, disegni, sobreteixims, grafica*. Milan: Mazzotta, 1981.

DORIVAL 1948A
Dorival, Bernard. "La Peinture surréaliste." *Cobalto* (Barcelona), vol. 2 (1948), pp. 28–31.

DORIVAL 1948B
Dorival, Bernard. "Un An d'activité au Musée d'Art Moderne." *Musées de France* (Paris), vol. 13 (August–September 1948), pp. 172–80.

DORIVAL 1966
Dorival, Bernard. "Musée National d'Art Moderne: Les Préemptions de l'état à la seconde vente André Lefèvre." *La Revue du Louvre* (Paris), vol. 16, no. 2 (1966), pp. 117–19.

DUMAS 1929
Dumas, François Ribadeau. "La Presse artistique." *Presse* (Paris), vol. 94, no. 33805 (January 25, 1929), p. 8.

DUMAS 1930
Dumas, François Ribadeau. "Une Rétrospective des maquettes de Serge Diaghilew." *Semaine de Paris*, October 24, 1930 (in Palma I).

DUPIN 1956
Dupin, Jacques. "Miró." *Quadrum* (Brussels), no. 1 (May 1956), p. 96–106.

DUPIN 1961A
Dupin, Jacques. "Nouvelles Peintures de Miró." *Derrière le miroir* (Paris), nos. 125–26 (April 1961), pp. 2–19.

DUPIN 1961B
Dupin, Jacques. "Peintures récentes de Miró." *XXe Siècle* (Paris), vol. 23, no. 16 (May 1961), pp. 32–37.

DUPIN 1962
Dupin, Jacques. *Joan Miró: Life and Work*. New York: Harry N. Abrams, 1962.

DUPIN 1966
Dupin, Jacques. Introduction to *Joan Miró*. Tokyo: National Museum of Modern Art and Mainichi Newspapers, 1966.

DUPIN 1974
Dupin, Jacques. "Notes sur les peintures récentes." In *Joan Miró*. Paris: Editions des Musées Nationaux, 1974.

DUPIN 1983
Dupin, Jacques. "The Transmutation." In *Joan Miró: Anys vint—Mutació de la realitat*. Barcelona: Fundació Joan Miró, 1983.

DUPIN 1985
Dupin, Jacques. "Joan Miró et la réalité catalane." In *Picasso, Miró, Dalí: Evocations d'Espagne*. Brussels: Europalia, 1985.

DUPIN 1987A
Dupin, Jacques. "The Birth of Signs." In *Joan Miró: A Retrospective*. New York: Solomon R. Guggenheim Museum; New Haven, Conn.: Yale University Press, 1987.

DUPIN 1987B
Dupin, Jacques. "Miró's *Woman in Revolt*, 1938." In *Joan Miró: A Retrospective*. New York: Solomon R. Guggenheim Museum; New Haven, Conn.: Yale University Press, 1987.

DUPIN 1992
Dupin, Jacques. "Joan Miró et Pierre Matisse." In *Joan Miró Centennial Exhibition: The Pierre Matisse Collection*. Yokohama: Yokohama Museum of Art, 1992.

DUTHUIT 1936A
Duthuit, Georges. "Où allez-vous, Miró?" *Cahiers d'art* (Paris), vol. 11, nos. 8–10 (1936), pp. 261–65.

DUTHUIT 1936B
Duthuit, Georges. *Chinese Mysticism and Modern Painting*. Paris: Chroniques du Jour; London: A. Zwemmer, 1936.

DUTHUIT 1937
Duthuit, Georges. "Fantasy in Catalonia." *Magazine of Art* (Washington, D.C.), vol. 30, no. 7 (July 1937), pp. 440–43, 462.

DUTHUIT 1939
D[uthuit], G[eorges]. "Enquête." *Cahiers d'art* (Paris), vol. 14, nos. 1–4 (1939), pp. 65–73.

DUTHUIT 1953
Duthuit, Georges. "Joan Miró." *Mizue* (Tokyo), no. 570 (February 1953), pp. 1–48.

EGGERMONT 1929
Eggermont, Armand. "Les Arts plastiques: Le Centaure." *Le Thyrse*

(Brussels), 4th ser., vol. 31, no. 6 (June 1, 1929), pp. 193–94.

EINSTEIN 1929
Einstein, C[arl]. "L'Exposition de l'art abstrait à Zurich." *Documents* (Paris), vol. 1, no. 6 (November 1929), p. 342.

EINSTEIN 1930
Einstein, Carl. "Joan Miró: Papiers collés à la Galerie Pierre." *Documents* (Paris), vol. 2, no. 4 ([May 1,] 1930), pp. 241–43.

EINSTEIN 1931
Einstein, Carl. *Die Kunst des 20. Jahrhunderts.* Berlin: Propyläen-Verlag, 1931.

ELGAR 1945
Elgar, Frank. "Joan Miró et quelques autres." *Carrefour* (Paris), vol. 2, no. 34 (April 14, 1945), p. 5.

ELGAR 1954
Elgar, Frank. *Miró.* Paris: Fernand Hazan, 1954.

ELUARD 1937
Eluard, Paul. "Naissances de Miró." *Cahiers d'art* (Paris), vol. 12, nos. 1–3 (1937), pp. 78–83.

E.M.P. 1918
E.M.P. "Les Exposicions." *La Revista* (Barcelona), vol. 4, no. 66 (June 16, 1918), pp. 209–11.

ERBEN 1959
Erben, Walter. *Joan Miró.* New York: George Braziller, 1959.

ERBEN 1961
Erben, Walter. "Zu den 'Holländischen Interieurs' von Joan Miró." *Du* (Zurich), vol. 21, no. 243 (May 1961), pp. 22–23.

ERBEN 1988
Erben, Walter. *Joan Miró, 1893–1983: The Man and His Work.* Cologne: Benedikt Taschen, 1988.

ERNI 1935
Erni, Hans. "The Lucerne Exhibition." *Axis* (London), no. 2 (April 1935), pp. 27–29.

ESPÀTULA 1919
Espàtula. "L'Exposició d'art." *D'ací i d'allà* (Barcelona), vol. 3, no. 6 (June 1919), pp. 503–06.

ESTIENNE 1954
Estienne, Charles. "Le Surréalisme et la peinture à la Biennale de Venise." *Combat* (Paris), July 1954, p. 4 (in Palma V).

FAISON 1949
Faison, Hans, Jr. "Joan Miró: A Truly Modern Painter." *New York Times*

(New York), January 30, 1949, Book Review section, p. 4.

FALGAIROLLE 1931
Falgairolle, Adolphe de. "Les Peintres catalans." *Les Nouvelles littéraires, artistiques et scientifiques* (Paris), vol. 2, no. 456 (July 11, 1931), p. 8.

F.D. 1945
F.D. "A travers les expositions." *Gavroche* (Paris), April 5, 1945 (in Palma II).

FEGDAL 1936
Fegdal, Charles. "Art: Collection Henri Laugier." *La Semaine à Paris* (Paris), no. 711 (January 10–16, 1936), p. 53.

FEGDAL 1938
Fegdal, Charles. "Les Surréalistes s'amusent." *La Semaine à Paris* (Paris), no. 818 (January 26–February 1, 1938), pp. 5–6.

FEGDAL 1939A
Fegdal, Charles. "Du nouveau dans l'art." *La Semaine à Paris* (Paris), no. 880 (April 5–11, 1939), p. 6.

FEGDAL 1939B
Fegdal, Charles. "Art: A travers les expositions." *La Semaine à Paris* (Paris), no. 893 (July 5–11, 1939), p. 45.

FELS 1921
Fels, Florent. "Les Expositions." *L'Information* (Paris), vol. 23, no. 141 (May 21, 1921), p. 2.

FELS 1925A
Fels, [Florent]. "Chronique artistique: Les Expositions." *Les Nouvelles littéraires, artistiques et scientifiques* (Paris), July 11, 1925, p. 25.

FELS 1925B
Fels, [Florent]. "Les Expositions." *L'Art vivant* (Paris), vol. 1, no. 14 (July 15, 1925), p. 22.

FERNÁNDEZ MIRÓ 1987
Fernández Miró, David. "La Santa Inquietud davant la Mar." In *Joan Miró, Son Abrines i Son Boter—Olis, dibuixos i graffiti.* Palma de Mallorca: Fundació Pilar i Joan Miró, 1987.

FERRIER 1945
Ferrier, G.-L. "Les Arts: Divertissement." *Les Nouvelles du matin,* April 4, 1945 (in Palma II).

FERRY 1966
Ferry, W. Hawkins. "My Motivations in Collecting." In *The W. Hawkins Ferry Collection.* Detroit: The Detroit Institute of Arts, 1966.

FEUILLES VOLANTES 1928
Feuilles volantes, June 1, 1928 (in Palma I).

FIERENS 1929
Fierens, Paul. "Paris Letter." *The Art News* (New York), vol. 27, no. 20 (February 16, 1929), pp. 17–18.

FIERENS 1930
Fierens, Paul. "Paris Letter: In the Galleries—Sculpture by Gimond, Salendre, Paintings by Leopold Levy, Thomsen, Eugene Berman, Ozenfaut [sic], Miro [sic], Kandinsky, Several Women Painters." *The Art News* (New York), vol. 28, no. 28 (April 12, 1930), p. 20.

FIERENS 1933
Fierens, Paul. "Les Deux Salons de la Porte de Versailles: Les Surindépendants." *Journal des débats* (Paris), vol. 145, no. 300 (October 29, 1933), p. 4.

FITZSIMMONS 1952
Fitzsimmons, James. "'All Sorts of Wonderful Events.'" *The Art Digest* (New York), vol. 26, no. 15 (May 1, 1952), pp. 16–17.

FLECK 1991
Fleck, Robert. "André Breton: Writing the Revolution." *Flash Art* (Milan), vol. 24, no. 159 (Summer 1991), pp. 94–97.

FLEISCHMAN 1931
Fleischman, Théo. "Lettre de Belgique: Du souvenir d'Ysaye à la commémoration d'Albert Giraud." *Comoedia* (Paris), no. 5708 (June 2, 1931), p. 4.

FLUEGEL 1980
Fluegel, Jane. "Chronology." In William Rubin, ed., *Pablo Picasso: A Retrospective.* New York: The Museum of Modern Art, 1980.

FLINT 1933
Flint, Ralph. "Art Trends Seen in International 1933 Exhibition." *The Art News* (New York), vol. 31, no. 20 (February 11, 1933), pp. 3–4.

FLORISOONE 1945
Florisoone, Michel. "Les Expositions: Joan Miró." *Arts* (Lyon and Paris), April 6, 1945, p. 2.

FOCIUS 1930A
Focius. "Les Lletres: Meridians." *La Publicitat* (Barcelona), vol. 52, no. 17442 (March 4, 1930), p. 4.

FOCIUS 1930B
Focius. "Les Lletres: Meridians." *La Publicitat* (Barcelona), vol. 52, no. 17448 (March 12, 1930), p. 6.

FOIX 1928
Foix, J. V. "La Literatura: Presentació de Joan Miró." *L'Amic de les arts* (Sitges), vol. 3, no. 26 (June 30, 1928), p. 198.

FOIX 1932
Foix, J. V. "Lletres: Les Idees i els esdeveniments." *La Publicitat* (Barcelona), vol. 54, no. 18001 (April 21, 1932), p. 5.

FOIX 1934
Foix, J. V. "Joan Miró." *Cahiers d'art* (Paris), vol. 9, nos. 1–4 (1934), p. 52.

FOLCH 1919
Folch, L. "Exposición de arte." *Diario de Barcelona* (Barcelona), no. 146 (June 18, 1919, afternoon ed.), pp. 6877–78.

FOREST HILLS POST 1941
"Art Chapter." *Forest Hills Post* (Forest Hills, N.Y.), November 21, 1941 (in The Museum of Modern Art Archives, Public Information Scrapbook no. 52).

FORMES 1932
"Art at Paris." *Formes* (Paris and Philadelphia), no. 30 (1932), p. 337.

FOSCA 1928
Fosca, François. "Chronique des expositions: Joan Miró (Georges Bernheim)." *L'Amour de l'art* (Paris), vol. 9, no. 6 (June 1928), p. 233.

F.P. 1953
F.P. "Reviews and Previews: Joan Miró." *The Art News* (New York), vol. 52, no. 8 (December 1953), p. 40.

F.P. 1958
F.P. "Reviews and Previews: Mirós." *The Art News* (New York), vol. 57, no. 8 (December 1958), p. 12.

FRANKFURTER 1941
Frankfurter, Alfred M. "341 Documents of Modern Art: The Chrysler Collection." *The Art News* (New York), vol. 39, no. 16 (January 18, 1941), pp. 8–18, 24.

FREEDBERG 1986
Freedberg, Catherine Blanton. *The Spanish Pavilion at the Paris World's Fair of 1937.* 2 vols. New York and London: Garland Publishing Co., 1986.

FREEMAN 1980
Freeman, Judi. "Miró and the United States." In Charles W. Millard, *Miró: Selected Paintings.* Washington, D.C.: Smithsonian Institution Press and the Hirshhorn Museum and Sculpture Garden, 1980.

FREEMAN 1989
Freeman, Judi. "Layers of Meaning: The Multiple Readings of Dada and Surrealist Word-Images." In Judi Freeman and John C. Welchman, *The Dada and Surrealist Word-Image.* Los Angeles: Los Angeles County Museum of Art, 1989.

FREY 1936
Frey, John G. "Miró and the Surrealists." *Parnassus* (New York), vol. 8, no. 5 (October 1936), pp. 13–15.

FRIE UDSTILLINGS BYGNING 1935
International Kunstudstilling: Kubisme-Surrealisme. Copenhagen: Den Frie Udstillings Bygning, 1935.

FRIED 1934
Fried, Alexander. "Miró Paintings Lack Meaning." *San Francisco Chronicle*, May 20, 1934 (in Palma II).

FRIGERIO 1961
Frigerio, Simone. "Les Expositions à l'étranger: Bâle—La Collection Dotrement." *Aujourd'hui Art et Architecture* (Boulogne), vol. 6, no. 32 (July 1961), pp. 54–55.

FRIGERIO 1962
Frigerio, Simone. "Les Expositions à Paris: Miró." *Aujourd'hui Art et Architecture* (Boulogne), vol. 7, no. 38 (September 1962), p. 54.

FROST 1943
Frost, Rosamund. "Living Art Walks and Talks." *The Art News* (New York), vol. 42, no. 1 (February 15–28, 1943), pp. 14, 27–28.

FUNDACIÓ JOAN MIRÓ 1983
Joan Miró: Anys vint—Mutació de la realitat. Barcelona: Fundació Joan Miró, 1983.

FUNDACIÓ JOAN MIRÓ 1988
Obra de Joan Miró. Barcelona: Fundació Joan Miró, 1988.

FUNDACIÓ PILAR I JOAN MIRÓ 1987
Joan Miró, Son Abrines i Son Boter—Olis, dibuixos i graffiti. Palma de Mallorca: Fundació Pilar i Joan Miró, 1987.

F.V. 1918
F.V. "Les Exposicions: Joan Miró." *La Revista* (Barcelona), vol. 4, no. 61 (April 1, 1918), p. 114.

GACETA LITERARIA 1928
"Joan Miró en Madrid." *La Gaceta literaria* (Madrid), vol. 2, no. 37 (July 1, 1928), p. 6.

GAFFÉ 1929
Gaffé, René. "Réflexions d'un collectionneur." *Cahiers de Belgique* (Brussels), vol. 2, no. 2 (February 1929), pp. 55–64.

GAFFÉ 1934
Gaffé, René. *Cahiers d'art* (Paris), vol. 9, nos. 1–4 (1934), pp. 30–33.

GAFFÉ 1963
Gaffé, René. *A la verticale: Réflexions d'un collectionneur.* Brussels: André De Rache, 1963.

GALLATIN 1930
Gallatin, A. E., and Jacques Mauny. *Gallery of Living Art, New York University.* Paris: Horizons de France, 1930.

GALLATIN 1933
Gallatin, A. E., et al. *Gallery of Living Art, New York University.* New York, 1933.

GALLATIN 1936
Gallatin, A. E., et al. *Museum of Living Art, A. E. Gallatin Collection 1937.* New York: George Grady Press, 1936.

GALLATIN 1940
Gallatin, A. E., et al. *Museum of Living Art, A. E. Gallatin Collection.* New York: George Grady Press, 1940.

GANTENYS 1929
Gantenys, Antoni. "Joan Miró." *Hèlix* (Vilafranca del Penedès), no. 1 (February 1929), p. 2.

GARCÍA-MÁRQUEZ 1990
García-Márquez, Vicente. *The Ballets Russes: Colonel de Basil's Ballets Russes de Monte Carlo, 1932–1952.* New York: Alfred A. Knopf, 1990.

GARCÍA Y BELLIDO 1929
García y Bellido, A. "Los Nuevos Pintores españoles: La Exposición del Botánico." *La Gaceta literaria* (Madrid), vol. 3, no. 55 (April 1, 1929), p. 1.

GARDY ARTIGAS 1961
Gardy Artigas, Joan. "La Céramique murale pour Harvard." *Derrière le miroir* (Paris), no. 123 (February 1961), pp. 3–9.

GASCH 1925
Gasch, Sebastià. "Els Pintors d'avantguarda: Joan Miró." *Gaseta de les arts* (Barcelona), vol. 2, no. 39 (December 15, 1925), pp. 3–5.

GASCH 1926A
Gasch, Sebastià. "L'Obra actual del pintor Joan Miró." *L'Amic de les arts* (Sitges), vol. 1, no. 5 (August 1926), pp. 15–16.

GASCH 1926B
Gasch, Sebastià. "Max Ernst." *L'Amic de les arts* (Sitges), vol. 1, no. 7 (October 1926), p. 7.

GASCH 1927A
Gasch, Sebastià. "El Pintor Joan Miró." *La Gaceta literaria* (Madrid), vol. 1, no. 8 (April 15, 1927), p. 3.

GASCH 1927B
Gasch, Sebastià. "Cop d'ull sobre l'evolució de l'art modern." *L'Amic de les arts* (Sitges), vol. 2, no. 18 (September 30, 1927), pp. 91–93.

GASCH 1928A
Gasch, Sebastià. "Llibres i revistes: André Breton, 'Le Surréalisme et la peinture,' N.R.F. París 1918." *La Veu de Catalunya* (Barcelona), vol. 38, no. 9969 (May 15, 1928, morning ed.), p. 3.

GASCH 1928B
Gasch, Sebastià. "Joan Miró." *L'Amic de les arts* (Sitges), vol. 3, no. 26 (June 30, 1928), pp. 202–03.

GASCH 1928C
Gasch, Sebastià. "Arte: Joan Miró." *La Gaceta literaria* (Madrid), vol. 2, no. 39 (August 1, 1928), p. 5.

GASCH 1929A
Gasch, Sebastià. "Joan Miró." *Gaseta de les arts* (Barcelona), vol. 2, no. 7 (March 1929), pp. 68–69.

GASCH 1929B
Gasch, Sebastià. "Joan Miró." *Cahiers de Belgique* (Brussels), vol. 2, no. 6 (June 1929), pp. 202–05.

GASCH 1929C
Gasch, Sebastià. "Panorama internacional: Abstracción." *La Gaceta literaria* (Madrid), vol. 3, no. 60 (June 15, 1929), p. 5.

GASCH 1929D
Gasch, Sebastià. "Vida artística: Revistes." *La Veu de Catalunya* (Barcelona), vol. 39, no. 10323 (July 5, 1929, morning ed.), p. 4.

GASCH 1929E
Gasch, Sebastià. "Vida artística: Expansió catalana." *La Veu de Catalunya* (Barcelona), vol. 39, no. 10329 (July 12, 1929, morning ed.), p. 4.

GASCH 1929F
Gasch, Sebastià. "In-fighting." *Hèlix* (Vilafranca del Penedès), no. 6 (October 1929), pp. 4–5.

GASCH 1929G
Gasch, Sebastian (sic). "Arte: Superrealismo." *La Gaceta literaria* (Madrid), vol. 3, no. 67 (October 1, 1929), p. 3.

GASCH 1929H
Gasch, Sebastià. "Les Arts: L'Elogi del mal gust." *La Publicitat* (Barcelona), vol. 51, no. 17361 (November 29, 1929), p. 4.

GASCH 1930A
Gasch, Sebastià. "Joan Miró." *Mirador* (Barcelona), vol. 2, no. 57 (February 27, 1930), p. 7.

GASCH 1930B
Gasch, Sebastià. "Variedades superrealistas." *La Gaceta literaria* (Madrid), vol. 4, no. 77 (March 1, 1930), pp. 8–9.

GASCH 1930C
Gasch, Sebastià. "Intensidad." *La Gaceta literaria* (Madrid), vol. 4, no. 81 (May 1, 1930), p. 9.

GASCH 1930D
Gasch, Sebastià. "Superrealisme." *Butlletí de l'Agrupament Escolar de l'Acadèmia i Laboratori de Ciències Mèdiques de Catalunya* (Barcelona), vol. 2, nos. 7–9 (July–September 1930), pp. 195–97.

GASCH 1931A
Gasch, Sebastià. "Punts de vista: Elogi de la irresponsabilitat." *Mirador* (Barcelona), vol. 3, no. 112 (March 26, 1931), p. 7.

GASCH 1931B
Gasch, Sebastià. "Joan Miró a Montroig." *Mirador* (Barcelona), vol. 3, no. 140 (October 8, 1931), p. 7.

GASCH 1948
Gasch, Sebastian (sic). "Juan [sic] Miró." *Cobalto* (Barcelona), vol. 2, no. 1 (1948), pp. 32–34.

GASCH 1950
Gasch, Sebastian (sic). "Joan Miró." *Das Kunstwerk* (Baden-Baden), vol. 4, no. 5 (1950), pp. 21–25.

GASCH 1953
Gasch, Sebastià. *Expansió de l'art català al món.* Barcelona: Clarasó, 1953.

GASCH 1963
Gasch, Sebastià. *Joan Miró.* Barcelona: Clarasó, 1963.

GASCOYNE 1935
Gascoyne, David. *A Short Survey of Surrealism.* London: Cobden-Sanderson, 1935.

GASSER 1965
Gasser, Manuel. *Joan Miró.* New York: Barnes & Noble, 1965.

GASSIER 1946
Gassier, Pierre. "Miró et Artigas." *Labyrinthe* (Geneva), vol. 2, nos. 22–23 (December 1946), pp. 10–11.

GATEAU 1982
Gateau, Jean-Charles. *Paul Eluard et la peinture surréaliste, 1910–1939.* Geneva: Librairie Droz, 1982.

GEE 1981
Gee, Malcolm. *Dealers, Critics, and Collectors of Modern Painting.* New York and London: Garland Publishing, 1981.

GEELHAAR 1992
Geelhaar, Christian. *Kunstmuseum Basel: The History of the Paintings Collection and a Selection of 250 Masterworks*. Basel: The Friends of the Kustmuseum Basel and Eidolon AG, 1992.

GENAUER 1936
Genauer, Emily. "Fantastic Works of Miró and Chagall Featured in New Gallery of Exhibitions." *New York World Telegram* (New York), December 5, 1936 (in Matisse).

GENAUER 1938A
G[enauer], E[mily]. "Present-Day Impressionists Exhibit Recent Paintings." *New York World Telegram* (New York), vol. 70, no. 160 (January 8, 1938), p. 13.

GENAUER 1938B
Genauer, Emily. "Galleries Preparing Another Tidal Wave: Paintings by Lie and Miró." *New York World Telegram* (New York), vol. 70, no. 250 (April 23, 1938), p. 13.

GENAUER 1939A
Genauer, Emily. "Work of Picasso, Matisse, Derain, Miró and Others Makes Interesting Exhibit." *New York World Telegram* (New York), January 7, 1939 (in Matisse).

GENAUER 1939B
Genauer, Emily. "Miró at Matisse." *New York World Telegram* (New York), April 15, 1939 (in Matisse).

GENAUER 1939C
Genauer, Emily. "Group Show at Matisse." *New York World Telegram* (New York), November 4, 1939 (in Matisse).

GENAUER 1941A
Genauer, Emily. "Modern Pinnacles in French Painting: Pierre Matisse Gallery's Exhibit of Landmarks Attracts Crowds." *New York World Telegram* (New York), January 4, 1941 (in Matisse).

GENAUER 1941B
Genauer, Emily. "Joan Miró's Imaginative Paintings." *New York World Telegram* (New York), March 8, 1941 (in Matisse).

GENAUER 1941C
Genauer, Emily. "Miró's an Antipode to Shocking Dalí: Both Exhibits Superbly Installed at The Museum of Modern Art." *New York World Telegram* (New York), November 22, 1941 (in The Museum of Modern Art Archives, Public Information Scrapbook no. 52).

GEORGE 1928
George, Waldemar. "Les Expositions: Joan Miró (Galerie Georges Bernheim)." *Presse* (Paris), no. 4838 (May 16, 1928), p. 2.

GEORGE 1929A
George, Waldemar. "Miró et le miracle ressuscité." *Le Centaure* (Brussels), vol. 3, no. 8 (May 1, 1929), pp. 200–05.

GEORGE 1929B
George, Waldemar. "Retour à l'Italie: Lettre ouverte à Georges Marlier." *Cahiers de Belgique* (Brussels), vol. 2, no. 6 (June 1929), pp. 209–15.

G.H. 1962
G.H. "Livres sur l'art: Miró par Jacques Dupin." *L'Oeil* (Paris), no. 93 (September 1962), pp. 73–74.

GIBBS 1949
Gibbs, Jo. "Surrealist-Period Miró for Miró Fans." *The Art Digest* (New York), vol. 23, no. 15 (May 1, 1949), p. 17.

GIFREDA 1936
Gifreda, Màrius. "I Saló d'artistes decoradors." *Mirador* (Barcelona), vol. 8, no. 380 (May 28, 1936), p. 7.

GILBERT 1938
Gilbert, Paul T. "'Dreams' Become Nightmare." *Herald Examiner*, [November] 1938 (in Kuh).

GIMÉNEZ CABALLERO 1928
Giménez Caballero, Ernesto. "Eoántropo." *La Revista de Occidente* (Madrid), no. 57 (March 1928), pp. 309–42.

GIMFERRER 1975
Gimferrer, Pere. "Joan Miró a Barcelona." In *Un Camí compartit: Miró–Maeght*. Barcelona: Galeria Maeght, 1975.

GIMFERRER 1978
Gimferrer, Pere. *Miró, catalan universel*. Paris: Editions Hier & Demain, 1978.

GIMFERRER 1985
Gimferrer, Pere. "De Montroig à Varengeville." In *Picasso, Miró, Dalí: Evocations d'Espagne*. Brussels: Europalia, 1985.

GINDERTAIL 1951
Gindertail, R. V. "Du tableau à l'art monumental: Sur quatre murs." *Combat* (Paris), May 8, 1951 (in Palma III).

GLOVERSVILLE HERALD 1937
"This Crazy World! Surrealism Is Proving Contagious." *Gloversville Herald* (Gloversville, N.Y.), January 5, 1937 (in Palma II).

GOHR 1986A
Gohr, Siegfried. *Museum Ludwig, Cologne: Paintings, Sculptures, Environments, from Expressionism to the Present Day*, vol. 1. Munich: Prestel-Verlag, 1986.

GOHR 1986B
Gohr, Siegfried, ed. *Museum Ludwig Köln: Gemälde, Skulpturen, Environments, vom Expressionismus bis zur Gegenwart — Bestandskatalog*, vol. 2. Munich: Prestel-Verlag, 1986.

GOLDING 1973
Golding, John. "Picasso and Surrealism." In Roland Penrose and John Golding, eds., *Picasso in Retrospect*. New York and Washington, D.C.: Praeger Publishers, 1973.

GOLDWATER/D'HARNONCOURT 1949
Goldwater, Robert, and René d'Harnoncourt. "Modern Art in Your Life." *The Museum of Modern Art Bulletin* (New York), vol. 17, no. 1 (1949), pp. 5–48.

GOLS 1927
Gols, Joan. "Després del Saló de Tardor." *La Nau*, vol. 1, no. 29 (November 3, 1927), p. 1.

GOMIS/PRATS 1959
Gomis, Joaquín, and Joan Prats Vallés. *The Miró Atmosphere*. Preface by James Johnson Sweeney. New York: George Wittenborn, 1959.

GOODMAN 1989
Goodman, Cynthia. "The Art of Revolutionary Display Techniques." In Lisa Phillips, ed., *Frederick Kiesler*. New York: Whitney Museum of American Art, 1989.

GOODRICH 1930
Goodrich, Lloyd. "November Exhibitions: Miró." *The Arts* (New York), vol. 17, no. 2 (November 1930), pp. 119–20.

GORDON 1938
Gordon, Jan. "Art and Artists: Twenty Exhibitions — Quality and Variety." *The Observer* (London), May 8, 1938 (in Mayor).

GRAFLY 1938
Grafly, Dorothy. "The Carnegie International." *The Christian Science Monitor* (Boston), October 18, 1938, p. 12.

GREEN 1987
Green, Christopher. *Cubism and Its Enemies: Modern Movements and Reaction in French Art, 1916–1928*. New Haven, Conn., and London: Yale University Press, 1987.

GREENBERG 1941
Greenberg, Clement. "Art." *The Nation* (New York), vol. 152, no. 16 (April 19, 1941), pp. 481–82.

GREENBERG 1944
Greenberg, Clement. "Art." *The Nation* (New York), vol. 158, no. 21 (May 20, 1944), pp. 604–05.

GREENBERG 1945
Greenberg, Clement. "Art." *The Nation* (New York), vol. 160, no. 23 (June 9, 1945), pp. 657, 659.

GREENBERG 1948
Greenberg, Clement. *Joan Miró*. New York: Quadrangle Press, 1948.

GRENIER 1944
Grenier, Jean. "Au Salon d'Automne: Peinture baroque et sculpture classique." *Combat* (Paris), vol. 4, no. 107 (October 13, 1944), p. 2.

GRENIER 1960
Grenier, Jean. "The Revolution of Color." *XXe Siècle* (Paris), vol 22, no. 15 (Christmas 1960), pp. 3–56.

GRIGORIEV 1953
Grigoriev, S. L. *The Diaghilev Ballet, 1909–1929*. London: Constable, 1953.

GROHMANN 1934
Grohmann, Will. "Vom abstrakten Realismus zur realen Abstraktion (zu Mirós Bildern)." *Cahiers d'art* (Paris), vol. 9, nos. 1–4 (1934), p. 38.

GROS 1925
Gros, G.-J. "Les Arts: Galeries d'été." *Paris-Midi* (Paris), n.s., vol. 15, no. 76 (June 14, 1925), p. 2.

GROS 1933
Gros, G.-J. "Les Expositions: Le Groupe moderne — Exposition de l'A.B.C. — André Vallaud — Gravures de Matisse et Dufy — Joan Miró." *Beaux-Arts* (Paris), vol. 72, no. 44 (November 3, 1933), p. 3.

GUÉGUEN 1934
Guéguen, Pierre. *Cahiers d'art* (Paris), vol. 9, nos. 1–4 (1934), pp. 44–46.

GUÉGUEN 1957
Guéguen, Pierre. "L'Humour féerique de Joan Miró." *XXe Siècle* (Paris), no. 8 (January 1957, double issue), pp. 39–44.

GUETTA 1938
Guetta, René. "A Paris: L'Expo de rêve." *Marianne* (Paris), vol. 6, no. 275 (January 26, 1938), p. 13.

G.V. 1934
G.V. "Du Côté des surréalistes: L'Exposition du *Minotaure* à Bruxelles." *La Vie française* (Brussels), vol. 1, no. 8 (June 10, 1934), p. 5.

GYBAL 1921
Gybal, A. "Les Expositions: Per Grogh — Joan Miró." *Journal du peuple* (Paris), vol. 6, no. 125 (May 6, 1921), p. 2.

HALLIDAY 1991
Halliday, Nigel Vaux. *More than a Bookshop: Zwemmer's and Art in the Twentieth Century.* London: Philip Wilson Publishers, 1991.

HANSEN 1985
Hansen, Robert C. *Scenic and Costume Design for the Ballets Russes.* Ann Arbor, Mich.: UMI Research Press, 1985.

HARRIS 1928
Harris, Ruth Green. "A Few Artists Who Are Now Exhibiting." *New York Times* (New York), June 10, 1928, p. 10X.

HARVARD ALUMNI BULLETIN 1951
"Mural by Miró." *Harvard Alumni Bulletin* (Cambridge, Mass.), vol. 54, no. 3 (October 27, 1951), p. 110.

HAYTER 1945
Hayter, Stanley William. "The Language of Kandinsky." *Magazine of Art* (Washington, D.C.), vol. 38, no. 5 (May 1945), pp. 176–79.

HAYWARD 1986
Homage to Barcelona: The City and Its Art, 1888–1936. London: Hayward Gallery; Thames & Hudson, 1986.

H.C. 1964
H.C. "Ausstellungen: Zürich." *Werk* (Zurich), vol. 51, no. 12 (December 1964), p. 289.

HÈLIX 1929
Hèlix (Vilafranca del Penedès), no. 1 (February 1929), pp. 7–8.

HELLER 1961
Heller, Ben. "The Roots of Abstract Expressionism." *Art in America* (New York), vol. 49, no. 4 (1961), pp. 40–49.

HELLMAN 1964
Hellman, Geoffrey T. "Profile of a Museum." *Art in America* (New York), vol. 52, no. 1 (February 1964), p. 54.

HEMINGWAY 1933
Hemingway, Ernest. In *Joan Miró.* New York: Pierre Matisse Gallery, 1933.

HEMINGWAY 1934
Hemingway, Ernest. "The Farm." *Cahiers d'art* (Paris), vol. 9, nos. 1–4 (1934), pp. 28–29.

HENNING 1979
Henning, Edward B. "A Painting by Joan Miró." *The Bulletin of The*

Cleveland Museum of Art (Cleveland), vol. 66, no. 6 (September 1979), pp. 234–40.

HENRY 1935
Henry, Maurice. "Joan Miró." *Cahiers d'art* (Paris), vol. 10, nos. 5–6 (1935), pp. 115–16.

HERALDO DE MADRID 1926
"El Arte superrealista." *Heraldo de Madrid* (Madrid), vol. 36, no. 12.680 (September 21, 1926), n.p.

HERNÁNDEZ LEÓN 1988
Hernández León, Juan Miguel. Preface to *Joan Miró: Viaggio delle figure.* Rivoli: Castello di Rivoli, 1988.

HESS 1948
H[ess], T[homas] B. "Spotlight on: Miró." *The Art News* (New York), vol. 47, no. 2 (April 1948), p. 33.

HESS 1950
Hess, Thomas B. "Introduction to Abstract." *Art News Annual, 20* (New York), vol. 49, no. 7, part 2 (November 1950), pp. 127–58.

HESS 1952
H[ess], T[homas] B. "Reviews and Previews: Miró's." *The Art News* (New York), vol. 50, no. 9 (January 1952), p. 40.

HESS 1958
H[ess], T[homas] B. "The Promised Land." *The Art News* (New York), vol. 57, no. 6 (October 1958), pp. 37, 59.

HIRSCHFELD/LUBAR 1987
Hirschfeld, Susan B., and Robert S. Lubar. "Chronology." In *Joan Miró: A Retrospective.* New York: Solomon R. Guggenheim Museum; New Haven, Conn.: Yale University Press, 1987.

HIRTZ 1928
Hirtz, Lise. *Il était une petite pie.* Paris: Editions Jeanne Bucher, 1928.

HODIN 1964
Hodin, J. P. "Quand les artistes parlent du sacré." *XXe Siècle* (Paris), vol. 26, no. 24 (December 1964), pp. 17–26.

HODIN 1966
Hodin, J. P. "Un Musée idéal de la peinture moderne à Düsseldorf." *Chroniques du jour,* supplement to *XXe Siècle* (Paris), vol. 40, no. 26 (May 1966), pp. 28–29.

HOPPE 1934
Hoppe, Ragnar. *Cahiers d'art* (Paris), vol. 9, nos. 1–4 (1934), pp. 34–35.

HOPPE 1949
Hoppe, Ragnar. *Joan Miró: Malignar, keramik, litografier.* Stockholm: Galerie Blanche, 1949.

HUGNET 1931A
Hugnet, Georges. "L'Homme de face." *Cahiers d'art* (Paris), vol. 6, nos. 4–5 (1931), p. 432.

HUGNET 1931B
Hugnet, Georges. "Joan Miró, ou l'enfance de l'art." *Cahiers d'art* (Paris), vol. 6, nos. 7–8 (1931), pp. 335–40.

HUGNET 1936
Hugnet, Georges. "In the Light of Surrealism." *The Bulletin of The Museum of Modern Art* (New York), vol. 4, nos. 2–3 (November–December 1936), pp. 19–36.

HUGNET 1940
Hugnet, Georges. "Joan Miró." *Cahiers d'art* (Paris), vol. 15, nos. 3–4 (1940), p. 48.

HUIDOBRO 1934
Huidobro, Vicente. *Cahiers d'art* (Paris), vol. 9, nos. 1–4 (1934), pp. 40–43.

HUMEAU 1934
Humeau, Edmond. "Les Evénements et les hommes." *Spirit,* June 1, 1934 (in Palma II).

HÜTTINGER 1957
Hüttinger, Eduard. *Miró.* Bern, Stuttgart, Vienna: Alfred Scherz Verlag, 1957.

INTRANSIGEANT 1929
"L'Art à l'étranger." *L'Intransigeant* (Paris), October 7, 1929, p. 6.

INTRANSIGEANT 1930
"Poils de pinceau." *L'Intransigeant* (Paris), October 20, 1930, p. 5.

INTRANSIGEANT 1932
"Poils de pinceau." *L'Intransigeant* (Paris), December 27, 1932, p. 7.

INTRANSIGEANT 1936
"Nos Echos." *L'Intransigeant* (Paris), June 18, 1936, p. 2.

JAHRBUCH DER JUNGEN KUNST 1923
Jahrbuch der Jungen Kunst (Leipzig), no. 3 (1923), p. 330.

JAKOVSKY 1944
Jakovsky, Anatole. "Le Salon de la libération et le surréalisme." *Action* (Paris), no. 8 (October 27, 1944), p. 8.

JAMIN 1992
Jamin, Jean, ed. *Michel Leiris: Journal, 1922–1989.* Paris: Gallimard, 1992.

JARDÍ 1976
Jardí, Enric. *Història del Cercle Artístic de Sant Lluc.* Barcelona: Edicions Destino, 1976.

JARDÍ 1983
Jardí, Enric. *Els Moviments d'avantguarda a Barcelona.* Barcelona: Edicions del Cotal, S.A., 1983.

JEAN 1936
Jean, Marcel. "Arrivée de la belle époque." *Cahiers d'art* (Paris), vol. 11, nos. 1–2 (1936), p. 60.

JEANNERAT 1952
Jeannerat, Pierre. "The Reply to Totalitarian Critics: Manifestation of Western Liberty." *Daily Mail,* July 28, 1952 (in Palma IV).

JEFFETT 1988
Jeffett, William. "Una 'Constel·lació' d'imatges: Poesia i pintura — Joan Miró, 1929–1941." In *Impactes: Joan Miró, 1929–1941.* Barcelona: Fundació Joan Miró, 1988.

JEFFETT 1989A
Jeffett, William. "A 'Constellation' of Images: Poetry and Painting — Joan Miró, 1929–1941." In *Joan Miró: Paintings and Drawings, 1929–1941.* London: Whitechapel Art Gallery, 1989.

JEFFETT 1989B
Jeffett, William. "Chronology." In *Joan Miró: Paintings and Drawings, 1929–1941.* London: Whitechapel Art Gallery, 1989.

JEFFETT 1989C
Jeffett, William. "Joan Miró's Vagabond Sculpture." In *Joan Miró: Sculpture.* London: South Bank Centre, 1989.

JEFFETT 1993
Jeffett, William. "*L'Antitête*: The Book as Object in the Collaboration of Tristan Tzara and Joan Miró, 1946–47." *The Burlington Magazine* (London), vol. 135, no. 1073 (February 1993), pp. 81–93.

JENA 1938
Jena, Jeanette. "Paintings of Eleven Nations in International Opening Tonight: Annual Carnegie Show Proves Art Has No Frontiers, American Section Most Vigorous of Entire Exhibition." *Pittsburgh Post-Gazette* (Pittsburgh), October 13, 1938 (in Palma II).

JEWELL 1931A
Jewell, Edward Alden. "Again a Storm Rages over 'Modern Art.'" *The New York Times Magazine* (New York), February 22, 1931, pp. 12–13, 21.

JEWELL 1931B
Jewell, Edward Alden. "'Primitive' and Otherwise." *New York Times* (New York), September 27, 1931, p. XII.

JEWELL 1932
Jewell, Edward Alden. "Art in Review: Works of Two Surrealists Offer Opportunity to Understand Them with a Struggle." *New York Times* (New York), November 5, 1932, p. 18.

JEWELL 1933
Jewell, Edward Alden. "Adroit Art Marks Large Miró Show." *New York Times* (New York), December 30, 1933, p. L11.

JEWELL 1936A
Jewell, Edward Alden. "Exhibition Opens of 'Fantastic Art.'" *New York Times* (New York), December 9, 1936, p. L25.

JEWELL 1936B
Jewell, Edward Alden. "Fantasy in Perspective: The Museum of Modern Art Opens Show of Dada and Surrealism, Old and New." *New York Times* (New York), December 13, 1936, p. X11.

JEWELL 1937A
Jewell, Edward Alden. "Fantasy Rears Its Head: The Museum of Modern Art Shows Recent Accessions—Calder and Kristians Tonny." *New York Times* (New York), February 28, 1937, p. X9.

JEWELL 1937B
J[ewell], E[dward] A[lden]. "By French Modernists." *New York Times* (New York), April 18, 1937, p. X10.

JEWELL 1937C
Jewell, Edward Alden. "Abstraction: A Debate Rages." *The New York Times Magazine* (New York), July 18, 1937, p. 10.

JEWELL 1938A
Jewell, Edward Alden. "Sundry Variations on an Old Theme." *New York Times* (New York), January 9, 1938, p. X9.

JEWELL 1938B
Jewell, Edward Alden. "Art Shows Given by Lie and Miró: Miró's Latest Phase." *New York Times* (New York), April 19, 1938, p. L22.

JEWELL 1939
Jewell, Edward Alden. "Tracing Sources of Modern Painting: Other Shows." *New York Times* (New York), April 30, 1939, p. X9.

JEWELL 1940
Jewell, Edward Alden. "French Moderns Among Art Shows." *New York Times* (New York), December 31, 1940, p. L13.

JEWELL 1941A
Jewell, Edward Alden. "Three Art Shows Offer Abstracts." *New York Times* (New York), March 5, 1941, p. L17.

JEWELL 1941B
Jewell, Edward Alden. "Modern Museum Shows Dalí, Miró: Two Large One-Man Offerings Under One Roof Portray Plenty of Surrealism." *New York Times* (New York), November 19, 1941 (in The Museum of Modern Art Archives, Public Information Scrapbook no. 52).

JEWELL 1941C
Jewell, Edward Alden. "Mélange: From the Antipodes to Surrealism." *New York Times* (New York), November 23, 1941 (in The Museum of Modern Art Archives, Public Information Scrapbook no. 52).

JEWELL 1941D
Jewell, Edward Alden. "Dalí and Miró Shows Stir Wrath: Layman and Artist Cudgel Paintings and Attack The Museum of Modern Art—The Institution's Relation to the Public." *New York Times* (New York), November 30, 1941 (in The Museum of Modern Art Archives, Public Information Scrapbook no. 52).

JEWETT 1934
Jewett, Eleanor. "Three Exhibits Get Attention at Arts Club: Compositions of Modernist Puzzle Critic." *Chicago Tribune* (Chicago), February 17, 1934 (in Palma II).

JEWETT 1937
Jewett, Eleanor. "Quest Gallery Shows Latest in Surrealism: Critic Says to Leave Your Mind at Home." *Chicago Tribune* (Chicago), March 24, 1937 (in Palma II).

JEWETT 1938A
Jewett, Eleanor. "An Old Blotter Becomes Art in Miró Exhibition." *Chicago Tribune*, [November] 1938 (in Kuh).

JEWETT 1938B
Jewett, Eleanor. "Salisbury Is A and Miró Z of City Art Shows." *Chicago Tribune*, [November] 1938 (in Kuh).

J.F.R. 1919A
J.F.R. "Les Arts plàstiques: Dibuixos de l'Agrupació Courbet (Galeries Laietanes, 17 a 30 maig)." *La Revista* (Barcelona), vol. 5, no. 90 (June 16, 1919), p. 177.

J.F.R. 1919B
J.F.R. "Les Arts plàstiques: Exposició d'art (Palau de Belles Arts, 24 maig a 30 juny)." *La Revista* (Barcelona), vol. 5, no. 90 (June 16, 1919), pp. 176–77.

J.K. 1961
J.K. "Reviews and Previews: Joan Miró." *The Art News* (New York), vol. 60, no. 8 (December 1961), p. 10.

J.L. 1958
J.L. "The Urvater Collection." *The Studio* (London and New York), vol. 156, no. 789 (December 1958), pp. 176–79.

JOFFROY 1979
Joffroy, André Berne, et al. *L'Aventure de Pierre Loeb: La Galerie Pierre, Paris, 1924–1964*. Paris: Musée d'Art Moderne de la Ville de Paris; Brussels: Musée d'Ixelles, 1979.

JOUBIN 1930
Joubin, André. "Le Studio de Jacques Doucet." *L'Illustration* (Paris), vol. 88, no. 4548 (May 3, 1930), pp. 17–20.

JOUFFROY 1955
Jouffroy, Alain. "La Collection André Breton." *L'Oeil* (Paris), no. 10 (October 1955), pp. 32–39.

JOUFFROY 1974
Jouffroy, Alain. "The Corner of the Tablecloth." In Alain Jouffroy and Joan Teixidor, *Miró Sculpture*. New York: Leon Amiel Publisher, 1974.

JOUFFROY/TEIXIDOR 1974
Jouffroy, Alain, and Joan Teixidor. *Miró Sculpture*. New York: Leon Amiel Publisher, 1974.

JUIN 1967
Juin, Herbert. "Miró." *Le Arti* (Milan), vol. 17, no. 3 (March 1967), pp. 8–30.

JUNOY 1918
Junoy, J[osep] M[aria]. "Exposición de primavera en el Palacio de Bellas Artes." *El Sol* (Madrid), vol. 2, no. 130 (May 31, 1918), p. 3.

JUNOY 1925
Junoy, Josep Maria. "Les Idees i les imatges: El Testimoniatge artístic d'en Joan Miró." *La Veu de Catalunya* (Barcelona), vol. 35, no. 9072 (July 9, 1925, morning ed.), p. 7.

J.W.L. 1935
J.W.L. In *Parnassus* (New York), vol. 7, no. 2 (February 1935), p. 21.

J.W.L. 1940
J.W.L. "New Exhibitions of the Week: Joan Miró's Early Wit in Colorful Painting." *The Art News* (New York), vol. 38, no. 24 (March 16, 1940), p. 13.

KAISER-WILHELM MUSEUM 1954
Miró. Krefeld: Kaiser-Wilhelm Museum, 1954.

KELLY 1942
Kelly, Mary. *Sioux City Journal* (Sioux City, Iowa), January 14, 1942 (in The Museum of Modern Art Archives, Public Information Scrapbook no. 52).

KLEIN 1936A
Klein, Jerome. "The Critic Takes a Glance Around the Galleries." *New York Post* (New York), January 18, 1936, p. 26.

KLEIN 1936B
Klein, Jerome. "Exhibit Surveys Joan Miró Work." *New York Post* (New York), December 5, 1936, p. 12.

KLEIN 1937
Klein, Jerome. "Art Comment." *New York Post* (New York), January 9, 1937, p. 12.

KLEIN 1938
Klein, Jerome. "New Talents From Paris." *New York Post* (New York), January 8, 1938, p. 14.

KLEIN 1939A
Klein, Jerome. "Americans Come to Fore in New Art Exhibitions: But European Moderns Are Also in the Picture." *New York Post* (New York), January 7, 1939, p. 5.

KLEIN 1939B
Klein, Jerome. "Classic Nudes in Art on View at Knoedler's: Ides of March." *New York Post* (New York), April 15, 1939, p. 5.

KLEIN 1939C
Klein, Jerome. In *New York Post* (New York), November 4, 1939 (in Matisse).

KLEIN 1940
Klein, Jerome. "Squirming Genius." *New York Post* (New York), March 16, 1940 (in Matisse).

KNOX 1955
Knox, Sanka. "Modern Museum Gets Six Paintings." *New York Times* (New York), August 3, 1955, p. 47.

KNOX 1959
Knox, Sanka. "Painting Proves Hard to Borrow." *New York Times* (New York), February 24, 1959, p. L26.

KOCHNITZKY 1934
Kochnitzky, Léon. "Le Strapontin volant à Zurich." *Les Nouvelles littéraires, artistiques et scientifiques* (Paris), vol. 12, no. 628 (October 27, 1934), p. 6.

KOCHNO 1970
Kochno, Boris. *Diaghilev and the Ballets Russes*. Translated by Adrienne Foulke. New York: Harper & Row, 1970.

KOELLA 1992
Koella, Rudolf, and Dieter Schwarz, eds. *Kunstmuseum Winterthur: Modern Art from the Collection of the Kunstverein Insel Verlag*. Frankfurt: Insel Verlag, 1992.

KOENIG 1934
Koenig, Leon. "Les Surréalistes, 'Le Minotaure' à Bruxelles." *Anthologie der Modern Art* (Liège), June 1, 1934 (in Palma II).

KOSPOTH 1937
Kospoth, B. J. "Fleeting Phases of Modern Art Seen in Jeu de Paume Show." *New York Herald Tribune*, September 21, 1937 (in Palma II).

KRAMER 1959
Kramer, Hilton. "Month in Review." *Arts* (New York), vol. 33, no. 8 (May 1959), pp. 48–51.

KRAMER 1968
Kramer, Hilton. "The Secret History of Dada and Surrealism." *Art in America* (New York), vol. 56, no. 2 (March–April 1968), pp. 108–12.

KRAUSS 1972
Krauss, Rosalind. "Magnetic Fields: The Structure." In *Joan Miró: Magnetic Fields*. New York: Solomon R. Guggenheim Museum, 1972.

KRAUSS/ROWELL 1972
Krauss, Rosalind, and Margit Rowell. "Catalogue of the Exhibition." In *Joan Miró: Magnetic Fields*. New York: Solomon R. Guggenheim Museum, 1972.

KRUSE 1941A
Kruse, A. Z. *Brooklyn Daily Eagle* (New York), January 5, 1941 (in Matisse).

KRUSE 1941B
Kruse, A. Z. "At the Art Galleries: A Critic Looks upon Salvador Dalí and Finds Him 'Prosaic Painter.'" *Brooklyn Daily Eagle* (Brooklyn, N.Y.) November 30, 1941 (in The Museum of Modern Art Archives, Public Information Scrapbook no. 52).

KUNSTLER 1935
Kunstler, Charles. "Les Arts: Expositions." *L'Intransigeant* (Paris), June 13, 1935, p. 4.

KUNSTMUSEUM BERN 1960
Aus der Sammlung Kunstmuseum Bern. Bern: Kunstmuseum Bern, 1960.

KUNSTMUSEUM WINTERTHUR 1976
Katalog: Sammlung der Gemälde und Plastischen des Kunstvereins. Winterthur: Kunstmuseum Winterthur, 1976.

KUNZ 1988
Kunz, Martin, ed. *Von Matisse bis Picasso: Hommage an Siegfried Rosengart*. Stuttgart: Verlag Gerd Hatje, 1988.

LADER 1982
Lader, Melvin P. "Howard Putzel: Proponent of Surrealism and Early Abstract Expressionism in America." *Arts* (New York), vol. 56, no. 7 (March 1982), pp. 85–96.

LALOY 1926
Laloy, Louis. "L'Enchantement des Ballets Russes." *Le Figaro* (Paris), vol. 73, no. 132 (May 12, 1926), p. 1.

LANCASTER 1952
Lancaster, Osbert. "The End of the Modern Movement in Architecture." *Architectural Record* (New York), vol. 112, no. 3 (September 1952), pp. 115–23.

LANCHNER 1987
Lanchner, Carolyn. "Klee in America." In Carolyn Lanchner, ed., *Paul Klee*. New York: The Museum of Modern Art, 1987.

LANE 1939
Lane, James W. "Caviar from Contemporary Paris: Selected Pictures Illustrating Quality in French Painting." *The Art News* (New York), vol. 38, no. 5 (November 4, 1939), pp. 10, 17.

LANE 1941
Lane, James W. "Milestones of Modern Taste from 1915 to 1940." *The Art News* (New York), vol. 39, no. 14 (January 4, 1941), pp. 10–11.

LANNES 1938
Lannes, Roger. "On se souvient d'Apollinaire." *Le Journal*, June 21, 1938 (in Palma II).

LAROSE 1979
Larose, Françoise. "La Marionnette, c'est la fête." *Actualité de la scénographie* (Paris), vol. 2, no. 9 (February 1979), p. 48.

LARREA 1937
Larrea, Juan. "Miroir d'Espagne: A propos du *Faucheur* de Miró au Pavillon Espagnol de l'Exposition 1937." *Cahiers d'art* (Paris), vol. 12, nos. 4–5 (1937), pp. 157–59.

LASSAIGNE 1945
Lassaigne, Jacques. "Peintres et sculpteurs." *La Bataille*, May 3, 1945 (in Palma II).

LASSAIGNE 1963
Lassaigne, Jacques. *Miró*. Lausanne: Editions d'Art Albert Skira, 1963.

LEE 1947
Lee, Francis. "Interview with Miró." *Possibilities* (New York), no. 1 (Winter 1947–48), pp. 66–67.

LEIDER 1968
Leider, Philip. "Dada, Surrealism, and Their Heritage, 1: A Beautiful Exhibition." *Artforum* (New York), vol. 6, no. 9 (May 1968), pp. 22–23.

LEIRIS 1926
Leiris, Michel. "Joan Miró." *The Little Review* (New York), vol. 12, no. 1 (Spring–Summer 1926), pp. 8–9.

LEIRIS 1929
Leiris, Michel. "Joan Miró." *Documents* (Paris), vol. 1, no. 5 (1929), pp. 263–69.

LEIRIS 1961
Leiris, Michel. "Marrons sculptés pour Miró." In *Joan Miró: Oeuvre graphique original, céramiques*. Geneva: Musée de l'Athénée, 1961.

LEON-MARTIN 1925
Leon-Martin, Louis. "Coups de bichon: A la galerie Pierre—Joan Miro [*sic*]." *Paris-Soir* (Paris), vol. 3, no. 629 (June 26, 1925), p. 2.

LEON-MARTIN 1934
Leon-Martin, Louis. "Arts, danse . . . cuisine: Lucullus chez Cardo." *Paris-Soir* (Paris), vol. 12, no. 3873 (May 15, 1934), p. 6.

LERNER 1980
Lerner, Abram. Foreword to Charles W. Millard, *Miró: Selected Paintings*. Washington, D.C.: Smithsonian Institution Press and the Hirshhorn Museum and Sculpture Garden, 1980.

LESBATS 1931
Lesbats, Roger. "Les Arts: Joan Miró." *Le Populaire* (Paris), vol. 14, no. 3244 (December 26, 1931), p. 4.

LEVAILLANT 1990
Levaillant, Françoise, ed. *André Masson: Les Années surréalistes—Correspondance, 1916–1942*. Paris: La Manufacture, 1990.

LEYMARIE 1974A
Leymarie, Jean. Preface to *Joan Miró*. Paris: Editions des Musées Nationaux and Grand Palais, 1974.

LEYMARIE 1974B
Leymarie, Jean. "Joan Miró." *Louisiana Revy* (Humlebaek), vol. 15, no. 3 (November 1974), pp. 4–7.

LHOTE 1937
Lhote, André. "La Peinture: Dictature de la qualité à l'Expo 37." *Ce Soir* (Paris), vol. 1, no. 256 (November 13, 1937), p. 2.

LIBRE BELGIQUE 1952
La Libre Belgique (Brussels), May 8, 1952 (in Palma IV).

LIEBERMAN 1948
Lieberman, William S. "Modern French Tapestries." *The Metropolitan Museum of Art Bulletin* (New York), vol. 6, no. 5 (January 1948), pp. 142–49.

LIEBERMAN 1989
Lieberman, William S., ed. *Twentieth-Century Modern Masters: The Jacques and Natasha Gelman Collection*. New York: The Metropolitan Museum of Art, 1989.

LIFAR 1940
Lifar, Serge. *Serge Diaghilev: His Life, His Work, His Legend—An Intimate Biography*. New York: G. P. Putnam's Sons, 1940.

LIMBOUR 1947
Limbour, Georges. "Souvenirs sur un peintre: Joan Miró." *Arts de France* (Paris), nos. 17–18 (1947), pp. 47–50.

LIPPARD 1965
Lippard, Lucy R. "New York Letter: Miró and Motherwell." *Art International* (Lugano), vol. 9, nos. 9–10 (December 20, 1965), pp. 33–35.

LISEUR 1937
Le Liseur. "A l'Expo." *Paris-Midi* (Paris), vol. 27, no. 3232 (November 15, 1937), p. 7.

LISSIM 1930
Lissim, Simon. "Les Beaux Arts: L'Exposition des Ballets Russes (Galerie Billiet)." *Chantecler* (Paris), vol. 5, no. 229 (October 25, 1930), p. 5.

LIVERPOOL DAILY POST 1938
Liverpool Daily Post (Liverpool), May 19, 1938 (in Mayor).

LLORCA 1990
Llorca, Vicent. "Joan Miró, uma cronologia." In *Os Mirós de Miró*. Porto: Fundação de Serralves, 1990.

LLOYD/DESMOND 1992
Lloyd, Michael, and Michael Desmond. *European and American Paintings and Sculptures, 1870–1970, in the Australian National Gallery*. Canberra: Australian National Gallery, 1992.

LOEB 1946
Loeb, Pierre. *Voyages à travers la peinture*. Paris: Bordas, 1946.

LONDON BULLETIN 1938
"Catalogue of Miró Exhibition." *London Bulletin* (London), no. 2 (May 1938), pp. 3–5.

LONDON BULLETIN 1939
"Catalogue of Joan Miró Exhibition." *London Bulletin* (London), no. 13 (April 15, 1939), p. 2.

LONG ISLAND PRESS 1941
"Forest Hills Women to Visit Museum of Modern Art." *Long Island Press* (Jamaica, N.Y.), November 20, 1941 (in The Museum of Modern Art Archives, Public Information Scrapbook no. 52).

LONNGREN 1964
L[onngren], L[illian]. "Reviews and Previews: Joan Miró and Joseph [*sic*] Llorens Artigas." *The Art News* (New York), vol. 62, no. 9 (January 1964), p. 10.

LÓPEZ RODRÍGUEZ 1985
López Rodríguez, Artur. "L'Escola d'art de Francesc d'A. Galí." *Serra d'or* (Montserrat), nos. 310–11 (July–August 1985), pp. 74–78.

LOUISIANA REVY 1974
Louisiana Revy (Humlebaek), vol. 15, no. 3 (November 1974).

LOWE 1939
Lowe, Jeannette. "Modern Masters in Their Youth: Eight Precocious Painters." *The Art News* (New York), vol. 37, no. 16 (January 14, 1939), pp. 13, 24.

LUBAR 1987
Lubar, Robert S. "Miró Before *The Farm*: A Cultural Perspective." In *Joan Miró: A Retrospective*. New York: Solomon R. Guggenheim Museum; New Haven, Conn.: Yale University Press, 1987.

LUBAR 1988
Lubar, Robert S. "Joan Miró Before *The Farm*, 1915–1922: Catalan Nationalism and the Avant-garde." Ph.D. dissertation, New York University, October 1988.

LUBAR/MARTÍ/ESCUDERO 1987
Lubar, Robert S., Teresa Martí i Armengol, and Carme Escudero i Anglès. "Selected Bibliography, 1961–86." In *Joan Miró: A Retrospective*. New York: Solomon R. Guggenheim Museum; New Haven, Conn.: Yale University Press, 1987.

LYNTON 1964
Lynton, Norbert. "London Letter: Miró." *Art International* (Lugano), vol. 8, no. 9 (November 25, 1964), p. 44.

M. 1925
M. "Les Petites Expositions." *La Semaine à Paris* (Paris), no. 183 (November 27–December 4, 1925), pp. 116–20.

M.A. 1933
M.A. "Los 'Ibéricos' en el extranjero: Exposiciones en Copenhague y Berlín." *Arte: Revista de la Sociedad de Artistas Ibéricos*, vol. 11, no. 11 (June 1933), pp. 31–32.

MACMILLAN 1982
Macmillan, Duncan. "Miró's Public Art." In Barbara Rose, *Miró in America*. Houston: The Museum of Fine Arts, 1982.

MAILFEET 1938
Mailfeet, Denise. "Le Salon surréaliste." *Jeunesse de France*, February 6, 1938 (in Palma II).

MAINICHI SHINBUN 1966A
Mainichi Shinbun, July 16, 1966 (special issue), p. 1.

MAINICHI SHINBUN 1966B
Mainichi Shinbun, September 3, 1966 (evening ed.), p. 1.

MAINICHI SHINBUN 1966C
Mainichi Shinbun, September 8, 1966 (evening ed.), p. 1.

MALET 1983A
Malet, Rosa Maria. "Joan Miró: Working Processes." In *Joan Miró: Anys vint — Mutació de la realitat*. Barcelona: Fundació Joan Miró, 1983.

MALET 1983B
Malet, Rosa Maria. *Joan Miró*. Barcelona: Ediciones Polígrafa, 1983.

MALET 1986
Malet, Rosa Maria. "El Objeto en la obra de Joan Miró: De la superficie al volumen." In Gloria Moure, *Miró escultor*. Madrid: Ministerio de Cultura, 1986.

MALET 1988A
Malet, Rosa Maria. "Joan Miró: El Surrealisme entre l'afinitat i la divergència." In *Surrealisme a Catalunya, 1924–1936: De "L'Amic de les arts" al Logicofobisme*. Barcelona: Centre d'Art Santa Mònica, 1988.

MALET 1988B
Malet, Rosa Maria. "De l'assassinat de la pintura a les Constel·lacions." In *Impactes: Joan Miró, 1929–1941*. Barcelona: Fundació Joan Miró, 1988.

MALET 1989
Malet, Rosa Maria. "From the Murder of Painting to the Constellations." In *Joan Miró: Paintings and Drawings, 1929–1941*. London: Whitechapel Art Gallery, 1989.

MANDELBAUM 1968
Mandelbaum, Ellen. "Dada, Surrealism, and Their Heritage, 3: Surrealist Composition — Surprise Syntax." *Artforum* (New York), vol. 6, no. 9 (May 1968), pp. 32–35.

MARC 1945
Marc, Jean. *Le Populaire*, April 28, 1945 (in Palma II).

MARCHIORI 1972
Marchiori, Giuseppe. "Miró Through the Years." In G. di San Lazzaro, ed., *Homage to Miró*. New York: Tudor Publishing Co., 1972. Special issue of the review *XXᵉ Siècle*.

MARCIAL 1920A
Marcial, [Marco Valerio]. "Del extranjero: Los artistas catalanes en el Salón de Otoño." *Las Noticias* (Barcelona), vol. 25, no. 8885 (October 14, 1920), p. 6.

MARCIAL 1920B
Marcial, M[arco] V[alerio]. "Desde París: El Salón de Otoño, III." *Las Noticias* (Barcelona), vol. 25, no. 8895 (October 26, 1920), p. 3.

MARCK 1984
Marck, Jan van der. "The Miró Amidst Us." In *Joan Miró in Miami*. Miami: Center for the Fine Arts, 1984.

MARÉS DEULOVOL 1964
Marés Deulovol, Federico. *Dos Siglos de enseñanza artística en el Principado*. Barcelona: Real Academia de Bellas Artes de San Jorge, 1964.

MARIANNE 1938
"Les Expositions: Joan Miró (Galerie Pierre)." *Marianne* (Paris), vol. 6, no. 321 (December 14, 1938), p. 11.

MARIE-LOUISE JEANNERET ART MODERNE 1979
"Selection de la donation James Thrall Soby, Musée d'Art Moderne, New York." In *Hommage à James Thrall Soby*. Geneva: Marie-Louise Jeanneret Art Moderne, 1979.

MARINEL·LO 1919
Marinel·lo, Manuel. "Crónica de arte: La Exposición de Arte, III." *Las Noticias* (Barcelona), vol. 24, no. 8458 (June 16, 1919), p. 2.

MARQUINA 1926A
Marquina, Rafel. "De Madrid estant: Exposició d'art català, I." *La Veu de Catalunya* (Barcelona), vol. 36, no. 9250 (January 23, 1926, morning ed.), p. 5.

MARQUINA 1926B
Marquina, Rafel. "De Madrid estant: Exposició d'art català." *La Veu de Catalunya* (Barcelona), vol. 36, no. 9254 (January 27, 1926, morning ed.), p. 5.

MARTÍN 1982
Martín Martín, Fernando. *El Pabellón español en la Exposición Universal de París en 1937*. Seville: Servicio de Publicaciones de la Universidad de Sevilla, 1982.

MASTAI 1961
Mastai, M. L. D'Otrange. "New York News: Tip of a Spark Is a Surface." *Apollo* (London), vol. 75, no. 442 (December 1961), pp. 194–95.

MAUNY 1930
Mauny, Jacques. "New-York Letter." *Formes* (Paris), no. 7 (July 1930), pp. 21–23.

MAUR/INBODEN 1982
Maur, Karin v., and Gudrun Inboden, eds. *Malerei und Plastik des 20. Jahrhunderts*. Stuttgart: Staatsgalerie Stuttgart, 1982.

MCBRIDE 1928A
McBride, Henry. "Modern Art." *The Dial* (Chicago), vol. 85 (December 1928), pp. 526–28.

MCBRIDE 1928B
McBride, Henry. "Gallery of Living Art Adds to Its Permanent Collection." *New York Sun* (New York), December 8, 1928, p. 9.

MCBRIDE 1930A
McBride, Henry. "The Palette Knife." *Creative Art* (New York), vol. 6, no. 1 (January 1930), pp. sup. 9–11.

MCBRIDE 1930B
McBride, Henry. "Mystic Art of Jean [*sic*] Miró: A Difficult Parisian Shows Here at the Valentine Gallery." *New York Sun* (New York), October 25, 1930, p. 8.

MCBRIDE 1934
McBride, Henry. "Attractions in Other Galleries." *New York Sun* (New York), January 6, 1934, p. 11.

MCBRIDE 1935
McBride, H[enry]. "New Work by Miró Entrances: Modern Spanish Master Attracts Attention of Elite." *New York Sun* (New York), January 19, 1935, p. 32.

MCBRIDE 1936A
McBride, H[enry]. "Attractions in the Galleries." *New York Sun* (New York), January 18, 1936, p. 16.

MCBRIDE 1936B
McBride, Henry. "Exhibition of Abstract Art at The Museum of Modern Art." *The New York Sun* (New York), March 7, 1936. Reprinted in *The Flow of Art: Essays and Criticisms of Henry McBride*, ed. Daniel Catton Rich. New York: Atheneum Publishers, 1975.

MCBRIDE 1936C
McB[ride], H[enry]. "Joan Miró's New Show: Pierre Matisse Gallery First in the Arena of Sur-realism." *New York Sun* (New York), December 5, 1936, p. 43.

McBride 1937a
McBride, H[enry]. In *New York Sun* (New York), January 9, 1937, p. 37.

McBride 1937b
McB[ride], H[enry]. "Photography or Painting? Modern Museum Presents a Past While Suggesting a Future." *New York Sun* (New York), March 20, 1937, p. 18.

McBride 1937c
McBride, Henry. "Modern French Drawings: Picasso and Miró Again Make Difficulties for the Unwary." *New York Sun* (New York), April 17, 1937, p. 18.

McBride 1938a
McBride, Henry. "Meet Mr. Balthus, Painter: A New French Artist Makes a Promising Debut in N.Y." *New York Sun* (New York), January 8, 1938, p. 12.

McBride 1938b
McBride, Henry. "Abstract Art by Miró: Spanish Master Enchants the Few and Puzzles Many." *New York Sun* (New York), April 23, 1938, p. 10.

McBride 1939a
McBride, Henry. "Attractions in the Galleries." *New York Sun* (New York), January 7, 1939, p. 15.

McBride 1939b
McBride, Henry. "Attractions in the Galleries." *New York Sun* (New York), April 15, 1939, p. 10.

McBride 1939c
McBride, Henry. "Modern French Art: Pre-War Pictures by Parisians Shown at Matisse Gallery." *New York Sun* (New York), November 4, 1939, p. 9.

McBride 1940
McBride, Henry. "Varied Gallery Attractions." *New York Sun* (New York), March 16, 1940, p. 8.

McBride 1941
McB[ride], H[enry]. "Dalí and Miró." *New York Sun* (New York), November 21, 1941 (in The Museum of Modern Art Archives, Public Information Scrapbook no. 52).

McBride 1947
McBride, Henry. "Joan Miró Is Here: Noted Spanish Painter Comes to New York to See His Own Pictures." *New York Sun* (New York), May 16, 1947, p. 29.

McCandless 1982
McCandless, Judith. "Miró Seen by His American Critics." In Barbara Rose, *Miró in America*. Houston: The Museum of Fine Arts, 1982.

McCausland 1936
McCausland, Elizabeth. "Work of Man Ray, Miró, and Salvadore [sic] Dalí." *Springfield Union and Republican* (Springfield, Mass.), December 27, 1936 (in Matisse).

McCausland 1941
McCausland, Elizabeth. "Miró Shows at Matisse, Léger at Marie Harriman." *Springfield Union and Republican* (Springfield, Mass.), March 9, 1941 (in Matisse).

McCormick 1930
McCormick, William B. "Paris Modern Works Rouse Ire of Critic." *Plain Dealer* (Cleveland), January 25, 1930 (in Palma I).

McEvilley 1988
McEvilley, Thomas. "La Peinture monochrome . . ." In *La Couleur seule: L'Expérience du monochrome*. Lyon: Musée Saint-Pierre Art Contemporain, 1988.

McNeil 1936
McNeil, Warren A. "Fantastic Art Having Its Day in Gotham Now." *Buffalo Courier Express* (Buffalo), December 13, 1936 (in Palma II).

Melgar 1931
Melgar, Francisco. "Los Artistas españoles en París: Juan [sic] Miró." *Ahora* (Madrid), January 24, 1931, pp. 16–18.

Melià 1975
Melià, Josep. *Joan Miró: Vida y testimonio*. Barcelona: DOPESA, 1975.

Mellquist 1952
Mellquist, Jerome. "Paris Revisited by American-Owned Masterpieces." *The Art Digest* (New York), vol. 26, no. 17 (June 1, 1952), pp. 6–8.

Mercereau 1920
Mercereau, Alexandre. "Le Salon d'Automne." *Les Hommes du jour* (Paris), n.s., no. 6 (October–November 1920), pp. 3–16.

Messaggero di Roma 1952
Il Messaggero di Roma, July 22, 1952 (in Palma IV).

Messer 1987
Messer, Thomas M. "Miró's *Alicia* Mural at the Guggenheim." In *Joan Miró: A Retrospective*. New York: Solomon R. Guggenheim Museum; New Haven, Conn.: Yale University Press, 1987.

Meuse 1928
"Chronique des Beaux Arts: Palais des Beaux Arts: Les Expositions." *La Meuse* (Liège), December 18, 1928, p. 3.

Meuse 1929
"Galerie 'Le Centaure': M. Jean [sic] Miró." *La Meuse* (Liège), May 17, 1929, p. 5.

Meyers 1985
Meyers, Jeffrey. *Hemingway: A Biography*. New York: Harper & Row, Publishers, 1985.

Millard 1980
Millard, Charles W. "Miró." In Charles W. Millard, *Miró: Selected Paintings*. Washington, D.C.: Smithsonian Institution Press and the Hirshhorn Museum and Sculpture Garden, 1980.

Milo 1929
Milo, Jan. "Jeune Peinture espagnole (Palais des Beaux-Arts)." *Cahiers de Belgique* (Brussels), vol. 2, no. 1 (January 1929), p. 41.

Milo 1935
Milo, Jean. "Expositions: En Belgique." *Beaux-Arts* (Paris), vol. 73, no. 148 (November 1, 1935), p. 8.

Minotaure 1937
Minotaure (Paris), 3rd ser., vol. 4, no. 10 (Winter 1937), pp. 31, 58.

Miró 1938
Miró, Joan. "Je rêve d'un grand atelier." *XXᵉ Siècle* (Paris), vol. 1, no. 2 (May–June 1938), pp. 25–28.

Miró 1939
Miró, Joan. "Harlequin's Carnival." *Verve* (Paris), vol. 1, no. 4 (January–March 1939), p. 85.

Miró 1945–46
Miró, Joan. "Jeux poétiques (poèmes)." *Cahiers d'art* (Paris), vols. 20–21 (1945–46), pp. 269–76.

Miró 1959
Miró, Joan. "Je rêve d'un grand atelier." *XXᵉ Siècle* (Paris), vol. 21, no. 13 (December 1959), pp. 29–35.

Miró 1961
Miró, Joan. "Propos de Joan Miró recueillis par Rosamond Bernier." *L'Oeil* (Paris), nos. 79–80 (July–August 1961), pp. 12–19.

Miró 1964
Miró, Joan. *Je travaille comme un jardinier*. Paris: Société Internationale d'Art XXᵉ Siècle, 1964.

Miró 1965
Miró, Joan. In *Aperture* (New York), vol. 12, no. 3 (1965), pp. 106–07.

Miró 1977
Miró, Joan. *"Ceci est la couleur de mes rêves": Entretiens avec Georges Raillard*. Paris: Editions du Seuil, 1977.

Miró 1987
Miró, Joan. "Memories of the Rue Blomet." In *Joan Miró: A Retrospective*. New York: Solomon R. Guggenheim Museum; New Haven, Conn.: Yale University Press, 1987.

Mirror 1941
Mirror (New York), November 1941 (in The Museum of Modern Art Archives, Public Information Scrapbook no. 52).

M.M. 1934
M.M. "Pierre Matisse Exhibits Miró." *The Art News* (New York), vol. 32, no. 14 (January 6, 1934), p. 4.

M.M. 1935
M.M. "Joan Miró: Pierre Matisse Galleries." *The Art News* (New York), vol. 33, no. 16 (January 19, 1935), p. 9.

Moeller 1985
Moeller, Magdalena M., ed. *Sprengel Museum Hannover: Malerei und Plastik des 20. Jahrhunderts*. Hannover: Sprengel Museum Hannover, 1985.

MoMA Bulletin 1955
"Paintings from Private Collections." *The Museum of Modern Art Bulletin* (New York), vol. 22, no. 4 (Summer 1955), pp. 9–35.

MoMA Bulletin 1956
"Painting and Sculpture Acquisitions: June 1, 1953, through June 30, 1955." *The Museum of Modern Art Bulletin* (New York), vol. 23, no. 3 (1956), pp. 34–39.

MoMA Bulletin 1958
"Works of Art: Given or Promised." *The Museum of Modern Art Bulletin* (New York), vol. 36, no. 1 (Fall 1958), pp. 12–52.

MoMA Bulletin 1962a
"The Drawing Collection and New Acquisitions." *The Museum of Modern Art Bulletin* (New York), vol. 29, no. 1 (1962), p. 14.

MoMA Bulletin 1962b
"Painting and Sculpture Acquisitions: January 1, 1961, through December 31, 1961." *The Museum of Modern Art Bulletin* (New York), vol. 29, nos. 2–3 (1962), p. 36.

Monde 1945
"A Travers les expositions." *Monde*, July 25, 1945 (in Palma II).

Monitor 1930
Monitor. "Tres Pinturas catalanas recientes." *La Gaceta literaria* (Madrid), vol. 4, no. 79 (April 1, 1930), pp. 9–10.

MONOD-FONTAINE 1991
Monod-Fontaine, Isabelle. "Le Tour des objets." In Agnès Angliviel de la Beaumelle, Isabelle Monod-Fontaine, and Claude Schweisguth, eds., *André Breton: La Beauté convulsive*. Paris: Editions du Centre Pompidou, 1991.

MONTPAR. 1925A
Montpar. "Art: Les Petites Expositions." *La Semaine à Paris* (Paris), no. 160 (June 19–26, 1925), pp. 70–71.

MONTPAR. 1925B
Montpar. "Art: Les Petites Expositions." *La Semaine à Paris* (Paris), no. 161 (June 27–July 3, 1925), pp. 76–77.

MONTPAR. 1925C
Montpar. "La Peinture surréaliste." *La Semaine à Paris* (Paris), no. 182 (November 20–27, 1925), pp. 113–15.

MONTPAR. 1926A
Montpar. "Les Beaux-Arts: Les Petites Expositions." *Chantecler* (Paris), vol. 1, no. 30 (November 20, 1926), p. 5.

MONTPAR. 1926B
Montpar. "A fermé la nuit." *La Semaine à Paris* (Paris), no. 234 (November 19–26, 1926), pp. 67–68.

MONTPAR. 1928A
Montpar. "Les Petites Expositions: Groupes surréalistes." *Chantecler* (Paris), vol. 3, no. 90 (January 14, 1928), p. 5.

MONTPAR. 1928B
Montpar. "Il était une petit pie." *La Semaine à Paris* (Paris), December 21, 1928 (in Palma I).

MORNAC 1945
Mornac, Jean. "Dans les galeries." *France d'abord*, March 29, 1945 (in Palma II).

MORRIS 1938
Morris, George L. K. "Art Chronicle: Miró and the Spanish Civil War." *Partisan Review* (New York), vol. 4, no. 3 (February 1938), pp. 32–33.

MORRIS 1942
Morris, George L. K. "Art Chronicle: Sweeney, Soby and Surrealism." *Partisan Review* (New York), vol. 9, no. 2 (March–April 1942), pp. 125–27.

MORSELL 1936
Morsell, Mary. "Matisse Display Vividly Reveals Modern Trends: Large Works by Eight Moderns Found in Notable Exhibition Ranging from Cubist Theory to Sheer Romanticism." *The Art News* (New York), vol. 34, no. 16 (January 18, 1936), pp. 3, 5, 17.

MORTENSEN 1974
Mortensen, Richard. "Joan Miró." *Louisiana Revy* (Humlebaek), vol. 15, no. 3 (November 1974), pp. 34–35.

MOTHERWELL 1959
Motherwell, Robert. "The Significance of Miró." *The Art News* (New York), vol. 58, no. 4 (May 1959), pp. 32–33, 65–67.

M.R. 1943
M.R. "War and the Artist — Sans Propaganda." *The Art Digest* (New York), vol. 17, no. 12 (March 15, 1943), p. 12.

MUMFORD 1932
Mumford, Lewis. "Marin, Miró." *The New Yorker* (New York), vol. 8 (November 19, 1932), pp. 77–78.

MUMFORD 1935
Mumford, Lewis. "The Art Galleries: Platitudes in Paint — Charm and Humanity — The Jokes of Miró." *The New Yorker* (New York), no. 50 (January 26, 1935), pp. 50–54.

MUMFORD 1936
Mumford, Lewis. "The Art Galleries: Surrealism and Civilization." *The New Yorker* (New York), [1936] (in Palma II).

MUNSTERBERG 1958
M[unsterberg], H[ugo]. "In the Galleries: Joan Miró." *Arts* (New York), vol. 33, no. 3 (December 1958), p. 53.

MURRAY 1941
Murray, Marian. "Thousands Flock to See Dalí Exhibition Arranged by James T. Soby: Retrospective Show of Surrealist Seen at Modern Museum." *Hartford Times* (Hartford), December 6, 1941 (in The Museum of Modern Art Archives, Public Information Scrapbook no. 52).

MUSEUM OF ART 1991
Oeuvres de Joan Miró: Collection Maeght. Osaka: Museum of Art, 1991.

MYCHO 1929
Mycho, André. "Notre Enquête: Que pensez-vous de la peinture moderne?" *L'Oeuvre*, May 28, 1929 (in Palma I).

NADEAU 1989
Nadeau, Maurice. *The History of Surrealism*. Translated by Richard Howard. Cambridge, Mass.: Belknap Press of Harvard University Press, 1989.

NASH 1979
Nash, Steven A. *Painting and Sculpture from Antiquity to 1942*. New York: Rizzoli; Buffalo: Albright-Knox Art Gallery, 1979.

N.D.L.R. 1931
N.D.L.R. "Exposition Miró de sculptures-objets." *Cahiers d'art* (Paris), vol. 6, nos. 9–10 (1931), p. 431.

NEUE PARISER ZEITUNG 1930
"Aus den Galerien." *Neue Pariser Zeitung*, April 20, 1930 (in Palma I).

NEW MASSES 1941
New Masses (New York), December 13, 1941 (in The Museum of Modern Art Archives, Public Information Scrapbook no. 52).

NEW STATESMAN AND NATION 1938
"Plays and Pictures." *The New Statesman and Nation* (London), May 14, 1938 (in Mayor).

NEW YORK AMERICAN 1936
"French Moderns." *New York American* (New York), January 18, 1936 (in Matisse).

NEW YORK AMERICAN 1937
"Parade of French Painting Exhibitions Continues Unabated: French Moderns." *New York American* (New York), no. 19533 (January 9, 1937), p. 8.

NEW YORK HERALD TRIBUNE 1931
"News and Comment on Current Art Events." *New York Herald Tribune* (New York), September 27, 1931, section 8, p. 8.

NEW YORK HERALD TRIBUNE 1936A
"Eight Modern Painters." *New York Herald Tribune* (New York), January 19, 1936, section 5, p. 10.

NEW YORK HERALD TRIBUNE 1936B
"Fur-Lined Cup School of Art Gets Spotlight: Modern Museum Showing Dada, Surrealism, and Frankly Insane Works." *New York Herald Tribune* (New York), December 9, 1936, p. 23.

NEW YORK HERALD TRIBUNE 1938
"Modern French Art." *New York Herald Tribune* (New York), January 9, 1938, p. 8.

NEW YORK HERALD TRIBUNE 1939
"Some Modern Frenchmen." *New York Herald Tribune* (New York), January 8, 1939, p. 8.

NEW YORK HERALD TRIBUNE 1941A
"Dinners Precede Show of Dalí and Miró Art: Wheeler, Barr, Warren Clark Guests Meet." *New York Herald Tribune* (New York), November 19, 1941 (in The Museum of Modern Art Archives, Public Information Scrapbook no. 52).

NEW YORK HERALD TRIBUNE 1941B
"Museum Opens a Show of Dalí and Miró: Complete Survey of Work of Surrealists Given in Modern Art Exhibitions." *New York Herald Tribune* (New York), November 19, 1941 (in The Museum of Modern Art Archives, Public Information Scrapbook no. 52).

NEW YORK HERALD TRIBUNE 1941C
"Salvador Dalí." *New York Herald Tribune* (New York), November 30, 1941 (in The Museum of Modern Art Archives, Public Information Scrapbook no. 52).

NEW YORK HERALD TRIBUNE 1945
New York Herald Tribune (New York), December 28, 1945 (in Palma II).

NEW YORK JOURNAL AMERICAN 1941
"Museum of Modern Art Shows Dalí, Miró Works." *New York Journal American* (New York), November 30, 1941 (in The Museum of Modern Art Archives, Public Information Scrapbook no. 52).

NEW YORK POST 1938A
"Miró Warms Up His Curves." *New York Post* (New York), April 23, 1938, p. 12.

NEW YORK POST 1938B
"About Renoir, Miró, and Others." *New York Post* (New York), April 23, 1938, p. 12.

NEW YORK SUN 1932
"Attractions in the Gallery." *New York Sun* (New York), November 5, 1932, p. 10.

NEW YORK SUN 1941
New York Sun (New York), November 28, 1941 (in The Museum of Modern Art Archives, Public Information Scrapbook no. 52).

NEW YORK TIMES 1929
"To Show Eighteen New Paintings: Gallery of Living Art of N.Y.U. Acquires Exhibit for November." *New York Times* (New York), October 17, 1929, p. 29.

NEW YORK TIMES 1936
"Miró Is As Miró Does." *New York Times* (New York), December 6, 1936, p. 12.

NEW YORK TIMES 1938A
"Paris Joke: Art World Ponders Surrealist Show." *New York Times* (New York), March 6, 1938, p. X9.

NEW YORK TIMES 1938B
"Other Shows: Joan Miró." *New York Times* (New York), April 24, 1938, p. X7.

NEW YORK TIMES 1941
New York Times (New York), November 25, 1941 (in The Museum

of Modern Art Archives, Public Information Scrapbook no. 52).

NEW YORK TIMES 1959
"President Eisenhower Presents Award to Miró, Spanish Artist." *New York Times* (New York), May 19, 1959, p. 15.

NEW YORK TIMES 1983
"Friends and Relatives Honor Miró at a Service on Majorca." *New York Times* (New York), December 28, 1983, p. A20.

NEW YORK WORLD TELEGRAM 1940
"Pierre Matisse Interprets Joan Miró's Exhibition." *New York World Telegram* (New York), March 16, 1940 (in Matisse).

NEW YORKER 1941
"Athlete and Aesthete." *The New Yorker* (New York), December 13, 1941 (in The Museum of Modern Art Archives, Public Information Scrapbook no. 52).

NEWTON 1938
Newton, Eric. "Unacademic Art: Adventurousness in Paint." *The Sunday Times* (London), no. 6004 (May 8, 1938), p. 13.

NORDLAND 1962A
Nordland, Gerald. "Los Angeles Letter." *Das Kunstwerk* (Baden-Baden), vol. 5–6, no. 16 (November 1962), p. 67.

NORDLAND 1962B
Nordland, Gerald. "Report from Los Angeles." *Arts Magazine* (New York), vol. 37, no. 3 (December 1962), pp. 54–56.

OBSERVATEUR 1951
"Sur quatre murs." *L'Observateur*, May 10, 1951 (in Palma III).

OBSERVER 1933
"Mr. Joan Miró." *The Observer* (London), July 16, 1933 (in Mayor; in Palma II).

O.F. 1918
O.F. "Les Tendències artístiques en l'actual exposició d'art." *D'ací i d'allà* (Barcelona), vol. 1, no. 6 (June 10, 1918), pp. 502–11.

OKADA 1974
Okada, Takahiko. *Miró*. Tokyo: Shinchosha, 1974.

OLIVER 1918
Oliver, Pere. "Sala Dalmau: Joan Miró." *Vell i nou* (Barcelona), vol. 4, no. 62 (March 1, 1918), p. 89.

OMER 1930
Omer, Georges. "Un 'Potlach' au Musée du Trocadéro: Pour la réception du premier mât totémique arrivé en France." *Paris-Midi* (Paris), vol. 20, no. 1402 (March 15, 1930), p. 2.

OOKA 1984
Ooka, Makoto. "Joan Miró: Witness of the Earth Force and Freedom." In *Miró*. Fukushima: Fukushima Prefectural Museum of Modern Art in collaboration with Fuji Television Gallery, 1984.

ORSANMICHELE 1979
Joan Miró: Pittura, 1914–1978. Florence: Vallecchi, 1979.

OZENFANT 1928
Ozenfant, Amédée. *Art*. Paris: Jean Budry & Cie., 1928.

PAILLE 1943
Paille, A. "Expositions: Joan Miró." *Beaux-Arts* (Paris), no. 120 (November 12, 1943), p. 9.

PARIS-PRESSE 1954
"Une Vraie Corde dans le tableau de Miró." *Paris-Presse*, February 9, 1954 (in Palma V).

PARIS TIMES 1927
"In the Quarter." *Paris Times* (Paris), vol. 4, no. 1268 (December 1, 1927), p. 3.

PARIS TIMES 1928
"Concerning Art and Artists: The Academic Season in Full Swing." *Paris Times* (Paris), vol. 4, no. 1300 (January 3, 1928), p. 3.

PARISER DEUTSCHE ZEITUNG 1928
"Galerie Quatre Chemins: Einige Maler." *Pariser deutsche Zeitung* (Paris), January 7, 1928 (in Palma I).

PARK AVENUE SOCIAL REVIEW 1941
Park Avenue Social Review (New York), November 1941 (in The Museum of Modern Art Archives, Public Information Scrapbook no. 52).

PARK AVENUE SOCIAL REVIEW 1961
Park Avenue Social Review (New York), vol. 36, no. 1 (January 1961), p. 30.

PARROT 1945
Parrot, Louis. Preface to *Joan Miró*. Paris: Galerie Vendôme, 1945.

PATRIE 1928
"Expositions: Boschère [sic], Miro [sic], Borès, de la Serna (aux Quatre Chemins)." *Patrie* (Paris), vol. 93, no. 4702 (January 1, 1928), p. 5.

PENROSE 1958
Penrose, Roland. *Picasso: His Life and Work*. London: Victor Gollancz, 1958.

PENROSE 1964
Penrose, Roland. Introduction to *Joan Miró*. London: The Arts Council of Great Britain, 1964.

PENROSE 1969
Penrose, Roland. *Miró*. New York: Harry N. Abrams, [1969].

PENROSE 1981
Penrose, Roland. *Scrapbook, 1900–1981*. New York: Rizzoli, 1981.

PENROSE/GOMIS/PRATS 1966
Penrose, Roland, Joaquín Gomis, and Joan Prats Vallés. *Joan Miró: Creación en el espacio*. Barcelona: Ediciones Polígrafa, 1966.

PÉREZ-JORBA 1920
Pérez-Jorba, J. "Crónica de París: El Salón de Otoño." *El Día gráfico* (Barcelona), November 11, 1920 (in Palma I).

PÉREZ-JORBA 1921
Pérez-Jorba, J. "Crónica de París: Joan Miró y su pintura en El Unicornio." *El Día gráfico* (Barcelona), vol. 9, no. 2461 (May 6, 1921), p. 4.

PÉREZ-JORBA 1922
Pérez-Jorba, J. "Els Artistes catalans en el Saló de Tardor II." *La Publicitat* (Barcelona), vol. 45, no. 15526 (November 9, 1922), p. 3.

PERLMAN 1955
Perlman, Bennard B. "The Baltimore Museum of Art: Twenty-five Years of Growth." *Arts Digest* (New York), vol. 29, no. 16 (May 15, 1955), pp. 14–19.

PERMANYER 1978A
Permanyer, Lluís. "Vuelta de Miró al teatro." *La Vanguardia* (Barcelona), no. 34.759 (March 15, 1978), p. 70.

PERMANYER 1978B
Permanyer, Lluís. "Revelaciones de Joan Miró sobre su obra." *Gaceta ilustrada* (Madrid), April 23, 1978, pp. 45–46. Reprinted in Rowell 1986.

PERUCHO 1968
Perucho, Juan. *Joan Miró y Cataluña*. Barcelona: Ediciones Polígrafa, [1968].

PETITE ANTHOLOGIE 1934
Petite Anthologie poétique du surréalisme. Paris: Editions Jeanne Bucher, 1934.

P.F. 1928A
P.F. "Les Petites Expositions." *Journal des débats* (Paris), vol. 140, no. 4 (January 5, 1928), p. 4.

P.F. 1928B
P.F. "Les Petites Expositions." *Journal des débats* (Paris), vol. 140, no. 135 (May 15, 1928), p. 4.

P.F. 1929
P.F. "Pour la Cité Universitaire de Paris: Une Belle Exposition." *Journal des débats* (Paris), vol. 141, no. 19 (January 20, 1929), p. 3.

PHILADELPHIA MUSEUM BULLETIN 1952
"Review of the Year Presented at the Annual Meeting on June 9, 1952." *Philadelphia Museum Bulletin* (Philadelphia), vol. 47, no. 234 (Summer 1952), pp. 51–59.

PHILADELPHIA MUSEUM OF ART 1954
The Louise and Walter Arensberg Collection: Twentieth-Century Section. Philadelphia: Philadelphia Museum of Art, 1954.

P.I. 1933
P.I. "Les Vrais Indépendants et les surindépendants." *A Paris*, November 3–10, 1933 (in Palma II).

PICON 1971
Picon, Gaëtan. "A notre orient, Miró . . ." In *Joan Miró*. Brussels: André de Rache, 1971.

PICON 1976
Picon, Gaëtan. *Joan Miró: Carnets catalans*. 2 vols. Geneva: Editions Albert Skira, 1976.

PICON 1981
Picon, Gaëtan. "A Oriente, Miró . . ." In *Miró Milano: Pittura, scultura, ceramica, disegni, sobreteixims, grafica*. Milan: Mazzotta, 1981.

PICTURES ON EXHIBIT 1938
Pictures on Exhibit (New York), November 1938 (in Kuh).

PICTURES ON EXHIBIT 1939
"The French Moderns: Pierre Matisse Assembles Their Early Examples." *Pictures on Exhibit* (New York), January 1939, pp. 16–17 (in Matisse).

PICTURES ON EXHIBIT 1945
"Heard at the Galleries." *Pictures on Exhibit* (New York), vol. 6, no. 4 (January 1945), pp. 14, 16, 25.

PICTURES ON EXHIBIT 1952
Pictures on Exhibit (New York), May 1952 (in Palma IV).

PIENE 1966
Piene, Nan R. "New York: Gallery Notes." *Art in America* (New York), vol. 54, no. 3 (May–June 1966), p. 109.

PIERRE 1987
Pierre, José. *André Breton et la peinture*. Lausanne: Editions l'Age d'Homme, 1987.

PIERRE MATISSE 1959
Constellations. Introduction and *proses parallèles* by André Breton. New York: Pierre Matisse, 1959.

PIERRE MATISSE GALLERY 1951
Joan Miró. New York: Pierre Matisse Gallery, 1951.

PINTURRICHIO 1925
Pinturrichio. "Le Carnet des ateliers: *Ut pictura*." *Le Carnet de la semaine* (Paris), vol. 11, no. 524 (June 21, 1925), p. 7.

PINTURRICHIO 1928
Pinturrichio. "Le Carnet des ateliers." *Le Carnet de la semaine* (Paris), vol. 13, no. 675 (May 13, 1928), p. 12.

PLA 1920
Pla, José. "Crónica de Francia: El Salón de Otoño." *La Publicidad* (Barcelona), vol. 43, no. 14831 (October 16, 1920), p. 1.

PLANAS 1928
Planas, J. M. "Vida de ahora: La Estupenda Paradoja del vanguardismo." *La Noche* (Barcelona), vol. 5, no. 1158 (July 27, 1928), p. 1.

PLESSIX 1965
Plessix, Francine du. "Anatomy of a Collector: Nelson Rockefeller." *Art in America* (New York), vol. 53, no. 2 (April 1965), pp. 27–29.

POLITIKER 1934
Politiker (Copenhagen), October 24, 1934 (in Palma II).

POPULAIRE 1931
"Coups de pinceau." *Le Populaire* (Paris), vol. 14, no. 3066 (July 1, 1931), p. 4.

PORCEL 1989
Porcel, Baltasar. "Joan Miró o l'equilibri fantàstic." In *Els Tallers de Miró*. Barcelona: Institut Català d'Estudis Mediterranis, 1989.

POWYS 1951
Powys, Marian. "Only a Skein of Thread." *Interiors* (New York), vol. 110, no. 7 (February 1951), pp. 86–93.

PRÉVERT/RIBEMONT-DESSAIGNES 1956
Prévert, Jacques, and Ribemont-Dessaignes, Georges. *Joan Miró*. Paris: Maeght Editeur, 1956.

PUBLICITAT 1927
La Publicitat (Barcelona), January 4, 1927 (in Palma I).

PUBLICITAT 1929
"Les Lletres: Meridians." *La Publicitat* (Barcelona), vol. 51, no. 17365 (December 4, 1929), p. 5.

PUCCINELLI 1942
Puccinelli, Dorothy. "Art: San Francisco." *California Arts and Architecture* (Los Angeles), vol. 59 (August 1942), pp. 10, 12.

QUADRUM 1965
Quadrum (Brussels), no. 19 (1965), pp. 165–66.

QUENEAU 1949
Queneau, Raymond. *Joan Miró, ou le poète préhistorique*. Paris: Albert Skira Editeur, [1949].

RÀFOLS 1925
Ràfols, Josep F[rancesc]. "El Pintor Joan Miró." *D'ací i d'allà* (Barcelona), vol. 15, no. 92 (August 1925), p. 243.

RÀFOLS 1929
Ràfols, Josep F[rancesc]. "Joan Miró a Bèlgica." *El Matí* (Barcelona), vol. 1, no. 30 (June 27, 1929), p. 9.

RÀFOLS 1931A
Ràfols, [Josep Francesc]. "Carnet d'art: Joan Miró." *El Matí* (Barcelona), vol. 3, no. 714 (September 6, 1931), p. 10.

RÀFOLS 1931B
Ràfols, [Josep Francesc]. "Carnet d'art: Les Recents Creacions de Miró." *El Matí* (Barcelona), vol. 3, no. 788 (December 2, 1931), p. 7.

RÀFOLS 1932
Ràfols, [Josep Francesc]. "Carnet d'art: Exposicions de la quinzena." *El Matí* (Barcelona), vol. 4, no. 900 (April 18, 1932), p. 9.

RÀFOLS 1933
Ràfols, Josep Francesc. "Variacions sobre Joan Miró." *La Veu de Catalunya* (Barcelona), vol. 43, no. 11531 (May 31, 1933), p. 18.

RÀFOLS 1948
Ràfols, J[osep] F[rancesc]. "Miró antes de La Masía." *Anales y boletín de los Museos de Arte de Barcelona* (Barcelona), vol. 6, nos. 3–4 (July–December 1948), pp. 497–502.

RAGON 1962
Ragon, Michel. "A la recherche d'un nouvel space pictural." *XXe Siècle* (Paris), vol. 24, no. 18 (February 1962), pp. 55–60.

RAILLARD 1989
Raillard, Georges. *Miró*. London: Bracken Books, 1989.

RAMBOSSON 1938
Rambosson, Yvanhoé. "Le Surréalisme éternel." *Les Heures de Paris*, January 25, 1938 (in Palma II).

RAYMER 1942
Raymer, Dorothy. "Joan Miró." *Miami Daily News* (Miami), June 14, 1942, p. 6B.

RAYNAL 1922
Raynal, Maurice. "Au Salon d'Automne." *L'Intransigeant* (Paris), November 1, 1922, p. 5.

RAYNAL 1927
Raynal, Maurice. *Anthologie de la peinture en France de 1906 à nos jours*. Paris: Editions Montagne, 1927.

RAYNAL 1934A
Raynal, Maurice. *Cahiers d'art* (Paris), vol. 9, nos. 1–4 (1934), pp. 22–24.

RAYNAL 1934B
Raynal, Maurice. "Les Arts: Joan Miró." *L'Intransigeant* (Paris), May 17, 1934, p. 6.

RAYNAL 1935
R[aynal], M[aurice]. "Exposition Miró." *La Bête noire* (Paris), vol. 1, no. 4 (July 1, 1935), p. 5.

RAYNAL 1947
Raynal, Maurice. *Peintres du XXe siècle*. Geneva: Editions d'Art Albert Skira, [1947].

R.B. 1920
R.B. "Les Arts plàstiques: L'Exposició d'art francès a can Dalmau II." *La Revista* (Barcelona), vol. 6, no. 125 (December 1, 1920), p. 339.

R.B. 1921
R.B. "Galeries Dalmau: Exposició clausura del curs 1920–1921." *La Revista* (Barcelona), vol. 7, no. 141 (August 1, 1921), p. 239.

READ 1930
Read, Helen Appleton. "Painting in Paris." *Brooklyn Daily Eagle* (New York), vol. 90, no. 25 (January 26, 1930), p. E7.

READ 1933A
Read, Herbert. "The Function of Décor." *The Listener* (London), July 12, 1933 (in Mayor).

READ 1933B
Read, Herbert. "Seeing Is Believing." *The Listener* (London), August 2, 1933 (in Mayor).

READ 1935
R[ead], H[elen] A[ppleton]. "Indian Painting by Reiss; Two Superrealist Exhibits." *Brooklyn Daily Eagle* (New York), vol. 94, no. 19 (January 20, 1935), p. C6.

READ 1948
Read, Herbert. "Joan Miró." In *Picasso, Gris, Miró: The Spanish Masters of Twentieth-Century Painting*. San Francisco: San Francisco Museum of Art, 1948.

REFLETS 1938
"Joan Miró." *Reflets*, December 15, 1938 (in Palma II).

REINA SOFÍA 1987
Pabellón español: Exposición Internacional de Paris, 1937. Madrid: Museo Nacional Centro de Arte Reina Sofía, 1987.

RENÉ-JEAN 1921
René-Jean. "Les Petites Expositions." *Comoedia* (Paris), no. 3064 (May 7, 1921), p. 2.

RENÉ-JEAN 1935
René-Jean. "Le Temps présent: Une Exposition pour établir le bilan de la Jeune Peinture." *Comoedia* (Paris), no. 8008 (January 12, 1935), p. 3.

RENNE 1945
Renne, René. "Le Salon d'Automne, 1944." *Cahiers du sud* (Marseille), no. 269 (January–February 1945), pp. 3–6.

REVEL 1962
Revel, Jean-François. "Minotaure." *L'Oeil* (Paris), no. 89 (May 1962), pp. 66–79.

REVEL 1964
Revel, Jean-François. "XXXIe Biennale de Venise." *L'Oeil* (Paris), nos. 115–16 (July–August 1964), p. 3.

RÉVOLUTION SURRÉALISTE 1925A
La Révolution surréaliste (Paris), vol. 1, no. 4 (July 15, 1925), pp. 4, 15.

RÉVOLUTION SURRÉALISTE 1925B
La Révolution surréaliste (Paris), vol. 1, no. 5 (October 15, 1925), pp. 10, 25.

RÉVOLUTION SURRÉALISTE 1926A
La Révolution surréaliste (Paris), vol. 2, no. 7 (June 15, 1926), p. 31.

RÉVOLUTION SURRÉALISTE 1926B
La Révolution surréaliste (Paris), vol. 2, no. 8 (December 1, 1926), p. 19.

RÉVOLUTION SURRÉALISTE 1927
La Révolution surréaliste (Paris), vol. 3, nos. 9–10 (October 1, 1927), p. 62.

RÉVOLUTION SURRÉALISTE 1928
La Révolution surréaliste (Paris), vol. 4, no. 11 (March 15, 1928), back cover.

R.F. 1941
R.F. "The Passing Shows: Joan Miró." *The Art News* (New York), vol. 40, no. 3 (March 15–31, 1941), p. 43.

R.F.C. 1959
R.F.C. "Una Grande Mostra di Miró." *Emporium* (Bergamo), 65th year, vol. 130, no. 779 (November 1959), pp. 220–22.

R.G. 1930
R.G. "Una Exposición de arquitectura y pintura modernas." *La Gaceta literaria* (Madrid), vol. 4, no. 91 (October 1, 1930), pp. 8, 13.

RIDDER 1930
Ridder, André de. "La Jeune Peinture

française." *Le Centaure* (Brussels), vol. 4, no. 8 (May 1, 1930), pp. 157–62.

RILEY 1945A
Riley, Maude. "New Temperas and Ceramics by Miró." *The Art Digest* (New York), vol. 19, no. 7 (January 1, 1945), p. 13.

RILEY 1945B
Riley, Maude. "Insufficient Evidence." *The Art Digest* (New York), vol. 19, no. 17 (June 1, 1945), p. 12.

RIVIÈRE 1930
Rivière, G. H. "La Gallery of Living Art à l'Université de New York." *Documents* (Paris), vol. 2, no. 6 (1930), p. 374.

R.J. 1931
R.J. "Quelques Peintres catalans exposent à Paris." *Comoedia* (Paris), no. 6744 (July 8, 1931), p. 3.

ROBERT ELKON GALLERY 1981
Robert Elkon: Two Decades. New York: Robert Elkon Gallery, 1981.

ROBERTS 1964
Roberts, Keith. "Current and Forthcoming Exhibitions: London." *The Burlington Magazine* (London), vol. 106, no. 739 (October 1964), pp. 477–79.

ROCHESTER DEMOCRAT AND CHRONICLE 1937
"Dada: Art 'Ism' Gains Notice in Exhibition." *Rochester Democrat and Chronicle* (Rochester, N.Y.), January 3, 1937, p. 6A.

RODITI 1958
Roditi, Edouard. "Interview with Joan Miró." *Arts* (New York), vol. 33, no. 1 (October 1958), pp. 38–43.

ROH 1925
Roh, Franz. *Nach-Expressionismus: Magischer Realismus — Probleme der neuesten europäischen Malerei.* Leipzig: Klinkhardt & Biermann, 1925.

ROLNIK 1983
Rolnik, Marc. *Miró's Constellations: The Facsimile Edition of 1959.* Purchase, N.Y.: Neuberger Museum, 1983.

ROSE 1982A
Rose, Barbara. "Miró in America." In Barbara Rose, *Miró in America.* Houston: The Museum of Fine Arts, 1982.

ROSE 1982B
Rose, Barbara. "Interview with Miró (Barcelona, June 30, 1981)." In Barbara Rose, *Miró in America.* Houston: The Museum of Fine Arts, 1982.

ROSE 1992
Rose, Barbara. "Joan Miró." In *Joan Miró Centennial Exhibition: The Pierre Matisse Collection.* Yokohama: Yokohama Museum of Art, 1992.

ROWELL 1972
Rowell, Margit. "Magnetic Fields: The Poetics." In *Joan Miró: Magnetic Fields.* New York: Solomon R. Guggenheim Museum, 1972.

ROWELL 1976
Rowell, Margit. *Joan Miró: Peinture-poésie.* Paris: Editions de la Différence, 1976.

ROWELL 1985
Rowell, Margit. "*Bleu II*, 1961, de Joan Miró." *Cahiers du Musée National d'Art Moderne* (Paris), vol. 15 (March 1985), pp. 48–59.

ROWELL 1986
Rowell, Margit, ed. *Joan Miró: Selected Writings and Interviews.* Boston: G. K. Hall & Co., 1986.

ROWELL 1987A
Rowell, Margit. "Miró at the Museum: Works in the Philadelphia Museum of Art." *Philadelphia Museum of Art Bulletin* (Philadelphia), vol. 83, nos. 356–57 (Fall 1987), pp. 3–38.

ROWELL 1987B
Rowell, Margit. *The Captured Imagination: Drawings by Joan Miró from the Fundació Joan Miró, Barcelona.* New York: The American Federation of Arts, 1987.

ROWELL 1991
Rowell, Margit. "André Breton et Joan Miró." In Agnès Angliviel de la Beaumelle, Isabelle Monod-Fontaine, and Claude Schweisguth, eds., *André Breton: La Beauté convulsive.* Paris: Editions du Centre Georges Pompidou, 1991.

ROWELL 1993
Rowell, Margit. "Joan Miró: Campo-Stella." In *Joan Miró: Campo de Estrellas,* Madrid: Museo Nacional Centro de Arte Reina Sofía, 1993.

RUBIN 1959
Rubin, William. "Miró in Retrospect." *Art International* (Zurich), vol. 3, nos. 5–6 (1959), pp. 34–41.

RUBIN 1966
Rubin, William. "Toward a Critical Framework." *Artforum* (New York), vol. 5, no. 1 (September 1966), pp. 36–55.

RUBIN 1967A
Rubin, William. "Jackson Pollock and the Modern Tradition, Part 3." *Artforum* (New York), vol. 5, no. 8 (April 1967), pp. 18–31.

RUBIN 1967B
Rubin, William. "Jackson Pollock and the Modern Tradition, Part 4." *Artforum* (New York), vol. 5, no. 9 (May 1967), pp. 28–33.

RUBIN 1968
Rubin, William. *Dada, Surrealism, and Their Heritage.* New York: The Museum of Modern Art, 1968.

RUBIN 1973
Rubin, William. *Miró in the Collection of The Museum of Modern Art.* New York: The Museum of Modern Art, 1973.

RUDENSTINE 1976
Rudenstine, Angelica Z[ander]. *The Guggenheim Museum Collection: Paintings 1880–1945,* vol. 2. New York: Solomon R. Guggenheim Museum, 1976.

RUDENSTINE 1985
Rudenstine, Angelica Zander. *Peggy Guggenheim Collection, Venice.* New York: Harry N. Abrams, Publishers, and the Solomon R. Guggenheim Foundation, 1985.

RUDENSTINE 1988
Rudenstine, Angelica Zander. *Modern Painting, Drawing and Sculpture Collected by Emily and Joseph Pulitzer, Jr.,* vol. 4. Cambridge, Mass.: Harvard University Art Museums, 1988.

RUDKIN 1941
Rudkin, W. Harley. "Art in the News." *Springfield News* (Springfield, Mass.), November 27, 1941 (in The Museum of Modern Art Archives, Public Information Scrapbook no. 52).

RUSSELL 1964
Russell, John. "The Art News from London: Miró Magic." *The Art News* (New York), vol. 63, no. 6 (October 1964), p. 10.

RUSSELL 1966
Russell, John. "Rich Museums of the Rhineland." *Art in America* (New York), vol. 54, no. 3 (May–June 1966), pp. 90–94.

RUSSELL 1967
Russell, John. *Max Ernst: Life and Work.* New York: Abrams, 1967.

RUSSELL 1991
Russell, John. "A Grand Design Quietly Emerges in Chicago." *New York Times* (New York), November 17, 1991, p. H35.

RYKWERT 1962
Rykwert, Joseph. "A Parigi." *Domus* (Milan), no. 396 (November 1962), p. 39.

SAARINEN 1957
Saarinen, Aline B. "Collecting Modern Masters on a Master-Plan." *The Art News* (New York), vol. 56, no. 6 (October 1957), pp. 5, 32–35, 64–66, cover.

SACS 1918A
Sacs, Joan. "Exposición Juan [*sic*] Miró en las Galerías Dalmau." *La Publicidad* (Barcelona), vol. 41, no. 13972 (February 24, 1918), p. 4.

SACS 1918B
Sacs, J[oan]. "Exposición general de arte, IV." *La Publicidad* (Barcelona), vol. 41, no. 14071 (June 8, 1918), p. 3.

SACS 1919A
Sacs, Joan. "L'Istil." *Vell i nou* (Barcelona), vol. 5, no. 92 (June 1, 1919), pp. 209–14.

SACS 1919B
Sacs, Joan. "La Exposición de Bellas Artes de Primavera: Proemio — Sociedad Artística y Literaria — Associació Courbet." *La Publicidad* (Barcelona), vol. 42, no. 14405 (June 15, 1919), p. 3.

SAINT-ANDRÉ 1945
Saint-André, P. "Dessins des grands." *L'Assistance française,* May 5, 1945 (in Palma II).

SALMON 1921
Salmon, André. "Expositions diverses: Mme G. Agutte — Tableaux de fleurs, etc. . . ." *L'Europe nouvelle* (Paris), vol. 4, no. 23 (June 4, 1921), pp. 733–34.

SALMON 1931
Salmon, André. "Les Arts." *Gringoire* (Paris), vol. 4, no. 120 (February 20, 1931), p. 7.

SAN FRANCISCO NEWS 1934
"Is It Art?" *San Francisco News,* May 19, 1934 (in Palma II).

SANDLER 1968
Sandler, Irving. "Dada, Surrealism, and Their Heritage, 2: The Surrealist Emigrés in New York." *Artforum* (New York), vol. 6, no. 9 (May 1968), pp. 24–31.

SANTOS TORROELLA 1951
Santos Torroella, Rafael. "Miró aconseja a nuestros pintores jóvenes." *Correo literario* (Madrid), March 15, 1951, p. 1. Reprinted in Rowell 1986.

SANTOS TORROELLA 1968
Santos Torroella, Rafael. "Bibliografía." In *Miró.* Barcelona: Recinto del Antiguo Hospital de la Santa Cruz, 1968.

SARRADIN 1935
Sarradin, Edouard. "Prestige du

dessin." *Journal des débats* (Paris), vol. 147, no. 11 (January 12, 1935), p. 2.

SAURA 1989
Saura, Antonio. "Le Mirador de Miró." In *Miró*. Paris: Galerie Adrien Maeght, 1989.

SAWYER-LAUÇANNO 1989
Sawyer-Lauçanno, Christopher. *An Invisible Spectator: A Biography of Paul Bowles*. New York: Weidenfeld & Nicolson, 1989.

SCAUFLAIRE 1931
Scauflaire, Ed. "L'Exposition de l'Art Vivant en Europe au Palais des Beaux-Arts de Bruxelles." *La Wallonie* (Liège), vol. 12, nos. 115–16 (April 25–26, 1931), p. 3.

SCHEIDEGGER 1957
Scheidegger, Ernst, ed. *Joan Miró: Gesammelte Schriften, Fotos, Zeichnungen*. Zurich: Verlag der Arche, 1957.

SCHIFF 1953
Schiff, Gert. "Gespräche mit spanischen Malern: Joan Miró." *Das Kunstwerk* (Baden-Baden), vol. 7, nos. 3–4 (1953), pp. 66, 71.

SCHIFFMAN 1985
Schiffman, Winifred. "Artist Biographies and Bibliographies." In *L'Amour Fou: Photography and Surrealism*. Washington, D.C.: The Corcoran Gallery of Art; New York: Abbeville Press, 1985.

SCHMALENBACH 1982
Schmalenbach, Werner. *Joan Miró: Zeichnungen aus den späten Jahren*. Berlin: Propyläen Verlag, 1982.

SCHMALENBACH 1986
Schmalenbach, Werner. *Bilder des 20. Jahrhunderts. Die Kunstsammlung Nordrhein-Westfalen, Düsseldorf*. Munich: Prestel-Verlag, 1986.

SCHMITZ 1927
Schmitz, Marcel. "Les Salons d'art." *XXᵉ Siècle*, October 16, 1927 (in Palma I).

SCHNEEBERGER 1922
Schneeberger, A. "La Vie des arts et des lettres: Trois Peintres catalans." *La Nervie* (Brussels and Paris), 3rd ser., vol. 3, no. 5 (1922), pp. 108–09.

SCHNEIDER 1962
Schneider, Pierre. "Art News from Paris: Miró." *The Art News* (New York), vol. 61, no. 6 (October 1962), p. 48.

SCHNEIDER 1972
Schneider, Pierre. Preface to *Miró:*

Sobre Papel. New York: Pierre Matisse Gallery, 1972.

SCHWARTZ 1958
Schwartz, Marvin D. "News and Views from New York: The Tenth Anniversary of the Sidney Janis Gallery." *Apollo* (London), vol. 68, no. 406 (December 1958), pp. 223–24.

SCHWARTZ 1959
Schwartz, Marvin D. "News and Views from New York: Miró at The Museum of Modern Art." *Apollo* (London), vol. 69, no. 411 (May 1959), p. 151.

SCHWARTZ 1968
Schwartz, Paul Waldo. "Calder and Miró, Now Past 70, Feted in France." *New York Times* (New York), July 23, 1968.

SCHWOB 1933
Schwob, André. "International, 1933." *Creative Art* (New York), vol. 12, no. 3 (March 1933), pp. 220–23.

SCOTSMAN 1933
"Surrealism in Paint: The Work of Joan Miró." *The Scotsman* (Edinburgh), July 18, 1933 (in Mayor).

SÉCULO 1947
O Século (Lisbon), February 9, 1947 (in Palma II).

SEMAINE À PARIS 1929
"Commentaires: Oeuvres des XIXᵉ et XXᵉ siècles." *La Semaine à Paris* (Paris), no. 348 (January 25–February 1, 1929), p. 48.

SERGE 1935
Serge. "7 *Minotaure*: Nature nocturne." *Comoedia* (Paris), no. 8193 (July 21, 1935), p. 3.

SERRA 1986
Serra, Pere A., ed. *Miró and Mallorca*. New York: Rizzoli International, 1986.

SERRA 1987
Serra, Pere A. "Monòleg Mironià." In *Joan Miró, Son Abrines i Son Boter—Olis, dibuixos i graffiti*. Palma de Mallorca: Fundació Pilar i Joan Miró, 1987.

SERVICES PUBLICS 1931
"Exposition de peinture et sculpture catalanes." *Les Services publics*, September 23, 1931 (in Palma I).

SHORE 1941
Shore, Sherman. "Dalí Exhibit Brings Warm Controversy." *Winston-Salem Journal* (Winston-Salem, N.C.), December 7, 1941 (in The Museum of Modern Art Archives, Public Information Scrapbook no. 52).

SICRE 1948
Sicre, José Gómez. "Joan Miró in New

York." *Right Angle* (Washington, D.C.), vol. 1, no. 10 (January 1948), pp. 5–6.

SILVER 1989
Silver, Kenneth E. *Esprit de Corps: The Art of the Parisian Avant-Garde and the First World War, 1914–1925*. Princeton, N.J.: Princeton University Press, 1989.

S.N.H. 1965
S.N.H. "Los Angeles: Group Show, Frank Perls Gallery." *Artforum* (New York), vol. 3, no. 8 (May 1965), p. 12.

SOBY 1959
Soby, James Thrall. *Joan Miró*. New York: The Museum of Modern Art, 1959.

SOBY 1961
Soby, James Thrall. "Genesis of a Collection." *Art in America* (New York), vol. 49, no. 1 (1961), pp. 68–81.

SOLDEVILA 1925
Soldevila, Carles. "Full de dietari: El Pintor Miró a París." *La Publicitat* (Barcelona), vol. 47, no. 16002 (July 3, 1925), p. 1.

SPRINGFIELD SUNDAY UNION AND REPUBLICAN 1935
Springfield Sunday Union and Republican (Springfield, Mass.), January 20, 1935 (in Matisse).

SPRINGFIELD SUNDAY UNION AND REPUBLICAN 1941
"Dalí and Miró Exhibitions at Museum of Modern Art." *Springfield Sunday Union and Republican* (Springfield, Mass.), November 23, 1941 (in The Museum of Modern Art Archives, Public Information Scrapbook no. 52).

S.T. 1962
S.T. "New York Exhibitions: In the Galleries—Joan Miró." *Arts* (New York), vol. 36, no. 4 (January 1962), pp. 34–35.

STAR 1936
"The Star Man's Diary." *The Star*, June 11, 1936, p. 3 (in Palma II).

STAVITSKY 1990
Stavitsky, Gail. "The Development, Institutionalization and Impact of the A. E. Gallatin Collection of Modern Art," 9 vols. Ph.D. dissertation, Institute of Fine Arts, New York University, May 1990.

STICH 1980
Stich, Sidra. *Joan Miró: The Development of a Sign Language*. Saint Louis: Washington University Gallery of Art, 1980.

STICH 1990
Stich, Sidra. *Anxious Visions:*

Surrealist Art. New York: Abbeville Press; Berkeley: University Art Museum, University of California, 1990.

STUCKEY 1991
Stuckey, Charles. *French Painting*. New York: Hugh Lauter Levin Associates; distributed by the Macmillan Publishing Company, 1991.

STUYVESANT 1932
Stuyvesant, Elizabeth. "Pierre Matisse Gallery: Joan Miró, Paintings and Drawings." *Creative Art* (New York), vol. 11, no. 4 (December 1932), pp. 314–15.

SUNDAY REFEREE 1933
The Sunday Referee, July 23, 1933 (in Mayor).

SUNDAY TIMES MAGAZINE 1967
"Key Men." *The Sunday Times Magazine* (London), June 4, 1967, pp. 22–27.

SURRÉALISME AU SERVICE DE LA RÉVOLUTION 1931
Le Surréalisme au service de la révolution (Paris), no. 3 (December 1931), p. 38.

SWANSON 1971
Swanson, Dean. "The Artist's Comments." In *Miró Sculptures*. Minneapolis: Walker Art Center, 1971.

SWEENEY 1934
Sweeney, James Johnson. *Cahiers d'art* (Paris), vol. 9, nos. 1–4 (1934), pp. 46–49.

SWEENEY 1935
Sweeney, James Johnson. "Miró and Dalí." *The New Republic* (New York), vol. 81 (February 6, 1935), p. 360.

SWEENEY 1941
Sweeney, James Johnson. *Joan Miró*. New York: The Museum of Modern Art, 1941.

SWEENEY 1945
Sweeney, James Johnson. "Miró's Modern Magic." *Town and Country* (New York), vol. 100, no. 4271 (April 1945), pp. 93, 126–27.

SWEENEY 1948
Sweeney, James Johnson. "Joan Miró: Comment and Interview." *Partisan Review* (New York), vol. 15, no. 2 (February 1948), pp. 206–12.

SWEENEY 1949
Sweeney, James Johnson. "Miró." *Theatre Arts* (New York), vol. 33, no. 2 (March 1949), pp. 38–41.

SWEENEY 1953
Sweeney, James Johnson. "Miró." *Art News Annual*, 23 (New York), vol. 52,

no. 7, part 2 (November 1953), pp. 58–81, 185–88.

SWEENEY 1973
Sweeney, James Johnson. Preface to *Miró: Sobreteixims*. New York: Pierre Matisse Gallery, 1973.

SYLVESTER 1972
Sylvester, David. "About Miró's Sculpture." In David Sylvester, *Miró Bronzes*. London: The Arts Council of Great Britain and Hayward Gallery, 1972.

SYLVESTER 1974
Sylvester, David. "Mirós Skulpturen." *Louisiana Revy* (Humlebaek), vol. 15, no. 3 (November 1974), pp. 9–14.

SZARKOWSKI 1984
Szarkowski, John. *Irving Penn*. New York: The Museum of Modern Art, 1984.

TAILLANDIER 1961
Taillandier, Yvon. "Miró." In *Miró, 1959–1961*. New York: Pierre Matisse Gallery, 1961.

TAILLANDIER 1962
Taillandier, Yvon. "Miró précurseur." *XXᵉ Siècle* (Paris), vol. 24, no. 19 (June 1962), pp. 37–41.

TAILLANDIER 1964
Taillandier, Yvon. "Pour une cosmogonie de Miró." *XXᵉ Siècle* (Paris), vol. 26, no. 24 (December 1964), pp. 107–11.

TAILLANDIER 1974
Taillandier, Yvon. "Miró: Maintenant, je travaille par terre . . ." *XXᵉ Siècle* (Paris), vol. 36, no. 43 (December 1974), pp. 15–19. Reprinted in Rowell 1986.

TAILLANDIER/GOMIS/PRATS 1962
Taillandier, Yvon, Joaquín Gomis, and Joan Prats Vallés. *Création Miró 1961*. Barcelona: Editorial R.M., 1962.

TAMBLYN 1991
Tamblyn, Christine. "Berkeley: Freshness, Surprise, and Horror." *The Art News* (New York), vol. 90, no. 1 (January 1991), p. 161.

TAMIR 1973
Tamir, Ilan. Preface to *Joan Miró: His Graphic Work*. Tel Aviv: Tel Aviv Museum, 1973.

TATE GALLERY 1988
The Tate Gallery, 1984–86: Illustrated Catalogue of Acquisitions. London: Tate Gallery Publications, 1988.

TAYLOR 1932
Taylor, Francis Henry. "The Triumph of Decomposition." *Parnassus* (New York), vol. 4, no. 4 (April 1932), pp. 4–9, 39.

TAYLOR 1933
Taylor, Bertha Fanning. "Sur-Independent Show Opens at Pte. de Versailles." *New York Herald Tribune*, October 28, 1933 (in Palma II).

TEIXIDOR 1972
Teixidor, Joan. "Constellations." In G. di San Lazzaro, ed., *Homage to Miró*. New York: Tudor Publishing Co., 1972. Special issue of the review *XXᵉ Siècle*.

TEIXIDOR 1974
Teixidor, Joan. "Miró Sculptor." In Alain Jouffroy and Joan Teixidor, *Miró Sculpture*. New York: Leon Amiel Publisher, 1974.

TELEGRAAF 1928
"Droomschilder-Kunst: Beleven wij een terugkeer der inspiratie? Joan Miró en zijn duivelarijen." *De Telegraaf* (Amsterdam), June 6, 1928 (in Palma I).

TEMKIN 1987A
Temkin, Ann. "Klee and the Avant-Garde, 1912–1940." In Carolyn Lanchner, ed., *Paul Klee*. New York: The Museum of Modern Art, 1987.

TEMKIN 1987B
Temkin, Ann. "Catalogue of Works in the Collection." *Philadelphia Museum of Art Bulletin* (Philadelphia), vol. 83, nos. 356–57 (Fall 1987), pp. 39–44.

TERENTS 1934
Terents. "Udstilling af fransk kunst paa Charlottenborg." *Linien* (Copenhagen), vol. 1, no. 7 (November 20, 1934), pp. 1–4.

TÉRIADE 1928A
Tériade, E. "On expose: Joan Miró (Galerie Georges Bernheim, 109, Faubourg Saint-Honoré)." *L'Intransigeant* (Paris), May 7, 1928, p. 4.

TÉRIADE 1928B
T[ériade], E. "On expose: Exposition d'oeuvres de maîtres de la peinture contemporaine." *L'Intransigeant* (Paris), November 5, 1928, p. 5.

TÉRIADE 1929
Tériade, E. "Documentaire sur la jeune peinture, I: Considérations liminaires." *Cahiers d'art* (Paris), vol. 4, nos. 8–9 (1929), pp. 359–64.

TÉRIADE 1930A
Tériade, E. "Documentaire sur la jeune peinture, IV: La Réaction littéraire." *Cahiers d'art* (Paris), vol. 5, no. 2 (1930), pp. 69–84.

TÉRIADE 1930B
Tériade, E. "Joan Miró (Galerie Pierre, 2, rue des Beaux-Arts)." *L'Intransigeant* (Paris), March 18, 1930, p. 6.

TÉRIADE 1931
Tériade, E. "A travers les expositions: Où allons-nous? (Galerie Pierre, 2, rue des Beaux-Arts)." *L'Intransigeant* (Paris), June 8, 1931, p. 5.

TÉRIADE 1932
T[ériade], E. "Expositions: Joan Miró (Galerie Pierre Colle, 29, rue Cambacérès)." *L'Intransigeant* (Paris), December 19, 1932, p. 7.

TÉRIADE 1936
Tériade, E. "La Peinture surréaliste." *Minotaure* (Paris), vol. 3, no. 8 (June 15, 1936), pp. 5–17.

THÉBERGE 1986
Théberge, Pierre. "Miró: Sculpture and Nature." In *Miró in Montreal*. Montreal: The Montreal Museum of Fine Arts, 1986.

THEROUDE 1945
Theroude, Jean. "Rétrospective de dessins d'Ingres à Picasso." *Heures nouvelles* (Paris), vol. 1, no. 4 (December 25, 1945), p. 4.

THEVENON 1974
Thevenon, Patrick. "Le Choix insolent de Douglas Cooper." *L'Express* (Paris), September 9–15, 1974, p. 19.

THWAITES 1936
Thwaites, J., and M. Thwaites. "Surrealism and Abstraction: The Search for Subjective Form." *Axis* (London), no. 6 (Summer 1936), pp. 21–25.

TILLIM 1966
Tillim, Sidney. "Surrealism as Art." *Artforum* (New York), vol. 5, no. 1 (September 1966), pp. 66–71.

TIME 1934
"Shows in Manhattan: Miró." *Time* (Chicago and New York), vol. 23, no. 4 (January 22, 1934), p. 34.

TIME 1941
"Inclusive Ism." *Time* (New York), vol. 37, no. 11 (March 17, 1941), p. 46.

TIMES 1926
"Art Exhibitions: New Chenil Galleries." *The Times* (London), July 2, 1926 (in Palma I).

TIMES 1933
"Mr. Joan Miró." *The Times* (London), July 14, 1933 (in Mayor; in Palma II).

TIMES 1938
"Little Bethels: An Artistic Alliance." *The Times* (London), May 17, 1938 (in Mayor).

TIMES DISPATCH 1941
"Museum of Modern Art Opens Exhibition of Paintings and Drawings by Salvador Dalí." *Times Dispatch* (Richmond, Va.), November 22, 1941 (in The Museum of Modern Art Archives, Public Information Scrapbook no. 52).

TRABAL 1928
Trabal, Francesc. "Les Arts: Una Conversa amb Joan Miró." *La Publicitat* (Barcelona), vol. 50, no. 16932 (July 14, 1928), p. 4.

TYLER 1945
Tyler, Parker. "The Amorphous and the Fragmentary in Modern Art." *The Art News* (New York), vol. 44, no. 10 (August 1945), pp. 16–20, 27.

TYLER 1961
Tyler, Parker. "Soby: Grand Passions in Casuals." *The Art News* (New York), vol. 59, no. 10 (February 1961), pp. 42, 62–63.

TZARA 1926
Tzara, Tristan. "Paysages et accidents." *Integral* (Bucharest), vol. 2, no. 9 (December 1926), pp. 10–11.

TZARA 1930
Tzara, Tristan. *L'Arbre des voyageurs*. Paris: Editions Montagne, 1930.

TZARA 1931
Tzara, Tristan. "Le Papier collé, ou le proverbe en peinture." *Cahiers d'art* (Paris), vol. 6, no. 2 (1931), pp. 61–74.

TZARA 1940
Tzara, Tristan. "A propos de Joan Miró." *Cahiers d'art* (Paris), vol. 15, nos. 3–4 (1940), pp. 37–47.

TZARA 1945–46
Tzara, Tristan. "Pour passer le temps . . ." *Cahiers d'art* (Paris), vols. 20–21 (1945–46), pp. 277–93.

UHDE 1931
Uhde, Wilhelm. "Tagebuch der Kunst: Pariser Ausstellungen." *Das Tage-Buch* (Berlin), vol. 12, no. 29 (July 18, 1931), p. 1146.

UMLAND 1992
Umland, Anne. "Joan Miró's *Collage of Summer 1929*: 'La Peinture au défi'?" In *Studies in Modern Art 2: Essays on Assemblage*. New York: The Museum of Modern Art, 1992.

UPTON 1941
Upton, Melville. "Group Shows Crowd Week: Chicago Society, Local Americans, and Foreign Artists Figure." *New York Sun* (New York), October 10, 1941, p. 38.

V. 1931
V. "Salons et expositions." *Le Petit Parisien* (Paris), vol. 5, no. 20.027 (December 29, 1931), p. 8.

VALLESCÁ 1918
Vallescá, Antonio. "Crónicas de arte: Galería Dalmau." *El Liberal* (Barcelona), vol. 18, no. 7073 (March 7, 1918, evening ed.), p. 1.

VALLESCÁ 1919
Vallescá, Antonio. "La Exposición de arte: 'Circol Artistich de Sant Lluch.'" *El Liberal* (Barcelona), vol. 18, no. 7521 (June 28, 1919, evening ed.), p. 2.

VALLIER 1960
Vallier, Dora. "Avec Miró." *Cahiers d'art* (Paris), vols. 33–35 (1960), pp. 160–74.

VARGAS 1939
Vargas, L. "Joan Miró." *Konstrevy* (Stockholm), vol. 15, no. 2 (1939), pp. 70–71.

VARIÉTÉS 1929A
Le Surréalisme en 1929, special issue of *Variétés* (Brussels), June 1929.

VARIÉTÉS 1929B
Variétés (Brussels), vol. 2, no. 7 (November 15, 1929), n.p.

VARNEDOE 1976
Varnedoe, J. Kirk T., ed. *Modern Portraits: The Self and Others*. New York: Columbia University, 1976.

VAUGHAN 1936A
Vaughan, Malcolm. "World of Art, Exhibitions, Antiques, Interior Decoration." *New York American* (New York), December 5, 1936 (in Palma II).

VAUGHAN 1936B
Vaughan, Malcolm. "Vast Hodge-Podge of Surrealistic Art in Week's Parade." *New York American* (New York), December 12, 1936 (in Palma II).

VEIDLE 1928
Veidle, V. "Miró." *Vozrojdenie* (Paris), vol. 3, no. 1080 (May 17, 1928), p. 4.

VELL I NOU 1918
"Galeries Dalmau: Exposició col·lectiva." *Vell i nou* (Barcelona), vol. 4, no. 65 (April 15, 1918), p. 152.

VENTURI 1947
Venturi, Lionello. *Pittura contemporanea*. Milan: Ulrico Hoepli Editore, [1947].

VERDET 1957A
Verdet, André. "Sortilèges de Miró." In *Joan Miró*. Nice: Galerie Matarasso, 1957.

VERDET 1957B
Verdet, André. *Joan Miró*. Nice: Matarasso, 1957.

VEU DE CATALUNYA 1925
La Veu de Catalunya (Barcelona), vol. 35, no. 9063 (June 28, 1925, morning ed.), p. 7.

VEU DE CATALUNYA 1928
"Joan Miró a can Bernheim." *La Veu de Catalunya* (Barcelona), vol. 38, no. 9969 (May 15, 1928, morning ed.), p. 3.

VIDAL ALCOVER 1970
Vidal Alcover, Jaume. "Joan Miró." Preface to *Joan Miró*. Palma de Mallorca: Sala Pelaires, 1970.

VILÀ I FOLCH 1978
Vilà i Folch, Joaquim. "Espectacles estrenats entre l'1 de gener i el 15 de juliol." *Serra d'or* (Montserrat), vol. 20, no. 228 (September 15, 1978), pp. 51–53.

VILLEBOEUF 1937
Villeboeuf, André. "Les Arts: D'une rive à l'autre." *Gringoire* (Paris), vol. 10, no. 448 (June 11, 1937), p. 9.

VIOT 1934
Viot, Jacques. *Cahiers d'art* (Paris), vol. 9, nos. 1–4 (1934), pp. 57–58.

VIOT 1936
Viot, Jacques. "Un Ami: Joan Miró." *Cahiers d'art* (Paris), vol. 11, nos. 8–10 (1936), pp. 257–60.

VOGUE 1941
"Two Shows." *Vogue* (Greenwich, Conn.), November 15, 1941 (in The Museum of Modern Art Archives, Public Information Scrapbook no. 52).

VOLBOUDT 1961
Volboudt, Pierre. "Univers de Miró." *Chroniques du jour*, supplement to *XXe Siècle* (Paris), no. 17 (December 1961), pp. 7–9.

VOLBOUDT 1962A
Volboudt, Pierre. "Miró au Musée National d'Art Moderne." *Chroniques du jour*, supplement to *XXe Siècle* (Paris), no. 20 (December 1962), n.p.

VOLBOUDT 1962B
Volboudt, Pierre. "L'Imaginaire et l'infini." *XXe Siècle* (Paris), vol. 24, no. 20 (December 1962), pp. 69–78.

VOLNÉ SMĚRY 1935
Volné Směry (Prague), vol. 31, nos. 5–6 (1935), p. 113.

VOORUIT 1937
Vooruit, June 20, 1937 (in Palma II).

WALDBERG 1967A
Waldberg, Patrick. "Le Miromonde."

Derrière le miroir (Paris), nos. 164–65 (April–May 1967), pp. 1–25.

WALDBERG 1967B
Waldberg, Patrick. "Les Travestis du réel." *XXe Siècle* (Paris), vol. 29, no. 29 (December 1967), pp. 69–74.

WALDBERG 1970
Waldberg, Patrick. *La Documentation photographique: Le Surréalisme*, nos. 5-306–5-307 (June–July 1970).

WALLONIE 1934
"Au Palais des Beaux-Arts de Bruxelles: Exposition du 'Minotaure.'" *La Wallonie* (Liège), May 11, 1934 (in Palma II).

WALTON 1966
Walton, Paul H. *Dalí, Miró*. New York: Tudor Publishing Co., 1967.

WARNOD 1928
Warnod, André. "Les Expositions de la semaine." *Comoedia* (Paris), no. 5477 (January 5, 1928), p. 3.

WARNOD 1930
Warnod, André. "Les Décors de ballet de Serge de Diaghilew évoquent une grande époque." *Comoedia* (Paris), no. 6479 (October 15, 1930), p. 1.

WARNOD 1933
Warnod, André. "Les Beaux-Arts: Joan Miró, un surréaliste qui est aussi un peintre." *Comoedia* (Paris), no. 7576 (November 6, 1933), p. 3.

WARNOD 1939
Warnod, André. "Dans les ateliers: Un Portrait, deux peintres." *Beaux-Arts* (Paris), vol. 76, no. 329 (April 21, 1939), p. 2.

WARNOD 1945
Warnod, André. "Quelques Expositions." *Le Figaro* (Paris), March 30, 1945 (in Palma II).

WARNOD 1951
Warnod, André. "Les Expositions." *Le Figaro* (Paris), April 30, 1951 (in Palma III).

WATSON 1941
Watson, Peter. "Joan Miró." *Horizon* (London), vol. 4, no. 20 (August 1941), pp. 131–33.

WEEK END REVIEW 1933
"Letter to the Editor." *The Week End Review* (London), vol. 8, no. 177 (July 29, 1933), p. 112.

WELCHMAN 1989
Welchman, John C. "After the Wagnerian Bouillabaisse: Critical Theory and the Dada and Surrealist Word-Image." In Judi Freeman and John C. Welchman, *The Dada and Surrealist Word-Image*. Los Angeles:

Los Angeles County Museum of Art, 1989.

WEMBER 1957
Wember, Paul. *Miró: Das graphische Werk*. Krefeld: Kaiser-Wilhelm Museum, 1957.

WENNECKERS 1929
Wenneckers, Louis. "Les Revues." *Le Thyrse* (Brussels), 4th ser., vol. 26, no. 7 (July 1, 1929), pp. 224–25.

WESCHER 1955
Wescher, Herta. "Collages and the Breakdown of Optical Unity." *Graphis* (Zurich), vol. 11, no. 57 (1955), pp. 52–59.

WESCHER 1971
Wescher, Herta. *Collage*. New York: Harry N. Abrams, [1971].

WEST 1937
West, Anthony. "No Revolution." *Axis* (London), no. 8 (Winter 1937), p. 19.

WESTERDAHL 1936
Westerdahl, Eduardo. "Joan Miró y la polémica de las realidades." *Gaceta de arte* (Tenerife), no. 38 (April–June 1936), pp. 5–18.

WESTERN MORNING NEWS 1933
"A Spanish Painter." *Western Morning News*, July 11, 1933 (in Mayor).

WESTHEIM 1938
Westheim, Paul. "Surrealismus: Internationale Ausstellung in der Galerie des Beaux-Arts." *Pariser Tageszeitung* (Paris), vol. 3, no. 595 (January 29, 1938), p. 3.

W.G. 1932
W.G. "Art in Paris." *Formes* (Paris and Philadelphia), no. 21 (January 1932), p. 210.

WHITING 1941
Whiting, F. A., Jr. "Mr. Chrysler Collects." *Magazine of Art* (Washington, D.C.), vol. 34, no. 2 (February 1941), pp. 93, 103, 105.

WHITNEY 1989
"Frederick Kiesler: Chronology, 1890–1965." In Lisa Phillips, ed., *Frederick Kiesler*. New York: Whitney Museum of American Art, 1989.

WHITTET 1964
Whittet, G. S. "Symbols of Carnival." *Studio International* (London), vol. 168, no. 859 (November 1964), pp. 224–25.

WILL-LEVAILLANT 1976
Will-Levaillant, Françoise, ed. *André Masson: Le Rebelle du surréalisme — Ecrits*. Paris: Hermann, 1976.

WOLF 1947
Wolf, Ben. "Miró Show, Delayed in Transit, Opens in N.Y." *The Art Digest* (New York), vol. 21, no. 17 (June 1, 1947), p. 10.

WOMEN'S WEAR DAILY 1941
"Miró and Dalí Art in Exhibit at Modern Museum." *Women's Wear Daily* (New York), November 24, 1941 (in The Museum of Modern Art Archives, Public Information Scrapbook no. 52).

XENIUS 1919
Xenius. "Glosari: Més Gloses en l'Exposició d'Art." *La Veu de Catalunya* (Barcelona), vol. 29, no. 7235 (June 12, 1919, evening ed.), p. 7.

XENIUS 1920
Xenius. "Las Obras y los días." *Las Noticias* (Barcelona), vol. 25, no. 8900 (October 31, 1920), p. 4.

XURRIGUERA 1929
Xurriguera, Ramon. "Les Arts: Una Estona amb Joan Miró." *La Publicitat* (Barcelona), vol. 51, no. 17218 (June 15, 1929), p. 6.

YANAIHARA 1957
Yanaihara, I. "Joan Miró and His Ceramics." *Mizue* (Tokyo), no. 619 (March 1957), pp. 3–22.

YOKOHAMA MUSEUM OF ART 1992
Joan Miró Centennial Exhibition: The Pierre Matisse Collection. Yokohama: Yokohama Museum of Art, 1992.

YORKSHIRE POST 1933
"Joan Miró." *Yorkshire Post*, July 10, 1933 (in Mayor).

Z. 1928
Z. "Els Artistes catalans a París: Exposició Joan Miró." *La Veu de Catalunya* (Barcelona), vol. 38, no. 9978 (May 25, 1928, morning ed.), p. 5.

ZAHAR 1937
Zahar, Marcel. "Miró (Galerie Pierre)." *Nouvelles Lettres françaises*, n.d. (in Palma II).

ZENON 1925
Zenon. "De París estant: Pintura sobre-realista." *La Veu de Catalunya* (Barcelona), vol. 35, no. 9203 (November 27, 1925, morning ed.), p. 5.

ZERVOS 1931
Zervos, Christian. "La Nouvelle Génération: Joan Miró." *Cahiers d'art* (Paris), vol. 6, nos. 9–10 (1931), pp. 424–26.

ZERVOS 1934
Zervos, Christian. "La Jeune Peinture: Joan Miró." *Cahiers d'art* (Paris), vol. 9, nos. 1–4 (1934), pp. 11–21.

ZERVOS 1938
Zervos, Christian. *Histoire de l'art contemporain.* Paris: Editions Cahiers d'Art, 1938.

ZERVOS 1945–46
Z[ervos], C[hristian]. "Nouvelles Acquisitions du Museum of Modern Art de New York." *Cahiers d'art* (Paris), vols. 20–21 (1945–46), pp. 421–23.

ZERVOS 1949
Zervos, Christian. "Remarques sur les oeuvres récentes de Miró." *Cahiers d'art* (Paris), vol. 24, no. 1 (1949), pp. 114–38.

Lenders to the Exhibition

The Baltimore Museum of Art
Fundació Joan Miró, Barcelona
Kunstmuseum Bern
Albright-Knox Art Gallery, Buffalo, New York
Fogg Art Museum, Harvard University Art
 Museums, Cambridge, Massachusetts
National Gallery of Australia, Canberra
The Art Institute of Chicago
The Cleveland Museum of Art
Museum Ludwig, Cologne
The Meadows Museum, Southern Methodist
 University, Dallas
The Detroit Institute of Arts
Kunstsammlung Nordrhein-Westfalen,
 Düsseldorf
Scottish National Gallery of Modern Art,
 Edinburgh
Kimbell Art Museum, Fort Worth
Fukuoka Art Museum
Sprengel Museum, Hannover
Wadsworth Atheneum, Hartford
The Menil Collection, Houston
Ohara Museum of Art, Kurashiki, Japan
Tate Gallery, London
Los Angeles County Museum of Art
Museo del Prado, Madrid
Museo Nacional Reina Sofía, Madrid
Fundació Pilar i Joan Miró a Mallorca
New Orleans Museum of Art
Solomon R. Guggenheim Museum, New York
Musée National d'Art Moderne, Centre
 Georges Pompidou, Paris
Musée Picasso, Paris
Philadelphia Museum of Art
Vassar College Art Gallery, Poughkeepsie,
 New York
National Gallery, Prague
The Saint Louis Art Museum
Fondation Marguerite et Aimé Maeght,
 Saint-Paul, France
Moderna Museet, Stockholm
Staatsgalerie Stuttgart
The Hakone Open-Air Museum, Tokyo
The Toledo Museum of Art, Ohio
Musée d'Art Moderne, Villeneuve d'Ascq
Hirshhorn Museum and Sculpture Garden,
 Smithsonian Institution, Washington, D.C.
National Gallery of Art, Washington, D.C.

The Phillips Collection, Washington, D.C.
Kunstmuseum Winterthur
Kunsthaus Zürich

Alsdorf Collection
Beyeler Collection
Mrs. Gustavo Cisneros
Stefan T. Edlis
Mrs. Roy J. Friedman
The Jacques and Natasha Gelman Collection
Hubert de Givenchy
Richard and Mary L. Gray
Stephen Hahn
Kay Hillman
Joseph Holtzman
Kazumasa Katsuta
Mr. and Mrs. Herbert J. Klapper
Alvin S. Lane
H. Gates Lloyd
The Margulies Family Collection
Collection Masaveu
Maria Dolores Miró de Punyet
Pilar Juncosa de Miró
Jose Mugrabi
The Morton G. Neumann Family Collection
A. Rosengart
Judy and Michael Steinhardt
Mr. and Mrs. A. Alfred Taubman
Richard S. Zeisler
Gustav Zumsteg

Acquavella Modern Art
Artcurial, Paris
Galerie Lelong Zürich
Galerie Maeght, Paris
Kouros Gallery, New York
The Pace Gallery, New York
Perls Galleries, New York

An anonymous lender, courtesy Berry-Hill
 Galleries, New York
An anonymous lender, courtesy The
 Metropolitan Museum of Art, New York
An anonymous lender, England, courtesy
 Scottish National Gallery of Modern Art,
 Edinburgh
37 other anonymous lenders

Credits

Photographs of works of art reproduced in this volume have been provided in most cases by the owners or custodians of the works, identified in the captions. Individual works of art appearing herein may be protected by copyright in the United States of America or elsewhere, and may thus not be reproduced in any form without the permission of the copyright owners. The following copyright and/or other photo credits appear at the request of the artist's heirs and representatives and/or the owners of individual works.

All works of Joan Miró: ©1993 Estate of Joan Miró/Artists Rights Society (ARS), New York

The following list applies to photographs for which a separate acknowledgment is due, and is keyed to page numbers. For clarity, illustrations in the Catalogue section are also identified by *cat.* numbers and those in the Appendix to the Catalogue by *app.* numbers.

David Allison: 159, 183 top, 224, 225, 263, 280 bottom, 389 (cat. 70, left), 398 (cat. 97), 426 (cat. 194)

Oliver Baker: 404 (cat. 118)

Scott Bowron, New York: 155, 177, 203, 213 bottom, 255, 405 (cat. 123, left), 409 (cat. 137), 422 (cat. 180)

Will Brown, Pennsylvania: 249, 419 (cat. 167)

M. Bühler, Basel: 148, 180, 388 (cat. 68), 395 (cat. 89, left)

Christopher Burke, New York: 335, 337 top, 340 bottom

Javier Campano: 144, 288

©Martí Català: 25 top, 401 (cat. 108, right)

©F. Català-Roca: 25 middle, 30 far left, 30 second from left, 30 second from right, 34, 37 right, 56, 57 bottom, 59 bottom, 68 top left

The Art Institute of Chicago: 37 left bottom, 301, 435 (app. 19, left); ©1990, 194, 257, 402 (cat. 112), 411 (cat. 142, left); ©1991, 114; ©1992, 132, 184 bottom, 212 bottom, 217, 376 (cat. 33, left), 380 (cat. 44, left), 398 (cat. 99), 409 (cat. 135), 421 (cat. 175)

©1993 Jacques Gael Cressaty: 244, 417 (cat. 162)

Beno Dermond: 110

©The Detroit Institute of Arts: 229; ©1991, 413 (cat. 147)

Rory Terence Doepel: 320 top

Walter Dräyer, Zurich: 271, 274, 370 (cat. 19), 400 (cat. 104), 426 (cat. 192)

Courtesy "Editions Cahiers d'Art": photographs by Joaquim Gomis, 73 top right, center right, bottom left

Susan Einstein Photography, California: 165, 393 (cat. 81, left)

Ali Elai: 251, 252, 419 (cat. 169), 420 (cat. 170)

Jacques Faujour: 147, 154

Fondation Marguerite et Aimé Maeght, Saint-Paul, France: photograph by Claude Gaspari, 307

Galerie Lelong Zürich: photograph by Michel Nguyen, 220 top; photograph by Hans Humm, 221 top

Claude Germain: 116, 117, 375 (cat. 30), 376 (cat. 31, left)

©The Solomon R. Guggenheim Foundation, New York: 23, 35 top left, 111, 130; ©1989, 390 (cat. 73, left); photographs by David Heald, 89, 158, 163, 237, 415 (cat. 155); photograph by David Heald and Myles Aronowitz, 374 (cat. 27); photograph by Robert E. Mates, 366 (cat. 8), 380 (cat. 43, left); photograph by Carmelo Guadagno, 392 (cat. 78, left)

Peter Harholdt, Maryland: 207, 406 (cat. 126)

Harvard University Art Museums, Cambridge, Massachusetts: ©President and Fellows, Harvard College, 388 (cat. 67, left); Fogg Art Museum, photograph by Bob Kolbrener, Saint Louis, 151

Helga Photo Studio: 377 (cat. 34, left)

Hirshhorn Museum and Sculpture Garden, Smithsonian Institution, Washington, D.C.: photograph by John Tennant, 150; photograph by Lee Stalsworth, 388 (cat. 69)

Jacqueline Hyde, Paris: 122, 126 top, 172, 182 bottom left, 330 bottom, 334

Enrique Juncosa: 318

Kimbell Art Museum, Fort Worth: photograph by Michael Bodycomb, 92 top

Bob Kolbrener: 143, 386 (cat. 60, left)

©Dan Kramer: 153

Kunstmuseum Bern: photograph by Peter Lauri, Bern, 1991, 189

Kunstsammlung Nordrhein-Westfalen, Düsseldorf: photographs by Walter Klein, 369 (cat. 17), 382 (cat. 50, left), 402 (cat. 113)

Los Angeles County Museum of Art, ©1991 Museum Associates: 44, 407 (cat. 129)

Etude Loudmer: 176 bottom left, 434 (app. 10, left)

The Menil Collection, Houston: photographs by Hickey and Robertson, 181, 396 (cat. 90, left)

©Claude Mercier: 174

The Metropolitan Museum of Art, New York: 52 bottom, 368 (cat. 15), 389 (cat. 71), 392 (cat. 79, left), 393 (cat. 80, left), 416 (cat. 159), 420 (cat. 171); ©1992, 93; ©1993, 164; ©1988, photograph by Malcolm Varon, 253; ©1988–90, photographs by Malcolm Varon, 99, 161, 166; ©1988–92, photograph by Malcolm Varon, 241

©1992 Miller/Silver Photography, Chicago: 210 top, 407 (cat. 130)

Enric Miralles: 393 (cat. 80, right)

Marc Morceau: 178

Peter Muscato: 286 right

©Musée National d'Art Moderne, Centre Georges Pompidou, Paris: 43, 219, 223, 289, 405 (cat. 121), 411 (cat. 144, left), 424 (cat. 184), 433 (app. 6, left), 434 (app. 8, left); photographs by Philippe Migeat, 126 bottom, 127 bottom, 201, 269, 308 left; photographs by Jacques Faujour, 182 bottom right, 254

The Museum of Modern Art, New York: photographs by David Allison, 127 top, 162, 268, 282 bottom, 366 (cat. 10), 383 (cat. 51, left), 422 (cat. 179), 434 (app. 7, left); photograph by Colten, 421 (cat. 176); photographs by Kate Keller, 24 bottom, 53, 92 bottom, 108, 109, 113,

125 top, 133, 139, 152, 170, 173 bottom, 179, 182 top, 191, 192 top, 195, 198, 204, 227, 228, 236, 239, 258, 276–77, 278, 290–91, 294, 340 top, 391 (cat. 77, right), 393 (cat. 82, right), 395 (cat. 86, left), 395 (cat. 87, right), 399 (cat. 102), 401 (cat. 109, right), 416 (cat. 157), 429 (cat. 201, left), 429 (cat. 202, left), 429 (cat. 203, left), 433 (app. 3, left); photograph by Robert E. Mates and Paul Katz, 425 (cat. 189); photographs by James Mathews, 300, 382 (cat. 49, left), 404 (cat. 119), 430 (cat. 205), 435 (app. 18, left); photographs by Mali Olatunji, 105, 184 top, 218, 279, 286 left, 371 (cat. 20), 425 (cat. 190); photographs by Eric Pollitzer, 415 (cat. 154), 426 (cat. 191, bottom); photographs by Soichi Sunami, 26, 35 top right, 47, 115, 373 (cat. 24), 373 (cat. 25), 375 (cat. 29, left), 376 (cat. 32, left), 383 (cat. 54, left), 391 (cat. 77, left), 393 (cat. 82, left), 396 (cat. 92, left), 401 (cat. 109, left), 403 (cat. 116), 406 (cat. 124), 411 (cat. 143, left), 412 (cat. 145), 412 (cat. 146); photograph by Charles Uht, 403 (cat. 114)

©National Gallery, Prague: photograph by Oto Palán, 190; photograph by Jaroslav Jeřábek, 401 (cat. 108, left)

National Gallery of Art, Washington, D.C.: ©1992, 121; ©1993, 20 bottom, 371 (cat. 22), 378 (cat. 39, left); photograph by Philip A. Charles, 107

Oeffentliche Kunstsammlung Basel: photograph by Martin Bühler, 32

The Pace Gallery, New York: 287

©Philadelphia Museum of Art: photograph by Will Brown, 370 (cat. 18); photograph by Graydon Wood, 377 (cat. 36, left)

©The Phillips Collection, Washington, D.C.: 272, 424 (cat. 186)

Photo du Perron: photograph by Jean Netuschil, 97

Eric Pollitzer, New York: 380 (cat. 42, left)

©Postals Tretzevents, Barcelona: photograph by Melba Levick, 61

Antonia Reeve Photography, Edinburgh: 129

©Réunion des Musées Nationaux, Paris: 46, 101, 104, 368 (cat. 14), 371 (cat. 21), 387 (cat. 64, left)

©Rheinisches Bildarchiv, Cologne: 141, 383 (cat. 53, left)

©Jacques D. Rouiller: 84

Rafael Salazar, Miami: 246

Gonzalo de la Serna: 215, 410 (cat. 139)

©Statens Konstmuseer/Moderna Museet, Stockholm: 367 (cat. 12), 381 (cat. 46, left); photograph by Tord Lund, 96; photograph by Anders Allsten, 135

©Kjell Söderbaum AB: 124 top

Jim Strong: 402 (cat. 110)

Duane Suter: 283, 427 (cat. 196)

©Tate Gallery, London: 231, 413 (cat. 148)

Michael Tropea: 52 top right, 86, 112, 124 bottom, 167, 176 top, 193 left, 205, 275, 341, 391 (cat. 75), 402 (cat. 111), 406 (cat. 125), 425 (cat. 188), 433 (app. 5, left), 434 (app. 9, left)

Joan-Ramon Bonet Verdaguer: 222, 293, 310 left

©Wadsworth Atheneum, Hartford: photograph by E. Irving Blomstrann, 418 (cat. 165)

©1992 Sarah Wells: 418 (cat. 163)